# Guide
# to the Literature
# of Art History

# Guide to the Literature of Art History

Etta Arntzen
Robert Rainwater

American Library Association, Chicago
The Art Book Company, London
*1980*

Published 1980 by

AMERICAN LIBRARY ASSOCIATION
  50 East Huron Street, Chicago, Illinois 60611
  ISBN 0-8389-0263-4

THE ART BOOK COMPANY
  91 Great Russell Street, London WC1B3PS, England
  ISBN 0-905309-05-7

**Library of Congress Cataloging in Publication Data**

Arntzen, Etta.
  Guide to the literature of art history.

  Includes indexes.
  1.   Art—Historiography—Bibliography.
I. Rainwater, Robert, joint author.   II. Title.
Z5931.A67 [N380]      016.709      78-31711
ISBN 0-8389-0263-4

For Our Friends in the
New York Public Library

# Contents

ix

# Contents

# Preface

This bibliography has its roots in the pioneering work of the late Mary W. Chamberlin. Her intention in the *Guide to Art Reference Books* (ALA, 1959) was "to organize and to evaluate the vast and ever growing literature of art history—the basic reference works as well as the resources for the most advanced research." Although probably impossible twenty years later, this is nonetheless our intent for this publication.

Since 1959 there has been an enormous increase in the numbers of art historians, art connoisseurs, art collectors, good art books, periodicals, reprints, exhibitions, important exhibition catalogues, collections, catalogues of collections, and published catalogues of art libraries. New indexes and bibliographies continually reflect the changed picture of the world of art; photographic reprinting and computer indexing have now come into their own.

What we began in 1971 as a revision and updating of a basic art bibliography has become a largely new work. Although approximately 40 percent of the titles in the Chamberlin *Guide* are listed here, most of these have been rewritten and brought up-to-date with additional volumes, later editions, notes on reprints, closing dates, and so on. Decisions on individual titles were based on a critical re-examination of the books in the light of more recent literature. Even so, a limited number of pre-1959 publications, not in Chamberlin, can be found here.

This guide is addressed primarily to persons doing serious subject research in the field of art history. It is intended for graduate students laying the groundwork for research efforts and for art historians, in particular those who seek background and specific information outside of their areas of specialization. It will also be valuable to librarians who are concerned with the acquisition and use of art literature. We have kept in mind others who have relied on Chamberlin—collectors, scholars in the related humanistic disciplines, bibliographers, writers, editors, booksellers, and reprint publishers. The bibliography is not a reading list, yet certain sections may directly or indirectly assist college students and interested general readers.

The organization is based on Chamberlin, but with modifications. The major subjects included are painting, sculpture, architecture, prints, drawings, photography, and the decorative arts. The treatment of archaeology is selective, having been limited to basic reference literature and general works in an art-historical nature. A few works on the history of urban planning and landscape architecture are classified as architecture. Aesthetics, the philosophy of art, and art criticism are treated only peripherally in the

chapters on bibliography, historiography, and periodicals, and are reflected in the histories and handbooks sections. Among those subjects excluded or marginally included are advertising art, theater and festival arts, film, numismatics, seals, and guidebooks.

Following the Chamberlin precedent, monographs on individual artists are not included. We have included, however, certain important exhibition catalogues, those which clearly represent the most advanced research in a subject. For similar reasons, a few catalogues of great art collections have been listed.

Most of the titles are in Western languages; for those few in non-Western languages the transliterated forms are given. The bibliographies should lead the student to more advanced research in the art of Russia and the Eastern European countries and the Orient. Finally, since this guide is addressed to the English-speaking student, whenever possible English translations are listed.

The selection of the new titles has been grounded in the critical examination of virtually all of the books, with attendant bibliographic research. The choices reflect the background and experience of the compilers as art historians with particular knowledge and interests, and as art librarians who have assisted art historians, artists, students, and general readers with a myriad of topics and requests. Further, we have been advised by other art historians on the literature in their particular subjects; and we have talked with art librarians about the value of specific reference tools.

The bibliography is divided into four broad catagories: general reference sources, materials for the study of art history, literature concerning the various media, and serials. Within each category, the number of subdivisions depends upon the amount of material to be organized. The arrangement within the divisions is alphabetical. Cross-references have been selective—the detailed subject index is intended to bring related material together. Books in the important monographic series, such as *The Pelican History of Art* and the *Propyläen Kunstgeschichte* are listed twice, both with the series and as individual works. Each entry is assigned a letter-number code. The letter sequence for the various chapters is alphabetical.

The cut-off date is 1977, although a few later works and a few important books which are projected or in press are listed. A very few of the books were unavailable for examination. These have been listed without annotation or with information taken from publisher's prospectuses or authoritative reviews.

# Acknowledgments

This bibliography was prepared with the financial assistance of a grant from the Council on Library Resources. I am also indebted to the University of Georgia for a summer research grant and a research quarter during which I was able to work full-time on the book.

The preliminary thinking and a great deal of the subsequent research were done in the great institutions of New York City. My collaborator, Robert Rainwater, and I owe an inestimable debt, tangible and intangible, to our professors, fellow students, and librarian colleagues in New York and elsewhere.

The late Mary Chamberlin left some notes for a supplement to her *Guide;* most of these are incorporated in this bibliography. My appreciation and professional respect for her work have not diminished over the past nine years. Like Miss Chamberlin before me, I am indebted to Rudolf Wittkower. If the sections on Italian art, sources, and documents have particular critical value, it is because they reflect my long association with the late Professor Wittkower, first as a student and then as a colleague at Columbia University. Eight years ago Professor Robert Branner, now deceased, reviewed the entries for medieval art. He characteristically gave firm and authoritative suggestions as to what should be taken out and what should be added.

Professor Edith Porada, Columbia University, looked over and amended the sections on Egypt and the Ancient Near East; she gave me notes with critical comments and advised me of forthcoming books and research in progress. Professor Alfred Fraser, Columbia University, reviewed and augmented lists of entries for the literature of Roman and Early Christian architecture. I wish especially to thank Adolf K. Placzek, Librarian of Avery Library, for much-needed encouragement and help in this, and in other projects. Herbert Mitchell, Avery Library, has generously shared his extensive knowledge of rare books and prints. Mary Schmidt, former Fine Arts Librarian at Columbia University, has frequently given us information on books and excellent advice.

Professor Alexander Soper, Institute of Fine Arts, New York University, generously reviewed Mr. Rainwater's lists of books on Oriental art, making invaluable comments and suggestions. Mr. Rainwater also consulted with Roald Nasgaard, Art Gallery of Ontario, on the literature of Canadian art, Scandinavian art, and various fields of 19th- and 20th-century art. Ella Milbank Foshay, Vassar College, contributed considerable time and expertise to the areas of American painting and sculpture.

Julia Van Haaften, the New York Public Library, compiled the completely new chapter on Photography, her field of special knowledge and interest. She also undertook the major part of revising, editing, and adding to the Chamberlin list of periodicals.

In the field of the decorative arts, I have been most fortunate to have had the collaboration of a friend, Ronald Freyberger. The critical notes on the literature of French furniture and collections are largely his. And Mr. Freyberger relayed Winthrop Edey's pertinent comments on the literature of clocks and watches. Morrison Heckscher, Metropolitan Musem of Art, checked through the sections on British and American furniture. Peter Rainey, formerly at the New York Public Library and an authority on Oriental carpets and rugs, presented us with an excellent annotated bibliography of books on the subject. Zillah Halls generously reviewed the Chamberlin entries on costume and advised on revisions and additions.

Several people have assisted with the typing, bibliographical research, editing, and occasionally with the preliminary writing of annotations. Many thanks go to H. Ward Jandl for his substantial help in preparing the entries for books in his field of modern architecture, and for his fast and accurate typing of considerable portions of the manuscript. Mary Lea Bandy brought to the *Guide* her professional experience as an editor of art books. She checked and edited large parts of the manuscript. Maryellen Thirolf assisted with bibliographical research in the University of Illinois libraries and prepared the typescript of major portions of the longest chapters. My gratitude goes to Linda McGreevy, University of Georgia, who worked part-time on the bibliography for over a year, doing bibliographical research, typing, and some drafts of annotations. I had the good fortune to find in Larry Logan a master in the art of meticulous library research. Mr. Logan has solved many bibliographical muddles in the University of Georgia library and in the libraries of the University of North Carolina and Duke University. Further, he has shared the work of numbering the entries, the making of cross-references, additions, and retyping. Two other graduate students at the University of Georgia, Thomas Pitts and Elizabeth Walter, worked for shorter periods of time during the earlier stages of the bibliography.

Although we worked in several large libraries in New York and elsewhere, the home library for the bibliography has been the New York Public Library. We are especially indebted to the librarians and staff of the Art and Architec-

ture Division and the Prints Division. Joseph T. Rankin, Curator of the Arents and Spencer Collections (formerly Chief of the Art Division), has given us encouragement and professional counsel from the start. Donald Anderle, Chief of the Art Division, has helped to solve any number of bibliographical problems and has kept us informed about new publications. We would like to express special thanks to other friends who serve in the Art Division: David Combs, Anthony Cardillo, Jerry Romero, and Julia Van Haaften. They have assisted with critical evaluations of reference tools, as well as with suggestions for additions to the *Guide*. Gloria Deák willingly provided us with her superb editorial skills whenever needed and throughout our task offered words of understanding and encouragement. Roberta Waddell, formerly of the Prints Division, now at the Toledo Museum of Art, checked and evaluated the literature on all areas of prints. Elizabeth Roth, Keeper of Prints, shared her knowledge of print reference literature and informed us promptly of new works in the field. And there are many others from the other divisions of the Library, too numerous for individual acknowledgment.

Elizabeth Usher, Librarian of the Metropolitan Museum of Art, and the staff of the library have been helpful in making available books from the Museum's collection. We are also indebted to scholars in the Pierpont Morgan Library: Felice Stampfle, Curator of Drawings and Prints, and William Voelkle, Curator of Autograph Manuscripts, for recommendations in the areas of drawings and Christian iconography.

I am indebted to the librarians of the University of Illinois, Champaign-Urbana, where I worked during summers and holidays. I am grateful to Dee Wallace, Librarian of the Ricker Library of Architecture, for her suggestions, professional advice, above all for her sustained enthusiasm and belief in the potential value of the bibliography.

Fellow art historians at the University of Georgia have given recommendations and other assistance in their special fields. This book owes much to Alice Fischer. She has pointed out the value of any number of scholarly reference books; and she has advised me of fundamental books in the area of medieval art. The reference librarians at Georgia have been extremely helpful. Vivian Branch Phillips, Associate Professor Emeritus, can be credited with the building up of a fine reference collection, and she provided superb reference service. Leslie Friedman and Marykay Witlock, art bibliographers, have greatly facilitated bibliographical research.

We would also like to thank Herbert Bloom and Bonnie Oberman for their professional suggestions, editorial assistance, and their patience in the complex preparations of the manuscript for press.

My last acknowledgment is both professional and personal. My sister, Mary Vance, gave sound professional counsel when tough decisions had to be made. And she and the other members of our family have given encouragement and moral sustenance during the nine long years of work on this bibliography.

Etta Arntzen

# General Reference Sources

# A.
# Bibliography

The art bibliographies listed in this chapter are general in nature inasmuch as they include entries for more than one art medium. Those dealing exclusively with architecture, painting, sculpture, prints, photography, and the decorative arts are classified with these subjects, and the general bibliographies of iconography are to be found in chapter F, Iconography.

For a good summary of the current state of art bibliography see *Bibliographie d'histoire de l'art* (A23).

---

## CURRENT SERIALS

A1    Art and archaeology technical abstracts. v.1, 1955- . London; N.Y., Institute of Fine Arts, New York Univ. for the International Institute for Conservation of Historic and Artistic Works (called 1955-58, International Institute for the Conservation of Museum Objects), 1955- .

Continues Gettens and Usilton (A36).

Title varies: 1955-57, *Studies in conservation. Études de conservation. I.I.C. abstracts;* 1958-65, *I.I.C. abstracts; abstracts of the technical literature on archaeology and the fine arts.*

Classified abstracts of publications dealing specifically or relatedly with the examination, investigation, analysis, restoration, preservation, and documentation of works of artistic or historic interest. Includes reports on physical or chemical properties of substances important in the structure of art objects. Also includes articles of general interest to professionals in all fields of conservation.

Contents: (A) General methods and techniques; (B) Paper; (C) Wood; (D) Fiber and textiles; (E) Paint and paintings; (F) Glass and ceramics; (G) Stone and masonry; (H) Metals; (I) Other natural and synthetic organic materials. Bibliographies on special topics published as supplements.

A2    Art exhibition catalogues on microfiche, 1- , ed. by Alice Mackrell, Donald E. Gordon, and Bernard Karpel. Cambridge, Chadwyck-Healey, 1974- . (Distr. in U.S. by Somerset House, Teaneck, N.J.) Irregular.

Annual index, 1976- .

Periodic lists of out-of-print art exhibition catalogues which are being reprinted on microfiche. Classified by subject and place. "The purpose of the series is to make available once again those catalogues that have lasting interest through their text or their illustrations. While early lists can only contain a selection of the many thousands of catalogues published in the last century, every aspect of art will eventually be covered and the series will contain out-of-print publications of museums and galleries throughout the world."—*Introd.* The annual index lists catalogues by keywords, subject, museum or gallery, and the serial numbers of the microfiches.

The first lists include general selections, 575 exhibitions organized by the Arts Council of Great Britain, a selection of pre-1926 catalogues from the library of the Victoria and Albert Museum, catalogues from surrealist exhibitions, and catalogues of the national museums of France.

A3    Art index; a cumulative author and subject index to a selected list of fine arts periodicals and museum bulletins. v.1- , Jan. 1929- . N.Y., Wilson, 1930- . Issued quarterly, with an annual cumulation in September; three-year cumulations.

The most up-to-date continuing bibliography of periodical literature on art and a basic tool for art research. Subjects: art, archaeology, architecture, arts and crafts, ceramics, decoration, landscape architecture, painting, photography, sculpture, and urban design.

The list of periodicals is reviewed approx. every ten years by a committee of the American Library Assn.; recommendations for additions and deletions are submitted to the subscribers for the final decision. The latest change in periodicals indexed began with the April 1979 issue. Includes book reviews (from 1974 under heading *Book Reviews*). Illustrations without text indexed under the names of the artists.

List of periodicals indexed at the beginning of each volume.

A4    Art/Kunst. International bibliography of art books. 1972- . Basel, Helbing & Lichtenhahn, 1973- . Annual.

The only annual international bibliography of art books. Based upon information provided by publishers. Includes

some exhibition catalogues. Does not include deluxe editions. Classified (general aesthetics, art epochs, art forms, techniques, etc.). Prices indicated.

Index of authors, editors, and artists.

A5    ARTbibliographies CURRENT TITLES. Santa Barbara, Calif., ABC-CLIO; Oxford, Eng., EBC-CLIO, v.1, no. 1, Sept., 1972- . Monthly, except for July and August.
Editor: Peter Fitzgerald.

A photographic reproduction of the tables of contents of approx. 250 periodicals. Arranged alphabetically by title of periodical. International coverage. Helps the scholar keep up with recent literature.

A6    "Bibliographical survey of publications in the field of art history and several related areas published in the Netherlands." Published in *Simiolus*, v.1. 1966/67- .
Compilers: P. Hecht and D. P. Snolp, with the help of E. Grosfeld.

A classified bibliography of books and articles published in the Netherlands. The bibliography for one year appears at the end of the following year. Exhibition catalogues and book reviews are included on a selective basis.

Contents: List of periodicals surveyed (approx. 60); General; Architecture; Applied arts; Iconology, art theory, aesthetics, and Early Christian art; Painting, sculpture, graphic arts, printing; Catalogues and exhibition catalogues.

A7    Bibliographie zur kunstgeschichtlichen Literatur in ost- und südosteuropäischen Zeitschriften. (mit Nachträgen) Jahrg. 1- 1971- . München, Zentralinstitut für Kunstgeschichte, 1974- .
"Unter Mitarbeit von Eva Benko (Budapest), Miodrag Jovanovic (Belgrad), Michael Liebmann (Moskau), Ioana Popovici (Bukarest), Jaroslav Slavik (Prag) und Bozena Steinborn (Wroclaw) redigiert von Hilda Lietzmann."

A continuation of *Bibliographie zur kunstgeschichtlichen Literatur in slawischen Zeitschriften* (A8) with a new title and numbering beginning with Bd. 1. Expanded to encompass the art literature in Hungarian, Rumanian, and Albanian periodicals. Journals issued in the following countries are analyzed: Albania, Bulgaria, Yugoslavia, Poland, Russia, Rumania, Czechoslovakia, and Hungary. The articles are classified into general works and then by country and medium. There are several articles on art in the countries of Western Europe and the U. S.

Index of authors.

A8    Bibliographie zur kunstgeschichtlichen Literatur in slawischen Zeitschriften. München, Zentralinstitut für Kunstgeschichte, 1965-72. Folge 1-5, 1960/63-1969/70.
Printed in a small ed. A current index of articles on art history (from late antiquity until c. 1945) in Russian, Polish, Czech, Yugoslavian, and Bulgarian periodicals. v.5 analyzes 1,675 articles in 82 journals. Arranged by country, and then by medium. Index of authors, artists, and places. Continued by *Bibliographie zur kunstgeschichtlichen Literatur in ost- und südosteuropäischen Zeitschriften* (A7).

A9    Cataloghi d'arte: Bolletino primario. Art catalogues: Primary bulletin. Florence, Centro Di, 1971- . Bimonthly.
Italian and English.

A listing of exhibition catalogues. International coverage. Divided into ancient and modern art. Each entry includes title, place of exhibition, name of body organizing exhibition, name of museum or private collection, publication date, author or authors of text, references to subjects and artists, language or languages of text, number of pages, and illustrations. Compiled by data processing.

A10    Cataloghi d'arte: Indici analitici. Art catalogues: Analytical indexes. Florence, Centro Di, 1971- . Issued twice a year, the last issues being cumulative.
Analytical indexes to the exhibition catalogues listed in *Cataloghi d'arte: Bolletino primario* (A9). The catalogues are analyzed as follows: (1) Alphabetical listing of titles; (2) Classification by media, style, subjects, and historical, geographical, or cultural subdivisions which are further subdivided by period; (3) Artists; (4) Places of exhibitions; (5) Museums or private collections. Computer indexing.

A11    Istituto Nazionale d'Archeologia e Storia dell'Arte. Rome. Biblioteca. Annuario bibliografico di storia dell'arte, anno I- , 1952- . Modena, Soc. Tip, Modenese, 1954- .
Compiler: Maria Luisa Garroni. Anno XI-XVI (1962-67) in 2v., comp. by Antonella Aquilina, Agnese Fantozzi, Maria Sicco, Anna Maria Tomassini.

A classified bibliography of art books and periodical literature acquired by this large research library in Rome. The entries in v.I-X have annotations; those in v.XI-XVI do not.

Indexes of abbreviations, authors, and proper names.

A12    Literaturbericht zur Kunstgeschichte. Deutschsprachige Periodika, 1971- . Hrsg. Staatliche Museen Preussischen Kulturbesitz, Berlin. Berlin, Mann, 1975- .
Editors: Verena Haas and Stephan Waetzholdt.

A continuing bibliography of articles on art history in German-language periodicals. (This bibliography has not been examined by the compilers.)

A13    Novinky literatury. Umění. 1964-. [Praha] Státní knihovna ČSR. 1964-.
Supersedes in part *Novinky literatury. Společinské vědy. Řada III: Jazykověda, literární věda, umění.*

Title varies. Issued ten times a year, 1964-70; quarterly 1971- .

Series 7 of *Novinky literatury* (New Literature) is a current general bibliography of the visual and performing arts. Includes articles in periodicals. Classification: aesthetics, theory, city planning, architecture, sculpture, painting, graphic arts, film, music, ballet, radio, and television. Author index in each issue. Up-to-date.

A14    Répertoire d'art et d'archéologie. Paris, Éditions du Centre National de la Recherche Scientifique. 1st ser., v.1-68, 1910-64. n.s., v.1- , (année 1964) 1965- .

At head of title: Comité International d'Histoire de l'Art.

"Publié sous la direction du Comité Français d'Histoire de l'Art, avec une subvention de l'Organisation des Nations Unies pour l'Education, la Science et la Culture, sur la recommandation du Conseil International de la Philosophie et des Sciences Humaines."—*Title page of 1st ser.*

Publisher of o.s. varies.

Reprints of first 42v., 1910–37: Nendeln, Liechtenstein, Kraus, 1969.

By far the most comprehensive international bibliography of current art literature. A classified listing of books and periodical articles (including Festschriften), with short descriptive entries. Volumes through v.8 (o.s. v.76, année 1972) contain a detailed classification plan at the beginning of each volume and alphabetical author and artist indexes at the end. Beginning with v.9 (o.s. v.77), the *Répertoire* is issued quarterly and with a modified arrangement. The table of contents; list of publications indexed; indexes of artists, subjects, and authors; and classification plan appear at the beginning of the volume. Chronological classifications cover longer periods of time.

Beginning with the n.s., antiquity, Islam, and the Far East (except for the 20th century) have been eliminated. Primitive art is not included; indexing for 20th-century art is more selective.

A15   RILA: Répertoire international de la littérature de l'art. International repertory of the literature of art. [Williamstown, Mass.] College Art Assn. of America [1975–]. v.1– .

v.1 of *RILA* is a double issue which covers publications primarily of 1974 and the first half of 1975. Beginning with v.2, issues are normally published twice a year, with a complete author-subject index for each issue.

"RILA publishes abstracts and detailed subject indexes of current books, periodical articles, newspaper articles, Festschriften, congress reports, exhibition catalogues, museum publications and dissertations in the field of post-classical European and post-Columbian American art. Bibliographical citations and abstracts are collected from the authors of the publications cited with the assistance of numerous libraries, museums, academic institutions, publishers and editors, and from a variety of published and unpublished sources including bibliographies, periodical indexes and journal summaries. . . ."—*Notes on contents.* Modeled on *RILM (Répertoire international de littérature musicale).*

Contents of v.1, pt. 1, Abstracts: Preface; Reference works; General works; Medieval art, 4th–14th centuries; Renaissance and Baroque art; Modern art, 19th–20th centuries; Collections; Exhibitions; Abbreviations. Pt. 2 of v.1 is the index.

A demonstration issue, published in 1973, contained approx. 1,300 periodical articles, 250 books, 200 exhibition catalogues, 12 Festschriften, and 25 dissertations.

A16   "Svensk konsthistorisk bibliografi," no. 1, 1959– . Published annually in *Konsthistorisk tidskrift,* v.29, 1960– .

For its first seven years, the annual bibliography appeared at the end of the following year; since 1969, after every two years.

A classified bibliography of all art historical literature written in Swedish, works by foreign authors on Swedish art, and all literature by Swedish authors regardless of language or subject.

A17   The Worldwide art catalogue bulletin. v.1– . Boston, Worldwide Books, 1963– . Quarterly.

A continuing bibliography of international exhibition catalogues. The entries include annotations and Library of Congress classification numbers. Each issue has an index; the annual index lists catalogues by artist, medium, subject, and art historical period.

A18   Zeitschrift für Kunstgeschichte: Bibliographischer Teil. Berlin, Deutscher Kunstverlag, 1931– .

Editor: Hilda Lietzmann.

Since 1959 this bibliography has constituted the last issue (Nov.-Dec.) of the *Zeitschrift für Kunstgeschichte.* The bibliography for a given year appears in the last issue of the *Zeitschrift* of the following year. From 1959 on, each bibliography has had its own pagination and author index.

Scope: 500 A.D. to 1850 A.D.

The size has been limited to between 3,000 and 3,500 entries. The selective nature and quality of the selections make this international bibliography unique and indispensable for the art historian.

## RETROSPECTIVE

A19   Art Institute of Chicago. Ryerson Library Index to art periodicals. Boston, Hall, 1962. 11v.

1st supplement, 1975.

A unique subject index to periodical literature dating from 1907. Supplements *Art index* (1929–   ); also indexes major foreign periodicals during those years when these were suspended by *Art index.* Subjects included are painting, sculpture, and the decorative arts. Contains many analytics of museum publications.

"The *First Supplement* to the *Index to Art Periodicals* represents indexing activity from 1961 to October, 1974. A glance at the list of titles and volumes reveals that the *Supplement* covers a number of substantial runs but also, firstly, older but previously lacking volumes and issues of titles included in the *Index to Art Periodicals;* and secondly, retrospective indexing of titles added in 1969 to the coverage of the *Art Index.*"—*Pref.*

A20   Berlin. Staatliche Museen. Kunstbibliothek. Verzeichnis der Zeitschriftenbestände in den kunstwissenschaftlichen Spezialbibliotheken der Bundesrepublik und West-Berlin. Berlin, Mann, 1973. xvi, 621p.

Editor: Marianne Prause.

A union list of over 12,000 art periodicals in West Germany, West Berlin, the Biblioteca Hertziana in Rome, and the Kunsthistorisches Institut in Florence.

A21    Besterman, Theodore. Art and architecture; a bibliography of bibliographies. Totawa, N.J., Rowman and Littlefield, 1971. 216 p. (The Besterman world bibliographies)

Includes all separately published art bibliographies from the 4th ed. of Theodore Besterman, *A world bibliography of bibliographies,* 4th ed., 1965–66.

Contents: Art; Archaeology; Architecture; Towns, town planning; Ceramics; Painting; Posters; Cinematography; Special subjects. No index.

A22    Bibliografia del libro d'arte italiano. Roma, Bestetti [1952–74]. 3v. il.

v.1 comp. by Erardo Aeschlimann.

A bibliography of art literature published in Italy, but not limited to Italian art. Especially useful for exhibition catalogues and publications of the many congresses held in Italy.

Classifications of v.1 (1940–52), v.2 (in two parts, 1952–62), and v.3 (1963–70) are similar, including sections on art, archaeology, architecture, decorative arts, city planning, sculpture, painting, prints and drawings, monographs on artists, guidebooks, exhibition catalogues, periodicals, and acts of congresses and conventions.

A23    Bibliographie d'histoire de l'art. Paris, Éditions du Centre National de la Recherche Scientifique, 1969. xii, 237p. (Colloques internationaux du Centre National de la Recherche Scientifique. Sciences humaines)

Forty papers of an international conference (1969) on the bibliography of the history of art (organized by the Comité Français d'Histoire de l'Art). The papers provide a valuable summary of the state of art historical documentation in Europe and the United States. The reports are in French, German, or English, with resumés in two of these languages.

Contents: (I) Recherches scientifique et bibliographique d'histoire de l'art; (II) Les bibliographies nationales et l'histoire de l'art; (III) Les bibliographies internationales en sciences humaines et la bibliographie d'histoire de l'art; (IV) Les besoins et les ambitions de l'histoire de l'art: bibliographie et documentation internationales ou speciales; (V) Méthodes traditionnelles et techniques modernes dans la bibliographie d'histoire de l'art; (VI) La cooperation internationale dans les projets de formalisation et d'automatisation pour l'histoire de l'art.

A24    Bleha, Josef, ed. Bibliografie české výtvarně umělecké literatury, 1918–1958. V. Praze, Státní knihovna ČSSR, 1960. 315p. (Bibliograficky katalog ČSSR. České knihy, 1960. Zvlaštni seš. 7, prosinec 1960)

A list of the art literature published in Czechoslovakia between 1918–58. Classified as follows: General art history; Art history of Czechoslovakia and other countries; Museums, historic preservation, restoration; Iconography; Places; Artists' monographs.

A25    Borroni, Fabia. "Il Cicognara"; bibliografia dell'archeologia classica e dell'arte italiana. Firenze, Sansoni, 1954–67. 2v. in 30 parts. il. (Biblioteca biblio-grafica italica. 6, 7, 10, 11, 19, 23, 25, 27, 29, 31, 32, 34)

The title "Il Cicognara" was inspired by the famous bibliography of Count Cicognara (A28). The new "Cicognara" is a worthy successor, being a comprehensive listing of the sources of classical archaeology and Italian art. Not limited to Greece, Rome, and Italy, although the emphasis is on these subjects. Arranged by sections (see below); within each section the works are listed by date of publication. Thorough bibliographical descriptions with listings of editions and variants. Annotations consist of quotations from critical bibliographical sources, *i.e.* Schlosser, Brunet, Graesse, etc. Illustrated with facsimiles of title pages. Must be used with tables of contents and indexes.

Contents: v.1, t.I: Opere bibliografiche citate; pt. 1, Bibliografia; pt. 2, Cataloghi di biblioteche d'arte e di libri d'arte; pt. 3, Enciclopedie, lessici e dizionari; pt. 4, Estetica; t.II: pt. 5, Orazioni, accademiche, dissertazioni, conferenze; pt. 6, Poemetti didascalici e sulle arti; pt. 7, Tecnica; pt. 8, Conservazioni e restauro (a) opere generali, (b) applicazioni in ordine topografico, (c) mostre, (d) varie.

v.2, t.I: Archeologia classica; pt. 1, Trattati e letteratura periegetica; pt. 2, Metodologia, manuali, opere generali; pt. 3, Congressi e convegni; pt. 4, Cataloghi; t.II: pt. 5, Musei; t.III: pt. 6, Periodici; pt. 7, Viaggi nel mondo classico; t.IV: pt. 8, Topografia (A-Great) -(Grecia-Rodiapoli)-Roma [1471–c.1850]. Roma (dal 1851)-Zurigo; t.V: pt. 1, Manuali, fonti, repertori; pt. 2, Architettura, topografia, urbanistica; pt. 3, Pittura e disegno; pt. 4, Arti plastiche; pt. 5, Arti minori, decorative e applicate; pt. 6, Ceramica; pt. 7, Vasi; pt. 8, Mosaico; pt. 9, Glittica e sfragistica; pt. 10, Arti del metallo; pt. 11, Armi; pt. 12, Oreficeria, gioielli, argenterie; pt. 13, Arte vetraria e smalto; pt. 14, Avori; pt. 15, Arazzi e tessuti; pt. 16, Mobili e arredamento; t.VI: pt. 17, Numismatica e medaglistica; pt. 18, Epigrafia; pt. 19, Costume e usanze feste-spettacoli; pt. 20, Iconografia e ritratti; pt. 21, Varia; t.VII: Indici; Indice dei luoghi di edizione e di stampa e dei tipografi, editori e calcografi; Indice analitico; Indice a soggetto; Indice dei facsimili; Indice generale.

A26    Carrick, Neville. How to find out about the arts; a guide to sources of information. Oxford, N.Y., Pergamon [1967]. 164p. il.

A teaching guide to the major sources of information in art libraries. A good beginning for British and American students. Contents are arranged according to the Dewey classification scheme. Well-chosen reference tools. Illustrations are specimen pages from reference books.

A27    Chamberlin, Mary Walls. Guide to art reference books. Chicago, American Library Assn., 1959. xiv, 418p.

"Organizes and appraises reference sources for the history of art. Lists more than 2500 titles, ranging from ready reference to highly specialized works, in the Fine Arts (N) section of the Library of Congress classification scheme, i.e. architecture, painting, sculpture, prints and engravings, drawings, and the applied arts. Omits monographs on individual artists, and specialized subjects, catalogs of museums and private collections, guidebooks, and all but

a few picture books. Arrangement is basically by subject, preceded by general chapters by form, e.g. bibliographies, directories, encyclopedias, iconography, etc. Annotations are descriptive and often evaluative.

"The last three chapters describe Documents and sources; Periodicals (some 250 titles, omitting museum bulletins); Series of art books (more than 100 titles of the most used series). The Appendix describes the holdings of the most important special art collections and libraries of the United States and western Europe."—Winchell, *Guide to Reference Books*, 8th ed.

A28 Cicognara, Leopold, *conte*. Catalogo ragionato dei libri d'arte e d'antichità posseduti dal conte Cicognara. Pisa, Capurro, 1821. 2v. (Repr.: Cosenza, Casa del libro, 1960.)

An early classified bibliography of the art books owned by Count Cicognara. The critical annotations by Cicognara are documents of neoclassical taste. Author index at end of v.2. This celebrated collection is now part of the Vatican Library.

A29 Clapp, Jane. Museum publications. N.Y., Scarecrow, 1962. 2v.

"A classified bibliography of the publications available from 276 museums in the U. S. and Canada," listing "books, pamphlets, and other monograph and serial reprints." —*Foreword*.

Information collected from questionnaires in 1961. Gives prices and pagination. Alphabetical list of "Museums distributing publications," p.xv–xliv. Useful for a listing of catalogues of collections. Lists only those exhibition catalogues which were in print at the time of the questionnaire.

Contents: pt. 1, Anthropology, archaeology, and art; pt. 2, Publications in biological and earth sciences.

A30 Comolli, Angelo. Bibliografia storico-critica dell'architettura civile ed arti subalterne. Rome, Stamperia Vaticana, 1788–92. 4v. (Repr.: Milan, Labor [1964–65].)

The first critical bibliography of architecture and related arts (including lives of artists); classed by type of literature. Long excerpts and extensive documentation. A rich source of material for the history of architectural ideas, especially 18th–century currents of thought.

At the end of v.4 the reprint has an analytical index by Bruno Della Chiesa, which includes early works the author would have examined had he lived to complete the bibliography.

A31 Destailleur, Hippolyte. Catalogue de livres et estampes relatifs aux beaux-arts . . . provenant de la bibliothèque de feu M. Hippolyte Destailleur. Paris, Morgand, 1895. xxviii, 420p.

The sale catalogue of a portion of the collection of Hippolyte Destailleur (1822–93), French architect and collector of rare books, prints, and drawings. A bibliography for bibliophiles and rare book librarians. A large part of the library was acquired by the Bibliothèque Nationale, Paris.

A32 Deville, Étienne. Index du Mercure de France, 1672–1832, donnant l'indication . . . de toutes les notices, mentions, annonces, planches, etc., concernant les beaux-arts et l'archéologie. Publications pour faciliter les études d'art en France. Paris, Schemit, 1910. 269p. (Repr.: Geneva, Minkoff, 1973.)

An index of the material on art published in this important historic periodical. Most valuable for students of 18th-century French art and architecture.

"Table de concordance" is a chronological list of the issues, with months and numbers. This is followed by the author and subject index (12,500 entries) arranged alphabetically.

A33 Duplessis, Georges. Catalogue de la Collection de pièces sur les beaux-arts, imprimées et manuscrites. Recueille par Pierre-Jean Mariette, Charles-Nicolas Cochin, et M. Deloynes et acquise récemment par le Département des estampes de la Bibliothèque Nationale. Paris, Picard, 1881. 224p.

The critical catalogue of a rich collection of art literature housed in the Bibliothèque Nationale. The collection, 54 volumes in all, was started in the 18th century by Mariette and continued by Deloynes. Includes manuscripts, excerpts from contemporary journals, and all the exhibition catalogues of the French Academy since 1673. "Table des matières," p.[201]–23.

A34 _____. Essai d'une bibliographie générale des beaux-arts; biographies individuelles, monographies, biographies générales. Paris, Rapilly, 1866. 144p.

Useful for listing of editions of early sources.

Contents: Section I, Biographies individuelles, Monographies (nos. 1–2901 listed alphabetically by name of artist); Section II, Biographies générales (nos. 2902–3299 listed chronologically by date of publication): pt. 1, Biographies des artistes (subdivided by schools), pt. 2, Biographies des peintres (subdivided by schools), pt. 3, Biographies des sculpteurs, pt. 4, Biographies des architectes, pt. 5, Biographies des graveurs.

No indexes.

A35 Ehresmann, Donald L. Fine arts; a bibliographic guide to basic reference works, histories, and handbooks. Appendix by Julia M. Ehresmann. Littleton, Colo., Libraries Unlimited, 1975. 283p.

A systematic, annotated bibliography of 1,127 entries in two parts: pt. I, Reference works, published from 1900–73; pt. II, Histories and handbooks of world art history, the majority of which were published from 1958–73. Based on Mary W. Chamberlin's *Guide to art reference books* (A27), the bibliography is an updated complement to approximately one-third of the contents of Chamberlin rather than a thorough revision of it. Works listed are in all Western languages and are limited to those dealing with "two or more of the major arts of architecture, sculpture and painting." Does not include exhibition catalogues or catalogues of museum collections. The aim is "to guide the general reader, the beginning student, and the advanced

student to the basic books in the field of art history."—*Pref.* The annotations are uniformly concise and generally authoritative.

Contents: Pt. I, Reference works: (1) Bibliographies; (2) Library catalogs; (3) Indexes; (4) Directories; (5) Dictionaries and encyclopedias; (6) Iconography. Pt. II, Histories and handbooks: (7) Prehistoric and primitive art; (8) Periods of Western art history; (9) National histories and handbooks of European art; (10) Oriental art; (11) New World art; (12) Art of Africa and Oceania.

The Appendix is a "Selected list of fine arts books for small libraries," drawn from titles in the main bibliography and intended "for libraries serving readerships with general and, for the most part, non-scholarly interests."—*p.257.*

The Author and title index and Subject index at the end of the book are generally serviceable despite some omissions and misplaced listings.

A companion volume to the author's *Applied and decorative arts: a bibliographic guide to basic reference works, histories, and handbooks* (P2).

A36  Gettens, Rutherford J., and Usilton, Bertha M. Abstracts of technical studies in art and archaeology, 1943-1952. Wash., D.C., 1955. 408p. (Freer Gallery of Art. Occasional papers, v.2, no.2)
Smithsonian Institution Publication 4176.

Includes signed abstracts of popular and technical books and articles.

Preceded by *Technical studies in the field of the fine arts,* a quarterly publication of the Fogg Art Museum, Harvard Univ., July 1932–April 1942. 10v. (Repr.: N.Y., Garland, 1975)

Contents: General literature; Museology; Materials; Construction and conservation of objects; Technological examination of objects and analysis of materials. Periodical abbreviations, p.4-32; List of contributors, p.1-3.

After Jan. 1, 1953, this material appears in *Studies in conservation,* later published as *Art and archaeology technical abstracts* (A1).

A37  Goddé, Jules. Catalogue raisonné d'une collection de livres, pièces et documents, manuscrits et autographes relatifs aux arts de peinture, sculpture, gravure et architecture . . . réunie par M. Jules Goddé, peintre, avec des notes du collecteur. Paris, Potier, 1850. 400p.
The classified auction catalogues of a large collection (1,650 items). Critical annotations by the collector; variant editions noted, illustrated books meticulously described, including the names of the engravers.

A38  Goldman, Bernard. Reading and writing in the arts: a handbook. Detroit, Wayne State Univ. Pr., 1972. 163p. Rev. ed. 1978.
A useful, portable handbook for beginning students of art history. Available in a reasonably priced paperback edition. Includes a judicious selection of basis reference works, introductory remarks for each category indicating further avenues of research. The last chapter, a guide to methods of research and writing, should be welcomed by professors,

librarians and others reading and writing in the arts.
Contents: (1) Introduction; (2) Reference key by subject; (3) Bibliographical references and source materials—art history bibliographies, art history dictionaries.

A39  Internationale Bibliographie der Kunstwissenschaft. 1-15 Bd., Apr. 1902-1917/18. Berlin, Behr, 1903-20. 15v. in 14. (Repr.: Nendeln, Liechtenstein, Kraus, 1978.)
A classified bibliography of books, periodicals, and book reviews published from 1902-18.
Author and subject indexes.

A40  Istituto Nazionale di Archeologia e Storia dell'Arte, Rome. Bollettino bibliografico [pubblicazioni entrate in Biblioteca, 1935-39]. Roma, Arte grafichi, 1938-43.
Forms pt. 2 of Bollettino del R. Istituto d'Archeologia e Storia dell'Arte, v.8-10.
Volume for 1935 (anno VIII) covers books published in 1935 and 1936 which entered the library from Jan. 1 to Dec., 1936. Anno IX covers 1937, and anno X covers Jan. 1 to Dec., 1939.
Each volume contains alphabetical listings of books received, periodical articles, and a detailed subject index; also a list of periodicals.

A41  Jones, Lois Swan. Methods and resources: a guide to finding art information. Dubuque, Kendall/Hunt, 1978. 243p.
"The emphasis of this guide is on methods of research, the many ways reference tools can be used to find art information."—*Introd.* Most areas of art research are discussed, including art education and film. The highly selective bibliographies include general reference works.
Contents: pt. I, Art research methods; pt. II, Art research resources; pt. III, Obtaining reference material. Appendixes: (A) French-English dictionary; (B) German-English dictionary; (C) Italian-English dictionary; (D) Multilingual glossary of French, English, German, Italian, and Spanish terms. Indexes: Index to publications and institutions; Index to subjects, terms, and professions.

A42  Krienke, Gisela, and Nündel, Ursula. Bibliographie zu Kunst und Kunstgeschichte; Veröffentlichungen im Gebiet der Deutschen Demokratischen Republik, 1945-1956. Leipzig, VEB Verlag für Buch- und Bibliothekswesen [1956-61]. 2v.
v.1, 1945/53 comp. by Gisela Krienke; v.2, 1954/56 comp. by Ursula Nündel.
A classified bibliography of art books and periodical articles published in E. Germany. Also includes unpublished university papers. Each volume has indexes of periodicals and serials, artists, places, key words, names, and authors. The original intention was to publish the bibliography triennially.

A43  Kunstgeschichtliche Anzeigen. Neue Folge, Jahrg. 1-7. 1955-65/66. Graz-Köln, Hermann Böhlaus Nachf., 1955-67.

A joint publication of the Kunsthistorisches Institut der Universität Wien and the Institut für Österreichische Geschichtsforschung.

Ceased with v.7.

Each issue constituted a review of current research in two or three particular areas of art history. Bibliographical references in the text; short classified bibliography and author index at the end.

A44   Lebel, Gustave. Bibliographie des revues et périodiques d'art parus en France, de 1746 à 1914. Paris, *Gazette des beaux-arts,* 1960. 64p. (Repr.: Nendeln, Liechtenstein, Kraus, 1976.)

Constitutes the issue of *Gazette des beaux-arts* (no. 997, Jan.–Mar., 1951) which was published in 1960.

An alphabetical listing of art periodicals, as ~~well~~ ~~as~~ and general journals, published in France fro~~m~~ For each entry gives dates, frequency, cha~~nges~~ names of editors, location in the libraries ~~and~~ critical notes. "Table de la bibliographie" (p.4~~ )~~ of the periodicals arranged by year.

A45   Lucas, Edna Louise. Art books; a basic ~~list~~ on the fine arts. Greenwich, Conn., N~~.Y.~~ Society [1968]. 245p.

Available in paperback.

Based on the author's bibliographies previous~~ly~~ under the title *The Harvard list of books o~~n art,~~* 1952.

"The criterion of selection has been that o~~f use~~ to the four year college undergraduate working ~~in the field~~ of art history."—*Pref.* The list of monographs ~~is~~ the most useful section.

A46   Muehsam, Gerd. Guide to basic information sources in the visual arts. Santa Barbara, Calif., Oxford, Eng., Norton/ABC-CLIO, 1978. 266p.

This critical guide to basic reference sources promises to become a standard introduction to library research in all areas of art. Although primarily directed to college-level students, it is also intended for other researchers in the field of art, including graduate students of art history and librarianship.

Consists of a series of brief essays, mostly bibliographical, arranged by subject. Divided into 4 major categories: (1) Core materials; (2) Periods of Western art; (3) Art forms and techniques; (4) National schools of art. Subdivided into 23 topics which are organized according to methods of research, types of sources, styles, media, techniques, and individual national schools in the Americas, Europe, and the Orient.

The bibliography (p.199–247) of 1,045 entries also serves as an index to books and other sources discussed in the text. General index.

A47   Pacey, Philip, ed. Art library manual; a guide to resources and practice. London & N.Y. in association with the Art Libraries Society, Bowker, 1977. xviii, 423p.

A valuable reference tool which should be open on the desks of all art librarians. The manual "tackles the whole range of practical librarianship with reference to the documentation of art and design in all its forms. It is a manual of the sources of 'art library power', and also of the ways in which these source materials can be marshalled, in order to be most effectively brought into active service. As such it is a direct result of the collective 'power' of art librarians closing ranks in the face of common problems."—*Introd.* Each section has bibliographical references.

Contents: (1) General art bibliographies, by Vera Kaden; (2) Quick reference material, by Vera Kaden; (3) The art book, by Philip Pacey; (4) Museum and gallery publications, by Antony Symons; (5) Exhibition catalogues, by Anthony Burton; (6) Sales catalogues and the art market, by Elizabeth ~~Leach; (7)~~ ...

LINCOLN, Betty Woelk. Festschriften in art history, 1960–1975; bibliography and index. Garland, 1988. 220p (Garland Reference Library of the Humanities, 745) bibl indexes 87-22767. 40.00 ISBN 0-8240-8497-7. N 7442. CIP

There are few tools that index festschriften in art. Paul O. Rave's *Kunstgeschicte in Festschriften* (1962) covers them to 1960. *Répertoire international de la littérature de l'art* abstracts and indexes them from 1975. The 15-year gap was partly covered by Otto Leistner's *Internationale Bibliographie de Festschriften* (1976), in which he indexed all subject fields, including art, to 1975. Lincoln (SUNY) has compiled this work to complete the indexing in art history. The book is comprehensive and international in scope. Close to 5,000 essays in the major European languages are indexed. The volume is divided into four parts: the bibliography, a subject index, an index of authors, and an index to dedicatees. The subject indexing is detailed and meticulous. For all who need complete indexing of festschriften in art history.—*P. Brauch, Brooklyn College, CUNY*

~~Rave, Paul Ortwin.~~ Kunstgeschichte in Festschriften; allgemeine Bibliographie kunstwissenschaftlicher Abhandlungen in den bis 1960 erschienen Festschriften . . . unter Mitarbeit von Barbara Stein. Berlin, Mann, 1962. 314p.

An important index to 5,865 articles which have appeared in Festschriften published before 1960.

"Verzeichnis der Festschriften" (p.13–99) is an alphabetical list of Festschriften arranged by the name of the person or institution honored. Full bibliographical information. The main text is a listing of individual articles classified by subject.

Indexes: (1) Titles, p.270–77; (2) Authors of articles, p.278–97; (3) Artists and other names, p.298–305; (4) Place names, p.306–14.

A49   Schlosser, Julius von. La letteratura artistica; manuale delle fonti della storia dell'arte moderna. Trad. di Filippo Rossi. 3. edizione italiana aggiornata da Otto Kurz. Firenze, "La nuova Italia" [1964]. 792p.

At head of title: Julius Schlosser-Magnino.

Originally published in German, *Die Kunstliteratur,* Vienna, 1924.

1st Italian ed. translated by Filippo Rossi, Florence, 1935; 2d Italian ed. (Florence, 1956) is a reprint of the 1935 text with additional bibliography by Otto Kurz; 3d Italian ed.

has additional bibliography for the period 1955–63 in an appendix, p.[707]–35.

The classic history of art literature and ideas on art from late antiquity to the early 19th century, with emphasis on the Renaissance. Extensive bibliographies of primary and secondary sources at the end of each chapter. In augmenting these bibliographies Otto Kurz has also made a great contribution to art historical research.

A50   Schmidt, Mary M., ed. [Index to nineteenth-century American art journals]. Publisher and publication date to be announced.

An index to approx. 20–30 19th-century American art journals. Should be an invaluable tool for research in 19th-century American art.

A51   [South Kensington Museum, London. National Art Library.] First proofs of the Universal catalogue of books on art. London, Chapman & Hall, 1870. 2v.
_____. Supplement to the Universal catalogue of books on art. London. Printed for H.M. Stat. Off. by Eyre & Spottiswoode, 1877. 654p. (Repr.: N.Y., Burt Franklin [1963].)

Especially useful for the verification of titles; includes information not found elsewhere.

Includes "not only the books in the library, but all books printed and published at the date of the issue of the Catalogue, that could be required to make the library perfect."—*p. iv.* Includes the books in Cicognara (A28).

Subjects: painting, sculpture, architecture, mosaics, enamels, archaeology, coins, anatomy; also lists books on travel, history, criticism, and art instruction. Many extracts from journals. The listing is alphabetical by author or main entry; locations are given, mostly in the British Museum or the South Kensington Museum (now the Victoria and Albert Museum).

A52   Syndicat National des Éditeurs (France). Groupe des éditeurs des livres d'art. Catalogue des livres d'art français. Paris [1970]. 368p. il., col. plates.

To be supplemented.

A catalogue of 2,000 French art books available from 100 publishers. Classified arrangement, analytical table of contents, and alphabetical index. Richly illustrated.

A53   Vatican. Biblioteca Vaticana. Centro Bibliografico della Copia Vaticana del "Princeton art index." Catalogo delle pubblicazioni periodiche esistenti in varie biblioteche di Roma e Firenze; pubblicato con la collaborazione dell'Unione Internazionale degli Istituti de Archeologia, Storia, e Storia dell'Arte in Roma. Città del Vaticano, Biblioteca Apostolica Vaticana, 1955. 495p.

Compiler: Guy Ferrari.

At head of title: Biblioteca Apostolica Vaticana, copia Vaticana dell'indice di arte cristiana.

A union list of periodicals in the libraries of Rome and Florence. Especially useful for locating publications of Italian academies and societies.

A54   Vinet, Ernest. Bibliographie méthodique et raisonnée des beaux-arts. Esthétique et histoire de l'art, archéologie, architecture, sculpture, peinture, gravure, arts industriels. Paris, Firmin-Didot, 1874–77. 2 pts. [1.–2. livr.]. (Repr.: Hildesheim, Olms, 1967.)

A classified bibliography, never completed, of books published before 1870. Lengthy bibliographical and critical notes. Intended as a complement to Brunet, *Manuel du libraire et de l'amateur de livres.*—Winchell, *Guide to reference books,* 8th ed., AA 58.

A55   Weigel, Rudolf. Kunstcatalog. Leipzig, Weigel, 1837–66. 35 pts. in 5v.

Title varies.

A unique collection of the catalogues issued by a book dealer in Leipzig. 25,374 titles of books, prints, and drawings; 3,832 portraits of artists. Prices given.

Index at the end of each volume; general index (318p.) at the end of v.5.

A56   Worldwide art book bibliography; a select list of in-print books on the history of art and archaeology. Boston, Art Catalogue Centre, 1966–71.

v.I–II, *Worldwide art book syllabus,* published in N.Y.

Classified bibliographies of art books available from Worldwide Art Catalogue Centre.

v.I: no. 1, Ancient to Medieval (254 entries); no. 2, Medieval to late Renaissance (420 entries). v.II: no. 1, Baroque and Rococo (352 entries); no. 2, European art and architecture: 19th century (387 entries). v.III: no. 1, American art and architecture: origins to present-day (321 entries); no. 2, 20th-century art and architecture (530 entries). v.IV: no. 1, Primitive art (350 entries); no. 2, Decorative arts (280 entries). v.V: no. 1, LOMA 1969 (A116).

Each issue lists carefully selected American and foreign art books. Brief critical abstracts by art historians frequently include quotations from book reviews and a listing of reviews. A valuable aid to the librarian and to the student of art history. A new series is projected.

SEE ALSO: the series *Art and architecture bibliographies* (R6); Grassi, L. *Teorici e storia della critica d'arte* (G8).

## CATALOGUES OF ART LIBRARIES

A57   Amsterdam. Rijksmuseum. Kunsthistorische Bibliotheek. Catalogus der Kunsthistorische Bibliotheek in het Rijksmuseum te Amsterdam. Amsterdam, Dept. van Onderwijs, Kunsten en Wetenschappen, 1934–36. 4v.

A general classified bibliography of the holdings of the Kunsthistorische Bibliotheek of the Rijksmuseum, Amsterdam. Contents are listed at the beginnings of v.1–3. v.4 contains indexes of authors, artists, illustrators, subjects, places, collectors and dealers, and anonymous works.

A58   Columbia University. Library. Avery Architectural Library. Catalog of the Avery Memorial Architectural

Library of Columbia University. 2d. ed., enl. Boston, Hall, 1968. 19v.

1st ed. 1958. An earlier catalogue, representing 13,000 books, was published in 1895.

A union catalogue of all art and architecture books and periodicals on the Columbia University campus. The Avery Library collection of architectural books is the largest in the world. The associated Fine Arts Library houses a research collection in the fields of painting, sculpture, and the graphic arts.

The Catalog includes entries for architectural manuscripts and a large collection of architectural drawings.

_____. 1st supplement. Boston, Hall, 1972. 4v.

"A record of all cataloged books and periodicals added to the Avery Library and the associated Fine Arts Library from early 1968 through June 1972, approximately 18,000 titles."—*Pref.*

_____. 2d supplement. Boston, Hall, 1976. 4v.

_____. 3d supplement. Boston, Hall, 1977. 3v.

"Records all cataloged books, drawings and periodicals added to the Avery Architectural Library and the associated Fine Arts and Ware libraries from July 1972 through May 1974, an approximate 17,500 titles."—*Pref.*

A59   Deutsches Archäologisches Institut. Römische Abteilung. Bibliothek. Katalog der Bibliothek des Deutschen Archäologischen Instituts in Rom, von August Mau; neue Bearbeitung von Eugen von Mercklin und Friedrich Matz. Rom, Löscher, 1913-14; Berlin, de Gruyter, 1932. 2v. in 4.

_____. Ergänzungen zu Band 1 für die Jahre 1911-1925, bearb. von Friedrich Matz. Berlin, de Gruyter, 1930. 516p.

v.1 issued in two parts, 1913-14, each with a special title page; includes works published before 1911. v.2, in two parts, 1932, includes works published before 1925.

An early systematic catalogue of one of the most complete archaeological libraries in the world. The *Systematischer Katalog* of the *Kataloge* (A60), supplements this with entries beginning in 1956.

A60   _____. _____. _____. Kataloge der Bibliothek des Deutschen Archäologischen Instituts. [Catalogs from the Libraries of the German Institute of Archaeology]. Boston, Hall, 1969. 13v.

"The total collection of the library involves over 90,000 volumes. Of 1,305 periodicals 590 are current. The core of the collection relates to subjects in the field of classical archaeology. Besides archaeology the library provides copious material on classical philology, epigraphy and numismatics. There is coverage of all ancient Mediterranean cultures. Research in the prehistory of middle and northern Europe is well represented."—*Foreword.*

*Autoren- und Periodica Kataloge* (7v.) also include the "Bibliotheca Platneriana."

*Systematischer Katalog* (3v.), beginning with 1956, classifies monographs, periodical and Festschriften articles, and special publications into approximately 1,200 categories. Includes book reviews. Continues earlier classified catalogue (A59).

*Zeitschriften-Autorenkatalog* (3v.) lists authors of periodicals and Festschriften articles and reviews from 1956.

A61   Florence. Kunsthistorisches Institut. Katalog des Kunsthistorischen Instituts in Florenz [Catalog of the Institute for the History of Art in Florence]. Boston, Hall, 1964. 9v.

1st supplement, 2v., 1968; 2d supplement, 2v., 1972; 3d supplement, 2v., 1977.

An alphabetical author catalogue, with many entries under places.

This library specializes in Italian art and is particularly rich in topographical literature. v.2 of the 3d supplement contains section: Austellungen von Italienischen Künstlern die nach 1870 geboren sind (Exhibitions of Italian artists born after 1870).

A62   Freer Gallery of Art, Wash., D.C. Library. Dictionary catalog. Boston, Hall, 1967. 6v.

The card catalogue of this important art library which specializes in art of the Far East, India, and the Near East. Also has research materials on James Abbott McNeill Whistler and his contemporaries.

Contents: v.1-4, Western languages; v.5-6, Oriental languages.

A63   Harvard University. Fine Arts Library. Catalogue of the Harvard University Fine Arts Library, the Fogg Art Museum. Boston, Hall, 1971. 15v.

Reproduces the dictionary catalogue of the Harvard Univ. Fine Arts Library. v.1-14 are intended as a union catalogue of the more than 130,000 volumes (books and bound periodicals) in the Fine Arts Library as well as many entries for books and periodicals relevant to the study of the visual arts in other libraries at Harvard. Outstanding for its "exhaustive listings of the literature of master drawings, Romanesque sculpture, Italian primitives, and the Dutch seventeenth century. Other fields, notably American art, the history of still photography, the history of film, and several of the decorative arts are also collected in depth." —*Introd.*

v.15 comprises approximately 20,000 entries for auction sales catalogues of European and American auction houses. Arranged alphabetically by dealer, then by sale date.

_____. _____. 1st supplement. Boston, Hall, 1976. 3v.

A64   _____. Villa I Tatti, Florence. Berenson Library. Catalogues of the Berenson Library of the Harvard University Center for Italian Renaissance Studies at Villa I Tatti, Florence, Italy. Boston, Hall, 1972. 4v.

v.1-2, Author catalogue; v.3-4, Subject catalogue.

The library collection of Bernard Berenson (1865-1959) reflects his wide-ranging intellectual interests and pursuits, especially those aspects dealing with Italian painting of the late Middle Ages and the Renaissance. "The Harvard Center, which opened in 1961, has concentrated on maintaining the strength of the collection in Italian Renaissance art and increasing the holdings in Renaissance

history and literature, especially humanist texts. There has also been added the Gordon and Elizabeth Morrill Library of Renaissance Music consisting of scores and modern periodicals and literature. The total holdings now amount to probably more than 70,000 volumes."—*Introd.*

A65    Henry Francis du Pont Winterthur Museum. Libraries. The Winterthur Museum Libraries collection of printed books and periodicals. Introduction by Frank H. Sommer, III. Published with the cooperation of the Henry Francis du Pont Winterthur Museum by Scholarly Resources, Wilmington, Del. [1974]. 9v.
The dictionary catalogue of the library (general catalogue, rare books, auction catalogues, Edward Deming Andrews Shaker collection). Especially important for its collection of primary sources in the areas of Anglo-American decorative arts and architecture. Significant holdings in the fields of painting, graphics, early technology, town planning, and early travel in the U.S. Includes a good collection of secondary sources for the use of the curatorial staff. This collection of printed books is of interest to advanced collectors, graduate students, and historians; it gives an idea of the Winterthur resources for research in the history of the British Empire in the U.S. and for study of the works of art produced or used in this country up to 1913.

A66    London University. Warburg Institute. Library. Catalog. [2d. ed.]. Boston, Hall, 1967. 12v.
1st supplement, 1971.
   The subject catalogue of this important collection of literature on the humanities, with stress on the history of ideas, in particular the survival of the classical tradition and the revival of antiquity. Difficult to use.
   Contents by volume: (1) Social patterns; (2) History; (3) History of religion; (4) History of science; (5) History of philosophy; (6) Classical and vernacular literature; (7) Humanism; (8) Preclassical and classical art; (9, 10, 11) Postclassical art; (12) Reading room and periodicals.

A67    New York. Metropolitan Museum of Art. Library catalog. Boston, Hall, 1960–(77). 25v., 7 supplements.
The dictionary catalogue of the library of the Metropolitan Museum of Art. The selection of books and periodicals is determined by areas of the Museum's collections of art works. Includes approx. 200,000v. (with supplements), periodicals, and indexing of some periodicals and of journals and reports of learned societies. v.24 and 25 list the invaluable collection of sales catalogues.
   The catalogue is brought up to date by periodic supplements, seven of which have been published (1962, 1965, 1968, 1970, 1973, 1975, 1977). Sales catalogues are listed at the end of each supplement. The 1975 supplement has updated cards for the collection of exhibition catalogues.

A68    New York. Museum of Modern Art. Library. Catalog of the Library of the Museum of Modern Art. Boston, Hall, 1976. 14v.
The dictionary catalogue of a unique, comprehensive collection of literature on modern art. The library's "holdings parallel the Museum's varied activities and cover the visual

arts from around 1850 to present. The term 'visual arts' is taken in a broad sense, embracing not only painting and sculpture, drawings and prints, but also architecture and design, photography and film. The scope is international, but with emphasis on Western European and American art . . .
   "Articles in many periodicals not included in the *Art Index* and the *Répertoire d'art et d'archéologie* have been indexed by the Library (usually only by subject approach) and the cards are interfiled in the catalog. Major exhibition catalogs are cataloged extensively as books, and minor ones are given an abbreviated cataloging, with all cards interfiled.
   "In addition to the main Library's holdings, the catalog includes the cards for the book collection in the Department of Photography, most of the illustrated books in the Department of Prints, and some material in the Architecture Study Center and the Film Study Center.
   "The cataloging in the Library is original and gives comprehensive bibliographical information as well as extensive subject analysis."—*Introd.*

A69    New York Public Library. The Research Libraries. Bibliographic guide to art and architecture, 1975–(76). Boston, Hall, 1976–(79). v.1–(4).
"Annual supplement to the *Dictionary Catalog of the Art and Architecture Division* [A70], published by the Research Libraries of the New York Public Library. Publications in all languages catalogued by the Research Libraries. Additional entries from Library of Congress MARC tapes cover the related areas of manuscript illumination, graphic arts, costume, metalwork, and city planning. Access by author, title, series, and subjects, with full cataloguing information."—Staff, *RILA*, v.2, no. 1, 1976, 21.

A70    _____. _____. Dictionary catalog of the Art and Architecture Division. Boston, Hall, 1975. 30v.
The dictionary catalogue of one of the major research collections of literature on painting, sculpture, the history and design aspects of architecture, and the decorative and applied arts from prehistory to the present. References are given not only to books in the Art and Architecture Division, but to books, periodicals, and society publications in other divisions of the Library. Includes extensive indexing of periodicals, analyses of books, and references to source materials in the Library's special collections and language divisions. Does not include book arts, book illumination, the history of photography, archaeological reports, city planning, pre-Columbian and American Indian art, or numismatics. Contains entries for materials catalogued through Dec. 1971.
   _____. _____. Supplement 1974. Boston, Hall, 1976.
   References to the history and techniques of printmaking are included only peripherally; full coverage is given in the *Dictionary Catalog of the Prints Division* (N9).
   Supplemented by the *Bibliographic guide to art and architecture* (A69).

A71    Ottawa. National Gallery of Canada. Library. Catalogue of the Library of the National Gallery of Canada.

Catalogue de la Bibliothèque de la Galerie Nationale du Canada. Boston, Hall, 1973. 8v. 6,090p.

A dictionary catalogue of this research library with over 35,000 books. "The catalogue includes exhibition and auction catalogues and museum bulletins and reports, as well as art periodicals. It has been the library's policy to be as comprehensive as possible in collectng material relating to Canadian art and art activities in Canada. Documentation about Canadian artists, art associations, collectors and dealers, maintained in clipping and pamphlet files, is being added to the catalogue, as well as periodical offprints relating to Canadian art. Group catalogues of international exhibitions are analyzed for their Canadian content."—*Pub. prospectus.*

Lists in one alphabet all the holdings of the National Gallery Library under author, title, and subject.

A72    Paris. Université. Bibliothèque d'Art et d'Archéologie (Fondation Jacques Doucet). Catalogue général publié sous la direction de Georges Wildenstein. XIV. Périodiques. Paris, Les Beaux-Arts [1937]. 125p.

A list of periodicals in the library of the Institut d'Art et d'Archéologie; arranged by type, i.e., bulletins, annuaires, actes, cahiers, etc.

A73    Victoria and Albert Museum. London, England. National Art Library Catalogue. Author catalogue. Boston, Hall, 1972. 10v.

To be supplemented.

An estimated 314,000 entries, divided into two sections: v.1-9, books acquired since 1890; v.10, books acquired before 1890. Although universal in scope, this library probably has no equal in the fields of decorative and applied arts. Subject areas include architecture, painting, the graphic arts, ornament, textiles, costume, ceramics, glass, woodwork, furniture, metalwork, jewelry, illuminated manuscripts, and book arts.

A74    _____. _____. _____. Catalogue of exhibition catalogues. Boston, Hall, 1972. 623p.

An estimated 10,200 entries for more than 50,000 exhibition catalogues of the last 150 years. Catalogues are recorded by title and date under organizing gallery or institution. In two parts: (1) Great Britain and provincial galleries; (2) Foreign and Commonwealth galleries. The only catalogue of its size which provides a key to this important area of art research.

A75    Vienna. Österreichisches Museum für Kunst und Industrie. Bibliothek. Katalog. Wien, 1902-04. 5v.

An early catalogue of this important library.

Contents: v.1, Gruppe I. C. Zeitschriften, 50p.; v.2, Gruppe XII Glasfabrikation und Glasmalerei, 29p.; v.3, Gruppe XIII Tonwarenfabrikation (Keramik), 75p.; v.4, Gruppe XIV Arbeiten aus Holz, XV Drechslerei, 62p.; v.5, Gruppe XVII A. Schmied und Schlosserarbeiten, 18p.

SEE ALSO: Berlin. Staatliche Museen. Kunstbibliothek. *Katalog der Ornamentstichsammlung der Staalichen Kunstbibliothek, Berlin* (P63); Paris. Bibliothèque Forney. *Catalogue d'articles de périodiques, arts décoratifs et beaux arts* (P4); _____. _____. *Catalogue matières; arts-décoratifs, beaux-arts, métiers* (P5).

# PREHISTORIC

A76    Bulletin signalétique. Série 525: Préhistoire. v.24- . Paris, Centre National de la Recherche Scientifique, 1970- . Quarterly with annual cumulative indexes.

Supersedes in part *Bulletin signalétique 521: Sociologie, ethnologie, préhistoire et archéologie,* and continues its volume numbering.

A major current bibliography of books and periodical articles on all fields of prehistoric studies, including sections on the ethnology and art of prehistoric Europe, Asia, Africa, the Americas, Australia, and Oceania. Brief descriptive annotations. Each fascicle has a list of periodicals analyzed and indexes of sites and regions, geographical areas, cultures, subjects, and authors.

# ANCIENT—MEDIEVAL

## Current Serials

A77    L'année philologique; bibliographie critique et analytique de l'antiquité gréco-latine, pub. sous la direction de J. Marouzeau [and others], 1924/26- . Paris, Soc. d'édit. "Les Belles-Lettres," 1928- . Annual.

A current bibliography of the literature on Greek and Roman antiquity. Encompasses all regions which had trade and cultural relations with Greece and Rome. Also lists relevant publications on prehistory and the medieval period in the East and West, as well as references to the survival of antiquity in later periods.

Divided into an author and a subject section. Subjects are further subdivided; pt. IV, Antiquités, is most valuable for archaeologists and art historians.

A78    Annual Egyptological bibliography. Bibliographie égyptologique annuelle. 1947- . Leiden, Brill, 1948- . International Assn. of Egyptologists)

Current editor: J. J. Janssen.

An annotated bibliography of books and periodical articles on ancient Egypt. Alphabetical arrangement of authors and titles. Full descriptive and critical annotations in English, French, or German. Continues the "Bibliografia metodica degli studi di egittologia e di papirologia," published in *Aegyptus,* 1920-43.

_____. Indexes, 1947-1956, by Jozef M.A. Janssen. Leiden, Brill, 1960. 475p.

Includes author index and the following specialized subject indexes: topography, pharaohs, hieroglyphs, divinities, Biblical references and Hebrew words, classical authors, subjects.

A79   "Bibliographische Notizen und Mitteilungen." In *Byzantinische Zeitschrift*, 1892– .

Pt. 7, "Kunstgeschichte" is a classified bibliography of the current literature of Byzantine art and the arts of antiquity and the Middle Ages which are related to those in Byzantium. Some abstracts. Classified as follows: (A) Allgemeines; (B) Einzelne Orts; (C) Ikonographie, Symbolik, Technik; (D) Architektur; (E) Plastik; (F) Malerei; (G) Kleinkunst (Gold, Elfenbein, Email, u.s.w.); (H) Byzantinische Frage: (I) Museen, Institute, Ausstellungen, Bibliographie.

A cumulative bibliography of the art historical literature listed in the topographic and categorical classifications of *Byzantinische Zeitschrift* from 1892–1967 has been published: Dumbarton Oaks bibliographies based on *Byzantinische Zeitschrift* (A93).

A80   Bulletin signalétique 526: Art et archéologie. Proche-Orient, Asie, Amérique. v.24– . Paris, Centre National de la Recherche Scientifique, 1970– . Quarterly, with annual cumulative indexes.

Supersedes in part *Bulletin signalétique 521: Sociologie, ethnologie, préhistoire et archéologie* and continues its volume numbering.

A major current bibliography of books and periodical articles on the art and archaeology of the ancient civilizations of the Near East and Asia and the pre-Columbian and primitive art and archaeology of the Americas. Complements the *Répertoire*, n.s. 1965– (A14) and *L'année philologique* (A77). Brief descriptive annotations. Each fascicle has a list of periodicals analyzed and subject and author indexes.

A81   Cahiers de civilisation médiévale, Xe-XIIe siècles; revue trimestrielle publié par le Centre d'Études Supérieures de Civilisation Médiévale. Bibliographie. Année 1– . Poitiers, Société d'Etudes Médiévales, 1958– .

A classed bibliography of the 10th, 11th, and 12th centuries, issued as a supplement to the quarterly *Cahiers*. Includes literature on history, sciences related to history, the history of ideas, archaeology, art, and music. Analyzes approx. 700 specialized reviews. Subjects arranged alphabetically with author indexes.

A82   C.O.W.A. surveys and bibliographies. Cambridge, Mass., Council on Old World Archaeology, 1957– .

Divided into 22 regions of Europe, Africa, and Asia, with a separate series of bibliographies for each region. Compiled by scholars. Short, critical annotations. Although the plan was to review the current literature of each region every two years, publication has been irregular.

A83   Deutsches Archaeologisches Institut. Archaeologische Bibliographie. Beilage zum Jahrbuch des Deutschen Archaeologischen Instituts, 1913– . Berlin, de Gruyter, 1914– .

Current editor: Gerhard Reincke.

Annual, except for some irregular two-, four-, and five-year cumulative issues. Continues the bibliographies published in *Jahrbuch des Deutschen Archäologischen Instituts* (1886-88 and in *Archäologischer Anzeiger* (1889-1912). Current time lag is two years.

An international bibliography classified by place and by subject. Covers archaeological literature on the arts, architecture, numismatics, epigraphy, religion, mythology, iconography, and cultural history of the ancient Near East and Egypt, Greece, Asia Minor, Italy, North Africa, Gaul, Switzerland, Spain, Britain, Scandinavia, Germany, and the Soviet Union. No annotations. General index.

A84   Fasti archaeologici: annual bulletin of classical archaeology. [v.]1–, 1946– . Firenze, Sansoni, 1948– . il. (Published for the International Association for Classical Archaeology, Rome.)

A comprehensive classified bibliography of books and articles on the archaeology and art of the classical world, including early Christianity. Has an international editorial board, and correspondents from over 30 countries. Many of the entries have abstracts.

Contents: (1) General; (2) Prehistoric and classical Greece: (3) Italy before the Roman empire; (4) The Hellenistic world and the eastern provinces of the Roman empire; (5) The Roman West; (6) Christianity and Late Antiquity. Indexes: (1) Authors, ancient and modern; (2) Geographical names; (3) Subjects; (4) Lexicalia; (5) Literary and epigraphical sources.

A85   Pearson, James Douglas. Index Islamicus, 1906-1955; a catalogue of articles on Islamic subjects in periodicals and other collective publications, comp. by J. D. Pearson with the assistance of Julia F. Ashton. Cambridge, Heffer, 1958. 897p.

Comp. by the Library of the School of Oriental and African Studies, Univ. of London.

1st supplement, 1956-60, ed. J. D. Pearson (1962); 2d supplement, 1961-65, ed. J. D. Pearson (1967); 3d supplement, 1966-70, ed. J. D. Pearson and A. Walsh (1972); 4th supplement, annual cumulations published by Mansell, London. Replaced by *The Quarterly Index Islamicus*, 1977– .

Extensive classified bibliography on all fields of Islamic studies. Section V of the primary sequence and of each supplement is on art. No annotations. Author index at end of primary sequence and supplements.

A86   Swedish archaeological bibliography, v.1, 1939/48– . Stockholm, Almqvist & Wiksell, 1951– .

Published for Svenska Arkeologiska Samfundet, the Swedish Archeological Society. Current editor: Marten Stenberger in collaboration with Anders Hedvall.

English ed. translated from the Swedish. Pt. 1 consists of essays by scholars on current research and is divided as follows: Swedish research in the areas of classical archaeology, Egyptology, Asian archaeology, and American archaeology. Pt. 2 is the bibliography: literature in Swedish; literature in other languages.

## Retrospective

A87   Annual bibliography of Islamic art and archaeology, India excepted. v.1-3, 1935-37. Jerusalem, Divan, 1937-39.

Editor: L. A. Mayer.

A classified bibliography with index. Covers books and (predominantly) periodical articles.

"No reviews are noted which, although they appeared in 1935, deal with books or articles published in previous years. Pre-Islamic material is excluded by definition."—*Pref.*

Superseded in 1954 by *Islamic art and archaeology,* Cambridge, Eng., 1954–55.

A88    Association Internationale d'Études du Sud-est Européen-Comité National Hellénique. Bibliographie de l'art byzantin et post-byzantin 1945–1969; pub. à l'occasion du IIème Congrès International des Études Balkaniques et Sud-est Européenes à Athènes, mai 1970. Athènes, 1970. 115p.

A bibliography of Byzantine and medieval art literature from 1945–69. Prepared for the occasion of the 1970 Athens meeting of the International Assn. of South-East European Studies. The majority of the 1,602 entries are in Greek (with French translation). Refers to periodicals, encyclopedias, acts of congresses, books, etc.

A89    Bibliografia d'archaeologia classica. Roma, "L'Erma" di Bretschneider. 1969. 129p.

A selective bibliography, almost exclusively of books (3,154 entries), on classical sculpture, painting, architecture, and the minor arts. No annotations.

A90    Coulson, William D. E. An annotated bibliography of Greek and Roman art, architecture and archaeology. N.Y. and London, Garland, 1975. 135p.

A well-annotated selected bibliography in the field of Greek and Roman art. Detailed discussions of each book, with a classification system which gauges its difficulty for the student, the teacher, or the scholar. The sections are alphabetically arranged by author.

Contents: General: Aims, methods, and history of archaeology; Prehistoric Greek archaeology; The Etruscans; Roman art, architecture, and archaeology; Miscellaneous. Appendixes: (I) Ancient urbanism and urban planning; (II) Useful hardcover editions above $10; (III) French and German books.

A91    Creswell, Keppel Archibald Cameron. A bibliography of the architecture, arts and crafts of Islam to 1st Jan. 1960. [Cairo], American Univ. at Cairo Pr., 1961. (Dist. by Oxford Univ. Pr., London). xxiv, 1330, xxvp.

An exhaustive bibliography of "every branch of Muslim Architecture and Art, except Numismatics."—*Pref.* Comprises approx. 15,850 items in two parts: pt. 1, Architecture (arranged by country); pt. 2, Arts and crafts (arranged by material or craft, e.g., arms and armour, ceramics, costume, gardens, painting). Occasional brief annotations. Important works are usually accompanied by an abbreviated table of contents. Reviews indicated.

Index of authors, p.[I]–[XXV].

———. ———. Supplement; Jan. 1960 to Jan. 1972. [Cairo] American Univ. at Cairo Pr., 1973. (Distr. by Oxford Univ. Pr., London). xiii, 366, ixp.

Continues the above bibliography. Includes fuller coverage of material in Turkish and Russian.

Index of authors, p.[I]–[IX].

A92    Ettinghausen, Richard, ed. A selected and annotated bibliography of books and periodicals in Western languages dealing with the Near and Middle East with special emphasis on medieval and modern times. Completed Summer 1951 with Supplement, Dec. 1953. Wash., D.C., Middle East Institute, 1954. 137p.

Prepared under the auspices of the Committee on Near Eastern Studies, American Council of Learned Societies.

An authoritative bibliography devoted to humanistic studies, including art and archaeology.

A93    Harvard University. Dumbarton Oaks Center for Byzantine Studies, Wash., D.C. Dumbarton Oaks bibliographies based on *Byzantinische Zeitschrift.* Series I: Literature on Byzantine art, 1892–1967. v.1. By location. [pt. 1, Africa, Asia, Europe (A-Ireland); pt. 2, Europe (Italy-Z), Indices]. v.2, By categories. Ed. by Jelisaveta S. Allen. Published for the Dumbarton Oaks Center for Byzantine Studies, Wash., D.C., [London] Mansell, 1973–76. 2v in 3.

v.1 (in 2) is a "cumulative topographic classification of art historical literature listed in Volumes 1–60 of the *BZ* (1892–1967)." v.2 covers "the same issues of the *BZ* for literature on the history of Byzantine art in general and according to media (Architecture, Painting, Sculpture, Minor Arts, Illuminated Manuscripts), as well as on Iconography, Museums, and Literary Sources."—*Introd., v.1.*

Reproduces the original entries with critical annotations from the *BZ,* III. Abteilung-Bibliographische Notizen und Mitteilungen. Index of names of places and Index of authors in v.1; General index and Index of authors in v.2.

A94    Istituto Nazionale di Archeologia e Storia dell'Arte, Rome. Biblioteca. Annuario bibliografico di archeologia, 1952–(1962/67), anno 1–(11/16). Modena, Soc. Tip. Modenese, 1954–(72).

Editors: A. Aquilina, et al.

A classified bibliography of archaeological literature by the library of the research institute in Rome. Includes short abstracts. Indexes of abbreviations, authors, and proper names.

A95    Moon, Brenda E. Mycenaean civilization publications since 1935; a bibliography. [London] University of London, Institute of Classical Studies, 1957. 77p. (London Univ. Institute of Classical Studies. Bulletin supplement, no. 3)

A bibliography of books and periodical articles on Mycenaean civilization (c. 1600 to 1100 B.C.) published between Jan. 1936 and June 1956. Arranged alphabetically by author, with subject list, p.68–77.

———. Mycenaean civilization publications, 1956–60; a bibliography. [London] University of London, Institute of Classical Studies, 1961. xxv, 130p. (London Univ. Institute of Classical Studies. Bulletin supplement, no. 12)

Supplements the above bibliography with books and periodical articles published to the end of 1960, including a few published between Jan. and Apr. 1961.

A96    Porter, Bertha, and Moss, Rosalind L. B. Topographical bibliography of ancient Egyptian hieroglyphic texts, reliefs, and paintings. Oxford, Clarendon, 1927-51. 7v. diagrs.

An exhaustive compilation of the literature on the subject, arranged by monuments and their respective details. Contents: v.1, The Theban necropolis; v.2, The Theban temples; v.3, Memphis; v.4, Lower and Middle Egypt; v.5, Upper Egypt: sites; v.6, Upper Egypt: chief temples (excluding Thebes); v.7, Nubia, the deserts, and outside Egypt. Each volume has its own indexes, list of abbreviations, and list of collections of manuscripts.

A97    _____. Topographical bibliography of ancient Egyptian hieroglyphic texts, reliefs and paintings, by the late Bertha Porter and Rosalind L. B. Moss, assisted by Ethel W. Burney. 2d ed. Oxford, Clarendon, 1960-(74). v.1-(3¹) maps, diagrs., plans.

Complete revisions of the 1st ed. In progress.

Contents: v.1. The Theban necropolis. Pt. 1. Private tombs. Pt. 2. Royal tombs and smaller cemeteries; v.2. The Theban temples; v.3. Memphis. Pt. 1. Abû Rawâsh to Abûsîr. 2d ed. rev. and augmented by Jaromír Málek.

A98    Rounds, Dorothy. Articles on antiquity in Festschriften, an index; the ancient Near East, the Old Testament, Greece, Rome, Roman law, Byzantium. Cambridge, Harvard Univ. Pr., 1962. 560p.

"An index to *Festschriften,* including in one alphabet: names of scholars and institutions honored, names of authors of articles, and all significant words in the titles of the articles." —Winchell, *Guide to reference books,* 8th ed., DA 82.

A99    Vermeule, Cornelius C. A bibliography of applied numismatics in the fields of Greek and Roman archaeology and the fine arts. London, Spink, 1956. viii, 172p.

"These pages endeavour to present a useful list of works which are of value to the numismatist as demonstration of the way in which numismatic evidence has been utilized in the fields of classical *archaeology and the fine arts.* The material should also aid the scholar who is not primarily a numismatist locate references in fields in which numismatics are fundamental for understanding of non-numismatic problems."—*Introd.*

Contents: pt. 1, Archaeology and art history; pt. 2, Iconography; pt. 3, Greek, Hellenistic, and general; pt. 4, Related works in the fields of history, politics, and religion.

## RENAISSANCE-MODERN

### Current Serials

A100    Arntz-Bulletin; Dokumentation der Kunst des 20. Jahrhunderts. v.1, no. 1- . Haag/Oberbayern, Arntz-

Winter, 1968- . Published periodically in installments. (Distr. in America: N.Y., Wittenborn.) il.

Edited by Wilhelm F. Arntz.

Attempts to present as completely as possible a bibliography of *oeuvre catalogues* of 20th-century artists. Besides listing catalogues (either published or in public collections or institutions), existing catalogues are "critically evaluated and brought up to date through additions and corrections." —*Pub. notes.*

Appendixes containing documentation outside the alphabetical arrangement of the main section are published occasionally. Examples: "Beilage A zu Folge 8" lists *catalogues raisonnés* published since 1968; "Beilage B zu Folge 9" is a listing of additions and corrections to *catalogues raisonnés* already published.

A101    Art Design Photo: Annual bibliography on modern art, graphic design, photography. v.1. 1972-. Hempstead, Eng., Alexander Davis Publications, 1973-. il.

Compiler: Alexander Davis.

Essentially a continuation of LOMA (A116). A bibliography of literature on late 19th- and 20th-century art and artists, photography, design, and decorative art (ceramics, textiles, jewelry, etc.). v.1 (for 1972) has 5,345 entries in two alphabetical sequences: Artists A-Z; Subjects A-Z. v.2 (for 1973) has 6,306 entries in two alphabetical sequences and includes a list of serials indexed. v.3 (for 1974) and v.4 (for 1975) continue this format.

See review by Alexander Ross in *ARLIS/NA Newsletter,* v.2, Apr. 1974.

A102    ARTbibliographies MODERN, v.1, 1969- . Santa Barbara, Calif., ABC-CLIO, Oxford, Eng., EBC-CLIO, 1971- .

Current editor: Peter Fitzgerald.

The 1969, 1970, and 1971 editions of the annual bibliography *LOMA: Literature on modern art,* (A116) comp. by Alexander Davis, represent v.1-3 of *ARTbibliographies MODERN.* Beginning with v.4 (1973), the bibliography for 1972, ABM consists of two issues published semiannually.

v.1-3 cover all aspects of the art and architecture of the 20th century, including books, periodical articles, and exhibition catalogues. Starting with v.4 coverage includes the 19th century. Most entries have abstracts.

Since subscription rates vary with the budget of the library, ABM is very expensive for large research libraries.

See review by Alexander Ross in *ARLIS/NA Newsletter,* v.2, Apr. 1974.

A103    Bildende Kunst 1850-1914; Dokumentation aus Zeitschriften des Jugendstil, hrsg. von G. Bott. Berlin, Mann, 1970- . v.1. pt. 1-2- .

1st volume of a series sponsored by the Fritz Thyssen-Stiftung.

Compiler: Ingrid Dennerlein.

Detailed analytical indexes of the complete text of *Pan* (Q271), an important journal of art and literature published in Germany from 1895-1900. The subjects, referring to the arts from 1850-1914, are arranged alphabetically into catalogues and indexes. Pt. 1 consists of the catalogues

and indexes and pt. 2 comprises the annotations. A computer was used for the documentation.

A104 International Federation of Renaissance Societies and Institutes. Bibliographie internationale de l'humanisme et de la renaissance. 1- , 1965- . Genève, Droz, 1966- . Annual.
Considerable time lag.

A current bibliography of books and articles on humanism and the Renaissance. For the most part limited to the 15th and 16th centuries. A list of the periodicals indexed is followed by the year's bibliography of numbered entries arranged alphabetically by author.

Index of persons, places, and subjects.

## Retrospective

A105 Anderson, David L., ed. Symbolism: a bibliography of Symbolism as an international and multi-disciplinary movement. N.Y., New York Univ. Pr., 1975. 160p.

A bibliography of literature on Symbolism. Limited to approx. 3,000 works written in European languages from 1880-1973. Multidisciplinary, includes literature, art, music, and philosophy. Divided into four parts: (1) General and miscellaneous; (2) National and international movements; (3) Forms and genres; (4) Individual. No annotations.

A106 Andreoli-deVillers, Jean-Pierre. Futurism and the arts: a bibliography, 1959-73. Le futurisme et les arts: bibliographie, 1959-73. Il futurismo e le arti: bibliografia, 1959-73. Toronto and Buffalo, Univ. of Toronto Pr., [1975]. xxix, 189p.

Title page and introduction in English, French, and Italian; annotations in French.

An annotated bibliography of 1,835 items on all areas of Futurism published in the period 1959-73. Arranged by year, then alphabetically. Includes material on the related fields of Cubism, Orphism, Rayonism, German Expressionism, and Vorticism. Intended as a supplement to the bibliographies published in *Archivi del futurismo* (M358).

A107 Arntz, Wilhelm F., ed. Werkkataloge zur Kunst des 20. Jahrhunderts; catalogues raisonnés. Haag/Oberbayern, Arntz-Winter [1975?].

At head of title: Verzeichnis der seit 1945 erschienenen.

A supplementary volume to the Arntz-Bulletin (A100). A bibliography of all known *catalogues raisonnés* on the works of 20th-century artists published since 1945. Includes catalogues of paintings, sculpture, drawings, prints, and applied and decorative arts. A second supplementary volume on all *catalogues raisonnés* published from 1900-44 is planned.

A108 Boskovits, Miklós, ed. L'art du gothique et de la renaissance, (1300-1500): bibliographie raisonnée des ouvrages publiés en Hongrie. Budapest [Comité National Hongrois d'Histoire de l'Art], 1965. 2v.

Published on the occasion of the International Congress of the History of Art, 1965. A classified bibliography of the literature on Gothic and Renaissance art (1300-1500)

published between approx. 1800-1963. Limited to works published in Hungary and in regions attached thereto. Includes publications of Hungarian institutions abroad.

Translations of Hungarian titles into French. Brief annotations in French. Contents: v.1, Généralités; Topographie, urbanisme, protection des monuments; Architecture; v.2, Sculpture; Peinture et gravure; Arts décoratifs. At end of v.2, indexes of authors and artists.

A109 Chicago. Art Institute. Surrealism and its affinities, the Mary Reynolds collection. A bibliography compiled by Hugh Edwards. Chicago, [1956]. 131p.

Introduction by Marcel Duchamp.

A bibliography of the illustrated books, pamphlets, exhibition catalogues, announcements, etc. which were collected by Mary Reynolds in Paris. These documents for Dada, Surrealism, and other modern art movements are now in the Ryerson Library of the Art Institute of Chicago. Precise bibliographical descriptions of French books illustrated by artists.

Indexes of names and artists.

A110 Gershman, Herbert S. A bibliography of the surrealist revolution in France. Ann Arbor, Univ. of Michigan Pr. [1969]. 57p.

An extensive bibliography of the surrealist movement. Contents: (1) Books and articles (including exhibition catalogues); (2) Periodicals (A selected list of periodicals in which the major French surrealists and para-surrealists were published, including a number of the principal Dada-oriented periodicals); (3) Collected tracts and manifestoes. No annotations.

A111 Gordon, Donald E. Modern art exhibitions, 1900-1916. Selected catalogue documentation. München, Prestel-Verlag, 1973. 2v. il. (Fritz Thyssen-Stiftung. Forschungsunternehmen neunzehntes Jahrhundert. Materialien zur Kunst des neunzehten Jahrhunderts. 14)

Documentation on 851 exhibitions of modern art held between 1900-16 in 15 countries (including not only Western European countries and the U.S., but also Russia, Hungary, Czechoslovakia, and Japan) and 82 cities. Data collected from 55 libraries and archives; arranged in one chronological listing. Entries for 426 painters and sculptors of national or international importance. 1,905 illustrations on 205 plates by 272 individual artists.

Contents: v.1, Introduction (in English, German, French, and Russian); (1) The early modern period: three essays (in English and German); (2) List of catalogues consulted; (3) Illustrations; (4) Index of artists; v.2, (5) Exhibition entries; (6) Index of cities and exhibiting groups.

A112 Hesse, Gritta. Kunst der jungen Generation; ein Literaturverzeichnis und biographisches Nachschlagewerk. [Berlin] Amerika-Gedenkbibliothek, Berliner Zentralbibliothek, 1968-72. 3v.

A selective bibliography of contemporary art and artists. The general bibliography is followed by country divisions and biographies of living artists, each with one or two

bibliographical references. Index of artists at the end of v.3.

A113   Index Expressionismus: Bibliographie der Beiträge in den Zeitschriften und Jahrbüchern des literarischen Expressionismus, 1910-1925. Im Auftrage des Seminars für deutsche Philologie der Universität Göttingen und in Zusammenarbeit mit dem Deutschen Rechenzentrum Darmstadt. Herausgegeben von Paul Raabe. Nendeln, Liechtenstein, Kraus-Thomson, 1972. 18v.
A bibliography of contributions to 103 Expressionist literary magazines during the period 1910-25. Includes numerous references to art and artists. In five parts: Index A, Alphabetical name index (4v.); Index B, Systematic (or subject) index (5v.); Index C, Index to individual magazines (5v.); Index D, Alphabetical title list (2v.); Index E, Classified index (2v.).

A114   Kempton, Richard. Art Nouveau: an annotated bibliography. Los Angeles, Hennessey & Ingalls. v.1- , 1977- . 303p. (Art and architecture bibliographies, 4)
An annotated bibliography of books and articles by and about the artists involved in the international art nouveau movement. Format is similar to other bibliographies in this series. To be complete in 3v.
    Contents: v.1, General, Austria, Belgium, and France.

A115   Lietzmann, Hilda. Bibliographie zur Kunstgeschichte des 19. Jahrhunderts; Publikationen der Jahre 1940-1966. Mit Referaten von K. Lankheit, F. Novotny, und H. G. Evers. München, Prestel-Verlag, 1968. 234p. il., ports. (Studien zur Kunst des neunzehnten Jahrhunderts, Bd. 4)
A judiciously selected classified bibliography of art historical literature dealing with 19th-century architecture, sculpture, painting, and the decorative arts. Limited to material published between 1940-66. Includes references to articles in periodicals, Festchriften, collected papers of congresses; important bibliographies in books; theses.
    Preceded by three articles on the current state of research: "Der Stand der Forschung zur Plastik des 19. Jahrhunderts," by Klaus Lankheit; "Die neue Literatur zu Cézanne," by Fritz Novotny; "Gedanken zur Neubewertung der Architektur des 19. Jahrhunderts," by Hans Gerhard Evers.

A116   LOMA: Literature on modern art. v.1, 1969-v.3, 1971. 1971-73.
Publisher varies. v.1 (LOMA 1969) published in the U.S. as *Worldwide art book bibliography* (A56), v.V, 10. 1, Sept. 1971. v.2-3 of LOMA continued with co-title *ARTbibliographies MODERN* (A102). However, v.4 of *ARTbibliographies MODERN* is not a continuation of LOMA and the old LOMA is essentially continued by *Art Design Photo* (A101), also comp. by Alexander Davis. For more precise clarification of this cataloguer's nightmare see review by Alexander Ross: *ARLIS/NA Newsletter,* v.2, Apr. 1974, p.40-42.
    An annual bibliography of literature on 20th-century art. Divided into two parts: Artists A-Z; Subjects A-Z.

No annotations. Each issue has a list of periodicals from which articles have been indexed and a subject index.

A117   Perkins, G.C. Expressionismus; eine Bibliographie zeitgenössischer Dokumente, 1910-1925. Zürich, Verlag für Bibliographie, 1971. xix, 144p. il.
A classified, annotated bibliography (473 entries) of writings by artists, historians, critics, and dealers of the Expressionist movement, 1910-25.
    Contents: (1) Bücher; (2) Sammelwerke: (3) Almanache und Jahrbücher; (4) Schriftenreihen; (5) Zeitschriften; (6) Zeitschriftenliteratur. "Nachweis der Namen," p.95-113. Indexes.

# WESTERN COUNTRIES

## Baltic Countries

A118   Reklaitis, Paul. Einführung in die Kunstgeschichtsforschung des Grossfürstentums Litauen; mit Bibliographie und Sachregister. Marburg, Herder-Institut, 1962. 217p. map. (Wissenschaftliche Beiträge zur Geschichte und Landeskunde Ost-Mitteleuropas. 59)
Contains 944 numbered items listed alphabetically by author on all aspects of Lithuanian art. Numbers in the classified index refer to items in the bibliography.
    Contents: Die Geschichte der Kunstforschung in Litauen, p.1-39; Bibliographisches Verzeichnis nach Verfassern, p.44-197; Systematisches Sachregister, p.199-216.

## France

A119   France. Archives Nationales. Les sources de l'histoire de l'art aux Archives Nationales, par Mireille Rambaud, conservateur-adjoint aux Archives Nationales. Avec une étude sur les sources de l'histoire de l'art aux Archives de la Seine, par Georges Bailhache et Michel Fleury, archivistes-adjoints du département de la Seine et de la ville de Paris. Avant-propos de Charles Braibant. Paris, Impr. Nationale, 1955. 173p.
From 1970 supplemented in *Société de l'Histoire de l'Art Française. Bulletin.*
    An indispensable guide to the art resources in the national archives of France. Bibliographical footnotes.
    Contents: Tableau méthodique des séries; Table chronologique des séries; Instruments généraux de recherches: pt. 1, Documents écrits; pt. 2, Documents iconographiques; pt. 3, Les sources de l'histoire de l'art aux Archives de la Seine. Index.

A120   Inventaire général des monuments et des richesses artistiques de la France. Répertoire des inventaires. Paris, Impr. Nationale, 1971- . fasc. 1- .
At head of title: Ministère des affaires culturelles.
    An exhaustive artistic and topographical bibliography, to be published in 23 fascicles, one for each region in France. Part of the monumental artistic inventory in progress.

Each issue is preceded by an essay on the established method for conducting the inventory. The literature is classified by media (architecture, sculpture, painting, minor arts) and by place. Topographical and author indexes.

Published to date: fasc. 1, Région Nord (1971); fasc. 9, Poitou-Charentes (1975); fasc. 10, Limousin (1972); fasc. 14, Lorraine (1973); fasc. 20, Languedoc-Roussilon (1972).

A121 Lasteyrie du Saillant, Robert Charles. Bibliographie générale des travaux historiques et archéologiques publiés par les sociétés savantes de la France, dressée sous les auspices du Ministère de l'instruction publique. Paris, Impr. Nationale, 1888-1918. 6v. (Repr.: N.Y., Burt Franklin [1972].)
Issued in parts, 1885-1918.

Publication of the Comité des Travaux Historiques et Scientifiques.

v.1-4 cover the literature published to the year 1885; v.5-6, 1886-1900.

v.1, by R. de Lasteyrie and E. Lefèvre-Pontalis; v.2, by R. de Lasteyrie with the collaboration of E. Lefèvre-Pontalis and E. S. Bougenot; v.3, by R. de Lasteyrie; v.4-6, by R. de Lasteyrie with the collaboration of A. Vidier.

Supplemented for the literature published after 1900 by *Bibliographie annuelle des travaux historiques et archéologiques publiés* par les Sociétés Savantes de la France. t.1- . années 1901/04- . Pub. 1906- . (The first two numbers of v.1, covering the literature 1901/02- 1902/03, were issued under same title as main work.)

Contents: t.1. Ain-Gironde. 1888; t.2. Hérault-Haute-Savoie. 1893; t.3. Seine: Paris, 1 ptie. 1901; t.4. Seine: Paris (suite), Seine-et-Marne-Yonne, Colonies, Instituts français à l'étranger. 1904; t.5-6. Supplement, 1886-1900: t.5. Ain-Savoie (Haute-). 1911; t.6. Seine: Paris, Seine-et-Marne-Yonne, Colonies, Instituts français à l'étranger. Supplément (p.[779]-804). Index des volumes analysés dans les tomes I à VI.

A monumental bibliography of the publications of French societies (includes all artistic societies and local historical societies). Arranged alphabetically by title of society and then by publication. Titles, collation, and contents of each issue of a serial publication. Basic to scholarly research in French art, architecture, and archaeology.

A122 Marquet de Vasselot, Jean Joseph. Répertoire des publications de la Société de l'Histoire de l'Art Français (1851-1927). Paris, Colin, 1930. xxxii, 219p.
An index of books, articles, documents, sources, etc. published by the Société de l'histoire de l'art français from 1851-1927. Almost 2,400 references. Especially valuable as a key to the various documents and sources published in *Archives de l'art français, Nouvelles archives de l'art français, Mémoires inédits sur la vie et les ouvrages des membres de l'Académie Royale de Peinture et de Sculpture, Bulletin de la Société de l'Histoire de l'Art Français,* and *Revue de l'art français.*

A123 Mustoxidi, Théodore Mavroïdi. Histoire de l'esthétique française, 1700-1900, suivie d'une bibliographie générale de l'esthétique française des origines à 1914.

Paris, Champion, 1920. 240p. (Repr.: N.Y., Burt Franklin [1968].)
A chronological arrangement of books and periodical literature. Alphabetical index at end.

## Germany and Austria

A124 Badstübner-Gröger, Sibylle. Bibliographie zur Kunstgeschichte von Berlin und Potsdam. Berlin, Akademie-Verlag, 1968. 320p. (Deutsche Akademie der Wissenschaften, Berlin. Arbeitsstelle für Kunstgeschichte. Schriften zur Kunstgeschichte, Heft 13.)
The fifth and next-to-last volume of the regional bibliographies on art in the DDR (E. Germany). Comprehensive; includes Berlin and Potsdam; classified, with indexes of authors, outstanding persons, artists, places, and subjects.

A125 "Bibliographie zur Kunstgeschichte Österreichs. Schrifttum des Jahres 1963-." In *Österreichische Zeitschrift für Kunst- und Denkmalpflege.* v.20, 1966-.
Current editor: O. Brosch
A continuing bibliography compiled at the Kunsthistorisches Institut of the Univ. of Vienna. It encompasses all art historical literature on Austrian art and includes relevant books and articles on the art of the neighboring regions of central Europe and the Danube basin. Selective indexing of publications on the 20th century. Classified according to the scheme of the Institute's library. Each issue has a general index.

A126 Fründt, Edith. Bibliographie zur Kunstgeschichte von Mecklenburg und Vorpommern. Berlin, Akademie-Verlag, 1962. xxiii, 123p. (Deutsche Akademie der Wissenschaften, Berlin. Arbeitsstelle für Kunstgeschichte. Schriften zur Kunstgeschichte, Heft 8)
The art historical literature on Mecklenburg and Vorpommern (west of the Oder) up to 1956. The third in the series of bibliographies for regions in DDR (E. Germany). Comprehensive in scope; classified, with indexes of authors, artists, other persons, places, and subjects.

A127 Harksen, Sibylle. Bibliographie zur Kunstgeschichte von Sachsen-Anhalt. Berlin, Akademie-Verlag, 1966. 431p. (Deutsche Akademie der Wissenschaften, Berlin. Arbeitsstelle für Kunstgeschichte. Schriften zur Kunstgeschichte, Heft 11)
A bibliography of art historical literature on the region of Sachsen-Anhalt (Halle and Magdeburg). The fourth in the series of bibliographies for regions in the DDR (E. Germany). Comprehensive; classified, with indexes of authors, artists, other persons, places, and subjects.

A128 Hentschel, Walter. Bibliographie zur sächsischen Kunstgeschichte. Berlin, Akademie-Verlag, 1960. 273p. (Deutsche Akademie der Wissenschaften, Berlin. Arbeitsstelle für Kunstgeschichte. Schriften zur Kunstgeschichte, Heft 4)

A classified listing of books and periodical articles on the history of Saxon art, the first in a series of bibliographies for regions in the DDR (E. Germany). Comprehensive in scope; classified with indexes of authors, artists, other persons, places, and subjects.

A129   Möbius, Helga. Bibliographie zur thüringischen Kunstgeschichte. Berlin, Akademie-Verlag, 1974. x, 227p. (Deutsche Akademie der Wissenschaften, Berlin. Arbeitsstelle für Kunstgeschichte. Schriften zur Kunstgeschichte, Heft 16)

A classified bibliography of the art historical literature on the East German region of Thuringia; the sixth and final volume of bibliographies on the art and architecture of the DDR (E. Germany). Includes indexes of authors, artists, notable individuals, places, and subjects.

A130   Neubauer, Edith, and Schlegelmilch, Gerda. Bibliographie zur brandenburgischen Kunstgeschichte. Berlin, Akademie-Verlag, 1961. 231p. (Deutsche Akademie der Wissenschaften, Berlin. Arbeitsstelle für Kunstgeschichte. Schriften zur Kunstgeschichte, Heft 7)

This bibliography of the art historical literature on the Brandenburg region is the second in the series of bibliographies on regions in the DDR (E. Germany). Comprehensive; classified, with indexes of authors, artists, other persons, places, and subjects.

A131   Schrifttum zur deutschen Kunst: hrsg. vom Deutschen Verein für Kunstwissenschaft. Jahrg. 1-(31) [okt. 1933]-(67). Berlin, Deutscher Verein für Kunstwissenschaft, 1934-(75).

Ed. by Deutscher Verein für Kunstwissenschaft. 1st volume undertaken by Hans Kauffmann, 1933; since 1961, comp. by the Bibliothek des Germanischen Nationalmuseums.

A classified, annotated bibliography of the art and architecture of German-language countries. Excludes the 20th century. Each volume covers either one or two years. Time period between the year reviewed and year of publication varies.

Indexes of artists, places, and authors.

Supplement: *Schrifttum zur deutsch-baltischen Kunst, zusammengestellt von Hans Peter Kügler. Beiheft zum Schrifttum der deutschen Kunst hrsg. vom Deutschen Verein für Kunstwissenschaft. Berlin, Deutscher Verein für Kunstwissenschaft, 1939. 42p.*

A132   Schrifttum zur deutschen Kunst des. 20. Jahrhunderts; eine Bibliographie des Deutschen Kunstrates EV. Bearb. von Ernst Thiele. 2. Aufl. Köln, Oda-Verlag, 1960. 1v.

All published.

A bibliography of published literature and dissertations from 1945-60 on 20th-century German painters, sculptors, and printmakers. Annotated entries.

A133   Sepp, Hermann. Bibliographie der bayerischen Kunstgeschichte bis ende 1905. Strassburg, Heitz, 1906. 345p.

_____. Nachtrag für 1906-1910. Strassburg, Heitz, 1912. 208p. (Studien zur deutschen Kunstgeschichte, Bd. 67-155)

A classified bibliography of books and periodical literature on Bavarian art. Continued by Wichmann (A135).

Index of persons and subjects, p.327-29; author index, p.330-45. *Nachtrag* follows same format.

A134   Spalek, John M. German expressionism in the fine arts: a bibliography. Los Angeles, Hennessey & Ingalls, 1977. 272p. (Art and architecture bibliographies, 3)

"More than 4000 entries include books by and about the artists, books illustrated by the artists, and exhibition catalogues. Concentration is on painting and graphic work. Special sections deal with such groups as Der Blaue Reiter, Die Brücke, Bauhaus, and Der Sturm, as well as 36 individual artists. The thorough indexing and cross-referencing make it possible to refer from an artist to those exhibitions in which he was included."—*Pub. prospectus.* 1972 is the cutoff date claimed for inclusion.

A135   Wichmann, Hans, ed. Bibliographie der Kunst in Bayern. Wiesbaden, Harrassowitz, 1961-73. 5v. (Bayerische Akademie der Wissenschaften, Munich. Kommission für bayerische Landesgeschichte. Bibliographien. Bd. 1-5)

A monumental classified bibliography on Bavarian art. Occasional brief annotations.

Contents, Bd. I-IV: (A) Schrifttum und Quellen; (B) Kunstpflege-Organisation-Sammlungen-Forschung; (C) Gestalten des Christlichen Glaubens, ihr Kult-Heraldik und Sphragistik-Bildgattungen; (D) Von Bayerischer Art und Kunst; (E) Bayerische Kunstgeschichte nach Epochen; (F) Kunstgattungen (Architektur, Plastik, Malerei, Handzeichnung und Druckgraphik, Kunsthandwerk). Bd. V (Sonderband), Dürer-Bibliographie von Matthias Mende (1971).

## Great Britain

A136   Archaeological bibliography for Great Britain & Ireland, 1950/51- . London, Council for British Archaeology, 1949- . Annual.

1940/46-1948/49 *Archaeological bulletin for the British Isles.*

A classified index of book and periodical literature. Scope: English and Irish archaeology (including art history) from the earliest times to 1600 A.D., with a few entries for literature on monuments of the 17th century. Topographical and period classification. Subject index.

A137   Bonser, Wilfrid. An Anglo-Saxon and Celtic bibliography (450-1087). Berkeley and Los Angeles, Univ. of California Pr., 1957. 2v.

A comprehensive bibliography on Anglo-Saxon and Celtic history and culture including archaeology and a sizeable section on art (p.480-574). Lists books and periodical literature published up to 1954. v.2 consists of author and subject indexes.

A138 British archaeological abstracts. v.1- . London, Council for British Archaeology, 1968- .
v.1, no. 1 preceded by an introductory issue (1967). Published twice a year in Apr. and Oct. Ed. by Cherry Lavell.

"Concise summaries of published articles with the bibliographical information which allows the originals to be traced and consulted."—*Pref.*

Covers material on archaeology in the broad sense from earliest times to 1600 A.D. Complements *Archaeological bibliography for Great Britain and Ireland* (A136). Includes digests of articles in a few continental publications and in those American periodicals likely to contain interesting material. Includes book reviews. The index to authors and subjects appears in the Oct. issue.

A139 Dobai, Johannes. Die Kunstliteratur des Klassizismus und der Romantik in England. Bern, Benteli [1974-77]. 3v.
A detailed critical study of 18th- and 19th-century literature on art in England.

Contents: v.1, 1700-50: (I) Allgemeine Kunstlehre; (II) Architektur; (III) Gartenkunst; (IV) Malerei; (V) Kunstgeschichte; (VI) Auslandreisen. Abkürzungen von Zeitschriften und Nachschlagewerken, p.15; Bibliographien, p.15-22; Gekürzt zitierte Literatur, p.22-43. v.2, 1750-90: (I) Allgemeine Kunstlehre; (II) Architektur; (III) Malerei; (IV) Gartenkunst; (V) Kunstleben und seine institutionellen Formen; (VI) Kunstgeschichte; (VII) Auslandreisen; v.3, 1790-1840: (I) Allgemeine Kunstlehre und Quellen; (II) Architektur; (III) Malerei und Skulptur; (IV) Gartenkunst; (V) Kunstgeschichte; (VI) Auslandreisen; (VII) Urteile von Ausländern über die englische Kunst.

Extensive references in footnotes. Includes bibliographies at the end of each section.

A140 London. University. Courtauld Institute of Art. Annual bibliography of the history of British art. 6v. 1934-1946/48. Cambridge, Cambridge Univ. Pr., 1936-56. (Repr.: N.Y., Johnson, 1970.)
A classed bibliography with index at end of each volume.

"Includes both books and articles on the history of British art excluding Roman but including Celtic and Viking art, and covering architecture, painting, sculpture, the graphic arts and the applied arts."—*Pref.* The 161 periodicals indexed are mostly in English (25 foreign journals are included).

Beginning with v.4, subjects included in other bibliographical publications were omitted or curtailed, for example, coins and costume, included in *Writings on British History.* (Winchell, *Guide to reference books,* 8th ed., DC 128.)

## Italy

A141 "Bibliografia dell'arte veneta." Published annually in *Arte veneta,* v.1, 1947- .
A classified bibliography of current literature on Venetian art; each year's bibliograhy appears in the *Arte veneta* (Q83) of the following year.

A142 Ceci, Giuseppe. Bibliografia per la storia delle arti figurative nell'Italia meridionale. Napoli, Presso la R. Deputazione, 1937. 2v.

A detailed, classified bibliography on the art and artists of southern Italy. Basic to research on Neapolitan art. Includes references to documents, topographical literature, and literary sources, as well as books and articles.

Contents: v.1, L'arte nell'Italia meridionale dal medioevo alla prima metà del secolo XVIII; v.2, Dalla metà del secolo XVIII ai nostri giorni.

v.1 divided into works before 1742 and those beginning with De Dominici. v.2 contains a plan of the work (indice generale), author index, index of artists, index of places, and list of periodical sources including newspapers.

A143 Lozzi, Carlo. Biblioteca istorica della antica e nuova italia. Saggio di bibliografia analitico, comparato e critico sulla propria collezione con un discorso proemiale. Imola, Galeati, 1886-87. 2v. (Repr.: Bologna, Forni, 1963.)
An annotated bibliography of Italy, most valuable to art historians for the location of documentary material and the specialized literature on local artists.

Contents: v.1, Letteratura e parte generale degli statuti; Statuti de' municipii italiani e relativi o affini ordinamenti; Storia d'Italia in generale; Storia de' municipii e di luoghi e cose particolari d'Italia; A-O. v.2, P-Z.

A144 Schudt, Ludwig. Le guide di Roma: Materialien zu einer Geschichte der römischen Topographie, unter Benützung des handschriftlichen Nachlasses von Oskar Pollak. Wien, Filser, 1930. 544p. (Quellenschriften zur Geschichte der Barockkunst in Rom . . .). (Repr.: Farnborough, Gregg, 1971.)
Definitive. A monument to bibliographical and art historical scholarship. pt. 1 (p.5-180) is a documented history of guidebooks to Rome; pt. 2 (p.185-518) is the bibliography, arranged chronologically. Index of names and titles, table of publication dates, index of places of publication.

*[handwritten: New: 016.7 098 : Findlay F 494 Mod. L. Am. M 689 Art : Biblog. 1983 (Desk)]*

## Latin America

A145 Buschiazzo, Mario José. Bibliografía de arte colonial argentino. Buenos Aires, Universidad de Buenos Aires [Instituto de Arte Americano e Investigaciones Estéticas] 1947. 150p.
A classified bibliography of books, periodical articles and documents on colonial art in Argentina. Short annotations.

A146 Giraldo Jaramillo, Gabriel. Bibliografía selecta del arte en Colombia. Bogotá, Editorial A B C, 1956. 147p. (Biblioteca de bibliografía colombiana)
A classified, annotated bibliography of Colombian art. Author index, p.135-42.

A147 Handbook of Latin American studies. Cambridge, Harvard Univ. Pr.; Gainesville, Univ. of Florida Pr., 1936- . v.1- .
The only continuing bibliography of Latin American art and architecture.

Author index of v.1-28, 1936-66 (1968). Before 1964 (v.26), each volume (except v.1) includes the current bib-

21

liography of Latin American art and archaeology. Thereafter the section has appeared in the Humanities volume of the *Handbook,* published in alternate years.

Comprehensive listings classified into the subjects of art and ethnohistory (includes pre-Columbian art). Short descriptive annotations. Compiled by scholars and preceded by reviews of the current state of research.

A148   Smith, Robert Chester, and Wilder, Elizabeth. A guide to the art of Latin America. Wash., D.C., U.S. [Govt. Print. Off.] 1948. 480p. ([U.S.] Library of Congress. Latin American ser., no. 21) (Repr.: N.Y., Arno, 1971)

A selective, annotated, classified bibliography of books and periodical articles published before 1943, containing about 5,000 entries.

Literature on architecture, painting, sculpture, graphic arts, minor arts, photography, museums, and art education. Arranged by period: (1) colonial; (2) 19th century; (3) modern. These are subdivided by country and media. Call numbers for books in the Library of Congress are given; locations in other libraries indicated for books not in the Library of Congress.

A149   Tapia Claure, Osvaldo. Los estudios de arte en Bolivia; intento de bibliografía crítica. [1. ed.] La Paz, Instituto de Investigaciones Artísticas, Facultad de Arquitectura, Universidad Mayor de "San Andrés," 1966. 112, [13]p.

Bibliography: p.[113-21].

A thorough discussion of historical research on Bolivian art. A bibliography from the colonial period to the present is incorporated.

A150   Valladares, José. Estudos de arte brasileira, publicações de 1943-1958; bibliografia seletiva e comentada. Salvador, 1960. xvii, 193p. (Bahia, Museu do Estado, Publicação, 15)

A classed bibliography of all of the arts of Brazil. Short annotations.

Index of authors, artists, museums, galleries, and collectors, p.[181] -89; List of periodicals cited, p.[191] -93.

SEE ALSO: entries under Bibliography-Primitive-The Americas

## Low Countries

A151   Hall, H. van. Repertorium voor de geschiedenis der Nederlandsche schilder- en graveerkunst sedert het begin der 12de eeuw. 's Gravenhage, Nijhoff, 1936-49. 2v.

Book and periodical literature on Dutch painting and engraving from the 12th century to 1946; includes early Flemish art.

Deel I covers 12th century to 1932; deel II, 1933-46.

Subject arrangement with author index. List of works treated (including about 450 periodicals) given at beginning of each volume.

"Lijst van afkortingen der geraadpleegde tijdschriften en verzamelwerken": v.1, p.[xiii]-xxviii; v.2, p.[xi]-xxii.

A152   Netherlands. Rijksbureau voor Kunsthistorische Documentatie. Bibliography of the Netherlands Institute for Art History. v.1-(14¹), 1943-(67-68). The Hague, Rijksbureau . . ., 1943-(75?). Irregular. Editors vary.

A classed bibliography of the literature on Dutch and Flemish art. Does not include architecture. v.1-10 include publications on the 19th and 20th century; thereafter only pt.1 (Old art) has appeared. Classification varies. Contents of v.14: pt. 1, Painting, old art; pt. 2, Sculpture, old art; pt. 3, Arts and crafts, old art; pt. 4, Personalia.

A153   Repertorium betreffende nederlandse monumenten van geschiedenis en kunst (voornamelijk van tijdschriftartikelen). 's Gravenhage, Nederlandsche Oudheidkundige Bond, 1940-(71).

Title varies slightly.

A classified list of periodical articles on historical and artistic monuments of the Netherlands. [v.]I (1940) indexes articles which appeared 1901-34; [v.]II (1943) covers the period 1935-40; [v.]III (1943) covers 1941-50; [v.]IV (1971) covers 1951-60 and includes an introduction and table of contents in English. Each volume has a systematic table of contents and an index of persons and places.

Contents: pt. 1, (A) Preservation of monuments; (B) Dutch art history and archaeology; (C) Architecture; (D) Sculpture; (E) Printing and cartography; (F) Heraldry; (G) Ecclesiastical art; (H) Applied arts; (I) Museum. Pt. 2, Regions and municipalities. Index.

A154   Repertorium van boekwerken betreffende nederlandse monumenten van geschiedenis en kunst verschenen tot 1940. 's Gravenhage, Nederlandsche Oudheidkundige Bond, 1950. v.1. 169p.

A classified bibliography of books on the historic and artistic monuments of the Netherlands up to 1940. Does not include painting. Pt. 1 includes art history, architecture, sculpture; pt. 2 is a topographical listing arranged by region and municipalities. General index, p.146-62.

## Russia and Eastern Europe

A155   Biró, Béla. A magyar művészettörténeti irodalom bibliográfiája; Bibliographie der ungarischen kunstgeschichtlichen Literatur. Budapest, Képzőművészeti alap Kiadóvállata, 1955. 611p.

A classified bibliography of books and articles on Hungarian art and all Hungarian writings on art history. Covers 18th century to 1954. Table of contents and foreword in Hungarian and German.

A156   "A magyar művészettörténeti irodalom bibliográfiája" (Bibliography of Hungarian art history), 1962- .

Published in *Művészettörténti értesítő,* v.12- , 1963- .
An annual, classified bibliography of books, articles, and exhibition catalogues on Hungarian art (written almost entirely in Hungarian) by Hungarian scholars. Published irregularly as a special section of *Művészettörténeti Értesítő.* Includes, among others, sections on aesthetics, archaeology, architecture, city planning, preservation, sculpture, painting, printmaking, applied arts, folk art, museums, art education, exhibitions, and bibliography. No annotations.

A157  Polska bibliografia sztuki 1801-1944. Opracowały Janina Wiercińska, Maria Liczbińska. Wrocław, Zakład Narodowy im. Ossolińskich, 1975- . v.1- .
At head of title: Polska Akademia Nauk. Instytut Sztuki.
A comprehensive bibliography of the arts from 1801-1944. Projected in several volumes. Includes book and periodical literature on Polish art from both Polish and foreign publications as well as all of the writing of Polish art historians regardless of subject. Index.

## Scandinavia

A158  Bodelsen, Merete (Christensen), and Marcus, Aage. Dansk kunsthistorisk bibliografi. København, Reitzel, 1935. 503p.
A classified bibliography of books and periodical literature on Danish art. Includes architecture, sculpture, painting, graphic arts, art museums and collections, art academies, and art historians. List of Danish art periodicals, p.14-15.
No index.

A159  Copenhagen. Kunstakademiets Bibliotek. Bibliografi over dansk kunst [Bibliography of Danish art], v.1, 1971- . København, Kunstakademiets Bibliotek, 1972- .
"This new annual bibliography follows Bodelsen and Marcus (A158), and plans five-year cumulations. The period 1933-1970 is in preparation. Includes works on Danish art (arranged by architecture, painting and graphic arts, and decorative arts) published in Denmark and elsewhere, in books, journals, and exhibition catalogues. Auction sales catalogues are excluded. The editor is Emma Salling."—*RILA,* Demonstration issue, 1973, no. 6.

A160  Lundqvist, Maja. Svensk konsthistorisk bibliografi. Sammanställd ur den tryckta litteraturen till och med år 1950. (Acta Universitatis Stockholmiensis. Stockholm studies in history of art. 12) Stockholm, Almqvist & Wiksell, 1967. 432p.
Preface and table of contents in English and Swedish.
Contents: pt. 1, The art in Sweden (includes material on foreign artists working in Sweden, as well as foreign studies of Swedish art); pt. 2, Art in foreign countries (works by Swedish authors and those by foreign authors in Swedish publications). "The Table of Contents is the key to be

used for finding literature on a certain subject. The Supplementary Index should also be consulted. A list of the subject entries in English has been added to it."—*Pref.*

## Spain and Portugal

A161  "Apportaciones recientes a la historia del arte español." Published in *Archivo español de arte,* v.20, 1948- .
Frequency varies.
A classified bibliography of recent literature on Spanish architecture, sculpture, painting, and minor arts. Often includes catalogues, the history of cities, and sales. "Apportaciones" for the years 1948-49 is a critical evaluation of the current bibliography; thereafter published as a classified list. From 1954 it frequently concludes the section entitled "Bibliografía," which includes book reviews. Within each classification, books and articles are listed separately; articles are numbered and abstracted.

A162  López Serrano, Matilde. Bibliografía de arte español y americano 1936-40. Madrid [Gráficas Uguina], 1942. 243p.
At head of title: Consejo Superior de Investigaciones Científicas, Instituto Diego Velázquez.
No more published. A classified bibliography of art and archaeology of Spain, Spanish America, and the Philippines. Index of persons and places, p.199-240; Outline of classification, p.241-43.

## Switzerland

A163  Haendcke, Berthold. Architecture, sculpture et peinture. Réd. par le Dr. Berthold Haendcke. . . . Berne, Wyss, 1892. 100p. (Bibliographie nationale suisse. Répertoire méthodique de ce que a été publié par la Suisse et ses habitants. Pub. avec le concours des autorités fédérales et d'administrations fédérales et cantonales et en collaboration avec de nombreux savants par la Commission centrale pour la bibliographie suisse [fasc. 6a-c])
On p.4 of cover: Bibliographie der schweizerischen Landeskunde. Architektur, Plastik, Malerei. . . .
A classed bibliography of material on Swiss art with prefatory notes in French and German. Alphabetical index of artists, p.89-100.

## United States

A164  [A bibliography of the arts in America from colonial to modern times, ed. by Bernard Karpel. Sponsored by the Archives of American Art. Wash., D.C.: Smithsonian Institution, 1980?]
Title, publication date, and number of volumes tentative.

A classified, fully annotated bibliography by approx. 20 contributors on the painting, sculpture, graphic arts, architecture, photography, etc. produced in America from colonial times to the present.

A165   McCoy, Garnett. Archives of American Art: a directory of resources. N.Y., Bowker, 1972. 163p.
"The following guide to the collections of the Archives of American Art lists and briefly describes 555 groups of papers."—*Pref.* Materials are listed in one alphabet under artists, art galleries, art organizations, critics, collectors, etc. Preface contains procedures for using the resources in the five regional offices (main office: Wash., D.C.). Microfilms are loaned to scholars through regular interlibrary loan arrangements.
   Index, p.149-62.
   A complete checklist of the papers held by the Archives is now available: Archives of American Art, *A checklist of the collection, Spring 1975,* Comp. by Arthur J. Breton, Nancy H. Zembala, and Anne P. Nicastro ([Washington] Smithsonian Inst. 1975). "Periodic revisions of the Checklist will include our most recent acquisitions and add information or necessary corrections to earlier listings."—*Foreword.*

A166   Sokol, David M. American architecture and art: a guide to information sources. Detroit, Gale, 1976. 341p. (American studies information guide series. v.2)
A comprehensive, classified bibliography on American architecture and art. Includes 1,590 annotated entries (books, exhibition catalogues, and a few periodical articles). Limited primarily to English-language, in-print works, with an emphasis on the 18th and 19th centuries.
   Contents: General reference sources; General histories, aesthetics and taste; American architecture; Period surveys of American architecture; Individual architects; American painting; Period surveys of American painting; Individual painters; American sculpture; Individual sculptors; American decorative arts. Indexes of authors, short titles, and subjects.

A167   Whitehill, Walter Muir. The arts in early American history; an essay by Walter Muir Whitehill. A bibliography by Wendell D. Garrett and Jane N. Garrett. Chapel Hill, published for the Institute of Early American History and Culture at Williamsburg, Va., by the Univ. of North Carolina Pr. [1965]. xv, 170p. (Needs and opportunities for study series)
The introductory essay, "An unexploited historical resource," is a critical discussion of the resources and current state of research in early American art. The annotated bibliography on American art before 1826 lists important books and significant articles published from 1924-64 and a few earlier books and articles published between 1876-1924.
   The bibliography is classified as follows: (I) Writings on the arts in early America, 1876-1964; (II) General works; (III) Architecture; (IV) Topography; (V) Painting; (VI) Sculpture and carving; (VII) Graphic arts; (VIII) Medals, seals, and heraldic devices; (IX) Crafts; (X) Furniture;

(XI) Silver; (XII) Pewter; (XIII) Other metals and wooden ware; (XIV) Pottery; (XV) Glass; (XVI) Lighting devices; (XVII) Wall decoration; (XVIII) Folk art; (XIX) Textiles; (XX) Serial publications.

SEE ALSO: entries under Bibliography-Primitive-The Americas

# ORIENTAL COUNTRIES

A168   "Bibliography." Published in *Oriental Art,* v.1-3, 1948-51; n.s. 1- , 1955- .
A classified bibliography published (with rare exceptions) in each quarterly issue of *Oriental Art.* Includes recent literature (books, periodical and Festschriften articles, conference proceedings, catalogues, etc.) on the art, architecture, and archaeology of China, Korea, Japan, India, Pakistan, Southeast Asia, the Middle East, and Islam. Some of the early bibliographies include annotated entries. In 1974, only one bibliography, devoted entirely to Japan, was published (summer 1974, v.20, no. 2).

A169   "Bibliography of Asian studies." Published as no. 5 (Sept.) of each volume of the *Journal of Asian Studies,* 1956- . Ann Arbor, Assn. for Asian Studies, 1957- . Annual.
Continues the "Far Eastern bibliography" included in the *Far Eastern quarterly* (1941-55), which superseded the *Bulletin of Far Eastern bibliography* (1936-40).
   This comprehensive bibliography of books and periodical articles in European languages is classified by country (China, Japan, India, etc.) or by region (Central Asia and Soviet Far East, Himalaya, etc.). Within these geographic headings it includes varying subdivisions on the arts, archaeology, and architecture. No annotations. Index.
   These annual bibliographies are published cumulatively under the same general classification system in: *Cumulative bibliography of Asian studies, 1941-1965. Author bibliography* (1969) 4v., and *Subject bibliography* (1970) 4v. Boston, Hall; *Cumulative bibliography of Asian studies, 1966-1970. Author bibliography* (1973) 3v., and *Subject bibliography* (1972) 3v. Boston, Hall.

A170   Kyoto. Imperial University. Research Institute for Humanistic Science. Bibliography of Oriental studies. 1946/50- . Kyoto. 1952- . Annual (irregular).
A classified bibliography of books and periodical articles on Japan, China, and Korea in Japanese and Western languages (including Russian). Each issue contains sections on archaeology and the history of art, with slightly varying subdivisions: general, architecture, sculpture, painting, calligraphy, technology, industrial arts, and music. No annotations. Entries often include references to reviews. Author indexes at the end.

A171   Rowland, Benjamin, Jr. The Harvard outline and reading lists for Oriental art. 3d ed. Cambridge, Mass., Harvard Univ, Pr., 1967. 77p.

Earlier editions of 1952 and 1958 were revisions of *Outline and bibliographies of Oriental art,* published in 1938, 1940, and 1945.

"The outline is intended primarily for the use of students in introductory courses in all branches of Oriental art and as a handy reference book for everyone interested in the subject. It is arranged by countries and periods, and within these categories under headings of architecture, sculpture, and painting. The lists of examples are selective rather than complete. . . . The bibliographies are intended both for the beginner and as reference lists for the advanced student."—*Pref.* No annotations.

Contents: Outline, p.1-28; (2) Readings lists, p.29-77. List of periodicals and serials in the field, p.29-31.

## China

A172   Chen, C. M., and Stamps, Richard B. An index to Chinese archaeological works published in the People's Republic of China, 1949-1965. East Lansing, Asian Studies Center, Michigan State Univ., 1972. ix, 75p. map. (East Asia series, no.3)

A classified bibliography of books and articles on Chinese archaeological subjects published in the People's Republic of China from its establishment in 1949 to 1965. Titles are translated from the Chinese into English and are arranged chronologically, then geographically, and finally by date of publication. No annotations.

Chronology of Chinese civilization, p.iii; China, a political map, p.[v]; Names of political subdivisions, People's Republic of China, p.vii.

A173   Revue bibliographique de sinologie. v.1- , 1955- . Paris, Mouton, 1957- .

At head of title: École pratique des hautes études. VI^e section.

An annual, general bibliography on Chinese studies. Each volume contains a section on "Archéologie, art et épigraphie" with subdivisions: (1) Archéologie; (2) Céramique; (3) Bronzes; (4) Sculpture et architecture; (5) Peinture, gravure et calligraphie; (6) Art mineurs; (7) Épigraphie. Includes literature in Western and Oriental languages. Each entry includes a signed, analytical annotation in French, English, or German. Index of authors; index of subjects and proper names.

A174   Yuan, Tung-li. The T. L. Yuan bibliography of western writings on Chinese art and archaeology, ed. by Harrie A. Vanderstappen. [London] Mansell, 1975. xlvii, 606p.

A classified bibliography of over 15,000 entries of writings on Chinese art and archaeology in English, German, French, Dutch, Scandinavian, Slavic, and other Western languages, published from 1920-65. The bibliography is in two parts, the books section and the articles section, and is arranged by subject with subdivisions. The books section includes exhibition catalogues and references to reviews. Among the entries are a number on the arts of the surrounding areas of Tibet, Mongolia, Central Asia, Korea, and Japan. The primary arrangement for both sections is as follows: (I) General; (II) Archaeology; (III) Architecture; (IV) Calligraphy; (V) Painting; (VI) Graphics; (VII) Sculpture; (VIII) Bronzes; (IX) Ceramics; (X) Decorative arts and handicrafts.

List of sources, p.xi-xxxv. Index to authors, p.541-98. Index to collectors and collections, p.599-606.

## India

A175   Coomaraswamy, Ananda K. Bibliographies of Indian art. Boston, Museum of Fine Arts, 1925. 54p.

"Partly reprinted with additions from parts I, II, and IV of the Catalogue of the Indian collections in the Museum of Fine Arts."—*Pref.*

Some entries annotated.

A176   Instituut Kern, Leyden. Annual bibliography of Indian archaeology. v.[1- ], 1926- . Leyden, Brill, 1928- . plates.

An annotated, classified bibliography of books and articles on Indian archaeology in its widest sense, including cultural history and art. The bibliography also includes a large section, "Regions within the sphere of Indian cultural influence," which lists literature in fully annotated entries on Ceylon, Southeast Asia, Afghanistan and Central Asia, Nepal and Tibet, and the Far East (China, Korea, Japan). Reviews are often indicated. Some volumes have introductions outlining recent research.

A177   Mitra, Haridas. Contribution to a bibliography of Indian art and aesthetics. Santiniketan, Visva-Bharati, 1951. 240p.

A bibliography consisting mainly of sources. Introduction covers iconography, table of linear measurements, architecture, painting, history of chronology of masters.

Contents: Introduction, p.8-76; Classified list of texts, p.77-237; Additions and corrections, p.238-40.

## PRIMITIVE

A178   Bulletin signalétique. Série 521: Sociologie-Ethnologie. v.21- . Paris, Centre National de la Recherche Scientifique, 1967- .

Quarterly, with annual cumulative indexes.

Supersedes section 21 of *Bulletin signalétique* and continues its volume numbering. Subtitle varies: 1969: *Sociologie, ethnologie, préhistoire et archéologie.* In 1970 its part *Préhistoire* superseded by *Bulletin signalétique 526: Art et archéologie. Proche-Orient, Asie, Amérique.*

A major current bibliography of books and periodical articles in all fields of sociology and ethnology, including the arts of primitive cultures. The ethnology bibliography contains listings on museum activities and exhibitions and a section on sculpture and handicrafts. Brief descriptive

25

annotations. Each fascicle has a list of periodicals analyzed and indexes of subjects and authors.

A179   Primitive art bibliographies. N.Y., Library, Museum of Primitive Art. no. 1, 1963–(no. 9, 1971).
A numbered series of bibliographies of books and periodical literature by scholars and specialists on the arts of Oceania, Africa, and the Americas. Published to date: (1) Fraser, Douglas. *Bibliography of Torres Straits art* (1963; 6p.); (2) Jones, Julie. *Bibliography of Olmec sculpture* (1963; 8p.); (3) Cole, Herbert M., and Thompson, Robert Farris. *Bibliography of Yoruba sculpture* (1964; 11p.); (4) Newton, Douglas. *Bibliography of Sepik District art*, pt.1 (1965; 20p.); (5) not published; (6) Ben-Amos, Paula. *Bibliography of Benin art* (1968; 17p.); (7) not published; (8) Wardwell, Allen, and Lebov, Lois. *Annotated bibliography of Northwest Coast Indian art* (1970; 25p.); (9) Chevrette, Valerie. *Annotated bibliography of the precolumbian art and archaeology of the West Indies* (1971; 18p.).

## Africa

A180   Gaskin, L. J. P. A bibliography of African art; compiled at the International African Institute by L. J. P. Gaskin under the direction of Guy Atkins. London, International African Inst., 1965. x, 120p. (African bibliography series. B)
Arranged geographically, with subheadings covering the principal genres for every region. Includes author, geographical and ethnic, and subject indexes. "This work is unique for the area and therefore mandatory for any library."—*Primitive art* (A56).

A180a  Western, Dominique Coulet. A bibliography of the arts of Africa. Waltham, Mass., African Studies Assn., Brandeis Univ., 1975. iv, 123p.
"A compilation of material on Art, Architecture, Oral Literature, Music, and Dance in Sub-Saharan Africa. Each of these major categories has been subdivided into both a general listing (e.g. under Art, survey books covering the entire continent), as well as broad geographical areas: West, Central, South, and East Africa. Art, Oral Literature, and Music have been further subdivided into ethnic groups and some nations. Finally, an author index has been provided for additional reference. African films and recordings have not been included."—*Author's note.*

## The Americas

A181   Bernal, Ignacio. Bibliografía de arqueología y etnografía: Mesoamerica y norte de México, 1514–1960. México, Instituto nacional de antropología e historia, 1962. xvi, 634p. fold. col. map. (Mexico. Antropología é historia, Instituto nacional de. Memorias. 7)
A bibliography of 13,990 entries, classified geographically. Larger classifications are subdivided, including sections on archaeology, sculpture, the minor arts. No annotations. Author index and classification system at end of volume.

A182   Harding, Anne Dinsdale, and Bolling, Patricia, comp. Bibliography of articles and papers on North American Indian art. Under the direction of Dr. Otto Klineberg in cooperation with Dr. George Vaillant and Dr. W. D. Strong. [Washington, 1938] 365p. map. (Repr.: N.Y., Kraus, 1969.)
At head of title: Department of the Interior, Indian Arts and Crafts Board, Washington.
Contents: pt. I, Annotated list of articles and papers arranged alphabetically by authors; pt. II, Lists of those articles and papers in pt. I which cover the entire area of N. America, (a) Articles and papers on general aspects of Indian arts and crafts, (b) Articles and papers on specific techniques and types of products; pt. III, List of those articles and papers in pt. I which deal with regional arts and crafts only (eastern woodlands tribes, southeastern tribes, plains tribes, Mackenzie tribes, northwest coast tribes, Eskimo tribes); pt. IV, List of articles and papers arranged alphabetically by name of craft.
List of abbreviations at beginning is a key to the annotations. Publications covered, p.360–65.

A183   Kendall, Aubyn. The art of pre-Columbian Mexico: an annotated bibliography of works in English. Austin, Inst. of Latin-American Studies, Univ. of Texas at Austin, 1973. x, 115p. il.
An annotated bibliography of books and periodical articles on pre-Columbian art of Mexico. Limited to English-language publications. Includes an appended list of references not examined by the compiler.

A184   Murdock, George Peter. Ethnographic bibliography of North America. 3d ed. New Haven, Human Relations Area Files, 1960. xxiii, 393p. maps. (Behavior science bibliographies)
1st ed. 1941.
An exhaustive bibliography of published material (approx. 17,300 entries) on all ethnographical subjects relating to aboriginal N. America. Although most useful to the anthropologist, the bibliography does include entries on archaeology and art. Arranged by geographical areas and within each area by tribal groups in alphabetical order. Contains references up to 1960. No annotations. Index of tribal names, p.391–93.

A185   O'Leary, Timothy J. Ethnographic bibliography of South America. New Haven, Human Relations Area Files, 1963. xxiv, 389p. maps. (Behavior science bibliographies)
An exhaustive bibliography of published material (approx. 24,000 entries) on all ethnographical subjects relating to S. America. Follows Murdock's (A184) organization by arrangement in geographical areas and within each area by tribal groups in alphabetical order. Includes entries on archaeology and art. Covers the literature through 1961. No annotations. Index of tribal names, p.373–87.

SEE ALSO:  *Bulletin signalétique 526: Art et archéologie. Proche-Orient, Asie, Amerique* (A80).

## Oceania

A186 Taylor, Clyde Romer Hughes. A Pacific bibliography; printed matter relating to the native peoples of Polynesia, Melanesia and Micronesia. 2d. ed. Oxford, Clarendon, 1965. xxx, 692p. fold. map.

A classified bibliography divided into four main areas: (1) Oceania; (2) Polynesia; (3) Melanesia; (4) Micronesia. The main areas are subdivided into categorical sections, including arts, archaeology, dress, ornament, artefacts and handicrafts. The "Guide to arrangements" gives the complete classification breakdown. No annotations.

Appendix: Principal islands and groups as arranged in the bibliography, p.589-91. General index at end of volume.

*see also 016.5356 (slack) 018 F115 1982*

# SPECIALIZED SUBJECTS

A187 Buckley, Mary, and Baum, David. Color theory: a guide to information sources. Detroit, Gale [1975], 173p. (Art and architecture information guide series. v.2)

An annotated bibliography on color theory, classified into 22 sections: Adaptation; Aesthetics; Architecture; Artists' concepts; Decoration; Design; Discrimination; Easel painting; Education; Form; Imagery; Harmony; Colorimetry; Ideology; Kinetics; Palettes; Perception; Psychology; Systems; Theories; Vision; Vocabulary. General index.

"This bibliography is for the artist interested in the pursuit of the mysteries of color and is not intended to supply information about books that will tell anyone 'how to' apply color in any of the visual arts. Rather, I have included those sources that have influenced the concepts, theories, and particularly the paintings of practicing artists."—*Introd.*, p.ix.

A188 Graf, Hermann. Bibliographie zum Problem der Proportionen; Literatur über Proportionen, Mass und Zahl in Architektur, bildenden Kunst und Natur. Teil 1. Speyer, Pfälzische Landesbibliothek, 1958. 96p. (Pfälzische Arbeiten zum Buch- und Bibliothekswesen und zur Bibliographie, Heft 3)

A bibliography of the art historical writings on proportion and other formal elements; covers the period from 1800-1958. Arranged by date of publication. The first chapter deals summarily with earlier literature.

A189 Hammond, William Alexander. A bibliography of aesthetics and of the philosophy of the fine arts from 1900 to 1932. Rev. and enl. ed. N.Y., Longmans, Green, 1934. 205p. (Repr. of 1934 ed.: N.Y., Russell & Russell [1967].)

A selective bibliography.

A190 Internationale volkskundliche Bibliographie. International folklore bibliography. Bibliographie internationale des arts et traditions populaires. Ouvrage publié par la Commission Internationale des Arts et Traditions Populaires sous les auspices du Conseil International de la Philosophie et des Sciences Humaines et avec le concours de l'UNESCO. 1939/1941- . Rédigé . . . par Robert Wildhaber. Bâle, Krebs; Bonn, Habelt, 1949- .

Frequency varies.

Title in German, English, and French. Order on title page varies. Language of subtitle varies. Publisher varies.

Contents: 1939-41 (1949); 1942-47 (1950); 1948-49 (1954); 1950-51 (1955); 1952-54 (1959); 1955-56 (1962). (Biennial thereafter).

This extensive bibliography covers the folklore of all countries and of all periods. Includes the literature on vernacular architecture, folk arts and crafts, costume, etc. Also useful for art historical research in certain areas of iconography.

A191 Kiell, Norman, ed. Psychiatry and psychology in the visual arts and aesthetics; a bibliography. Madison, Univ. of Wisconsin Pr., 1965. 250p.

7,208 books and periodical references relating to the visual arts, aesthetics, and psychology. Authors include psychologists, psychoanalysts, philosophers, aestheticians, art critics, art historians, and educators. Divided in 22 sections, or categories, arranged alphabetically (i.e., Aesthetics and criticism, Architecture, Art therapy, Caricature and cartoon, Children and art, Color, etc.); within each category arrangement is alphabetical by author. No annotations.

A192 Mayer, Leo Ary. Bibliography of Jewish art, ed. by Otto Kurz. Jerusalem, Magnes Pr., Hebrew Univ., 1967. 374p.

A bibliography of over 3,106 items on all aspects of Jewish art. Short annotations provided for items whose titles are not self-explanatory. Items dealing exclusively or mostly with Jewish art are more fully described. Subject index, by Isaiah Shachau, p.347-74.

The most authoritative work in the field.

A193 Reisner, Robert George. Fakes and forgeries in the fine arts; a bibliography. N.Y., Special Libraries Assn., 1950. 58p.

Covers books and periodical literature published 1848-1948. The technical references are now largely superseded by more recent research.

The general bibliography is followed by several media subdivisions: paintings, prints, drawings, miniatures, sculpture, antiques and antiquities, ceramics, and miscellaneous art forms. Within each section the bibliography is subdivided into the following: (1) Books devoted entirely to the subject; (2) Books which contain a section devoted to the subject; (3) Periodical articles.

Author index, p.55-58. Bibliography of articles from the *New York Times,* 1897 to the present, p.37-54, arranged chronologically with slight annotations.

A194 Warburg Institute. A bibliography of the survival of the classics. v.1-2, 1931-32/33. London, Cassell (v.1), 1934-38. 2v. (Repr.: Nendeln, Liechtenstein, Kraus-Thomson.)

Editors: Edgar Wind and Richard Newald.

An annotated critical bibliography of the survival and revival of antiquity from late antiquity on. Text in German and introduction in English; published soon after the Warburg Library was moved from Hamburg to London. Short-lived yet still an important document which reflects the Warburg approach to cultural history (see also *Journal of the Warburg and Courtauld Institutes,* Q226). Arranged by topic and chronological period.

Author index and index of persons and subjects at end of each volume.

The period 1920–30 is covered by a similar bibliography by Richard Newald entitled *Nachleben der Antike,* published in the *Jahresbericht über die Forschritte der klassischen Altertumswissenschaft,* v.232, 1931, and v.250, 1935.

# B.
# Directories

This chapter is divided into two sections, which list general directories and museums directories. General directories include works containing information of various kinds as well as information on American and international art organizations and institutions. The museums directories give information on collections, administrative and curatorial staff, and museum hours. The directories of museums in individual countries are listed selectively, where more comprehensive published guides are available.

The *Directory of art libraries and visual resource collections in North America* (B3) should prove an invaluable guide to reference collections for librarians, scholars, students, and researchers in all fields of art. An older, descriptive list of the major art research libraries of the United States and Western Europe may be found in the appendix of Chamberlin, *Guide to art reference books* (A27). Other directories of libraries and educational institutions are listed in E. Sheehy, *Guide to reference books,* 9th ed., AB33–AB118 and CB120–CB200.

## GENERAL DIRECTORIES

B1    American art directory, v.1-(47), 1898-(1978). N.Y., Bowker, 1898-(1978). il., plates, ports.
Frequency varies: 1898-1900, 1911-49 irregular; 1904-10 biennial; 1952-70 triennial. None published 1901-03.

v.35, 1941-42, includes art activities for 1938-41; v.36, for July 1941-June 1945; v.37, for July 1945-June 1948. v.33-37, 1936-1945/48 issued in two parts: (1) Organizations: (2) *Who's who in American art* (E179). The latter published as a separate volume after 1952.

Title varies: 1898-1945/48, *American art annual.* From 1913-76 published or sponsored by the American Federation of Arts. v.45- comp. by Jaques Cattell Pr.

v.47 lists 2,300 national and regional art organizations and museums in the U.S. by state, 223 in Canada by province, 393 major museums abroad by country, and more than 1,500 art schools in the U.S., Canada, and other countries. Also includes art magazines, newspapers carrying art notes and their critics, scholarships and fellowships, traveling exhibitions, open exhibitions, booking agencies, and corporate art holdings.

B2    Chamberlain, Betty. The artist's guide to his market. N.Y., Watson-Guptill [1970]. 128p.
Rev. ed. 1975.

Valuable practical information for the artist, the dealer, and the gallery owner. Based on the author's working experience as head of the Art Information Center, New York City.

Contents: (1) Are you ready to exhibit?; (2) Galleries and how they function; (3) Shopping for a gallery; (4) Showing work to dealers; (5) Business terms and agreements; (6) Pricing and selling; (7) Publicity; (8) Co-operative galleries; (9) Artist groups and organizations; (10) Exhibiting without gallery or group affiliation; (11) Miscellaneous tips and observations.

B3    Directory of art libraries and visual resource collections in North America. Comp. by Judith A. Hoffberg and Stanley W. Hess for the Art Libraries Society of North America. N.Y., Neal-Schuman, 1978. (Distr. by ABC/CLIO, Santa Barbara, Calif.) 298p.
Foreword by Katherine M. Ratzenberger.

A guide to art reference collections and visual resource collections. Section 1 is a directory of art libraries and includes a subject index to special collections. Section 2 is a directory of visual resource collections and includes three indexes: Collection emphases; Subscription series; Subject index to special collections. Section 3 is an index to institutions.

B4    Documentation of modern art: a handlist of resources. AICARC 1975. [Published for the International Assn. of Art Critics with financial support of UNESCO]. Lund, CWK Gleerup, 1975. 264p.
"The main purpose of this handlist is to indicate institutions and organizations all over the world which are able to supply *specialized, nonbibliographical documentation on art and art life of this century*. It is supposed to be of value for students, critics and researchers in the area of art and art history. 'Art' is here taken to include not only pictorial arts such as painting, sculpture and original prints, but also architecture, urbanism, applied art and photography etc." —*Introd.*

The museums, libraries, and archives listed are arranged alphabetically by country and then by city. For each gives name, general information on the resources, examples of

major groups of materials, accessibility, and name of person in charge. Types of materials indicated are publications; press-cuttings; unpublished documents such as letters, diaries, business documents, photographs, interviews, and art films. General index, p.247–64.

B5   Feldman, Franklin, and Weil, Stephen E. Art works: law, policy, practice. [N.Y.] Practicing Law Institute [1974]. xxv, 1,241p.

A comprehensive handbook which identifies and explains various laws and legal procedures concerning works of art.

Contents: (I) The rights of the artist in his work; (II) Purchase and sale of works of art; (III) Transport of works of art across national boundaries; (IV) Insuring works of art; (V) Lending works of art; (VI) Tax aspects of works of art; (VII) Civil and criminal liabilities involving works of art; (VIII) Private ownership and public trust. Selected bibliography, p.1193–1200. Index.

B6   Fine arts market place. 73/74– . N.Y., Bowker, 1973– . Biannual.

Editor: Paul Cummings.

A guide to firms, organizations, and individuals in the U.S. and Canada involved with commerce in the fine arts. For each entry provides name, location, telephone number, key personnel, and specialties, products, or activities.

Contents of main sections: Art dealers; Print publishers & wholesalers; Auction houses; Art press; Art book & museum stores; Art book publishers; Services (photographers, packers & movers, etc.); Suppliers; Organizations & associations; Exhibitions. Index.

B7   Fundaburk, Emma Lila, and Davenport, Thomas G., compilers. Art at educational institutions in the United States; a handbook of permanent, semi-permanent and temporary works of art at elementary and secondary schools, colleges and universities. Metuchen, N.J., Scarecrow, 1974. xv, 670p. il.

"The purpose of this book is to document with photographs and text representative works of art at educational institutions in the United States."—*Pref.*

Contents: pt. 1, The places of art in educational institutions; pt. 2, Museums, galleries, and chapels; pt. 3, Location of artwork in educational institutions; pt. 4, Inreach and outreach programs for schools; pt. 5, Means of acquiring art works for educational institutions. Appendix I: Museums, galleries, art collections, and exhibition areas in educational institutions by states. Appendix II: Sources of inreach information and material. General index. Bibliography, p.523–65.

B8   Grants and aid to individuals in the arts; containing listings of most grants, prizes, and awards for professional work in the U.S. and abroad, and information about universities and schools which offer special aid to students. 3d ed. Wash., D.C., Washington International Arts Letter, 1976. 221p.

1st ed. 1970; 2d ed. 1972.

A listing of institutions and organizations in the U.S. and abroad which award financial assistance to individuals in all areas of the arts. Includes sources of aid for painters, sculptors, printmakers, art historians, and architects.

B9   Institute of International Education. International awards in the arts: for graduate and professional study. N.Y., Institute of International Education [1969]. 105p.

First published as *Directory of international scholarships in the arts,* 1958.

Lists awards open to U.S. and foreign nationals in the fields of archaeology, architecture, art education, art history, arts and crafts, cinematography, radio, and television. Additional sources of information in appendix, p.101.

Not a comprehensive listing.

B10   International directory of arts. Internationales Kunst-Adressbuch. Annuaire international des beaux-arts, 1952/53–1979/80 (14th ed.). Berlin, Deutsche Zentral-druckerei [1952–(79)].

Replaces virtually all other directories of international scope. Recent directories are published in 2v.

Lists museums and art galleries, universities, academies, colleges, associations, artists, collectors, art and antique dealers, galleries, auctioneers, art publishers, art periodicals, antiquarian and art booksellers, restorers, experts, and dealers specializing in numismatics. These categories are generally arranged by country, then by city.

Although primarily an address book, pertinent information concerning personnel, faculties, hours of opening for institutions, and character of collections is often given. Includes advertising matter in appropriate sections.

B11   Mastai's classified directory of American art & antique dealers. v.1–7. N.Y., Mastai, 1942–61. il. Irregular.

Editor: Boleslaw Mastai.

Contents of last edition: (1) Art museums; (2) Classified lists: Americana, antique dealers, art galleries, etc. arranged alphabetically by states and by towns therein, and alphabetically classified; (3) Appendix: Paintings sold at auction, 1957–60. Index of advertisers.

Out-of-date, yet the list of dealers in section 2 is still the most complete of its kind.

B12   Wasserman, Paul, ed. Museum media; a biennial directory and index of publications and audiovisuals available from U.S. and Canadian institutions. Esther Herman, associate editor. Editorial staff: Gary Blemaster [et al.]. 1st ed. Detroit, Gale, 1973. vii, 455p.

"Intended to provide bibliographic control of books, booklets, monographs, catalogs, pamphlets and leaflets, films and filmstrips, and other media which are prepared and distributed by museums, art galleries and related institutions in the United States and Canada. Biennial publication is planned."—*Pref.*

The main body is an alphabetical listing of 732 institutions with materials available. Extensive indexes: Title and keyword index; Subject index; Geographic index.

# MUSEUMS DIRECTORIES

B13    Almeida, Fernanda de Camargo e. Guia dos museus do Brasil. Pesquisadoras: Lourdes Maria Martins do Rêgo Novaes [e] Edna Palatnik Benoliel. [1. ed. Rio de Janeiro]. Editôra Expressão e Cultura; [distribuição: Expansão Editorial, 1972]. 317p.

A directory of all types of museums in Brazil. Arranged alphabetically by name of museum. Gives varying kinds of information for each, including address, history and nature of collections, hours, publications, and library and archival resources. Geographical index; Alphabetical index; Index by museum type.

B14    American Association of Museums. The official museum directory. U.S./Canada, 1978/79. [4th ed. Wash., D.C.] American Association of Museums and National Register Publishing Co. [1978]. 942p.

1st ed. 1971; 2d ed. 1973; 3d ed. 1975. Supersedes the *Handbook of American museums* and the *Museums directory of the United States and Canada* (1st ed. 1961, 2d ed. 1965).

A directory of all types of museums of the U.S. and Canada. Includes over 5,400 museums. Provides information on museums, principal staff members, addresses, telephone numbers, collections, and major programs.

Contents: Institutions by state and province (alphabetically by city or town and then by institution); Institutions by name alphabetically; Institution directors and department heads by name alphabetically; Institutions by category.

B15    Barnaud, Germaine. Répertoire des musées de France et de la Communauté. Paris, Institut Pédagogique National, 1959. 416p.

A somewhat out-of-date directory of museums in France and French territories (at that time), giving for each institution practical and administrative information, a brief history of the museum, a description of its principal collections, a partial list of publications, and library and research resources. Also included are collections of church treasures.

B16    Gaya Nuño, Juan Antonio. Historia y guía de los museos de España. Madrid, Espasa-Calpe, 1955. 916p. il., 9 col. plates.

A somewhat out-of-date directory of museums in Spain, arranged alphabetically by geographical location. For each museum gives description of its holdings, historical survey, and, in most cases, bibliography. Geographical index, p.807–38; Artists index, p.839–61; Index of various names, p.862–98; Index of principal subjects, p.899–901.

B17    Handbuch der Museen. Deutschland BRD/DDR, Österreich, Schweiz. Hrsg. v. Gundrun-Kloster. München-Pullach, Berlin, Verlag Dokumentation, 1971. 2v.

A guide to German, Austrian, and Swiss museums. For each institution lists address, telephone number, key administrators, schedules, admission charges, areas of holdings, and publications.

Contents: v.1, Federal Republic of Germany; v.2, German Democratic Republic, Austria, Switzerland. Index at end of v.2.

B18    Hudson, Kenneth, and Nicholls, Ann, eds. The directory of world museums. N.Y., Columbia Univ. Pr., 1975. xviii, 864p.

Also published in Great Britain as *The directory of museums,* London, Macmillan, 1975.

An international directory of approx. 25,000 museums and galleries of all types. Each listing gives basic information on address, hours, areas of collection, etc.

Glossary, p.xv–xviii. Classified index of specialised and outstanding collections. Select bibliography of national museum directories and articles, p.861–64.

B19    Lapaire, Claude. Museen und Sammlungen der Schweiz. Musées et collections de la Suisse. Bern, Haupt [1965]. 245p. il., maps.

Lists alphabetically by city museums of art, history, ethnography, folklore, and science, treasures of churches, historic houses, and libraries and archives attached to museums. Gives for each institution practical information, a brief history, administration and description of collections, and publications. Sometimes includes bibliographical references, catalogues of collections, guides, and catalogues of temporary exhibitions generally.

B20    Museums in Africa; a directory. Comp. and ed. by German Africa Society/Deutsche Afrika-Gesellschaft. N.Y., Africana Pub. Corp. [1970]. 594p.

Compiler: Gundolf Seidenspinner.

A listing of museums in Africa "including open-air museums, botanical and zoological gardens, art galleries, libraries housing articles other than books alone and various other collections of special interest."—*Pref.* The directory lists the museums alphabetically by country, then city; the appendix classifies the museums by subjects. Keyword index, p.580.

B21    Museums of the world. Museen der Welt. A directory of 17,500 museums in 150 countries, including a subject index. 2d ed., enlarged. Pullach bei München, Verlag Dokumentation; N.Y., Bowker, 1975. 808p.

1st ed. 1973. Comp. by Eleanor Braun. English text with prefatory material in English and German.

A directory of 17,500 museums in 150 countries. Entries give name of museum, address, year of foundation, name of director or curator, type of museum, and information on major holding areas. Subject index; Index of names; Geographic index.

B22    Netherlands. Departement van Cultuur, Recreatie en Maatschappelijk Werk. De Nederlandse musea. Uitgegeven in opdracht van het Ministerie van Cultuur, Recreatie en Maatschappelijk Werk. 4. druk. [Gravenhage, Staatsuitgeverij, 1967]. xxxiii, 385p.

The basic directory of museums in the Netherlands. Arranged alphabetically by city. For each museum gives the names of director and curators, a short history, bibliography, list of

publications, and library resources. Includes an alphabetical list of museums and private collections. Subject index; index of directors and curators.

B23    Roberts, Laurance P. The connoisseur's guide to Japanese museums. Rutland, Vt., published for the Japan Society of New York by C.E. Tuttle [1967]. 239p.
New ed. entitled *Roberts' Guide to Japanese Museums.* Tokyo; N.Y., Kodansha, 1978.

Foreword by Laurence Sickman. A comprehensive directory of public and semipublic collections in Japan. "The main text is arranged alphabetically by the English names of the museums, while the Indexes provide cross references by Japanese names, prefectures, and types of collection." —*Pref.* Glossary, p.215–35.

SEE ALSO:  *American art directory* (B1); *International directory of arts* (B10).

# C.
# Sales Records

The reference works listed in this chapter are divided into three sections. The first two sections—Current Serials and Retrospective—record sales of and prices paid for works of art. The third section—Collectors' Marks—includes two basic works which identify collectors and collections in systematic compilations of marks on works of art.

## CURRENT SERIALS

C1    The annual art sales index. [v.1- ]. [Weybridge, Eng., Art Sales Index], 1972- . il.
Editor: Richard Hislop. Supersedes *Connoisseur art sales annual,* 1969-71.

An annual report (published with considerable time lag) on the results of over 600 public auction sales, primarily in Europe and the U.S. The most recently published volume lists prices gained in the 1974/75 season for more than 35,000 paintings (sold for over £150) by about 12,000 artists. Includes paintings in oil, watercolor, pastel, gouache, and mixed media; does not include drawings, prints, or sculpture. "Directory of auctioneers" and a "Chronological list of sales" are at the beginning of each volume.

C2    Art at auction; the year at Sotheby Parke Bernet. 1962/63- . N.Y., Viking, 1963- . il. (part col.)
Current editor: Diana de Froment.

Publisher varies. Supersedes *Sotheby's annual review* [of the] *season,* 1956/57-1961/62. Title varies: 1962/63-1963/64, the *Ivory hammer.*

An annual review of the most important sales at the auction houses of Sotheby Parke Bernet in London and N.Y. Includes signed and unsigned articles and copious illustrations. General index at the end of each volume.

C3    Art-price annual. 1948/49- . n.s. v.4- . London, Art and Technology Pr.; Munich, Kunst & Technik, 1949- . il., plates.
Title varies: *European art prices annuary* (or *annual*), v.4-7, 1948/49-1951/52. German ed. called *Kunstpreisverzeichnis* and *Kunstpreisjahrbuch.* French ed. called *Annuaire des ventes d'objets d'art.*

One of the most comprehensive current listings of sales. Reports annually the results of important public sales in Europe, the U.S., and other countries. Sections on furniture, antiques, non-European art, paintings, and prints. For each item gives price, description, size, and place and date of sale.

C4    Art prices current. A record of sale prices at the principal London, Continental and American auction rooms . . . with indexes to the artists, engravers and collectors. v.[1]-9, 1907/08-1915/16; n.s. v.1- , 1921/22- . London, Dawson [etc.], 1908- .
Subtitle varies. Publication suspended 1917-20. Current v. in two parts: A, paintings, drawings, miniatures; B, engravings and prints. Text of each part is arranged chronologically by sales. Indexes of pictures, drawings, miniatures, engravings, and collections, listed alphabetically by artist, follow sale records of each part. "Authorities referred to in the text" included in each volume.

C5    Christie, Manson & Woods. Christie's review of the season. 1956- . London, Hutchinson, 1957- . (Distr. by Harry N. Abrams) il. (part col.)
Current editor: John Herbert.

Title previously *Christie's review of the year.* Supersedes the earlier *Christie's season,* 1928-31.

An annual review of the most important sales at the auction houses of Christie's in London, Greece, Rome, Amsterdam, Sydney, and Montreal. Includes sales of paintings, sculpture, drawings, furniture, photographs, stamps, and wines. Volumes consist of short signed and unsigned articles on various areas and trends. No footnotes or bibliography.

C6    International art market; current world market prices of art, antiques & objets d'art. v.1, no. 1- . Mar., 1961- . Woodbury, N.Y., Interart Publishers Inc., 1961- . il. Monthly.
Issued in loose-leaf format.

Current editor: Howard L. Katzander. Incorporates *Art and Auctions* (1957-61). Subtitle varies.

A monthly report on world market prices of paintings, prints, drawings, sculpture, furniture, carpets, clocks and watches, silver, porcelain, Americana, musical instruments,

antique scientific instruments, etc. Covers the major auction houses in Europe and the U.S. Quarterly indexes are replaced by annual cumulative indexes. Numbering of issues is occasionally incorrect.

C6a   Martin Gordon Inc. Gordon's print price annual. 1978- . N.Y., Martin Gordon, 1978- .
A new annual record of prints sold at the most important European and American auction houses during the previous year. "The Print Price Annual has tried to list every single print sold in the world's major auctions of the past year. In addition, the listings take in sets, pairs, portfolios, and other groupings with some cohesive sense to them. Only decorative, sporting, and topographical prints have received a somewhat cursory treatment, though the Print Price Annual offers a light sampling of these as well. In all there are well over 13,000 entries."—*Introd., v.1, 1978.*

1978 ed. in 2v. v.1 contains the listing of prints sold in 1977. Entries are arranged alphabetically by artist and include title, medium, edition size, date, references, measurements, indication of signature, edition number, margins, and general condition. The sale information for each entry gives the auction house, auction date, lot number, price in currency of sale place, and price converted into U.S. dollars. v.2 contains a cross-index of references, a list of reference short titles and abbreviations, and a list of works cited.

C7   Mayer, Enrique. International auction records, v.1- . Paris, Éditions Mayer, 1967- . il.   *to date*
French ed. 1963- published as *Annuaire international des ventes: peinture-sculpture.* Title of 1967 English ed.: *The International yearbooks of sales.*

Current volume "quotes over 24,000 prices collected in the course of the principal auction sales, both in the United States and abroad, between January 1974 and January 1975." Arranged alphabetically by artist within classified chapters: engravings, drawings, watercolors, paintings, sculpture. The index lists chronologically the reported sales in Europe and the U.S.

C8   World collectors annuary. v.1- , 1946/49- . [Voorburg] World Collectors [etc.], 1950- . il.   *1946- date*
Current editor: A. M. E. van Eijk van Voorthuijsen. Major portion of sales listed by artist in "Alphabetical classification of paintings, watercolours, pastels and drawings." A list of the recorded auction galleries in Europe, the U.S., and Argentina is at the beginning of each volume. Sales of prints are reported in the "Alphabetical classification of graphic arts" through v.23 (1971).
Index to v.1-26 (1946-72) published in 1976.

# RETROSPECTIVE

C9   Annuaire du collectionneur; répertoire des prix des tableaux . . . estampes, sculpture vendus à Paris et en province . . . Année 1-3. Paris, Diffusion Artistique et Documentaire, 1949-51. 3v. il.
Année 2- includes as supplement "Les grandes ventes de l'étranger." Subtitle varies. Arranged by medium: pt. 1 devoted to painting; pt. 2 covers sculpture, jewelry, ceramics, rugs, etc. "Répertoire des prix" is arranged alphabetically by artist, with a number referring to the sale and the price realized.

C10   Annuaire général des ventes publiques en France. Année 1-2, 1941/42-1942/43. Paris, Art et Technique, 1942-43. 2v. plates.
"Commentaires d'André Fage." Superseded by *Les ventes publiques en France* (C25). Année 1 lists works chronologically by date of sale, with a separate alphabetical index for each section. Année 2 issued in two parts: (1) Tableaux; (2) Livres, autographes, graveurs, monnaies, sculptures, etc.; also has supplement, "Les ventes en Belgique." At beginning of both parts of Année 2 a chronological list of sales held in France for the 1942/43 season is followed by the lists of works sold.

C11   Bérard, Michèle. Encyclopedia of modern art auction prices. N.Y., Arco, 1971. 417p.
Lists prices paid between Sept., 1961 and July, 1971 for works of 282 painters of the modernist tradition. Includes for each painter a biographical outline, followed by a sales list. Works are classified into three categories: (1) Drawings; (2) Watercolors, gouaches, tempera, pastels; (3) Paintings. Each entry includes a boldface key number referring to the Index of Sales, p.403.

C12   Blanc, Charles. Le trésor de la curiosité, tiré des catalogues de vente de tableaux, dessins, estampes, livres, marbres, bronzes, ivoires, terres cuites, vitraux, médailles, armes, porcelaines, meubles, émaux, laques et autres objets d'art, avec diverses notes & notices historiques & biographiques. Paris, Renouard, 1857-58. 2v. il.
Reports sales of collections for the period 1737-1855. Arranged by collector, then by artist. Short discussions on the collectors and the nature of the collections often precede the lists of works. Indexes: "Table des catalogues, analysés dans les deux volumes du trésor de la curiosité," v.2, p.[605]-11; "Table des noms des artistes cités dans cet ouvrage," v.2, p.[613]-36.

C13   Cote des tableaux, ou Annuaire des ventes de tableaux, dessins, aquarelles, pastels, gouaches, miniatures, guide du marchand, de l'amateur, publié par L. Maurice Lang. t.1-11. Tous les prix des ventes de l'année oct. 1918- fin juillet 1929. Paris, L. Maurice Lang [1919-31]. 11v.
Title varies: 1918-22, *Annuaire des ventes de tableaux;* 1923-29, *Cote des tableaux.* Arranged alphabetically by artist. Lists of important sales at beginning of each volume. For each item gives size, sale, and price.

C14   Duplessis, Georges. Les ventes de tableaux, dessins, estampes et objets d'art aux XVIIe et XVIIIe siècles

(1611-1800); essai de bibliographie. Paris, Rapilly, 1874. 122p.

A bibliography of sales catalogues of the 17th and 18th centuries. Arranged chronologically. Index, p.|113|-22.

C15    Graves, Algernon. Art sales from early in the eighteenth century to early in the twentieth century. (Mostly old master and early English pictures). London, Graves, 1918-21. 3v. (Repr.: N.Y., Burt Franklin, 1970.)

Arranged alphabetically by artist. For each work gives date of sale, auctioneer, owner, lot number, title, and purchaser.

C16    Lancour, Adlore Harold. American art auction catalogues, 1785-1942; a union list. N.Y., The New York Public Library, 1944. 377p.

"This compilation is a union check list of over 7000 catalogues of auction sales of art objects held in the U.S. during the period from 1785 to the end of 1942. |Includes| paintings, drawings, engravings, statuary, decorative objects, furniture and furnishings, jewelry, textiles, tapestries, rugs, carpets, mineral carvings, musical instruments, and curios. The only material excluded . . . has been books, maps, bookplates, stamps and coins."—*Introd.*

For each entry; (1) date of first day of sale; (2) owner's name; (3) short descriptive title; (4) auction firm; (5) simple collation; (6) number of lots; (7) location of copies. List of American auction houses, p.11-28; List of catalogues, p.29-319. Index of owners, p.321-77.

C17    Lugt, Frits. Répertoire des catalogues de ventes publiques, intéressant d'art ou la curiosité: tableaux, dessins, estampes, miniatures, sculptures, bronzes, émaux, vitraux, tapisseries, céramiques, objets d'art, meubles, antiquités, monnaies, médailles, camées, intailles, armes, instruments, curiosités naturelles, etc. La Haye, Nijhoff, 1938-(64). v.1-(3). (Publications du Rijksbureau voor Kunsthistorische en Ikonografische Documentatie)

Indispensable for ascertaining provenances of works of art and for locating copies of sales catalogues.

v.1 lists catalogues for the period 1600-1825; v.2, 1826-60; v.3, 1861-1900. Information reported for each entry: (1) number given in this catalogue; (2) date; (3) location of sale; (4) name of collector, artist, merchant, or proprietor; (5) contents; (6) number of lots; (7) auctioneers; (8) number of pages in catalogue; (9) libraries in which the catalogue may be found and whether it is priced.

Index of names of collections, v.1, p.[477]-96; v.2, p.|697|-726; v.3, p.|705|-63. List of libraries, v.1, p.xii-xiv; v.2, p.xiv-xvi; v.3, p.xiii-xvii.

Additions to these three volumes are being planned.

C18    Mireur, Hippolyte. Dictionnaire des ventes d'art faites en France et à l'étranger pendant les XVIIIme et XIXme siècles. Paris, Soullié, 1901-12. 7v. (Repr.: Hildesheim, Olms, 1971.)

Important for documentation of works of art. Includes paintings, drawings, prints, watercolors, miniatures, pastels, gouaches, sepia drawings, charcoal drawings, enamels,

painted fans, and stained glass. Arranged alphabetically by artist. Contains approx. 3,000 public sales, names of 30,000 artists, and the prices of approx. 50,000 items.

C19    Monod, Lucien. Le prix des estampes, anciennes et modernes, prix atteints dans les ventes—suites et états, biographies et bibliographies. Paris, Morancé |1920-31|. 9v. (Repr.: Nendeln, Liechtenstein, Kraus, 1973.)

At head of title: Aide-mémoire de l'amateur et du professionnel.

Arranged alphabetically by engraver, with brief biographical information and record of print prices paid.

"Graveurs identifiés par leurs monogrammes ou par des désignations particulières (XVe et XVIe siècles)," v.9, p.61-73. "Bibliographie générale," v.9, p.77-109. "Nomenclature des estampes par catégories et par sujets (indication des planches typiques, bibliographies, planches anonymes)," v.9, p.113-281.

C20    Moulin, Raoul Jean. Le marché de la peinture en France. |Paris| Éditions de Minuit |1967|. 610p.

A scholarly study incorporating extensive documentation on the commerce of painting as it developed in 19th-century France and continued into the mid-20th century. Concentrates on the economic, sociological, and philosophical implications.

Contents: Pt. 1, Les préalables: (1) Les antécédents; (2) Les conditions actuelles. Pt. 2, Les acteurs: (3) Les marchands de tableaux; (4) Les critiques d'art; (5) Les clients: les collectionneurs; (6) Les clients: l'état, les villes, l'eglise; (7) Les peintres. Pt. 3, Les transactions: (8) Les ventes publiques; (9) Marché des chromos et marché des chefs-d'oeuvre; (10) Le marché de la peinture contemporaine.

Bibliography, p.573-89. 22 appendixes, e.g., (1) Liste des titulaires successifs des quatorze fauteuils de la section peinture de l'Académie des Beaux-Arts; (2) Table des coefficients de réévaluation en francs 1961; (3) Paul Durand-Ruel et le monopole. Lettres de Camille Pissarro à son fils Lucien et à Octave Mirbeau.

Index des noms propres; Index des collectivités; Index des thèmes.

C21    Paris. Bibliothèque Forney. Catalogue des catalogues de ventes d'art. Boston, Hall, 1972. 2v.

The photographic reproduction of the catalogue of illustrated sales catalogues in the Bibliothèque Forney. Supplements Lugt (C17).

"The cataloging of these publications produced some 50,000 entries arranged into 3 catalogs: *Collectors* (entries are classified in alphabetical order of collectors; no identification research was made regarding the collectors); *places of auctions* (entries are classified in alphabetical order of places); *dates of auctions* (entries are classified in chronological order). An additional card is added to the general alphabetical subject catalog of the Bibliothèque Forney when the auction sales concern a very definite subject. Whenever sale prices are mentioned in the catalogs, the word 'PRICE' appears at the bottom of the cards."—*Pref.*

C22   Print prices current; being a complete alphabetical record of all engravings and etchings sold by auction in London, each item annotated with the date of sale and price realised. . . . v.1–21, Oct. 1918–Aug. 1939. London, Courville, 1919–40. 21v. Annual.

Subtitle varies. Beginning with v.13, 1930/31, American prices are included.

C23   Redford, George. Art sales; a history of sales of pictures and other works of art, with notices of the collections sold, names of owners, titles of pictures, prices and purchasers, arranged under the artists of the different schools in order of date, including the purchasers and prices of pictures for the National Gallery. Illustrated with autotypes from small sketches of great pictures and water-colour drawings sold, portraits of eminent collectors and views of their residences, objects of ornamental art etc. London, pub. by the author, 1888. 2v.

Invaluable for documentation of works of art. v.1 contains an historical account of sales and items relating to specific sales. v.2 contains lists of sales of pictures with prices, owners, and buyers, representing a selection from sales catalogues in the British Museum Library, Christie's records, and other sources.

A continuation of Redford's *Art sales* for the period 1887–1918 exists in a two volume manuscript in the Metropolitan Museum of Art Library.

C24   Reitlinger, Gerald. The economics of taste. London, Barrie and Rockliff [1961–70]. 3v. il.

v.3 published by Barrie and Jenkins.

A detailed study of the fluctuations of taste in the collecting of works of art based on prices paid from 1750–1970.

v.1, The rise and fall of picture prices 1760–1960, in two parts: (1) Eight essays on various aspects of commerce in paintings from 1760–1960; (2) Sales analysis of the most popular painters 1760–1960. Bibliography, p.503–06; Index of artists; Index of collectors, dealers and others.

v.2, The rise and fall of objets d'art prices since 1750, in two parts; (1) Nine essays on various aspects of commerce in objets d'art from 1750–1962; (2) Sales analysis of selective types of objets d'art since 1750 (includes among others arms and armour, European carpets, Chinese art, classical art, crystal objects of the Renaissance, Egyptian and ancient Near Eastern art, glass, miniatures, European sculpture, European silver, tapestry). Bibliography, p.691–94; General index.

v.3, The art market of the 1960s, in three parts: (1) Paintings and drawings; (2) Sales analysis of sculpture; (3) Objets d'art.

C25   Les ventes publiques en France; répertoire générale des prix, 1941/42–1946/47. Paris, Bureau International d'Édition et de Publicité [1943–47]. il.

Supersedes *Annuaire général des ventes publiques en France.* "Sous la direction et avec commentaires d'André Fage." For 1943/44 and 1944/45 issued in 3v: (1) Tableaux; (2) Livres et autographes; (3) Meubles, gravures, sculptures, monnaies, céramiques, objets d'art européen et d'Extrême-Orient, tapis, tapisseries, bijoux, argenterie.

SEE ALSO: Harvard Univ. Fine Arts Library. *Catalogue* (A63); New York. Metropolitan Museum of Art. *Library Catalogue* (A67).

# COLLECTORS' MARKS

C26   Fagan, Louis Alexander. Collectors' marks, arr. and ed. by Milton I. D. Einstein . . . and Max A. Goldstein. St. Louis, Laryngoscope, 1918. 128p. 50 plates.

A reprint of the 1883 ed. of 671 marks, with 203 marks added. For each mark the author attempted to give the collector's name, dates, residence, dates of sales, and auctioneer's name.

Collectors' marks are all reproduced in the plates.

C27   Lugt, Frits. Les marques de collections de dessins et d'estampes; marques estampillées et écrites de collections particulières et publiques. Marques de marchands, de monteurs et d'imprimeurs. Cachets de vente d'artistes décédés. Marques de graveurs apposées après le tirage des planches. Timbres d'édition. Avec des notices historiques sur les collectionneurs, les collections, les ventes, les marchands et éditeurs, etc. Amsterdam, Vereenigde Drukkerijen, 1921. 598p. il. facsims. (Repr.: San Francisco, Alan Wofsy Fine Arts, 1975.)

Arranged alphabetically. Identifies the marks and gives facts concerning, or description of, the collections. Contents: Noms et inscriptions en toutes lettres, et initiales separées ou monogrammées, p.1–50; Figures: armoiries, corps humain, animaux, plantes et fleurs, objets, soleils et étoiles, croix, figures géométriques, p.506–41; Marques difficiles à déchiffrer, et marques japonaises, p.542–55; Numéros, p.556–61; Spécimens d'écritures, p.562–70; Index, p.577–94.

————. Supplément. La Haye, Nijhoff, 1956. 464p.

Approximately 2,350 new marks with notes; 810 additions to entries in the principal volume.

SEE ALSO: *Signatures and seals on painting and calligraphy* (M546).

# D. Visual ~~So~~urces

...lections of photo-
...ks of art. No single
...yet no single work
...with individual or
...ources for original
...e *Directory of art*
... *in North America*
...lfill the need for a

...lides, photographs,
...*LIS/NA newsletter*
...al resources news,
...ns' group.

...olor reproductions.
...w, 1971. 625p.

...ail print dealer. It is
...rd of the art repro-
...as of about January
...o both the original
...s which reproduced
...dex of artists under
... dimensions, sources
... titles. Abbreviations

...s. N.Y., Scarecrow,

...rt available from 95
...'The Index includes
...phic arts and drawing,
...ls portrayed, locations
...Animals; Mythological
...ssified according to
....243-344; Additional
...0.

...r's guide. 3d ed. N.Y.,
...esources Committee,

...s for the slide librarian,
...mmercial and museum
...n includes information
...ount suppliers. Subject

index divided according to historical periods, art forms, and geographical areas. Index of names.

D4    Evans, Hilary; Evans, Mary; and Nelki, Andra. The picture researcher's handbook: an international guide to picture sources, and how to use them. London, Newton Abbott; New York, Scribner [1975]. 365p. il.

A practical guide to sources of illustrations for picture researchers in all fields. The scope is international, with some emphasis on English sources. Contents in three parts: Pt. 1, General (text in English, French, German, Italian, and Spanish): (1) How to use this handbook; (2) The techniques of illustration; (3) Photography: a brief history; (4) The picture researcher: the role and the responsibilities; (5) Copyright; (6) Rates; (7) Credits; (8) Types of picture source; (9) Useful books. Pt. 2, Directory of sources. Pt. 3, Indexes: (1) Subjects discussed in pt. 1; (2) Geographical; (3) Specialist subjects; (4) Alphabetical list of sources.

D5    Irvine, Betty Jo. Slide libraries; a guide for academic institutions and museums. Littleton, Colo., Libraries Unlimited, 1974. 219p.

A useful manual for anyone setting up or administering a slide collection. Based on the results of 120 questionnaires received from 120 libraries in the U.S. The section on classification of slides would seem to be especially valuable. Oriented to the profession of librarianship rather than art history.

Contents: (1) Background for slide librarianship; (2) Administration; (3) Classification and cataloging; (4) Use of standard library techniques and tools; (5) Acquisition, production methods, and equipment; (6) Storage and access systems; (7) Planning for physical facilities; (8) Projection systems; (9) Miscellaneous equipment supplies. Selected bibliography. Directory of distributors and manufacturers of equipment and supplies; Directory of slide sources; Directory of slide libraries. Index. Bibliographies at the end of each chapter.

D6    London University. Courtauld Institute of Art. Courtauld Institute illustration archives. London, Miller, 1976- . plates.

A quarterly publication (by annual subscription) of paper-bound or loose-leaf photographic reproductions of works

of sculpture and architecture in public ownership. The photographs are drawn from the unparalleled collections in the Witt and Conway Libraries of the Courtauld Institute, London. Prepared under the general supervision of Peter Lasko, Director of the Courtauld Institute; individual archives are edited by specialists in the fields represented. "Each Archive illustrates a specific area of study in detail and depth . . . In each year these will contain up to 800 individual illustrations, many of them not available from any other source . . . The *Courtauld Archives* provide detailed and properly identified illustrations, selected especially for their relevance to teaching and study."—*Pub. prospectus.*

Archives published or announced: Archive 1. Cathedrals and monastic buildings in the British Isles. Pt. 1, Lincoln: Romanesque west front. Pt. 2, Wells: north-west tower. Pt. 3, Lincoln: St. Hugh's choir & transepts. Pt. 4, Wells: west front; Archive 2. Fifteenth- and sixteenth-century sculpture in Italy. Pt. 1, Rome: S. Maria del Popolo, S. Maria di Monserrato. Pt. 2, Rome: S. Maria sopra Minerva, S. Maria in Aracoeli, SS. Apostoli. Pt. 3, Rome: S. Agostino, S. Giacomo Maggiore at Vicavaro. Pt. 4, Emilia; Archive 3. Medieval architecture and sculpture in Europe. Pt. 1, Poland. Pt. 2, Prague: cathedral & castle. Pt. 3, Germany. Pt. 4, Germany; Archive 4. Late eighteenth- and nineteenth-century sculpture in the British Isles. Pt. 1, London: Albert Memorial, Kensington & Hyde Park Monuments. Pt. 2, London: Holborn, City, Victoria Embankment. Pt. 3, Gloucestershire. Pt. 4, Northamptonshire.

D7    Marburger Index: Bilddokumentation zur Kunst in Deutschland. München, Verlag Dokumentation, 1977-81.

Editors have not examined.

The publication in 4″ x 5″ microfiche format of the photographic archives of the Bildarchiv Foto Marburg and the Rheinisches Bildarchiv Köln. Includes photographs of architecture in Germany and paintings, sculptures, and examples of the decorative and applied arts in German collections which date from prehistory to the present. Works of art represented are of both German and foreign origin. The series will be published from 1977-81 with about 100,000 photographs per year, reaching a total of approx. 500,000 when the project is complete. Full documentation and detailed indexes will accompany the microfiche cards.

D8    Monro, Isabel Stevenson, and Monro, Kate M. Index to reproductions of American paintings; a guide to pictures occurring in more than 800 books. N.Y., Wilson, 1948. 731p.

"Lists the work of artists of the U.S. occurring in 520 books and in more than 300 catalogs of annual exhibitions held by art museums."—*Pref.* Paintings are listed by artist, by title, and sometimes by subject.

_____. 1st supplement. N.Y., Wilson, 1964. 480p.

"Continues the earlier index through 1961. It lists the paintings of artists reproduced in more than 400 general books on art, books on individual artists, and catalogs of museums and of special exhibitions."—*Pref.*

D9    _____. Index to reproductions of European paintings; a guide to pictures in more than 300 books. N.Y., Wilson, 1956. 688p.

"A guide to pictures by European artists that are reproduced in 328 books."—*Pref.* Paintings are listed by artist, by title, and sometimes by subject. Useful as a quick reference for determining locations of paintings and identifying artists when titles or subjects of paintings are known.

D10    Petrini, Sharon. A handlist of museum sources for slides and photographs [by] Sharon Petrini [and] Troy-Jjohn Bromberger. [Santa Barbara, Slide Library, Art Dept., Univ. of California, 1972]. ii, 147p.

The results of a questionnaire concerning color slides and black-and-white photographs which was sent to 137 museums throughout the world. Arranged alphabetically by country. Information for each entry includes availability of material, techniques of reproductions, services, and prices. Appendix I, Commercial slide sources; Appendix II, Noncommercial slide sources.    *also 4, 1983 770.257 R 666 P611*

D11    Special Libraries Association. Picture Division. Picture sources 3: Collections of prints and photographs in the U.S. and Canada. [3d ed.] Ann Novotny, editor; Rosemary Eakins, assistant editor. N.Y., Special Libraries Assn., 1975. 387p.

A compilation of 1,084 entries for picture sources in the U.S. and Canada intended for "picture researchers, editors, librarians, artists and all other professional users of pictures." In most of the collections listed, "the pictures are regarded as visual documents, as sources of information (available for reference use or for publication) rather than as works of art."—*p. iv.* Of limited use to the art historian.

"Fine, graphic, and applied arts," nos. 581-729, lists museums and other institutions and commercial sources which can provide photographs and/or other types of reproductions.

D12    Smith, Lyn Wall, and Moure, Nancy Dustin Wall. *R 759.1 S 6541* Index to reproductions of American paintings appearing in more than 400 books, mostly published since 1960. Metuchen, N.J.; London, Scarecrow, 1977. 931p.

Supplements Monro (D8). Gives dates of paintings, names of owners, dates of artists.

Contents: (1) Index to reproductions of American paintings—by artist, p.1-635; (2) Index to reproductions of American paintings—by subject, p.636-931. Subjects included: allegorical, animals, architectural subjects, certificates, signs, figural, genre, historical, illustrations from literature, Indians of North America, interior room views (without figures), landscapes, marines, Negro subjects, non-representational, portraits, still life, vehicles.

D13    Thomson, Elizabeth W., ed. Index to art reproductions in books. Comp. by the professional staff of the Hewlett-Woodmere Public Library under the direction of Elizabeth W. Thomson. Metuchen, N.J., Scarecrow, 1974. xii, 178p.

An index to reproductions of works of art (paintings, sculpture, architecture, graphic art, photography, and stage design) in 65 books published between 1956–71. Supplements the two works by Monro (D8, D9). Useful as a ready reference tool for a small library with a limited collection. Divided into an artist index and a title index.

"List of books indexed and their symbols," p.ix–xii.

D14    United Nations Educational, Scientific and Cultural Organization. Catalogue de reproductions en couleurs de peintures antérieures à 1860. Catalogue of color reproductions of paintings prior to 1860. Catálogo de reproducciones de pinturas anteriores à 1860. |9th ed., rev. and enl.| Paris, UNESCO, 1972. 501p.

1,391 entries. Criteria for inclusion: "the fidelity of the colour reproduction, the significance of the artist and the importance of the original painting."

Information given for the original painting: "name of painter; places and dates of birth and death; title of painting, and date when known; medium; size; collection of original." For the reproduction: "process used in printing; size; Unesco archives number; printer; publisher and price."—*Introd.*

Index of artists, p.|486|–92; List of publishers, p.|493|–99; Procedure for purchasing the reproductions, p.500–01.

D15    _____. Catalogue de reproductions de peintures— 1860–1973 et quinze plans d'expositions; Catalogue of reproductions of paintings 1860–1973. . . .; Catálogo de reproducciones de pinturas 1860– 1974 . . .; |10th ed. rev.|. Paris, UNESCO, 1974. 343p.

1,534 entries. Format, criteria for inclusion, and entry information is the same as UNESCO *Catalogue* (D14). Index of painters, p.335–37; Lists of publishers and printers, p.338–|42|.

D16    _____. Répertoire international des archives photographiques d'oeuvres d'art. International directory of photographic archives of works of art. Paris, Dunod, 1950–54. 2v.

Out-of-date but still useful. At the time of publication, the aim was "to draw up as complete a list as possible of the photographic collections of works of art at present existing in the various countries." v.1 contains entries for 1,195 collections from 87 countries; v.2 adds 100 more in 24 countries. Arranged alphabetically by place.

# E.
# Dictionaries
# and
# Encyclopedias

This chapter contains general dictionaries and encyclopedias of art, archaeology, and artists. Other dictionaries and encyclopedias, those which treat specific arts, are listed in subsequent chapters. Early collections of the lives of artists are to be found in chapter H, Sources and Documents.

E1    Adeline, Jules. The Adeline art dictionary, including terms in architecture, heraldry, and archaeology. Trans. from the French. With a suppl. of new terms by Hugo G. Beigel. N.Y., Ungar [1966]. 459p. il.
Based on *Lexique des termes d'art.* 1st English ed. 1891, with many subsequent editions.

An old standard work which reflects 19th-century concepts and understanding; still useful for locating antiquated terminology. Material not in the original French work is based on Fairholt (E5). The supplement to the present edition is an inadequate attempt at updating.

E2    Bray, Warwick, and Trump, David. A dictionary of archaeology. London, Allen Lane, 1970. 269p. il.
American ed.: *The American Heritage guide to archaeology.* N.Y., American Heritage, 1970. Paperback ed.: *The Penguin dictionary of archaeology.* Baltimore, Penguin, 1972.

A convenient up-to-date dictionary for the interested lay person and for the scholar working outside his area of specialization. Does not cover classical, medieval, or industrial archaeology. Includes names of persons (including famous archaeologists), places, and terms. Illustrated with photographs and line drawings by Judith Newcomer. Regional index and maps at end.

E3    Demmin, Auguste Frédéric. Encyclopédie historique, archéologique, biographique, chronologique et monogrammatique des beaux-arts plastiques, architecture et mosaïque, céramique, sculpture, peinture et gravure. Paris, Furne, Jouvet [1873-74]. 3v. in 5. il.
Contents: v.1, General introduction, epigraphy, paleography, coats of arms, letters and marks, church ornaments, art and architecture in general, military and naval architecture, general architecture, mosaics, enamels, mirrors, sculpture; v.2, painting; v.3, engraving.

Gives lists of artists under different categories. General index at end of v.3. Well illustrated with many line engravings.

E4    Encyclopedia of world art. N.Y., McGraw-Hill [1959-68]. 15v. il., plates (part col.), maps.
Italian ed.: Enciclopedia universale dell'arte. Sotto gli auspici della Fondazione Giorgio Cini. Istituto per la collaborazione culturale Venezia-Roma. [c1958-67]. 15v. "La parte editoriale dell'opera è curata dalla casa editrice G. C. Sansoni, Firenze." Corrected repr. of Italian ed. 1971-76.

A monumental encyclopedia of "art, architecture, sculpture, and painting, and every other man-made object that, regardless of its purpose or technique, enters the field of aesthetic judgment because of its form or decoration. No limits of any kind have been set with regard to time, place, or cultural environment of the manifestations of artistic interest."—*Pref.* v.1. Articles written by an international team of scholars and specialists. Three major kinds of articles: historical (broad periods of art, individual cultures, schools, individual artists, etc.); conceptual and systematic (theory, methodology, iconography, techniques, genres of art, etc.); geographical (documentary articles on specific areas). Many articles now appear as standard bibliographical references in monographic works. Excellent illustrations.

v.15 is a comprehensive index.

E5    Fairholt, Frederick William. A dictionary of terms in art . . . with 500 engravings on wood. [London] Virtue, Hall & Virtue [1854]. 474p. il. (Repr.: Detroit, Gale, 1969.)
An early dictionary of terms used in aesthetics, painting, sculpture, engraving, vases, pottery, costume, etc.

E6    Gay, Victor, and Stein, Henri. Glossaire archéologique du moyen-âge et de la renaissance. Paris, Société Bibliographique, 1887-1928. 2v. il. (Repr.: Paris, Picard, 1968.)
Each term is defined and accompanied by quotations from documentary or literary sources. Illustrated by line drawings.

v.1 originally issued in five fascicles, 1882-87. v.2: "texte revu et complété par Henri Stein, illustration dirigée par Marcel Aubert . . . Paris, Picard, 1928."—*Title page, v.2.*

E7    Glossarium artis. Deutsch-Französisches Worterbuch zur Kunst. Veröffentlicht unter der Schermherrschaft des Comité International d'Histoire de l'Art. Tübingen, Niemeyer, 1971- .

Wissenschaftliche Kommission: Hans R. Hanloser (Universität Bern), Louis Grodecki (Sorbonne), Norbert Lieb (Universität München), Pierre Moisy (Université de Strasbourg).

Issued in fascicles. Projected in 10 v.

A comprehensive German-French dictionary-encyclopedia of art terms, the first of its kind. Each fascicle will range in length from 150 to 250 pages, and include line drawings, bibliography, and indexes of German, French, and some widely-used Latin terms.

The first six fascicles published or to be published: (1) Der Wehrbau. L'Architecture militaire (152p., 56 illus.); 2d ed., 1975; (2) Liturgische Geräte, Kreuze und Reliquaire der christlichen Kirchen. Objets liturgiques, croix et reliquaires des églises chrétiennes (159p., 108 illus.); (3) Bogen und Arkaden. Arcs et arcades (167p., 164 illus.); (4) Paramente und liturgische Bücher der christlichen Kirchen. Parements et livres liturgiques des églises chrétiennes (203p., 73 illus.); (5) Treppen und Rampen. Escaliers et rampes (260p., 210 illus.); (6) Gewölbe und Kuppeln. Voûtes et coupoles.

Later volumes will deal with painting, sculptural ornament, decorative arts, heraldry, numismatics, symbols and emblems, historiography, criticism, and aesthetics.

General indexes for each subject will be published.

E8    Larousse encyclopedia of archaeology. General editor, Gilbert Charles-Picard. Trans. from the French by Anne Ward. N.Y., Putnam, 1972. 432p. il. (part col.)
A convenient encyclopedia of archaeology, directed to the nonspecialist. Consists of contributions by various specialists. Well illustrated. Does not include the medieval cultures of Europe and Asia. "Further reading list," p.421-23.

Contents: Pt. 1, Archaeology at work: (1) What is archaeology?; (2) How monuments survive; (3) How to locate a site; (4) The excavation; (5) Establishing dates; (6) Restoration, exhibition and publication. Pt. 2, The recovery of the past: (7) Prehistoric archaeology; (8) Western Asia before Alexander; (9) The Nile valley; (10) The Aegean world; (11) Classical Greece; (12) The Etruscans; (13) The Romans; (14) Europe in the Bronze and Iron Ages; (15) The Americas; (16) India, Pakistan and Afghanistan; (17) The Far East: Southeast Asia; (18) The Far East: China.

E9    Lexikon der Kunst; Architektur, bildende Kunst, angewandte Kunst, Industrieformgestaltung, Kunsttheorie. Hrsg. von Ludger Alscher, et al. Leipzig, Seemann, 1968-(75). v.1-(3). il. (part col.)
A general dictionary of art, architecture, applied arts, and industrial design. Includes entries on artists, architects, periods, movements, individual monuments, the art of individual countries and cultures, etc. Entries include bibliographical references. Illustrated with line drawings, small black-and-white photographic reproductions, and a few color plates.

Contents: v.1, A-F; v.2, G-Lh; v.3, Li-P.

E10    McGraw-Hill dictionary of art. N.Y., McGraw-Hill [1969]. 5v. il. (part col.)
Authoritative articles, generously illustrated; replaces most older works of similar scope. A major portion of the 15,000 entries is devoted to biographies of "painters, sculptors,

architects, industrial designers, and decorative artists from all periods and all countries." In addition "there are a very substantial number of articles on styles, periods, cities, buildings, museums, and definitions."—*Introd.* Includes the Far East, the Near East, and primitive art. Many articles are signed and include selective bibliographies.

E11    Mayer, Ralph. A dictionary of art terms and techniques. N.Y., Crowell [1969]. 447p. il. (part col.)
A general dictionary with succinct definitions of terms in the fields of painting, drawing, sculpture, printmaking, and ceramics. Does not include architectural terms. Particularly useful for definitions of technical terms, processes, and materials. Classified bibliography, p.441-47.

E12    Mollett, John William. An illustrated dictionary of words used jn art and archaeology; explaining terms frequently used in works on architecture, arms, bronzes, Christian art, colour, costume, decoration, devices, emblems, heraldry, lace, personal ornaments, pottery, painting, sculpture, etc., with their derivations. Boston, Houghton Mifflin, 1883. 350p. il. (Repr.: N.Y., American Archives of World Art [1966].)
Full of definitions of unusual terms not to be found in other standard dictionaries. Illustrated by 707 engravings. Based on a rev. ed. of the dictionary by Ernest Bosc; completely revised, rewritten, and checked against Fairholt (E5).

E13    Murray, Peter, and Murray, Linda. A dictionary of art and artists. London, Thames & Hudson [1965]. xv, 464p. (part col.)
American ed.: N.Y., Praeger [1966]. Also published in a paperback ed., without illustrations: *A dictionary of art and artists.* 3d ed. Harmondsworth; Baltimore, Penguin [1972]. 467p. (Penguin reference books, R14)

An excellent 1v. dictionary for students. Restricted to the arts of painting, sculpture, drawing, and other graphic processes, chiefly in Western Europe. Limited, with occasional exceptions, to the period between 1300 and the present day. Includes terms, biographies of artists, articles on movements, styles, techniques, etc. The 1,250 illustrations (52 in color) are arranged by national school to form "A visual history of art," p.269-413. Each artist has at least one illustration. Bibliographies: Classified bibliography of general books, p.435-39; List of specialized monographs on individual artists or movements, p.440-64.

E14    Osborne, Harold, ed. The Oxford companion to art. Oxford, Clarendon, 1970. xii, 1,277p.
A comprehensive, 1v. handbook in dictionary form; equal to the other "Oxford companions" in its value as a reference tool. Articles by experts are "neither popular in tone nor do they assume specialized knowledge in their own field."—*Pref.* Includes important areas of the decorative and applied arts; few illustrations. An extensive guide to further reading is divided as follows: (1) Dictionaries, encyclopedias, general histories, and bibliographical works; (2) Theory and criticism; (3) General works on the 19th and 20th centuries; (4) Materials and techniques; (5) Selective list of works on specific subjects.

E15    Praeger encyclopedia of art. N.Y., Praeger [1971]. 5v. 2,139p. il. (part col.)

A translation, with additional new material, of *Dictionnaire universel de l'art et des artistes,* Paris, Hazan, 1967.

A universal dictionary-encyclopedia intended for the student and the general reader. Contains nearly 4,000 alphabetically arranged, signed articles by an international team of scholars and experts. Articles are accompanied by over 5,000 illustrations (1,700 in color). Four types of entries: biographies of artists and architects; articles on the art of individual countries; periods, styles, schools, movements; survey articles. No bibliographies.

E16    Réau, Louis. Dictionnaire illustré d'art et d'archéologie. Paris, Larousse [c1930]. 488p. il., 16 plates.

Short concise definitions. Comprehensive in scope; includes decorative arts, costume, arms, music, choreography, and theater, as well as painting, sculpture, and architecture. Equivalents in two or more other European languages are given for most of the terms.

E17    _____. Dictionnaire polyglotte des termes d'art et d'archéologie. [1st ed.]. Paris, Presses Universitaires de France, 1953. viii, 247, [5]p.

A French polyglot dictionary (no definitions). Languages included: Greek, Latin, Italian, Spanish, Portuguese, Rumanian, English, German, Dutch, Danish, Swedish, Czech, Polish, and Russian. Greek and Russian are transliterated. Equivalents are not given in all of these languages for each term.

E18    _____. Lexique polyglotte des termes d'art et d'archéologie. Paris, Laurens, 1928. 175p.

Divided into the following sections: Latin, Italian, Spanish, Portuguese, English, German, Dutch and Flemish, Danish and Norwegian, Swedish, Czech, Polish, and Russian. Lists most important terms with French equivalents.

E19    Runes, Dagobert David. Encyclopedia of the arts, ed. by Dagobert D. Runes and Harry G. Schrickel. N.Y., Philosophical library [1946]. 1,064p.

[1st British Commonwealth ed.] Owen, London [1965]. 1,064p.

An excellent 1v. encyclopedia of the visual and performing arts. The articles and definitions were written by recognized specialists and signed with initials; a list of the contributors appears in the preface. Succinct general summaries of art historical styles. Does not include entries for individual artists. Includes brief bibliographies after some entries.

# HISTORICAL (BEFORE 1850)

E20    Elmes, James. A general and bibliographical dictionary of the fine arts. Containing explanations of the principal terms used in the arts of painting, sculpture, architecture, and engraving, in all their various branches; historical sketches of the rise and progress of their different schools; descriptive accounts of the best books and treatises on the fine arts; and every useful topic connected therewith. London, Tegg, 1826. 760p.

"A dictionary exclusively devoted to the Literature of the Fine Arts is peculiarly necessary. Such a work has never before appeared in the English language."—*Pref.*

Valuable for bibliographies of sources and early works. Does not include entries of artists by name.

E21    Lacombe, Jacques. Dictionnaire portatif des beaux-arts, ou, Abregé de ce qui concerne l'architecture, la sculpture, la peinture, la gravure, la poésie et la musique; avec la définition de ces arts, l'explication des termes et des choses qui leur appartiennent; ensemble les noms, la date de la naissance et de la mort, les circonstances les plus remarquables de la vie, et le genre particulier de talent des personnes qui se sont distinguées dans ces différens arts parmi les anciens et les modernes, en France et dans les pays étrangers. Paris, Estienne, 1752. 707p.

The first "portable" dictionary of art. Entries for artists, terms, etc., in one alphabet.

E22    Millin, Aubin Louis. Dictionnaire des beaux-arts; ouvrage adopté par le Gouvernement pour les bibliothèques des lycées. Paris, Desray, 1806. 3v.

An early dictionary of the arts which in concept and format recalls the Diderot *Encyclopédie.* Includes music and the dance as well as the visual arts. Lengthy articles with many bibliographical references. Numerous cross-references.

E23    Sulzer, Johann Georg. Allgemeine Theorie der schönen Künste in einzeln, nach alphabetischer Ordnung der Kunstwörter auf einander Folgenden, Artikeln abgehandelt. Neue verm. 2. Aufl. Leipzig, Weidmann, 1729-99. 5v. (Repr.: Hildesheim, Olms, 1967-70.)

Supplement on literature in 8v., 1792-1808. (Repr.: Frankfurt am Main, Athenäum, 1972).

1st ed. 1771. 2d ed. has additional bibliography by F. von Blanckenburg. v.5 is a detailed analytical index of the whole work.

A major dictionary of the visual arts, music, and drama. The recent reprint (Hildesheim, Olms) includes a brief biographical essay (Einleitung) on Sulzer by Giorgio Tonelli and an up-to-date bibliography on Sulzer's work. Basic to the study of the theory and the art historical thinking of the late 18th century. The voluminous bibliography in the 2d edition was described by Schlosser (A49), as a veritable mine of all previously published art literature.

E24    Watelet, Claude Henri de, and Levesque, P. C. Dictionnaire des arts de peinture, sculpture et gravure. Paris, Prault, 1792. 5v. (Repr.: Geneva, Minkoff, 1972.)

Trans. into German and elaborated as *Aesthetisches Wörterbuch über die bildenden Künste* by C. H. Heydenreich (Leipzig, 1793-95).

A scholarly alphabetical dictionary of terms, places, styles, etc. Many long articles. Outstanding contemporary artists are listed under the articles on painting, sculpture, and prints. Reflects the ideas of 18th-century neoclassicism.

E25    Zani, Pietro. Enciclopedia metodica critico-ragionata delle belle arti. Parma, Tipografia Ducale, 1817-24. 2 pts. in 28v.

First published Parma, 1794, in 8v.

The first 19 volumes constitute a dictionary of approx. 400 artists with their specialties, nationalities, and dates. The second part, on the graphic arts, contains a wealth of material on the subject matter and characteristics of engravings.

# PREHISTORIC

E26    Ebert, Max, ed. Reallexikon der Vorgeschichte, unter Mitwirkung zahlreicher Fachgelehrter. Berlin, de Gruyter, 1924-32. 15v. in 16. il., plates (part col.), maps, facsims.

Scholarly, signed articles on prehistoric archaeology and art; bibliography; many illustrations.

Contents: v.1-14; A-Z; v.15, Register. List of authors, v.1, p.vi-vii; abbreviations, p.viii-xviii; transliteration of foreign alphabets, p.xix-xx.

# ANCIENT

E27    Caffarello, Nelida. Dizionario archeologico di antichità classiche. Firenze, Olschki, 1971. xii, 529p. il.

Contains succinct, authoritative definitions of terms relating to classical art and archaeology. Gives derivations of terms. Well illustrated with photographs of monuments and line drawings.

E28    Daremberg, Charles Victor, and Saglio, Edmond. Dictionnaire des antiquités grecques et romaines d'après les textes et les monuments. Paris, Hachette, 1877-1919. 5v. and index. il. (incl. maps, plans, facsims.) (Repr.: Graz, Akademische Druck- u. Verlagsanstalt, 1962-69.)

A fundamental scholarly work with long, signed articles by specialists. Subjects included: arts, costume, furniture, institutions, public and private life, manners and customs, religion, sciences, etc. Biography and literature are excluded. Biographical references.

E29    Enciclopedia dell'arte antica, classica e orientale. Roma, Istituto della enciclopedia italiana [1958-66]. 7v. il., col. plates, maps, facsims., plans.

Editor in chief: Ranuccio Bianchi Bandinelli; Co-editor: Giovanni Becatti.

A milestone encyclopedia of art and archaeology in the antique world from prehistory to c.500 A.D. Alphabetical arrangement of places, artists, and subjects relating to the art of antiquity in Europe, Asia, N. Africa, and Ethiopia. Emphasizes the classical period of the Mediterranean world. Signed articles by over 200 scholars. Each term which is not a simple definition has a bibliography. Includes ancient art criticism. Richly illustrated with photographs chosen expressly for quality.

_____. Supplemento 1970. Roma [1973]. xv, 951p. il., col. plates, maps, plans.

_____. Atlante dei complessi figurati e degli ordini architettonici. Roma [1973]. xii, 40p., 384 plates.

E30    Lexikon der alten Welt. [Redaktion: Klaus Bartels und Ludwig Huber] Zürich, Artemis [1965]. xv, 3,524 cols. il., maps.

A dictionary of approx. 10,000 entries concerning all aspects of the geography, history, culture, and literature, as well as the art and architecture of the ancient world around the Mediterranean. Written by a team of scholars; all entries are signed. Many entries include bibliographical references.

Appendixes: I. Verzeichnis der antiken Bildnisse; II. Benennungen griechischer und lateinischer Handschriften; III. Sammlungen griechischer Papyri; IV. Die wichtigsten Ausgrabungen; V. Masse und Gewichte; VI. Geflügelte Worte; Abkürzungsverzeichnisse; Nachweise; Register.

E31    Pauly, August Friedrich von. Pauly's Real-Encyclo-pädie der classischen Altertumswissenschaft; neue Bearb. begonnen von Georg Wissowa, unter Mitwirkung zahlreicher Fachgenossen hrsg. von Wilhelm Kroll und Karl Mittelhaus. Stuttgart, Metzler, 1894-(1973). v.1-(24¹). 2. Reihe v.1-(10 A¹) and Suppl. 1-(13). maps. (Repr.: Stuttgart and München, Druckenmüller)

The standard classical encyclopedia covering antiquities, biography (including artists), classical literature, and history. Long, signed articles by specialists, and bibliographies. In English usually referred to as "Pauly-Wissowa"; sometimes cited in German as "R.E." Published in two series.

Contents: Bd. 1-24¹, A-Quosenus; 2. Reihe (R-Z), Bd. 1-10A¹, R-Zythos; Supp. 1-(15), 1903-(78).

_____. Der Kleine Pauly: Lexikon der Antike, auf der Grundlage von Pauly's Real-Encyclopädie der classischen Altertumswissenschaft. Unter Mitwirkung zahlreicher Fachgelehrter, bearb. und hrsg. von Konrat Ziegler und Walther Sontheimer. Stuttgart, Alfred Druckenmüller, 1964-(75). v.1-(5).

Abridged version of Pauly's Real-Encyclopädie includes "a high percentage of its articles in concise form. Articles are signed with initials. New advances in scholarship, where relevant, are reflected, and bibliographic references have been updated as necessary."—(Winchell, *Guide to reference books,* 8th ed., DA88)

Contents: Bd. 1, Aachen-Dichalkon; Bd. 2, Dicta Catonis-Iuno; Bd. 3, Iuppiter-Nasidienus; Bd. 4, Nasidius-Scaurus; Bd. 5, Schaf-Zythos. Nachträge.

E32    The Princeton encyclopedia of classical sites. Richard Stillwell, ed. William L. MacDonald, associate ed. Marian Holland McAllister, assistant ed. Princeton, Princeton Univ. Pr., 1976. 1,019p. maps.

Advisory board: Peter H. von Blanckenhagen, Frank E. Brown, John Arthur Hanson, Frances F. Jones, Marian H. McAllister, William L. MacDonald, Erik Sjöqvist, Homer A. Thompson.

A 1v. reference work on approx. 3,000 sites with remains from the Greek and Roman civilizations of the classical period (750 B.C.-A.D. 565). The more than 2,800 entries are listed alphabetically under their classical names, with modern names, if different, following. The signed articles, written by 375 scholars, include extensive descriptions of architecture, with historical summaries and museum holdings. Each entry is keyed to one of the 16 maps in the maps section at the end and concludes with bibliographical references. Many cross-references.

Glossary, p.[1003]-08. Maps, p.1010. Map indexes, p.[1011]-19.

## BYZANTINE

E33   Reallexikon zur byzantinischen Kunst, hrsg. von Klaus Wessel unter Mitwirkung von Marcell Restle. v.1-(3). Stuttgart, Anton Hiersemann, 1963-(78).

A scholarly dictionary which covers all aspects of Byzantine art and architecture. Includes entries under iconographic themes. Consists of well-documented articles by the authors. Illustrated with numerous line drawings, mostly of measured plans and selections of buildings.

Projected in 4v.

Contents to date: Bd. 1, Abendmahl-Dura-Europos; Bd. 2, Durchzug durch das Rote Meer-Himmelfahrt; Bd. 3, Himmelsleiter-(Karm Abu Mena).

## ISLAMIC

E34   Encyclopaedia of Islam. New ed. Ed. by H. A. R. Gibb, J. H. Kramers, E. Lévi-Provençal, J. Schact, under the patronage of the International Union of Academies. Leiden, Brill; London, Luzac, 1954-(76). v.1 (1960), v.2 (1965), v.3 (1971), v.4 (1978- ). il., maps, plans.

Published in fascicles.

1st ed. 1911-38, 4v. and supplement.

An authoritative, scholarly reference work in English. Lengthy articles, with bibliographies, on all aspects of Islamic civilization. The articles on architecture are by K. A. C. Creswell, on ivory by R. Pinder-Wilson, on the arabesque by E. Kühnel, on the art of masonry construction by. C. Marçais. Other articles on the arts will be in forthcoming volumes. Contents to date: v.1, A-B; v.2, C-G; v.3, H-Iram; v.4, Iran-(Kna). Well illustrated with clear black-and-white photographs, fold-out maps, and plans.

## MODERN

E35   Phaidon dictionary of twentieth-century art. London and N.Y., Phaidon [1973]. 420 il.

Written by an international team of experts. Contains more than 1,600 entries on individual artists and over 140 entries on art movements and groups. Some entries include brief bibliographies.

E36   Walker, John A. Glossary of art, architecture and design since 1945. London, Bingley [1973]. 240p.

A lively glossary of terms describing art movements, groups, and styles since 1945. Terms listed are derived from published literature, primarily Anglo-American. "The topics covered include architecture, art—painting, sculpture, ceramics—some graphic and industrial design, and some town planning; excluded are films, theatre, music, literature and fashion. Terms relating to craft operations, tools and technical processes have been excluded." The concentration is "on the more conceptual and theoretical notions which are so often neglected by art dictionary compilers. A number of artists's groups and names of art organizations are included." —*Introd.*

Bibliographical note and select bibliography, p.213-15.

## GENERAL DICTIONARIES OF ARTISTS

E37   Bénézit, Emmanuel. Dictionnaire critique et documentaire des peintres, sculpteurs, dessinateurs et graveurs. [3d ed. Paris] Gründ, 1976. 10v. approx. 7,400p. facsims.

1st ed., 1913-22; 2d ed., 1948-55; repr. 1957, 1960, 1966.

A revised and expanded edition. After Thieme-Becker (E50) the most useful universal dictionary of artists. Contains almost 300,000 biographies of artists who have worked from the 5th century B.C. to present times. The length of individual entries varies from a few lines to long articles which are signed. Frequently includes facsimiles of artists' signatures, prizes received, holding museums and collections, prices realized, and bibliographies.

E38   Bryan, Michael. Bryan's dictionary of painters and engravers. New ed. rev. and enl. under the supervision of George C. Williamson. London, Bell, 1903-05. 5v. plates, ports. (Repr.: Port Washington, N.Y., Kennikat 1968-69.)

First published in 1816. Revised in 1849 by G. Stanley; a supplement prepared by H. Ottley was published in 1876. A new edition (2v., 1884-89) was published under the editorship of R. E. Graves and W. Armstrong. The last edition of 1903-05 is greatly expanded.

Still the standard universal dictionary of artists in English. Longer articles are signed and include lists of artists' works.

E39   Dohme, Robert. Kunst und Künstler des Mittelalters und der Neuzeit. Biographien und Charakteristiken. Unter Mitwirkung von Fachgenossen hrsg. von Dr. Robert Dohme. Leipzig, Seemann, 1877-86. 4v. in 8. il., plates.

A collection of biographical and critical essays written by various specialists and illustrated by line drawings.

Contents: Abt. 1, Bd. 1-2, Kunst und Künstler Deutschlands und der Niederlande bis gegen die Mitte des acht-

zehnten Jahrhunderts (1877-78); Abt. 2, Bd. 1-3, Kunst und Künstler Italiens bis um die Mitte des achtzehnten Jahrhunderts (1878-79); Abt. 3, Kunst und Künstler Spaniens, Frankreichs und Englands bis gegen das Ende des achtzehnten Jahrhunderts (1880); Abt. 4, Bd. 1-2, Kunst und Künstler der ersten Hälfte des neunzehnten Jahrhunderts (1886).

E40　Édouard-Joseph, René, Dictionnaire biographique des artistes contemporains, 1910-1930, avec nombreux portraits, signatures et reproductions. Paris, Art & Édition, 1930-34. 3v. il., incl. ports. plates.
　　　_____. Supplément. Paris, 1936. 162p. il.
English trans. announced 1974.

Publisher varies.

Includes primarily French artists or artists working in France during the period 1910-30. Besides biographical information, many articles give a list of works, holding museums, bibliographical references, illustrations, and sometimes a reproduction of the artist's signature.

Errata list and Index of monograms at the end of v.3.

E41　Füessli, Johann Rudolf. Allgemeines Künstlerlexicon; oder, Kurze Nachricht von dem Leben und den Werken der Mahler, Bildhauer, Baumeister, Kupferstecher, Kunstgiesser, Stahlschneider u.a., nebst angehängsten Verzeichnissen der Lehrmeister und Schüler; auch der Bildnisse, der in diesem Lexicon enthaltenen Künstler. Zürich, Orell, 1779-1821. 2v. in 4.
Original edition published in Zurich, 1763, in one folio volume with bibliography. This is the expanded edition incorporating the three supplements published separately between 1767-77.

The first German dictionary of artists. According to Schlosser (A49) the most important before the great work of Nagler (E47). Still useful.

E42　Havlice, Patricia Pate. Index to artistic biography. Metuchen, N.J., Scarecrow, 1973. 2v. 1,362p.
"This volume is an attempt at providing an index for the location of artists' biographies. Sixty-four works in ten languages constitute the compilation. The information consists of the artist's name, dates, nationality, the media employed and a three-letter code which refers to the bibliography."—Pref.

An index which would seem to supplement Mallett (E44). Major standard dictionaries not included here are Bénézit (E37), Thieme-Becker (E50), and Vollmer (E52).

E43　Kaltenbach, Gustave Émile. Dictionary of pronunciation of artists' names, with their schools and dates, for American readers and students. 2d ed. [Chicago] The Art Institute [1938]. 74p. (Repr: Chicago, Art Institute, 1965.)
1st ed. [1934].

Includes over 1,500 names. Has not been replaced.

E44　Mallett, Daniel Trowbridge. Mallett's Index of artists, international-biographical, including painters, sculptors, illustrators, engravers and etchers of the past and the present. N.Y., Bowker, 1935. xxxiv, 493p.

　　　_____. Supplement. 1940. 319p. (Repr.: N.Y., Peter Smith, 1948; Detroit, Gale, 1976.)
An index to biographical material. Sources of biographical and bibliographical information given at beginning of each volume.

For each artist includes name, nationality, dates, medium (if other than painting), residence (if artist then living), and sources of biographical information.

Still helpful for quick references but should be used with caution.

E45　Meyer, Julius, ed. Allgemeines Künstler-Lexikon. Unter Mitwirkung der namhaftesten Fachgelehrten des In- und Auslandes hrsg. von Dr. Julius Meyer. 2. gänzlich neubearb. Aufl. von Nagler's Künstler-Lexikon. Leipzig, Engelmann, 1872-85. 3v.
No more published. The beginning of a scholarly dictionary of artists based on Nagler (E47). All articles are long and signed. List of collaborators at beginning of v.1.

Contents: v.1, Aa-Andreani; v.2, Andreas-Domenico del Barbiere; v.3, Giambattista Barbiere-Giuseppe Bezzuoli.

E46　Müller, Hermann Alexander, and Singer, Hans Wolfgang. Allgemeines Künstler-Lexikon. Leben und Werke der berühmtesten bildenden Künstler. 3. umbearb. und bis auf die neueste Zeit ergänzte Aufl. Frankfurt a. M., Literarische Anstalt, Rütten & Loening, 1895-1901. 5v.
Bd. 1, "Vorbereitet von H. A. Müller, hrsg. von H. W. Singer"; Bd. 2, "Hrsg. von H. W. Singer."
　　　_____. Nachträge und Berichtigungen. Frankfurt a. M. Literarische Anstalt, Rütten & Loening, 1906. 295p.

A 5th ed. (unrev.) was published in 1921-22 in 6v., in which v.6 contains a 2d supplement with corrections. Gives basic biographical information about each artist and his work. No bibliographies. Articles are not signed.

E47　Nagler, Georg Kaspar. Neues allgemeines Künstler-Lexikon. München, Fleischmann, 1835-52. 22v. (Repr.: Leipzig, Schwarzenberg & Schumann [1924].) 25v.
A predecessor of Thieme-Becker (E50). Contains entries on the lives and works of painters, sculptors, architects, engravers, lithographers, medalists, ivory carvers, and some patrons. Arranged alphabetically. No bibliographies or list of sources.

E48　Naylor, Colin, and P-Orridge, Genesis, eds. Contemporary artists. N.Y., St. Martin's, 1977. 1,077p. il.
A monumental dictionary of detailed information on over 1,300 contemporary artists. Comp. and written by a team of more than 100 experts and critics. Although international in scope, greatest coverage is given to American and Western European artists. Despite some omissions, the dictionary represents a major advance over previous similar attempts. Entries include a biographical sketch, artist's mailing address, dealer, a list of one-man shows, a selective list of group shows, bibliography, collections, a signed critical essay, and frequently a statement by the artist. Illustrated with approx. 1,250 black-and-white reproductions.

E49  Spooner, Shearjashub. A biographical history of the fine arts; or, Memoirs of the lives and works of eminent painters, engravers, sculptors, and architects. From the earliest ages to the present time. Alphabetically arranged and condensed from the best authorities. N.Y., Bouton, 1865. 2v. plates.

Originally published as *A biographical and critical dictionary of painters and engravers* (N.Y., Putnam, 1853). Preface claims 2,000 more names included than in Bryan (E38).

Contents: Introduction, consisting of articles on painting, engraving, etc.; A brief explanation of the principal terms used by writers on the fine arts; Table of Christian names in English, French, German, Italian, Dutch, and Spanish; Alphabetical list of the names acquired by distinguished artists; Alphabetical list of copyists and imitators of great masters, listed under master whose work they copied. Alphabetical list of authorities, p.|lxi|-lxii.

E50  Thieme, Ulrich, and Becker, Felix. Allgemeines Lexikon der bildenden Künstler von der Antike bis zur Gegenwart; unter Mitwirkung von 300 Fachgelehrten des In- und Auslandes. Leipzig, Seemann, 1907-50. v.1-37. (Repr.: Leipzig, Seemann |1954- |; London, Dawson, 1964.)

The most comprehensive scholarly dictionary of artists. Commonly known as Thieme-Becker. Includes, as nearly as possible, all known painters, sculptors, engravers, architects, and decorative artists. v.37 is entitled "Meister mit Notnamen und Monogrammisten." Signed articles by outstanding scholars, long bibliographies. Locations of works of art frequently given. Numerous cross-references.

Supplemented by Vollmer, *Allgemeines Lexikon der bildenden Künstler des XX. Jahrhunderts.* (E52).

E51  Tufts, Eleanor. Our hidden heritage, five centuries of women artists. London and N.Y. |Paddington, 1974|. xix, 256p. il.

A study of 22 women artists from the 16th century to the present. Black-and-white illustrations. Bibliography, p.247-51. Index, p.252-56.

E52  Vollmer, Hans. Allgemeines Lexikon der bildenden Künstler des XX. Jahrhunderts. Unter Mitwirkung von Fachgelehrten des In- und Auslandes, bearb., redigiert und hrsg. von Hans Vollmer. Leipzig, Seemann, 1953-62. 6v.

Supplements Thieme-Becker (E50). The most comprehensive, scholarly dictionary of artists working in the 20th century.

Contents: v.1-5, p. 222, A-Z; v.5, p.223- v.6, Nachträge, A-Z.

E53  Waters, Clara (Erskine) Clement, and Hutton, Laurence. Artists of the 19th century and their works. A handbook containing two thousand and fifty biographical sketches. 7th ed. rev. Boston, Houghton Mifflin, 1894. 2v. in 1. (Repr.: N.Y., Arno, 1969.)

Originally published in 1870. Over 2,000 brief biographical entries followed by critical quotations from authorities (the unique feature of this reference work). The introduction discusses art academies and institutions for art education.

Contents: Authorities consulted; Introduction; Artists of the 19th century; Index to authorities quoted; Index of places; General index.

## ARTISTS' MARKS

E54  Brulliot, Franz. Dictionnaire des monogrammes, marques figurées, lettres initiales, noms abrégés etc. avec lesquels les peintres, dessinateurs, graveurs et sculpteurs ont designé leurs noms. Nouv. éd. rev., cor. et augm. d'un grand nombre d'articles. Munich, Cotta, 1832-34. 3v. (Repr.: Farnborough, Gregg, 1969.)

1st ed. 1817.

Contents: v.1, Monogrammes; v.2, Les lettres initiales; v.3, Les noms abrégés et estropiés, ainsi que les appendices.

An index of names of artists cited is at the end of each volume; a cumulative index of artists is at the end of v.3.

E55  Caplan, H. H. The classified directory of artists signatures, symbols & monograms. London, H. H. Caplan, in association with George Prior Pub., 1976. 738p.

A dictionary of facsimile reproductions of the signatures, symbols, and monograms of artists of all periods. Artists included are primarily British and continental European, with some American, Canadian, and Australian. Contents in four main sections: (1) A-Z classification; (2) Monograms (listed alphabetically); (3) Illegible or misleading signatures; (4) Symbols (grouped by form). Entries give artists' dates, types of works and/or predominate media, and location of works. Sources for the facsimile reproductions are not cited.

E56  Goldstein, Franz. Monogramm-Lexikon; internationales Verzeichnis der Monogramme bildender Künstler seit 1850. Berlin, de Gruyter, 1964. 931p. il.

Continues Nagler (E58). Includes monograms, figurative marks and signs, anonymous artists, and Cyrillic marks. Arranged by mark within these categories. Index of names followed by mark, p.|835|-931.

E57  Heller, Joseph. Monogrammen-Lexikon, enthaltend die bekannten, zweifelhaften und unbekannten Zeichnen, so wie die Abkürzungen der Namen der Zeichner, Maler, Formschneider, Kupferstecher, Lithographen u.s.w. mit kurzen Nachrichten über Dieselben. Bamberg, Sickmüller, 1831. xxv, 412p.

Dictionary of monograms and marks of European artists. Includes a reproduction of each monogram.

E58  Nagler, Georg Kaspar. Die Monogrammisten und diejenigen bekannten und unbekannten Künstler aller Schulen. München, Franz, 1858-79. 5v. il., facsims.

———. General-Index zu G. K. Nagler Die Monogrammisten. . . . München, Hirth, 1920. 109p. (Repr.: Nieuwkoop, De Graaf, 1966. Including index.)

The standard work on artists' monograms. Arranged alphabetically by monogram. Index of artists' names.
Continued by Goldstein (E56).

E59 Ris-Paquot, Oscar E. Dictionnaire encyclopédique des marques et monogrammes, chiffres, lettres initiales, signes figuratifs contenant 12,156 marques. . . . Paris, Laurens, 1893. 2v. il., 3 plates. (Repr.: N.Y., Burt Franklin [1964].)
"Concernant les aquafortistes, architectes, armuriers, bibliophiles, célébrités littéraires, céramistes, ciseleurs, damasquineurs, dessinateurs, dinandiers, ébénistes, émailleurs, fabricants de papier, fondeurs, graveurs sur bois, cuivre, pierres fines, métaux, horlogers, huchiers, imprimeurs, libraires, maîtres des monnaies, miniaturistes, modeleurs, nielleurs, numismatique, ordres de chevaleries, orfèvres, peintres, potiers d'étain, relieurs, sculpteurs sur bois, pierre, ivoire, albâtre, nacre, etc., tapissiers, tisserands, tourneurs, etc."—*Title page.*
A standard work on all types of artists' marks. Contents: pt. 1, Marks and monograms arranged alphabetically; pt. 2, Figurative or symbolic marks listed by subject; Index of names; Index of places.

# WESTERN COUNTRIES

## Australia

E60 McCulloch, Alan. Encyclopedia of Australian art. London, Hutchinson, 1968. 668p. plates (part col.)
"The aim of this book is to provide a complete, compact work of reference giving comprehensive information in easily accessible, alphabetical form, about the visual arts in Australia dating from the year 1770 until the present time."
—*Author's note.* The majority of entries are biographical sketches of varying length of Australian artists. Includes some entries on galleries, prizes, societies, exhibitions, etc. Some entries include bibliographical references. The introduction, p.11–18, is a survey of Australian art.

## Baltic Countries

E61 Campe, Paul. Lexikon liv-und kurländischer Baumeister. Bauhandwerker und Baugestalter von 1400–1850. Stockholm [the author] 1951–57. 2v.
100 copies.
A dictionary of architects, artists, and craftsmen working in Livonia and Kurland (Baltic regions) from 1400–1850. Entries arranged chronologically. "Alphabetisches Namenverzeichnis der Baumeister . . . ," v.1, p.446–508; "Chronologisch geordnetes Meisterverzeichnis nach deren Heimatland bezieh. Volkstum," v.1, p.509–39; "Register der Personen, Orte, Bauwerke, Sachen und Geschehnisse," v.1, p.541–644. v.2, "Nachtrag und Ergänzung zum I Bande."

E62 Neumann, Wilhelm. Lexikon baltischer Künstler. Riga, Jonck & Poliewsky, 1908. 171p. (Repr.: Hannover-Döhren, Hirschheydt, 1972.)
A biographical dictionary of painters, sculptors, illustrators, draughtsmen, printmakers, and art historians of the Baltic states and Russia, primarily of the 19th century.

## Canada

E63 Creative Canada; a biographical dictionary of twentieth-century creative and performing artists. Compiled by Reference Division, McPherson Library, Univ. of Victoria. [Toronto]. Pub. in association with McPherson Library, Univ. of Victoria, by Univ. of Toronto Pr. 1971– . v.1– . 310p.
Includes authors, musicians, persons active in the theater, etc., as well as the creators of the visual arts. Gives biographical information, including awards and honors, as well as noting artistic activities such as theater, radio and television performances, writings, exhibitions, and commissions.

E64 Harper, J. Russell. Early painters and engravers in Canada. [Toronto] Univ. of Toronto Pr. [1970]. 376p.
A comprehensive dictionary of Canadian painters and engravers born before 1867 or whose works were in public exhibitions or whose names are mentioned in pre-1900 listings. Also includes foreign-born artists who painted Canadian subjects or views. For each entry gives date and place of birth and death, brief biographical details, public exhibitions, collections, and keys to further references listed in the bibliography, p.343–76.

E65 MacDonald, Colin S. A dictionary of Canadian artists. Ottawa, Canadian Paperbacks, 1967–(77). v.1–(5).
In progress. 2d ed. 1969– . Contents: v.1–5, Adams-Perrigard.
Biographical information on native-born Canadian artists and foreign artists who have worked in Canada. Bibliographical references conclude many entries.

## France

E66 Audin, Marius, and Vial, Eugène. Dictionnaire des artistes et ouvriers d'art du Lyonnais. Paris, Bibliothèque d'art et d'archéologie, 1918/19. 2v.
A comprehensive dictionary of artists who worked in the historical region of Lyonnais (the modern departments of Rhône and Loire). Limited to those who died before 1900 or began working before 1850. Introduction includes excerpts from the statutes of the city of Lyons. Archival and bibliographical references in text. Bibliography, v.2, p.[325]–46.

E67 Bellier de La Chavignerie, Émile. Les artistes français du XVIIIe siècle, oubliés ou dédaignés. Paris, Renouard, 1865. 180p. (Repr: Genève, Minkoff, 1973.)
"Extrait de la Revue Universelle des Arts."
A dictionary of 18th-century French painters, sculptors, draftsmen, and engravers who were not members of the

Académie Royale but who exhibited at the *Salon de la Correspondance* (1779-87). The information is drawn primarily from the organ of the *Salon*, the *Nouvelles de la République des Lettres et des Arts*.

E68    _____. Dictionnaire général des artistes de l'école française depuis l'origine des arts du dessin jusqu'à nos jours. Architectes, peintres, sculpteurs, graveurs et lithographes. Ouvrage commencé par Émile Bellier de La Chavignerie, continué par Louis Auvray. Paris, Renouard, 1882-85. 2v.
    _____. Supplément et table topographique. Paris, Renouard, 1887. 266p.

Includes all artists whose works, given to a jury, were admitted three times to the Salon. Lists pictures and tells in which Salons they were exhibited. In many cases subsequent sales are listed. This "classic" dictionary, basic for research in French art from 1673-1882, is especially valuable for tracing the provenance of individual works of art.

Contents: v.1, A-L; v.2, M-Z; and *Supplément* bringing the work up to 1882. "Table topographique des artistes français" lists artists by province and then by city.

E69    Bérard, André. Dictionnaire biographique des artistes français du XIIe au XVIIe siècle, suivi d'une table chronologique et alphabétique comprenant en vingt classes les arts mentionnés dans l'ouvrage. Paris, Dumoulin, 1872. 864 col.

Includes painters, sculptors, musicians, miniaturists, calligraphers, engravers, goldsmiths, ironworkers, clockmakers, bookbinders, embroiderers, tapestry weavers, and other artisans. Numbers after names refer to the list of works consulted, p.|xi]-xv. "Table chronologique et alphabétique," p.|826]-63, is an index of the artists arranged according to medium.

E70    Bonnaffé, Edmond. Dictionnaire des amateurs français au XVIIe siècle. Paris, Quantin, 1884. 353p. (Repr.: N.Y., Burt Franklin, 1967; Geneva, Slatkine; Amsterdam, Israël, 1966.)

An encyclopedia of 17th-century art collectors with literary references to their collections and bibliographical notes. At end of volume a supplement and "tables" arranged by medium (painting, tapestry, etc.) and then by artist and title of work. Bibliography, p.[xiii]-xvi.

E71    Brune, Paul. Dictionnaire des artistes et ouvriers d'art de la Franche-Comté. Paris, Bibliothèque d'art et d'archéologie, 1912. 337p.

Biographical notices on the artists and artisans from the historical region of Franche-Comté. Includes exhibitions, holding museums, and bibliographies.

Sources of documentation, p.xiii-xxviii; Index of names and places, p.[295]-337.

E72    Camard, Pierre, and Belfort, Anna Marie. Dictionnaire des peintres et sculpteurs provençaux, 1880-1950. Ile de Bendor, Éditions Bendor [1975?]. x, 444p.

At head of title: Fondation Paul Ricard.

A dictionary of over 700 19th- and 20th-century painters and sculptors from Provence. Ranges in scope from those artists who were old during the Third Republic to those who were born before World War I. For each gives place and date of birth and death, media, short biography, exhibitions, location of works, and, in many cases, bibliographical references. General bibliography, p.435-44.

E73    Du Peloux, Charles. Répertoire biographique & bibliographique des artistes du XVIIIe siècle français; peintres, dessinateurs, graveurs, sculpteurs, ciseleurs, fondeurs, architectes, ébénistes; accompagné de notices sur l'art du XVIIIe siècle, les expositions, les académies et manufactures royales, les ventes publiques et d'une importante bibliographie. Paris, Champion, 1930-41.

v.2 has imprint: Paris, Droz.

The most extensive listing of 18th-century artists and master craftsmen, with an even more important bibliography. An indispensable aid for advanced research on all aspects of 18th-century French art.

Intended as a repertory of all the recognized artists. The biographies are based on innumerable published sources; they range in length from one line to two or three pages. v.1 includes artists who worked in France; at the end are lists of manufacturers, members of the academies and societies, amateurs, principal sales, etc. Index of artists, with sources used. v.2 has biographies of French artists who worked in Germany and Scandanavia; at end are lists of the manufacturers of porcelain, faience, tapestries, provincial academies, collectors, public sales, etc. Subject index and index of artists, with sources used.

The classified bibliographies (v.1, p.|329]-432; v.2, p.|38]-97) are virtually exhaustive, containing more than 7,000 entries for books and articles relative to 18th-century French art.

E74    Dussieux, Louis Étienne. Les artistes français à l'étranger. 3 éd. Paris, Lecoffre, 1876. 643p. (Repr.: Amsterdam, Israël [1973].)

1st ed. 1852; 2d ed. 1856.

An introductory essay on the arts in France (p.|3]-146) is followed by a dictionary of French artists who worked abroad (p.147-615). The dictionary is arranged by country. Index of artists (with media), p.623-37; index of artists whose works are found in museums or large collections, p.639-43.

E75    Gabet, Charles Henri Jospeh. Dictionnaire des artistes de l'école française au XIXe siècle. Peinture, sculpture, architecture, gravure, dessin, lithographie et composition musicale. Orné de vignettes gravées par M. Deschamps. Paris, Vergne, 1831. 709p. il.

Biographies of painters, sculptors, architects, engravers, designers, lithographers, and composers living in France during the first three decades of the 19th century.

E76    Gérard, Charles. Les artistes de l'Alsace pendant le Moyen-âge. Colmar, Barth; Paris, Aubry, 1872-73. 2v.

Continues Graves, *The Royal Academy of Arts; a complete dictionary of contributions and their work from its foundation in 1769 to 1904* (E93). To be complete in 8v.

E98  Royal Society of British Artists—members exhibiting 1824-1930. [Comp.] by Maurice Bradshaw. Leigh-on-Sea, Lewis, 1973-75. 3v.

A compilation of all the members of the Royal Society of British Artists who exhibited with the society from its inception in 1824 to 1930. Arranged alphabetically by artist, giving titles of pictures, dates exhibited, address of artist, and prices asked. Further volumes are planned to extend coverage to 1970.

Contents: v.1, 1824-92 (113p.; 1973); v.2, 1893-1910 (116p., 1975); v.3, 1911-30 (99p., 1975). Abbreviations, p.6.

E99  Strickland, Walter G. A dictionary of Irish artists. Dublin, Maunsel, 1913. 2v. il., plates (incl. ports.) (Repr.: N.Y., Hacker, 1968.)

The standard dictionary. Artists of Irish birth, including those who worked abroad, and other artists who worked in Ireland "from the earliest times to the present day." Index includes names and subjects of art works, names of owners, and places. Appendix (v.2, p.579-664) is an historical essay on the art institutions of Ireland.

E100  Waters, Grant M. Dictionary of British artists working 1900-1950. Eastbourne, Eastbourne Fine Art, 1975. 368p.

A biographical dictionary of British artists working during the period 1900-50. Emphasizes members of leading London societies. Includes provincial, foreign-born, colonial, and Irish artists, as well as artists working in London and other major English cities. Abbreviations, p.[2].

E101  Who's who in art. Biographies of leading men and women in the world of art today—artists, designers, craftsmen, critics, writers, teachers, collectors and curators, with an appendix of signatures. 18th ed. Havant, Hants, Art Trade Pr. [1977]. 553p.

1st ed. 1927.

"In compiling *Who's Who in Art* it is our aim to produce a truly comprehensive list of biographical details of living artists in Britain today .... And as so far as overseas artists are concerned we include only a representative selection of the most outstanding contemporaries."—*Pub. notes.* Aims and activities of academies, groups, societies, etc., p.xi-xx. Appendix I, Monograms and signatures; Appendix II, Obituary; Appendix III, Abbreviations.

## Italy

E102  Alizeri, Federigo. Notizie dei professori del disegno in Liguria dalla Fondazione dell'Accademia. Genova, Sambolino, 1864-66. 3v. plates.

Three introductory chapters are followed by a list of 18th- and 19th-century artists of Genoa and its vicinity. Each

volume has its own index and v.3 has a subject index to the whole.

E103  Baudi di Vesme, Alessandro. Schede Vesme; l'arte in Piemonte dal XVI al XVIII secolo. Torino, Società Piemontese di Archeologia e Belle Arti, 1963-68. 3v.

A dictionary of Italian and foreign-born artists who worked in the Savoy states and environs, now the Piedmont region. Extensive entries often include lengthy quotations from documents, locations of known works, and many bibliographical references. Based on source materials collected by Count Baudi di Vesme (1854-1923) over a period of 40 years. In the second part of *Schede Vesme* (to be published) the relevant documentary material with notes by the author will be arranged in topographical order.

E104  Bindi, Vincenzo. Artisti abruzzesi. Pittori, scultori, architetti, maestri di musica, fonditori, cesellatori, figuli dagli antichi a' moderni. Notizie e documenti. Napoli, G. de Angelis, 1883. 300p. (Repr.: Bologna, Forni, 1970.)

A biographical dictionary of artists of the Abruzzi. Includes painters, sculptors, architects, musicians, castmakers, engravers, and potters. Based on archival material.

E105  Bolognini Amorini, Antonio. Vite dei pittori ed artefici bolognesi. Bologna, Volpe, 1841-43. 5 pts. in 2v. ports.

Individual essays on painters, sculptors, and architects of Bologna through the 17th century. An attempt to bring Malvasia, *Felsina pittrice* (H65) up to date. Introduced by a life of Malvasia. Full treatment of the major Bolognese artists. Index of artists at the end of each part.

E106  Brenzoni, Raffaello. Dizionario di artisti veneti: pittori, scultori, architetti, etc., dal XIII al XVIII secolo. Firenze, Olschki, 1972. 306p. 6 il.

A dictionary of approximately 450 Veronese artists, based on archival sources in Verona and other cities of the Veneto and Lombardy. Includes painters, sculptors, architects, miniaturists, engravers from the 13th through the 18th century. Each entry contains biographical information, discussion of work, bibliographical and archival references. Occasional marks of signature and genealogies.

E107  Campori, Giuseppe. Memorie biografiche degli scultori, architetti, pittori, ec. nativi di Carrara e di altri luoghi della provincia di Massa, con cenni relativi agli artisti italiani ed esteri che in essa dimorarono ed operarono, e un saggio bibliografico. Modena, Vincenzi, 1873. 466p. (Repr.: Bologna, Forni, 1969.)

Well-documented notes on artists who worked in Carrara or elsewhere in the province of Massa and others who came to select marble for their sculpture. Alphabetical arrangement within the first two sections.

Contents: (1) Artisti nativi della provincia, p.1-260; (2) Artisti estranei alla provincia, p.261-373; (3) Saggio bibliografico artistico, p.375-430. Appendice, p.431-40. Indexes to each of the first two sections, and index of places.

E108    Catalogo nazionale Bolaffi d'arte moderna. 1960/1961-(1974/1975). Torino, Bolaffi, 1962-(76). v.1-(11). Irregular. il. (part col.)

Title, subtitle, and format vary. Began publication as *Il Collezionista d'arte moderna; Annuario della vita artistica italiana.*

Devoted to modern artists and current modern art activities in Italy.

v.11 (1976) includes five separate parts and a supplementary booklet of prefatory and statistical information. Pt. 1, *Critico-finanziario; pittori e gallerie italiane nella stagione artistica 1974/1975,* contains lists of artists, with biographical data for each and illustrations of works by many, price indications, and exhibitions. Pt. 1 also contains a section on the activities of art galleries in Italy for 1974–75 and a cumulative index of artists cited in all published editions.

Pt. 2, *Rassegna 1976,* is a compilation of artists, with reproductions of their works, in which the information and photographs were furnished by the artists and by their galleries. Pt. 3, *Segnalati Bolaffi,* comprises a critical selection of 50 artists, given more extensive coverage than that in pts. 1 and 2. Pt. 4, *Rapporto statistico-finanziario,* gives prices for works by prominent artists; Pt. 5, *Premio Bolaffi: Eliseo Mattiacci,* is devoted to the work of one artist.

E109    Coddè, Pasquale. Memorie biografiche poste in forma di dizionario dei pittori, scultori, architetti ed incisori mantovani per la più parte finora sconosciuti; raccolte dal fu dottore Pasquale Coddè . . ., augm. e scritte dal Dott. fisico Luigi Coddè. Mantova, Negretti, 1837. xxiii, 174p. (Repr.: Bologna, Forni, 1967.)

A well-documented dictionary of artists in Mantua. Annotazioni e documenti, p.[155]-70; Indici dei pittori scultori architetti ed incisori mantovani, p.[171]-74.

E110    Colombo, Giuseppe. Documenti e notizie intorno agli artisti vercellesi. Vercelli, Francesco, 1883. 502p.

Documents and notices from the archives of Vercelli are arranged by artist. The families of artists covered are Oldoni, Lanino, Giovenoni, and Tressini of Lodi. A section on other artists (p.[315]-75) and an appendix consisting of documents and notices on Giovanni Antonio Bazzi, known as Il Sodoma. List of *documenti* and *notizie* by section and date, p.[485]-501.

E111    Comanducci, Agostino Mario. Dizionario illustrato dei pittori, disegnatori e incisori italiani moderni e contemporanei. 4. edizione in cinque volumi completamente rifatta e ampliata a cura di una redazione diretta da Luigi Servolini. Milano, Patuzzi, 1970-74. 5v. il. (part col.)

1st ed. 1934; 2d ed. 1945; 3d ed., ed. by L. Pelandi and L. Servolini, 1962.

An illustrated dictionary of Italian painters, draftsmen, and engravers from the beginning of the 19th century to the present. For each gives biography, indication of style, representative works, and bibliographical references. Lavishly illustrated, many in color. "Bibliografia generale essenziale," at end of v.5.

E112    Corna, Andrea. Dizionario della storia dell'arte in Italia, con duecento illustrazioni; seconda edizione corretta ed aumentata. Piacenza, Tarantola [1930]. 2v. il.

1st ed. 1916.

A biographical dictionary of Italian painters, sculptors, architects, potters, goldsmiths, and engravers.

E113    Dizionario biografico degli Italiani. [Redazione, Alberto M. Ghisalberti]. Roma, Enciclopedia Italiana, 1960-(77). v.1-(20).

*PL v.1-24 (83)*
*→v.25 in 1982*

In progress.

Contents: v.1-(18), Aaron-Carusi.

This dictionary of Italian national biography is the indispensable source for bio-bibliographies of Italian artists, archaeologists, art historians, critics, etc. Long articles with full bibliographies, each written by a specialist. Excludes living persons.

*on ord. v. 8-11  4/86*

E114    Dizionario enciclopedia Bolaffi dei pittori e degli incisori italiani. Dall' XI al XX secolo. Torino, Bolaffi, [1972-76]. 11v. il., plates.

A biographical dictionary of Italian painters and engravers from the 11th through the 20th centuries. The generally brief articles are occasionally signed and include up-to-date bibliographical references. Artists' signatures are sometimes reproduced. Well illustrated with black-and-white photographs of works and color plates.

E115    Fenaroli, Stefano. Dizionario degli artisti bresciani. Brescia, Pio Istituto Pavoni, 1877. 317p.

A biographical dictionary of painters, sculptors, and architects of Brescia, including the outstanding goldsmiths, engravers, and metalworkers. The lives are based on local documents. Bibliographical references.

E116    Giannelli, Enrico. Artisti napoletani viventi: pittori, scultori ed architetti; opere da loro esposte, vendute e premii ottenuti in esposizioni nazionali ed internazionali. Con testata e pref. di Eduardo Dalbono. Napoli, Melfi & Joele, 1916. xvii, 749p. 171 ports.

A biographical dictionary of Neapolitan painters, sculptors, and architects living c.1916.

E117    Grasselli, Giuseppe. Abecedario biografico dei pittori, scultori ed architetti cremonesi, del ragioniere collegiato Giuseppe Grasselli da Cremona. Milano, Manini, 1827. 290p.

A biographcal dictionary of painters, sculptors, and architects of Cremona. Preceded by a preliminary discourse. Index of names. Bibliographical references in text.

E118    Gubernatis, Angelo de. Dizionario degli artisti italiani viventi, pittori, scultori e architetti. Firenze, Le Monnier, 1906. 640p.

A dictionary of Italian painters, sculptors, and architects living c.1888.

E119    Pietrucci, Napoleone. Biografia degli artisti padovani. [Padova, Bianchi] 1858. 295p. (Repr.: Bologna, Forni [1970].)

A biographical dictionary of Paduan artists from the 14th to the 19th century. Based on archival research; scholarly notes.

E120　Zannandreis, Diego. Le vite dei pittori, scultori e architetti veronese. Giuseppe Biadego, ed. Verona, Franchini, 1891. 559p. (Repr.: Bologna, Forni, 1968.)
The first published ed. of a work written early in the 19th century on the artists of Verona. Extensive documentation. Index to the lives, p.535–43; Index of places, p.545–59. Bibliography of sources, p.|xxvii–xxxv|.

## Latin America

E121　Acuña, Luis Alberto. Diccionario biográfico de artistas que trabajaron en el nuevo reino de Granada. Bogotá, Instituto Colombiano de Cultura Hispánica, 1964. 71p. 40 plates.
A biographical dictionary of Colombian painters, sculptors, architects, and artisans working during the colonial period. Bibliography, p.|69|-71.

E122　Image of Mexico; the General Motors of Mexico Collection of Mexican graphic art, ed. by Harry H. Ransom. Special eds.: Thomas Mabry Cranfill and Hans Beacham. |Austin| Univ. of Texas, 1969. 2v. il. (*Texas quarterly*, autumn-winter, 1969, v.12, no. 3-4)
At head of title: A special issue. Articles, captions, and biographical sketches in English and Spanish.
　Each volume includes a section of photographs of artists, reproductions of drawings and prints, and a section of artists' biographical data (in English and Spanish). Not a full biographical dictionary but provides information on Mexican artists not found elsewhere.
　Contents: v.1, A–K; v.2, L–Z.

E123　Merlino, Adrián. Diccionario de artistas plásticos de la Argentina, siglos XVIII-XIX-XX. |Buenos Aires, Instituciones de la Argentina vinculadas a las artes plásticas, 1954|. 433p. il.
For each artist gives the places of exhibiton, the museums containing the individual's works, and the prizes received. Bibliography, p.408–14. "Instituciones de la Argentina vinculadas a las artes plásticas," p.416–28.

E124　Ortega Ricaurte, Carmen. Diccionario de artistas en Colombia: pintores, escultores, grabadores, arquitectos coloniales, ingenieros militares (s. XVI-XVIII) ceramistas, orfebres, plateros, caricaturistas y dibujantes Bogotà |Tercer Mundo| 1965. 448p. il. (part col.)
Contains more than 400 entries. Gives for each a biographical outline, including career data, a noncritical stylistic analysis, a list of holding institutions and collections, and bibliographical references. 20th-century architects are not included.
　"Indice de artistas por profesiones," p.|449|-|58|.

E125　Pontual, Roberto. Dicionário das artes plásticas no Brasil. Introdução histórico-crítica de Mário Barata

|et al. Rio de Janeiro| Civilização Brasileira |1969|. 559p. il., col. plates.
A biographical dictionary of Brazilian painters, sculptors, and graphic artists from colonial to contemporary time. Includes illustrations and bibliographical references for many entries.

E126　Vargas Ugarte, Ruben. Ensayo de un diccionario de artifices coloniales de la America meridional. |Lima?| Baiocco, 1947. 391p.
　　　　　. Apendice. |Lima?| Baiocco, 1955. 118p.
A dictionary of South American artists from the 16th through the 19th centuries. Well documented, based mostly on Spanish archives.

## Low Countries

E127　Duverger, Jozef. De Brusselsche steenbikkeleren: beeldhouwers, bouwmeesters, metselaars enz. der XIVe en XVe eeuw met een aanhangsel over Klaas Sluter en zijn Brusselsche medewerkers te Dijon. Gent, Vyncke, 1933. 134p.
Covers sculptors, architects, stonemasons, etc., of Brussels in the 14th and 15th centuries. Contents: Voorrede. (1) Het handschrift; (2) Het steenbikkeleren-ambacht te Brussel; (3) De beteekenis van het handschrift; (4) Aanhangsel: Klaas Sluter en zijn Brusselsche medewerkers; (5) Ledenlijst van het steenbikkeleren-ambacht. Index of names, p.77-130.

E128　Hymans, Henri Simon. Près de 700 biographies d'artistes belges, parues dans la Biographie nationale, dans L'art flamand et hollandais, dans le Dictionnaire des Drs. Thieme et Becker et dans diverses publications du pays et de l'étranger. Bruxelles, Hayez, 1920. 789p. (Oeuvres, t. 2)
A biographical dictionary of Belgian artists of all periods. Entries contain bibliographical references as well as archival sources. "Table des matières," p.|781|-87 lists the Belgian artists covered. "Biographies diverses," p.787-88 lists non-Belgian artists included (Frans Hals, Mabuse, Quentin Metsys, Rembrandt, etc.).

E129　Immerzeel, Johannes, *Jr*. De levens en werken der Hollandsche en Vlaamsche kunstschilders, beeldhouwers, graveurs en bouwmeesters, van het begin der vijftiende eeuw tot heden |1840| . . . uit. door Mr. C. H. Immerzeel en C. Immerzeel. Amsterdam, van Kestern, 1842-43. 3v. il.
2d ed. 1855, Amsterdam, Diedericks. (Repr. of 1855 ed.: Amsterdam, Israël, 1974.)
　A basic work. Includes some entries under names of museums as well as artists. Numerous portraits of artists. "Monogrammen," v.3, p.|263|-307.

E130　Kramm, Christiaan. De levens en werken der Hollandsche en Vlaamsche kunstschilders, beeldhouwers, graveurs en bouwmeesters, van den vroegsten tot op onzen tijd. Amsterdam, Diedericks,

1857–64. 6 pts. and supp. in 4v. (Repr.: Amsterdam, Israël, 1974.)
Based on Immerzeel (E129), with additional material.

E131   Lerius, Théodore François Xavier van. Biographies d'artistes anversois. Pub. par P. Génard. Antwerpen, Kockx, 1880–81. 2v. (Maatschappij der Antwerpsche Bibliophilen, uitgave 8, 11)
Useful for biographies of minor Antwerp artists. v.1: 27 artists (265p.); v.2: 20 artists (395p.). Sources given throughout.

E132   Mélicocq, Alexandre de la Fons, *baron* de. Les artistes du nord de la France et du midi de la Belgique, aux XIVe, XVe et XVIIe siècles. Béthune, Savary, 1848. 249p.
Based on local documents.
    Contents: (1) Notre Dame de Noyen; (2) Artistes des XVe et XVIe siècles qui ont construit, embelli et decoré l'Hotel de Ville et le Beffroi de Béthune; (3) Artistes du nord de la France et du midi de la Belgique qui ont construit ou réparé les fortifications d'Arras, de Béthune, de Guise, de Noyon, de Péronne, etc. aux XVe et XVIe siècles; (4) Artistes dramatiques de Béthune aux XVe et XVIe siècles.
    Bibliographical references and documentation in footnotes.

E133   Scheen, Pieter A. Lexicon Nederlandse beeldende kunstenaars 1750–1950. 's Gravenhage, Kunsthandel Pieter A. Scheen, 1969–70. 2v. il.
An authoritative dictionary of Dutch artists who were born after 1750 and before 1950. Supplements Wurzbach (E135). Includes painters, sculptors, draftsmen, engravers, potters, furniture makers, etc. Based on original research. Good bibliographies; excellent illustrations.
    Contents: v.1, A–L (751p., 954 il.); v.2, M–Z (692p., 1,017 il., suppl., A–Z, 54p.).

E134   Willigen, Adriaan van der. Les artistes de Haarlem; notices historiques avec un précis sur la gilde de St. Luc. Éd. rev. et augm. Haarlem, Bohn, 1870. 366p. geneal. tables, facsims. (Repr.: Amsterdam, De Graaf, 1970.)
Trans. from the Dutch. A collection of documents. First part (p.1–57) is on the Guild of St. Luke. Notes on various Haarlem artists, arranged alphabetically (p.66–351). Chronological survey of persons mentioned in the second part (p.61–65). Appendix, Haarlem potters (p.353–59). Index of names (p.360–66). Genealogical tables of various families of artists and four pages of facsimiles of signatures.

E135   Wurzbach, Alfred von. Niederländisches Künstler Lexikon, auf Grund archivalischer Forschungen. Wien, Halm, 1906–11. 3v. facsims. (Repr.: Amsterdam, Israël, 1968.)
The standard dictionary of Dutch and Flemish artists. Contains biographical information, lists of important works, and bibliographies, with many facsimiles of signatures. v.3 is a supplement and includes anonymous masters and monogrammists. Somewhat antiquated. "The author's

outspoken prejudices add to rather than detract from its readability."—Rosenberg, Slive, and Kuile (I388).

## Russia and Eastern Europe

E136   Dlabač, Jan Bohumir. Allgemeines historisches Künstler-Lexikon für Böhmen und zum Theil auch für Mähren und Schlesien. Gesammelt und bearb. von Gottfried Johann Dlabacž. Auf Kosten der hochlöblichen Herrenstände Böhmens herausgegeben. Prag, Hasse, 1815. 3v. in 1. (Repr.: Hildesheim, Olms, 1973.)
Repr. ed. contains: Sternberg-Manderscheid, Franz von. *Beiträge und Berichtigungen zu Dlabacž: Lexikon bömischer Künstler. Herausgegeben und durch Anmerkungen ergänzt von Paul Bergner.* Prag, Verlag der K. Andréischen Buchhandlung Max Berwald, 1913. 63p.
    A dictionary of artists, architects, clockmakers, engravers, musicians, and composers of Bohemia, Moravia, and Silesia. Sources are included for the majority of the entries.

E137   Khudozhniki narodov SSSR. Biobibliograficheskiy Slovar. Moskou, Iskusstvo, 1970– . v.1– .
In progress; to be complete in 6v.
    Editor: Tat'iana Nikolaevna Gorina.
    On leaf preceding title page. Akademiia khudozhestv SSSR. Naucho-issledovatel'skiĭ institut teorii i istorii izobrazitel' nykh iskusstv.
    A biographical dictionary of Soviet artists. Each entry includes a brief biography and bibliographical references. v.1–2, by O. E. Vol'tsenburg, et al.

E138   Művészeti lexikon. Főszerkesztők: Zádor Anna és Genthon István. [Szerkesztők: Balogh Jolán, et al.]. Budapest, Akadémiai Kiadó, 1965–68. 4v. il., ports.
Over 14,000 articles on art and artists from prehistoric to modern times. Includes architecture, painting, sculpture, decorative arts, archaeology, and ethnology. Bibliographical references at the end of many articles.
    The best source for biographical information on Hungarian artists. Especially strong in material on Eastern European art.

E139   Rastawiecki, Edward, *baron*. Słownik malarzów polskich, tudzież obcych w Polsce osiadłych lub czasowo w niéj przebywających. Warszawa, Nakł. autora, 1850–57. 3v. ports.
A biographical dictionary of Polish painters and foreign artists who worked in Poland. Includes statutes of the painters, glaziers, gilders, and apothecaries guilds.

E140   Słownik artystów polskich i obcych w Polsce działających; malarze, rzeźbiarze, graficy. Zespół redakcyjny: Jolanta Maurin-Białostocka [et al.]. Konsultant naukowy: Andrzej Ryszkiewicz. Wrocław, Zakład Narodowy im. Ossolińskich, 1971– . v.1– .
At head of title: Instytut Sztuki Polskiej Adademii Nauk.
    To be published in 6v. Contents, v.1: A–C; v.2: D–G (1975).

A biographical dictionary of Polish painters, sculptors, and printmakers and non-Polish artists working in Poland from the earliest known to those active in 1966. Each entry contains biographical information, a list of works, and bibliographical references.

E141  Sobko, Nikolaĭ Petrovich. Slovar' russkikh khud-
      ozhnikov . . . . (XI–XIX vv.). S. Petersburg, Stasule-
      vich, 1893–99. 3v. il.

A biographical dictionary of Russian artists from the 11th through the 19th century. Includes bibliographies for individual artists.

## Scandinavia

E142  Billedkunstens hvem—hvad—hvor. København,
      Politiken, 1969–70. 2v. il.

Editors: Marianne Marcussen, Mogens Rud, Jan Garff.

A dictionary of Danish artists with illustrations of their works and portraits.

Contents: v.1. Danmark [1500–1875, 287p.] Kunstnere født før 1876; v.2, Danmark. Kunstnere født efter 1876 [344p.].

E143  Illustrert norsk kunstnerleksikon: stemmeberettigede
      malere, grafikere/tegnere, billedhoggere. [2d ed.].
      Redigert av Henning Gran og Peter Anker. Oslo,
      Broen, 1956. 291p. 360 il., ports.

Brief biographical information, including training, exhibitions, and collections and museums owning works. Most entries accompanied by a photograph of the artist.

E144  Koroma, Kaarlo. Suomen kuvataiteilijat; Suomen
      Taiteilijaseuran julkaisema elämäkerrasto. Porvoo,
      Söderström, 1962. 278p. ports.

"Suomen Kuvataiteilijat (Finland's Pictorial Artists) gives information on all Finnish artists of importance—about one thousand altogether. The criteria for inclusion was participation a certain number of times in (a) national exhibitions with a jury, (b) big international art exhibitions (e.g. Venice, São Paulo Biennales), (c) Finnish exhibitions sent abroad."—*Foreword.*

List of abbreviations from Finnish to English, p.268–71.

E145  Ohlén, Carl Eric. Nytt svenskt konstnärsgalleri.
      Målare, grafiker, skulptörer. Redaktion: Carl-E.
      Ohlén, Gunnar Hellman. Inledande artikel, Gunnar
      Hellman. Malmö, Svensk facklitteratur [1966]. 595p.
      il.

A dictionary of contemporary Swedish painters, engravers, and sculptors. Vital statistics, exhibitions, representation in museums, honors, etc. are given for each artist. Includes signatures, photographs of the artists, and illustrations of their work (several in color).

E146  Svenska konstnärer; biografisk handbok. 5. uppl.
      Malmö, Skånetryckeriets [1955]. 438p.

Brief factual information on more than 4,100 Swedish architects, painters, sculptors, engravers, and dealers.

E147  Svenskt Konstnärslexikon . . . [Redaktion: Gösta Lilja,
      et al.]. Malmö, Allhem, 1952–67. 5v. il., plates (part
      col.)

Biographical information on approx. 12,500 living and deceased Swedish artists. Includes native-born artists, foreign artists who worked in Sweden (coverage emphasizes activities in Sweden), and artists who worked outside the country but under commissions from Sweden. Most articles are signed and give bibliography. Profusely illustrated; many portraits. Corrections and supplement at end of v.5.

E148  Weilbach, Philip. Weilbachs kunstnerleksikon.
      Udgivet af en komité med støtte af Carlsbergfondet.
      Redaktion: Merete Bodelsen og Povl Engelstoft.
      [København] Aschehoug, 1947–52. 3v. il.

3d ed. 1st ed., 1877–78: *Dansk kunstnerlexikon;* 2d ed., 1896–97: *Nyt dansk kunstnerlexikon.*

The standard biographical dictionary of Danish artists. Articles are signed and include bibliographies. Contents: v.1, A–H; v.2, I–P; v.3, Q–Ø and supplement: bibliography, p.[52]–53; "Rettelser og tilføjelser," p.57–86; "Arkitektur index," p.89–135.

## South Africa

E149  Berman, Esmé. Art and artists of South Africa: an
      illustrated biographical dictionary and historical
      survey of painters & graphic artists since 1875. Cape
      Town, Balkema, 1970. 368p. il.

2d ed. announced 1974.

Arranged alphabetically by artist, with biographical information and critical analysis of works. Also includes a number of subject entries. Many illustrations. "Historical table," p.xi–xvi; "Historical survey," p.1–21. Bibliography, p.353–55.

## Spain and Portugal

E150  Alcahalí y de Mosquera, José Maria Ruiz de Lihori y
      Pardines. Diccionario biográfico de artistas valen-
      cianos, por el barón de Alcahalí; obra premiada en
      los Juegos florales de lo Ratpenat el año 1894.
      Valencia, Impr. de F. Domenech, 1897. 443, [1]p.

A biographical dictionary of the artists from the province of Valencia. Based on research in archives. Includes excerpts from documents within text.

Contents: Introducción, p.1–41; Diccionario de artistas valencianos, p.[43]–442.

E151  Aldana Fernández, Salvador. Guía abreviada de
      artistas valencianos. [Valencia] Ayuntamiento de
      Valencia, 1970. 382p. (Publicaciónes del Archivo
      municipal de Valencia. Serie primera: Catálogos,
      guías y repertorios, 3)

A biographical guide to the artists of Valencia, based on the larger standard works, i.e. Céan Bermúdez (E152), Orellana (H109), Palomino (H111), etc. Dictionary arrangement. Brief factual information and bibliographical references. Indexes

of architects, sculptors, engravers, illuminators, goldsmiths, and painters.

E152   Ceán Bermúdez, Juan Agustín. Diccionario histórico de los más ilustres profesores de las bellas artes en España. Madrid, Ibarra, 1800. 6v. (Repr.: N.Y., Kraus, 1965.)

A dictionary of Spanish artists and others working in Spain. Includes architects, painters, sculptors, miniature painters, engravers, silversmiths, glassworkers, embroiderers, and metalworkers. Information based on local documents.

v.6: "Suplemento," p.55–91; "Tablas cronológicas de los profesores de las bellas artes en España," p.95–184, arranged by medium; "Tablas geográficas de los profesores de las bellas artes en España," p.187–376.

E153   Elías de Molíns, Antonio. Diccionario biográfico y bibliográfico de escritores y artistas catalanes del siglo XIX (apuntes y datos). Barcelona, Administración, 1889–[95]. 2v. il., plates.

A dictionary of Catalan artists of the 19th century. Includes bibliographies.

E154   Furio, Antonio. Diccionario histórico de los ilustres profesores de las bellas artes en Mallorca. Palma, Gelabert y Villa longa socios, 1839. viii, 50, 292p. (Repr.: Palma, Mallorquina, 1946.)

A dictionary of artists who worked in Majorca. Preliminary list of artists by century and medium, p.9–12; Introd., p.13–84.

E155   Gestoso y Pérez, José. Ensayo de un diccionario de los artífices que florecieron en Sevilla desde el siglo XIII al XVIII inclusive. Sevilla, Oficina de La Andalucía Moderna, 1899–1909. 3v. facsims.

A dictionary of artists of Seville from the 13th through the 18th centuries. Contents: v.1, A–O; v.2, P–Y; v.3, Apéndices a los tomos 1 y 2. v.3 is illustrated with 20 facsimiles of signatures. Index at end of each volume.

E156   Machado, Cyrillo Volkmar. Collecção de memorias relativas ás vidas dos pintores, e escultores, architetos, e gravadores portuguezes, e dos estrangeiros, que estiverão em Portugal, recolhidas e ordenadas por Cyrillo Volkmar Machado, seguidas de notas pelos Dr. J. M. Teixeira de Carvalho e Dr. Vergilio Correia. Coimbra, Imprensa de Universidade, 1922. 295p. facsim. (Subsídios para a historía da arte portuguesa [v.] 5)

1st ed. 1823.

A dictionary of Portuguese artists and others who worked in Portugal. The biographies are arranged chronologically with an alphabetical list at the end. "Memorias concernentes a' vida e algumas obras de Cyrillo Volkmar Machado, escriptas por elle mesmo," p.[243]–60.

E157   Ossorio y Bernard, Manuel. Galería biográfica de artistas españoles del siglo XIX. Continuación del Diccionario de Ceán Bermudez hasta el año 1882. Madrid, Moreno y Rojas, 1883–84. viii, 749p. il.,

ports. (Repr.: Madrid, Gaudi, 1975.)

1st ed. 1868.

Biographical sketches of 3,000 19th-century Spanish artists.

E158   Pamplona, Fernando de. Dicionário de pintores e escultores portugueses ou que trabalharam em Portugal. Edição dirigida e prefaciada por Ricardo do Espírito Santo Silva. [Lisboa, 1954–59]. 4v. plates.

A dictionary of Portuguese painters and sculptors, including foreign-born artists who worked in Portugal. Bibliographies and signatures for the more important artists. v.4 (Sa–Seq) last volume published.

E159   Peréz-Costanti, Pablo. Diccionario de artistas que florecieron en Galicia durante los siglos XVI y XVII. Santigo, Seminario c. Central, 1930. 610p.

A dictionary of artists who worked in the region of Galicia during the 16th and 17th centuries. Some signatures. Bibliographical references to documents. Index of places, p.595–609.

E160   Raczyński, Atanazy. Dictionnaire historico-artistique du Portugal, pour faire suite à l'ouvrage ayant pour titre: Les arts en Portugal, lettres adressées à la Société artistique et scientifique de Berlin et accompagnées de documens. Paris, Renouard, 1847. 306p. plates.

Intended as a sequel to the author's *Les arts en Portugal*. Arranged in dictionary form with a few lines for each artist. Sources are usually given.

E161   Ráfols, José F., ed. Diccionario biográfico de artistas de Cataluña desde la época romana hasta nuestros días. Barcelona, Millá, 1951–54. 3v. il.

Painters, sculptors, engravers, architects, ceramicists, goldsmiths, glassworkers, armorers, etc. of Catalonia. Arranged alphabetically with a short paragraph for each artist. Topographical index at the end of each volume. v.3 includes a supplement (A–Z) and a separate index for Barcelona.

"Complemento al diccionario," p.[365]–662, consists of brief histories of the various media, each with an index of artists.

E162   Ramiréz de Arellano, Rafael. Diccionario biográfico de artistas de la provincia de Córdoba. Madrid, Perales y Martínez, 1893. 535p. (Colección de documentos inéditos para la historia España . . . t. CVII)

The alphabetical arrangement of biographies (p.63–282) is followed by a chronological list subdivided by medium, and an essay on goldsmithing in Cordoba.

E163   Saltillo, Miguel Lasso de la Vega y López de Tejada, *marqués* del. Artistas y artífices sorianos de los siglos XVI y XVII (1509–1699). 1. ed. Madrid, Maestre, 1948. 476p. il., 30 plates.

A lexicon of painters, sculptors, and architects from the province of Soria. Long entries which incorporate inventories and documents.

E164   Sampaio de Andrade, Arsénio de. Dicionário histórico e biográfico de artistas e técnicos portugueses, séc.

xiv–xx. Sobre a vida e actividade, tanto em Portugal como no estrangeiro, de pintores, escultores, ceramistas, gravadores, cinzeladores, arquitectos, caricaturistas, críticas de arte, engenheiros, músicos, contraponistas, compositores, etc. [1. ed.] Lisbon, 1959. 276p. il. ports.

Contains brief biographical entries. Includes some bibliographical references in footnotes. Bibliography, p.273–76.

E165  Stirling-Maxwell, *Sir* William. Annals of the artists of Spain . . . a new ed., incorporating the author's own notes, additions, and emendations with portraits and 24 steel and mezzotint engravings, also numerous engravings on wood. 2d ed. London, Nimmo, 1891. 4v. il., plates (incl. ports.)

Ed. by Robert Guy. Preface to 1st ed. (publ. 1848) refers to earlier bibliography. Bibliographical footnotes.

"Velasquez and his works," v.4, p.[1551]–65; "Catalogues of the works of Velasquez and Murillo," v.4, p.[1567]–1641; "Monograms of artists," v.4, p.1645–70.

E166  Viñaza, Cipriano Muñoz y Manzano, *Conde* de la. Adiciones al Diccionario histórico de los más ilustres profesores de las bellas artes en España de D. Juan Agustín Ceán Bermúdez. Madrid, Tip. de los huérfanos, 1889–94. 4v. in 2.

Contents: t.1, Edad media . . . ; t.2–4, Siglos XVI, XVII y XVIII. Supplements Ceán Bermúdez (E152).

## Switzerland

E167  Brun, Carl. Schweizerisches Künstler-Lexikon; dictionnaire des artistes suisses. Hrsg. vom Schweizerischen Kunstverein. Frauenfeld, Huber, 1905–17. 4v. (Repr.: Nendeln, Liechtenstein, Kraus, 1967.)

A dictionary of painters, sculptors, architects, glass-painters, enamelers, medalists, goldsmiths, cabinetworkers, etc., either native to Switzerland or active there.

E168  Künstler-Lexikon der Schweiz XX. Jahrhundert. Frauenfeld, Huber, 1958–67. 2v.

2d ed. 1974.

Issued in parts. Published under the auspices of the Verein zur Herausgabe des schweizerischen Künstler-Lexikons. Ed. by Eduard Plüss and Hans Christoph von Tavel.

A major dictionary of 20th-century Swiss artists; supplements Brun (E167). Includes bibliographical references.

## United States

E169  The Britannica encyclopedia of American art. Chicago, Encyclopaedia Britannica Educational Corp.; world book trade distribution by Simon and Schuster, N.Y., [1973]. 669p. il. (part col.)

A comprehensive, authoritative encyclopedia of more than 1,100 signed articles by 32 art historians, critics, and curators on all aspects of American art—painting, sculpture architecture, glass, silver, furniture, prints, folk art, photography, and handicrafts. Includes over 800 illustrations (350 in color).

Guide to entries by arts, p.622–26. Abbreviations of museums and collections, p.627. Guide to museums and public collections, p.628–33. Glossary (300 terms), p.634–37. Classified bibliography, p.638–42; bibliography according to entries, p.643–68.

E170  Cederholm, Theresa Dickason. Afro-American artists; a bio-bibliographical directory. [Boston] Trustees of the Boston Public Library, 1973. 348p.

A biographical dictionary of approx. 2,000 American black artists from the 18th century to the present. Includes for each artist biographical data, a list of works, exhibitions, collections, awards, and bibliographical sources.

E171  Collins, Jimmie Lee. Women artists in America; eighteenth century to the present. Chattanooga, Univ. of Tennessee, 1973–75. 2v. il.

v.1 contains brief biographies of 400 women artists from the 18th century to the 1970s, including painters, sculptors, printmakers, and potters. Valuable for references to more obscure artists, but useful only as a primary source. Illustrated sparsely in black and white. v.2 continues the work, concentrating on 400 contemporary artists. Includes an index to both volumes, and 210 illustrations.

E172  Cummings, Paul. A dictionary of contemporary American artists. 3d ed. N.Y., St. Martin's, 1977. 545p. il.

1st ed. 1966; 2d ed. 1971.

A dictionary of 872 better-known contemporary American artists, living and deceased. For each artist gives biographical information, address, dealer, locations of exhibitions, permanent collections with representative works, and selected bibliography.

Index of artists, p.8–18. Bibliography, p.511–45.

E173  Fielding, Mantle. Dictionary of painters, sculptors and engravers. Philadelphia, Printed for the subscribers [1926]. vii, 433p. il.

Reprints: N.Y., Struck, 1945; N.Y., Carr, 1965 (includes "an addendum containing corrections and additional material on the original entries" by James Carr); enlarged edition, ed. by Genevieve C. Doran, Green Farms, Conn., Modern Books and Crafts, 1974 (includes "over 2,500 new listings of seventeenth, eighteenth, and nineteenth century American artists").

A basic biographical dictionary of American artists. The original edition of 1926 contains short biographies and records of almost 8,000 artists. Bibliography, p.424–33. Inadequacies and inaccuracies have been corrected in the revisions and enlargements listed above.

E174  Groce, George Cuthbert, and Wallace, David H. The New-York Historical Society's dictionary of artists in America, 1564–1860. New Haven, Yale Univ. Pr.; London, Oxford Univ. Pr., 1957. 759p.

A fundamental reference work of between 10,000 and 11,000 entries listing "painters, draftsmen, sculptors, engravers, lithographers, and allied artists, either amateur or professional, native or foreign-born, who worked within the present

continental limits of the United States between the years 1564 and 1860, inclusive." — *Introd.* Based for the most part on the extensive use of primary sources — directories, exhibition catalogues, autobiographies, signed and dated works of art, vital statistics, newspapers, and early periodicals.

"The aim has been to give for every artist as much as possible of the following information: full name, dates and places of birth and death, media and subject matter of his work, chronology of residences and exhibitions, pupils, and in some instances locations and reproductions of representative works." — *Introd.*

E175    Index of 20th century artists. v.1-4, no. 7, Oct. 1933-Apr. 1937. N.Y., College Art Assn., 1933-37. (Repr. edition by Arno Pr., N.Y. [1970] has a "new cumulative index.")

Issued monthly, with yearly supplements. Includes several 19th-century American artists who lived into the 20th century. For each artist gives a short biography and extensive listings of awards and honors, affiliations, holding museums, exhibitions, bibliography, and illustrations in publications.

E176    Michigan. State Library. Biographical sketches of American artists. 5th ed. Lansing, Michigan State Library, 1924. 370p.

Compiled by Helen L. Earle.

Includes painters, sculptors, etchers, illustrators, and stained glass designers. Indexed in Mallett (E44). Anecdotal biographies punctuated with quotations from contemporary sources and lists of pictures. The periodical references, arranged by artist, would probably be useful to the student of American art.

E177    Smith, Ralph Clifton. A biographical index of American artists. Baltimore, Williams & Wilkins, 1930. 102p. (Repr.: Detroit, Gale, 1976.)

An alphabetical listing of approx. 4,700 artists, each followed by a brief entry with place and date of birth and death, media, and references to further information.

E178    Tuckerman, Henry Theodore. Book of the artists: American artist life, comprising biographical and critical sketches of American artists: preceded by

The 1976 ed. (756p.) includes biographical sketches of approx. 8,000 artists, craftsmen, administrators, collectors, dealers, scholars, critics, curators, and illustrators in the U.S. and Canada. Also contains a necrology, geographical index, and a professional classifications index.

SEE ALSO:  Dunlap, W. *A history of the rise and progress of the arts of design in the United States* (I473).

## ORIENTAL COUNTRIES

E180    Kim, Yŏng-Yun. Hanguk sŏhwa immyŏng sasŏ. Seoul, Hangyang munhwasa, 1959. 43, 566p. 26 plates.

Complete text in Korean. Title page only in English: *Biographical dictionary of Korean artists and calligraphers.* Bibliography, p.478-80.

E181    Hansford, S. Howard. A glossary of Chinese art and archaeology. London, China Society, 1961. 2d rev. ed. 104p. il. (China Society, Sinological Series, no. 4)

1st ed. 1954.

"The glossary is addressed both to readers of Chinese who require precise definitions of technical and conventional terms met with in current writings on art and archaeology, and also to those, already familiar with Chinese arts, crafts and antiquities, who have embarked on the study of the written language." — *Pref.*

Line drawings of shapes of bronzes, ceramics, jades and decorative ornament, p.89-96.

E182    Weber, Victor Frédéric. "Ko-ji hô-ten"; dictionnaire à l'usage des amateurs et collectionneurs d'objets d'art japonais et chinois; on y trouvera: l'explication des noms usuels et des noms propres qui se rencontrent dans les ouvrages traitant de l'art et des religions de l'Extrême-Orient; des renseignements sur les lieux célèbres de la Chine et du Japon, ainsi que sur les nombreux personnages et héros historiques et légendaires; la description des jeux, des moeurs et coutumes, des fêtes et des pratiques religieuses ou laïques; les biographies, les signatures et autres signes ... des peintres, sculpteurs, ciseleurs, ... et autres artistes et artisans; et enfin le ... contes et légendes de la Chine et du ... ont inspiré les artistes de ces deux pays ... stration des ouvrages et l'ornementation ... eubles et objets usuels. Le dictionnaire est ... plus de 2100 gravures et dessins intercalés ... te et sur 75 planches dont 5 en couleurs. ... uteur, 1923. 2v. il., plates (part col.) (Repr.: ... ker, 1976.)

... ts of Chinese and Japanese art for signatures ... nese printmakers, family crests, and mytho- ... rical subjects.

... o Ary. Islamic woodcarvers and their works. ... Kundig, 1958. 97p. 12 plates.

"In this volume are classified as one group carpenters, joiners, cabinet-makers, inlayers and sculptors in wood in general." —*Introd.* Alphabetical "Roll of woodcarvers," p.[22]-67. Includes bibliographical references. "Chronological list of woodcarvers," p.[75]-78. Bibliography, p.[79]-97.

E184   Roberts, Laurance, P. A dictionary of Japanese artists. Painting, sculpture, ceramics, prints, lacquer. With a foreword by John M. Rosenfield. Tokyo, N.Y., Weatherhill [1976]. xi, 299p.

A comprehensive biographical dictionary of Japanese artists who were born before 1900, or if born after 1900, who died before 1972. The dictionary lists artists alphabetically by name most commonly known, followed by all alternate names known for each. The Index of alternate names, p.233-64, lists all alternate names given in the dictionary. Each entry gives biographical information, a list of public collections which include the artist's works, and bibliography.

Appendixes: Collections, p.211-14; Art organizations and institutions, p.214-16; Art periods of Japan, Korea, and China, p.216-17; Japanese provinces and prefectures, p.217. Glossary, p.218-22. Index of alternate names, p.233-64. Character index, p.265-99.

Bibliography, p.223-32, in three parts: (1) Books referred to in the dictionary; (2) Journals and serial publications keyed to the dictionary with an alphabetical code; (3) Dictionaries and encyclopedias referred to in the dictionary.

E185   Who's who among Japanese artists. Prepared by [the] Japanese national committee for the International Association of Plastic Arts under the auspices of [the] Japanese National Commission for UNESCO. [Tokyo] Printing Bureau, Japanese government, 1961. 250p. il.

Primarily a biographical dictionary of modern Japanese artists, listed within four categories: Japanese-style painters, Western-style painters, graphic artists, sculptors. Includes a survey of contemporary Japanese art, p.1-26, and lists of art organizations, artist groups, and exhibitions sponsored by other than artist groups. Museums of modern art, p.248-49; bibliography, p.250.

SEE ALSO:  Mayer, L. A. *Islamic metalworkers and their works* (P467).

# F.
# Iconography

Iconography is classified as follows: Bibliography; General works; Ancient; Christian; Jewish; Oriental; Emblem literature; Portraits.

Most of the books listed here can be designated reference literature, that is, bibliographies, indexes, dictionaries, encyclopedias. However, a few specialized works—classics such as *Studies in iconology*, by Erwin Panofsky, and *Apes and ape lore*, by H. W. Janson—have been included. Other iconographical studies, such as the fundamental works by Émile Mâle, are to be found in the appropriate sections in the Histories and Handbooks chapter. Art historians will also find important articles and books in the *Journal of the Warburg and Courtauld Institutes* (Q226), and in *Studies of the Warburg Institute* (R73).

Only bibliographies of emblem books and general surveys of emblem literature are listed here, the exception being *Iconologia*, by Cesare Ripa, probably the most important source of imagery for Baroque artists.

Comprehensive general indexes of portraits, as well as more specialized catalogues and inventories of American portraits, are listed here. Inventories, catalogues, and indexes of the portraits of other countries have not been included. Works on iconography of ancient portraiture in coins, medals, and sculpture are to be found in the sections on ancient art. Likewise the entries for books which treat portraiture as art history or as a genre of art, e.g. miniatures, medals, have been placed in other categories.

## BIBLIOGRAPHY

F1  Lurker, Manfred. Bibliographie zur Symbolkunde. Unter Mitarbeit von Ferdinand Herrmann, Eckhard Unger und weiteren Fachgelehrten. Baden-Baden, Heitz, 1964-68. 3v. (Bibliotheca bibliographica Aureliana, 12, 18, 24)

An exhaustive bibliography of the literature dealing with all aspects of symbolism. Bd. I, "Kunstgeschichte-Archäologie-Prähistorie," p.143-70. Bd. II, "Symbolerscheinungen" (subject arrangement) is especially useful to the art historian. Bd. III, Autorenregister; Sachregister; Nachträge.

Supplemented by the annual periodical *Bibliographie zur*

*Symbolik. Ikonographie und Mythologie,* Baden-Baden, [v.1] 1968-, ed. by M. Lurker. Alphabetical arrangement of recent literature with abstracts.

## GENERAL WORKS

F2  Chevalier, Jean. Dictionnaire des symboles: mythes, rêves, coutumes, gestes, formes, figures, couleurs, nombres, sous la direction de Jean Chevalier, avec la collaboration d' Alain Gheerbrant. Dessins de Bernard Gandet. Paris, Laffont, [1969]. xxxii, 844p. il.

A dictionary of 1,200 symbols and terms subject to symbolic interpretation in the widest sense. Signed articles by specialists. Bibliography, p.827-44. Only 400 drawings.

F3  Cirlot, Juan Eduardo. A dictionary of symbols. Trans. from the Spanish by Jack Sage. Foreword by Herbert Read. 2d ed. London, Routledge & Paul; N.Y., Philosophical Library, 1971. lv, 419p. il., diagrs., facsims.

1st ed. 1962.

Trans. of: *Diccionario de símbolos tradicionales.*

A general dictionary of symbols intended "for the elucidation of those many symbols which we encounter in the arts and in the history of ideas."—*Introd.* An introductory essay precedes the dictionary proper. Few illustrations. Bibliography, p.[386]-99.

F4  Dreyfuss, Henry. Symbol sourcebook; an authoritative guide to international graphic symbols. N.Y., McGraw-Hill [1972]. 292p. il.

A convenient handbook of 1,500 graphic symbols used in all disciplines and in all nations. Table of contents in 18 languages; captions for the symbols in English. In the first section the symbols are arranged alphabetically by subject and within each subject by key form (p.32-165). This is followed by "Graphic form section" (p.166-230) in which the symbols are arranged by key form regardless of subject, and a section on color symbolism (p.231-46) in which meanings are listed under each color. Especially useful for designers and artists. Bibliography, p.252-67. Detailed index, p.268-92.

**F5**   Droulers, Eugène. Dictionnaire des attributs, allégories, emblèmes, et symboles. Turnhout, Belgique, Brépols [1948?]. viii, 281p. il.

Short entries of names of persons, attributes, and allegories arranged in one dictionary. Many cross-references. Numerous line drawings and other illustrations. Bibliography, p.[276]–81. Useful as a quick reference tool but not comprehensive.

**F6**   Errera, Isabella. Répertoire abrégé d'iconographie. Wetteren, Meester, 1929–32. 3v.

Only A through C published. One alphabetical arrangement of artists and mythological, biblical, and historical persons and subjects. Each entry is followed by a list of representations in painting, sculpture, engraving, etc. Bibliography, v.1, p.ix–xxiv.

**F7**   Hall, James. Dictionary of subjects and symbols in art. Introd. by Kenneth Clark. London, N.Y., Murray, Harper and Row, 1974. xxix, 345p. il.

A one-volume dictionary of the principal themes and symbols of Western art. Devoted mainly to Christian and classical subjects, including persons. Does not list works of art. Convenient and reliable, especially useful to students, teachers, librarians, and nonspecialists. Many cross-references. Sources, p.[xix]–xxiv; bibliography, p.[xxv]–xxix. Sparsely illustrated with line drawings.

**F8**   Hopper, Vincent Foster. Medieval number symbolism. Its sources, meaning, and influence on thought and expression. N.Y., Columbia Univ. Pr., 1938. 241p. (Repr.: N.Y., Cooper Square, 1969.)

A scholarly study of the pervasive number symbolism of the medieval church. Useful for the student and art historian.

Contents: (I) Elementary number symbolism; (II) The astrological numbers; (III) Pythagorean number theory; (IV) The Gnostics; (V) The early Christian writers; (VI) Medieval number philosophy; (VII) The beauty of order—Dante. Appendix: Number symbols of northern paganism. Bibliography, p.[213]–32. Index of symbols and names, p.[233]–41.

**F9**   Janson, Horst Woldemar. Apes and ape lore in the Middle Ages and the Renaissance. London, Warburg Inst., Univ. of London, 1952. 384p. il., port. (Studies of the Warburg Institute, v. 20) (Repr.: Nendeln, Liechtenstein, Kraus.)

A fascinating iconographic study of apes and ape lore, now a classic. Each chapter treats a theme, beginning with the *figura diaboli* in early Christianity, and ending with a vision of Franz Kafka in "the coming of the anthropoids." Especially thorough treatment of the late Gothic period and the Renaissance. Appendix: Titian's Laocöon caricature and the Vesalian-Galenist controversy.

Admirable scholarship, extensive notes with bibliography. Illustrated with pictures of apes and monkeys from works of art.

**F10**   Klingender, Francis Donald. Animals in art and thought to the end of the Middle Ages, ed. by Evelyn Antal and John Harthan. Cambridge, Mass., MIT Pr.; London, Routledge & Paul [1971]. xxviii, 580p. il., facsims.

A study of animals in art from prehistoric times to c.1500. Does not include Oriental art. Frequently uses Marxist and Freudian theories to explain the use of animals in art as symbols of society's unconscious or hidden drives. A brief epilogue includes comments on later examples, from the Renaissance to the end of the 19th century. Excellent illustrations; copious notes. Bibliography, p.540–64. General index; index of animals.

**F11**   Lanoë-Villène, Georges. Le livre des symboles; dictionnaire de symbolique et de mythologie. Paris, Bossard, 1927–33. 5v.

A dictionary of symbols and mythology; many of the articles are several pages in length. Includes literary references and quotations, and occasionally references to works of art. Index and table of contents at end of each volume. Bibliographical references in footnotes.

Contents: [v.1] L'abeille– [v.5] La croix. No more published.

**F12**   Marle, Raimond van. Iconographie de l'art profane au moyen-âge et à la Renaissance et la décoration des demeures. La Haye, Nijhoff, 1931–32. 2v. il., plates. (Repr.: N.Y., Hacker, 1971.)

A comprehensive study of the secular iconography of the Middle Ages and Renaissance. Profusely illustrated. Bibliography at the end of each volume. No index.

v.1, La vie quotidienne (539p.): Le noble, les agréments de la vie du noble, les passe-temps, la nature, la chasse et la pêche, la guerre, l'enseignement et le savant, la vie rurale, les rapports entre les deux sexes; v.2, Allégories et symboles (506p.): L'allégorie éthique, les allégories philosophiques, les sciences et les arts, allégories diverses, la mort, l'amour.

**F13**   Panofsky, Erwin. Studies in iconology. Humanistic themes in the art of the Renaissance. N.Y., Harper [1967]. xliii, 262p. il.

1st ed. 1939; 2d ed. 1962; paperback ed. 1972.

The author presents a philosophical system of iconographic analysis, working from primary (natural) subject matter, through secondary (conventional) subject matter, to ascertain intrinsic meaning (content). A discussion of Neoplatonism concludes the study of various motifs. Important for the specialist and the advanced student of Renaissance art. Bibliographical footnotes. Well illustrated.

Contents: (I) Introductory; (II) The early history of man in two cycles of paintings by Piero di Cosimo; (III) Father Time; (IV) Blind Cupid; (V) The Neoplatonic movement in Florence and north Italy (Bandinelli and Titian); (VI) The Neoplatonic movement and Michelangelo; Appendix; Bibliography of references cited, p.235–50; Index of names and places, p.251–62.

**F14**   Petity, Jean Raymond de. Le manuel des artistes et des amateurs ou dictionnaire historique et mythologique des emblèmes, allégories, énigmes, devises, attributs et symboles, relativement au costume, aux mœurs, aux usages & aux cérémonies. Paris, Costard, 1770. 4v.

An early iconographical dictionary. "Catalogue raisonné des auteurs qu'on a consultés pour la composition de cet ouvrage," v.4, p.549–655; "Discours sur la connaissance des tableaux," v.4, p.656–764.

**F15**   Pigler, Andor. Barockthemen; ein Auswahl von Verzeichnissen zur Ikonographie des 17. und 18. Jahrhunderts. 2, erw. Aufl. Budapest, Akadémiai Kiadó, 1974. 3v.
1st ed. 1956.

A fundamental reference work for the study and identification of iconographic themes of the 17th and 18th centuries. Also includes many examples of Renaissance art. v.1, 557p., is devoted to Christian iconography—scenes from the Old and New Testament, the stories of the saints, religious tradition and history, and other religious themes. v.2, 651p., lists secular themes—classical mythology, Greek and Roman history, allegories, legends and folktales, general history, etc. v.3 contains 364 plates. Artist, artist's dates, medium, location, and bibliography are given in abbreviated form for each work listed. Difficult to use because of the inadequate list of abbreviations.

Each volume has a detailed table of contents; name and subject index at end of v.2.

**F16**   Schramm, Percy Ernst. Herrschaftszeichen und Staatssymbolik; Beiträge zu ihrer Geschichte vom dritten bis zum sechzehnten Jahrhundert. Stuttgart, Hiersemann, 1954–56. 3v. xxiv, 1165p. plates. (Schriften der Monumenta Germaniae Historica, Bd. 13$^{1-3}$)

A scholarly work on governmental symbols from late antiquity through the 16th century. Extensive references in footnotes. Indexes at end of v.3: names and subjects, p.1111–54; monuments arranged by place, p.1155–65.

**F17**   Tervarent, Guy de. Attributs et symboles dans l'art profane, 1450–1600: dictionnaire d'un langage perdu. Genève, Droz, 1958–64. 3v. plates. (Travaux d'humanisme et renaissance. 29)

A well-documented iconographical dictionary of symbols and attributes in secular Renaissance art. Each entry includes a list of literary and artistic sources.

Contents: v.1–2, Abaque-zodiac; v.3, Supplément et index.

**F18**   Waal, Henri van de, ed. ICONOCLASS. An iconographic classification system devised by H. van de Waal, completed and ed. by L. D. Couprie with R. H. Fuchs and E. Tholen. Publ. for the Royal Netherlands Academy of Arts and Science. The Hague, North-Holland Pub. Co., 1973- .

A detailed iconographic classification system organized by the late H. de Waal and other Dutch art historians. An abridged version of this decimal index was published in 1968 by the Rijksbureau voor Kunsthistorische Documentatie. Originally devised for the filing of reproductions of works of art according to subject.

This monumental reference tool will consist of seven volumes of the classification system, seven volumes of related bibliography, and an alphabetical index of three volumes.

Nine general divisions: (1) Supernatural; (2) Nature; (3) Man; (4) Society; (5) Abstracts; (6) History; (7) The Bible; (8) Sagas, legends and tales; (9) Classical mythology.

**F19**   Whittick, Arnold. Symbols: signs and their meaning and uses in design. 2d ed. London, Hill, 1971. xv, 383p. il., 78 plates, coats of arms, facsims.
1st ed. (1960): *Symbols, signs, and their meaning.*

A convenient handbook of traditional symbols in all fields. Used mainly by artists and designers.

Contents: pt. I, Introduction (The meaning and types of symbolism); pt. II, Symbolism in its precise and applied forms, and its practical uses; pt. III, Individual and collective expression—instinctive, creative and imaginative symbolism; pt. IV, Encyclopedic dictionary. Bibliographical note and bibliographical references in text. Index.

SEE ALSO:  Salis, A von. *Antike und Renaissance* (I226); Waal, H. van de. *Drie eeuwen vaderlandsche geschieduitbeelding* (I391).

# ANCIENT

**F20**   Goldsmith, Elizabeth E. Ancient pagan symbols. N.Y., London, Putnam, 1929. xxxvii, 220p. il., plates. (Repr.: N.Y., AMS Pr., 1973.)

A convenient dictionary of ancient symbols. The entries are arranged alphabetically under the following chapter headings: Elements; Lotus; Tree of Life; The dual principle; The cross; The serpent; Chinese trigrams; The four supernatural creatures of the Chinese; Animal symbolism in Chinese art; The sun; The moon; The wheel; The swastika; The trisula; Sacred birds; Sacred animals; Ancient gods and goddesses; Twice-born gods; Triads and the triangle; Some general symbols and symbolic figures in early art.

Index, p.213–20.

**F21**   Goodenough, Erwin Ramsdell. Jewish symbols in the Greco-Roman period. [N.Y.] Pantheon, 1953–68. v.1–13. il. (Bollingen series, 37)

An important scholarly study of Jewish symbolism during the Greco-Roman period and the Early Christian era. Based on archaeological evidence and literary and philosophical sources. Many illustrations; excellent literary references. Each volume has indexes; v.13 consists of general indexes and maps.

Contents: v.1, The archeological evidence from Palestine; v.2, The archeological evidence from the Diaspora; v.3, 1,209 illustrations; v.4, The problem of method; symbols from Jewish cult (117 illustrations); v.5–6, Fish, bread, and wine (455 illustrations); v.7–8, Pagan symbols in Judaism (459 illustrations); v.9–11, Symbolism in the Dura synagogue, v.11 has 354 illustrations, 21 color plates; v.12, Summary and conclusions; v.13, Indexes and maps: Index of citations; Index of names; Index of subjects; Corrigenda and comments (corrections for the preceding volumes compiled from

marginalia by the late author); List of reviews; Maps; Index to maps.

For an evaluation of the work and further corrections see: Morton Smith, "Jewish Symbols in retrospect," *Journal of Biblical literature,* v.86 (Mar. 1967) 53–68.

F22 Ladendorf, Heinz. Antikenstudium und Antikenkopie; Vorarbeiten zu einer Darstellung ihrer Bedeutung in der mittelalterlichen und neueren Zeit. Berlin, Akademie-Verlag, 1953. 190p. 50 plates. (Abhandlung der Sächsischen Akademie der Wissenschaften zu Leipzig. Philologischhistorische Klasse, Bd. 46, Heft 2)

A stimulating discussion of copies of Greek and Roman works of art, from medieval times to the present, with a section of notes, p.81–120, and a valuable classed bibliography of the subject, p.121–61. Index to authors listed in the bibliography, p.162–67.

A supplement, p.168–75, lists by city and then by collection, ancient works of art, with mention of copies or studies made of them and pertinent references to be found in the bibliography, notes, or plates section. An index of the copyists, referring back to the city wherein the original art work is located, is on p.175.

The plates are composite groupings of various treatments of the same theme. Index to the plates, p.176–81.

General index, p.182–90.

F23 Mackenzie, Donald Alexander. The migration of symbols and their relations to beliefs and customs. London, Paul, Trench, Trubner; N.Y., Knopf, 1926. xvi, 219p. il. (Repr.: N.Y., AMS Pr., 1970.)

An excellent study of prevalent ancient symbols.

Contents: (1) The swastika; (2) The spiral; (3) Ear symbols; (4) Tree symbols. Index, p.184–219.

F24 Roscher, Wilhelm Heinrich. Ausführliches Lexikon der griechischen und römischen Mythologie. Leipzig, Teubner, 1884–1937. 6v. and 3 suppl. in 5v. il., geneal. tables. (Repr.: Hildesheim, Olms, 1965. 6v. in 9 plus suppl.)

The most complete reference work on classical mythology. Widely used for advanced research in iconography. Scholarly signed articles with bibliographies. Each personage or myth is considered with reference to its appearance in art.

Contents: v.1–6, A–Z; Supplements: Epitheta deorum, ed. by C. F. H. Bruchmann and I. B. Carter (1893–1902, 2v.); Mythische Kosmographie der Griechen, by E. H. Berger (1904, 2v.); Geschichte der klassischen Mythologie und Religionsgeschichte, by Otto Grupp, 1921.

F25 Smith, *Sir* William. A concise dictionary of Greek and Roman antiquities; based on Sir William Smith's larger dictionary, and incorporating the results of modern research, ed. by F. Warre Cornish with over 1,100 illustrations taken from the best examples of ancient art. N.Y., Holt, 1898. vi, 829p. il.

Tables of Greek and Roman measures, weights, and money, p.753–75. Greek index, p.776–96; Latin index, p.797–823; English index, p.824–29.

SEE ALSO: Brilliant, R. *Gesture and rank in Roman art* (K63); Brown, W. L. *The Etruscan lion* (K64); Cartari, V. *Imagini delli dei de gl'antichi* (H35); Daremberg, C. V., and Saglio, E. *Dictionnaire des antiquités grecques et romaines d'après les textes et les monuments* (E28); Goff, B. *Symbols of prehistoric Mesopotamia* (I71); Pauly, A. F. von. *Pauly's Real-Encyclopädie der classischen Altertumswissenschaft* (E31); *Reallexikon für Antike und Christentum* (F45). Reinach, S. *Répertoire de la statuaire grecque et romaine* (K34); _____. *Répertoire de reliefs grecs et romains* (K35); Salis, A. von. *Antik und Renaissance* (I226); Seznec, J. *The survival of the pagan gods* (I227); Wind, E. *Pagan mysteries in the Renaissance* (I232).

# CHRISTIAN

F26 Aurenhammer, Hans, ed. Lexikon der christlichen Ikonographie. Wien, Hollinek [1959–67]. Bd. 1, Lfg. 1–6. 640p. No more published.

1st volume of a dictionary of Christian iconography which was published in sections. Signed articles by scholars. Entries often include symbols and attributes, a list of representations in art, documentation of sources, and a bibliography.

Contents: Bd. 1, Alpha und Omega-Christus und die Vierundzwanzig Ältesten.

F27 Bonaventura, *Saint. Cardinal. 1221–1274. Spurious and doubtful works.* Meditations on the life of Christ; an illustrated manuscript of the fourteenth century. Paris, Bibliothèque Nationale, Ms. Ital. 115. Trans. by Isa Ragusa. Completed from the Latin and ed. by Isa Ragusa and Rosalie B. Green. Princeton, N.J., Princeton Univ. Pr., 1961. xxxvi, 465p. il. (Princeton monographs in art and archaeology, 35)

A new translation of the popular medieval book on the life of Christ. Much of the narrative is not to be found in the Gospels. Also includes material on the life of the Virgin, the fifth Gospel, and Apocrypha. Based on *B.N. Ms. Ital. 115,* one of the best illustrated of the numerous extant copies. Notes by the editors indicate sources, errors, variations in the Latin, etc. Bibliographic footnotes. The index lists the locations of various literary and pictorial motifs.

F28 Braun, Joseph. Tracht und Attribute der Heiligen in der deutschen Kunst. Mit 428 Abbildungen. Stuttgart, Metzler, 1943. 4p., 854 cols. il. (Repr.: Stuttgart, Druckenmüller, 1964.)

A scholarly dictionary of the dress and attributes of the saints depicted in German art. The first part (p.17–765) consists of an alphabetical arrangement by saint; the second part, in two sections, is a typological classification and discussion of the costumes and attributes (p.777–833). Extensive documentation. Bibliographical references in the text. Well illustrated with 428 plates in the text.

F29 Cabrol, Fernand. Dictionnaire d'archéologie chrétienne et de liturgie, publié par le r.p. dom Fernand

Cabrol . . . avec le concours d'un grand nombre de collaborateurs. Paris, Letouzey et Ané, 1907-53. 15v. il., plates (part col.), plans, facsims.

Issued in parts, 1903-53. v.3-14¹ "publié par le Rme. dom Fernand Cabrol . . . et le R.P. dom Henri Leclercq. — *Title page.* Scholarly signed articles with full bibliographies and excellent illustrations. Includes art, iconography, symbols, liturgy, rites, ceremonies, and other traditions of the early church. Basic to the study of Early Christian and medieval art.

**F30**  Detzel, Heinrich. Christliche Ikonographie. Ein Handbuch zum Verständniss der christliche Kunst. Freiburg im Breisgau, Herder, 1894-96. 2v. il., double plates.

Contents: Bd. 1, Die bildlichen Darstellungen Gottes, der allerseligsten Jungfrau und Gottesmutter Maria, der guten und bösen Geister und der göttlichen Geheimnisse. Anhang: Die Weltschöpfung. Die Sibyllen. Die apokalyptischen Gestalten. Judas Iskariot; Bd. 2, Die bildlichen Darstellungen der Heiligen.

**F31**  Didron, Adolphe Napoléon. Christian iconography; or, The history of Christian art in the Middle Ages. Trans. from the French by E. J. Millington and completed with additions and appendices by Margaret Stokes. London, Bell, 1886. 2v. il. (Repr.: N.Y., Ungar, 1965.)

A standard portable reference work available in English, now largely antiquated and superseded by recent works.

Contents: v.1, The history of the nimbus, the aureole and the glory, representations of the persons of the Trinity; v.2, The Trinity: angels, devils, death, the soul, the Christian scheme; Appendices: (1) Short descriptions of various scenes from Old and New Testament as represented in art; (2) Byzantine guide to painting; (3) Text of the Biblia Pauperum. General index, v.2, p.440-52.

**F32**  Ferguson, George Wells. Signs and symbols in Christian art. With illustrations from paintings of the Renaissance. N.Y., Oxford Univ. Pr. [1954]. xiii, 346p. il., plates (part col.)

Contains alphabetically arranged sections on animals; birds and insects; flowers, trees and plants; earth and sky; the human body; the Old Testament; St. John the Baptist; the Virgin; Christ; the Trinity; Madonna and Angels; the Saints; radiances, letters, colors and numbers; religious dress, objects and artifacts. Line drawings and illustrations from the Kress Collection. Index, p.239-41. Bibliography, p.343-46. The inexpensive paperback edition is a useful handbook for students.

**F33**  Ferrando Roig, Juan. Iconografía de los santos; con 325 ilustraciones. Barcelona, Omega [1950]. 302p. il.

A dictionary of saints and their attributes, important for material on Spanish saints. Illustrated with works of Spanish art.

Contents: Atributos de los santos (text); Iconografía particular de los santos (dictionary); Índice de atributos; Patrocinio de los santos; Índice alfabético de los santos tratados en esta obra.

**F34**  Hirn, Yrjö. The sacred shrine; a study of the poetry and art of the Catholic church. London, Macmillan, 1912. xv, 574p. (Repr.: Boston, Beacon, 1957. 432p. With additions to the bibliography and notes by Dr. C. H. Talbot.

1st Swedish ed., 1909.

An iconographical handbook with clear explanations of custom, belief, dogma, etc. essential for the understanding of Catholic art of all periods.

Contents: (1) Catholic art; The altar; The relics; The reliquary; The Mass; The Holy of holies; The Host; The monstrance; The tabernacle; (2) The dogma of Mary; The Gospel of Mary; Mary's conception — Saint Anna; The Incarnation; The childhood of Mary; The Annunciation; The Visitation; The Virginal Birth; The Holy manger; The sorrowing Mother; Mary's death and Assumption; The symbols of the Virgin; The sacred shrine. Index of authorities quoted; index of subjects.

**F35**  Jacobus de Varagine. The golden legend of Jacopus de Voragine, trans. and adapted from the Latin by Granger Ryan and Helmut Ripperger. London, Longmans, Green, 1941. 2v. (Repr.: N.Y., Arno, 1969.)

Translation based on the Latin edition ed. by Graesse, pub. in Leipzig, 1850.

Popular religious stories collected by Jacopus da Voragine in the 13th century. Because these were widely used by medieval and Renaissance artists they are invaluable for the study of iconography. The legends of the saints are arranged according to the calendar or days on which their feasts were celebrated. Index.

**F36**  Jameson, Anna Brownell (Murphy). The history of Our Lord as exemplified in works of art; with that of His types; St. John the Baptist; and other persons of the Old and New Testament, commenced by the late Mrs. Jameson. Continued and completed by Lady Eastlake. 2d ed. London, Longmans, Green, 1865. 2v. il. plates. (Repr.: Detroit, Gale, 1976. 2v.)

Indexes at end of v.2: (1) Names of artists; (2) Galleries, churches, museums and other depositories of art; (3) General index.

**F37**  _____. Legends of the Madonna as represented in the fine arts. Cor. and enl. ed. Boston, Houghton Mifflin, 1891. 483p. il. (Repr.: Detroit, Gale, 1972.)

"Forms third series of Sacred and Legendary Art." — *Title page.* Old but still useful. Illustrated with line drawings. Index of artists, galleries, churches, museums, and general index.

**F38**  _____. Sacred and legendary art. Ed. with additional notes by Estelle M. Hurll. Boston and N.Y., Houghton Mifflin, 1896. 2v. il., plates. (Repr.: N.Y., AMS Pr. [1970]; St. Clair Shores, Mich., Scholarly Pr.)

1st ed. 1848, frequently reprinted until 1911.

Popular, readable, informative, antiquated, yet still the most comprehensive reference work on the subject in English. Contents: (1) Introduction; (2) Of angels and archangels; (3) The four evangelists; (4) The twelve apostles; (5) The doctors of the church; (6) St. Mary Magdalene, St. Martha, St. Lazarus, St. Maximin, St. Marcella, St. Mary of

Egypt and the beautiful penitents; (7) The patron saints of Christendom; (8) The virgin patronesses; (9) The early martyrs; (10) The Greek martyrs; (11) The Latin martyrs; (12) The Roman martyrs; (13) Martyrs of Tuscany, Lombardy, Spain, and France; (14) The early bishops; (15) French bishops; (16) The hermit saints; (17) Warrior saints of Christendom. Index of places, p.783-87. General index, p.788-800.

F39 Kaftal, George. Iconography of the saints in Central and South Italian schools of painting. Florence, Sansoni [1965]. xxx, 1,426 numb. col. 1,380 il., col. plate. (Saints in Italian art. 2)

2d volume of Kaftal's monumental study. v.1 is *Iconography of the saints in Tuscan painting* (F40). The format and contents are the same as in the earlier volume. Includes iconography of the saints on panel paintings, frescoes, and mosaics from the 2d to the early 16th century in central and southern Italy.

v.3: *Iconography of the saints in the painting of North East Italy* (1978).

F40 _____. Iconography of the saints in Tuscan painting. Florence, Sansoni [1952]. 1,274 numb. cols. 1,185 il., 8 col. plates. (Saints in Italian art. 1)

A monumental reference work for art historians. Although generally limited in scope to saints depicted in Tuscan painting of the 14th and 15th centuries, it is valuable to students of other areas of European art. For each saint gives a short biography, relics, types, images, narrative cycles, and scenes in which the saint is depicted, followed by an art bibliography, literary sources of scenes, and a hagiographical bibliography.

Contents: Introduction; (1) Saints and blessed, Unidentified saints and blessed; (2) Index of attributes and distinctive signs, Index of painters, Topographical index of paintings, Bibliographical index, Index of saints and blessed, Calendar, Addenda.

F41 Künstle, Karl. Ikonographie der christlichen Kunst. Freiburg im Breisgau, Herder, 1926-28. [v.1, 1928]. 2v. il.

An old standard work on Christian iconography, now largely replaced. Many illustrations. Bibliography at end of each chapter. Each volume has its own index. v.1 is on the history of iconography, animal symbolism in the Middle Ages, angels, subjects from Old and New Testaments, etc.; v.2 is a dictionary of saints.

F42 Lexikon der christlichen Ikonographie. Hrsg. von Engelbert Kirschbaum in Zusammenarbeit mit Günter Bandmann [et. al.]. Rom, Herder, 1968- . v.1- . il. In progress.

From v.5 ed. by Wolfgang Braunfels.

An important scholarly dictionary of Christian iconography. The signed articles by recognized scholars are arranged alphabetically by subject. Each article includes types of representation, iconography, sources, and bibliography. Well illustrated. Numerous cross-references. v.1 is prefaced by a classified list of abbreviations used throughout the entire work.

Divided into two sections: [Pt. 1] Allgemeine Ikonographie. v.1, A-Ezechiel; v.2, Fabelwesen-Kynokephalen; v.3, Laban-Ruth; v.4, Saba, Königin von- Zypresse Nachträge. [Pt. 2] Ikonographie der Heiligen; v.5, Aaron bis Crescentianus von Rom; v.6, Crescentianus von Tunis bis Innocentia; v.7, Innozenz bis Melchisedech; v.8, Meletius bis Zweiundvierzig Martyrer. At end of v.4 (the section of general iconography) is the addenda and a list of English and French equivalents of the German nomenclature. The final volume will contain indexes of attributes, art topography, and artists.

F43 Lexikon der Marienkunde. Hrsg. von Konrad Algermissen, Ludwig Böer, Carl Feckes, Julius Tyciak. Regensburg, Pustet, 1957-[60], v.1 pt. 1-[8]. il. (part col.). (v.1 reprinted in 1967.)

In progress; to be completed in approx. 25 parts. v.1: pt. 1, Aachen-Anath—pt. 8, Cimabue-Elizabeth.

A scholarly dictionary dealing with all aspects of the Virgin Mary and her cult. Signed articles on persons, places, and subjects. Valuable to the art historian for the iconography of the Virgin and material on works of art in which she is depicted. Well illustrated.

F44 Molsdorf, Wilhelm. Christliche Symbolik der mittelalterlichen Kunst. Zweite, wesentlich veränderte und erweiterte Auflage des "Führers durch den symbolischen und typologischen Bilderkreis der Christlichen Kunst des Mittelalters." Leipzig, Hiersemann, 1926. xv, 294p. 11 plates. (Repr.: Graz, Akademische Druck u. Verlagsanstalt, 1968; Stuttgart, Hiersemann, 1970.)

A handbook of Christian art types, antitypes, and symbols as represented in Old and New Testament scenes. The material is systematically arranged under 1,153 categories. Bibliography, p.[ix]-xiii. Full index, p.265-93. Few illustrations.

F45 Reallexikon für Antike und Christentum; Sachwörterbuch zur Auseinandersetzung des Christentums mit der antiken Welt. In Verbindung mit Franz Joseph Dolger, Hans Lietzmann, [and others], hrsg. von Theodor Klauser. Stuttgart, Hiersemann, 1950-(77). v.1-(10).

A scholarly encyclopedia of topics concerning the relationship between antiquity and Early Christianity up to the 6th century. Long signed articles by authorities. Bibliographies of primary and secondary sources. Valuable for research in Christian iconography.

F46 Réau, Louis. Iconographie de l'art chrétien. Paris, Presses Universitaires de France, 1955-59. 3v. in 6. il. (Repr.: Nendeln, Liechtenstein, Kraus-Thomson, 1974.)

An indispensable reference tool for research in Christian iconography. A new edition with corrections of bibliographical errors and various inconsistencies would be welcome. The scope ranges from Early Christian representations to those of the 20th century, with emphasis on Western medieval art. Since each subject heading is translated in from two to eight other languages, it also constitutes a polyglot dictionary

of terms. Examples are chosen from painting, sculpture, tapestries, glass, and enamels. Illustrated with good plates.

Contents: v.1, Introduction générale; v.2, L'iconographie de la Bible, Ancien et Nouveau Testament; v.3, L'iconographie des saints suivie d'un répertoire de leurs patronages et de leurs attributs, pt. 1, A–F; pt. 2, G–O; pt. 3, P–Z and Répertoire. Bibliographies at the end of each chapter. General bibliographies in v.1, p.21–26 and v.3, p.1382–84.

**F47** Ricci, *Signora* Elisa. Mille santi nell'arte. Prefazione di Corrado Ricci; 700 illustrazioni. Milan, Hoepli, 1931. xx, 734p. il., plates.

A dictionary of saints in art. For each gives a few lines of identification and a list of works of art in which the saint is depicted. Many illustrations. Bibliography, p.xiii–xiv. Calendar, p.xv–xx. Index of attributes, p.687–99. Index of protectors, p.701–15. Index of artists, p.717–34.

**F48** Roeder, Helen. Saints and their attributes; with a guide to localities and patronage. London, Longmans, Green [1955]. 391p. il.

A concise handbook of saints and their attributes, arranged by attribute, feast day, and death date. Indexes of saints and localities.

**F49** Rohault de Fleury, Charles. La messe; études archéologiques sur ses monuments continuées par son fils. Paris, Morel, 1883–89. 8v. il., 680 plates.

v.4–8 have imprint: Paris, Librairie des imprimeries réunies (in portfolios).

A monumental work on the Mass and its iconography, covering developments during various periods from the Early Christian era. Illustrated with line drawings. Each volume has individual table of contents.

**F50** Schiller, Gertrud. Iconography of Christian art. Trans. by Janet Seligman. Greenwich, Conn., New York Graphic Society [1971– ]. il., facsims.

First published in English by Lund Humphries, London, 1971. Trans. from the variant German editions: *Ikonographie der christlichen Kunst* (see F51).

This valuable iconographic work is now available to the English-speaking reader. Abundantly illustrated. References to the Bible in text; references to published works in footnotes. At the end of each volume: Bibliography and abbreviations of titles cited; Index of biblical and legendary texts cited. At the end of v.2: Thematic index of v.1–2, p.662–92. Additional volumes are projected: v.3., Resurrection and glorification of Christ and the images of the Majestas Domini and the Trinity; the final 2v. will treat the images of Ecclesia, the Virgin Mary, the Last Judgment, and the Old Testament.

Contents: v.1, Christ's incarnation. Childhood. Baptism. Temptation. Transfiguration. Works and miracles; v.2, The Passion of Jesus Christ. (Does not include the Ascension of Christ which is in v.3 of the German ed.)

**F51** _____. Ikonographie der christlichen Kunst. [1. Aufl. Gütersloh] Mohn, [1966– ]. plates.

2d German ed. 1969– .

An iconographic encyclopedia treating representations of major events in the life of Christ. Although intended for the beginning student and other nonspecialists, it is also a valuable research tool for the scholar. Arranged chronologically by event. Includes bibliographies. Copiously illustrated. To date 4 v. have been published and others are projected.

Contents: Bd. 1, Inkarnation, Kindheit, Taufe, Versuchung, Verklärung, Wirken und Wunder Christi; Bd. 2, Die Passion Jesu Christi; Bd. 3, Die Auferstehung und Erhöhung Christi; Bd. 4/1, Die Kirche.

**F52** Schneider Berrenberg, Rüdiger. Kreuz, Kruzifix: eine Bibliographie. München, Schneider Berrenberg [1973]. 317p.

An alphabetical arrangement of more than 2,000 entries for books and articles dealing with the art history and iconology of the cross and the crucifix. Index of names, places, and subjects, p.[210]–317.

**F53** Sill, Gertrude Grace. A handbook of symbols in Christian art. N.Y., Macmillan, 1975. xii, 241p. Available in paperback.

"Arranged in 50 alphabetical categories, from Angels to Zodiac, this pocket-sized handbook will help museum-goers, travelers, and students recognize and understand Christian symbolism. Illustrated with 162 works of art in clear offset, saints and symbols as well as iconographical data are fully explained in clear, direct handy format to help the user 'read' as well as respond to religious paintings.

"A short introductory essay explains the functions of symbols in art and how to use the handbook. Copious cross-references, the clear illustrations, the detailed but accessible index, and the handy size of volume make this an indispensable reference work especially for public collections. There is a selected bibliography, as well as a long list of sources and credits."—*ARLIS newsletter.* Dec., 1975.

**F54** Thoby, Paul. Le crucifix, des origines au Concile de Trente; étude iconographique. [Nantes, Bellanger] 1959. xiv, 287p. il., part. col. plates.

A history of the crucifix from its beginning to the 16th century; thorough detailed descriptions and analyses of 400 examples in all media. Each work described is reproduced. Contents: (1) La croix et le crucifiement dans l'Antiquité; (2) Des origines à la fin du VIIIe siècle; (3) IXe, Xe et XIe siècles; (4) L'art de Byzance; (5) XIIe siècle; (6) XIIIe siècle; (7) XIVe siècle; (8) XVe siècle; (9) XVI siècle. Indexes of monuments, places, and artists. Classified bibliography, p.[233]–40.

_____. Supplément. Nantes, Bellanger, 1963. 47p. il.

Describes 38 additional crucifixes in chapters which correspond to those in the original study.

**F55** Timmers, J. J. M. Symboliek en iconographie der Christelijke kunst, met 138 illustraties. Roermond-Maaseik, Romen & Zonen, 1947. 1,125p. 137 il. on 69 l.

The introduction gives a brief history of Christian symbolism.

Contents: (1) De godheid; (2) De openbaring; (3) De H. Kerk en de genademiddelen; (4) Maria, moeder des Heren; (5) De deugden en de zonden; (6) De tijd; (7) Het kerkgebouw; (8) De mens; (9) De zichtbare wereld; (10) De heiligen en hun attributen. Bibliography, p.1015–30. Index of subjects, people, and places, p.1033–1116.

F56  Waters, Clara (Erskine) Clement. A handbook of Christian symbols and stories of the saints as illustrated in art, ed. by Katherine E. Conway. Boston, Ticknor, 1886. ix, 349p. il., 31 plates. (Repr.: Detroit, Gale, 1971.)

An old handbook but still useful to the nonspecialist and the English-speaking student. Contents: (1) Symbolism in art, p.1–36; (2) Legends and stories illustrated in art, p.37–324, arranged alphabetically. General index, p.325.

F57  Webber, Frederick Roth. Church symbolism; an explanation of the more important symbols of the Old and New Testament, the primitive, the mediaeval and the modern church. Introduction by Ralph Adams Cram. 2d ed., rev. Cleveland, Jansen, 1938. ix, 413p. il., plates. (Repr.: Detroit, Gale, 1972.)

Originally published in 1927. A standard handbook primarily directed to designers of traditional churches and church furniture. Includes drawings of the many variant forms of the cross.

"The more important saints of church art," p.265–98; "Examples of old and modern symbolism," p.301–56; "A glossary of the more common symbols," p.357–86; Bibliography, p.389–94; Index to the text, p.395–413.

F58  Woodruff, Helen. The Index of Christian art at Princeton University; a handbook by Helen Woodruff, with a foreword by Charles Rufus Morey. Princeton, Princeton Univ. Pr., 1942. ix, 83p. front. (facsim.) il. Xerox copy available from University Microfilms, Ann Arbor, Mich.

A detailed description of a unique, monumental iconographical tool constituting several hundred thousand index cards arranged by subjects (approx. 25,000 headings) of Early Christian and medieval art. Supplemented by a large photographic file which is arranged by medium and locations of the works of art.

Copies are to be found in the Dumbarton Oaks Research Library of Harvard Univ. in Wash., D.C., and in the Pontifical Institute for Christian Archaeology in the Vatican. Available to scholars.

SEE ALSO:  Grabar, A. *Christian iconography; a study of its origins* (I159); Hopper, V. F. *Medieval number symbolism* (F8); Katzenellenbogen, A. *The sculptural programs of Chartres Cathedral* (K114); Knipping, J. B. *Iconography of the Counter Reformation in the Netherlands* (I383); Lejeune, R., and Steinnon, J. *The Legend of Roland in the Middle Ages* (I199); the works of Mâle, É. (I283–I286); Sauer, J. *Symbolik des Kirchengebäudes und seiner Ausstattung in der Auffassung des Mittelalters* (J120).

# JEWISH

SEE:  Goodenough, E. R. *Jewish symbols in the Greco-Roman period* (F21); Metzger, M. *La Haggada enluminée* (M141).

# ORIENTAL    *Not checked PL*

F59  Banerjea, Jitendra Nathan. The development of Hindu iconography. [2d ed. rev. and enl. Calcutta] Univ. of Calcutta, 1956. 653p. 48 plates.

1st ed. 1941.

A standard work for the study of Indian art. Contents: (1) Study of Hindu iconography; (2) The antiquity of image-worship in India; (3) The origin and development of image-worship in India; (4) Brahmanical divinities and their emblems on early Indian coins; (5) Deities and their emblems on early Indian seals; (6) Iconoclastic art in India—factors contributing to its development; (7) Iconographic terminology; (8) Cannons of iconometry; (9) Cult icons—Vyantara Devatas; (10) Cult icons—Visnu and Surya; (11) Cult icons—Silva and Sakti; (12) Miscellaneous and syncretistic icons. List of abbreviations, p.xix–xv. Select bibliography, p.[627–32].

F60  Bhattacharyya, Benoytosh. The Indian Buddhist iconography, mainly based on the Sādhanamālā and cognate Tāntric texts of rituals. [2d ed. rev. and enl.] Calcutta, Mukhopadhyay, 1958. xxxiii, 478p. il.

1st ed., London, N.Y., Oxford Univ. Pr., 1924. 3d ed. with same pagination and number of illustrations, Calcutta, Mukhopadhyay, 1968.

"An attempt to write a comprehensive work on the Buddhist iconography of India."—*Pref to 1st ed.* Contents: (I) Dhyāni and mortal Buddhas; (II) The Bodhisattvas; (III) Bodhisattva Mañjuśri; (IV) Bodhisattva Avalokiteśvara; (V) Emanations of Amitābha; (VI) Emanations of Akṣobhya; (VII) Emanations of Akṣobhya (cont.); (VIII) Emanations of Vairocana; (IX) Emanations of Amoghasiddhi; (X) Emanations of Ratnasambhava; (XI) Collective deities; (XII) Philosophical deities; (XIII) Hindu gods in Vajrayāna; (XIV) Conclusion. Appendix: 108 forms of Avalokiteśvara. Glossary, p.432–41. Index of words; Index of illustrations. Select bibliography, p.[xxx]–xxxiii.

F61  Davidson, J. Leroy. The Lotus Sutra in Chinese art: a study in Buddhist art to the year 1000. New Haven, Yale Univ. Pr., 1954. 105p. 41 plates. (Yale studies in the history of art [8])

A study of the images and incidents of the Lotus Sutra as represented in Buddhist art in China. The "Bibliographical note," p.94–100, categorizes and describes sources useful for the study of Chinese Buddhist art.

F62  Edmunds, William H. Pointers and clues to the subjects of Chinese and Japanese art, as shown in drawings, prints, carvings and the decoration of

porcelain and lacquer. With brief notices of the related subjects. London, Low, Marston |1934|. 706p. An older work, now largely superseded. Contents: Pointers and clues (a list of subjects or attributes in English, with their equivalents under the vernacular); Chinese chronological table with Japanese readings. Chinese subjects; Buddhist subjects; Japanese chronological table; Japanese subjects; Glossary of Japanese words.

F63    Fergusson, James. Tree and serpent worship; or, Illustrations of mythology and art in India in the first and fourth centuries after Christ; from the sculptures of the Buddhist topes at Sanchi and Amravati. 2d ed. rev., corrected, and in great part re-written. London, India Museum, 1873. 274p. il. 100 plates (part double, incl. photos, map, plans)
1st ed. 1868.
An early work by a pioneering writer on Indian art. Treats the theme of tree and serpent worship in the Eastern and Western world. Illustrated with woodcuts in the text and photographs as plates. Chronological table of dynasties and rulers, p.264–65.

F64    Gopinātha Rāo, T. A. Elements of Hindu iconography. Madras, Law Printing House, 1914-16. 2v. in 4. plates, tables. (Repr.: N.Y., Paragon, 1968.)
Contains texts in Sanskrit and English. Each volume includes an index of 30 to 35 pages and many plates. Bibliography, v.1, p.xxvii, xxix-xxx.

F65    Gordon, Antoinette K. The iconography of Tibetan Lamaism. N.Y., Columbia Univ. Pr., 1939. 129p. il., plates (part col.) (Repr.: Rutland, Vt., Tuttle, 1959.)
The aim is "to give a descriptive outline of the principal gods of the Tibetan pantheon, those which are commonly encountered in sculpture and painting."—*Pref.* Includes rules of Sanskrit pronunciation, a glossary of Sanskrit terms in general use, and a short account of the development of Buddhism into Lamaism. Contains numerous charts, illustrations, and diagrams. Excellent charts of the various mudras, p.20–24, with descriptions, Bibliography, p.109-16.

F66    Gupte, Ramesh Shankar. Iconography of the Hindus, Buddhists, and Jains. Bombay, Taraporevala |1972|. xviii, 201p. il.
A comprehensive survey of the iconographies of the three major religions of India as represented in their icons. Illustrated with line drawings and photographic reproductions of works.
Contents: Introduction; Hindu iconography (Brahma; Vishnu; Siva; Minor deities; The goddesses; Iconographical tables, p.58–107); Buddhist iconography (Iconographical tables, p.122-52); Jain iconography (Iconographical tables, p.177-85).

F67    Hackin, Joseph. Asiatic mythology, a detailed description and explanation of the mythologies of all the great nations of Asia, by J. Hackin . . . |and others| with an introduction by Paul-Louis Couchoud; with 15 plates in colour and 354 other illustrations.

London, Harrap; N.Y., Crowell |1932|. 459, |1| p. incl. front., il., col plates. (Repr.: London, Harrap; N.Y., Crowell, 1963.)
Contents: The mythology of Persia, by C. Huart; The mythology of the Kāfirs, by J. Hackin; The mythology of Buddhism in India, by R. Linossier; Brahmanic mythology, by H. de Wilman-Grabowska; The mythology of Lamaism, by J. Hackin; The mythology of Indo-China and Java, by C. H. Marchal; Buddhist mythology in Central Asia, by J. Hackin; The mythology of modern China, by H. Maspero; The mythology of Japan, by S. Eliséev. Subject and name index at the end.

F68    Joly, Henri Louis. Legend in Japanese art; a description of historical episodes, legendary characters, folk-lore, myths, religious symbolism illustrated in the arts of old Japan. With upwards of 700 illustrations including 16 full-color reproductions. |Repr. ed.| Rutland Vt., Tuttle |1967|. 623p. il., plates.
1st ed. 1908.
Consulted frequently as a reference work, though poorly organized. Contains both major and minor errors. Bibliography, p.595-609.

F69    Thomas, Paul. Epics, myths and legends of India; a comprehensive survey of the sacred lore of the Hindus and Buddhists. Bombay, Taraporevala |194-?|. 132p. plates.
A concise work which attempts "to give the reader a faithful representation of the Hindus and Buddhists."—*Pref.* Bibliography, p.124. Glossary and index, p.125-32.

F70    Toki, Hôryû. Si-do-in-dzou; gestes de l'officiant dans les cérémonies mystiques des sectes Tendaï et Singon. Paris, Leroux, 1899. 234p. il. plates. (Paris. Musée Guimet. Annales, Bibliothèque d'études, t. 8)
Trans. from the Japanese under the direction of S. Kawamoura. Introduction and annotations by L. de Milloué. The gestures considered are well-illustrated by line drawings. Index of Japanese names and terms, p.203-10. Index of Chinese names and terms, p.211-14. Index of Sanskrit names and terms, p.219-22. Table of contents, p.223-24.

F71    Werner, Edward Theodore Chalmers. A dictionary of Chinese mythology. Shanghai, Kelly & Walsh, 1932. 627p. (Repr.: N.Y., Julian, 1961.)
"This dictionary has been written with the object of furnishing, in a compact form, information concerning the entities, animate and inanimate, constituting the Chinese supernatural and infernal hierarchies. It is a *Who's Who* of the Chinese Otherworld."—*Pref.* Bibliography, p.625-27.

F71a   Williams, Charles Alfred Speed. Encyclopedia of Chinese symbolism and art motives; an alphabetical compendium of legends and beliefs as reflected in the manners and customs of the Chinese throughout history. N.Y., Julian, 1960. 469p. il.
Unaltered reprint of the 2d rev. ed. of *Outlines of Chinese symbolism and art motives,* Shanghai, Kelly and Walsh, 1932.

Intended as "a practical handbook of the science of Chinese symbolism as based on the early folklore, with illustrations of typical forms."—*Pref.* Contains articles of varying lengths, some with bibliographies.

SEE ALSO: Olschak, B. C. *Mystic art of ancient Tibet* (I540).

# EMBLEM LITERATURE

F72 Heckscher, William S., and Wirth, Karl-August. "Emblem, Emblembuch." In Schmitt, Otto, *Reallexikon zur Deutschen Kunstgeschichte,* (E87) V, col. 85–228.
This article is a book-length survey of the emblem literature of western Europe. It is followed by a classed bibliography of the emblem books along with references to related secondary sources.

F73 Henkel, Arthur, and Schöne, Albrecht, eds. Emblemata; Handbuch zur Sinnbildkunst des XVI. und XVII. Jahrhunderts. Hsg. von Arthur Henkel und Albrecht Schöne. Im Auftrage der Göttinger Akademie der Wissenschaften. Stuttgart, Metzler [1967]. lxxxip., 2,196 cols. il., facsims.
New supplemented ed. with new introduction and greatly enlarged bibliography, Stuttgart, Metzler, 1976; the new material is also available as a supplement to the 1st ed. 1967.
A monumental reference work for literary historians and art historians. Encompasses 47 German, Dutch, French, Spanish, Italian, and English emblem books from the 16th and 17th centuries. Following an expository preface and bibliography, the emblems are classified as follows: (1) Makrokosmos; (2) Die vier Elemente; (3) Pflanzenwelt; (4) Tierwelt; (5) Menschenwelt; (6) Personifikationen; (7) Mythologie; (8) Biblisches. 2,428 small, clear illustrations, each followed by quotations from classical and Renaissance sources.
Classified bibliography, p.xxix–xliii. Indexes of mottoes, images, and meanings. See review by H. M. von Erffa in *Art Bulletin* 53:412–15 (Sept. 1971).

F74 Landwehr, John. Emblem books in the Low Countries, 1554–1949; a bibliography. Utrecht, Haentjens Dekker & Gumbert [1970]. xlvii, 150p. il. (Bibliotheca emblematica, III)
"The present bibliography is limited to the production of emblem books in the Low Countries, irrespective of the nationality of the author, and of the language in which the books were published."—*Pref.* An exemplary bibliography for scholars. Includes collation and, in most cases, signatures. Location of copies given for very rare books. Bibliographical references in notes. Many illustrations.
Contents: Introduction; Illustrations; Chronological list (by century); Bibliography, nos. 1–752; Indexes: Publishers-Printers-Booksellers, Printers, Artists, Laudatory poets, Dedicatees.

F75 _____. French, Italian, Spanish, and Portuguese books of devices and emblems, 1534–1827; a bibliography. Utrecht, Haentjens Dekker & Gumbert, 1976. xviii, 230p. (Bibliotheca emblematica, VI, Romanic emblem books)
Includes 789 editions of emblem books published in the Latin countries between 1534–1827. "Emblem and device books published in any language in France, Italy, Spain, and Portugal and in French, Spanish, and Italian in any country"—*Pref.*
Contents: Introductory notes; Milestones, 1531–1615; Chronological list, 1534–1827 (divided by century); Bibliography; Indexes: (I) Artists; (II) Anonymous works-pseudonyms; (III) Translators-editors; (IV) Translations: French books translated; (V) Translations: French translations; (VI) Italian books translated; (VII) Italian translations; (VIII) Spanish books translated; (IX) Spanish translations; (X) Bilingual books; (XI) Polyglot books; (XII) Printers-publishers; (XIII) Privately printed.

F76 _____. German emblem books, 1531–1888; a bibliography. Utrecht, Haentjens Dekker & Gumbert [1972]. (Bibliotheca emblematica, V). vii 184p.
"A survey of emblem books in all languages produced in German-speaking countries and of books in German printed outside Germany. The bibliography of 661 items is arranged alphabetically by author and is preceded by a chronological list. The 15 indexes are: (I) Printers, publishers, booksellers; (II) Editors and translators; (III) Books by members of religious orders and ministers; (IV) Books by alchemists, Rosicrucians and astrologers; (V) Books by *Die Fruchtbringende Gesellschaft*; (VI) Artists; (VII) Anonymous and pseudonymous works; (VIII) Translations and adaptations; (IX) Bilingual books; (X) Polyglot books; (XI) Books with identical plates; (XII) Books with musical notes; (XIII) Academies, theses; (XIV) Iconographies and collections of emblems; (XV) Festivities and funerals."—*RILA*, Demonstration issue.

F77 Praz, Mario. Studies in seventeenth-century imagery. 2d ed. considerably increased. Roma, Edizioni di storia e letteratura, 1964. 607p. il. (Sussidi eruditi, 16)
1st ed., London, Warburg Institute, 1939–47 (Studies of the Warburg Institute, 3); rev. Italian ed., *Studi sul concettismo*, Florence, Sansoni, 1946.
A comprehensive study of 17th-century emblems and devices. The Appendix is a critical bibliography of the emblem books, including important earlier books. Detailed bibliographical descriptions. Locations in selected major libraries noted. For each gives references to secondary sources.
Contents: (1) Emblem, device, epigram, conceit; (2) The philosophy of the courtier; (3) Profane and sacred love; (4) The pleasing and the useful. Appendix: Emblems and devices in literature. Bibliography of emblem books, p.233–576, comprising the 2d section of this edition, was published as v.2 of the original edition.
Index of names, p.579–88; Index of emblems, p.589–607.

_____. Studies in seventeenth-century imagery: Part II. Roma, Edizioni di storia e letteratura, 1974. 108p. (Sussidi eruditi, 17)

Supplements the 2d expanded edition of 1964. Contains addenda and corrigenda by Mario Praz and a "Chronological list of emblem books" by Hilary M. S. Sayles. The chronological list is limited to first editions.

F78    Ripa, Cesare. Baroque and Rococo pictorial imagery. The 1758-60 Hertel edition of Ripa's "Iconologia." Introd., trans., and 200 commentaries by Edward A. Maser. N.Y., Dover [1971] xxi, 200 (i.e. 400)p. 200 il. (The Dover pictorial archives series)

"This first modern English-language edition of *Iconologia* of Cesare Ripa is a republication, much amplified with notes and thus rendered more useful for the contemporary reader, of the finest illustrated edition of one of the most famous handbooks of allegories, personifications, and symbols in the history of art."—*Introd.*

For each image gives explanation in English which has been translated from the original Italian. Indexes from the 18th-century edition are included as well as a modern index.

F79    _____. Iconologia del cavaliere Cesare Ripa Perugino; notabilmente accresciuta d'immagini, di annotazioni, e di fatti dall'abate Cesare Orlandi . . . Perugia, Nella stamperia de Pier-Giovanni Costantini, 1764-67. 5v. il., ports.

1st ed. (without illustrations) 1593. Other Italian editions 1618, 1620, 1625, 1630, 1645, and 1669. *See* E. Maser (F78), p.viii-xi. For a bibliographical description of the major additions and translations *see* M. Praz (F77) p.472-75.

The most famous iconographical reference book. The allegories, personifications, conceits, symbols, etc. collected by Ripa were widely used by artists and writers, especially during the Baroque period.

F80    Volkmann, Ludwig. Bilderschriften der Renaissance; Hieroglyphik und Emblematik in ihren Beziehungen und Fortwirkungen. Leipzig, Hiersemann, 1923. 132p. il. (Veröffentlichungen des Deutschen Vereins für Buchwesen und Schrifttum) (Repr.: Nieuwkoop, De Graaf, 1969; Leipzig, Hiersemann, 1969.)

A standard work on the emblems and hieroglyphics of the Renaissance. Index of names and subjects, p.125-29. Index of hieroglyphics and emblems, p.130-32.

# PORTRAITS

F81    A.L.A. portrait index; index to portraits contained in printed books and periodicals. Ed. by W. C. Lane and N. E. Browne. Wash., D.C., Library of Congress, 1906. 1,600p. (Repr.: N.Y., Burt Franklin [1967])

Antiquated, difficult to use, but still the only work of its kind. An index to portraits contained in 6,216 volumes (1,181 sets of works) of books and periodicals published before 1905. Gives birth and death dates, artist, engraver, and brief characterization of the subject for 120,000 portraits of 35,000 to 45,000 persons; and indication of where the portrait may be found in books, excluding local histories, genealogical works, collections of engravings, or portraits of writers in sets of their collected works. List of books indexed at beginning of the volume.

F82    Cirker, Heyward, and Cirker, Blanche, eds. Dictionary of American portraits. 4,045 pictures of important Americans from earliest times to the beginnings of the twentieth century. Ed. by Heyward and Blanche Cirker and the staff of Dover publications. N.Y., Dover, 1967. xiv, 756p. chiefly ports.

A pictorial archive of American portraits from the earliest period to 1905. Gives birth and death dates of the sitters, and a brief comment on their contributions to American history.

"Persons not included," p.705-6; "Sources of pictures," p.707-11; "Bibliography," p.713-15; "Index of variant names," p.717-21; "Table of contents to index," p.723-24. The detailed index is arranged by name and type of portrait.

F83    Lee, Cuthbert. Portrait register. [Asheville, N.C.,] Biltmore Pr., [1968- .] ports.

A partial inventory of portraits located in the U.S. [v.1] lists portraits in 41 states, 268 cities, 629 institutions, and many private collections. In all approx. 8,000 paintings and 1,200 artists are listed. Included are portraits of Americans by Americans (the larger number), portraits painted in the U.S. by Europeans, and selected "old master" portraits located in the United States.

Classified in three parts: General reference sections; Portrait subject section (for each gives dates of sitter, painter, date, and collection); Painter section.

F84    New-York Historical Society. Catalogue of American portraits in the New-York Historical Society. New Haven, published for the New-York Historical Society by Yale Univ. Pr., 1975. 2v. ix, 964p. il.

A catalogue of 2,420 portraits (939 illustrated) in the collection of the New-York Historical Society. Includes "not only persons of national importance, but particularly those prominent, and sometimes not so prominent, from New York City and New York State."—*Foreword.* The entries are arranged alphabetically by sitter's name. Each entry gives sitter's name, dates, biographical information, artist, date or portrait, medium, dimensions, indication of inscriptions, source of acquisition, and acquisition number.

Contents: v.1, A-L; v. 2, M-Z; Unidentified portraits. Bibliography, v.2, p.939-55. Index of artists, v.2, p.957-64.

F85    Singer, Hans Wolfgang. Allgemeiner Bildniskatalog. Leipzig, Hiersemann, 1930-36. 14v. (Repr.: Nendeln, Liechtenstein, Kraus-Thomson, 1967; Stuttgart, Hiersemann, 1967.)

Continued by *Neuer Bildniskatalog* (F86). An index of engraved portraits of all times and countries to 1929, from 17 German public collections, including approx. 25,000 sitters and 180,000 portraits. Arranged alphabetically by sitter. Information includes name of artist, medium and

location. At end of each volume is an index of artists and an index of calling or profession of the subjects portrayed, for that volume only. v.13 is complete index to the set.

F86 ⟍⟋. Neuer Bildniskatalog. Leipzig, Hiersemann, 1937–38. 5v. (Repr.: Nendeln, Liechtenstein, Kraus-Thomson, 1967; Stuttgart, Hiersemann, 1967.)

Continues the *Allgemeiner Bildniskatalog* (F85). An index to painted and sculptured portraits, also some early photographic portraits and illustrative newspaper material. Same information and format as in the previous work. v.1 contains a list of sources from which this catalog was compiled. v.5 contains an index of artists and an index of calling or profession of the subjects portrayed.

# General Primary and Secondary Sources II

# G.
# Historiography and Methodology

This chapter is limited to general works on historiography and methods of art historical research. The selections have been made with the advanced graduate student in mind. Histories of aesthetics and methods of art criticism are not included; certain basic studies in the history of art criticism and theory are listed.

G1  Ackerman, James S., and Carpenter, Rhys. Art and archaeology. Englewood Cliffs, N.J., Prentice-Hall [1963], xi, 241p. (The Princeton studies; humanistic scholarship in America)
Essays on archaeology by Rhys Carpenter, and Western art history by James Ackerman. Each scholar evaluates the progress, methods, and present state of his discipline, with a commentary on its contribution to humanistic scholarship in America. Bibliography, p.230–31.

G2  Białostocki, Jan. Stil und Ikonographie. Studien zur Kunstwissenschaft. Dresden, VEB Verlag der Kunst [1966]. 237p. il. (Fundusbücher, 18)
Nine thought-provoking essays dealing with the art-historical problems of changes of style (pt. 1) and methods of iconography (pt. 2). Includes bibliographical notes.
Contents: "Das Modusproblem in den bildenden Künsten"; "Manierismus und 'Volkssprache' in der polnischen Kunst"; "Der Manierismus zwischen Triumph und Dämmerung"; "'Barock': Stil, Epoche, Haltung"; "Die 'Rahmenthemen' und die archetypischen Bilder"; "Ikonographie Forschungen zu Rembrandt's Werk"; "Romantische Ikonographie"; "Van Goghs Symbolik"; "Kunst und Vanitas."

G3  Chambers, Frank Pentland. The history of taste; an account of the revolutions of art criticism and theory in Europe. N.Y., Columbia Univ. Pr., 1932. ix, 342p. plates, facsim. (Repr.: Westport, Conn., Greenwood Pr., 1975.)
A stimulating, readable history of the changing ideas on art from the Middle Ages through the 19th century. Appendix entitled "The cycle of antiquity." Bibliography, p.307–12; "Notes," p.315–24.
Index, p.327–42.

G4  Dittman, Lorenz. Stil, Symbol, Struktur. Studien zu Kategorien der Kunstgeschichte. Munich, Fink, 1967. 243p.

A critical historical study of the various methodological approaches of the so-called schools of art history. Excellent bibliographical notes, p.238–42.

G5  Dresdner, Albert. Die Entstehung der Kunstkritik im Zusammenhang der Geschichte des europäischen Kunstlebens. Mit einem Vorwort von Peter M. Bode: Die Stellung der Kunstkritik heute, ihre Chance und ihre Krise. München, Bruckmann [1968]. xv, 294p.
1st ed. 1915.
A history of the gradual development of art criticism from antiquity through the 18th century. 2d ed. has a foreword and essay (4p.) on the role of art criticism today, written by Peter M. Bode.

G6  Frankl, Paul. Das System der Kunstwissenschaft. Mit 58 Abbildungen. Brünn, Rohrer, 1938. ix, 1,063p. il.
"The most serious attempt . . . to create a systematic foundation for art forms. No other writer has analyzed the types of style so thoroughly."—Meyer Schapiro in "Style" (G25).

G7  Fritz Thyssen-Stiftung, Arbeitskreis Kunstgeschichte. Historismus und bildende Kunst; Vorträge und Diskussion im Oktober 1963 in München und Schloss Anif. München, Prestel-Verlag, 1965. 124p. (Studien zur Kunst des neunzehnten Jahrhunderts. 1)
Editor: Ludwig Grote.
An important collection of essays derived from lectures presented at an art historical conference (1963) dealing with problems of historicism in 19th-century art and architecture. Included in the appendix are two seminal articles (by Nikolaus Pevsner and Hans Gerhard Evers) around which arguments given in the papers evolve.
Contents: Tätigkeitsbericht des Arbeitskreises Kunstgeschichte, von L. Grote; Möglichkeiten und Aspekte des Historismus, von N. Pevsner; Historismus, von H. G. Evers; Viollet-le-Duc. Seine Stellung zur Geschichte, von M. Besset; Funktionalismus and Stil, von L. Grote; Diskussion unter Leitung, von N. Pevsner; Nachwort, von N. Pevsner. Anhang: Die Wiederkehr des Historismus, von N. Pevsner; Vom Historismus zum Funktionalismus, von H. G. Evers.

G8  Grassi, Luigi. Teorici e storia della critica d'arte. Roma, Multigrafica, 1970–(73). 2v. plates.

A comprehensive history of art theory and criticism which provides the scholar with a valuable review of the field. Two introductory essays on historiography and the relationship of theory to criticism. Promises to become a companion to Schlosser (A49) as a bibliographical guide to sources and published materials. Literary references in the text, bibliographical notes at the end of each chapter. Exhaustive bibliographies, edited by Vittorio Casale, at the end of each volume (pt. 1, p.241–85; pt. 2, p.163–80).

Contents: Prima parte. Dall'antichità a tutto il Cinquecento con due saggi introduttivi (1970); Parte seconda. L'Età moderna: il Seicento (1973). Two more volumes dealing with the modern period are projected.

G9    Grinten, Evert van der. Enquiries into the history of art-historical writing; studies of art-historical functions and terms up to 1850. [Venlo?, 1952?]. 152p.

An examination of writers on art history, arranged chronologically. Includes extensive quotations and analyses by the author.

Contents: pt. 1, Art historical writing: an inspection of the writings of a number of authors as seen in the light of the art historical functions and terms; pt. 2, An outline of the development of the individual art historical functions and terms in the course of time since the Middle Ages.

Bibliographical index, p.131–50.

G10    Hauser, Arnold. The philosophy of art history. N.Y., Knopf, 1959. 410p.

A discussion of the principal theories of the history of art. Intended as a methodological framework for his ideas as expressed in *The social history of art* (I12). Bibliographical footnotes. No illustrations or bibliography.

Contents: (I) Introduction: The scope and limitations of a sociology of art; (II) The sociological approach: The concept of ideology in the history of art; (III) The psychological approach: Psychoanalysis and art; (IV) The philosophical implications of art history; "Art history without names;" (V) Educational strata in the history of art: Folk art and popular art; (VI) Conflicting forces in the history of art: Originality and conventions.

G11    Kleinbauer, W. Eugene. Modern perspectives in Western art history; an anthology of 20th-century writings on the visual arts. N.Y., Holt, [1971]. xiii, 528p. il., plans, ports.

An excellent introduction to the discipline of art history, recommended for all students of the humanities. Pt. 1 is concerned with the nature of art history, methods of investigation, types of modern scholarship, and historiography. Essentially a bibliographical essay. Pt. 2 is an anthology of representative essays chosen from the writings of art historians to illustrate the "intrinsic perspectives" of connoisseurship, syntactical analysis, formal change, period distinctions, documentary studies, iconography and iconology. The writings in pt. 3 illustrate the "extrinsic perspectives" of art history and psychology, society and culture. Small illustrations. No general index.

G12    Kubler, George. The shape of time; remarks on the history of things. New Haven, Yale Univ. Pr., 1962. 136p.

A brilliant, unconventional examination of the historical evolution of forms. "The purpose of these pages is to draw attention to some of the morphological problems of duration in series and sequence. These problems arise independently of meaning and image. They are problems that have gone unworked for more than forty years, since the time when students turned away from "mere formalism" to the historical reconstruction of symbolic complexes"—*Pref.*

Contents: (1) The history of things; (2) The classing of things; (3) The propagation of things; (4) Some kinds of duration; Conclusion.

G13    Kultermann, Udo. Geschichte der Kunstgeschichte. Der Weg einer Wissenschaft. Wien, Düsseldorf, Econ [1966]. 477p. il., facsims.

The first systematic history of art history. Includes information on about 700 scholars from Vasari to the present. Not an in-depth study. Many portraits of art historians. Bibliographical references included in "Anmerkungen," p.435–62.

G14    Kunstgeschichte und Kunsttheorie im 19. Jahrhundert. [Hrsg. von Hermann Bauer, Lorenz Dittman, et al. Redaktion: H. Bauer] Berlin, de Gruyter, 1963. 233p. (Probleme der Kunstwissenschaft. Bd. 1)

A collection of seven learned essays on art history and theory in the 19th century. Contents: Einleitung, by Mohammed Rassem; Der historische Stilbegriff und die Geschichtlichkeit der Kunst, by Friedrich Piel; Schellings Philosophie der bildenden Kunst, by Lorenz Dittmann; Zur Kunsttheorie Wilhelm Diltheys, by Herbert Schade; Architektur als Kunst, by Hermann Bauer; Zu extremen Gedanken über Bestattung und Grabmal um 1800, by Wilhelm Messerer; Plastisches Ideal, Symbol und der Bilderstreit der Goethezeit, by Bernhard Rupprecht.

Bibliographical footnotes.

G15    Lavalleye, Jacques. Introduction aux études d'archéologie et d'histoire de l'art. Louvain, Nauwelaerts, 1958. 274p.

1st ed. 1946.

A handbook on methods, intended for French students of art history. Index of names and people, p.183–91; Index of places, p.193–206.

G16    Lee, Rensselaer Wright. Ut pictura poesis; the humanistic theory of painting. N.Y., Norton [1967]. viii, 79p. il. [Ut pictura poesis: The humanistic theory of painting. [N.Y.] 1940. [197]–269p. plates (Repr. from *Art bulletin.* v.22, no. 4, Dec. 1940.)]

A classic; extremely valuable for students and scholars in all of the humanistic disciplines. "This essay attempts to define the humanistic theory of painting and to record in broad terms its development from its beginning in the fifteenth century to the eighteenth when new forces in critical thought and in art began to cause its decline. Everywhere in the theory is the fundamental assumption — an assumption

which is made no longer—that good painting, like good poetry, is the ideal imitation of human action." —*Pref.*

Contents: (I) Imitation; (II) Invention; (III) Expression; (IV) Instruction and delight; (V) Decorum; (VI) The learned painter; (VII) Rinaldo and Armida; (VIII) Virtù Visiva; (IX) The unity of action; (X) Conclusion. Appendixes: (1) "On the lack of ancient criticism of painting"; (2) *Inventio, Dispositio, Elocutio*"; (3) "Lomazzo on expression"; (4) "The Cartesian theory of the passions"; (5) "Symposium on the passion of wrath"; (6) "Decorum and verisimilitude." Index.

G17  Lodovici, Sergio. Storici, teorici e critici delle arti figurative (1800-1940). Roma, E.B.B.I., Istituto editoriale italiano B. C. Tosi [1942]. 412p. il. (ports., facsims.) (Enciclopedia biografica e bibliografica "Italiana," ser. IV)

Bio-bibliographies of Italian art historians and critics from 1800-1940, with summaries of their theories; many photographs. Alphabetical list of Italian periodicals, p.389-402; Chronological list of periodicals, p.403-12.

G18  Munro, Thomas. Evolution in the arts, and other theories of cultural history. [Cleveland] Cleveland Museum of Art [1963?]. (Distr. by Abrams.) 561p.

An important book by the former editor of the *Journal of aesthetics and art criticism*. "The aim of this book is not confined to arguing that the arts evolve. It also seeks to throw some light on the many associated theories and problems, such as the comparative influence of hereditary, social, and psychological factors. It discusses the question of analogous sequences and stages in the various arts in different cultures"—*Introd.* Bibliography, p.543-[52]; Index of concepts and writers concerned with theories and culture history, p.553-[62].

G19  Panofsky, Erwin. Aufsätze zu Grundfragen der Kunstwissenschaft/Erwin Panofsky; hrsg. von Hariolf Oberer und Egon Verheyen. 2., erw. und verb. Aufl. Berlin, Hessling, 1974. ix, 204p. il. 12 leaves of plates.

1st ed. 1964.

A collection of Panofsky's essays on the principles of art history, and a bibliography of his writings (p.1-17).

G20  _____. "The history of art as a humanistic discipline," in *Meaning in the visual arts: papers in and on art history*. N.Y., Overlook Pr., 1974. (Distr. by Viking.)

1st ed. of *Meaning in the visual arts*, N.Y., Doubleday, 1955.

The essay was originally published in T. M. Greene, ed. *The meaning of the humanities*, Princeton Univ. Pr., 1940.

An excellent introduction to the meaning and methods of art history, written by the famous art historian.

G21  _____. Idea; a concept in art theory. Trans. by Joseph J. S. Peake. Columbia, S.C., Univ. of South Carolina Pr., 1968. xiii, 268p. il., facsims. (Repr.: N.Y., Harper, 1974.)

Trans. of *Idea: ein Beitrag zur Begriffsgeschichte der älteren Kunsttheorie*, 2d ed. 1960.

1st German ed. 1924.

A classic art historical study of a concept—the "idea" of the beautiful.

Contents: (1) Introduction; (2) Antiquity; (3) The Middle Ages; (4) The Renaissance; (5) "Mannerism"; (6) Classicism; (7) Michelangelo and Dürer. Appendix I, G. P. Lomazzo's chapter on the beautiful proportions and Marsiglio Ficino's commentary on the Symposium; Appendix II, G. P. Bellori's "The Idea of the painter, sculptor, and architect, superior to nature by selection from natural beauties." "Notes to text and appendices," p.181-253.

Good index.

G22  Pevsner, *Sir* Nikolaus. Academies of art, past and present. Cambridge, The Univ. Pr., 1940. xiv, 323p. plates, ports., facsims. (Repr.: N.Y., Da Capo, 1973.)

"My task was accordingly to provide a straightforward description of four centuries of artists' education, linked up with certain political, social, and aesthetic data."—*Pref.* A unique history of art academies from the 16th century in Italy through the first decades of the 20th century. Basic to the study of the artist's changing role in society, the development of institutions, and the history of ideas on art.

Detailed table of contents. Appendix I, Code of rules of Vasari's *Academia del disegno;* Appendix II, Literature on academies treated in chapters IV and V. Index. Contains bibliographical footnotes.

G23  Roskill, Mark. What is art history? N.Y., Harper, 1976. 192p. il.

English ed.: London, Thames & Hudson, entitled *How art history works*, 1976.

"This book is an introduction to the way art history works. It aims to show, in terms which can be understood without any background knowledge, that art history is a science, with definite principles and techniques, rather than a matter of intuition or guesswork. Basic questions which the professional finds himself asked are answered in it, in a form resembling a series of miniature detective stories." —*Introd.* Each chapter focuses on particular problems in the history of painting; these have been chosen as representative of their period, from Renaissance to modern.

Contents: Introduction: the origins and growth of art history; (1) The attribution of paintings: some case histories; (2) Collaboration between two artists: Masaccio and Masolino; (3) Deciding the limits of an artist's work: Piero della Francesca; (4) Cutting through mystery and legend: Giorgione; (5) Reconstructing how works were displayed: Raphael's tapestries in the Sistine Chapel; (6) A forgotten artist rediscovered: Georges de la Tour; (7) Disguised meaning in pictures: Vermeer and Velasquez; (8) Forgery and its detection: the hand of Hans van Meegeren; (9) Understanding a modern picture: Picasso's *Guernica*; Epilogue: The art historian today. Bibliography, p.183-[88]. General index.

G24  Salerno, Luigi. "Historiography," in *Encyclopedia of world art* [E4] v.7, p.507-59.

An excellent overview of the history of the historiography of art, in the Western tradition and in the East.

G25   Schapiro, Meyer. "Style," in *Anthropology today; an encyclopedic inventory,* ed. by A. L. Kroeber. Chicago, Univ. of Chicago Pr., 1953, p.287–312. (Repr.: Philipson, Morris, ed., *Aesthetics today* Cleveland, Meridian, 1961, p.81–113.)
A brilliant analysis of the problems of style in the study of art history. Bibliography, p.311–12.

G26   Tietze, Hans. Die Methode der Kunstgeschichte, ein Versuch. Leipzig, Seemann, 1913. xi, 489p. (Repr.: N.Y., Burt Franklin, 1967.)
A comprehensive treatment of art historical methods, written by a distinguished art historian.
   Bibliographical footnotes. Author index, p.481–89.

G27   Venturi, Lionello. History of art criticism; trans. from the Italian by Charles Marriott. N.Y., Dutton, 1936. xv, 345p. (Repr.: N.Y., Dutton, 1964.)
A standard survey of art historical writing and art criticism from the Greeks to the third decade of the 20th century. Bibliography, p.325–45.

G28   Waetzoldt, Wilhelm. Deutsche Kunsthistoriker. Leipzig, Seemann, 1921–24. 2v.

A history of art history and theory in Germany. Excellent treatment of the pioneer German art historians from the 17th century to the early 20th century.
   Contents: v.1, Von Sandrart bis Rumohr; v.2, Von Passavant bis Justi. "Zeittafel der Quellenschriften," v.1, p.319–23 and v.2, p.279–84. "Literatur," v.1, p.325–32 and v.2, p.285–96.

G29   Wölfflin, Heinrich. Gedanken zur Kunstgeschichte, gedrucktes und ungedrucktes; mit 24 Abbildungen. 3 Aufl. Basel, Schwabe [1941]. vii, 165p. il.
The thoughts of a great art historian on the subject of art history.

SEE ALSO: Assunto, R. *La critica d'arte nel pensiero medioevale* (I181); Becatti, G. *Arte e gusto negli scrittori latini* (I116); Grinten, E. *Elements of art historiography in medieval texts* (H21); Mahon, D. *Studies in Seicento art and theory* (I338); Wölfflin, H. *Principles of art history* (I233). *Kunstgeschichte und Kunsttheorie im 19. Jahrhundert* (R53).

# H.
# Sources and
# Documents

This bibliography of sources and documents is selective. With the exception of the general collections and anthologies, the titles cover a time span ranging from antiquity to nineteenth-century neoclassicism. Later collections, such as the *Archives of impressionism* and the *Documents of modern art,* are listed elsewhere.

Art historians will not find here complete listings of variant editions. In many instances the critical edition is listed as the main entry. For more comprehensive coverage of the early sources of Western art see the classic study by Julius von Schlosser, *La letteratura artistica* with the supplementary bibliography by Otto Kurz (A49), *Teorici e storia della critica d'arte,* by Luigi Grassi (G8), and the individual volumes in the series *Sources and documents in the history of art* (H6), each of which is an excellent guide to the range of sources, documents, and letters pertinent to an area of art history. This chapter follows a precise, if rather complex, arrangement, first being divided into the large category of Western sources and documents, and then into the smaller category of Oriental sources and documents. Western art is arranged according to the ancient, medieval, and Renaissance-neoclassical periods. In turn each of these is subdivided into (1) single sources, and (2) collections of sources, documents, letters, etc. Further, because of the great number of single sources published in the Renaissance and Baroque periods, this section has been divided into (1) 15th–16th centuries, (2) 17th century, and (3) 18th–early 19th centuries.

H1    Goldwater, Robert John, and Treves, Marco, ed. and trans. Artists on art, from the XIV to the XX century. 3d ed. N.Y., Pantheon, 1974. 499p. il.
Available in paperback.

A collection of excerpts from the writings of painters and sculptors from the 14th century to the present. Arranged chronologically. The editors give a brief introduction to each artist which is followed by significant excerpts from the artist's writings. Portraits accompany most selections. Of general interest to artists as well as art historians. Extensive bibliography.

H2    Guhl, Ernst, and Rosenberg, Adolf. Künstlerbriefe, übersetzt und erläutert von Dr. Ernst Guhl. 2. umgearbeitete und sehr vermehrte Aufl. von Dr. Adolf Rosenberg. Berlin, Guttentag, 1880. 2v. in 1.

A valuable collection of 311 letters written by artists of the 15th, 16th, and 17th centuries. Translated into German, with important commentaries. Guhl chose the most interesting published letters. Alphabetical list of the artists (with dates) whose letters were included, p.369–82.

H3    Holt, Elizabeth B. (Gilmore), ed. A documentary history of art. [2d ed.] N.Y., Doubleday, 1957–66. 3v. il.
1st ed. 1947, entitled *Literary sources of art history: an anthology of texts from Theophilus to Goethe.* Expanded and revised in the 2d ed. v.3 originally published as *From the classicists to the impressionists; a documentary history of art and architecture in the 19th century* by New York Univ. Pr., 1966.

Available in paperback.

Translations of excerpts from original sources, including treatises, letters, journals, etc. from the mid-10th century to the end of the 19th century. Especially useful to students of art history, teachers, and other historians. Each selection is preceded by a brief biography of the author. Bibliographical footnotes.

Contents: v.1, The Middle Ages and Renaissance; v.2, Michelangelo and the Mannerists; the Baroque and the 18th century; v.3, From the Classicists to the Impressionists; art and architecture in the 19th century.

H4    Müntz, Eugène. Les archives des arts; recueil de documents inédits ou peu connus. Paris, Librarie de l'art, 1890. 196p.
A collection of documents and letters related to Italian and French art. Bibliographical notes. Table of contents.

H5    Quellenschriften für Kunstgeschichte und Kunsttechnik des Mittelalters und der Neuzeit, mit Unterstützung des Österreichischen K.K. Ministeriums für Kultur und Unterricht . . . hrsg . . . I–XVIII Bd.; neue Folge, I–XV., Bd. Wien, Braumüller [etc.], 1871–1908. (Bd. I, 1888). 33v. in 19. il., map. (Repr. of original series, v.1–18: Osnabrück, Zeller, 1970.)
Editors: v.1–18, R. Eitelberger von Edelberg; n.F. v.1–8, A. Ilg; v.9–15, C. List.

v.1–18 have title: *Quellenschriften . . . des Mittelalters und der Renaissance.*

Contents: (1) Cennini, Cennino. *Das Buch von der Kunst,* 1871. Neue Ausgabe, 1888; (2) Dolce, Lodovico. *Aretino, oder Dialog über Malerei,* 1871; (3) Dürer, Albrecht. *Dürers Briefe, Tagebücher und Reime,* 1872; (4) Eraclius. *Heraclius, von den Farben und Künsten der Römer,* 1873; (5) Biondo, Michelangelo. *Von der Hochedlen Malerei,* 1873; (6) Condivi, Ascanio. *Das Leben des Michelangelo Buonarroti,* 1874; (7) Theophilus, called also Rugerus. *Theophilus Presbyter Schedula diversarum artium,* 1. Bd., 1874; (8) Stockbauer, Jacob. *Die Kunststrebungen am Bayerischen Hofe unter Herzog Albert V. und seinem Nachfolger Wilhelm V,* 1874; (9) Semper, Hans. *Donatello, seine Zeit und Schule,* 1875; (10) Neudörfer, Johann. *Des Johann Neudörfer Schreib und Rechenmeisters zu Nürnberg Nachrichten von Künstlern und Werkleuten daselbst aus dem Jahre 1547,* 1875; (11) Alberti, Leone Battista. *Leone Battista Alberti's kleinere kunsttheoretische Schriften,* 1877; (12) Unger, F. W. *Quellen der byzantinischen Kunstgeschichte,* 1. Bd., 1878; (13) Prague. Malerzeche. *Das Buch der Malerzeche in Prag,* 1878; (14) Houbraken, Arnold. *Arnold Houbraken's Grosse Schouburgh der niederländischen Maler und Malerinnen,* 1880; (15-18) Leonardo da Vinci. *Das Buch von der Malerei,* Deutsche Ausgabe, 1882.

Neue Folge: (1) Michiel, Marcantonio. *Der Anonimo Morelliano* (1. Abth.), 1888; (2) Pacioli, Luca da Borgo. *Divina proportione,* 1896; (3) Filarete, Antonio Averlino. *Antonio Averlino Filarete's Tractat über die Baukunst,* 1896; (4) Schlosser, Julius von. *Schriftquellen zur Geschichte der karolingischen Kunst,* 1896; (5) Ilg, Albert. *Beiträge zur Geschichte der Kunst und der Kunsttechnik aus Mittelhochdeutschen Dichtungen,* 1892; (6) Hainhofer, Philipp. *Des Augsburger Patriciers Philipp Hainhofer Beziehungen zum Herzog Philipp II von Pommern-Stettin,* 1896; (7) Schlosser, Julius von. *Quellenbuch zur Kunstgeschichte des abendländischen Mittelalters,* 1896; (8) Richter, J. P. *Quellen der byzantinischen Kunstgeschichte,* 1897; (9) Hollanda, Francisco de. *Vier Gespräche über die Malerei geführt zu Rom 1538,* 1899; (10) Hainhofer, Philipp. *Des Augsburger Patriciers Philipp Hainhofer Reisen nach Innsbruck und Dresden,* 1901; (11-13) Hampe, Theodor. *Nürnberger Ratsverlässe über Kunst und Künstler im Zeitalter der Spätgotik und Renaissance (1449) 1474-1618 (1633),* 1904; (14) Ertinger, F. F. *Des Bilderhauergesellen Franz Ferdinand Ertinger Reisebeschreibung durch Österreich und Deutschland,* 1907; (15) Kallab, Wolfgang. *Vasaristudien,* 1908.

**H6**    Sources and documents in the history of art series. Englewood, N.J., Prentice-Hall, 1965- .
Series editor: Horst W. Janson.

Anthologies of excerpts from important texts (in translation) on the major periods and fields of Western art. Each volume, compiled by an outstanding authority (or authorities) in the field, includes critical essays, selected texts, and bibliographical references. These selections provide the best introductions to documentary literature for the advanced undergraduate and graduate student.

Published thus far: Pollitt, Jerry Jordan, *The art of Greece, 1400-31 B.C.* (1965); _____. *The art of Rome, 753 B.C.-337 A.D.* (1966); Mango, Cyril, *Art of the Byzantine Empire, 312-1453* (1972); Frisch, Teresa G., *Gothic art, 1140-c.1450*

(1971); Klein, Robert, and Zerner, Henri, *Italian art, 1500-1600* (1966); Stechow, Wolfgang, *Northern Renaissance, 1400-1600* (1966); Enggass, Robert, and Brown, Jonathan, *Italy and Spain 1600-1750* (1970); Eitner, Lorenz, *Neoclassicism and Romanticism, 1750-1850:* [v.I] *Enlightenment/ Revolution;* [v.II] *Restoration/The twilight of humanism* (1970); Nochlin, Linda, *Realism and tradition in art, 1848-1900* (1966); _____. *Impressionism and Post-Impressionism, 1874-1904* (1966); McCoubrey, John W. *American art, 1700-1960* (1965).

In preparation: Costello, Jane, *France and England, 1600-1750;* Davis, Cäcilia, *Early medieval art;* Gerson, H., *Flemish-Dutch-German art, 1600-1750;* Gilbert, Creighton, *Italian Renaissance art, 15th century.*

**H7**    Troescher, Georg. Kunst- und Künstlerwanderungen in Mitteleuropa 800-1800; Beiträge zur Kenntnis des deutsch-französisch-niederländischen Kunstaustausches. Baden-Baden, Verlag für Kunst und Wissenschaft, 1953-54. 2v.

v.1 contains a collection of documentary references to the activities of German artists in France and the Netherlands and the influence of German art therein. v.2 contains a collection of documentary references to the activities of French and Netherlandish artists in the German-speaking countries (Germany, Switzerland, Austria) and the influence of French and Netherlandish art therein. The references are arranged according to the places where these exchanges occurred and are listed chronologically within that arrangement. Thoroughly indexed. "Schrifttumsverzeichnis," v.1, p.xiii-xviii.

SEE ALSO:    *Quellen und Schriften zur bildenden Kunst* (R54).

# ANCIENT

## Single Sources

**H8**    Pausanias. Pausanias's Description of Greece, trans. with a commentary by J. G. Frazer. London, Macmillan, 1898. 6v. il., plates, maps, plans.
2d ed. 1913. 3d ed. 1931-55, in 5v. of the Loeb Classical Library, London, Heinemann.

A description of Greece in the 2d century A.D., with some information on its arts, gleaned by the author from other sources; translated from the original Greek with a commentary.

Contents: v.1, Translation; v.2, Commentary on Book I: Attica; Appendix: The pre-Persian temple on the Acropolis; v.3, Commentary on Books II-V: Corinth, Laconia, Messenia, Elis; v.4, Commentary on Books VI-VIII: Elis, Archaia, Arcadia; v.5, Commentary on Books IX, X: Boeotia, Phocis, addenda; v.6, Indices, maps.

**H9**    Plinius Secundus, C. The Elder Pliny's chapters on the history of art. Trans. by K. Jex-Blake. With commentary and historical introd. by E. Sellers, and

additional notes contributed by Heinrich Ludwig Urlichs. (1st American ed.) Chicago, Argonaut, 1968. 252p. facsim., geneal. tables.

The text is a reprint of the 1896 ed.

Translation of selected portions of *Historia naturalis;* Latin and English on facing pages.

A useful ed. of the selections from Pliny's *Historia naturalis,* with detailed discussions of Greek artists and their achievements. Based on Hellenistic sources. Bibliography, p.xcv–c.

H10 Vitruvius, Pollio. Vitruvius, the ten books on architechture, trans. by Morris Hicky Morgan. With illustrations and original designs prepared under the direction of Herbert Langford Warren. Cambridge, Harvard Univ. Pr., 1914. xiii, 331, [1] p. il. (incl. plans), plates, diagrs.

The best English ed. of *De Architectura.* Available in paperback from Dover, N.Y.

First printed c.1486. Many translations, editions, and commentaries. The most important illustrated editions, with notes, are the Italian translations of Cesariano (Como, 1521), that of Daniele Barbaro (Venice, 1567), and the French ed. of Claude Perrault (2d ed. 1684).

The only surviving ancient treatise on the principles of architecture, written by a Roman architect in the early part of the 1st century A.D. Most important for its influence on Renaissance and later architectural theory.

SEE ALSO: Pollitt, J. J. *The art of Greece, 1400–31 B.C.* and *The art of Rome, 753 B.C.–337 A.D.* (H6).

## Collections

H11 Dudley, Donald Reynolds, *comp.* Urbs Roma: a source book of classical texts on the city & its monuments, selected & trans. with a commentary by Donald R. Dudley. London, Phaidon, 1967. 339p. il.

A compendium of inscriptions and writings of ancient authors on the monuments of Rome. Indexes: Ancient authors; inscriptions; names; places. Bibliographical references included in "Notes to the text," p.228–37.

H12 Jones, Henry Stuart, ed. Select passages from ancient writers, illustrative of the history of Greek sculpture, ed. with a trans. and notes by Stuart Jones. London and N.Y., Macmillan, 1895. 231p. (Repr.: Chicago, Argonaut, 1966.)

The original texts and the English translations are given in parallel columns. Although the work is not comprehensive, it represents one of the first attempts to relate ancient texts with specific statues. "As a rule, the inscriptions of artists (which may be read in Loewy's *Inschriften* . . . [H13]) have not been included."—*Pref.*

H13 Loewy, Emanuel. Inschriften griechischer Bildhauer mit Facsimiles. Gedruckt mit Unterstützung der Kaiserlichen Akademie der Wissenschaften zu Wien. Leipzig, Teubner, 1885. 410p. il., facsims. (Repr.: Osnabrück, Zeller, 1965.)

A standard work of inscriptions on Greek sculpture, arranged chronologically by centuries and then geographically.

"Bibliographisches Register," p.[xxvii]–xxxvii.

Index of artists (in Greek) at the end.

H14 Marcadé, Jean. Recueil des signatures des sculpteurs grecs. Paris, Boccard, 1953–(57). v.1–(2). il., plates.

At head of title: École Française d'Athènes.

Intended to replace Loewy (H13). Attempts to give for each sculptor the complete epigraphical evidence and a résumé of the literary sources. Arranged alphabetically by name of sculptor. v.1 contains sculptors whose work at Delphi is proven by epigraphy. v.2 covers Delos.

H15 Overbeck, Johannes. Die antiken Schriftquellen zur Geschichte der bildenden Künste bei den Griechen. Leipzig, Engelmann, 1868. 488p. (Repr.: Hildesheim, Olms, 1959.)

A collection of ancient writings, in the original Greek and Latin, relating to art (excluding architecture) in classical Greece. No translations or commentary. Some of the writings are translated in Pollitt (H6) and Jones (H12). Index of artists, p.477–88.

H16 Reinach, Adolph Joseph. Recueil Milliet; textes grecs et latins relatifs à l'histoire de la peinture ancienne, pub., tr. et commentés, sous le patronage de l'Association des Études Grecques. Avant-propos par S. Reinach. Paris, Klincksieck, 1921. v.1.

Revised and prepared for publication by Salomon Reinach. A collection of Greek and Latin texts concerning ancient painting. Still useful.

Alphabetical index of painters mentioned, p.423–25. "Table des matières," p.427–29.

SEE ALSO: Becatti, G. *Arte e gusto negli scrittori latini* (I116); Philipp, H. *Tektonon daidala; der bildende Künstler und sein Werk im vorplatonischen Schrifttum* in series *Quellen und Schriften zur bildenden Kunst* (R54).

# MEDIEVAL

## Single Sources

H17 Cennini, Cennino. Il libro dell'arte. New Haven, Yale Univ. Pr.; London, Milford, Oxford Univ. Pr., 1932–33. 2v. il., plates, facsims.

Critical ed. by Daniel V. Thompson.

A fundamental source, written by a Tuscan painter c.1390. Basic for an understanding of the practice and conception of art at that time, and important for the detailed information on all the traditional techniques of the arts.

v.I is the Italian text with an account of the prior editions of this work. Index, p.133–42. v.II is *The craftsman's handbook,* translated by D. V. Thompson.

H18 Suger, Abbot of Saint Denis. Abbot Suger on the Abbey Church of St. Denis and its art treasures. Ed.,

trans. and annot. by Erwin Panofsky. Princeton, N.J., Princeton Univ. Pr., 1946. xiv, 250p. il., plates. (Repr.: Princeton, N.J., Princeton Univ. Pr., 1978)

A brilliant study, with English translations, of the writings of Abbot Suger (1081-1151) on the rebuilding of the abbey church of St. Denis.

H19   Theophilus, called also Rugerus. The various arts. Trans. from the Latin with introd. by C. R. Dodwell. London, N.Y., Nelson [1961]. lxxvii, 171, 171, 175-178p.

Critical ed. with new English translation.

A medieval treatise on the techniques of art, probably written during the first half of the 12th century by a German author. Divided into books on painting, glass, and metalwork. In the introduction, C. R. Dodwell discusses contents, date, author, the "Lumen Animal," early descriptions, former editions, and method of the present edition. Scholarly notes and select bibliography. The treatise has parallel Latin and English texts. Index.

Another English translation, ed. by John H. Hawthorne and Cyril Stanley Smith; pub. by Univ. of Chicago Pr., 1963.

H20   Villard de Honnecourt, 13th century. Kritische Gesamtausgabe des Bauhüttenbuches ms. fr. 19093 der Pariser Nationalbibliothek. [Hrsg. von] Hans R. Hahnloser. 2. revidierte und erw. Aufl. Graz, Austria, Akademische Druck u. Verlagsanstalt, 1972. 1v. (various pagings). il., plates.

1st ed. 1935.

Facsimile of the important 13th-century sketchbook of Villard de Honnecourt (Paris. Bibliothèque Nationale ms. fr. 19093). The illustrations and text are accompanied by the definitive critical commentary (in German) and a discussion of the pertinent literature. Bibliography since 1935, p.341-42; 1971 supplement to the critical discussion, p.345-403.

SEE ALSO:  Frisch, T. G. *Gothic art 1140-c.1450*, and Mango, C. *Art of the Byzantine Empire, 312-1453* (H6).

## Collections

H21   Grinten, Evert van der. Elements of art historiography in medieval texts; an analytic study. Trans. from the Dutch by D. Aalders. The Hague, Nijhoff, 1969. 158p.

A compilation of medieval texts referring directly to works of art and to artists. The author's arrangement "juxtaposes these texts while tracing the words, terms or turns of speech which were used by the chronicle writers (as representatives of men of letters) in describing or mentioning works of art in their immediate environment."

Divided into two parts: "the first part approaches and comments on characteristic terms and ways of expression arranged in a number of paragraphs; the second part is an appendix containing a number of fragments from texts in the original language, references to which are made in the first part."—*Introd.*

H22   Knögel, Elsmarie. Schriftquellen zur Kunstgeschichte der Merowingerzeit. Darmstadt, Wittich'sche Hofbuchdruckerei, 1936. 258p.

Also appeared in *Bonner Jahrbücher des Vereins von Altertumsfreunden im Rheinlande* (Darmstadt, 1936, Hft. 140/141, 1.T., p.1-258.)

A valuable collection of documents or texts relating to Merovingian art, covering the years 500-750. Includes 60p. of introductory text.

"Abkürzungen," p.229-30; "Alphabetisches Verzeichnis der ausgezogenen Quellen," p.230-36; "Verzeichnis der wichtigeren allgemeinen Literatur," p.237; "Register zur Textsammlung," p.238-58, divided into: "Personennamen," p.238-44; "Ortsnamen," p.245-52; "Sachregister und Glossar," p.252-58.

H23   Lehmann-Brockhaus, Otto. Lateinische Schriftquellen zur Kunst in England, Wales und Schottland, vom Jahre 901 bis zum Jahre 1307. München, Prestel, 1955-60. 5v. (Veröffentlichungen des Zentralinstituts für Kunstgeschichte in München, 1)

A collection of Latin sources for art in England, Wales, and Scotland from 901 to 1307. Sources include passages from chronicles, registers, etc. Pipe rolls, plea rolls, wills, and sources written after 1500 have been excluded.

Contents: Bd. 1, Quellen in topographischer Ordnung, A-K (nr. 1-2248); Bd. 2, Quellen in topographischer Ordnung, L-Z (nr. 2249-5072); Bd. 3, Quellen, die sich topographisch nicht einordnen lassen (nr. 5073-6773); Bd. 4, Quellennachweis, geographisches Register, Personenregister; Bd. 5, Sachregister, Ikonographisches Register, Heiligenregister einschliesslich der Gestalten des Alten und Neuen Testaments sowie der heidnischen Götter und Gestalten der Mythologie und Dichtung.

Includes bibliographical references.

H24   _____. Schriftquellen zur Kunstgeschichte des 11. und 12. Jahrhunderts für Deutschland, Lothringen und Italien. Berlin, Deutscher Verein für Kunstwissenschaft, 1938. 2v. (Repr.: N.Y., Burt Franklin, 1971.)

3,026 documents selected from the pontifical books of Rome and Ravenna. Covers Germany, Lothringen, and Italy for the years 1002-1190.

Contents: [v.1] Text; [v.2] Register. "Quellen-nachweis," †v.2, p. 1]-54. v.2 also contains indexes of places, persons, saints and pagan gods, and subjects.

H25   Mortet, Victor. Recueil de textes relatifs à l'histoire de l'architecture et à la condition des architectes en France, au moyen âge, XIe-XIIe siècles; publié avec une introduction, des notes, un glossaire et un répertoire archéologique. Paris, Picard, 1911. lxv, 513p. (Collection de textes pour servir à l'étude et à l'enseignement de l'histoire, 44)

The introduction is followed by a collection of original texts relevant to the history of medieval architecture in France. Documents of the 11th and 12th centuries are arranged by date. Critical footnotes. Appendix contains alphabetical indexes of persons, places, and archaeological material, and a glossary.

H26 Mortet, Victor, and Deschamps, Paul. Recueil de textes relatifs à l'histoire de l'architecture et à la condition des architectes en France, au moyen âge, XIIᵉ-XIIIᵉ siècles; pub. avec une introduction, des notes, un glossaire et un répertoire archéologique. Paris, Picard, 1929. xlii, 407p. (Collection de textes pour servir à l'étude et à l'enseignement de l'histoire, 51)

A companion volume to the preceding Mortet (H25), which expands the coverage to the 13th century.

H27 Richter, Jean Paul. Quellen der byzantinischen Kunstgeschichte. Ausgewählte Texte über die Kirchen, Klöster, Paläste, Staatsgebäude und andere Bauten von Konstantinopel. Wien, Graeser, 1897. li, 432p. (Quellenschriften [für Kunstgeschichte] . . . n.F. VIII. Bd.)
"Sonder-Ausgabe aus Eitelberger-Ilgs Quellenschriften."

A collection of excerpts from documents dealing with Byzantine monuments; arranged chronologically, then subdivided by monument.

"Inhaltsverzeichnis," p.ix-xxiv; "Verzeichnis der benützten Schriftsteller," p.xxv-xxxix; "Chronologie der byzantinischen Kaiser," p.li-liii. Index, p.421-32.

H28 Schlosser, Julius von. Quellenbuch zur Kunstgeschichte des abendländischen Mittelalters. Ausgewählte Texte des vierten bis fünfzehnten Jahrhunderts. Wien, Graeser, 1896. xxiv, 406p. diagrs. (Quellenschriften für Kunstgeschichte. n.F. VII. Bd.)
"Sonder-Ausgabe aus Eitelberger-Ilgs Quellenschriften."

A collection of excerpts from documents covering Western art from the early Christian period to the 15th century.

Contents: (1) Christliches Altertum und frühes Mittelalter; (II) Hohes Mittelalter; (III) Vierzehntes und fünfzehntes Jahrhundert.

Indexes: (1) Verzeichnis der Autoren, p.388-89; (2) Ortsregister, p.389-92; (3) Sachregister, p.392-94; (4) Verzeichnis der Künstlernamen, p.395; (5) Verzeichnis der technischen Ausdrücke, p.396-406.

H29 _____. Schriftquellen zur Geschichte der karolingischen Kunst. Gesammelt und erläutert von Julius von Schlosser. Wien, Graeser, 1896. xvi, 482p. (Quellenschriften für Kunstgeschichte. n.F. IV. Bd. 1892)
"Sonder-Ausgabe aus Eitelberger-Ilgs Quellenschriften."

A collection of excerpts from documents dealing with Carolingian art. Contents: Quellenverzeichnis, p.ix-xvi; (I) Architektur und Kleinkunst; (II) Malerei und Plastik; (III) Anhang: (1) Notizen über einzelne Künstler etc.; (2) Die Antike in karolingischer Zeit.

Indexes: (1) Ortsregister, p.445-51; (2) Sach- und Personenregister, p.452-63; (3) Heiligenverzeichnis, p.463-68; (4) Künstlernamen, p.469; (5) Glossarium der technischen Ausdrücke, p.470-82.

SEE ALSO: Frankl, P. *The Gothic: literary sources and interpretations through eight centuries* (J113); Frisch, T. G.

*Gothic art 1140-c.1450* and Mango, C. *Art of the Byzantine Empire, 312-1453* in the series *Sources and documents in the history of art* (H6).

# RENAISSANCE—NEOCLASSICAL

## Single Sources

### 15th-16th Centuries

H30 Alberti, Leone Battista. De pictura praestantissima, et nunquam satis laudata arte libri tres absolutissimi. Basileae, 1540. 120p.
Printer's mark of Bartholomaeus Westheimer (Heitz, Basler Büchermarken 159) on verso of last leaf.

The 1st printed ed. of the influential treatise on painting (1st ms. version, 1435). The first English translation is included in Leoni's translation of *De re aedificatoria*, 1726. A modern translation by John R. Spencer (New Haven, Yale Univ. Pr., 1956) is available in paperback. Another translation, with critical notes by C. Grayson, is listed below (H32).

H31 _____. De re aedificatoria. Florentiae, Laurentii, 1485. 204 l.
Word concordance and facsimile of this 1st Latin ed.: Lucke, Hans-Karl. *Alberti index: Leon Battista Alberti. De re aedificatoria, 1485: Index verborum.* München, Prestel, 1975- . 4v.

Critical ed., with an introduction, extensive notes, textual cross-references, explanations of terms: *L'Architettura. De re aedificatoria.* Testo latino e traduzione a cura di Giovanni Orlandi; introduzione e note di Paolo Portoghesi. Milano, Il Polifilo, 1966. 2v. (Classici italiani di scienze techniche e arti. Trattati di architettura, 1). The bibliography, p.xlviii-liv, includes a chronological listing of 23 editions in various languages, and the literature on Alberti. Indexes of subjects, names, and illustrations.

English ed., *Ten books of architecture,* trans. by James Leoni (London, Edlin, 1726); reissued 1955 (London, Tiranti), with notes by Joseph Rykwert.

*De re aedificatoria* is the first and most important architectural treatise of the Renaissance. Basic to the understanding of architecture. See: Richard Krautheimer, "Alberti and Vitruvius," in *Studies in Early Christian, Medieval, and Renaissance art* (I16) and Rudolf Wittkower, *Architectural principles in the age of humanism* (J248).

H32 _____. On painting and on sculpture. The Latin texts of De pictura and De statua, [by] Leon Battista Alberti. Ed., with trans., introd. and notes by Cecil Grayson. [London] Phaidon [1972]. viii, 159p. il.
Critical ed. of *De pictura* (1st version 1435) and *De statua* (after 1443). The introduction gives full bibliographical information for the original manuscripts and the published editions in Latin and Italian. The editor reviews textual and dating problems and includes an art historical essay on each work.

The Latin texts, reconstructed from variant manuscripts, are paralleled by English translations. Footnotes and a separate section of notes to the texts, both with bibliographical references.

Appendix: Alberti's work on painting and sculpture.

H33   Armenini, Giovanni Battista. De' veri precetti della pittura. Ravenna, Tebaldini, 1587. 229p. 3v. in 1. (Repr.: Hildesheim, Olms, 1971.)
2d ed., Venice, 1678. Early reprints: Milan, 1820; Pisa, 1823, ed. by Stefano Ticozzi.

A practical treatise on design, draftsmanship, and painting technique, written by a painter from Faenza. Also contains anecdotes and other information about artists and works of art. Important for the study of 16th-century painting. The text is preceded by an index of 15p.

H34   Borghini, Raffaello. Il Riposo. [Facsimile of the 1st ed. Florence, 1584]. Saggio biobibliografico e indice analitico a cura di Mario Rosci. Milano, Labor, 1967. 2v. (Gli storici della letteratura artistica italiana, 13-14)
Another reprint of the 1st ed.: Hildesheim, Olms, 1969; 2d ed., Florence, 1730, has critical notes by G. Bottari; 3d ed., Siena, 1780. Other editions and reprints are listed in v.2 of the Rosci edition (listed above).

An important 16th-century source, written by a friend and compatriot of Vasari. The biographical material supplements Vasari's *Lives*. In dialogue form, the text consists of long conversations on art theory, artists, art history, and techniques. The Rosci ed. (1967) is supplemented by a bio-bibliographical essay, an annotated bibliography (v.2, p.vii–xxvi), and an excellent, detailed, analytical index (v.2, p.[1–154]).

H35   Cartari, Vincenzo. Imagini delli dei de gl'antichi. Nachdruck der Ausgabe, Venedig, 1647, vermehrt durch ein Inhaltsverzeichnis und neue Register. Einleitung: Walter Koschatzky. Graz, Akademische Druck- u. Verlagsanstalt, 1963. lxviii, 400p. il. (Instrumentaria artium, Bd. 1)
1st ed., Venice, Ziletti, 1587; many subsequent editions in the 16th and 17th centuries.

This first encyclopedia of classical iconography is a compendium of woodcuts illustrating the gods, heroes, allegories, and myths of antiquity. Widely used by Renaissance and Baroque artists. The 1963 reprint (listed above) of the 1647 ed. (Venice, Tomassini) is prefaced by a critical introduction by Walter Koschatzky, a bio-bibliography of Vincenzo Cartari, an index to the texts of the illustrations, an alphabetical subject index to the pictures, and an index of attributes.

H36   Cellini, Benvenuto. Dve trattati vno intorno alle otto principali arti dell'oreficeria. L'altro in materia dell'arte della **scvltura**; doue si veggono infiniti segreti nel lauorar le figure di marmo, & nel gettarle di bronzo. Composti da m. Benvenvto Cellini scvltore fiorentino. Fiorenza, Panizzij & Peri, 1568. [146] p.

2d ed., Florence, Tartini e Franchi, 1731, rewritten in the authorized Italian of the Accademia Crusca; reprint of this ed., Turin, 1795. English trans. by C. R. Ashbee, London, Arnold, 1898. (Repr. of the Ashbee ed.: N.Y., Dover, 1967.)

Important for the study of Florentine sculpture of the period. The text consists of two treatises on the techniques of goldsmithing and sculpture, along with some thoughts on architecture and design. The six-page table of contents follows the dedication, preceding the body of the work.

H37   Colonna, Francesco. Hypnerotomachia Poliphili. Venice, Aldus Manutius, 1499. [234] 1.
2d ed. 1545.
*Hypnerotomachia Poliphili.* Edizione critica e commento a cura di Giovanni Pozzi e Lucia A. Ciapponi. Padova, Antenore, 1964. 2v. il. (Itinera erudita 1–2)
Repr. of 1st ed.: Farnborough, Gregg, 1969; N.Y., Garland, 1976. The anonymous Elizabethan translation of the first book of the *Hypnerotomachia* (*Hypnerotomachia, The Strife of Love in a Dreame*, London, 1592) has been issued in reprint by Johnson, 1969, and Garland, 1976.

A poetic, quasi-medieval romance illustrated with beautiful woodcuts, the only art book stemming from Venice in the 15th century. The illustrations of fanciful ruins and the reconstructions of ancient monuments have been widely used by artists; many of the designs have been echoed in actual buildings, particularly in France and England.

H38   Delorme, Philibert. Architectvre de Philibert de l'Orme, conseiller et avmosnier ordinaire dv roy, et abbé de sainct Serge lez-Angers. Oeuvre entiere contenant vnze liures, augmentée de deux; & autres figures non encores veuës, tant pour desseins qu'ornemens de maison. Avec vne belle invention povr bien bastir, & à petits frais. Tres-vtile pour tous architectes, & maistres iurez audit art, vsant de la regle & compas. Roven, Ferrand, 1648. 348 (i.e., 350) numb. 1. il. (incl. port., plans, diagrs.) (Repr.: Ridgewood, N.J., Gregg, 1964.)
Half-title: Oeuvres de Philibert de l'Orme.

The 1st collected ed. of *Novvelles inventions povr bien bastir et à petits fraiz* (1561) and *Le premier tôme de l'architectvre* (1567). Contains additional plates.

A practical and theoretical treatise based in part on Vitruvius and Alberti. For a detailed study see Anthony Blunt, "The treatise on architecture," in *Philibert de L'Orme*, London, Zwemmer, 1958, p.108–35.

H39   Dolce, Lodovico. Dialogo della pittvra di m. Lodovico Dolce, intitolato l'Aretino. Nel quale si ragiona della dignità di essa pittvra, e di tutte le parti necessarie, che a perfetto pittore si acconuengono: con esempi di pittori antichi, & moderni: e nel fine si fa mentione delle uirtù e delle opere del diuin Titiano. Venezia, Ferrari, 1557.
2d ed., Firenze, Nestenus & Moücke, 1735; 1st English ed., London, Dodsley, 1770. (Repr. of the 1770 London ed.: Menston, Scolar, 1970.)
Modern critical ed. with English translation: Roskill, Mark Wentworth, ed. *Dolce's "Aretino" and Venetian art*

*theory of the cinquecento.* N.Y., Published for the College Art Association by New York Univ. Pr., 1968. 354p. front., facsim. (Monographs on archaeology and fine arts, 15)

A dialogue on painting and notes on painters written by a member of the Venetian circle of Aretino, Titian, and Sansovino.

Contents of the modern critical ed. listed above: Introduction (on Dolce, the history and theory of the *Dialogue*, the circle of Aretino, the literary and artistic climate in Venice, etc.); Appendix A. The subsequent history and influence of the *Dialogue;* Appendix B. On artistic relations between Venice and Central Italy, 1500–57. Text and translation (the *Dialogue* and three letters of Dolce with parallel Italian text and English translation). Commentary on the text of the *Dialogue* and letters. Bibliographical references in the commentary and in the extensive footnotes.

H40    Filarete, Antonio Averlino, *known as.* Filarete's treatise on architecture; being the treatise by Antonio di Piero Averlino, known as Filarete. Trans. with an introd. and notes by John R. Spencer. New Haven, Yale Univ. Pr., 1965. 2v. il., facsims., diagrs., plans. (Yale publications in the history of art, 16)

v.1 is the translated text; v.2 is the facsimile of the Magliabecchiana manuscript in the Biblioteca Nazionale Centrale in Florence (Bib. Naz., Magl. II, I 140.).

First published in an incomplete ed. in *Eitelberger-Ilgs Quellenschriften.* n. F. III (Vienna, 1896), ed. by W. von Oettingen.

An early architectural treatise written in Milan between 1460 and 1464. Now most significant for the descriptions and illustrations of the imaginary city of Sforzinda. For a scholarly study of the treatise see Tigler, Peter, *Die Architekturtheorie des Filarete,* Berlin, 1963.

H41    Gaurico, Pomponio. De sculptura (1504) [by] Pomponius Gaurius. Édition annotée et traduction par André Chastel et Robert Klein, avec un groupe de travail de l'École Pratique des Hautes Études. Genève, Droz, 1969. 288p. 22 plates. (Hautes études médiévales et modernes, 5)

1st ed., Florence, 1504. A critical ed. by H. Brockhaus with Latin and German texts, Leipzig, 1816.

The 1969 ed. (listed above) has an introduction, the Latin text with a parallel French translation, critical notes with bibliography, a detailed index, 52 illustrations, and a table of contents.

A Renaissance treatise on bronze sculpture, written by a scholar from Naples who was also a member of the humanist circle in Padua. Important for theory and facts; relevant to sculpture in northern Italy during the 15th century.

H42    Lafreri, Antonio. Speculum Romanae magnificentiae, omnia fere quaecunque in urbe monumenta extant, partim juxta antiquam, partim juxta hodiernam formam accuratissime delineata repraesentans. Rome [c.1574]. [Size and number of plates vary from copy to copy.]

The most complete copy in the U.S. is in the library of the Univ. of Chicago. The copy in Avery Library, Columbia Univ., has 607 plates in 6v.

A great collection of engravings illustrating ancient and Renaissance Rome. Most important for research in architectural history. Only a few complete copies are known to exist. A printed catalogue in the Biblioteca Marucelliana, Florence, dated 1573, lists the nucleus of the collection. *Cf.* Christian Huelsen in *Collectanea variae doctrinae Leoni S. Olschki Bibliopolae Florentino sexagenario obtulerunt.* Monachii, Rosenthal, 1921, p.121–70. An English translation of Huelsen's essay and a facsimile of the 1573 catalogue are included in *The marvels of Rome; Lafreri's Speculum Romanae,* ed. by Lawrence McGinniss, N.Y., Abaris, 1979.

H43    Lomazzo, Giovanni Paolo. Trattato dell' arte della pittvra, scoltvra et architettvra. Milano, Pontio, 1584. 7v. in 1. 700p. (Repr.: Hildesheim, Olms, 1968.)

Reprinted in 1585. Also issued in Rome by Saverio Del-Monte in 1884 (Biblioteca artistica 1–3). English translation by R. Haydocke, London, 1598, entitled *A tracte containing the artes of curious paintinge, caruinge & buildinge.*

The most complete treatise on the art theory, design, and iconography of the Mannerist period. Also important for the study of Milanese painters. Bk. 7 includes a veritable dictionary of iconography for the period. Contents (translated): Bk. 1, Proportion; Bk. 2, Expression of emotions; Bk. 3, Color; Bk. 4, Light and shade; Bk. 5, Perspective; Bk. 6, Painting practice, genres of painting, painting for various places, composition, etc.; Bk. 7, Representation of subjects (Religious and mythological).

√H44    Martini, Francesco di Giorgio. Trattati di architettura ingegneria e arte militare. A cura di Corrado Maltese. Trascrizione di Livia Maltese Degrassi. Milano, Il Polifilo, 1967. 2v. 613p. 335 figs. (Trattati di architettura, 3) (Classici italiani di scienze tecniche e arti)

An influential architectural treatise written after 1482 in the Court of Urbino. This 1st complete ed. includes transcripts of four manuscripts and reproductions of the original drawings. The complicated history of the various manuscript versions is clarified in the editor's introduction. Scholarly notes with bibliographical references. Analytical index, concordances, and a general index at end of v.2. See the informative review by Richard J. Betts in *Society of Architectural Historians Journal.* 31:62–64 (Mar. 1972).

H45    Michiel, Marcantonio. The Anonimo; notes on pictures & works of art in Italy made by an anonymous writer in the sixteenth century; trans. by Paolo Mussi; ed. by George C. Williamson. London, Bell, 1903. xx, 143p. 32 plates. (Repr.: N.Y., Blom, 1969.)

The 1903 ed. is based on the Italian ed. of 1884, Bologna, Zanichelli, with notes by Gustavo Frizzioni.

A 16th-century guidebook to public and private collections in Padua, Cremona, Pavia, Bergamo, Crema, and Venice. As with Vasari's *Vite,* which was written about the same time, the author knew most of the artists personally. The manuscript was discovered by Jacopo Morelli in 1800 in the Liberia Marciana, Venice, and is known as the "Anonimo Morelliano."

**H46**    Palladio, Andrea. I qvattro libri dell'architettvra di Andrea Palladio. Ne' quali, dopo vn breue trattato de' cinque ordini, & di quelli auertimenti, che sono più necessarij nel fabricare; si tratta delle case private, delle vie, de i ponti, delle piazze, di i xisti, et de' tempij. Con privilegi. Venetia, Franceschi, 1570. 4v. in 1. il. (incl. plans, diagrs.)

Facsimile ed., Milan, Hoepli, 1945. The best English ed. (1738), is an accurate translation by Isaac Ware, available in reprint: *The four books of architecture,* with a new introduction by Adolf K. Placzek. N.Y., Dover, 1965.

An important treatise on architecture, both theoretical and practical in nature. Divided into four books concerning the principles of architecture and the orders, palaces and villas, public buildings and city planning, and temples. Many illustrations of Palladio's own villas and palaces, and the remains of antiquity. The buildings illustrated, especially the villas, were widely imitated in Great Britain and America.

**H47**    Serlio, Sebastiano. Tvtte l'opere d'architettvra, et prospetiva, di Sebastiano Serlio, Bolognese, dove si mettono in disegno tvtte le maniere di edificij, e si trattano di quelle cose, che sono più necessarie a sapere gli architetti. Con la aggivnta delle inventioni di cinqvanta porte e gran numero di palazzi publici, e priuati nella città, & in villa, e varij accidenti, che possono occorrere nel fabricare. Diviso in sette libri. Con vn'indice copiosissimo con molte consideratoni, & vn breue discorso sopra questa materia, raccolto da M. Gio. Domenico Scamozzi Vicentino. Di nuouo ristampate, & con ogni diligenza corrette. Venetia, Franceschi, 1619. 25p. 1, 3–219, 27 numb. 1., 1 1., 243p. il., diagrs.

Repr. of the 1619 ed.: London, Gregg, 1964. The 1st complete ed. of the seven books. The first five books were originally published separately in Venice and Paris between 1537–47 (v.4, 1537; v.3, 1540; v.1–2, 1545; v.5, 1547). The English translation of books 1–5 appeared in London in 1611. (Repr., with an introd. by A. E. Santaniello. N.Y., Blom, 1970.) These five books were augmented by a sixth "libro extra-ordinario" published in Lyon, 1551, and a seventh (post-humous) published in Frankfurt, 1575. Manuscripts of another sixth book are in the Staatsbibliothek in Munich (Cod. icon. 189) and in the Avery Library. A facsimile ed. of the Munich manuscript has been published: *Delle habitationi di tutti li gradi degli homini.* Milano, I.T.E.C. [1966]. The following essay was published as a companion volume to the above facsimile ed.: Rosci, Marco. *Il trattato di architettura de Sebastiano Serlio.* Presentazione di Anna Maria Brizio. Milano, I.T.E.C. [1966]. Facsimile ed. of the Avery manuscript: *Sebastiano Serlio on domestic architecture: different dwellings from the meanest hovel to the most ornate palace: the sixteenth-century manuscript of book VI in the Avery Library of Columbia University.* Text by Myra Nan Rosenfeld. N.Y., Architectural History Foundation, 1978.

**H48**    Vasari, Giorgio. Le vite de' piv eccelenti architetti, pittori et scvltori italiani, da Cimabve insino a' tempi nostri: descritte in lingua toscana da G.- V.-, pittore Aretino. Con vna sua vtile e necessaria introduzzione a le arti loro. Firenze, Torrentino, 1550. 3v. in 2. plates.

This original ed., issued in 3 parts in two quarto volumes (992p.), with indexes, and dedicated to Duke Cosimo de' Medici, is now a bibliographical rarity. A reprint, ed. by Corrado Ricci, was issued in Rome by Bestetti and Tumminelli in 1927, in 4v.

The key source of Renaissance biography, also important for theory and historiography.

**H48a**    _____. Le vite de' piv eccelenti pittori, scvltori e architettori, scritte (di nuovo ampliate), de M. Giorgio Vasari pittore et architetto Aretino. Co' ritratti loro et con le nuoue vite dal 1550 insino al 1567, con tauole copiosissime de' nomi, dell' opere, e de' luoghi ou' ell sono. Firenze, Givnti, 1568. 3v. il.

This 2d ed. is especially noted for the fine woodcut portraits which were executed in Venice.

The classic ed. of Vasari is that of Gaetano Milanesi, pub. by Sansoni, Florence, 1878–81 and an index volume dated 1885. Reissued by Sansoni in 1906 and 1973. Important for the critical apparatus based on research with documents.

New critical ed., with textual analysis and commentary by P. Barocchi and R. Bettarini, Florence, Sansoni, 1967–(76). v.I, II, III$^1$, IV published; v.III$^2$, V–VII in preparation.

The most complete English translation is that of Gaston du C. De Vere, London, The Medici Society, 1912–15 in 10v. It is fairly reliable.

For a listing of other editions, see: J. Schlosser (A49), p.332–46, and L₁ Grassi (G8), v.1, p.235–36.

**H49**    Vignola, Giacomo Barozzio, *known as.* Regola delli cinqve ordini d'architettvra. Roma, n.p., 1562. 32 plates.

1st ed. of the popular and influential book on the orders, as well as other classical features of architecture. Based on Vignola's firsthand knowledge of the antiquities of Rome. Many subsequent editions and reissues. Consists of en-gravings with brief explanations.

## 17th Century

**H50**    Baglione, Giovanni. Le vite de' pittori, scultori ed architetti, dal pontificato di Gregorio XIII del 1572. in fino a' tempi di Papa Urbano Ottavo nel 1642. Roma, Fei, 1642. 304p.

2d ed., Rome, Manelfi, 1649; 3d ed., Naples, 1733, contains a life of Salvator Rosa written by Passeri, and a biography of Baglione.

A facsimile ed. made from the 1642 copy in the library of the Accademia dei Lincei, Rome, containing marginal notes by G. P. Bellori, was issued by the R. Istituto d'Archeologia e Storia dell'Arte, Rome, in 1935. Introduction and index by Valerio Mariani.

A major source, important for its wealth of information (much from oral accounts) on the artists in Rome from 1572

to 1642. Although the emphasis is on Roman artists, it includes the Roman work of foreign artists, e.g. Rubens, Bril, and Goltzius. The arrangement is chronological within the reign of each pope.

H51 Baldinucci, Filippo. Cominciamento, e progresso dell'arte dell' intagliare in rame, colle vite di molti de' più eccellenti maestri della stessa professione. Firenze, Matini, 1686. viii, 124p.

2d ed., includes annotations by Domenico Maria Manni, Florence, Stecchi, 1767. A 2d ed. also published as v.1 of *Opere di Filippo Baldinucci*, Milan, Società tipografica de' Classici italiani, 1808.

Includes articles on Dürer, Lucas van Leyden, Raimondi, Goltzius, Tempesta, Saenredam, Stefano della Bella, and other master engravers. "Indice delle cose notabili," p.113-22.

H52 _____. Notizie de' professori del disegno da Cimabue in qua, per le quali si dimostra come, e per chi le bell'arti di pittura, scultura, e architettura lasciata la rozzezza delle maniere greca, e gotica, si siano in questi secoli ridotte all'antica loro perfezione. Opera di Filippo Baldinucci Fiorentino distinta in secoli, e decannali. Firenze, Santi Franchi, 1681-1728. 6v. in 3. geneal. tables.

Subtitle and imprint vary. 2d ed. with notes by Domenico Maria Manni (Florence, Stecchi, 1767-74, 21v. in 10); 3d ed. prepared by Giuseppe Piacenza (Turin, Stamperia reale, 1768-1817, 5v.). Also appeared in *Opere di Filippo Baldinucci, Società tipografica de'Classici Italiani* (v.4-14, 1808-12, Milan). An ed. with notes by F. Ranalli (Florence, Batelli, 1845-47, 5v.). There is no modern ed.

A scholarly work on Italian artists, beginning with Cimabue and ending with the life of Matteo Preti. Includes northern artists. Based on earlier published sources as well as original research with documents. A separate article is devoted to each artist.

Contents (in translation): v.[1], Dedication to Cosimo III de' Medici; preface; privilege of Pope Innocent XI, Duke Cosimo III, and Carlos II, king of Spain; approbations. Decades 1260-1300; v.[2], Decades 1300-40; v.[3], Decades 1400-1550 (on title page, 1400-1540); v.[4], Decades 1550-80; v.[5], Decades 1580-1610; v.[6], Decades 1610-70.

A separate index of all artists included in the work, p.i-xx, and an index of "cose piú notabili," v.[6], p.636-62.

H53 _____. Vocabolario toscano dell'arte del disegno, nel quale si esplicano i propri termini e voci, non solo della pittura, scultura, & architettura; ma ancora di altre arti a quelle subordinate, e che abbiano per fondamento il disegno, con la notizia de' nomi e qualità della gioie, metalli, pietre dure, marmi, pietre tenere, sassi, legnami, colori; strumenti, ed ogn'altra materia, che servir possa, tanto alla costruzione di edificj e loro ornato, quanto alla stessa pittura e scultura. Firenze, Santi Franchi, 1681. xii, 188p.

Other editions: Florence and Verona, 1806; Milano, 1809, v.2-3 of *Opere di Filippo Baldinucci, Società tipografica de' Classici Italiani.*

The language of painting, sculpture, architecture, and the decorative arts comprises this pioneer dictionary of art terms, a milestone in Italian philological research.

H54 Bellori, Giovanni Pietro. Le vite de' pittori, scultori, ed architetti moderni. Parte prima. Roma, Il success. al Mascardi, 1672. 462p. engr. plates.

2d ed., Rome, 1728, contains a biography of Luca Giordano. The biography of Carlo Maratta, partially by Bellori, was published separately in Rome and included in the widely used 3d ed., Pisa, 1821, 3v. in 2.

The best modern ed. for scholars is a facsimile of the 1st ed., edited by Evelina Borea with an introduction by Giovanni Previtali, pub. by Einaudi, Turin, in 1976. It contains extensive critical notes, a detailed index, and an excellent bibliography, p.lxxiii-cxxii.

English translations have been published for Bellori's Life of Caravaggio (in Walter Friedlaender, *Caravaggio studies,* Princeton, 1955) and his *Lives of Annibale and Agostino Carracci,* trans. by Catherine Enggass, University Park, Pa., 1968.

Invaluable as a source for information on 12 artists of the 17th century. Includes biographies of Rubens and Poussin. Prefaced by an important theoretical essay, 'L'Idea del pittore, dello scultore e dell'architetto," trans. in *Documentary history of art* v.2 (H3). See also Erwin Panofsky, *Idea; a concept in art theory,* Columbia, S.C., 1968.

H55 Bie, Cornelis de. Het gulden cabinet vande edele vry schilderconst waer-inne begrepen is den loff vande vermaerste constminnende geesten ende schilders van dese eeuw, hier inne meest naer het leven afgebeeldt, verciert mot rijmen ende spreucken. [Antwerpen, Van Montfort, 2d ed., 1662]. 3 pts. in 1v. 584p., incl. 88 engr. plates. (Repr.: Soest, Davaco, 1971.)

An earlier and more limited ed., Antwerp, Meyssens, 1661.

An early source of biography and portraiture of artists, influenced by Vasari. A good part is in rhyme. Some of the portraits were engraved by Hollar. Pt. 2 covers painters; pt. 3, architects, sculptors, and engravers. "Tafel oft register van dit gulden cabinet," p.578-84.

H56 Boschini, Marco. La carta del navegar pitoresco. Edizione critica con la "Breve instruzione" premessa alle "Ricche minere della pittura veneziana." A cura di Anna Pallucchini. Venezia-Roma, Istituto per la Collaborazione Culturale [1966]. lxxxiv, 810p. facsims., plates, ports. (Civiltà veneziana. Fonti e testi, 7. Ser. I: Fonti e documenti per la storia dell'arte veneta, 4)

The critical ed. of the 1660 work.

Boschini conducts the reader "across the sea of Venetian painting" in a guide to major works of art, beginning with Tintoretto at San Rocco. This Baroque poem in the Venetian dialect is also an important literary work. Contains 43 engravings.

Contents: Introduzione, p.ix-lxxxiii; La carta del navegar pitoresco, p.1-697 (includes original index and a list of abbreviations to the works cited in the editor's footnotes);

Breve instruzione from *Ricche minere della pittura veneziana* (H57); Avvertenza II, Criteri di edizione del testo della *Breve instruzione,* p.702-56; Illustrazione, p.757; Indice generale, p.759-808; Elenco della illustrazione, p.809-10.

H57   _____. Le ricche minere della pittura veneziana. Compendiosa informazione di Marco Boschini, non solo delle pitture publiche di Venezia, ma dell'isole ancora circonvicine. Venezia, Nicolini, 1674. [120], 115, [5], 3-77, [3] p.

1st ed. entitled *Le minere della pittura*, Venezia, Nicolini, 1664; 3d ed., Venice, 1733. (Repr.: Ann Arbor, Mich., University Microfilms, 1965.)

Schlosser (A49) calls this the first true artistic guide to Venice, and a mine of brief and objective notes on the 16-century paintings in the churches, confraternities, and public buildings. Arranged by quarter of the city and then by building. Index of places (15p.) at the beginning of volume.

H58   Bosse, Abraham. Sentimens sur la distinction des diverses manières de peinture, dessein & gravure, & des orginaux d'avec leurs copies. Ensemble du choix des sujets, & des chemins pour arriver facilement & promptement à bien pourtraire. Paris, Chez l'autheur, 1649. 114p. 2 plates. (Repr.: Geneva, Minkoff, 1973.)

An important treatise on painting, drawing, and engraving written by a follower of Callot.

H59   Carducci, Vincenzio. Diálogos de la pintura; su defensa, origen, essēcia, definición, modos y diferencias, al gran monarcha de las Españas y Nueuo Mundo, don Felipe III. Siguēse a los Diálogos, informaciones, y pareceres en sabor del arte, escritas por varones insignes en todas letras. Madrid, Martinez, 1633. 229p. 9 plates.

2d ed., Madrid, Galiano, 1865.

Dialogues on art between a master and his pupil, written by an Italian painter who emigrated to Spain. A Spanish source for ideas and examples of Italian art. Index, p.[231-41].

H60   Celio, Gaspare. Memoria delli nomi dell'artefici delle pitture che sono in alcune chiese, facciate, e palazzi di Roma. Facsimile della edizione de 1638 di Napoli. Introduzione e commento critico a cura di Emma Zocca. Milano, Electa, 1967. xiv, 133p. il., port. (Fonti e trattati di storiografia artistica)

1st ed., Naples, Bonino, 1638.

The facsimile ed. (listed above) has a critical introduction and commentary.

An important early guidebook to the art of Rome, written c.1620 by a painter of conservative taste. Valuable for material on late Mannerist painters. Bibliography, p.113-17.

H61   Du Fresnoy, Charles Alphonse. L'art de peinture. Traduit en françois, enrichy de remarques & augmenté d'un dialogue sur le coloris [par Roger de Piles] 2.éd. Paris, Langlois, 1673. [22] 277, [4], 80p.

Includes the original poem, in Latin, with title: *De arte graphica liber;* Latin and French on opposite pages.

1st Latin ed., Paris, 1668; 1st ed. with the French translation by Roger de Piles, Paris, 1668; 2d ed. (1673) includes critical notes by R. de Piles and his famous dialogue on the value of color in painting. Several subsequent French editions; also Italian and English editions.

1st English ed.: Du Fresnoy, Charles Alphonse. *De arte graphica. The art of painting. With remarks. Translated into English, together with an original preface containing a parallel betwixt painting and poetry. By Mr. Dryden. As also A short account of the most eminent painters, both ancient and modern, continued down to the present times. . . By another hand. . .* London, Printed by J. Heptinstall for W. Rogers, 1695. lxiv, 355p. Later English editions 1716, 1750, 1769; edition rendered into verse by William Mason and published with notes by Sir Joshua Reynolds, London, 1783.

A didactic poem about painting, written between 1641 and 1665. Sets down theoretical principles, based on Italian precedents, which were most influential for the theory and teaching of art in France and England.

H62   Félibien, André, *Sieur des Avaux et de Javercy.* Entretiens sur les vies et sur les ouvrages des plus excellens peintres, anciens et modernes. Paris, Mabre-Cramoisy, [etc.], 1666-88. 5v.

1st ed.: v.1, 1666; v.2, 1672; v.3, 1679; v.4., 1685; v.5, 1688. 2nd ed., 1685-88; frequently reprinted up to 1725. German ed., 1711; Italian ed., Venice, 1755. (Repr.: Farnborough, Gregg, 1967, 6v. in 1 of the 1725 Trévoux ed.; Geneva, Minkoff, 1972.)

A major source on the lives of French artists of the 16th and 17th centuries, written by an important liberal historian and theoretician. The theory of art is skillfully combined with historical facts and anecdotes.

H63   Hoogstraten, Samuel van. Inleyding tot de hooge schoole der schilder-konst anders de zichtbaere werelt. Rotterdam, F. van Hoogstraten, 1678. il. (Repr.: Soest, Davaco, 1969.)

A handbook for artists, written by one of Rembrandt's pupils. Illustrated with engravings.

H64   Junius, Franciscus. De pictura veterum libri tres, tot in locis emendati, & tam multis accessionibus aucti, ut plane novi possint videri: accedit catalogus, adhuc ineditus, architectorum, mechanicorum, sed praecipue pictorum, statuariorum, caelatorum, tornatorum, aliorumque artificum, & operum quae fecerunt, secundum seriem litterarum digestus. Roterodami, Regneri Leers, 1694. 2v. in 1. port.

1st ed., Amsterdam, Blaeu, 1637; the most useful Latin ed. is 1694, listed above, with index. English ed. translated by the author with additions and alterations, London, Hodgkinsonne, 1638.

An early work by a member of the circle of Rubens. According to Schlosser (A49) it is even today a rich source of antiquarian erudition.

H65   Malvasia, Carlo Cesare, *conte.* Felsina pittrice; vite de' pittori bolognesi alla maestà cristianissima di Lvigi

XIIII, consagrata dal co. Carlo Cesare Malvasia. Con indici in fine copiosissimi. Bologna, Barbieri, 1678. 2v. il. (incl. ports.)

Enlarged by addition of 3d volume by Luigi Crespi entitled: *Vite de' pittori bolognese non descritte nella Felsina pittrice. Alla maestà di Carlo Emanuele III, Re di Sardegna, etc.* Roma, Pagliarini, 1769 (xx, 344p. il., ports.) Supplemented by Bolognini Amorini, A. *Vite dei pittori ed artefici bolognesi* (E105).

1841 ed.: *Felsina pittrice; vite de' pittori bolognesi, aggiunte, correzione e note inedite del medesimo autore, di Giampietro Zanotti, e di altri scrittori viventi* (Bologna, Ancora, 1841). Has corrections and is augmented with the life of Malvasia and notes by Zanotti. Important because of the good index. (Repr. of 1841 ed.: Bologna, Forni, 1967.)

An important source for the history of Italian painting. At beginning of v.1 is an alphabetical list of painters treated in this volume. At end of v.2 are indexes of churches mentioned in the work, names of owners, artists (p.511), and important subjects. Corrections for both volumes are on the last page of v.2.

H66 _____. Felsina pittrice. Vite dei pittori bolognesi. Introduzione e testi a cura di Marcella Brascaglia. Bologna, ALFA, 1971. iv, 621p. il., plates (col.) (Fonti e studi per la storia di Bologna e delle province emiliane, 3)

A transcription of selected passages of Malvasia (H65), in particular those on the lives of the Bolognese painters. Most valuable because of the new illustrations and critical introduction by M. Brascaglia. The introduction presents the art historical background in Bologna, the life of Malvasia, and a critical evaluation of the text. Includes bibliographical references.

H67 _____. La pitture de Bologna, 1686. Ristampa anastatica corredata da indici di ricerca, da un commentario di orientamento bibliografico e informativeo e da un repertorio illustrato. A cura di Andrea Emiliani. Bologna, ALFA [1969]. xix, 535p. il., 36 plates. (Fonti e studi per la storia di Bologna e delle province emiliane, 1)

2d ed. 1706 (con aggiunte di G. P. Zanotti). Other editions, 1732, 1755, 1766, 1776.

A reprint of the original ed. of 1686, with textual corrections, critical commentary, and bibliography by Andrea Emiliani. Includes a repertory of illustrations of paintings mentioned by Malvasia.

An early guide to painting in Bologna, "the most important contemporary guidebook."—R. Wittkower (I359).

H68 Mancini, Giulio. Considerazioni sulla pittura, pubblicate per la prima volta de Adriana Marucchi con il commento di Luigi Salerno. Ed. critica e introd. di Adriana Marucchi. Presentazione di Lionello Venturi. Roma, Accademia Nazionale dei Lincei, 1956-57. 2v. facsims. (Fonti e documenti inediti per la storia dell'arte, 1.)

The first complete publication of a well-known treatise on painting and painters, written between 1614-30 by a physician who was interested in art. Compiled from variant extant manuscripts. An important source of first-hand information on the art of the period. Bibliography, v.2, p.[225]-30.

Contents: v.1, Considerazioni sulla pittura. Viaggio per Roma. Appendici. Edizione critica e introd. di Adriana Marucchi, presentazione di Lionello Venturi; v.2, Commento alle opere del Mancini, di Luigi Salerno. Note. Addenda. Bibliografia. Indice generale.

H69 Mander, Carel van. Het schilder-boeck, waer in voor eerst de leerlustighe iueght den grondt der edel vry schilderconst in verscheyden deelen wort voorghedraghen. Daer nae in dry deelen t'leuen der vermaerde doorluchtighe schilders des ouden, en nieuwen tyds. Eyntlyck d'wtlegghinghe op den Metamorphoseon pub. Ouidij Nasonis, oock daer lem. Haerlem, van Wesbvsch, 1604. 2v. engr. plates.

2d ed. 1618 includes an anonymous biography of Carel van Mander. The entire book has not been translated. English ed. of the biographies of Netherlandish and German painter, by C. Van de Wall (N.Y., 1936) has faults.

"It contains some original sections (e.g. the chapter on landscape painting is the first extensive treatment of the subject in occidental literature), but most of it codifies well-known Italian art theory and practice."—Rosenberg, Slive, Kuile (I388), p.23.

Contents: (1) Het leven der onde antijcke doorluchtighe schilders. Het leven der moderne, oft dees-tijsche doorluchtighe Italiaensche schilders; (2) Het leven der doorluchtighe Nederlandtsche, en Hooghduytsche schilders. Wtlegghingh op den Metamorphosis Pub. Ouidij Nasonis.

H70 Martinez, Jusepe. Discursos practicables del nibilísimo arte de la pintura. Edición, prólogo y notas por Julián Gállego. Barcelona, [n.p.] 1950. 303p. (Selecciones bibliófilas, v.8)

This critical ed. has an introduction, notes, and index of painters.

A 17th-century manuscript (c.1675) which was first published in the 19th century—1852 and 1866. The theoretical part (chapters I-XVII) reflects the artistic ideas of the Bolognese artists who worked in Rome. Chapters XV-XXI contain informal accounts of the lives of artists, mostly Spanish.

H71 Pacheco, Francisco. Arte de la pintura. Edición del manuscrito original, acabado el 24 de enero de 1638. Preliminar, notas e indices de F. J. Sánchez Cantón. Madrid, Instituto de Valencia de Don Juan, 1956. 2v.

1st ed., Seville, 1649; 2d ed., Madrid, Galiano, 1866.

A theoretical work on art in the service of religion. Written by the teacher and future father-in-law of Velázquez. In 3 books and 12 chapters.

H72 Passeri, Giovanni Battista. Vite de' pittori, scultori ed architetti che anno lavorato in Roma, morti dal 1641 fino al 1673. Roma, Barbiellini, 1772. xvi, 492p.

1st ed. published posthumously by Giovanni Lodovico Bianconi with notes by Giovanni Bottari. Baglione's Neapolitan edition of 1733 contains Passeri's biography of Salvatora Rosa (H50). The critical edition for art historians is the one reissued in 1934 as Bd. XI of the *Römische Forschungen der Bibliotheca Hertziana,* with notes by Jacob Hess.

Consists of long biographical articles on Roman artists, arranged chronologically by death date, from 1641–73. Continues where Baglione (H50) ends. Passeri, an artist-writer who belonged to a conservative circle (he omitted Bernini), recorded the artistic life in Rome from 1641–73.

H73    Ridolfi, Carlo. Le meraviglie dell'arte; ovvero le vite degli illvstri pittori veneti e dello stato, descritte da Carlo Ridolfi; ed. da Detlev Freiherrn von Hadeln. Roma, SOMU, 1965. 2v. ports. (Fonti per la storia dell'art)

1st ed., Venice, Sgaua, 1648; 2d ed., Padua, Cartallier, 1835–37.

The 1965 ed. listed above is a reprint of the valuable critical edition by D. von Hadeln, Berlin, 1914–24. Scholarly notes, detailed tables of contents, bibliography, and indexes of artists and places.

A primary source of information on painters from Venice and the Veneto region. Especially valuable for material on the author's contemporaries of the 17th century. Not a work of literary value. Contains engraved portraits of artists.

H74    Sandrart, Joachim von. L'Academia todesca della architectura, scultura & pittura; oder, Teutsche Academie der edlen Bau- Bild- und Mahlerey-Künste. Nürnberg, Sandrart; Frankfurt, Merian, 1675–79. 2v. in 3. il., plates, ports.

v.2 entitled: *Der Teutschen Academie zweyter und letzter Haupttheil* (1679).

Latin ed. 1683, trans. by Christianum Rhodius. A new ed. of Johann Jacob Volkmann, Nürnberg, 1768, in 8v.; also a modern ed. with commentary by A. R. Peltzer, Munich, 1925. (Repr.: Graz, Akad. Druck-u. Verlagsanstalt, 1965; Farnborough, Gregg, 1971.)

A monumental work written by a German classicist and artist who judged artists from his level of academic eminence. The theoretical material is based on Italian precedent.

Contents: pt. 1, General introduction based on Vasari, Palladio, Serlio, Van Mander, etc.; pt. 2, Lives of the artists; pt. 3, An attempt at a general inventory of works of art. Index of artists and important subjects, v.1, p.377–87. Illustrated with numerous plates and portraits.

H75    Scamozzi, Vincenzo. L'Idea della architettura universale. Divisa in X. libri. Venetiis, expensis avctoris, 1615. 2v. in 1. il., plans. (Repr.: Ridgewood, N.J., Gregg Pr., 1964.)

1st English ed., 1690; Dutch, 1662; French, 1713; German, 1664.

The last great Vitruvian treatise of the Renaissance. Never completed. Of the projected 10 books, 4, 5, 9, and 10 were never published. Bk. 6, on the orders, has been widely used by later European architects.

H76    Scannelli, Francesco. Il microcosmo della pittura. Saggio biobibliografico; appendice di lettere dello Scannelli e indice analitico, a cura Guido Giubbini. Milano, Labor [1966]. xxxii, 394, 103p. facsims. (Gli storici della letteratura artistica italiana, 15)

A facsimile of the original ed. (Cesena, 1657) with an added bio-bibliography of Scannelli, and an appendix containing his letters, a recent bibliography, and a general analytical index.

An art historical work of the 17th century in which the "microcosm" of painting is organized into three schools: Tuscan-Roman (Raphael and followers); Venetian (Titian); Lombard (Correggio).

H77    Scaramuccia, Luigi Pellegrini (*known as* Il Perugino). Le finezze de' pennelli italiani ammirate e studiate da Girupeno sotto la scorta e disciplina del genio di Raffaello d'Urbino [di] Luigi Scaramuccia. Saggio biobibliografico, catalogo delle opere pittoriche dello Scaramuccia e indice analitico a cura di Guido Giubbini. [Ristampa anastatica]. Milano, Labor [1965]. [23] 216p. 59p. port. (Gli storici della letteratura artistica italiana, 16)

1st ed., Pavia, Magri, 1674.

A 17th-century artistic guidebook to the cities of Italy, written in narrative style by a literary painter with classical taste. A facsimile of the original ed. (Pavia, 1674) preceded by a bio-bibliography of Scaramuccia and bibliography. The treatise is followed by notes, the itinerary of the trip of Girupeno accompanied by the Spirit of Raphael, and an analytical index of names, places, terms, and concepts.

H78    Soprani, Raffaele. Le vite de' pittori, scoltori, et architetti genovesi. E de' forastieri, che in Genoua operarono. Con alcuni ritratti de gli stessi. Opera postvma, dell'illustrissimo Signor Raffaele Soprani. Aggiontaui la vita dell'autore per opera di Gio. Nicolo Cavana. Genova, Bottaro e Tiboldi, 1674. 340p. plates.

An expanded ed.: *Delle vite de' pittori, scultori, ed architetti genovesi, tomo secondo scritto de Carlo Giuseppe Ratti in continuazione dell'opera de Raffaello Soprani.* Genova, Casamara, 1768-69. 2v. This ed. continues the work up to the middle of the 18th century.

Reprints: Facsimiles of the 1st and 2d ed., Bologna, Forni, 1971; 2d ed., issued with separate volume of indexes, ed. by Maria Grazia Rutteri, Genova, "Carletto" per Tolozzi, 1965.

This major source for material on Genoese artists and those who worked in Genoa contains a wealth of reliable information.

_____. Indici, a cura di Maria Grazia Rutteri. Genova, "Carletto" per Tolozzi, 1965. 109p.

H79    Vedriani, Ludovico. Raccolta de'pittori, scultori, et architetti modenesi più celebri. Modena, Soliani, 1662. 151p. (Repr.: Bologna, Forni, 1970. (Italica Gens, 16))

The earliest work on the artists of Modena.

## 18th — Early 19th Centuries

H80    Baruffaldi, Girolamo. Vite de' pittori e scultori ferraresi. Ferrara, Taddei, 1844-46. 2v. 57 plates. (Repr.: Bologna, Forni, 1971.)

Written between 1697 and 1722 but not published until 1844. The earliest history of the Ferrarese school of artists. A chapter is devoted to each artist; many line portraits. Arranged chronologically. A list of the artists treated is at the end of each volume.

"Vita dell'autore," v.1, p.ix-xx. "Quadro cronologico degli artisti ferraresi non rammentati dal Baruffaldi, e poco cogniti per opera," v.2, p.584-96. General index, v.2, p.597-604.

H81    Blondel, Jacques-François. Architecture françoise, ou, Recueil des plans, elevations, coupes de profils des églises, maisons royales, palais, hôtels & edifices les plus considérables de Paris, ainsi que des châteaux & maisons de plaisance situés aux environs de cette ville, ou en d'autres endroits de la France, bâtis par les plus célèbres architectes, & mesurés exactement sur les lieux. Avec la description des ces edifices, & des dissertations utiles & interéssantes sur chaque espece de bâtiment. Paris, Jombert, 1752-56. 4v. il., 500 plates (partly fold, incl. plans).

Luxury reprint with addendas: Paris, Librarie centrale des beaux-arts, Lévy [1904-05].

An indispensable source for research in the field of French architecture and planning of the 17th and 18th centuries. A monumental corpus of beautiful engravings of buildings in Paris and Versailles. Plans, elevations, sections, projects, perspective drawings. Also important for its introduction, notes, and descriptive commentaries by a great teacher. Succeeds and supplements the earlier Mariette (H105).

H82    [Bonafons, Louis Abel de] *known as* Abbé de Fontenay. Dictionnaire des artistes; ou, Notice historique et raisonnée des architectes, peintres, graveurs, sculpteurs, musiciens, acteurs et danseurs, imprimeurs, horlogers et méchaniciens. Paris, Vincent, 1776. 2v. (Repr.: Geneva, Minkoff, 1972.)

Primarily a biographical dictionary of artists but also includes actors, dancers, and academies. Sources are listed in the preface.

H83    Campbell, Colin. Vitruvius Britannicus, or, The British architect, containing the plans, elevations, and sections of the regular buildings, both publick and private, in Great Britain, with variety of new designs; Vitruvius Britannicus, ou, L'architect britannique, contenant les plans, élevations, & sections des bâtiments réguliers, tant particuliers que publics de la Grande Bretagne. [London, printed by the author and J. Smith, 1715-71].

Reprint: Vitruvius Britannicus, or, the British architect. Introduction by John Harris. N.Y., Blom, 1967-72. 4v. (chiefly plans, plates). Contents: v.1. Vitruvius Britannicus, v.1, 2, 3, by C. Campbell. First published, London 1715-25; v.2. Vitruvius Britannicus, the hitherto unpublished, volume the fourth, by J. Badeslade and J. Rocque. First announced, London, 1739. Vitruvius Britannicus, v.4 and 5, by J. Woolfe and J. Gandon. First published, London 1767-71; v.3. The new Vitruvius Britannicus, v.1 and 2, by G. Richardson. First published, London 1802-08; v. 4. Guide to Vitruvius Britannicus: annotated and analytic index to the plates [by] Paul Breman and Denise Addis. Foreword by John Harris.

This collection of engraved elevations and plans of English houses and other secular buildings of the late 17th and 18th centuries constitutes a primary source for the architectural historian. The reprint with index is most valuable for research.

H84    Chambers, *Sir* William. A treatise on civil architecture, in which the principles of that art are laid down, and illustrated by a great number of plates, accurately designed, and elegantly engraved by the best hands. London, Printed for the author, by J. Haberkorn, 1759. iv, 85p. plates.

2d ed., London, Dixwell, 1768. 86p. 50 plates (incl. plans, diagrs.); 3d ed. aug., 1791. (Repr. of the 3d ed. (1791): N.Y., Blom, 1968, entitled *A treatise on the decorative part of civil architecture.*)

The most influential architectural treatise of the latter half of the 18th century, written by a prominent architect. For a thorough discussion of the treatise—its genesis, character, theoretical approach, and reception—see "The treatise on civil architecture" by Eileen Harris, ch. 9 in John Harris, *Sir William Chambers,* London, Zwemmer, 1970.

H85    Cicognara, Leopoldo, *conte.* Storia della scultura dal suo risorgimento in Italia fino al secolo di Canova. Per servire di continuazione all'opere di Winckelmann e di d'Agincourt. Ed. 2. riveduta ed ampliata. Prato, Giachetti, 1823-24. 7v. front. (port.), 185 plates.

1st ed. 1813-18, 3v. 181 plates.

The information in this early history of Italian sculpture is still useful. The art historical treatment of the material typifies neoclassical and nationalist attitudes of the time. At end of v.7: "Indice degli scultori, architetti, fonditori, intagliatori e coniatori nominati nell' opera," and "Indice generale delle materie" for the 7v.

H86    Cumberland, Richard. Anecdotes of eminent painters in Spain, during the sixteenth and seventeenth centuries; with cursory remarks upon the present state of arts in that kingdom. 2d ed. London, Dilly, 1787. 2v.

1st ed., London, Walter, 1782.

Notes on Spanish painters and the art of Spain, written by a prominent English dramatist during a year's sojourn in Spain. Index of artists is at the end of each volume.

H87    Dallaway, James. Anecdotes of the arts in England; or comparative remarks on architecture, sculpture and painting, chiefly illustrated by specimens at Oxford. London, Cadell and Davies, 1800. xii, 526p. (Repr.: London, Cornmarket, 1970.)

An account of classical art in England, with emphasis on ancient sculpture in English collections. Written by the antiquarian who edited Walpole's *Anecdotes of painting in*

*England* (H127). Important for the study of English neo-classicism.

H88    Descamps, Jean Baptiste. La vie des peintres flamands, allemands et hollandois, avec des portraits gravés en taille-douce, une indication de leurs principaux ouvrage, et des réflexions sur leurs différentes manières. Paris, Jombert, 1753–64. 4v. front., il. (ports.) (Repr. of the original ed.: Geneva, Minkoff, 1972.)
A reissue of this work, with material on French and Italian painters by Dézallier d'Argenville, was published in Marseilles by Barile, 1840–43.

Biographies of 80 Flemish, German, and Dutch painters from the late 14th century to 1706. The preface outlines the limitations of the author's predecessors, his purpose, and sources. The lives are arranged chronologically; they include lists of the principal paintings and critical evaluations of those works known to the author. Index at the end of each volume.

H89    Dézallier d'Argenville, Antoine Joseph. Abrégé de la vie des plus fameux peintres, avec leurs portraits gravés en taille-douce, les indications de leurs principaux ouvrages, quelques réflexions sur leurs caractères, et la manière de connoître des desseins et les tableux des grands maîtres. Paris, De Bure l'Aîné, 1745–52. 3v. engr. plates, ports. (New ed., rev., corr., augm., 1762, Paris, De Bure l'Aîné, 4v.; German ed. trans. by J. J. Volkmann, Leipzig, 1767–68, 4v.; Repr. of the rev. ed. of 1762: Geneva, Minkoff, 1972.)
A collection of 250 lives of painters, including about 100 whose biographies are not to be found elsewhere. The articles are arranged by school; an engraved portrait precedes each biography.

Contents: v.1, Italian school; v.2, French, Dutch, Flemish, German and Swiss schools; v.3, is a supplement. Each volume has a "Table des matières."

H90    Dézallier d'Argenville, Antoine Nicolas. Vies des fameux architects depuis la renaissance des arts, avec la description de leurs ouvrages. Paris, De Bure l'Aîné, 1787. 2v. (Repr.: Geneva, Minkoff, 1972.)
v.2 has the title: *Vies des fameux sculpteurs depuis la renaissance des arts.*

An important early source of the lives of architects and sculptors written by the son of Antoine Joseph Dézallier d'Argenville (H89). Essays on architecture and sculpture are followed by the biographies. "Discours sur l'architecture et sur ses progrès sous nos rois," v.1, p.[xi]–lxxxiv; "Discours sur la sculpture," v.2, p.[i]–xxxvi. Index of architects, v.1, p.486–88; Index of sculptors, v.2, p.416–19.

H91    Diderot, Denis. Salons. Texte établi et présenté par Jean Seznec et Jean Adhémar. Oxford, Clarendon, 1957–67. 4v. plates, ports., facsims.
2d ed. of v.1 (1759, 1761, 1763), Oxford, Clarendon, 1975, has additional illustrations and includes critical notes on more works of art.

An important work of art criticism. The comments of Diderot on works of art exhibited in the *Salons* of the

Académie Royale de Peinture et de Sculpture from 1759–81. The official catalogue of each exhibition is reprinted. The editors, Seznec and Adhémar, have added biographical and critical notes. Well illustrated.

Contents: v.1. 1759, 1761, 1763; v.2. 1765; v.3. 1767; v.4. 1769, 1771, 1775, 1781.

H92    Dominici, Bernardo de. Vite de' pittori, scultori, ed architetti napoletani, non mai date alla luce di autore alcuno. Napoli, Ricciardi, 1742–43. 3v. (Repr.: Bologna, Forni, 1971.)
A new ed., Naples, Trani, 1840–46, in 4v. Modern abridged ed. with a critical introduction, notes, and bibliography by Felice de Filippis (Napoli, E.D.A.R.T., 1970). 299p., 113 plates (32 col.)

The principal source for the study of the Neapolitan School, despite some inaccuracies and falsifications. Alphabetical index of persons and subjects at the end of each volume.

H93    Doppelmayer, Johann Gabriel. Historische Nachricht von den Nürnbergischen Mathematicis und Künstlern. Nürnberg, Monath, 1730. 2v. plates.
Bk. 1 is devoted to mathematics, and Bk. 2 is concerned with artists from Nuremberg, at that time an important artistic center. Engraved plates of the works of art at the end. Bibliographical footnotes. Index in v.2.

H94    Duvaux, Lazare. Livre-journal de Lazare Duvaux, marchand-bijoutier ordinaire du roy 1748-1758. Précédé d'une étude sur le goût et sur le commerce des objets d'art au milieu du XVIIIᵉ siècle, et accompagné d'une table alphabétique des noms d'hommes, de lieux et d'objets mentionnées dans le journal et dans l'introduction [par] Louis Courajod. Paris, Pour la Société des Bibliophiles François, 1873. 2v. il. (Repr.: Paris, Nobele, 1965.)
v.I, by Louis Courajod, is a valuable study of the furniture collectors, commerce, makers, and *cabinets des curieux* of the mid-18th century. Based on extensive research in the French national archives. v.II is the actual journal of Duvaux, with entries dating from September, 1748 to February, 1762. The journal records names of buyers, identifying descriptions of the pieces, bills, and receipts. Extensive bibliographical footnotes. At end of v.II is a detailed index of subjects, names, and places.

H95    Edwards, Edward. Anecdotes of painters who have resided or been born in England; with critical remarks on their productions, intended as a continuation to the Anecdotes of painting by the late Horace, earl of Orford. London, Leigh and Sotheby, 1808. 327p. plates. (Repr.: London, Cornmarket, 1970, with a new introduction and bibliography by R. W. Lightbown.)
Continues Walpole (H127). Index, p.321–27.

H96    Gool, Jan van. De nieuwe schouburg der Nederlantsche kunstschilders en schilderessen: waer in de levens- en kunstbedryven der tans levende en reets overleedene schilders, die van Houbraken, noch eenig ander schryver, zyn aengeteekend, verhaelt worden.

's Gravenhage, Gedrukt voor den autheur, 1750-51.
2v. il. (Repr.: Soest, Davaco, 1971, 2v. in 1.)
Biographical accounts of Netherlandish painters, a continuation of Houbraken (H97). Numerous engraved portraits of artists. Alphabetical index of artists at the end of each volume.

H97    Houbraken, Arnold. De groote schouburgh der Nederlantsche konstschilders en schilderessen. Waar van 'er vele met hunne beeltenissen ten tooneel verschynen, en hun levensgedrag en konstwerken beschreven worden: zynde een vervolg op het Schilderboek van K. van Mander. Amsterdam, gedruckt voor den autheur, 1718-21. 3v. engr. il. 48 engr. plates.
2d ed. 1753 ('s Gravenhage, Swart, etc.); a critical ed. by P.T.A. Swillens, Maastricht; Leiter-Nypeis, 1943-53. A German translation abbreviated by Wurzbach in Eitelberger's *Quellenschriften* XIV (H5).
An important source for 17th-century painting in the Low Countries. Anecdotal, but more reliable than most art historians want to concede. Index at the end of each volume.

H98    Hüsgen, Heinrich Sebastian. Nachrichten von Franckfurter Künstlern und Kunst-Sachen enthaltend das Leben und die Wercke aller hiesigen Mahler, Bildhauer, Kupfer- und Pettschier-Stecher, Edelstein-Schneider und Kunst-Gieser. "Nebst einem Anhang von allem was in öffentlichen und Privat-Gebäuden, merckwürdiges . . . ist." Frankfurt am Main, 1780. 378p.
Contains biographical information on artists from Frankfurt.
Contents: Voorrede, p.v-xxxii; Nachrichten von Frankfurter Künstlern und Kunst-Sachen, p.3-216; Anhang von allem was in öffentlichen und Privat-Gebäuden der Stadt Frankfurt am Mayn merwürdiges von Kunst-Sachen . . . ist, p.221-366; Register aller hiesigen Künstler, p.367-78.

H99    Knorr, George Wolfgang. Allgemeine Künstler-Historie, oder, Berühmter Künstlere Leben, Werke und Verrichtungen, mit vielen Nachrichten von raren alten und neuen Kupferstichen beschrieben. Nürnberg, Bieling, 1759. 282p. plates, ports.
Notes on 127 Northern artists, followed by the lives of certain Italian artists (p.184-282). Includes a long section on Dürer (p.21-94). Portraits of the artists are on 11 engraved plates.

H100    Lairesse, Gérard de. Het groot schilderboek. Amsterdam, Erfgenaamen van W. de Coup, 1707. 2v. in 1. plates. (Repr.: Soest, Davaco, 1969 of the 2d ed., Haarlem, Marshoorn, 1740.)
Also published in Amsterdam, 1712, 1714, 1716, 1836; in Haarlem, 1740; in French, Paris, 1787; in German, Nürnberg, 1728 and 1780, under the title *Grosses Maler-buch;* in English (trans. by Fritsch), London, 1738, 1778, and 1817.
Basically a handbook of artistic theory. Schlosser (A49) described it as a typical representative of academic theory with little or nothing new.

H101    Lanzi, Luigi Antonio. Storia pittorica della Italia dal risorgimento delle belle arti fin presso al fin del XVIII secolo. Bassano, Remondini, 1795-96. 3v.
The 1st complete ed.

Repr. of the 1st ed.: Firenze, Sansoni, 1968- . 1824-25 ed. (Milano, Società Tipografica de' Classici Italiani, 4v.) is based on the 3d rev. ed. of Bassano, 1809, and is amended, expanded, and in better order than the 1796 ed. 4th ed.: Pisa, 1815-17; Bassano, 1818; Firenze, 1822. 5th ed.: Firenze, 1834 and 1845. English ed. trans. by Thomas Roscoe. London, Simpkin and Marshall, 1828. Other English editions in 1847 and 1852-54 by H. G. Bohn.
An early history of Italian painting "still unequalled for knowledge of the material and breadth of approach." —R. Wittkower (I359).
Contents: (1) Ove se descrivono le scuole della Italia inferiore, la Fiorentina, la Senese, la Romana, la Napolitana; (2) Ove se descrivono alcune scuole della Italia superiore, la Veneziana; e le Lombarde di Mantova, Modena, Parma, Cremona e Milano; (3) Ove se descrivono altre scuole della Italia superiore, la Bolognese, la Ferrarese, e quelle di Genova e del Piemonte.
Indexes in v.3: artists, p.387; historical and critical books listed in the work, p.522-43; subjects, p.543-52.

H102    Lépicié, François Bernard. Vies des premiers-peintres du roi, depuis M. LeBrun, jusqu'à présent. Paris, Durand, 1752. 2v. in 1. (Repr.: Geneva, Minkoff, 1972.)
Detailed information on the painters who worked for Louis XIV and Louis XV, from LeBrun to the mid-18th century. Very useful.

H103    Marcheselli, Carlo Francesco. Pitture delle chiese di Rimini. 1754. Ristampa anastatica corredata da indici di ricerca, da un commentario di orientamento bibliografico e informativo, da un repertorio illustrato. In appendice, il manoscritto di Marcello Oretti sulle Pitture nella città di Rimini (1777). A cura di Pier Giorgio Pasini. Bologno, ALFA, 1972. 287p. il. 32 plates. (Fonti e studi per la storia di Bologna e delle province emiliane e romagnole, 4)
1st ed., Rimini, Albertiniana, 1754.
A critical ed. of the 18th-century guidebook to paintings in the churches of Rimini, illustrated with many recent photographs. Includes an introduction, critical and bibliographical notes, an index of artists and works cited, and a repertory of those paintings which still exist.

H104    Mariette, Pierre Jean. Abecedario de P. J. Mariette et autres notes inédites de cet amateur sur les arts et les artistes. Ouvrage publié d'après les manuscrits autographes conservés au Cabinet des Estampes de la Bibliothèque Impériale, et annoté par M. M. Ph. de Chennevières et A. de Montaiglon. Paris, Dumoulin, 1851/53-1859/60. 6v. (Archives de l'art français, t. 2, 4, 6, 8, 10, 12)
Intended to correct the errors of P. A. Orlandi's *Abecedario pittorico* (1704) (H110). Contains notes and biographical sketches on artists of various nationalities.
Contents: t.1, A-Col; t.2, Col-Isac; t.3, Jabach-Mingozzi; t.4, Mocchi-Roberti; t.5, Robusti-Van Oye; t.6, Van Santen-Zumbo, Appendices, Supplément.

H105    Mariette, Jean. L'architecture françoise, ou Recueil des plans, elevations, coupes et profils des eglises, palais, hôtels & maisons particulieres de Paris, & des chasteaux & maisons de campagne ou de plaisance des environs, & de plusieurs autres endroits de France, bâtis nouvellement par les plus habils architectes, et levés & mesurés exactement sur les lieux. Paris, Chez Jean Mariette, MDCCXXVII. 2v. plates. (Repr.: Paris, Van Oest, 1927-29, with introd. and index by M. Louis Hautecoeur.)

This great collection of engravings is a primary source for the study of French classical architecture. It precedes J.-F. Blondel (H81).

H106    Marot, Jean. L'architecture française. [Paris? c.1670]. [4]p. 195 plates.

Called "Le Grand Marot." A collection of architectural engravings, important as a source for the study of 17th-century French architecture.

H107    _____. Recueil des plans, profils et eleuations des plusieurs palais, chasteaux, eglises, sepultures, grotes et hostels batis dans Paris . . . et aux enuirons, auec beaucoup de magnificence, par les meilleū architectes du royaume, desseignez, mesurés et grauez par Jean Marot, architecte parisien. [Paris? c.1660-70]. 116 plates (incl. plans)

Called "Le Petit Marot." A series of beautiful engravings of facades and plans of important French buildings and monuments.

H108    Milizia, Francesco. Memorie degli architetti antichi e moderni. 3d. ed. Parma, Stamperia Reale, 1781. 2v.

1st ed. 1768.

English ed.: *The lives of celebrated architects, ancient and modern; with historical and critical observations on their works, and on the principles of art.* Trans. from the Italian by Mrs. Edward Cresy. With notes and additional lives. London, Taylor, 1826.

An early history of architecture. Follows the Vasari format of a series of lives arranged chronologically, with critical introductions to each period or century. Especially valuable as a source for 18th-century Italian architects. Also noted as a remarkable example of lively architectural criticism. The comments reflect the author's classical taste.

H109    Orellana, Marcos Antonio de. Biografía pictórica valentina; o, Vida de los pintores, arquitectos, escultores y grabadores valencianós; obra filológica. 2d. ed. preparada por Xavier de Salas, [Valencia], Ayuntamiento de Valencia, 1967. xlvii, 654p.

Lives of Valencian artists written in the 18th century, first published by Xavier de Salas in 1930 (Madrid, Marinas). Erudite, based on documents. The 2d critical ed. of 1967 contains a prologue, a bibliography of Orellana, scholarly notes, and a detailed index.

H110    Orlandi, Pellegrino Antonio. Abecedario pittorico nel quale compendiosamente sono descritte le patrie, i maestri, ed i tempi, ne'quali fiorirono circa quattro mila professori di pittura, di scultura, e d'architettura, diviso in tre parti. Il tutto disposto in alfabetto per maggior facilità de' dilettanti. Bologna, Pisarri, 1704. 436p. il. (Repr.: Geneva, Minkoff, 1973, under the title *Abecedario pittorico, contenente le notizie de' professori de pittura, scultura ed architettura.*)

2d ed. enl., 1719. Other editions: Florence, 1731, 1776, 1788; Venice, 1753; Naples, 1733 and 1763 (enlarged editions with additional biographies of Neapolitan artists, including Solimena, to whom the work is dedicated).

An early biographical dictionary containing one of the first bibliographies of art literature, p.390-407. List of artists at the end.

H111    Palomino de Castro y Velasco, Acisclo Antonio. El museo pictórico, y escala óptica. Madrid, Sancha, 1715-24. 3v. in 1. fronts. (v.1-2), plates, diagrs. (part fold.). v.3 entitled: El parnaso español pintoresco laureado. Con las vidas de los pintores, y estatuarios eminentes españoles. (Repr.: Madrid, Aguilar, 1947.)

English trans. by Isaac Ware: *An account of the lives and works of the most eminent Spanish painters, sculptors and architects; and where their several performances are to be seen.* London, Harding, 1739.

A fundamental Spanish source on art theory, history, and practice. Schlosser (A49) refers to Palomino as the Spanish Vasari. v.3 contains the lives of Spanish painters from the beginning of the 16th century to the beginning of the 18th century.

Contents: (I) Teórica de la pintura; (II) Práctica de la pintura; (III) Noticias, elogios, y vidas de los pintores, y escultores eminentes espānoles.

H112    Pascoli, Lione. Vite de' pittori, scultori, ed architetti moderni. Roma, Rossi, 1730-36. 2v. (Repr.: Amsterdam, Israël, 1965.)

The lives of artists who worked in Rome in the 17th and early 18th centuries. Includes foreign artists in Rome. On the whole the information is reliable. Each volume is divided into three sections: painting, sculpture, and architecture.

H113    Piles, Roger de. Abrégé de la vie des peintres avec des réflexions sur leurs ouvrages, et un traité du peintre parfait, de la connoissance des desseins & de l'utilité des estampes. Paris, Langlois, 1699. 540p. (Repr.: Hildesheim, Olms, 1969; Geneva, Minkoff, 1973, of the 2d. ed.)

2d ed. Paris, Estienne, 1715. Also published in Amsterdam, 1767. Published in German by Marperger, Hamburg, 1710; in English in London, 1706 and 1744.

Contains general articles on painting, drawing, prints, and short articles on about 300 painters, as well as an article on taste.

The French ed. of 1699 has an alphabetical list of painters at the end. The English ed. of 1706, in addition to the biographies, contains sections on composition, design, expression, perspective, color, prints, and landscape, as well as an "Essay towards an English school." The 1744 English ed. has an alphabetical list of painters at the beginning of the volume.

*See* Teyssèdre, B. *L'histoire de l'art; vue du grand siècle. Recherches sur l'abrégé de la vie des peintres, par Roger de Piles (1699), et ses sources.* Paris, Julliard [1964]. A thorough study of the art historical literature, methods, criticism, and taste of the 17th century, with special attention to the sources and writings of Roger de Piles. Contains an exhaustive bibliography.

H114 _____. Cours de peintre par principes. Paris, Estienne, 1708. 493p. 2 plates. (Repr.: Geneva, Slatkine, 1969.)
Published in Paris, 1708, 1720, 1791; in English, London, 1743. The German ed., Leipzig, 1760, is entitled *Einleitung in die Malerei aus Grundsätzen.* Also published in Dutch with *L'Aretino* of L. Dolce, Amsterdam, 1756.

The author classifies painters according to composition, design, color, and expression.

For a detailed study of Roger de Piles, the Academy, and the debates on color vs. drawing, see B. Teyssèdre, *Roger de Piles et les débats sur le coloris au siècle de Louis XIV,* Paris, 1965, with an exhaustive bibliography of sources and later publications, p.[539]–[678].

H114a Pio, Nicola. Le vite di pittori, scultori et architetti [Cod. ms. Capponi 257]. Ed. with an introduction by Catherine and Robert Enggass. Città del Vaticano, Biblioteca Apostolica Vaticana, 1977. 468p. (Vatican. Biblioteca Vaticana. Studi e testi, 278)
The first publication of Pio's *Vite,* a collection of 225 biographies of artists which was completed in 1724. Nicola Pio was a well known collector of drawings and prints who lived in Rome. His manuscript is in the Vatican Library. This critical ed., prepared by Catherine and Robert Enggass, has extensive documentation, including up-to-date bibliographies of lesser-known Italian artists of the late Baroque period.

Contents: Introduction; Text: *Le Vite di pittori, scultori et architetti* di Nicola Pio; Notes; Bibliographies of individual artists born after 1650; List of destroyed or secularized churches; List of members of the Accademia de S. Luca; List of portraits of artists drawn for Pio's *Lives* (the Stockholm Portraits); List of the Lives of the artists in Pio; Index of names; Index of places.

H115 Ponz, Antonio. Viaje de España, en que se da noticia de las cosas mas apreciables, y dignas de saberse, que hay en ella. Madrid, Ibarra, 1772–94. 18v.
"Su autor D. Pedro Antonio de la Puente."
2d ed., 1774–83; 3d ed., 1787–94. Italian ed., Parma, 1793–97, in 4v.

A modern reprint, *Viaje de España, seguido de los dos tomos del Viaje fuera de España. Preparación, introducción e índices adicionales de Castro María del Rivero* (Madrid, Aguilar, 1947, lx, 2039p. il.), is a critical ed., which includes indexes of names and places, works and authors, as well as a detailed table of contents.

An early description of Spanish monuments written during the author's travels in Spain. Prefaced by a life of the author.

H116 Pozzo, Bartolomeo dal. Le vite de' pittori, degli scultori et architetti Veronesi raccolte da varj autori stampati, e manuscritti, e da altre particolari memorie. Con la narratiua della pitture, e sculture, che s'attrouano nelle chiese, case & altri luoghi publici, e priuati de Verona, e suo territorio. Uerona, Berno, 1718. 313p.
The lives of artists from Verona, and descriptions of the art treasures in the city, including private collections and decorative paintings in buildings. Based on documents and earlier sources. Index of artists (4p.) at the beginning of the volume.

_____. Aggiunta alle Vite de' pittori, degli scultori et architetti veronesi del Signor Fr. Bartolomeo. Verona, Berno, 1718. 42p.

H117 Quatremère de Quincy, Antoine Chrysostome. Histoire de la vie et des ouvrages des plus célèbres architectes du XIe siècle jusqu'à la fin du XVIIIe, accompagnée de la vie du plus remarquable édifice de chacun d'eux. Paris, Renouard, 1830. 2v. plates. (Repr.: N.Y., Hacker, 1970.)
An early history of architecture by the celebrated neoclassicist. The lives and works of 45 famous architects are arranged chronologically by architect. Elegant line engravings.

H118 Seroux d'Agincourt, Jean Baptiste Louis Georges. Histoire de l'art par les monuments, depuis sa décadence au IVe siècle jusqu'à son renouvellement au XVIe. Paris, Treuttel et Würtz, 1823. 6v. in 3. 325 plates (incl. plans)
Italian trans. by Ticozzi, Prato, 1826–29; English ed., London, Quaritz, 1847, and London, Longmans, 1847.

An early general history of art published in 24 pts., 1810–23.

Contents: v.1, Architecture; v.2, Sculpture, painting; v.3, Text and description of plates; v.4, Plates; v.5, Plates of painting. "Notice sur la vie et les travaux de J.L.G. Seroux d'Agincourt" by A. E. Gigault de La Salle, v.1., p.1–10.

H119 Susinno, Francesco. Le vite de' pittori messinesi. Testo, introd. e note bibliografiche a cura di Valentino Martinelli. Florence, LeMonnier, 1960. lx, 331p. plates. (Pubblicazioni dell'Istituto di Storia dell'Arte Medioevale e Moderna, Facoltà di lettere e filosofia, Università di Messina, 1)
An early collection of lives of painters from Messina, published for the first time in this critical ed. by Valentino Martinelli, based on a 1724 manuscript by the painter Francesco Susinno. Bibliographical notes, p.297–302; Index, p.305–31.

H120 Tassi, Francesco Maria. Vite de' pittori, scultori e architetti bergamaschi. Saggio bibliografico; edizioni critiche dei manoscritti; "Catalogo dei libri del conte F. M. Tassi," 21 lettere di F. M. Tassi a G. Carrara; scelte critiche dai manoscritti "Memorie raccolte per service alla storia dei pittori etc." di F. M. Tassi e suoi corrispondenti, "Giunte," "Notizie" e "Memorie" di G. Carrara; indice analitico generale a cura di Franco Mazzini. Milano, Labor, 1969–70. 2v. front. (port.) (Gli storici della letteratura, 31–32)
A photographic reprint of the original ed. (Bergamo, 1793) with a valuable supplement consisting of Tassi's list of churches and their art, the preliminary notes for the *Vite,* a catalogue

of Tassi's library, and 21 letters. Detailed analytical index by F. Mazzini.

A basic source for artists from Bergamo.

H121  Temanza, Tommaso. Vite dei più celebri architetti e scultori veneziani che fiorirono nel secola decimosesto. Venice, Palese, 1778. 550p. il. (Repr.: Milan, Labor, 1966 [Gli storici della letteratura artistica italiana, 29]. Includes critical commentaries, a chronology, bibliography, and an analytical index by L. Grassi.)

A primary source on architects and sculptors who worked in the Veneto during the 16th century. Based on documentary research.

H122  Ticozzi, Stefano. Dizionario degli architetti, scultori, pittori, intagliatori in rame ed in pietra, coniatori di medaglie, musaicisti, niellatori, intarsiatori d'ogni età a d'ogni nazione. Milano, Schiepatti, 1830-33. 4v.

A biographical dictionary of architects, sculptors, painters, engravers, medalists, mosaicists, niellists, and intarsia workers of all periods and countries.

H123  Tiraboschi, Girolamo. Notizie de' pittori, scultori, incisori, e architetti natii degli stati del serenissimo signor duca di Modena. Modena, Società tipografica, 1786. 399p. fold. geneal. tab. Also published as a supplement in v.6 of *Biblioteca modenese; o, notizie della vita e delle opere degli scrittori natii degli stati del duca di Modena*. Modena, 1781-86.

Notes on the artists and musicians from the region of Modena, compiled by a renowned literary historian. Each area of art is arranged alphabetically by the name of the artist.

H124  Valle, Guglielmo della. Lettere senesi di un socio dell'Accademia di Fossano sopra le belle arti. Venezia, Pasquali, 1782-86. 3v. il.

v.2 has imprint: Roma, Salomoni; v.3: Roma, Zempel.

A collection of letters concerning the history, principles, and practice of art. Scholarly, reliable, based on documentary research. v.3 contains the lives of artists. Most important for information on works of artists from Siena. Bibliographical notes. General index at end of v.3.

H125  Verci, Giovanni Battista. Notizie intorno alla vite e alle opere de'pittori, scultori e intagliatori della città di Bassano. Venezia, Gatti, 1775. viii, 328p. front.

Contains indexes of painting and sculpture to be found in the churches in Bassano and surrounding towns. Painting, p.1-277; sculpture and engraving, p.278-313. Well documented.

H126  Vertue, George. The note-books of George Vertue relating to artists and collections in England. [Ed. by Sir Henry Hake]. Oxford, Printed for the Walpole Society at the Univ. Pr., 1930-55. 6v. in 7. il., plates, facsims.

The notes have been published in the *Walpole Society annual* (Q345), v.18, 1929/30; v.20, 1931/32; v.22, 1933/34; v.24, 1935/36; v.26, 1937/38 and Index to volumes I-V, v.29, 1947; v.30, 1955.

7v. of notes on artists and private collections, written by George Vertue between 1718 and his death in 1757. These were intended to be compiled into a history of painting and sculpture in England.

H127  Walpole, Horace, *Earl of Orford*. Anecdotes of painting in England; with some account of the principal artists; and incidental notes on other arts; collected by the late Mr. George Vertue; and now digested and published from his original mss. by Mr. Horace Walpole . . . Strawberry Hill, Printed by Thomas Farmer, 1762-71. 5v. engr. incl. plates.

Includes an article, "The history of the modern taste in gardening." v.5 consists of *A catalogue of engravers who have been born, or resided in England*, also a "Life of Mr. George Vertue," and a list of Vertue's works (printed in 1771, published in 1780). Subsequent editions: 2d ed., 1765-80; 3d ed., with additions (no illustrations), 1782; 4th ed., 1786; Ed. with notes by J. Dallaway, 1828; another ed. with additional notes by R. N. Wornum, 1849; reprint of the 4th ed., with the additions and notes by J. Dallaway, 1871.

Modern reprint of the 1871 ed.: N.Y., Arno, 1969, in 4v. v.4 consists of the 1937 supplement, *Anecdotes of painting in England 1760-1795* ed. by F. W. Hilles and P. B. Daghlian (H128).

The *Anecdotes* were collected and digested in what Walpole called his "years of Vasarihood." An important pioneering work, still basic. The history ranges in scope from "the earliest accounts of painting in England" to the reign of George II (includes only artists who died at this time). Not limited to painting as the title suggests; contains notes on architecture, sculpture, and the other arts. The reliable text is interspersed with critical, quotable comments on the art and artists, reflecting the personal taste of the owner of Strawberry Hill.

The biographies of the artists are arranged chronologically by reigns. Index of artists at the end of each volume; later editions have general indexes at the end of the work. Continued by the modern supplement, *Anecdotes of painting* (H128).

H128  ———. Anecdotes of painting in England; 1760-1795, with some account of the principal artists; and incidental notes on other arts; collected by Horace Walpole; and now digested and published from his original mss. by Frederick W. Hilles and Philip B. Daghlian. Volume the fifth and last. New Haven, Yale Univ. Pr., 1937. xv, 262p. facsim. (Repr.: N.Y., Arno, 1969.)

Forms a supplement to his *Anecdotes of painting in England* (H127).

The bulk of the material has been selected from Walpole's *Book of materials*, in the Folger Shakespeare Library. Other selections are from the author's set of annotated catalogues of exhibitions, owned by Wilmarth Lewis.

Contents: (1) Introduction, Principal artists, societies, and academies of art, Miscellaneous notes; (2) Painters of portraits; (3) Painters of history, landscape; (4) Painters in enamel and miniature; (5) Statuaries; (6) Architecture and architects; (7) Engravers and medallists; (8) Ladies and

gentlemen distinguished by their artistic talents. Index of names, p.241-62.

H129 Weyerman, Jacob Campo. De levens-beschryvingen der Nederlandsche konst-schilders en konst-schilderessen, met een uytbreyding over de schilder-konst der ouden, Verrykt met de konterfeytsels der voornaamste konst-schilders en konst-schilderessen, cierlyk in koper gesneden door J. Houbraken. 's Gravenhage, Boucquet, [etc.] 1729-69. 4v. il.

Weyerman plagiarized Houbraken (H97) and most scholars in the field have questioned the reliability of the original material. Index at the end of each volume.

H130 Winckelmann, Johann Joachim. Geschichte der Kunst des Altertums. Dresden, Walther, 1764. 2v. in 1. 431p. Repr. of German ed.: Vienna, Phaidon, 1934; Weimar, Böhlaus, 1964; Baden-Baden, Strasbourg, Heitz, 1966. An English trans. by G. Henry Lodge: Boston, Osgood, 1872-73. Repr. of English ed.: N.Y., Ungar, 1969.

An important book, sometimes called the first modern history of art. Now most useful for art historiography and for the study of all phases of the neoclassical movement. For a good discussion of Winckelmann's ideas on art, with selections (in English) from his works, see David Irwin, *Writings on art by Johann Winckelmann*, London, Phaidon, 1972.

SEE ALSO: Eitner, L. *Neoclassicism and Romanticism, 1750-1850* (H6); Wiebenson, D. *Sources of Greek revival architecture* (J141). See also the list of early dictionaries and encyclopedias: E20-E25.

# Collections

## France

H131 Archives de l'art français; recueil de documents inédits relatifs à l'histoire des arts en France. t.1-12; 2. sér., t.1-2. Paris, Dumoulin [etc.], 1851-[66]. 14v. (Repr.: Paris, Nobele, 1967, of v.2, 4, 6, 8, 10, 12, and n.s. v.1-2.)

A collection of source material and documents relative to French art. The odd-numbered volumes contain the "Documents, t.1-6." (1-3 "pub. sous la direction de Ph. de Chennevières; [4-6] pub. sous la direction de M. Anatole de Montaiglon." v.6, "suivi d'une table complète des noms de personnes et de lieux compris dans les six volumes.") The even-numbered volumes contain the "Abecedario de P. J. Mariette et autres notes inédites de cet amateur sur les arts et les artistes. Ouvrage publié et annoté par M. Ph. de Chennevières et A. de Montaiglon. t.1-6." An index to the two series is included in "Table générale des documents contenus dans les Archives de l'art français, et leurs annexes (1851-1896)" issued in *Nouvelles archives de l'art français,* 3 sér., t.12, p.[253]-428.

Continued as *Nouvelles archives de l'art français,* 1872-1906; *Archives de l'art français* . . . pub. par la Société de l'Histoire de l'Art Français. Nouvelle période, 1907- (H144).

*Nouvelles archives de l'art français,* 1872-78; 2 sér., t.1-6, 1879-85; 3 sér., t.1-22, 1885-1906; nouv. période, 4 sér., t.1- , 1907- . Paris, Baur, [etc.].

H132 Bertolotti, Antonino. Artisti francesi in Roma nei XV, XVI e XVII; ricerche e studi negli archivi romani. Mantova, Mondivi, 1886. 255p.

A collection of documents concerning French artists in Rome during the 15th, 16th, and 17th centuries. Indexes of subjects and names.

H133 Fontaine, André, ed. Conférences inédites de l'Académie Royale de Peinture et de Sculpture d'après les manuscrits des archives de l'École des Beaux-arts. Paris, Fontemoing, [1903]. lxiii, 232p.

An important collection of the reports, discussions, and debates which took place in the meetings of the Royal Academy from its foundation until the early 18th century.

Contents: Préface; Les conférences de l'Académie Royale de Peinture et de Sculpture au XVII<sup>e</sup> siècle [by André Fontaine]; (1) La querelle du dessin et de la couleur [lectures by Philippe and J. B. de Champaigne, Charles Le Brun, and others]; (2) Conférences de Le Brun, de Philippe et de Jean Baptiste de Champaigne; (3) L'année 1672 [lectures by Michel Anguier]. Appendice: (A) Retouches du XVIII<sup>e</sup> siècle sur un discours de Philippe de Champaigne; (B) Conférence de M. Nocret sur le portrait du Marquis del Vasto, du Titien (7 septembre 1668).

H134 France. Archives Nationales. (Minutier des notaires parisiens). Documents du Minutier Central concernant les peintres, les sculpteurs et les graveurs au XVIIe siècle (1600-1650) [par] Marie-Antoinette Fleury. Paris, S.E.V.P.E.N., 1969- . 1v. plates, ports., map., facsims.

A listing and analysis of those documents from ten *études* in the Parisian archives which relate to painters, sculptors, and engravers during the first half of the 17th century. Introduction on the social condition of the artists and artistic trade with Spain. The analyses are arranged alphabetically by artist.

Detailed subject index and index of artists. Appendices: (1) Commerce de l'imagerie française en Espagne; (2) Un chef-d'oeuvre de menuisier, bordure et fond de tableau; (3) Listes chronologiques des marchés et des inventaires après décès. Index. p.799-970; Table des illustrations, p.971; Table des matières, p.973.

H135 _____. _____. _____. Documents du Minutier Central concernant l'histoire de l'art (1700-1750) [par] Mireille Rambaud, conservateur. Préf. d'André Chamson. Paris, S.E.V.P.E.N., 1964-71. 2v. il.

A methodical listing and analysis of the documents in 20 of the *études* in the French national and departmental archives. The documents analyzed concern art of the first half of the 18th century. Arranged alphabetically by artist (architect, painter, draftsman, engraver, sculptor). v.1 includes musicians and a section related to tapestries. Each entry gives archive locations and an analytical description of the contracts. General index at the end of each volume. At end of v.2:

"Index des sujets de peintures, dessins, gravures et sculptures mentionnés dans les états et inventaires," p.1269-98.

H136 Granges de Surgères, Anatole, *marquis* de. Artistes français des XVIIe et XVIIIe siècles (1681-1787). Extraits des Comptes des états de Bretagne. Paris, Charavay, 1893. 246p. (Société de l'Histoire de l'Art Français)

A collection of extracts from documents relevant to Baroque and Rococo art in Brittany. Arranged alphabetically by artist. Index, p.203-40.

H137 Guiffrey, Jules Marie Joseph, ed. Collection des livrets des anciennes expositions depuis 1673 jusqu'en 1800. Paris, Liepmannssohn et Dufour, 1869-73. 43v.

The collected catalogues of the Salons from 1673 to 1800; an indispensable resource for French painting and sculpture of the *ancien régime* and the Revolution.

v.43 consists of "Table générale des artistes ayant exposé aux salons du XVIII^e siècle, suivie d'une table de la bibliographie des salons, précédée de notes sur les anciennes expositions et d'une liste raisonnée des salons de 1801 à 1873 par J. J. Guiffrey" (Paris, Baur, 1873).

See also: Paris. Salon. *Catalogues* (H146).

H138 _____. Comptes des bâtiments du roi sous le règne de Louis XIV. Paris, Impr. Nationale, 1881-1901. 5v. (Collection des documents inédits sur l'histoire de France; 3^e série)

A year-by-year record of building expenses and related matters in connection with the art enterprises of the French crown. Each volume has a list of artists and an alphabetical index.

Contents: (I) Colbert, 1664-80; (II) Colbert et Louvois, 1681-87; (III) Louvois et Colbert de Villacerf, 1688-95; (IV) Colbert de Villacerf et Jules Hardouin-Mansart, 1696-1705; (V) Jules Hardouin-Mansart et le duc d'Antin, 1706-15.

H139 Laborde, Léon Emmanuel Simon Joseph, *marquis* de, ed. Les Comptes des bâtiments du roi (1528-1571) suivis de documents inédits sur les châteaux royaux et les beaux-arts au XVIe siècle, recueillis et mis en ordre par le marquis Léon de Laborde. Paris, Baur, [etc.], 1877-80. 2v. in 1.

At head of title: Société de l'Histoire de l'Art Français.

Editor: Jules Guiffrey.

A year-by-year record of building expenses and related matters in connection with the architectural enterprises of the kings of France.

"Table du deuxième volume dont le manuscrit est aujourd'hui perdu des Comtes des batiments (1571-1599)," v.1, p.[xxxi]-xlviii. "Liste bibliographique des ouvrages de M. le marquis L. de Laborde," v.1, p.[xlix]-lxii.

H140 _____. La Renaissance des arts à la cour de France; études sur le seizième siècle. Tome 1 [with "Additions"]. Peinture. Paris, Potier, 1850-55. 2v. (paged continuously) xlviii, 1088p. No more published. (Repr.: Geneva, Slatkine, 1970.)

A collection of original documents pertaining to 16th-century French painters and painting. At end of v.1: "Table des chapitres," p.[542]-44; "Table méthodique et chronologique des peintres employés à la cour de France," p.[545]-48; "Table alphabétique," p.[549]-63. At end of "Additions" [v.2]: "Table des matières contenues dans les additions au tome premier," p.[1085]-88.

H141 Leblond, Victor. L'art et les artistes en Ile-de-France au XVIe siècle. (Beauvais & Beauvaisis) d'après les minutes notariales; avec 7 phototypies et 80 marques, signatures et monogrammes. Paris, Champion, 1921. 352p. plates (part fold., incl. facsims.) (Publication collective de la Société Académique de l'Oise et de la Société Historique du Vexin. Documents. t.VI)

Contains more than 400 documents relating to the art and artists of the region. Includes art fairs, contracts of apprenticeship of master masons, painters, image carvers, glassworkers, bell casters, embroiderers, organ makers, and clockmakers.

Signatures, marks, and monograms are on seven plates at the end. Bibliographical footnotes. Iconographic index, p.312-14. "Table," p.315-52.

H142 Montaiglon, Anatole de Courde de, ed. Correspondance des directeurs de l'Académie de France à Rome avec les surintendants des bâtiments, publiée d'après les manuscrits des Archives Nationales par M. Anatole Montaiglon et Jules Guiffrey sous le patronage de la direction des beaux-arts, 1666-[1804]. Paris, Charavay, 1887-1912. 18v. (Repr.: t.I, II, III, XVI, XVIII, Paris, Nobele, 1967.)

Seal of the Société de l'Histoire de l'Art Français on title page of each volume.

The complete official correspondence of the directors of the French Academy in Rome from 1666-1804. An important resource for the history of French classicism. Complements *Procès-verbaux* (H143). t.18, "Table général," ed. by M. Paul Cornu, was published in 1912.

H143 _____. Procès-verbaux de l'Académie Royale de Peinture et de Sculpture, 1648-1793; pub. pour la Société de l'Histoire de l'Art Français d'après les registres originaux conservé à l'École des Beaux-Arts. Paris, Baur [etc.], 1875-92. 10v.

v.4-10 published by Charavay frères, Paris.

A fundamental source, with full documentation of the proceedings, lectures, and discussions of the French Academy from its origin in 1648 to 1793. "Table chronologique," v.10, p.[225]-42. "Table des Procès-verbaux de l'Académie Royale de Peinture et de Sculpture, 1648-1793, rédigée pour la Société de l'Historie de l'Art Français par M. Paul Cornu," Paris, Schemit, 1909, vii, 228p. Full names and dates of artists are given in this index.

H144 Nouvelles archives de l'art français, 1872-78; 2. sér., t.1-6, 1879-85; 3. sér., t.1-22, 1885-1906. Paris, Baur [etc.]. Frequency varies; sér. 3 monthly.

Selectively reprinted: Paris, Nobele, 1966.

Preceded by *Archives de l'art français*, 1851-62. Continued as *Archives de l'art français . . . pub. par la Société de*

*l'Histoire de l'Art Français*. Nouvelle période. Subtitle varies; sér. 3 is entitled *Nouvelles archives de l'art français . . . revue de l'art français ancien et moderne* and is in two sections, the second devoted to current sales, acquisitions, and books. "Table générale des documents contenus dans les *Archives de l'art français* et leurs annexes (1851-96)" in sér. 3, v.12.

An important collection of documents concerning the arts in France during various periods.

H145 Paris. Châtelet. Artistes parisiens du XVIe et du XVIIe siècles; donations, contrats de mariage, testaments, inventaires, etc. tirés des insinuations du Châtelet de Paris, publiés et annotés par Jules Guiffrey. Paris, Impr. Nationale, 1915. 379p. (Histoire générale de Paris; collection de documents publiée sous les auspices de l'Édilité parisienne)

Archival materials on Parisian artists of the 16th and 17th centuries.

Contents: (1) Les maîtres jurés saisis, élections, pièces diverses (1454-1581); (2) Les peintres (1534-1650); (3) Les sculpteurs (1521-1650); (4) Les tailleurs de'antiques (1571-1622); (5) Les fondeurs en sable (1541-1604); (6) Les architectes (1454-1647); (7) Les tapissiers (1519-1620); (8) Les graveurs en taille-douce (1560-1646); (9) Les graveurs de sceaux, de monnaies et de pierres fines (1454-1620); (10) Les peintres verriers (1534-1648); (11) Artistes divers-brodeurs, doreurs sur fer et sur cuivre; menuisiers en ébane, pâtenotriers en émail; jardiniers. "Table alphabétique," p.323-79.

H146 _____. Salon. Catalogues of the Paris Salon 1673 to 1881. 101 livrets in 60 volumes comp. by H. W. Janson. N.Y., Garland, 1977-78.

A facsimile ed. of the catalogues of the Paris Salons. Includes supplements. "The official art exhibition sponsored by the Académie Royale de Peinture et de Sculpture and, after 1789, the Direction des Beaux-Arts was the oldest and most prestigious institution of its kind. Widely imitated in other countries, it is of incalculable importance not only for the development of public exhibitions but for the history of art from the Age of Enlightenment to the late nineteenth century." —"Editor's note" in *Pub. prospectus.*

A comprehensive index of artists and subjects is in preparation by the Dept. of Fine Arts, Oxford Univ., and is scheduled for publication in 1979.

H147 Wildenstein, Daniel. Documents inédits sur les artistes français du XVIIIe siècle, conservés au Minutier Central des Notaires de la Seine aux Archives Nationales et publiés avec le concours de la Fondation Wildenstein de New York. Paris, Beaux-Arts, 1966. 171p.

A selected list of documents relating to 18th-century artists, culled from the French archives (dating from 1700-95). Complements the list published in *Archives de l'art français*, 1915, and *Documents du Minutier Central des Notaires de la Seine*, v.1, 1964. Arranged alphabetically by artist with an index of artists' names.

H148 _____. Inventaires après décès d'artistes et de collectionneurs français du XVIIIe siècle, conservés au Minutier Central des Notaires de la Seine, aux Archives Nationales. Paris, Beaux-Arts, 1967. iv. 303p.

A collection of approx. 800 inventories of paintings in the possession of affluent, middle-class, 18th-century Frenchmen. A valuable resource for the social historian as well as the art historian, and a significant contribution to the history of taste and collecting.

Contents: Préface, par D. Wildenstein; Liste des études consultées au Minutier Central; Texte des inventaires classés par ordre chronologique; Table alphabétique des peintres avec leurs oeuvres; Liste, par sujets, des tableaux cités dans les inventaires (Tableaux religieux; mythologie; allégories; armoiries, attributs [etc.]); Index des noms propres des collectionneurs; Table par états et professions des collectionneurs.

H149 Wildenstein, Georges. Rapports d'experts 1712-1791; procès-verbaux d'expertises d'oeuvres d'art extraits du fonds du Châtelet, aux Archives Nationales, publiés par Georges Wildenstein. Paris, Beaux-Arts, 1921. xi p., 170 col., p.174-86. (Études et documents pour servir à l'histoire de l'art français du dix-huitième siècle [no. 2]) (Repr.: N.Y., Burt Franklin, 1969.)

Accounts of the appraisal of works of art, culled from the Châtelet and the National Archives.

Contents: Introduction; Texte des rapports, p.1-172; Table des parties cités dans les rapports d'experts non publiés, p.173-79; Table des matières contenues dans les rapports d'experts publiés, p.180-86. Bibliography, p.xii, is in "Table des abréviations contenues dans les notes."

SEE ALSO: Fontaine, A. *Les doctrines d'art en France; peintres, amateurs, critiques, de Diderot à Poussin* (I279); Locquin, J. *La peinture d'histoire en France de 1747 à 1785 . . .* (M210); Troescher, G. *Kunst- und Künstlerwanderungen in Mitteleuropa 800-1800* (H7).

### Germany and Switzerland

H150 Akademie der Künste, Berlin. Die Kataloge der Berliner Akademie-Ausstellungen 1786-1850, bearb. von Helmut Börsch-Supan. Berlin, Hessling, 1971. 2v. (Quellen und Schriften zur bildenden Kunst, 4)

Photomechanical reproductions of the catalogues of the Berlin Academy of Arts, 1786-1850. Contents: v.1, 1786-1824; v.2, 1826-50.

_____. Registerband. Berlin, Hessling, 1971. 165p.

H151 Bertolotti, Antonio. Artisti svizzeri in Roma nei secoli XV, XVI e XVII; ricerche e studi negli archivi romani. Bellinzona, Colombi, 1886. 71p.

Documents from the Roman archives concerning Swiss artists in Rome in the 15th, 16th, and 17th centuries.

H152 Rott, Hans. Quellen und Forschungen zur südwestdeutschen und schweizerischen Kunstgeschichte im XV und XVI Jahrhundert. Stuttgart, Strecker und Schröder, 1933-38. 3v. in 6. il., plates.

Sources and commentary dealing with southwest German and Swiss art history in the 15th and 16th centuries.

Contents: Bd. 1A (Quellen), B (Text): Bodenseegebiet; Bd. 2 (Quellen und Text); Altschwaben und die Reichsstädte; Bd. 3A & B (Quellen), C (Text); Baden, Pfalz, Elsass, Schweiz (called Oberrhein on title page).

Bibliographical footnotes. v.3C contains a general index of artists by Gustav Rommel, p.275-368, subdivided according to medium in which the artist worked. v.1-2 have person and place indexes.

SEE ALSO:   Stechow, W. *Northern Renaissance, 1400-1600* (H6); Troescher, G. *Kunst- und Künstlerwanderungen in Mitteleuropa 800-1800* (H7).

### Great Britain and Ireland

SEE:   Dobai, J. *Die Kunstliteratur des Klassizismus und der Romantik in England* (A139); Lehmann-Brockhaus, O. *Lateinische Schriftquellen zur Kunst in England, Wales und Schottland, vom Jahre 901 bis zum Jahre 1307* (H23); *Wren Society, London [Publications]* (J217).

### Italy

H153  Arco, Carlo d', *conte*. Delle arti e degli artefici di Mantova; notizie raccolte ed illustrate con disegni e con documenti. 2v. Mantova, Agazzi (v.1); Benevenuti (v.2), 1857-59. il.

v.1 is a critical history of art in Mantua, with a detailed table of contents (p.115-19) and an index of the names of artists (p.121-26). v.2 is a collection of letters and documents culled from the archives in Mantua. Important for research on Giulio Romano.

H154  Bacci, Pèleo, ed. Documenti toscani per la storia dell'arte. [Firenze, Gonnelli, 1910-12]. 2v. 27 plates.

For the most part these documents refer to the history of art in Pistoia. Bibliographic footnotes. At the end of each volume is a table of contents which lists the documents included.

H155  _____. Fonti e commenti per la storia dell'arte senese; dipinti e sculture in Siena, nel suo contado ed altrove. Siena, Accademia degli Intronati, 1944. 259p. plates. (Collezione di monografie d'arte senese, Ser. 1)

A collection of sources relating to painting and sculpture in Siena and environs. Critical commentary. Table of contents and index of artists at end of volume.

H156  Barocchi, Paolo, ed. Trattati d'arte del Cinquecento, fra manierismo e controriforma. 3v. Bari, Laterza, 1960-62. (Scrittori d'Italia, n. 219, 221-22)

A valuable collection of Italian 16th-century writings on art. Most of these treatises, dialogues, letters, etc. have never before been published in modern critical editions. Does not include the most famous works, *i.e.* Vasari, Borghini, Lomazzo, etc. At the end of each volume: "Nota critica, nota filologica, commento." These notes have extensive bibliographical references.

Contents: v.1. Benedetto Varchi. *Lezzione della maggioranza delle arti*; Benedetto Varchi. *Libro della beltà e grazia*; Paolo Pino. *Dialogo di pittura*; Lodovico Dolce. *Dialogo della pittura intitolato l'Aretino*; Vincenzio Danti. *Il primo libro del trattato delle perfette proporzioni*; Cristoforo Sorte. *Osservazioni nella pittura*; v.2. Giovanni Andrea Gilio. *Degli errori e degli abusi de pittori*; Gabriele Paleotti. *Discorso intorno alle imagini sacre e profane*; Ulisse Aldrovandi. *Avvertimenti al Card. Paleotti*; v.3. Carlo Borromeo. *Instructiones fabricae et suppellectilis ecclesiasticae*; Bartolomeo Ammannati. *Lettera agli Accademici del Disegno*; Francesco Bocchi. *Eccellenza del San Giorgio di Donatello*; Romano Alberti. *Trattato della nobiltà della pittura*; Gregorio Comanini. *Il Figino overo del fine della pittura*.

At the end of v.3: "Indice analitico dei tre volumi," a detailed subject index of themes; motifs; philosophical, cultural, technical terms; and proper names.

H157  Baudi di Vesme, Alessandro. L'art negli stati Sabaudi ai tempi di Carlo Emanuele I, di Vittoria Amedeo I e dalle reggenza di Cristina di Francia. Torino, Bocca, 1932. 2v. xi, 869p. (Atti della Società Piemontese di Archeologia e Belle Arti, v.14)

Documents dated from 1580 to 1650 related to art in the Piedmont region of Italy. This selection of material from the rich collection of Count Baudi di Vesme is extremely important for research in early Baroque painting, sculpture, architecture, and the decorative arts in Turin and other parts of Savoy. *See also* Baudi di Vesme, A. *Schede Vesme* (E103).

*The documents collected by Antonino Bertolotti (1836-1893) are important for research in Renaissance and Baroque art. Most of the documents relate to Italian and foreign artists who worked in Rome and Mantua during the 15th, 16th, and 17th centuries. Bertolotti was the first archivist to sort and classify these documents; he published these without critical commentary.*

H158  Bertolotti, Antonino. Alcuni artisti siciliani a Roma nei secoli XVI e XVII; notizie e documenti, raccolti nell'archivio di stato romano. Palermo, Virzi, 1879. 38p.

Documents regarding Sicilian artists who worked in Rome during the 16th and 17th centuries. Arranged by century and then by medium. Bibliographical footnotes; no index or table of contents.

H159  _____. Le arte minori alla corte di Mantova nei secoli XV, XVI e XVII; ricerche storiche negli archivi Mantovani. Milano, Prato, 1889. 257p. (Repr.: Bologna, Forni, 1974.)

Extracts from documents relating to the minor arts of goldsmithing, metal engraving, work in alloys, wood and ivory carving, crystal and glass, embroidery, silversmithing, jewelry, seal cutting, enameling, niello work, and clockmaking. Index of artisans and other names, p.241-57.

H160  _____. Artisti bolognesi, ferraresi ed alcuni altri del già Stato Pontifico in Roma nei secoli XV, XVI e

XVII. Bologna, Regio tipografia, 1885. xi, 295p. (Repr.: Bologna, Forni, 1962; N.Y., Burt Franklin, 1972.)

Subtitle: "Studi e ricerche tratte dagli archivi romani."

Documents concerning architects, engineers, painters, sculptors, goldsmiths, engravers, intarsia workers, potters, etc. who were from Bologna, Ferrara, and other cities of the former papal states and who worked in Rome. Arranged by century (1400-1700) and then by medium. Index.

H161 _____. Artisti in relazione coi Gonzaga signori di Mantova; ricerche e studi negli archivi mantovani. Modena, Vincenzi, 1885. 266p. (Repr.: Bologna, Forni, 1969.)

Documents relating to artists who worked at the Gonzaga court in the 16th and 17th centuries.

H162 _____. Artisti lombardi a Roma nei secoli XV, XVI e XVII. Milano, Hoepli, 1881. 2v. (Repr.: Bologna, Forni, 1968; N.Y., Burt Franklin, 1973.)

Documents concerning Lombard artists who worked in Rome in the 15th, 16th, and 17th centuries. Includes architects, painters, sculptors, goldsmiths, cabinetmakers, clockmakers, and makers of musical instruments. Arranged by century and then by medium.

"Indice delle cose più notevoli nei volumi," v.2, p.327-35; "Indice degli artisti e di altri accennati nei due volumi," p.337-87.

H163 _____. Artisti modenesi, parmensi e della Lunigiana in Roma nei secoli XV, XVI e XVII. Ricerche e studi negli archivi romani. Modena, Vincenzi, 1882. 123p. (Repr.: Bologna, Forni, 1970.)

Archival material on artists from Modena, Parma, Lunigiana, who worked in Rome during the 15th, 16th, and 17th centuries. Arranged by medium.

"Indice delle cose più notevoie," p.175-78; "Indice nominale," p.179-93.

H164 _____. Artisti urbanati in Roma prima del secolo XVIII; notizie e documenti raccolti negli archivi romani. Urbino, Cappella per Righi, 1881. 69p. (Repr.: Bologna, Forni, 1970.)

"Estratto dal periodico *Il Raffaello*." Contains documents relating to artists from Urbino who worked in Rome before the 18th century.

H165 _____. Artisti veneti in Roma nei secoli XV, XVI e XVII; studi e ricerche negli archivi romani. Venezia, A spese della Società, 1884. 99p. (Repr.: Bologna, Forni, 1965.)

Published in *Reale Deputazione Veneta di Storia Patria. Monumenti storici,* Ser. 4, v.3.

Documents culled from the Roman archives concerning artists from the Veneto. Covers architecture, painting, sculpture, engraving, goldsmithing, wood carving, typography, and music. Arranged by century and then by medium.

H166 _____. Figuli, fonditori e scultori in relazione con la corte di Mantova nei secoli XV, XVI, XVII. Milano,

Prato, 1890. 115p. (Repr.: Bologna, Forni, 1970.)

A collection of documents concerning the potters, founders, and sculptors working for the court at Mantua in the 15th, 16th, and 17th centuries.

"Indice delle sezioni," p.110; "Indice degli artisti e altri nominati," p.111-15.

H167 Borghesi, Scipione, and Banchi, Luciano. Nuovi documenti per la storia dell'arte senese, raccolti da S. Borghesi e L. Banchi; appendice alla raccolta dei documenti pubblicata dal comm. Gaetano Milanesi. Siena, Torrini, 1898. ix, 702p. plates, facsim. (Repr.: Utrecht, Davaco, 1970.)

Preface signed: A. Lisini.

Contains 350 documents related to Sienese art, arranged by date from 1297 to 1679. Supplements the documents published by Milanesi (H186). Critical notes by the editors. "Tavola dei documenti," p.649-76, is a chronological list with type of document and page. Index of places and major subjects, p.695-702.

H168 Boselli, Camillo, ed. Nuove fonti per la storia dell'arte. L'archivio dei conti Gambara presso la Civica Biblioteca Queriniana di Brescia. Venezia, presso la sede dell'Istituto Veneto, Palazzo Loredan (Campo e Stefano), 1971- . 137p. (Istituto Veneto di Scienze, Lettere ed Arti Venezia. Memorie, v.35, fasc. 1. classe dei scienze morali, lettere ed arti)

Documents and letters concerning painters, sculptors, and architects working in Lombardy and the Veneto region, in particular Brescia, from the end of the 14th to the 18th century. These sources, collected by Count Gambara, are located in the Biblioteca Queriniana in Brescia.

H169 Bottari, Giovanni Gaetano, and Ticozzi, Stefano. Raccolta di lettere sulla pittura, scultura ed architettura scritte da' più celebri personaggi dei secoli XV, XVI, e XVII, pubblicata da M. Gio. Bottari, e continuata fino ai nostri giorni da Stefano Ticozzi. Milano, Silvestri, 1822-25. 8v. front. (port.) (Repr.: Hildesheim, Olms, 1976.)

Half title: Biblioteca scelta di opere italiane antiche e moderne, v.107-14.

First published in Rome, 1754-68 in 7v.; v.7 was completed by L. Crespi. 2d ed. (listed above) was enlarged by Ticozzi. An abridged French ed. (Paris, 1817), trans. by L. J. Jay, has been reprinted by Minkoff, Geneva, 1973.

A rich collection of correspondence concerning painting, sculpture and architecture from the 15th to the 18th century; fundamental for research in the history of Italian art, and, to a lesser extent, French art. These letters were culled from Roman archives, libraries, and private collections, and assembled and edited by Bottari, an outstanding scholar in Rome during the 18th century.

Index at the end of each volume; general index of authors at the end of v.8.

H170 Braghirolli, Willelmo. Lettere inedite di artisti del secolo XV cavate dall'archivio Gonzaga. Mantua, 1878. 152p.

A collection of artists' letters of the 16th century, from the Gonzaga archives in Mantua. Biographical notes. No index.

H171    Calvi, Girolamo Luigi. Notizie sulla vita e sulle opere dei principali architetti, scultori e pittori che fiorirono in Milano durante il governo dei Visconti e degli Sforza. Milano, Ronchetti, 1859-69. 3v. in 1. (Repr.: Bologna, Forni, 1968.)

Archival material on architects, sculptors, and painters who worked in Milan.

Contents: Pte. I-II, Dei professori di belle Arti che fiorirono in Milano sotto il governo dei Visconti e degli Sforza; Pte. III, Leonardo da Vinci (con nuovi documenti).

H172    Campori, Giuseppe. Gli artisti italiani e stranieri negli stati estensi; catalogo storico corredato di documenti inediti per G. Campori. Modena, Camera, 1855. 537p. (Repr.: Roma, Multigrafica, 1969.)

A valuable collection of documents concerning Italian and foreign artists who worked in the states of the House of Este. This was the first of many such collections made during the latter half of the 19th century.

Index of cities and regions, p.503-06; Index of artists, p.507-37.

H173    _____. Memorie biografiche degli scultori, architetti, pittori, ec. nativi di Carrara e di altri luoghi della provincia di Massa, con cenni relativi agli artisti italiani ed esteri che in essa dimorarono ed operarono, ed un saggio bibliografico. Modena, Vincenzi, 1873. xiii, 466p. (Repr.: Bologna, Forni, 1969.)

Well-documented notes on artists from Carrara and other places in the province of Massa, as well as those who lived there or came there to select marble. Bibliographical essay.

H174    Chambers, David Sanderson. Patrons and artists in the Italian Renaissance. comp. and trans. from the Italian by D. S. Chambers. London, Macmillan, 1970, xxxv, 200p., il., 4 plates, 2 ports.

This carefully selected collection of extracts from documents provides the student of the Italian Renaissance a good introduction to the various types of archival material used in research. The author documents patronage and the working practice of artists with letters, contracts, extracts from books of payment, etc. All documents are translated. Critical footnotes and a brief bibliographical essay.

Classified as follows: pt. 1. Clerical patronage; pt. 2. Guild patronage; pt. 3. Civic patronage; pt. 4. Princely and private patronage; pt. 5. The artists' working life; a miscellany.

H175    Cittadella, Luigi Napoleone. Documenti ed illustrazioni risguardanti la storia artistica ferrarese. Ferrara, Taddei, 1868. xi, 368p.

A collection of documents regarding the history of art in Ferrara. Bibliographical footnotes.

H176    Colombo, Giuseppe. Documenti e notizie intorno gli artisti vercellesi. Vercelli, Francesco, 1883. 502p.

Documents and notes from the archives of Vercelli; arranged by artist. Appendix of material concerning Giovanni Antonio Bazzi, known as Il Sodoma. Index.

H177    Corbo, Anna Maria. Artisti e artigiani in Roma al tempo di Martino V e di Eugenio IV. Roma, De Luca, 1969. 257p. (Raccolta di fonti per la storia dell'arte. Seconda serie I)

Documents related to artistic activity in Rome during the papacies of Martin V (1417-31) and Eugenius IV (1431-47). Arranged chronologically under basilica, church, monument, or artist's name.

Contents: pt. 1. Basilica di San Pietro e Palazzo Vaticano; Basilica di San Giovanni e Palazzo Lateranese; Basilica di Santa Maria Maggiore; Chiese di Santa Maria sopra Minerva, di Santa Maria del Popolo, di Santa Maria in Trastevere; Ospedale di Santo Spirito; Palazzo di San Lorenzo in Lucina; Castel Sant'Angelo; Campidoglio; Ponti, porte e mura della città; Opere fuori Roma; Ingegneri; Artisti e lavori diversi; Orefici; Ricamatori. pt. 2. Senatore, camerlengo e gabelliere della *Camera Urbis;* Istituti giuridici e linguaggio; Chiese, cappelle gentilizie, sepolture; Case e torri; Pittori; Marmorari; Muratori; Carpentieri; Falegnami; Ferrari, Orefici, Armaiuoli; Sartori. Bibliography, p.239-40.

Index of names, p.241-57.

H178    Crespi, Luigi. Vite de' pittori bolognesi non descritte nella Felsina pittrice. Roma, Pagliarini, 1769. xx, 344p. il., ports. (Repr.: Bologna, Forni, 1970.)

A continuation of Malvasia (H65). Considered to be less than reliable.

H179    Filangieri, Gaetano Angerio Guglielmo, ed. Documenti per la storia, le arti e le industrie delle provincie napoletane. Napoli, Accademia Reale delle Scienze, 1883-91. 6v. plates, facsim.

A collection of documents dealing with the history, art, and industry of the Neapolitan provinces.

Contents: v.1, Effemeridi delle cose fatte per il duca di Calabria (1484-91) di Joampiero Leostello, da un codice della Biblioteca Nazionale di Parigi; v.2-4, Estratti di schede notarili; v.5-6, Indice degli artefici dell'arti maggiori e minori.

H180    Filippini, Francesco, and Zucchini, Guido. Miniatori e pittori a Bologna; documenti dei secoli XIII e XIV. Firenze, Sansoni [1947]. xv, 262p. (Raccolta di fonti per la storia dell'arte, 6)

A collection of archival material related to miniature painters and other painters who worked in Bologna during the 13th and 14th centuries. The alphabetical arrangement by artist is followed by a section on anonymous painters. Bibliography, p.[ix]-xv. Indexes of names and institutions holding the documents.

Continued by:

H181    _____. Miniatori e pittori a Bologna. Documenti del secolo XV. Roma, Accademia Nazionale dei Lincei, 1968. xv, 202p. (Accademia Nazionale dei Lincei. Fonti e documenti inediti per la storia dell'arte, 3)

Revised by Antonio Maria Adorsio.

Published posthumously, a continuation of *Miniatori e pittori a Bologna, documenti dei secoli XIII e XIV* (H180).

A collection of documents related to miniature painters and other painters of the 15th century who worked in Bologna.

The material was culled from scattered local archives. Arranged by artist. Appendice: (I) "Anonimi del sec. XV." (II) "Ercole de' Roberti da Ferrara." Bibliography, p.[xi]-xv. Indexes of names and places.

H182  Gaye, Johann Wilhelm, ed. Carteggio inedito d'artisti dei secolo XIV, XV, XVI., publicato ed illustrato con documenti pure inediti. Firenze, Molini, 1839-40. 3v. facsims. (Repr.: Torino, Erasmo, 1961.)
v.3 ed. by A. von Reumont.
"An incomparable anthology in spite of its inaccuracies." —D. Chambers (H174). Documents and letters culled from the archives of Florence and other Italian cities, the first of many 19th-century collections of such material. Arranged chronologically: v.1, 1326-1500; v.2, 1500-57; v.3, 1501-1672.
Each volume contains facsimiles of documents at the end, and an index of documents. v.3 has an index of the writers of the letters, and an index of the titles of the other documents.

H183  Golzio, Vincenzo. Documenti artistici sul Seicento nell'Archivio Chigi; con presentazione di Roberto Paribeni. Roma, Palombi, 1939. xii, 435p. plates, plans, facsims., ports.
At head of title: R. Istituto d'Archeologia e Storia dell'Arte.
These documents from the Chigi archives in Ariccia (near Rome) are divided into those related to the works of art executed for Cardinal Flavio Chigi, and those made for Alexander VII (Fabio Chigi), pope from 1655-67. Important for most research on Bernini and his followers. Bibliography at the end of each chapter.

H184  Gonetta, Giuseppe. Bibliografica statuaria delle corporazioni d'arti e mestieri d'Italia, con saggio di bibliografica estera. Roma, Forzani, 1891. 99p.
A bibliography of the statutes of trade guilds, arranged alphabetically by city. Lists published and unpublished sources.
Contents: (1) Statuti editi ed inediti, p.19-77; (2) Bibliografia italiana, p.78-88. Saggio di bibliografia estera, p.89-99.

H185  Gualandi, Michelangelo, ed. Nuova raccolta di lettere sulla pittura, scultura ed architettura scritte da' più celebri personaggi dei secoli XV. a XIX. con note ed illustrazione. Bologna, A spese dell'editore ed annotatore, 1844-56. 3v. il. (Repr.: Hildesheim, Olms, 1975.)
A collection of letters by Italian artists, intended as a continuation of Bottari-Ticozzi (H169). Many of the letters are from the Medici and other archives. List of letters at the end of each volume.

H186  Milanesi, Gaetano. Documenti per la storia dell'arte senese, raccolti ed illustrati dal dott. Gaetano Milanesi. Siena, Porri, 1854-56. 3v. (Repr.: Utrecht, Davaco, 1969.)
A collection of statutes and other documents concerning the history of Sienese art. Chronological list of documents at the end of each volume. Indexes of artists, places, and subjects at the end of v.3.

H187  _____. Nuovi documenti per la storia dell'arte toscana dal XII al XV secolo. Per servire d'aggiunta all'edizione del Vasari edito da Sansoni 1885. Raccolti e annotati da G. Milanesi. Firenze, Dotti, 1893-1901. (Repr.: Utrecht, Davaco, 1972.)
A group of documents related to Tuscan art of the 12th through the 15th century, mostly from the Archivo de' Contratti, Florence. Collected by Milanesi to supplement his critical edition of Vasari.

H188  Müntz, Eugène. Les archives des arts recueil de documents inédits ou peu connus. Paris, Librarie de l'art, 1890. 196p. (Bibliothèque internationale de l'art [18])
A collection of documents and letters related to Italian and French art. Bibliographical notes. Table of contents.

H189  _____. Les arts à la cour des papes: Innocent VIII, Alexandre VI, Pie III (1484-1503); recueil de documents inédits ou peu connus, publié sous les auspices de l'Académie des Inscriptions et Belles-Lettres. Ouvrage accompagné de 10 planches tirées à part et de 94 gravures dans le texte. Paris, Leroux, 1898. 303p. il.
At head of title: Fondation Eugène Piot.
A good source for concrete facts and dates on the arts of the papal court. The documents are arranged by name of the reigning pope and by the medium. Alphabetical index of artists and monuments, p.293-99. Table of contents, p.301-3.

H190  _____. Les arts à la cour des papes; nouvelles recherches sur les pontificats de Martin V, d'Eugène IV, de Nicolas V, de Calixte III, de Pie II et de Paul II. Rome, Cuggiani, 1884. 88p.
From *Mélanges d'archéologie et d'histoire*, 1881-82, 1884-85, published by L'École Française de Rome.
Arranged chronologically; no index.

H191  _____. Les arts à la cour des papes pendant le XVe et le XVIe siècle; recueil de documents inédits tirés des archives et des bibliothèques romains. Paris, Thorin, 1878-82. 3v. plates.
A collection of documents concerning the arts commissioned by the papal court. Arranged chronologically by the name of pope, and then by monument or medium. Culled from the archives and libraries of Rome.
Contents: pt. 1. Martin V—Pie II, 1417-67; pt. 2. Paul II, 1467-71; pt. 3. Sixte IV—Léon X, 1471-1521. Table of contents at the end of each volume.

H192  Orbaan, Johannes Albertus Franciscus. Documenti sul barocco in Roma. Roma, nella sede della Società alla Biblioteca Vallicelliani, 1920. 2v. plates. (Miscellanea della R. Società Romana di Storia Patria, v.6)
A collection of documents relating to Baroque art in Rome.
Contents: v.1, Introduzione, p.v-[clxvi]; Il diario del cerimoniere (anni 1605-62), p.1-[38]; La Roma di Paolo V negli Avvisi, p.39-[272]; Notizie sulla vita artistica e intellettuale, p.273-[91]; La depositoria generale, p.293-

[361]; Viaggi de pontefici, p.365-[486]; Appendice: Collezioni romane d'arte, p.489-[522].

Indexes: "Indice dei nomi delle persone," p.525-[68]; "Indice delle materie," p.569-[606]; "Indice topografico," p.607-[59].

v.2 is an atlas of seven plans.

H193   Pollak, Oskar. Die Kunsttätigkeit unter Urban VIII. Aus dem Nachlass hrsg. von Dagobert Frey unter Mitwirkung von Franz Juraschek, Ernst Trenkler. 2v. Wien, Filser, 1928-31. (Quellenschriften zur Geschichte der Barockkunst in Rom) (Repr.: Hildesheim, Olms, 1971.)

A collection of documents regarding the churches, palaces, etc. built during the pontificate of Urban VIII (1623-44). Arranged by type of monument. Each voiume has an index of persons, lists of sources, and locations of the material.

Contents: Bd. I, Kirchliche Bauten (mit Ausnahme von St. Peter) und Paläste; Bd. II, Die Peterskirche in Rom.

H194   Quellenschriften zur Geschichte der Barockkunst in Rom. Hrsg. vom Österreichischen Akademie der Wissenschaften, vom Leo Santifaller und Heinrich Schmidinger. Rom, Wien, Köln, Graz, Böhlaus, 1972. il. (Publikationen des Österreichischen Kulturinstituts in Rom, 2. Quellen, 3. Reihe.)

Chief editor: Jörg Garms.

A collection of documents (culled from the Doria-Pamphilj archives) related to the art and architecture commissioned by the Pamphilj family during the papacy of Innocent X (1644-55). Intended as a continuation of the project to publish all documents on Baroque art in Rome. See the first collections by Oskar Pollak (H193). More volumes containing archival material, biographies, and topographical sources are projected.

Divided into two sections: Documents, with indexes of persons, places, and subjects; Inventories (1657-66), with indexes of subjects, themes of the art works, and artists.

H195   Raccolta di fonti per la storia dell'arte. Firenze, Sansoni [(1936-50)]. v.1-7 in 8. plates.

Editor: Mario Salmi. A series of volumes which contain documents and reprints of Italian sources.

Contents: (1) Gronau, Giorgio. Documenti artistici urbinati; (2) Giannotti, Donato. Dialogi; (3) Emert, Giulio Benedetto. Fonti manoscritte inedite per la storia dell'arte nel Trentino; (4) Baroni, Costantino. Documenti per la storia dell'architettura a Milano nel rinascimento e nel barocco; (5) Francheschi, Pietro di Benedetto dei. De prospectiva pingendi, edizione critica a cura di G. Nicco Fasola (with atlas of 49 plates); (6) Filippini, Francesco. Miniatori e pittori a Bologna; documenti dei secoli XIII e XIV; (7) Alberti, Leone Battista. Della pittura; edizione critica, a cura di Luigi Mallè.

H196   Strazzullo, Franco. Documenti inediti per la storia dell'arte a Napoli. [v.1: Pittori] Napoli, Fuidoro, 1955. 73p. plates. No more published.

Documents referring to painters who were born in Naples or who worked there during the 16th, 17th, and 18th centuries. Dictionary arrangement by artist. Comprehensive bibliographies for each artist. Index of places, artists, and archives.

H197   Tanfani Centofanti, Leopoldo. Notizie di artisti tratte dai documenti pisani. Pisa, Spoerri, 1897. vii, 583p. (Repr.: Bologna, Forni, 1972.)

Notes on the artists and architects of Pisa and on those who worked there from the 12th to the 17th century; based on archival sources in Pisa. References to sources are given in footnotes.

"Indice cronologico degli artefici secondo i documenti riferiti o citati," p.[497]-512. "Indice dei nomi e delle materie," p.[513]-80.

H198   Vatican. Biblioteca Vaticana. Seventeenth-century Barberini documents and inventories of art [by] Marilyn Aronberg Lavin. N.Y., New York Univ. Pr., 1975. xv, 741p., [4] leaves of plates, ports.

The archival material in the Archivo Barberini, housed in the Vatican Library. Intended as a sequel to the pioneer work of Oskar Pollak (H193). The records document the history of the Barberini family as patrons; most of the material relates to its activities during the 17th century, beginning with the papacy of Urban VIII (1623-44). Only household inventories of the 17th century are listed.

The archival material is classified (as follows) and accompanied by a formidable scholarly apparatus.

Contents: Introduction; Patrons of the Documents: Biographical data and list of dwelling places; Section I—Documents; Section II—Inventories; Section III—Master index: Introduction, p.457, Artist index (alphabetical), p.458-533, Subject index, p.534-714; Concordance of certain numbered Barberini paintings, p.715-19; List of artisans in Barberini employ not included in Documents or Master index, p.720-22; Glossary, p.723; List of manuscripts consulted, p.724-34; Bibliography, p.735-36; Index of names, p.737-41.

SEE ALSO:  Campori, G. *Memorie biografici degli scultori, architetti, pittori* (E107); Comolli, A. *Bibliografia storico-critica dell' architettura civile ed arti subalterne* (J6); Enggass, R. and Brown, J. *Italy and Spain, 1600-1750* (H6); Klein, R. and Zerner, H. *Italian art, 1500-1600* (H6); Murray, P. *An index of attributions made in Tuscan sources before Vasari* (M338).

## Low Countries

H199   Antwerp. Saint Lucas Gilde. De liggeren en andere historische archieven der Antwerpsche Sint Lucasgilde. Afgeschreven en bewerkt door P. Rombouts en T. van Lerius. Antwerpen, Baggerman [1864-75]. 2v. il.

Excerpts from the archives of the St. Lucas Guild of Antwerp. Contents: (1) Liggere van 1453-1615. Volledige rekeningen van 1585-1586 en 1588-1589. Rekeningen van ontvangsten van 1616-1629; (2) Liggere van 1629-1729. Inschryvings register van 1749-94. Rekeningen van ontvangsten van 1629-1736.

v.1 has "Table des prénoms," p.681-98; "Table des professions mentionées dans ce volume," p.698-706; and "Table des noms propres," p.707-92. v.2 has "Table des

professions," p.869–76 and "Table des noms propres," p.877–1002.

H200 Bertolotti, Antonino. Artisti belgi ed olandesi a Roma nei secoli XVI e XVII; notizie e documenti raccolti negli archivi romani. Firenze, Gazzetta d'Italia, 1880. 429p. (Repr.: N.Y., Burt Franklin, 1968.)
Documents concerning Belgian and Dutch artists in Rome during the 16th and 17th centuries. "Indice degli cose principali," p.427–29. "Indice degli artisti ed altri accennati," p.393–426.

H201 Bredius, Abraham, ed. Künstler-Inventare; Urkunden zur Geschichte der holländischen Kunst des XVIten, XVIIten, und XVIIIten Jahrhunderts. 8v. Haag, Nijhoff, 1915–22. plates, facsim.
Comprises the estate inventories, lives, and collections of Dutch and Flemish artists. The last volume consists of indexes of persons, places, pictures, and an alphabetical list of the inventories.

H202 Deshaines, Chrétien César Auguste. Documents et extraits divers concernant l'histoire de l'art dans le Flandre, l'Artois et le Hainaut avant le XVe siècle. Lille, Danel, 1886. 2v.
Documents culled from various archives of France and Belgium. Arranged chronologically: pt. 1, 627–1373; pt. 2, 1374–1401.
Glossary, p.921–28. "Table des matières," p.929–1006. "Table des noms des artistes et des fournisseurs d'objets d'art," p.1007–65.

H203 Duverger, Jozef. Bijdragen en documenten tot de kunstgeschiedenis. Ghent, Vyncke, 1942. 64p. 66 plates.
A discussion of available Renaissance documents in the Netherlands.
Contents: (1) Bijdragen tot de studie der renaissance in de Nederlanden; (2) Vorstelijke grafmonumenten uit het begin van de XVIe eeuw.

H204 Historical sources for the study of Flemish art. [Antwerp, De Sikkel, 1931–49]. v.1–5. plates, facsims., geneal. tables.
First 4v. issued in both Dutch and English editions; v.5 in Dutch only. All five compiled by Jean Denucé.
Contents: (1) Art export in the 17th century in Antwerp, 1931; (2) The Antwerp art galleries: inventories of the art collections in Antwerp in the 16th and 17th centuries, 1932; (3) Letters and documents concerning Jan Breugel I and II, 1934; (4) Antwerp art tapestry and trade, 1936; (5) Documenten uit den kunsthandel te Antwerpen in de XVIIe eeuw van Mattijs Musson.

H205 Obreen, Frederik D.O., ed. Archief voor Nederlandsche Kunstgeschiedenis. Verzameling van meerendeels onuitgegeven berichten en mededeelingen betreffende Nederlandsche schilders, plaatsnijders, beeldhouwers, bouwmeesters, stempelsnijders, verlichters, glasschilders, landmeters, kaartmakers, enz. van de vroegst tijden tot op het einde der XVIIIe eeuw.

Herdruk van de uitgave Rotterdam Van Hengel & Eeltjes etc., 1877–90. 7v. plates, port. (Repr.: Utrecht, Davaco, 1971.)
A collection of previously unpublished documents relating to all of the arts in the Netherlands from the earliest period until the end of the 18th century. The material, culled from various archives, includes copies of letters from private collections. Index at the end of each volume.

H206 Pinchart, Alexandre. Archives des arts, sciences et lettres; documents inédits. Gand, Hebbelynck, 1860–81. 3v. plates (part col.)
v.3 has imprint: Gand, Vanderhaeghen.
A collection of documents relating to artists and the arts, listed according to approx. 100 categories. Index at end of each volume, referring only to material in that volume.

H207 Quellenstudien zur holländischen Kunstgeschichte. Haag, Nijhoff, 1893–1928. 15v. plates, facsims.
A series of reprints of important sources for Dutch art history.
Contents: (1) Hofstede de Groot, Cornelis. Arnold Houbraken und seine "Groote Schouburgh," kritisch beleuchtet (1893); (2) Greve, H. E. De bronnen van Carel van Mander voor "Het leven der doorluchtighe Nederlandsche en Hoogduytsche schilders" (1903); (3) Hofstede de Groot, Cornelis. Die Urkunden über Rembrandt (1575–1721) (1906); (4) Lilienfeld, Karl. Arent de Gelder, sein Leben und seine Kunst (1914); (5–7, 10–14) Bredius, Abraham. Künstler-Inventare, 8v. (1915–22); (8) Mander, Carel van. Das Lehrgedicht des Karel van Mander (1916); (9) Hirschmann, O. Hendrick Goltzius als Maler 1600–17 (1916); (15) Buchelius, Arend van. Arnoldus Buchelius, "Res pictoriae" (1928).

H208 Rathgeber, Georg. Annalen der niederländischen Malerei. Formschneide- und Kupferstecherkunst. Gotha, Müller, 1844. 5 pts. in 1v.
A collection of documents and other information concerning artists and their work. Arranged chronologically. Bibliographical references.
Contents: (1) Von den Brüdern Van Eyck bis zu Albrecht Dürers Anwesenheit in den Niederlanden; (2) Von Albrecht Dürers Anwesenheit in den Niederlanden bis zu Frans Floris Tod; (3) Von Frans Floris Tod bis zu Peter Paul Rubens Abreise nach Italien; (4) Von Peter Paul Rubens Abreise nach Italien bis auf Rubens Tod; (5) Von Rubens Tod bis auf Rembrandts Tod.

SEE ALSO: Stechow, W. *Northern Renaissance 1400–1600* (H6).

## Spain and Portugal

H209 Datos documentales inéditos para la historia del arte español, 1–3. Madrid, 1914–43. 3v.
At head of title: v.1–2, Junta para ampliación de estudios e investigaciones científicas. Centro de Estudios Históricos; v.3, Consejo Superior de Investigaciones Científicas. Instituto Diego Velázquez.

A collection of documents dealing with the history of Spanish art.

Contents: (1) Pérez Sedano, Francisco. Notas del archivo de la cathedral de Toledo, 1914; (2) Zarco del Valle, M. R. Documentos de la cathedral de Toledo, 1916, 2v.; (3) Ferrandis, José. Inventarios reales (Juan II a Juana la Loca), 1943.

General index at end of v.3.

**H210**   Documentos para a história da arte em Portugal. Lisboa. Fundação Calouste Gulbenkian, v.1- . 1969- . il., facsims.

Editors: Raul Lino: Luis Silveira; A. H. de Oliveira Marques.

The systematic publication of the documents from various Portuguese archives which are relevant to the history of art in Portugal.

Contents: (1) Baixela Victoria, Arquivo de Tribunal de Contas; (2) Posturas diversas dos séculos XIV a XVIII, Arquivo Histórico de Câmara Municipal de Lisboa; (3) Colégios de Coimbra, Porto, Bragança, Braga e Gouveia, Arquivo de Tribunal de Contas; (4) Noviciado da Cotovia e Hospício da São Francisco de Borja (Companhia de Jesus), Arquivo do Tribunal de Contas; (5) Colégios de Santo Antão, São Roque, São Francisco Xavier e Noviciado de Arroios (Companhia de Jesus), Arquivo do Tribunal de Contas; (6) Núcleo de pergaminhos e papéis do sécolo XVII, Arquivo Histórico Ultramarino; (7) Visitações de Alvalade, Casével, Aljustrel e Setúbal (Ordem de São Tiago), Arquivo Nacional da Torre do Tombo; (8) Jóias e outros bens de Rainha D. Catarina, Arquivo Nacional da Torre do Tombo; (9) Arquivo Histórico da Câmara Municipal de Lisboa. Livros de almotaçaria (séculos XVI a XIX); (10) Arquivo Histórico Ultramarino. Núcleo de pergaminhos e papéis dos séculos XVII a XIX; (11) Arquivo National da Torre do Tombo. Visitações de Pamela e Panóias (ordem de São Tiago); (12) Arquivo do Tribunal de Contas. Colégios de Lisboa, Setúbal, Santarém, Évora e Elvas (Companhia de Jesus); (13) Colégios de Portalegre, Portimão, Faro, Angra, Ponta Delgada e Funchal (Companhia de Jesus) Arquivo do Tribunal de Contas; (14) Documentos dos séculos XV a XIX, Arquivo Histórico da Câmara Municipal de Lisboa; (15) Documentos dos séculos XVI a XIX. Arquivo Histórico Ultramarino.

**H211**   García Chico, Esteban. Documentos para el estudio del arte en Castilla. Valladolid, Universidad de Valladolid, 1940-41. 2v. plates, facsims.

At head of title: Universidad de Valladolid. Facultad de historia. "Publicacíon del Seminario de Arte y Arqueología adscrito al Consejo Superior de Investigaciones Científicas [Instituto Diego Velázquez]"

A collection of documents concerning Castillian artists, extracted from the archives of Valladolid Residencia Provincial, the University, and from Medina de Rioseco. Arranged by artists. Indexes of artists and places. General index. Contains bibliographies.

**H212**   Igual Úbeda, Antonio. Diccionario biográfico de escultores valencianos del siglo XVIII. Castellón de la Plana [Talleres de hijo de J. Armengot] 1933. 150p.

A collection of excerpts from documents relating to Valencian sculptors of the 18th century. Index of artists and index of places.

**H213**   Sánchez Cantón, Francisco Javier, ed. Opúsculos gallegos sobre bellas artes de los siglos XVII y XVIII; Publicados en facsímile, o transcritos, con notas preliminares. Compostela, Bibliófilos gallegos, 1956. xiv, 288, [43]p. facsims. (Colección de los bibliófilos gallegos, 3)

The work consists of reprints of seven Spanish treatises on art, three of which are published for the first time.

Contents: (1) Vega y Verdugo, José. Memorias sobre obras en la Catedral de Santiago (1657-66, from the illustrated ms.); (2) Andrade, Domingo de. Excelencias, antiqüedad y nobleza de la arquitectura (1695); (3) Feijoo, Fr. Benito Jerónimo. Razón del gusto (1733); (4) Feijoo, Fr. B. J. El no sé qué (1733); (5) Sarmiento, Fray Martín. Sistema de los adornos de escultura del nuevo Real Palacio de Madrid (1743-47), from the ms. with facsimile of the inscriptions; (6) Castro, Felipe de. Dedicatorias de la lección de Varqui (1753); (7) Prado Mariño, Melchor. Disertación sobre la calidad del edificio para Biblioteca Real (1796, ms. in facsim.). One-page list of artists follows text.

**H214**   Seville. Universidad. Laboratorio de Arte. Documentos para la historia del arte en Andalucía. Sevilla, Facultad de Filosofia y Letras, 1927-(40). 10v.

A series of monographs on the arts of Andalusia, based on documentary research. Each volume has indexes of persons, places, and subjects.

Contents: v.1-2, Documentos varios, 1927-28, 2v.; v.3, Sancho Corbacho, Heliodoro. Arte sevillano de los siglos XVI y XVII, 1931; v.4, Muro Orejon, Antonio. Artifices sevillanos de los siglos XVI y XVII, 1932; v.5, Bago y Quintanilla, Miguel de. Arquitectos, escultores y pintores sevillanos del siglo XVII, 1936; v.6, Hernández Diaz, José. Arte y artistas del renascimiento en Sevilla, 1933; v.7, Sancho Corbacho, Heliodoro. Arquitectura sevillana del siglo XVIII, 1934; v.8, Muro Orejon, Antonio. Pintores y doradores . . . 1935; v.9, Hernández Diaz, José. Arte hispalense de los siglos XV y XVI, 1937; v.10, Marin, Enrique Respeto. Artifices gaditanos del siglo XVII, 1946.

**H215**   Zarco del Valle, Manuel Remón. Documentos inéditos para la historia de las bellas artes en España. Madrid, Viuda de Calero, 1870. 438p. facsims. (Publicado en los Documentos inéditos para la historia de España, LV)

A collection of documents relating to the history of Spanish art.

"Colección de pintores, escultores y arquitectos desconocidos, sacada de instrumentos antiquos y auténticos, por el r.p.m. fray Agustin de Arques Jover," p.[5]-112. Index of artists, p.429-38.

SEE ALSO:  Angulo Iñiquez, D. *Planos de monumentos arquitectónicos de America y Filipinas existentes en el Archivo de Indios* (J249); Enggass, R. and Brown, J. *Italy and Spain 1600-1750* (H6); Llaguno y Amírola, E. *Noticias de los*

*arquitectos y arquitectura de España desde su restauración* (J290).

## ORIENTAL SOURCES AND DOCUMENTS

H216  Acker, William Reynolds Beal. Some T'ang and pre-T'ang texts on Chinese painting, translated and annotated. Leiden, Brill, 1954–74. 2v. in 3. (Sinica Leidensia, v.8, 12)

Contents, v.1 (414p.; 1954): Introduction; (1) *The Ku Hua P'in Lu* or old record of the classification of painters by Hsieh Ho of the southern Ch'i dynasty; (2) The *Hsü Hua P'in* with its preface by Yao Tsui of the Ch'en dynasty a native of Wu-hsing; (3) A record of the famous painters of all the dynasties by Chang Yen-yüan, finished in the year A.D. 847. Bibliography and sources, p.383–98. v.2 in two parts (vii, 327, 74p.; 1974): (4–10) Chang Yen-yüan, Li tai ming hua chi (pt. 1, translation and annotations; pt. 2, Chinese text). Bibliography, p.[303]–9.

H217  Bush, Susan. The Chinese literati on painting; Su Shih (1037–1101) to Ch'i-ch'ang (1555–1636). Cambridge, Harvard Univ. Pr., 1971. x, 227p. il. (Harvard-Yenching Institute studies. [v.] 27)

An analytical study of the doctrines of Chinese literary painters and their influences on painting styles from Northern Sung to Ming through an examination of their writings.

Contents: (I) Northern Sung (960–1127); (II) The views of Northern Sung literati; (III) Chin (1122–1234) and Southern Sung (1127–1260); (IV) Yüan (1260–1368); (V) Ming (1368–1644); (VI) Conclusion. Appendix: Chinese texts, p.187–203.

Bibliography, p.[205]–13 (General collections; Works cited in the notes). Bibliographical references in footnotes. Glossary, p.215–19.

H218  Hsi, Kuo. An essay on landscape painting. Trans. by Shio Sakanishi. London, Murray [1935]. 64p.

Trans. of *Lin Ch'üan Kao Chih,* an influential essay on landscape painting, composed of the sayings of the painter Kuo Hsi (born ca. 1020) and written by his son Kuo Jo-Hsü.

Contents: Foreword by L. Cramner-Byng; Preface; Introduction. An essay on landscape painting: Preface by Kuo Jo-Hsü; Comments on landscapes; The meaning of painting; Rules for painting. Notes, p.63–64.

H219  Kuo, Jo-hsü. Kuo Jo-hsü's experiences in painting. (T'u-hua chienwên chih). An eleventh century history of Chinese painting together with the Chinese text in facsimile. Trans. and annot. by Alexander Coburn Soper. Washington, American Council of Learned Societies, 1951. 216p., 33 1. front. (American Council of Learned Societies. Studies in Chinese and related civilizations. no. 6)

The first translation by an impeccable scholar of one of the standard early histories of Chinese painting.

Contents: (1) General discussion; (2) Art history I (Late T'ang masters, Five dynasties masters); (3) Art history II (His imperial majesty Jên Tsung, Sung princes, nobles, scholars-officials, Sung figure painters, Sung portraitists; (4) Art history III (Sung landscape painters, Sung flower and bird painters, miscellaneous Sung painters); (5) Gleanings from history; (6) Anecdotes from recent times.

Includes a summary in the appendix of Kuo Jo-hsü's life and career and 753 footnotes to the main text.

H220  Lin, Yu-T'ang. The Chinese theory of art; translations from the masters of Chinese art. N.Y., Putnam [1967]. 244p. il.

An anthology of "translations from writings by Chinese artists and art critics on problems and techniques, style and taste."—*Introd.* The introduction contains brief, general discussions of the historical background, schools and styles, influences, charts of development, and charts of derivation. The author-translator's comments accompanying the individual texts appear within brackets.

Table of dynasties, p.212–15; List of artists, in English and Chinese, p.216–[36].

H221  Maeda, Robert Junji. Two twelfth century texts on Chinese painting; translations of the Shan-shui ch'un-ch'üan chi by Han Cho, and chapters nine and ten of Hua-Chi by Teng Ch'un. [Ann Arbor, Univ. of Michigan Center for Chinese Studies] 1970. 74p. (Michigan papers in Chinese studies, no. 8)

Documented, annotated translations of two 12th-century texts on Chinese painting. "Both provide valuable information regarding the history and tenets of the Imperial Painting Academy of Emperor Hui-tsung . . . in the late Northern Sung period"—Review by T. Lawson in *Artibus Asiae,* v.34, 1972, p.349. Important additions to the literature for Western students of Chinese art.

H222  Sakanishi, Shio. The spirit of the brush, being the outlook of Chinese painters on nature, from eastern China to five dynasties, A.D. 317–960. London, Murray, and N.Y., Grove, 1939. 108p.

Translations of ten essays, arranged chronologically, by Chinese painters comprising "an attempt to trace through written records the gradual developments of theories concerning this branch of art [landscape painting], beginning with the period when the independent landscape painting was scarcely known and concluding with the age when it became a predominant theme."—*Pref.*

H223  Soper, Alexander Coburn. Textual evidence for the secular arts in the period from Liu Sung through Sui (A.D. 420–618) excluding treatises on painting. Ascona, Switzerland, Artibus Asiae, 1967. 71p. 2 plates. (Artibus Asiae. Supplementum. 24)

A translation of texts, with the author-translator's comments, on early Chinese art drawn from "secular, non-artistic sources, or from the works of artists of a different breed, the poets of the time."—*Introd.* Excludes, for the most part, familiar texts concerned specifically with painting which are translated elsewhere.

Bibliographical references included in footnotes.

H224  Ts'ao, Chao. Chinese connoisseurship: the Ko Ku Yao Lun, the essential criteria of antiquities. A translation made and edited by Sir Percival David, with a facsimile of the Chinese text of 1388. London, Faber and Faber; N.Y., Praeger [1971]. lxii, 351p. il., 3 col. plates.

A critical translation of the *Ko Ku Yao Lun*, written by the antiquarian Ts'ao Chao in 1388 and expanded by Wang Tso in 1462; an important contribution to Chinese art studies. Included in the treatise are sections on ancient bronzes, paintings, calligraphy, tablets and rubbings, zithers, inkstones, precious objects, metals, porcelain, lacquer, textiles, rare woods, and rare stones.

The translator's introductory essay is a detailed bibliographical study of the work. Following the translation is a facsimile reproduction of the original text, p.295–344. Indexes of names, subjects, and books referred to in the essay.

H225  Vandier-Nicolas, Nicole. Le Houa-che de Mi Fou (1051–1107) ou le carnet d'un connaisseur à l'époque des Song du Nord. Paris, Presses Universitaires de France, 1964. xxiv, 195p. (Bibliothèque de l'Institut des Hautes Études Chinoises, XVI)

A critical translation of the *Hua-shih*, a treatise on the aesthetics of painting by the great northern Sung painter and calligrapher Mi Fu. A major contribution to Western studies in Chinese art.

The translator is also the author of a fuller study of Mi Fu: *Art et sagesse en Chine: Mi Fou.* Paris, Presses Universitaires de France, 1963. 346p. (Annales du Musée Guimet, Bibliothèque d'Études, Tome LXXe)

SEE ALSO:  Soper, A. C. *Literary evidence for early Buddhist art in China* (K219).

# I.
# Histories and Handbooks

This chapter includes the entries for those histories, handbooks, encyclopedic series, collections, and exhibition catalogues which are general inasmuch as they treat more than one art medium. The universal dictionaries of art and archaeology are contained in chapter E. Sources and documents (before c.1830) are in chapter H, and general bibliographies are in chapter A.

## COLLECTIONS AND INVENTORIES

I1    The Frick Collection, New York. The Frick Collection; an illustrated catalogue, N.Y., 1968-(77). (Distr. by Princeton Univ. Pr.) v.1-(4), 7-(8). il. (part col.)
To be complete in 9v.

An exemplary catalogue prepared by scholars. Based on the monumental folio catalogue, *An illustrated catalogue of the works of art in the collection of Henry Clay Frick, 1949-56.* The entries have been revised to include new attributions and recent research. All works are illustrated.

Contents: v.1, Biebel, Franklin M., and Davidson, Bernice. *Paintings: American, British, Dutch, Flemish and German* (1968); v.2. _____. *Paintings: French, Italian and Spanish* (1968). Index of painters, Index of portrait subjects, and Index of religious subjects for v.1-2 at the end of v.2; v.3, Pope-Hennessy, John, assisted by Radcliffe, Anthony F. *Sculpture: Italian* (1970); v.4., _____. *Sculpture: German, Netherlandish and French, 15th through 17th centuries* and Hodgkinson, Terence W. I. *Sculpture: French and British, 18th and 19th centuries* (1970). Index of sculptors, Index of subjects, Concordance of changes of attribution and title, and Sculpture not included in the folio catalogue of 1953-54 for v.3-4 at the end of v.4; v.5, *Furniture: Renaissance, French 17th and 18th century* (not yet published); v.6, *Furniture: French 18th century, English 18th century and gilt bronzes* (not yet published); v.7, Pope, John A., and Brunet, Marcelle. *Porcelains: Oriental and French* (1974). Biographies, Index to French pottery and porcelain, and Concordance at the end of v.7; v.8, Verdier, Philippe, Dimand, Maurice S., and Buhler, Kathryn C. *Limoges painted enamels, Oriental rugs and English silver*

(1977); v.9, *Prints, drawings, recent accessions* (to be published).

I2    Inventaire des collections publiques françaises. v.1-(18). Paris, Éditions des Musées nationaux, 1959-(72). il., plates.
v.1-4 published under series title *Inventaire général des dessins des musées de province.*

A series of inventory catalogues of public collections in museums in all parts of France. Includes collections of various kinds of works, ranging from ancient sculpture to 20th-century painting. All volumes contain full scholarly entries, each with detailed description, inventory number, provenance, bibliography, analysis, and illustration.

Published to date: (1) Besançon. Musée des Beaux-Arts. Cornillot, M.L. *La collection Pierre-Adrien Pâris* (1957); (2) Toulouse. Musée Paul-Dupuy. Mesuret, Robert. *Des dessins antérieurs à 1830* (1958); (3) Montauban. Musée Ingres. Ternois, Daniel. *Les dessins d'Ingres: Les portraits* (1959); (4) Bayonne. Musée Bonnat. Bean, J. *Les dessins italiens de la collection Léon Bonnat* (1960); (5) Toulouse. Musée des Augustins. Mesplé, Paul. *Les sculptures romanes* (1961); (6) Montpellier. Musée Fabre. Claparède, Jean. *Dessins de la collection Alfred Bruyas et autres dessins des XIXe et XXe siècles* (1962); (7) Tours. Musée des Beaux-Arts. Lossky, Boris. *Peintures du XVIIIe siècle* (1962); (8) Grenoble. Musée de Peinture et de Sculpture. Kueny, Gabrielle, et Viatte, Germain. *Les dessins modernes* (1963); (9) Strasbourg. Musée Archéologique. Hatt, Jean-Jacque. *Les sculptures gallo-romaines* (1964); (10) Nantes. Musée Thomas Dobrée. Costa, Dominique. *Collections mérovingiennes* (1964); (11) Montauban. Musée Ingres. Ternois, Daniel. *Ingres et son temps, peintures* (1965); (12) Sèvres. Musée National de Céramique. Reyniers, F. *Céramiques américaines* (1966); (13) Paris. Musée National d'Art Moderne. Fédit, Denise. *Kupka* (1966); (14) Rouen. Musée des Beaux-Arts. Rosenberg, Pierre. *Peintures françaises et italiennes du XVIIe siècle, peintures italiennes du XVIIIe siècle* (1966); (15) Paris. Musée National d'Art Moderne. Hoog, Michel. *Robert et Sonia Delaunay* (1967); (16) Chantilly. Musée Condé. Châtelet, Albert (XVe et XVIIe siècles); Pariset, François-Georges et Broglis, Raoul de (XVIe siècle). *Peintures de l'école française* (1970); (17) Vienne. Musée d'Archéologie et de Peinture. Boucher,

Stéphanie. *Les bronzes antiques* (1971); (18) Paris. Musée du Louvre, Cabinet des Dessins. Monnier, Geneviève. *Pastels: XVIIème et XVIIIème siècles* (1972); (19) Paris. Musée Jacquemart-André. La Moureyre-Gavoty, Françoise de. *Sculpture italienne:* préf. par Julien Cain (1975); (20) Dijon. Musée Archéologique. Deyts, Simone. *Sculptures gallo-romaines mythologiques et religieuses* (1976); (21) Avignon. Musée du Petit Palais. Laclotte, Michel et Mognetti, Elisabeth. *Peinture italienne* (1976).

SEE ALSO: *The James A. Rothschild Collection at Waddesdon Manor* (P19); Wrightsman, C. B. *The Wrightsman Collection* (P31).

# GENERAL WORKS

**I3**      Art of the world. N.Y., Crown; London, Methuen [1959– ]. il. (part col.)

The English-language ed. of the German series *Kunst der Welt*, Baden-Baden, Holle. French series title: *L'Art dans le monde,* Paris, Michel.

A series of monographs on the major periods and styles of the arts of Western, Eastern, and primitive cultures. The series is divided into two subseries: (1) European cultures: the historical, sociological, and religious backgrounds; (2) Non-European cultures: the historical, sociological, and religious backgrounds. Most of the volumes in the series have been translated. The level of scholarship in the individual volumes varies; all volumes are very well illustrated, primarily with color plates.

Volumes in English: (1) Leuzinger, Elzy. *Africa; the art of the Negro peoples.* 1960; (2) Disselhoff, Hans Dietrich, and Linné, Sigvald. *The art of ancient America.* 1961; (3) Porada, Edith, and Dyson, R. H. *The art of ancient Iran; pre-Islamic cultures.* 1965; (4) Homann-Wedeking, Ernst. *Archaic Greece.* 1968; (5) Seckel, Dietrich. *The art of Buddhism.* 1964; (6) Griswold, Alexander B.; Kim, Chewon; and Pott, Peter H. *The art of Burma, Korea, Tibet.* 1964; (7) Grabar, André. *The art of the Byzantine Empire; Byzantine art in the Middle Ages.* 1966; (8) Rowland, Benjamin. *Art of Central Asia.* 1974; (9) Speiser, Werner. *The art of China: spirit and society.* 1961; (10) De Silva, Anil. *The art of Chinese landscape painting; the caves of Tun-huang.* 1967; (11) Schefold, Karl. *The art of classical Greece.* 1966; (12) Du Bourguet, Pierre M. *The art of the Copts.* 1971; (13) Matz, Friedrich. *The art of Crete and early Greece; the prelude to Greek art.* 1962; (14) Woldering, Irmgard. *The art of Egypt; the time of the Pharoahs.* 1963; (15) Mansuelli, Guido Achille. *The art of Etruria and early Rome.* 1965; (16) Verzone, Paola. *The art of Europe: the Dark Ages from Theodoric to Charlemagne.* 1968; (17) Webster, Thomas Bertram Lonsdale. *The art of Greece; the age of Hellenism.* 1966; (18) Akurgal, Ekrem. *The art of Greece; its origins in the Mediterranean and Near East.* 1968; (19) Aubert, Marcel. *The art of the high Gothic era.* 1965; (20) Goetz, Hermann. *The art of India; 5000 years of Indian art.* 1964; (21) Groslier, Bernard Philippe. *The art of Indochina; including Thailand, Vietnam, Laos and Cambodia.* 1962; (22) Wagner, Frits A. *Indonesia; the art of an island group.* 1959; (23) Swann, Peter C. *The art of Japan, from the Jōmon to the Tokugawa period.* 1966; (24) Woolley, Charles Leonard. *The art of the Middle East including Persia, Mesopotamia and Palestine.* 1961; (25) Evers, Hans Gerhard. *The art of the modern age.* 1970; (26) Kähler, Heinz. *The art of Rome and her empire.* 1963; (27) Bühler, Alfred; Barrow, Terry; and Mountford, Charles P. *The art of the South Sea Islands, including Australia and New Zealand.* 1962; (28) Jettmar, Karl. *Art of the Steppes.* 1967; (29) Bandi, Hans-Georg, et al. *The art of the Stone Age.* 2d ed. 1970; (30) Wuthenau, Alexander von. *The art of terracotta pottery in pre-Columbian Central and South America.* 1970.

**I4**      Arts of mankind. N.Y., Golden Pr., Braziller; London, Thames & Hudson [1961–(76)]. v.[1–(24)]. il. (part col.), maps.

Editors: André Malraux and André Parrot. Editor-in-charge: Albert Beuret. French ed. series title: *L'Univers des formes,* Paris, Gallimard. German ed. series title: *Universum der Kunst,* München, Beck.

The American ed. of a French series of volumes on the major periods of art, which when complete will form a comprehensive world history of art and architecture. Most of the authors are French, a few German and Italian. All volumes are lavishly illustrated, largely in color, but coordination of texts and illustrations is often confusing. The English ed. of the series, published by Thames & Hudson, London, is identical to the American ed. but corresponding volumes have different titles. Most individual volumes are also listed under their appropriate classifications. Latest volumes not yet published in English editions.

Published to date: (1) Parrot, André. *Sumer: the dawn of art.* 1961; (2) _____. *The arts of Assyria.* 1961; (3) Ghirshman, Roman. *Persian art, the Parthian and Sassanian dynasties, 249 B.C.–A.D. 651.* 1962; (4) Guiart, Jean. *The arts of the South Pacific.* 1963; (5) Ghirshman, Roman. *The arts of ancient Iran from its origins to the time of Alexander the Great.* 1964; (6) Demargne, Pierre. *The birth of Greek art.* 1964; (7) Chastel, André. *The flowering of the Italian Renaissance.* 1965; (8) _____. *Studios and styles of the Italian Renaissance.* 1965; (9) Grabar, André. *Early Christian art; from the rise of Christianity to the death of Theodosius.* 1969; (10) _____. *The golden age of Justinian, from the death of Theodosius to the rise of Islam.* 1967; (11) Leiris, Michel, and Delange, Jacqueline. *African art.* 1968; (12) Hubert, Jean; Porcher, Jean; and Volbach, W. F. *Europe of the invasions.* 1969; (13) _____. *The Carolingian renaissance.* 1970; (14) Charbonneaux, Jean; Martin, Roland; and Villard, François. *Archaic Greek art (620–480 B.C.).* 1971; (15) Bianchi Bandinelli, Ranuccio. *Rome, the center of power, 500 B.C. to A.D. 200.* 1970; (16) Charbonneaux, Jean; Martin, Roland; and Villard, François. *Classical Greek art (480–330 B.C.).* 1972; (17) Bianchi Bandinelli, Ranuccio. *Rome, the late Empire; Roman art, A.D. 200–400.* 1971; (18) Charbonneaux, Jean; Martin, Roland; and Villard, François. *Hellenistic art (330–50 B.C.).* 1973; (19) Heydenreich, Ludwig Heinrich. *Italienische Renaissance: Anfänge und Entfaltung in der Zeit von 1400 bis 1460.* 1972; (20) Grodecki, Louis. *Die Zeit der Ottonen und Salier.* 1973; (21) Bianchi Bandinelli, Ranuccio. *Les Étrusques et l'Italie avant Rome.* 1973; (22)

Heydenreich, Ludwig Heinrich. *Italienische Renaissance: Die grossen Meister in der Zeit von 1500 bis 1540.* 1975; (23) Parrot, André. *Les Phéniciens: l'expansion phénicienne, Carthage.* 1975; (24) Bittel, Kurt. *Die Hethiter: die Kunst Anatoliens vom Ende d. 3. bis zum Anfang d. 1. Jahrtausends v. Chr.* 1976.

I5     Cossío, Manuel Bartolomé, and Pijoán y Soteras, José. Summa artis; historia general del arte. Bilbao, Madrid, Espasa-Calpe, s.a., 1931–(77). v.1–(25). il., plates (part col.)

A monumental series on the general history of art by various authors. Special emphasis is on Spanish art. Well illustrated with many color plates. José Pijoán was the sole author of v.12–16; v.17 and 18 were the first volumes devoted exclusively to Spanish art; v.23, the last work of Pijoán, published posthumously.

Contents by volume: (1) Arte de los pueblos aborígenes (1931); (2) Arte del Asia occidental (1931); (3) El arte egipcio hasta la conquista romana (1932); (4) El arte griego hasta la toma de Corinto por los Romanos (146 a. J.C.) (1932); (5) El arte romano hasta la muerte de Diocleciano; Arte etrusco y arte helenístico después de la toma de Corinto (1934); (6) El arte prehistórico europeo (1934); (7) Arte cristiano primitivo; Arte bizantino, hasta la saqueo de Constantinopla por los cruzados el año 1204 (1935); (8) Arte bárbaro y prerrománico, desde el siglo IV hasta el año 1000 (1942); (9) El arte románico, siglos XI y XII (1944); (10) Arte precolombiano, mexicano y maya (1946); (11) Arte gótico de la Europa occidental, siglos XIII, XIV y XV (1947); (12) Arte islámico (1949); (13) Arte del período humanistico, trecento y cuatrocento (1950); (14) Renacimiento romano y veneciano, siglo XVI (1951); (15) El arte del renacimiento en el norte y el centro de Europa (1952); (16) Arte barroco en Francia, Italia y Alemania, siglos XVII y XVIII (1957); (17) La arquitectura y la orfebrería españolas del siglo XVI (1959); (18) La escultura y la rejería españolas del siglo XVI (1961); (19) El arte de la India (1964); (20) El arte de la China (1966); (21) El arte del Japón (1967); (22) Pintura medieval española (1966); (23) Arte europeo de los siglos XIX y XX (1967); (24) La pintura española del siglo XVI (1970); (25) La pintura española del siglo XVII (1977).

I6     Elsen, Albert Edward. Purposes of art: an introduction to the history and appreciation of art. [3d ed.]. N.Y., Holt [1972]. 488p. 720 il. (100 col.)

1st ed. 1962; 2d ed. 1967.

An intelligent, stimulating book, planned as an "alternative to the linear, chronological history of art, and also to the art appreciation book that dissects works of art into 'elements'." Presents the history of art "as a type of mosaic composed of both themes and chronological evolution."—*Author's pref.* Well illustrated. The classified bibliography has been updated with each new edition and a glossary of terms added to this ed.

I7     Gardner, Helen. Art through the ages. 6th ed. [Revised by Horst de la Croix and Richard G. Tansey] N.Y., Harcourt [1975]. 976p. il., col. plates, maps, plans.

1st ed. 1926.

An updated, expanded ed. of this standard textbook for college survey courses. The 6th ed. is a rev. ed. of the 5th ed. (1970), which was based on the extensively rewritten 4th ed. (1959). The 4th ed. was a collaborative work by well-known historians, ed. by Sumner McK. Crosby.

The 6th ed. restores sections on non-Western and non-European art (the arts of Asia, primitive art, and the art of the Americas), which were excluded from the 5th ed. It includes a new section on Islamic art and an updated chapter on 20th-century art. Illustrated with 995 black-and-white reproductions and 112 color reproductions. The bibliography at the end is arranged by chapter and includes critical evaluations.

I8     The Garland library of the history of art. Editorial selection committee: James S. Ackerman, Sumner McKnight Crosby, Horst W. Janson, Robert Rosenblum. N.Y., Garland, 1976–77. 14v. il.

A compendium of facsimile reprints of 152 articles, each of which was considered to be an outstanding contribution to art historical scholarship. All of these articles are in English. Another series is being planned.

Classified by area of art history: v.1, Ancient art: pre-Greek and Greek architecture; v.2, Ancient art: pre-Greek and Greek art; v.3, Ancient art: Roman art and architecture; v.4, Medieval architecture; v.5, Medieval art; v.6, 15th-century art and architecture; v.7, 16th-century art and architecture; v.8, 17th-century art in Italy, France, and Spain; v.9, 17th-century art in Flanders and Holland; v.10, Rococo to Romanticism: art and architecture 1700–1850; v.11, 19th- and 20th-century architecture; v.12, Painting from 1850 to the present.

I9     Gombrich, Ernst Hans Josef. The story of art. [12th ed., enl. and redesigned. London] Phaidon. [Distr. by Praeger, N.Y., 1972.] 488p. 397 il.

Paperback ed.: London, N.Y., Phaidon [1972]; 13th ed., N.Y., Dutton, 1978.

A modern classic by a preeminent art historian. Although intended for the beginner, it also gives the advanced student a broad view of art historical trends. Only the works illustrated are discussed. Includes "A note on art books," p.491–94, and a glossary.

I10    Handbuch der Kunstwissenschaft. Berlin-Neubabelsberg, Wildpart-Potsdam, Athenaion, c.1913–30. il., plates.

An old series of 27 scholarly volumes on Western and Eastern art which form a comprehensive history of art. Most volumes are now superseded by later works. For a complete listing of the series, see Chamberlin 444 (A27).

I11    Hartt, Frederick. Art; a history of painting, sculpture, architecture. N.Y., Abrams [1976]. 2v il. (part col.)

Paperback text ed.: Englewood Cliffs, N.J., Prentice-Hall [1976].

A new 2v. survey of the history of art. Includes brief chapters on African, North American Indian, Oceanic, and Islamic art; excludes Oriental art. Each volume has a "time line" which correlates specific works of art with political

history, religion, music, science and technology. Glossary, bibliography, and index in each volume.

I12    Hauser, Arnold. The social history of art. [Trans. in collaboration with the author by Stanley Godman]. N.Y., Knopf; [London] Routledge & Paul [1951]. 2v. il.
Paperback ed. in 4v., N.Y., Random.
Presents the history of art in terms of the connections between social forces and works of art (including literature and film) from prehistory to the 20th century.
Bibliographical references in "Notes" at the end of each volume. Indexes of subjects and names at the end of v.2.

I13    Histoire de l'art. [Paris, Gallimard, 1961-69]. 4v. il., maps. (Encyclopédie de la Pléiade. 12, 17, 21, 28)
A comprehensive history of art; various sections written by recognized authorities. Illustrated with a few line drawings; no photographs. Includes selective bibliographies.
Contents: v.1, Le monde non-chrétien, sous la direction de Pierre Devambez (1961); v.2, L'Europe médiévale, sous la direction de Jean Babelon (1966); v.3, Renaissance, baroque, romanticisme, sous la direction de Jean Babelon (1965); v.4, Du réalisme à nos jours, sous la direction de Bernard Dorival (1969).

I14    Huyghe, René, ed. L'art et l'homme. Paris, Larousse [1957-61]. 3v. il., col. plates, maps.
The English ed. consists of 4v. with the following titles: (1) *Larousse encyclopedia of prehistoric and ancient art; Art and mankind.* N.Y., Prometheus Pr. [1962]; (2) *Larousse encyclopedia of Byzantine and medieval art.* N.Y., Prometheus Pr. [1963]; (3) *Larousse encyclopedia of Renaissance and Baroque art.* N.Y., Prometheus Pr. [1964]; (4) *Larousse encyclopedia of modern art from 1800 to the present day.* N.Y., Prometheus Pr. [1965].
Each volume is divided chronologically into sections which are preceded by general essays. Each section includes essays by well-known scholars and historical summaries. Profusely illustrated. Limited number of excellent color plates.

I15    Janson, Horst Woldemar. History of art; a survey of the major visual arts from the dawn of history to the present day [by] H. W. Janson and Dora Jane Janson. [Rev. and enl.] N.Y., Abrams; Englewood Cliffs, N.J., Prentice-Hall [1969]. 616p. il., maps (on lining papers), plans, col. plates.
First published 1962; 2d rev. ed., 1977.
A stimulating, well-written survey of art history, emphasizing European painting and sculpture, written by a distinguished scholar. The standard textbook for many American college survey courses. Superb black-and-white illustrations, color plates, line drawings, and plans.
Synoptic tables (political history; religion; literature; science, technology; architecture, sculpture; painting) for the ancient world, the Middle Ages, the Renaissance, and the modern world, p.579-93. Classified bibliography, p.594-603.

I16    Krautheimer, Richard. Studies in early Christian, medieval, and Renaissance art. N.Y., New York

Univ. Pr.; London, Univ. of London Pr., 1969. xxviii, 464p. 139 il.
A collection of important articles previously published in journals. Largely on architectural subjects, for example, "Introduction to an iconography of medieval architecture" (1942), and "Alberti and Vitruvius" (1963). Each essay is followed by a postscript and additional bibliography, bringing the material up-to-date. Bibliographical notes. "Richard Krautheimer bibliography 1925-1967," p.xi-xv. Contains a good selection of illustrations to the studies in the text.
Index, p.361-73.

I17    Michel, André. Histoire de l'art depuis les premiers temps chrétiens jusqu'à nos jours, pub. sous la direction de André Michel. Paris, Colin, 1905-[29]. 8v. in 17. il., plates.
_____. Index d'ensemble; noms d'artistes, noms de lieux, sujets et table générale par Louise Lefrançois-Pillon. Paris, Colin [1929]. 279p.
An early scholarly work, largely superseded by more recent general histories of art. Each section written by a specialist.
Contents: (1) Des débuts de l'art chrétien à la fin de la période romane (2v.); (2) Formation, expansion et évolution de l'art gothique (2v.); (3) Le réalisme: les débuts de la Renaissance (2v.); (4) La Renaissance (2v.); (5) La Renaissance dans les pays du Nord, Formation de l'art classique moderne (2v.); (6) L'art en Europe au XVIIe siècle (2v.); (7) L'art en Europe au XVIIIe siècle (2v.); (8) L'art en Europe et en Amérique au XIXe siècle et au début du XXe (3v.).

I18    The Pelican history of art, ed. by Nikolaus Pevsner. Harmondsworth; Baltimore, Penguin, 1953-(78). v.1-(42). il., plates, maps, plans.
Each volume is listed separately under its appropriate classification.
The most comprehensive history of art and architecture in English. When complete, the series will consist of about 50 volumes on all countries and periods, with emphasis on stylistic development rather than on cataloguing artists and works of art. Each volume is written by a foremost scholar, or scholars, of the field; the majority of the authors are English or American. All volumes follow a uniform format: a text of approx. 250 to 350 pages; line drawings illustrating the text; a section of black-and-white plates; notes, which include references to specialized literature; a classified bibliography, occasionally annotated. The volumes are periodically revised and updated. Revised paperback editions contain integrated text and plates. By almost universal consent, the *Pelican history of art* represents one of the most distinguished publishing achievements in the field of art history and replaces most older historical surveys.
Published to date: (1) Waterhouse, Ellis. *Painting in Britain, 1530-1790* (1953; 3d ed. 1969); (2) Rowland, Benjamin. *The art and architecture of India: Buddhist, Hindu, Jain* (1953; 3d rev. ed. 1971; paperback ed. 1970); (3) Summerson, John. *Architecture in Britain, 1530-1830* (1954; 5th ed. 1969; paperback ed. 1970); (4) Blunt, Anthony. *Art and architecture in France, 1500-1700* (1954; 2d ed. 1970; paperback ed. 1973); (5) Rickert, Margaret. *Painting in Britain: the Middle Ages*

(1954; 2d ed. 1965); (6) Hamilton, George Heard. *The art and architecture of Russia* (1954; 2d ed. 1975); (7) Frankfort, Henri. *The art and architecture of the ancient Orient* (1955; 4th rev. ed. 1969; paperback ed. 1970); (8) Paine, Robert Treat, and Soper, Alexander. *The art and architecture of Japan* (1955; 2d ed. 1974; paperback ed. 1975); (9) Stone, Lawrence. *Sculpture in Britain: the Middle Ages* (1955; 2d ed. 1972); (10) Sickman, Lawrence, and Soper, Alexander. *The art and architecture of China* (1956; 3d ed. 1968; paperback ed. 1971); (11) Lawrence, Arnold Walter. *Greek architecture* (1957; 2d ed. 1967); (12) Webb, Geoffrey. *Architecture in Britain: the Middle Ages* (1956; 2d ed., 1965); (13) Conant, Kenneth John. *Carolingian and Romanesque architecture, 800-1200* (1959; 2d ed. 1966; paperback ed. 1978); (14) Smith, William Stevenson. *The art and architecture of ancient Egypt* (1958; reprint with corrections 1965); (15) Hitchcock, Henry-Russell. *Architecture: ninteenth and twentieth centuries* (1958; 3d ed. 1968; paperback ed. 1971); (16) Wittkower, Rudolf. *Art and architecture in Italy, 1600-1750* (1958; 3d ed. 1973; paperback ed. 1973); (17) Kubler, George, and Soria, Martin. *Art and architecture in Spain and Portugal and their American dominions, 1500 to 1800* (1959); (18) Gerson, Horst, and Kuile, E. H. ter. *Art and architecture in Belgium, 1600 to 1800* (1960); (19) Frankl, Paul. *Gothic architecture* (1962); (20) Novotny, Fritz. *Painting and sculpture in Europe, 1780-1880* (1960; 2d ed. 1970; paperback ed. 1971); (21) Kubler, George. *The art and architecture of ancient America; the Mexican, Maya and Andean peoples* (1962; 2d ed. 1975); (22) Hempel, Eberhard. *Baroque art and architecture in Central Europe: Germany, Austria, Switzerland, Hungary, Czechoslovakia, Poland. Painting and sculpture: 17th and 18th centuries. Architecture: 16th to 18th centuries* (1965); (23) Whinney, Margaret Dickens. *Sculpture in Britain, 1530-1830* (1964; 2d ed. 1975); (24) Krautheimer, Richard. *Early Christian and Byzantine architecture* (1965; paperback ed. 1975); (25) Müller, Theodor. *Sculpture in the Netherlands, Germany, France and Spain, 1400-1500* (1966); (26) Seymour, Charles. *Sculpture in Italy, 1400 to 1500* (1966); (27) Rosenberg, Jakob; Slive, Seymour; and Kuile, E. H. ter. *Dutch art and architecture, 1600 to 1800* (1966; paperback ed. 1972); (28) White, John. *Art and architecture in Italy, 1250 to 1400* (1966); (29) Hamilton, George Heard. *Painting and sculpture in Europe, 1880 to 1940* (1967; paperback ed. 1972); (30) Sandars, Nancy K. *Prehistoric art in Europe* (1968); (31) Osten, Gert von der, and Vey, Horst. *Painting and sculpture in Germany and the Netherlands, 1500-1600* (1969); (32) Boëthius, Axel, and Ward-Perkins, J. B. *Etruscan and Roman architecture* (1970); (33) Beckwith, John. *Early Christian and Byzantine art* (1970); (34) Dodwell, Charles Reginald. *Painting in Europe, 800-1200* (1971); (35) Freedberg, Sydney. *Painting in Italy, 1500-1600* (1971; paperback ed. 1975); (36) Lasko, Peter. *Ars Sacra, 800-1200* (1972); (37) Kalnein, Wend Graf, and Levey, Michael. *Art and architecture of the eighteenth century in France* (1972); (38) Heydenreich, Ludwig Heinrich, and Lotz, Wolfgang. *Architecture in Italy, 1400-1600* (1974); (39) Strong, Donald. *Roman art* (1976); (40) Wilmerding, John. *American art* (1976); (41) Hood, Sinclair. *The arts in prehistoric Greece* (1978); (42) Brendel, Otto J. *Etruscan art* (1978).

I19    Propyläen-Kunstgeschichte. Berlin, Propyläen Verlag, 1923-[35]. 16v. and 9 suppl. v. il. (part col.)

Some volumes are listed separately under their appropriate classifications.

The strength of this series lies in the illustrations which form an invaluable body of visual material. Various editions published for some volumes.

The Spanish ed. of this series, *Historia del arte Labor*, includes rewritten and expanded parts dealing with Spanish art.

Contents: (1) Sydow, Eckart von. *Die Kunst der Naturvölker und der Vorzeit*, 1923 (I587); (2) Schäfer, H. *Die Kunst des alten Orients*, 1925; (3) Rodenwaldt, G. *Die Kunst der Antike*, 1927; (4) Fischer, Otto. *Die Kunst Indiens, Chinas und Japans*, 1928 (I490); (5) Glück, H. *Die Kunst des Islam*, 1925; (6) Hauttmann, Max. *Die Kunst des frühen Mittelalters*, 1929; (7) Karlinger, Hans. *Die Kunst der Gotik*, 1927; (8) Bode, W. *Die Kunst der Frührenaissance in Italien*, 1926; (9) Schubring, Paul. *Die Kunst der Hochrenaissance in Italien*, 1926; (10) Glück, G. *Die Kunst der Renaissance in Deutschland*, 1928; (11) Weisbach, W. *Die Kunst des Barock in Italien, Frankreich und Spanien*, 1924; (12) Friedländer, M. J. *Die niederländischen Maler des 17. Jahrhunderts*, 1923; (13) Osborn, Max. *Die Kunst des Rokoko*, 1929; (14) Pauli, G. *Die Kunst des Klassizismus und der Romantik*, 1925; (15) Waldmann, E. *Die Kunst des Realismus und des Impressionismus im 19. Jahrhundert*, 1927; (16) Einstein, Carl. *Die Kunst des 20. Jahrhunderts*, 1926 (I241).

Ergänzungsbande: Bock, E. *Geschichte der graphischen Kunst*, 1930; Feulner, A. *Kunstgeschichte des Möbels*, 1927; Hofmann, F. H. *Das Porzellan der europäischen Manufakturen im XVIII. Jahrhundert*, 1932; Horst, Carl. *Die Architektur der deutschen Renaissance*, 1928; Kühn, Herbert. *Die vorgeschichtliche Kunst Deutschlands*, 1935; Platz, G. A. *Die Baukunst der neuesten Zeit*, 1927; Platz, G. A. *Wohnräume der Gegenwart*, 1933; Karlinger, H. *Deutsche Volkskunst*, 1928; Schmidt, Max. *Kunst und Kultur von Peru*, 1929.

I20    _____. [n.F.] Hrsg. unter Beratung von Kurt Bittel [et al.]. Berlin, Propyläen Verlag [1966-(77)]. 18v. il., plates (part col.), plans.

Individual volumes are also listed separately under their appropriate classifications.

An extremely important new series by foremost authorities which comprises a comprehensive history of Western and Eastern art. Invaluable for the large body of illustrations and scholarly texts. Each volume follows a uniform format in four main parts: (1) General introductory essays which survey the various arts of the period; (2) A section of plates; (3) A *Dokumentation* section which includes detailed commentaries on the plates; (4) An appendix which contains an extensive classified bibliography and synoptic tables.

Contents: Bd. 1, Schefold, Karl. *Die Griechen und ihre Nachbarn*, 1967; Bd. 2, Kraus, Theodor. *Das römische Weltreiche*, 1967; Bd. 3, Volbach, Wolfgang Friedrich, and Lafontaine-Dosogne, Jacqueline. *Byzanz und der christliche Osten*, 1968; Bd. 4, Sourdel-Thomine, Janine, and Spuler, Bertold. *Die Kunst des Islam*, 1973; Bd. 5, Fillitz, Hermann. *Das Mittelalter I*, 1969; Bd. 6, Simson, Otto von. *Das Mittelalter*

*II: Das hohe Mittelalter,* 1972; Bd. 7, Białostocki, Jan. *Spätmittelalter und beginnende Neuzeit,* 1972; Bd. 8, Kauffmann, Georg. *Die Kunst des 16. Jahrhunderts,* 1970; Bd. 9, Hubala, Erich. *Die Kunst des 17. Jahrhunderts,* 1970; Bd. 10, Keller, Harald. *Die Kunst des 18. Jahrhunderts,* 1971; Bd. 11, Zeitler, Rudolf Walter. *Die Kunst des 19. Jahrhunderts,* 1966; Bd. 12, Argan, Giulio Carlo. *Die Kunst des 20. Jahrhunderts,* 1977; Bd. 13, Mellink, Machteld J., and Filip, Jan. *Frühe Stufen der Kunst,* 1974; Bd. 14, Orthmann, Winfried. *Der alte Orient,* 1975; Bd. 15, Vandersleyen, Claude. *Das alte Ägypten,* 1975; Bd. 16, Härtel, Herbert, and Auboyer, Jeannine. *Indien und Südostasien,* 1971; Bd. 17, Fontein, Jan, and Hempel, Rose. *China, Korea, Japan,* 1968; Bd. 18, Willey, Gordon R. *Das Alte Amerika,* 1974.

I21   Robb, David Metheny, and Garrison, Jesse James. Art in the Western world. 4th ed. N.Y., Harper [1963]. 782p. il.

1st ed. 1935.

A standard 1v. history of the architecture, sculpture, painting, and minor arts of the West.

Glossary, p.727–33. Classified bibliography, p.735–43. Chronological table, p.745–56.

I22   Storia universale dell'arte. [Torino] Unione Tipografico-Editrice Torinese [1953–68] 6v. in 10. il., plates, plans.

A series of broad surveys by recognized Italian historians covering the history of art from prehistory through the 19th century.

Contents: v.1. Tea, Eva. *Preistoria e civilità estraeuropea* (1953); v.2 (2v.). (1) Arias, Paolo Enrico. *L'arte della Grecia* (1967). (2) Frova, Antonio. *L'arte di Roma e del mondo romano* (1961); v.3 (2v.). Tea, Eva. *Medioevo* (1957); v.4 (2v.). Tea, Eva, and Mazzini, Franco. *Quattrocento e Cinquecento* (1964–68); v.5 (2v.). Golzio, Vincenzo. *Seicento e Settecento* (1955); v.6. Brizio, Anna Maria. *Ottocento e Novecento.* 3d ed. riv., accresciunta e in gran parte rifatta [1962].

Each volume has a substantial, classified bibliography, with some annotations.

I23   Style and civilization, ed. by John Fleming and Hugh Honour. Harmondsworth; Baltimore, Penguin [1967–(75)]. [v.1–(9)]. il.

An excellent series of monographs by English and American scholars on the history and the major styles of European art. "The aim is to discuss each important style in relation to contemporary shifts in emphasis and direction both in the other, non-visual arts and in thought and civilization as a whole.... The series is intended for the general reader but it is written at a level which should interest the specialist as well."—*Editorial foreword.* All volumes are very well-illustrated, often with little-known works. Each volume contains a "Catalogue of illustrations," which includes descriptions, commentaries, and references, and "Books for further reading," a critical, annotated bibliography. Individual volumes are listed separately under their appropriate classifications.

Volumes published to date: (1) Boardman, John. *Preclassical: from Crete to Archaic Greece* (1967); (2) Henderson, George. *Gothic* (1967); (3) Levey, Michael. *Early Renaissance* (1967); (4) Shearman, John. *Mannerism* (1967); (5) Honour, Hugh. *Neo-classicism* (1968); (6) Nochlin, Linda. *Realism* (1971); (7) Henderson, George. *Early medieval* (1972); (8) Levey, Michael. *High Renaissance* (1975); (9) Runciman, Steven. *Byzantine style and civilization* (1975).

I24   Upjohn, Everard Miller; Wingert, Paul S.; and Mahler, Jane Gaston. History of world art. 2d ed., rev. and enl. N.Y., Oxford Univ. Pr., 1958. 876p. 671 il., 17 col. plates, maps (on lining papers)

1st ed. 1949.

A basic 1v. survey of art. Includes chapters on prehistoric art; the art of primitive peoples; and the arts of India and Southeast Asia, China, and Japan. Captions to the illustrations give dimensions of works.

Glossary, p.831–39. "Suggested readings," p.841–50.

I25   Vermeule, Cornelius. European art and the classical past. Cambridge, Harvard Univ. Pr., 1964. xvi, 206p. il.

A study of classical influence in art from the medieval era to Neoclassicism, culled from lectures given by a recognized authority. Emphasizes the diversity of the classical styles and the history of antiquarianism. Addressed to the general reader rather than to the advanced student. Includes valuable sections on coins and medals, an introductory chapter on the physical survival of the works, and documentation on the availability of the piece to the artists. Good illustrations.

SEE ALSO:  Seroux d'Agincourt, J. *Histoire de l'art par les monuments* (H118).

# TECHNIQUES

I26   Marijnissen, Roger H. Dégradation, conservation et restauration de l'oeuvre d'art. Bruxelles, Éditions Arcade, 1967. 2v. plates (part col.)

A comprehensive, scholarly survey of the deterioration, conservation, and restoration of works of art. Written by an art historian.

Contents, v.1: (I) Aperçu historique; (II) L'oeuvre d'art en tant que phénomène matériel; (III) Essai de méthode; (IV) L'exécution; (V) Le problème de la conservation et de la restauration face à la culture contemporaine; Conclusion. "Légendes," p.467–512, and "Notes des légendes," p.513–14, refer to the plates in v.2.

v.2: Illustrations, 1–329; Abréviations, p.331–35; Notes explicatives, p.337–426, include bibliographical references; Bibliographie systématique, p.427–560, arranged by chapters and sections within chapters; Terminologie, p.561–618, defines terms in French, with equivalents in German, English, and Dutch; Index synoptique.

I26a   Plenderleith, Harold James, and Werner, A. E. A. The conservation of antiquities and works of art;

treatment, repair, and restoration. 2d ed. London, N.Y., Toronto, Oxford Univ. Pr., 1971. xix, 394p. il. 1st ed. 1956.

The standard, comprehensive work. "Intended as a handbook for the collector, the archaeologist, and the museum curator, and as a workshop guide for the technician."—*Pref. to the 1st ed.*

Contents: Introduction, the influences of the environment; pt. 1, Organic materials; pt. 2, Metals; pt. 3, Siliceous and related materials. Appendixes I–XVIII, p.355–78. Reference material, p.379. Suppliers of materials, p.380–82, lists English sources for materials mentioned.

SEE ALSO: Cennini, C. *Il libro dell'arte* (H17); Mayer, R. *A dictionary of art terms and techniques* (E11); Theophilus. *The various arts* (H19); Painting — Techniques (M28–M48); Sculpture — Techniques (K13–K18).

# PREHISTORIC

I27    Graziosi, Paolo. L'arte preistorica in Italia. Firenze, Sansoni, 1973. iv, 203p. 201 plates (10 col.)

An authoritative history of the prehistoric art of Italy from its origins to the beginning of historical times. Includes extensive documentation and excellent illustrations, many of objects not reproduced elsewhere.

Contents: Premessa. Pt. 1, L'arte dei popoli caciatori: L'arte mobiliare; L'arte parietale; Stile franco-cantabrico e provincia mediterranea. Pt. 2, L'arte dei popoli agricoltori e allevatori: La ceramica; L'arte mobiliare; Stele antropomorfe; L'arte rupestre. Pt. 3, Conclusioni. Bibliography, p.[183]–93 (2d group). Indexes of names and places.

I28    _____. Palaeolithic art. London, Faber and Faber; N.Y., McGraw-Hill [1960]. 278p. il., plates (part col.), maps.

Rev. trans. of *L'arte dell'antica età dell' pietra,* Florence, Sansoni, 1956.

"Presents an encyclopedic view of the art of the European continent and part of Siberia during the Upper Palaeolithic period (approx. 40,000 to 10,000 B.C.)."—Review by Douglas Fraser, *Art Bulletin,* Mar. 1963, p.61. Excellent illustrations accompanied by commentary comprise the major portion of the book.

Bibliography, p.[221]–36.

I29    Kühn, Herbert. Die Felsbilder Europas. Stuttgart, Kohlhammer [1952]. 322p. 144 il., 116 plates (5 col.)

English trans. by Alan Houghton Brodrick, *The rock pictures of Europe,* London, Sidgwick and Jackson; Fair Lawn, N.J., Essential Books, 1956. Repr. of English ed.: N.Y., October House, 1967.

Attempts to describe and interpret the rock carvings of Europe of all periods from the standpoint of the history of art. Illustrated with line drawings and photographs. Bibliographical references in "Anmerkungen," p.217–31. "Verzeichnis der Felsbilder," arranged by region, p.233–96. "Literatur-Verzeichnis," p. 297–300. Indexes of names and places.

I30    Leroi-Gourhan, André Mazenod. Treasures of prehistoric art. [Trans. from the French by Norbert Guterman]. N.Y., Abrams [1967]. 543p. il., plates (part col.), maps.

Trans. of *Préhistoire d'art occidental,* Paris, Mazenod, 1965.

"Magnificently illustrated and well documented . . . . In spite of its critical apparatus, this volume does not give sufficient statistical material to carry agreement with all the author's contentions."—N. Sandars in *Prehistoric art in Europe* (I33), p.330.

Contents: Pt. 1, Descriptions and theories: (1) The discovery of prehistoric art; (2) Known and unknown in paleolithic chronology; (3) Decorated weapons, tools, and ornaments; (4) Objects of religious significance; (5) The meaning of cave art; (6) Paleolithic sanctuaries; (7) Toward a revised chronology; (8) A survey of paleolithic art; (9) The animals of cave art: stylistic evolution. Pt. 2, Documentation: (10) Description of sites; (11) Documentary photographs; (12) Charts supporting the hypotheses. Classified bibliography, p.525–37; index of sites, p.539–43.

I31    Megaw, J. V. S. Art of the European Iron Age: a study of the elusive image. N.Y., Harper, 1970. 195p. 17 il., 140 plates (part col.)

Primarily a compilation of plates of Iron Age objects, accompanied by a "Catalogue to the plates" in which the purposes are "to place the individual pieces in their precise archaeological setting . . . and secondly to discuss each object as an individual work of art and to suggest stylistic comparisons . . . —*Notes.*

Contents: Introduction; Notes on abbreviations and references used; Catalogue; Chronological chart.

I32    Powell, T. G. E. Prehistoric art. N.Y., Praeger [1966]. 284p. il. (part col.), maps.

A worthy attempt to place European prehistoric objects within an archaeological context. Valuable for illustrations. Bibliography, p.263–64.

I33    Sandars, Nancy K. Prehistoric art in Europe. Harmondsworth; Baltimore, Penguin [1968]. xlix, 350p. il., 189 plates, maps. (The Pelican history of art. Z 30)

An outstanding volume of the Pelican series in which the author masterfully covers the immense time span and variety of art in prehistoric Europe. Contents: (1) The beginning; (2) Upper paleolithic art, 15,000–8000; (3) Mesolithic art, 8000–2000; (4) Neolithic art in eastern Europe, 5000–2000; (5) From the Mediterranean to the Baltic, 4000–2000; (6) Bronze age art, 2000–1200; (7) Ferment and new beginnings, 1200–500; (8) Continental art in the last centuries B.C.; (9) Insular La Tène and the problem of La Tène art; (10) Postscript.

Ample notes; bibliography, p.329–32, with a few annotations; excellent line drawings and plates.

SEE ALSO: Camón Aznar, J. *Las artes y los pueblos de la España primitiva* (I440); Déchelette, J. *Manuel d'archéologie préhistorique, celtique et gallo-romaine* (I140); Ebert, M., ed. *Reallexikon der Vorgeschichte...* (E26); *Handbuch der*

*Archäologie* (I35); Mellink, M. *Frühe Stufen der Kunst* (I54); Pericot-Garcia, L., Galloway, J., and Lommel, A. *Prehistoric and primitive art* (I586).

# ANCIENT

I34   Frankfort, Henriette Antonia (Groenewegen), and Ashmole, Bernard. Art of the ancient world; painting, pottery, sculpture, architecture from Egypt, Mesopotamia, Crete, Greece, and Rome. N.Y., Abrams [1971?]. 528p. il. (part col.)

An authoritative introductory survey of the arts of the ancient world by two preeminent scholars. Near Eastern sections by Groenewegen-Frankfort; Greek and Italic sections by Ashmole. Excellent illustrations. Bibliography, p.509-14.

I35   Handbuch der Archäologie, im Rahmen des Handbuchs der Altertumswissenschaft; in Verbindung mit E. Walter Andrae, Helmut Arntz, Friedrich Wilh. Freiherr von Bissing, hrsg. von Walter Otto. München, Beck, 1937-(53). 4v. il., plates. (Müller, Ivan Philipp Edvard, Ritter von. Handbuch der Altertumswissenschaft, 6. Abt.)

Published in parts, 1937-(53). v.1 contains: General introduction; List of abbreviations; the Stone Age and the ancient Orient (Babylonia, Syria, Egypt, Assyria, etc.). v.2 covers the Stone and Bronze Ages in Europe and adjoining territory before 1000 B.C. v.3, *Die Griechische Plastik* by Georg Lippold, is an older standard treatment of Greek sculpture. v.4, *Malerei und Zeichnung* by Andreas Rumpf, is an account of Greek painting. Each volume has its own indexes.

I36   Handbuch der Archäologie im Rahmen des Handbuchs Altertumswissenschaft. Neu hrsg. von Ulrich Hausmann. München, Beck, 1969- . il.

A new series, continuing the *Handbuch der Archäologie* (I35).

   Contents: Bd. 1, Brunner, Helmut, et al. Allgemeine Grundlagen der Archäologie (1969); Bd. 2, Hrouda, Barthel. Vorderasien I: Mesopotamien, Babylonien, Iran und Anatolien (1971).

SEE ALSO: *Enciclopedia dell'arte antica, classica e orientale* (E29); *Lexikon der alten Welt* (E30).

# Egypt

I37   Aldred, Cyril. Akhenaten and Nefertiti [Catalog of an exhibition celebrating the 150th anniversary of the Brooklyn Institute of Arts and Sciences]. N.Y., Brooklyn Museum in association with the Viking Pr. [1973]. 231p. il. (part col.)

The catalogue of a major loan exhibition at the Brooklyn Museum, written by an outstanding specialist. Limited to the revolutionary Amarna style, 14th century B.C.

   Contents: Introduction: The Amarna revolution; The historical outline (1372-1350 B.C.). The monuments of Akhenaten and Nefertiti. The development of the Amarna style—the early period. The development of the Amarna style—the later phases. Iconography. The character of Amarna art. Notes. The catalogue, nos. 1-175, gives collection, measurements, conditions, provenance, commentary, and bibliography. Each work is illustrated. Bibliography, p.224-29.

I38   ———. The development of ancient Egyptian art, from 3200 to 1315 B.C. London, Tiranti, 1962. 3v. in 1. 329 il., plates, maps. (Chapters in art)

A 1v. ed. which contains the author's three works: *Old Kingdom art in ancient Egypt, Middle Kingdom art in ancient Egypt,* and *New Kingdom art in ancient Egypt during the 18th dynasty, 1570 to 1315 B.C.,* with an additional introductory preface and an index. Each volume has a separate title page with imprint dates 1949, 1956, and 1961 (2d ed.).

   A concise survey of the art of ancient Egypt, emphasizing sculpture, for the beginning student and general reader. Includes the bibliographies of all three works.

I39   Bille-de Mot, Élénore. The age of Akhenaten. Trans. from the French by Jack Lindsay. London, Evelyn, Adams & MacKay; N.Y., McGraw-Hill [1966]. 200p. 120 il. (24 col.), plans, table, diagrs.

A good survey of the history and art from the age of Akhenaten, written by a Belgian Egyptologist. The illustrations comprise the best collection of the art of the Amarna period. Bibliographical references included in "Notes," p.187-93.

I40   Capart, Jean. L'art égyptien. Première partie: études et histoire. Deuxième partie: Choix de documents, accompagnés d'indications bibliographiques. Bruxelles, Vromant, 1922-48. 5v. plates, plans.

Contents of pt. 1, v.1 (1924; all published of pt. 1): Introduction générale; ancien & moyen empires. More useful for pt. 2, which includes four volumes of illustrations, with catalogue information of 800 works of Egyptian art. Contents of pt. 2: (v.I) L'architecture (1-200). 1922; (v.II) La statuaire (201-400). 1948; (v.III) Les arts graphiques (401-600). 1942; (v.IV) Les arts mineurs (601-800). 1947.

I41   Hayes, William Christopher. The scepter of Egypt; a background for the study of the Egyptian antiquities in the Metropolitan Museum of Art. [N.Y.] Metropolitan Museum of Art. (Distr. by New York Graphic Society, Greenwich, Conn. [1968]) 2v. il., fold. maps.

3d printing of v.1; 2d printing of v.2.

An excellent historical study which is based upon the collection of the Metropolitan Museum. Incorporates recent scholarship.

   Contents: pt. 1, From the earliest times to the end of the Middle Kingdom; pt. 2, The Hyksos period and the New Kingdom (1675-1080 B.C.).

   Each part has a bibliography, indexes of proper names (kings, personal names, divinities, geographic and ethnic names) and a general index. Includes full bibliographies.

I42   Lange, Kurt. Egypt; architecture, sculpture, painting in three thousand years [by] Kurt Lange and Max Hirmer. With contributions by Eberhard Otto and

Christiane Desroches-Nobelcourt. [4th. ed., rev. and enl.]. London, N.Y., Phaidon [1968]. viii, 559p. 85 il. (incl. maps, plans), 330 plates (60 col.)
Photographs by M. Hirmer and his colleagues. Trans. from the original German ed. by R. H. Boothroyd with additional material in the 4th German ed. trans. by J. Filson and B. Taylor.

1st ed. 1956.

An excellent introduction to Egyptian art for the student and general reader. Not a coffee-table book. Magnificent illustrations, many in color. The text, written by the late author, has been completely revised by two recognized scholars. The scope of the notes has been enlarged with historical summaries, and the whole orientation is now more art-historical.

Contents: Foreword, Introduction; Plates; Gods and temples; Descriptive section and notes on the plates; The Nubian temples; List of Places; Short bibliography; Acknowledgements; Index.

I43  Michalowski, Kazimierz. Art of ancient Egypt. [Trans. and adapted from the Polish and the French by Norbert Guterman]. N.Y., Abrams [1969?]. 600p. il. (part col.), charts, maps, plans.
2d ed. 1977.

A magnificently illustrated book on Egyptian art from its beginnings through the Coptic period. Popular text for the general reader. Pt. 1 is a broad introductory survey. Pt. 2 is a topographical survey with documentation for each monument. Selective bibliography, p.587–90.

I44  Schäfer, Heinrich. Principles of Egyptian art, ed. with an epilogue by Emma Brunner-Traut; trans. and ed. with an introduction by John Baines. Oxford, Clarendon, 1974.
A pioneer stylistic and philosophical study of Egyptian art, first published in 1918. This 1st ed. is based on the 4th German ed. of 1963, edited and expanded with the late author's additions and notes by Emma Brunner-Traut. Many new line drawings, better photographs, and a different chronological scheme.

Contents: (1) What value does Egyptian art have for us?; (2) On the formation and essential character of Egyptian art; (3) Painting and relief; (4) Basic principles of the rendering of nature in two dimensions; (5) On perspective; (6) The basic form in which the standing human body is rendered in two dimensions; (7) The basic principles of the rendering of nature. . .; (8) Conclusion. At end: Chronological table, bibliography, general index, and index of names.

I45  Smith, William Stevenson. The art and architecture of ancient Egypt. Harmondsworth; Baltimore, Penguin [1958]. xxvii, 301p. il., 192 plates, plans, maps. (The Pelican history of art. Z14) (Repr. with corrections: Baltimore, Penguin 1965.)
This Pelican history of Egyptian art and architecture is both the standard survey and an excellent reference book for the English-speaking reader. Covers the wide range of art from 4000 B.C. to 332 B.C. Good illustrations.

Bibliography, p.289–90.

I46  _____. A history of Egyptian sculpture and painting in the Old Kingdom. 2d ed. London, published on behalf of the Museum of Fine Arts, Boston, by Oxford Univ. Pr. [1949]. xv, 422p. il., 63 plates (part col.)
1st ed. 1946.

An important work on the art of the Old Kingdom. Interprets and illustrates the craftsmanship of ancient Egyptian sculptors and painters. Appendix: "The colouring of Old Kingdom hieroglyphs," p.366–82.

I47  Vandersleyen, Claude. Das alte Ägypten. Mit Beiträgen von Professor Dr. Hartwig Altenmüller [u. a.]. Berlin, Propyläen, 1975. 457p. il., plates (part col.), text figs. (Propyläen Kunstgeschichte [n.F.] Bd. 15)
A thorough scholarly review of ancient Egyptian art from its beginnings to the late Roman period. Summarizes and furthers the state of research. Superbly illustrated with 661 figures on 500 plates (75 in color), maps, and 79 drawings in the text. Follows the tripartite format of other volumes in the series, with an introductory survey by Vandersleyen, a corpus of plates, and a *Dokumentation* section which consists of essays by various specialists and full documentation of the works illustrated. Extensive classified bibliography, p.436–45.

Dokumentation: Architektur der Frühzeit; Architektur des Alten Reiches; Architektur des Mittleren Reiches; Architektur des Neuen Reiches; Architektur der Spätzeit; Rundplastik der Frühzeit und des Alten Reiches; Rundplastik des Mittleren Reiches; Rundplastik des Neuen Reiches; Rundplastik der Spätzeit; Flachbildkunst der Frühzeit und des Alten Reiches; Flachbildkunst des Mittleren Reiches; Flachbildkunst des Neuen Reiches; Flachbildkunst der Spätzeit; Bildostraka und Buchmalerei; Keramik; Kleinkunst und Grabmobiliar; Schmuck; Die Kunst im nubischen Gebiet bis zur Zeit der 25. Dynastie; Die Kunst im Reich von Kusch zur Zeit der 25. Dynastie und der Herrscher von Napata; Die Kunst im Reich von Meroe.

I48  Vandier, Jacques. Manuel d'archéologie égyptienne. Paris, Picard, 1952–69. 5v. il., maps.
A fundamental reference work by a leading authority. Detailed tables of contents, good organization, analytic indexes. Well illustrated. Illustrations for v.I and II are in the text; those for v.III, IV and V are in separate albums with a larger format.

Contents: (I) Les époques de formation. [pt.] 1, La préhistoire. [pt.] 2, Les trois premières dynasties; (II) Les grandes époques. [pt.] 1, Architecture funéraire. [pt.] 2, Architecture religieuse et civile; (III) [pt.] 1, Les grandes époques. La statuaire. [pt.] 2, Album; (IV) Bas-reliefs et peintures. Scènes de la vie quotidienne. Tombes. [and plates]; (V) [pt.] 1, Bas-reliefs et peintures; scènes de la vie quotidienne (élevage, chase, navigation). [pt. 2] Album. Bibliography in v.I–IV; bibliographical footnotes. Indexes in v.1, 2, and 3.

I49  Yoyotte, Jean. Treasures of the pharaohs; the early period, the New Kingdom, the late period. Introd. by Christiane Desroches Noblecourt. [Trans. from the French by Robert Allen]. Geneva, Skira. [Distr. **117**

in the U.S. by World, Cleveland, 1968]. xii, 257p. il. (part col.), map. (Treasures of the world. 7)

Trans. of *Les Trésors des pharaohs.*

A comprehensive chronological review of Egyptian art. Emphasizes historical and religious backgrounds as it describes artistic styles and developments. Index of names and places, p.246-[52]; list of illustrations, p.253-[58].

SEE ALSO: Frankfort, H. A. *Arrest and movement* (I53); Smith, W. S. *Interconnections in the ancient Near-East* (I59).

## Western Asia

I50    Contenau, Georges. Manuel d'archéologie orientale depuis les origines jusqu'à l'époque d'Alexandre. Paris, Picard, 1927-47. 4v. il., maps.

Surveys Persia, Mesopotamia, Syria (Upper Syria), Palestine, and Asia Minor (Assyria, Babylonia, Sumeria, Phoenicia, and Arabia). v.4 is a supplement which covers the more recent excavations.

A general bibliography at the end of each volume is followed by separate bibliographies for each chapter. "Bibliographie depuis 1930," v.4, p.2307-43. General index, v.3, p.1621-60. Index, to v.4, p.2345-57.

I51    Ehrich, Robert W., ed. Chronologies in old world archaeology. Chicago, Univ. of Chicago Pr. [1965]. xii, 557p. il., tables, maps.

Supersedes *Relative chronologies in old world archaeology* (1954).

A basic handbook for archaeologists and art historians. Consists of a series of essays by prominent archaeologists on the chronologies of regions of the ancient world (excluding Greece and Rome) as determined by their archaeological evidence. "The time span covered in each area begins with the earliest known appearance of Neolithic culture and extends to the most convenient breaking point in the early part of the second millennium B.C."—*Foreword.*

Documentation with literary references in the texts. Chronological tables, radiocarbon dates, maps, and bibliographies at the ends of the sections. General index to the whole volume, p.527-57.

I52    Frankfort, Henri. The art and architecture of the ancient Orient. [4th rev. impression]. Harmondsworth; Baltimore, Penguin [1969]. 289p. il., plates. (Pelican history of art. Z7)

1st ed. 1954; paperback ed. of 4th rev. impression, 1970.

The basic history of ancient Near Eastern art in English.

Contents: Pt. 1, Mesopotamia: (1) The emergence of Sumerian art: the protoliterate period (c.3500-3000 B.C.); (2) The early dynastic period (c.3000-2340 B.C.); (3) The Akkadian period (2340-2180 B.C.); (4) The Neo-Sumerian period (2125-2025 B.C.) and the period of Isin, Larsa, and Babylon (2025-1594 B.C.); (5) The art of the Kassite dynasty (c.1600-1100 B.C.); (6) The beginnings of Assyrian art (c.1350-1000 B.C.); (7) The late Assyrian period (c.1000-612 B.C.); (8) The Neo-Babylonian period (c.612-539 B.C.); Pt. 2, The peripheral regions: (9) Asia Minor and the Hittites;

(10) The Levant in the second millenium B.C.; (11) Aramaeans and Phoenicians in Syria: North Syrian art (850-65 B.C.); (12) The art of ancient Persia. Bibliography, p.269-70; Additional bibliography to 1968 for the 4th impression [classified, with excellent annotations by John Watson (ch. 1-6), Leri Davies (ch. 7-12)]. Editor: Helene J. Kantor.

I53    Frankfort, Henriette Antonia (Groenewegen). Arrest and movement; and essay on space and time in the representational art of the ancient Near East. London, Faber & Faber; Chicago, Univ. of Chicago Pr., 1951. xxiv, 222p. il., plates. (Repr.: Chicago, Argonaut, 1972.)

An extended essay on the fundamental problem of monumentality in the art of the ancient Near East (Egypt, Mesopotamia, Crete). Based on the criterion that monumental art "should, in fact, lie in a tension between the ephemeral and the lasting, between concrete event and transcendent significance."—*Pref.* Bibliographical footnotes.

I54    Mellink, Machteld J., and Filip, Jan. Frühe Stufen der Kunst. Mit Beiträgen von George F. Dales, Vladimir Dumitrescu, Helene J. Kantor, Vassos Karageorghis, Alfred Kernd'l, Edith Porada, Jean Perrot, Wilfried Seipel, Günter Smolla, Raci Temizer, Henrik Thrane. ([Mit] 640 Abbildungen auf 474 Tafelseiten, davon 63 farbig, eine Karte sowie 53 Zeichnungen im Text). Berlin, Propyläen Verlag, 1974. il., plates. (Propyläen Kunstgeschichte [n.F.] Bd. 13)

A volume in the new Propyläen-Kunstgeschichte series containing encyclopedic surveys of the beginnings of art in the ancient Near East (Anatolia, Mesopotamia and Iran, Syria, Palestine and Cyprus, the Aegean, Egypt) and the prehistoric art of Europe. The essays and commentaries are written by a distinguished team of specialists. Superb reproductions.

Contents: [pt.1] Die Anfänge der Kunst im östlichen Mittelmeerraum und in Vorderasien (Einführung; Anatolien; Mesopotamien und Iran; Syrien, Palästina und Zypern; Die Ägäis; Ägypten); Die Anfänge der Kunst in Europa (Grundlagen der frühen Kunstentwicklung; Der frankokantabrische Kreis und das paläolithische Mittel- und Osteuropa; Mesolithikum und Neolithikum; Die europäische Bronzezeit; Die Hallstatt-Zeit; Die Latène-Zeit; [pt.2] Abbildungen; [pt.3] Dokumentation: Anatolien; Mesopotamien und Iran; Turkmenistan, Afghanistan und Pakistan; Syrien und Palästina; Zypern; Malta; Die Ägäis; Ägypten; Afrika; Europäische Alt- und Mittelsteinzeit; Südosteuropäische Jungsteinzeit; Mitteleuropäische Agrarkulturen; Südosteuropäische Bronzezeit; Mitteleuropäische Bronze- und Hallstatt-Zeit; Der Nordische Kreis; Keltische Kunst.

Verzeichnis der Siglen und Abkürzungen, p.343-48; Literaturverzeichnis, p.349-62; Synchronoptische Übersicht, p.364-65.

I55    Orthmann, Winfried. Der alte Orient. Mit Beiträgen von Pierre Amiet, Rainer Michael Boehmer, Jutta Börker-Klähn, Johannes Boese, Donald P. Hansen, Ernst Heinrich, Gerhard Hiesel, Vassos Karageorghis,

Maurits N. van Loon, Paolo Matthiae, Edith Porada, Wulf Schirmer, Ursula Seidel. Berlin, Propyläen, 1975. 567p. [539] leaves of plates, il. (part col.), maps. (Propyläen Kunstgeschichte [n.F.] Bd. 14)

A comprehensive work on the art of the ancient Near East. Contains critical-historical essays and commentaries on the many excellent illustrations of works.

Contents: [Pt. 1] Sumer und Akkade; Babylon und Assur; Die Kunst des Iran; Die Kunst der Hethiter; Die Kunst Syriens; Die Kunst Zyperns. [Pt. 2] Abbildungen. [Pt. 3] Dokumentation (includes bibliographical references in the commentaries). [Pt. 4] Anhang: Verzeichnis der Siglen und Abkürzungen, p.533–41; Literaturverzeichnis (classified), p.542–57; Zeittafel zur Geschichte des alten Orients (Mesopotamien, Iran, Kleinasien, Syrien), p.558–59; Namen- und Sachregister.

I56    Pritchard, James Bennett, ed. The ancient Near East; an anthology of texts and pictures. Translators and annotators: W. F. Albright, et al. Princeton, N.J., Princeton Univ. Pr., 1958–76. 2v. il.

Available in paperback.

v.2 (1976) entitled *The ancient Near East. Volume II: a new anthology of texts and pictures.*

Both volumes combine selections and condensations from the editor's *The ancient Near East in pictures relating to the Old Testament* (I57) and *Ancient Near Eastern texts relating to the Old Testament* (I58). The 1976 volume "makes available some of the most important recently discovered source material for the historian of the ancient Near East" —*Pub. notes.*

I57    _____. The ancient Near East in pictures relating to the Old Testament. 2d ed. with supplement. Princeton, N.J., Princeton Univ. Pr., 1969.

1st ed. 1954; supplement published separately, 1969.

A companion volume to *Ancient Near Eastern texts relating to the Old Testament* (I58). A collection of 769 photographs of monuments and other cultural artifacts dating from the Chalcolithic period to Hellenistic times. These are mostly from Mesopotamia, Asia Minor, and Syria-Palestine. Useful arrangement by subject: Peoples and their dress; Daily life; Writing; Scenes from history and monuments; Royalty and dignitaries; Gods and their emblems; The practice of religion; Myth, legend, and ritual on cylinder seals; Views and plans of excavations. Each picture has an entry with provenance, descriptive data, photographic credit, and references to literature. General index to text and supplement.

I58    _____. Ancient Near Eastern texts relating to the Old Testament. Translators and annotators: W. F. Albright [et al.] 3d ed. with supplement. Princeton, N.J., Princeton Univ. Pr., 1969.

1st ed. 1950; 2d ed. 1966. Supplementary texts and pictures published separately, 1969.

"The purpose of this work is to make available to students of the ancient Near East . . . the most important extrabiblical texts in translations which represent the best understanding which present-day scholarship has achieved."—*Introd.*

Contents: (1) Myths, epics, and legends; (2) Legal texts; (3) Historical texts; (4) Rituals, incantations, and descriptions of festivals; (5) Hymns and prayers; (6) Didactic and wisdom literature; (7) Lamentations; (8) Secular songs and poems; (9) Letters; (10) Miscellaneous texts.

I59    Smith, William Stevenson. Interconnections in the ancient Near-East; a study of the relationships between the arts of Egypt, the Aegean, and western Asia. New Haven, Yale Univ. Pr., 1965. xxxii, 202p. 221 il. (part fold.), maps.

An authoritative, original study of cross-influences in the art of Egypt and other countries of the ancient Near East. The emphasis is on pictorial representation in monumental decorative schemes (wall paintings and reliefs). Contents: pt. I. Historical survey of interconnections; pt. II. The composition of wall scenes. Illustrated with line drawings based on the author's reconstructions. Bibliography, p.187–89.

I60    Woolley, *Sir* Charles Leonard. The art of the Middle East including Persia, Mesopotamia and Palestine. [Trans. by Ann E. Keep]. N.Y., Crown [1961]. 259p. il., map, col. plates. (Art of the world, non-European cultures; the historical, sociological and religious backgrounds)

"A stringent condensation of complex historical data and an assessment of artistic achievement in the Middle East" for the period 6000 B.C. to 500 A.D. Overall "aim is to determine the original and characteristic elements in the art and architecture of Sumerian, Elamite, Babylonian, Assyrian, Phoenician, Hurrian, Mittanian, Urartian, Nabataean, and Sabaean cultures."—Review by Louise Ballard, *Journal of aesthetics and art criticism,* Spring 1964, p.343.

Chronological table, p.237–43; Glossary, p.244–46; Classified bibliography, p.247–50.

I61    Wright, George Ernest. Biblical archaeology. [New & rev. ed.] Philadelphia, Westminster Pr. [1962]. 291p. 220 il., maps.

1st ed. 1955.

"The purpose of this volume is to summarize the archaeological discoveries which directly illumine biblical history." —*Foreword.* A good beginning for the interested general reader and the student of art history, although this is not an art historical work. Bibliographical footnotes.

SEE ALSO:   Hrouda, B. *Vorderasien* (I36).

## Anatolia

I62    Akurgal, Ekrem. The art of the Hittites. Photos. by Max Hirmer. [Trans. by Constance McNab]. London, Thames & Hudson [1962]. 315p. il.

German ed. 1961.

A comprehensive, authoritative survey of pre-Hittite and Hittite art up to c.760 B.C. Superb plates. Poor translation of text. Bibliography, p.306–12.

I63 _____. Die Kunst Anatoliens von Homer bis Alexander. Berlin, de Gruyter, 1961. ix, 350p. il., plates (part col.), fold. map.
A scholarly study of Anatolian art from 1200–300 B.C., with emphasis on the relationship between the art of Asia Minor and that of Greece. Bibliographical notes, p.309–29.

I64 Azarpay, Guitty. Urartian art and artifacts; a chronological study. Berkeley, Univ. of California Pr., 1968. xviii, 169p. il., map, plates. (Also published by Cambridge Univ. Pr., London.) (Univ. of California Publications: Occasional Papers Number 2: Art)
A chronological presentation and discussion of the art and artifacts from the Urartian kingdom (Eastern Turkey and nearby areas) of the 8th and 7th centuries B.C. Bibliographical references in "Notes," p.[77]–120. Well illustrated with drawings and plates.

I65 Loon, Maurits Nanning van. Urartian art; its distinctive traits in the light of new excavations. Istanbul, Nederlands Historisch-Archaeologisch Instituut, 1966. xv, 190p. il., map, plans, 33 plates, table. (Nederlands Historisch-Archaeologisch Instituut in het Nabije Oosten te Istanbul. Uitgaven. 20)
A scholarly study of the Urartian art which flourished in Armenia between 1000 and 500 B.C. Based on artistic analysis and historical, epigraphical, and archaeological evidence. Good illustrations. Bibliographical footnotes. Bibliography, p.[181]–83.

I66 Vieyra, Maurice. Hittite art, 2300–750 B.C. London, Tiranti, 1955. vi, 91p. il., plates, plans.
A compact survey of the history and art of the Hittites. Excellent illustrations. Bibliographical references. Bibliography, p.55–58. Descriptive notes to the 122 plates, p.59–89.

SEE ALSO: Akurgal, E. *Treasures of Turkey* (I464); Aslanapa, O. *Turkish art and architecture* (I465); Smithsonian Institution. *Art treasures of Turkey* (I466); and the journal *Anatolian studies* (Q21).

### Cyprus

I67 Buchholz, Hans-Günter, and Karageorghis, Vassos. Altägäis und Altkypros. Tübingen, Wasmuth [1971]. 516p. il. (part col.), diagrs., maps.
An exhaustive scholarly survey of archaeological finds of the past century on Cyprus and in the area of the Aegean. Each type of artifact, from weapons to pottery, wall-painting, and sculpture, is described and catalogued. A discussion of the general periods precedes this detailed work. 1,910 illustrations.

I68 Karageorghis, Vassos. The ancient civilization of Cyprus. [Geneva, Nagel, 1969]. 259p. 181 il. (part col.), maps.
Written by an archaeologist, this study confines itself to the results of recent excavations on the island. Describes

sites from prehistory to the Hellenistic and Roman periods. Meticulous description of artistic finds and their significance. Illustrated with excellent color and black-and-white photographs.

I69 Spētērēs, Tōnēs P. The art of Cyprus. Trans. by Thomas Burton. N.Y., Reynal and Company in association with William Morrow [1970]. 213p. il. (part col.), map.
A good general introduction to the art of Cyprus, focusing on a "panoramic view of the artistic and cultural heritage of the island."—*Pref.* Iconographic documentation is stressed. Excellent plates of the pottery, sculpture, and mosaics found at various sites, showing the influence of several cultures. Comparative tables, p.[208–11]; Notes, p.[212]; Selected bibliography, p.[213].

SEE ALSO: Frankfort, H. A. *Arrest and movement* (I53); Smith, W. S. *Interconnections in the ancient Near-East* (I59).

### Mesopotamia

I70 Frankfort, Henri. Cylinder seals; a documentary essay on the art and religion of the ancient Near East. London, Macmillan, 1939. xlvii, 328p. il., 47 pl., fold. tab. (Repr.: Farnborough, Gregg, 1965.)
An important contribution to the study of art and civilization of the ancient Near East. "The cylinder seals of Mesopotamia constitute her most original contribution to art. They reflect, moreover, several aspects of her civilisation of which detailed knowledge from other sources is scanty."—*Pref.* Bibliographical footnotes.
Contents: Preliminaries; Sect. 1, The seals of the prehistoric age; Sect. 2, The early dynastic cylinders; Sect. 3, The seals of the Sargonid age; Sect. 4, Mesopotamian glyptic from the end of the Akkadian to the Kassite dynasty; Sect. 5, The seals from the Kassite to the Persian period; Sect. 6, The derivative styles of the ancient Near East; Indexes: General; Chronological.

I71 Goff, Beatrice Laura. Symbols of prehistoric Mesopotamia. New Haven and London, Yale Univ. Pr., 1963. 276p. 728 figs., map, col. front.
An exhaustive study of Mesopotamian religious symbolism. Investigates the dominance of basic forms and their interrelationships. Examines pottery, seals, amulets, wall decorations, and architectural motifs from the Hassunah to the Sumerian period. Bibliographical footnotes. Well illustrated.

I72 Madhloom, T. A. The chronology of neo-Assyrian art. [London] Univ. of London, Athlone, 1970. xix, 133p. [171]p. of plates.
The first history of artistic development during the last three centuries of the Assyrian Empire, from the 11th to the 9th centuries B.C. Includes a consideration of the artist in society. Arranged by subject: (I) Chariots and siege-engines; (II) Armour and weapons; (III) Costume and fashion; Guardian figures. Bibliography, p.123–30. Illustrated with line drawings of reconstructions.

I73    Moortgat, Anton. The art of ancient Mesopotamia; the classical art of the Near East. [Trans. from the German by Judith Filson]. London and N.Y., Phaidon [1969]. 356p. il., map, plans, 164 plates.

An authoritative, comprehensive survey of the major periods of ancient Mesopotamian art and architecture (Sumero-Akkadian, Old Babylonian, Middle Babylonian [Kassite], Assyrian). Excellent plates, many plans. Bibliographical references included in "Notes," p.[329]-40.

I74    Parrot, André. The arts of Assyria. Trans. by Stuart Gilbert and James Emmons. N.Y., Golden Pr. [1961]. xviii, 383p. il. (part col.), maps. (The arts of mankind. 2)

Also published as *Nineveh and Babylon*, London, Thames & Hudson [1961].

The 2d volume of Parrot's survey of Mesopotamian art, a companion to *Sumer* (I75). Covers the 13th century B.C. to the 4th century B.C. Splendid illustrations.

Glossary-index, p.315-40; classified, annotated bibliography, p.343-59.

I75    _____. Sumer: the dawn of art. Trans. by Stuart Gilbert and James Emmons. N.Y., Golden Pr. [1961]. 1, 397p. il. (part col.). col. maps (part fold.). (The arts of mankind. 1)

Also published as *Sumer*, London, Thames & Hudson [1960].

A superbly illustrated survey devoted to the art of Mesopotamia and Western Iran from its origins to the 12th century B.C. Continued by *The arts of Assyria* (I74).

Glossary-index, p.341-60. Classified, annotated bibliography, p.361-70.

I76    Saggs, H. W. F. The greatness that was Babylon; a sketch of the ancient civilization of the Tigris-Euphrates Valley. N.Y., Hawthorn [1966]. 562p. il.

A general history of the civilizations of Babylonia, Assyria, and Sumeria. Emphasizes the cultural, political, and social components of these ancient civilizations. Directed to the interested layman as well as the specialist. Bibliography, p.505-30; Chronological tables, p.531-36; Indexes of Biblical references, p.537-38; Indexes of subjects, proper names, and Sumerian, Akkadian, Hebrew, and Greek works, p.539-62.

I77    Strommenger, Eva. 5000 years of the art of Mesopotamia. Photos. by Max Hirmer. [Trans. by Christina Haglund] N.Y., Abrams [1964]. 480p. il., maps (1 fold.), 44 col. plates.

Trans. of *Fünf Jahrtausende Mesopotamien*.

A pictorial survey of Mesopotamian art, with a brief text. The 280 magnificent photographs by Max Hirmer are followed by notes on plates, bibliography, chronology, and index.

## Persia (Ancient Iran)

I78    Ghirshman, Roman. The arts of ancient Iran from its origins to the time of Alexander the Great.

Trans. by Stuart Gilbert and James Emmons. N.Y., Golden Pr. [1964]. xxi, 439p. il. (part col.), maps (part fold.). (The arts of mankind. 5)

Also published as *Persia, from the origins to Alexander the Great,* London, Thames & Hudson [1964].

This lavishly illustrated survey of the arts and architecture of ancient Iran has become a standard work. Includes the related protohistoric art, the Luristan bronzes, Median and Scythian art, as well as the art of Achaemenian Persia. Pt. 3: Appendix of illustrations; Glossary-Index; Bibliography; List of illustrations; Maps. The companion volume is Ghirshman (I78a).

I78a    _____. Persian art, the Parthian and Sassanian dynasties, 249 B.C.-A.D. 651. Trans. by Stuart Gilbert and James Emmons. N.Y., Golden Pr. [1962]. 401p. il. (part col.), maps (1 fold.). (The arts of mankind. 3)

Also published as *Iran: Parthians and Sassanians*, London, Thames & Hudson, 1962.

Like its companion volume (I78), an essential book for students. A survey of Parthian and Sassanian art which incorporates all previous research. Pt. 3: Glossary-Index; Bibliography, p.[367]-77; List of illustrations. Well illustrated, many in color.

I78b    Porada, Edith. The art of ancient Iran: pre-Islamic cultures. With the collaboration of R. H. Dyson and contributions by C. K. Wilkinson. N.Y., Crown [1965]. 279p. il. (part mounted col.), map, plans, tables. (Art of the world: non-European cultures; the historical, sociological, and religious backgrounds)

1st German ed. 1962.

A pioneer work based on recent research; the fundamental survey of ancient Iranian art. The English ed. includes material on prehistoric cultures.

Bibliography included in "Notes," p.228-46, and classified bibliography, p.262-67. Charts of painted pottery of Iran, p.250-52; Chronological chart, p.254-61; Glossary, p.268-71.

SEE ALSO: Paris. Palais de Beaux-Arts. *Sept mille ans d'art en Iran* (I547); Pope, A. *A survey of Persian art from prehistoric times to the present* (I548); Smithsonian Institution. *7000 years of Iranian art* (I549).

## Syria and Palestine

I79    Harden, Donald Benjamin. The Phoenicians. London, Thames & Hudson [1962]. 336p. il., maps. (Ancient people and places, v. 26)

"An erudite survey of Phoenician civilization with an illuminating view of its art."—E. Porada in *Natural history*, (Nov. 1963). Bibliography, p.238-49.

I79a    Kenyon, Kathleen Mary. Archaeology in the Holy Land. 3d ed. N.Y., Praeger [1970]. 360p. il., maps, plans.

1st ed. 1960; 2d ed. 1965.

While this is primarily an important study of archaeological evidence for the rise of civilization in Palestine, it is useful also to the art historian and to the student of the period. It attempts to link the Biblical history of the area with the excavated sites. Appendix: Excavated sites and bibliography, p.305–28; Revisions and addenda, p.329–52; Index, p.355–60.

I79b  Matthiae, Paolo. Ars syra; contributi alla storia dell' arte figurativa siriana nelle età del medio e tardo bronzo. Roma, Centro di Studi Semitici, Istituto di Studi del Vicino Oriente, Università, 1962. 156p. 29 plates (1 col.). (Università di Roma, Centro di Studi Semitici. Serie archeologica, 4)

"These essays on the principal aspects of Syrian figurative art in the Middle and Late Bronze Ages constitute an inquiry which has for its object the clarification of some of the basic problems connected with this art: the nature of its development, the part played in it by foreign artistic traditions, its coherence, its unity, and finally, whether it is to be accounted the original product of an independent civilization or a peripheric manifestation of a broader cultural unity. Inasmuch as there is no tradition of real artistic historiography in the form of a coherent and unitary critical examination of the Syrian experience in figurative art, the present inquiry aims at laying the foundations for a historical consideration of the art of Syria, in the broadest geographical sense of that term, that is to say, including also Palestine."— *English résumé.* Bibliography, p.9–11. Contents: Introduzione, La statuaria in pietra, La statuaria in bronzo, Le stele, Gli avori, La glittica, Conclusione; English résumé, p.139–41; Indice delle tavole, p.143–45; Indice dei nomi, p.147–53.

SEE ALSO:  Pritchard, J. B. *The ancient Near East; an anthology of texts and pictures* (I56); ———. *The ancient Near East in pictures relating to the Old Testament* (I57); ———. *Ancient Near Eastern texts related to the Old Testament* (I58).

# Classical World

I80  Adriani, Achille. Repertorio d'arte dell 'Egitto greco-romano. Palermo, Fondazione "Ignazio Mormino" del Banco di Sicilia. Ser. A¹⁻²; Ser. B¹⁻² [1961–(66)]. il., plates.

In progress (15v. projected).

A corpus of representative illustrations of Greco-Roman arts and architecture of Alexandria. Contents: Ser. A, 2v., Sculpture (1961); Ser. B, Painting (proposed); Ser. C, 2v., Architecture (1966); Ser. D, Minor arts (proposed). Technical descriptions and bibliographical references in text commentaries on the illustrations.

Indexes of works and museums.

I81  Becatti, Giovanni. The art of ancient Greece and Rome from the rise of Greece to the fall of Rome. [Trans. by John Ross]. N.Y., Abrams [1967]. 440p. il. (part col.)

A masterfully condensed survey of the painting and sculpture of ancient Greece and Rome. Does not include architecture. Beautifully illustrated with 385 reproductions of works. Glossary, p.391–99. Classified bibliography, p.401–23.

I81a  Helbig, Wolfgang. Führer durch die öffentlichen Sammlungen klassischer Altertümer in Rom. 4., völlig neu bearbeitere Aufl., hrsg. von Hermine Speier. Tübingen, Wasmuth, 1963–72. 4v.

At head of title: Deutsches Archäologisches Institut.

The incomparable guides to the public collections of Greek and Roman art in Rome. Extremely valuable for descriptions, commentaries, and bibliographical references. Contents: v.1, Die Päpstlichen Sammlungen im Vatikan und Lateran; v.2, Die Städlischen Sammlungen (Kapitolinische Museen und Museo Barracco), Die Staatlichen Sammlungen (Ara Pacis, Galleria Borghese, Galleria Spada, Museo Pigorini, Antiquarien auf Forum und Palatin); v.3, Die Staatlichen Sammlungen (Museo Nazionale Romano, Museo Nazionale di Villa Giulia); v.4, Die Staatlichen Sammlungen (Museo Ostiense in Ostia Antica, Museo der Villa Hadriana in Tivoli), Villa Albani.

SEE ALSO:  Caffarello, N. *Dizionario archeologico di antichità classiche* (E27); Daremberg, C.V. and Saglio, E. *Dictionnaire des antiques...* (E28); *Enciclopedia dell'arte antica, classica e orientale* (E29); Pauly, A. F. von. *Pauly's Real Encyclopädie der classischen Altertumswissenschaft* (E31); *The Princeton encyclopedia of classical sites* (E32).

## Crete, Mycenae, Greece

I82  Akurgal, Ekrem. The art of Greece: its origins in the Mediterranean and Near East. [Trans. by Wayne Dynes]. N.Y., Crown [1968]. 258p. il. (part col.), plates, map, plans. (Art of the world: non-European cultures; the historical, sociological, and religious backgrounds)

Trans. of *Orient und Okzident: die Geburt der griechischen Kunst,* Baden-Baden, Holle, 1966.

A study of the influences of the arts of ancient Near Eastern civilizations on the art of archaic Greece. Focuses on the products of the most important centers of the Near East between 1000 and 500 B.C. Contents: Pt. 1, the Orient: (1) Neo-Assyrian art; (2) Babylonian art; (3) Aramaean art; (4) Neo-Hittite art; (5) Phoenician and Syrian art region. Pt. 2, Greece: (6) Early Greek art and its connections with the Near East. Bibliographical references in "Notes to text," p.225–44, and "Notes," p.244–45.

I83  Beazley, John Davidson, and Ashmole, Bernard. Greek sculpture and painting to the end of the Hellenistic period. Cambridge, Cambridge Univ. Pr., 1966. xviii, 111p. 248 il.

Reprint of the 1932 ed., which was a reprint of the chapters on Greek art in *The Cambridge ancient history,* with additions in the Appendix, p.[103]–4.

A classic short handbook. Classified bibliography, p.[105]–11.

I84 Boardman, John. Greek art. Rev. ed. N.Y., Praeger
 |1973|. 252p. il. (part col.), map. (Praeger world of
 art series)
1st ed. 1964.

An authoritative, concise, readable general history of
Greek arts and architecture from the beginnings through
the Hellenistic period. Chronological chart, p.|236-37|.
Selected classified bibliography, p.238-41.

I85 _____. Pre-classical: from Crete to Archaic Greece.
 Harmondsworth, Penguin, 1967. 186p. 104 il., map.
 (Style and civilization)
A succinct survey of the full range of preclassical Greek
art from the end of the Neolithic period to the end of the
Archaic. Contents: (1) Minoans and Mycenaeans; (2) The
dark ages: Geometric Greece; (3) The Orientalizing period;
(4) The Archaic period of the 6th century; (5) The
Etruscans; (6) The Scythians. "Books for further reading,"
p.183-84.

I86 Boardman, John; Dörig, José; Fuchs, Werner; and
 Hirmer, Max. Greek art and architecture. Photos.
 by Max Hirmer. N.Y., Abrams |1967|. 600p. il., plates
 (part col.), map, plans.
Texts by Dörig, Fuchs, and Hirmer translated from the
German.

Primarily a volume of illustrations of Greek art and
architecture accompanied by authoritative texts. Comprises
a general survey of Greek art and architecture from the
beginnings through the Hellenistic period.

Bibliographical references in Notes, p.585-87. Select
bibliography, p.587-88.

I87 Brilliant, Richard. Arts of the ancient Greeks. N.Y.,
 McGraw-Hill |1973|. xxiii, 406p. il. (part col.)
A "representative, rather than encyclopedic" survey of Greek
arts and architecture for the educated amateur and student.
"Major stylistic movements, the activities of the leading
artists, significant motifs and iconographic themes, and the
principal monuments all appear set within the appropriate
historical and cultural context."—*Pref.*

Contents: (1) The heroic age of the Mycenaeans; (2)
Greek beginnings and the remembrance of the heroic age;
(3) Archaic Greek art; (4) Archaic Greek architecture; (5)
Greek art, 500-450 B.C.; (6) Greek classic art; (7) Greek
art in its second classic phase: late fifth century to Alexander
the Great; (8) Greek religious sanctuaries, urban architecture,
and city planning; (9) Hellenistic art from Alexander to
Actium. Bibliographies at the end of each chapter.

I88 Charbonneaux, Jean. Archaic Greek art (620-480
 B.C.) |by| Jean Charbonneaux, Roland Martin |and|
 François Villard. |Trans. from the French by James
 Emmons; Robert Allen (pt. 3)|. N.Y., Braziller |1971|.
 xi, 437 |10|p. 444 il. incl. maps, plans. (The arts of
 mankind. 14)
A lavishly illustrated survey of Greek art in the archaic
period. The 1st volume of the 3v. comprehensive survey,
which includes *Classical Greek art* (I89) and *Hellenistic
art* (I90).

Plans, p.|361-75|; Chronological table, p.|377|-81.
Classified bibliography, p.|383|-95. List of illustrations,
p.|397-415|, includes dimensions, references, occasional
comments. Glossary-index. p.|417-38|; Maps, p.|439|.

I89 _____. Classical Greek art (480-330 B.C.) |by| Jean
 Charbonneaux, Roland Martin |and| François Villard.
 |Trans. from the French by James Emmons|. N.Y.,
 Braziller |1972|. xi, 422, |11|p. 436 il. incl. fold. maps,
 plans. (The arts of mankind. 16)
A survey of Greek architecture (by R. Martin), sculpture
(by J. Charbonneaux), and painting and pottery (by F. Villard)
in the classical period. The 2d volume of the 3v. survey of
Greek art beginning with *Archaic Greek art* (I88), and
concluding with *Hellenistic art* (I90).

Reconstructions and antique replicas, p.|345|-58; Chrono-
logical table, p.|359|-63. Classified bibliography, p.|365-
78|. List of illustrations, p.|379-98|, includes dimensions,
pottery inventory numbers, and occasional comments.
Glossary-index, p.|399-423|; Maps, p.|425|.

I90 _____. Hellenistic art (330-50 B.C.) |by| Jean Char-
 bonneaux, Roland Martin, |and| François Villard.
 |Trans. from the French by Peter Green|. N.Y.,
 Braziller |1973|. x, 422p. 421 il. incl. fold. maps,
 plans. (The arts of mankind. 18)
A survey of Greek architecture (by R. Martin), painting
(by F. Villard), and sculpture (by J. Charbonneaux) in the
Hellenistic period. Concludes the 3v. survey of Greek art
beginning with *Archaic Greek art* (I88) and *Classical Greek
art* (I89).

Plans and reconstructions, p.|349-62|; Chronological table,
p.|363-67|. Classified bibliography, p.|369|-82. List of illus-
trations, p.|383-400|, includes dimensions, comments.
Glossary-index, p.|401-20|; Maps, p.|423|.

I91 Cook, Robert Manuel. Greek art; its development,
 character and influence. N.Y., Farrar |1973|. 277p.
 96p. of il.
An excellent introductory survey of Greek art and archi-
tecture. Well illustrated.

Contents: (1) Introduction; (2) Painted pottery; (3) Panel
and mural painting; (4) Sculpture; (5) Metalwork; (6) Gems
and coins; (7) Architecture; (8) Interior decoration. Notes on
museums, p.255-60. Glossary, p.267-70. Expertly anno-
tated bibliography, p.261-66.

I92 Demargne, Pierre. The birth of Greek art. Trans. by
 Stuart Gilbert and James Emmons. N.Y., Golden Pr.
 |1964|. 446p. il. (part col.), maps (part fold. col.),
 plans, plates (part col.), ports. (The arts of mankind.
 6)
Also published as *Aegean art: the origins of Greek art*,
London, Thames & Hudson.

A comprehensive survey of Aegean art from the Neolithic
period through the late 7th century B.C. Considers parallel
works from Anatolia, Cyprus, and the Levant. The excellent
illustrations are not keyed to the text.

Contents: pt. 1, Pre-Hellenic and Mycenaean arts; pt. 2,
The early Archaic period. Glossary-index, p.407-|18|;
classified bibliography, p.|420-32|.

I93   Desborough, Vincent Robin d'Arba. The last Myce-
      naeans and their successors; an archaeological survey,
      c.1200–c.1000 B.C. Oxford, Clarendon, 1964. xviii,
      288p. 25 plates, map.
The standard study. "The aim of this work is to examine,
and as far as possible to clarify, the circumstances attendant
on the breakdown of the Mycenaean power, the question
of the survival of Mycenaean communities and ideas into
later times, the extent to which non-Mycenaean elements
made their appearance during and after the general break-
up, and the circumstances under which the mainland of
Greece and the islands of the southern Aegean reverted to
conditions of relative normality."—*p.|1|.* Based on archaeo-
logical evidence, primarily pottery.
Bibliography, p.|273|–76; bibliographical footnotes.

I94   Evans, *Sir* Arthur John. The palace of Minos; a
      comparative account of the successive stages of the
      early Cretan civilization as illustrated by the dis-
      coveries at Knossos. London, Macmillan, 1921–35.
      4v. in 6. il., plates (part col.), maps, plans, facsims.
      (Repr.: N.Y., Biblo & Tannen, 1964.)
Still a basic work.
      Contents: v.1, The neolithic and early and middle Minoan
ages; v.2, pt. 1, Fresh lights on origins and external relations:
the restoration in town and palace after seismic catastrophe
towards close of M.M. III, and the beginnings of the new
era; v.2, pt. 2, Town houses in Knossos of the new era and
restored west palace section, with its state approach; v.3,
The great transitional age in the northern and eastern
sections of the palace: the most brilliant records of Minoan
art and evidences of an advanced religion; v.4, pt. 1,
Emergence of outer western enceinte, with new illustrations,
artistic and religious, of the middle Minoan phase; chrys-
elephantine "lady of sports," "snake room" and full story
of cult; late Minoan ceramic evolution and "palace style";
v.4, pt. 2, "Camp-stool fresco"—long-robed priests and
beneficent genii; chryselephantine boy-god and ritual hair-
offering; intaglio types, M. M. III-L. M. II; late hoards of
sealings; deposits of inscribed tablets and the palace stores;
linear script B and its mainland extension; closing palatial
phase—"room of throne"—and final catastrophe with
epilogue on the discovery of "ring of Minos" and "temple
tomb."
      _____. Index to the Palace of Minos, by Joan Evans.
London, Macmillan, 1936. 221p. (Repr.: N.Y., Biblo &
Tannen, 1964.)
      _____. Knossos fresco atlas. |Farnborough| Gregg |1967|.
19 col. plates (in portfolio).
      "A previously unpublished collection of illustrations. . . .
Most of the original fragments concerned can only be seen
today at the Museum in Herakleion, Crete; seven cannot
now be traced and may have been destroyed, while twenty-
nine have never been published before."—*Pub. notes.*
      "Catalog of plates in Sir Arthur Evans' Knossos fresco
atlas, by Mark Cameron & Sinclair Hood." 42p. (laid in).

I95   Havelock, Christine Mitchell. Hellenistic art: the art
      of the classical world from the death of Alexander
      the Great to the battle of Actium. Greenwich, Conn.,
      New York Graphic Society |1971|. 282p. il., col. plates.

A stimulating introduction to the arts of Hellenistic Greece
(323 B.C.–31 B.C.), written with the recognition of Hellenistic
art as "an enrichment and enlargement, not a degeneration,
of earlier styles."—*Foreword.* Contents: (1) Portraits; (2)
Architecture; (3) Sculpture in the round; (4) Sculpture in
relief; (5) Painting and mosaics; (6) Decorative arts.
      Excellent illustrations. Classified bibliography, p.273–74.

I96   Higgins, Reynold Alleyne. Minoan and Mycenaean
      art. N.Y., Praeger; London, Thames & Hudson
      |1967|. 216p. il. (part col.), plans, map.
An excellent introductory survey of the arts of "the three
principal civilizations of the Aegean in the Bronze Age:
those of Crete, the Cycladic islands, and Mainland Greece."
Selected bibliography, p.195–96.

I97   Homann-Wedeking, Ernst. The art of archaic Greece.
      Trans. by J. R. Foster. N.Y., Crown |1968|. 224p. il.
      (part mounted col.), map, plan. (Art of the world)
A comprehensive survey of archaic Greek art stressing the
cultural, historical, and religious backgrounds. Contents:
(1) Intellectual foundations: the geometric age (c.1050–700
B.C.); (2) Revolution and consolidation: the orientalizing
age (c.700–620 B.C.); (3) Ripe archaic: early period (c.620–
550 B.C.); (4) Ripe archaic: late period (c.550–490 B.C.).
Chronological table, p.198–99; glossary, p.212–13. Biblio-
graphical references in "Notes on the text," p.209–11.

I98   Langlotz, Ernst. Die Kunst der Westgriechen in
      Sizilien und Unteritalien. Aufnahmen von Max
      Hirmer. München, Hirmer |1963|. 106p. il., 188 plates
      (20 col.), map.
English translation: *Ancient Greek sculpture of South Italy
and Sicily,* N.Y., Abrams |1965|; *The art of Magna Graecia,*
London, Thames & Hudson |1965|.
      The most comprehensive general survey of the Greek art
of Magna Graecia, including sculpture, architectural sculp-
ture, figurines, jewelry, and painting. Excellent photographs.
Includes bibliographical references.

I99   Marinatos, Spyridon. Crete and Mycenae. Photos.
      by Max Hirmer. N.Y., Abrams |1960|. 177, |13|p. il.
      (part mounted col.), 236 plates, map, plans.
Translation from the Greek of *Kreta und mykenische Hellas*
by John Boardman.
      A concise, comprehensive introductory essay tracing
the development of Minoan and Mycenaean cultures is
followed by a section of superb photographs of objects,
fully described and documented.
      "Bibliographical notes," p.|180|.

I100  Matz, Friedrich Ludwig Johannes. The art of Crete
      and early Greece: the prelude to Greek art. |Trans.
      by Ann E. Keep|. N.Y., Crown |1962|. 260p. il.
      (part mounted col.), maps, plans. (Art of the world.
      European cultures: the historical, sociological, and
      religious backgrounds)
A survey of the arts of the Minoan and Mycenaean cultures
as the necessary, early stages in the development of classical

Greek art. Contents: (1) Incunabula. Styles of the Neolithic; (2) The age of development. Styles of the early Bronze Age; (3) The age of maturity. Minoan style in the palace period; (4) Transformation and renaissance. Mycenaean style.

Chronological table, p.239; glossary, p.244-47. Classified bibliography, p.248-50.

I101 _____. Geschichte der griechischen Kunst. Frankfurt am Main, Klostermann [1950]. v.1 in 2. il., plates, plans.

v.1, *Die geometrische und die fr001archaische Form,* of a proposed comprehensive history of Greek art. No more published.

Contents: v.1, Textband: [1] Kunstgeschichte und Struktur-forschung; [2] Die geometrische Form; [3] Die früharchaische Form; [4] Die früharchaische Plastik; [5] Die früharchaische Malerei ausserhalb Attikas; [6] Die frühattischen Vasen; [7] Die früharchaische Architektur; [8] Das früharchaische Kunsthandwerk. v.2, Tafelband. Bibliography in "Anmerkungen" v.1, p.511-38.

I102 Mylonas, George Emmanuel. Mycenae and the Mycenaean age. Princeton, N.J., Princeton Univ. Pr., 1966. xvi, 215p. il., maps, plans.
"The purpose of the present volume is to attempt to bring up to date our knowledge of the Mycenaean Age."—*Pref.* Comprehensive presentation for the various aspects of Mycenaean culture, including the arts and architecture, from the end of the 17th century B.C. to the end of the 12th century B.C.

Contents: (1) Introduction; (2) Mycenaean citadels; (3) Mycenaean palaces and houses; (4) The grave circles of Mycenae; (5) Tholos and chamber tombs; (6) Shrines and divinities; (7) Ceremonial equipment and the cult of the dead; (8) Some aspects of Mycenaean culture; (9) Epilogue: the end of an age.

Chronology, p.236-37. Selected bibliography, p.239-41; bibliographical references in footnotes.

I103 Pendlebury, John Devitt Stringfellow. The archaeology of Crete; an introduction. London, Methuen [1939]. xxxii, 400p. 53 il., 50 plates, plans, 24 maps. (Repr.: N.Y., Biblo & Tannen, 1963. Biblo & Tannen's archives of civilization, 2)
The basic survey of the material aspects of the culture of Crete. Contents: (1) The island; (2) The Neolithic period, the early Minoan period; (3) The middle Minoan period; (4) The late Minoan period; (5) A survey of the Minoan civilization; (6) Post-Minoan Crete. Bibliography, p.381-93.

I104 Pollitt, Jerry Jordan. The ancient view of Greek art: criticism, history, and terminology. New Haven, Yale Univ. Pr., 1974. xiv, 464p. (Yale publications in the history of art, 25)
"The point of departure selected in this study is the critical terminology of the Greeks, the terms they used to describe and evaluate sculpture, painting, and architecture."—*Prologue.* The text is followed by a glossary of terms of Greek art criticism derived from writings by ancient Greek and Latin authors, primarily of the 5th and 4th centuries B.C.

Contents: pt. 1, Art criticism in antiquity: (1) Professional criticism; (2) Art criticism in Greek philosophy; (3) Rhetorical and literary criticism; (4) Popular criticism; (5) Roman variants; pt. 2, Art history in antiquity: (6) The Elder Pliny and his sources; (7) Quintilian and Cicero.

Bibliographical references in Notes, p.86-111. Glossary, p.113-449. General index; Index of ancient authors and passages; Index of Greek and Latin terms.

I105 _____. Art and experience in classical Greece. Cambridge, Cambridge Univ. Pr., 1972. xiv, 205p. 87 il.
Also published in a paperback ed.
"This book is designed for 'general readers', students, and even Classical philologists, who are interested in Greek art but do not normally have occasion to read in the vast scholarly literature of it. . . . The purpose of this study is to suggest some of the basic cultural experiences which the arts were used to express and to analyze how they were used to express them. My primary focus of interest will be on the Classical period, i.e. the period between c.480 and 323 B.C."—*Pref.*

Contents: Prologue: On the meaning of 'classical'; (1) Antecedents and first principles; (2) Consciousness and conscience; (3) The world under control; (4) The world beyond control; (5) The world of the individual; Epilogue.

Supplementary references for illustrations, p.197-98. Supplementary suggestions for further reading, p.[199]-202.

I106 Richter, Gisela Marie Augusta. Archaic Greek art against its historical background: a survey. N.Y., Oxford Univ. Pr., 1949. 226p. plates, map (on lining papers). (The Mary Flexner lectures, 9)
A survey of archaic Greek sculpture and painting (c.650-480 B.C.). A more generalized work than the author's *Kouroi* (K56). "Abbreviations and bibliography," p.xiii-xviii.

I107 _____. A handbook of Greek art. [6th ed., redesigned] London; N.Y., Phaidon [1969]. 431p. il., maps.
Also published in paperback ed.
The general handbook of Greek art most extensively used by undergraduate students. The approach is categorical rather than chronological (i.e., architecture, larger works of sculpture, statuettes and small reliefs in various materials exclusive of terra cottas, decorative metalwork, etc.). Excellent classified bibliography (by chapter), p.399-410; bibliographical references in "Notes."

I108 Robertson, Martin. A history of Greek art. London; Cambridge, Cambridge Univ. Pr. [1976]. 2v. v.1, 611p.; v.2, 835p. plates, map.
The most comprehensive history of Greek art from the archaic through the Hellenistic period, written by a recognized authority in the field. "Professor Robertson's approach is chronological rather than topical; he presents changes in the different branches of representational art as aspects of a single historical development. He concentrates on the genuinely Greek and markedly different artistic tradition whose first impulse appears at about 1000 B.C. and which atrophies eventually in the first century B.C."—*Pub. notes.*

Contents, v.1: Prologue: Art in Greece before the Iron Age; The seeds of Greek art: the Geometric and Orientalizing periods; The beginning of monumental Greek art: the early archaic period; Ripe archaic art; The great change: late archaic and early classical; The classical moment; Developments into the 4th century; The second change: Classical to Hellenistic; Hellenistic art; Epilogue: Greek art and Rome. v.2: Notes; Abbreviations and bibliography, p.740–59; List of illustrations; Figures; Plates; Indexes.

I109    Schefold, Karl. The art of classical Greece. [Trans. by J. R. Foster]. N.Y., Crown [1966]. 294p. 127 il. (50 mounted col.), map.

Also published as *Classical Greece,* London, Methuen, 1967; originally published as *Klassisches Griechenland,* Baden-Baden, Holle, 1965.

A general historical synthesis of the art of Greece in the classical period (c.500 B.C. to the death of Alexander the Great, 323 B.C.).

Bibliographical references in notes to text, plates, and figures. Chronological table, p.270–71.

I110    _____. Die Griechen und ihre Nachbarn. Mit Beiträgen von Ludwig Berger, George M. A. Hanfmann [et al]. Berlin, Propyläen Verlag, 1967. 372p. 464 plates (part col.), il. plans. (Propyläen Kunstgeschichte [n. F.] 1)

An excellent, comprehensive survey of Greek art and architecture. Directed at the serious student and scholar. In the principal essay, Schefold "surveys the range of Greek art in simple art history terms, unafraid of dwelling on the obscurer details and careful to observe historical setting. Special attention is given to the criteria and evidence for chronology in each period."—Review by John Boardman, *American journal of archaeology* 73:250 Apr. 1969. Incorporates recent archaeological research.

The "Dokumentation" section includes 12 brief essays on the various arts of the Greeks and their neighbors, followed by detailed commentaries and bibliographical references to the plates. Contents: Lullies, R. Griechische Plastik; Greifenhagen, A. Griechische Kleinkunst; Scheibler, I. Griechische Malerei; Krause, C. Griechische Baukunst; Young, R. S. Phrygische Kunst; Hanfmann, G. M. A. Lydische Kunst; Schefold, K. Skythisch-thrakische Kunst; Luschey, H. Die Kunst Irans zur Zeit der Achaimeniden, Alexanders des Grossen und der Seleukiden; Kukahn, E. Phönikische und iberische Kunst; Jucker, H. Vorrömische Kunst in Sardinien, Mittel-und Norditalien; Berger, L. Frühkeltische Kunst; Schefold, K. Übersicht der Perioden.

I111    Schweitzer, Bernhard. Greek geometric art. [Ed. by Ulrich Hausmann in cooperation with Jochen Briegleb. Trans. by Peter and Cornelia Urborne. N.Y.] Phaidon [1971]. 352p. il., map (on lining paper), plans.

Trans. of *Die geometrische Kunst Griechenlands; Frühe Formenwelt im Zeitalter Homers,* Cologne, DuMont Schauberg, 1969.

"While it attempts to present a relatively full summary for the art of Greece during the geometric period, this work is primarily designed as an interpretation of the geometric style rather than as a compendium of Greek art from the late 10th to the early 7th century B.C."—Review by Philip P. Betancourt, *American journal of archaeology,* 75:99 Jan., 1971. Concentrates primarily on pottery, the minor arts, and architecture.

I112    Vermeule, Emily. Greece in the Bronze Age. Chicago, Univ. of Chicago Pr. [1964]. xix, 406p. il., maps, 48 plates.

A comprehensive, up-to-date survey of Greek civilization between 6500 and 1100 B.C. "As a handbook it reports facts, beginning with an account of the Neolithic period and substantial chapters on the Early and Middle Bronze Ages, then proceeding to much larger sections on the rise and fall of Mycenaean civilization in all its aspects."—Review by John L. Caskey, *Archaeology,* Winter, 1965, p.308.

General bibliography, p.351–52; Chapter (classified) bibliographies, p.353–83. Bibliographical references in "Notes," p.331–50. Glossary, p.385–87.

I113    Wace, Alan John Bayard. Mycenae, an archaeological history and guide. Princeton, Princeton Univ. Pr., 1949. 150p. 110 plates, maps.

"Intended as an introduction to Mycenae and its civilization and, though Homeric illustrations are quoted, its main concern is the accurate description of archaeological facts."—*Pref.* Bibliography, p.139–41.

I114    Webster, Thomas Bertram Lonsdale. The art of Greece; the age of Hellenism. N.Y., Crown [1966]. 243p. il. (part col., part mounted), maps, (Art of the world. European cultures, the historical, sociological, and religious backgrounds)

A well-illustrated survey of the arts of the Hellenistic period, from the death of Alexander to the death of Julius Caesar. Chronological table, p.214–19; glossary; p.220. Bibliography and notes, p.224–32.

**Etruria and Rome**

I115    Banti, Luigi. Etruscan cities and their culture. Trans. by Erika Bizzarri. London, Batsford, 1973. 424p. 237 il., 13 maps.

First published as *Il mondo degli Etruschi,* Rome, Biblioteca di Storia Patria, 1960; expanded version, 1968.

A scholarly survey which admirably reconstructs the Etruscan civilization by means of archaeological evidence. 96 plates with 237 illustrations. Extensive notes on the text, selected bibliography, p.280–303. Indexed.

I116    Becatti, Giovanni. Arte e gusto negli scrittori latini. [Firenze] Sansoni [1951]. vii, 500p. 81 plates.

An important study of art ideas and taste in ancient Rome and art criticism in Rome with relation to Greek thought. Based on ancient sources. Bibliographical notes at the end of each chapter. The appendix (p.299–454) consists of selections from Roman authors. Indexes: authors; names, concepts, and artistic terms; descriptive index of the 153 illustrations.

I117 Bianchi Bandinelli, Ranuccio. Rome: the center of power 500 B.C. to A.D. 200. Trans. from the French by Peter Green. N.Y., Braziller [1970]. xii, 437p. il. (part col.), col. plans. (The arts of mankind. 15)
Published in England by Thames & Hudson.
Trans. of: *Rome, le centre de pouvoir.*
A major work by a distinguished scholar on the origins, development, and influence of Roman art as distinct from that of Greece and the other ancient Mediterranean civilizations. The illustrations are limited to the art of the center of power—the city of Rome—from the birth of her society through the first crisis of the Hellenistic tradition.
Also an important historiographical study. Well documented; full bibliography, p.[389]-96; illustrated by 451 figures and 90 color plates.

I118 _____. Rome, the late Empire; Roman art, A.D. 200–400. Trans. by Peter Green. N.Y. Braziller [1971]. x, 463p. il. (part col.), col. maps. (The arts of mankind. 17)
Trans. of: *Rome, la fin de l'art antique.*
A continuation of *Rome: the center of power* (I117). Largely limited to sculpture, painting, and mosaics. "A stimulating, valuable introduction, perhaps the best discussion of late Roman art since Riegel and Rodenwalt."—R. Brilliant, *Art bulletin,* June, 1973. Divided into two sections: (1) Rome and the western provinces as the foundation of European art; (2) Africa and the eastern provinces as the foundation of Byzantine art.
Well documented; bibliography, p.411-20.

I119 Brendel, Otto J. Prolegomena to a book on Roman art. (*In* American Academy in Rome. Memoirs, v.21, 1953, p. [9]-73) (Repr.: New Haven, Yale Univ. Pr., 1979.)
A theoretical essay on the aesthetic, historical, and terminological approaches to the problems of Roman art. Basic to a study of the history of attitudes towards Rome.

I120 Brilliant, Richard. Roman art from the Republic to Constantine. London, Phaidon, 1974. 288p. 300 il. (Distr. in the U.S. by Praeger.)
An art historical survey of Roman art (c.200 B.C. to 300 A.D.) directed to students and the serious general reader. The introduction is a summary of the historiography of Roman art from Winckelmann to the present. The text is divided into two parts: pt. 1, Major themes of Roman art (topical essays on architecture, triumphal monuments, decorative portraiture, typological styles, and historicism); pt. 2, Into the history of art (survey of the historical development). Selected bibliography, p.[269]-72, and chronology.

I121 Ducati, Pericle. L'arte in Roma dalle origini al secolo VIII. Bologna, Cappelli, [c1938]. 500p. il., 303 plates, plans, diagrs. ([Instituto di Studi Romani] Storia di Roma, v.XXVI)
A well-illustrated survey of Roman art from its origins to the 8th century. Bibliography, p.[421]-36, with annotations. Indexes of places, names, and things.

I122 _____. Storia dell'arte etrusca. Firenze, Rinascimento del Libro, 1927, 2v. 284 plates (incl. plans).
A standard history of Etruscan art, still basic.
Contents: v.1, Text; v.2, Plates. Bibliography at end of each chapter. Index at end of v.1.

I123 Frova, Antonio. L'arte di Roma e del mondo romano. Con 14 tavole in rotocalco e 713 figure nel testo. [Torino] Unione tipografico-editrice torinese [1961]. xi, 947p. il., ports., plans. (Storia universale dell'arte, v.2, t.2)
A broad survey of Roman art and architecture in two parts: [1] Arte di Roma in Italia; [2] Arte del mondo romano (Europa, Africa, Asia). Extensive classified, annotated bibliography, p.839-93.

I124 Giglioli, Giulio Quirino. L'arte etrusca. Milano, Treves, 1935. 7p. 1, xvii-lxxii, 95p. plates (part col.)
A good pictorial survey of Etruscan architecture, sculpture, painting, and the minor arts. Still useful. "Descrizione e bibliografia dei monumenti," p.5-78.

I125 Grenier, Albert. Manuel d'archéologie gallo-romaine. Paris, Picard, 1931-[60]. il., plans.
v.1-2 issued as v.5-6 of Déchelette (I140).
The standard work on the archaeology of Gaul during the Roman period. v.3-4, dealing with Gallo-Roman architecture and town planning, are most useful for art historians.

I126 Hanfmann, George. Roman art; a modern survey of the art of imperial Rome. Greenwich, Conn., New York Graphic Society [1964]. [345]p. il., 52 col. plates, maps.
An introduction to Roman art, prepared by a distinguished scholar. "The purpose of this book is to put into the hands of the public a selection of pictures of Roman art which would present some of the major creative achievements of Roman artists."—*Foreword.* Limited to imperial art. The introduction is followed by an historical outline (p.44-51), the selective bibliography (p.53-55), captions for the black-and-white illustrations (p.59-126), 145 black-and-white illustrations (p.129-223), and color plates V-LII (p.224-345). The plates are arranged by medium, fully described, with indexes.

I127 Kähler, Heinz. The art of Rome and her empire. [Trans. by J. R. Foster]. N.Y., Crown [1963]. 262p. il. (part col.), map, plans. (Art of the world, European cultures: the historical, sociological, and religious backgrounds)
An excellent introduction to Roman art from the reign of Augustus until the move to Constantinople in 325 A.D. Directed to the serious reader; widely used as an art history text. The emphasis is on architecture, which is treated as the unique Roman contribution to the history of ancient art. Illustrated with line drawings and color plates.
Bibliography, p.216-24; Chronological table, p.226-39; Notes on the additional illustrations, p.240; Additional illustrations, p.241-48; Map of the Roman Empire, p.250-51; Index, p.253-59; Corrigenda, p.260-63.

I128    _____. Rom und seine Welt; Bilder zur Geschichte und Kultur. München, Bayerischer Schulbuch-Verlag, 1958-60. 2v. il., plates, maps, plans.

An excellent introduction to Roman culture, history, and art. Well-chosen photographic plates supplemented by line drawings and plans. Chronological table, v.2, p.429-41. Indexes of persons, places, ancient sources, and general index at end of v.2. No bibliography.

Contents: v.[1] Plates; v.[2] Text.

I129    Kraus, Theodor. Das römische Weltreich. Mit Beiträgen von Bernard Andreae [u.a.] Berlin, Propyläen, 1967. 335p. il. (part col.), text figs. (Propyläen Kunstgeschichte [n. F.] Bd. 2)

A good review of Roman art. Follows the established format of the new Propyläen series. In the 1st section the author surveys the art, treating it as an expression of the time. The 2d part is a large corpus of superb plates; the 3d part, "Dokumentation," consists of essays by various scholars and documentation of the illustrations. Classified bibliography, p.305-19.

Dokumentation: Spätetruskische-italische Kunst; Römische Architektur; Römische Malerei; Römische Stuckdekoration; Römische Reliefkunst; Römische Idealplastik; Römische Bildniskunst; Römische Mosaikkunst; Spätantike Buchmalerei; Römisches Kunstgewerbe; Römische Glyptik und Münzprägekunst; Der Osten zur Zeit der römischen Machtenfaltung.

I130    Mansuelli, Guido Achille. The art of Etruria and early Rome. [Trans. by C. E. Ellis]. N.Y., Crown [1965]. 255p. il., map, plates (part col.) (Art of the world, non-European cultures: the historical, sociological, and religious backgrounds)

An authoritative, encyclopedic treatment of the art and society of ancient Italy. Intended for the general reader. The appendix, p.196-215, correlates the history of Asia and Egypt, Greece and Italy, with periods and movements in Greece, Etruria, Rome, and Latium from 800 B.C. to 20 A.D. Bibliography, p.240-46.

I131    Mau, August. Pompeii, its life and art; trans. into English by Francis W. Kelsey . . . with numerous illustrations from original drawings and photographs. New ed., rev. and cor. N.Y., London, Macmillan, 1904. 557p. il., plates, plans. (Repr. of 1902 ed.: College Park, Md., McGrath, 1971.)

A basic work, old but still useful. "Key to the plan of Pompeii," p.559-[60]. "Bibliographical appendix," p.513-50. Index, p.551-57.

I132    Pallottino, Massimo. Art of the Etruscans. 126 photos by Walter Dräyer and Martin Hürlimann. Text by Massimo Pallottino. Notes by H. and I. Jucker. N.Y., Vanguard [1955]. 154p. il. (part col.), map.

126 superb pictures, with a brief text by a famous Italian Etruscologist. Bibliography, p.29.

I133    Richardson, Emeline Hill. The Etruscans, their art and civilization. Chicago, Univ. of Chicago Pr. [1964]. xvii, 285p. il., 48 plates, maps.

A well-written general study based on ancient sources and recent archaeological research. Valuable to the scholar and a fascinating story for the general reader. Critical bibliography. Excellent illustrations with notes on the plates.

I134    Riis, Poul Jørgen. An introduction to Etruscan art. Copenhagen, Munksgaard, 1953. 144p. 82 plates.

A compendium of subject essays which together form an excellent introduction to Etruscan art and archaeology. Includes bibliographies.

I135    Strong, Donald Emrys. Roman art. Prepared for the press by J. M. C. Toynbee. Harmondsworth; Baltimore, Penguin [1976]. xviii, 184p. il., map. (Pelican history of art. Z39)

This new volume of the *Pelican history of art* is an excellent. if brief, survey of Roman art from its beginnings to the period after Constantine. Media included are sculpture, painting, mosaics, decorative arts, coins and medals. Written by the outstanding scholar, Donald Emrys Strong. The manuscript of the late author's first draft was edited and prepared for publication by Jocelyn M. C. Toynbee. Bibliographical notes were left in the text. The extensive bibliography (classified by subject), p.175-84, was compiled by J. M. C. Toynbee. Well illustrated

I136    Strong, Eugénie (Sellers). Art in ancient Rome. N.Y., Scribner, 1928. 2v. il. (incl. plans). (Ars una: species mille. General history of art) (Repr.: Westport, Conn., Greenwood, 1971.)

A standard handbook on Roman art, now out-of-date, perhaps still useful.

Contents: v.1, From the earliest times to the principate of Nero; v.2, From the Flavian dynasty to Justinian, with chapters on painting and the minor arts in the 1st century, A.D.

Bibliography at end of most of the chapters; "General bibliography," v.1, p.xii. Index, v.2, p.209-20.

I137    Toynbee, Jocelyn M. C. Art in Britain under the Romans. Oxford, Clarendon, 1964. xxiv, 473p. 249 il., 100 plates.

"This book, while not a *corpus* of all extant material, surveys the great majority of known objects of every class, character, and degree of quality, and aims at offering a picture as complete as possible of the parts played in Roman-British life by art and craftsmanship and by those religious cults and beliefs that sound artistic expression in a great variety of media."—*Foreword*.

Bibliographical footnotes; bibliography, p.[444]-45. Glossary of Latin and Greek words and phrases, p.[447]-48. Indexes: (1) Recognized Romano-British sites and other places in Britain productive of works of Roman art; (2) Persons, personifications, deities, mythological figures, peoples, museums, and places (other than those in Index 1).

I138    Vermeule, Cornelius. Roman imperial art in Greece and Asia Minor. Cambridge, Mass., Belknap, 1968. xxiv, 548p. il., maps.

An important scholarly survey—the first of Roman official art in the Eastern provinces of Greece, Asia Minor, Syria,

and Egypt. The period covered ranges from c.165 B.C. until the late 6th century. Includes architecture, sculpture, epigraphy, and numismatics. Well-documented, literary references in the notes. The beautiful plates in the text constitute a unique corpus of illustrations.

Appendixes: (A) Imperial portraits from Greece, Asia Minor, Syria, and Egypt; (B) Works of art in museums and private collections; (C) Works of art and inscriptions by site. Index of places, people, and monuments.

I139  Wickhoff, Franz. Roman art; some of its principles and their application to early Christian painting. Trans. and ed. by Mrs. S. Arthur Strong. London, Heinemann; N.Y., Macmillan, 1900. 198p. il., 14 plates. (Repr. of 1912 German language ed.: Soest, Holland, Davaco, 1972.)
1st published in Vienna in 1895 with title: *Die Wiener Genesis*, ed. by Wilhelm von Hartel and Franz Wickhoff.

The pioneer work of Roman art history. For an assessment of its importance, see R. Brilliant, *Roman art* (I120), p.14.

# CELTIC AND GERMANIC

I140  Déchelette, Joseph. Manuel d'archéologie préhistorique, celtique et gallo-romaine. Paris, Picard, 1908-34. 6v. in 7. il., maps.
v.2-4 called v.2, pt. 1-3, and paged continuously.
v.6, pt. 1-2 paged continuously.
v.5-6 by Albert Grenier.
A useful manual of prehistoric, Celtic, and Gallo-Roman archaeology. Contents: v.1, Archéologie préhistorique; v.2, Archéologie celtique ou protohistorique; Âge du bronze; v.3, Premier âge du fer ou époque de Hallstatt; v.4, Seconde âge du fer ou époque de LaTene; v.5, Archéologie gallo-romaine; Généralités, travaux militaires; v.6, L'Archéologie du sol. pt. 1. Les routes; pt. 2. Navigation, occupation du sol.
Each volume contains bibliographies and a general index.

I141  Finlay, Ian. Celtic art; an introduction. London, Faber and Faber, 1973. 183p. il. (part col.)
American ed.: Park Ridge, N.J., Noyes [1973].

"The purpose of the present volume is to draw together in one volume some of the ablest artistic achievements of the Celtic peoples from prehistoric times to the earlier centuries of the Christian era and to comment on their significance"—*Introd.* Bibliographical footnotes; bibliography, p.174-75.

I142  Hubert, Jean; Porcher, Jean; and Volbach, W. F. Europe of the invasions. [Trans. by Stuart Gilbert and James Emmons]. N.Y., Braziller [1969]. xv, 387p. 362 il., incl. facsims., maps, plans (part col.) (The arts of mankind. 12)
Also published as *Europe in the Dark Ages,* London, Thames & Hudson.

A broad survey of art in Italy, Gaul, Spain, Britain, the Roman East, and Byzantium from c.200 to 770 A.D. Richly illustrated, includes 118 color plates.

Contents: Introduction [by] Jean Porcher; pt. 1. Architecture and decorative carving [by] Jean Porcher; pt. 2. Book painting [by] Jean Porcher; pt. 3. Sculpture and applied arts [by] W. F. Volbach; Conclusion [by] Jean Hubert; pt. 4. General documentation, includes plans, list of manuscripts reproduced, note on ornament, chronological table, bibliography (p.329-46), list of illustrations, glossary-index, and maps.

I143  Jacobsthal, Paul. Early Celtic art. Oxford, Clarendon, 1944. 2v. il., plates. (Repr.: Oxford, Clarendon, 1969.)
"Covers the 4th and 3d centuries B.C. and parts of the 2d and 5th of the art of the Gauls."—*Pref.* Not a corpus of all specimens preserved but a selection of works chosen for their style and technique. Glass and Celtic art in Spain are omitted. Excellent clear plates.
v.1, text; v.2, plates. Contents: (1) The image of man; (2) Animals; (3) Grammar of Celtic ornament; (4) A survey of implements and some remarks on their technique; (5) Chronology; (6) Celtic crafts, their origin and connexions; Epilogue; Catalogue, p.165-205.
Indexes, p.214-42: (1) References to the catalogue; (2) Key to plates, p.216-60; (3) References to the pages where patterns decorating objects other than those illustrated are explicitly or implicitly mentioned or discussed; (4) Proveniences; (5) Ancient writers and inscriptions; (6) Arts and styles (other than early Celtic); (7) Some matters of interest; (8) Concordance to some books especially familiar to students of the subject.

I144  Puig y Cadafalch, José. L'art wisigothique et ses survivances; recherches sur les origines et le développement de l'art en France et en Espagne du IVe au XIIe siècle. Paris, Nobele, 1961. 204p. 105 il., 56 plates.
A basic work on Visigothic architecture, decoration, mural painting, mosaics, etc. in France and Spain. Published posthumously. Includes the origins, development, and survivals of the style in Mozarabic, Carolingian, and Romanesque art. Bibliography, p.[189]-98.

I145  Verzone, Paolo. The art of Europe: the Dark Ages from Theodoric to Charlemagne. Trans. by Pamela Waley. N.Y., Crown [c1968]. 276p. il. (part col.), plans. (Art of the world, European cultures; the historical, sociological, and religious backgrounds)
Covers the period from 425 to 800 A.D. Its object is "to show that the cultural influence of Byzantium always accompanied the actions of its soldiers, sailors and statesmen, and that it continued to spread for some time, even in the lost territories, through religion and through works of art which were acknowledged models of luxury and beauty, eagerly sought after by the great."—*Pref.* Incorporates much little-known material; useful to the specialist. Bibliography, p.259-60.

SEE ALSO:  Grenier, A. *Manuel d'archéologie gallo-romaine* (I125); Rice, D. T. *The dawn of European civilization* (I169).

# EARLY CHRISTIAN — BYZANTINE

I146    Aĭnalov, Dimitriĭ Vlas'evich. The Hellenistic origins of Byzantine art. Trans. from the Russian by Elizabeth Sobolevitch and Serge Sobolevitch. Ed. by Cyril Mango. New Brunswick, N.J., Rutgers Univ. Pr. |1961|. xv, 322p. il.

"Published for the first and only time, in 1900–1901 in the Bulletin of the Imperial Russian Archeological Society." —*Editor's pref., p.vii.* The pioneer work on the classical heritage of Byzantine miniatures, pictorial relief, and wall painting. Bibliographical references included in "Notes" (p.282–308) augmented with later literature by Cyril Mango.

I147    Athens. Zappeion. Greece. Byzantine art, an European art. |Exhibition organized by the Greek gov. under the auspices of the Council of Europe in the Zappeion Exhibition Hall, Athens, April 1–June 15, 1964| 2d ed. Athens, 1964. 597p. plates. (Exhibition of the Council of Europe, 9th)

This catalogue of an exhibition of 650 Byzantine art objects, ed. by M. Chatzidakis, consists of a collection of essays arranged according to artistic medium. Contributors include the foremost historians and art historians of the Byzantine period. Bibliography, p.|519|–69; |589|–91.

I148    Beckwith, John. The art of Constantinople: an introduction to Byzantine art 330–443. 2d ed. London, N.Y., Phaidon, 1968. viii, 184p. 203 il. (Distr. in the U.S. by Praeger.)

1st ed. 1961.

A survey of the art of the city of Constantinople from its foundation to the conquest by the Turks. Bibliographical references included in "Notes," p.155–68.

I149    _____. Early Christian and Byzantine art. Harmondsworth; Baltimore, Penguin [1970]. 211p. il. (incl. 1 col.), 193 plates, facsims., map. (The Pelican history of art, Z32)

A concise history of art in the distinguished Pelican series. The period covered ranges from Early Christian Rome to the 15th century in the East. Scholarly notes, glossary, and selected bibliography.

I150    Bologna. Università. Corsi di cultura sull'arte Ravennate e bizantina, v.|1| 1955– .

Title varies: 1955, Corsi d'arte ravennate e bizantina.

At head of title, 1963– : Università degli studi di Bologna. Istituto di Antichità Ravennati e Bizantine, Ravenna.

Scholarly papers on Byzantine art and the art of Ravenna, presented at the annual international conferences organized by Giuseppe Bovini.

I151    Bourguet, Pierre du. The art of the Copts. Trans. by Caryll Hay-Shaw. N.Y., Crown, 1971. 253p. il. (part col.)

A scholarly survey of Coptic art and architecture in Egypt from its Pharaonic and Hellenistic origins to its end under Moslem rule. The only summary in English. Many illustrations

with 53 color plates. References to literature in the notes and an excellent, selective bibliography.

I152    _____. Early Christian art. Trans. from the French by Thomas Burton. N.Y., Reynal |1971|. 219p. il.

"A thoughtful, coherent and comprehensive picture of the beginnings and early phases of Christian art. Sensibly limiting himself to the period from about 200 A.D. to about 400— roughly a century on either side of Constantine the Great's edict of 313 A.D. annulling anti-Christian measures and granting the new religion freedom to grow—the author, who is keeper of Early Christian and Coptic aniquities at the Louvre, traces the gradual emergence and development of the new style."—Robert Branner, *Art in America* 61:112 (Mar.-Apr. 1973).

Good illustrations, many large plates in color. Notes, bibliography, glossary, and map.

I153    Deichmann, Friedrich Wilhelm. Ravenna, Hauptstadt der spätantiken Abendlandes. Wiesbaden, Steiner, 1969–(75). 3v. il., plates (part col.). In progress.

An exhaustive work on Ravenna—the late antique, early Christian capital of the West. Scholarly text and commentaries with a monumental corpus of illustrations.

Contents: Bd. 1. Geschichte und Monumente (405 plates) 1969; Bd. 2. Geschichte und Monumente. Kommentar. t.1. Die Bauten bis zum Tode Theoderichs des Grossen. (56 plates) 1974; t.2. Die Bauten des Julianus Argentarius. Übrige Kirchen, 1975; t.3. Geschichte, Topographie, Kunst und Kultur (to be published); Bd. 3. Frühchristliche Bauten und Mosaiken von Ravenna. Ed. by Franz Bartl, Julie Boehromger (405 plates) 1969.

I154    Delvoye, Charles, L'art byzantin. |Grenoble| Arthaud, 1967. 457p. il., plates (part col.)

A comprehensive, well-organized survey of the Byzantine arts from 324 to 1453 A.D. in both the East and West. Useful to the scholar and the general reader. 220 photographs, 4 color plates, and 36 plans. Glossary, bibliography, p.407–|26|, tables of illustrations, plans, and proper names. Detailed table of contents.

I155    Demus, Otto. Byzantine art and the West. N.Y., New York Univ. Pr. |1970|. xxi, 274p. 264 il., 8 col. plates. (The Wrightsman lectures. 3)

"The stress is not on 'influences' which lead as often as not to deviations, but on the functioning of Byzantine artists as teachers and pacemakers and on the object lessons provided by Byzantine models in the West."—*Foreword.*

Contents: (1) Subtilitas Graecorum; (2) Early lessons and revivals; (3) Towards the Romanesque; (4) Colonial art; (5) The birth of Gothic; (6) The dawn of European painting. References are made only to the works illustrated. Illustrations in text. Bibliographical notes, p.243–52.

I156    Diehl, Charles. Manuel d'art byzantin. 2. éd. rev. et augm. Paris, Picard, 1925–26. 2v. il.

Originally published in 1910.

This old standard work is still listed in the bibliographies of contemporary scholars.

Bibliographical notes and abbreviations, v.1, p.|xiii|-xv. Also bibliographical footnotes. General index, p.911-33. Iconographical index, p.934-40.

I157 Dumbarton Oaks papers. no. 1- . Cambridge, Harvard Univ. Pr., 1941- . il., plates.

A series of papers devoted to classical, Byzantine, and medieval art, issued by the Dumbarton Oaks Research Library and Collection of Harvard University.

I158 Essen: Villa Hügel. Koptische Kunst: Christentum am Nil. |Ausstellung| 3. Mai bis 15. Aug., 1963. Veranstalter der Ausstellung ist der gemeinnützige Verein Villa Hügel e. V. [Essen, 1963] 628p. il., (part col.), map, music, plans.

Editor: W. F. Volbach.

A significant exhibition which started a wave of new research and opinion on Coptic art. Also held in Zurich, Vienna, and Paris.

Essays by scholars, critical and bibliographical notes on the works exhibited. Bibliography, p.519-69. For a review of the Essen, Paris, and Vienna catalogues and the other literature published in 1963 and 1964 see H. Torp in *Art bulletin,* Sept. 1965, p.361-75.

I159 Grabar, André. Christian iconography; a study of its origins [N.Y., Published for the Bollingen Foundation by] Princeton Univ. Pr. |Princeton, N.J., 1968|. 1, 178p. 202 plates, 346 figs. (5 col.) (Mellon lectures in the fine arts. 10)

A scholarly and highly readable collection of essays dealing with the origin and function of the most characteristic Paleo-Christian images. Illustrations well coordinated with text. The "Selective bibliography," p.149-58, follows the theme of each chapter.

I160 _____. Early Christian art: from the rise of Christianity to the death of Theodosius. Trans. by Stuart Gilbert and James Emmons. N.Y., Odyssey |1968|. 325p. il., maps, plans. (The arts of mankind. 9)

Trans. of: *Le premier art chrétien.*

English ed.: *The beginnings of Christian art.* London, Thames & Hudson |1967|.

The arrangement follows the pattern of the series. Especially valuable for its excellent pictures and full bibliography, p.307-13. Although not suitable as a college text, it is a semipopular book by a well-known scholar.

Contents: (1) General characteristics; (2) Christian painting and sculpture before the peace of the Church; (3) The art of the 4th century.

I161 _____. L'empereur dans l'art byzantin. Recherches sur l'art officiel de l'Empire d'Orient. Paris, Belles lettres, 1936. viii, 296p. il., plates. (Strasbourg, Univ. |Faculté des Lettres| Publications, 75) (Repr.: London, Variorum, 1971.)

This important scholarly study of the emperor in Byzantine art is again available.

I. Index des noms et des choses, p.|273|-83. II. Index iconographique, p.|285|-89. Table des illustrations, Table des matières.

I162 _____. The golden age of Justinian, from the death of Theodosius to the rise of Islam. Trans. by Stuart Gilbert and James Emmons. N.Y., Odyssey |1967|. 408p. 392 il. (part col.), col. maps, plans. (The arts of mankind. 10)

Trans. of: *L'âge d'or de Justinien.*

Published in England with title: *Byzantium, from the death of Theodosius to the rise of Islam,* London, Thames & Hudson |1967|.

A companion volume to *Early Christian art* (I160) covering the Byzantine period of Christian art, east and west, in the 5th and 6th centuries. Many illustrations in text (125 in color). Divided by artistic medium: (1) Architecture; (2) Painting; (3) Sculpture; (4) Sumptuary arts and art industries. The text is followed by plans, a chronological table, an exhaustive bibliography (p.381-92), a list of illustrations, and maps.

I163 Hutter, Irmgard. Early Christian and Byzantine art. Foreword by Otto Demus. N.Y., Universe Books |1971|. 191p. il. (part col.), plans.

Trans. of: *Frühchristliche Kunst, byzantinische Kunst.* (Belser Stilgeschichte, IV)

An excellent text for the beginning student of medieval art. 189 illustrations. A good selective bibliography.

I164 Mathew, Gervase. Byzantine aesthetics. N.Y., Viking |1964|. xiii, 189p. 25 plates (part col.)

Byzantine aesthetics in the context of neo-Platonic and neo-Pythagorean ideas, the religious and political institutions, and social structure.

Bibliography, p.179-80; index.

I165 Meer, Frederik van der, ed. Atlas of the Early Christian world |by| F. van der Meer |and| Christine Mohrmann. Trans. and ed. by Mary F. Hedlund and H. H. Rowley. |London, N.Y.| Nelson, 1958.

A unique historical atlas documented by a corpus of 614 illustrations. "Emperors, monuments, mosaics, churches, baptisteries, and manuscripts figure among the subjects of these illustrations, which will be studied by historians of Christian art no less than by those who are interested in the life of the Church during the first six centuries of its existence." —*Foreword.*

Contents: (I) The Church of the martyrs A.D. 30-313; (II) The Church of the empire A.D. 313-600; (III) The fathers of the church and early Christian literature.

References to the literary sources in text. Geographical index to the maps and plates, p.|185|-204; Index of persons and things in the maps, plates, and text, p.205-11; Index of authors and inscriptions, p.211; Notes to the maps, p.213-15.

I166 Morey, Charles Rufus. Early Christian art; an outline of the evolution of style and iconography in sculpture and painting from antiquity to the eighth century. |2d ed.|. Princeton, Princeton Univ. Pr., 1953. 296p. il. (Repr.: N.Y., Hacker, 1973.)

First published in 1941. For arguments against the basic thesis, see the review by Sirarpie der Nersessian in *Art bulletin,* March 1943, p.80-86.

The 2d ed. includes a discussion of the frescoes of S. Maria di Castelseprio, as well as minor corrections and alterations of the original text; the notes and bibliography are brought up to date. Architecture and textiles are not included. Illustrated with collotype plates.

Bibliographical abbreviations, p.200; Bibliographical references included in "Notes," p.201-32. Index, p.235-58; Description of the illustrations, p.261-96.

I167    Perkins, Ann. The art of Dura-Europos. Oxford, Clarendon, 1973. 130p. il.

The first art historical survey of the painting, sculpture, and architecture of Dura-Europos. A good introduction for the general reader; the scholar now has a general work which incorporates the Yale archaeological reports and other research published after the book by Rostovtsev (I171). Bibliographical references in footnotes.

I168    Rice, David Talbot. The art of Byzantium. Text and notes by David Talbot Rice; photographs by Max Hirmer. London, Thames & Hudson [1959]. 348p. 44 mounted col. il., 196 plates.

A corpus of illustrations (p.93-284 plates) of the Byzantine art of Constantinople, with a short introductory text and notes on the plates by an authoritative scholar. Includes bibliographies. "Key to sources," p.286; General index, p.341-45; Iconographical index, p.346-48.

I169    _____. The dawn of European civilization: The dark ages. Texts by David Oates et al. N.Y., McGraw-Hill [1965]. 360p. il., facsims., geneal. tables, maps, plans, plates (part col.)

A beautifully illustrated survey of European culture and art from the Migration period to the Ottonian empire. Each section is contributed by a scholar in the field.

Contents: (I) Introduction; the myth of the 'dark ages,' by David Talbot Rice; *The East*: (II) Beyond the frontiers of Rome; the rise and fall of Sassanian Iran, by David Oates; (III) The empire of the prophet; Islam and the tide of Arab conquest; (IV) Between West and East; Armenia and its divided history, by Sirarpie der Nersessian; *Byzantium*: (V) The heir of Rome; Byzantium from Justinian to Theophilus, by Cyril Mango; (VI) The Christian citadel; the Byzantine world of the 9th and 10th centuries, by J. M. Hussey; *Migration and Settlement*: (VII) The crucible of peoples; Eastern Europe and the rise of the Slavs, by Tamara Talbot Rice; (VIII) Germanic Italy; the Ostrogothic and Lombard Kingdoms, by Donald Bullough; (IX) 'The ends of the earth;' Spain under the Visigoths and Moors, by William Culican; (X) Prelude to empire; the Frankish kingdom from the Merovingians to Pepin, by Peter Lasko; (XI) From the vigorous north; the Norsemen and their forerunners, by David M. Wilson; (XII) The coveted isles; Celtic Britain and the Anglo-Saxons, by Charles Thomas; *The New Europe*: (XIII) The great king; Charlemagne and the Carolingian achievement, by Philip Grierson; (XIV) After Charlemagne; the Empire under the Ottonians, by Donald Bullough; (XV) The concept of Christendom; Medieval Europe takes shape, by Denys Hay. Chronological chart, p.344-45; select bibliography, p.346-47; list of illustrations, p.348-54; index, p.356-60.

I170    Rossi, Giovanni Battista de. La Roma sotterranea cristiana, descritta ed illustrata dal cav. G. B. de Rossi, pub. per ordine delle santità di n.s. papa. Pio Nono. Roma, Cromolitografia Pontificia, 1864-77. 3v. il., col. plan, and 3 atlases of plates (part fold., part col., incl. plans, facsims.) (Repr.: Frankfurt, Minerva, 1966.)

A monumental archaeological publication on the Roman catacombs, their history and topography; with extensive documentation and detailed descriptions of each catacomb and its contents. Amply illustrated with chromo-lithographs of views, maps, copies of paintings, sculpture, inscriptions, etc. Each volume has a table of contents; an analytical table of contents for the whole work is at the end of v.3.

I171    Rostovtsev, Mikhail Ivanovich. Dura-Europos and its art. Oxford, Clarendon, 1938. 162p. il., plates, map, plan.

A cultural history of Dura-Europos, written before publication of the archaeological reports by Yale Univ. (1943-49). Until recently the only general account. See A. Perkins (I167). General bibliography and index.

I172    Volbach, Wolfgang Friedrich. Early Christian art. Photography by Max Hirmer. Trans. by Christopher Ligota. N.Y., Abrams [1961]. 363p. p.43-302 plates (part col.). il., plans.

Covers the period from just before Constantine until the 6th century. "The English edition of this book is to be recommended for its wealth of illustrations and its concise, informative text"—A. Grabar, *The art of the Byzantine Empire* (I3). The pictures are accompanied by a brief introduction and notes on each plate by a recognized scholar. "Index of plates and figures by location," p.363-64.

I173    Volbach, Wolfgang, F., and Lafontaine-Dosogne, Jacqueline. Byzanz und der christliche Osten. Mit Beiträgen von Milko Bicev [u.a.] Berlin, Propyläen, 1968. il. (part col.), text figs., plans, elevations. (Propyläen Kunstgeschichte, [n.F.] Bd. 3)

An important volume of the new Propyläen Kunstgeschichte encompassing the art of the Byzantine Empire and its relationship with the Christian art of the West. Follows the series format with introductory essays by the authors, documentation of each area by specialists, and illustrations. Classified bibliography, p.380-98.

I174    Wulff, Oskar K. Altchristliche und byzantinische Kunst von ihren Anfängen bis zur Mitte des ersten Jahrtausends. Berlin-Neubabelsberg, Athenaion [c1918]. 2v. il., plates (part col.)

A standard reference work, now out-of-date. Contents: v.1, Die altchristlicher Kunst von ihren Anfängen bis zur Mitte des ersten Jahrhunderts; v.2, Die byzantinische Kunst von der ersten Blüte bis zu ihren Ausgang.

Includes bibliographies. Index of subjects, p.617-25; Index of historical names, p.625-26; Geographical index, p.626-29; Index of plates, p.[631-32].

_____. Bibliographisch-kristischer Nachtrag zu altchristliche und byzantinische Kunst von Dr. Oskar Wulff.

Potsdam, Akademische Verlagsgesellschaft Athenaion
|1939|. 88p. il. (incl. plans).

Index of subjects and names, p.86-87; Geographical
index, p.87-88.

SEE ALSO:  Assunto, R. *La critica d'arte nel pensiero medioe-
vale* (I181); *Reallexikon zur byzantinischen Kunst* (E33);
Zarnecki, G. *Art of the medieval world . . .* (I209); *Venezia
e Bisanzio* (I354).

## ISLAMIC

I175  Arts Council of Great Britain. The arts of Islam:
        Hayward Gallery 8 April–4 July 1976. Ed. by Dalu
        Jones and George Mitchell. London, Arts Council
        of Great Britain, 1976. 396p. il. (some col.)

The catalogue of a major exhibition of Islamic arts held in
conjunction with other London exhibitions during the World
of Islam Festival of 1976. The Islamic arts represented in
the show were textiles, rock crystal and jade, glass, ivory,
metalwork, ceramics, wood, marble and stucco, the arts of
the book (including painting and calligraphy), and architecture.

"The organizers have procured outstanding artifacts from
all over the world and their catalogue is an important book
of reference. . . . Most of the introductions present an up-to-
date review of opinion and discovery in their fields. . . ."
—G. Goodwin, *Burlington magazine* 118:452 (June, 1976).
These introductions to the ten sections and documented
catalogue entries for the over 600 works exhibited were
prepared by well-known authorities on the arts of Islam.
Each work is illustrated. Bibliography, p.357-82; Further
reading, p.383.

I176  Grabar, Oleg. The formation of Islamic art. New
        Haven, Yale Univ. Pr., 1973. xix, 233p. il., plans.

An important recent study of early Islamic religious and
secular art and decoration. Typological discussion of the
monuments and design. The emphasis is on religious and
cultural origins.

"It is not a manual of early Islamic art and it does not
pretend to discuss all monuments and all problems. It consists
of seven essays related to each other through a question
defined in the first essay: if it exists at all, how was Islamic
art formed?"—*Introd.*

Bibliography, p.217-27; index, p.229-33; illustrations,
p.237-|312|.

I177  Grube, Ernst J. The world of Islam. N.Y., McGraw-
        Hill |1967|. 176p. il., col. map, plans, col. plates,
        ports. (part col.)

A well-organized, easy-to-read survey of the Islamic arts
(architecture, ceramics, paintings, rugs, metalwork, and
carvings) from India to Spain. Written by a recognized
scholar, the best introduction in English for students and
general readers. Good illustrations; excellent color plates.
Further reading list, glossary, and index.

I178  Kühnel, Ernst. Islamic art & architecture. Trans.
        by Katherine Watson. Ithaca, N.Y., Cornell Univ.
        Pr., |1966|. 200p. il., maps, plans, 80 plates.

Trans. of: *Die Kunst des Islam.*

The last work of the renowned German scholar of Islamic
art and architecture, and the most comprehensive introductory
handbook in English. Written in simple language, with clear
explanations of the history, culture, styles, and artistic
terminology of Islam. The ten chapters, arranged according
to style, are organized into three parts—early, medieval,
and modern. Glossary, p.15-16; Bibliography (books),
p.185-89. 80 illustrations with good captions.

I179  Sourdel-Thomine, Janine, and Spuler, Bertold. Die
        Kunst des Islam. Berlin, Propyläen, 1973. 426p. il.,
        plates (part col.). (Propyläen Kunstgeschichte |n.F.|
        Bd. 4)

Another volume in this important series.

Introductory text: Der Islam, Entstehung und Ausbreitung
einer Weltreligion; Die Kunst des Islam. The plate section
is followed by the documentation prepared by the authors
with the assistance of an international group of specialists.
Full bibliography.

I180  Welch, Anthony. Collection of Islamic art. |Geneva|
        Prince Sadruddin Aga Khan |Château de Bellerive|
        |1972| 2v. il. (part col.), maps.

The sumptuously produced catalogue of the Sadruddin
Collection, one of the most important private collections of
Islamic art. Includes ceramics, paintings, manuscripts,
calligraphy, and metalwork. Each entry gives detailed
historical and stylistic data, authoritative commentary, and
frequently bibliographical references. Individual pieces are
often related to previously published pieces. Each catalogue
section is preceded by an introductory essay. Superbly
illustrated.

Contents, v.1: Introduction; Author's preface; Iran before
the Mongol conquest; Arab scientific illustration; The Īl-
Khān period; Early 14th century painting in Tabrīz; Early
14th century painting in Shīrāz; The Timurid period; The
Safavid period. v.2: Calligraphy; Manuscripts; Islamic
pottery; Mesopotamian ware; Samarqand ware; Nīshāpūr
ware; Sārī ware; Sgraffiato ware; Rayy ware; Kāshān ware;
Minai ware; Other Persian wares; Sultānābād ware; Kubachi
ware; Islamic metalwork; Handlist of objects not catalogued
in v.1-2. v.3 is in preparation.

SEE ALSO:  Bravmann, R. A. *Islam and tribal art in West
Africa* (I591); *Encyclopedia of Islam* (E34); Paris. Palais
des Beaux-Arts. *Sept mille ans d'art en Iran* (I547); Pope,
A. U., ed. *A survey of Persian art from prehistoric times to
the present* (I548); Smithsonian Institution. *7000 years of
Iranian art* (I549).

## CAROLINGIAN — GOTHIC

I181  Assunto, Rosario. La critica d'arte nel pensiero
        medioevale. Milano, Il Saggiatore |1961|. 461p. il.

An excellent history of art criticism in the medieval period, beginning with the final phases of Roman classicism, ending with the early Renaissance. Scholarly notes with references to early sources and later publications. "Tavola cronologica," p.429–443, also useful as a bibliography. "Index analitico," of names and subjects, p.445–[62]. Sparsely illustrated.

I182    Aubert, Marcel. High Gothic art. [By] Marcel Aubert with the collaboration of J. A. Schmoll and contributions by Hans H. Hofstätter. [Trans. by Peter George]. London, Methuen [1964]. 227p. il. (part mounted col.), maps, plans, plates. (Art of the world)
Trans. of: *Le triomphe de l'art gothique.* American ed. (N.Y., Crown) has title: *The art of the high Gothic era.*
    A good introductory survey of Gothic art between c.1220 and 1350. The emphasis is on the major arts. Illustrated with color plates and line drawings. Chronological table, good bibliography, and an index.

I183    Beckwith, John. Early medieval art: Carolingian, Ottonian, Romanesque. London, Thames & Hudson; New York, Praeger [1964]. 270p. il. (part col.), map, plans.
Also published in a paperback ed.
    A concise, authoritative survey frequently used as a college textbook. Scholarly notes. Selected bibliography with brief critical comments (p.264–65).
    Contents: (1) The revival of the imperial tradition; (2) The consolidation of the imperial tradition; (3) Diffusion and development.

I184    Białostocki, Jan. Spätmittelalter und beginnende Neuzeit. Berlin, Propyläen, 1972. 544 il. (76 col.), text figs., plans, elevations. (Propyläen Kunstgeschichte, [n.F.] Bd. 7)
An important volume of the new Propyläen Kunstgeschichte series; encompasses European art of the period from c.1370 to 1500—the high Gothic and early Renaissance. Follows the established format of the series: Introductory history by the author; corpus of illustrations; documentation of each area, by an international group of specialists, consisting of commentaries, short biographies, notes on the illustrations. Plans and elevations are included in this section. Classified bibliography, p.430–52.

I185    Braunfels, Wolfgang, ed. Karl der Grosse: Lebenswerk und Nachleben. Unter Mitwirkung von Helmut Beumann [et al. 1. Aufl. Düsseldorf, Schwann, 1965–68] 5v. il., facsims. (part col.), maps, plans, plates.
A series of essays by scholars on Charlemagne and his era. Published after the great Council of Europe exhibition. Bd. III, on Carolingian art, is by W. Braunfels and H. Schnitzler.
    Contents: Bd. 1. Persönlichkeit und Geschichte; Bd. 2. Das geistige Leben; Bd. 3. Karolingische Kunst; Bd. 4. Das Nachleben; Bd. 5. Registerband. Inhaltsverzeichnis der Bände I–IV: (I) Verzeichnis der Handschriften nach ihren Bibliotheksorten; (II) Verzeichnis der Handschriften nach den Nummern der von E. A. LOWE herausgegebenen Codices

Latini Antiquiores (v.I–v.XI); (III) Namen- und Sachregister der Bände I–IV.

I186    Collon-Gevaert, Suzanne. Art roman dans la vallée de la Meuse aux XIe, XIIe, et XIIIe siècles. Texte et commentaires du Suzanne Collon-Gevaert, Jean Lejeune et Jacques Stiennon. Avant-propos et préface par Germaine Faider-Feytmans. 5th ed. Bruxelles, Éditions Arcade, 1969. 237p. 70 plates, 13 figures, 3 maps.
Published in 1961 as *Art mosan aux XIe et XIIe siècles.*
    English ed., *A treasury of Romanesque art,* trans. by Susan Waterston, London, Phaidon, 1972.
    A comprehensive work on Mosan art of the Romanesque period, the first since 1906. Divided into three books: (I) L'art mosan et le diocese de Liège, par Jean Lejeune; (II) L'Orfèvrerie, par Suzanne Collon-Gevaert; (III) Autres techniques: la miniature, par Jacques Stiennon; les ivoires, par Jean Lejeune; la sculpture sur pierre, par Jacques Stiennon. Bibliography, p.299–307.

I187    Cologne. Schnütgen-Museum. Rhein und Maas; Kunst und Kultur 800–1400. Eine Ausstellung des S.-M. der Stadt Köln und der belgischen Ministerien für fränzosische und niederländische Kultur. Köln, 1972. 2v. (v.1, 425p.; v.2, 510p.). il., maps, col. plates.
The 2v. catalogue of a major exhibition shown at the Kunsthalle, Cologne, and the Royal Museum for Art and History, Brussels, in 1972. Also published in French and Flemish editions.
    Provides the most comprehensive study of the arts of the neighboring regions of the Rhine and Meuse rivers from 800 to 1400, with concentration on works produced in the Ottonian period when the arts of these regions were allied by common ideology. The catalogue includes church treasures (reliquaries, ivories, sculpture, seals, manuscripts, and enamels), drawn from museums and churches throughout Europe. Also includes scholarly essays by specialists on relationships and parallels between the art and aspects of material culture, the economy, poetry, music, religion, and politics of the areas considered. Catalogue entries and essays give extensive documentation and bibliographical references. Superbly illustrated with hundreds of reproductions of works.

I188    Fillitz, Hermann. Das Mittelalter I. Mit Beiträgen von Anton von Euw [et al.]. Berlin, Propyläen, 1969. 351p., 486 plates with 534 reproductions (64 col.). (Propyläen Kunstgeschichte, [n.F.] Bd. 5)
An introductory survey of art from the pre-Carolingian through the Romanesque period (p.11–111) is followed by superb plates (several in color) and the documentation of painting, sculpture, architecture, and decorative arts of the 11th and 12th centuries. This part consists of six essays and scholarly notes on the plates. Other than H. Fillitz and A. von Euw, the contributing scholars are F. Mütherich, R. Wagner-Rieger, and G. Zarnecki.
    Anhang: Verzeichnis der Siglen und Abkürzungen, p.287–91; Literaturverzeichnis, p.292–328; Synchronoptische Übersicht, p.328–37; Register, p.339–50; Quellennachweis der Abbildungen, p.350–51.

I189 Focillon, Henri. The art of the West in the Middle Ages. Ed. and introduced by Jean Bony. Trans. from the French by Donald King, with a glossary by P. Kidson. [N.Y.] Phaidon. (Distr. by New York Graphic Society, Greenwich, Conn. [1963]) 2v. plates.

This art historical survey by a great scholar and teacher should be in the personal library of every student of medieval and Renaissance art. The author's ideas on the evolution of styles and the role of artistic techniques are summarized by J. Bony in "Henri Focillon (1881–1943)" at beginning of v.1. The emphasis is on sculpture and architectural sculpture. Includes bibliographies. Well illustrated with 159 plates in v.1, 165 plates in v.2. Glossary by P. Kidson, v.1, p.297; Indexes at the end of each volume.

Contents: v.1. Romanesque; v.2. Gothic. Detailed tables of contents in each volume.

I190 Harvey, John Hooper. The Gothic world, 1100–1600; a survey of architecture and art. London, N.Y., Batsford, [1950]. xii, 160p. il., maps.

Still the most suitable textbook for Gothic architecture in Europe. "A high proportion of the illustrations is devoted to areas comparatively little known"—*Pref.* Well organized. Short bibliography, p.133–36; Notes to the text, p.138–46.

Index, p.147–60.

I191 Hinks, Roger. Carolingian art; a study of early medieval painting and sculpture in western Europe. [Ann Arbor] Univ. of Michigan Pr. [1962]. 226p. il. (Ann Arbor paperbacks, AA71)

First published by Sidgwick & Jackson, 1935.

A pioneer art historical study, inspiring and beautifully written. "Perhaps the very compartmentalization of modern art-historical studies may leave relatively intact, and still useful, a book the original reason for which was the evident need for a study of the *relations* between two phases of Western art which had hitherto been studied *in isolation*. Late antique art and early medieval art had long been examined separately in great detail: what had not been attempted was to consider the latter historical exercise in terms of the former. Such success as *Carolingian Art* may have enjoyed since its first appearance can be ascribed to the fact that no one had hitherto attempted to define exactly what was implied in the term 'antique' when studying the indebtedness of the art of the ninth century to the art, or arts, of the fourth, fifth, and sixth centuries."—*Introd.*

Contents: pt. 1, The origins of medieval art in Western Europe; pt. 2, The subject matter of Carolingian art; pt. 3, The form and structure of Carolingian art. Bibliography, p.215; Index, p.221. Additions to bibliography, p.218–19.

I192 Hubert, Jean. The Carolingian Renaissance [by] J. Hubert, J. Porcher [and] W. F. Volbach. N.Y., Braziller [1970]. xi, 380p. il. (part col.), maps (part fold.), plans. (The arts of mankind. 13)

A survey of Carolingian art by French art historians, forming part of the distinguished series ed. by André Malraux. Parts I and IV trans. by James Emmons; Part II by Stuart Gilbert; and Part III by Robert Allen.

Contents: Introduction, by Jean Hubert; pt. I, Architecture and its decoration, by Jean Hubert; pt. II, Book painting, by Jean Porcher; pt. III, Sculpture and applied art, by W. F. Volbach; Conclusion, by Jean Hubert; pt. IV, General documentation: Supplementary illustrations (p.271–91); Plans (p.293–305); List of manuscripts reproduced (p.307–08); Chronological table (p.309–19); Bibliography (p.321–39); List of illustrations (p.341–65); Glossary-index (p.367–81); Maps (p.383).

I193 Huizinga, Johan. The waning of the middle ages, a study of the forms of life, thought, and art in France and the Netherlands in the XIVth and XVth centuries. London, Arnold, 1924.

Several reprints. Paperback ed.: N.Y., Doubleday, 1956.

An inspirational, now classic, study of religious and social life and thought in the transitional period at the end of the Middle Ages. The author treats general aesthetic values, art and society, verbal and plastic expression. Essential reading for an understanding of Gothic and early Renaissance art of the North. Bibliography, p.309–18.

I194 Huth, Hans. Künstler und Werkstatt der Spätgotik. [2., erw. Aufl.]. Darmstadt, Wissenschaftliche Buchgesellschaft, 1967. 148p. [32]p. of il.

1st ed. 1925. 2d ed. has 22 additional documents.

A valuable study of the artist in the late Gothic period. Based on documents and artistic sources. Well illustrated with pictures of artists at work, mostly details from manuscript illuminations and larger works of sculpture.

Contents: Künstler und Zunft; Künstler und Recht; Der Werkstattbetrieb; Arbeitsteilung. Anmerkungen (Notes), p.87–102; Anhang; Quellennachweis der Verträge, p.105–07; Vertrags-Urkunden, p.108–39 (24 documents); Verzeichnis der Abbildungen, p.140–41; Personen- und Sachregister, p.142–48.

I195 Jantzen, Hans. Ottonische Kunst. Mit 182 Abbildungen und 31 Zeichnungen. [München] Münchner Verlag [1947]. 180p. il., plates.

Paperback ed.: Hamburg, Rowohlt [1959].

An authoritative, well-illustrated treatment of Ottonian art (mid-10th century to mid-11th century). Bibliographical references included in "Anmerkungen," p.163–71. Place index, p.176–78.

I196 Kitzinger, Ernst. Early medieval art in the British Museum. 2d ed. London, Trustees of the British Museum, 1955. ix, 114p. il. (Repr.: London, British Museum, 1963.)

First published in 1940. Paperback ed.: Bloomington, Indiana Univ. Pr., 1964.

A small, well-written art historical survey of early medieval art based on the outstanding collection of art objects in the British Museum. Has often been used as an introduction to the field.

Contents: (I) Late antique and early Christian periods: (II) Carolingian art; (III) 10th and 11th centuries (Byzantium, Winchester, Ottonian Germany, Italy and Spain); (IV) 12th century Romanesque art; The plates (1–48); Description of the plates.

I197   Kubach, Hans Erich, and Bloch, Peter. Früh- und Hochromanik. Baden-Baden, Holle [1964]. 292p. il. (part col.), maps (Kunst der Welt. Die Kulturen des Abendlandes)
French trans.: Paris, Albin Michel, 1966.

A survey of Romanesque art in the West, written by two specialists who present recent thinking on the major art historical problems. Should be translated into English. Like other volumes in the series, it includes a chronological table, map, bibliography, numerous illustrations and plans. No footnotes.

I198   Lasko, Peter. Ars sacra, 800-1200. Harmondsworth; Baltimore, Penguin [1972]. xxix, 338p. il., maps (Pelican history of art, Z36)

A scholarly study of the arts of goldsmithing, metalworking, and ivory carving in the Carolingian, Ottonian, and Romanesque periods. Well illustrated. Bibliographical footnotes. Selected bibliography, p.315-17. Index, p.321-38.

I199   Lejeune, Rita, and Stiennon, Jacques. The legend of Roland in the Middle Ages. [N.Y.] Phaidon. [Distr. by Praeger Publishers, 1971] 2v. il., map, col. plates.
Trans. of original French ed. of 1966.

A definitive scholarly study of representations of the legend of Roland in sculpture, mosaics, metalwork, stained glass, painting, and tapestries in the Romanesque and Gothic periods.

Bibliographical references in "Notes" at end of each chapter.

I200   Mâle, Émile. Religious art from the twelfth to the eighteenth century. [N.Y.] Pantheon; London, Routledge & Paul [1949]. 208p. 48 plates.
Paperback ed.: N.Y., Noonday.

Originally published in a French ed., Paris, Colin, 1945; 2d ed. 1946.

A collection of excerpts from the author's four standard works (I222, I283, I284, I285). Selected by the author.

I201   New York. Metropolitan Museum of Art. The Year 1200. N.Y., Metropolitan Museum of Art. (Distr. by The New York Graphic Society [1970]). 2v. il. (part col.), facsims., plans. (The Cloisters studies in medieval art, 1-2)

Contents: v.1, A centennial exhibition at the Metropolitan Museum of Art, Feb. 12 through May 10, 1970; catalogue, written and ed. by K. Hoffmann; v.2, A background survey, published in conjunction with the centennial exhibition at the Metropolitan Museum of Art. Comp. and ed. by F. Deuchler. Bibliography, v.1, p.337-54.

———. ———. The Year 1200: a symposium. Texts by François Avril et al. Introd. by Jeffrey Hoffeld. N.Y., Metropolitan Museum of Art, [1975]. 594p. il.

The exhibition catalogue, background survey, and papers presented at the later symposium represent a significant contribution to scholarship in the field of medieval art and civilization.

I202   Salin, Édouard. La civilisation mérovingienne d'après les sépultures, les textes et le laboratoire, Paris, Picard, 1949-59. 4v. il., maps.

This definitive work on Merovingian civilization is based on literary and archaeological remains. Indispensable for research in Merovingian and Romanesque art. Illustrated with line drawings. Each volume has a table of contents and a list of illustrations. Bibliography and detailed general index to the whole at end of v.4.

I203   Schiller, R. W. A survey of medieval model books. Haarlem, Bohn., 1963. 215p. il.

A significant, pioneering study. Important aspects of the model book are discussed in the introduction, including an attempted definition, the remaining works, techniques and layout, content, sources (documentary and works of art), etc. A catalogue lists and analyzes in detail 31 extant books or parts from 1st century B.C. Egypt through the mid-15th century.

Selected bibliography, p.40-41.

I204   Schnitzler, Hermann. Rheinische Schatzkammer. Düsseldorf, Schwann [1957-59]. 2v. il. (part col.)

Two excellent plate volumes for a proposed text on Rhenish church treasures not published to date. Although published as plate volumes, they are of sufficient completeness and interest in themselves to justify consideration as independent studies.

Contents: v.[1] Vorromanische Schatzkammer. Tafelband; v.[2] De Romanik. Tafelband.

v.1 contains an extensive catalogue of 52 pieces of various types (manuscripts, book covers, reliquaries, crowns, crosses, chalices, altar frontals, chancels) arranged by Rhenish center and dating from Early Christian times through late Ottonian. v.2 contains a catalogue of 42 pieces of the Romanesque period. Entries for each object include detailed descriptions and analyses, with bibliography; each object is shown in several plates. The introductions in both volumes provide outlines of their respective periods and relate the objects in the catalogues to a broader historical perspective.

I205   Schramm, Percy Ernst, and Mütherich, Florentine. Denkmäl der deutschen Könige und Kaiser; ein Beitrag zur Herrschergeschichte von Karl dem Grossen bis Friedrich II, 768-1250. München, Prestel [1962]. 484p. 215 plates. (Veröffentlichen des Zentralinstituts für Kunstgeschichte in München, 2)

An important publication dealing with the art possessions of the German kings and emperors from Charlemagne to Frederick II. Introductory essay by Percy Schramm, p.11-112. The scholarly catalogue by Florentine Mütherich, p.114-98, has 215 entries, each with a description and full documentation. Many excellent illustrations. Bibliographical footnotes.

I206   Simson, Otto Georg von. Das Mittelalter II: das Hohe Mittelalter. Mit Beiträgen von Thomas S. R. Boase et al. Berlin, Propyläen, 1972. 475p. il. plates (part col.) (Propyläen Kunstgeschichte, [n.F.] Bd. 6)

Follows the established format of the new Propyläen Kunstgeschichte series. Covers the Gothic period. Magnificent plates with commentary by specialists. Full bibliography.

I207 Swarzenski, Hanns. Monuments of Romanesque art: the art of church treasures in north-western Europe. 2d ed. Chicago, Univ. of Chicago Pr. [1967]. 102p. 238 plates.
1st ed. 1954.

A collection of excellent illustrations of important monuments in ivory, gold, bronze, enamel, and manuscript painting in northwestern Europe from 800–1200. Includes a short introduction and a catalogue of the plates.

Bibliographies included in "Notes on the plates," p.37–85. Indexes: Iconography, p.86–91; Names, p.92–93; Places of origin, p.94–96; Present locations, p.97–100; Materials and techniques, p.101.

I208 Timmers, J. J. M. A handbook of Romanesque art. [trans. from the Dutch by Marian Powell]. London, Nelson, 1969. 240p. il., maps, plans.
Originally published as *Atlas van het Romans*. Amsterdam, Elsevier, 1965.

A brief, well-organized handbook for the library reference shelf and for the beginning student of art history. "Most emphasis in this book has been given to architecture, the mother of all arts. Then come sculpture and painting, subjects closely related to architecture; and finally the applied arts" —*Pref.* No footnotes. Bibliography, p.234–35.

I209 Zarnecki, George. Art of the medieval world: Architecture, sculpture, painting, the sacred arts. N.Y., Abrams; Englewood Cliffs, N.J., Prentice-Hall [1975]. 476p. il. (part col.)
An introductory survey of medieval art and architecture from the age of Constantine to the 14th century. Very well illustrated.

Chronological chart, p.449. Glossary, p.[456]–61. Classified bibliography, p.[462]–67.

I210 Zentralinstitut für Kunstgeschichte, Munich. Mittelalterliche Schatzverzeichnisse. Hrsg. vom Zentralinstitut für Kunstgeschichte in Zusammenarbeit mit Bernhard Bischoff. München, Prestel [1967]. v.1– . (Veröffentlichungen des Zentralinstituts für Kunstgeschichte in München. 4)
A collection of all known inventories of sacred and secular art treasures in the German Empire. Contents: v.1, Von der Zeit Karls des Grossen bis zur Mitte des 13. Jahrhunderts: Vorwort von Ludwig H. Heydenreich; Einführung von Bernhard Bischoff; Schatzverzeichnisse p.13–118 (arranged alphabetically by location, with sources and bibliography for each); Zeugnisse für die Entstehung, Verwendung und Auflösung von Schätzen, p.119–53; Lateinisch-Althochdeutsches Glossar, p.154–56; Sachregister und Glossar, p.157–202; Register der Personennamen und Ortsnamen; Register der Heiligen.

## RENAISSANCE — BAROQUE

I211 Benesch, Otto. The art of the Renaissance in northern Europe; its relation to the contemporary spiritual and intellectual movements. Cambridge, Harvard Univ. Pr., 1945. xiv, 174p. il., plates, ports., facsims., diagrs. (Repr. of 1947 ed.: Hamden, Conn., Shoe String, 1964.)
A series of brilliant art-historical essays on Northern art as it relates to the intellectual and religious climate of the 16th century. Focuses on major painters.

Bibliographical references in "Notes," p.[145]–61.

I212 Chastel, André. The crisis of the Renaissance, 1520–1600. Trans. by Peter Price. Geneva, Skira [1968]. 217p. il. (part col.)
A good introduction for the beginning student and general reader to the Mannerist style of the 16th century. The historical and cultural backgrounds help explain the development of the style. The emphasis is on painting and sculpture, with attention given to architecture, pageantry, and decoration. Excellent illustrations, with some seldom-reproduced works. No bibliography.

Contents: (I) Image and speech; (II) Unity of the divided west; (III) Naturalism and symbolism; (IV) Pageantry, court art and the marvelous.

I213 Gilbert, Creighton. History of Renaissance art: painting, sculpture, architecture throughout Europe. N.Y., Abrams [1973]. 460p. il. (part col.)
A general survey of the art of the Renaissance in Europe, intended as a textbook for beginning students. Each section has supplementary notes supporting the text which covers Italy and the North in some detail. Many excellent illustrations are scattered throughout the chapters. Ample bibliography, p.423–36, arranged by subject and artist as covered in the text; chronological chart of artists and architects.

Contents: pt. 1, The early Renaissance in Italy; pt. 2, The high Renaissance in Italy; pt. 3, The Renaissance outside Italy. Bibliography, p.423; Chronological chart, p.437. Index, p.445.

I214 Griseri, Andreina. Le metamorfosi del barocco. [Torino] Einaudi [1967]. xxiii, 383p. il., plates. (Biblioteca di storia dell'arte, 8)
An art historical survey of the Baroque style, its metamorphosis and variations. "An unusual and fascinating work, containing many challenging ideas; concentration on the Piedmont."—R. Wittkower (I359). Considerable attention is given to city planning. Also discusses the new decoration. Extensive notes with a critical bibliography at the end of each chapter. 329 illustrations.

I215 Hauser, Arnold. Mannerism, the crisis of the Renaissance and the origin of modern art. Trans. by the author and Eric Mosbacher. London, Routledge & Paul. [1965]. 2v. plates.
A controversial, stimulating study of Mannerism and its psychological relationship to the arts of the 20th century. Written by the author of *The social history of art* (I12).

Bibliographic footnotes, p.397–406; index of subjects, p.409–45; of names, p.419–25. v.2 contains the plates.

I216  Hempel, Eberhard. Baroque art and architecture in Central Europe: Germany, Austria, Switzerland, Hungary, Czechoslovakia, Poland. Painting and sculpture: seventeenth and eighteenth centuries; Architecture: sixteenth to eighteenth centuries. [Trans. from the German by Elisabeth Hempel and Marguerite Kay]. Harmondsworth; Baltimore, Penguin, 1965. xxiii, 370p. il., maps, plans, 200 plates. (Pelican history of art, Z22)

This unique history, written by a well-known authority on Baroque architecture, fulfills its purpose of giving the English-speaking world an understanding and appreciation of a flourishing period of art in central Europe. Treats the historical background, the influence of Italian precedents, the homogeneity, and the diversity of Baroque painting, sculpture, and architecture in the various regions. Bibliographical notes. Classified bibliography, p.335–43.

Contents: pt. 1, Introduction (Characteristics and antecedents, Special conditions); pt. 2, The heroic age 1600–1639; pt. 3, The years of recovery after the Thirty Years War 1640–82; pt. 4, The Baroque period 1683–1739 (subdivided by region); pt. 5, Rococo and its end 1740–80 (subdivided by region).

I217  Hubala, Erich, ed. Die Kunst des 17. Jahrhunderts. Mit Beiträgen von Per Bjurström [et al.]. Berlin, Propyläen, 1970. 387p. il. with 533 plates, 44 drawings, map. (Propyläen Kunstgeschichte, [n.F.] Bd. 9)

A broad, scholarly survey of the art and architecture of the 17th century in Europe. Covers Italian, Dutch, French, and central European works, as well as the great masters of the era, in a general introductory section. Lavishly illustrated. The 2d section, written by various experts, concentrates on such diverse subjects as French painters, Italian sculpture and architecture, Polish art, and the minor arts. Extensive bibliography, p.347–58. The synchronological overview of the 17th century gives a cross section of humanistic endeavors of the period.

I218  Kauffmann, Georg. Die Kunst des 16. Jahrhunderts. Mit Beiträgen von Josef Benzing [et al.]. Berlin, Propyläen, 1970. 468p. il. (Propyläen Kunstgeschichte, [n.F.] Bd. 8)

The most comprehensive and up-to-date reference work on 16th-century art. Follows the established format of the new Propyläen Kunstgeschichte series. The introductory survey (150p.) is followed by a corpus of superb illustrations (408 black-and-white illustrations, 68 color), then "Dokumentation," general commentaries, bibliographical references, and descriptions of the plates. Includes brief biographies of artists. Divided into sections: painting, prints, book illustration, sculpture, decorative arts, and architecture. Illustrated with plans, sections, line drawings, etc. Excellent bibliography; "Synchronoptic" table, p.399–441.

Index of names and subjects.

I219  Keller, Harald. Die Kunst des 18. Jahrhunderts. Mit Beiträgen von Jeannine Baticle [et al.]. Berlin,

Propyläen, 1971. 479p. il., plans. (Propyläen Kunstgeschichte, [n.F.] Bd. 10)

An indispensable reference work for students of 18th-century Western art. Includes painting, sculpture, graphic arts, architecture, landscape gardening, and decorative arts. Follows the established scheme of the new Propyläen Kunstgeschichte series: introductory survey by H. Keller; corpus of splendid illustrations (438 black-and-white, 68 color); "Dokumentation," consisting of essays and catalogue entries for the illustrations written by recognized specialists. With biographies of artists. Illustrated with plans and drawings. Full bibliography, p.446–57; "Synchronoptic" table, p.458–67; index of names and subjects, p.469–79.

I220  Levey, Michael. Early Renaissance. Harmondsworth, Penguin [1967]. 224p. 112 il. (Style and civilization)

Available in paperback: Baltimore, Penguin, 1968.

A series of essays on the Renaissance in Italy and the North during the 15th century. Brilliant, original, and well written. Directed to the student, the historian, and the general reader. Arranged by topic, with detailed analyses of a limited number of carefully chosen works.

Contents: (1) What is the Renaissance?; (2) "Men of renown"; (3) For art's sake; (4) Humanism and humanity; (5) The uses of antiquity; (6) New earth and new heaven. In "Catalogue of illustrations" each entry includes size, date, and bibliographical references. "Books for further reading" is a brief, critical bibliography.

I221  _____. High Renaissance. Harmondsworth, Penguin, 1975. 320p. il. (Style and civilization)

A broad, scholarly survey of the High Renaissance style; concentrates on the painting and sculpture of Italy and the North. Excellent black-and-white illustrations scattered through the text, including many examples not usually reproduced.

Contents: (1) The "highest province" and the High Renaissance; (2) "Mine eye hath play'd the painter"; (3) Enduring monuments; (4) Natural magic; (5) "A goodly paterne"; (6) "In scorn of nature, art. . . . " Bibliography, p.307–09.

I222  Mâle, Émile. L'art religieux de la fin du XVIe siècle, du XVIIe siècle et du XVIIIe siècle; étude sur l'iconographie après le Concile de Trente. Italie, France, Espagne, Flandres. 2d éd., rev. et corr., illustrée de 294 gravures. Paris, Colin, 1951. 532p. 294 il.

1st ed. published as L'art religieux après le Concile de Trente, 1932.

A fundamental history of religious iconography in the Catholic world during the Counter Reformation and its aftermath in the 17th and 18th centuries. Topical arrangement. Bibliographic footnotes. "Index des oeuvres d'art citées dans cet ouvrage," p.513–26; "Table générale des matières," p.527–32.

An English translation, Religious art after the Council of Trent, by Marthiel Mathews, is in preparation as one of four translations of Mâle's works in the series Studies in religious iconography, ed. by Harry Bober, Princeton Univ. Pr. This edition will include revised notes, taking into

account recent scholarship, new illustrations, and an amplified index.

I223    Osten, Gert von der, and Vey, Horst. Painting and sculpture in Germany and the Netherlands, 1500 to 1600. Trans. from the German by Mary Hottinger. Harmondsworth; Baltimore, Penguin, 1969. (Pelican history of art, Z31)

A broad survey of the painting and sculpture of the 16th century, covering Germany, the Netherlands, Belgium, the Rhine region of France and Switzerland, and the western parts of Austria. Bibliographical references in notes. "List of principal abbreviations and bibliography," p.375-78, does not meet the standards of the other bibliographies in the series.

Contents: pt. 1, The age of Maximilian I: Late Gothic, classicism, and proto-Baroque; pt. 2, The early years of Charles V: Late Gothic and post-classic Mannerism; pt. 3, The end of the age of Charles V and Ferdinand I and the early years of Philip II: Academic Mannerism; pt. 4, The age of Philip II, Maximilian II, and Rudolf II: Later Mannerism.

I224    Panofsky, Erwin. Renaissance and renascences in Western Art. Stockholm, Almqvist & Wiksell [1960]. 2v. xix, 242p. il., atlas (plates) (The Gottesman Lectures. Uppsala University, 7)

Paperback ed.: N.Y., Harper, 1972.

Essays on the history of revivals of classical art forms and the spirit of classicism from medieval "renascences" to the Italian Renaissance of the 14th and 15th centuries. The problems of art are treated within the broader context of cultural and intellectual history. Footnotes. Bibliography, v.1, p.211-30.

I225    Pope-Hennessy, John. The portrait in the Renaissance. N.Y., Bollingen Foundation. (Distr. by Pantheon Books [1966]). xxxii, 348p. il. (Mellon lectures in the fine arts, no. 12)

A good critical treatment of the development of the Renaissance portrait, based on six lectures. Deals with courtly and individual portraiture and the attempts to penetrate personality, as well as the influence of humanistic thought. Good illustrations, extensive bibliographical notes, index.

Contents: (1) The cult of personality, (2) Humanism and the portrait, (3) The motions of the mind, (4) The court portrait, (5) Image and emblem, (6) Donor and participant.

I226    Salis, Arnold von. Antike und Renaissance; über Nachleben und Weiterwirken der Alten in der neueren Kunst. Mit 64 Tafeln und 30 Abbildungen in Text. Erlenbach-Zürich, Reutsch [1947]. 280p. il. (incl. plans).

An important study of the revival and survival of ancient themes and motifs in the Renaissance. Written by an authority on ancient art. The examples are mostly from Rome. Bibliographical references in notes.

Contents: (I) Neros Goldenes Haus und die Malerei der Renaissance; (II) Grablegung; (III) Reiterschlacht; (IV) Die Leiden eines Knaben; (V) Statuengruppen; (VI) Torso; (VII) Die Villa Farnesina und ihre Vorgängerin im Altertum.

I227    Seznec, Jean. The survival of the pagan gods; the mythological tradition and its place in Renaissance humanism and art. Trans. from the French by Barbara F. Sessions. N.Y., Pantheon, 1953. xvi, 376p. il. (Bollingen series, no. 38)

Originally published as *La survivance des dieux antiques.*

A classic iconographical study. The general argument is that "the ancient gods survived during the Middle Ages by virtue of their origin and nature propounded by antiquity itself."—*Introd.* Good bibliography, sparsely illustrated.

Contents: Bk. I., pt. 1, The concepts (divided into the historical, physical, moral, and encyclopedic traditions); pt. 2, The forms (the metamorphoses and the reintegration of the gods); Bk. II, pt. 1, The science of mythology in the 16th century. Theories regarding the use of mythology; pt. 2, The influence of manuals; Bibliography, p.327-45: (1) Sources (2) Studies; Scholarly notes.

I228    Shearman, John K. G. Mannerism. Harmondsworth, Penguin [1967]. 215p. 102 il., plan. (Style and civilization)

An historical interpretation of Mannerism; the best recent study of the style, especially recommended for students. Organized by topic: (1) The historical reality; (2) The arrival of Mannerism in the visual arts; (3) Characteristic forms; (4) A 'more cultured age' and its ideals; (5) Mannerism in the history of art. "Catalog of illustrations" with documentation. Short critical bibliography.

I229    Starobinski, Jean. The invention of liberty, 1700-1789. [Trans. from the French by Bernard C. Swift. Geneva] Skira [1964]. 222p. il. (part col.)

A stimulating work on various aspects and themes of 18th-century art, written by a cultural historian.

Contents: (I) Man's universe in the 18th century; (II) Philosophy and mythology of pleasure; (III) Anxiety and festivity; (IV) The imitation of nature; (V) Nostalgia and utopianism. Beautifully illustrated.

Bibliography, p.213-14. Index of names.

I230    Tapié, Victor Lucien. The age of grandeur: Baroque art and architecture. Trans. from the French by A. Ross Williamson. 2d ed., with new bibliography. N.Y., Praeger [1966]. 294p. plates.

Trans. of: *Baroque et classicisme.* 1st English ed.: N.Y., Grove [1960]. Paperback of 1st ed.: N.Y., Praeger [1961].

Not a good translation.

An historical survey of monumental Baroque art and architecture from its origins in the late 16th century to the late Baroque styles of the 18th century. Divided into 3 books, 12 chapters. Bk. I is on art in Rome; Bk. II deals with art in France; Bk. III treats the Baroque in England, Germany and Austria, Poland and Russia, and the European colonies. The essay on French art is very thorough. Bibliographical notes, p.[259]-84; Bibliography, p.[285]-88.

I231    Vienna. Kunsthistorisches Museum. Europäische Kunst um 1400. Achte Ausstellung unter den Auspizien des Europarates. Wien [1962]. 536p. 160 plates.

The catalogue of a major exhibition of art in all its various forms (excluding architecture) produced in Europe, centering on the International Style of around 1400. Introductory essays and catalogue entries are written by foremost scholars.

Contents: Die Zeitenwende um das Jahr 1400, by A. Lhotsky; Die geistesgeschichtliche Situation der Zeit um 1400, by H. Schulte-Nordholt; Die Gotik der Zeit um 1400 als gesamteuropäische Kunstsprache, by O. Pächt; Die Malerei um 1400, by Ch. Sterling; Die Buchmalerei um 1400, by J. Porcher; Die Glasmalerei um 1400, by L. Grodecki; Die Zeichnung, by O. Benesch; Die Einblattholzschnitte, by E. Mitsch; Plastik, by C. Th. Müller; Die Goldschmiedekunst um 1400, by P. Verlet; Textilkunst um 1400, by D. King; Kriegskleid und Waffe um 1400, by B. Thomas and O. Gamber; Die Medaille um 1400, by E. Holzmair; Die Münzkunst, by B. Koch; Die Kunst im Siegel, by B. Koch. Register der Künstnamen; Verzeichnis der Handschriften nach Aufbewahrungsorten; Verzeichnis der Bildtafeln.

I232    Wind, Edgar. Pagan mysteries in the Renaissance. 2d (enl.) ed. London, Faber; N.Y., Barnes and Noble, 1968. xiii, 345p. 100 il. 64 plates.
1st ed. 1958.

A scholarly study of meaning in certain Renaissance works of art whose imagery and content were derived from ancient literary sources. Well documented. Bibliography, p.285-315.

I233    Wölfflin, Heinrich. Principles of art history; the problem of the development of style in later art. Trans. from the 7th German ed. by M. D. Hottinger. London, Bell, 1932. 237p. incl. il. plates.
1st German ed. 1915, as *Kunstgeschichtlichen Grundbegriffe*. Paperback ed. is available from Dover, N.Y., 1951.

A classic art historical study, important primarily for the author's systematic differentiation between the Renaissance and Baroque styles.

Contents: (1) Linear and painterly; (2) Plane and recession; (3) Closed and open form; (4) Multiplicity and unity; (5) Clearness and unclearness.

SEE ALSO:  Białostocki, J. *Spätmittelalter und beginnende Neuzeit* (I184); Pigler, A. *Barockthemen; eine Auswahl von Verzeichnissen zur Ikonographie des 17. und 18. Jahrhunderts* (F15).

# NEOCLASSICAL — MODERN

I234    The age of Neo-classicism: [catalogue of] the fourteenth exhibition of the Council of Europe [held at] the Royal Academy and the Victoria & Albert Museum, London, 9 September-19 November, 1972. London, Arts Council of Great Britain, 1972. [2], civ, xvi, 1037, 160, [2]p. 160 il., 16 col. plates.
The catalogue of a monumental exhibition on neoclassicism in Europe, Russia, and America. Indispensable for study in the field. Includes 1,912 works in all media and categories—

paintings, sculpture, drawings and prints, books and manuscripts, book bindings, medals, miniatures, models, architecture, town planning, ceramics, wallpapers, furniture and clocks, glass, metalwork, textiles. Detailed entries for all works represented, with biographies of artists and bibliographical references.

The catalogue proper is preceded by a series of scholarly essays: Pope-Hennessy, John. Foreword; Honour, Hugh. Neo-classicism; Ettlinger, L. D. Winckelmann; Einem, Herbert von. Goethe and the contemporary fine arts; Pietrangeli, Carlo. Archaeological excavations in Italy 1750-1850; Kalnein, Wend von. Architecture in the age of Neo-classicism; Laclotte, Michel. Louis David, reform and revolution; Herbert, Robert. Neo-classicism in the French Revolution; Hubert, Gerard. Early neo-classical sculpture in France and Italy; Helsted, Dyveke. Sergel and Thorvaldsen; Praz, Mario. The meaning and diffusion of the Empire style; Monteverdi, Mario. Themes and aspects of neo-classical stage design.

I235    Arnason, H. H. History of modern art: painting, sculpture, architecture. Newly rev. and enl. ed. N.Y., Abrams, 1977. 740p. il. (part col.)
1st ed., 1968.

An authoritative history of modern art and architecture in Europe and America from their roots in the 19th century, through the major movements of the 20th century, to the various directions of the 1970s. Extremely well illustrated.

Classified bibliography, p.709-22, includes general works and a section on individual artists and architects.

I236    Bann, Stephen, comp. The tradition of Constructivism. Edited with an introd. by Stephen Bann. N.Y., Viking; London, Thames & Hudson [1974]. xlix, 334p. il. (Documents of 20th-century art)
Also published in paperback ed.

An anthology of English translations of writings, manifestos, essays, and statements by the major artists and critics of the Constructivist movement. Each section is preceded by an introductory essay.

Contents: Introduction: Constructivism and constructive art in the 20th century; (1) Constructivism in Russia: 1920-23; (2) Toward international Constructivism: 1921-22; (3) Constructivism and the little magazines: 1923-24; (4) Extension of constructivist principles: 1923-28; (5) Retrospect, theory, and prognosis: 1928-32; (6) The constructive idea in Europe: 1930-42; (7) The constructive idea in the postwar world: 1923-24. Brief chronology, xv-xvii; Notes, p.297-301, include bibliographical references. Excellent bibliography, p.303-34, comp. by Bernard Karpel, partially annotated.

I237    Barr, Alfred H. Cubism and abstract art. N.Y., The Museum of Modern Art [1936]. 249, (1)p. incl. il., plates.
Published originally as the catalogue of an exhibition at the Museum of Modern Art in 1936.

Reprints: N.Y., published for the Museum of Modern Art by Arno Pr., 1966; paperback ed., the Museum of Modern Art, 1974.

"Although only a survey it is still one of the soundest comprehensive studies of the movement."—Chipp, I238, p.640. Bibliography, p.234-49.

I238   Chipp, Herschel Browning, comp. Theories of modern art; a source book by artists and critics. [With] contributions by Peter Selz and Joshua C. Taylor. Berkeley, Univ. of California Pr., 1968. xv, 664p. il. (California studies in the history of art, 11)
Paperback ed.: Berkeley, Univ. of California Pr.

A collection of excerpts and translations of "the fundamental theoretical documents of twentieth-century art."— *Introd.* Omits architectural theory. Some sections are preceded by critical introductory essays. In general the texts are arranged chronologically.

Contents: (1) Postimpressionism; (2) Symbolism and other subjectivist tendencies; (3) Fauvism and Expressionism; (4) Cubism; (5) Futurism; (6) Neo-plasticism and Constructivism; (7) Dada, Surrealism, and *Scuola metafisica;* (8) Art and politics; (9) Contemporary art.

Excellent bibliography, arranged by chapter, partially annotated.

I239   Documents of modern art. N.Y., Wittenborn, 1944-61. il., plates (part col.)
Editor: Robert Motherwell. A series of 14 key texts and anthologies of writings on important aspects of modern art.

Contents: (1) Apollinaire, G. *The Cubist painters,* 2d rev. ed. (1962); (2) Mondrian, P. *Plastic art and pure plastic art* (1945); (3) Moholy-Nagy, L. *The new vision,* 4th ed. rev. (1949), and *Abstract of an artist* (1961); (4) Sullivan, L. H. *Kindergarten chats* (1947); (5) Kandinsky, W. *Concerning the spiritual in art* (1947); (6) Arp, J. *On my way* (1948); (7) Ernst, M. *Beyond painting* (1948); (8) Motherwell, R. *The Dada painters and poets: an anthology* (1951) [rev. ed. in preparation in series Documents of 20th-century art]; (9) Kahnweiler, D. H. *The rise of Cubism* (1949); (10) Raymond, M. *From Baudelaire to Surrealism* (1949); (11) Duthuit, G. *The Fauvist painters* (1950); (12) Giedion-Welcker, C. *Contemporary sculpture,* rev. ed. (1961) (K102); (13) Karpel, B. *Arts of the 20th century,* never published; (14) Duchamp, M. *The Bride stripped bare by her bachelors, even,* (1960); (15) Klee, P. *The thinking eye* (1961).

I240   The documents of 20th-century art. N.Y., Viking; London, Thames & Hudson, 1971- . il.
General editor: Robert Motherwell. Documentary editor: Bernard Karpel. Managing editor: Arthur A. Cohen.

A series of important texts on 20th-century art, written by artists and critics and newly edited by authorities. All volumes include bibliographies.

Volumes published and announced for publication: (1) Cabanne, P. *Dialogues with Marcel Duchamp* (1971); (2) Kahnweiler, D. H. *My galleries and painters* (1971); Breunig, L. C., ed. *Apollinaire on art: essays and reviews 1902-1918* (1972); (3) James, P., ed. *Henry Moore on sculpture* (1971); (4) Jean, M., ed. *Arp on Arp: poems, essays, memories* (1972); (5) Ashton, D. *Picasso on art: a selection of views* (1972); (6) Lipchitz, J. *My life in sculpture* (1972); (7)

Kandinsky, W., and Marc, F. *The Blaue Reiter Almanac* (1974); (8) Leger, F. *Functions of painting,* ed. by E. F. Fry (1973); (9) Apollonio, U., ed. *Futurist manifestoes* (1973); (10) Bann, S., ed. *The tradition of Constructivism* (1974); (11) Ball, H. *Flight out of time: a Dada diary,* ed. by J. Elderfield (1974); (12) Huelsenbeck, R. *Memoirs of a Dada drummer* (1974); (13) Reinhardt, A. *Art as art: the selected writings of Ad Reinhardt,* ed. by B. Rose (1975); (14) Bowlt, J. E., ed. *Russian art of the avant-garde* (1976); (15) Jean, M., ed. *The autobiography of Surrealism* (1978); (16) Mondrian, P. *The new art/the new life: the complete writings of Piet Mondrian,* ed. by H. Holtzman; (17) Motherwell, R., and Karpel, B., eds. *The Dada painters and poets* (rev. ed.); (18) Delaunay, R., and Delaunay, S. *The new art of color: the writings of Robert and Sonia Delaunay,* ed. by A. A. Cohen (1978); (19) Kandinsky, W. *The complete writings of Wassily Kandinsky,* ed. by K. C. Lindsay and P. Vergo; (20) Motherwell, R. *The writings of Robert Motherwell,* ed. by A. A. Cohen (1978); (21) Karpel, B., and Ross, C., eds. *The annals of Abstract Expressionism.*

I241   Einstein, Carl. Die Kunst des 20. Jahrhunderts. Berlin, Propyläen-Verlag, 1926. 576p. plates (part col.) (Propyläen-Kunstgeschichte. Bd. 16)
An initial attempt at surveying the advanced art of the early 20th century. Although now largely out-of-date, the work is of interest because of the author's original insights and early critical perspective.

Contents: Beginn; Der Kubismus; Der Futurismus; Die Deutschen; Russen; Zur Plastik; Abbildungen.

I242   Eitner, Lorenz. Neoclassicism and Romanticism, 1750-1850; sources and documents. Englewood Cliffs, N.J., Prentice-Hall [1970]. 2v. il. (Sources and documents in the history of art series)
A selection of documents and literary sources which "attempts to give a picture of the world of art in the period which began with Winckelmann and ended with Baudelaire."—*Pref. to v.1.* Contents: v.1, Enlightenment/Revolution; v.2, Restoration/Twilight of humanism. Includes bibliographical footnotes.

I243   Fry, Edward F. Cubism. [Translations from French and German by Jonathan Griffin]. N.Y., McGraw-Hill; London, Thames & Hudson [1966]. 200p. il.
Reissued: N.Y., Oxford Univ. Pr., 1978.

An anthology of 48 key documentary texts, in translation, on the Cubist movement (devoted primarily to painting). Texts arranged chronologically. Informative commentaries accompany the texts. The introductory essay surveys the history of Cubism and traces its stylistic reverberations in 20th-century art.

Bibliography, p.176-87, includes a critical survey of writings on Cubism, a general bibliography, a list of Cubist exhibitions, and important early auction sales of Cubist works. Notes, p.192-97, include numerous references.

I244   Golding, John. Cubism: a history and an analysis, 1907-1914. 2d ed. London, Faber and Faber; Boston, Boston Book and Art Shop, 1968. 208p. il., col. plates, il.

1st ed. 1959. Available in paperback.

The indispensable work on Cubism, covering the period from its creation by Picasso and Braque to the outbreak of war and dissolution of the movement. The detailed documentation is reinforced by the author's penetrating visual analyses. Devoted almost exclusively to Cubist painting.

Contents: (1) The history and chronology of Cubism; (2) Picasso and Braque, 1907-12; (3) Picasso, Braque and Gris, 1912-14; (4) The influence of Cubism in France, 1910-14. Bibliographical references in footnotes. Classified bibliography, p.118-200 (unpublished material; newspapers and periodicals; catalogues; general).

I245   Goldwater, Robert John. Primitivism in modern art. Rev. ed. N.Y., Vintage Books [1967]. xxv, 289p. il.
1st ed. published in 1938 as *Primitivism in modern painting.*

A pioneering, influential work in which the author's aims are to establish precisely the early contacts of late 19th- and early 20th-century artists with primitive works; to define the influences of primitive art on modern art; and to describe the nature of the influences.

Contents: (1) Primitive art in Europe; (2) The preparation; (3) Romantic primitivism; (4) Emotional primitivism; (5) Intellectual primitivism; (6) The primitivism of the subconscious; (7) Primitivism in modern sculpture; (8) A definition of primitivism. Numerous references in notes at the ends of chapters. Appendix: Summary chronology of ethnographical museums and exhibitions.

I246   Great Britain. Arts Council. The Romantic movement; fifth exhibition to celebrate the tenth anniversary of the Council of Europe, 10 July to 27 September 1959. The Tate Gallery and the Arts Council Gallery, London, 1959. 540p. plates (98 figs.), plan.
An indispensable catalogue of 988 works of the Romantic period (c.1780-1848). Includes introductory essays by Kenneth Clark, Michel Florisoone, Geoffrey Grigson, Ludwig Grote, E. R. Meijer, Josèphe Jacquiot, David Green. Catalogue entries include biographical sketches of artists, complete technical descriptions, provenances, and bibliographical references.

Contents: Pt. 1, The inspiration of the old masters; Paintings; Drawings and prints; Sculpture; The art of the medal in France; Models, toys, and 'novelties'. Pt. 2, Drawings and prints; Sculpture; Manuscripts, British and French Romantic writers; Books; Bookbindings; Addenda. Indexes of artists, authors, lenders.

I247   Hamilton, George Heard. Painting and sculpture in Europe, 1880-1940. [Baltimore] Penguin [1967]. xxiv, 443p. 193 plates (The Pelican history of art, Z29)
Paperback ed.: Harmondsworth; Baltimore, Penguin, rev. and corr., 1972. (The Pelican history of art, PZ29)

A masterful study of the major movements and artists of European painting and sculpture from 1880 to the beginning of World War II. Especially commendable for the author's lucid, succinct discussion of many of the complex problems of modern art and modern art theory.

Contents: (1) Introduction; (2) Later Impressionism; (3) Symbolist art; (4) Expressionism; (5) Cubism; (6) Abstract and nonobjective art; (7) Dada and Surrealism; (8) The

School of Paris: 1920-40; (9) Independent schools and masters; (10) Postscript: towards tomorrow. Notes, p.359-90, include bibliographical references. Classified bibliography, p.391-419.

I248   Hofmann, Werner. The earthly paradise; art in the nineteenth century. Trans. by Brian Battershaw. N.Y., Braziller [1961]. 436p. il. (part col.)
Trans. of *Das irdische Paradies; Kunst im neunzehnten Jahrhundert,* Munich, Prestel-Verlag, 1960, also available in paperback. English ed. published as *Art in the nineteenth century,* London, Faber and Faber, 1961.

A provocative, challenging study based on the author's interpretations of familiar and unfamiliar 19th-century works as representative of recurring iconographical types, or "experiential constants." Considerations of style are treated only incidentally. Superbly illustrated with 218 black-and-white plates (grouped according to iconographical type) and 16 color plates.

Contents: (1) The Artist's studio; (2) Nature and history; (3) Art without certainty; (4) The inner compulsion; (5) Pictures of humanity; (6) Mankind on show; (7) The great man; (8) The earthly hell; (9) Still life; (10) Woman as myth; (11) The earthly paradise; (12) The divided century. Bibliographical references in Notes, p.415-20. Index of artists and illustrations, p.421-34, includes biographical sketches of artists and commentaries on works reproduced. Index of names, p.435-36.

I249   Honour, Hugh. Neo-classicism. Harmondsworth, Penguin, 1968. 221p. 109 il. (Style and civilization)
A series of stimulating essays on the neoclassical style of the late 18th century. Based largely on original sources, not on modern evaluations, "the more positive, conscious aspects of this complex style" are investigated through familiar and forgotten examples of neoclassical paintings, sculpture, architecture, and decorative arts in Europe and America.—*Introd.*

Contents: (1) Classicism and Neo-classicism; (2) The vision of antiquity; (3) Art and revolution; (4) The ideal; (5) Sensibility and the sublime; (6) Epilogue. The catalogue of illustrations, p.193-203, lists illustrations with commentary and bibliographical references. Books for further reading, p.209-11, is a critical appraisal of literature in the field. General index.

I250   Madsen, Stephan Tschudi. Sources of Art Nouveau. [English trans. by Ragnar Christophersen] Oslo, Aschebourg, 1956. 488p., 266 il. (Repr.: N.Y., DaCapo, 1975.)
"To those interested in the developments of architecture and the decorative arts of the second half of the nineteenth century this is an invaluable reference book and an excellent stepping-off ground in many directions."—Review by Elizabeth M. Aslin in *Burlington magazine* 99:389 (Nov. 1957).

Bibliographical references in footnotes. Contents of pt. IV, Sources; Recent exhibitions; Contemporary catalogues; Contemporary articles; Contemporary periodicals (listed by country of publication); Bibliography.

I251 Nadeau, Maurice. The history of Surrealism. Trans. from the French by Richard Howard. With an introd. by Roger Shattuck. N.Y., Macmillan [1965]. 351p. il. Originally published as *Histoire du surréalisme,* 2v., Paris, Editons du Seuil, 1945-48 (repr. 1964).

A detailed survey of the Surrealist movement, with almost exclusive attention given to "history and theory—as expressed in statements, manifestos, expository texts, programs, and anecdotes—and thus does not convey any sense of the works produced."—*Introd., p. 34.* Pt. 6, "Famous manifestos and documents," includes translations of 22 articles from 1924-37.

"Principal works in which the Surrealist spirit has been manifested: an unsystematic bibliography," p.319-24. "Surrealist periodicals, manifestos, tracts, leaflets, catalogues, films, and critical works," p.325-35. Biographical notes, p.337-43.

I252 Nochlin, Linda. Impressionism and Post-Impressionism, 1874-1904; sources and documents. Englewood Cliffs, N.J., Prentice-Hall [1966]. ix, 222p. il. (Sources and documents in the history of art series)
A collection of "familiar and less well-known sources" as well as "a representative selection of views of those literary spokesmen who played such an important role in the formulation of programs and doctrines, often putting into words, whether accurately or not, the aspirations of the artists themselves."—*Pref.*

Contents: (1) Impressionism: critical views; (2) Impressionism: major masters; (3) After Impressionism: Cézanne and the Neo-Impressionists; (4) After Impressionism: Van Gogh, Gauguin, Symbolists, and Synthetists. Includes bibliographical footnotes.

I253 _____. Realism. Harmondsworth, Penguin, 1971. 283p. il. (Style and civilization)
A brilliant study of aspects of the Realist movement (c.1840-1870/80), of which the "aim was to give a truthful, objective and impartial representation of the real world, based on meticulous observation of contemporary life."—*p.13.* The concentration is on developments in France, with considerations of related movements in continental Europe, England, and the U.S.

Contents: (1) The nature of Realism; (2) Death in the mid-19th century; (3) 'Il faut être de son temps': Realism and the demand for contemporaneity; (4) The heroism of modern life; Epilogue. The "Catalogue of illustrations," p.249-69, includes extensive notes and numerous bibliographical references. "Books for further reading" is a critical bibliography of Realism.

I254 _____. Realism and tradition in art, 1848-1900; sources and documents. Englewood, Cliffs, N.J., Prentice-Hall [1966]. x, 189p. il. (Sources and documents in the history of art series)
An excellent selection of texts (in translation) in which the editor attempts "to strike a balance between old, familiar, yet incontrovertibly central documents and less well-known, perhaps more peripheral ones, which nevertheless add to our understanding of the art of the second half of the 19th century."—*Pref.*

Contents: (1) Traditional art: its supporters and its critics; (2) Realism and naturalism in France; (3) England: The Pre-Raphaelites and their friends; (4) Italy and Germany. Includes bibliographical footnotes.

I255 Novotny, Fritz. Painting and sculpture in Europe, 1780 to 1880. 2d ed. Trans. from the German by R. H. Boothroyd. Harmondsworth; Baltimore, Penguin, 1970. xxii, 290p. 22 il., 192 plates. (The Pelican history of art, Z20)
Paperback ed.: Harmondsworth, Penguin. (The Pelican history of art, PZ20)
A condensed history of the art of continental Europe from David to Cézanne. Undervalues the role of French artists in the development of 19th-century art.

Bibliographical references in Notes, p.241-51. Classified bibliography (general, individual countries, individual artists), p.253-72.

I256 Pevsner, Nikolaus. Pioneers of modern design from William Morris to Walter Gropius. Rev. ed. Harmondsworth, Penguin [1964]. 253p. il. (Pelican books, A497)
1st ed. published in 1936; has title: *Pioneers of the modern movement from William Morris to Walter Gropius.* 2d ed. published by the Museum of Modern Art, N.Y., 1949.

An early attempt to chronicle the development of the modern movement from the mid-19th century until 1914, covering art, architecture, and the decorative arts.

I257 Rosenblum, Robert. Cubism and twentieth-century art. [Rev. ed.] N.Y., Abrams [1966]. 328p. il. (part col.)
1st ed. 1959. Reissued in slightly revised, reduced format, 1977.

A study of the evolution of Cubism through the early works of Picasso and Braque, the expansion of Cubism among Parisian painters, and the influences and reflections of Cubism in the works of subsequent modern movements. Includes a chapter on Cubism and 20th-century sculpture. An important contribution, as distinguished for its witty, original insights as for its sound scholarship.

Chronology 1906-25, p.307-11. Fully annotated bibliography, p.312-17.

I258 _____. Transformations in late eighteenth century art. Princeton, N.J., Princeton Univ. Pr., 1967. xxvi, 203p. il.
Available in paperback.
A series of original, stimulating topical essays on the form and content of early neoclassical art and architecture as related to the ideas of the late 18th century, in particular the historicist approach to history. Not a survey of the period.

Contents: (1) Neoclassicism: some problems of definition; (2) The *Exemplum Virtutis*; (3) Aspects of neoclassical architecture; (4) Toward the *Tabula Rosa.* Extensive footnotes with bibliography. 215 illustrations relevant to the text.

I259   Rubin, William Stanley. Dada and surrealist art. N.Y., Abrams [1968]. 525p. il., plates (part col.)
A massive, scholarly history of Dada and Surrealist art. The author provides some of the most lucid, creative analyses of the various Surrealist artists in the literature on the movement. Restricted primarily to activities before World War II. Superbly illustrated with over 800 black-and-white reproductions and color plates.

Contents: pt. 1, Dada; pt. 2, The background of Surrealist painting; pt. 3, The heroic period of Surrealist painting (1924-29); pt. 4, The Surrealism of the thirties; pt. 5, Surrealism in exile. Bibliographical references in Notes, p.411-17. Documentary illustrations, p.421-52. Chronology, comp. by Irene Gordon, p.453-72. Classified bibliography, p.492-512.

I260   Scharf, Aaron. Art and photography. London, Lane, Penguin, 1968. xv, 314p. 264 il.
Paperback ed.: Harmondsworth, Penguin, 1974.
An indispensable study of the interactions between photography and other artistic media from the 1830s to the 1960s. Confined primarily to art and photography in England and France.

Contents: Introduction; (1) The invention of photography; (2) Portraiture; (3) Landscapes and *genres*; (4) Delacroix and photography; (5) The dilemma of Realism; (6) The power of photography; (7) Impressionism; (8) Degas and the instantaneous image; (9) The representation of movement in photography and art; (10) Photography as art: art as photography; (11) Beyond photography; (12) Beyond art; Conclusion.

Exhaustive documentation in "Notes," p.255-96. The state of research in the field is discussed in the preface.

I261   Schmutzler, Robert. Art Nouveau. [English trans. by Edouard Roditi]. N.Y., Abrams [1962]. 322p. il. (part col.)
Paperback ed.: N.Y., Abrams.
An excellent survey of the origins and development of Art Nouveau. Beautifully illustrated. Bibliographical references in Notes, p.281-86. Selected bibliography, p.299-307, classified into periodicals, contemporary literature (to 1914), literature since 1915. Index of names, p.318-21.

I262   Wingler, Hans Maria. The Bauhaus: Weimar, Dessau, Berlin, Chicago. [Trans. by Wolfgang Jabs and Basil Gilbert. Ed. by Joseph Stein]. Cambridge, Mass., MIT Pr. [1969]. xviii, 653p. il., col. plates, plans.
Paperback ed.: Cambridge, Mass., MIT Pr., 1978.
Trans. and adapted from the German, 2d rev. ed., 1968, with supplementary material.
An enormous anthology of documents and illustrations which trace the history of the Bauhaus from its founding at Weimar in 1919 through its reestablishment at Dessau, Berlin, and Chicago.

Contents, The documents of the Bauhaus: (1) The prehistory of the Bauhaus; (2) Bauhaus Weimar (from its founding to the 1923 exhibition); (3) Bauhaus Weimar (from the 1923 exhibition to the declaration of dissolution); (4) Transfer from Weimar to Dessau; (5) Bauhaus Dessau (the Gropius era); (6) Bauhaus Dessau (the Hannes Meyer era); (7) Bauhaus Dessau (Mies van der Rohe era); (8) Bauhaus Berlin; (9) The new Bauhaus. Illustrations: Staatliches Bauhaus Weimar 1919-25; Bauhaus Dessau 1925-32; Hannes Meyer era; Mies van der Rohe era; Bauhaus Berlin 1932-33; The influence of the Bauhaus; The new Bauhaus Chicago (Institute of Design). Roster of Bauhaus students, 1919-33, p.615-21. Immatriculation list of Bauhaus students of the Dessau and Berlin periods, p.622-25. Classified bibliography, p.627-47.

I263   Zeitler, Rudolf Walter. Die Kunst des 19. Jahrhunderts. Beiträgen von Anders Åman, Per Bjurström, Gerhard Bott, Hans-Gerhard Evers, Thomas Heinemann, Fritz Novotny. ([Mit] 599 Abbildungen auf 488 Tafelseiten, davon 48 farbig, und 29 Zeichnungen im Text) Berlin, Propyläen, 1966. 411p. il., plates. (Propyläen Kunstgeschichte [n.F.] Bd. 11)
A comprehensive work on 19th-century arts (c.1820 to c.1895). Contains critical-historical essays and commentaries on the many illustrations of works. Attempts a reevaluation of academic and neglected art, while it sacrifices a general emphasis on the modernist tradition. Includes the art and artists of France, Germany, and England, as well as of less prominent European countries, Russia, and the U.S.

Contents: [Pt. 1] Die Kunst des 19. Jahrhunderts: Das unbekannte Jahrhundert, von F. Zeitler; Der Impressionismus, von F. Novotny; Graphik, von T. Heinemann; Kunstgewerbe, von G. Bott; Plastik, von H.-G. Evers; Architektur, von A. Åman. [Pt. 2] Abbildungen; [Pt. 3] Dokumentation (includes bibliographical references in the commentaries): Malerei, Graphik; Karikatur und Illustrationskunst; Bühnenbild; Photographie; Kunstgewerbe; Plastik; Architektur. [Pt. 4] Anhang: Literaturverzeichnis (classified), p.378-83; Synchronoptische Übersicht, p.384-99; Namen- und Sachregister, p.400-10.

SEE ALSO: Hautecoeur, L. *Rome et la renaissance de l'antiquité* (I333); Kassel (Germany). *Documenta, Internationale Ausstellung* (R37); *Phaidon dictionary of twentieth-century art* (E35); Venice. *Biennale internationale d'art* (R75); Walker, J.A. *Glossary of art, architecture and design since 1945* (E36).

# WESTERN COUNTRIES

## Australia

I264   Moore, William. The story of Australian art, from the earliest known art of the continent to the art of today. Sydney, Angus & Robertson, 1934. 2v. il., plates (part col.)
A general history of Australian art, partially based on a series of newspaper articles begun in 1905. Although faulted for inaccuracies and irrelevancies, these volumes "formed

the basis for all subsequent studies."—McCulloch, E60, p.391.
"A dictionary of Australian artists," v.2, p.[155]–234. Cumulative index at the end of v.2.

I265  Smith, Bernard William. European vision and the South Pacific, 1768–1850; a study in the history of art and ideas. Oxford, Clarendon, 1960. xviii, 287p. plates.
Paperback ed. 1969.
A scholarly study of the origins of European art in Australia and the South Pacific beginning with the work of artists who traveled on Cook's three voyages.
Bibliographical footnotes. "Bibliography and sources," p.[258]–74.

SEE ALSO:  McCulloch, A. *Encyclopedia of Australian art* (E60).

## Canada

I266  Colgate, William G. Canadian art, its origin and development. With a foreword by C. W. Jefferys. Toronto, Ryerson [1943]. 278p. il., col. plate.
A general survey of art in Canada from 1820–1940. Bibliography, p.267–70.

I267  Hubbard, R. H. The development of Canadian art. [Ottawa] Trustees of the National Gallery of Canada [1963]. 137p. il. (part col.)
A well-illustrated summary of Canadian art and architecture from the 17th century through the mid-20th century.
Contents: (I) The early architecture of Canada; (II) The arts of French Canada; (III) Early painting in Canada; (IV) Art at the turn of the century; (V) The periods of the national movement; (VI) Contemporary art. Bibliography, p.17. Index of artists.

I268  McInnes, Graham. Canadian art. [Rev. ed.] Toronto, Macmillan, 1950. 140p. il. (part col.)
1st ed., *A short history of Canadian art,* 1939. A brief, general history of Canadian art.
Appendixes: (A) Art institutions and public art collections; (B) Chronology; (C) Select list of Canadian artists. Bibliography, p.126–31.

I269  MacTavish, Newton. The fine arts in Canada. Toronto, Macmillan, 1925. 181p. il., plates (part col.)
An old, sketchy survey of art in Canada. Ten of the 24 chapters are devoted to individual artists. Biographical notes, p.161–81. No bibliography; no index.

I270  National Gallery of Canada, Ottawa. Catalogue of paintings and sculpture. Vol. III: Canadian school, by R. H. Hubbard. Ottawa, published for the trustees by the Univ. of Toronto Pr., 1960. 463p. il.
A catalogue of the collection of Canadian paintings and sculpture in the National Gallery of Canada, Ottawa, the largest representative collection in Canada. The introductory essay, p.ix–xxiii, is a summary of the development of Canadian

painting and sculpture. The catalogue includes biographical information on each artist, a reproduction of each work described, and bibliographical references.
Contents: Paintings, p.1–337; Sculpture, p.339–61; Royal Canadian Academy Diploma Collection, p.[363]–423; Checklist of works in the study collection, p.424–25; Checklist of Canadian works in the First and Second World War Collections, p. 423–33.
Indexes: accession numbers; portraits; religious, mythological, allegorical, historical, and literary subjects; genre subjects; topography and landscape; artists.

I271  _____. Three hundred years of Canadian art; an exhibition. Trois cents ans d'art canadien. An exhibition arranged in celebration of the Centenary of Confederation. Catalogue by R. H. Hubbard and J. R. Ostiguy. 1967. [Ottawa, 1967]. v, 254p. 378 il., 31 col. plates.
The catalogue of a major exhibition of 378 works in which the aim was to survey 300 years of the visual arts in Canada. Arranged chronologically by date of work exhibited, in five sections: (1) French colonial period; (2) English colonial period; (3) Post-Confederation period (later 19th century); (4) The 20th century (1900–1950); (5) The 20th century (1951– ). Each section is preceded by an introductory essay. Text and captions in English and French. Bibliographies of artists, p.222–54. Bibliography, p.v.

## France

I272  Académie Royale de Peinture et de Sculpture, Paris. Mémoires inédits sur la vie et les ouvrages des membres de l'Académie Royale de Peinture et de Sculpture, publiés d'après les manuscrits conservés a l'Ecole Imperiale des Beaux-Arts, par MM. L. Dussieux, E. Soulié, Ph. de Chennevières, Paul Mantz, A. de Montaiglon. Paris, Dumoulin, 1854. 2v. (Repr.: Paris, Nobele, 1968.)
A collection of papers on the lives, works and methods of members of the Académie. Includes, among others, Le Brun, Bourdon, De La Hire, De Champagne, De Lafosse, Jouvenet, Mignard, Rigaud, Nattier, Oudry, Chardin. Reprint includes an index of names added by A. de Montaiglon to the 2d ed.

I273  Adhémar, Jean. Influences antiques dans l'art du moyen âge français, recherches sur les sources et les thèmes d'inspiration. London, Warburg Institute, 1939. 344p. 40 plates. (Studies of the Warburg Institute, no. 7) (Repr.: Nendeln, Liechtenstein, Kraus, 1968.)
The classic study of survival and revival of antiquity in medieval France. The introduction summarizes previous research, beginning with that of Muratori in the 18th century. Bibliographical references in footnotes.
Contents: Pt.1, Les études classiques et l'humanisme au moyen âge. (1) Les études classiques à l'époque préromane, (2) Les études classiques au XIe et à XIIe siècle, (3) Réforme des études au XIIIe siècle et déclin de l'humanisme; sa réapparition au XVe siècle; Pt.2, La connaissance du l'art

antique. (1) Les monuments conservés d'après les textes du moyen-âge, (2) Les oeuvres conservées d'après les textes, (3) L'art antique hors de France, (4) L'intérêt pour l'art antique du VIIIe au XII siècle, (5) L'art antique négligé du XIIIe au XVe siècle; Pt. 3, Les sources et les thèmes des influences. (1) L'époque préromane, (2) La renaissance carolingienne, (3) L'époque romane: Les sources antiques de la sculpture, (4) L'époque romane: Les thèmes antiques de la sculpture et les variantes régionales, (5) L'époque romane (suite), (6) L'époque gothique, (7) Le préhumanisme.

"Index des oeuvres d'art citées," p.315-26; "Index des noms propres," p.327-33.

I274    Blunt, Anthony. Art and architecture in France, 1500 to 1700. Harmondsworth; Baltimore, Penguin, 1973. 471p. il. 193 plates, plans. (The Pelican history of art, PZ4)
"First paperback edition, based on second hardback edition, with revisions." 1st ed. 1953; 2d rearranged impression, 1957; 2d ed. 1970.

The indispensable survey of French art and architecture of the 16th and 17th centuries. Well-written and well-organized by an outstanding scholar. Presents an objective picture of the Italian role in the development of French art. Includes summaries of the historical background and artistic theory for each period. Bibliographical references in notes; classified bibliography, p.441-49. 336 illustrations.

I275    Bréhier, Louis. L'art en France des invasions barbares à l'époque romane. Paris, La Renaissance du Livre [1930]. 210p. plates, facsims.
A general study covering early French art—Merovingian and Carolingian—including architecture, sculpture, mosaics, illuminated manuscripts, metalwork, etc. "Bibliographie sommaire," p.[207]-8.

I276    L'École de Fontainbleau. Exhibition au Grand Palais, 17 octobre 1972-15 janvier 1973. Paris, Éditions des Musées Nationaux, 1972. xxxviii, 517p. il.
Introduced by André Chastel and Sylvie Béguin. Contributions by various scholars.

The monumental catalogue of a major exhibition on the 16th-century School of Fontainbleau. Both sums up and advances the state of research. Includes paintings, drawings, illustrated manuscripts, prints, tapestries, stained glass, sculpture, armor, wood-carving, embroidery, medals, pottery and porcelain, enamels, metalwork, and jewelry. In all, over 700 works of art were exhibited. Long, descriptive entries by experts. Bibliography, p.487-[503].

A somewhat smaller exhibition was held at the National Gallery, Ottawa, which also had an excellent catalogue.

I277    Evans, Joan. Art in medieval France, 987-1498. London, N.Y., Oxford Univ. Pr., 1948. xxvii, 317p. [281] plates, fold. map, plans. (Repr.: N.Y., Oxford Univ. Pr., 1969.)
A basic cultural history, readable and rewarding for the general reader as well as for the art historian. "My whole endeavour . . . is to show that French medieval art took the forms it did because of the needs of the men who commis-

sioned it. For this reason I have taken the different classes of society — monks, bishops, canons, friars, kings, nobles, citizens, and the rest — and have described the art that was created to meet their needs." — Pref.

"List of books consulted," p.[293]-300. Index, p.303-17. Excellent halftone illustrations.

I278    _____. Cluniac art of the Romanesque period. Cambridge, Univ. Pr., 1950. xxxv, 134p. plates. (Repr.: N.Y., AMS, 1972.)
An excellent overview of Cluniac sculpture, painting, mosaics, and numismatics. A companion to J. Evans, Romanesque architecture of the order of Cluny (J160). Divided into three parts: development, ornament, and iconography. 209 illustrations. Bibliography.

I279    Fontaine, André. Les doctrines d'art en France; peintres, amateurs, critiques, de Poussin à Diderot. Paris, Laurens, 1909. iii, 316p. 12 pl. (incl. front., ports, facsims.) (Repr.: Geneva, Slatkine, 1970.)
A classic history of the doctrines of art in France during the 17th and 18th centuries. Readable, valuable as a critical guide to sources, with many bibliographical references.

"Index alphabétique des noms d'artistes cités dans l'ouvrage," p.[299]-302; "Index alphabétique des noms d'écrivains et d'amateurs cités dans l'ouvrage," p.[303]-7. Detailed table of contents.

I280    Inventaire général des monuments et des richesses artistiques de la France. Paris, Impr. Nationale, 1969-.
A monumental inventory of the arts in France (in progress). The methods of procedure are laid out in Principes d'analyse scientifique, 1971- . Accompanying the larger compendium is the Répertoire des inventaires, 1970- (A120), which includes the art and architecture of the French regions. Each text volume has an introductory historical essay, a bibliography of major sources, and the inventory catalogue of the works of art arranged by place. Each work is described and fully documented. Recent photographic illustrations for each work.

Published so far: Finistère. Canton de Carhaix-Plouguer. 2v.; Haut-Rhin. Canton de Guebwiller. 2v.; Gard. Canton d'Aigues-Mortes. 2v.; Landes. Canton de Peyrehorade; Morbihan. Les cantons de Faouët et Gourin; Eure. Canton Lyons-la-Forêt; Poitou-Charentes Côte d'Or. Canton Sombernon.

I281    Kalnein, Wend G., and Levey, Michael. Art and architecture of the eighteenth century in France. Trans. of pt. 2 by J. R. Foster. Harmondsworth; Baltimore, Penguin, 1972. xxv, 443p. il. (The Pelican history of art, Z37)
An authoritative, up-to-date survey of the development of 18th-century art and architecture in France, a welcome addition to the distinguished Pelican series. Pt. 1 gives the first scholarly treatment of the sculpture in English. Pt. 2 summarizes succinctly the important works of architecture and interior decoration, with a clear exposition of the developments in a period of great change. The notes and bibliographies for each section guide the student to sources and the literature of art. Richly illustrated, good plans.

I282 Louis XV: un moment de perfection de l'art français. |exposition: catalogue| Paris, Hôtel de la Monnaie, 1974. lxvi, 682p., 983 il. (part col.)

A sumptuous catalogue of a major exhibition on French art of the period of Louis XV held in Hôtel de la Monnaie, Paris, on the 200th anniversary of the King's death. Divided into the following sections: urbanism, architecture, garden art; sculpture; painting; drawing; prints; the book; tapestry; decorative arts; music, ballet, dance, costume, coins, medals and folk art. Each section has an essay by a specialist, a catalogue, entries of works exhibited with full documentation, and, in some, a separate bibliography. "Liste des ouvrages cités" (bibliography), p.[659]-68; "Index des artistes," p.669-[76].

I283 Mâle, Émile. L'art religieux du XIIIe siècle en France; étude sur l'iconographie du moyen âge et sur ses sources d'inspiration. 8. éd. Paris, Colin, 1948. xv, 428p. il. (Repr.: N.Y., French & European, as v.2 of *L'art religieux en France.*)

1st ed., Paris, Leroux, 1898.

A classic work on the iconography of 13th-century French art. "Index des oeuvres d'art citées dans cet ouvrage," p.[415]-21. Bibliography, p.[411]-14. An English translation of the 3d ed. (Paris, Colin) published as: *Religious art in France, XIII century . . .* (I286).

A new English translation, *Religious art in France: the thirteenth century,* by Marthiel Mathews, is in preparation as one of four translations of Mâle's works in the series *Studies in religious iconography,* ed. by Harry Bober, Princeton Univ. Pr. This edition will include revised notes taking into account recent scholarship, new illustrations, and an amplified index.

I284 _____. L'art religieux de la fin du moyen âge en France; étude sur l'iconographie du moyen âge et sur ses sources d'inspiration; 250 gravures. Paris, Colin, 1908. 558p. il. (Repr.: N.Y., French & European, as v.3 of *L'art religieux en France*)

A 4th ed., Paris, Colin, 1931, with 265 illustrations; 5th ed., 1949, is not a revision but contains the same material with a different arrangement of pagination.

A classic work. "Index des oeuvres d'art citées dans cet ouvrage," p.543-54.

An English translation by Marthiel Mathews, *Religious art in France: the end of the Middle Ages,* is in preparation as one of four translations of Mâle's works in the series *Studies in religious iconography,* ed. by Harry Bober, Princeton Univ. Pr. This edition will also include revised notes taking into account recent scholarship, new illustrations, and an amplified index.

I285 _____. Religious art in France: the twelfth century; a study of the origins of medieval iconography. [Princeton] Princeton Univ. Pr. [1978]. xxi, 575p. il. (Bollingen series, XC, 1)

Trans. by Marthiel Mathews of the rev. and corrected 6th ed. of *L'art religieux du XIIe siècle en France; étude sur les origines de l'iconographie du moyen âge,* Paris, Colin, 1953. The first volume of a series of English translations of the works of Émile Mâle, *Studies in religious iconography,* ed. by Harry Bober.

A classic work on the iconography of French art of the 12th century. The editor's foreword, p.[v]-xxiv, outlines the historiography of medieval art and surveys the contributions to it by Mâle. This translated ed. incorporates Mâle's additions and corrections into the footnotes and makes minor changes. "Citations of recent publications directly relevant to Mâle's discussion constitute the only substantive additions to his footnotes . . . Such additions are set off in square brackets to distinguish these from Mâle's own footnotes . . . Also added to this edition is a new and much expanded index . . . All the subjects illustrated in the original book are illustrated here, but they are now reproduced from the best photographs available."—*Editor's foreword.*

Bibliography, p.[517]-40.

I286 _____. Religious art in France, XIII century; a study in medieval iconography and its sources of inspiration. Tr. from the 3d ed. (rev. and enl.) by Dora Nussey. London, Dent; N.Y., Dutton, 1913. 414p. 190 il. (Repr.: N.Y., Harper [Icon Editions], 1973.

Trans. of *L'art religieux du XIIIe siècle en France . . .* (I283).

Appendix: List of the principal works devoted to the life of Christ (end of the 12th, 13th, and 14th centuries), p.401-6. Bibliography, p.407-10. Index of works of art, p.411-15, arranged alphabetically by place.

I287 Réau, Louis. Histoire de l'expansion de l'art français. Paris, Laurens, 1924-33. [v.1, 1933]. 3v. in 4. plates.

Covers French art in various countries, from the Renaissance to the 20th century. Mentions that Dussieux (E74) is full of inaccuracies. Each volume contains a section called "Documents" which includes, among other kinds of information, names of foreign artists belonging to the Academy.

Contents: v.1, Le monde latin—Italie, Espagne, Portugal, Roumanie, Amérique du Sud; v.2, pt. 1, Belgique et Hollande, Suisse, Allemagne et Autriche, Bohême et Hongrie (1928); v.2, pt. 2, Pays scandinaves, Angleterre, Amérique du Nord (1931); v.3, Le monde slave et l'Orient (1924).

Includes bibliographies. Each volume contains an alphabetical index.

I288 Rey, Raymond. L'art gothique du Midi de la France. Paris, Renouard, 1934. 352p. 278 il., plans.

A scholarly survey of Gothic architecture, sculpture, and painting in southern France. Footnotes with bibliography. Detailed table of contents.

I289 Roy, Maurice. Artistes et monuments de la renaissance en France; recherches nouvelles et documents inédits . . . avec une préface de M. Paul Vitry. Paris, Campion, 1929-34. 2v. il., plates, ports.

At head of title: Ouvrage publié sous le patronage de la Société de l'Histoire de l'Art Français.

v.2 was published after the death of the author and edited by Adrien Blanchet. Paris, Pichard. Continuously paged.

A scholarly work on 16th-century art, based on documents from the national and departmental archives. Arranged by artist.

"Bibliographie des travaux de M. Maurice Roy," v.2, p.[577]-82. "Index général," v.2, p.583-624.

I290    Stoddard, Whitney S. Monastery and cathedral in France; medieval architecture, sculpture, stained glass, manuscripts, the art of the church treasuries. Middletown, Conn., Wesleyan Univ. Pr. [1966]. xxi, 412p. il., map, plans.

Paperback ed. entitled *Art and architecture in medieval France.* N.Y. Harper and Row, 1972.

An excellent survey for the student and general reader. Traces the development of architecture and related arts in medieval France, from the 11th to the early 16th century. Detailed examination of important works. 433 illustrations, most of which were taken expressly for this book. Extensive bibliography, p.393-402.

Contents: Pt. I, Romanesque France; Pt. II, Early Gothic of the 12th century; Pt. III, High Gothic of the early 13th century; Pt. IV, From Rayonnant to Flamboyant; Pt. V, The treasuries of monasteries and cathedrals.

I291    Wixom, William D. Treasures from medieval France. [Cleveland] Cleveland Museum of Art [1967]. xxi, 394p. plates (part col.)

The catalogue of a major exhibition, organized by the Cleveland Museum, of French art from the Merovingian inheritance through the late Gothic period. Each plate has a descriptive text. The entries in the catalogue (p.347-[86]) include descriptions, ex-collections, and bibliographies.

## Germany and Austria

For the most complete, if not entirely satisfactory, listing with contents of the more important official regional inventories of the art and architecture of Germany, see Ehresmann, *Fine arts* (A35), p.183-95, nos. 815-48, arranged according to the principal regions of Germany, with the current name of each state or region given in parentheses following. The latter may be supplemented by the inventories found in the *Catalogue of the Harvard University Fine Arts Library, the Fogg Art Museum* (A63) and the Metropolitan Museum of Art, New York, *Library catalog* (A67), and updated by the supplements to these catalogues published periodically.

I292    Augsburger Barock. Ausstellung (Augsburg, Rathaus and Holbeinhaus, 15. Juni bis 13. Oktober 1968. Redaktion des Kataloges: Christian Thon. Augsburg, Kunstsammlungen, 1968) 478p., 97 l. of il.

The catalogue of an exhibition of the painting, sculpture, drawings, printmaking, architecture, metalwork, musical instruments, and the important gold- and silversmith's work produced in Augsburg in the Baroque period. The 701 catalogue entries follow essays written by various authorities. Essays include bibliographical notes at the end of each.

Verzeichnis der abgekürzt zierten Literatur, p.469-71.

I293    Bayern, Kunst und Kultur: Ausstellung des Freistaates Bayern und der Landeshauptstadt München. Veranstaltet von den Münchner staatlichen und städtischen Museen, dem Zentralinstitut für Kunstgeschichte und dem Bayerischen Rundfunk; Münchner Stadtmuseum vom 9. Juni-15. Okt. 1972. [Katalog red.: Michael Petzet. Autoren: Charlotte Angeletti u.a. Katalog-gestaltung: Eugen Sporer; Wolfgang Mudrak]. München, Prestel, 1972. 574p. il., 36 col. plates.

The catalogue of an enormous exhibition of 2,461 works which documents and traces the development of all the arts in Bavaria from their earliest appearances to the 1970s. Introductory essays and detailed catalogue entries written by over 40 authorities in their various fields. Illustrated with over 500 reproductions of works.

Abkürzungen, p.304-6; introductory essays; and catalogue entries include bibliographical references.

I294    Benesch, Otto. German and Austrian art of the 15th and 16th centuries. Ed. by Eva Benesch. London, Phaidon, 1972. 667p. 443 il. (*Collected writings* v.3)

A collection of 45 articles on German and Austrian art of the 15th and 16th centuries written by a preeminent scholar over a period of four decades and updated by the author's widow. Incorporates research on chronologies, attributions, and the iconography of the works of such artists as Dürer, Lucas Cranach, the Altdorfers, the Holbeins, the Master of the Linz Crucifixion, and the Master of the Krainburg Altar.

Contents: (1) German and Austrian art of the 15th and 16th centuries; (2) Museums and collections; (3) Drawings. Related publications by the author, p.418-20. Notes to the text, p.421-52.

I295    Dehio, Georg Gottfried. Geschichte der deutschen Kunst. Berlin und Leipzig, de Gruyter, 1923-34. 3. Aufl. 4v. and atlas of plates (4v.). plans.

An early, standard history of German art from its beginnings to the 20th century. Each volume has a separate index.

v.4, *Das neunzehnte Jahrhundert,* by Gustav Pauli.

I296    _____. Handbuch der deutschen Kunstdenkmäler. (Begründet vom Tag für Denkmalpflege 1900. Neubearb. durch die Arbeitsstelle für Kunstgeschichte bei der Deutschen Akademie der Wissenschaften zu Berlin in Einvernehmen mit der Vereinigung zur Herausgabe des Dehio-Handbuches). München, Berlin, Deutscher Kunstverlag, 1964-(77). v.[1-(11)], maps, plans.

Revised, expanded editions of the indispensable topographical guides to the artistic monuments of Germany; further revisions are continuously in preparation. Each volume gives detailed descriptions of all accessible works of art in the state or county covered and includes an index of artists.

Contents: (1) Baden-Württemberg, bearb. von Friedrich Piel (1964); (2) Hamburg; Schleswig-Holstein, bearb. von Johannes Habich (1971); (3) Hessen, bearb, von Magnus Backes (1975); (4) Die Bezirke Dresden, Karl-Marx Stadt, Leipzig, bearb, von Arbeitsstelle für Kunstgeschichte (1965); (5) Rheinland, bearb. von Ruth Schmitz-Ehmke (1967); (6) Rheinland-Pfalz, Saarland, bearb. von Hans Caspary, Wolf-

gang Götz, Ekkart Klinge (1972); (7) Die Bezirke Neubrandenburg, Rostock, Schwerin, bearb. von Arbeitstelle für Kunstgeschichte (1968); (8) Westfalen, bearb. von Dorothea Kluge und Wilfried Hansmann (1969); (9) Bezirk Magdeburg (1974); (10) Der Bezirk Halle (1976); (11) Bremen, Niedersachsen, bearb. von Gottfried Kiesow (1977).

I297   Dehio-Handbuch; die Kunstdenkmäler Österreichs; hrsg. von Bundesdenkmalamt, Institut für Österreiche Kunstforschung. Begründet von Dagobert Frey, fortgeführt von Karl Ginhart. Wien, Schroll [1953-(60). v.1-(6)]. il., maps, plans.
Revised editions of Dehio's indispensable topographical guides to artistic monuments in Austria: *Handbuch der deutschen Kunstdenkmäler . . . 2. Abteilung: Österreich,* Berlin, Deutscher Kunstverlag, 1933-35.
   Contents: (1) Wien, von J. Schmidt und H. Tietze. Neubearb. von A. Macku und E. Neumann. 5., neubearb. Aufl. [pref. 1960, c1954]; (2) Niederösterreich. Neubearb. von R. K. Donin, unter Mitwirkung von M. Capra, E. Neumann [und] A. Schmeller. 4. neubearb. Aufl. [1953]; (3) Salzburg: Land und Stadt, von F. Martin. Erneut durchgesehen und verb. von F. Fuhrmann. 5., verb. Aufl. [1963]; (4) Steiermark, von E. Hempel und E. Andorfer. Neubearb. von M. Schaffler, E. Hempel und E. Andorfer. 3., neubearb. Aufl. [1956]; (5) Oberösterreich, von E. Hainisch. Neubearb. von K. Woisetschläger. Mit Beiträgen von J. Schmidt und B. Ulm. 3., neubearb. Aufl. [1958]; (6) Tirol, von H. Hammer [et al]. Neubearb. von H. Mackowitz. 4., neubearb. Aufl. [1960]. Further volumes on the remaining Austrian provinces are projected. The guides do not include collections of works in museums.

I298   Deutsche Kunstgeschichte. München, Bruckmann, 1942-58. 6v. il., col. plates.
An important, comprehensive history of German art and architecture from the Carolingian period through the first half of the 20th century. Often referred to as "Bruckmann's *Deutsche Kunstgeschichte.*" Each volume contains a classified bibliography, an index, and good illustrations.
   Contents: (1) Hempel, Eberhard. *Geschichte der deutschen Baukunst* (1947; 2d ed., 1956); (2) Feulner, Adolf, and Müller, Theodor. *Geschichte der deutschen Plastik* (1953); (3) Fischer, Otto, and Feulner, Adolf. *Geschichte der deutschen Malerei* (1942; 3d ed. 1956); (4) Fischer, Otto. *Geschichte des deutschen Zeichnung und Graphik* (1951); (5) Kohlhaussen, Heinrich. *Geschichte des deutschen Kunsthandwerkes* (1955); (6) Roh, Franz. *Geschichte der deutschen Kunst von 1900 bis zur Gegenwart* (1958; English ed. with additions, *German art in the 20th century,* 1969?, I304).

I299   Gotik in Österreich. Ausstellung Gotik in Österreich. Krems an der Donau [Stadt Krems a.d. Donau, Kulturverwaltung] 1967. xxii, 455p. il. (part. col.)
The catalogue of a very important exhibition on the arts and architecture of the Gothic period of present-day Austria. Contains 25 sections on a wide range of topics, including mural and panel painting, cartography, drawing, printmaking, book illumination, glass painting, the decorative arts, architecture, and literature. Each section contains a scholarly

essay with bibliography, and full, detailed catalogue entries. Illustrated with 98 black-and-white and 16 color plates.

I300   Hamann, Richard, and Hermand, Jost. Epochen deutscher Kultur von 1870 bis zur Gegenwart. [2d ed.] München, Nymphenburger Verlagshandlung, 1971-76. 5v. il., col. plates.
First published as *Deutsche Kunst und Kultur von der Gründerzeit bis zum Expressionismus,* Berlin, Akademie-Verlag, 1959-67.
   A comprehensive history of the major movements of late 19th- and early 20th-century German art. Predominant attention given to painting. Well illustrated.
   Contents: v.1, Gründerzeit (1971); v.2, Naturalismus (1972); v.3, Impressionismus (1972); v.4, Stilkunst um 1900 (1973); Expressionismus (1976).

I301   Oberösterreich. Die Kunst der Donauschule, 1490-1540. Ausstellung des Landes Oberösterreich, Stift St. Florian und Schlossmuseum, Linz, 14. Mai bis 17. Oktober, 1965. [Verantwortlich für den Inhalt: Otto Wutzel. Linz, OÖ. Landesverlag, 1965]. xxiii, 289p. il., 80 plates (16 col.)
The catalogue of an exhibition of the painting, sculpture, printmaking, and architecture of the Danube School. The 723 catalogue entries are grouped by theme or type of work and follow essays written by various authorities. Essays include specialized bibliographies. General bibliography, p.17. Index of artists at the end.
   Fifteen papers presented at a symposium organized by the Oberösterreichische Musealverein and held in conjunction with the exhibition are published in: *Werden und Wandlung. Studien zur Kunst des Donauschule.* Linz, OÖ. Landesverlag, 1967. 239p. il., map.

I302   Österreichische Kunsttopographie. [n.s.] Bd. 1-(43). Wien, In Kommission bei A. Schroll, 1907-(77). il., plates, maps, plans.
Published by the Institut fur Österreichische Kunstforschung des Bundesdenkmalamtes (varies). Edited by successive generations of distinguished scholars. Current editor: Eva Frodl-Kraft.
   The official inventory by region and monument of Austrian art and architecture. Each volume on one region begins with a history of the region, which is followed by detailed descriptions of buildings, monuments, and sites.
   Volumes published to date: Bd. 1, Bezirk Krems (1907); Bd. 2, Stadt-Wien (XI-XII Bezirk) (1908); Bd. 3, Bezirk Melk (1909); Bd. 4, Pöggstall (1910); Bd. 5, Bezirk Horn (1911); Bd. 6, Bezirk Weidhofen a.d. Thaya (1911); Bd. 7, Benediktiner-Frauen-Stift Nonnberg in Salzburg (1911); Bd. 8, Bezirk Zwettl (ohne Stift Zwettl) (1911); Bd. 9, Stadt Salzburg-Kirchliche Denkmale der Stadt Salzburg (1912); Bd. 10, Bezirk Salzburg (1913); Bd. 11, Bezirk Salzburg (1916); Bd. 13, Profanen Denkmale der Stadt Salzburg (1914); Bd. 14, Hofburg in Wien (1914); Bd. 15, Kunsthistorischer Atlas Wien (1916); Bd. 16, Die Kunstsammlungen der Stadt Salzburg (1919); Bd. 17, Urgeschichte des Kronlandes Salzburg (1918); Bd. 18, Bezirk Baden (1924); Bd. 19, Stift Heiligenkreuz (1926); Bd. 20, Bezirk Hallein (1927); Bd. 21, Bezirk

Schärding (1927); Bd. 22, Bezirk Tamsweg (1929); Bd. 23, St. Stephansdom in Wien (1931); Bd. 24, Bezirk und Städte Eisenstadt und Rust (1932); Bd. 25, Bezirk Zell am See (1933); Bd. 26, Volkskunde des Burgenlandes (1935); Bd. 27, Vorgeschichtlichen Vorarlbergs (1937); Bd. 28, Landkreise Bischofshofen (1940); Bd. 29, Zisterzienserkloster Zwettl (1940); Bd. 30, Bezirk Braunau (1947); Bd. 31, Benediktinerstift St. Lambert (1971); Bd. 32, Bezirk Feldkirch (1949); Bd. 33, not published; Bd. 34, Bezirk Lambach (1959); Bd. 35, Bezirk Murau (1964); Bd. 36, Der Linzer Kirchen (1964); Bd. 37, Benediktinerstift St. Paul im Lavnattal (1969); Bd. 38, Die Profanen Kunstdenkmäler der Stadt Innsbruck (1972); Bd. 39, Gerichtsbezirk Oberwölz (1973); Bd. 40, Bezirk Oberwart (1974); Bd. 41, Die Kunstdenkmäier Wiens. Die Kirchen des III. Bezirks (1974); Bd. 43, Die Kunstdenkmäler des Benediktinerstiftes Kremsmünster (1977).

I303    Pinder, Wilhelm. Vom Wesen und Werden deutscher Formen; geschichtliche Betrachtungen. Frankfurt, Menck [1952-57]. v.1-4 in 7. il., plates, plans.
1st ed., Leipzig, Seemann [1937-51].
Concise surveys of four periods of German art. Well illustrated.
Contents: Bd. 1, Die Kunst der deutschen Kaiserzeit bis zum Ende der staufischen Klassik (Text, 5th ed. 1952; Plates, 2d ed. 1952); Bd. 2, Die Kunst der ersten Bürgerzeit bis zur Mitte des 15. Jahrhunderts (Text, 3d ed. 1953; Plates, 2d ed. 1956); Bd. 3, Die deutsche Kunst der Dürerzeit (Text, 2d ed. 1952; Plates, 2d ed. 1957); Bd. 4, Holbein der Jüngere und das Ende der altdeutschen Kunst (Text and plates, 2d ed. 1952). Revised editions are by various experts.

I304    Roh, Franz. German art in the 20th century, by Franz Roh, with additions by Juliane Roh. [English language ed. Trans. from the German by Catherine Hutter and ed. by Julia Phelps] Greenwich, Conn., New York Graphic Society [1969?]. 516p. 623 il., 42 col. plates.
First published in 1958 with title: Geschichte der deutschen Kunst von 1900 bis zur Gegenwart, v.6 of Bruckmann's Deutsche Kunstgeschichte (I298). Additional material for this edition covers the period 1955-68.
A comprehensive, if superficial, survey of the major artists and movements of 20th-century art and architecture produced in Germany. Well illustrated; inadequate information in captions. No bibliography.

I305    Weigert, Hans. Geschichte der deutschen Kunst [2d ed.]. Frankfurt am Main, Umschau [1963]. 2v. il., plates (part col.)
1st ed. 1942.
A well-illustrated, comprehensive history of German art from its prehistoric beginnings to the mid-20th century. The 1st ed. reflects the antimodernist and anti-Semitic attitudes of the Third Reich. In the 2d ed., prejudicial statements and biases are expunged and the former "degenerates" (Nolde, Klee, Kirchner, etc.) exonerated. (See review by Alfred Werner, Arts, 38: 110 (May 1964)).

SEE ALSO:  Hempel, E. Baroque art and architecture in Central Europe: . . . (I216); Osten, G. von der, and Vey, H. Painting and sculpture in Germany and the Netherlands 1500-1600 (I223); Schmitt, O. Reallexikon zur deutschen Kunstgeschichte (E87); Studien zur deutschen Kunstgeschichte (R63); Studien zur Oesterreichischen Kunstgeschichte (R66).

# Great Britain

I306    Aslin, Elizabeth. The aesthetic movement: prelude to Art Nouveau. N.Y., Praeger [1969]. 192p. 151 il., 121 plates (part col.)
A systematic study of the "aesthetic movement" and its influence on the styles of architecture, interiors, book illustration and typography, china, and pottery in the second half of the 19th century in England.
Contents: (1) Introduction; (2) Red brick and sunflowers; (3) The aesthetic interior; (4) The Japanese taste; (5) Oscar Wilde and America; (6) Satire and comment; (7) 'Art' industry; (8) The fashionable aesthete; (9) Kate Greenaway and company. Notes, p.189, include bibliographical references. Bibliography, p.190, is limited to "publications which can be considered as sources."

I307    Brown, Gerard Baldwin. The arts in early England. London, Murray, 1903-37. 6v. in 7. il., plates, maps, plans, tables.
Reprinted in part from The Builder. Contents: v.1, The life of Saxon England in its relation to the arts; v.2, Ecclesiastical architecture in England from the conversion of the Saxons to the Norman Conquest; Appendix: Index list, and map of Saxon churches; v.3-4, Saxon art and industry in the pagan period (2v.); v.5, The Ruthwell and Newcastle crosses, the Gospels of Lindisfarne and other Christian monuments of Northumbria; v.6, pt.1, Completion of the study of the monuments of the great period of the art of Anglican Northumbria; v.6, pt. 2, Anglo-Saxon sculpture, prepared for press by E. H. L. Sexton.
Each volume has its own index.

I308    Cork, Richard. Vorticism and abstract art in the first machine age. Berkeley, Univ. of California Pr. [1976]. 2v. il. (part col.)
The first complete survey and critical evaluation of the Vorticist movement in England. v.1, Origins and development (344p., 289 il.), traces the formation of the Vorticist group, which included, among others, Wyndham Lewis, Gaudier-Brzeska, Ezra Pound, Jacob Epstein, and Christopher Nevinson. v.2, Synthesis and decline (320p., 242 il.), is an analytical study of the paintings, sculpture, and drawings produced under the aegis of the Vorticist aesthetic and of their influences on subsequent 20th-century art. Includes illustrations of works not previously reproduced.

I309    Fawcett, Trevor. The rise of English provincial art: artists, patrons, and institutions outside London, 1800-1830. Oxford, Clarendon, 1974. xiii, 242p. 25 il., [8] leaves of plates. (Oxford studies in the history of art and architecture)

A study of the development of interest in the fine arts in various provincial English towns in the early 19th century. Considers "not only the activities of professional artists, but also questions of patronage, dissemination, regional diversity, and above all the establishment of art institutions and public exhibitions." — *Pref.*

Contents: (1) Professional artists; (2) Dealers, patrons, and collectors; (3) Public exhibitions; (4) Art and the wider public; (5) Individual centres; (6) Provinces and metropolis. List of sources, p.[215]-31: Manuscripts; Contemporary exhibition catalogues (institutions); Contemporary newspapers; Other printed sources. Bibliographical references in footnotes. Index.

I310    Finlay, Ian. Art in Scotland. London, Oxford Univ. Pr., 1948. 180p. plates (1 col.)
"My purpose in this book has been to piece together the significant trends, the Scottish trends, of art in Scotland." — *Pref.* A general survey, from the "Celtic ascendancy" to the contemporary movement. Index, p.175-80. Bibliographical footnotes.

I311    Henry, Françoise. Irish art. Trans. from French by the author. Ithaca, Cornell Univ. Pr. [1965-70]. 3v. il., plates. maps.
An art historical study of the major works of early Irish art (5th-12th centuries), written by a recognized authority in the field. Each volume contains a broad survey of the historical background, followed by chapters on such subjects as sites and architecture, metalwork, carvings, the decoration of manuscripts, crosses, and churches. Excellent general indexes. Lists of monochrome and documentary plates.

Contents: v.1, Irish art in the early Christian period, to 800 A.D. (Bibliography, p.225-32); v.2, Irish art during the Viking invasions, 800-1020 A.D. (Bibliography, p.206-13); v.3, Irish art in the Romanesque period, 1020-1170 A.D. (Bibliographical footnotes).

I312    Irwin, David G. English neoclassical art: studies in inspiration and taste. London, Faber and Faber; Greenwich, Conn., New York Graphic Society [1966]. 230p. col. front., 94 plates (157 illus.)
The author examines the works of English neoclassical painters and sculptors from the 1760s to the 1820s. Concerned primarily with history painters. "The main emphasis will be on ideas and taste in an attempt to discover the principal aims of these artists, basing the study largely on the artists' writings in the form of letters, journals, lectures and occasional poems." — *Pref.* Bibliography, p.171-212.

I313    The Oxford history of English art, ed. by T. S. R. Boase. Oxford, Clarendon, 1949-(76). il., plates, plans.
This excellent survey was to have been completed in 11v. Each monograph within the series was written by a well-known English scholar. The aim of the *Oxford history of English art* is "to set out chronologically the development of the visual arts as part of the general history of England." — *Pref.*, v.5.

Volumes published: v.2, D. Talbot Rice, *English art, 871-1100* (1952); v.3, T. S. R. Boase, *English art, 1100-1216* (1953); v.4, Peter Brieger, *English art, 1216-1307* (1957); v.5, Joan Evans, *English art, 1307-1461* (1949); v.7, Eric Mercer, *English art, 1553-1625* (1962); v.8, Margaret Whinney and Oliver Millar, *English art, 1625-1714* (1957); v.9, Joseph Burke, *English art, 1714-1800* (1976); v.10. T. S. R. Boase, *English art, 1800-1870* (1959).

Other volumes in the series are in preparation.

I314    Saxl, Fritz, and Wittkower, Rudolf. British art and the Mediterranean. London, N.Y., Oxford Univ. Pr., [1948]. 86p., [86]p. of il. (Repr.: Oxford Univ. Pr., 1969.)
A unique pictorial survey showing the influence of Mediterranean art and culture on the arts of Britain from prehistoric times to "the loosening of classical ties in modern times." The first part, to 1500, was written by Fritz Saxl; the later chapters were written by Rudolf Wittkower. The text consists of carefully chosen examples and scholarly commentaries. References to classical sources are in the commentaries. Occasional footnotes. Index compiled by Joan Wallis.

I315    Waagen, Gustav Friedrich. Treasures of art in Great Britain: being an account of the chief collections of paintings, drawings, sculptures, illuminated manuscripts. London, Murray, 1854. 3v.
Trans. from the German by Lady Eastlake. A supplementary volume published 1857 with title: *Galleries and cabinets of art in Great Britain.* Both volumes are indexed in: Graves, Algernon, *Summary of and index to Waagen* (London, Graves, 1912. 366p. 125 copies printed). Includes all of the pictures mentioned in Waagen (over 9,000), plus a list of those mentioned by Waagen in his tour of 1835 and not repeated in the later work. A special section is devoted to portraits and an index of owners.

Written in the form of a travel diary. Valuable for locating works of art in private collections. Index, v.1, p.xiii-ix, lists all works mentioned in the text.

I316    Whitley, William Thomas. Art in England, 1800-1820. N.Y., Macmillan; Cambridge, Univ. Pr., 1928. 344p. 16 plates. (Repr.: N.Y., Hacker, 1973.)
A continuation of *Artists and their friends in England 1700-1799* (I318). "Contemporary opinions have been gathered from newspapers and other sources on the principal pictures shown year by year at the Academy exhibitions . . . Reports of interesting actions at law connected with the arts are given, with occasional references to picture sales of importance, and an account of the hitherto unrecorded return to art criticism of the notorious Anthony Pasquin." — *Pref.*

The source material is arranged by date.

I317    _____. Art in England, 1821-1837. Cambridge, Univ. Pr., 1930. 371p. plates. (Repr.: N.Y., Hacker, 1973.)
A continuation of *Artists and their friends in England 1700-1799* (I318) and *Art in England, 1800-1820* (I316). Based on contemporary sources.

This volume discusses the formation of the National Gallery and traces its early history as well as that of the Royal Academy. It also covers contemporary newspaper and magazine criticism of various exhibitions, and includes some letters and notes concerning important art sales of the period. Arranged by date.

Appendix: The National Gallery—the early days in Trafalgar Square, p.345-48. Index, p.349-72.

I318    _____. Artists and their friends in England 1700-1799. London, The Medici Society, 1928. 2v. plates, facsims. (Repr.: N.Y., Blom, 1968.)

A discussion of 18th-century British artists, their friends, and environment. Traces the development of early art schools and societies of artists, and includes material on American painters who settled in England.

The information in these volumes was culled from letters, anecdotes, contemporary criticism, and various records, all gathered from such sources as the Royal Society, the Society of Arts, the Old Incorporated and Free Societies of Artists, the notebooks of George Vertue, newspapers, and letters and manuscripts at the British Museum and the Record office.

Appendix of "Identified pictures, 1760-91," v.2, p.367-96. Index at end of v.2.

## Italy

I319    Amici dei Musei di Roma. Il Settecento a Roma. Mostra promossa dall'associazione Amici dei Musei di Roma, realizzata sotto gli auspici del Ministero della Pubblica Istruzione e del Comune di Roma, con la partecipazione dell'Ente Provinciale per il Turismo di Roma, 19 marzo-31 maggio, 1959. [Roma] De Luca [1959]. 566p. 80 plates.

The catalogue of a major exhibition of art and artistic life in Rome during the 18th century. Includes foreign artists who worked in Rome. Sections on painting and sculpture; architecture, topography, city planning; history; artistic life; music, theatre, festival designs; decorative arts; archaeology; collections. Contains a great deal of interesting material on this neglected period. Bibliography; especially useful year-by-year chart of important artistic events; selective illustrations.

I320    Arslan, Edoardo. La pittura e la scultura veronese dal secolo VIII al secolo XIII, con un'appendice sull'architettura romanica veronese. Milano, Bocca, 1942. 232p. 281 plates, plans. (Pubblicazioni della Facoltà di Lettere e Filosofia della R. Università di Pavia, 2)

Intended as a companion piece to the author's *Architettura romanica veronese*, 1940.

Appendix: "Nuove osservazioni e aggiunte sull'architettura romanica veronese," p.189-223. Bibliographical footnotes. Index of artists, p.225-26; of places, p.227-32.

I321    Ballo, Guido. La linea dell'arte italiana dal simbolismo alle opere moltiplicate. Roma, Mediterranée, 1964. 2v. il., plates (part col.)

An original study of modern Italian art from the symbolist movement of the 19th century to the plurality of 20th-century styles and movements. Traces a broken line of artistic change, and compares artistic developments with language and poetry. Well illustrated with 339 good color plates and 588 black-and-white illustrations. The bibliography, p.365-[78], summarizes recent scholarship.

I322    Bertaux, Émile. L'art dans l'Italie méridionale. Tome premier: De la fin de l'empire romain à la conquête de Charles d'Anjou, ouvrage accompagné de 404 figures dans le texte, 38 planches hors texte en phototypie et deux tableaux synoptiques; dessins et photographies de l'auteur. Paris, Fontemoing, 1904. 3p. l., xiv, 835, [1]p. front. il. (incl. maps, plans), 37 pl. (Repr. of 1903 ed.: Paris, Boccard, 1968.)

No more published.

A fundamental work on art in southern Italy from the end of the Roman Empire until the Norman Conquest. Has not been replaced. Table des illustrations, p.817; Tables des figures, p.819-24; Table géographique, p.825-30; Table des noms d'artistes, p.831-32; Table sommaire des matières, p.833-35.

I323    Blunt, Anthony. Artistic theory in Italy, 1450-1600. Oxford, Clarendon, 1940. vi, [2], 168p. plates.

Paperback ed.: London, Oxford Univ. Pr. [1962].

2d impression, 1956, is a reprint of the 1st ed. except for minor corrections and a few additions to the bibliography.

Required supplemental reading for students of Italian Renaissance art. Authoritative, well written, with a clear exposition of ideas.

Contents: (I) Alberti; (II) Leonardo; (III) Colonna, Filarete, Savonarola; (IV) The social position of the artist; (V) Michelangelo; (VI) The minor writers of the High Renaissance; (VII) Vasari; (VIII) The Council of Trent and religious art; (IX) The later Mannerists.

Bibliographical footnotes, bibliography, and index.

I324    Burckhardt, Jakob Christoph. The civilization of the Renaissance in Italy; an essay. [Trans. by S. G. C. Middlemore, 3d ed., rev.]. N.Y., Phaidon. (Distr. by Oxford Univ. Pr. [1950].) xxiii, 462 p. plates.

Many editions and reprints; always in print. Originally published in 1860.

The pioneer cultural study of the Renaissance in Italy, now a classic.

Contents: The state as a work of art; The development of the individual; The revival of antiquity; The discovery of the world and of man; Society and festivals; Morality and religion; The civilization of the Renaissance in pictures, p.345-440; Notes on the plates, p.441-53. Index, p.455-62.

I325    Chastel, André. Art et humanisme à Florence au temps de Laurent le Magnifique; études sur la renaissance et l'humanisme platonicien. 2d ed., Paris, Presses Universitaires de France, 1961. 578p. il., 96 plates. (Paris. Université. Institut d'Art et d'Archéologie. Publications. t.4)

1st ed. 1959.

A scholarly study of the art of Florence during the period 1470-1500, written in the context of the history of ideas. Attempts to match images with intellectual events. Many footnotes; excellent bibliography.

I326 _____. The studios and styles of the Renaissance: Italy, 1460-1500. Trans. by Jonathan Griffin. [London] Thames & Hudson [1966]. xii, 417 p. il. (part col.) maps, diagrs. (The arts of mankind. 8)

A lavishly illustrated study of the styles and studios of the Italian Renaissance. Most helpful for the beginning student and the general reader. While stressing the *bottega's* importance to the development of style, the author does not neglect the "nomadism" that was prevalent. Covers architecture, sculpture, and painting. The conclusion is entitled "The power of style." Includes a useful glossary. Illustrated documentation, p.329-50; notes, p.351-53; glossary, index, p. 357-86; bibliography, p.388-99.

I327 Detroit. The Institute of Arts. The twilight of the Medici. Late Baroque art in Florence, 1670-1743. Detroit, Wayne State Univ. Pr., 1974. 507p. il. (part col.)

This exemplary catalogue of a large loan exhibition of Florentine Baroque art (also held at the Pitti·Palace, Florence) represents a major contribution to a neglected field of study. Essays on the historical background are by Harold Acton and Klaus Lankheit. The catalogue is divided into sections on sculpture, painting, decorative arts, architecture, festivals, and theatricals. Each has an introduction by a specialist, fully documented catalogue entries, and commentaries. Includes illustrations of each work exhibited, with several in color. Bibliography, p.494-503. List of lenders; Index of artists.

I328 Fokker, Timon Henricus. Roman Baroque art, the history of a style. London, Oxford Univ. Pr., Milford, 1938. 2v. plates, plans. (Repr.: N.Y., Hacker, 1972.)

Now most useful for the illustrations. The main divisions — Early, Full, and Late Baroque — are subdivided as follows: church interiors, church facades, palaces, town planning and fountains, painting, and sculpture. Contents: v.1, Text; v.2, Plates.

Bibliography, v.1, p.[xvii]-xxii. Index of artists, v.1, p.359-61; of popes, prelates, and other persons, v.1, p.362-64; of works of art and localities, v.1, p.365-68.

I329 Golzio, Vincenzo. L'arte in Roma nel secolo XV [di] Vincenzo Golzio [e] Giuseppe Zander. Bologna, Cappelli, 1968. 624p. il., 120 plates. (Istituto di Studi Romani, Roma. Storia di Roma, v.28)

The first comprehensive study of art in Rome and the surrounding region of Lazio during the transitional period of the 15th century. Text followed by "Note critiche," p.359-439 (a critical discussion of the existing literature and the current state of research), "Bibliografia" for each chapter in the text arranged by date, p.441-85, and "Repertorio di artefici," a listing of architects, patrons, entrepreneurs, brickmasons, and stonecutters who worked in Rome in the 15th century.

I330 _____. Il Seicento e il Settecento. Turin, 1955. 2v. xx, 1,292p. 1,102 il., 16 plates. (Storia universale dell'arte, 5)

1st ed. 1950·

A useful encyclopedic survey of 17th- and 18th-century art in Italy. Not intended to be a work of original research, rather a compilation of the critical precepts of others. Emphasis on the Baroque as a religious art. Includes only important artists. Each century is divided into sections on architecture, sculpture, painting, with a brief summary of urbanism, scenographic arts, music, and the minor arts. Extensive bibliography in v.2, p.1205-31. Indexes of places and monuments and of artists at the end of each volume.

I331 Guida d'Italia del Touring Club Italiano. Milan, 1950- . 23v. In progress.

Many editions, constant revisions with corrections and augmentations.

Detailed guidebooks to each of 23 regions in Italy; generally reliable, up-to-date factual information on the art and architecture. Good maps, many plans of buildings. Each volume has an historical introduction, bibliography, an index of artists, and an index of places and subjects.

I332 Hartt, Frederick. History of Italian Renaissance art; painting, sculpture, architecture. N.Y., Abrams [1969]. 636p. il. (part col.)

A broad survey of the three major arts in the Italian Renaissance, directed to the beginning student and general reader. Well illustrated with a helpful glossary and chronological chart. "Books for further reading," p.608-13. Indexed.

I333 Hautecoeur, Louis. Rome et la renaissance de l'antiquité à la fin du XVIIIe siècle. Paris, Fontemoing, 1912. xiii, 316p., 2 l. plates. (Bibliothèque des Écoles Françaises d'Athènes et de Rome . . . fasc. 105)

An important history of intellectual and artistic life in Rome during the period of classical revival from c.1755-1800. Contains a wealth of information; well documented. Indispensable for research in the field of French neoclassicism and basic for background in any phase of 18th-century classicism.

"Index bibliographique": I. Documents, p. [281]-294; II. Études, p.294-302. "Index des noms cités," p.[303]-14. "Table des matières," p.[315]-16. "Table des gravures," p.317.

I334 Hersey, George L. Alfonso II and the artistic renewal of Naples, 1485-1495. New Haven, Yale Univ. Pr., 1969. xii, 159p. 175 il. (incl. maps, plans, ports.) (Yale publications in the history of art, 19)

An illuminating, original study, based on documents and literary sources. More than the specialized work which the title indicates, this book makes a far-reaching contribution to Italian Renaissance studies, particularly in problems relating to architecture and sculpture. Chronology. Bibliography, p.131-47.

I335 Heydenreich, Ludwig H. Italienische Renaissance; Anfänge und Entfaltung in der Zeit von 1400 bis 1460. München, Beck [1972]. 430p. 407 il. (90 col.), maps, plans. (Universum der Kunst. 19)

Published in French as: *Éclosion de la Renaissance: Italie 1400–1460,* Paris, Gallimard [1972]. (L'Univers des formes, 19). The English language series is *Arts of Mankind.*

"Summarizes the first phase of the development of Italian Renaissance art in the fields of architecture, sculpture and painting. Includes a chronology and a synchronous list of artists." (*RILA,* Demonstration issue, p.30, no. 386)

Bibliography, p.409–15.

I336    Lavignino, Emilio. L'arte moderna dai neoclassici ai contemporanei. [Torino] Unione Tipografico-Editrice Torinese [1956]. 2v. ix, 1343p. il., plates. (Storia dell'arte classica e italiana, v.5)

The standard survey of 19th- and 20th-century Italian art which concludes this important series. Bibliography, p.1263–78. Indexes of artists, and places and monuments.

I337    _____. Storia dell'arte medioevale italiana. Con 12 tavole in rotocalco e 898 figure nel testo. Torino, Unione Tipografico-Editrice Torinese, 1936. 803p. il. (incl. plans), 12 plates.

A standard survey of medieval Italian art. Most useful as a reference tool for facts and illustrations. Annotated bibliography, p.770–79, and indexes of artists, p.781–84, places and monuments, p.785–803.

I338    Mahon, Denis. Studies in Seicento art and theory. London, Warburg Institute, Univ. of London, 1947. 351p. plates. (Studies of the Warburg Institute, 16) (Repr.: Westport, Conn., Greenwood, 1971.)

An important scholarly book on classicist art theory in the Baroque period. Long descriptive footnotes with references to sources and later publications.

Contents: (1) Guercino's change of style: its nature and origins; (2) Agucchi and the *Idea della Bellezza*: a stage in the history of a theory; (3) Art theory in the newly founded Accademia di San Luca, with special reference to the academic criticism of Caravaggio; (4) The construction of a legend: the origins of the classic and eclectic misinterpretations of the Carracci. Appendix: (1) Agucchi's *Trattato*: annotated reprint of Mosini's preface of 1646 containing the surviving fragment of the treatise; (2) Notes on the manuscripts of Mancini's *Trattato.* Index, p.333–51.

I339    Mallè, Luigi. Le arti figurative in Piemonte dalle origini al periodo romantico. [Torino] Casanova [1963]. ix, 496p. il., plates (part col.)

English trans.: Turin, RIV-SKF, 1972.

The first comprehensive study, covering "the evolution of Piedmontese art from prehistoric times up to the 19th century . . . paying special attention to the minor arts, such as goldsmiths' and intaglio work . . . Undoubtedly an indispensable work of reference." — Review by Andreina Griseri in *Burlington magazine,* Oct. 1965, p.531. Bibliography, annotated and evaluated, p.437–52; indexes of names and places.

I340    Maltese, Corrado. Storia dell'arte in Italia 1785–1943. [Torino] Einaudi, 1960. xxvi, 471p. 277 il., plates.

A thorough, stimulating history of the many movements in Italian painting, sculpture, and architecture from the end of the 18th century to 1943. Analyzes all variations of classicism, romanticism and realism; treats all influential artists. Also valuable for the critical bibliographical notes at the end of each chapter. Well illustrated. Detailed index.

I341    Mantova, le arti. Mantova, Istituto Carlo d'Arco per la Storia di Mantova [1960–65]. 3v. in 5. il. (part col.), plates, plans. (Mantova: La storia, le lettere, le arti)

A comprehensive history of the arts of Mantua, part of a monumental history of the city. Each section written by a specialist. Includes bibliographies. Well illustrated.

Contents: v.1. Il medioevo, a cura di G. Paccagnini; v.2. Dall' inizio del secolo XV alla meta dell'XVI, testo di E. Marani e C. Perina. 2v. (text and plates); v.3. Dalla meta del secolo XVI ai nostri giorni, testo di E. Marani e C. Perina. 2v. (text and plates).

I342    Marchiori, Giuseppe. Arte e artisti d'avanguardia in Italia, 1910–1950. Milano, Edizioni di Comunità, 1960. 309p. mounted col. il., plates. (Studi e documenti di storia de arte, 1)

A reference book treating the avant-garde painters and sculptors in Italy from Futurism to the present. Arranged chronologically by artist. For each gives a short essay, in many cases excerpts from his writing, a list of principal works, and essential bibliography. Bibliographical footnotes. "Bibliografia generale," p.305–9. 134 black-and-white figures, 1–3 color plates of each artist's work, with descriptive notes.

I343    Martin, Marianne W. Futurist art and theory, 1909–1915. Oxford, Clarendon, 1968. xxx, 228p. il., col. front., plates (234 figs.) (Repr.: N.Y., Hacker, 1977.)

The major work on the Futurist movement in Italy. Based on an exhaustive study of published material, documents, background literature, correspondence, and interviews.

Contents: (1) Painting and sculpture in Italy during the later 19th century; (2) New directions: the Florentine movement; (3) F. T. Marinetti: Life and work before the launching of Futurism; (4) The first manifesto and the Futurist aesthetic; (5) Futurist painting theory and its sources; (6) The Artists: their beginnings; (7) The first Futurist paintings of Boccioni, Carrà, and Russolo: 1910 to summer 1911; (8) Severini's work, 1910–11; (9) The Milanese artists and Cubism in 1911; (10) The Paris exhibition and its aftermath: theory 1912–13; (11) Painting 1912–13: Severini; (12) Painting 1912–13: The Milanese artists and Soffici; (13) Boccioni's sculpture: 1912–13; (14) Giacomo Balla: 1912–13; (15) The final years: 1914–15. Appendix: On the Futurists' controversies.

Extensive documentation and bibliographical references in the footnotes. Selected bibliography, p.[207]–13.

I344    Mezzanotte, Gianni, ed. Milano nell'arte e nella storia. [Di] Paolo Mezzanotte [e] Giacomo C. Bascapè. Milano, Roma, Bestetti, 1968. civ, 543p. il.

The fundamental reference book for art and architecture in the city of Milan. Too large for a guidebook. General

introduction on the history of architecture and building from its Roman origins to the present, p.xi–xcix. Bibliographical notes, followed by a list and illustrations of the coats of arms. Illustrated with prints and drawings. This is followed by a region-by-region discussion of the city, its planning, architecture, and art. Bibliographical notes. Abundantly illustrated in the text with photographs, plans, engravings, drawings, color plates of topographical paintings. Selected bibliography in "Elenco della abbreviazione" at beginning. "Indice analitico" at end.

I345    Milan. Palazzo Reale. Il Seicento lombardo [mostra, giugno-ott., 1973, Palazzo Reale, Pinacoteca Ambrosiana]. Milano, Electa [1973?]. 3v. il., incl. plates.
The catalogue of a major loan exhibition of 17th-century painting, architectural drawings, sculpture, drawings, prints and books. Essays by leading scholars. Bibliographical notes. Each work discussed is illustrated, with full documentation.
    Contents: (1) Saggi introduttivi, (2) Catalogo dei dipinti e delle sculture, (3) Catalogo dei disegni, libri, stampe.

I346    Muraro, Michelangelo, and Grabar, André. Treasures of Venice. Geneva, Skira [1963]. ix, 217p. il. (part col.)
A scholarly study of the arts and culture of Venice by two experts. Large format with the customary Skira wealth of tipped-in plates.
    Contents: (1) The myth of Venice, by M. Muraro, (2) The Byzantine heritage, by A. Grabar, (3) Art as an instrument of power: the ducal palace, by M. Muraro, (4) The flowering of the arts, by M. Muraro. Bibliography, p.213–14; Index, p.215–18.

I347    Paatz, Walter. The arts of the Italian Renaissance: painting, sculpture, architecture. N.Y., Abrams [1974]. 227p. il. (part col.)
Textbook paperback ed.: Englewood Cliffs, N.J., Prentice-Hall [1974].
    A well-organized review of the panorama of the arts of the Italian Renaissance, written by a scholar. Presents a clear summary of ideas, historical background, major types of art, subject matter, characteristics of style. Recommended as an introduction for the student and the general reader.
    Contents: (1) Renaissance: word and idea; (2) Cultural and historical factors; (3) Architecture; (4) Monumental decoration; (5) Sculpture; (6) Painting; (7) The graphic arts; (8) Decorative arts; (9) Ornamental motifs. Notes with bibliographical references; good bibliography.

I348    Pastor, Ludwig, Freiherr von. The history of the popes, from the close of the Middle Ages. Drawn from the secret archives of the Vatican and other original sources. Trans. from the German and ed. by F. I. Antrobus, E. F. Peeler et al. London, Hodges, 1899–1967. 40v.
English trans. of *Geschichte der Päpste seit dem Ausgang des Mittelalters,* 1899–1909. Imprint varies.
    The definitive history of the activities of the popes, from the time of the return of the papacy to Rome (Clement V) to the Napoleonic era (Pius VI). Indispensable for

background and research on the monumental painting, sculpture, and particularly the architecture and city planning in Rome. Index to each volume; general index in v.40.

I349    Ricci, Amico. Memorie storiche delle arti e degli artisti della Marca di Ancona. Macerata, Mancino, 1834. 2v. (Repr.: Bologna, Forni, 1970. (Italica gens, no. 15))
An early history of art and artists in the Marche of Ancona from its beginnings through the 18th century. "Note e documenti" at the end of each chapter; "Indici dei capitoli" at the end of each volume; at end of v.2: "Tavola alfabetica, delle città e terre nominate nell'opera," p.449–75; "Indici degli artisti esteri nominati nell'opera," p.477–91.

I350    Schudt, Ludwig. Italienreisen im 17. und 18. Jahrhundert. Wien, Schroll [1959]. 448p. 129 figs. (Romische Forschungen der Bibliotheca Hertziana, Bd. 15)
This study by the author of *Guide di Roma* (A144) presents a picture of Italy during the 17th and 18th centuries as seen through the eyes of Flemish, German, English, French, Dutch, Scandanavian, and Russian travelers. Based on published descriptions, letters, early guidebooks, etc. The first part is a general history of the travelers; the second part analyzes the facts and impressions by topic: general, landscape, customs, art and aesthetic judgment. Valuable bibliography of sources, p.400–20. "Exkurse," p.420–38, deals with excerpts from documents, collection inventories, etc.

I351    Storia di Milano. [1. ed., Milano] Fondazione Treccani degli Alfieri per la storia di Milano [1953–66]. 17v. il., plates (part col.), map, facsims.
A monumental history of Milan, arranged chronologically. Each volume includes surveys of art, architecture, and the minor arts by recognized authorities. (For example, some of the articles on architecture are by E. Arslan, A. Romanini, and P. Mezzanotte.) Extensive bibliographies; well illustrated (some color). v.17 is a valuable index volume; "Architettura milanese," p.38–50.

I352    Symonds, John Addington. Renaissance in Italy. N.Y., B. A. Cerf, D. S. Klopfer, Modern Library [1935]. 2v.
An early history of the Renaissance, first published in 1875. The first full-scale study of the period in English. Symonds was a man of letters, and this work reflects his personal taste, as well as late 19th-century attitudes towards the Renaissance.
    Contents: (I) The age of the despots; (II) The revival of learning; (III) The fine arts; (IV-V) Italian literature; (VI-VII) The Catholic reaction.

I353    Toesca, Pietro. Storia dell'arte italiana. Torino, Unione Tipografico-Editrice Torinese, 1927–[51]. 2v. in 3. il., plates (part col.) (Storia dell'arte classica e italiana [by Rizzo and Toesca] 3) (Repr. of both vol-

umes, *Il Medioevo* and *Il Trecento*: Torino, Unione Tipografico-Editrice Torinese, 1965.)

A scholarly work, well illustrated. *Il Trecento* (222p.) is the most comprehensive survey of Italian art in the 14th century.

Bibliographical references in notes at ends of chapters and in footnotes. At end of each volume are indexes of artists, places, and things.

I354    Venezia e Bisanzio: Venezia, Palazzo Ducale, 8 giugno-30 settembre 1974/catalogo a cura di Italo Furlan . . . [et al.]; saggio introduttivo di Sergio Bettini. [Milano] Electa [1974]. 222p. il.

The scholarly catalogue of a major exhibition on Byzantine influences in Venetian art from the 4th century on. Each of the 130 entries has a description, bibliographical references, previous exhibitions, and an illustration. Esposizioni citate, p.215; bibliografia, p.216–22.

I355    Venturi, Adolfo. Storia dell'arte italiana. Milano. Hoepli, 1901–40. 11v. in 25 pts. il., plates. (Repr.: Nendeln, Liechtenstein, Kraus-Thomson, 1967.)

A monumental history of Italian art, beginning with the early Christian period and ending with 16th-century painting, sculpture, and architecture. Now most valuable for its many examples and illustrations. A long-needed index (I356) greatly increases its usefulness.

Contents: (1) Dai primordi dell'arte cristiana al tempo di Giustiniano; (2) Dall'arte barbarica alla romanica; (3) L'arte romanica; (4) La scultura del Trecento e le sue origini; (5) La pittura del Trecento e le sue origini; (6) La scultura del Quattrocento; (7) La pittura del Quattrocento. parte 1–4; (8) L'architettura del Quattrocento. parte 1–2; (9) L'architettura del Cinquecento. parte 1–7; (10) La sculture del Cinquecento. parte 1–3; (11) Architettura de Cinquecento. parte 1–2.

I356    _____. _____. Index. Prep. by Jacqueline D. Sisson. Nendeln, Liechtenstein, Kraus-Thomson, 1975.

Anyone who has tried to use the Venturi (I355) as a reference tool indeed welcomes this key to its wealth of illustrations and information. "This new Index to the 11 volumes of Venturi's *Storia dell'Arte Italiana* (q.v.), contains over 92,000 entries divided into two sections. 1.) Cumulative Location Index, giving: city, building, name of artists and title or brief description of work, and illustration numbers; subdivided into the following categories: architectural drawings, architectural ornaments, architecture, drawings, graphics, minor arts, mosaics, paintings and sculpture— thus providing convenient access to a given work. 2.) Artist Index with alphabetical listing of works and, wherever possible, cross references for all variants of an artist's name. Venturi's own table of contents has also been incorporated." — *Pref.*

I357    Viale, Vittorio, ed. Mostra del barocco piemontese, Palazzo Madama, Palazzo Reale, Palazzini di Stupinigi. Catalogo a cura di Vittorio Viale, 1963. Torino. 3v. il. plates (part col.)

A monumental catalogue of a major exhibition of the art of the Piedmont region in Italy. Advances the state of research in Piedmontese art in the fields of architecture, stage design, painting, sculpture, tapestries, the decorative arts, and the minor arts. The material in each medium was prepared by a specialist; general essays, biographies of artists, documented catalogue entries, and bibliography. Lavishly and richly illustrated with photographs, drawings, plans, etc.

Contents: v.1. La mostra, di V. Viale. Le sedi, di M. Bernardi. Architettura, di N. Carboneri. Scenografia, di M. Viale Ferrero; v.2. Pittura, di A. Griseri. Scultura, di L. Mallè. Arazzi, di M. Viale Ferrero; v.3. Mobili e intagli, di V. Viale. Tessuti e ricami, di M. Viale Ferrero. Maioliche. Porcellane, di V. Viale. Argenti, di A. Bargoni. Libri e rilegature, di M. Bersano Begey. Monete e medaglie, di A. S. Fava. Casa di caccia di Stupinigi; itinerario, di G. Grandi. Restauri a Palazzo Reale, di R. Amerio Tardito.

I358    White, John. Art and architecture in Italy, 1250 to 1400. Harmondsworth; Baltimore, Penguin, 1966. 449p. plates, figs., diagrs., map (Pelican history of art, Z28)

A general treatment of the major Italian artists from 1250 to 1400, including painters, sculptors and architects. It is especially helpful for architecture and sculpture, where there is little material in English. Good, clear illustrations and fairly extensive notes, but a rather thin bibliography.

Contents: pt.1. Architecture 1250–1300; pt.2. Sculpture 1250–1300; pt.3. Painting 1250–1300; pt.4. Architecture 1300–1500.

I359    Wittkower, Rudolf. Art and architecture in Italy, 1600 to 1750. 3d rev. ed. Harmondsworth; Baltimore, Penguin [1973]. xxix, 485, 200p. il. (part col.) (The Pelican history of art, Z16)

First published 1958; 2d rev. ed. 1965; 1st paperback ed., based on 3d rev. ed., 1973.

The indispensable survey, handbook, and reference work on Italian art and architecture of the Baroque period, the culmination of a lifetime of primary research in the field. Filled with factual information, brilliant stylistic analyses of major works. Difficult but rewarding for the beginning student. Full documentation in notes and an excellent, up-to-date critical bibliography. Detailed index. Illustrations, plans, projects of all major works.

I360    Wölfflin, Heinrich. Classic art, an introduction to the Italian Renaissance. 2d ed. Trans. by Peter and Linda Murray from the 8th German ed. Introd. by Herbert Read. N.Y., Phaidon, 1952. 296p. 200 il. (Repr.: 1959, 1961)

Originally published in German, 1899; an English ed., by Putnam, 1913, was translated by Walter Armstrong and called the *Art of the Italian Renaissance*. Available in paperback.

A scholarly work on Renaissance classicism by a renowned art historian. After detailed formal analysis of the works of such artists as Leonardo, Michelangelo, Raphael, Fra Bartolommeo, and Andrea del Sarto, the author takes up the problems of the new ideals and attitudes toward beauty and general aspects of the new formal content. Well illustrated.

SEE ALSO: Drudi Gambillo, M., ed. *Archivi del futurismo* (M358).

## Latin America

I361     Angulo Iñiguez, Diego. Historia del arte hispano-americano. Barcelona-Buenos Aires, Salvat, 1945–56. 3v. il., plates (part col.), plans.

The basic reference work dealing with major monuments of Spanish-American architecture and sculpture.

A preliminary chapter on pre-Columbian architecture and decorative art is followed by a survey of the art from the Conquest through the 18th century. Arranged by region within broad chronological divisions. Well illustrated with photographs, drawings, and plans. Bibliography at the end of each chapter of v.1 and 2; bibliography classified by region at the end of v.3.

I362     Castedo, Leopoldo. A history of Latin American art and architecture, from pre-Columbian times to the present. Trans. and ed. by Phyllis Freeman. N.Y., Praeger [1969]. 320p. il. (part col.)

A compressed, informative survey of approx. 3,000 years of art in Latin America. Bibliography, p.297–99.

I363     Catlin, Stanton Loomis, and Grieder, Terence. Art of Latin America since independence. [Rev. ed. New Haven] Yale Univ. Art Gallery and Univ. of Texas Art Museum [1966]. xiv, 246p. 116 plates (part col.)

The catalogue of an exhibition shown at the Yale University Art Gallery, the University of Texas Art Museum and other museums in the U.S. in 1966.

An excellent catalogue of 395 items, including paintings, political caricatures, architectural and mural designs, drawings, and prints produced by Latin American artists in the post-colonial period. Especially useful for the "Biographies" section, p.157–203.

Bibliography, p.205–7.

I364     Chase, Gilbert. Contemporary art in Latin America. N.Y., The Free Pr. [1970]. viii, 292p. il.

An initial attempt to survey critically contemporary art and architecture (c.1920 to c.1970) produced in Latin America. Sparsely illustrated with 24 black-and-white reproductions of works.

I365     Cossió del Pomar, Felipe. Arte del Perú colonial. Dibujos de Emilio Sanchez y Robert Davison. México, Fondo de Cultura Economica [1958]. xix, 253p. il., 110 plates (2 col.), map.

A well-illustrated, critical history of the architecture, sculpture, painting, gold, and minor arts produced in Peru during the colonial period. Bibliographies at the end of each chapter.

I366     Cuarenta siglos de plástica mexicana. [1.ed. en español]. México, Herrero [1969–71]. 3v. il. (part col.), maps, plans.

A lavishly illustrated 3v. survey of the art and architecture of Mexico from their beginnings in prehistoric times to the present. Written by a team of specialists.

Contents, v.1, *Arte prehispánico:* Westheim, Paul. La creación artística en el México antiguo; Ruz, Alberto. El arte antiguo de México en el espacio y el tiempo; Armillas, Pedro. Volumen y forma en la plástica aborigen; Robina,

Ricardo de. Arquitectura prehispánica; Caso, Alfonso. La pintura en Mesoamérica. v.1 published in English as *Prehispanic Mexican art* (I623).

v.2, *Arte colonial:* Maza, Francisco de la. Panorama del arte colonial de México; Pardinas, Felipe. El arte mesoamericano del siglo XVI; Encina, Juan de la. Del barroco europeo al barroco mexicano; Ortiz Macedo, Luis. El siglo XVIII o un nuevo estilo de vida; Moyssén, Xavier. El arte neoclásico.

v.3, *Arte moderno y contemporáneo:* O'Gorman, Edmundo. La historia nacional y el arte; Fernández, Justino. El siglo romántico. El arte de México en siglo XIX; Cardoza y Aragón, Luis. La pintura y la revolución mexicana; Rodríguez Prampolini, Ida. Las expresiones plásticas contemporáneas de México; Mijares Bracho, Carlos G. Arquitectura de nuestro tiempo.

I367     Fernández, Justino. El arte del siglo XIX en México. [2.ed.]. México, Impr. Universitaria, 1967. 256p. 343 il. (incl. ports.), 23 col. plates.

A revision and amplification of the 19th-century material in the author's *Arte moderno y contemporáneo de México* (I368).

A well-illustrated history of Mexican painting, sculpture, architecture, and graphic arts for the period 1810–1910. In three parts: (1) Historia y arte en torno a la Independencia; (2) El arte moderno del siglo XIX; (3) El arte entre los siglos XIX y XX. Bibliography, p.228–32. Bibliographical notes.

I368     ———. Arte moderno y contemporáneo de México. Prólogo de Manuel Toussaint. México, Impr. Universitaria, 1952. xxii, 521p. 581 il., 10 col. pl. (Historia del arte en México. 3)

A comprehensive survey of Mexican arts and architecture of the 19th and 20th centuries. 19th-century sections are revised and amplified in the author's *El arte del siglo XIX en México* (I367). Contents: (1) Historia y arte en torno a la Independencia; (2) El arte moderno del siglo XIX; (3) El arte entre el siglo XIX y el XX; (4) El arte contemporáneo; (5) El arte moderno y contemporáneo y su sentido en la cultura. Bibliography, p.505–12; bibliographical notes.

I369     ———. A guide to Mexican art from its beginnings to the present. Trans. by Joshua C. Taylor. Chicago, Univ. of Chicago Pr. [1969]. 398p. il.

Trans. from *Arte mexicano de sus orígenes a nuestros días,* 2d ed. (Mexico City: Editorial Porrúa, 1961), with additions by the author.

A reliable 1v. history of Mexican architecture, painting, sculpture, graphic art, and folk art. In four sections: (1) Ancient indigenous art; (2) The art of New Spain; (3) Modern art; (4) Contemporary art. "Selected bibliography of works in English and in Spanish," p.194–96. "A brief chronology of modern Mexico," p.389–91.

I370     Fondo Editorial de la Plástica Mexicana. The ephemeral and the eternal of Mexican folk art. México, 1971. 2v. 756p. 690 col. il.

A lavishly illustrated survey of Mexican folk art, presented as a living tradition rather than from an historical perspective.

Contents, v.1: Introduction; Objects from everyday life; Dress and adornments; Mexican toys; Comments on the illustrations. v.2: The roots of Mexico's ceremonial life; The first fiesta; The great god is worshipped with dancing; Our body is a flower; Architecture and painting; Feats of gods and heroes; The golden feathers; The flying ritual; Syncretism in folk art; The tree of life; Rattles and Judases; The noble tiger continues to die; Splendor in costume; The carnival; Fragrance and sweets for our dead; Comments on the illustrations. The commentary on the illustrations is primarily explanatory; dimensions of objects sometimes given.

I371 Historia general del arte mexicano. [Director de la obra: Pedro Rojas. México] Hermes [1962-64]. 3v. il. (part col.), maps.
A beautifully illustrated 3v. survey of the art and architecture of Mexico. Contents: v.1, Época prehispánica, por Raúl Flores Guerrero; v.2, Época colonial, por Pedro Rojas; v.3, Época moderna y contemporánea, por Raquel Tibol.
Bibliographies at the end of each volume.

I372 Kelemen, Pál. Art of the Americas; ancient and Hispanic, with a comparative chapter on the Philippines. N.Y., Crowell [1969]. xiii, 402p. il., maps.
A well-written survey of pre-Columbian and colonial Latin American art and architecture. Bibliography, p.359-61.
Incorporates material from *Medieval American art* (I616).

I373 _____. Baroque and Rococco in Latin America. N.Y., Macmillan, 1951. 302p. 192 plates, map. (Repr.: N.Y., Dover, 1967)
A basic survey of 17th- and 18th-century architecture and art of Central and South America. Classified bibliography, p.279-94.

I374 Mattos, Anibal. História de arte brasileira. Belo Horizonte, Apollo, 1937. 266, 310p. il., plates. (Bibliotheca mineira de cultura. [v.13])
A collective edition of two previously published works: *Das origens da arte brasileira* and *Arte colonial brasileira.*
General, inadequately illustrated studies of the pre-Columbian and colonial art and architecture of Brazil. Bibliography in pt. 1, p.265-66; no bibliography in pt. 2. No indexes.

I375 Pagano, José León. El arte de los argentinos. Buenos Aires, Edición del autor, 1937-40. 3v. il. (incl. plans), 33 col. plates.
A general work on Argentine art, with emphasis on modern painting. v.1 includes a chapter on the art of the Jesuit foundation and a section on architecture.
Contents: t.1, Desde los aborigenes hasta el período de los organizadores; t.2, Desde la acción innovadora del "nexus" hasta neustros días; t.3, Desde la pintura en Córdoba hasta las expresiones mas recientes; pintura, escultura, grabado. Indexes at end of each volume.

I376 Schiaffino, Eduardo. La pintura y la escultura en Argentina, 1783-1894. Buenos Aires, Edición del autor, 1933. 418p. 144 il., plates.

The introduction is a survey of colonial art in Latin America, followed by a discussion of 19th-century native and visiting artists. Valuable for the personal recollections and anecdotes of the author, a late 19th-century painter. No bibliography; some bibliographical references in the footnotes.

I377 Toussaint, Manuel. Colonial art in Mexico. Trans. and ed. by Elizabeth Wilder Weismann. Austin, Univ. of Texas Pr. [1967]. xxvi, 493p. il., map, plans, col. plates, ports. (Texas Pan-American series)
Trans. of *Arte colonial en México,* 2d ed., México, Impr. Universitaria, 1962.
The standard history of colonial painting, sculpture, architecture, and the minor arts in Mexico. Well illustrated. Contents: pt. 1, Art in New Spain at the time of the conquest, the middle ages in Mexico, 1519-50; pt. 2, Art during the colonization of New Spain, the Renaissance in Mexico, 1550-1630; pt. 3, Art in New Spain during the formation of the nation, the Baroque style in Mexico, 1630-1730; pt. 4, Pride and wealth, the climax of the Baroque in Mexico, 1730-81; pt. 5, Art and the independence of Mexico, neoclassic art, 1781-1821.
Bibliography, p.461-76.

SEE ALSO: Dorta, E. M. Arte en América y Filipinas, v.21 of *Ars Hispaniae* (I438). Kubler, G. A. and Soria, M. *Art and architecture in Spain and Portugal and their American dominions* (I450).

## Low Countries

There are several local topographical inventories of the provinces and cities of Belgium. The following regions have inventories: Antwerp, 1902-40; Brabant, 1904-12; Gand (Ghent), 1897-1915; Hainaut, 1923-41; Liège, 1911-30; Limbourg, 1916-35; Oostvlaanderen (East Flanders), 1911-15, 1951- ; West-Vlaanderen (West Flanders), 1965-. For the titles and holdings of the inventories in progress (excepting the inventory of West-Vlaanderen), see Ehresmann, *Fine arts* (A35), p.205-6.

I378 Dehaisnes, Chrétien César Auguste. Histoire de l'art dans la Flandre, l'Artois et le Hainaut avant le XVe siècle. Lille, Quarré, 1886. viii, 665p. 15 plates. (Repr.: N.Y., Collectors Editions, 1971.)
An older, comprehensive history of art in Flanders, and the historical French and Flemish regions of Artois and Hainaut. The study is divided into two main parts, from the invasion of the Barbarians to the Crusades, and from the Crusades to the 15th century.
"Table analytique de l'ouvrage" at the end is a detailed table of contents. "Table des matières" is the index. "Table des noms des artistes et des fournisseurs d'objets d'art" is also at the end.

I379 Detroit. Institute of Arts. Flanders in the fifteenth century: art and civilization; catalogue of the exhibition Masterpieces of Flemish art: Van Eyck to Bosch organized by the Detroit Institute of Arts and the city of Bruges. The Detroit Institute of Arts, October-

December, 1960. [Detroit, published jointly by the Detroit Institute of Arts and the Centre National de Recherches "Primitifs flamands," Brussels, 1960]. 467p. il. (part col.), col. map.

The American ed. of the catalogue of a major exhibition held in Bruges and Detroit. The categories exhibited were: painting, drawings and woodcuts, sculpture, metalwork, goldsmith's work, arms and armor, textiles, furniture, glass and stained glass, historical documents, and illuminated manuscripts. Scholarly entries by an international group of specialists. The extensive bibliography is divided into two parts: an alphabetical listing of the references cited in the entries, and a list of the catalogues of museums, exhibitions, and sales arranged by date of publication.

I380    Fokker, T. H. Werke niederländischer Meister in den Kirchen Italiens. Haag, Nijhoff, 1931. 156p. 15 plates. (Studien van het Nederlandsch Historisch Instituut te Rome. I)

An inventory of Dutch and Flemish paintings and sculpture in Italian churches, with notes on the artists.

"Künstlerregister," p.4-67, gives biographical material on artists arranged in dictionary form. "Inventar der Kunstwerke," p.68-150, is a listing by place of the works of art, with bibliographical references. Bibliography, p.151-56.

I381    Gelder, Hendrik Enno van, and Duverger, J. Kunstgeschiedenis der Nederlanden van de Middeleeuwen tot onze tijd. Utrecht, W. de Haan, 1954-55. 2v. il., col. plates.

A general history of Dutch and Flemish art from the medieval period to modern times. Consists of articles written by various scholars. Halftone illustrations in text and color plates.

Contents: v.1, De Middeleeuwen de zestiende eeuw; v.2, Van het cinde van de zestiende eeuw tot onze tijd in Noord-Nederland.

I382    Gerson, Horst, and Kuile, E. H. ter. Art and architecture in Belgium, 1600 to 1800. [Trans. from the Dutch by Olive Renier. Harmondsworth; Baltimore] Penguin [1960]. xix, 236p. 160 plates (incl. ports.) (The Pelican history of art, Z18)

The standard history of Flemish art of this period. Includes separate chapters on Rubens, Van Eyck, and Jordaens.

Contents: pt. 1, Architecture and sculpture by E. H. ter Kuile (p.9-42); pt. 2, Painting by H. Gerson. Notes; full scholarly bibliography with occasional critical annotations by H. Gerson.

I383    Knipping, John Baptist. Iconography of the Counter Reformation in the Netherlands: Heaven on earth. Nieuwkoop, De Graaf; Leiden, Sijthoff, 1974. v2. il.

Trans. of *De iconografie van de contra-reformation in de Nederlanden*. 1st Dutch ed., 1939-42.

A fundamental study of Christian iconography of the Low Countries, in the tradition established by Panofsky and the historians of the Warburg Institute. Important not only for the Netherlands but for other European countries. 472 illustrations in the text.

"The English version and thorough remodelling of the Dutch edition of this book ... contains several altered opinions and views concerning the whole and also quite a number of details. More attention is paid to artistic trends outside the Low Countries and to the artistic and cultural trends discovered outside the Low Countries and to the development of a few themes during the following centuries." — *Introd.*

Contents arranged by theme: v.I: (1) The Netherlands and the Counter Reformation; (2) Humanism; (3) The new asceticism; (4) The new devotion; (5) The Bible. v.II: (6) The saint in cult and culture; (7) Christian love and life; (8) The militant church; (9) Form and content; (10) The great stream of tradition. Bibliography, v.II, p.497-503; detailed index, p.515-39.

I384    Kunstreisboek voor Nederland in beeld. Foto's Herman Hessler, Hadamer Jeiter, Ursula Pfistermeister, e.a. Amsterdam, Van Kampen, 1972, 368p. il.

The Dutch equivalent of Dehio (I296). Arranged by region.

I385    Leurs, Stan, ed. Geschiedenis van de Vlaamsche kunst, met de mederwerking van prof. dr. Arthur H. Cornette, dr. Marthe Crick-Kuntziger [en anderen] ... onder leiding van prof. dr. ir. Stan Leurs. Antwerpen, Uitgeverij "De Sikkel," 1936-39. 2v. il. (incl. plans), col. plates.

The standard general history of Flemish art. Includes architecture, sculpture, and painting, Well illustrated.

Bibliographies at ends of chapters. Index at end of v.2 is divided into names, p.954-61, and buildings, p.962-70. List of illustrations at end of each volume.

I386    De Nederlandse monumenten van geschiedenis en kunst. Utrecht, Oosthoek, 1912- . 16v. to date.

The official inventories of art and architecture in the Netherlands, written by recognized authorities. Ed. by the Royal Commission for the Description of Monuments of History and Art.

Published so far: (1) De provincie Noordbrabant. pt. 1, De monumenten in de voormalige baronie van Breda; (2) De provincie Utrecht. pt. 1, De gemeente Utrecht, pt. 2, De Dom van Utrecht; (3) De provincie Gelderland. pt. 1, Het kwartier van Nijmegen (2v.), pt. 2, Het kwartier van Zutphen; (4) Die provincie Overijsel. pt. 1, Twente; pt. 2, Zuid-Salland; (5) Die provincie Limburg. pt. 1, Gemeente Maastricht, pt. 2, Noord-Limburg, pt. 3, Zuid-Limburg; (6) De provincie Groningen. pt. 1, Oost-Groningen; (7) Die provincie Zuidholland. pt. 1, Leiden en westelijk Rijnland; (8) De provincie Noordholland. pt. 1, Waterland, en Omgeving, pt. 2, Westfriesland, Tessel en Wieringen.

I387    Netherlands Rijkscommissie voor de monumentenzorg. Voorloopige lijst der Nederlandsche monumenten van geschiedenis en kunst. Utrecht, Leijdenroth van Boekhoven, 1909-33. 11v. in 13.

An inventory and description of Dutch monuments of history and art before 1850. Largely supplanted by *De Nederlandse monumenten van geschiedenis en kunst* (I386), in progress.

Contents: (1) Utrecht; (2) Drente; (3) Zuidholland; (4) Gelderland; (5) v.1 Noordholland (uitgezonderd Amsterdam), v.2 De Gemeente Amsterdam; (6) Zeeland; (7) Overijsel; (8) Limburg (2v.); (9) Friesland; (10) Noordbrabant; (11) Groningen.

I388    Rosenberg, Jakob; Slive, Seymour; and Kuile, E. H. ter. Dutch art and architecture, 1600 to 1800. Harmondsworth; Baltimore, Penguin [1966]. xxiii, 329p. il., 209 plates (1 col.), map. (Pelican history of art, Z27)

Paperback ed.: Harmondsworth, Penguin [1972].

A standard, authoritative history of 17th- and 18th-century Dutch art. Painting is organized by major artist and by genre.

Contents: pt. 1, Painting: 1600–75, by J. Rosenberg and S. Slive; pt. 2, Painting: 1675–1800, by J. Rosenberg and S. Slive; pt. 3, Architecture, by E. H. ter Kuile; pt. 4, Sculpture, by E. H. ter Kuile. Good bibliography, p.279–308, with helpful critical annotations.

I389    Timmers, J. J. M. A history of Dutch life and art. Trans. by Mary E. Hedlund. London; N.Y., Nelson, 1959. 201p. il., ports., col. map.

An excellent introductory survey of Dutch civilization and art from its origins to modern times. Profusely illustrated; includes pictures of many lesser-known works. Index. No bibliography.

I390    Tovell, Ruth Massey. Flemish artists of the Valois courts; a survey of the fourteenth- and early fifteenth-century development of book illumination and panel painting at the courts of the princes of the house of Valois . . . including a chapter on the sculptor, Claus Sluter, and a discussion of the Ghent altarpiece . . . together with other early works of Jan van Eyck. [Toronto] Univ. of Toronto Pr., 1950. xviii, 157p. il. (part col.), map.

An excellent review of the early Netherlandish art commissioned by the princes of the House of Valois. Introduced by a succinct historical survey of medieval Flanders. Easy to read, adequately illustrated; recommended an an introduction for college students.

Appendix A. The Renders thesis, p.115–26. Appendix B. Genealogical table, p.127–28. Notes, p.129–40, Map, p.141, Bibliography, p.143–50, Index of works of art, p.151–53, General index, p. 154–57.

I391    Waal, H. van de. Drie eeuwen vaderlandsche geschieduitbeelding, 1500–1800; een iconologische studie. 's Gravenhage, Nijhoff, 1952. 2v. il., 120 plates.

A brilliant study of the historical iconography of the Dutch school during the period 1500–1800. "It not only describes the way Dutch artists represented events from the history of their own nation, but it also provides an enlightening discussion of the exotic, classical, and religious imagery they adopted to express things not appearing before in works of art." Not treated strictly from the art historical viewpoint but as "the interpenetration between art, politics, moral

philosophy, historical thinking, literature and religion." — Review by Jan Białostocki, *Art Bulletin,* v.53, no. 2, June, 1971, p. 263.

Includes English summaries and translations of captions to plates and text illustrations. Contents: (1) The representation of historical events; (2) Relationship between the historiography and Christian typology; (3) Artistic treatment of historical subjects according to the Renaissance art doctrine; (4) Historical elements in 16th- and 17th-century Dutch art; (5) Nonhistorical or nonnational elements in Dutch visual representation of history; (6) The first attempts at portraying the past; (7) The past as a primitive period; (8) The past as an heroic period; (9) Pseudo-historical representation.

SEE ALSO:  Osten, G. von der, and Vey, H. *Painting and sculpture in Germany and the Netherlands 1500 to 1600* (I223).

## Russia and Eastern Europe

I392    Akademiiā nauk SSSR. Institut istorii iskusstv. Geschichte der russischen Kunst. [Redaktion I. E. Grabar, W. N. Lasarew und W. S. Kemenow. Übersetzt von Kurt Küppers. Hrsg. mit Unterstützung des Kulturfonds der Deutschen Demokratischen Republik]. Dresden, Verlag der Kunst, 1957–70. 5v. il. (part col.), plans.

The most comprehensive history in a non-Russian language of Russian art and architecture from their beginnings through the first half of the 18th century. A partial translation of *Istoriiā russkogo iskusstva* (I393). Very well illustrated. Each volume contains a classified bibliography. Bibliographical references in footnotes.

Contents, v.1, 1957: (I) Die älteste Kunst Osteuropas; (II) Die Kunst der alten Slawen; (III) Die Kunst der Kiewer Rus; (IV) Die Kunst der westrussischen Fürstentümer; (V) Die Kunst der Wladimir-Susdaler Rus; v.2, 1958: (I) Die Kunst Nowgorods; (II) Die Kunst Pskows; v.3, 1959: (I) Die Kunst der zentralrussischen Fürstentümer im 13. bis 15. Jahrhundert; (II) Die Kunst des grossfürstlichen Moskaus; (III) Die Kunst des russischen zentralisierten Staates; v.4, 1965: (I) Das 17. Jahrhundert und seine Kultur; (II) Architektur und Bauschmuck im 17. Jahrhundert; (III) Schnitzerei und Plastik des 17. Jahrhunderts; (IV) Malerei, Miniaturmalerei und Graphik des 17. Jahrhunderts; (V) Die angewandte Kunst im 16. und 17. Jahrhundert; (VI) Überblick über die Entwicklung der altrussischen Kunst; v.5, 1970: (I) Die russische Kunst in der ersten Hälfte des 18. Jahrhunderts; (II) Architektur; (III) Malerei und Graphik; (IV) Die Bildhauerkunst in der ersten Hälfte des 18. Jahrhunderts; (V) Die angewandte Kunst in der ersten Hälfte des 18 Jahrhunderts.

I393    _____. _____. Istoriiā russkogo iskusstva. Pod obshchei red. I. E. Grabaria, V. N. Lazareva, V. S. Kemenova. Moskva, Akademiiā Nauk SSSR, 1953–68. 13v. in 16. il., plates (part col.), plans.

"Revised and enlarged edition of Grabar's history of 1909–16 [I404]. Indispensable for contemporary Soviet scholar-

ship." — Hamilton, I406, p.318. Covers architecture, painting, sculpture, decorative arts, and folk art.

Extensive, classified bibliographies at the end of each volume. Bibliographical references included in the footnotes.

I394 Alpatov, Mikhail Vladimirovich, and Brunov, Nikolai. Geschichte der altrussischen Kunst. With a new preface in English by the authors. N.Y., Johnson Reprint, 1969. xx, 423, 137p. il., plans, plates. (Repr. of the ed. published in Augsburg by B. Filser in 1932.)
A standard, scholarly history of Russian architecture, by N. Brunov, and Russian painting and sculpture, by M. Alpatov, from their beginnings through the 17th century.

Bibliography at the end of each chapter. Index of names, places, and subjects, p.414-23.

I395 Bachmann, Erich. Romanik in Böhmen. Geschichte, Architektur, Plastik, Malerei, Kunstgewerbe. Hrsg. von Erich Bachmann. [Mitarb.: Karl Schwarzenberg, Erich Bachmann, Jiri Mašin, Hermann Fillitz]. München, Prestel [1977]. 312p. 150 il., 6 col. plates, 25 plans.
Scholarly essays on Romanesque art in Bohemia accompany sections of excellent reproductions of works. References included in notes. Also includes a general bibliography and an index of names and places.

I396 Białostocki, Jan. The art of the Renaissance in Eastern Europe: Hungary, Bohemia, Poland. Ithaca, N.Y., Cornell Univ. Pr. [1976]. xxiv, 312p. 351 il., 5 col. plates. (The Wrightsman lectures, v.8)
Based on the author's series of lectures delivered under the auspices of the Institute of Fine Arts of New York Univ., this volume comprises the first overall survey of the Renaissance style in Hungary, Bohemia, and Poland. "It is not within the scope of this book to publish unknown works of art or to solve the detailed art-historical problems of eastern Europe. The book is rather an endeavour to draw a coherent image of the main trends and achievements of the east European Renaissance considered as a whole . . . Our attention will go first of all to the Renaissance understood as a 'style' rather than a period of history or a humanistic outlook." — *p.[1]*.

Contents: Some important dates in the history of Eastern Europe, p.[xx]-xxi; (1) Humanism and early patronage; (2) The castle; (3) The chapel; (4) The tomb; (5) The town; (6) Classicism, Mannerism and vernacular.

Notes, p.[89]-102, include references. Extensive bibliography, p.[281]-306.

I397 Bihalji-Merin, Oto, ed. Art treasures of Yugoslavia. Texts by Milutin Garašanin [et al.]. N.Y., Abrams [1972]. 445p. il. (part col.)
A series of essays by 18 contributors which "attempts, probably for the first time, to provide a condensed chronological and geographical survey of art in what is today Yugoslavia." — *p.15*. Contents: (I) Horizons, limits, and boundaries; (II) Lepenski Vir; (III) The Neolithic age; (IV) Art in the age of metals; (V) The art of antiquity; (VI) Mosaics of antiquity; (VII) Art during the great migrations; (VIII) Medieval wall painting and architecture in Serbia and Macedonia; (IX) The icons of Serbia and Macedonia; (X) Illuminated manuscripts; (XI) The Romanesque; (XII) The Gothic; (XIII) Medieval tombstones (*Stećci*); (XIV) Islamic architecture and decorative art; (XV) The Renaissance; (XVI) The Baroque; (XVII) The 19th century; (XVIII) The architecture of the 20th century; (XIX) The 20th century.

Very well illustrated with 460 black-and-white and color plates, and line drawings and plans in the texts. Classified bibliography, p.427-34. General index.

I398 Bunt, Cyril George Edward. Russian art from Scyths to Soviets. London and N.Y., Studio [1946]. 272p. plates (part col.)
Also published as *A history of Russian art,* London and N.Y., Studio [1946].

A very compact history of Russian art and architecture. Bibliography, p.268.

I399 Filov, Bogdan Dĭmĭtrov. Early Bulgarian art. Berne, Haupt, 1919. 86p. 72 il., 58 plates (10 col.)
A brief survey of Bulgarian architecture, painting, and applied art covering the first Kingdom of Bulgaria (679-1018), the second Kingdom of Bulgaria (1186-1393), and the Turkish period (1393-1878). Revised slightly and coverage extended to 1930 in the author's *Geschichte der altbulgarischen Kunst bis zur Eroberung des bulgarischen Reiches durch die Türken* (I400) and *Geschichte der bulgarischen Kunst unter der türkischen Herrschaft und in der neueren Zeit* (I401).

I400 _____. Geschichte der altbulgarischen Kunst bis zur Eroberung des bulgarischen Reiches durch die Türken. Berlin and Leipzig, de Gruyter, 1932. 100p., incl. plans. 48 plates on 24 l. (Grundriss der slavischen Philologie und Kulturgeschichte [10])
A survey of Bulgarian architecture, painting, and applied arts from 679 to 1393 (first and second kingdoms). Bibliographies at the ends of chapters.

I401 _____. Geschichte der bulgarischen Kunst unter der türkischen Herrschaft und in der neueren Zeit. Berlin and Leipzig, de Gruyter, 1933. 94p. 64 plates. (Grundriss der slavischen Philologie und Kulturgeschichte [10])
A survey of Bulgarian architecture, painting, and applied arts from 1393 to 1930. Bibliographies at the ends of chapters.

I402 Gerevich, László. The art of Buda and Pest in the Middle Ages. [Trans. by L. Halpay]. Budapest, Akadémiai Kiadó, 1971. 146p. il. (plans, line drawings), 379 il. on 140 plates.
A scholarly re-evaluation of the art of medieval Budapest, based largely upon archaeological evidence recently excavated. "The art of mediaeval Budapest is not merely the art of a town in the Middle Ages, in the strict sense of the term, but that of a focal centre of the Carpathian Basin and, in a broader sene, of Central Europe . . ." — *Introd., p.7.* Extensive documentation and references in footnotes. Excellent illustrations.

Contents: Introduction; (1) Architecture of the first settlements; (2) The architecture of Buda and Pest before

the Mongol invasion of Hungary; (3) Reconstruction and the spread of the Gothic style; (4) The 14th-century town and its art; (5) The court of King Sigismund and the role of the new bourgeoisie in art; (6) 'Opus Regis Matthiae" and the style of the 16th century. "List of plates," p.139–46, includes commentary.

I403  Gieysztor, Aleksander; Walicki, Michał; and Zachwatowicz, Jan. Sztuka polska przedromańska i romańska do schyłku XIII wieku. [Polish art of the Pre-Romanesque and Romanesque periods to the end of the 13th century]. Warszawa, Państwowe Wydawnictwo Naukowe, 1971. 2v. 915p. 1,256 il. (8 col.), 123 text figs., plans, elevations, maps. (Dzieje sztuki polskiej, 1)

"A comprehensive history of art and architecture in the territories of Poland from late antiquity to the second half of the 13th [century]. The five chapters, dealing with prehistoric remains, and urbanism, architecture, sculpture, painting and decorative art in the Polish state (10th–13th [centuries]) include almost all significant works of art which have survived, many of which are archaelogical discoveries of the last few years."—S. Mossakowski, *RILA*, Demonstration issue, 172. Contents and list of illustrations also in English and Russian.

I404  Grabar', Igór Emmanuēlovĭch. Istoriīa russkago iskusstva. Moskva, Knebel' [1909–16]. 6v. il., plates (part col.)

An older, basic history of Russian art and architecture. "Grabar's monumental history, although interrupted by World War I and superseded by the new enlarged edition [see I393], remains indispensable for the clarity of the reproductions."—Hamilton, I406, p.317.

Contents: v.1, Architecture up to the time of Peter the Great; v.2, Architecture of Moscow and the Ukraine up to the time of Peter the Great; v.3, Architecture of St. Petersburg in the XVIII and XIX centuries; v.4, Moscow architecture in the Baroque and classical periods. Russian architecture after the classical period (p.1–104 only of v.4, 1914, published); v.5, Sculpture, by Baron N. N. Wrangell; v.6, Painting up to the time of Peter the Great. No more published. Table of contents at the end of each volume.

I405  Gray, Camilla. The great experiment: Russian art, 1863–1922. London, Thames & Hudson; N.Y., Abrams [1962]. 326p. 257 il. (part col.)

Reissued in reduced format as *The Russian experiment in art, 1863–1922.* London, Thames & Hudson, and N.Y., Abrams [1970]. The 1970 ed. omits sections of artists' statements and biographies and does not include the Russian language bibliography.

The most comprehensive study of the avant-garde movements of Russian art from the "Wanderers" to the Constructivists. Based on an extensive examination of unpublished material, artists' memoirs and writings, and widely dispersed works of art.

Artists' statements, p.281–87; Biographies of the artists, p.288–96. Excellent bibliography in two parts: bibliography in Western languages, p.297–999; bibliography in Russian

language, p.300–6. Text references, p.307–9 include bibliographical references.

I406  Hamilton, George Heard. The art and architecture of Russia. [2d ed. Harmondsworth; Baltimore, Penguin [1975]. xxiv, 342p. 180 plates, map, plans. (The Pelican history of art. Z6)

1st ed. 1954.

A scholarly, well-documented survey of Russian architecture, painting and sculpture "intended as a history of the formal structure of a national art, rather than as an exercise in criticism."—*Foreword*. Covers the art created in European Russia by Russian artists from Christianization in 988 to 1917. Does not include enamels, embroidery, or folk arts. The basic work for the English-speaking reader.

Contents: pt. 1, Kievan Russia; pt. 2, Icon painting; pt. 3, The art of Muscovy; pt. 4, St. Petersburg; pt. 5, Modern Russian art. Numerous references in "Notes," p.285–316, including the principal Russian sources. Bibliography, p.317–22, cites works in Western European languages and Russian works for their illustrations, bibliographies, or summaries of recent research.

I407  Hare, Richard. The art and artists of Russia. London, Methuen [1965]. 294p. 178 il., 32 col. plates.

A sound introductory survey of Russian art from the founding of Orthodox Christianity in the 10th century A.D. to the fall of the Russian Empire in the 20th century. Does not include architecture or monumental sculpture.

Contents: (1) Icons and the Byzantine tradition; (2) Religious and secular silver, and artistic work in precious metals; (3) The birth of Russian portrait painting; (4) Porcelain of the Russian Empire; (5) Painters of the early 19th century; (6) Painters of the later 19th and early 20th centuries; (7) Some distinctive Russian decorative arts.

I408  Kampis, Antal. The history of art in Hungary. [Trans. by Lili Halápy. Budapest] Corvina Pr. [published in cooperation with Collet's, London, 1966]. 399p. il.

Trans. of *A magyar művészet története.*

A well-illustrated, concise history of art in Hungary from the Magyar conquest (9th-10th centuries) to the mid-20th century.

List of plates, p.371–83. Indexes of artists and places. No bibliography.

I409  Korin, Pavel Dmitrievich. Drevnerusskoe iskusstvo v Sobranii Pavla Korina. [By] V. I. Antonova. Moscow [1966]. 186p. 161 plates (part col.)

Text in Russian. List of illustrations also in French, German, English, and Spanish.

The catalogue of the Korin collection of Russian art, now in the Tretyakov Gallery, Moscow. The collection includes icon paintings, liturgical objects, and wooden sculpture from the 12th through the 19th centuries. Contains an introductory essay on the collection (p.7–[22]) and a detailed catalogue, with full descriptions and references. 161 works are illustrated.

I410  Németh, Lajos. Modern art in Hungary. [Budapest, Corvina, 1969]. 187p. il., 142 plates, 36 col. plates.

A survey of 20th-century Hungarian art against the mainstream developments of modern European art. Bibliography, p.171-72. Index of artists, p.183-87.

I411 Neumann, Jaromír. Das bömische Barock. [Ins Deutsche übertragen von Hans Gaertner unter Mitarbeit des Autors]. Hannover, Fackelträger [1970]. 293p. 360 plates.
Trans. of Česky barok.
  Primarily a visual survey of Baroque art and architecture in Bohemia. Includes introductory essays on general topics and on each of the major arts, with commentary on the 360 plates. Contents: Die Kunst des Barocks und unsere Zeit; Das Barock und die böhmischen Länder; Das Barock als Stil und Epoche; Die Architektur; Die Plastik; Die Malerei; Die Eigenart des böhmischen Barocks.
  General index.

I412 Oprescu, George, ed. Istoria artelor plastice în România. Redactată de un colectiv sub êngrijirea Acad. Prof. George Oprescu. [Colectiv de autori: Virgil Vătășianu, et al]. București, Meridiane, 1968-70. 2v. il. (part col.), plates, plans.
A comprehensive history of Rumanian art, including painting, sculpture, folk arts, architecture, manuscripts, embroidery, gold, icons, and furniture from neolithic times to the 19th century. Written by a team of experts. Contains an index and summary of both volumes in v.2, p.253-[300].
  Contents, v.1, Originile artei-sfîrșitul secolului al XVI-lea. Bibliography, p.429-46; v.2, Arta pe teritorul României de la începutul secolului al XVIII-lea pînă în primele decenii ale secolului XIX-lea. Bibliography, p.214-[22].

I413 Petrov, Petr Nikolaevich, ed. Sbornik materialov dlīa istorii I. S.-Peterburgskoĭ akademii khudozhestv za 100 let. S.-Peterburg, 1864-66. 3v. tables.
A history of the Russian Academy over a 100-year period.

I414 Radojčić, Svetozar. Geschichte der serbischen Kunst; von den Anfängen bis zum Ende des Mittelalters. [Übersetzung von Dagmar Burkhart]. Berlin, de Gruyter, 1969. vi, 126p., il., 65 plates (Grundriss der slavischen Philologie und Kulturgeschichte. Bd. 16)
A brief, scholarly history of Serbian art from its beginnings through the 15th century.
  Contents: Einleitung; Die älteste serbische Kunst bis zum Ende des 12. Jahrhunderts; Die Anfänge der monumentalen Kunst in Raszien; Der reife raszische Stil (1200-1300); Der serbische Kunst vom Ende des 13. Jh. bis zur Schlacht an der Marica (1371): (A) Die serbische Kunst während der Herrschaft von König Milutin (1300-21), (B) Die serbische Kunst von Tod König Milutins bis 1371; Die Kunst des Morava- und Donaugebiets von 1371 bis 1459.
  Bibliography in "Abkürzungen," p.[viii].

I415 Réau, Louis. L'art russe. Paris, Laurens, 1921-22. 2v. il., plates. (Repr.: Verviers, Gerard, 1968.)
A standard, general history of Russian art. "Admirably ordered, but written with a pronounced French bias."—Ham-

ilton, I406, p.295. Contents: v.1, Des origines à Pierre le Grand; v.2, De Pierre le Grand à nos jours.
  "Bibliographie de l'art russe ancien," v.1, p.[365]-71; "Bibliographie de l'art russe moderne," v.2, p.[271]-77.
  "Index des noms propres," v.1, p.[372]; "Lexique d'archéologie et d'iconographie russes," v.1, p.[373]-87; "Vocabulaire de l'art russe moderne," v.2, p.[278]-86; "L'art russe dans les musées français," v.2, p.[287].
  The author's L'Art russe, Paris, 1945 (I416), is an updated, 1v. summary of this 2v. work.

I416 _____. _____. Paris, Larousse [1945]. 138p. 64 plates. (Arts, styles et techniques)
A general survey in outline form which updates and summarizes the author's 1921-22 work (I415). Biographical descriptions of the principal artists cited, p.126-31. Bibliography, p.132-35.

I417 Rice, Tamara (Abelson) Talbot. A concise history of Russian art. N.Y., Praeger [1967]. 288p. il. (part col.), map, plans.
A popular, compact history of Russian arts and architecture from the 10th century through the early 20th. "Some significant dates," p.270-71, is a chronology (860-1917). Short unclassified bibliography, p.272-73.

I418 Swoboda, Karl Maria. Barock in Böhmen. Hrsg. von Karl M. Swoboda. Die Architektur und Plastik von Erich Bachmann. Die Malerei von Erich Hubala. Das Kunstgewerbe von Hermann Fillitz und Erwin Neumann. München, Prestel [1964]. 359p. 210 il., plans.
A series of scholarly essays on Baroque art and architecture in Bohemia; each essay is followed by a section of plates.
  "Tafelverzeichnis" gives description and commentary on each of the 210 plates. "Anmerkungen," p.336-45, include bibliographical references. "Namen- und Ortsregister."

I419 _____. Gotik in Böhmen. Geschichte, Gesellschaftsgeschichte, Architektur, Plastik und Malerei. Hrsg. von Karl M. Swoboda. [Mitarb.: Karl Schwarzenburg [u.a.] (Fotos: Werner Neumeister.). München, Prestel [1969]. 487p. il. (part col.), plans, map.
Abridged English ed.: Bachmann, Erich, ed., Gothic art in Bohemia, N.Y., Praeger, 1977.
  A series of scholarly essays on Gothic art and architecture in Bohemia; each essay is followed by a section of plates.
  Contents: Schwarzenberg, Karl. Zur Geschichte Böhmens im Zeitalter der Gotik; Seibt, Ferdinand. Zur Gesellschaftsgeschichte; Bachmann, Erich. Architektur bis zu den Hussitenkriegen; Bachmann, Erich. Plastik bis zu den Hussitenkriegen; Schmidt, Gerhard. Malerei bis 1400: Tafelmalerei - Wandmalerei - Buchmalerei; Fehr, Götz. Architektur der Spätgotik; Salm, Christian. Malerei und Plastik der Spätgotik. "Tafelverzeichnis," p.399-413, gives technical information and descriptions (including inscriptions) and commentary, with references, on each work reproduced. "Anmerkungen," p.414-[39], include references. Bibliographie, p.450-[63]. "Namen- und Ortsregister."

I420   Wulff, Oskar K. Die neurussische Kunst im Rahmen der Kulturentwicklung Russlands von Peter dem Grossen bis zur Revolution. Augsburg, Filser [1932]. 2v. plates.
A standard work. "Art in relation to the history of the period." — Hamilton, I406, p.296. Contents: Bd. 1, Textband; Bd. 2, Tafelband.
   "Literaturverzeichnis," v.1, p.[350]. "Quellennachweis der entlehnten Abbildungen," v.1, p.[351]-55. "Namenregister," v.1, p.[356]-61.

SEE ALSO: Hempel, E. *Baroque art and architecture in Central Europe* (I216); the section in Histories and Handbooks: Oriental Countries—Central Asia (I498-I507).

## Scandinavia

I421   Adama van Scheltema, Frederik. Die altnordische Kunst; Grundprobleme vorhistorischer Kunstentwicklung. Berlin, Mauritius, 1923. 252p. il., plates.
A study of early Nordic art forms, including pottery, metalwork, etc. Contents: (1) Vom Anfang der Kunst; (2) Die Form der Steinzeit; (3) Die Form der Bronzezeit; (4) Die Form der Eisenzeit; (5) Grundprobleme der altnordischen Kunstentwicklung. Das mechanische und das organische Formprinzip. Bibliographical references in footnotes. No bibliography. No index.

I422   Alfons, Sven, and Lindwall, Bo. Svensk konströnika under 100 år. Redaktion och inledning: Ragnar Josephson. Stockholm, Natur och Kultur [1944]. [427], 19p. il., col. plates.
A generously illustrated survey of painting, sculpture, and architecture in Sweden for the period 1843-1943.
   "Person-och illustrationsregister" of 8p. at end; "Generationsregister" of 3p. is a chronology; "Motivregister" of 8p.

I423   Anker, Peter, and Andersson, Aron. The art of Scandinavia. London and N.Y., Hamlyn [1970]. 2v. (v.1, 452p.; v.2, 393p.), il.
First published in French ed.: *L'Art scandinave,* 1968-69.
   A beautifully illustrated history of the art of Denmark, Norway, and Sweden from c.400 A.D. to c.1200.
   Contents, v.1: The historical background; The development of the early Scandinavian animal style; The great monuments of the Viking age: Oseberg, Jelling, and the Danish fortresses; Figurative art of the early Scandinavian and Viking ages; The stave churches; The origin and development of the Norwegian stave churches and their sculpted portals. Bibliography, p.11-15. v.2: Churches; Wall paintings; Sculpture; Metalwork; Wrought iron; Tapestries. Bibliography, p.7-9.

I424   Beckett, Francis. Danmarks Kunst. København, Koppel, 1924-27. 2v. il.
A general history of Danish art·and architecture from the earliest forms through the Gothic period. Contents: v.1, Oldtiden og den aeldre middelalder; v.2, Gotiken.

Each volume contains "Henvisninger" (notes with bibliographical references), and an index of names.

I425   Cornell, Henrik. Den svenska konstens historia. 2d ed. Stockholm, Aldus/Bonnier, 1966. 2v. il.
1st ed. 1944.
The standard general history of Swedish painting, sculpture, architecture, and the graphic arts from their beginnings to about 1800. Well illustrated.
Bibliography, p.421-32, arranged by chapters. Indexes of names, places, monuments.

I426   Laurin, Carl; Hannover, Emil; and Thiis, Jens. Scandinavian art; illustrated. With an introd. by Christian Brinton. N.Y., The American-Scandinavian Foundation, 1922. 662 p. il. (Scandinavian monographs, V) (Repr.: N.Y., Blom, 1968.)
A useful work on various areas of Swedish, Danish, and Norwegian art. Contents: pt. I, A survey of Swedish art; pt. II, Danish art in the 19th century; pt. III, Modern Norwegian art.

I427   Lexow, Einar Jacob. Norges kunst. Oslo, Steenske [1926]. 342p. il., plates (part col.)
A compact survey of Norwegian art and architecture from its beginnings to the 20th century. Bibliography, p.340-42. No index.

I428   Lindblom, Andreas Adolf Fredrik. Sveriges konsthistoria från forntid till nutid. Stockholm, Nordisk Rotogravyr [1944-46]. 3v. il., plans, col. plates.
A well-illustrated general history of Swedish art. Contents: v.1, Från stenåldern till Gustav Vasa; v.2, Från Gustav Vasa till Gustav III, v.3, Från Gustav III till Våra Dagar.
   Contents of each volume: Afterword; Notes on paintings; Glossary of terms; Indexes of locations of art works and artists.

I429   Nordensvan, Georg Gustaf. Svensk konst och svenska konstnärer i nittonde århundradet. Ny, grundligt omarbetad, upplaga. Stockholm, Bonnier, 1925-28. 2v. il.
A comprehensive survey of Swedish art and architecture from the late 18th through the 19th century. Contents: v.1, Från Gustav III till Karl XV; v.2, Från Karl XV till sekelslutet. Bibliography v.2, p.[511]-13.

I430   Okkonen, Onni. Suomen taiteen historia. Porvoo, Söderström [1945]. 2v. 637 il., 8 col. plates.
A history of painting, sculpture, and architecture in Finland from the earliest examples to the time of publication.
   Contents: v.1, Edellinen osa. Muinaisudesta 1800-luvun realismiin; v.2, Jälkimmäinen osa. 1880-luvulta nykypäiviin. No bibliography.

I431   Romdahl, Axel Ludvig, and Roosval, Johnny August Emanuel. Svensk Konsthistoria, utgifven af A. L. Romdahl och Johnny Roosval, under medverkan af Sigurd Curman, Axel Gauffin, Georg Göthe. Stock-

holm, Aktiebolaget Ljus, 1913. 612p. 428 il., 16 col. plates.

A basic, older history of painting, sculpture, and architecture in Sweden to the early 20th century. The section on the 18th century was written by Axel Gauffin, Georg Göthe, and Sigurd Curman; sections on other subject areas written by specialists.

Bibliography at end of each chapter. Index of artists, p.603–6; index of places, p.607–12. Table of contents, p.613.

I432  Roosval, Johnny August Emanuel. Swedish art, being the Kahn lectures for 1929. Princeton, Princeton Univ. Pr., 1932. 77p. il., plans, 39 plates. (Princeton monographs in art and archaeology, XVIII)

Eight essays on various aspects of Swedish art based on a series of lectures delivered at Princeton Univ. in 1929.

Contents: (1) The earliest Christian sculpture and Viking art; (2) Architecture of the Romanesque period; (3) The Gothic of the Baltic north; (4) Romanesque and early Gothic mural painting and a few remarks about wooden sculpture in the XIII century; (5) Mural painting of the later Gothic. Medieval style continued by peasant art; (6) Saint George of Stockholm; (7) The seven waves of the Renaissance, studied in the royal castles of Sweden; (8) Modern architecture. Bibliographical references in footnotes.

I433  Shetelig, Haakon, and Falk, Hjalmar. Scandinavian archaeology . . . . Trans. by E. V. Gordon. Oxford, Clarendon, 1937. 458p. il., 62 plates, diagrs.

A basic reference work which covers art, religion, customs, etc., from the earliest Scandinavian settlements through the Viking and Iron Ages.

Abbreviations, p.xx. Note on terminology, p.xviii–xix. Bibliographical footnotes.

I434  Strömbom, Sixten Georg Mauritz. Konstnärsförbundets historia. Med företal av Prins Eugen. Stockholm, Bonnier, 1945–65. 2v. illus., plates (part col.).

A scholarly, detailed history of artists' societies and organizations in Sweden in the 19th and early 20th centuries. Comprises a survey of the period. Extremely well documented.

Contents: v.1, Till och med 1890; v.2, Nationalromantik och radikalism, 1891–1920. Bibliographical references in "Noter" v.1, p.327–70 and v.2, p.427–69. Index of artists v.1, p.371–77. Appendices, v.2: (I) Medlemmarnas bidrag till förbundets utställningar, 1891–1916; (II) Inbjudna utställare, 1891–1916; (III) Utställningsverksamheten, 1901–16. Medlemsförteckning, v.2, p.499. Bibliography, v.2, p.505–10, includes a list of personal interviews and a classified listing of published works.

I435  Tirranen, Hertta. Suomen taiteilijoita Juho Rissasesta Jussi Mäntyseen; elämäkertoja. Porvoo, Helsinki, Söderström [1950]. 494p. il.

Includes information on 47 20th-century Finnish artists, with illustrations and portraits of the artists.

I436  Wennervirta, Ludvig. Suomen taide; esihistoriallisista ajasta meidän päiviimme; avustajia; Aarne Europaeus, U. T. Sirelius, K. K. Meinander, Carolus Lindberg,

Rafael Blomstedt. Helsingissä, Kustannusosakeyhtiö Otava [1927]. 652p. 546 il., 6 col. plates.

Swedish ed. 1927.

A history of architecture, painting, and sculpture in Finland to the early 20th century.

Contents: Esihistoriallinen taide [by] Aarne Europaeus; Kansantaide [by] U. T. Sirelius; Vanhempi kuvaamataide [by] K. K. Meinander; Rakennustaide [by] Carolus Lindberg; Uudempi kuvasmataide [by] L. Wennervirta; Taideteollisius [by] Rafael Blomstedt. Index of artists, p.645–52.

I437  Wilson, David McKenzie, and Klindt-Jensen, Ole. Viking art. London, Allen & Unwin; Ithaca, N.Y., Cornell Univ. Pr., 1966. 173p. 69 il., 80 plates.

First published in Danish: *Vikingetidens kunst,* Købenthavn, Nationalmuseet, 1965.

An excellent history of Viking art "from its beginnings in pagan Scandinavia to its last flickering brillancy in Christian Britain [800 A.D.–1100]."—p.161.

Contents: Pt. 1, by O. Klindt-Jensen: (I) Scandinavian art before the Vikings; (II) The earliest Viking styles. Pt. 2, by D. Mck. Wilson; (III) The Borre style; (IV) The Jellinge style; (V) The Mammen style; (VI) The Ringerike style; (VII) The Urnes style. Bibliography, p.162–66.

## Spain and Portugal

I438  Ars Hispaniae. Historia universal del arte hispánico. Madrid, Editorial Plus-Ultra [1947–77]. 22v. il., plates.

A comprehensive, multivolume history of Spanish art and architecture written by specialists in each area. Well illustrated. Each volume has a detailed bibliography and indexes by subjects, places, and persons.

Contents: v.1. Arte prehistórico, por Martín Almagro. Colonizaciones púnica y griega. El arte ibérico. El arte de las tribus célticas, por Antonio García y Bellido. 1947; v.2. Arte romano, por Blas Taracena. Arte paleocristiano, por Pedro Batlle Huguet. Arte visigodo. Arte asturiano, por Helmut Schlunk. 1947; v.3. El arte árabe español hasta los almohades. Arte mozárabe, por M. Gómez-Moreno. 1951; v.4. Arte almohade. Arte nazarí. Arte mudéjar, por L. Torres Balbás. 1949; v.5. Arquitectura y escultura románicas, por José Gudiol Ricart y Juan Antonio Gaya Nuño. 1948; v.6. Pintura e imaginería románicas, por W. W. S. Cook y J. Gudiol Ricart. 1950; v.7. Arquitectura gótica, por L. Torres Balbás. 1952; v.8. Escultura gótica, por Agustín Durán Sanpere y Juan Ainaud de Lasarte. 1956; v.9. Pintura gótica, por José Gudiol Ricart [n.d.]; v.10. Cerámica y vidrio, por J. Ainaud de Lasarte. 1952; v.11. Arquitectura del siglo XVI, por Fernando Chueca Goitia. 1953; v.12. Pintura del Renacimiento, por Diego Angulo Iñiguez. 1954; v.13. Escultura del siglo XVI, por J. M. Azcárate. 1958; v.14. Arquitectura de los siglos XVII y XVIII, por George Kubler. 1957; v.15. Pintura del siglo XVII, por Diego Angulo Iñiguez, 1971; v.16. Escultura del siglo XVII, por M. E. Gómez-Moreno. 1963; v.17. Escultura y pintura del siglo XVIII. Francisco Goya, por F. J. Sánchez Cantón. 1965; v.18. Miniatura, por J. Domínguez Bordona.

Grabado, por J. Ainaud de Lasarte. Encuadernación, por J. Ainaud de Lasarte. 1962; v.19, Arte del siglo XIX, por J. A. Gaya Nuño. 1966; v.20. Artes decorativas en la España cristiana, siglos XI–XIX, por Santiago Alcolea. 1975; v.21. Arte en América y Filipinas, por E. M. Dorta. 1973; v.22. Arte del siglo XX, por J. A. Gaya Nuño, 1977.

I439    Bottineau, Yves. L'art de cour dans l'Espagne de Philippe V, 1700–46. Bordeaux, Feret & Fils, 1960. 681p. 128 il.
A brilliant, well-written account of art and cultural life in the court of Spain during the first half of the 18th century. Scholarly, based largely on research with sources and documents. List of sources and a full bibliography of older works, published texts, and modern studies.

I440    Camón Aznar, José. Las artes y los pueblos de la España primitiva. Madrid, Espasa-Calpe, 1954. xi, 935p. il., col. plates, maps.
A well-illustrated, comprehensive treatment of the earliest art in Spain from prehistoric cave paintings to proto-historic art. Bibliography, p.861–74.
"Indice geográfico y onomástico," p.875–903. "Indice de figuras," p.905–27. "Indice de materias," p.929–34.

I441    Catálogo monumental de España. Madrid, Ministerio de Instrucción Publica y Bellas Artes, 1915– . il.
The official inventory of Spanish art and architecture. Each volume contains bibliographical footnotes. Volumes have been published so far for the following provinces: Alava, 1915; Cáceres (3v.), 1924; León (2v.), 1925–26; Badajoz (3v.), 1925–26; Zamora (2v.), 1927; Cadiz (2v.), 1934; Huesca, 1942; Palencia (4v.), 1946–51; Barcelona, 1947; Zaragoza (2v.), 1957; Salamanca (2v.), 1967.
There are also separate inventories for the following provinces: Sevilla, pub. by Servicio de Defensa del Patrimonio Artístico Nacional, 1939– ; Toledo, pub. by Publicaciónes de la Excelentisma Diputación Provincial de Toledo, 1959; Valladolid, pub. by Editado por la Excelentisma Diputación Provincial de Valladolid, 1960–75; Diócesis de Vitoria, 1967–75; Vizcaya, 1958.

I442    Durliat, Marcel. Art catalan. [Maquette d'illustration d'Annie Vaillant. Paris] Arthaud [1963]. 417p. il., 8 col. plates, map (in pocket). (Art et paysages, 21)
An authoritative, beautifully illustrated survey of Catalonian architecture, painting, and sculpture from their beginnings to the first half of the 20th century. The emphasis is on ecclesiastical architecture and sculptural decorations.
The critical bibliography, p.371–[81], is arranged by chapter. Plans, p.[382–90]. The table of illustrations, p.391–[405], includes brief commentaries.

I443    _____. L'art dans le royaume de Majorque. [Toulouse] Privat, 1962. 404p. il. 48 plates on 24 l., maps, plans.
A scholarly study of the art and architecture in the Kingdom of Majorca from the late 13th through mid-14th century, with primary concentration on architecture.

Contents: Introduction; Pt. 1. L'architecture religieuse; Pt. 2. L'architecture civile et militaire; Pt. 3. Sculpture, peinture, orfèvrerie. "Sources et bibliographie" p.357–72. Extensive footnotes with references. "Petit glossaire de termes catalans," p.397–98. "Index général."

I444    _____. L'art roman en Espagne. Photographies de Jean Dieuzaide (Yan). Paris, Braun, 1962. 86p., 248 plates, map.
A pictorial compendium of Romanesque art and architecture in Spain, with concentration on architecture. Important introduction and commentaries on the plates by a foremost scholar in the field. Classified bibliography, p.[89–90].

I445    Franca, José Augusto. A arte em Portugal no século XIX. Lisboa, Bertrand [1966]. 2v. il., col. plates.
A scholarly, comprehensive history of Portuguese painting, sculpture, and architecture in the 19th century.
Contents, v.1: Primeira parte (1780–1835) (O Neoclassicismo); Segunda parte (1835–80) (O Romantismo). Índices: Gravuras foro texto (a cores); Gravuras no texto. v.2: Terceira parte (1880–1910) (O Naturalismo); Quarta parte (depois de 1910). Notas (for both volumes), p.[367–452], include bibliographical references. Quadro cronológico, p.[453]–71. Índices: Onomástico; Gravuras foro do texto (a cores); Gravuras no texto. Detailed table of contents at end of both volumes.

I446    _____. A arte em Portugal no século XX [1911-61]. [Lisboa] Bertrand, [1974]. 644p. il. (part col.), 8 plates.
A continuation of *A arte em Portugal no século XIX* (I445) covering the arts of the 20th century. Written by a foremost authority on Portuguese art. Includes bibliographical references and index.

I447    Gudiol i Ricart, Josep, and Alcolea, Santiago. Hispania; guia dal arte español. Barcelona, Argos [1962]. 2v. il.
The collaboration of several Spanish art historians resulted in this guidebook to the most important and most characteristic works of art and architecture in Spain. Intended for the traveler. Many illustrations in the text. At end of v.2: "Indice geografico général," p.451–64; "Indice onomastico général," p.465–83.

I448    Hagen, Oskar. Patterns and principles of Spanish art. 2d ed. Madison, Univ. of Wisconsin Pr., 1943. 279p. il.
A completely rewritten ed.; 1st ed. 1936.
The introductory chapters discuss the "Spanish character" of Iberian art, its deterministic pattern, and its general principles. These are followed by an outline summary of the art, with an emphasis on painting. Until recently the only handbook in English.
Some bibliographical footnotes. Index of personal names, p.265–72; of place names, p.275–79.

I449    Inventário artístico de Portugal. Lisbon, Academia Nacional de Bellas Artes, 1943–(66). v.1-(7). il.
In progress.
A monumental inventory of Portuguese art and architecture. Each volume includes an introductory section on

the art history and political background of the area. Bibliographic footnotes.

Published to date: I. Distrito de Portalegre (1943); II. Cidade de Coimbra (1947); III. Distrito de Santarém (1949); IV. Distrito de Coimbra (1952); V. Distrito de Leiria (1955); VI. Distrito de Aveiro (1959); VII. (2v.) Concelho de Évora (1966).

I450   Kubler, George A., and Soria, Martin. Art and architecture in Spain and Portugal and their American dominions, 1500–1800. Harmondsworth; Baltimore, Penguin, 1959. 445p. il., maps. (Pelican history of art, Z17)

A standard, comprehensive treatment by two recognized scholars. Traces the development of Iberian art from the Renaissance to the period of Goya. Condensed but clear presentation contains new findings and theories. Generous bibliography, p.404–16.

Contents: Pt. 1. Architecture, by George Kubler; Pt. 2. Sculpture, by Martin Soria; Pt. 3. Painting, by Martin Soria.

I451   Lacerda, Aarão de, et al. História da arte em Portugal. Pôrto, Portucalense, 1942–56. 3v. il. (part col.), ports., facsims., plans.

A standard history of Portuguese art from prehistoric times through the 19th century. Written by Portuguese art historians: Aarão de Lacerda, Mário Chicó, Maria José de Mendonça, Fernando de Pamplona, Damião Peres. Bibliography, v.1, p.555–60; v.2, bibliographical notes; v.3, no bibliography. Table of contents at end of each volume. Quality of illustrations varies.

I452   Lees-Milne, James. Baroque in Spain and Portugal, and its antecedents. London, Batsford [1960]. 224p. il.

A well-written, reliable introduction, suitable for an introductory text or a *vademecum* for the serious traveler. The emphasis is on Baroque architecture and architectural sculpture, from its origins in the Plateresque style of the 16th century through the Rococo style of the 18th century. Bibliography, p.215–17.

I453   Lozoya, Juan Contreras y López de Ayala, *marqués* de. Historia del arte hispánico. 1. ed. Barcelona, Salvat, 1931–49. 5v. il. (part col.)

An important history, indispensable to the student of Spanish art. Well illustrated, mainly with black-and-white plates.

Bibliography: v.1, p.xxv–xxx, and at end of each chapter. v.5 has a supplementary bibliography to the entire work (p.671–83) arranged by volume and chapter. Each volume contains a geographical index, one of artists, and one of others mentioned in the volume, as well as a listing of plates and illustrations.

I454   Palol, Pedro de. Early medieval art in Spain. Text by Pedro de Palol and Max Hirmer. Photos by Max Hirmer. N.Y., Abrams, 1967. 500p. 468 il. (54 col.), incl. diagrs., plans, plates.

Trans. of German ed. of 1965. A history of Spanish art from the Visigothic period of the 5th century to the end of the Romanesque period in the mid-13th century. Includes

political history. Superior color plates with notes. Bibliographical references.

I455   Sánchez Cantón, F. J., ed. Treasures of Spain. Geneva, Skira. [Distributed in the U.S. by World Pub. Co., Cleveland, 1965–67]. 2v., il. (172 col.), 2 maps. (Treasures of the world)

The material in v.1 extends from cave paintings to Spanish art of the 15th century; v.2 covers Spanish painting from the Renaissance to the present century. Superb color plates; well-written text by authorities on Spanish art. No bibliography or footnotes. Index of names and places in each volume.

Contents: v.1, From Altamira to the Catholic kings, by José Manuel Pita Andrade [1967]; v.2, From Charles V to Goya, by Alejandro Cirici-Pellicer [1965].

I456   Santos, Reynaldo dos. Oito séculos de arte portuguesa; história e espírito. [Lisboa] Empresa Nacional de Publicidade [1964?–]. 3v. il. (col. plates)

A history of Portuguese painting (v.1), sculpture and architecture (v.2), and decorative arts (v.3), written by a recognized authority. 29 fascicles have been published; only no. 30 (index?) has not as yet appeared. Well illustrated. Includes bibliography.

I457   Smith, Bradley. Spain; a history in art. N.Y., Simon and Schuster, 1966. 296p. col. il.

A pictorial survey of Spanish history with illustrations ranging from the cave paintings of Altamira (20,000 B.C.) to modern times. Contains 300 color photographs of paintings, sculptures, tapestries, murals, illuminations, and *objets d'art* in Spanish museums and private collections. Art introduction by Juan de Contreras: historical introduction by Manuel Fernandez Alvarez. Bibliography, p.294–96.

I458   Smith, Robert Chester. The art of Portugal, 1500–1800. N.Y., Meredith [1968]. 320p. il. 17 col. plates, map, plans.

An authoritative, readable survey of the greatest period of Portuguese art, written by a leading scholar in the field. "This is the first volume written in English to be devoted entirely to the general history of Portuguese art. It is intended to serve as an introduction to the subject and makes no claim to be exhaustive, although it includes a considerable amount of new material drawn from the researches of the author."—*Pref.* Includes ceramics, silver, furniture, and textiles as well as architecture, sculpture, and painting. Excellent illustrations with many beautiful color plates. Notes and bibliographies, p.313–16.

I459   ————. A talha em Portugal. Lisboa, Livros Horizonte [1962]. 198p. il., 147 plates.

An historical study of an important, spectacular Portuguese art form—the retable, or reredos—from its Gothic origins through its final rococo phase, with a neoclassical epilogue. Scholarly notes and bibliography. General index, topographical index, indexes of illustrations. Well illustrated.

SEE ALSO: Bosque, A. de. *Artistes italiens en Espagne du XIVme siècle aux rois Catholiques* (M469); Cossío, M.B.,

and Pijoán y Soteras, J. *Summa artis* (I5); *Madrider Forschungen* (R40).

## Switzerland

I460    Gantner, Joseph, and Reinle, Adolf. Kunstgeschichte der Schweiz von den Anfängen bis zum Beginn des 20. Jahrhunderts. Frauenfeld und Leipzig, Huber |1936-62|. 4v. il., plans.
v.1, 2d ed., 1968.

The definitive, scholarly work on the architecture, sculpture, painting, and minor arts of Switzerland from their beginnings to the end of World War I. Well illustrated. Extensive documentation. Each volume contains "Orts- und Künstlerregister" and bibliographies.

Contents: v.1, Von den helvetisch-römischen Anfängen bis zum Ende des romanischen Stils, 1936, 1968; v.2, Die gotische Kunst, 1947; v.3, Die Kunst der Renaissance, des Barock und des Klassizismus, 1956; v.4, Die Kunst des 19. Jahrhunderts, 1962.

I461    Ganz, Paul. Geschichte der Kunst in der Schweiz von den Anfängen bis zur Mitte des 17. Jahrhunderts. Durchgesehen und ergänzt von Paul Leonhard Ganz. Mit 389 Abbildungen und 16 Farbtafeln. Basel, Schwabe |1960|. viii, 646p. plates (part col.), maps, plans.

A lucid, compact general history of art in Switzerland from its beginnings to the mid-18th century. Well illustrated.

Classified bibliography, p.613-16.

I462    Die Kunstdenkmäler der Schweiz. Les monuments d'art et d'histoire de la Suisse. Basel, Birkhäuser, 1927-(76). Bd. 1-(64). il., plates, maps.
Some volumes reprinted.

Herausgegeben von der Schweizerischen Gesellschaft für Erhaltung Historischer Kunstdenkmäler, mit eidgenössischen, kantonalen und privaten Subventionen.

The official systematic inventory of the art and architecture of Switzerland and Liechtenstein. All volumes are written by specialists. The emphasis is on the period from the early Middle Ages to the mid-19th century, with prehistoric and Roman periods covered in introductory sections. The arrangement of the series is by canton, then by district. All significant buildings and sites are described in great detail as are the permanent art holdings and interior decoration contained within. Very well illustrated. All volumes contain bibliographies, extensive references in footnotes, and indexes of places and names.

Published to date: Kanton Aargau (6v.; 1948-76); Kanton Basel-Stadt (5v.; 1932-66); Kanton Basel-Landschaft (2v.; 1969-74); Kanton Bern (5v.; 1947-69); Canton de Fribourg (3v.; 1956-64); Kanton Graubünder (7v.; 1937-48); Kanton Luzern (6v.; 1946-63); Canton de Neuchâtel (3v.; 1955-68); Kanton St. Gallen (5v.; 1951-70); Kanton Schaffhausen (3v.; 1951-60); Kanton Schwyz (2v.; 1927-30); Kanton Solothurn (1v., 1957); Kanton Thurgau (3v.; 1950-62); Canton de Vaud (2v.; 1944-65); Kanton Zug (2v.; 1934-35); Kanton Zürich (5v.; 1938-52); Fürstentum Liechtenstein (1v.; 1950); Canton Ticino (1v.; 1972); Kanton Appenzell Ausserhoden (1v.; 1973); Kanton Unterwalden (1v., 1971); Kanton Wallis (1v., 1976).

I463    Kunstführer durch die Schweiz. Begr. von Hans Jenny. 5., vollst. neu bearb. Aufl. Hrsg. von der Gesellschaft für Schweizerische Kunstgeschichte. Wabern, Büchler, 1971-. v.1 922p. 275 il.
1st ed. 1934.

A long standard, well-documented topographical guide to the artistic monuments of Switzerland. Well illustrated with plans, line drawings, and photographs of architecture, paintings, sculpture, and church treasures. Arranged by canton. An excellent on-site guide for the serious student and interested tourist.

Contents, v.1: Aargau, Appenzell, Glarus, Graubünden, Luzern, St. Gallen, Schaffhausen, Schwyz, Thurgau, Unterwalden, Uri, Zug, Zürich. "Fachwort-Erläuterungen," p.891-99. "Orts- und Künstlerregister," p.901-90.

SEE ALSO:  Hempel, E. *Baroque art and architecture in Central Europe* (I216).

## Turkey

I464    Akurgal, Ekrem. Treasures of Turkey. |Geneva| Skira |1967|. 253p. mounted il. (part col.), map. (Treasures of the world)

A collection of essays by scholars on the art of Turkey from the earliest civilizations through the Islamic period.

Contents: The earliest civilizations of Anatolia, by Ekrem Akurgal |trans. from German by R. Allen|; Byzantium, by Cyril Mango; The Islamic period, by Richard Ettinghausen.

Index of names and places. Dramatic illustrations in the Skira tradition.

I465    Aslanapa, Oktay. Turkish art and architecture. N.Y., Praeger |1971|. 422p. il. (part col.), plans.

Aslanapa seeks to trace history of art and architecture from its origins in Central Asia down to the end of the Ottoman period. Covers such diverse fields as calligraphy, metalwork, and textiles, but emphasis is on architecture. Carefully selected examples stress unity and continuity of Turkish art. Profusely illustrated.

Glossary, p.333-45. Useful bibliography, p.355-99.

I466    Smithsonian Institution. Art treasures of Turkey. Circulated by the Smithsonian Institution, 1966-68. Wash., 1966. 120p. il. (part col.), map (on lining papers). (Smithsonian publication 4663)

An important exhibition catalogue. The art objects date from the early settlements of the 7th millenium B.C. to the Turkish Seljuk and Ottoman periods. 281 illustrations of the 282 objects on exhibit. The illustrations with descriptive data are prefaced by essays (with bibliography by scholars): The art of Anatolia until c.1200 B.C., by Machteld Mellink; Early Iron Age, Classical, and Roman Empire, by Rodney S. Young; The Byzantine period, by Paul A. Underwood; The Islamic period, by Richard Ettinghausen.

SEE ALSO: Entries in Histories and Handbooks: Ancient
— Western Asia — Anatolia (I62-I66) and the journal *Anatolian studies* (Q21).

## United States

I467    Alloway, Laurence. American pop art. N.Y., Collier
        Books in assoc. with the Whitney Museum of American Art [1974]. 144p. 105 il. (part col.)
The catalogue of an exhibition shown at the Whitney
Museum of American Art in 1974.
    An authoritative summation of the American pop art
movement of the 1960s. Contents: Catalogue of the exhibition; Introduction; (1) Definition; (2) Signs and objects;
(3) Artists: Jasper Johns, Robert Rauschenberg, Roy
Lichtenstein, James Rosenquist, Claes Oldenbourg, Andy
Warhol; (4) Context.
    Notes, p.127. Bibliography, p.133-40, includes general
books, exhibition catalogues, articles, and bibliographies
on 15 artists.

I468    The arts in America: the colonial period [by] Louis
        B. Wright, George B. Tatum, John W. McCoubrey
        [and] Robert C. Smith. N.Y., Scribner [1966]. xvi,
        368p. 267 il. (incl. ports., plans)
Authoritative general essays as well as a good pictorial
survey of American art in the colonial period. Contents:
From wilderness to republic: 1607-1787, by L. B. Wright;
Architecture, by G. B. Tatum; Painting, by J. W. McCoubrey;
The decorative arts, by R. C. Smith.
    Classified bibliography, p.353-57.

I469    The arts in America: the 19th century [by] Wendell
        D. Garrett, Paul F. Norton, Alan Gowans [and]
        Joseph T. Butler. N.Y., Scribner [1969] xix, 412p.
        302 il. (incl. facsims., plans)
Companion volume to *The arts in America: the colonial
period* (I468).
    Contents: A century of aspiration, by W. D. Garrett;
Architecture, by P. F. Norton; Painting and sculpture, by
A. Gowans; The decorative arts, by J. T. Butler.
    Classified bibliography, p.385-90.

I470    Baur, John Ireland Howe. Revolution and tradition
        in modern American art. Cambridge, Harvard Univ.
        Pr., 1951. 170p. plates. (The Library of Congress
        series in American civilization)
Not a history but "an attempt to define and trace the
development of the chief movements" of American painting
and sculpture in the first half of the 20th century.—*Pref.*
    Bibliographical references included in "Notes," p.157-
60.

I471    Boston. Museum of Fine Arts. M. and M. Karolik
        Collection. Eighteenth-century American arts; the
        M. and M. Karolik Collection of paintings, drawings,
        engravings, furniture, silver, needlework & incidental
        objects gathered to illustrate the achievements of
        American artists and craftsmen of the period from
        1720 to 1820, by Edwin J. Hipkiss. With notes on

drawings and prints by Henry P. Rossiter, and
comments on the collection, by Maxim Karolik.
Cambridge, Mass., Pub. for the Museum of Fine
Arts; Boston, Harvard Univ. Pr., 1941. xvii, 366p.
il., plates.
A catalogue of 18th-century American art in the Karolik
Collection, the first major gift presented to the Museum of
Fine Arts, Boston by the Karoliks (see also M495).
    Contents: Paintings (entries 1-17, including 8 Copleys
and 2 Stuarts); Furniture (entries 18-142); Silver (entries
143-182); Glass (entries 183-196); Miscellany (entries
197-227); Prints and drawings (entries 228-275). Includes
full, detailed entries for each work represented. Supplementary illustrations at the end of the volume.

I472    Cowdrey, Mary Bartlett. American Academy of Fine
        Arts and American Art-Union, 1816-1852. N.Y., New-
        York Historical Society, 1953. 2v. il.
Contents: v.1, Foreword, by James Thomas Flexner; The
American Academy of Fine Arts, by Theodore Sizer; The
American Art-Union, by Charles E. Baker; Publications of
the Art-Union, by Mary Bartlett Cowdrey; Sale of Art-
Union holdings, 1852, by Malcolm Stearns, Jr.; v.2, Exhibition
record, p.3-427; Index, p.429-504.
    v.1 also contains lists of members, patrons, honorary
members, academicians, and associates of the American
Academy, as well as a chronology of its activities for the
years 1801-43. For the Art-Union, v.1 contains the officers
and managers (1839-51); plan, charter, constitution; by-
laws of the committee on management; relations with other
art unions; relations with artists; relations with the National
Academy of Design.
    Includes bibliographical references.

I473    Dunlap, William. A history of the rise and progress
        of the arts of design in the United States. New ed.,
        il., ed., with additions, by Frank W. Bayley and
        Charles E. Goodspeed. Boston, Goodspeed, 1918.
        3v. plates. (Repr.: N.Y., Blom, 1964; Magnolia, Mass.,
        Peter Smith, n.d.)
1st ed. 1834; a 2v. paperback reprint with an introd. by
James Thomas Flexner, newly edited by Ruth Weiss, N.Y.,
Dover [1969].
    The most important early study of American art. Contains
extensive biographical information on many artists. The
bibliography, v.3, p.346-77, by Frank H. Chase, is an
invaluable listing of early sources and published works.

I474    Geldzahler, Henry. New York painting and sculpture:
        1940-1970. Foreword by Thomas P. F. Hoving. N.Y.,
        Dutton [1969]. 494p. il. (part col.)
Published as the catalogue of an exhibition organized by
Geldzahler at the Metropolitan Museum of Art. Despite
omissions and distortions in the exhibition, this catalogue
provides many important references and illustrations of
works and reprints significant essays on various aspects of
the New York School by five leading critics (Harold
Rosenberg, Robert Rosenblum, Clement Greenberg, William
Rubin, Michael Fried).

Bibliographical data about the artists, p.429-51. Selected bibliography, p.455-83.

I475 Green, Samuel M. American art: a historical survey. N.Y., Ronald [1966]. xi, 706p. il.
"This book, an introductory history of American art and architecture from the first European settlement to the present, is designed for courses offered in college departments of art and in schools of fine arts."—*Pref.* Covers architecture, community planning, painting, sculpture, the graphic arts, folk art, and photography.

Contents: pt. 1, The 17th century; pt. 2, The 18th century; pt. 3, The early republic; pt. 4, From Jackson to the Civil War; pt. 5, From the Civil War to 1900; pt. 6, The 20th century.

Notes to the text, p.645-54, include bibliographical references. Glossary, p.655-61. Suggested reading (classified bibliography), p.663-68. General index.

I476 Harris, Neil. The artist in American society: the formative years, 1790-1860. N.Y., Braziller [1966]. xvi, 432p. il., ports.
Paperback ed.: N.Y., Simon and Schuster [1970].

An important, well-documented study of the relationships between 19th-century American artists and the cultural life of the U.S. "Selected bibliography," p.317-24, includes comments on and evaluations of source material and published works on American art. Bibliographical references are included in "Notes," p.326-412.

I477 Hunter, Sam. American art of the 20th century; painting, sculpture, architecture. With sections on architecture by John Jacobus. Enl. ed. N.Y., Abrams; Englewood Cliffs, N.J., Prentice-Hall [1973]. 583p. il. (part col.)
An excellent, critical survey of 20th-century American painting, sculpture, and architecture. Illustrated with 988 reproductions of works.

Selected references on American painting and sculpture from 1900-59, by B. Karpel, p.[525]-32; selected references on American painting and sculpture since 1959, by R. P. Smith, with N. S. Metzner, p.533-58; selected references on American architecture of the 20th century, by J. Jacobus.

I478 Larkin, Oliver W. Art and life in America. Rev. and enl. ed. N.Y., Holt [1960]. xvii, 559p. il. (part col.)
1st ed. 1949.

"An introductory survey of the history of architecture, sculpture, painting, and to some degree of the so-called 'minor arts' in the United States."—*Foreword.* Authoritative, lively text. Often cited as the best one-volume survey of American art, despite its limited coverage of 20th-century art.

Bibliography arranged by sections corresponding to the text in "Bibliographical notes," p.491-525.

I479 Lipman, Jean, and Winchester, Alice. The flowering of American folk art, 1776-1876. N.Y., Viking, in cooperation with the Whitney Museum of American Art [1974]. 288p. il. (part col.) (A Studio book)
A book-catalogue published in conjunction with a major exhibition shown at the Whitney Museum of American Art, the Virginia Museum of Fine Arts, and the Fine Arts Museums of San Francisco in 1974.

A beautifully produced, sensitively written book which surveys the entire range of American folk art through 410 examples created in the century 1776-1876. The criteria for inclusion as folk art are characterized as "independence from cosmopolitan, academic tradition; lack of formal training, which made way for interest in design rather than optical realism; a simple and unpretentious rather than sophisticated approach, originating more typically in rural than urban places and from craft rather than fine-art traditions."—*Pref.*

Contents: Preface; Introduction; Pictures: painted, drawn and stitched; Sculpture in wood, metal, stone and bone; Decoration for home and highway; Furnishings. Appendix: Biographical index of artists (includes biographical data and bibliography); Authors' bookshelf (classified bibliography).

I480 Mendelowitz, Daniel Marcus. A history of American art. 2d ed. N.Y., Holt, [1970]. x, 522p. 695 il., col. plates.
A comprehensive, well-illustrated "history of the visual arts produced in the geographical area that now constitutes the United States."—*Pref.* Contents: pt. 1, The arts of the Indians; pt. 2, The arts of the colonial period; pt. 3, The young republic: 1776-1865; pt. 4, Between two wars: 1865-1913; pt. 5, The modern period. Classified bibliography, p.510-12.

I481 Miller, Lillian B. Patrons and patriotism, the encouragement of the fine arts in the United States, 1790-1860. Chicago and London, Univ. of Chicago Pr., 1966. xv, 335p. 74 il.
A scholarly study of the roles of government and institutions in fostering the fine arts in 19th-century America. Contents: (1) Apologia for the arts; (2) Art and the federal government; (3) Art and the community; (4) Patrons and taste; (5) Frontiers of art.

Extensive documentation and bibliographical references in "Notes," p.233-95. Classified bibliography (manuscript materials, government publications, magazines and newspapers, contemporary sources, secondary works), p.299-315.

I482 Mumford, Lewis. The brown decades; A study of the arts in America, 1865-1895. N.Y., Harcourt, 1931. xii, 266p. il. (Repr.: paperback ed., N.Y., Dover, 1971; hardbound ed., Magnolia, Mass., Peter Smith, 1971.)
A positive reappraisal of post-Civil War architecture, painting, and literature in their historical and cultural contexts. Traces the emergence of modern architecture from the period of the brownstones to the Chicago School. Sparsely illustrated. Short annotated bibliography, p.249-58.

I483 Naylor, Maria. The National Academy of Design exhibition record, 1861-1900. N.Y., Kennedy Galleries, 1973. 2v. v, 1,075p.
On cover: Exhibition of the National Academy of Design, 1861-1900.

Continues the *National Academy of Design exhibition record, 1826-1860* (I484) to the end of the 19th century.

I484  New York. National Academy of Design. National Academy of Design exhibition record, 1826-1860. N.Y., printed for the New-York Historical Society, 1943. 2v.
Halftitle: Collections of the New-York Historical Society for the year 1941-1942. The John Watts DePeyster publication fund series, LXXIV-LXXV.
Prepared by Bartlett Cowdrey. A complete record of the first 35 annual exhibitions. Within the alphabetical arrangement by artists' names the works are listed chronologically. Index (v.2, p.235-365) of subjects, artists, and owners.
Continued by Naylor (I483).

I485  Quirarte, Jacinto. Mexican American artists. Austin, Univ. of Texas Pr., 1973. xxv, 149p. il. (25 col.)
A well-illustrated survey of the art of Mexican-American artists from the colonial mission period to the 20th-century muralists.
Contents: Pt. 1, Antecedents: (1) Lands and peoples: Discovery, exploration, and settlement; (2) Art and architecture: 17th to 19th centuries; (3) Mexican muralists in the U.S. Pt. 2, Mexican-American art: 20th century; (4) 1st decade: 1901-12; (5) 2d decade: 1915-23; (6) 3d decade: 1926-34; (7) 4th decade; (8) Mexican, Mexican-American, Chicano art: Two views; Conclusion.
Bibliography, p.139-41.

I486  Rose, Barbara. American art since 1900. Rev. and expanded ed. N.Y., Praeger [1975]. 320p. il. (part col.)
Available in paperback.
1st ed. 1967.
A compact, well-written survey of American painting and sculpture from The Eight to the art of the 1970s. Notes, p.285-88, include bibliographical references. Bibliography, p.289-92, arranged by chapter.

I487  _____. Readings in American art since 1900: a documentary survey. N.Y., Praeger [1968]. xiv, 224p. 71 il., plates.
Available in paperback.
A collection of writings by artists and critics which supplement and correspond to the editor's *American art since 1900* (I486).
Bibliography, p.209-24, classified by text chapters.

I488  Rutledge, Anna Wells, ed. Cumulative record of exhibition catalogues: The Pennsylvania Academy of the Fine Arts, 1807-1870; the Society of Artists, 1800-1814; the Artists' Fund Society, 1835-1845. Philadelphia, American Philosophical Society, 1955. 450p. (Memoirs of the American Philosophical Society, v.38)
A record of the paintings and statues exhibited by the leading Philadelphia art institutions of the 19th century. Does not include engravings, medals, or casts of classical sculpture.

Contents: List of catalogues; Index by artist; Index by owner; Index by subject.

I489  Wilmerding, John. American art. Harmondsworth; N.Y., Penguin [1976]. xxiv, 322p. 300 il. on plates. (The Pelican history of art. Z40)
A broad survey of American painting and sculpture from their European origins in the 16th century to the latest movements of the mid-1970s.
Contents: pt. 1, The colonial period, 1564-1776: from discovery to revolution; pt. 2, Transition to the 19th century, 1776-1836: from federalism to nationalism; pt. 3, The mid-19th century, 1836-1865: from nature's nation to civil war; pt. 4, The later 19th century, 1865-1893: from Reconstruction to the White City; pt. 5, Transition to the 20th century, 1893-1945: from fin-de-siècle to World War II; pt. 6, The mid-20th century, 1945-1976: from World War II to the Bicentennial.
Extensive notes, p.239-68. Bibliography in two major sections: (I) General (includes subdivisions on black and Indian art, folk art, regional arts and schools, American culture, art institutions, and art criticism, as well as painting, sculpture, etc.); (II) Individual artists.

SEE ALSO: *The Britannica encyclopedia of American art* (E169).

# ORIENTAL COUNTRIES

I490  Fischer, Otto. Die Kunst Indiens, Chinas und Japans. Berlin, Propyläen [1928]. 643p. il. 45 plates (part col.) (Propyläen-Kunstgeschichte. Bd. 4)
A comprehensive survey of the arts of India, China, and Japan. Now largely superseded by more recent works.
Contents: Der indische Kunstkreis; Der chinesische Kunstkreis (includes Japanese art); Abbildungen.

I491  Fontein, Jan, and Hempel, Rose. China, Korea, Japan. Mit Beiträgen von Yvon d'Argence [u.a.]. ([Mit] 527 Abbildungen auf 456 Tafelseiten, davon 56 farbig, 33 Zeichnungen und 4 Karten im Text). Berlin, Propyläen, 1968. 362p., il., plates. (Propyläen-Kunstgeschichte [n.F.] Bd. 17)
A major contribution to the literature on the arts and architecture of China, Korea, and Japan. The large section of plates presents a superb pictorial survey of Far Eastern art. The essays and commentaries by foremost authorities in their fields meet the highest standards of scholarship.
Contents: [Pt. 1] China, Korea, Japan: Die Kunst der Chinesen, von Jan Fontein; Die Kunst der Koreaner, von Jan Fontein; Die Kunst der Japaner, von Rose Hempel. [Pt. 2] Abbildungen. [Pt. 3] Dokumentation (includes bibliographical references in individual commentaries): Chinesisches Kunsthandwerk; Chinesische Plastik; Chinesische Malerei und Schriftkunst; Chinesische Architektur; Die Steinpagoden des Kamŭn-sa und des Pulguk-sa in Korea und ihre Schätze; Koreanische Kunst: Architektur, Kunsthandwerk, Plastik, Malerei; Japanische Architektur; Japanische Plastik; Japanische Malerei und Holzschnittkunst; Japan-

isches Kunsthandwerk. [Pt. 4] Anhang: Verzeichnis der Siglen und Abkürzungen, p.315-17; Literaturverzeichnis (classified), p.318-37; Synchronoptische Übersicht, p.339-51; Namen- und Sachregister, p.353-62.

I492 Griswold, Alexander B.; Kim, Chewon; and Pott, Peter H. Burma, Korea, Tibet. London, Methuen; N.Y., Crown [1964]. 277p. il. (part col.), maps. (Art of the world)
Three independent sections, of unequal value, are devoted to the arts of Burma, Korea, and Tibet. The section on Burma, by A. B. Griswold, is limited largely to one location, Pagán; the sections on Korea, by C. Kim, and Tibet, by P. H. Pott, present more fully balanced surveys. Appendixes: Chronological table, p.242-47, on Japan, Korea, China, Burma, Tibet, and India; Maps; Bibliography, divided by section, p.255-62; Index.

I493 Grousset, René. The civilizations of the East. Trans. from the French by Catherine Alison Phillips. N.Y., London, Knopf [1931]-34. 4v. il.
Trans. of *Les civilisations de l'Orient*, Paris, Crès, 1929-30.
"A general introduction to the study of the arts in Asia for the cultivated public . . . [with] no pretence of giving a detailed account of the archaeological and artistic data within this short compass."—*Introd.* Still useful for the beginning student and the general reader.
Contents, v.1, The Near and Middle East: (I) The earliest civilizations of the East: Neolithic civilization; (II) Egyptian civilization; (III) Chaldeo-Assyrian civilization; (IV) Persian pre-Islamic civilization; (V) Arab civilization; (VI) Persian Islamic civilization. v.2, India: (I) Buddhist and Brahman India; (II) Farther India and the Malay Archipelago; (III) Moslem India. v.3, China: (I) Formation of the Chinese aesthetic ideal; (II) Buddhist influence in China; (III) Definitive establishment of the Chinese canon of art; (IV) The period of dilettantism and academic art. v.4, Japan: (I) Japan; (II) Bengal, Nepal, Tibet.
Bibliographical references in footnotes. Index to all four volumes at the end of v.4.

I494 Härtel, Herbert, and Auboyer, Jeannine. Indien und Südostasien. Mit Beiträgen von Jean Boisselier, Albert Le Bonheur, Margaret M. Hall, Volker Moeller, Ernst Waldschmidt. ([Mit] 596 Abbildungen auf 476 Tafelseiten, davon 72 farbig, 61 Zeichnungen und 4 Karten im Text). Berlin, Propyläen, 1971. 369p. il., plates. (Propyläen Kunstgeschichte [n.F] Bd. 16)
An encyclopedic, scholarly survey of the major arts and architecture of India and Southeast Asia. Written by foremost scholars in their fields. Invaluable for the large number of plates.
Contents: [Pt. 1] Indien und Südostasien: Die Kunst Indiens, von Herbert Härtel; Die buddhistische Kunst Zentralasiens, von Herbert Härtel; Die Kunst Südostasiens, von Jeannine Auboyer; Die Kunst der Khmer, von Jeannine Auboyer; Die Kunst Champas, von Jean Boisselier; Die Kunst Indonesiens, von Albert Le Bonheur; Die Kunst Birmas, von Jeannine Auboyer; Die Kunst Thailands, von Jean Boisselier. [Pt. 2] Abbildungen. [Pt. 3] Dokumentation

(includes bibliographical references in individual commentaries): Frühgeschichtliche Kunst in Indien; Indische Plastik; Indische Malerei; Indische Architektur; Indisches Kunsthandwerk; Die buddhistische Kunst Zentralasiens; Die Kunst der Khmer; Die Kunst Champas; Die Kunst Indonesiens; Die Kunst Birmas; Die Kunst Thailands. [Pt. 4] Anhang: Verzeichnis der Siglen und Abkürzung, p.327-29; Literaturverzeichnis (classified), p.330-45; Synchronoptische Übersicht, p.346-59; Namen- und Sachregister, p.361-68.

I495 Lee, Sherman E. A history of Far Eastern art. Rev. [3d] ed. N.Y., Abrams [1973]. 532p. il. (part col.), map.
First published 1964.
The standard textbook survey of Far Eastern art by a distinguished scholar, connoisseur, and museologist. Includes the arts of China, Korea, Japan, Central Asia, India, Southeast Asia, and Indonesia. Excellent illustrations of works from prehistory through the 18th century.
Contents: Pt. 1, Early culture and art: the Stone Age, the Bronze Age, and the early Iron Age: (1) Urban civilization and the Indus valley; Neolithic and pre-Shang China; (2) The Steppes and the "animal style"; (3) Chinese art of the Shang and Chou Dynasties; (4) The growth and expansion of early Chinese culture through the Han Dynasty; Korea and Japan. Pt. 2, International influence of Buddhist art: (5) Early Buddhist art in India; (6) The international Gupta style; (7) The expansion of Buddhist art to the Far East. Pt. 3, The rise of national Indian and Indonesian styles: (8) Early Hindu art in India; (9) Medieval Hindu art: the southern styles; (10) Medieval Hindu art: the northern styles; (11) The medieval art of Southeast Asia and Indonesia. Pt. 4, Chinese and Japanese national styles and the interplay of Chinese and Japanese art: (12) The rise of the arts of painting and ceramics in China; (13) The beginnings of developed Japanese art styles; (14) Japanese art of the Kamakura period; (15) Chinese painting and ceramics of the Sung Dynasty; (16) Japanese art of the Ashikaga period; (17) Later Chinese art: the Yuan, Ming, and Ch'ing Dynasties; (18) Later Japanese art: the Momoyama and Tokugawa periods.
A guide to pronunciation, p.9. A comparative time chart, p.12-13. Chronological tables, p.14-16. Classified bibliography of books, catalogues, and periodical articles, p.499-[516].

I496 Seckel, Dietrich. The art of Buddhism. Trans. by Ann E. Keep. London, Methuen; N.Y., Crown, 1965. 331p. 35 il. 59 col. plates. (Art of the world).
An excellent survey of the most important aspects of Buddhist art in Asia. Not comprehensive. Contents: pt. 1, The spread of Buddhist art through Asia; pt. 2, Types and forms.
Chronological tables, p.302-9. Classed bibliography, p.313-18.

I497 Swann, Peter C. Art of China, Korea, and Japan. London, Thames & Hudson; N.Y., Praeger [1963]. 285p. il. (part col.)
An intelligent introductory survey of the arts of the three great Far Eastern cultures. Attention is given to economic, political and religious as well as stylistic aspects of the arts.

Includes little on architecture. Summary bibliography, p.279–81.

SEE ALSO: *Enciclopedia dell'arte antica . . .* (E29); Weber, V.F. "Ko-ji hô-ten" (E182).

## Central Asia

I498 Borovka, Grigorii Iosifovich. Scythian art. Trans. from the German by V. G. Childs. N.Y., Stokes; London, Benn, 1928. 111p. 74 plates on 371. (Kai-Khosru monographs on Eastern art) (Repr.: N.Y., Paragon, 1967.)

An early, brief summary of Scythian art. Bibliographical note, p.11–14.

I499 Jettmar, Karl. Art of the steppes. [Trans. by Ann E. Keep]. N.Y., Crown [1967]. 272p. il. (part col.), maps. (Art of the world)

An authoritative, comprehensive study of the arts of the nomadic peoples of Central Asia, with particular emphasis on the important contributions of the Scythians.

Contents: (I) Discovery of early steppe art; (II) Pontic Scythia; (III) Scythian finds in Central Europe; (IV) Scythian elements in the Caucasus; (V) Anan'ino culture in eastern Russia; (VI) Expansion of the Sarmatians; (VII) Minusinsk bronzes; (VIII) Graves of the Scythian era in the Altai; (IX) The Hsiung-nu in Transbaikalia and northern Mongolia; (X) Ordos bronzes; (XI) Tuva: an area of withdrawal; (XII) The Saka in middle Asia; (XIII) Siberian gold: the steppes of northern and eastern Kazakhstan; (XIV) The aftermath; (XV) The rise of the mounted warriors and the birth of animal style.

Chronological table, p.238–39. Extensive bibliography, p.242–58.

I500 Kabul, Afghanistan. Museum. Ancient art from Afghanistan, by Benjamin Rowland, Jr. [N.Y.] Asia Society; [Distr. by H. N. Abrams, 1966.] 144p. il. (part col.) map.

The catalogue of a traveling exhibition shown at the Asia House Gallery, New York; the Los Angeles County Museum of Art; and other museums in the U. S. in 1966.

An important exhibition catalogue by a respected authority, which documents 111 works from the Kabul Museum. Includes ivories, stuccowork, clay figures, bronzes, etc. produced by the various cultures which flourished within the boundaries of present-day Afghanistan from the mid-third millenium B.C. to the early 13th century A.D.

Classified bibliography, p.141–44.

I501 LeCoq, Albert von. Die buddhistische Spätantike in Mittelasien. Berlin, Reimer, 1922–33. 7v. il. (incl. maps, plans), 205 plates (part col.) (Repr.: Graz, Akademische Druck, 1972.)

At head of title: Ergebnisse der Kgl. preussischen Turfan-expeditionen.

A fundamental work on the art of Central Asia. Excellent illustrations.

Contents: v.1, Die Plastik; v.2, Die manichaeischen Miniaturen; v.3, Die Wandmalereien; v.4, Atlas zu den Wandmalereien; Beschreibender Text zum Atlas der Wandmalereien (laid in); v.5, Neue Bildwerke; v.6, Neue Bildwerke II; v.7, Neue Bildwerke III.

"Chronologische Tabelle," v.1, p.17–18. "Verzeichnis der Tafeln," v.1, p.19–29, gives dimensions of works. "Verzeichnis der erhaltenen Malereien Indo-Iranischen Stils aus den wichtigsten Fundstätten der Oase von Kutscha," v.7, p.69–78. "Schlagwort-verzeichnis zu Text und Tafeln von Bd. I–VII," v.7, p.78–80.

I502 Minns, Ellis Hovell. Scythians and Greeks; a survey of ancient history and archaeology of the north coast of the Euxine from the Danube to the Caucasus. Cambridge, Univ. Pr., 1913. 720p. il., 9 plates, 9 maps. (Repr.: N.Y., Biblo & Tannen, 1965.)

An early, scholarly work. Still useful. "General Russian bibliography," p.xxiv–xxxiii, and bibliographies at ends of chapters. "Museums," p.xxxvi, gives a descriptive list of Russian museums with significant holdings. General index.

I503 Rosenfield, John M. The dynastic arts of the Kushans. Berkeley, Univ. of California Pr., 1967. xliii, 377, [131]p. il. maps, plans, plates. (California studies in the history of art. 6)

The definitive study of the art of the Kushānas. Very well illustrated with almost all known examples of this art and many examples of comparative objects.

Contents: (1) The creation of the empire; (2) Kanishka: legends and imperium; (3) Huvishka and the Kushan Pantheon; (4) Vāsudeva I and his successors; (5) Śakas and Parthians; (6) The Mothurā portraits; (7) Other royal portraits, Kushan and Iranian; (8) Stylistic and iconographic aspects of the Mothurā imperial portraits; (9) Kushan figures as donors and devotees in Buddhist sculpture.

Extensive notes, p.[277]–316, include bibliographical references. Bibliography, p.[319]–49.

I504 Rostovtsev, Mīkhaīl Īvanovīch. The animal style in South Russia and China. Princeton, Princeton Univ. Pr.; London, Milford, Oxford Univ. Pr., 1929. 112p. 33 plates. (Princeton monographs in art and archaeology, XIV) (Repr.: N.Y., Hacker, 1973.)

An important early study of the evolution of the animal style. Contents: (1) The Scythian period; (2) The Sarmatian period; (3) Origin of the Scythian animal style and the animal style in China of the Chou Dynasty; (4) Animal style in China in the time of the Han Dynasty. Notes at the end of each chapter include bibliographical references.

I505 ———. Iranians & Greeks in South Russia. Oxford, Clarendon, 1922. 260p. il. (incl. plans), plates, map. (Repr.: N.Y., Russell & Russell, 1969.)

"A history of the South Russian lands in the prehistoric, the protohistoric, and the classical periods down to the epoch of the migration."—*Pref.*

Contents: The prehistoric civilization; The Cimmerians and the Scythians in South Russia (8th to 5th centuries B.C.); The Greeks on the shores of the Black Sea down to

the Roman period; The Scythians at the end of the 4th and in the 3d century B.C.; The Sarmatians; The Greek cities of South Russia in the Roman period; The polychrome style and the animal style; The origins of the Russian state on the Dnieper.

Bibliography, p.223-38.

I506    Stein, *Sir* Mark Aurel. Innermost Asia; detailed report of explorations in Central Asia, Kan-su and eastern Iran, carried out and described under the orders of H.M. Indian government. Oxford, Clarendon, 1928. 4v. il. plates (part col.), plans, maps.

A monumental, well-illustrated work on the trade route countries of Central Asia. "With descriptive lists of antiques by F. H. Andrews and F. M. G. Lorimer; and appendixes by J. Allan, E. Benveniste, A. H. Francke, L. Giles, R. L. Hobson, T. A. Joyce, S. Konow, A. von LeCoq, W. Lentz, S. Lévi, H. Maspero, F. E. Pargiter, R. Smith, W. J. Soolas, R. C. Spiller, F. W. Thomas, V. Thomsen."

Contents: v.1-2, Text; v.3, Plates and plans; v.4, Maps. "List of abbreviated titles," v.1, p.[xxiii]-xxvi.

I507    _____. Serindia; detailed report of explorations in Central Asia and Westernmost China carried out and described under the orders of H. M. Indian government. Oxford, Clarendon, 1921. 5v. il. plates (part col.), 94 (i.e. 96) maps, 59 plans.

A monumental work on Central Asia and China. "A full record of the explorations, archaeological in the first place but to a large extent also geographical ... of my second Central-Asian expedition ... 1906-8." — *Introd.* "With descriptive lists of antiques by F. H. Andrews, F. M. G. Lorimer, C. L. Woolley, and others; and appendixes by J. Allan, L. D. Barnett, L. Binyon, E. Chavannes, A. H. Church, A. H. Francke, A. F. R. Hoernle, T. A. Joyce, R. Petrucci, K. Schlesinger, F. W. Thomas."

Contents: v.1-3, Text; v.4, Plates; v.5, Maps. Bibliography, v.1, p.[xxv]-xxviii.

## China

I508    Argence, René-Yvon Lefebvre d'. Chinese treasures from the Avery Brundage collection. N.Y., Asia Society, 1968. 151p. 117 il. (part col.)

An exemplary catalogue of an exhibition of 117 objects selected from the Brundage Collection, exhibited at the Asia House Gallery and other locations. Objects include ritual bronzes, miscellaneous bronzes, jades, ceramics, decorative arts, gilt bronze sculpture, stone sculpture, and paintings. Selected bibliography, p.150-51.

I509    Arts of China. Tokyo, Palo Alto, Calif., Kodansha [1968]-70]. 3v. plates (part col.), maps, plans.

Trans. of *Chūgoku bijutsu*, with some additions. Superb compendia of photographic illustrations, accompanied by scholarly texts by Japanese scholars, expertly translated into English. Invaluable for new material presented and for faithful renditions of non-Western points of view.

v.1. Neolithic cultures to the T'ang dynasty: recent discoveries. Texts by Terukazu Akiyama, Kōsei Andō,

Saburō Matsubara, Takashi Okazaki, Takeshi Sekino. Coordinated by Mary Tregear. Comprises a "comprehensive examination of the most recent archaeological discoveries in China." — *Foreword.* Contents: Neolithic, Yin and Chou; Han to T'ang; Painting; Monumental animal sculpture; Burial objects. Bibliography, p.245, in Chinese.

v.2. Buddhist cave temples: new researches. Texts by Terukazu Akiyama and Saburo Matsubara. Translated by Alexander C. Soper. Reproduces some museum-owned objects but primarily works *in situ* from the period of great Buddhist art. Contents: The Tun-Huang caves and their wall paintings; Buddhist sculpture. Classified bibliography, in Chinese, p.245.

v.3. Paintings in Chinese museums: new collections. Texts by Yoshiho Yonezawa and Michiaki Kawakita. Trans. by George C. Hatch. Reproduces 153 paintings from the Five Dynasties to the present owned by museums of the People's Republic of China. Includes notes for each painting. Contents: The course of Chinese painting; Painting in modern China. Bibliography in Chinese, p.17; List of artists, p.234.

I510    Bachhofer, Ludwig. A short history of Chinese art. [N.Y.] Pantheon [1946]. 139p. il., plates.

A brief survey of Chinese pottery, bronzes, sculpture, and painting from the neolithic age through the 18th century.

Bibliographical references are included in "Notes," p.129-31.

I511    Chang, Kwang-chih. The archaeology of ancient China. 3d ed. New Haven and London, Yale Univ. Pr., 1977. xvii, 535p. il., maps.

1st ed. 1963; 2d ed. 1968.

"To provide a balanced view of the early history of China according to the archaeological evidence is the immediate aim of the present book." — *Pref. to the 1st ed.* Takes into account all archaeological writings on ancient China through 1976.

Contents: Introduction; (1) The environmental setting and time scale; (2) Palaeolithic and Mesolithic foundations; (3) The earliest farmers; (4) The Lungshanoid cultures; (5) The spread of agriculture and Neolithic technology; (6) The emergence of civilization in China; (7) Further developments of civilization in North China to 221 B.C., (8) Farmers and nomads of the northern frontier; (9) Early civilizations in South China; Conclusions and prospects. Appendixes: (1) Radiocarbon dates in Chinese archaeology up to Jan. 1976; (2) Chinese characters for proper names and technical terms; (3) Chinese archaeology, 1976.

Abbreviations, p.xix. Recommendations for further reading, p.517-20, is a classified bibliography: (1) Major periodicals and serial publications; (2) Other important titles. The most important bibliographical references are given in full in the footnotes.

I512    Cheng, Te-k'un. Archaeology in China. Cambridge, Heffer [1959-(63)]. 3v. il., maps, tables.

The aim is to "present some of the outstanding results of archaeological discoveries in China which have been made in the last few decades." — *Introd.* An essential reference work, especially for the Western reader.

Contents: v.1, Prehistoric China (1959); v.2, Shang China (1960); v.3, Chou China (1963); v.4, Han China, in preparation. Bibliographies in each volume.

_____. Supplement: New light on prehistoric China. Cambridge, Heffer [1966].

I513   Great Britain. Arts Council. The arts of the Ming dynasty. London [1958]. 80p. 104 plates.

The catalogue of an exhibition organized by the Arts Council of Great Britain and the Oriental Ceramic Society, held at the Arts Council Gallery, 1957.

Presents a comprehensive view of Ming dynasty arts. Introductory essays precede the "List of exhibits" and illustrations. Contents: Introduction, by H. Garner; Paintings, printing and textiles, by B. Gray; Ceramics, by A. Lane; Lacquer and furniture, by H. Garner; Metal work, including cloisonné, by H. Garner; Carvings in jade, ivory and other materials, by S. H. Hansford.

Bibliographical references in footnotes.

I514   Kuo li ku kung po wu yüan. Taiwan. Chinese art treasures; a selected group of objects from the Chinese National Palace Museum and the Chinese National Central Museum, Taichung, Taiwan. [Geneva, Skira, 1961]. 286p. il. (part col.)

The catalogue of a major exhibition shown in the U.S. by the government of the Republic of China at the National Gallery of Art, Washington, D.C., the Metropolitan Museum of Art, New York, and other museums in 1961-62.

Introductory essay, p.15-[25]. The catalogue includes 231 entries on paintings, porcelain, lacquers, jades, and bronzes, with description and commentary for each. Map of China showing the principal places mentioned in the catalogue, p.25; Chinese chronology, p.27; Selected bibliography, p.28; List of titles in Chinese, p.29-31; Index of painters and calligraphers, p.32.

I515   _____. _____. Masterpieces of Chinese art in the National Palace Museum. Taipai, National Palace Museum [1970- ]. v.[1- ]. col. plates.

To be complete in 15v.

A series of volumes on various aspects of Chinese art, each volume of which contains 50 color plates reproducing treasures in the collection of the National Palace Museum. Selection of works and essays by staff members of the Museum. Texts and commentaries in English, Chinese, and Japanese.

Contents: (1) Painting; (2) Bronze; (3) Porcelain; (4) Jade; (5) Calligraphy; (6) Album painting; (7) Enamel ware; (8) Rare books and historical documents; (9) Writing materials; (10) Miniature crafts; (11) Portrait painting; (12) Tibetan Buddhist altar fittings; (13) Silk tapestry and embroidery; (14) Bronze mirrors; (15) Carved lacquer ware.

I516   Lee, Sherman E., and Ho, Wai-kam. Chinese art under the Mongols: the Yüan dynasty, 1279-1368. [Cleveland] Cleveland Museum of Art [1968]. 403p. il.

The catalogue of an exhibition of 321 objects held at the Cleveland Museum of Art in 1968; 84 objects from the

exhibition were shown at Asia House, N.Y., in 1969.

Important for its comprehensive presentation of the arts in the Yüan period. Contains well-informed introductory essays and fully detailed catalogue entries.

Contents: The art of the Yüan dynasty, by Sherman E. Lee; Chinese under the Mongols, by Wai-kam Ho; Catalogue. Bibliography, p.381-87.

I517   Lion-Goldschmidt, Daisy, and Moreau-Gobard, Jean-Claude. Chinese art: bronze, jade, sculpture, ceramics. Trans. by Diana Imber, with a foreword by George Savage. N.Y., Universe [1960]. 425p. il.

Original French ed., *Arts de la Chine.*

"This book is primarily intended to be a collection of plates illustrating the important stages in the history of Chinese art."—*Introd.* A general introduction precedes each section of plates. Description and comments are given for each object reproduced. Objects are drawn primarily from European private collections.

I518   Medley, Margaret. A handbook of Chinese art for collectors and students. London, Bell [1964]. 140p. il.

Addressed to the general reader. "The terms included are, in the main, limited to those which one might encounter in any book on Chinese art written in English."—*Pref.* Terms defined in seven sections: bronzes, Buddhism, ceramics, decoration, jade and hardstones, painting, miscellaneous. Many terms illustrated with line drawings.

Lists of "Recommended books" conclude each sections.

I519   Seligman, Charles Gabriel. The Seligman Collection of Oriental art. London, Published for the Arts Council of Great Britain by Lund Humphries, 1957-1964. 2v. il., plates.

The superb catalogue of a fine collection of Oriental art, primarily Chinese. All works are fully described, with citations of comparable pieces and of exhibition history. Includes concise introductory essays on the various categories of works represented.

v.1: Chinese, Central Asian, and Luristan bronzes and Chinese jades and sculptures, by S. Howard Hansford. v.2: Chinese and Korean pottery and porcelain, by J. Ayers.

Bibliographies: v.1, p.[123]-27; v.2, p.128-32.

I520   Sickman, Laurence C. S., and Soper, Alexander Coburn. The art and architecture of China. 3d ed. Harmondsworth; Baltimore, Penguin, 1968. xxix, 350p. il. (1 col.), 192 plates, 2 maps, plans. (The Pelican history of art. Z10)

Paperback ed. 1971 (The Pelican history of art. PZ10). Appendixes of 3d ed. are incorporated into text of paperback ed.

1st ed. 1956; 2d ed. 1960.

An excellent survey of the painting, sculpture, and architecture of China by two of the foremost historians of Chinese art. Pt. I, by Laurence Sickman, is a masterfully condensed history of painting and sculpture from their earliest evidence through almost 3,000 years of development. Pt. II, by Alexander Soper, covers in approx. 80 pages the

evolution of architecture from prehistory to the end of the Ch'ing dynasty in 1912.

Chronological table, p.xxviii. References to specialized literature in notes to parts 1 and 2, p.299–321. Appendixes to parts 1 and 2 discuss the more recent developments in research since the original ed. The classified bibliography, p.327–34, includes sections on Chinese history, philosophy, and religion, as well as general works on Chinese art and books and articles on painting, sculpture, and architecture.

I521    Speiser, Werner. The art of China: spirit and society. |Trans. by George Lawrence|. N.Y., Crown |1960|. 256p. il. (part col.) (Art of the world)

Surveys aspects of Chinese art against the background of its social and political history. Appendixes: Comparative chronological table, p.232–44; Bibliography, p.245–47; Glossary, p.248–50.

I522    Speiser, Werner; Goepper, Roger; and Fribourg, Jean. Chinese art: painting, calligraphy, stone rubbing, wood engraving. Trans. by Diana Imber. N.Y., Universe |1964|. 360p. il.

A companion volume to *Chinese art: bronze. jade. sculpture. ceramics.* (I517). Primarily a compendium of plates, with commentaries. General, introductory essays accompany each section.

I523    Sullivan, Michael. The arts of China. Berkeley, Univ. of California Pr., |1973|. 256p. il. (part col.), maps.

Rev. ed. of the author's *A short history of Chinese art*, 1967. 3d ed. 1978. Incorporates corrections and new material in light of recent discoveries. Widely praised as an excellent introduction to the study of Chinese art.

Contents: (1) Before the dawn of history; (2) The Shang dynasty; (3) The Chou dynasty; (4) The period of the warring states; (5) The Ch'in and Han dynasties; (6) The six dynasties; (7) The Sui and T'ang dynasties; (8) The five dynasties and the Sung dynasty; (9) The Yüan dynasty; (10) The Ming dynasty; (11) The Ch'ing dynasty; (12) The 20th century.

Classified bibliography, p.247–48. Bibliographical references in "Note to the text," p.244–46.

I524    _____. Chinese art in the twentieth century. Berkeley, Univ. of California Pr., 1959. 110p. il.

A serious attempt to survey important aspects of 20th-century Chinese art. Useful appendixes.

Contents: (1) The rebirth of China; (2) Traditional Chinese painting; (3) The modern movement; (4) The realist movement; (5) Sculpture and the decorative arts; (6) An age of transition. Appendix I, Leading Chinese art schools and societies; Appendix II, A biographical index of modern Chinese artists.

Bibliographical note, p.98.

I525    Watson, William. Ancient China: the discoveries of post-Liberation Chinese archaeology; with an introd. by Magnus Magnusson. London, British Broadcasting Corporation; Greenwich, Conn., New York Graphic Society |1974|. 108p. 85 il., 9 col. plates, map.

A summary of the author's study of important archaeological discoveries in China since 1949, with particular emphasis on those made since the beginning of the Cultural Revolution in 1966. Published to coincide with the exhibition, "Treasures of Chinese Art," at Burlington House, London in 1973–74. Includes much of the same material presented in the catalogues of this exhibition and the catalogues of similar exhibitions shown in Paris, Toronto, Wash., D.C., and Kansas City.

Contents: Introduction, p.7–12; (1) Lan-t'ien man, Peking man, and their successors; (2) Neolithic; (3) The Bronze Age; (4) The Han empire; (5) The T'ang dynasty; (6) The Sung dynasty; (7) The Yüan dynasty. Chronological table, p.|13|.

I526    _____. China before the Han dynasty. London, Thames & Hudson |1961|. 264p. il., maps. (Ancient peoples and places. v. 23)

"The purpose of this book is to give a brief account of the material culture of ancient China as revealed by archaeological study."—*Introd.*

Contents: Introduction; (I) The Palaeolithic and Neolithic periods; (II) The earlier Bronze Age: The Shang dynasty; (III) The late Bronze Age: the Chou dynasty; (IV) The art of the Bronze Age. Plates, p.205–52.

Notes, p.187–91, include references. Classified bibliography, p.192–203. Notes on plates, p.253–60.

I527    Willetts, William. Foundations of Chinese art from Neolithic pottery to modern architecture. N.Y., McGraw-Hill |1965|. 456p. il. (part col.), maps, plans.

A revision and abridgement of the author's *Chinese art* |1958|.

Exceptional for illustrations. Focuses on a branch of art in each period as representative of the aesthetic achievement of the period.

Contents: (1) China: geography and early man; (2) Jade: the Neolithic period; (3) Bronze: Shang and Chou dynasties; (4) Lacquer and silk: Han dynasty; (5) Sculpture: Six dynasties and early T'ang; (6) Pottery: the T'ang and Five dynasties; (7) Painting and calligraphy: Sung and Yüan dynasties; (8) Architecture: Han to Ming and Ch'ing dynasties; Postscript: Architecture in modern China.

Bibliography, classified by chapters, p.437–41.

SEE ALSO:   Fontein, J. and Hempel, R. *China, Korea, Japan* (I491); Hansford, S. H. *A glossary of Chinese art and archaeology* (E181); Lin, Yu-T'ang, *The Chinese theory of art . . .* (H220); Rostovtsev, M. I. *The animal style in South Russia and China* (I504); Soper, A. C., *Textual evidence for the secular arts . . .* (H223); Ts'ao, Chao, *Chinese connoisseurship . . .* (H224).

## India, Nepal, Tibet

I528    Ānand, Mulk-Rāj. The Hindu view of art, with an introductory essay on art and reality by Eric Gill. |2d ed.|. Bombay, Asia Pub. House |1957|. xxiii, 128p. il.

1st ed. 1933.

Not a history of Hindu art but a study of the aesthetic values of Hindu art in India.

Contents: (1) The religio-philosophical hypothesis; (2) The aesthetic hypothesis; (3) Principles of aesthetic practice. Appendixes: (1) The philosophy of ancient Asiatic art, by Ananda Coomaraswamy; (2) Chronology. Bibliography, p.119–23.

I529 Bussagli, Mario, and Sivaramamurti, Calembus. 5,000 years of art of India. N.Y., Abrams [1971]. 335p. 397 col. il.

A volume of beautifully reproduced illustrations of Indian art and architecture (prehistory to the present) with an accompanying introductory text.

Contents: (1) Introduction; (2) Early Indian civilization; (3) India of the Mauryas; (4) The archaic schools (Bharhut, Sanchi, etc.); (5) The art of Gandhara; (6) The school of Mathura; (7) The classical art of India: from Amaravati to Gupta times; (8) Indian influence in Central Asia; (9) Indian influence in Southeast Asia; (10) The art of medieval Hindu India; (11) Muslim art in India, and the Indo-Islamic school; (12) Conclusion.

General index, p.321–35. No bibliography.

I530 Coomaraswamy, Ananda Kentish. History of Indian and Indonesian art. N.Y., Weyhe; Leipzig, Hiersemann; London, Goldston, 1927. 295p. incl. maps. 128 plates. (Repr.: N.Y., Dover [1965].)

A standard, if now somewhat out-of-date, history of Indian and Indonesian art by a prëeminent scholar. Contents: (1) Pre-Maurya; (2) Maurya, Śunġa, early Āndhra and Scytho-Parthian (Kṣatrapa); (3) Kuṣana, later Āndhra, and Gupta; (4) Early mediaeval, mediaeval, Rājput painting and later arts and crafts; (5) Kaśmīr, Nepāl, Tibet, Chinese Turkistan, and the Far East; (6) Farther India, Indonesia and Ceylon. Bibliography, p.214–28.

I531 Fischer, Klaus. Schöpfungen indischer Kunst, von den frühesten Bauten und Bildern bis zum mittelalterlichen Tempel. Köln, DuMont Schauberg [1959]. 412p. il., maps.

A scholarly survey of Indian sculpture and architecture examined from wide-ranging viewpoints. Very well illustrated with 44 line drawings and plans in the text and 275 photographic reproductions of works.

Contents: (1) Einleitung und Fragestellung; (2) Denkmälerkunde; (3) Leben und Kunst im alten und neuen Indien; (4) Entstehung und Wandlung altindischer Kunstformen (Volk, Geschichte und Kunst in der Vor- und Frühzeit; Die erste Kunst geschichtlicher Zeit; Indische Kunst im Austausch mit der Fremde; Der Beginn des Freibautempels und das Ende der Felskunst; Bauten und Bilder des indischen Mittelalters).

Classified bibliography, p.353–84. Index of authors, p.385–89; Index of places, p.397–412. "Erklärung der Sanskritausdrücke," p.390–96.

I532 Foucher, Alfred. L'art gréco-bouddhique du Gandhāra; étude sur les origines de l'influence classique dans l'art bouddhique de l'Inde et de l'Extrême-Orient.

Paris, Leroux, 1905–51. 2v. in 4. il., map. (Publication de l'École Française d'Extrême-Orient, V–VI.)

A standard study of the Greco-Buddhist art of Gandhara. Contents: (1) Introduction — Les édifices, Les bas-reliefs; (2$^{1-2}$) Les images — L'histoire — Conclusions; (2$^3$) Additions et corrections — Index.

Index of contributors, v.2$^3$, p.889–94; Index of collections, v.2$^3$, p.895–96. General index, v.2$^3$, p.897–920.

I533 Ghosh, A., ed. Jaina art and architecture. Published on the occasion of the 2500th Nirvana anniversary of Tirthankara Mahavira. New Delhi, Bharatiya Jnanpith [1974–75]. 3v. 664p. il. (part col.)

A collection of studies by Indian scholars on the architectural monuments, sculpture, and arts produced under the aegis of Jainism, founded by Mahavira in the 6th century B.C. After an introductory section, the main portion of the work is devoted to sections on Jainist monuments and sculpture within the periods 300 B.C. to A.D. 300, A.D. 300–600, A.D. 600–1000, A.D. 1000–1300, and A.D. 1300–1800. These chronological sections are followed by sections on Jainist paintings and wood carvings, epigraphic and numismatic sources, canons and symbolism, and art objects in museums.

Glossary of technical terms, v.3, p.603–09. General index, v.3, p.613–56. Includes bibliographical references in the footnotes.

I534 Goetz, Hermann. The art of India: five thousand years of Indian art. N.Y., Crown [1962]. 280p. il. (part col.), maps. (Art of the world)

A reliable, compact history of Indian arts and architecture from prehistory to the present. Includes a glossary and a chronological table.

Select bibliography (classified), p.263–69.

I535 Hallade, Madeleine. Gandhāran art of North India and the Graeco-Buddhist tradition in India, Persia, and Central Asia. Photographs by Hans Hinz. N.Y., Abrams, 1968. 256p. il., col. plates.

A good introduction to North Indian Gandhāran art, including the Mediterranean, Parthian, and Sassanian constituents. Beautifully illustrated.

Contents: Introduction; Historical events and cultural ties; their influence on art; The art of Gandhāra; Schist school; The stucco school; Evolution and Indo-Sassanian art; The art of Gandhāra and ancient Afghanistan; Relationships between Gandhāran or Irano-Buddhist art and other Indian styles.

Glossary, p.233–39. Bibliography, p.241–42. Maps, p.[246]–51. Chronological table, p.[253]–59.

I536 Ingholt, Harald. Gandhāran art in Pakistan. With 577 illustrations photographed by Islay Lyons and 77 pictures from other sources. Introd. and descriptive catalogue by Harald Ingholt. [N.Y.] Pantheon [1957]. 203p. plates.

A significant contribution to the small body of literature on Gandhāran art. Not an introductory work. Following the introduction, the major portion of the book is a "Descriptive catalogue" of works reproduced on 577 plates. Includes a wealth of bibliographical references.

I537    Kramrisch, Stella. The art of India; traditions of Indian sculpture, painting and architecture. |3d ed. London| Phaidon |1965|. 231p. il., col. plates, map.
An authoritative, well-illustrated introductory history of Indian art and architecture from the Harappan period to the beginnings of the Industrial Revolution, by one of the foremost scholars in the field. The basic bibliography, p.230–31, includes books, exhibition catalogues, and periodical articles.

I538    _____. The art of Nepal. |N.Y.| Asia Society. |Distr. by H. N. Abrams, 1964|. 159p. il. (part col.)
The catalogue of an exhibition shown in the Asia House Gallery, N.Y., in 1964.
   An important catalogue which constitutes an authoritative, succinct survey of Buddhist and Hindu Nepalese painting and sculpture from 467 A.D. to the early 19th century.
   Bibliography, p.159.

I539    Mackay, Ernest John Henry. Early Indus civilizations. 2d. ed. rev. London, Luzac, 1948. 169p. plates, maps, plans.
2d ed. rev. and enl. by Dorothy Mackay; first published 1935 as *The Indus civilization.*
   A succinct account of excavations of early Indus sites. "Chronology and connections with other countries," p.146–58. Bibliography at end of Addendum, p.159–60. Bibliography, p.161–62. Index, p.165–69.

I540    Olschak, Blanche Christine, and Wangyal, Geshé Thupten. Mystic art of ancient Tibet. London, Allen & Unwin; N.Y., McGraw-Hill |1973|. 224p. il. (part col.)
Not primarily a history of Tibetan art but an exposition of the iconography, symbolism, and doctrine of its complex, esoteric imagery. Extremely well illustrated with about 514 line drawings and color plates.
   Bibliography, p.207–8. Index of proper names; Index of symbols; Guide to spiritual paths and schools; Index of geographical and mythological places; Names of artists and schools of art.

I541    Pal, Pratapaditya. The art of Tibet. With an essay by Eleanor Olson. |N.Y.| Asia Society. |Distr. by New York Graphic Society, Greenwich, Conn., 1969|. 163p. 136 il., 5 col. plates, map.
The catalogue of an exhibition shown at the Asia House Gallery, N.Y.; the National Collection of Fine Arts, Wash., D.C.; and the Seattle Museum in 1969.
   An excellent catalogue documenting 119 objects (paintings, bronzes, sculpture, textiles, embroideries) from museums and collections in the U.S., Europe, and India. Presents a survey of Tibetan art based on a tentative chronology beginning with the 13th century A. D. and extending to the 20th. Includes detailed catalogue entries with technical descriptions, commentaries, and bibliographical references.
   Contents: (1) Historical background; (2) Religion; (3) The Pantheon; (4) The artist and the patron; (5) Materials and techniques; (6) Sculptures; (7) Painting. "The meditation and the ritual," by E. Olson.

I542    Rowland, Benjamin. The art and architecture of India: Buddhist, Hindu, Jain. |3d ed., rev.| Harmondsworth, Baltimore, Penguin |1967|. xxi, 314p. il., maps, plans, 216 plates. (The Pelican history of art. Z2)
Paperback ed. 1971. (The Pelican history of art. PZ2)
   1st ed. 1953.
   An authoritative, comprehensive history of Indian art and architecture from prehistory through the 19th–century Hindu dynasties.
   Contents: (1) The prehistoric and epic periods in art and religion; (2) The early classic periods; (3) Romano-Indian art in North-West India and Central Asia; (4) The golden age and end of Buddhist era; (5) The Hindu renaissance; (6) Indian art in Ceylon and South-East Asia. Chronological table and pronunciation of Indan words, p.xxi. Glossary, p.293–96.
   Classified bibliography of books and periodical articles, p.297–303. References to specialized literature in notes.

I543    Singh, Mandanjeet. Himalayan art; wall-painting and sculpture in Ladakh, Lahaul and Spiti, the Siwalik Ranges, Nepal, Sikkim and Bhutan. Greenwich, Conn., New York Graphic Society, published in agreement with UNESCO |1968|. 295p. il. (part col.)
A sumptuously illustrated volume on the diverse arts of the Himalayan regions of Ladakh, Lahaul and Spiti, the Siwalik Ranges, Nepal, Sikkim, and Bhutan. Authoritative text based on the research of leading scholars.
   Glossary and index, p.286–|93|; Bibliography, p.294–95.

I544    Smith, Vincent Arthur. A history of fine art in India and Ceylon. 2d ed. rev. by K. de B. Codrington. 3d ed. rev. and enl. by Karl Khandalavala. Bombay, Taraporevala |1962?|. xxiii, 219p. il., col. plates.
"The original text of Vincent Smith and the footnotes by K. de B. Codrington to the second edition remain unaltered." 1st ed. 1911; 2d ed. 1930.
   A standard, early survey of the art and architecture of India, Ceylon, Java, Central Asia, Tibet, and Nepal. Generously illustrated. Bibliography, p.|209|–10.

I545    Welch, Stuart C. The art of Mughal India: painting and precious objects. With an introd., text, and catalogue notes by Stuart C. Welch. N.Y., Asia House. (Distr. by H. N. Abrams, 1963?). 179p. il. (part col.)
The catalogue of an exhibition shown in the galleries of Asia House, N.Y., in 1964.
   A significant, scholarly contribution to the study of Mughal art. Includes paintings, weapons, jewels, costumes, and implements. Beautifully illustrated.
   Bibliography, p.177–79.

I546    Zimmer, Heinrich Robert. The art of Indian Asia; its mythology and transformations. Completed and ed. by Joseph Campbell. With photographs by Eliot Elisofon and others. |2d ed., 3d printing with revisions.

Princeton] Princeton Univ. Pr. [1968]. 2v. il., plates, maps. (Bollingen series, 39)
1st ed. 1955; 2d ed. 1960.

An historical and theoretical study of Indian art and architecture from prehistoric times to the mid-19th century. Although not intended as a handbook, this is a stimulating, provocative work for serious readers on all levels of experience and knowledge. Extensive references in the notes. Superbly illustrated.

Contents, v.1, text: (1) The great periods of Indian art; (2) The Indus Valley civilization; (3) The Vedic Āryan style; (4) Mesopotamian patterns in Indian art; (5) Indian ideals of beauty; (6) The symbolism of the lotus; (7) Indian architecture; (8) Indian sculpture. Appendix A: Some notes on the art of painting. Appendix B: Maps and chronological charts. Description of plates, p.397–427, gives dimensions, description, date, location, photograph source, sometimes commentary. General index.

Contents, v.2, plates.

SEE ALSO: Griswold, A. B., et al. *Burma, Korea, Tibet* (I492); Härtel, H. and Auboyer, J. *Indien und Südostasien* (I494).

# Iran

I547   Paris. Palais des Beaux-Arts. Sept mille ans d'art en Iran. [Exposition organisée sous les auspices de l'Association Française d'Action Artistique avec le concours de la ville de Paris, au Petit Palais, octobre 1961–janvier 1962. Paris, 1961]. 209p. 120 plates, ports., map, table.

The catalogue of the first major exhibition of Iranian art since 1931. Arranged by Romain Ghirshman. Includes art works from prehistoric times through the Islamic period. Subsequent exhibitions, with essentially the same pieces, were held in Essen, Zürich, The Hague, and Milan. See also the related Smithsonian exhibition (I549). These exhibitions with well-documented catalogues mark the beginning of renewed research in the art of ancient and modern Iran.

I548   Pope, Arthur Upham, ed. A survey of Persian art from prehistoric times to the present. Phyllis Ackerman, assistant editor. [Reissue with corrigenda and addenda]. v.1-[14]. London, N.Y., Oxford Univ. Pr. [1964-   ]. il. plates (part mounted col., 7 fold.), maps, diagrs., plans (1 fold.)

A lavishly produced reissue of the classic work edited by Pope and Ackerman, first published 1938–39 in 6v. (Chamberlin, 687). The reissue is in smaller format, easier to use; incorporates the index volume by Theodore Besterman, published separately by Oxford Univ. Pr. in 1958.

A monumental work, comprehensive in scope, indispensable for research on all of the arts of Persia. Critical essays by 70 scholars from 12 countries. Bibliographical footnotes. Copiously illustrated with 1,482 plates (201 col.).

The plan is to issue additional volumes dealing with the sources, diffusions, and interrelations between Persia and other countries, and other volumes which summarize new research. A total of no less than 25 is projected.

Contents: Text volumes: (I) Pre-Achaemenid, Achaemenid and Parthian periods; (II) Sāsānian periods; (III) Architecture; (IV) The ceramic arts, calligraphy, and epigraphy; (V) The art of the book and textiles; (VI) Carpets, metalwork, and minor arts. Index compiled by Theodore Besterman, 1958 (separately paged, 1–63); (VII) Plates 1–257. Pre-Achaemenid, Achaemenid, Parthian and Sāsānian periods; (VIII) Plates 258–510. Architecture of the Islamic periods; (IX) Plates 511–554. Architectural ornament. Plates 812–980. The art of the book; (X) Plates 555–811. Pottery and faience; (XI) Plates 1107–1275. Carpets; (XII) Plates 981–1106. Textiles, metalwork. Plates 1276–1482. Minor arts; (XIII) not published; (XIV) New studies, 1938–60. Proceedings, the IVth International Congress of Iranian Art and Archaeology, part A, April 24-May 3, 1960. Produced under the auspices of the Asia Institute of Pahlavi Univ.; XV will be the plates for XIV.

I549   Smithsonian Institution. *Traveling Exhibition Service.* 7000 years of Iranian art. Circulated by the Smithsonian Institution: National Gallery of Art, Wash., D. C.; Denver Art Museum, Denver, Colorado; William Rockhill Nelson Gallery of Art, Kansas City, Missouri; the Museum of Fine Arts, Houston, Texas; the Cleveland Museum of Art, Cleveland, Ohio; Museum of Fine Arts, Boston, Massachusetts; California Palace of the Legion of Honor, San Francisco, California; Los Angeles County Museum of Art, Los Angeles, California, 1964–1965. [Wash., D.C., Smithsonian Institution, 1964]. 183p. map, plates (part col.) (Smithsonian publication no. 4535)

The catalogue of an important exhibition which was held in several American museums from 1964-66. Includes 250 pieces from the Archaeological Museum, Tehran (selected by R. Ettinghausen), and over 500 works from the Foroughi Collection (selected by R. Ghirshman). The name of the exhibition was taken from the larger European exhibition organized by Ghirshmann (I547); although smaller, the United States exhibition contained newly-discovered pieces and other works not shown in Europe. Important catalogue with well-documented entries, and a summary of Iranian art from prehistoric times to the Sassanian period, by Edith Porada.

SEE ALSO: Entries in the section Western Asia — Persia (Ancient Iran), I78-I78b.

# Japan

I550   Arts of Japan. N.Y., Weatherhill; Tokyo, Shibundō [1973-   ]. v.1-(8). il. (part col.)
English translations and adaptations of selected volumes of the series *Nihon no bijutsu*, Tokyo, Shibundō. Supervising ed. of English versions: John M. Rosenfield. General ed. of English versions: Louise Allison Cort.

The series provides well-illustrated surveys of various aspects of Japanese art. Contents: v.1. Mizoguchi, Saburō. Design motifs. Trans. and adapted by Louise Allison Cort

(1973); v.2, Satō, Masahiko. Kyoto ceramics. Trans. and adapted by Anne Ono Towle and Usher P. Coolidge (1973); v.3, Fujioka, Ryoichi, with Masaki Nakano, Hirokazu Arakawa, and Seizō Hayashiya. Tea ceremony utensils. Trans. and adapted with an introd. by Louise Allison Cort (1973); v.4. Kageyama, Haruki. The arts of Shinto. Trans. and adapted with an introd. by Christine Guth (1973); v.5. Okudaira, Hideo. Narrative picture scrolls. Trans. adapted with an introd. by Elizabeth ten Grotenhuis (1973); v.6. Harada, Minoru. Meiji Western painting. Adapted with an introd. by Bonnie F. Abiko (1974); v.7. Matsushita, Takaaki. Ink painting. Trans. and adapted with an introd. by Martin Collcutt (1974); v.8. Miki, Fumio. Haniwa. Trans. and adapted with an introd. by Gina Lee Barnes (1974).

I551    Buhot, Jean. Histoire des arts du Japon. Paris, van Oest, 1949- . v.1. il. (Annales du Musée Guimet. Bibliothèque d'art. Nouv. série, 5)
The only volume published of a projected history of Japanese art.

   Contents: Des origines à 1350. Bibliographical references in footnotes. Bibliographie générale et abréviations, p.|15|-17; Index des caractères, p.|255|-67; Index complémentaire, p.|268|-70.

I552    Heibonsha survey of Japanese art. Tokyo, Heibonsha; N.Y., Tokyo, Weatherhill, 1973- . 30v. il. (part col.)
Trans. of *Nihon no bijutsu*, Tokyo, Heibonsha.

   A series of authoritative, well-illustrated volumes on all aspects of Japanese art, which provide the most comprehensive survey in a Western language.

   Contents by volume: (1) Yoshikawa, Itsuji. Major themes in Japanese art; (2) Egami, Namio. The beginnings of Japanese art; (3) Watanabe, Yasutada. Shinto art: Ise and Izumo shrines; (4) Mizuno, Seiichi. Asuka Buddhist art; (5) Kobayashi, Tsuyoshi. Nara Buddhist art; (6) Hayashi, Ryoichi. The silk road and the Shoso-in; (7) O-oka, Minoru. Temples of Nara and their art; (8) Sawa, Takaaki. Art in Japanese esoteric Buddhism; (9) Fukuyama, Toshio. Heian temples: Byodo-in and Chuson-ji; (10) Ienaga, Saburo. Painting in the Yamato style; (11) Mori, Hisashi. Sculpture of the Kamakura period; (12) Tanaka, Ichimatsu. Japanese ink painting: Shubun to Sesshu; (13) Hirai, Kiyoshi. Feudal architecture of Japan; (14) Doi, Tsuguyoshi. Momoyama decorative painting; (15) Hayashi, T., Nakamura, M., and Hayashiya, S. Japanese art and the tea ceremony; (16) Noma, Seiroku. Japanese costume and textile arts; (17) Yamane, Yuzo. Momoyama genre painting; (18) Mizuo, Hiroshi. Edo painting: Sotatsu and Korin; (19) Okamoto, Yoshitomo. The Namban art of Japan; (20) Okawa, Naomi. Edo architecture: Katsura and Nikko; (21) Itoh, Teiji. Traditional domestic architecture of Japan; (22) Takahashi, Seiichiro. Traditional woodblock prints of Japan; (23) Yonezawa, Yoshiho and Yoshizawa, Chu. Japanese painting in the literati style; (24) Kawakita, Michiaki. Modern currents in Japanese art; (25) Terada, Toru. Japanese art in the world perspective; (26) Muraoka, Kageo and Okamura, Kichiemon. Folk arts and crafts of Japan; (27) Nakata, Yujiro. The art of Japanese calligraphy; (28) Hayakawa, Masao. Garden art of Japan; (29) Mikami, Tsugio. The art of Japanese ceramics; (30) Ienaga, Saburo. Japanese art: a cultural appreciation.

I553    Kidder, Jonathan Edward. Early Japanese art: the great tombs and treasures. Princeton, N.J., Van Nostrand |1964|. 358p. il., plates (part col.), maps, tables.
The first systematic survey of pre-Buddhist Japanese arts. Attempts to relate them to their religious and social contexts. Contents: (1) The background; (2) Yayoi period antecedents in symbolism and style; (3) The bronze mirrors; (4) The decorated equipment of the mounted archers; (5) Ceramic and related tomb arts; (6) The gold crowns; (7) the ornamental tombs; (8) The symbolism of the ornamental tombs. Appendixes: I, Catalogue of ornamental tombs; II, Catalogue of decorated sarcophagi; III, A critique of Japanese metal workmanship.

   Bibliography, p.|348|-|51|, subdivided into Japanese and Western languages.

I554    Kokuhō henshū-iin. Kokuhō. (National treasures of Japan). Tokyo, Mainichi shimbun-sha |1963-67|. 6v. il., plates (part col.), plans.
6v. of excellent plates of national treasures of Japan, with accompanying text in Japanese and English.

   Contents by volume: (1) Ancient, Asuka and Nara periods (up to the 8th century); (2) Heian period (8th-11th centuries); (3) Heian period and Northern Sung dynasty (11th-12th centuries); (4) Kamakura period (12th-14th centuries); (5) 13th-14th centuries; (6) 14th-19th centuries.

——. Index to 6v. |Tokyo, Mainichi shimbun-sha, 1967|. 68, 48p.

   In Japanese and English.

I555    Lee, Sherman E. Japanese decorative style. |Cleveland| Cleveland Museum of Art, 1961. 161p. il. (Repr.: N.Y., Harper, 1972.)
Issued in conjunction with an exhibition organized by the Cleveland Museum of Art and co-sponsored by the Art Institute of Chicago in 1961. A penetrating introduction to the Japanese decorative style represented in 176 works (including paintings, prints and decorative art objects) from around the 7th through mid-19th century.

   Bibliography, p.155-|58|.

I556    ——. Tea taste in Japanese art. |N.Y.| Asia Society, 1963. 111p. il. (part col.)
The catalogue of an exhibition at the Asia House Gallery, N.Y., 1963.

   An exhibition "concerned with the general taste for Chinese and Japanese art displayed during the earlier and more creative development of the tea ceremony and of tea taste."—*Pref.* Concise introductory essay and 65 catalogue entries.

   Bibliography, p.109-11.

I557    Munsterberg, Hugo. The arts of Japan: an illustrated history. Rutland, Vt., Tuttle |1957|. 201p. il. (part col.)
An introduction to the major arts and the most highly developed crafts in Japan. Well-chosen illustrations. Bibliography, p.187-90.

I558 Noma, Seiroku. The arts of Japan. Photos by Takahashi Bin. Tokyo, Kodansha International |1966-67|. 2v. il. (part col.)
Reissued in reduced format, 1978.

A masterful condensation of the history of Japanese art and architecture. Admirable text; superb illustrations.

v.1, Ancient and medieval, trans. and adapted by John Rosenfield. Contents: (1) From forest to village life; (2) The Yamato region; (3) Along the western side of Nara; (4) The Capital city of Nara; (5) The secluded mountain temples; (6) In and around the Heian capital; (7) From Daigo to Uji; (8) Provincial centers: Itsukushima and Hiraizumi; (9) The Kamakura district; (10) The Zen temples of Kyoto. Glossary, p.222-28. Classified bibliography, p.229. Chronology of Japanese art—until 1582, p.230-31.

v.2, Late medieval and modern, trans. and adapted by Glenn J. Webb. Contents: (1) Castle architecture; (2) Accoutrements of banquet society; (3) Public pleasures; (4) Further developments in military art; (5) The world of tea ceremony; (6) Kamagata values: the new art of the Kansai; (7) The arts of Edo; (8) Art and politics in the provinces; (9) Encounter with the outside world; (10) The past century. Bibliography, p.220.

Section of informative "Supplementary notes" in each volume. Index for both volumes at end of v.2.

I559 Paine, Robert Treat, and Soper, Alexander Coburn. The art and architecture of Japan. 2d ed. Pt. 1 brought up to date by D. B. Waterhouse; pt. 2 brought up to date by Bunji Kobayashi. Harmondsworth; Baltimore, Penguin, 1974. xviii, 328p. il., 173 plates. (The Pelican history of art. Z8)
Paperback ed. 1975.

The standard scholarly history of the art and architecture of Japan, written by two of the foremost authorities in the field. Pt. 1, by Robert Treat Paine, is a survey of painting, sculpture, and the graphic arts from the Archaic period through the Edo period (1615-1867). Pt. 2, by Alexander Soper, is on Japanese architecture from the pre-Buddhist age through the religious architecture of Muromachi, Momoyama, and Edo. The revisions of the 2d ed. consist primarily of updated references to Japanese collections and additional bibliography since 1960. Revisions to the text in pt. 2 appear in brackets.

Chronological table, p.xviii. Notes to pt. 1, p.276-77, and to pt. 2, p.278-88, include references to specialized works. Glossary to parts 1 and 2, p.289-92. Extensive classified bibliographies for parts 1 and 2; references in Japanese appear in the bibliography on architecture (part 2).

I560 Rosenfield, John M. Japanese arts of the Heian period: 794-1185. |N.Y.| Asia Society |1967|. 135p. il. (part col.)
The catalogue of an exhibition at the Asia House Gallery, N.Y., 1967, and at the Fogg Art Museum, Harvard Univ., 1968.

Contents: Introduction; Map of Heian Kyō; Esoteric Buddhist arts; The classic Buddhist tradition; The arts of the pure land creed; The arts of the court. Detailed notes and references in catalogue section. Glossary, p.127. Bibliography, p.135.

I561 Rosenfield, John M., and Shimada, Shūjirō. Traditions of Japanese art: selections from the Kimiko and John Powers collection. |Cambridge, Mass.| Fogg Art Museum, Harvard Univ., 1970. 393p. il., col. plates.
The catalogue of an exhibition held at the Fogg Art Museum, Princeton Univ., and the Seattle Museum.

A detailed book-length catalogue of over 150 objects from one of the outstanding collections of Japanese art in the West. The collection "reflects most major aspects of Japanese art from prehistoric times to the recent past."—Pref.

Contents: Japanese Buddhist arts: the ancient epoch (500-1200 A.D.); Japanese Buddhist arts: the middle ages (1200-1600 A.D.); Arts related to the Zen sect: ink painting (suiboku-ga), ceramics of the tea ceremony, Zenga; Koĕtsu, Sōtatsu and their tradition; Bunjin-ga: paintings of the literary men; Genre themes in painting and the decorative arts; Archaeological material; a comparative time chart. Glossary, p.383-93. Bibliographical references in catalogue entries.

I562 Swann, Peter C. The art of Japan from the Jōman to the Tokugawa period. N.Y., Crown; London, Methuen |1966|. 238p. il. (part col.)
An authoritative, concise history of Japanese art. Bibliography p.226-28.

I563 Tokyo. National Museum. Pageant of Japanese art. Tokyo, Tōto Bunka |1952-54|. 6v. il. (part col.), plates.
1958 ed. published in reduced size.

Compilations of plates with 75-100 pages of text in each volume, written by the staff of the National Museum of Tokyo.

Contents: v.1-2, Painting; v.3, Sculpture; v.4, Ceramics and metalwork; v.5, Textiles and lacquer; v.6, Architecture and gardens.

I564 Ueno, Naoteru, ed. Japanese arts and crafts in the Meiji era. English adaptation by Richard Lane. |Tokyo, pub. by Pan-Pacific Pr. for the Centenary Culture Council, 1958|. xi, 224p. 162 plates. |Centenary Cultural Council (Japan). A cultural history of the Meiji era (1868-1912). v.8|
A broad survey of the arts and architecture of the Meiji era (1868-1912). Includes painting only peripherally.

Contents: (I) The cultural background of Meiji art, with an outline of painting; (II) Meiji sculpture; (III) Meiji crafts, section 1 (introduction, metalwork, lacquerware, cloisonné and glass); (IV) Meiji crafts, section 2 (ceramics, textiles, other crafts); (V) Meiji calligraphy; (VI) Meiji architecture. The list of plates, p.213-24, gives dates, locations, and dimensions.

SEE ALSO: Fontein, J. and Hempel, R. *China, Korea, Japan* (I491).

## Korea

I565 Eckardt, Andreas. A history of Korean art, trans. by J. M. Kindersley. London, Goldston, 1929. 255p. il., plates, maps, plans, diagrs.

German ed., Leipzig, Hiersemann, 1929.

A well-illustrated survey of Korean art. Contents: Introduction to Korean art; pt. 1, Architecture; pt. 2, Sculpture and Pagoda-art; pt. 3, Buddhist sculpture; pt. 4, Painting; pt. 5, Pottery; pt. 6, Handicrafts other than pottery. "Remarks on the pronunciation of Korean, Japanese and Chinese words," p.xi. Comparative table of Far Eastern history, Plate A.

Bibliography on p.3 and at beginning of each section. General index and index of names with Chinese characters.

I566    Kim, Chewon, and Lee, Lena Kim. Arts of Korea. Photographs by Masakatsu Yamamoto. Tokyo, N.Y., Kodansha [1974]. 365p. 283 il. (part col.)

A lavishly illustrated anthology by two of the foremost scholars and connoisseurs of Korean arts. The independent contributions of Korean art as well as its relationships to other Far Eastern art are emphasized in the text.

Contents: Foreword, by Sherman E. Lee; Introduction; Historical map of Korea; Buddhist sculpture; Applied arts; Painting; Notes to the plates (identification, material, dimensions, date, location, commentary). Comparative chronology of East Asia (Korea, China, Japan), p.347–50. Classified bibliography, p.351–58.

I567    Korea (Republic). Foreign affairs, Ministry of Korean arts. Korean arts. [Seoul?] 1956–63. 3v. il. (part col.)
Primarily volumes of illustrations, with technical descriptions and commentaries for each work shown.

Contents: v.1, Painting and sculpture; v.2, Ceramics, ed. by Chewon Kim and G. St. G. M. Gompertz; v.3, Architecture, ed. by Won-yong Kim.

I568    _____. Masterpieces of Korean art, an exhibition under the auspices of the Government of the Republic of Korea. [Ed. by Robert T. Paine, Jr.]. [Boston, 1957]. 182p. il. (part col.)

The catalogue of an exhibition of Korean art from museums and private collections in the Republic of Korea shown at the National Gallery of Art, Washington, the Metropolitan Museum of Art, New York, and other museums.

A brief historical introduction is followed by a catalogue of 187 entries for gold objects, early stonewares and tiles, gilt bronze statues, gold alloy statuettes, tile sculpture, miscellaneous bronzes, ceramics, and paintings.

I569    McCune, Evelyn. The arts of Korea: an illustrated history. Rutland, Vt., Tuttle [1962]. il (part col.). 452p. maps.

An introductory survey of Korean arts.

Contents: pt. 1, Early Korea; pt. 2, The Three Kingdoms and United Silla; pt. 3, The Koryo dynasty; pt. 4, the Yi dynasty. Sections of illustrations follow each chronological part.

Appendix: Chronological table of major events in Far Eastern history. Bibliography, p.439–42. References in "Notes."

SEE ALSO:  Fontein, J. and Hempel, R. *China, Korea, Japan* (I491); Griswold, A. B. et al. *Burma, Korea, and Tibet* (I492).

## Southeast Asia

I570    Bernet Kempers, August Johan. Ancient Indonesian art. Cambridge, Harvard Univ. Pr., 1959. vi, 124p. 11 il., plates (353 figs.)

A comprehensive pictorial survey of the art and architecture (primarily sculpture and architectural sculpture) in Indonesia from prehistory to the mid-17th century. The development of Indonesian art is summarized in the introduction (23p.), followed by the detailed description of plates and the plates section at the end. Provides an adequate introduction for the student and the general reader.

Bibliography, p.[109]–14. Glossary and index, p.[121]–24.

I571    Bowie, Theodore Robert, ed. The arts of Thailand: a handbook of the architecture, sculpture and painting of Thailand (Siam). Bloomington, Indiana Univ. Pr. [1960]. 219p. il.

Includes the catalogue of an exhibition shown at Indiana Univ., the Metropolitan Museum, and other museums in 1960–62.

The main portion is given over to the essay on the architecture and sculpture of Siam, by Alexander B. Griswold, which includes the following sections: (1) Doctrines and reminders; (2) Dvāravatī and its neighbors; (3) The Khmer period and the School of Lophurî; (4) Sukhodaya; (5) Northern Siam; (6) Û Tòng, Ayudhyā and the national style; (7) Tonburî and Bangkok. Also includes "A Note on Thai painting," by Elizabeth Lyons, and the Catalogue and Notes, by M. C. Subhadradis Diskul.

Bibliography, p.217–18.

I572    Coral Rémusat, Gilberte de, *comtesse*. L'art khmer, les grandes étapes de son évolution. Avec un préface de Georges Coedès. 2. éd. Paris, van Oest, 1951. 128p. 159 il., 44 plates, maps. (Études d'art et d'ethnologie asiatiques, 1)

1st ed. 1940.

A scholarly study of Khmer art, concentrating on sculptural decoration. Contents: (1) Histoire; (2) Les religions; (3) Les villes d'Ankor et le problème de la chronologie; (4) L'architecture; (5) Les linteaux; (6) Les colonettes; (7) Les frontons; (8) Les fausses portes et les pilastres; (9) Les bas-reliefs à scènes; (10) La sculpture humaine; (11) Les animaux en ronde-bosse; (12) Résumé chronologique. Tableaux des principeaux monuments groupés par styles, p.[120]–22. Bibliographical footnotes.

I573    Groslier, Bernard Philippe. The art of Indochina, including Thailand, Vietnam, Laos and Cambodia. [Trans. by George Lawrence]. N.Y., Crown [1962]. 261p. il. (part col.), maps, plans. (Art of the world)

Also published as *Indochina; art in the melting-pot of races*, London, Methuen, 1962.

A basic survey of the arts and architecture of Thailand, Vietnam, Laos, and Cambodia, with concentration on the temple monuments. Does not include Burma.

Contents: (1) Prehistory and the dawn of history; (2) The contributions of China and India: the birth of Indochina; (3) The shaping of the Indianised states: the kingdom of Fu-

Nan; (4) Pre-Angkor Indochina: the empire of Chen-La; (5) The foundation of Angkor; (6) The Khmer empire; (7) Indochina in the shadow of Angkor; (8) The Khmer classical period: Angkor Vat; (9) The resurrection of Angkor; (10) The disintegration of the Indianised states; (11) The Thai conquest: Indochina under the spell of the Buddhism of renunciation; (12) Vietnamese invasion and the impact of Europeans.

Pronunciation, p.238. The names of the monuments, p.238. The names of the kings, p.239. Glossary of the most important technical terms. p.240. Tables of main events I-III. Maps. Classified bibliography, p.240–43.

I574    Groslier, Bernard Philippe, and Arthaud, Jacques. Angkor: art and civilization. [Trans. from the French by Eric Ernshaw Smith. Rev. ed.] N.Y., Praeger [1966]. 236p. il., maps, plans, col. plates.
1st ed. 1957.
"This book aims at providing a succinct visual conspectus of the civilization of ancient Cambodia." — *Introd.*

Contents of Appendix: Main stages in the development of Khmer art; Khmer iconography; Notes on proper names and their pronunciation; Bibliography, p.221–22; Synoptic table (Mediterranean world, India, Kindgom of the Khmers, South-East Asia, China).

I575    LeMay, Reginald Stuart. A concise history of Buddhist art in Siam. [2d ed.]. Rutland, Vt., Tuttle [1963]. xxiii, 169p. plates, maps.
"A complete photographic reprint of the original [Cambridge, Univ. Pr., 1938] with minor revisions and with several plates replaced."
"The aim of the present volume is to give a connected history of the different forms of Buddhist Art which have flourished in Siam from the early years of the Christian era up to the end of the sixteenth century." — *Pref.*
Bibliography, p.[155]–59.

I576    Louis-Frédéric, pseud. The art of Southeast Asia: temples and sculpture. Foreword by Jeannine Auboyer. [Trans. from the French by Arnold Rosin]. N.Y., Abrams [1965]. 434p. il., plates, maps, plans.
A valuable visual survey (454 black-and-white illustrations) of the art and architecture of all regions of Southeast Asia. The text, however, has been criticized for inaccuracies and distortions and should be approached with caution.
Contents: (I) Introduction; (II) Ceylon; (III) The Indianized kingdoms of the west; (IV) The Burmese kingdoms; (V) The island kingdoms; (VI) The oriental kingdoms; (VII) The Thai kingdoms.
Selected bibliography, p.425–27. Glossary, p.429–31. Selected index of sites, temples, tribes, and empires.

I577    Luce, Gordon Hannington. Old Burma-Early Pagán. Assisted by Bo-Hmu Ba Shin [and others]. Locust Valley, N.Y., pub. for Artibus Asiae and the Institute of Fine Arts, New York Univ. [by] J. J. Augustin, 1969–70. 3v. plates.

The monumental and definitive study of the rise of the Burmese city of Pagán in the 11th century A.D. and the construction of temples and shrines there during the century following. v.1, the text volume, is in three parts. Part A (chapters 1-7) is a *History* of Early Pagán, based on inscriptions and other records. Part B is a study of the *Iconography* of the arts of Early Pagán and of its relationships to Buddhist Indian arts and includes the following chapters: (8) Symbols and postures; (9) Scenes from the Buddha's life; (10) Mahayanist and Tantric; (11) Brahmanical. Part C, on the *Architecture* of Early Pagán includes (12) General survey; (13) Stupas; (14) Early Pagan shrines and temples; (15) Evolution of Burma temple; (16) Kyanzittha's reign I (1084-1113 A.D.); (17) Kyanzittha's reign II (1084-1113 A.D.)—Ruins; (18) Kyanzittha's reign III (1084-1113 A.D.); (19) Temples of the transition (1113-74 A.D.), and miscellaneous ruins; (20) The change (from 1113 onwards). The extensive notes include numerous references.

Contents of v.2: Catalogue of plates (exhaustively detailed entries on 455 plates in v.3); Bibliography, p.215–30; Index of proper names and place names; Index of Pagán sites; Index of subjects; Character-index of Chinese words; Botanical index; Old Burma calendar; Names, titles, and regnal dates of the kings of Pagán; Maps (in pocket).

v.3 contains the 455 plates, most of which include two or more illustrations.

I578    Lunet de Lajonquière, Étienne Edmond. Inventaire descriptif des monuments du Cambodge. Paris, Leroux, 1902-11. 3v. il., plans, map. (École Française d'Extrême-Orient. Publications. v.4, 8-9)
A detailed inventory of the monuments and sculptures of each of the provinces of Cambodia. Includes inscriptions (when present) on each monument described. Indexes at the end of each volume: monuments, places; names or expressions in Sanskrit and Cambodian. "Vocabulaire" at the end of v.1 and v.3 gives French equivalents of most used words in names of monuments and places. Includes bibliographical references at the end of many entries.
_____. Atlas archéologique de l'Indo-Chine. Monuments du Champa et du Cambodge. Paris, Imprimerie nationale, Leroux, éditeur, 1901. 24 p. incl. tables, 5 double maps. (École Française d'Extrême-Orient. Publications)

I579    Parmentier, Henri. L'art khmèr classique; monuments du quadrant nord-est. Paris, Les Éditions d'Art et d'histoire, 1939. 2v. il., plates, plans. (Publications de l'École Française d'Extrême-Orient. [v.39 bis])
An important, scholarly study of Khmer art from around the 9th century A.D. to the 15th century. Contents: v.1, Text; v.2, Plates, plans, drawings.
"Lexique des termes étrangers," v.1, p.343–47. "Table alphabétique des points archéologiques et géographiques mentionnés dans ce volume," v.1, p.349–53.

I580    _____. L'art khmèr primitif. Paris, van Oest, 1927. 2v. plates, maps, plans. (Publications de l'École Française d'Extrême-Orient. v.21-22)

A study of Khmer from the 7th to the 9th century. Contents: v.1, Text; v.2, Plates.

"Lexique des termes étrangers," v.1, p.377-78. "Table générale des monuments," p.379-97 gives in columns: (1) Names; (2,3) References; (4,5) Inscriptions; (6,7,8) Situation; (9,10,11) References to this volume (text, il., or plate). Index.

I581    Wagner, Frits A. Indonesia; the art of an island group. [Trans. by Ann E. Keep]. N.Y., McGraw-Hill [1959]. 256p. il. (part col.), maps. (Art of the world)
A history of Indonesian arts and architecture from prehistory to the 20th century. The excellent selection of illustrations includes objects rarely or never reproduced elsewhere.

Contents: (1) The Neolithic age; (2) Megalithic culture; (3) Dong-Son culture; (4) General observations on decorative art in Indonesia; (5) Applied art in islands other than Java and Bali until c.1850; (6) Indian culture in its country of origin; (7) The spread of Indian culture; (8) Literature within the area of Hindu-Javanese civilization; (9) Influence of Buddhism and Hinduism upon architecture, sculpture and the Wayang plays; (10) Cultural progress during the Islamic period to the beginnings of the 19th century; (11) Music and dancing on islands other than Java and Bali; (12) Bali; (13) Indonesia in the 19th and 20th centuries.

Comparative chronological table, p.238-41. Bibliography, p.243-[45]. Glossary of technical terms, p.246-[48].

SEE ALSO: Coomaraswamy, A. K. *History of Indian and Indonesian art* (I530); Griswold, A. B. et al. *Burma, Korea and Tibet* (I492); Härtel, H. and Auboyer, J. *Indien und Südostasien* (I494); Seckel, D. *The art of Buddhism* (I496).

# PRIMITIVE

I582    Adam, Leonhard. Primitive art. [3d ed., further rev. and enl.]. London; Baltimore, Penguin [1954]. 247p. il. (Pelican books, A67)
1st ed. 1940; 3d ed. reprinted in paperback.

An early general survey extending into such fields as prehistoric art, children's art, and the art of the insane.

I583    Boas, Franz. Primitive art. Cambridge, Harvard Univ. Pr., 1927. 376p. il., 15 plates. (Repr.: N.Y., Dover, 1955.)
An old, standard work. Contents: (1) Introduction; (2) The formal elements in art; (3) Representative art; (4) Symbolism; (5) Style; (6) The art of the Northwest coast of North America; (7) Primitive literature, music and dance.

I584    Fraser, Douglas, ed. The many faces of primitive art: a critical anthology. Englewood Cliffs, N.J., Prentice-Hall [1966]. xi, 300p. il.
An anthology of significant articles that "reflect various ways of looking at primitive art."—*Pref.* Contributors: Franz Boas, Raymond Firth, Douglas Fraser, Peter Buck, Felix Speiser, Robert Heine-Geldern, Julius F. Glück, Paul Bohannon, Roy Sieber, Deborah Waite.

I585    Fraser, Douglas. Primitive art. Garden City, N.Y., Doubleday [1962]. 320p. il. (part col.), maps.
An excellent general study incorporating a wealth of information and insights.
Bibliography, p.313-16.

I586    Pericot-Garcia, Luis; Galloway, John; and Lommel, Andreas. Prehistoric and primitive art. N.Y., Abrams [1969]. 340p. 489 il. (part col.)
A comprehensive treatment of three areas of primitive art and prehistoric art, regarded as one aspect of primitive art in general. Contents: Prehistoric art, by L. Pericot-Garcia; African art, by J. Galloway; The art of the North American Indian, by J. Galloway; The art of Oceania, by A. Lommel.
Classified bibliography, p.326-33.

I587    Sydow, Eckart von. Die Kunst der Naturvölker und der Vorzeit. Berlin, Propyläen, 1923. 568p. il. (part col.), 24 plates (part col.) (Propyläen-Kunstgeschichte. Bd. 1)
A pioneering work on primitive and prehistoric art by an important early scholar. Contents: (1) Die Kunst der Naturvölker; (2) Die altamerikanischen Kulturvölker; (3) Europäische Vorgeschichte; (4) Die nordgermanische Kunst der Völkerwanderungs- und Wikinger-Zeit. Excellent illustrations.

List of illustrations (including dimensions), p.493-550. "Literatur- und Quellenverzeichnis," p.551-58.

I588    Wingert, Paul Stover. Primitive art: its traditions and styles. N.Y., Oxford Univ. Pr., 1962. 421p. il., maps.
"In this excellent basic text, Wingert takes pains to establish both the cultural and psychological context of the art, and to define and elucidate the terms he uses (i.e., "primitive," "style," "function").—*Primitive art* (A56, GG30). Includes a select bibliography.

## Africa

I589    Bascom, William Russell. African art in cultural perspective; an introduction. N.Y., Norton [1973]. xii, 196p. il.
Available in paperback.

A brief, dense, and informative study of African art, concerned primarily with sculpture in the major stylistic regions.

Contents: (1) Introduction; (2) Egypt, Ethiopia, North Africa, and the Sahara; (3) The Western Sudan; (4) The Western Guinea coast (Poro styles); (5) The Akan region; (6) The Ewe region; (7) Southern Nigeria; (8) Northeastern Nigeria; (9) Cameroun (Grassland style); (10) Gabon; (11) Western Congo; (12) Angola-Zambia; (13) Central Congo (Kuba); (14) Southeastern Congo (Luba); (15) Northern Congo; (16) East and South Africa. Bibliography, p.189-91.

I590 Biebuyck, Daniel, ed. Tradition and creativity in tribal art. Berkeley and Los Angeles, Univ. of California Pr., 1969. xx, 236p. [64]p. of il.

Based on a lecture series and symposium entitled "Individual creativity and tribal norms in non-Western arts," given at the Univ. of California, Los Angeles, Dec. 1965-May 1966.

Contains revised lectures by a group of authorities (art historians, ethnographers, anthropologists) on specific problems in the so-called primitive arts.

Contents: (1) Introduction, by D. Biebuyck; (2) Judgments of primitive art, 1905–65, by R. Goldwater; (3) The African artist, by W. Fagg; (4) The concept of style in non-Western art, by A. Gerbrands; (5) Individual artistic creativity in pre-Columbian Mexico, by I. Bernal; (6) The concept of norm in the art of some Oceanian societies, by J. Guiart; (7) Creativity and style in African art, by W. Bascom; (8) Àbátàn: a master potter of the Egbádá Yorùbá, by R. Thompson; (9) Comments, by R. Altman, R. Sieber, E. Carpenter. Bibliography, p.215–24.

I591 Bravmann, René A. Islam and tribal art in West Africa. [London, N.Y.] Cambridge Univ. Pr. [1974]. xii, 189p. 83 il., 4 maps. (African studies series. no. 11)

"A rigorously researched, carefully organized, and well-written study of the interaction between Iconoclastic Islam and the figurative artistic traditions in the Cercle de Bondoukou (Ivory Coast) and west central Ghana." — Review by Patrick R. McNaughton in *African arts*, v.8, no. 1, autumn 1974, p.72.

Contents: Introduction; (1) The Islamization of West Africa; (2) Muslim dogma concerning representational art; (3) The syncretic nature of Islam: the survival of traditional art forms; (4) History of the Muslim Mande in the Cercle de Bondoukou and west central Ghana; (5) Muslim relationships with traditional art in the Cercle de Bondoukou and west central Ghana; (6) The Bedu masking tradition; (7) The Gbain masking tradition; (8) The Do masking tradition; Conclusion.

Bibliography, p.178–85. Bibliographical references in footnotes.

I592 Fraser, Douglas, and Cole, Herbert M., eds. African art and leadership. Madison, Univ. of Wisconsin Pr. [1972]. il.

A collection of essays by 14 authorities investigating "the interactions between African leaders and art forms." — *Pref. p.xv.*

Contents: (1) The *Kindi* aristocrats and their art among the Lega, by D. Biebuyck; (2) Chokwe: political art in a plebian society, by D. J. Crowley; (3) *Ndop*: royal statues among the Kuba, by J. Vansina; (4) *Gou*: a mask used in competition for leadership among the Bakwele, by L. Siroto; (5) Ibo art and authority, by H. M. Cole; (6) Humorous masks and serious politics among Afikpo Ibo, by S. Ottenberg; (7) Royal sculpture in the Cameroons Grasslands, by S. Rudy; (8) The symbols of Ashanti kingship, by D. Fraser; (9) The diffusion of Ashanti political art, by R. A. Bravmann;

(10) Kwahu terracottas, oral traditions, and Ghanaian history, by R. Sieber; (11) Gold-plated objects of Baule notables, by H. Himmelheber; (12) Ife, the art of an ancient Nigerian aristocracy, by F. Willett; (13) The sign of the divine king: Yoruba bead-embroidered crowns with veil and bird decorations, by R. F. Thompson; (14) The fish-legged figure in Benin and Yoruba art, by D. Fraser.

I593 Himmelheber, Hans. Negerkunst und Negerkünstler. Mit Ergebnissen von sechs Africa-Expeditionen des Verfassers. Braunschweig, Klinckhardt & Biermann [1960]. 436p. il., col. plates, map. (Bibliothek für Kunst- und Antiquitätenfreunde. Bd. 40)

An important work because of its comprehensive coverage of all major tribal styles. Largely based upon the author's own field research.

Bibliography, p.415–27.

I594 Leiris, Michel, and Delange, Jacqueline. African art. Trans. by Michael Ross. N.Y., Golden Pr. [1968]. xi, 453p. 451 il. (part col.), maps. (Arts of mankind. 11)

Trans. of *Afrique noire: la création plastique.*

"The most comprehensive and ambitious of the survey books. Solid scholarship, handsome format and many excellent illustrations. . . . Probably the best all around volume currently in print." — *Primitive art* (A56, GA25).

Bibliography, comp. by A. Darkowska-Nidzgarska, p.385–[408].

I595 Leuzinger, Elzy. Art of Africa. [3d ed.]. N.Y., Crown [1969]. 239p. 227 il. (part col.) (Art of the world)

A general, introductory survey of the major areas of African art. Bibliography, p.228–32.

I596 Murdock, George Peter. Africa; its peoples and their culture history. N.Y., McGraw-Hill, 1959. 456p. il., maps.

"The basic encyclopedic volume considering the peoples of Africa & their cultural relationships. It is possible to disagree with some of Murdock's classifications, but not to ignore them. Indispensable." — *Primitive art* (A56, GA30).

Contents in 11 parts: (1) Orientation; (2) African hunters; (3) Sudanic agricultural civilization; (4) North African agricultural civilization; (5) Synthesis in the Nile corridor; (6) Southward expansion of the Cushites; (7) Cultural impact of Indonesia; (8) Expansion of the Bantu; (9) East African pastoralism; (10) Spread of pastoralism to the Bantu; (11) North and West African pastoralism.

Bibliography at the end of each chapter. Key to bibliographical abbreviations, p.422–24. Index of tribal names.

I597 Thompson, Robert Farris. African art in motion; icon and act in the collection of Katherine Coryton White. Los Angeles, Univ. of California Pr. [1974]. xv, 275p. il. (part col.) (Reissued 1979.)

The catalogue of an exhibition shown at the National Gallery of Art, Wash., D.C., and at the Univ. of California, Los Angeles, in 1974.

An extremely well-illustrated catalogue of sculpture, masks, textiles, costumes, and musical instruments of certain west and central tribes discussed in relation to the author's theory that these works are used, and should be understood, in the context of dance.

Contents: pt. 1, African art and motion; pt. 2, Icon and attitude: Standing, sitting, riding, kneeling, supporting, balancing, conclusion; pt. 3, Icon and act: (1) Dan masks and the forces of balance; (2) The Ejagham leopard mime and the sign of greatness; (3) Yoruba makers of civilization; (4) Yoruba assuagers of the witches; (5) The choreographing of Banyang village harmony; (6) The whirling return of the eternal kings of Yorubaland. Appendix: Texts of artistic criticism of the dance in tropical Africa, 1965–73.

Bibliography, p.243–49. Notes include references.

I598   Willett, Frank. African art, an introduction. N.Y., Praeger [1971]. 288p. il. (part col.), maps, plan.
The author "begins by critically examining the major studies that have been made of African art in the past, and he then systematically explodes many of the myths and misconceptions concerning African art . . . Undoubtedly the finest general introduction to African art now available." —Review in *Times literary supplement,* Nov. 26, 1971, p.1468.

Bibliography, p.275–79.

## The Americas

I599   Covarrubias, Miguel. The eagle, the jaguar, and the serpent: Indian art of the Americas. North America: Alaska, Canada, the United States. N.Y., Knopf, 1954. xviii, 314, xip. il. (part col.), maps.
"Introduction to the various American Indian art styles of North America by an author who was influential in establishing these forms as legitimate works of art. . . . Justly regarded as a classic." —*Primitive art* (A56, GP130).

Bibliography, p.297–314.

I600   _____. Indian art of Mexico and Central America. N.Y., Knopf, 1957. xvii, 360p. il., plates (part col.), maps.
"Work of pivotal importance to the study of Pre-Columbian art from Mexico. Written by a pioneer in the area of aesthetic appreciation of ancient American Indian art, it is a perceptive and, as yet, almost unique study in the area." —*Primitive art* (A56, GP26).

Bibliography, p.335–[60].

I601   Disselhoff, Hans Dietrich, and Linné, S. The art of ancient America: civilizations of Central and South America [Trans. by Ann E. Keep]. N.Y., Crown [1960]. 274p. il. (part col.), maps. (Art of the world)
"Very brief historical sketches of the peoples of the mainland of southern North America from Mexico to Panama, and those of Ecuador, Peru, the Eastern Lowlands and Colombia in South America . . . The West Indies, the central northern parts of North America and the rest of South America are

not included . . ." —Review by R. W. Feachem, *Museums journal,* v.62, June, 1962, p.358.

I602   Dockstader, Frederick J. Indian art in America: the arts and crafts of the North American Indian. [3d ed.]. Greenwich, Conn., New York Graphic Society [1966]. 224p. il. (part col.), map.
An introductory essay is followed by illustrations with commentaries. Objects illustrated are drawn largely from the Museum of the American Indian, N.Y.,

Bibliography, p.222–24.

I603   _____. Indian art in Middle America. Photography by Carmelo Guadagno. Greenwich, Conn., New York Graphic Society [1967]. 221p. 249 il. (part col.), maps.
A popular work covering pre-Columbian and contemporary arts of Mexico, Central America, and the Caribbean. Objects illustrated are drawn largely from the collection of the Museum of the American Indian, N.Y.

Bibliography, p.217–21.

I604   _____. Indian art in South America. Photography by Carmelo Guadagno. Greenwich, Conn., New York Graphic Society [1967]. 222p. il. (part col.), maps.
"A popular work very useful for its illustrations, it includes a significant amount of material from countries other than Peru, particularly Colombia, Venezuela, Ecuador & Brazil. The art of these countries is not frequently illustrated in the literature," —*Primitive art* (A56, GP95).

Bibliography, p.219–22.

I605   Douglas, Frederic Huntington, and d'Harnoncourt, René. Indian art of the United States. N.Y., Museum of Modern Art [1941]. 219 [1]p. il., col. plates. (Repr.: N.Y., Arno [1969].)
Foreword by Eleanor Roosevelt. The catalogue of a landmark exhibition at the Museum of Modern Art, important for establishing the serious consideration of American Indian art.

Bibliography, p.211–18.

I606   Drucker, Philip. Cultures of the north Pacific coast. With an introd. by Harry B. Hawthorn. San Francisco, Chandler [1965]. xvi, 243p. il. (part col.), maps.
Available in paperback.
"Ethnographic background to the Indians of the Northwest Coast." —*Primitive art* (A56, GP145).

Bibliography, p.233–36.

I607   _____. Indians of the Northwest coast. [N.Y.] Published for the American Museum of Natural History [by] McGraw-Hill [1955]. 208p. il., map. ([American Museum of Natural History, N.Y.] Anthropological handbook, no. 10)
Paperback ed.: Garden City, N.Y., Natural History Pr., 1963.

A basic work on the economy, material culture, society, religion, ceremonials, cycle of life, art, sub-areas and cultural relationships of Northwest Coast Indians. Bibliography, p.197–99.

I608 Feder, Norman. American Indian art. N.Y., Abrams [1971]. 448p. 302 il. (60 col.)
An authoritatively written, beautifully illustrated volume on the various art forms of the North American Indians. The set limitations are to "historic or 'postcontact' art from the land mass .north of Mexico, taken area by area." —*Author's scope.*
Contents: Pt. 1, Indian art: Origins of Indian art; Difficulty of identifying tribal styles; Use of materials and techniques; Ecology versus art; Why artistic production?; Change versus stability; The Indian artist; Commercialization versus deeadence; Future prospects. Pt. 2, Indian art by culture areas: The Plains; The Southwest; California; The great basin and the Pacific plateau; The Pacific Northwest coast; The Arctic coast; The Woodlands.
Notes, p.437–[38], include bibliographical references. Bibliography, p.439–[46].

I609 Feuchtwanger, Franz, and Groth-Kimball, Irmgard. The arts of ancient Mexico. 109 photographs by Irmgard Groth-Kimball; text and notes by Franz Feuchtwanger. London, Thames & Hudson; N.Y., Vanguard, 1954. 125p. (p.[31–110] plates) 4 col. plates.
"One of the first pictorial surveys of the arts of Mexico, with a sympathetic, if now somewhat out-dated, introduction by one of the most knowledgeable amateurs in the field." —*Primitive art* (A56, GP29).

I610 Haberland, Wolfgang. The art of North America. N.Y., Crown [1968]. 251p. il., col. plates, maps. (Art of the world)
"Concise introd. to those Indian cultures of North America which were the major art producers. The author's approach to this material largely descriptive but the consolidation of a difficult field is important." —*Primitive art* (A56, GP134). Many works illustrated are in European collections. Bibliography, p.212–20.

I611 Handbook of Middle American Indians. Robert Wauchope, general ed. Austin, Univ. of Texas Pr. [1964–(76)]. v.1–(16). il., maps, plans.
A series of scholarly volumes on various aspects of the culture and history of Middle American Indians. Each volume is edited by one or more specialists and contains articles on specific subjects by American and Latin American scholars. All volumes are well documented and illustrated with photographs and line drawings.
v.2–3, *Archaeology of southern Mesoamerica* (1965), ed. by Gordon R. Willey, include articles on architecture, pottery, figurines, artifacts, sculpture, textiles, and ceramics. v.10–11, *Archaeology of northern Mesoamerica* (1971), ed. by Gordon F. Ekholm and Ignacio Bernal, include articles on

generally the same subjects as v.2 and v.3. References are given at the end of each article.

I612 Inverarity, Robert Bruce. Art of the Northwest Coast Indians. Berkeley and Los Angeles, Univ. of California Pr., 1950. xiv, 243p. il. (part col.), map.
2d ed. 1967, Berkeley, Univ. of California Pr.
Primarily a study of the culture of the Northwest Coast Indians, but also includes material on their clothing, stone carving, and especially wood carving. Three brief introductory essays are followed by a section of plates, which reproduce objects from various collections, with technical descriptions and analytical commentaries.
Contents: The people; Material culture; Social patterns; The art; Plates. Bibliography, p.237–43.

I613 Joyce, Thomas Athol. Central American and West Indian archaeology; being an introduction to the archaeology of the states of Nicaragua, Costa Rica, Panama, and the West Indies. N.Y., Putnam; London, Warner, 1916. 270p. il., 28 plates, maps. (Repr.: N.Y., Hacker, 1974.) (Handbooks to ancient civilizations series)
An older work which summarized the knowledge of the field at the time of publication. Bibliography, p.258–63.

I614 ———. Mexican archaeology; an introduction to the archaeology of the Mexican and Mayan civilizations of pre-Spanish America. London, Warner, 1920. 384p. il., 30 plates, map. (Repr.: N.Y., Hacker, 1970.) (Handbooks to ancient civilizations series)
1st ed. 1914; 2d impression 1920.
An older, standard work in which the aim was "to summarize shortly the extent of our knowledge concerning the life and culture of the Mexican and Maya peoples of pre-Spanish America." —*Pref.*
Appendixes: (I) Names of the days in the Mexican and Mayan calendars; (II) Names of the months in the Mexican and Mayan calendars; (III) Provisional scheme of dating.

I615 ———. South American archaeology; an introduction to the archaeology of the South American continent with special reference to the early history of Peru. N.Y., Putnam, 1912. 292p. il., plates, map. (Repr.: N.Y., Hacker, 1969.) (Handbooks to ancient civilizations series)
An older work which summarizes the knowledge of the field at the time of publication. Bibliography contained in Appendix, p.277–82.

I616 Kelemen, Pál. Medieval American art, a survey in two volumes. N.Y., Macmillan, 1946. 2v. plates.
1st ed. 1943; reissued 1946. Rev. ed. in 1v. 1956: N.Y., Macmillan, 414p., 308 plates. Paperback reprint of 1956 ed.: N.Y., Dover, 1969.
"Very influential in the early development of interest in pre-Columbian art. Extensively illustrated with pieces from the United States southwest southward through Andean

Peru. Text takes the form of lengthy captions to the illustrations."—*Primitive art* (A56, GP9).

Chronological chart, v.1, p.383. Bibliography, v.1, p.385-405.

I617    Kidder, Alfred Vincent. An introduction to the study of Southwestern archaeology with a preliminary account of the excavations at Pecos, by Alfred Vincent Kidder; and a summary of Southwestern archaeology today, by Irving Rouse. New Haven, Yale Univ. Pr. [1963]. 377p. il., maps.

Originally pub. 1924 as no. 1 of the Papers of the Southwestern Expedition, Dept. of Anthropology, Phillips Academy, Andover, Mass.

A standard work updated by the summary of Irving Rouse. "The first detailed synthesis of the archaeology of any part of the New World and, as such, sets the pattern for much subsequent work in other areas."—*Introd.*

Original bibliography, p.353-77. Additional bibliography, p.49-53.

I618    Kubler, George. The art and architecture of ancient America; the Mexican, Maya and Andean peoples. [2d ed.]. Harmondsworth; Baltimore, Penguin [1975]. xxiv, 421p. il., 192 plates, maps, plans. (The Pelican history of art. Z21)

1st ed. 1962.

A comprehensive history of the pre-Columbian art and architecture of the Mexican, Mayan, and Andean civilizations of Central and South America. This new ed. includes better photographs and corrected drawings.

Contents: (1) Introduction. Pt. 1, The Mexican civilizations: (2) The early valley of Mexico; (3) The valley of Mexico after A. D. 1000; (4) The Gulf coast; (5) Southern Mexico; (6) Western Mexico. Pt. 2, The Maya and their neighbours: (7) The Maya tradition: Architecture; (8) The Maya tradition: Sculpture and painting; (9) From the Toltec Maya to the Spaniards; (10) The neighbours of the Maya. Pt. 3, The Andean civilizations: (11) The northern Andes: Colombia and Ecuador; (12) The central Andes: Early northern Peru; (13) The upper north: Mochica and Chimu; (14) Central Peru; (15) The south coast valleys; (16) The south highlands.

List of principal abbreviations, p.337. Extensive notes, p.339-82, include bibliographical references. Glossary, p.383-84. Bibliography: (I) Comprehensive works; (II) Mesoamerica; (III) Ancient Mexico; (IV) Maya; (V) The southern neighbours of the Maya; (VI) Eastern Central America; (VII) The northern Andes; (VIII) The central Andes.

I619    Lehmann, Walter, and Ubbelohde-Doering, Heinrich. The art of old Peru. London, Benn, 1924. 67p. il., 140 plates, map. (Repr.: N.Y., Hacker, 1975.) (Publication of the Ethnological Institute of the Ethnographical Museum, Berlin)

An obsolete work, still useful for its excellent illustrations. The table of plates, p.56-65, includes dimensions of objects reproduced. Bibliography, p.66-68.

I620    Lothrop, Samuel Kirkland. Treasures of ancient America: the art of the pre-Columbian civilizations from Mexico to Peru. [Geneva] Skira; book trade distribution in the U.S. by the World Pub. Co. [Cleveland, 1964]. xiii, 229p. il. (part col.), map.

A lavishly illustrated overview of the arts of ancient Middle and South America. "This book is not a history of art. Rather it is a presentation of outstanding objects now in museums and private collections."—*Introd.*

Index of names and places. No bibliography.

I621    Lowie, Robert Harry. Indians of the plains. N.Y., Published for the American Museum of Natural History [by] McGraw-Hill, 1954. 222p. il., map. ([American Museum of Natural History, N.Y.] Anthropological handbook, no. 1)

Paperback ed.: Garden City, N.Y., Natural History Pr., 1963.

"The theme of this book is the culture of the Plains Indians from the time of their discovery until their virtually complete assimilation of the white man's ways."—*Introd.* Illustrated with line drawings and photographic reproductions.

Contents: (1) Introduction; (2) Material culture; (3) Social organization; (4) Recreation; (5) Art; (6) Supernaturalism; (7) Prehistory and history; (8) Acculturation; (9) Conclusion. Bibliography, p.205-07.

I622    Morley, Sylvanus Griswold. The ancient Maya. 3d ed. rev. by George W. Brainerd. Stanford, Calif., Stanford Univ. Pr., 1956. x, 507p. il., maps.

1st ed. 1946; 2d ed. 1947; 3d ed. repr. 1963.

"Comprehensive work on the ancient Maya by one of the great Maya archaeologists of this century. The revised ed. incorporates new data come to light after Morley's death. Although much additional information has become available since, the book remains an important background source." —*Primitive art* (A56, GP85).

Appendix: Correlation of Maya and Christian chronologies, p.443-48. Bibliography, p.467-81.

I623    Prehispanic Mexican art [by] Paul Westheim [et al.]. Trans. under the direction of Lancelot C. Sheppard. N.Y., Putnam [1972]. 447p. 418 il. (193 col.), maps, plans.

Trans. of *Arte prehispánico*, v.1 of *Cuarenta siglos de plástica mexicana* (I366).

A well-illustrated survey of the arts of pre-Columbian Mexico. Written by a team of specialists. Bibliography, p.397-98.

I624    Spinden, Herbert Joseph. Ancient civilizations of Mexico and Central America. N.Y., 1928. 270p. il., plates, map. (Repr.: N.Y., Biblo & Tannen, 1968.) (American Museum of Natural History. Handbook series no. 3, 3d and rev. ed.)

1st ed. 1917; 2d rev. ed. 1922.

"Still valuable introductory study of Mexican and Central American civilizations by an archaeologist early noted for

his Maya studies."—*Primitive art* (A56, GP37).
Bibliography, p.255–58.

I625 _____. Maya art and civilization. Rev. and enl. with added il. [Indian Hills, Colo.] Falcon's Wing Pr. [1957]. xliii, 432p. il., maps.
Basically an old work, though still useful. Contents in two parts: "The first part is an offset reproduction of Spinden's 1913 Peabody Museum of Harvard memoir; the second is an almost verbatim edition of his 1928 American Museum of Natural History Handbook [I624]."—*Handbook of Latin American studies*, v.20, no. 75.

I626 Thompson, John Eric Sidney. The rise and fall of Maya civilization. Norman, Okla., Univ. of Oklahoma Pr. [1970]. xxx, 415p. il., plates, maps.
1st ed. 1954.
"A major work on the ancient Maya by a well-known Maya archaeologist. The most up-to-date and informed single volume source on many aspects of Maya civilization and culture. The revised edition incorporates new findings."—*Primitive art* (A56, GP90).
Bibliography, p.374–402.

I627 Toscano, Salvador. Arte precolombino de México y de la América central. Prólogo del doctor Miguel León-Portilla. Edición de Beatriz de la Fuente. [3. ed.]. México, Universidad Nacional Autónoma de México, Instituto de Investigaciones Estéticas, 1970. 293p. il. (part col.), map.
1st ed. 1944; 2d ed. 1952.
"Large and lavishly illustrated volume describing regional styles in architecture, sculpture, ceramics, mosaics, feather-work, and metallurgy."—*Handbook of Latin American studies,* v.18, no. 100. The text of the 1970 ed. is unchanged from the 1952 ed. Some new illustrations have been substituted.
Extensive notes, p.197-224, include bibliographical references. Bibliography, p.225–56.

I628 Ubbelohde-Doering, Heinrich. On the royal highways of the Inca; archaeological treasures of ancient Peru. [Trans. from the German by Margaret Brown]. N.Y., Praeger [1967]. 311p. 304 il., map.
Trans. of *Kulturen Alt-Perus*, Tübingen, Wasmuth [1966].
"Beautifully illustrated large-size volume of sites, artifacts, burials of various archaeological sites visited and excavated by the author in 1931-32, 1937-39, 1953-54 and 1962-63. Written with long explanations of each plate. Some specimens and architectural views of importance to the specialist, especially sites of Pacatnamú and Tecapa and Jatanca; otherwise geared to popular audiences."—*Handbook of Latin American studies,* v.29, 1967, no. 1290a.
Chronological tables, p.[15–17]. Bibliography, p.307–08.

I629 Vaillant, George Clapp. Aztecs of Mexico; origin, rise and fall of the Aztec nation. Rev. ed. by Susannah B. Vaillant. Garden City, Doubleday, 1962. xxii, 312p. il., plates.

1st ed. 1941. (The American Museum of Natural History. Science series)
"One of the first books of its kind, written by an archaeologist who was influential in defining early archaeological sequences in the Valley of Mexico. These sequences culminated with the Aztecs, who are the major subject of the book. Unclarities present in the original have been eliminated in the revision by the late author's wife."—*Primitive art* (A56, GP71).

I630 _____. Indian arts in North America. N.Y. and London, Harper, 1939. 63p. 96 plates.
A brief, introductory book on American Indian art. Contents: (1) Social significance of Indian art today; (2) Nature of Indian art in North America; (3) Social background of Indian art; (4) Origins of Indian culture; (5) Indian art before white contact; (6) Indian arts after white contact; (7) Appraisal of North American Indian art.
Bibliography, p.55–63; arranged by chapter.

I631 Willey, Gordon R. Das alte Amerika. Mit Beiträgen von Ignacio Bernal, Sylvia M. Broadbent, Geoffrey H. S. Bushnell, Clemency Coggins, Peter T. Furst, Wolfgang Haberland, Donald Robertson, John H. Rowe. ([Mit] 579 Abbildungen auf 504 Tafelseiten, davon 64 farbig, fünf Karten sowie 66 Zeichnungen im Text). Berlin, Propyläen, 1974. 393p. il., plates. (Propyläen Kunstgeschichte [n.F.] Bd. 18)
A superb volume in the new Propyläen-Kunstgeschichte series. Surveys the art and architecture of pre-Columbian Latin America. Written by foremost authorities for the serious student and scholar.
Contents: [pt. 1] Das alte Amerika; Mesoamerika; Das Zwischengebiet; Peru und Bolivien. [pt. 2] Abbildungen. [pt. 3] Dokumentation: Kunst der Olmeken; Architektur der klassischen und nachklassischen Periode in Zentral- und Süd-México; Kunst der klassischen und nachklassischen Periode in Zentral- und Süd-México; Kunst der klassischen und nachklassischen Periode in West-México; Architektur der Maya; Kunst der Maya; Kunst im südlichen Zentral-amerika; Kunst in Kolumbien; Kunst in Ecuador; Kunst in Peru und Bolivien; Kunst der Randgebiete. [pt. 4] Anhang: Verzeichnis der Siglen und Abkürzungen, p.361–66; Literatur-verzeichnis (classified), p.367–85; Namen- und Sachregister, p.387–91.

I632 Winning, Hasso von, and Stendahl, Alfred. Pre-Columbian art of Mexico and Central America. N.Y., Abrams [1969]. 388p. 595 il. (part col.)
Includes a wide range of well-chosen illustrations, some of objects published for the first time. "By far and away the most useful book dealing with the art of Mexico and Central America that has appeared in recent years."—Review by Thomas C. Patterson, *Archaeology* 24:364, Oct. 1971.

SEE ALSO: Angulo Iñiguez, D. *Historia del arte hispano-americano* (I361); Biebuyck, D., ed. *Tradition and creativity in tribal art* (I590); Castedo, L. *A history of Latin American art and architecture . . .* (I362); Fernandéz, J. *A guide to*

*Mexican art . . .* (I369); *Historia general del arte mexicano* (I371); Kelemen, P. *Art of the Americas . . .* (I372); Mattos, A. *História de arte brasileira* (I374).

## Oceania

I633  Berndt, Ronald, ed. Australian aboriginal art. With chapters by R. M. Berndt, A. P. Elkin [et al.]. N.Y., Macmillan, 1964. 117p. il., col. plates.
A sound, well-illustrated introduction to the art and culture of the Aborigines.

Contents: Preface, by R. M. Berndt; (1) Art and life, by A. P. Elkin; (2) The art of Arnhem Land, by C. P. Mountford; (3) The art of the rock-faces, by Frederick D. McCarthy; (4) The art of circle, line, and square, by T. G. H. Strehlow; (5) Aboriginal art and the western world, by J. A. Tuchson; (6) Epilogue, by R. M. Berndt.

Descriptive annotations to the plates, p.75–107. Bibliography, p.108–12.

I634  Buck, Peter Henry. Arts and crafts of Hawaii, by Te Rangi Hiroa. [Honolulu] Bishop Museum Pr., 1957. xv, 606p. il., 7 tables. (Repr.: [Honolulu] Bishop Museum Pr., 1964.) (Bernice P. Bishop Museum, Special publication 45)
The first comprehensive work on the art of Hawaii by the Polynesian scholar Te Rangi Hiroa. "A thorough and interesting survey of the material culture and technology of Hawaii, covering techniques or production and associated practices and giving detailed descriptions of objects. Religious images, ornaments, death and burial practices, musucal instruments, canoes, houses, etc. are treated."—*Primitive art,* (A56, GO46).

Bibliography, p.581–85.

I635  Bühler, Alfred; Barrow, Terry; and Mountford, Charles P. The art of the South Sea islands, including Australia and New Zealand. N.Y., Crown [1962]. 249p. 166 il. (part col.), maps. (Art of the world)
"Provides a useful background to the visual arts of the South Seas . . . Devotes considerable space to the basis of Oceanic art, outlining religious beliefs, social organization, the position of the artist in society and the raw materials available to him."—Review by David M. Boston, *Museums*

*journal* 62:298, Mar. 1963. Separate chapters on Aboriginal art and Maori art.

Bibliography, p.235–[40].

I636  Chauvet, Stephen. Les arts indigènes en Nouvelle-Guinée. Paris, Société d'Éditions Géographiques, Maritimes et Coloniales, 1930. 350p. il., 114 plates on 57 l., map.
An older, standard work on the art of New Guinea. Well illustrated. Bibliography, p.[314]–16.

I637  Newton, Douglas. Art styles of the Papuan Gulf. N.Y., Museum of Primitive Art, 1961. 100p. 265 il., maps.
Prepared in conjunction with an exhibition at the Museum of Primitive Art.

"A comprehensive work presenting cultural background and material relevant to the art as well as an excellent analytical survey of styles (particularly the Kerewa area)." —*Primitive art* (A56, GO37).

Bibliography, p.98.

I638  Reichard, Gladys A. Melanesian design: a study of style in wood and tortoise-shell carving. N.Y., Columbia Univ. Pr., 1933. 251p. 715 il., maps. (Repr.: N.Y., Hacker, 1969.)
"Thorough analysis of motifs appearing on wooden bowls and tortoise-shell *kapkap* ornaments, primarily from the Admiralty Islands area. By analyzing the style of selected objects of a single area, the author endeavors to discover underlying principles applicable to a general Melanesian style. A classic work."—*Primitive art* (A56, GO39). Includes bibliography.

I639  Schmitz, Carl A. Oceanic art; myth, man, and image in the South Seas. [Trans. from the German by Norbert Guterman]. N.Y., Abrams [1971]. 405p. 337 il. (50 col.), 6 maps.
A lavishly illustrated survey of the arts of Oceania. An introductory section deals with the basic cultural, art, and style traditions and iconographic motifs in Oceanic art. The four major regions of Oceania—New Guinea, Melanesia, Polynesia, Micronesia—are treated in separate sections.

Bibliography, p.402–05, classed by region.

SEE ALSO: Biebuyck, D., ed. *Tradition and creativity in tribal art* (1590).

# The
# Particular
# Arts ▌▌▌

# J. Architecture

This chapter is intended primarily as a general resource for the architectural historian. However, certain of the bibliographical guides and dictionaries listed here are directed to the architect. Textbooks and technical manuals have not been included. Although we have included a selection of basic works concerning the history of city planning and landscape architecture, the coverage is not an in-depth treatment. Likewise, the entries for those books on historic preservation have not been set apart. Early sources—up to the first part of the 19th century—are listed in chapter H, Sources and Documents. Books on interior design and furnishings can be found in chapter P, Decorative and Applied Arts.

General dictionaries and encyclopedias are isolated, but those pertaining to specific periods and regions are within the histories and handbooks for that area. Biographies and directories of architects have been classified by subject rather than by form. (For example, the *American Architects Directory* is classified with the architecture of the U.S.) The index serves to bring together dictionaries and directories of architects.

The architectural literature of France, Great Britain and Ireland, and Italy has been further subdivided into broad chronological periods. In this instance, the convenience of the user took precedence over consistency.

## BIBLIOGRAPHY

J1      The architectural index. 1950- . [Sausalito, Calif.] 1951- . Annual.
A subject index to the major U.S. architectural and interior design periodicals. The index for 1977 analyzes the following: *American Institute of Architects journal; Architectural record; Contract interiors; House & home; Interior design; Interiors; Journal of architectural education; Journal of architectural research; Landscape architecture; Progressive architecture; Residential interiors; Urban design.* Entries are arranged alphabetically under building type with cross-references to architects and designers. Summary of headings in the back of each volume.

Useful for architects and libraries which do not subscribe to the *Art index.*

J2      Bibliografia di architettura e urbanistica. Prefazione di Vittorio Gregotti. Milano, La Città [1971]. vii, 220p.
Bibliography of approx. 2,300 titles on architecture and town planning. No annotations. Sections subdivided into language of text (Italian, English, French).

Contents: (1) Storia, teoria e critica dell'architettura, progettazione architettonica; (2) Storia e teoria della città, progettazione urbana; (3) Pianificazione urbana e territoriale; (4) Landscape; (5) Sociologia urbana; (6) Geografia urbana; (7) Ambiente fisico; (8) Design; (9) Arte e filosofia; (10) Studi tecnici, manuali e guide; Indice analitico.

J3      Breman, Paul, comp. The Weinreb catalogues. An annotated index. London, Breman, 1969. 70p.
A valuable index to the books on architecture and the allied arts listed in the 25 sales catalogues which were issued by Benjamin Weinreb between 1961 and 1968. This series of annotated and illustrated catalogues contains a wealth of accurate subject and bibliographical information not easily found elsewhere. Much of the original bibliographical research was done by Paul Breman.

J4      Columbia University. Libraries. Avery Architectural Library. Avery obituary index of architects and artists. Boston, Hall, 1963. 338p.
An index to obituaries of architects, mostly American and English. Includes some references to artists, art historians, and city planners. Supplements *Avery index to architectural periodicals* (J5).

J5      _____. Libraries. Avery Architectural Library. Avery index to architectural periodicals. 2d ed., rev. and enl. Boston, Hall, 1973- . 15v.
1st supplement, 1973-74; 2d supplement, 1975-76.
1st ed. 1963; supplements, 1-7. 1965- .
A photographic copy of a unique card index in the Avery Library. This author and subject index, begun in 1934, analyzes all of the major architectural periodicals and

architectural subjects in a selected list of general art periodicals located in the Avery Library. The subjects include architectural aspects of archaeology, interior design, decorative arts, housing, city planning, and landscape architecture. "List of periodicals indexed," v.1 [vii–xi].

J6    Comolli, Angelo. Bibliografia storico-critica dell'archi-
        tettura civile ed arti subalterne. Rome, Stamperia
        Vaticana, 1788–92. 4v. (Repr.: Milan, Labor [1964–
        65].)

The reprint has at the end of v.IV an analytical biblio-
graphical index by Bruno Della Chiesa which includes works which the author would have examined had he lived to complete the bibliography.

The first critical bibliography of architecture and related arts, classed by type of literature. Long excerpts and extensive documentation. A rich source of material for the history of architectural ideas, especially 18th-century currents of thought.

J7    Concerning architecture: essays on architectural
        writers and writing presented to Nikolaus Pevsner;
        ed. by John Summerson. [London] Land, 1968. xii,
        316p. il., facsims., plans.

This volume of 19 essays concerning British writers and writing on architecture contains a wealth of bibliographical information and criticism. Of interest and value to librarians and art historians. Examples: Harris, John. "English country house guides, 1740–1840"; Jenkins, Frank. "Ninteenth-century architectural periodicals." Copious bibliographical footnotes. "A select bibliography of the publications of Nikolaus Pevsner," by John Barr, p.275–85.

J8    Connally, Ernest Allen. Printed books on architecture,
        1485–1805. Urbana, Univ. of Illinois Pr., 1960. 39p.

An exhibition catalogue. "A brief but excellent history and a catalogue of 38 books designed to show the evolution and character of the printed architectural book from 1485 to 1805."—Charles B. Wood, III, "A survey and bibliography of writings of English and American architectural books published before 1895," *Winterthur portfolio* 2:129 (1965).

J9    Harris, Eileen; Wittkower, Rudolf; Connor, Timothy.
        English architectural literature before 1780 [pro-
        visional title]. With contributions by Damie Stillman,
        Paul Quarry, and others. London, Zwemmer [tenta-
        tive publication date 1980 or soon thereafter].

"The book is to be arranged alphabetically by author. For each author there will be (1) an essay on his total contribu-
tion to architectural theory, (2) a complete bibliography of his books, with full bibliographical description; listing of all editions, notes of bibliographical changes, etc.; references to major English and American libraries in which copies are to be found. Preceding all of this there will be general essays on types of books — books on the five orders, pattern books, translations of Italian treatises, builders manuals, books of classical topography, dictionaries and encyclopedias — as well as essays on publishers, printers, and translators."
— Eileen Harris.

J10    Harvard University. Graduate School of Design.
         Library. Catalogue of the Library of the Graduate
         School of Design, Harvard University. Boston, Hall,
         1968. 44v.

1st supplement, 1970, 2v.; 2d supplement, 1974, 5v.; 3d supplement, 1979, 3v.

A photographic copy of Harvard's unique card catalogue of books, periodical literature, and pamphlets in the fields of architecture, housing, landscape architecture, city and regional planning. The entries for 140,000 books, pamphlets, bound periodicals, and theses are arranged in one alphabet. The analytics for periodical literature are interfiled. Indexing of journals analyzed in the *Art index* was discontinued in 1963.

J11    Hitchcock, Henry-Russell. American architectural
         books: a list of books, portfolios, and pamphlets on
         architecture and related subjects published in America
         before 1895. Minneapolis, Univ. of Minnesota Pr.
         [1962]. xii, 130p. (Repr.: N.Y., Da Capo, 1975, with a
         new introd. by Adolf K. Placzek.)

1st printed ed. 1946. The 1962 ed. has addenda, p.vii–ix, in "Preface to the new printing." Originally issued 1938–39, Middletown, Conn., as a preliminary mimeographed bibliography. 2d ed., Middletown, Conn., issued in parts; various pagings, 1939–40. Parts 1–2 and 5, covering the letters A–D and S–Z, are a complete 2d ed; parts 3–4, covering the letters E–R, contain only addenda and corrigenda to the 1st ed.

Arranged alphabetically by author. Locations in some important collections are indicated. See also Jordy, William H., et al. *A chronological listing of all items in American architectural books by Henry-Russell Hitchcock.* Charlottes-
ville, Va., American Association of Architectural Bibliogra-
phers, Publication no. 4, 1955.

J12    Ingersoll, Phyllis W. Ideal forms for cities: an historical
         bibliography. Monticello, Il., Council of Planning
         Librarians, June 1959. 67p. (Exchange bibliography,
         10) (Repr.: Jan. 1969.)

An excellent, analytical bibliography (247 items) on concepts of the ideal urban form throughout Western history. Succinct annotations.

Contents: pt. 1, General references; pt. 2, 6th-century Greece through the Victorian era; pt. 3, 20th century; pt. 4, Index.

J13    Johns Hopkins University. John Work Garrett Library.
         The Fowler Architectural Collection of the Johns
         Hopkins University; catalogue comp. by Laurence
         Hall Fowler and Elizabeth Baer. Baltimore, Evergreen
         House Foundation, 1961. xvi, 383p. 30 plates.

The catalogue of the collection given to Johns Hopkins Univ. by Laurence Hall Fowler. Most of the books listed are editions of architectural classics. The collations and complete bibliographical descriptions make this work a valuable reference tool for rare book librarians, book dealers, and book collectors.

J14    Lasch, Hanna. Architekten-Bibliographie; deutsch-
         sprachige Veröffentlichungen, 1920–1960. Leipzig,
         Seemann, 1962. 215p.

A list of books, articles, and dissertations in German, written between 1920-60. Includes literature on architects of all periods and places. Arranged alphabetically by architect.

J15    New York State Historical Association. Guide to historic preservation, historical agencies, and museum practices: a selective bibliography. Comp. by Frederick L. Rath, Jr. and Merrilyn Rogers O'Connell. Cooperstown, New York State Historical Assn., 1970. xvi, 369p.

A successor to *NYSHA selective reference guide to historical preservation,* pub. in 1966.

A selective compilation of basic references in the field of historic preservation, concentrating on books, pamphlets, and articles published since 1945. Especially valuable for the preservation specialist. Divided into seven categories: preservation organizations; general reference; preservation principles and practices; administration; study and care of collections; research: methods and sources; interpretation. Comprehensive index, p.277-369.

J16    O'Neal, William B., ed. The American Association of Architectural Bibliographers. Papers. Charlottesville, Univ. of Virginia Pr., v.1-11, 1965-74; v.12- , N.Y., Garland, 1977- . Annual.

Editor, v.12- , Frederick Nichols.

A series of scholarly bibliographies by various compilers. For the most part these are devoted to works by and about famous architects and architectural historians, e.g. Walter Gropius, Henry-Russell Hitchcock, Sir Nikolaus Pevsner. v.11 is a detailed index to the first 10v.

J17    Park, Helen. A list of architectural books available in America before the Revolution. Rev. ed. Foreword by Adolf K. Placzek. Los Angeles, Hennessey & Ingalls, 1973. 79p. (Art and architecture bibliographies, no. 1)

Originally published in the *Journal of the Society of Architectural Historians* 20:115-30 (Oct. 1961).

A list of 106 books compiled from references in early library catalogues, inventories, book dealers' catalogues, and newspaper advertisements. Each entry includes 18th-century locations, symbols for modern locations, and general period of publication. Preceded by a bibliographical essay and list of sources.

J18    Pevsner, Nikolaus. Some architectural writers of the nineteenth century. Oxford, Clarendon, 1972. xiv, 338p. 78 figs.

A history of architectural literature from Horace Walpole to William Morris. Limited for the most part to English writers of the Gothic and Italianate Revivals. Bibliography in text is supplemented by many critical footnotes. Appendix I: "English architecture thirty years hence," by Robert Kerr. Appendix II: "The revival of architecture," by William Morris. Photographs, drawings, and illustrations from 19th-century books and periodicals.

J19    Phillips, Margaret. Guide to architectural information. Lansdale, Pa., Design Data Center [1971]. vi, 89p.

A bibliographical aid for research in architecture, intended for the architect and the librarian. Includes 230 entries (most of which are annotated), for bibliographies, indexes, directories, encyclopedias, and handbooks in the field of architecture. Also lists relevant tools in the areas of planning, environmental design, building, and engineering.

J20    Royal Institute of British Architects. Sir Banister Fletcher Library. Architectural periodicals index. London, v.1, 1972- . Quarterly index; the 4th issue is an annual cumulation. Continues and expands the index section of its *Library bulletin* and supersedes its *Annual review of periodical articles* (1967-1971/72).

A classified subject index to articles in approx. 200 periodicals received in the Royal Institute of British Architects Library. International in scope. Subjects included are architecture, building, town planning, and landscape architecture. The list of subject headings does not include names of architects, planners, and builders.

J21    Smith, Denison Langley. How to find out in architecture. A guide to sources of information. Oxford, Pergamon, 1967. xii, 232p. il.

"The aim of this volume has been to present the student and practitioners with details of sources of information likely to be found useful in the pursuit of the three related professions of building, planning, and architecture."—*Pref.* A handbook for the student and the librarian.

J22    Waetzholdt, Stephan, ed., and Haas, Verena, comp. Bibliographie zur Architektur im 19. Jahrhundert: Die Aufsätze in den deutschsprachigen Architekturzeitschriften 1789-1918. 8v. Nendeln, Liechtenstein, Kraus-Thomson, 1977.

"Lists all contributions on construction projects, reconstruction, renovation, design contests, architectural theory and criticism, as well as the technical aspects of building, which appeared in the 129 most important German-language journals on architecture and the construction industry published between 1789 and 1918 in the German and Austro-Hungarian empires and in Switzerland."—*Publisher's preface.* There are 78,693 entries classified in 22 main subject headings. Examples: Biographies; Fountains, monuments, towers; Public buildings; Commercial buildings; Private homes; Castles and fortifications.

Zeitschriftenverzeichnis, p.xix-xxiv. Indexes in v.8: Verfasserregister; Architektenregister; Topographisches Register.

J23    Wood, Charles B., III. "A survey and bibliography of writings on English and American architectural books published before 1895." *Winterthur portfolio* 2:127-37 (1965).

"This study is an effort to list and comment on the more pertinent writings about the publication and influences of the architectural books of England and America issued before 1895."—*p.127.*

The critical bibliographical essay is followed by the bibliography of 102 entries.

SEE ALSO:   Berlin. Staatliche Kunstbibliothek. *Katalog der Ornamentstichsammlung* (P63); Columbia University. Library. Avery architectural library. *Catalog of the Avery Memorial Architectural Library* (A58); Paris, Bibliothèque Forney. *Catalogue d'articles de périodiques, arts décoratifs et beaux-arts* (P4); _____. _____. *Catalogue matières; arts-décoratifs, beaux-arts, métiers, techniques* (P5); Sharp, D. *Sources of modern architecture: a bibliography* (J126); Wiebenson, D. *Sources of Greek revival architecture* (J141).

# DICTIONARIES AND ENCYCLOPEDIAS

J24   Architectural Publication Society. Dictionary of architecture. London, Richards, 1852–92. 8v. il., plates (part col.), plans, folio. (Repr. of the 8v. dictionary plus a supplementary volume of essays: N.Y., Da Capo, 1969.)

A monumental architectural dictionary, the work of many authors over a period of 50 years. Still an important reference work. Includes essays on architectural forms and subjects, biographies of architects, topographical articles, and terms. Many lithographic and wood-engraved illustrations. Bibliographical references.

J25   Britton, John. A dictionary of the architecture and archaeology of the Middle Ages, including words used by ancient and modern authors in treating of architectural and other antiquities . . . also, biographical notices of ancient architects. Illustrated by numerous engravings by J. Le Keux. London, Longman, Orme, Brown, Green, and Longmans, 1830–38. 498p. 39 plates (incl. plans).

An encyclopedic dictionary, important for the study of the medieval revival in Great Britain. Includes terms, building types, biographies of architects, and places. Bibliographical references.

*See* "John Britton and the genesis of the Gothic Revival," by J. Mordaunt Crook, in *Concerning architecture* (J7), p.98–119.

J26   Fleming, John; Honour, Hugh; and Pevsner, Nikolaus. The Penguin dictionary of architecture. Drawings by David Etherton. 2d ed. Harmondsworth, Penguin, 1972. 315p. il., plans.

1st ed. 1966; 2d ed. available in paperback, 1973. A new rev. and enl. ed.: Woodstock, N.Y., Overlook, 1976. 554p. il., plans. Includes new categories and expanded sections on national styles, the addition of short bibliographic notations for most entries, and numerous small photographs.

The best 1v. dictionary of architecture for students of art history. Written by three leading scholars. Includes biographical entries, technical terms, building materials, concise explanations of styles and art movements, and types of buildings. Illustrated with line drawings.

J27   Harris, Cyril M., ed. Dictionary of architecture and construction. N.Y., McGraw-Hill [1975]. xv, 553p. il.

An up-to-date dictionary of architecture and building, written by a team of 52 specialists. Directed primarily to the professional architect. Includes terms used in engineering, urban planning, and landscape architecture. "Specialists working in the fields of history of architecture, church architecture, restoration, and art history will find the in-depth, comprehensive coverage of terms in Classical, Medieval, and Renaissance architecture of particular value." —*Pref.*

J28   Harris, John, and Lever, Jill. Illustrated glossary of architecture, 850–1830. London, Faber and Faber, [1966]. xi, 78p. 224 plates, plans, diagrs.

Available in paperback (N.Y., Potter).

Although written for students of British architecture, this dictionary is useful for the study of all areas of Western architectural history. It is "a new type of glossary which, by use of photographs, would show an architectural detail not only *in situ* but also in relation to the whole facade or in part."—*Introd.* Includes terms not in the *Oxford English dictionary*. The photographs, with details clearly labeled, are arranged according to building types and architectural features within the chronological arrangement of styles.

J29   Portoghesi, Paolo, ed. Dizionario enciclopedico di architettura e urbanistica. [Roma] Istituto Editoriale Romano [1968–69]. 6v. il., maps, plans, plates.

An up-to-date scholarly encyclopedia in dictionary form, indispensable as a reference tool for architectural historians. Signed articles by specialists. Includes: (1) Biographies of about 8,000 architects (with lists of works), city planners, and authors of treatises of all times and all countries. Modern writers are treated selectively. For each has an extensive bibliography and a documented history of criticism; (2) Building types; (3) Terms; (4) Stylistic categories; (5) 700 entries on principal cities; (6) Entries under concepts, styles, geographical areas, and ethnic groups.

Many plans, excellent line drawings, and photographs.

J30   Sturgis, Russell, ed. A dictionary of architecture and building, biographical, historical, and descriptive, by Russell Sturgis . . . and many architects, painters, engineers and other expert writers, American and foreign. N.Y., Macmillan, 1901–02. 3v. il., plates. (Repr.: Detroit, Gale, 1966.)

Still the standard encyclopedia-dictionary in English. Especially good for the explanations of traditional architectural and building terms. The art historical material is antiquated. Illustrated with photographs and clear line drawings.

The bibliography of sources consulted, v.3, p.1141–1212, is arranged alphabetically by author.

J31   Vocabulaire international des termes d'urbanisme et d'architecture. Internationales Wörterbuch für Städtebau und Architektur. International vocabulary of town planning and architecture. Présenté par Jean-Henri Calsat [et] Jean-Pierre Sydler. Sous l'égide de: Union internationale des architectes [et la] Féderation Internationale por l'Habitation, l'Urbanisme et l'Aménagement des Territoires. 1. éd. Paris, Société de Diffusion des Techniques du Bâtiment et des Travaux Publics, 1970- .

*Mainstone, R.J. Developments in structural form. 1975.
→ (only hist. of the techniques of building)*

A trilingual dictionary of 4,000 planning and architectural terms in common usage. French, German, and English. Classification table of the concepts; trilingual systematic lists, with short definitions, alphabetical indexes of terms in each language.

J32   Wasmuths Lexikon der Baukunst. Berlin, Wasmuth [1929–37]. 5v. il., plates (part col.), diagr.

"Unter Mitwirkung zahlreicher Fachleute herausgegeben von Günther Wasmuth; Schriftleitung: Dr.-Ing. Leo Adler; Bildredaktion: George Kowalczyk."

Includes terms, biographies, and articles on the historical, legal, and social aspects of architecture. The longer articles are signed. Especially useful for research on early modern architecture. Bibliographies. Good illustrations, with many plans and diagrams. The supplement reflects Nazi ideology.

Contents: Bd. 1–4, A–Z; Bd. 5, Nachtrag A–Z.

J33   Whittick, Arnold, ed. Encyclopedia of urban planning. N.Y., McGraw-Hill [1974]. xxi, 1,218p. il.

A convenient authoritative reference work dealing with all aspects of urban planning. Signed articles by an international group of specialists. The architectural historian will find here entries on architects, planners, writers, and outlines of urban planning history under country and period. Contributors to these sections include Lewis Mumford, Jacqueline Tyrwhitt, Steven Curl, Constantine Doxiadis, and Arnold Whittick. Adequate illustrations. Index, p.[1189]–1218. Includes bibliographic references.

# HISTORIES AND HANDBOOKS

J34   Braunfels, Wolfgang. Monasteries of Western Europe: the architecture of the orders; with 286 photographs, engravings and plans. [Trans. from the German by Alastair Laing]. London, Thames & Hudson; Princeton, Princeton Univ. Pr., 1972. 263p. il., plans.

A stimulating study of monasteries from antiquity to Le Corbusier. The emphasis is on the correlation between the planning of the buildings and the rules and life of the various monastic orders. Includes "Selections from documentary sources" with parallel Latin text and English translations. Bibliography, p.[251]–54.

J35   DeZurko, Edward Robert. Origins of functionalist theory. N.Y., Columbia Univ. Pr., 1957. xii, 265p. il.

A thorough study of functionalist theory in architecture, based on the treatises of the architects and other literary sources. Demonstrates the antiquity of the theory, its various guises, and its recurrence up to the present. Most of the text deals with theory prior to 1850, ending with the period of Horatio Greenough (1805–52). Lucidly written with extensive bibliographical footnotes, and an excellent bibliography covering the major sources.

J36   Fergusson, James. A history of architecture in all countries from the earliest times to the present day. London, Murray, 1891–99. 5v. il., plans, maps.

Rev., expanded, and rearranged ed. of *The illustrated handbook of architecture*, first pub. in 1855, and frequently reprinted and revised.

Maurice Craig, in "James Fergusson," *Concerning architecture* (J7), p.140, notes that this general history is out-of-date, prejudiced, and factually unreliable, yet "in its vast synoptic sweep, Fergusson's book still stands alone in the English language. It is also endlessly stimulating."

Contents: v.1–2, History of ancient and medieval architecture; v.3, History of Indian and Eastern architecture; v.4–5, History of modern styles of architecture. Index to the entire work, v.5, p.439–53.

J37   Fletcher, *Sir* Banister Flight. A history of architecture. 18th ed., rev. by J. C. Palmes. N.Y., Scribner, 1975. 1,390p. 3,334 il.

1st ed. 1896. A standard reference work, now most useful as a compendium of clear illustrations, in particular the well-known line drawings of plans, sections, and elevations (with dimensions).

The 17th ed., 1961, by R. A. Cordingley, constituted an extensive revision, with new material and updating of the entire text on Baroque architecture, new chapters on 19th- and 20th-century architecture, and rewritten chapters on Belgian and Dutch, Chinese, Indian, Japanese, and Muslim architecture.

The 18th ed., 1975, is a further revision. The "Comparative analysis" sections are omitted. New chapters have been added on Renaissance architecture in Scandinavia, Russia, and outside Europe; on the indigenous architecture of Sri Lanka (Ceylon), Burma, Cambodia, Thailand, Indonesia, Tibet, Nepal, Afghanistan; on pre-Columbian architecture in America; and on the modern movement. All chapters in the 17th ed. incorporated in the 18th ed. have been revised and/or rewritten.

J38   Gothein, Marie Luise. A history of garden art. Ed. by Walter P. Wright; trans. from the German by Mrs. Archer-Hind, with over 600 illustrations. London and Toronto, Dent; N.Y., Dutton [1928]. 2v. il., double plans. (Repr.: N.Y., Hacker, 1966.)

A comprehensive overview of the history of garden art and architecture, now a classic. Still valuable to the architectural historian as a reference work. v.1 covers antiquity beginning with the gardens of ancient Egypt; the medieval period; and the Renaissance in Italy, Spain and Portugal, France, and England; v.2 covers the Renaissance in Germany and the Netherlands, France under Louis XIV, French influence in Europe, Oriental gardens, the English landscape garden, and 19th- and early 20th-century garden design. Chapter XVII, "Modern English gardening," by Walter P. Wright; Chapter XVIII, "Landscape architecture in North America," by Frank A. Waugh. Index to both volumes at the end of v.2.

J39   The great ages of world architecture. N.Y., Braziller, 1961–74. 12v. il.

Available in paperback.

An unnumbered series of short surveys by prominent scholars; together these volumes comprise an excellent

introductory history of architecture. Well illustrated, with good bibliographies.

Titles and authors of the volumes: Scranton, Robert L. *Greek architecture* (1963); Brown, Frank E. *Roman Architecture* (1961); MacDonald, William L. *Early Christian and Byzantine architecture* (1962); Saalman, Howard. *Medieval architecture* (1962); Branner, Robert. *Gothic architecture* (1961); Lowry, Bates. *Renaissance architecture* (1962); Millon, Henry A. *Baroque and Rococo architecture* (1961); Scully, Vincent. *Modern architecture* (2d ed. 1974); Hoag, John D. *Western Islamic architecture* (1963); Robertson, Donald. *Pre-Columbian architecture* (1963); Wu, Nelson T. *Chinese and Indian architecture* (1963); Alex, William. *Japanese architecture* (1963).

J40   Guadet, Julien. Éléments et théorie de l'architecture; cours professé à l'École Nationale et Spéciale des Beaux-Arts. Paris, Librairie de la construction moderne [1902]. 4v. il., 47 plates, plans.

A comprehensive work, compiled for architects and students of architecture, based on the course given at the École des Beaux-Arts, Paris. Now most valuable for the many examples of buildings, plans, architectural features, etc. of the Beaux-Arts style of the 19th century. Each volume has its own table of contents. v.3 contains "Table alphabétique des matières contenues dans l'ouvrage," p.535–64, and "Table alphabétique des figures contenues dans l'ouvrage," p.565–601. v.4, "Additions," has its own table of contents and the same indexes of subjects and illustrations as v.3.

J41   Gutkind, Erwin Anton. International history of city development. N.Y., Free Pr. of Glencoe, 1964–72. 8v. il., maps.

A monumental work on the development of cities and urbanism throughout the world. Based in part on original sources. Of special value to the art historian because of the many illustrations, including historical maps, drawings, paintings, engravings, photographs of urban spaces, and aerial photographs. The emphasis is on urban form rather than the socioeconomic development of cities.

J42   Hamlin, Talbot Faulkner. Architecture through the ages [Rev. ed.]. N.Y., Putnam [1953]. 684p. il., plates, plans.

Originally published in 1940. A good 1v. history of architecture. Bibliography (mostly background books) included in the foreword. Index, p.659–84.

J43   _____. Forms and functions of twentieth-century architecture. N.Y., Columbia Univ. Pr., 1952. 4v. il., plans.

"Prepared under the auspices of the School of Architecture of Columbia University" and compiled by specialists. "A new work to succeed Guadet's *Eléments et théorie de l'architecture.*"—*Pref.*

An attempt to give the architectural student of the mid-20th century a basic foundation in the elements of architecture, general principles of design and composition, as well as the forms and functions of all types of buildings which serve modern society. Based on the time-honored Beaux-Arts

course of instruction. Includes essays by architects. Each chapter is concluded with a list of suggested readings. Well illustrated. General index to the 4v. in v.4, p.843–906. "Index of architectural works," v.4, p.907–46.

J44   Handbuch der Architektur, unter Mitwirkung von Fachgenossen hrsg. von Josef Durm, Hermann Ende, Eduard Schmitt and Heinrich Wagner. Darmstadt, Diehl, 1883–(1943). 79v. il., plates, plans, diagrs.

A monumental work, old and for the most part obsolete. Divided into four sections: (1) General building; (2) Historical styles; (3) Building construction; (4) Design, building, and equipment. Contains bibliographies.

J45   Hansen, Hans Jürgen. Architecture in wood; a history of wood building and its techniques in Europe and North America. With contributions by Arne Berg, Emile Bonnel, Hermann Janse, Alfred Kamphausen, Toini-Inkeri Kaukonen, Agnoldomenico Pica, Nancy Halverson Schless, Georg R. Schroubek, and J. T. Smith. Trans. by Janet Seligman. London, Faber and Faber [1971]. 288p. il. (part col.)

German ed.: *Holzbaukunst: Eine Geschichte der abendländischen Holzarchitektur und ihrer Konstruktionselemente,* Oldenburg and Hamburg, Stalling, 1969.

A scholarly history of wooden architecture from its beginnings to the present day, the collaborative effort by a group of experts. All types of structures are discussed, from churches, shops, and private homes to stables and windmills. Extensive bibliography, p.273–76. Index of people and places, p.278–81; general index, p.282–88.

J46   Hegemann, Werner, and Peets, Elbert. The American Vitruvius: an architect's handbook of civic art. N.Y., Architectural Book Pub., 1922. vi, 298p. il., front., plans. (Repr.: N.Y., Blom, 1972.)

A pioneer work on historic civic design. Valuable as a corpus of plans, drawings, and photographs. "The objective has been the compilation of a thesaurus, a representative collection of creations in civic art, so grouped and so interpreted in text and captions as seems best suited to bring out the special significance of each design."—*Foreword.*

Contents: (1) The modern revival of civic art; (2) Plaza and court design in Europe; (3) The grouping of buildings in America; (4) Architectural street design; (5) Garden art as civic art; (6) City plans as unified designs; (7) The plan of Washington.

J47   Kimball, Sidney Fiske, and Edgell, George Harold. A history of architecture. [2d ed.] N.Y., Harper [1946]. 621p. il., plans. (Repr.: Westport, Conn., Greenwood.)

1st ed. 1918.

A readable introductory survey by scholars, for many years the standard textbook. Chronological list of key monuments at the end of each chapter. Glossary.

J48   Lavedan, Pierre. Histoire de l'urbanisme. Paris, Laurens, 1926–52. 3v. il., plates, plans, maps.

2d ed.: v.1, (1) Antiquité. Par Pierre Lavedan et Jeanne Hugueney, Paris, Laurens, 1966; v.2, Renaissance et temps modernes, rev. et complètée, Paris, Laurens, 1959.

This comprehensive history of city planning and urban design in the western world is an indispensable reference work for architectural historians. Scholarly notes with bibliography. Richly illustrated with plans, drawings, engravings, and photographs. Index of names and places at the end of each volume.

Contents: v.1, Antiquité-moyen âge; v.2, Renaissance et temps modernes; v.3, Époque contemporaine.

J49    Lundberg, Erik. Arkitekturens formspråk; studier över arkitekturens konstnärliga värden i deras historiska utveckling. Stockholm, Nordisk rotogravyr [1945-61]. 10v. il., plates (part col.), maps, plans.

A monumental history of architecture written by the foremost Swedish architectural historian. It has never been translated for the English-speaking reader. Many illustrations. Includes bibliographies. Contents: (1) Den äldre antiken; (2) Den yngre antiken, 300 f.Kr.-600 (300 B.C.-600 A.D.); (3) Västerlandets medeltid, 600-1200; (4) Västerlandets medeltid, 1200-1450; (5) Renässansen i Italien, 1420-1620; (6) Sengotiken samt renässansen utanför Italien, 1420-1540; (7) Renässansen utanför Italien, 1540-1620; (8) Organiserande klassicism och expressiv barock, 1620-1715; (9) Vägen till nutiden. Elementär struktur såsom arkitektoniskt ideal, 1715-1850; (10) Nutiden, 1850-1960.

J50    Millon, Henry A., and Frazer, Alfred. Key monuments of the history of architecture. N.Y., Abrams [1964]. 536p. il., maps, plans.

Text ed.: Englewood Cliffs, N.J., Prentice-Hall.

An excellent pictorial handbook for students, historians, and anyone who loves architecture. Accurate information and good illustrations (including plans) of significant buildings in the history of world architecture.

J51    Morini, Mario. Atlante di storia dell'urbanistica della preistoria all'inizio del secolo XX. 1,432 illustrazioni in 262 tavole. Milano, Hoepli [1963]. 381p. il., maps, plans.

An atlas of 1,432 illustrations, with explanatory text, of city plans, ideal cities, urban spaces, and gardens throughout history. Especially good for the Italian material. Includes bibliographies.

J52    Nervi, Pier Luigi, ed. History of world architecture. N.Y., Abrams, 1971- .

In progress.

A series of historical surveys, each written by a specialist or specialists. Projected in 13v., the whole will comprise a monumental universal history of architecture. Each book has approx. 400 pages, approx. 400 illustrations, a comprehensive bibliography, synoptic tables, biographies of major architects, and index. Drawings, plans, dramatic photographs.

Titles published to date: Martin, Roland; Müller, Hans Wolfgang; and Lloyd, Seton. *Ancient architecture* (1973); Mango, Cyril A. *Byzantine architecture* (1974); Kubach, Hans Erich. *Romanesque architecture* (1975); Murray, Peter. *Renaissance architecture* (1971); Norberg-Schulz, Christian. *Baroque architecture* (1971); _____. *Late Baroque and Rococo architecture* (1974); Bussagli, Mario. *Oriental architecture* (1974); Gendrop, Paul, and Heyden, Doris. *The architecture of Mexico and Mesoamerica* (1976); Ward-Perkins, John B. *Roman architecture* (1977); Hoag, John D. *Islamic architecture* (1977); Grodecki, Louis. *Gothic architecture* (1977). Projected titles: Middleton, R. *Modern architecture;* Tafuri, M., and Co, F. Dal. *Contemporary architecture.*

J53    Norberg-Schulz, Christian. Meaning in Western architecture. (Trans. by Anna Maria Norberg-Schulz). N.Y., Praeger [1975]. 445p. il.

Trans. of *Significato nell'architettura occidentale,* Milano, Electa, 1974. Available in paperback (N.Y., Praeger).

A stimulating history of architectural forms treated as symbols of their cultures and periods. Presents an overview of significant works from Egypt to the present plurality of styles. Each style is discussed in relation to its cultural, geographic, technical, and symbolic roles. Major buildings are analyzed in detail. Richly illustrated with photographs, plans, and elevations. Bibliographic footnotes. Selected bibliography, p.435-37; index of names and places, p.439-44.

J54    Pevsner, Nikolaus. A history of building types. Princeton, N.J., Princeton Univ. Pr. [1976]. 352p. 748 il. (A. W. Mellon lectures in the fine arts, Bollingen series, 35)

A pioneering history of types of buildings. Most of these evolved and were developed in the 18th and 19th centuries. Churches, schools, and dwellings are not included. The author outlines changes in style, function, and planning of 20 building types ranging "from the most monumental to the least monumental, from the most ideal to the most utilitarian, from national monuments to factories."—*Introd.* Superb visual documentation.

Contents: (1) National monuments and monuments to genius; (2) Government building from the late 12th to the late 17th centuries; (3) Government buildings from the 18th century: Houses of Parliament; (4) Government buildings from the 18th century: Ministries and public offices; (5) Government buildings from the 18th century; (6) Town halls and law courts; (7) Theatres; (8) Libraries; (9) Museums; (10) Prisons; (11) Hotels; (12) Exchanges and banks; (13) Warehouses and office buildings; (14) Railway stations; (15) Market halls, conservatories, and exhibition buildings; (16) Shops, stores, and department stores; (17) Factories. Bibliographies and notes.

J55    _____. An outline of European architecture. 7th ed. Baltimore, Penguin, 1963. 496p. il., plans.

Available in paperback.

1st ed. 1943; 6th Jubilee ed. 1960; repr. with revised bibliography, 1968.

James Ackerman calls this classic survey "the nearly perfect textbook, without equal in the history of architecture" (*Art bulletin,* Mar. 1961). An outline discussion of the main trends in European architecture after the Romans, illustrated by a limited number of key representative works.

The Jubilee ed. (1960) has additional essays on the German Baroque and architecture after World War I. Good photographs. Bibliography, p.727-31.

**J56**   Planning and cities. General ed., George R. Collins. N.Y., Braziller [1968-73] 12v. il.
An excellent series of surveys and monographs on various aspects of urban planning. Well illustrated with photographs and plans. Include bibliographies.

Titles and authors of series: Fraser, Douglas. *Village planning in the primitive world* (1968); Lampl, Paul. *Cities and planning in the ancient Near East* (1968); Hardoy, Jorge. *Urban planning in pre-Columbian America,* (1968); Saalman, Howard. *Medieval cities* (1968); Evenson, Norma. *Le Corbusier: the machine and the grand design* (1970); Wiebenson, Dora. *Tony Garnier: the Cité industrielle* (1970); Saalman, Howard. *Hausmann: Paris transformed* (1971); Fein, Albert. *Frederick Law Olmsted and the American environmental tradition* (1972); De La Croix, Horst. *Military considerations in the city planning: fortifications* (1972); Choay, Françoise. *Planning in the 19th century* (1969); Argan, Giulio C. *The Renaissance city* (1969); Ward-Perkins, J.B. *The cities of ancient Greece and Italy* (1973).

**J57**   Roisecco, Giulio, ed. L'architettura del ferro. Roma, Bulzoni, 1972- .
In progress.
A comprehensive history of the structural use of iron in architecture and building from the 17th century in England to the present. Written by a team of specialists under the direction of Giulio Roisecco and Romano Jodice. Art historical rather than technical in treatment; emphasizes cultural and historical factors as well as technological advances in the development of new styles of iron architecture. Based on extensive research. Well-documented with notes and bibliographies. Profusely illustrated, including many early prints and drawings.

Plan of the work: (1) L'Inghilterra (1688-1914) [di] Giulio Roisecco, Romano Jodice, [e] Pier Giorgio Babaloni, 1972; (2) La Francia (1715-1914), 1973; (3) Gli Stati Uniti (1776-1914), 1974. Projected volumes: L'Europa (1815-1914); Il Mondo contemporaneo (1914-ai giorni nostri).

**J58**   Rosenau, Helen. The ideal city, its architectural evolution. 2d rev. ed. London, Studio Vista; N.Y., Harper, 1974. 176p. il.
1st ed. (London, Routledge & Paul), 1959, entitled *The ideal city in its architectural evolution.*
A brief history of ideas and projects for ideal cities, ranging from the Greek tradition to present-day utopian schemes. Detailed bibliographical notes at the end of each chapter. "Concise bibliography," p.169-71. Well illustrated with photographs and early drawings, prints, and plans.

**J59**   Royal Institute of British Architects. Sir Banister Fletcher Library. Catalogue of the drawings collection of the Royal Institute of British Architects. London, Gregg [1968]-
At head of title: Royal Institute of British Architects, London.
Running title: RIBA drawings collection.

Prepared by Prunella Hodgson, John Harris, Alexandra Gordon Clark, Margaret Ballard, and assistants.
In progress. Projected in 20 v. with supplementary volumes and a cumulative index.
A monumental catalogue of approx. 300,000 architectural drawings in this great collection. The entries are arranged by architect. Separate volumes are devoted to those architects who are well represented in the collection, for example, Palladio and Voysey. For each drawing gives meticulous technical description, provenance, and literature. Most of the drawings are illustrated.

**J60**   Simpson, Frederick Moore. A history of architectural development. New ed. London, N.Y., Longmans, Green, 1954-62. 4v. il., maps, plans.
This "new" history of architecture has retained only the name and method of an old standard work.
Contents: v.1, Plommer, Hugh. *Ancient and classical architecture* (1956); v.2, Stewart, Cecil. *Early Christian, Byzantine and Romanesque architecture* (1954); v.3, ——. *Gothic architecture* (1962); v.4, Hughes, J. Quentin, and Lynton, Norbert. *Renaissance architecture* (1962); v.5, Howarth, Thomas. *Nineteenth and twentieth century architecture* (never published).

**J61**   Zucker, Paul. Town and square from the Agora to the village green. N.Y., Columbia Univ. Pr., 1959. xxiii, 287p. il., plans. (Paperback repr.: Cambridge, Mass., MIT Pr., 1970.)
"This book takes as its starting point a concept different from the usual position. It tries to develop the aesthetics of the artistically shaped *void,* which finds its most outspoken and characteristic form in the square, in the plaza, the focal point in the organization of the town." —*Pref.*
A survey from antiquity to 19th-century America. Many illustrations. Good basic bibliography, p. 256-75.

# ANCIENT

## Egypt and Western Asia

**J62**   Badawy, Alexandre. Architecture in ancient Egypt and the Near East. Cambridge, MIT Pr. [1966]. x, 246p. il., maps, plans.
An excellent handbook of the ancient architecture in Egypt, Mesopotamia, Asia Minor and Syria, the Levant, Elam and Persia, and Cyprus. Typological arrangement under each area. Bibliographical footnotes.

**J63**   ——. A history of Egyptian architecture. Giza, Misr, 1954-(68). (3)v. il.
Projected in 5v. v.2-3, Berkeley, Univ. of California Pr.
Contents: v.1. From the earliest times to the end of the Old Kingdom; v.2. The First Intermediate Period, the Middle Kingdom, and the Second Intermediate Period; v.3. The Empire (the New Kingdom) from the 18th dynasty to the end of the 20th dynasty, 1580-1085 B. C.

A comprehensive history, written by a scholar who is both an architect and historian. Promises to be the definitive work. Glossary. Well illustrated with photographs, plans, and drawings.

J64    Clarke, Somers, and Engelbach, Reginald. Ancient Egyptian masonry: the building craft. London, Oxford Univ. Pr., 1930. 242p. il., plates, map, diagrs.
A detailed treatment of "problems incident to the construction of a stone building in Ancient Egypt."—*Pref.* Well illustrated. Appendix I, Ancient Egyptian tools; Appendix II, "List of localities in Egypt and Lower Nubia mentioned in the volume," p.225–26; Appendix III, Chronology p.227-–29. Bibliography, p.230–32. Index, p.233–42.

J65    Naumann, Rudolf. Architektur Kleinasiens von ihren Anfängen bis zum Ende der hethitischen Zeit. 2., erw. Aufl. Tübingen, Wasmuth [1971]. xiii, 508p. il.
1st ed. 1955
The standard work of scholarship on ancient architecture in Asia Minor and North Syria (3rd and 2nd millenium B. C.). The 2d ed. incorporates research since 1955 and reconstruction drawings. Bibliographical references in footnotes.

J66    Smith, Earl Baldwin. Egyptian architecture as cultural expression. N.Y., London, Appleton-Century, 1938. 264p. il. (incl. plans). (Repr.: [Watkins Glen, N.Y.] American Life Foundation, 1968.)
A basic work. Well illustrated with line drawings and plans.

SEE ALSO:  Martin, R., Müller, H., and Lloyd, S., *Ancient architecture* (J52); Pope, A. U. *Persian architecture* (J104).

# Classical World

J67    Castagnoli, Ferdinando. Orthogonal town planning in antiquity. Trans. from the Italian by Victor Caliandro. Cambridge, Mass., MIT Pr., 1971. 138p. il., plans.
Trans. of *Ippodamo di Mileto e l'urbanistica a pianta ortogonale* (Rome, 1956).
A study of the influential regular plans of Greek, Etruscan and Italic, Hellenistic, and Roman cities. Well illustrated. Bibliographic footnotes. Appendix lists research since 1956. No index.

J68    Hanfmann, George M. A. From Croesus to Constantine: the cities of Western Asia Minor and their arts in Greek and Roman times. Ann Arbor, Univ. of Michigan Pr., [1975]. xiii, 127p. il., [31] leaves of plates. (Jerome lectures, 10th ser.)
A scholarly review of Roman influence in the ancient countries of western Asia Minor (Bythnia, Mysia, Lydia, Caria, and Lyria). The author's purpose is "to trace the changing character of the cities in that zone and of the arts which these cities had created, especially that of sculpture. It will be my special purpose to show how the Roman-Asiatic or eastern Roman art in turn was transformed into the art of Byzantium"—*p.1.* Good bibliography, p.98–109.

J69    Lyttelton, Margaret. Baroque architecture in classical antiquity. London, Thames & Hudson; Ithaca, N.Y., Cornell Univ. Pr., 1974. 336p., 227 plates. (Studies in ancient art and archaeology)
A unique study of ancient Greek and Roman architecture which can be called "Baroque" in the Wölfflinian definition of the term. Concentrates on the architecture and town planning in Alexandria, Petra, Syria, Asia Minor, Greece, and Lepcis Magna. Well illustrated (227 figs.) with plates, drawings, and plans. "Notes on the text," p.298–323; "Select glossary," p.324–26; "Select bibliography," p.327–31.

J70    Robertson, Donald Struan. A handbook of Greek and Roman architecture. 2d ed. Cambridge, Univ. Pr., 1945. xxvi, 507[1]p. il., 24 pl.
1st ed. 1929; 2d ed. 1943; repr. with corrections 1945, 1954, 1959, 1964. Latest reprint and first paperback ed. under title *Greek and Roman architecture*, Cambridge, Univ. Pr., 1969.
Still a standard English handbook of Greek and Roman architecture. Appendix I is a chronological table, with comments, on about 370 monuments. Appendix II is a "Select bibliography (up to 1928) of prehistoric, Greek, Etruscan, and Roman architecture from the earliest times to 330 A.D." Appendix III is a "Select glossary of architectural terms."

## Crete, Mycenae, Greece

J71    Dinsmoor, William Bell. The architecture of ancient Greece: an account of its historic development. Based on the first part of *The Architecture of Greece and Rome*, by William J. Anderson and R. Phené Spiers. 3d ed. rev. and enl. London, Batsford, 1950. xxiv, 424p. il., maps. (Repr.: N.Y., Biblo & Tannen, 1973; N.Y., Norton, 1975; available in paperback, N.Y., Norton, 1975.)
1st ed. 1902.
The most factual general history of Greek architecture. Indispensable for reference and research in the field.
Appendix of "Metric measurements of temples," p.337–40 (with measurements in feet). Chronological list of Greek temples (chart). Selected, classed bibliography, p.341–86; list of periodicals, p.386; glossary, p.387–97; detailed index, p.398–424.

J72    Fyfe, David Theodore. Hellenistic architecture: an introductory study. Cambridge, Univ. Pr., 1936. 247p. il., 29 plates. (Repr.: Rome, "L'Erma," di Bretschneider, 1965; Chicago, Ares, 1975.)
An introduction for the student and general reader. The main divisions are temples, tombs and monuments, scenic and baroque tendencies, materials, and constructions.

J73    Graham, James Walter. The palaces of Crete. Princeton, Princeton Univ. Pr., 1962. xii, 269p. il., maps, plans.
A comprehensive survey of the domestic architecture of Crete during the Bronze Age. Directed to scholars, laymen, and travelers.

**J74**   Lawrence, Arnold Walter. Greek architecture. |2d|
ed. Harmondsworth; Baltimore, Penguin, 1967. xxxiv,
338p. il., 152 plates, maps. (The Pelican history of art,
Z11)
1st ed. 1957.

An excellent survey of architecture from Crete and
Mycenae through the Hellenistic period. Good illustrations.
Bibliography, p.315-26.

**J75**   Martin, Roland. Manuel d'architecture grecque. Paris,
Picard (1965- ). v.(1- ). plates, diagrs. (Collection
des manuels d'archéologie et d'histoire de l'art)
This first volume of a projected series of three is an
exhaustive treatment of Greek materials and construction.
Extensive bibliographical footnotes.

"Martin has given us as nearly definitive as well as interesting
a treatment of the subject as is humanly possible in the
present state of knowledge."—Robert L. Scranton in
*Archaeology*, Apr. 1967, p.150.

Contents: v.1. Matériaux et techniques; v.2. Styles et
formes (projected); v.3. Plans et compositions (projected).

**J76**   _____. L'urbanisme dans la Grèce antique. Paris,
Picard, 1956. 301p. 32 plates on 16 l., plans.
An authoritative study of ancient Greek town planning and
urban design. Based on archaeological research. Biblio-
graphical footnotes. Many good illustrations.

Contents: Pte. (1) Principes et règlements; Pte. (2)
L'évolution architecturale des villes; Pte. (3) Les éléments
de la composition et l'esthétique urbaine.

**J77**   Travlos, John. Pictorial dictionary of ancient Athens.
|Prep. in collaboration with the| German Archaeo-
logical Institute. N.Y., Praeger |1971|. xvi, 590p. il.,
maps, plans.
Translated from the Greek. Published simultaneously in
German by Wasmuth, Tübingen, 1971.

A study of the area and monuments of ancient Athens
from an architectural point of view. Provides summaries of
excavation results and conclusions based on older literature
and the author's own observations. Excellent photographs,
line drawings, and plans. Extensive bibliography for each
chapter.

**J78**   Wycherly, Richard Ernest. How the Greeks built
cities. 2d ed. London, Macmillan, 1962. xxi, 235p. il.,
16 plates, plans.
1st ed. 1949.

A standard work. "The purpose of this brief survey of
Hellenic architecture is to define the form of the ancient
Greek city and the place of certain elements in it; and since
the place of some of these elements in the whole depends
on their form, I shall add a little about the nature of a
number of characteristically Greek building types, without
attempting, however, to cover the whole range."—*Pref. 1st
ed.*

The 2d ed. has supplementary notes and additional
illustrations. Bibliographies in notes.

SEE ALSO:  Ashmole, B. *Architect and sculptor in ancient
Greece* (R78); Evans, *Sir* A. J. *The palace of Minos* (I94);

Martin, R., Müller, H., and Lloyd, S., *Ancient architecture*
(J52); Scranton, R., *Greek architecture* (J39).

**Etruria and Rome**

**J79**   Anderson, William James. The architecture of ancient
Rome: an account of its historic development; being
the second part of the Architecture of Greece and
Rome, by William J. Anderson and R. Phené Spiers.
Rev. and rewritten by Thomas Ashby. London,
Batsford |1927|. 202p. il., plates, plans, map. (Repr.:
Freeport, N.Y., Books for Libraries |1971|)
A standard work which has not been revised. "Chronological
memoranda," p.xii. Selective bibliography, p.|175|-79.
Glossary p.|180|-92.

**J80**   Blake, Marion Elizabeth. Ancient Roman construction
in Italy from the prehistoric period to Augustus. A
chronological study based in part upon the material
accumulated by the late Dr. Esther Boise Van Deman.
Wash., D.C., Carnegie Institution of Washington,
1947. xxii, 421p. 57 plates. (Carnegie Institution of
Washington. Publication 570)
The first of a series of three books on ancient materials and
construction. Basic to research on Roman architecture.

**J81**   _____. Roman construction in Italy from Nerva
through the Antonines. Ed. and completed by Doris
Taylor Bishop. Philadelphia, American Philosophical
Society, 1973. xix, 328p. 110 il., 17 plans.
The 3d volume in her series on ancient Roman building
materials and construction. See *Ancient Roman construction
in Italy from the prehistoric period to Augustus* (J80) and
*Roman construction in Italy from Tiberius through the
Flavians* (J82). Finished after the death of the author by
Doris Taylor Bishop. Divided into three sections: Rome,
Ostia, and the rest of Italy. Each section has a table of
contents. Extensive documentation. Richly illustrated.

**J82**   _____. Roman construction in Italy from Tiberius
through the Flavians. Wash., D.C., Carnegie Institution
of Washington, 1959. xvii, 195p. 31 plates. (Carnegie
Institution of Washington. Publication 616).
Roman materials and construction in the early Empire,
between 14 A.D. and 96 A.D. To be used with her first study
(J80). Important for the understanding of arch and vault
construction.

**J83**   Boethius, Axel, and Ward-Perkins, J. B. Etruscan
and Roman Architecture. Harmondsworth; Balti-
more, Penguin |1970|. xxxiii, 622p. il., col. front.,
104 plates (275 figs.), 6 maps, plans. (The Pelican
history of art, Z32)
An important scholarly overview of Etruscan and Roman
architecture from its early origins in Italy to the period of
Constantine.

Contents: pt. 1, Architecture in Italy before the Roman
Empire, by A. Boethius; pt. 2, Architecture in Rome and
Italy from Augustus to the mid-third century, by J. B. Ward-

Perkins; pt. 3, The architecture of the Roman provinces, by J. B. Ward-Perkins.

List of abbreviations, select glossary, scholarly notes, bibliography, and index. Excellent illustrations.

J84    Canina, Luigi. Gli edifizi di Roman antica cogniti per alcune reliquie, descritti e dimostrati nell'intera loro architettura dal commendatore Luigi Canina. Roma, Canina, 1848-56. 6v. 517 plates.

Imaginative reconstructions of ancient Rome. For a long time an indispensable work, now largely replaced by accurate archaeological reconstructions.

J85    Crema, Luigi. L'architettura romana. Torino, Società editrice internazionale [1969]. xxiii, 688p. il., plans. (Enciclopedia classica, sezione III. Archeologia e storia dell'arte classica, v.12. Archeologia (arte romana) t.1)

The best comprehensive handbook of Roman architecture. The scope is from the 3d century B.C. to the period of Constantine. Divided into periods and types of building. Each section has an extensive bibliography in the text. Many illustrations.

According to Alfred Frazer, this volume "will certainly become the *vade mecum* of anyone interested in Roman architecture."—*Journal of the Society of Architectural Historians* 21:146 (Oct. 1962).

J86    Grenier, Albert. Manuel d'archéologie gallo-romaine. Paris, Picard, 1931-[60]. 4v. il., plans.

An authoritative handbook of Gallo-Roman archaeology. Extensive documentation. Well illustrated. Includes bibliographies. v.3 and v.4, on architecture, are especially useful to art historians.

Contents: v.1, Généralités. Travaux militaires; v.2 (pt. 1) L'archéologie du sol. Routes. (pt. 2) L'archéologie du sol. Navigation, occupation du sol; v.3 (pts. 1-2) L'architecture: l'urbanisme. Les monuments. Ludi et circuses; [v.4, (pts. 1-2)] Les monuments des eaux: aqueducs. Thermes. Villes d'eau et sanctuaires de l'eau.

J87    Lugli, Giuseppe. La tecnica edilizia romana, con particolare riguardo a Roma e Lazio. Roma, Bardi, 1957. 2v. il., plates. (Repr.: N.Y., Johnson, 1968.)

An important work on the technique of Roman construction based primarily on investigation of the ruins of Rome and the surrounding area of Lazio. Profusely illustrated.

J88    MacDonald, William Lloyd. The architecture of the Roman Empire. v.1. New Haven, Yale Univ. Pr., 1965. 211p. il., plates, diagrs., plans. (Yale publications in the history of art. 17)

v.1. An introductory study; v.2, never published. An important study of four key monuments of Imperial Rome. Should be reprinted.

Contents: Background; Nero's palaces; Domitian's palace; Trajan's markets; the Pantheon; Architects; Economy of construction; the new architecture. Appendix: Principal dimensions (in meters), p.[185]-88. Selected bibliography (classed), with occasional pertinent comments, p.[189]-98.

J89    McKay, Alexander G. Houses, villas and palaces in the Roman world. Ithaca, N.Y., Cornell Univ. Pr., 1975. 288p. il., plates.

English ed: London, Thames and Hudson, 1975.

A unique, well-written survey of Roman domestic architecture, intended for both the student and the general reader. Summarizes the latest research. The photographic illustrations, plans, and drawings have informative captions.

Contents: (I) The Etruscan background; (II) Italian town houses: Pompeii, Herculaneum and Cosa; (III) Rome and Ostia: domus and palatium; (IV) Italian multiple dwellings; (V) Italian villas: rural, suburban and maritime; (VI) Roman interior furnishing and decoration; (VII) European provinces and Britain; (VIII) Eastern provinces and North Africa. Notes; Bibliography; Architectural glossary.

J90    Nash, Ernest. Pictorial dictionary of ancient Rome. [2d. ed. rev.] N.Y., Praeger [1968]. 2v. il., plans.

Supplements Platner-Ashby (J91) with research since 1929 and illustrations of monuments (photographs and historic engravings). Also includes architectural ornament, sculptural decoration, and inscriptions. Alphabetical arrangement with an extensive bibliography for each entry.

J91    Platner, Samuel Ball. A topographical dictionary of ancient Rome. Completed and rev. by Thomas Ashby. London, Oxford Univ. Pr., 1929. 608p. il., plates, maps, plans.

An important work. The monuments, ruins, areas, etc. in the city of Rome are arranged in one alphabet. Bibliographical references in text. "Chronological index to dateable monuments," p.587-600. Sparsely illustrated. Supplemented but not entirely superseded by Nash (J90).

SEE ALSO:  Brown, F. *Roman architecture* (J39); Dudley, D. R. *Urbs Roma: a source book of classical texts on the city & its monuments* (H11); Ward-Perkins, J. B. *Roman architecture* (J52).

# EARLY CHRISTIAN — BYZANTINE

## Bibliography

J92    MacDonald, William. A selected bibliography of architecture in the age of Justinian. [Charlottesville, Va.] American Association of Architectural Bibliographers, 1960. (American Association of Architectural Bibliographers. [Publication] no. 16)

A classified bibliography of 287 entries; occasional, brief annotations. Contents: (1) Sources; (2) Handbooks and general works; (3) Works on specific areas or sites.

## Histories and Handbooks

J93    Krautheimer, Richard. Corpus basilicarum christianarum Romae. The early Christian basilicas of Rome, IV-IX cent. Città del Vaticano, Pontificio Istituto di Archeologia Cristiana, 1937-(70). v.1-(4). il., plates, plans. (Monumenti di Antichità Cristiana

pubblicati dal Pontificio Istituto di Archeologia Cristiana, ser, 2, v. II)

In progress; v.5 (the last) in press.

v.2–4 written in collaboration with Wolfgang Frankl and Spencer Corbett, and issued jointly with the Institute of Fine Arts, New York Univ.

The monumental work of the foremost authority in the field. Constitutes a "collection of the Early Christian Churches in Rome as far as this is at present possible and as far as these churches are still preserved either in their entirety or in remnants or through old drawings and illustrations which reproduced beyond doubt the original aspects. In any event, the emphasis is on the analysis of the structure of the buildings and on the architectural history of the monuments which results from this analysis."—*Pref. to v.1.*

Arranged alphabetically by Italian name of church. For each church generally gives introductory material, detailed description and analysis of existing building, and excavation results. Contents: v.1, S. Adriano - S. Gregorio Magno; v.2, S. Lorenzo fuori le mura - S. Maria in Domnica; v.3, S. Maria Maggiore - S. Pudenziana; v.4, SS. Quattro Coronati - S. Vitale; v.5 is a supplementary volume which includes St. John's in the Lateran, Old St. Peter's, and S. Paolo fuori le mura.

J94 _____. Early Christian and Byzantine architecture. Harmondsworth; Baltimore, Penguin, 1975. 2d ed. 575p. il. plates, maps, diagrs., plans. (The Pelican history of art, PZ24)

2d ed. available only in paperback. 1st ed. 1965; repr. 1967.

The fundamental survey and reference work. Incorporates the new research on over 200 churches, monasteries, martyria, and palaces. Virtually replaces most earlier comprehensive studies. Glossary of terms; good index which lists buildings by place and type. Many photographs, plans, maps, and diagrams. Extensive bibliography in notes; selective bibliography, p.539–41.

J95 Mathews, Thomas F. The early churches of Constantinople: architecture and liturgy. University Park, Pennsylvania State Univ. Pr. [1971]. xviii, 194, [60]p. il., plans.

A brilliant study of the ceremonial use of pre-iconoclastic Byzantine churches in Constantinople. Based upon archaeological evidence and liturgical sources. Excellent photographs and plan reconstructions.

Bibliography, p.[181]–87.

J96 Ovadiah, Asher. Corpus of the Byzantine churches in the Holy Land, trans. from the Hebrew by Rose Kirson. Bonn, Hanstein, 1970. 223p., 74p. of il. (Theophaneia; Beiträge zur Religions- und Kirchengeschichte des Altertums, 22)

"A compilation of the churches of the Byzantine period which have been found west of the Jordan—up to 1964. This study deals with the churches which have been excavated or surveyed during recent decades, and not with those mentioned in literary sources only."—*Introd.*

Lists 181 churches (from the first half of the 4th century A.D. to the beginning of the 8th century), with detailed technical data and bibliographical references for each entry.

Arranged alphabetically by site. Does not include separate buildings such as burial chapels, oratoria, crypts, or baptismal chapels.

SEE ALSO: MacDonald, W. L. *Early Christian and Byzantine architecture* (J39); Mango, C. A. *Byzantine architecture* (J52).

# ISLAMIC

The entries for the Islamic architecture of Africa and Asia (excluding Turkish Asia) are listed below. The entries for Turkish architecture are numbered J298–300.

J97 Creswell, Keppel Archibald Cameron. Early Muslim architecture: Umayyads, early 'Abbāsids & Tūlūnids. Oxford, Clarendon, 1932–40. il., plans, diagrs., folio.

v.1, A.D. 622–750, 1st ed. 1932, 2d ed. 1969, 1v. in 2; v.2, A.D. 751–905, 1940. A monumental work, both in size and scholarship. Covers the first three centuries of Islamic architecture. Arranged chronologically. For each monument gives a description of the original structure, an analysis, and its architectural origins.

Includes bibliographies.

J98 _____. The Muslim architecture of Egypt. Oxford, Clarendon, 1952–59. 2v. il., plates, maps, plans, folio.

A truly monumental study, with exhaustive descriptions and analyses of each monument. Includes bibliographies.

Contents: v.1, Ikhshīds and Fāṭimids, A.D. 939–1171; v.2, Ayyūbids and early Baḥrite Mamlūks, A.D. 1171–1326.

J99 Hill, Derek. Islamic architecture and its decoration, A.D. 800–1500. A photographic survey by Derek Hill, with an introductory text by Oleg Grabar. Chicago, Univ. of Chicago Pr., 1964. 88p. 296 plates (part col.), map.

A picture book (535 photographs) with a 60-page introduction by a well-known scholar. Limited to Asia Minor, Persia, Afghanistan, and Iransaxana. Bibliographical notes, p.86–87.

J100 _____. Islamic architecture in North Africa: a photographic survey by Derek Hill; with notes on the monuments and a concluding essay by Lucien Golvin; and an introduction by Robert Hillenbrand. London, Faber and Faber; Hamden, Conn., Archon, 1976. 167p. il. (part col.), 136 leaves of plates.

A corpus of superb new photographs of Islamic architecture in Egypt, Morocco, Algeria, and Tunisia. Glossary. Bibliography, p.155–56.

J101 Jairazbhoy, Rafique Ali. An outline of Islamic architecture. N.Y., Asia Pub. House [1972]. xvi, 386p. il.

This survey of Islamic architecture is directed to English-speaking students of art history. Concentrates on the innovative buildings, with a judicious selection of other works representative of various periods and countries.

Glossary (Arabic and other Islamic architectural terms), p.337–39. Bibliography (includes literary texts in translation), p.341–56. 189 plates; 65 figures in the text.

Contents: (1) Arabia, Syria, Tunisia, and Mesopotamia; (2) Spain; (3) How Islamic architecture transformed the face of Europe; (4) Egypt; (5) Turkey; (6) Iran; (7) India.

J102    Marçais, Georges. L'architecture musulmane d'occident: Tunisie, Algérie, Maroc, Espagne et Sicilie. Paris, Arts et métiers graphiques [1955]. x, 540p. il., plans.
Arranged the same as its predecessor *L'architecture . . .* (Paris, Picard, 1926–27, 2v.) with series title "Manuel d'art musulman [I]."

A fundamental handbook of the Muslim architecture in Spain, Sicily, and North Africa. Each chapter has a concise summary at end. Summary of important literature from 1927–54 in *avant propos;* comprehensive bibliography, p.497–[513]. "Index des termes techniques," p.515–18; "Index des noms de personnes," p.519–23; "Index des noms de lieux," p.525–[30].

J103    Mayer, Leo Ary. Islamic architects and their work. Genève, Kundig, 1956. 183p.
Brief biographies of architects in the Muslim world excluding Pakistan, India, Indonesia and the other Islamic, or partially Islamic, areas of the Far East. Extensive bibliographies. Topographical index, p.[137]–47. Bibliography, p.[149]–83.

J104    Pope, Arthur Upham. Persian architecture: the triumph of form and color. N.Y., Braziller, 1965. 288p. il., maps, plans, 33 col. plates.
An excellent survey of Persian architecture from prehistoric times through the first world empire. By the author of *Survey of Persian art* (I548). Many illustrations.
Bibliographical references included in notes, p.272–80; Bibliography, p.281–83.

J105    Rivoira, Giovanni Teresio. Moslem architecture, its origins and development. Trans. from the Italian by G. McN. Rushforth. London, N.Y., Milford, Oxford Univ. Pr., 1918. 383p. inc. plates, il., plans. (Repr.: N.Y., Hacker, 1975.)
A pioneer survey of the development of the mosque from its origin to the 12th century. Examines mosques in Medina, Mecca, Kufa, Jerusalem, Cairo, Kairawan, Damascus, Armenia, and Spain. Index of places, p.373–80. General index, p.381–83.

J106    Wilber, Donald Newton. The architecture of Islamic Iran; the Il Khānid period. Princeton, Princeton, Univ. Pr., 1955. 208p. il., maps, plans. (Princeton monographs in art and archaeology, 29)
An important work on Islamic architecture of the 13th and 14th centuries A.D. in Iran. Consists of an historical sketch and a catalogue of the surviving monuments, each with a full bibliography.
"Architectural monuments known only through literary references," p.190–91. Bibliography, p.192–200. Index, p.201–8.

SEE ALSO:   Brown, P. *Indian architecture* (v.2) (J349); Hoag, J. D. *Islamic architecture* (J52); _____. *Western Islamic architecture* (J39); Toussaint, M. *Arte mudéjar en América* (J259).

## CAROLINGIAN — GOTHIC

J107    Clapham, Alfred William. Romanesque architecture in Western Europe. Oxford, Clarendon, 1936. xv, 280p. 44 pl. on 22 l., maps, plans.
A standard handbook, still useful as an introduction in English. Includes the Holy Land and the East. Summary bibliography at the end of each chapter.

J108    Conant, Kenneth John. Carolingian and Romanesque architecture, 800 to 1200. [2d ed.]. Harmondsworth; Baltimore, Penguin [1966]. xxxviii, 343p. il., maps, plans, plates.
1st ed. 1959.
"The present volume is devoted to the genesis, development and transformation of Romanesque architecture and is concerned with the principal efforts of four centuries." —*Foreword.* A fundamental reference work which presents an overview of Romanesque styles throughout Europe. Especially thorough in the treatment of Clunaic architecture. Eight plates of restoration studies, plans, photographs, etc. Bibliographical notes; classed bibliography, p.320–26.

J109    Dehio, Georg Gottfried. Die kirchliche Baukunst des Abendlandes, historisch und systematisch dargestellt von G. Dehio und G. von Bezold. Stuttgart, Cotta, 1887–1901. 2v. il., atlas of 601 plates in 5v.
Still a standard reference work on medieval architecture.
Contents: Bd. 1, Der christlich-antike Stil, der romanische Stil; Bd. 2, Der gotische Stil. Extensive bibliographies at the beginning of the chapters. Index to both volumes in v.2, p.600–23.

J110    Dimier, M. Anselme. Recueil de plans d'églises cisterciennes. Grignan, Drôme, Abbaye Notre-Dame d'Aiguebelle, 1949. 2v. 336 plates in portfolio.
_____. Supplément, 2v. 360 plates in portfolio, 1967. Bibliography, v.1, p.29–37.
v.1 of the original inventory and the supplement contain: Table générale (alphabetical list with summary facts and bibliography); Table par pays; Table par filiations; Table des abbayes de moniales; Table chronologique. The supplement has in addition: Table des plans inédits; Table des églises de style baroque; Table de tous les plans reproduits dan le *Recueil* et dans le *Supplément*. v.2 of each is a repertory of illustrations arranged alphabetically.

J111    DuColombier, Pierre. Les chantiers des cathédrals: ouvriers, architectes, sculpteurs. Nouv. éd. revue et augm. Paris, Picard, 1973. 187p. il.
1st ed. 1953.
The fundamental and unique study of the cathedral workshops and other material conditions relevant to the

building of the great Gothic cathedrals. This 2d ed. has additional early drawings, new findings based on research in the archives of Germany and Austria, and a chapter on the sculptors and sculpture. Well illustrated with manuscript paintings and drawings; well documented with bibliographical references in notes; list of illustrations with commentary; bibliography.

Contents: (I) Les tâches; (II) Le patron; (III) La main-d'oeuvre; (IV) L'architecte; (V) Le sculpteur; Appendice: (I) Maestri comacini et architectes lombards; (II) Les signes lapidaires; (III) Les Quatre-Couronnés, patrons des tailleurs de pierre.

J112  Fitchen, John Frederick. The construction of Gothic cathedrals: a study of medieval vault erection. Oxford, Clarendon, 1961. xxi, 344p. il., diagrs.
"The present study does not attempt an exhaustive investigation of single buildings . . . Rather, it undertakes to recreate the operational procedures and sequences that are likely to have been practised, together with the equipment utilized, in the creation of the great Gothic churches as a class, particularly in France."—*Pref.* Extensive "Notes and comments," p.197–240; 16 appendixes, p.241–306. Glossary, p.307–16. Bibliography, p.317–36.

J113  Frankl, Paul Theodore. The Gothic: literary sources and interpretations through eight centuries. Princeton, Princeton Univ. Pr., 1960. x, 916p. plates, 957 figs.
A history of ideas on the Gothic style. "It is not a bibliography nor a collection of historical data relating to the individual buildings, but is concerned with the question of what has been thought and written about the phenomena of Gothic as a whole since Suger."—*Foreword.*
Consists of selected quotations (translated into English) accompanied by critical discussion. Indexes of persons, places, and subjects; 31 appendixes.

J114  ———. Gothic architecture. [Trans. from the German by Dieter Pevsner]. Harmondsworth; Baltimore, Penguin, 1962. xxii, 315p. il., 192 plates, maps, plans. (The Pelican history of art. Z19)
A history of Gothic architecture based on the author's theory of style. Good index. Special literature cited in the notes; bibliography (p.297–99) is a list of works of a general nature.

J115  Gall, Ernst. Die gotische Baukunst in Frankreich und Deutschland. Zweite, ergänzte Aufl. Braunschweig, Klinkhardt & Biermann [1955]. [v.1]. il., plans. (Handbücher der Kunstgeschichte)
1st ed. 1925.
Only v.1 published. A standard text, especially valuable for the study of form and space in Gothic architecture.
Contents: Die Vorstufen in Nordfrankreich von der Mitte des elften bis gegen Ende des zwölften Jahrhunderts. Bibliographical footnotes.

J116  Harvey, John Hooper. The mediaeval architect. London, Wayland, N.Y., St. Martin's, 1972. 296p. il., plans.

An invaluable study of the architect in medieval Europe. Emphasizes technical as well as theoretical aspects.
Contents: (1) The Middle Ages and medieval architecture; (2) The medieval architect; (3) Education of the architect; (4) Methods: drawings, models, and moulds; (5) Planning: proportional theories and techniques; (6) Organization and professionalism; (7) National and international art. Also includes six appendixes of sources. Bibliography, p.[262]–78.

J117  Hubert, Jean. L'art pré-roman. Paris, Les Éditions d'art et d'histoire, 1938. vii, 202p. il., xl plates.
A discussion and repertory of dated monuments and ornaments of the Merovingian and Carolingian periods. Documented. Good plates; figures and plans in the text.

J118  Munich. Zentralinstitut für Kunstgeschichte. Vorromanische Kirchenbauten. Katalog der Denkmäler bis zum Ausgang der Ottonen. Herausgegeben von Zentralinstitut für Kunstgeschichte. Bearbeitet von Friedrich Oswald, Leo Schaefer [und] Hans Rudolf Sennhauser. München, Prestel [1966–71]. 3v. il., plans. (Veröffentlichungen. 3)
A definitive scholarly catalogue of pre-Romanesque churches and monasteries up to the end of the Ottonian period. Areas included: Belgium, Germany, Luxembourg, the Netherlands, Austria, Poland, Switzerland, Denmark (Jutland), France (Alsace-Lorraine), Italy (South Tirol), and Czechoslovakia (Bohemia and Mähren). Arranged alphabetically by place. Extensive documentation.
Plans and diagrams. Indexes: Saints and patrons, persons, places, subjects.

J119  Puig y Cadafalch, José. La géographie et les origines du premier art roman. Paris, Laurens, 1935. 516p. il., maps, plans.
Trans. of *La geografia i els orígens del primer art romànic* (Barcelona, 1932).
A pioneering study of the origins and dissemination of Romanesque art and architecture.
Contents: pt. 1, La géographie générale du premier art roman; pt. 2, Du IXe siècle au premier quart du XIe siècle; pt. 3, Les églises ornées sur toutes leurs façades. Basiliques simples. Basiliques à transept; pt. 4, La coupole et sa migration en Europe; pt. 5, Analyse des éléments architectoniques; pt. 6, Les origines. Bibliography, p.[489]–502.

J120  Sauer, Joseph. Symbolik des Kirchengebäudes und seiner Ausstatung in der Auffassung des Mittelalters, mit Berücksichtigung von Honorius Augustodunensis, Sicardus und Durandus. 2 verm. Aufl. Freiburg im Breisgau, Herder, 1924. xxvii, 486p. il.
An important work on the symbolism of the medieval church building. Based on the literary sources. Indexes of places, persons, and subjects.

SEE ALSO:  Branner, R., *Gothic architecture* (J39); Saalman, H., *Medieval architecture* (J39).

# RENAISSANCE — BAROQUE

J121    Benevolo, Leonardo. Storia dell'architettura del Rinascimento. Bari, Laterza, 1968. 2v. il., plans, ports. English ed.: London, Routledge & Paul, 1978; Boulder, Westview, 1978.

A history of European architecture from the early 15th century to c.1750 (the Renaissance in its broadest interpretation). Topical arrangement. Stresses the city and the cultural context of architecture. Many good illustrations. Short bibliographical essay at the end of v.2. Continued by *History of modern architecture* (J128).

J122    Brinckmann, A. E. Die Baukunst des 17. und 18. Jahrhunderts. Berlin, Akademische Verlagsgesellschaft Athenaion [1915-19]. 2v. il., plans, plates. (Handbuch der Kunstwissenschaft)

A classic, "stimulating, but difficult to digest." — R. Wittkower (I359).

J123    Burckhardt, Jakob, and Lübke, Wilhelm. Geschichte der neueren Baukunst. Stuttgart, Ebner, 1882-1927. 10v. il. (incl. plans).

v.8-9 have imprint: Esslingen, Neff; v.10 has imprint: Stuttgart, Neff.

Pioneer studies in the history of architecture, a revolutionary work. Many are still useful.

Contents: Bd. 1, J. Burckhardt. *Geschichte der Renaissance in Italien*, 3. Aufl., 1891; Bd. 2-3, W. Lübke. *Geschichte der Renaissance in Deutschland*, 2. verb. & verm. Aufl., 1882; Bd. 4, W. Lübke. *Geschichte der Renaissance in Frankreich*, 2. verb. & verm. Aufl., 1885; Bd. 5, C. Gurlitt. *Geschichte des Barockstiles in Italien*, 1887; Bd. 6, C. Gurlitt, *Geschichte des Barockstiles, des Rococo und des Klassicismus in Belgien, Holland, Frankreich, England*, 1888; Bd. 7, C. Gurlitt. *Geschichte des Barockstiles und des Rococo in Deutschland*, 1889; Bd. 8, O. Schubert. *Geschichte des Barock in Spanien*, 1908; Bd. 9, P. Klopfer. *Von Palladio bis Schinkel*, 1911; Bd. 10, A. Haupt. *Geschichte der Renaissance in Spanien und Portugal*, 1927.

Each volume has index of artists and places.

J124    Kaufmann, Emil. Architecture in the age of reason: Baroque and post-Baroque in England, Italy, and France. Cambridge, Harvard Univ. Pr., 1955. xxvi, 293p. il., (Paperback repr.: N.Y., Dover, 1968.)

The pioneer critical study of 18th-century architecture in Europe. Attempts to classify the architecture into stylistic systems; neoclassical styles are discussed as harbingers of modern architecture.

Extensive bibliographical references included in "Notes," p.217-79.

J125    Wölfflin, Heinrich. Renaissance and Baroque. Trans. by Kathrin Simon. Introd. by Peter Murray. Ithaca, N.Y., Cornell Univ. Pr., 1966. 183p. il., plans.

1st English translation of the pioneer work, *Renaissance und Barock* (1888). The author examines the nature of the change in architectural style (painterly, grand style, massiveness, movement) and the development of the Baroque church, palace, villa, and garden. See also his later *Principles of art history* (I233).

SEE ALSO:  Lowry, B. *Renaissance architecture* (J39); Murray, P. *Renaissance architecture* (J52); Norberg-Schulz, C. *Baroque architecture* (J52); ———. *Late Baroque and Rococo architecture* (J52).

# NEOCLASSICAL — MODERN

## Bibliography

J126    Sharp, Dennis. Sources of modern architecture: a bibliography. N.Y., Wittenborn [1967]. 56p. facsims., ports. (Architectural Association, London. Paper 2)

Sections: (1) Brief biographies with bibliographies, arranged by architect; (2) Subject bibliographies — modern architecture, architectural theory, aesthetics, architecture and society, the Bauhaus, Art Nouveau/Jugendstil; (3) National bibliography; (4) Select list of periodicals. No annotations.

## Histories and Handbooks

J127    Banham, Reyner. The age of the masters; a personal view of modern architecture. Rev. ed. London, Architectural Pr. [1975]. 170p. il.

1st ed. 1962, entitled *Guide to modern architecture*. Paperback ed. of *The age of the masters*, N.Y., Harper [1975].

A compact, highly selective guide to modern architecture, written by an influential critic of modern architecture. Banham's personal view is grounded in sound scholarship. Excellent illustrations scattered throughout the text. Bibliographical references in the marginal notes.

J128    ———. Theory and design in the first machine age. [2d ed.]. London, Architectural Pr.; N.Y., Praeger [1967]. 338p. il., plans.

A brilliant and controversial book on the theory and style of architects and other designers as determined by machine-age technology. Covers the period from about 1880 to the thirties. Bibliographic footnotes.

J129    Benevolo, Leonardo. History of modern architecture. [Trans. from the Italian by H. J. Landry]. Cambridge, Mass., MIT Pr., 1971. 2v. 1,055 il., maps, plans.

1st Italian ed. 1960; English ed. trans from the 3d Italian ed. 1966.

Written for the student rather than the general reader. v.1, The tradition of modern architecture (408p.), covers the origins of modern architecture, architectural thinking, and urbanism from the late 18th century to 1914, v.2, The modern movement (504p.). Extensive bibliography.

J130    Collins, Peter. Changing ideals in modern architecture, 1750-1950. Montreal, McGill Univ. Pr., 1965. 308p. il., plans.

An attempt to trace all the various theories and ideas of the past 200 years which have made modern architecture what

it is today. Concerned not with the evolution of forms, but rather with the changes in those ideals which produced them. Also deals with the influence of the other arts and sciences on architectural theory.

J131   Conrads, Ulrich, comp. Programs & manifestoes on 20th-century architecture. Trans. by Michael Bullock [1st English language ed.]. Cambridge, Mass., MIT Pr., 1970. 192p. il.
German ed. 1964.
Excerpts from significant 20th-century writings on architecture, arranged according to year of first publication. Includes only those texts which were influential to the development of modern architecture in Europe.
Sources, p.187-90.

J132   Germann, Georg. Gothic Revival in Europe and Britain: sources, influences, and ideas. Trans. by Gerald Onn. Cambridge, Mass., MIT Pr., [1973]. 263p. il.
German ed. 1972.
A series of provocative essays in the history of ideas relevant to the emergence and development of the Gothic Revival in the 18th and 19th centuries. The author critically examines the architectural theory of England, France, Italy, and Germany. Bibliography (with quotations from sources) in extensive marginal notes. Well illustrated with 98 figures,
Contents: (I) The Gothic in Vitruvianism; (II) Early theories of the Gothic Revival; (III) The Gothic Revival as a reform movement; (IV) The influence exerted by the Gothic Revival; (V) Conclusion.

J133   Giedion, Sigfried. Space, time, and architecture: the growth of a new tradition. 5th ed., rev. and enl. Cambridge, Harvard Univ. Pr., 1967. lvi, 897p. il.
1st ed. 1941.
A classic in the literature of modern architecture. The 5th ed. includes many new examples, additional discussion of the legacy of Le Corbusier, the International Congress for Modern Architecture (CIAM), and a new chapter "Changing notions of the city." Excellent illustrations. Bibliographical footnotes.

J134   Hatje, Gerd, ed. Encyclopedia of modern architecture. [Trans. from the German by Irene and Harold Meek, from the French, Spanish and Italian by Harold Meek, from the Danish by G. D. Liversage, from the Dutch by E. van Daalen]. London, Thames & Hudson; N.Y., Abrams [1964]. 336p. il.
Rev. ed available in paperback: N.Y., Abrams, 1967. Originally published as *Knaurs Lexikon der modernen Architektur,* Munich [1963].
The introductory essay on architecture from the 19th century to the present is followed by an alphabetically-arranged section of short essays by 30 leading contributors. Comprehensive, well documented, and accurate. 446 illustrations.

J135   Hitchcock, Henry-Russell. Architecture: nineteenth and twentieth centuries. 3d ed. Baltimore, Penguin, 1968. xxix, 520p. il., 197 plates (1 col.), plans. (The

Pelican history of art, Z15)
1st ed. 1958; 2d ed. 1963.
1st paperback ed. 1971, based on 3d hardback ed. Illustrations integrated with text.
The most comprehensive general work on the period, beginning with romantic classicism and ending with the architecture of Aalto and Saarinen. The standard text as well as the best reference book. Divided into three sections: 1800-50, 1850-1900, 1890-1955, with an epilogue added to the 2d and 3d ed. Extensive notes with bibliographic references.
Bibliography, p.479-92.

J136   Jencks, Charles. Modern movements in architecture. Garden City, N.Y., Anchor, 1973. 432p. il.
Available in paperback.
A stimulating critical history of modern architecture. Stresses its pluralistic nature. While largely confined to European trends and architects, some influential American work is discussed. Well illustrated with photographs and line drawings. Bibliographical notes, p.381-96. Bibliography, p.397-98. Index, p.406-32.

J137   Joedicke, Jürgen. A history of modern architecture. [Trans. from the German by James C. Palmes]. N.Y., Praeger [1959]. 243p. 465 il.
A good introductory history for the student and general reader. Bibliographical references in "Notes," p.238.

J138   Platz, Gustav Adolf. Die Baukunst der neuesten Zeit. [2d Aufl. 6.-10. Tausend]. Berlin, Propyläen-Verlag in Verbindung mit der "Bauwelt" [1930]. 634, [1]p. il., plates (part col.), plans. (Propyläen Kunstgeschichte)
The first attempt to bring together the significant buildings of the modern movement. Still valuable as a corpus of illustrations. Bibliography, p.617-[20].

J139   **Sharp, Dennis, ed. A visual history of twentieth-century architecture. N.Y., New York Graphic Society [1972]. 304p. il. (part col.)**
A visual record of 20th-century architecture, containing photographs and some plans of over 400 buildings. Arranged chronologically by decade, from 1900-70, rather than by architect or style. The examples were chosen for their influence on successive structures or for their unique solutions to specific design problems. The text is concise and well written.

J140   **Whittick, Arnold.** European architecture in the twentieth century. London, Lockwood, 1950-53. 2v. il.
Especially useful for ready information on lesser known architects. Contents: v.1, Historical background and the early years of the century. Transition from war to peace 1919-24; v.2, The era of functionalism, 1924-33.
Bibliography: v.1, p.219-23; v.2, p.244-48.

J141   Wiebenson, Dora. Sources of Greek Revival architecture. London, Zwemmer, 1969. xvi, 136p. plates. (Studies in architecture. 8)

A detailed study of various major archaeological publications of the second half of the 18th century, especially concerning the "history of these publications and of their interconnection with architectural theory and taste prior to the Greek revival." —*Pref.* Contents: (1) External history of the *Antiquities of Athens;* (2) Expeditions, tourists, patrons, and publications; (3) Reception of the archaeological publications; (4) The Greek-Roman quarrel; (5) Archaeology and architecture. Appendixes: (1) Proposals, etc., for the archaeological publications; (2) Excerpts from reviews, correspondence, etc., on the archaeological publications; (3) Excerpts from the notes of Sir William Chambers.

J142    Zevi, Bruno. Storia dell'architettura moderna. 4. ed. riv. [Torino] Einaudi, 1961. 787p. il., plates.
1st ed. 1950; 2d ed. 1953; 3d ed. 1955.

An English translation is needed for this landmark history of modern architecture. The author polarizes two modern developments, organic and rational, in Europe and the U.S. Extensive bibliography.

SEE ALSO:  Gloag, J., and Bridgwater, D. *A history of cast iron in architecture* (P547); Hamlin, T. F. *Forms and functions of twentieth-century architecture* (J43); Robertson, E. G., and Robertson, J. *Cast iron decoration: a world survey* (P549) Scully, V. *Modern architecture* (J39).

# WESTERN COUNTRIES

## Australia

For a review of the literature of the history of architecture in Australia see Johnson, Donald Leslie, "Australian architectural histories, 1848-1968," *Journal of the Society of Architectural Historians* 31:323-32, Dec. 1972.

J143    Freeland, John Maxwell. Architecture in Australia; a history. Melbourne, Canberra [etc.] Cheshire [1968]. 328p. il.

The first survey of Australian architectural history, popular and readable. Well illustrated. Short bibliography, glossary, index.

J144    Hermann, Morton. The early Australian architects and their work. 2d ed. Sydney, Angus and Robertson, 1970. xvi, 248p. il. (col. front.)
1st ed. 1954.

A survey of the work of Australian architects during the colonial period (to 1840), with emphasis on the social and historical background. The illustrations include reconstructions of the original structures prepared by the author.

Includes a chronological listing of architects, designers, and town planners. Appendixes: (I) Works designed by Francis Greenway; (II) Further notes on designers. Bibliography, p.224-27. Index, p.244-48.

## Canada

J145    Gowans, Alan. Building Canada; an architectural history of Canadian life. [Rev. and enl. ed.]. Toronto, Oxford Univ. Pr., 1966. xx, 412p. il.

An extensive revision of *Looking at architecture in Canada* (1958). This group of essays comprises a basic survey of Canadian architecture. Many photographs; no plans. Includes bibliographies.

## France

J146    Basdevant, Denise. L'architecture française, des origines à nos jours. [Paris] Hachette [1971]. 416p. 300 il., 24 plates.

An excellent general history of French architecture from its origins to the present. Constitutes both an introduction to the field and an original contribution to scholarship. Text followed by a list of the major architects, a comprehensive bibliography, and a detailed index.

J147    Bauchal, Charles. Nouveau dictionnaire biographique et critique des architects français. Paris, André, Daly, 1887. xvi, 842p.

Pt. 1 is an alphabetical listing of French architects from the Early Christian era until the end of the 18th century; pt. 2 lists those architects who died between 1801-85. The index to monuments cited in the dictionary (p.735-822) is arranged first according to *département,* then cities, then architects. Monuments built in foreign countries by French architects, p.822-26. Bibliography, p.827-37.

J148    Dictionnaire des églises de France, Belgique, Luxembourg, Suisse [Préface d'André Chastel. Paris] Laffont [1966-71]. 5v. il., maps, plans, col. plates, ports.

A systematic inventory of churches and church art in France and the surrounding French-speaking areas. The work of several collaborating scholars. Convenient dictionary arrangement of the articles on individual churches under city or community; these in turn are listed alphabetically within the five broad regions. Signed articles, up-to-date bibliographies, and illustrations. Many plans.

Contents: (1) Histoire générale des églises; (2) France: Centre et Sud-Est; (3) France: Sud-Ouest; (4) France: Ouest et Ile-de-France; (5) Nord et Est, Belgique, Luxembourg, Suisse.

J149    France. Ministère de l'Éducation Nationale [Direction des Archives de France]. Catalogue général des cartes, plans et dessins d'architecture. I. Série N. Paris, 1958-(64). il., incl. plates, elevations.

Contents: v.1, Paris et le département de la Seine, by H. Thirion; v.2, Départements Ain à Nord, by M. Hébert and M. Le Moël; v.3, Départements Oise à Réunion, by M. Le Moël and F. Rochat.

J150    Inventaire général des monuments et des richesses artistiques de la France. Principes d'analyse scientifique. Architecture. Méthode et vocabulaire. Paris, Impr. Nationale, 1972. 2v. il.

A subseries of the new artistic inventory of France (I280). Indicates the procedure, methods, and terminology for the

architectural monuments to be surveyed. v.2 is a corpus of 500 illustrations.

J151   Inventaire général des richesses d'art de la France. Paris, Plon, 1876-1913. 22v. in 24. plans.

A detailed and extensive inventory of French architectural monuments and their decoration. Issued in fascicles treating individual buildings, then collected into the volumes and analytically indexed. Never completed. Five series: (1) Paris. Monuments religieux, 1876-1901, 3v. in 5; (2) Paris. Monuments civils, 1879-1913, 4v.; (3) Province. Monuments religieux, 1886-1907, 4v.; (4) Province. Monuments civils, 1877-1911, 8v; (5) Archives du Musée des Monuments Français, 1883-97, 3v., which contain historical museum papers relating to the organization of French museums. Will be superseded by the new inventory in progress (I280).

J152   Lance, Adolphe. Dictionnaire des architects français. Paris, Morel, 1872. 2v. plates.

An early dictionary with summary information on many French architects up to c.1870. Includes illustrations of architects' stamps, marks, and signatures. Comprehensive analytical index of all names of persons and places cited in the text.

J153   Lavedan, Pierre, [et] Goubet, Simone. Pour connaître les monuments de France. [Paris] Arthaud [1970]. 804p. 1,160 il., plans.

A history of French architecture from the pre-Romanesque period through the work of Le Corbusier. "M. Lavedan has succeeded . . . in giving us the best synthesis on French architecture which exists to this day."—F. Salet in *Bulletin monumental*, 1971, no. 4. Profusely illustrated with excellent photographs, plans, and sections. Informative notes on the illustrations by Simone Goubet. Recent scholarship cited in bibliographical footnotes. No general index of names.

Contents: (1) Comment l'édifice est construit; (2) Moyen âge. Monuments religieux; (3) Moyen âge. Monuments civils; (4) XVIe siècle; (5) XVIIe-XVIIIe siècles; (6) L'architecture moderne. Notices des illustrations, p.667-[764]; Plans et coupes, p.765-[84]; Index des termes techniques, p.785-[88]; Bibliographie sommaire, p.789-[90]; Index des illustrations, p.791-[96].

SEE ALSO: *Inventaire général des richesses d'art de la France* (I280).

## Carolingian — Gothic

J154   Aubert, Marcel. L'architecture cistercienne en France, avec la collaboration de la Marquise de Maillé. 2d éd., Paris, Les Éditions d'art et d'histoire, 1947. 2v. il., map, plans. (Repr.: Paris, Nobele, (n.d.), 2v.)

A definitive reference work on Cistercian architecture in France. Profusely illustrated with photographs and drawings in the text. Bibliographic footnotes.

Contents: [t.1] (I) L'ordre cistercien. (II) Les abbayes cisterciennes. (III) Les églises. [t.2] (IV) Les bâtiments monastiques. (V) Abbayes de femmes. Conclusions. Table des

illustrations, p.[217]-30. Index des noms de lieu, de personne et de matière, p.[231]-67.

J155   ———. L'art français à l'époque romane, architecture et sculpture. Paris, Morancé [1929-51]. 4v. il., 180 plates, plans.

A corpus of pictures (excellent collotype plates including plans) with a short text.

J156   Aubert, Marcel, and Goubet, Simone. Cathédrales, abbatiales, collégiales, prieurés romans de France. [Paris] Arthaud [1965]. 657p. il., plans, diagrs., maps..

A survey of Romanesque monastic architecture in France, directed to the student and general reader. 576 good illustrations. "Notices concernant les illustrations," p.517-636; "Plans et coupes," p.637-44; "Index des termes techniques," p.645-47; "Bibliographie sommaire," p.649-50; "Table des noms de lieux," p.651-58.

J157   Bony, Jean. French cathedrals. Photographs by Martin Hürlimann; descriptive notes by Peter Meyer. [New rev. ed.]. N.Y., Viking, [1967]. 229p. map, plans, 189 plates (part col.)

1st ed. 1951.

A superb picture book with an important introduction by a noted scholar.

J158   Branner, Robert. Burgundian Gothic architecture. London, Zwemmer, 1960. xx, 206p. il., 45 plates. (Studies in architecture. 3)

The first scholarly study of an important regional school of Gothic architecture. 100 pages of text; catalogue of 100 pages. Well illustrated, including plans and drawings of details.

J159   ———. St. Louis and the court style in Gothic architecture. London, Zwemmer, 1965. xvii, 157p. il., plates (Studies in architecture. 7)

A scholarly study of the sophisticated and influential court style of Parisian architecture during the reign of Saint Louis (1226-70). Valuable appendixes.

J160   Evans, Joan. The Romanesque architecture of the order of Cluny. Cambridge, Univ. Pr., 1938. xxxviii, 256p. il., maps. (Repr.: N.Y., AMS Pr., 1972.)

An important study of Cluniac architecture in France and surrounding areas. Organized typologically by plans and characteristic features. Contents: pt. 1, Abbey and priory churches; pt. 2, Monastic buildings. Bibliography, p.[xxvii]-xxxviii.

J161   Grodecki, Louis. L'architecture ottonienne. Paris, Colin, 1958. 342p. il., plates, plans.

The basic scholarly study of Ottonian architecture, essential for the understanding of medieval architecture in France. "Bibliographie sommaire," p.321-24; "Index topographique," p.325-33.

J162   Jantzen, Hans. High Gothic; the classic cathedrals of Chartres, Reims, Amiens. Trans. by James Palmes. N.Y., Pantheon, 1959. xiii, 181p. il., plates (Repr. in paperback: N.Y., Minerva Pr., 1962, 1967.)

An authoritative analysis of three French cathedrals. Provides the student and general reader with an excellent introduction to Gothic architecture of the 13th century.

Contents (I) Ecclesia materialis—the nave, the choir, the transepts, light, Gothic space and its containment, on the technique of the cathedral, the exterior, portals and sculpture, monumental stained glass; (II) Ecclesia spiritualis (the spiritual meaning and form). Bibliographical footnotes. No index.

J163   Lasteyrie du Saillant, Robert Charles, *comte* de. L'architecture religieuse en France à l'époque gothique, ouvrage posthume publié par les soins de M. Marcel Aubert. Paris, Picard, 1926-27. 2v. il., (incl. plans).
A standard work which provides the scholar with information not to be found elsewhere. Index, v.2, p.577-602.

J164   Mussat, André. Le style gothique de l'ouest de la France (XIIe-XIIIe siècles). Paris, Picard, 1963. 446p. il., plans.
A contribution to scholarship in the field of Gothic architecture and architectural sculpture. Limited to the great cathedrals of western France. Following a general discussion of problems of origin, style, and architectural centers, the author presents detailed studies of the cathedrals of Le Mans, Tours, Angers, and Poitiers. Scholarly footnotes. "Essai de bibliographie méthodique et critique," p.407-16. "Certitudes et hypothèsis chronologiques," p.418. Indexes of buildings and illustrations, including maps and plans. 64 plates. 50 figures in text.

J165   Sanfaçon, Roland. L'architecture flamboyante en France. Quebec, Les Presses de l'Université Laval, 1971. 219p. 232 figs., plans, 3 maps.
"An initial, strong, incisive, and provocative statement of many of the basic problems of the French Flamboyant style."—Review by Robert Branner in *Art bulletin* 55:290, no. 2, June, 1973.
Contents: (1) La recherche fébrile de l'individuel; (2) La découverte d'une logique dans l'expression individuelle; (3) Les renaissances régionales; (4) Un idéal communautaire: La région parisienne; (5) De la détente à l'expansibilité: Les grandes options régionales; Conclusion; Bibliographie; Index.

SEE ALSO:  Mortet, V. *Recueil de textes relatifs à l'histoire de l'architecture et à la condition des architectes en France, au moyen age* (H25-26); Stoddard, W. S. *Monastery and cathedral in France: medieval architecture, sculpture . . .* (I290).

## Renaissance — Modern

J166   Blomfield, *Sir* Reginald Theodore. A history of French architecture from the death of Mazarin till the death of Louis XV, 1661-1774. London, Bell, 1921. 2v. 200 plates (incl. plans). (Repr.: N.Y., Hacker, 1973. 1v.)
An old standard work, still the most comprehensive survey in English. Anti-Rococo. Bibliography, v.1, p.[xxiii]-xxviii; "A list of surintendants des bâtiments and of directeurs de

l'Académie de France à Rome," v.1, p.xxix-xxx; Appendix, "On the flat vaulting of the Roussillon," v.1, p.221-24. Appendix, "Soufflot and the dome of the Panthéon," v.2, p.201-2; Index, v.2, p.203-33.

J167   _____. A history of French architecture, from the reign of Charles VIII till the death of Mazarin. London, Bell, 1911. 2v. 178 plates (incl. plans, facsims.) (Repr.: N.Y., Hacker, 1973. 1v.)
A standard work on French classical architecture from its tentative beginnings in the late 15th century to its mature development in the second half of the 17th century. Illustrated by the author's drawings and halftones.
Bibliography, v.1, p.xxvii-xxxii.

J168   Evans, Joan. Monastic architecture in France from the Renaissance to the Revolution. Cambridge, Univ. Pr., 1964. xlii, 186p. il., plates, plans.
The first survey of post-medieval monastic architecture in France. Includes almost 800 buildings. Richly illustrated with photographs and plans.
Bibliography, p.153-58.

J169   Hautecoeur, Louis. Histoire de l'architecture classique en France. Paris, Picard, 1943-57. 7v. in 9. il., plans.
Nouv. éd., complètement refondue et augmentée. Paris, Picard, 1963- .
The milestone historical work on architecture in France from the Renaissance until the end of classicism at the close of the 19th century. Contents: t.1, La formation de l'idéal classique: I. La première renaissance (1495 à 1535-40) 2d ed. 1963; II. La renaissance des humanistes (1535-40 à 1589) 2d ed. 1965; III. L'architecture sous Henri IV et Louis XIII: [ptie. 1] La reconstruction de la France. L'architecture religieuse, 2d ed. 1966; [ptie. 2] L'architecture civile. Le décor et le style, 2d ed. 1967; t.2, La règne de Louis XIV; t.3, Première moitié du XVIIIe siècle: le style Louis XV; t.4, Seconde moitié du XVIIIe siècle: le style Louis XVI, 1750-92; t.5, Revolution et empire, 1792-1815; t.6, Le restauration et le gouvernement de juillet, 1815-48; t.7, La fin de l'architecture classique, 1848-1900.
Divided by historical period. Includes architectural theory and decoration. Richly illustrated with photographs, plans, drawings, etc. Numerous lists, charts, and appendices. Good bibliographies.

J170   Ward, William Henry. The architecture of the Renaissance in France: a history of the evolution of the arts of building, decoration and garden design under classical influence from 1495 to 1830. 2d ed. rev. N.Y., Scribner [1926]. 2v. il., plates, plans. (Repr.: N.Y., Hacker, 1971.)
1st ed. 1911. A well-illustrated basic work now largely antiquated. Contents: v.1, The early Renaissance (1495-1640); v.2, The later Renaissance (1640-1820).
Bibliography and index: v.1, p.266a-f; duplicated in v.2, p.502-33. Each volume has index to text and index to illustrations.

SEE ALSO:  Blondel, J. F. *Architecture françoise* (H81); Du Colombier, P. *L'architecture française en Allemagne au*   **211**

*XVIIIe siècle* (J173); Eriksen, S. *Early Neo-Classicism in France* (P41); Kimball, S. F. *The creation of the Rococo* (P42); Mariette, J. *L'architecture françoise* (H105); Marot, J. *L'architecture française* (H106); _____. *Recueil des plans, profils et eleuations des plusiers palais, chasteaux, églises, sepultures, grotes et hostels batis dans Paris* (H107).

## Germany and Austria

J171   Bourke, John. Baroque churches of Central Europe; photographs by Thomas Finkenstaedt. 2d ed., rev. and enl. London, Faber and Faber, 1962. 309p. plates. 1st ed. 1958.

An excellent introduction to the jubilant Baroque churches of Southern Germany, Switzerland, and Austria. Recommended for the beginning student and the general reader. Includes a chapter on the decorative stucco and other sculpture. Appendixes: (I) Some common attributes and symbols of apostles and saints; (II) Symbolic colours; (III) Short glossary of terms; (IV) Ground plans. Select bibliography. Indexes of persons, places, and subjects.

J172   Buchowiecki, Walther. Die gotischen Kirchen Österreichs. Wien Deuticke, 1952. xv, 490p. il.
A synoptic study of Austrian Gothic architecture, analyzed both by type of church and specific features. The bibliography, p.431-52, consists of 690 entries for literature on Gothic architecture in general.

J173   Du Colombier, Pierre. L'architecture française en Allemagne au XVIIIe siècle. Paris, Presses Universitaires de France, 1956. 2v., 306 il., map, plans. (Travaux et memoires des Instituts Français en Allemagne, 4-5)
A scholarly study of the artistic milieu of the various courts of Germany in the 18th century; concentrates on the French influence on German civil and domestic architecture and the works of French architects in the German dukedoms. Intended to complement Reau's *L'art français dans les pays du nord et de l'est de l'Europe (XVIIIe-XIXe siècles)* of 1932.
Contents: (I) Texte; (II) Planches.
v.1 has bibliographical notes, an index of names, places, and monuments, with illustrations of plans and engravings; v.2 is a corpus of photographic illustrations of the architecture and interior decoration. List of illustrations at beginning; lists of artists, places, and sources of plates at the end.

J174   Hempel, Eberhard. Geschichte der deutschen Baukunst. [2d ed.]. München, Bruckmann [1956]. 596p. il. (part col.), plans. (Deutsche Kunstgeschichte. Bd. 1)
A standard survey of German architecture written by a noted architectural historian.
Bibliography, p.578-85.

J175   Hitchcock, Henry-Russell. Rococo architecture in Southern Germany. London, Phaidon, 1968. viii, 427p. il., map, plans, glossary.
An important scholarly study of Rococo architecture in Bavaria and Baden-Württemberg. Covers the significant

aspects of Rococo architecture; the work of the Zimmermann brothers, however, is covered in a separate volume, *German Rococo: the Zimmermann brothers* (London, 1968).
Contents: (I) The Brothers Cosmas Damian and Egid Quirin Asam; (II) Johann Georg Fischer of Füssen; (III) The Schmuzers: Johann, Franz Xavier and Joseph; (IV) Peter II Thumb; (V) The limits of the Rococo: The work of Johann Michael Fischer and J. B. Neumann.
Notes, p.229-62. Bibliography, p.415.

J176   Möbius, Helga, and Möbius, Friedrich. Mediaeval churches in Germany: Saxony, Thuringia, Brandenburg and Mecklenburg. [Trans. from the German by Marianne Herzfeld and rev. by D. Talbot Rice] Boston] Boston Book & Art [1965]. 237p. il., plates (part col.).
A good introduction in English for the student and the general reader. Limited to architecture in E. Germany from the time of Charlemagne to the end of the medieval period. Includes a catalogue of monuments arranged by date. Bibliographical notes. Well illustrated.

SEE ALSO:  Dehio, G. *Handbuch der deutschen Kunstdenkmäler* (I296); Franz, H. G. *Bauten und Baumeister der Barockzeit in Böhmen* (J264).

## Great Britain and Ireland
### Bibliography

J177   Hall, *Sir* Robert de Zouche. A bibliography on vernacular architecture; ed. by Robert de Zouche Hall [for the Vernacular Architecture Group]. Newton Abbot, David & Charles, 1972. 191p.
A classified bibliography of books and articles on vernacular architecture in Great Britain and Ireland. Brief annotations for most of the entries. Includes early books on the design of farmhouses and other buildings.
Contents: (I) General; (II) Regional and local studies; (III) Rural houses; (IV) Rural buildings other than houses; (V) Town buildings; (VI) Construction and materials; (VII) Early and primitive building; (VIII) Economic and social background. Index of authors' names, p.177-91.

### Histories and Handbooks

J178   Clifton-Taylor, Alec. The pattern of English building. London, Faber and Faber, 1972. 3d ed. rev. and enl. 466p. il., maps.
1st ed. (London, Batsford) 1962.
Attempts to show "the close relationship between the geology of our country and the traditional materials which go to the making of the pattern of English building."—*Foreword.* Concentration on vernacular architecture. Each material—brick, wood, flint, etc.—is discussed in a separate chapter, with emphasis on its physical and aesthetic qualities.
Useful glossary, bibliography, and place index at end of volume.

J179    Colvin, Howard M. A biographical dictionary of British architects 1660–1840. Rev. and enl. ed. London, Murray, 1978. 1,080p.

1st ed., *A biographical dictionary of English architects 1660–1840.* London, Murray; Cambridge, Mass., Harvard Univ. Pr., 1954.

The new ed. includes Scottish and Welsh architects and has a starting date of 1600. An examplary dictionary of architects. Indispensable for any study of the period. Scholarly, based on extensive research with original documents. Aims "to include every architect (whether amateur, tradesman or professional, who habitually made architectural designs) . . . the major part of whose career falls within the limiting dates."—*Pref., 1st ed.* List of buildings is as full and accurate as possible and usually in chronological order. Bibliographical references. Also contains articles on the practice of architecture, the building trades, and the architectural profession.

Appendixes: (A) Some buildings erected before 1840 to the designs of Victorian architects not included in this dictionary; (B) Not included in *A biographical dictionary of English architects 1660–1840,* but excluded from the present work; (C) Public offices held by architects 1600–1840. Index of persons; Index of places: (I) British Isles; (II) Other countries.

J180    _____, ed. The history of the King's works. London, H. M. Stationery Off., 1963–[76]. v.1-3¹, 5-6. il., plates (part col.), maps, plans, portfolio.

A monumental history of the civil, military, and ecclesiastical buildings erected under royal authority in England. Written by experts, based on documentary research. Each volume has extensive footnotes with bibliography and appendixes of documents, illustrations of photographs and plans. v.1-2 are paged continuously (1139p.). Abbreviations for most frequently cited sources. Indexes at end of v.2 and v.6.

Contents: v.1-2, The Middle Ages, by R. A. Brown, H. M. Colvin, and A. J. Taylor; v.3, pt. 1, 1485-1660, by H. M. Colvin, D. R. Ransome, and J. Summerson; v.5, 1660-1782, by H. M. Colvin, J. Mourdant Crook, K. Downes, and J. Newman; v.6, 1782-1851, by J. M. Crook and M. H. Port; v.4 is in preparation.

J181    Dunbar, John G. The historic architecture of Scotland. London, Batsford, 1966. 268p. il., maps.

A survey of Scottish architecture from the Middle Ages to the early Victorian period. Typological in approach. Bibliography, p.255-56; no footnotes.

J182    Great Britain. Royal Commission on the Ancient and Historical Monuments and Constructions of England. An inventory of the historical monuments in [various counties of England], 1911- . il., plates, maps.

There are also comparable publications for Scotland and Wales.

Reprint on microfiche of the *Inventories* of England, Scotland, and Wales (1910-75): Cambridge, Chadwyck-Healey; Teaneck, N.J., Somerset House, 1977.

A scholarly work, well illustrated. Indexes, glossaries.

"These fundamental official catalogues of British antiquities have been proceeding since 1910 and the following areas have been covered. *England:* Buckinghamshire, Dorset, Essex, Herefordshire, Hertfordshire, Huntingdonshire, London, Middlesex, City of Cambridge, City of Oxford. *Scotland:* Berwick, Sutherland, Caithness, Wigtown, Kirkcudbright, Dumfries, the Lothians, Outer Hebrides, Skye, etc. *Wales* has been entirely covered. In all but the most recent English volumes (Dorset, Cambridge) and the Welsh series, only monuments prior to 1714 are described." —Summerson (J215).

J183    Harris, John. A catalogue of British drawings for architecture, decoration, sculpture, and landscape gardening, 1550-1900, in American collections. Introd. by Henry-Russell Hitchcock. Upper Saddle River, N.J., Gregg Pr. [1971]. xv, 355p. 263 il.

A superbly produced catalogue of drawings in American public and private collections. Arranged alphabetically by architect. Full descriptive entries, some including bibliographical references. Excellent illustrations.

J184    Hussey, Christopher, ed. English country houses. London, Country Life, 1955-70. 5v. il., plans.

A series based on Tipping, *English homes* (J191), which revises, supplements, but does not entirely replace the earlier work. Each volume consists of a general introduction and detailed description of from 24 to 28 major houses. Includes family history. Richly illustrated with photographs, sections, plans, elevations, contemporary drawings, and engravings. Bibliographies.

Titles and authors of individual volumes: [1] Hussey, Christopher. Early Georgian, 1715-60 (1955); [2] _____. Mid-Georgian, 1760-1800 (1956); [3] _____. Late Georgian. 1800-40 (1958); [4] Hill, Oliver, and Cornforth, John. Caroline, 1625-85 (1966); [5] Lees-Milne, James. Baroque, 1685-1715 (1970).

J185    Kidson, Peter; Murray, Peter; and Thompson, Paul. A history of English architecture. Rev. ed. Harmondsworth, Penguin [1965]. 352p. il.

Pts. I and II, by Peter Kidson and Peter Murray, were published with the same title (London, Harrap, 1962). The rev. ed. has half again as many illustrations (179) and an illustrated glossary.

tecture written by three noted scholars. Contents: pt. I, The Anglo-Saxon period to end of Middle Ages, by Peter Kidson; pt. II, Tudor and Jacobean architecture to Holland, Soane, and Nash: the Regency, by Peter Murray; pt. III, Victorian and modern architecture, by Paul Thompson. Bibliography, p.331; Glossary, p.334.

J186    Leask, Harold Graham. Irish churches and monastic buildings. Dundalk, Dundalgan Pr., 1955-60. 3v. il., plates.

A comprehensive survey of medieval ecclesiastical architecture in Ireland. Good line drawings, mostly by the author. Glossaries. Indexes: Buildings and plans; subjects and persons. Few footnotes and no bibliography.

J187    Lloyd, Nathaniel. A history of the English house from primitive times to the Victorian period. New ed.

London, Architectural Pr., 1951. 487p. il., plates, plans, diagrs. (Repr.: London, Architectural Pr.; N. Y., Hastings, 1975 [available in paperback as *The history of the English house*].)

1st ed. 1931.

Its chief value is in the arrangement of illustrations by building features: exteriors, entrances, windows, chimneys, staircases, etc., each with descriptive text. Bibliographic footnotes.

J188    London. County Council. Survey of London, issued by the Joint Publishing Committee representing the London County Council and the London Survey Committee, v.1-(37). London, 1900-(73). il., plates, plans.

In progress.

A methodical, parish-by-parish topographical and architectural survey of London. When finished it will provide a comprehensive inventory of the monuments of London. Especially valuable for the study of 18th- and 19th-century architecture. Extensive documentation. Many illustrations.

J189    MacGibbon, David, and Ross, Thomas. The castellated and domestic architecture of Scotland from the twelfth to the eighteenth century. Edinburgh, Douglas, 1887-92. 5v. il. (incl. plans).

Illustrated by numerous plans and line drawings in the text. "Scottish sundials," v.5, p.357-514; "Early Scottish masters of works, master masons, and architects," v.5, p.|515|-69.

Index at end of each volume and a "General index to the whole work," v.5, p.571-95. "Topographical index of buildings described in the whole work," v.5, p.597-603.

J190    Pevsner, *Sir* Nikolaus. The buildings of England. Harmondsworth; Baltimore, Penguin, 1951-74. 46v. il., plates, maps.

Joint authorship on several volumes that have been revised and published in new editions.

An outstanding series, "probably the most sustainedly distinguished feat of architectural writing in England in this century."—Reyner Banham in *Concerning architecture* (J7), p.273. Indispensable to the education of the traveler. The guides also provide the art historian with a convenient source of accurate information and material not to be found elsewhere.

The standard format for each county or region consists of a general historical introduction (including a summary of published sources) followed by the discussion of the specific buildings and towns. Arranged alphabetically by place. Glossaries and indexes at the end of each volume.

J191    Tipping, Henry Avery. English homes. London, Country Life, 1921-37. 9v. il. (incl. plans).

A classic work. Each volume includes a descriptive text and excellent halftone plates of exterior and interior views of about 24 English country houses of the period.

Contents: Period 1, Norman and Plantagenet, 1066-1485; Period 2, Early Tudor, 1485-1558; Periods 1 & 2, Medieval and Early Tudor, 1066-1558; Period 3, Late Tudor and Early Stuart, 1558-1649, in 2v.; Period 4, Late Stuart, 1649-

1714, in 2v.; Period 5, Early Georgian, 1714-60; Period 6, Late Georgian, 1760-1820.

Not entirely superseded by the later series *English country houses*, see Hussey (J184).

J192    The Victoria history of the counties of England. London, Constable, 1900- . il., plates (part col.), maps.

In progress.

A series of historical monographs on the counties of England. Some counties run to several volumes and have separate index volumes. Well illustrated. The later volumes in particular contain valuable information for the architectural historian.

## Early Christian — Gothic

J193    Bond, Francis. Gothic architecture in England; an analysis of the origin & development of English church architecture from the Norman conquest to the dissolution of the monasteries. London, Batsford, 1905. 782p. il., plates, plans, diagrs.

An old standard work. "Titles of authorities quoted," p.vii-xii; "Chronology of English churches," p.|638|-57. Index to illustrations, p.|709|-38; Index of places, p.|739|-72; Index of subjects and glossary, p.|773|-82.

J194    _____. An introduction to English church architecture from the 11th to the 16th century. London, N.Y., Milford, 1913. 2v. 1,400 il.

An early history of church architecture. Useful topical arrangement. A wealth of illustrations, including plans and drawings.

Paged continuously. Bibliography included in preface. English and French glossaries, p.xix-xxxv. Place index, p.961-80; subject index, p.981-86.

J195    Britton, John. The architectural antiquities of Great Britain, represented and illustrated in a series of views, elevations, plans, sections, and details of various ancient English edifices, with historical and descriptive accounts of each. London, Longman, Hurst, Rees, & Orme, 1807-26. 5v. il., 356 plates (incl. plans).

The various monuments are treated separately. v.5 contains a 'Chronological history of Christian architecture in England" and an appendix containing: (1) Alphabetical list of architects and founders of buildings; (2) Chronological list of ecclesiastical edifices in Great Britain; (3) Chronological list of architectural monuments; (4) List of pulpits; (5) List of fonts; (6) The stone crosses; (7) Glossary of terms, Index of references to architectural members and subjects comprised in the plates and letter press of the five volumes, and an Alphabetical index of names of persons, places, terms, etc. to the 5th volume. Each volume has its own index.

A monumental reference work. Its historical value is summarized by Pevsner in *Some architectural writers of the nineteenth century* (J18).

J196    _____. Cathedral antiquities. Historical and descriptive accounts, with 311 illustrations of the following English cathedrals, Viz. Canterbury, York, Salisbury, Norwich, Oxford, Winchester, Lichfield, Hereford,

Wells, Exeter, Worcester, Peterborough, Gloucester, and Bristol. The engravings mostly by J. Le Keux, esq. from drawings by W. Blore . . . [and others]. London, Nattali, 1836. 5v. il., plates, plans.
For each church gives bibliography, lists of archbishops, priors, deans, etc. and a chronological table of different parts of the cathedral, as well as an index.

J197   Clapham, Alfred William. English Romanesque architecture after the Conquest. Oxford, Clarendon, 1934. 180p. il., plates, plans, diagrs. (Repr.: Oxford, Clarendon [1964].)
Along with its companion volume (J198), a standard work on English Romanesque architecture. Bibliographical footnotes.

J198   _____. English Romanesque architecture before the Conquest. Oxford, Clarendon, 1930. 168p. il., plates, plans. (Repr.: Oxford, Clarendon [1964].)
A fundamental work on the English Romanesque before the Norman Conquest. Continued by his *English Romanesque architecture after the Conquest* (J197).

J199   Harvey, John Hooper. English medieval architects, a biographical dictionary down to 1550, including master masons, carpenters, carvers, building contractors, and others responsible for design. With contributions by Arthur Oswald. London, Batsford [1954]. xiii–xxiii, 411p.
Information on approx. 1,300 builders is conveniently arranged in dictionary form. Many cross-references. Includes dates of buildings. Based on local documents. Bibliography, p.xiii–xxiii. For later architects see Colvin (J178).

J200   Moore, Charles Herbert. The medieval church architecture of England. N.Y., Macmillan, 1912. xxiii, 237p. il., 23 plates. (Repr.: N.Y., Books for Libraries, n.d.)
"Its purpose is to set forth the character of medieval church architecture in England in the light of structural analysis and comparison with the French Gothic art, and of the conditions and influences under which it was produced." —*Pref.* Index, p.229–37.

J201   Salzman, Louis Francis. Building in England, down to 1540: a documentary history. Oxford, Clarendon, 1952. xv, 629p. il.
A rich source for the history of construction and materials. The appendixes list transcriptions of building contracts (1308–1538) and sources of building materials. Bibliographical footnotes.

J202   Taylor, Harold McCarter, and Taylor, Joan. Anglo-Saxon architecture. Cambridge, University Pr., 1965. 2v. 734p. il., maps, plans, plates.
A dictionary of 415 Anglo-Saxon buildings, mostly churches and other religious buildings. Extensive documentation, measured drawings, 279 photographs. Basic to the study of early English architecture.

J203   Webb, Geoffrey Fairbank. Architecture in Britain; the Middle Ages. [2d ed.] Harmondsworth; Baltimore,

Penguin [1965]. xxi, 234p. 91 il., 193 plates (1 col.) (Pelican history of art Z12)
1st ed. 1956.
A broad survey of English medieval architecture, from the church building of the 7th and 8th centuries to the late Gothic architecture of the 16th century. Does not include military architecture, excepting certain of the great halls in castles. Glossary, p.217–21. Bibliographical references in notes. Bibliography, p.222–24.

J204   Willis, Robert. Architectural nomenclature of the Middle Ages. Cambridge [Eng.] Deighton, 1844. 86p. incl. tables. 3 plates (incl. facsims) (Cambridge Antiquarian Society, Cambridge, Eng. Quarto publications, v.1, no. 9)
A fundamental work by a great 19th-century archaeologist. His classification of the various styles of medieval English architecture provided the basis for all subsequent historical investigation.

## Renaissance — Modern

### Bibliography

J205   Wodehouse, Lawrence. British architects, 1840–1976; a guide to information sources. Detroit, Gale [1978]. xxi, 353p. (Art and architecture information guide series, v.8.)
Like its companion volumes on American architecture (J303 and J303a) this guide promises to be a valuable key to architectural research.
Contents: Pt. 1, British architecture: Sect. A, General reference works on British architecture; Sect. B, Towns, cities, and counties of England; Sect. C, Irish architecture, including towns, cities, and geographic areas; Sect. D, Scottish Architecture, including towns, cities, and geographic areas; Sect. E, Building types. Pt. 2, Selected annotated biographical bibliography of British architects, 1840–1976. Indexes: General index, p.301–44; Building location index, p.345–53.

### Histories and Handbooks

J206   Clark, *Sir* Kenneth M. The Gothic Revival. An essay in the history of taste. Rev. and enl. ed. London, Constable, 1950. viii, 321p. il.
1st ed. 1928.
Available in paperback: N.Y., Harper, 1974.
A classic survey of the Gothic Revival styles in England, the first since the pioneer history by Charles Eastlake in 1872. Brings together all aspects of the revival—literary influences, the ecclesiastical movement, romanticism, nationalism, etc. Critical discussion of major architects and buildings; seminal text on the contributions of Pugin. Sparsely illustrated. Some bibliographical notes.
Contents: (1) The survival of Gothic; (2) Literary influences; (3) Ruins and Rococo; Strawberry Hill; (4) Romanticism

and archaeology; (5) Churches; (6) The Houses of Parliament; (7) Pugin; (8) Ecclesiology; (9) Gilbert Scott; (10) Ruskin.

**J207**  Crook, Joseph Mordaunt. The Greek Revival: neo-classical attitudes in British architecture, 1760-1870. London, Murray [1972]. 204p. il.
The first survey of an important period in British architecture.
Contents: Introduction (includes brief critical essay on bibliography); pt. 1, The rediscovery of Greece; pt. 2, The Greek Revival: classic and romantic; pt. 3, Greek Revival architecture in Britain: a photographic survey (250 excellent photographs). Map; extensive bibliography; index.

**J208**  Downes, Kerry. English Baroque architecture. London, Zwemmer, 1966. 135p. il., plates, diagrs., plans.
The first survey of the English Baroque (c.1690-1720). Lavishly illustrated with 578 plates and 68 figures in the text. The short text is a series of topical essays—the country house, town house, gardens, new churches, etc. Selective bibliography.

**J209**  Georgian Society, Dublin. Records of eighteenth-century domestic architecture and decoration in Dublin. Printed for the Society at the Dublin University Press by Ponsonby & Gibbs, 1909-13. 5v. il., plates, plans. (Repr.: Dublin, Irish Univ. Pr., 1970.)
A monumental repertory of Irish Georgian houses and decoration. Consists of a corpus of illustrations (photographs, measured drawings, details) with short, explanatory text.
"Catalogue of Georgian houses in Ireland," v.5, p.[81]-107. General index to the 5v. in v.5, p.109-29, divided into persons, places, and subjects.

**J210**  Girouard, Mark. The Victorian country house. Oxford, Clarendon, 1971. xxii, 218p. il., 162 plates, facsims., maps, plans, ports.
A worthy companion to the volumes in the series *English country houses* (J184) for which it was originally planned. Covers the country house from 1840-90. Contents: (I) Introduction (topical discussion); (II) 29 country houses; (III) Catalogue; (IV) Biographical notes on architects. Bibliographical references in footnotes. Good black-and-white illustrations, including 19th-century drawings and photographs.

**J211**  Gotch, John Alfred. Early Renaissance architecture in England; a historical & descriptive account of the Tudor, Elizabethan & Jacobean periods. 1500-1625. 2d ed. rev. London, Batsford; N.Y., Scribner, 1914. 319p. il., 18 plates.
1st ed. 1901.
"Although *Early Renaissance Architecture* is still the best available monograph on its period, by present-day standards it is far from satisfactory production. It is primarily a series of descriptions and illustration of individual aspects, with sections devoted to plans, gables, chimneys, ceilings, long galleries, market houses, gardens, and so on. Any attempt at a description of the historical development of Elizabethan architecture is of a rudimentary nature."—Mark Girouard, "Attitudes to Elizabethan architecture, 1600-1900," in *Concerning architecture* (J7), p.27.

**J212**  Hersey, George L. High Victorian Gothic: a study in associationism. Baltimore, Johns Hopkins Univ. Pr., 1972. 272p. il., plans. (John Hopkins studies in nineteenth-century architecture)
A study of High Victorian Gothic architecture in terms of "associationism," a term used in literary criticism. Based in part on 19th-century literary sources. The idea of a dramatic encounter between building and observer, or building and landscape, is a central theme of the study. Some bibliographical notes. Good bibliography, p.212-24. Photographs, drawings, plans, elevations.

**J213**  Hitchcock, Henry-Russell. Early Victorian architecture in Britain. New Haven, Yale Univ. Pr., 1954. 2v. il., maps, plans. (Yale historical publications. History of art, 9) (Repr.: N.Y., Da Capo, 1972.)
Available in abridged paperback: N.Y., Da Capo, 1976.
The definitive reference work on the architecture of Great Britain from c.1825 to c.1852. Detailed descriptions of many buildings. Does not emphasize historical and cultural background. All bibliographical references are in the text. Contents: v.1, Text; v.2, Illustrations. Index, v.1, p.615-35.

**J214**  Jordan, Robert Furneaux. Victorian architecture. Harmondsworth, Penguin, 1966. 278p. il. (incl. ports.)
An excellent outline history of English architecture from the aftermath of the Regency style to the late Edwardian age. Stresses the influence of Ruskin and Morris, two non-architects. Many illustrations. Bibliography, p.263-67.

**J215**  Muthesius, Stefan. The High Victorian movement in architecture, 1850-1870. London, Routledge & Paul [1972]. xvii, 252p. il.
A survey of High Victorian architecture which concentrates on ecclesiastical buildings. Many plans, photographs, and drawings. Bibliographical notes, p.208-42, is followed by a section recommending "further reading," p.243-46. Index, p.[247]-52.

**J216**  Summerson, *Sir* John N. Architecture in Britain, 1530 to 1830. 5th rev. ed. Harmondsworth; Baltimore, Penguin [1969]. xx, 391p. il., incl. 224 plates, sections, elevations, plans, map. (The Pelican history of art. Z3)
Paperback ed. 1970. 6th rev. ed., 1977, paperback.
This exemplary history—original, up-to-date, well organized, readable—has become the standard work on English architecture for the period. Good illustrations, including many photographs, sections, elevations, and clear plans. Bibliographical footnotes; bibliography with occasional annotations.

**J217**  Wren Society, London. [Publications]. v.1-20. Oxford, Oxford Univ. Pr., 1924-43. 20v. plates.
Drawings and documents of the work of Sir Christopher Wren and his followers. "Relevant not only to Wren but to the whole architectural scene from 1660-1715."—Summerson (J216). General index to v.1-19 (268p.) issued as part of v.20.

## Italy

**J218**  Congresso di Storia dell'Architettura. Atti. Roma, Centro di Studi per la Storia dell'Architettura [etc.]. 1936- . il., diagrs., plans.
Irregular.

Issued by the congress under earlier names: Convegno Nazionale di Storia dell'Architettura; Congresso Nazionale di Storia dell'Architettura.

An important series of learned papers, each of which deals with the architectural history of one region of Italy. Now includes essays by an international group of scholars. Well illustrated; with indexes.

**J219**  Fanelli, Giovanni. Firenze, architettura e città. Firenze, Vallecchi, 1973. 598p.
A comprehensive survey of the town planning, architecture, and urban life of Florence, from her origins to the present. Brings together a wealth of factual information not readily found elsewhere. The text volume consists of the history; the atlas volume is divided into two sections with illustrations: the development of the city from Roman times to the bombing of 1944; the form and space of the old city. The illustrations consist of photographs, paintings, drawings, plans, and sections. Commentary in captions.

The text volume has bibliographical notes; a bibliography, p.[505]-44, arranged by date from 1286 to 1972; and indexes of authors cited in the bibliographies, names, places, and subjects. Analytical table of contents. The atlas supplement has indexes of names and sources of illustrations.
————. Atlante. Firenze, Vallecchi, 1973. 369p. il.

**J220**  Godfrey, Frederick M. Italian architecture up to 1750. London, Tiranti, 1971. vi, 340 pl. il. (part col.), map.
A readable introduction to Italian architecture, recommended for the student and the serious traveler. Perceptive analyses of key monuments from the early Christian period to the mid-18th century. Good photographic illustrations; few plans. Bibliography, p.310-11. "A short glossary of terms," p.311-12; "Biographical notes and index to architects," p.313-30.

**J221**  Paatz, Walter, and Paatz, Elizabeth. Die Kirchen von Florenz: ein kunstgeschichtliches Handbuch. Frankfurt am Main, Klostermann [1940-54]. 6v. il., maps. (Frankfurter wissenschaftliche Beiträge; kulturwissenschaftliche Reiche.Bd. 4-5)
An inventory of the churches of Florence, arranged alphabetically. For each gives extensive information, including documentation, a summary of previous research, and bibliography. Indexes. Plans, maps, no photographs.

**J222**  Roma cristiana; collana diretta da Carlo Galassi Paluzzi. [Bologna] Cappelli [1964-(71)]. plates (part col.), maps.
To be published in 18v. All except v.17 (on St. Peter's) have appeared.

A numbered series of monographs, written by scholars, which together form the first systematic and comprehensive history of Christian architecture in Rome from early Christian

times to the present. Includes volumes on the history of the papacy, Roman life, ceremonies, ideas, etc.

v.3-6 are on the churches of Rome. Each volume has a uniform format and runs from 350 to 400p. (approx. one-third illustrations); has extensive bibliographies; has indexes of names, places, and subjects.

**J223**  Rome. Accademia Nazionale di San Luca. I disegni di architettura dell'Archivio Storico dell'Accademia di San Luca. [By] Paolo Marconi, Angela Cipriani, Enrico Valeriani. Roma, De Luca, 1974. 2v. il., plans, elevations.
Primarily illustrations documenting the activity of the Accademia from the end of the 17th century to the 1930s.

**J224**  Le Ville italiane. Milano, SISAR, 1968- . v.1- . il., plates (part col.), plans.
Editor of series: Pier Fausto Bagatti Valsecchi.

A numbered series of regional studies on the existing Italian country houses which can be classified as villas. Published to date: (1) Perogalli, Carlo, and Favole, Paolo. *Ville dei Navigli Lombardi.* Lombardia, v.1 [1968]; (2) Alpago Novello, Adriano. *Ville della provincia di Belluno.* Veneto, v.1 [1968]; (3) Langè, Santino. *Ville delle province di Como. Sandrio, e Varese.* Lombardia, v.2 [1968]; (4) Cevese, Renato. *Ville della provincia di Vicenza.* Veneto, v.2, pt. 1 and pt. 2 [1971]; (5) Perogalli, Carlo, and Sandri, Maria Grazia. *Ville delle province di Bergamo e Brescia.* Lombardia, v.3 [1969]; (6) Belli Barsali, Isa. *Ville di Roma.* Lazio, v.1 [1970]; (7) Perogalli, Carlo, and Sandri, Maria Grazia. *Ville delle province di Cremona e Mantova.* Lombardia, v.5 [1973]; (8) Langè, Santino. *Ville della provincia di Milano.* Lombardia, v.4 [1972]; (9) Belli Barsali, Isa, and Grazia Branchetti, Maria. *Ville della Campagna Romana.* Lazio, v.2. [1975].

These books follow a uniform format, with an introductory essay (including cultural and historical factors) followed by a catalogue of villas. Italian and English texts and captions. Extensive bibliographical notes and bibliographies. Richly illustrated with plans, drawings, and photographs (part col.).

### Early Christian — Gothic

**J225**  Arslan, Edoardo. Gothic architecture in Venice. Trans. by Anne Engel. [London] Phaidon [1972]. 409p. plates.
Italian ed., *Venezia gotica; l'architettura civile gotica veneziana.* 1970.

A lavishly illustrated study of secular Venetian Gothic architecture. Extensive bibliography; indexes of artists and buildings.

**J226**  Braunfels, Wolfgang. Mittelalterliche Stadtbaukunst in der Toskana. Berlin, Mann, 1953. 278p. plates, plans.
A study of the governmental planning of the existing cities in Tuscany during the greatest period of civic growth in the late Middle Ages. References to local documents and published material in extensive footnotes. Appendix includes excerpts from statutes and sources dating from 1262 to 1466. Well illustrated. Classified bibliography (p.265-69) of

city statutes, records, chronicles, published collections of documents, early published sources, and later publications.

J227    Delogu, Raffaello. L'architettura del medioevo in Sardegna. Roma, Libreria della Stato, 1953. 282p. il., 222 plates. (Architetture delle regioni d'Italia. 1)

The standard work on the provincial ecclesiastical architecture of Sardinia. Surveys church building from the earliest examples (based on Roman remains) through the period of the monumental Gothic cathedrals. Full bibliographies at end of each chapter. Excellent illustrations.

J228    Moretti, Mario. Architettura medioevale in Abruzzo. (Dal VI al XVI secolo). Roma, De Luca [1971?]. xi, 980p. il., plates.

A monumental documentary study of the major surviving churches, castles, towers, gates, and fountains of the 6th through the 16th century in the Abruzzi. Illustrated with hundreds of photographs of buildings and sculptural decoration. Numerous plans and line drawings. Bibliographical references for individual buildings. General bibliography. p.945-55; index of authors, p.957-58. "Elenco alfabetico degli artisti documentati," p.959. "Elenco cronologico dei monumenti sicuramente datati," p.961-64. "Datazione per secoli per i monumenti non documentabili che con approssimazione." p.965-66.

J229    Porter, Arthur Kingsley. Lombard architecture. New Haven, Yale Univ. Pr., 1915-17. 4v. 244 plates (incl. plans). (Repr.: N.Y., Hacker, 1967).

Antiquated text. Useful as a corpus of plates. v.1 covers structure, ornament, accessory arts, iconography, and contains "Chronological chart," p.xxi-xxxvii; v.2, Monuments: Abbazia di Albino-Milan; v.3, Monuments: Mizzole-Voltorre; v.4 is atlas of plates.

   Bibliography, v.1, p.[441]-83. Index, v.3, p.585-611.

J230    Romanini, Angiola Maria. L'architettura gotica in Lombardia. Milano, Ceschina, 1964. 2v. plates (part col.), plans. (Architetture delle regioni d'Italia. 2)

An exemplary history of Gothic architecture in Lombardy from the 13th through the 15th centuries. Based on meticulous research. v.1, text (526p., 151 illustrations); v.2, 258 excellent plates. Comprehensive bibliography. Indexes.

J231    Wagner-Rieger, Renate. Die italienische Baukunst zu Beginn der Gotik. Graz, Böhlaus Nachf., 1956-57. 2v. il., plates. (Österreichisches Kulturinstitut, Rome. Historische Studien, Abteilung für Publikationen. Abteilung 1: Abhandlungen. Bd. 2)

Contents: v.1, Oberitalien; v.2, Süd- und Mittelitalien.

   A scholarly review of Italian architecture of the 12th and 13th centuries. Valuable for the study of Cistercian architecture.

### Renaissance — Modern

J232    Anderson, William James. The architecture of the Renaissance in Italy; a general view for the use of students and others. 5th ed., rev. and enl. by Arthur Stratton. London, Batsford [1927]. 316p. 150 il., 90 plates, diagrs., plans.

A semiclassic, now out-of-date yet not wholly replaced by recent surveys.

J233    Bassi, Elena. Architettura del Sei- e Settecento a Venezia. Napoli, Edizioni scientifiche italiane [1962]. ix, 419p. 257 il. (incl. plans). (Collana di storia dell'architettura, ambiente, urbanistica, arti figurative, diretta da Roberto Pane)

"Standard work, superseding most previous studies of Venetian baroque architecture."—R. Wittkower (I359). Bibliography, p.387-91.

J234    Blunt, Anthony. Neapolitan Baroque and Rococo architecture. London, Zwemmer, 1975. 223p. 300 plates, fig. (Studies in architecture, 15)

An important study of Neapolitan architecture from the early 17th to the mid-18th century. Based on extensive research with local documents and early published sources. Introduced by a survey of the architectural history of the city. The author then examines over 300 churches, the city gates, palaces, etc. and the contributions of the individual architects. New illustrations, including many details. The bibliography (p.195-206) is partially annotated. Index, p.207-21.

J235    Brayda, Carlo. Ingegneri e architetti del Sei e Settecento in Piemonte. A cura del Comune di Torino e della Società Ingegneri e Architetti in Torino. [Torino, 1973]. vii, 101p. il., ports., fold. chart.

"Estratto da Atti e rassegna technica del Società degli Ingegneri e Architetti in Torino, Anno XVII, Marzo, 1963."

   A dictionary of 731 architects and engineers of the Piedmont region (Turin). Biographies, portraits, lists of buildings. Based on original documents. Annotated bibliography.

J236    Frommel, Christoph Luitpold. Der römische Palastbau der Hochrenaissance. Tübingen, Wasmuth, 1973. 3v. il. (Römische Forschungen der Bibliotheca Hertziana Bd. 21)

A monumental work on the palaces of the High Renaissance in Rome, basic to research in Italian Renaissance architecture. Reliable facts, new attributions, perceptive stylistic analyses. Full bibliographies of documents, sources, and later publications.

   Contents: Bd. 1, "Text," consists of essays on palace building, urbanism, palace types and functions, facades, and courtyards. Includes bibliography and indexes; Bd. 2, "Katalog," examines, describes, and documents 32 palaces built from 1501-56; Bd. 3, "Tafeln," comprises 200 pages of excellent illustrations.

   See review by James Ackerman, *Journal of the Society of Architectural Historians* (Mar. 1975), p.74-75.

J237    Giovannoni, Gustavo. Saggi sulla architettura del rinascimento. Con 324 illustrazioni. Seconda edizione augmentata. Milano, Treves [1935]. 305p. il. (incl. plans), diagrs.

Not a reference book, rather a series of important essays basic to scholarly work in Renaissance architecture. Bibliographical references in notes.

J238 Grassi, Liliana. Province del barocco e del rococò: proposta di un lessico biobibliografico di architetti in Lombardia. |Milano] Ceschina |1966]. lxv, 563p. 788 il., incl. sections, plans, and facsimiles.

"Dictionary of architects working in Lombardy between the late sixteenth and the second half of the eighteenth century. First-rate." R. Wittkower (I359). Biographies based on original research, with extensive bibliographies.

J239 Gurlitt, Cornelius. Geschichte des Barockstiles in Italien. Stuttgart, Ebner & Seubert (P. Neff), 1887. xvii, 561p. il.

Bd. 5 of Burckhardt, J., and Lübke, W., *Geschichte der neueren Baukunst* (J123). A pioneer study of late Renaissance and Baroque architecture in Italy. "A revolutionary work, still useful."—R. Wittkower (I359).

J240 Heydenreich, Ludwig H., and Lotz, Wolfgang. Architecture in Italy 1400 to 1600. Trans. by Mary Hottinger. Harmondsworth; Baltimore, Penguin |1974]. xxvii, 432p. il., map, plans, 360 plates.

Contents: Pt. 1. The Quattrocento, by Ludwig H. Heydenreich; Pt. 2, The Cinquecento, by Wolfgang Lotz.

A well-written survey of Italian Renaissance architecture, the collaboration of two of the foremost architectural historians. Summarizes the latest research of the authors and others. Essential for students of the Renaissance. The extensive bibliographical footnotes (p.327-96) and the bibliography (p.397-412) complement each other. Well illustrated with photographs, plans, and drawings.

J241 Magnuson, Torgil. Studies in Roman Quattrocento architecture. Stockholm, Almqvist & Wiksell |1958]. xv, 389p. il., plates, plans. (Figura 9)

The fundamental study of 15th-century architecture in Rome. Bibliography, p.365-75.

J242 Meeks, Carroll L. V. Italian architecture, 1750-1914. New Haven, Yale Univ. Pr., 1966. xxviii, 546p. 266 il. (incl. plans).

The definitive study of a neglected period of Italian architecture from the neoclassical styles to Art Nouveau. The appendixes and bibliography enhance its value as a reference tool. Appendix A: "Chronological list of publications 1700-1800," p.465-501, is a list of the important European art and architecture books of the 18th century, arranged by date. Includes pattern books, guide books, and *vedute,* with a listing of editions. Appendix B: "Visitors to Italy in the 18th century," p.502-6. Bibliography, p.507-26, classified under sources, general studies, cities and provinces, architects.

J243 Murray, Peter. The architecture of the Italian Renaissance. London, Batsford; N.Y., Schocken, 1963. xviii, 268p. il., plans.

Available in paperback.

The best introduction for the student and general reader. Emphasis is on stylistic development. No footnotes; short bibliographical essay at the end.

J244 Pane, Roberto. Architettura del rinascimento in Napoli. Napoli, E. P. S. A. Editrice politecnica, 1937. 4p., 1., |3]-327p., 2 l. il., plates, plans.

A general survey of Renaissance architecture in Naples. Bibliographical references in "Note." Indexes of artists, monuments, and illustrations.

J245 Stegmann, Carl Martin, *Ritter* von, and Geymüller, Heinrich von. Die Architektur der Renaissance in Toscana, dargestellt in den hervorragendsten Kirchen, Palästen, Villen und Monumenten nach den Aufnahmen der Gesellschaft San Giorgio in Florenz. München, Bruckmann |1885-1908]. 11v. il. (incl. plans), 370 pl.

An important monumental work on 15th- and 16th-century architecture in Tuscany. Elephant folios (64 cm.) with 370 plates—photographs, plans, and engravings after measured drawings. Divided into sections on architects, building types, and details. Scholarly text. Abridged ed. of selected illustrations in 2v., with English captions, N.Y., Architectural Pub. Co., 1924.

J246 Thiem, Gunther, and Thiem, Christel. Toskanische Fassaden-Dekoration in Sgraffito und Fresko, 14. bis 17. Jahrhundert. [München] Bruckmann [1964]. 158, |162]p. il., plates. (Italienische Forschungen. 3. Folge. 3. Bd.)

The definitive study of *sgraffito* and fresco decorations on the facades of Tuscan buildings. Following introductory historical and technical sections, the nucleus of the book is devoted to a catalogue of all known surviving examples, dating from the 14th to the 17th century. Each example is exhaustively described and fully illustrated.

Bibliography, p.154-56. Indexes of artists and building owners.

J247 Tomei, Piero. L'architettura a Roma nel Quattrocento. Roma, Palombi, 1942. 318p. plates, plans.

At head of title: R. Instituto d'Archeologia e Storia dell'Arte.

"A brilliant synthesis of historical data and visual observations, gave critical definition to the Renaissance of Rome as *Caput Mundi—*."—Heydenreich-Lotz (J240), p.xxv.

J248 Wittkower, Rudolf. Architectural principles in the age of humanism. |3d completely rev. ed.|. London, Tiranti, 1962. xii, 173p. il., plans, plates.

Originally published 1949 as v.19 of the Studies of the Warburg Institute; 2d ed. 1952; reprint of 3d ed. N.Y., Random, 1965 (Columbia Univ. Studies in art history and archaeology. 1: paperback reprint, N.Y., Norton, 1971.)

A series of brilliant essays on Italian Renaissance architecture and ideas. Fundamental for all students of the Renaissance.

Contents: pt. 1, The centrally planned church and the Renaissance; pt. 2, Alberti's approach to antiquity in architecture; pt. 3, Principles of Palladio's architecture; pt. 4, The problem of harmonic proportion in architecture.

See the article by Henry Millon: "Rudolf Wittkower, *Architectural Principles in the Age of Humanism:* its influence on the development and interpretation of modern architecture," *Journal of the Society of Architectural Historians* 31:83-91 (May 1972).

SEE ALSO: Lafreri, A. *Speculum Romanae magnificentiae* (H42).

219

## Latin America

J249   Angulo Iñiguez, Diego. Planos de monumentos arqui-
       tectónicos de América y Filipinas existentes en el
       Archivo de Indias. [Sevilla] Laboratorio de arte,
       1933-39. 4v. and atlas (3v.). plates, plans.
At head of title: Universidad de Sevilla. Sevilla.
   A monumental catalogue with facsimile reproductions
of original drawings of the major buildings and town plans
of the Spanish colonies in the Americas and the Philippines.
This important collection of documents, Archivo de Indias,
is in Seville.
   Contents: Catálogo, I-II;·Estudio de los planos y de su
documentación, I-II. "Bibliografía," Estudio, II, p.753-76.

J250   Baird, Joseph Armstrong. The churches of Mexico,
       1530-1810. Photos by Hugo Rudinger. Berkeley,
       Univ. of California Pr., 1962. xxii, 126p. 163 plates,
       maps, plans.
A first-rate book. "The present work is not intended to be
definitive nor all-inclusive. Examination of particular churches
of Mexico from 1530 to 1810 will give the reader insight into
the major foci of architecture, sculpture, and the other arts
in that period. Their principles can be applied to other
monuments not specifically discussed in the text or Catalogue
of Plates. The text has been written as a study of a complex
subject which does not bypass any of the obvious problems
of that subject by attempts to make those problems intelligible
in terms of contemporary art historical scholarship. The
Catalogue of Plates examines individual works more
specifically."—*Pref.* Includes appendices of chronologies,
biographies of architects, glossary, and selective bibliography.
Illustrated with photographs and drawings made for this
study.
   Contents: (I) The Spanish background; (II) The churches
of Mexico: building types; (III) The churches of Mexico:
styles and fashions of adornment.

J251   Bazin, Germain. L'architecture religieuse baroque
       au Brésil. São Paulo, Museu de Arte; Paris, Plon
       [1956-58]. 2v. il., plates, maps.
Contents, v.1: Étude historique et morphologique; Appen-
dice bibliographique, p.351-61 (a critical bibliography);
Glossaire, p.[363]-72. v.2: Répertoire monumental (arranged
by province); Documentation photographique (180 plates);
Tables des notices;  Table des illustrations; Index général.
Bibliographical footnotes.

J252   Corona, Eduardo, and Lemos, Carlos A. C. Dicionário
       da arquitetura brasileira. [São Paulo] Edart-São Paulo
       Livoria, 1972. 472p. il.
A dictionary of Portuguese terms relative to the architecture
of Brazil. Includes names of styles, critical terms, architectural
elements, technical terms, etc. Names of architects and
places are not listed as entries, rather 25 illustrative examples
of Brazilian architecture. Well illustrated with photographs
and drawings.

J253   Gasparini, Graziano. América, barroco y arquitectura.
       Caracas, Armitano, 1972. 526p. il., maps, plans,
       elevations.

A stimulating study of the Baroque style in Latin America.
Explores the sources of the style in Spain and Europe, and
then concentrates on the originality and unique beauty of
the important buildings in the Spanish provincial cities.
Documentation in text and footnotes. No general bibliography.
769 excellent illustrations.

J254   Gutierrez, Ramón. Notas para una bibliografía
       **hispanoamericana de arquitectura, 1526-1875.** [Resis-
       tencia, Argentina]. Departamento de Historia de la
       Arquitectura [1973]. xc, 420p. il.
A critical study and bibliography of the architectural books
which were used in Spanish America. Limited to works
written or translated in the Castillian language between
1526 and 1875. Includes works on civil and military archi-
tecture, mathematics, and documents related to the archi-
tecture, town planning, military engineering, academies,
etc. Also treats the usage and locations of this material. The
emphasis is on the region of the Río de la Plata.

J255   Kubler, George. Mexican architecture of the sixteenth
       century. New Haven, Yale Univ. Pr., 1948. 2v. il.,
       ports., maps, diagrs., facsims., plans. (Yale historical
       publications. History of art, 5)
A fundamental treatment of the architecture in its cultural
and historical context.
   Appendix: Documents for mendicant buildings, v.2,
p.450-535. "Bibliographical note," v.2, p.[432]-49.

J256   McAndrew, John. The open-air churches of sixteenth-
       century Mexico: *atrios, posas,* open chapels, and other
       studies. Cambridge, Harvard Univ. Pr., 1965. xxxi,
       755p. il., maps, plans.
A specialized study of the unique courtyard churches of the
converted Indians of southern Mexico. More than 300
photographs, drawings, prints, and maps. Bibliography,
p.667-709.

J257   Palm, Erwin Walter. Los monumentos arquitectónicos
       de la Española, con una introducción a América.
       Ciudad Trujillo. 1955. 2v. il., plates, plans. (Publica-
       ciones de la Universidad de Santo Domingo. Año
       del benefactor de la patria)
"A work of erudition which will for generations remain the
best work on the history of the first Spanish buildings in
western Atlantic waters."—G. Kubler, *Journal of the Society
of Architectural Historians* 8:35 (Mar. 1958). Pt. 1 is on
Spanish cultural influence in the Caribbean islands, the
forms of architecture and towns, and the stylistic development
of island architecture. Pt. 2 is a discussion of individual
monuments of Santo Domingo. Extensive documentation.
Bibliography, v.2, p.159-90. Index, v.2, p.191-217.

J258   Sanford, Trent Elwood. The story of architecture
       in Mexico, including the work of the ancient Indian
       civilizations and that of the Spanish colonial empire
       which succeeded them, together with an account of
       the background in Spain and a glimpse at the modern

trend. N.Y., Norton, 1947. 363p. il. (incl. maps), plates, diagrs.

A popular, readable history of architecture in Mexico.

Contents: (1) Anahuac; (2) Spain; (3) New Spain; (4) Mexico. List of "Cathedral cities of Mexico," p.329-31. Glossary, p.332-46. Bibliography, p.347-50.

J259   Toussaint, Manuel. Arte mudéjar en América. México, Porrúa [1946]. 143p. 108 plates (3 col.)

A series of studies on the influence of Moorish forms and motifs on the art, and especially the architecture, of the Dominican Republic, Cuba, Mexico, the United States, Central America, Venezuela, Colombia, Ecuador, Peru, Bolivia, Chile, Argentina, Uruguay, Paraguay, and Brazil.

General bibliography, p.18; bibliographies at the end of each article; "Apéndice de documentos," p.119-27; "Vocabulario de términos mudéjares," p.129-31.

J260   Wethey, Harold Edwin. Colonial architecture and sculpture in Peru. Cambridge, Harvard Univ. Pr., 1949. xvii, 330p. 367 il.

A well-illustrated study of the 16th- and 17th-century architecture and sculpture within the boundaries of modern Peru. "Catalogue of monuments in Lima," p.246-78. Bibliography, p.[279]-86.

SEE ALSO: Bottineau, Y. *Living Architecture: Iberian-American baroque* (J281).

# Low Countries

J261   Vermeulen, Frans. Handboek tot de geschiedenis der Nederlandsche bouwkunst. 's Gravenhage, Nijhoff, 1923-41. 3v. in 6. il. (incl. plans), plates. (Nijhoff's handboeken)

The standard history of Dutch architecture from prehistorical times to the end of the 17th century. Contents: v.1, Voorgeschiedenis en middeleeuwen; v.2, Kentering en renaissance; v.3, Barok en klassicisme.

Includes bibliographies. Indexes in v.3: places, p.467-79; persons, p.480-96; subjects, p.496-506.

# Russia and Eastern Europe

## Bibliography

J262   Senkevitch, Anatole. Soviet architecture, 1917-1962; a bibliographical guide to source material. Charlottesville, Univ. Pr. of Virginia [1974]. xxxii, 284p.

An important annotated bibliography of Soviet architecture consisting of 1,187 entries for books and articles. The emphasis is on Russian source material relevant to research in architectural history and theory in the period from the Revolution to the aftermath of the de-Stalinization period. Also includes publications in Western languages. Each section is subdivided into Russian publications and those in Romance and Western languages. All annotations are in English.

Contents: (I) Bibliographies and reference aids; (II) Documents; (III) Theoretical works; (IV) Histories of Soviet architecture; (V) Works about architectural institutions and movements; (VI) Trends in Soviet architecture 1932; (VII) Works by and about Soviet architects. Index (includes names of authors, compilers, editors, sponsoring organizations, and titles of publications).

## Histories and Handbooks

J263   Buxton, David Roden. Russian mediaeval architecture; with an account of the Transcaucasian styles and their influence in the West. Cambridge, Univ. Pr., 1934. 112p. il. (incl. plans), 108 plates, map.

An historical outline of medieval architecture in Russia and Transcaucasia. Includes traditional buildings up to the 19th century. Illustrated with photographs by the author. Annotated bibliography.

J264   Faensen, Hubert, and Ivanov, Vladimir. Early Russian architecture. Photographs by Klaus G. Beyer; trans. by Mary Whittal. London, Elek, 1975. 536p. il. (some col.)

Trans. of *Altrussische Baukunst.*

A history of church and monastic architecture in Russia from the 11th century to the end of the tradition in the early 18th century. Directed to both the tourist and the scholar. Divided into three parts: (1) Introductory art historical text, with a topical arrangement, p.9-67; (2) Plates (319 splendid photographs, many in color), p.69-326; (3) Commentary on 419 individual monuments, arranged chronologically, p.329-515. Plans, drawings, and sections. Glossary (Russian terms are transliterated), p.512-15; Bibliography, p.516-27 (English translations of titles listed after entries in Russian).

J265   Franz, Heinrich Gerhard. Bauten und Baumeister der Barockzeit im Böhmen. Leipzig, Seeman, 1962. 486p. il., plans.

A thorough art historical examination of Baroque architecture and architects in Bohemia. Traces Italian and German influence in its development; analyzes the later influence of Bohemian architecture in France, Germany, and Austria. Bibliographical notes, p.211-[240]; Illustrations, p.253-468; Bibliography, p.469-77. Indexes of names and places.

J266   Knox, Brian. The architecture of Poland. N.Y., Praeger [1971]. 161p. il., plans, maps.

A scholarly, well-written survey of architecture within the present boundaries of Poland, including parts of Prussia and Silesia. Includes a discussion of modern architecture. Epilogue and bibliography, p.152-55.

J267   Kopp, Anatole. Town and revolution: Soviet architecture and city planning, 1917-1935. Trans. by Thomas E. Burton. N.Y., Braziller [1970]. xii, 274p. il., port., plans.

Originally published in French, *Ville et revolution,* Paris, Anthropos, 1967.

Presents a soundly based chronology of the architecture of the Constructivist movement in Russia; discusses many

of the buildings and projects for the years 1917–35. "Documentary appendixes," p.245–60, includes translations of significant speeches, reports, letters, and an editorial of the period. Bibliography, with some brief annotations, p.261–67.

J268   Quilici, Vieri. L'architettura del costruttivismo. Bari, Laterza, 1969. 583p. il., plates.
The best of the books so far on the Soviet Constructivists' contribution to modern architecture. Emphasizes the relationship between architecture and Russian theater.

Divided into two major sections: an extended essay by Quilici, giving a circumstantial account of the complex currents underlying the movement; and an anthology of writings, manifestoes, polemics, programs, etc. by the architects themselves.

## Scandinavia

J269   Hauglid, Roar. Norske stavkirker: dekor og utstyr. Utgitt av Riksantikvaren [Oslo] Dreyer [1973]. 458p. il. (part col.), plates, plans.
A comprehensive, scholarly study of medieval Norwegian stave churches, their origins, construction, decoration, and furniture. Excellent photographic illustrations and line drawings (plans and reconstructions). Bibliography, p.[445]–54; bibliographical references in "Noter," p.[431]–44.

J270   Kavli, Guthorm. Norwegian architecture, past and present. Oslo, Dreyer [1958]. 147p. il., plates, plans, map.
The most comprehensive survey in English. Contents: pt. I, From the Viking period to the end of the Middle Ages, c.800–1540; pt. II, From Renaissance to national independence, c.1540–1814; pt. III, From national independence until today. Glossary, p.135; Bibliography, p.139–40.

J271   Langberg, Harald. Danmarks bygningskultur, en historisk oversigt. Udgivet med støtte af Grundejernes hypothekforening i anledning af foreningens jubilaeum 18. februar 1955. København, Nordisk, 1955. 2v. il., plans.
A brief survey of Danish architecture from prehistoric times to 1930.
Bibliography included in "Kommentar," v.2, p.239–66. Index, v.2, p.283–304.

J272   Lund, Hakon, and Millech, Knud. Danmarks bygningskunst fra oldtid til nutid. Af Elna Møller [et al.]. Redigeret af Hakon Lund og Knud Millech. With an English summary. København, Hirschsprung, 1963. 479p. il., plans.
Well-illustrated survey of Danish architecture from the earliest timber constructions to the present. Various chronological periods by different authors. Includes brief English summaries by chapter.
Classified bibliography, p.459–66.

J273   Lundberg, Erik. Byggnadskonsten i Sverige. [Stockholm] Nordisk rotogravyr [1940–48]. 2v. il., plates, plans.
The history of Swedish architecture (up to 1650) by the foremost Swedish architectural historian (see also J49). Many photographs and plans. Should be translated for the English-speaking reader.
Contents: v.1, Under medeltiden, 1000-1400; v.2, Sengotik och renässans, 1400–1650.

J274   Paulsson, Thomas. Scandinavian architecture; buildings and society in Denmark, Finland, Norway, and Sweden from the Iron Age until today. London, Hill, 1958. xvi, 256p. 80 il., 120 plates, maps, plans.
A chronological survey, the goal of which was "to publish a handbook that was as complete as possible and addressed both to the person interested in architecture and to the person interested in Scandinavia in general."—*Author's pref.*
Classified bibliography, p.245–50.

J275   Richards, James Maude. A guide to Finnish architecture. London, Evelyn, 1966. 112p. plates, plans, map.
"This book begins with an introductory essay on Finnish architecture and its special characteristics, after which each chapter deals with one building type or period." —*Foreword.* Glossary, p.291–99.

J276   Sveriges kyrkor; konsthistoriskt inventarium, med stöd av K. vitterhets-, hist.- o. ant.-akad. ut. av Sigurd Curman och Johnny Roosval. v.1–(142). [Stockholm Norstedt] 1912- . il., ports., plans.
Currently edited by Sten Karling, Armin Tuulse, and Per-Olaf Westlund.
A continuing topographical inventory of Swedish churches, church decoration, and furnishings. Systematically divided according to province. Summaries and picture captions in English. Full documentation, bibliographies, indexes. Richly illustrated.

J277   Wickberg, Nils Erik. Finnish architecture. Helsinki, Otava [1962]. 242p. il., maps, plans.
A translation of the Finnish ed. An excellent general history of Finnish architecture. Chiefly illustrations, includes sketches, cross-sections, and elevations.

## Spain and Portugal

For an authoritative survey of Spanish architecture see individual volumes in the series *Ars Hispaniae* (I438). Examples: *Arquitectura y escultura románicas,* by J. Gudiol Ricart and J. A. Gaya Nuño; *Arquitectura gótica,* by L. Torres Balbas.

For a critical bibliography of Portuguese architecture see: Wohl, H. "Recent studies in Portuguese post-medieval architecture, *Journal of the Society of Architectural Historians* 34:67–73 (Mar. 1975).

## Bibliography

J278    Zamora Lucas, Florentino, and Ponce de León, Eduardo. Bibliografía española de arquitectura (1526-1850). Madrid, Asoc. de Libreros y Amigos del Libro, 1947. 205p. il., facsim. (Publicaciones de la Asoc. de Libreros y Amigos del Libro, 3)
Arranged chronologically by century. Index of authors, collaborators, and anonymous works, p.195-202.

## Histories and Handbooks

J279    Azcárate, José María de. Monumentos españoles: catálogos de los declarados histórico-artísticos. 2d ed., revisada y ampliada. Madrid, Consejo Superior de Investigaciones Científicas, 1953-54. 3v. il., plans.
A catalogue of historical architectural monuments in Spain arranged alphabetically by place. For each monument gives a descriptive and historical paragraph, a photograph, usually a plan, and an extensive bibliography.

J280    Bevan, Bernard. History of Spanish architecture. London, Batsford [1938]. 199p. il., 94 plates.
Spanish ed. 1950; repr. of English ed.: N.Y., Hacker, 1974.
    The standard history of Spanish architecture for the English-speaking reader. Begins with the architecure of the Roman period and ends with the neoclassical styles. Bibliography, p.173-79.

J281    Bottineau, Yves. Living architecture: Iberian-American Baroque; photographs by Yvan Butler. English trans. [from the French] by Kenneth Martin Leake. N.Y., Grosset, [1970]. [6], 188p. il., maps, plans.
Trans. of: *Baroque ibérique. Espagne, Portugal, Amérique Latine.*
    A good introduction to Spanish Baroque architecture on the Iberian peninsula and in the colonies. The author's aim was to "reveal the basic tendencies . . . rather than furnish an account of its evolution"—*Pref.*
    Plans, sections, elevations, photographs. Bibliography, p.187-88.

J282    Camón Aznar, José. La arquitectura plateresca. Madrid [Aguirre] 1945. 2v. plates.
The standard work on plateresque architecture, the prevailing Spanish style from c.1480 to c.1570. Contents: v.1, text; v.2, plates. Bibliography, v.1, p.405-25. Index of names, v.1, p.427-39; Geographical index, v.1, p.441-55.

J283    Chueca Goitia, Fernando. Historia de la arquitectura española, edad antigua y edad media. Madrid, Dossat, 1965. xxii, 734p. il., maps, plans, 284 plates.
The 2d volume of the projected 2v. series is in preparation.
    A comprehensive scholarly survey of ancient and medieval Spanish architecture. Promises to be the definitive history. 284 photographs, many plans, drawings, and 6 maps. Includes bibliographies, p.[681]-91.

J284    Durliat, Marcel. L'architecture espagnole. Toulouse, Privat; [Paris] Didier, 1966. 335p. il., plans.

An excellent introductory history of Spanish architecture (from prehistoric times to the present) written by a distinguished art historian. Bibliography, p.[309]-11.

J285    Fernández Arenas, José. Mozarabic architecture. Greenwich, Conn., New York Graphic Society [1972]. 281p. il. (part col.)
Text in English, French, Spanish, and German.
    A survey of the Christian religious buildings built in northern Spain, beginning with the period of the Moslem conquest (711 A.D) and ending in the 11th century. Awkward English translation; difficult to read because of the parallel texts. Summary bibliography, p.280-81. No footnotes; no index. Most important for the splendid dramatic photographs, many in color.

J286    Flores, Carlos. Arquitectura española contemporanea. Madrid, Aquilar, 1961. 623p. il., plans.
The first comprehensive survey of 20th-century Spanish architecture, from Gaudí to 1960. Over 1,000 illustrations. Bibliography, p.617-18.

J287    Haupt, Albrecht. Die Baukunst der Renaissance in Portugal von den Zeiten Emmanuel's des Glücklichen bis zu dem Schlusse der spanischen Herrschaft. Frankfurt, Keller, 1890-95. 2v. il., plates, plan.
Still a basic work on Portuguese Renaissance architecture from the early 16th century up to c.1640. Good plans and perspective drawings; many of the buildings discussed are now destroyed.

J288    Kubler, George. Portuguese plain architecture: between spices and diamonds, 1521-1706. Middletown, Conn., Wesleyan Univ. Pr., 1972. 315p. il.
An innovative study of the simplified forms of Portuguese religious architecture from the second quarter of the 16th century to the end of the 17th century. It is "not only a brilliant, pioneering work in its field, but also a major contribution to the writing of architectural history, particularly in its method. Instead of attempting to fit Portuguese developments into the framework of abstract, Italian-based stylistic categories, Kubler concentrates his resources on four objectives: the detection of patterns of taste in the context of specifically Portuguese conditions, questions of architectural function and meaning, the selection and combination by designers of forms from a variety of present and past stylistic traditions, and the identification of what in *The Shape of Time* he called form-classes—linked sequences of gradually altered repetitions of a solution to the same problem."—Review by H. Wohl in *Journal of the Society of Architectural Historians* 34:70 (Mar. 1975).

J289    Lambert, Elie. L'art gothique en Espagne aux XIIe et XIIIe siècles; quarante-huit planches hors texte, 125 dessins dans le texte. Paris, Laurens, 1931. 314p. il. (incl. plans), 48 plates. (Repr.: N.Y., Burt Franklin, 1971.)
A basic scholarly survey of Gothic architecture in Spain and its relationship to French architecture. Bibliography, p.[291]-98, has brief annotations.

J290    Lampérez y Romea, Vicente. Historia de la arquitectura cristiana española en la edad media según el estudio de los elementos y los monumentos. 2. ed. Madrid, Espasa-Calpe, 1930. 3v. plates, maps, plans.
A standard work on medieval Christian Spanish architecture. Illustrated by poor halftones. Each volume has its own index and list of monuments. "Bibliografía española moderna" at end of several chapters.

J291    Llaguno y Amírola, Eugenio. Noticias de los arquitectos y arquitectura de España desde su restauración; ilustradas y acrecentadas con notas, adiciones y documentos, por D. Juan Agustin Ceán-Bermúdez. Madrid, En la Imprenta real, 1829. 4v.
An early documented history of Spanish architects and architecture from its beginnings to the Restoration. Each volume includes a long appendix of pertinent documents and inscriptions. Index of architects at end of each volume; general index of architects and places at end of v.4.

J292    Monumentos arquitectónicos de España, publicados á expensas del Estado, bajo la dirección de una comisión especial, creada por il Ministerio de fomento. Madrid, Calcografía Nacíonal, 1859-80. 8v. il., plates, plans
Ed. by José Gil Dorregaray. Pub. in parts: v.1-3 without text; v.4-8 with Spanish and French text in parallel columns. Plates partly in colors and gold.
A collection of plates illustrating the most important architectural monuments of Spain. Includes plans, sections, and details, with descriptive text.

J293    Puig y Cadafalch, José. L'arquitectura romànica a Catalunya, per J. Puig y Cadafalch, Antoni de Falguera, J. Goday y Casals. Barcelona, Institut d'Estudis Catalans, 1909-18. 3v. in 4. il. (incl. plans), facsims.
The fundamental work on Romanesque architecture in Catalonia. "Index bibliogràfich": v.1, p.[423]-31; v.2, p.[587]-95; v.3, p.[903]-14.
Contents: v.1, Precedents; L'arquitectura romana. L'arquitectura cristiana preromànica; v.2, L'arquitectura romànica fins a les darreries del segle XI; v.3, Els segles XII y XIII (2v.).

J294    Sousa Viterbo, Francisco, *marquez* de. Diccionario historico e documental dos architectos, engenheiros e constructores portuguezes ou a serviço de Portugal, publicado por indicação da Commissão dos Monumentos. Lisboa, Impr. nacional, 1899-1922. 3v. plan, plates.
Biographical dictionary of Portuguese architects, engineers, builders and those in the service of Portugal from about 1400 to 1922. Based on original documents.

J295    Watson, Walter Crum. Portuguese architecture. London, Constable, 1908. 280p. il., 55 plates.
An old standard work. Still the only survey in English.

J296    Weise, Georg. Studien zur spanischen Architektur der Spätgotik. Reutlingen, Gryphius [1933]. 132p. il., plans. (Tübinger Forschungen zur Archäologie und Kunstgeschichte, Bd. XIV)
A brief scholarly study of late Gothic architecture in Spain.

J297    Whitehill, Walter Muir. Spanish Romanesque architecture of the eleventh century. [London] Oxford Univ. Pr., 1941. 307p. il., plates, maps, plans. (Repr.: London, Oxford Univ. Pr., 1969.)
A scholarly treatment. Contents: (1) The historical setting of 11th-century architecture in Spain; (2) Catalonia; (3) Castille, León, Navarre, Aragón, and Galicia.
Bibliography, p.[285]-99.

SEE ALSO:  *Catálogo monumental de España* (I441); Durliat, M. *Art catalan* (I442); _____. *L'art dans le royaume de Majorque* (I443); _____. *L'art roman en Espagne* (I444); *Inventário artístico de Portugal* (I449); Jairazbhoy, R. A. *An outline of Islamic architecture;* (J101); Lees-Milne, J. *Baroque in Spain and Portugal, and its antecendents* (I452); Marçais, G. *L'architecture musulmane d'occident* (J102); Rivoira, G. T. *Moslem architecture, its origins and development* (J105).

## Turkey

For a critique of recent books on Turkish architecture see Howard Crane, "Recent literature on the history of Turkish Architecture," *Journal of the Society of Architectural Historians* 31:309-15 (Dec. 1972).

J298    Goodwin, Godfrey. A history of Ottoman architecture. Baltimore, Johns Hopkins Univ. Pr. [1971]. 511p. il. (part col.), plans, maps.
The definitive work on the architecture of the Ottoman Empire in Turkey. Includes all major monuments from c.1300 A.D. to the 20th century. "List of monuments by towns," p.503. Bibliography, p.496-502. Richly illustrated with 521 photographs and 81 plans.

J299    Ünsal, Behçet. Turkish Islamic architecture in Seljuk and Ottoman times, 1071-1923. London, Tiranti, 1959. vi, 118p. il., plates, maps. (Chapters in art. v.33)
Reissued, 1971.
A useful but brief outline of Anatolian Turkish architecture from the 12th century down to the 20th century revivalists. Typologically organized, with numerous plans and photographs.
Contents: (I) Conditions affecting Turkish architecture; (II) Architectural form and character (building types); (III) Materials and construction; (IV) Aesthetic considerations; (V) Comparison and conclusion (including dictionary of Turkish architects, short glossary, and bibliography).

J300    Yetkin, Suut Kemal. L'architecture turque en Turquie. Paris, Maisonneuve et Larose [1962]. 173p. plans, 104 plates.
The concisely written text concentrates on religious monuments (mosques, *medreses*, and *turbes*). Divided into three periods: Seljuk, Beylik, and Ottoman. Limited number of examples chosen to show consistent evolution of Turkish architecture.

## United States

With a few exceptions, only general books on American architecture are listed here. The bibliographies and the

bibliographical references in these works will lead the reader to the art historical literature and the guidebooks of individual states, smaller regions, cities, architects, building types, etc.

See the critical bibliographical essay in Vincent Scully's *American architecture and urbanism* (J331); the chapter on architecture in *The arts in early American history*, by Walter M. Whitehill (A167); *American architecture and art*, by David M. Sokol (A166). Current literature is listed in the Society of Architectural Historians *Newsletter* (Q323).

## Bibliography

J301    Historic preservations plans: an annotated bibliography. Wash., D.C., National Trust for Historic Preservation: Preservation Pr., 1976. 42p.

"This bibliography is a representative sampling of some of the plans of the nation's largest cities to its smallest towns, which are drawing up proposals to preserve historic areas, historic waterfronts, ethnically oriented neighborhoods and areas affected by highways. The plans are grouped according to area population so that planners in one area can see what planners in another area of similar size have proposed. The plans are further divided into those drawn up for districts and those proposed for entire municipalities. Regional and state plans also are included."—*ARLIS/Newsletter* 4:181 (Oct. 1976).

J302    Roos, Frank John. Bibliography of early American architecture; writings on architecture constructed before 1860 in Eastern and Central United States. New ed. Urbana, Ill., Univ. of Illinois Pr., 1968. 389p.

1st ed. 1943.

"Revised, updated and extensively annotated version." The most comprehensive bibliography on American architecture (4,377 items).

Contents: Introduction—Scope of the list of writings on early American architecture; General references; Colonial; Early Republican; New England; Middle Atlantic States; Southern States; North Central States; Architects. Bibliographies, p.320–25; General index, p.327–[89].

J302a   Tubesing, Richard L. Architectural preservation in the United States, 1941–1975: a bibliography of federal, state, and local government publications. New York, Garland, 1978. xvii, 452p. (Garland reference library of the humanities, v. 61)

A comprehensive bibliography, useful to all persons concerned with historic preservation. No annotations. "In the present volume, *architecture* is defined in its broadest sense, and materials listed include various man-made structures ranging from prehistoric Indian ruins and restored Colonial villages to now-defunct lighthouses, Victorian mansion-museums, and contemporary neighborhood preservation projects. The concept *preservation,* on the other hand, has been narrowly defined so as to exclude the large amount of material that more properly falls under the rubrics of archaeology and architectural or cultural history. Specifically, only those structures or their ruins which are still standing or which have been at least partially reconstructed are considered. General works on architectural preserva-

tion technology, legislation, master plans, policy statements, and such related materials as agency annual reports and grant information are also listed."—*Introd.*

Contents: (1) Agency annual and statistical reports, histories, and serial publications; (2) Historic preservation plans, programs, policies, and procedures; (3) Architectural and historical reports, development plans, and feasibility studies for historic sites and complexes; (4) Site registers, inventories, surveys, and historical marker guides; (5) Historic site brochures and maps: United States, Alabama through Montana; (6) Historic site brochures and maps: Nebraska through Wyoming; (7) Preservation legislation: Laws, statutes, acts, and ordinances; (8) Preservation technology, bibliography, graphics, and audio-visual material; (9) Addenda. Appendix I: Federal agencies, commissions, and departments responsible for historic preservation. Appendix II: State and territorial historic preservation officers and sources of information. Index: Augumented key phrases in entry.

J303    Wodehouse, Lawrence. American architects from the Civil War to the First World War. Detroit, Gale. 1976. xii, 343p. (Art and architecture information guide series, v.3)

An annotated bibliography of American architects and architecture from 1860–1914. Limited to works containing biographical information on architects.

Contents: Sect. 1, General reference works; Sect. 2, Selected annotated bibliography from the period of the Civil War to the First World War; Sect. 3, Architects of the period about whom little had been written. Addendum. Indexes: General index; Building location index.

J303a   _____. American architects from the First World War to the present. Detroit, Gale, 1977. xiii, 305p. (Art and architecture information guide series, v.4)

An annotated bibliography of American architects and architecture from 1914 to the mid-1970s; a continuation of the author's *American architects from the Civil War to the First World War* (J303). "The present volume in no way attempts to be all-inclusive in providing information on all architects or all of their works. Rather, it has selected 174 representative architects and what either the critic or historian has to say about them."—*Introd.*

Contents: Sect. 1, General reference works; Sect. 2, Selected annotated biographical bibligraphy of American architects from the period of the First World War to the present. Appendix: Ada Louise Huxtable and the location of her articles. Indexes: General index; Building location index.

SEE ALSO:  Hitchcock, H.-R. *American architectural books: a list of books, portfolios, and pamphlets on architecture and related subjects published in America before 1895* (J11).

## Histories and Handbooks

J304    American architects directory. N.Y., Bowker, Pub. under the sponsorship of American Inst. of Architects, 1955–(70). v.1–(3).

2d ed. 1962. Editor, 3d ed., John F. Gane.

3d ed. lists officers, regional directors, headquarters staff, honorary members, honorary fellows, college of fellows, medals and awards, officers and conventions (1857-1970). The biographical section contains brief entries for over 23,000 corporate members of the A.I.A. Geographical section, p.1,033, lists architects by state, then city. Necrology, p.1,111. Appendix: National Council of Architectural Boards; Association of Collegiate Schools of Architecture.

J305    Andrews, Wayne. Architecture, ambition and Americans; a history of American architecture, from the beginning to the present, telling the story of the outstanding buildings, the men who designed them and the people for whom they were built. N.Y., Harper [1955]. 315p. il.

Available in paperback: *Architecture, ambition and Americans; a social history of American architecture*, N.Y., Free Pr., 1964.

A history of American architecture which emphasizes economic, cultural, and social background. Good bibliography, p.289-303. Index, p.307-[15].

J306    Brooks, Harold Allen. The Prairie School; Frank Lloyd Wright and his midwest contemporaries. [Toronto, Univ. of Toronto Pr., 1972]. xxiii, 373p. il.

A sound historical treatment of the Prairie School of architecture which flourished in suburban Chicago and other areas of the Middle West during the first two decades of the 20th century. Traces the origins in the 19th century, the development of the style in the Prairie houses of Wright, and its demise in the twenties. Bibliographical footnotes in the margins. Bibliographical notes, p.[349]-[52].

J307    Condit, Carl W. American building art: the nineteenth century. N.Y., Oxford Univ. Pr., 1960. 371p. il.

The first volume of a "comprehensive history of structural forms and techniques in the U.S.," including chapters on wood framing, iron framing, the wooden bridge truss, the iron bridge truss, the suspension bridge, the iron arch bridge, the railway train shed, concrete construction, and an architectural appraisal. Detailed analyses of construction techniques are given in the "Notes," p.275-344. Bibliography, arranged by chapter subjects, p.345-51. Continued by *American building art: the twentieth century*, (J308).

J308    ———. American building art: the twentieth century. N.Y., Oxford Univ. Pr., 1961. 427p. il.

Modern steel and concrete construction methods. A continuation of the history of 19th-century building technology (J307). Extensive notes, p.307-91; bibliography arranged by chapter, p.393-405.

J309    Downing, Antoinette F., and Scully, Vincent J., Jr. The architectural heritage of Newport, Rhode Island, 1640-1915. 2d ed., rev. N.Y., Potter [1967]. xvi, 526p. il., maps, plans.

1st ed., Cambridge, Mass., Harvard Univ. Pr., 1952.

    Available in paperback.

    An exemplary history of the architecture of a town. Traces the history of Newport from 1640 to 1915, from the colonial period to the mansions of the 19th and 20th centuries. Meticulous scholarship.

    Contents: pt. 1., 17th-century colonial architecture: pt. 2, 18th-century colonial architecture; pt. 3, Early Republican architecture; pt. 4, 19th-century resort architecture. Pts. 1-3 by A. Downing; pt. 4. by V. Scully. Appendixes: (A) Detailed histories and descriptions of buildings; (B) Spot restoration program recommended for historic Newport. Bibliographical footnotes. Superbly illustrated with 230 plates—photographs, drawings, prints, etc.

J310    Early, James. Romanticism and American architecture. London, Yoseloff; N.Y., Barnes, [1965]. 171p. il., plans.

A study of the intellectual and cultural sources of the Romantic styles of the 19th century in the U.S. Many references to philosophers, writers, critics, statements of architects, etc. Good bibliographical notes at the end of each chapter. Well illustrated.

    Contents: Introduction: Jefferson's Capitol and the older classicism; The Romantic revivals: history and associationism; Romantic naturalism: The picturesque: Nature, the Gothic, and functionalism; The Gothic as a style for Protestantism; Nationalism and a new architecture; Index.

J311    Fitch, James Marston. American building. 2d ed., rev. and enl. Boston, Houghton Mifflin, 1966-72. 2v. il., maps, plans.

A major revision of *American building: the forces that shape it* (1st ed., 1948). Enlarged into 2v.

    v.1 *American building: the historical forces that shaped it.* A history of American architecture from the pre-Colonial period to the present, with emphasis on the social and historical aspects. Deterministic in approach.

    v.2 *American building: The environmental forces that shape it.* A provocative, far-reaching discussion of the technologies which have been developed to moderate the environment in which Americans live.

    Bibliographical references in notes, v.1., p.[321]-27.

J312    Forman, Henry Chandlee. The architecture of the Old South: the medieval style, 1585-1850. Cambridge, Harvard Univ. Pr., 1948. 203p. il., plates. (Repr.: N.Y., Russell and Russell, 1967.)

An innovative study of early Southern architecture: the origins of the building types and details are traced to late Gothic precedents in England. Bibliography, p.187-91. Clearly illustrated with drawings and a few photographs.

    Contents: pt. 1, Our English Gothic heritage; pt. 2, Virginia medieval architecture; pt. 3, Maryland medieval architecture; pt. 4, Medieval architecture of the Deep South.

J313    Gifford, Don Creighton, ed. The literature of architecture: the evolution of architectural theory and practice in nineteenth-century America. N.Y., Dutton, 1966. 640p. il.

An anthology of writings by various authors, including architects, reflecting the evolution of architectural theory and practice from the late 18th- to the early 20th century.

Contents: pt. 1, Prologue in Europe (1750-1825); pt. 2, The confluence of ideas (1820-65); pt. 3, The new technology (1820-80); pt. 4, Coordination of theory and practice (1880-1910); pt. 5, Reaction in America and epilogue in Europe (1890-1920). Bibliography, p.[637]-40.

J314    Gowans, Alan. Images of American living: four centuries of architecture and furniture as cultural expression. Philadelphia, Lippincott, [1964]. xv, 498p. il., diagrs., plans.

A stimulating study of American architecture as a record of American civilization; the author examines the patterns of living styles from the 17th century to the present, tracing the changes from the homestead to the megalopolis. Bibliographical footnotes. Well illustrated. Index of personal names, p.481-86; Index of architecture (arranged by state and town), p.487-93; General index, p.494-98.

J315    Hamlin, Talbot Faulkner. Greek revival architecture in America: being an account of important trends in American architecture and American life prior to the War between the States: together with a list of articles on architecture in some American periodicals prior to 1850 by Sarah Hull Jenkins Simpson Hamlin and an introduction by Dean Leopold Arnaud. N.Y., Oxford Univ. Pr., 1944. 439p. il., 94 plates. (Repr.: N.Y., Dover, 1964, paperback; Magnolia, Mass., Peter Smith, 1964, clothbound.)

The fundamental study of the Greek Revival in all parts of the U.S. from 1820-60.

Appendixes: (A) The American development of Greek-inspired forms: (B) Some articles of architectural interest published in American periodicals prior to 1851. Bibliography, p.383-409; detailed index, p.411-39.

J316    Historic American Buildings Survey. Catalog of the measured drawings and photographs of the Survey in the Library of Congress, March 1, 1941. Comp. and ed. by Historical American Building Survey, National Park Service. [Wash., U.S. Gov. Print. Off., 1941]. vii, 470p. il. (incl. plans). (Repr.: N.Y., Burt Franklin, 1971.)

1st ed. 1938. An annotated index to the collection of measured drawings and photographs of historic American buildings, assembled by HABS and housed in the Library of Congress. Over 6,000 buildings listed according to state and city.

———. Catalogue supplement (1955). [Wash., U.S. Gov. Print. Off., 1959] unpaged, il.

J317    ———. Recording historic buildings. Comp. by Harley J. McKee. [Wash] U.S. National Park Service [for sale by the Supt. of Docs. U.S. Govt. Print. Off.] 1970. xi, 169p. il.

A guide for the compilation of state and regional HABS catalogues. Lists the recent surveys as well as those in active preparation in 1970. Also serves as a general guide for locating the HABS records in the Library of Congress and the HABS offices in Wash., D.C. Bibliography, p. 157-62.

J318    ———. Selections, No. 1- , 1966- . Publisher, place vary.

These surveys are intended to provide historical documentation, accurate architectural descriptions, photographs, and frequently plans of representative buildings in a specific historic area. Based on information gathered by the Historic American Buildings Survey and housed in the Library of Congress. Places already covered in the series include the Virgin Islands; Georgetown; New York City; New Haven; Wash., D. C.; Cleveland; Carson City, Nevada; and the New England textile mill survey.

J319    Jordy, William H. American buildings and their architects: the impact of European modernism in the mid-twentieth century. Garden City, N.Y., Doubleday, 1972. 469p. il., plans.

Available in paperback.

v.4 of a 4v. series, *American buildings and their architects.* v.1 (J328) and v.2, pt. 1 (J328a) are by William H. Pierson; v.3 (J320) and v.4 are by Jordy.

A study of representative examples of American architecture from after World War I to the early sixties. Oriented to the beginning student rather than the scholar. Good illustrations. Bibliographical notes, p. 427-[45]; Glossary of terms, p.447-[50].

Contents: (1) Rockefeller Center and corporate urbanism; (2) The American acceptance of the International Style: George Howe and William Lescaze's Philadelphia Saving Fund Society Building; (3) The domestication of modern: Marcel Breuer's Ferry Cooperative Dormitory at Vassar College; (4) The laconic splendor of the metal frame: Ludwig Mies van der Rohe's 860 Lake Shore Apartments and his Seagram Building; (5) The encompassing environment of free-form architecture: Frank Lloyd Wright's Guggenheim Museum; (6) What the building "wants to be": Louis I. Kahn's Richards Medical Research Building at the University of Pennsylvania.

J320    ———. American buildings and their architects: Progressive and academic ideals at the turn of the twentieth century. Garden City, N.Y., Doubleday, 1972. xxi, 420p. il., plans.

Available in paperback.

v.3 of a 4v. series, *American buildings and their architects.* v.1 (J328) and 2, pt. 1 (J328a), are by William H. Pierson; v.3-4 (J319) by Jordy.

This volume covers the period from 1880 until World War I. Specific buildings are the objects of the critical case-study approach; not a thorough history of the period except as it relates to the examples chosen. Intended as an introduction for the beginner rather than the scholar. Good photographs. Bibliographical notes, p.376-[96]; Glossary of terms, p.397-[403].

Contents: (1) Masonry block and metal skeleton: Chicago and the "commercial style"; (2) Functionalism as fact and symbol: Louis Sullivan's commercial buildings, tombs, and banks; (3) The organic ideal: Frank Lloyd Wright's Robie house; (4) Craftsmanship as structural elaboration: Charles and Henry Greene's Gamble house; (5) Craftsmanship as reductive simplification: Irving Gill's Dodge house; (6)

Craftsmanship and grandeur in an architecture of mood: Bernard Maybeck's Palace of Fine Arts and First Church of Christ Scientist; (7) The Beaux-Arts renaissance: Charles McKim's Boston Public Library.

J321 Kimball, Sidney Fiske. Domestic architecture of the American colonies and of the early Republic. N.Y., Scribner, 1922. xx, 314p. il., plans. (Corrected repr.: N.Y., Dover, 1967, in paperback; Magnolia, Mass., Peter Smith, 1967, clothbound.)

This pioneer historical survey, based on original research, is again available. Well illustrated. Bibliographical footnotes.

Contents: Colonial houses: the 17th century, the 18th century; Houses of the early Republic; Notes on individual houses; Chronological chart; Index.

J322 Koyl, George Simpson. American architectural drawings: a catalog of original and measured drawings of buildings of the United States of America to December 31, 1917. Comp. and ed. by George S. Koyl. Assistant ed.: Moira B. Mathieson. Foreword by John F. Harbeson. |Philadelphia, Philadelphia Chapter, American Institute of Architects, 1969|. 5v. unpaged.

An impressive catalogue of architectural drawings of approximately 6,000 buildings by over 1,000 American architects and draftsmen. Concentrates on material from better known collections of the Northeastern seaboard, but all states, as well as Puerto Rico, are represented. Numbered entries listed by architect, often giving dimensions, medium, and brief description.

Contents: v.1: Foreword: Geographical index listing drawings alphabetically by states and towns; Index of repositories and their addresses; Index of architects, designers, and draftsmen. v.2-5: Drawings listed under the name of the architect.

J323 Kubler, George A. The religious architecture of New Mexico: in the colonial period and since the American occupation. |4th ed.|. Albuquerque, Published for the School of American Research by Univ. of New Mexico Pr. |1973|. xxvii, 232p. il., plans, diagrs., maps.

1st ed. 1940.

"The religious architecture of New Mexico has hitherto received attention chiefly from historians, whose admirable studies discuss the organization and influence of the Church throughout the province. Many others have written about the antiquity of the churches, or about the romantic aspects of Spanish influence in this country. The churches themselves have never been considered pertinent to the history of building. It therefore appeared to me that the monuments might be analyzed and classified according to their architectural aspect alone." —Pref.

Includes a chronological summary of important documents, excavations, and enthnographic studies since 1940; a chronological table of the churches, p.118-|27|. Complete bibliography, p.149-|59|: numerous black-and-white photographs.

J324 The Monograph series recording the architecture of the American colonies and the early Republic. v.1-

26. |July 1915-Oct. 1940|. N.Y., Whitehead, 1916-40. 24v. in 10. il., plates, plans. (Repr.: N.Y., Arno, 1977.)

Title varies: v.1-18, The White Pine series of architectural monographs. v.18-26 published in the periodical *Pencil points*. Editor: Russell F. Whitehead.

A unique collection of illustrations of historic American wooden architecture. These monographs "present classified illustrations of wood construction, critically described by representative American architects, of the most beautiful and suggestive examples of architecture, old and new, which this country has produced." —*Pref.*

J325 Morrison, Hugh Sinclair. Early American architecture, from the first colonial settlements to the national period. N.Y., Oxford Univ. Pr., 1952. 619p. il., maps, plans.

Still the best survey of 17th- and 18th-century American architecture for both students and scholars. Selected bibliography at the end of individual chapters, some references with annotations. "Reference notes," p.581-91.

J326 Newcomb, Rexford. Spanish-Colonial architecture in the United States. N.Y., Augustin, |1937|. 39p., front., 130 pl. (incl. plans).

Outlines Spanish-colonial architecture in Florida, Texas, New Mexico, Arizona, and California. Most useful for the drawings and photographic illustrations. No bibliography.

Contents: (I) Historical note, the background: social, political, economic, religious; (II) The Spanish architectural tradition; (III) Spanish-colonial architecture in Florida; (IV) Spanish-colonial architecture in Texas; (V) Spanish-colonial architecture in New Mexico; (VI) Spanish-colonial architecture in Arizona; (VII) Spanish-colonial architecture in California; (VIII) Present-day Spanish-colonial architecture in the U.S.; (IX) 130 full-page plates of photographs and drawings.

J327 Nichols, Frederick Doveton. The early architecture of Georgia. With a pictorial survey by Frances Benjamin Johnston. Chapel Hill, Univ. of North Carolina Pr., 1957. xvi, 292p. il., maps, plans.

An introduction to the 18th- and 19th-century architecture of Georgia. Well illustrated with many black and white photographs and plans. Bibliographical footnotes. Index of names and places.

Contents: pt. 1, The land and the people; pt. 2, Cities and towns; pt. 3, Domestic architecture of coastal Georgia; pt. 4, Domestic architecture of the Piedmont; pt. 5, Civil architecture; pt. 6, Conclusion.

J328 Pierson, William Harvey, Jr.. American buildings and their architects: the colonial and neoclassical styles. Garden City, N.Y., Doubleday, 1970. xxv, 503p. il., plans.

Available in paperback.

v.1 of a 4v. series, *American buildings and their architects.* v.2, pt. 1 (J328a) is also by Pierson. v.3-4 (J319-320) are by William H. Jordy.

A stimulating survey of the early styles of American architecture. Authoritative, informative, well written.

Introduced by general observations on style in architecture (p.|1|-16). Especially thorough in the treatment of European sources with relation to American architecture. Bibliographical references in the scholarly notes. "Glossary of terms," p.|483|-89. Well illustrated with 333 illustrations in the text.

J328a _____. American buildings and their architects: technology and the picturesque; the corporate and the early Gothic styles. Garden City, N.Y. Doubleday, 1978. xxviii, 500p. il., plans.

v.2, pt. 1 of a 4v. series, *American buildings and their architects*: v.2, pt. 2 not yet published. v.1 is also by Pierson. v.3-4 (J319, J320) are by William H. Jordy.

A detailed study of two major stylistic influences in American architecture before the Civil War—the "corporate" style of early industrial towns and the beginnings of the Gothic Revival. Relates important European sources to specific American examples. Bibliographical notes, p.456-81. Glossary of terms, p.482-90.

Contents: (1) Romanticism, technology, and the picturesque; (2) The new industrial order: the factory town; (3) The early Gothic Revival; (4) Richard Upjohn, Trinity Church, and the ecclesiological Gothic Revival; (5) John Renwick, St. Patrick's Cathedral, and the continental Gothic Revival; (6) Alexander Jackson Davis and the picturesque; (7) Andrew Jackson Downing: villa, cottage, and landscape; (8) The board and batten and the Gothic Revival church.

J328b ProFile: Professional file: architectural firms. The American Institute of Architects 1978. The Official AIA directory of architectural firms. Henry W. Schirmer, ed. Philadelphia, Archimedia, 1978. 674p.

To be published annually.

The first comprehensive listing of architectural firms in the U.S. Primary users are expected to include "private and institutional owners anticipating a building project, Governmental agencies, libraries, organizations and associations involved in the building process, and architectural and engineering firms seeking professional affiliation or joint venture associaion." — *Pref.*

Contents: How to find, evaluate, select, and negotiate with an architect: You and your architect; Code of ethics and professional conduct; The A. I. A.: from the client's viewpoint; How to use this ProFile; ProFile of architectural firms (by state). Indexes: Firms; Principals.

J329 Reps, John William. The making of urban America: a history of city planning in the United States. Princeton, Princeton Univ. Pr., 1965. xv, 574p. il., maps, plans.

A unique, scholarly history of the planned city in America from its European roots to the present. Basic to research in the history of town planning. 314 good illustrations, including a rich selection of reproductions of early maps, plans, and views. Comprehensive bibliographies, p.545-62.

J330 Schuyler, Montgomery. American architecture and other writings; ed. by William H. Jordy and Ralph Coe. Cambridge, Belknap, 1961. 2v. xvi, 664p. il., port.

Paperback ed.: N.Y. Atheneum, 1964.

A collection of essays selected from the writings of the great architectural critic, Montgomery Schuyler (1843-1914). Explanatory notes and bibliographical references by the editors. The original illustrations have been reproduced.

Contents: "Montgomery Schuyler" by William H. Jordy and Ralph Coe: (1) The point of view; (2) The heritage of Victorian Gothic; (3) The Richardsonian interlude; (4) Bridges: rationalistic engineering; (5) Skyscrapers: rationalistic architecture; (6) The Beaux Arts reaction; (7) Late Sullivan and early Wright. Bibliography. (Schuyler's architectural writings originally published in periodicals.)

J331 Scully, Vincent. American architecture and urbanism. N.Y., Praeger [1969]. 275p. il. (incl. plans).

"This book is concerned with the meaning of American architecture and with an assessment of the kind of human environment it has created in that geographical area which is now occupied by the United States." —*p.7*. A broad, environmental view of American architecture from Pueblo dwellings to the work of Louis Kahn and Robert Venturi.

"A note on method and bibliography," p.257-62, provides a good summary of the literature on American architecture.

J332 _____. The shingle style and the stick style: architectural theory and design from Richardson to the origins of Wright. Rev. ed. New Haven, Yale Univ. Pr., 1971. lix, 184p. il. (Yale historical publications. History of art, 20).

Available in paperback.

1st ed. 1955 published as: *The shingle style: architectural theory and design from Richardson to the origins of Wright*. A scholarly study of the wooden domestic building of the late 19th century from Richardson to the origins of Wright. Bibliographical footnotes; useful bibliographical essay followed by a chronological list of important pattern books, an alphabetical list of periodicals, and a selective list of books.

Contents: Introduction: Romantic rationalism and the expression of structure in wood. Downing, Wheeler, Gardner, and the "Stick Style," 1840-76; (1) The Stick Style reviewed. H. H. Richardson and English "Queen Anne," 1869-72; (2) Queen Anne and Colonial revival, 1869-76; (3) Romantic rationalism and the assimilation of Queen Anne and Colonial influences, 1876-77; (4) Experiments in design by 1877. Theoretical synthesis to 1883; (5) Formation of the Shingle Style; (6) Richardson and the mature Shingle Style; (7) Order and archetype, 1885; (8) McKim, Mead, and White. Originality, order, and academic reaction, 1880-87; (9) Conclusion: Frank Lloyd Wright.

J333 Stanton, Phoebe B. The Gothic Revival & American church architecture; an episode in taste, 1840-1856. Baltimore, Johns Hopkins Pr. [1968]. xxiv, 350p. il., plans. (The Johns Hopkins studies in nineteenth-century architecture.)

A pioneer study which "lays part of the foundation for a future definitive history of American 19th century architecture." — E. M. Upjohn, *Journal of the Society of Architectural Historians*, v.28, Dec. 1969. Includes bibliographical footnotes.

Contents: (I) The background: (II) Ecclesiology in the U.S.: the first phase, 1841–47: (III) Ecclesiology in the U.S.: the second phase, 1846–48: (IV) Christ Church Cathedral and the Chapel of St. Anne, Fredericton, New Brunswick: (V) The New York Ecclesiological Society and its journal: (VI) Some buildings and architects of the American Gothic and parish church revivals: (VII) Contributions of the parish church revival.

J334    United States Department of the Interior. National Park Service. The National Register of Historic Places, 1976. Wash., D.C., Gov. Print. Off., 1976. xvii, 961p. il.
Replaces the 1972 ed. and the 1974 supplement. The most comprehensive inventory of American historic landmarks, the National Register is the official schedule of the nation's cultural property deemed worth preserving. Arranged by state and county, properties on the Register include buildings, sites, structures, and historic districts. Annotated entries for each property include brief description and statement of significance.

The 1976 ed. includes approximately 12,000 entries compiled through Dec. 31, 1974. Additions after Dec. 31, 1974, can be located in the *Federal Register* under the following heading: U.S. Dep. of the Interior, National Park Service, National Register of Historic Places. The *Federal Register* also lists properties recorded by the Historic American Building Survey and the Historic American Engineering Record and properties receiving National Park Service grants-in-aid for historic preservation.

J335    United States Office of Archeology and Historic Preservation. Advisory list to the National Register of Historic Places. 1969. Wash., D.C. Gov. Print. Off. [1970] vii, 311p.
A listing by state and county of historic places not on the National Register as of June 30, 1969. Some are potential entries for the Register; others are of local interest only. All are places recognized by the Historic American Buildings Survey and the National Survey of Historic Sites and Buildings.

J336    Ware, William Rotch. The Georgian period: being photographs and measured drawings of colonial work. 1923 ed., with new classifications and indexes. N.Y., U.P.C. Book Co. [1923]. 6v. il., (incl. plans), 454 plates.
Originally published 1899–1904. A monumental work on 18th-century American architecture. Accurate measured drawings of buildings and building details. Contents: v.1, text and indexes: v.2–6, plates in portfolios.

"Books used by the early architects," v.1, p.253. v.1 also contains: Numerical chronology, p.xi–xiii: Alphabetical chronology, p. xv–xvii: Alphabetical list of plates, p. xix–xxv: Geographical index, p.xxvii–xxxv: Subject index of plates, p.xxxvii–xliv: Text on various sections of the country written by various authors: p.1–272: Alphabetical, geographical and historical index of text, p.273–99: Subject index of text, p.301–6.

J337    Waterman, Thomas Tileston. The dwellings of colonial America. Chapel Hill, Univ. of North Carolina Pr., [1950]. 312p. il., plans.
New ed. announced by Norton, date not set, paperback.

An excellent book on 17th- and 18th-century American architecture. Arranged by region. Glossary of terms and bibliography, p.291–93.

J338    _____. The mansions of Virginia, 1706–1776. Chapel Hill, Univ. of North Carolina Pr. [1946]. 456p. il. (incl. plans, facsims.)
The pioneer study of the great pre-Revolutionary houses in Virginia. Presents new findings based on meticulous research. Well illustrated with photographs, drawings, and plans.

Contents: (1) The English antecedents of Virginia architecture: (2) The 17th-century Virginia mansion: (3) The early Georgian period, 1706–50: (4) The mid-Georgian period, 1750–65: (5) The late-Georgian period, 1765–76. Summary sketches of mansions: bibliography, p.425–32; glossary of architectural terms; and map showing the location of the mansions.

J339    Waterman, Thomas Tileston, and Barrows, John A. Domestic colonial architecture of Tidewater Virginia: with an introduction by Fiske Kimball. New York, Scribner, 1932. xvii, 191p. il., plates, plans. (Repr.: N.Y., Da Capo, 1968; N.Y., Dover. 1970. paperback; Magnolia, Mass., Peter Smith. 1970, clothbound.)
An early study of 15 important Virginia mansions of the Colonial period. Based on thorough research with documents: a factual approach. Well illustrated with maps, plans, drawings, elevations, old photographs. No bibliography. Includes detailed drawings of profiles (pilasters, mouldings, etc.): table of brick sizes for the various structures: comparison of outline plans: a helpful glossary of architectural terms: index of persons, places, and architectural members.

J340    Whiffen, Marcus. American architecture since 1780: a guide to the styles. Cambridge, Mass., MIT Pr. [1969]. x, 313p. il.
A concise, informative handbook, the first in which the variety of architectural styles since 1780 is described and differentiated. It does more than fulfill its purpose of helping "the building watcher increase his knowledge of the architecture around him." —*Pref.* Divided into styles and substyles with selective examples. Classified bibliography of books published since 1915, p.281–89.

J341    Withey, Henry F., and Withey, Elise Rathbun. Biographical dictionary of American architects (deceased). Los Angeles, New Age. [1956]. 678p. (Repr.: Los Angeles, Hennessey & Ingalls, 1970.)
Biographies of nearly 2,000 American architects and builders from c.1740 to 1952. Entries include bibliographical references. Several omissions and factual errors.

SEE ALSO: Kidder, A. V. *An introduction to the study of Southwestern archaeology* . . . (I617); Mumford, L. *The*

*brown decades* (I482); Scully, V. *Pueblo: mountain, village, dance* (J366).

# ORIENTAL COUNTRIES

J342 Speiser, Werner. Oriental architecture in colour: Islamic, Indian, Far Eastern. |London| Thames & Hudson |1965|. 504p. 112 col. plates, plans.
Trans. of *Baukunst des Ostens* by Charles W. E. Kessler.

Outlines and analyzes major characteristics of various oriental styles through color illustrations and accompanying text.

SEE ALSO: Bussagli, M. *Oriental architecture* (J52).

## China

J343 Boerschmann, Ernst. Die Baukunst und religiöse Kultur der Chinesen; Einzeldarstellungen auf Grund eigener Aufnahmen während dreijähriger Reisen in China. Im Auftrage des Reiches bearbeitet und mit Unterstützung des Reiches hrsg. von E. Boerschmann. Berlin, Reimer, 1911-31. 3v. il., plates. v.3, Berlin, de Gruyter.

Contents: Bd. 1, P'u t'o shan, die heilige Insel der Kuan yin, der Göttin der Barmherzigkeit, 1911; Bd. 2, Gedächtnistempel, Tzé táng, 1914; Bd. 3, Pagoden, pao tá, 1931.

J344 _____. Chinesische Architektur. Berlin, Wasmuth [1925]. 2v. il. diagrs., map, plans, plates (part col.)
340 plates arranged by building types or forms, with a short introductory text. Bibliography, v.2, p.68.

J345 Boyd, Andrew Charles Hugh. Chinese architecture and town planning. 1500 B.C.—A.D. 1911. [Chicago] Univ. of Chicago Pr. [1962]. vi, 166p. il., map, plans, 158 plates. 84 figs.
"All that is attempted here is a brief and general introduction to the main tradition of classical Chinese architecture and town-planning ... It can only touch briefly on anything before 221 B.C. ... It does not include the varieties of local traditions nor the architecture of outlying parts of China. Save for a brief postscript it omits twentieth century developments, including all that is happening in China today." —*Pref.*
The bibliography, p. 160-61, is alphabetized by title.

J346 Prip-Møller, Johannes. Chinese Buddhist monasteries: their plan and its function as a setting for Buddhist monastic life. Copenhagen, Gad; London, Oxford Univ. Pr., 1937. 396p. plates. (Repr.: Hong Kong, Hong Kong Univ. Pr., 1967.)
Important for its detailed descriptions of architectural layouts and functions of Chinese Buddhist monasteries, particularly in the lower Yangtze area. Excellent photographic plates, plans, and drawings.

Contents: (1) The typical Buddhist monastery layout of today — central axis; (2) The typical Buddhist monastery layout of today — lateral groups; (3) The monastery Hui Chü Ssu, Pao Hua Shan, Kiangsu; (4) Building history of Hui Chü Ssu, Pao Hua Shan, Kiangsu; (5) The ordination unit, its ceremonies and its development; (6) Monks' offices and daily life in the monasteries.

J347 Sirén, Osvald. Gardens of China. N.Y., Ronald, 1949. xiv, 141p. il. 219 plates (part col.)
"The text falls into two parts, one analytic and the other descriptive; the former may be considered to represent the main substance of the text in which the general fundamental features and compositional elements of the Chinese gardens are briefly dealt with, while the latter contains historical and descriptive additions of more restricted local importance." —*Foreword.*

Illustrated with the author's photographs, some paintings of gardens, and figures illustrating brick patterns, ornamental window and balustrade designs, etc. Bibliography, p.138. Index, p.[139]-41.

Contents: (1) The Chinese garden — a work of art in forms of nature; (2) Mountains and water; (3) Flowers and trees; (4) Architectural elements of the gardens; (5) Gardens in literature and painting; (6) Older gardens in Japan; (7) Some private gardens; (8) The parks of the sea palaces (9) Yuan Ming Yuan; (10) The New Summer Palace and the Park of the Jade Fountain.

SEE ALSO: Wu, N. T. *Chinese and Indian architecture* (J39).

## India

J348 Barrett, Douglas. Early Cola architecture and sculpture. 866-1014 A.D. London, Faber and Faber [1974]. 142p. il., 99 plates, map.
A scholarly study of the evolution and chronology of the temple architecture and sculpture in the Colamandalam region of the South Indian peninsula from the second half of the 9th century A.D. to the death of Rajaraja I in 1014.
Contents: Introduction; (1) The early Colas (c.A.D. 866-1014); (2) The early Cola temple; (3) The first or Aditya I phase (c. A.D. 866-870); (4) The first or Aditya I phase (A.D. 870-907); (5) The first or Aditya I phase (A.D. 907-c.940); (6) The second phase (c. A.D. 940-970); (7) The third or Sembiyan Mahadevi phase (A.D. 969-985); (8) The third or Sembiyan Mahadevi phase (A.D. 985-1014); Conclusion. Appendix: Architectural features and styles.
Glossary of images, p.138-40. Index of temples, p.141-42. Bibliography in "Abbreviations," p.13. References in footnotes.

J349 Brown, Percy. Indian architecture. Bombay, Taraporevala, 1959-64? 2v. il., plates, maps, plans.
1st ed. 1942. Subsequent editions with minor corrections.
A standard basic history of Indian architecture. v.1, Buddhist and Hindu periods; v.2, The Islamic period. Both volumes have bibliographical references at the end of each chapter,

bibliographies, and glossaries. Well illustrated with photographs, drawings, and plans. Gives dimensions of the buildings.

**J350** Fergusson, James. History of Indian and Eastern architecture. Rev. and ed. with additions; Indian architecture by James Burgess, and Eastern architecture by R. P. Spiers. London, Murray, 1910. 2v. il., plates, maps, plans, diagrs. (Repr.: Delhi, Manoharlal, 1967)
1st ed. 1876; 2d ed. 1899.

One of the earliest treatments of the history of Indian and Eastern architecture, now a classic. See the article on James Fergusson in *Some architectural writers of the nineteenth century* (J18).

Contents: v.I, (1) Buddhist architecture; (2) Architecture in the Himalayas; (3) Dravidian style; (4) Chalukyan style; v.II, (5) Jaina architecture; The index, v.II, p.503–21, covers both volumes.

**J351** Prasanna-Kumăra, Ăchărya. A dictionary of Hindu architecture, treating of Sanskrit architectural terms, with illustrative quotations from Śilpaśāstras, general literature and archaeological records. London; N.Y., Oxford Univ. Pr. [1927]. 861p.
Rev. ed.: *An encyclopaedia of Hindu architecture,* London; N.Y., Oxford Univ. Pr., 1946.

"A full dictionary of all architectural terms used in the Manasara, with illustrations in English and illustrative quotations from cognate literature where available for the purpose." —*Pref.*

Appendix I, A sketch of Sanskrit treatises on architecture, p.749–804; Appendix II, A list of historical architects with short notes on their works, p. 805–24.

SEE ALSO: Wu, N. T. *Chinese and Indian architecture* (J39).

## Japan

A classified list of articles published in the periodical *Japan architect* (Q202) is to be found in "Additional bibliography to Part Two," in R. Paine and A. Soper, *The art and architecture of Japan* (I559), p.297. These articles are in English.

**J352** Engel, Heinrich. The Japanese house; a tradition for contemporary architecture. Rutland, Vt., Tuttle [1964]. 495p. il., plates, maps, charts, plans.
A study of traditional Japanese architecture with relation to modern architecture. Directed to the serious reader, in particular the architect. Bibliography, p.489–90.

Contents: (1) Structure; (2) Organism; (3) Environment; (4) Aesthetics.

**J353** Kirby, John B. From castle to teahouse; Japanese architecture of the Momoyama period. Tokyo; Rutland, Vt., Tuttle [1962]. xv, 222p. il., plans.
An outline of the architecture of the Momoyama period (1573–1615). Well written, accurate. Good illustrations, including drawings. No footnotes; short bibliography.

Contents: pt. 1, The forms; pt. 2, Representative examples. Appendix: List of other noteworthy examples.

**J354** Morse, Edward Sylvester. Japanese homes and their surroundings. With illus. by the author. Boston, Ticknor, 1885. (Repr.: N.Y., Dover, 1961, with new preface by Clay Lancaster.)
"Although three-quarters of a century has elapsed since Edward Morse's *Japanese Homes and their Surroundings* first appeared in 1885, the Western world has not seen another book its equal for thoroughness in dealing with every aspect of the Japanese house" — C. Lancaster in "New preface," of the Dover reprint. Excellent drawings with many details.

Contents: (1) The house; (2) Types of houses; (3) Interiors; (4) Interiors (continued); (5) Entrances and approaches: (6) Gardens; (7) Miscellaneous matters; (8) The ancient house; (9) The neighboring house. Glossary; index.

**J355** New York. Museum of Modern Art. The architecture of Japan, by Arthur Drexler. N.Y., 1955. 286p. il., map. (Repr.: N.Y., Arno, 1966.)
An excellent introduction to Japanese architecture, its history and principles. "The first section is devoted to the environment and some of the religious beliefs which have influenced all Japanese art. The second section is concerned with general principles of structure and design peculiar to Japanese architecture, and the third section is devoted primarily to buildings considered masterpieces by the Japanese themselves. Gardens in Japan are a separate art form, but because they play a part in Japanese architecture so much greater than our own they have been treated here with appropriate detail" —*Pref.*

"Supplement: Japanese exhibition house," p.262–86. Bibliographical acknowledgments in "Preface and acknowledgments."

**J356** Ota, Hirotaro, ed. Japanese architecture and gardens. (Trans. by Shinjiro Kirishiki. Photos. by Yonetaro Taujimoto). Tokyo, Kokusai bunka, 1966. 442p. 242il., map, plans, 270 plates (part col.) plans, table.
A pictorial history of Japanese architecture and gardens. The brief text, consisting of essays by specialists, is followed by the large corpus of superb illustrations. "Locations of important buildings and gardens," p.404–7; "Chronological table of architectural history," p. 408–9; "Bibliography," p.410–13; "List of plates," p.414–18; "Index and glossary," p.419–42.

Contents: pt. I, Survey of Japanese architecture and gardens; pt. 2, Particular building types; pt. 3, Plates.

**J357** Soper, Alexander Coburn. The evolution of Buddhist architecture in Japan. Princeton, Princeton Univ. Pr.; London, Milford, Oxford Univ. Pr., 1942. 330p. plates, plans. (Princeton monographs in art and archaeology, 22) (Repr.: N.Y., Hacker, 1979.)
Remains the definitive study of the history of Buddhist architecture in Japan. Classified bibliography, p. 307–17.

J358    Tempel, Egon. New Japanese architecture. N.Y., Praeger [1969]. 224p. il.
Text in English and German.

A good introduction to recent Japanese architecture. The brief historical background is followed by the main text which treats urban design, civic buildings, and individual dwellings from 1945 to 1969. Good illustrations with many details. Index of architects.

SEE ALSO:    Alex, W. *Japanese architecture* (J39).

# PRIMITIVE

## Africa

### Bibliography

J359    Prussin, Labelle, and Lee, David. "Architecture in Africa: an annotated bibliography," in *Africana library journal*, vol. 4, no. 3, Fall, 1973, p.2–47.
A comprehensive bibliography of architecture in Africa. Includes the profession of the author of the book or article and a brief descriptive annotation of the work.

Contents: "Architecture in Africa: An annotated bibliography," p.2–[32]; Bibliography, p.I, Subject section, p.34–[39]; p.II, Geographical section, p.39–[44]; Author index, p.45–[46]; Subject and key word index, p.47.

### Histories and Handbooks

J360    Gardi, René. Indigenous African architecture. English trans. by Sigrid MacRae, N.Y., Van Nostrand [1974]. 248p. il. (part col.)
Trans. of *Auch im Lehmhaus lässt sich's leben.*

A narrative guide to the traditional buildings and life in West Africa. Well illustrated. No bibliography or notes.

J361    Oliver, Paul ed. Shelter in Africa. London, Barrie and Jenkins. 1971. 240p. il., maps, diagrs., plans, sections, elevations.
A collection of 16 articles by various authors dealing with primitive housing. Most articles include notes and bibliographies.

"It is part of the intention of this second collection of new studies . . . to show that the precise relation of shelter to society can only be meaningfully studied by specific examples. In order that they should be to some extent representative, however, the examples chosen illustrate the dominance of one or other feature, and are drawn from varying kinds of ethnic, climatic, environmental and cultural regions."—*Introd.*

J362    Prussin, Labelle. Architecture in Northern Ghana; a study of forms and functions. Berkeley, Univ. of California Pr., 1969. xi, 120p. il., maps.
A pioneer study of tribal architecture in six communities of Northern Ghana. Based on considerations of environmental and cultural conditions. Bibliography, p.119–20.

SEE ALSO:    Fraser, D. *Village planning in the primitive world,* in the series *Planning and cities* (J56).

## The Americas

J363    Andrews, George F. Maya cities: placemaking and urbanization. Norman, Univ. of Oklahoma Pr. [1975]. xviii, 468p. il. (The civilization of the American Indian series, v. 131.)
A major new study of Mayan cities, their forms and functions. Based on recent archaeological investigation. The first part is a discussion of the urban centers with an analysis of the basic elements, building types, groupings, and building technology. This is followed by a study of 20 settlements. Profusely illustrated with maps, reconstruction drawings, and recent photographs. Bibliography, p. 457–62.

J364    Hardoy, Jorge E. Pre-Columbian cities; [trans. from the Spanish by Judith Thorne]. London, Allen & Unwin, 1973. xxxvi, 602p. il., maps, plans.
Rev. translation of *Ciudades precolombinas.*

"This volume is the first in an extensive study on the evolution of cities in Latin America. It deals only with those cities where America's Indian civilization lived until the arrival of the Spanish in the first decades of the sixteenth century. A second book on Colonial cities is in preparation, and the study will conclude with a third volume discussing urban evolution from Independence to the present time." —*Introd.*

Contents: (1) The origins of American civilizations; (2) The urban evolution of Teotihuacán; (3) Mesoamerican cities after the fall of Teotihuacán; (4) The Aztecs; (5) Tenochtitlán; (6) The Maya; (7) Did the Maya build cities?; (8) The first stages of urban evolution in South America; (9) Tiahuanaco and the urbanistic period; (10) The Chimú kingdom; (11) The Inca; (12) The Inca society — Cuzco; (13) The Inca city; (14) North and South Andean cities in South America; (15) General conclusions on pre-Columbian city planning and design.

Excellent illustrations, including aerial photographs. Bibliography, p. [539]–72.

J365    Marquina, Ignacio. Arquitectura prehispánica. [2. edicion]. Mexico, Instituto Nacional de Antropología e Historia, 1964. xix, 1055p. il., col. plates, maps, plans, tables. (Mexico. Instituto Nacional de Antropología e Historia. Memorias. 1)
The definitive scholarly work on prehispanic architecture in Mexico and Central America. Splendid illustrations.

J366    Scully, Vincent. Pueblo: mountain, village, dance. N.Y., Viking, 1975. xv, 398p. il.
"This book is written in love and admiration for the American Southwest and its people. It is primarily about Pueblo architecture and dances but is intended neither as a complete history of Pueblo buildings nor as a proper anthropological exploration of the mythology and ceremonials, of which the dances are only a part . . . Here is proposed only a general analysis of

the form of the existing pueblos ... and of some of the dances themselves as they are framed by the buildings and as both are related to the landscape forms." —*Pref.* Dramatic photographs, plans. "Notes: sources, critical bibliography, methods, commentary," p.371–89.

Contents: (1) Men and nature — Prehistory and the present; (2) The Rio Grande — Taos and Picuris; (3) The Rio Grande — The Tewa towns; (4) The Rio Grande — The Keres towns; (5) Jemez, Pecos, Sandia, Isleta, Laguna, Acoma, Zuni; (6) The Navaho hogan and the Hopi towns; (7) Epilogue: The puberty ceremony of the Mescalero.

J367   Totten, George Oakley. Maya architecture. Wash., D.C., Maya Pr., [c1926]. 250p. il., plates (part. col.), map, plans. (Repr. N.Y., Burt Franklin, 1971.)

The pioneer study of Maya architecture, now out-of-date. Consists of an outline history and three chronologies (p.17-23). Bibliography, p.249–50.

SEE ALSO:   Gendrop, P., and Heyden, D. *The architecture of Mexico and Mesoamerica* (J52); Hardoy, J. *Urban planning in pre-Columbian America* (J56); Robertson, D. *Pre-Columbian architecture* (J39); Kidder, A. V. *An introduction to the study of Southwestern archaeology . . .* (I617).

# K.
# Sculpture

Books dealing with the history of Western and Oriental sculpture, as well as a limited number of books on the various techniques of sculpture, are listed and described in this chapter. The regional subdivisions correspond in general to those in the Painting chapter of this guide.

## BIBLIOGRAPHY

K1    Bulletin signalétique. Arts plastiques. no. 1- . Paris, Centre National de la Recherche Scientifique, Centre de Documentation, Institut de l'Environnement, 1975- .

Six numbers per year. Announced for publication; compilers have not examined.

K2    Clapp, Jane. Sculpture index. Metuchen, N.J., Scarecrow, 1970. 2v. in 3 (v.2 in 2).

Contents: v.1, Sculpture of Europe and the contemporary Middle East; v.2, pt. 1-2, Sculpture of the Americas, the Orient, Africa, the Pacific area, and the classical world. 2v. Format for each volume: symbols for books indexed; sculpture location symbols; preface; index to pictures of sculpture.

A subject index to illustrations of works of sculpture in approx. 950 publications: handbooks, standard reference works, general and regional art histories in English, and a limited number of specialized works—museum publications, recurring group exhibitions, specialized art histories, and books in French, German, Spanish, and Italian.

A valuable ready reference work for libraries large and small. Should also be known by those doing research in iconography. Includes virtually all sculptural media and types. Arranged alphabetically by artist, distinctive title, subject, i.e. Byzantine sculpture, cats, flora, French sculpture, Rodin, etc. For each gives artist, original location, material of work, dimensions of work, location of work, and books in which picture of sculpture appears.

## GENERAL WORKS

K3    Bazin, Germain. The history of world sculpture. Trans. by Madeline Jay. Greenwich, Conn., New York Graphic Society [1968]. 459p. il.

The brief text is followed by 1,024 color illustrations of major examples in the history of sculpture. Index, p.452-59.

K4    Chase, George Henry, and Post, Chandler Rathfon. A history of sculpture. N.Y., London, Harper [1924]. 582p. il. (Repr.: Westport, Conn., Greenwood, 1972.)

The first 1v. history in English; still useful. One chapter is devoted to Oriental sculpture. "Bibliographical note" at the end of each chapter. Glossary, p.549-50. Index of sculptors, p.551-56; of monuments and places, p.557-82.

K5    A history of Western sculpture (series). N.Y., New York Graphic Society, 1967-70. 4v.

Consultant editor: John Pope-Hennessy.

These 4v. by specialists comprise a brief, popular survey of Western sculpture. General format: introduction (approx. 30-40p.); plates (part col.); notes on plates; index of sculptors and works illustrated.

Authors and titles: *Classical sculpture*, by George Hanfmann (with select bibliography and references in notes on plates); *Medieval sculpture*, by Roberto Salvini (with bibliography); *Renaissance to Rococo sculpture*, by Herbert Keutner; *Sculpture, 19th & 20th centuries*, by Fred Licht.

K6    Maskell, Alfred. Ivories. London, Methuen; N.Y., Putnam [1905]. 443p. 88 plates. (Repr.: N.Y., Tokyo, Tuttle, 1966.)

A general history of ivory carving from prehistoric times to c.1905.

"A list of ivories to which reference is made," giving size, p.416-30. Bibliography, p.431-37. Index, p.438-43.

**K7**    _____. Wood sculpture. London, Methuen; N.Y., Putnam [1911]. 425p. 59 plates.

A substantial work whose scope encompasses figure sculpture and other types of wooden sculpture in the West from prehistoric times to the end of the Gothic period. The emphasis is on Gothic sculpture. Bibliography, p.xv–xxxii. Index, p.417–26.

**K8**    Molesworth, Hender Delves, and Brookes, P. Cannon. European sculpture from Romanesque to Neoclassic. N.Y., Praeger [1965]. 288p. il. (part col.)

A broad introductory review of European sculpture from the Romanesque period through the 19th century. Consists of a series of essays on principal schools and periods. Contents: (1) Medieval sculpture in the North: Romanesque, early Gothic, mid-Gothic, late Gothic; (2) Italian sculpture: Trecento, Quattrocento, High Renaissance and Mannerism, Baroque and Rococo; (3) The beginning of modern sculpture: mid-16th to mid-17th centuries, mid-17th to 18th centuries; 19th century. Well illustrated. A good bibliography (limited to books) with authoritative evaluations.

**K9**    Panofsky, Erwin. Tomb sculpture; four lectures on its changing aspects from ancient Egypt to Bernini. Ed. by H. W. Janson, N.Y., Abrams [1964]. 319p. 446 il.

Available in paperback.

A brilliant overview of tomb sculpture from antiquity to the aftermath of the Renaissance, based on a series of four public lectures delivered in 1956. Since it was not originally intended for publication, this study has considerable less documentation than other works by the author.

Contents: (I) From Egypt to the "Tomb of the Nereids;" (II) From the mausoleum to the end of paganism; (III) The Early Christian period and the Middle Ages north of the Alps; (IV) The Renaissance, its antecedents and its sequel. Bibliography, p.301–10.

**K10**    Post, Chandler Rathfon. A history of European and American sculpture from the Early Christian period to the present day. Cambridge, Harvard Univ. Pr., 1921. 2v. plates. (Repr.: N.Y., Cooper Square, 1969.)

An old standard work by a recognized authority.

Bibliography, v.2, p.271–89. "Index to names of sculptors." v.2, p.291–99; "Index to plates mentioned in Parts I and II," v.2, p.301–12, includes only Early Christian, medieval, and anonymous works.

**K11**    Pyke, E. J. A biographical dictionary of wax modellers. Oxford, Clarendon, 1973. lxvi, 216, [79p.].

The first comprehensive work on wax modellers. "This book is divided into five main sections: (1) a list of private collections, (2) a list of public collections, (3) a Biographical Dictionary of Modellers, (4) a bibliography, and (5) an index. Each entry in the Dictionary consists of an abbreviated biography, a description of modelling technique, a list of extant works, details of principal references to the modeller concerned (including records of sales of waxes prior to 1939),

and a bibliography."—_Pref._ The excellent index includes extant works by known modellers, those by unknown modellers, names and places mentioned in the text, and additional subject entries.

**K12**    Tardy. Les ivoires, évolution décorative du 1er siècle à nos jours, par Tardy, avec la collaboration de P. Bidault, H. Levasseur, J. Joire et de MM. les conservateurs de musées européens qui nous ont aidés de leurs conseils et nous ont fourni la presque totalité des documents iconographiques que nous publions. Avant-propos de Janine Wettstein. Paris [1966]. 318p. (chiefly il.). (Collection Tardy, 122)

A comprehensive pictorial survey of the history of ivory-carving in Europe, Africa, and Asia from the 3d century B.C. to the end of the 19th century.

Contents: Europe et Byzance: sujets religieux. Europe et Byzance: sujets profanes. Islam et influence: siculo-arabe, hispano-mauresque; Inde-Ceylon, Chine, Japon, Afrique. Bibliography, p.[279]–80; "Essai de muséographie pour l'Europe," p.[281]–84; "Sculpteurs japonais de netsukés," p.[287]–89; "Liste des ivoiriers connus," p.[291]–309; "Table de l'iconographie religieuse," p.[311]–13; "Iconographie civile," p.313–16; "Table général des matières," p.[317]–18.

SEE ALSO:  Forrer, L. _Biographical dictionary of medallists_ (P562).

# TECHNIQUES

**K13**    Clarke, Geoffrey, and Cornock, Stroud. A sculptor's manual. London, Studio Vista; N.Y., Reinhold [1968]. 158p. il.

A compact manual of sculptors' materials and processes, rather than methods. Illustrated with line drawings of tools and processes and with photographs of modern works.

Contents: (1) Plastic usage; (2) Foundry practice; (3) Flame and electric welding; (4) Plastics; (5) Cement, stone, and wood; (6) Repetition casting; (7) General construction; (8) Finishing; (9) Surface coatings. Glossary, p.153–58. Each section is prefaced by introductory material and ends with a "Buyer's guide."

**K14**    Jackson, Harry. Lost wax bronze casting; a photographic essay on this antique and venerable art. Foreword by John Walker. [Historical research by Richard Fremantle]. Flagstaff, Arizona, Northland [1972]. 127p. il. (part col.)

An excellent, detailed description of the _cire perdue_, or lost wax method of bronze casting. The process is illustrated in 146 photographs of procedures, techniques, and equipment which trace the realization of a bronze from preliminary drawings to the final work.

Contents: The process (1, The creation and preservation of the original sculpture in solid wax; 2, Making the

reproductory wax; 3, Retouching the hollow reproductory wax; 4, Exterior preparation. Tie rods, circulatory system, outer investment; 5, The burn-out, where the wax is lost; 6, Preparation of the burned-out molds and pouring of the molten bronze; 7, Cleaning and rough finishing the bronze; 8, Chasing and final finishing of details); The patination and the painting of bronzes. Glossary of technical terms, p.113-21. Selected bibliography, p.123-25.

K15    Mills, John W. The technique of casting for sculpture. London, Batsford; N.Y., Reinhold [1967]. 168p. il.
A well-illustrated handbook on the various techniques of casting sculpture. Contents: (1) Casting; (2) Plaster of Paris; (3) Plastics; (4) Clay, wax and sand; (5) Metals; (6) Machine.
   Glossary, p.159-61. Suppliers of tools and materials in Great Britain, p.162. Suppliers of tools and materials in the U.S., p.163-64. Index.

K16    Rich, Jack C. The materials and methods of sculpture. N.Y., Oxford Univ. Pr., 1947. 416p. il.
A basic guide to the more traditional sculptural materials and methods. Contents: (1) The anatomy of sculpture; (2) The plastic earths; (3) Plastic wax; (4) Plaster of Paris; (5) Casting; (6) Metal; (7) Surface treatment of metals; (8) Stone; (9) Sculpture in stone; (10) Wood; (11) Other sculptural materials. The Appendix includes tables of various kinds of useful information.
   Bibliography, p.369-74. Glossary, p.375-80.

K17    _____. Sculpture in wood. N.Y., Oxford Univ. Pr., 1970. 155p. il. (1 col.)
"This book is designed to meet the student sculptor's need for a basic modern manual on wood carving. It includes a comprehensive listing of the many varieties of wood which are generally available commercially, describes the tools that are employed and the methods of using them and caring for them."—*Pref*. Especially useful for the chapter, "Varieties of wood," p.70-129, which is an alphabetical listing of wood types, many of which are described. Well illustrated with examples of Western and Eastern wooden sculpture and with a few drawings of tools, the structure of wood, etc.
   Contents: The nature of wood; Tools and equipment; The carving of wood; Preservation of wood; The base; Varieties of wood; Working qualities of wood; Toxicity of wood; Weight; Seasoning; Wood shrinkage. Bibliography, p.141-42. Glossary, p.143-44. Index.

K18    Verhelst, Wilbert. Sculpture: tools, materials, and techniques. Englewood Cliffs, N.J., Prentice-Hall [1973]. 287p. il.
An introductory handbook of traditional and recent tools, materials, and techniques of the sculptor's art. Very well illustrated with photographs of examples described and with line drawings of processes and techniques.
   Contents: (1) Modeling and pattern-making; (2) Mold-making techniques; (3) Casting and reproduction; (4) Carving; (5) Direct modeling; (6) Wood fabrication; (7) Plastic fabrication; (8) Metal fabrication; (9) Coating and finishing; (10) Abrasive finishing; (11) Adhesive binding; (12) Electrical

and mechanical problems; (13) Fountains; (14) Studio organization; (15) Safety. Bibliography, p.261-63. Guide to materials and suppliers, p.264-66. List of suppliers and manufacturers, p.267-82. Index.

SEE ALSO:   Adam, S. *The technique of Greek sculpture in the archaic and classical periods* (K36); Barnard, N. *Bronze casting and bronze alloys in ancient China* (K207).

# ANCIENT

## Egypt and Western Asia

For a basic bibliography see Frankfort, H. *The art and architecture of the ancient Orient*, 4th ed. (I52).

K19    British Museum. Department of Western Asiatic Antiquities. Assyrian palace reliefs and their influence on the sculptures of Babylonia and Persia [by] Richard David Barnett. Illustrations selected and photographed by Werner Forman. [London] Batchworth [1960]. 36p. 173 il., 25 col. plates.
A description, with illustrations, of the important collection of Assyrian reliefs in the British Museum. Bibliographical notes, p.25-26.

K20    _____. _____. A catalogue of the Nimrud ivories, with other examples of ancient Near Eastern ivories in the British Museum, by R. D. Barnett. London, Trustees of the British Museum, 1957. 252p. il., plates.
The catalogue of a major collection. Arranged by location where the ivories were found. Scholarly text and catalogue entries.

K21    Brooklyn Institute of Arts and Sciences. Museum. Egyptian sculpture of the late period, 700 B.C. to A.D. 100. [Catalogue comp. by Bernard V. Bothmer in collaboration with Herman de Meulenaere and Hans Wolfgang Müller. Ed. by Elizabeth Riefstahl. Brooklyn] Brooklyn Museum, 1960. xxxix, 197p. il. (Repr.: N.Y., Arno, 1969.)
The catalogue of a major loan exhibition of late-period Egyptian sculpture. "This is one of the few recent books on Egyptian art that belong on the shelf of everyone seriously interested in the subject"—H. G. Fischer in *Archaeology* 15:136 (June 1962). 135 black-and-white plates follow detailed descriptions and individual bibliographies for each piece exhibited. Bibliography, p.xxvii-xxix.

K22    Farkas, Ann. Achaemenid scupture. Istanbul, Nederlands Historisch-Archaeologisch Instituut in het Nabije Oosten, 1974. xiii, 134p. 75 il. on 40 plates. (Uitgaven van het Nederlands Historisch-Archaeologisch Instituut te Istanbul, XXXIII)
The basic scholarly study of Achaemenid sculpture, defined by the author as "the monumental art literally tied to the royal court, that is, the architectural decoration—in the

form of immense gate guardian figures or of reliefs, of glazed bricks or stone, applied to the exterior facades of buildings and terraces, to courtyards, and to the jambs of doorways—of the Persian capital cities of Pasargadae, Susa and Persepolis in modern Iran and of Babylon in modern Iraq. It includes also the rock relief at Behistum on the road from Ecbatana, the former Median capital . . ."—*Introd.* Does not include sculpture in the round.

Contents: Introduction; (I) The art of the reign of Cyrus the Great, 559-530 B.C.; (II) The art of the reign of Darius the Great, 522-486 B.C.; (III) The art of the reign of Xerxes, 486-465/464 B.C., and later kings; (IV) The Greek contribution to Achaemenid sculpture; Afterword. Appendix: Persepolis sculptures in the light of new discoveries, by Ann Britt Tilia.

Bibliography, p.120-26, includes a general section and sections classified by chapters. Bibliographical references in footnotes.

K23    Murray, Margaret Alice. Egyptian sculpture . . . with a preface by Ernest A. Gardner. London, Duckworth [1930]. 217p. il., 55 plates. (Repr.: Westport, Conn., Greenwood, 1970.)

Still the standard survey in English. Contents: Methods of the artist; Protodynastic period: Old Kingdom, Middle Kingdom, New Kingdom; Tell El Amarna; Late period; Ptolemaic period. Index, p.195-207.

K24    Oxford University. Ashmolean Museum. Catalogue of the ancient Persian bronzes in the Ashmolean Museum [by] Peter Roger Stuart Moorey. Oxford, Clarendon, 1971. xxiv, 343p. il., maps, 85 plates.

A detailed, scholarly catalogue of 528 bronze pieces from western Persia in the collection of the Ashmolean Museum. The works are classified first by function, then by style and iconography. Each work is illustrated.

Concise technical glossary, p.xxi-xxii. Appendix: Objects of gold, silver, and iron, p.310-19. Classified bibliography, p.320-27.

SEE ALSO:  Smith, W. S. *A history of Egyptian sculpture and painting in the Old Kingdom* (I46).

## Classical World

K25    Antike Plastik. Herausgegeben im Auftrage des Deutschen Archäologischen Institutes von Walter-Herwig Schuchhardt. Berlin, Mann, 1962-(78). Lfg. I-(XVII). mounted il., plates.

Beginning with Lfg. XII ed. by Felix Eckstein.

A serial publication of the monuments of Greek and Roman sculpture covering roughly the time from the Greek archaic period to the decline of ancient Rome. Includes articles on sculpture in the widest sense (statues, bronzes, terracottas, reliefs, and the minor arts). Most of the volumes contain several articles by various authors on more or less unrelated works; some volumes are monographs by one author on a single monument or related group. The articles are in German, English, Italian, French, and Greek; the

majority are in German by German scholars. The texts as a whole and the accompanying reproductions meet the highest standards of scholarly publication.

———. Register: Lfg. I-X [1962-70]. Berlin, Mann, 1973. 56p.

Contents: Vorwort; Verzeichnis nach Autoren; Verzeichnis der Rezensionen; Inschriftenverzeichnis (a. Griechische Inschriften; b. Lateinische Inschriften; c. Etruskische Inschriften); Antike Textstellen (a. Griechische Autoren; b. Lateinische Autoren); Alphabetisches Sachregister; Standortsregister.

K26    Boston. Museum of Fine Arts. Greek, Etruscan and Roman bronzes in the Museum of Fine Arts, Boston, by Mary Comstock and Cornelius Vermeule. Greenwich, Conn., New York Graphic Society, 1971. 511p. il.

The catalogue of an outstanding collection of classical bronzes. 713 entries, with a supplement of 10 entries. Each is concise, with technical descriptions, critical opinions, and bibliographical references. Each work is illustrated in the text of the catalogue.

"Bibliography," p.xi-xviii; "Short title index," p.xix-xxiv; "Abbreviations," p.xxv-xxvii.

K27    Brunn, Heinrich von. Denkmäler griechischer und römischer Skulptur. München, Bruckmann, 1888-(1939?). 785 plates.

An important corpus of plates of Greek and Roman sculpture, with accompanying text. Frequently referred to as "Brunn-Bruckmann."

The 1st ser. of 500 plates pub. 1888-1900. A *Register* to these 500 plates was prepared by Paul Arndt and pub. in 1897. A 2d ser. of plates (nos. 501-550) with text and index by Arndt was pub. in 1902; plates 551-600 with text by Arndt, pub. 1906; plates 601-650 with text by Arndt, pub. 1912; plates 651-700 with text by Arndt and G. Lippold, pub. 1926; plates 701-750 with text by Arndt and Lippold, pub. 1932; plates 751-785 with text by Arndt and Lippold, pub. 1934.

*Register* (to plates 1-500) at end of text volume includes: (1) list of plates in order issued, indicating where sculpture was previously published and where located; (2) index of plates arranged by location; (3) chronological list of plates arranged by period, then subdivided by type.

K28    ———. Griechische und römische Porträts, nach Auswahl und Anordnung von Heinrich Brunn und Paul Arndt, hrsg. von Friedrich Bruckmann. München, Bruckmann, 1891-(1939). 1,210 plates.

———. Register zu Tafel 1-760. München, Bruckmann, 1909. 53p.

———. Texts zu den Tafeln 1-840 (1891-1912). München, Bruckmann [1929]. 59p.

A valuable corpus of Greek and Roman portraits, with accompanying text, similar to "Brunn-Bruckmann" (K27). Frequently referred to as "Brunn-Arndt." Plates from 1011- also bear name of Georg Lippold.

*Register* lists plates in order of issue, by place, and in chronological order.

K29   Cambridge. Fitzwilliam Museum. A catalogue of the Greek and Roman sculpture. By Ludwig Budde and Richard Nicholls. Cambridge, Univ. Pr. for the Fitzwilliam Museum. 1964. xix, 138p. 62 plates.

The catalogue of an important collection of ancient sculpture. 62 plates, 192 figures. For each work gives description and full documentation. "Index" consists of concordances of inventory numbers, concordances of 3 publications, epigraphical index, index of donors, general index, and glossary.

K30   Hanfmann, George M. A. Classical sculpture. Greenwich, Conn., New York Graphic Society [1967]. 352p. il. 8 col. plates. (A history of Western sculpture; consultant editor, John Pope-Hennessy)

A pictorial survey of the rise and decline of classical sculpture from the Neolithic period in Greece to Early Christian times. Following a 33-page introductory essay, the author traces the development of Greek and Roman sculpture through over 350 reproductions of works. "Notes on the colour plates," p.301, and "Notes on the monochrome illustrations," p.302–43, include dimensions, commentaries, and references.

   Bibliography, p.344–45. General index, p.346–51. Guide to location, p.352.

K31   Lamb, Winifred. Ancient Greek and Roman bronzes. Enl. ed. with a foreword and reference bibliography by Lenore Keene Congdon. Chicago, Argonaut, 1969. xliii, 261, [97]p. il., plates.

This is a reprint, with additions, of the original ed. published under title: *Greek and Roman bronzes*, London, Methuen; N.Y., Dial, 1929.

   A general survey of Greek and Roman bronzes, now largely superseded by more recent research. Subject index and museum index.

   Bibliography, p.xiii–xliii.

K32   Lawrence, Arnold Walter. Greek and Roman sculpture. Rev. ed. London, Cape; N.Y., Harper [1972]. 371p. 96 plates.

A rev. ed., with slightly altered text and new illustrations, of the author's *Classical sculpture*, London, Cape, 1929. A compressed survey of classical sculpture from the beginnings of Greek sculpture to the beginnings of Byzantine art. Appendix I: Deities, their attributes and types. Appendix II: Greek and Roman dress.

   Includes a list of museums with significant collections of Greek and Roman sculpture. Select bibliography, p.325. Abbreviations and references, p.326–57. General index.

K33   Mitten, David Gordon, and Doeringer, Suzannah F. Master bronzes from the classical world. Mainz on Rhine, printed by P. von Zabern, 1967. 319p. il. (part col.)

The catalogue of an exhibition held at the Fogg Art Museum, Harvard Univ.; the City Art Museum of St. Louis; and the Los Angeles County Museum of Art in 1967–68.

   An excellent catalogue which provides a comprehensive survey of 2,300 years of ancient bronzes from all parts of the Mediterranean world. Includes over 300 pieces of all types (statuettes, armor, safety-pins, cooking pots, etc.)

from 79 collections in 9 countries. The emphasis is on the representation of the human figure in works from Greece, Etruria, and Rome and on the period 800 B.C. to 400 A.D.

   Contents: Techniques of working bronze, by Arthur Steinberg; Greek bronzes, by David Gordon Mitten; Catalogue of the Greek bronzes (nos. 1–152); Etruscan bronzes, by George M. A. Hanfmann; Catalogue of the Etruscan bronzes (nos. 153–227); Roman bronzes, by Heinz Menzel; Catalogue of the Roman bronzes (nos. 228–316). Bibliographical and museum abbreviations, p.315–19.

K34   Reinach, Salomon. Répertoire de la statuaire grecque et romaine. Paris, Leroux, 1897–(1930). v.1–(6) in (8). il. (Repr.: Rome, "L'Erma" di Bretschneider, 1964; Nendeln, Liechtenstein, Kraus, 1977.)

A collection of line drawings of ancient statues, arranged roughly by subjects. Still useful for examples of various subjects in ancient free-standing sculpture.

   Contents: t.1, Clarac de poche, contenant les bas-reliefs de l'ancien fonds du Louvre et les statues antiques du Musée de Sculpture de Clarac; t.2, 7,000 statues antiques, réunies pour la première fois . . . 2v.; t.3, 2,640 statues antiques; t.4, 4,000 statues antiques; t.5, 2,380 statues . . . 2v.; t.6, 1,350 statues antiques. A list of publications in which the statues are found is in each volume. Each volume has an index; v.5 has a general index for the work.

K35   ———. Répertoire de reliefs grecs et romains. Paris, Leroux, 1909–12. 3v. il. (Repr.: Roma, "L'Erma" di Bretschneider, 1968.)

A corpus of small line drawings of ancient relief sculpture. Useful for subject research. v.1 is arranged alphabetically by place of origin; v.2 and 3 are classified by place of conservation. In each section the reliefs are classed as follows: (1) Gods and heroes; (2) Historic scenes, legends of Rome, iconography; (3) Religious life; (4) Military life; (5) Civil life, occupations; (6) Theater, games, dancing; (7) Funerary reliefs; (8) Banquets; (9) Horsemen, horses, other animals; (10) Landscape, inanimate objects, ornaments; (11) Miscellaneous.

   Contents: t.1, Les ensembles; t.2, Afrique, Iles brittaniques; t.3, Italie, Suisse.

   Errata and addenda and a general index for the three volumes appear at the end of v.3.

SEE ALSO:  *Handbuch der Archäologie* (I35); Hanfmann, G. M. A. *From Croesus to Constantine: the cities of western Asia Minor and their arts in Greek and Roman times* (J68).

## Greece

K36   Adam, Sheila. The technique of Greek sculpture in the archaic and classical periods. British School of Archaeology at Athens; London, Thames & Hudson, 1966. 179p. 72 plates, diagrs. (British School of Archaeology at Athens. Supplementary volume no. 3)

The basic scholarly study of the tools and working methods of the ancient Greek sculptor. Excellent illustrations.

Contents, pt. 1: (1) The point, punch, and mallet; (2) The claw; (3) The drove; (4) The flat chisel; (5) The drill; (6) The rasp; (7) Abrasives; (8) a, Cements and glues, b, the cutting compass, c, the saw. Pt. 2: (9) Freestanding statues; (10) Grave reliefs. Appendix on the Hermes at Olympia, p.124–28.

Bibliography in abbreviations, p.2. References in footnotes. General index and museums index.

K37   Alscher, Ludger. Griechische Plastik. Berlin, Deutscher Verlag der Wissenschaften, 1954–63. 4v. in 5. plates.

A comprehensive, scholarly survey of Greek sculpture from the Geometric period beginning in the 10th century B.C. through the Hellenistic period ending in the mid–1st century B.C. Includes extensive notes with references. The illustrations are only adequate.

Contents: Bd. 1, Monumentale Plastik und ihre Vorstufen in der griechischen Frühzeit (1954); Bd. 2, t.1, Archaik und die Wandlung zur Klassik (1962), t.2, Ergänzungsband. Götter vor Gericht: das Fälschungsproblem des Bostoner "Throns," die klassisch-griechische Kunst, und die Archäologen (1963); Bd. 3, Nachklassik und Vorhellenismus (1956); Bd. 4, Hellenismus (1957).

Each volume contains "Verzeichnis der Abkürzungen" and "Register der Kunstwerke" ("Register der plastischen Bildwerke" in Bd. 1).

K38   Bernouilli, Johann Jakob. Griechische Ikonographie mit Ausschluss Alexanders und der Diadochen. München, Bruckmann, 1901. 2v. il., plates, (Repr.: Hildesheim, Olms, 1969.)

An older, standard work on Greek portrait sculpture. Updated, corrected, and expanded by Richter, *The portraits of the Greeks* (K57). Arranged by subject.

Contents: v.1, Die Bildnisse berühmter Griechen von der Vorzeit bis an das Ende des V. Jahrhunderts v. Chr.; v.2, Die Bildnisse berühmter Griechen vom IV. Jahrhundert v. Chr. bis an die römische Zeit.

Bibliography, v.1, p.xii–xv. Index of subjects and names, v.2, p.227–30; Index of places, v.2, p.231–41.

K39   Bieber, Margarete. The sculpture of the Hellenistic Age. Rev. ed. N.Y., Columbia Univ. Pr. [1961]. xi, 259p. il., plates.

1st ed. 1955.

The fundamental, scholarly study of Hellenistic sculpture from the beginning of the reign of Alexander to the beginning of the reign of Augustus (330–30 B.C.), including consideration of the transitional periods before and after. Illustrated with 818 figures on plates as well as text illustrations. An indispensable book for the study of Greek sculpture.

Contents: (1) Introduction: Characteristics of Hellenistic art; (2) Greek sculpture of the 4th century B.C.; (3) Lysippos and the early Hellenistic age; (4) Atticism in the late 4th and early 3d centuries B.C.; (5) Asianism in the 3d century B.C.; (6) The art of Alexandria; (7) The art of Priene; (8) The art of Pergamon; (9) Rhodes and the Southwest of Asia Minor (10) Rococo trends in Hellenistic art; (11) Classicism in the 2d and 1st centuries B.C.; (12) Transition from Hellenistic to Roman sculpture.

Chronology (historical facts and dated works of art), p.195. Selected bibliography (classified), p.[201]–10.

K40   Carpenter, Rhys. Greek sculpture; a critical review. [Chicago] Univ. of Chicago Pr. [1960]. 276p. 47 plates.

"The most perceptive general study, though erratic."—R. M. Cook (I91).

Contents: (I) The beginnings; (II) The archaic phase; (III) Early reliefs and hollow-cast bronzes; (IV) Toward the formation of a classic style; (V) Temple pediments: classic drapery; (VI) High classi; (VII) Sculpture in the third century; (VIII) The renascence of classic form; (IX) The intrusion of plastic form.

Bibliography of sources, p.255–65, contains a critical evaluation of the basic literature on Greek sculpture, notes on the text (with references), and a section on illustrative material. Topical index.

K41   Charbonneaux, Jean. Les bronzes grecs. Paris, Presses Universitaires de France, 1958. vii, 145p. 21 il., 32 plates (8 col.)

English ed.: *Greek bronzes*, trans. by Katherine Watson, N.Y., Viking, 1962.

A three-part handbook on Greek bronze statuettes and figured reliefs. Does not include implements and utensils without figured decoration. Pt. 1 is a general discussion of bronze, with more detailed considerations of alloys and technical processes used in ancient bronze casting and of the various types of figure-decorated bronzes made by the Greeks. Pt. 2 is a history of Greek bronzes from Minoan beginnings to the end of the Hellenistic age. Pt. 3, on collections and collectors, includes sections on reproductions and fakes, conservation and restoration, public and private collections, the bronze market, and the techniques of displaying bronzes.

Classified bronzes, p.131–33. Indexes of sites, artists, and subjects, and museums and collections at end.

K42   Clairmont, Christoph W. Gravestone and epigram: Greek memorials from the archaic and classical period. Mainz, Zabern, 1970. xix, 185p. 37 plates.

A corpus of the archaic and classical gravestones carved or painted with figures and inscribed with epigrams. The main objective of the study is to establish the correlation between epigrams and figured scenes. 93 gravestones are described and discussed in detail; almost all the examples are illustrated.

Indexes: Epigraphical, general, museums and collections, concordances, ancient authors. Bibliography and list of abbreviated titles, p.xi–xii.

K43   Collignon, Maxime. Histoire de la sculpture grecque. Paris, Firmin-Didot, 1892–97. 2v. il., plates (part col.)

An early history of Greek sculpture, now largely superseded by 20th-century scholarship.

Contents: t.1, Les origines, les primitifs, l'archaïsme avancé, l'époque des grands maîtres du cinquième siècle; t.2, L'influence des grands maîtres du cinquième siècle, le quatrième siècle, l'époque hellénistique, l'art grec après la conquête romaine.

Bibliographical notes, v.1, p.xi–xii; v.2, p.262. Alphabetical index of artists' names, v.2, p.693–96. General index, v.2, p.697–704.

K44 Conze, Alexander Christian Leopold, ed. Die attischen Grabreliefs, hrsg. im Auftrage der Kaiserlichen Akademie der Wissenschaften zu Wien von Alexander Conze unter Mitwirkung von Adolf Michaelis, Achilleur Postolakkas, Robert von Schneider, Emanuel Loewy, Alfred Brueckner [und] Paul Wolters. Berlin, Spemann, 1893–1922. 4v. and atlas of plates (4v. in 6).

Imprint varies: v.3, Berlin, Reimer, 1906; v.4, Berlin und Leipzig, Vereinigung Wissenschaftlicher Verlager, 1911–22. An important corpus of plates of Attic grave reliefs, arranged by period.

"Nachträge und Berichtigungen zu Band I–V," v.4, p.112–26. "Register" to the 4v. in v.4, p.127–45, divided into: (1) Arte der Aufbewahrung; (2) Namen; (3) Anfänge der Epigramme; (4) Sachregister.

K45 Furtwängler, Adolf. Masterpieces of Greek sculpture; a series of essays on the history of art. Ed. by Al. N. Oikonomides. [1st American] new and enl. ed. Chicago, Argonaut, 1964. xvi, 439p. il., plates.

1st German ed. 1893; 1st English ed. 1895.

An older, basic work; now largely outdated by subsequent research. Contents: Pheidias; Kresilas and Myron; Polykleitos; Skopas, Praxiteles, Euphranor; The Venus of Milo; The Apollo of the Belvedere.

Bibliography, p.[425]–27.

K46 Harrison, Evelyn B. Archaic and archaistic sculpture. Princeton, N.J., American School of Classical Studies at Athens, 1965. xix, 192p. 1 il., 68 plates, plan. (American School of Classical Studies at Athens. The Athenian Agora. v.11)

"This volume continues the catalogue of ancient stone sculpture from the excavations in the Athenian Agora that was begun with *Athenian Agora, I, Portrait sculpture.*"—*Pref.* Continues the numbering sequence of the author's *Portrait sculpture* (K47) with numbers 65–242.

Meets the highest standards of analytical description and scholarly interpretation. Four-part arrangement of materials: archaic, archaistic, Hekataia, and herms. Surveys Athenian sculpture from the earliest archaic period (c.600 B.C.) through the Roman period. Each section begins with an introduction in which Agora evidence is related to extant examples excavated elsewhere. An essential work for the serious student and scholar of Greek sculpture.

Bibliography, p.[xiii]–xix.

K47 _____. Portrait sculpture. Princeton, N.J., American School of Classical Studies in Athens, 1953. xiv, 114p. 49 plates. (American School of Classical Studies at Athens. The Athenian Agora. v.1.)

"The object of the present volume is to publish all the portrait sculpture that has been found by the American School of Classical Studies at Athens in the excavation in the Athenian Agora since the beginning of that excavation

in 1931. The most recently discovered of the pieces discussed came to light during the season of 1952."—*Pref.*

Following a general introduction on Greek portrait sculpture, the main section is given to a catalogue of 64 pieces. Includes exhaustive technical and analytical information for each piece and general information placing the piece in context for the nonspecialist. The catalogue is continued with numbers 65–242 in the author's *Archaic and archaistic sculpture* (K46). An essential work for the study of Greek sculpture.

Bibliography, p.[xi]–xiv.

K48 Higgins, R. A. Greek terracottas. London, Methuen [1967]. 169p. il., 68 plates (part col.), map.

An authoritative history-handbook of Greek terracottas, tracing their evolution from the earliest evidence (c.7000 B.C.) through the Hellenistic period. Confined primarily to statuettes and small reliefs; does not include larger statues or architectural decoration. The introduction, which outlines uses and classification methods, is followed by a chapter on technical processes and eight chapters of the chronological survey.

Bibliography (general works, catalogues of collections, and references classified by text chapters), p.[135]–57. Glossary, p.158. Index of sites; Index of coroplasts; General index.

K49 Lawrence, Arnold Walter. Later Greek sculpture and its influence on East and West. N.Y., Harcourt, 1927. 158p. 112 plates. (Repr.: N.Y., Hacker, 1969.)

Surveys Greek sculpture from the campaigns of Alexander the Great to the foundation of the Roman Empire.

Bibliography, p.91–92. The Appendix includes a list of the important sculptures arranged by date. Subject index; Index of places and museums.

K50 Lullies, Reinhard, and Hirmer, Max. Greek sculpture. Text and notes by Reinhard Lullies. Photographs by Max Hirmer. [Rev. and enl. ed., trans. from the German by Michael Bullock]. N.Y., Abrams [1960]. il., plates (part col.)

1st English ed. 1957. 1st German ed.: *Griechische Plastik von den Anfängen bis zum Ausgang des Hellenismus,* München, Hirmer [1956].

An excellent 50-page introductory text surveys Greek sculpture from late Geometric through Hellenistic, with consideration given to problems of style, technique, and intellectual and social background. The plates section contains 282 black-and-white plates; the text section includes 11 color plates. "Notes on the plates," p.53–108 gives for each sculpture reproduced full description (dimensions, material, restorations), provenance, location, commentary, and references.

"Chronological table" (776 B.C.–since 1930), p.109–11. "List of published works on Greek sculpture selected for their bearing on the works of art reproduced in this book," p.112–13. "Alphabetical list of present locations of works illustrated," p.114–15.

K51    New York. Metropolitan Museum of Art. Catalogue of Greek sculptures [in the Metropolitan Museum of Art] by Gisela M. A. Richter. Cambridge, Harvard Univ. Pr.; Oxford, Clarendon, 1954. xviii, 123p. il., 164 plates (245 figs.)

"This catalogue comprises the Greek sculptures and the Roman copies of Greek sculptures in the Metropolitan Museum of Art that are executed in stone."—*Pref.* 245 pieces arranged in chronological categories: (1) Archaic period, about 610–480 B.C.; (2) Archaizing sculptures; (3) 5th century B.C.; (4) Gravestones of the 5th and 4th centuries B.C.; (5) 4th century B.C.; (6) Statues and statuettes of Aphrodite of the 4th to 2d century B.C.; (7) Hellenistic period, about 325–100 B.C.; (8) Miscellaneous fragments. Full description, comments, and bibliographical references.

K52    Payne, Humfry, and Mackworth-Young, Gerard. Archaic marble sculpture from the Acropolis; a photographic catalogue. With an introduction by Humfry Payne. London, Cresset [1936]. xiii, 75p. 141 plates incl. front.

2d ed., London, Cresset [1950].

A photographic catalogue of the archaic marble sculpture from the Acropolis which complements the descriptive *Catalogue of the Acropolis Museum,* v.1, *Archaic sculpture* (1912), by Guy Dickens and the students of the British School of Athens.

Contents of Introduction: Early Attic; The korai; Various; Notes: (I) On the relation of the Attic and Ionic korai in the second half of the 6th century, (II) On the relation of the kore of Antenor to the East pediment of the Alcmaeonid temple at Delphi. List of plates and bibliography, p.66–74, includes bibliographical references for works reproduced. Concordance of museum-numbers and plates, p.75.

K53    Picard, Charles. Manuel d'archéologie grecque. La sculpture. Paris, Picard, 1935–66. 5v. in 8. il. (incl. maps, plans), plates (part col.)

An indispensable history of Greek sculpture, more comprehensive than any other standard survey. Incorporates extensive detailed documentation.

Contents: v.1, Période archaïque; v.2, Période classique-Ve siècle; v.3–4, Période classique-IVe siècle; v.5, Index général des tomes III et IV (IVe siècle). Includes bibliographies.

K54    Richter, Gisela Marie Augusta. The archaic gravestones of Attica. London, Phaidon, 1961. viii, 184p. 216 il.

An introductory chapter on the origins, development, techniques, and meaning of Attic stone *stelai* (late 7th to early 5th century B.C.) is followed by a full descriptive catalogue of 79 examples arranged by type.

Bibliography, p.57–8. Epigraphical appendix by Margherita Guarducci, p.155–72. Museum index and general index at end.

K55    _____. Korai: archaic Greek maidens: a study of the development of the kore type in Greek sculpture.

Photographs by Alison Frantz. [London, N.Y.] Phaidon [1968]. xi, 327p. 800 il., plates.

A companion volume to the author's *Kouroi* (K56).

Traces the evolution of the kore type from its beginnings in the 7th century to its disappearance in the first half of the 5th century through detailed analyses of over 200 examples. An indispensable study.

Contents: General introduction; Prologue: the forerunners; Group I: The Nikandre-Auxerre group (about 660–600 B.C.); Group II: The Olympia Hera-Berlin Kore-Akropolis 593 group (about 600–570 B.C); Group III: The Cheramyes-Geneloes group (about 575–555 B.C); Group IV: The Lyons Kore-Ephesos group (about 555–535 B.C.); Group V: The Siphnian Treasury-Temple of Apollo group (about 535–500 B.C.); Group VI: The Euthydikos kore group (about 500–480 B.C.); Epilogue: Successors.

Museum index. List of inscriptions. Index of persons and places.

K56    _____. Kouroi: archaic Greek youths: a study of the development of the kouros type in Greek sculpture. In collaboration with Irma A. Richter; photographs by Gerard Mackworth-Young. 3d ed. London, N.Y., Phaidon, 1970. xvii, 365p. 656 il.

1st ed. 1942; 2d ed. 1960.

Traces the development of the kouros type from its first appearance in the 7th century to its disappearance in the first half of the 5th century B.C. through detailed analyses of approx. 200 examples. Although limited to the kouros type, this classic study is an indispensable guide to the relative chronology of archaic Greek sculpture as a whole.

Contents: (I) The kouros type; (II) The technique; (III) Summary of anatomical analyses; (IV) Prologue: the forerunners; (V) The Sounion group, c.615–590 B.C.; (VI) The Orchomenos-Thera group, c.590–570 B.C; (VII) The Tenea-Volomandra group, c.575–550 B.C.; (VIII) The Melos group, c.555–540 B.C.; (IX) The Anavysos-Ptoon group, c.540–520 B.C.; (X) The Ptoon 12 group, c.520–485 B.C.; (XI) Epilogue, c.485–460 B.C.

Museum index. List of inscriptions. Concordance of numbers in the 1st and 2d ed. General index.

K57    _____. The portraits of the Greeks. [London] Phaidon [1965]. 3v. xiii, 337p. il., plates, map.

An important study, primarily iconographical, of Greek portraits, with special consideration of the problems of stylistic development. Updates, corrects, and expands Bernouilli, *Griechische Ikonographie* (K38). Includes "(1) all reliably identified portraits of Greek poets, philosophers, orators, statesmen, generals, and artists: (2) the portraits for which plausible identifications have been proposed; and (3) the portraits merely cited in ancient literature and inscriptions." The portraits are arranged by century of persons portrayed and grouped within each century by profession. Gives for each portrait: "(1) A concise, tabulated sketch of the man's career . . .; (2) what, if anything, is known of his physical appearance; (3) a list of the portraits recorded in extant ancient literature and in inscriptions . . .; (4) the evidence for the identifications; (5) a list of the extant examples . . .; (6) A general discussion of the type and its probable date." —*Introd.*

Contents, v.1: Introduction; (I) The early period; (II) The 5th century. v.2: (IIIA) the 4th and 3d centuries; (IIIB) The 3d and 2d centuries. v.3: (IV) Hellenistic rulers; (V) Greeks of the Roman period.

Bibliographies: (A) The chief books and articles on Greek portraits cited in or referring to the text; (B) The chief ancient authors referred to in the text; (C) Abbreviations used for the epigraphical books cited in the text; (D) The chief periodicals cited in the text. Index of places; Index of names.

_____. Supplement. [London] Phaidon [1972]. 24p. il.

**K58**  _____. The sculpture and sculptors of the Greeks. 4th ed., newly rev. New Haven, Yale Univ. Pr., 1970. xvi, 345p. il., maps.

At head of title: The Metropolitan Museum of Art.
1st ed. 1929.

A classic work on the history of Greek sculpture from the archaic period through the Hellenistic. Pt. I is a systematic survey primarily by sculpture type. Pt. II is a chronological history of sculpture by the most important Greek sculptors. Includes 853 illustrations, plus figures and maps in the text.

Contents, pt. I, Greek sculpture: (1) The historical background of Greek sculpture, (2) The general characteristics of Greek sculpture, (3) The human figure, (4) The head, (5) Drapery, (6) Animals, (7) Relief, (8) Composition, (9) Technique, (10) Greek sculpture compared with Roman copies and modern; pt. II, Greek sculptors: (1) Archaic period; (2) Transitional or early classical period; (3) Second half of 5th century B.C.; (4) 4th century B.C; (5) 3d and 2d centuries B.C.; (6) 1st century B.C; (7) Tentative chronology of outstanding Greek sculpture.

Selected bibliography, p.261-70.

**K59**  Ridgway, Brunilde Sismondo. The Severe Style in Greek sculpture. Princeton, N.J., Princeton Univ. Pr., 1970. xviii, 155, [67]p. plates.

Presents thoughtful new approaches to the study of Severe Style sculpture. A few important pieces are analyzed in each chapter in terms of the relevant categorical problems. Each chapter is followed by an appendix, which lists and briefly discusses related pieces, and a critical bibliography.

Contents: (1) What is the Severe Style? Methods of approach; (2) Greek originals and their chronology: architectural sculpture; (3) Greek originals: sculpture in the round; (4) Greek originals: reliefs; (5) Roman copies: the problem of schools; (6) Discussion of copies: the artists; (7) Lingering archaic and lingering Severe; (8) The Severe Style in late Hellenistic and Roman times: Neo-Attic reliefs and akroliths; (9) The Severe Style in late Hellenistic and Roman times: sculpture in the round.

SEE ALSO:  Ashmole, B. *Architect and sculptor in ancient Greece* (R78); Jones, H. S., ed. *Select passages from ancient writers, illustrative of the history of Greek sculpture* (H12); Lippold, G. *Die Griechische Plastik* (I35); Loewy, E. *Inschriften griechischer Bildhauer* (H13); Marcadé, J. *Recueil des signatures des sculpteurs grecs* (H14); Toynbee, J. M. C. *The Hadrianic school: a chapter in the history of Greek art* (K77).

## Etruria and Rome

**K60**  Die antiken Sarkophagreliefs; im Auftrage des Kaiserlich Deutschen Archaeologischen Instituts, mit Benützung der Vorarbeiten von Friedrich Matz, hrsg. und bearb. von Carl Robert und Gerhart Rodenwaldt. Berlin, Grote, 1890–[1975]. v.2–3$^{1-3}$, 4$^{1-3}$, 5$^{1-3}$, 7, 12$^6$. il., plates.

Publisher varies. v.1, and 6, 8-11 not published; imprint varies: v.4$^{1-3}$, 5$^3$, 7, Berlin, Mann.

A monumental corpus of the various types of ancient sarcophagi reliefs. Essential for research.

Contents: v.2, Mythologische Cyklen; v.3, Einzel-mythen. pt. 1, Actaeon-Hercules; pt. 2, Hippolytos-Meleagros; pt. 3, Niobiden-Tryptolemos ungedeutet; v.4, Die dionysischen Sarkophage, bearb. von Friedrich Matz; v.5, pt. 1, Die Meerwesen auf den antiken Sarkophag-reliefs, bearb. von Andreas Rumpf; pt. 3, Die Musen-sarkophage, bearb. von Max Wegner; v.7, Die jüngeretruskischen Steinsarkophage, bearb. von Reinhard Herbig; v.12, pt. 6, Die mythologischen Sarkophage, Meleager, bearb. von Guntram Koch.

**K61**  Becatti, Giovanni. La colonna coclide istoriata; problemi storici, iconografici, stilistici. Rome, "'L'Erma" di Bretschneider, 1960. 402p. 83 plates. (Studi e materiali del Museo dell'Impero Romano, n. 6)

The definitive scholarly work on the relief sculpture of the historiated commemorative columns of ancient Rome. Complete documentation, well illustrated with photographs and drawings of reconstructions. Indexes of illustrations and subjects. Bibliographical footnotes.

**K62**  Bernouilli, Johann Jakob. Römische Ikonographie. Stuttgart, Spemann, 1889-94. 2v. in 4. il., plates. (Repr.: Hildesheim, Olms, 1969.)

A standard work on Roman portrait sculpture, arranged by subject. Contents: (I) Die Bildnisse berühmter Römer mit Ausschluss der Kaiser und ihrer Angehörigen (1882); (II) Die Bildnisse der römischen Kaiser und ihrer Angehörigen— pt. 1, Das Julisch-Claudische Kaiserhaus (1886); pt. 2, Von Galba bis Commodus (1891); pt. 3, Von Pertinax bis Theodosius (1894).

Each volume has place index and subject index at end.

**K63**  Brilliant, Richard. Gesture and rank in Roman art; the use of gestures to denote status in Roman sculpture and coinage. New Haven, The Academy, 1963. 238p. 479 il., ports. (Memoirs of the Connecticut Academy of Arts & Sciences. v.14)

This critical analysis of gesture in Roman art and its use to denote status is a valuable contribution to the scholarship of Roman art. Codifies the gestures and traces the changes in form and meaning from their origins in Etruscan art to the final period of the Roman Empire. Pt. IV, "The Late Empire; codification," is important for the study of medieval and Renaissance art. Excellent illustrations. Classified bibliography, p.[221]-26.

K64   Brown, W. Llewellyn. The Etruscan lion. Oxford, Clarendon, 1960. xxvi, 209p. 64 plates, port., map. (Oxford monographs on classical archaeology)
"Though it deals specifically with the lion in Etruscan art, the book manages to be a remarkably illuminating study of the history of Etruscan sculpture as a whole . . ."—E. Richardson (I133). Traces the theme of the lion from the earliest orientalizing period to after the 5th century B.C. Scholarly notes; select bibliography; indexes of sites, museums, publications, and subjects. 64 good photographic plates.

K65   Calza, Raissa, ed. Iconografia romana imperiale. Da Carausio a Giuliano (287-363 d.C.). A cura di Raissa Calza. Roma, "L'Erma" di Bretschneider, 1958. 434p. 491 il. on plates. (Quaderni e guide di archeologia, 3)
A sequel to Felletti Maj, B., *Iconografia romana imperiale. Da Severo Alessandro a M. Aurelio Carino (222-285 d.C.)* (K67).
Contents: pt. 1, Fonte e testimonianze, a cura di Marina Torelli; pt. 2, Iconografia (includes a biography for each person, iconography of the imperial coins and medals, and portraits). Bibliographical references in footnotes.

K65a  Copenhagen. Ny Carlsberg Glyptotek. Les portraits romains. Par Vagn Poulsen. Copenhague, Ny Carlsberg Glyptotek, 1962- . 2v. in 4. il.
Reissued 1973-74.
The exemplary catalogue of a great collection of Roman portraits, written by an outstanding scholar. Each volume has a long introduction followed by the catalogue entries. Meticulous scholarship with full documentation of each portrait. Comprehensive illustrations of high quality.
Contents: (I) République et Dynastie Julienne: pt. 1, Texte; pt. 2, Planches; (II) De Vespasien à la Basse-Antiquité: pt. 1, Texte; pt. 2, Planches. Index of names and concordance at the end of each text volume.

K66   Espérandieu, Émile. Recueil général des bas-reliefs de la Gaule romaine. Paris, Imprimerie nationale, 1907-38. 11v. il. (incl. plans). (Repr.: Ridgewood, N.J., Gregg, 1965-66.)
Half-title: Collection de documents inédits sur l'histoire de France . . .
v.3-11 have title: Recueil général des bas-reliefs, statues et bustes de la Gaule romaine.
A comprehensive inventory of remaining works of Gallo-Roman sculpture. All works are illustrated. Bibliographies.
Contents: t.1. Alpes maritimes, Alpes cottienes, Corse, Narbonnaise; t.2. Aquitaine; t.3-4. Lyonnaise; t.5-6. Belgique; t.7. Gaule germanique. Germanie supérieure; t.8. Gaule germanique (deuxième partie); t.9. Gaule germanique (troisième partie) et supplément; t.10. Supplément (suite) et tables générales du recueil; t.11. Suppléments (suite).

K67   Felletti Maj, Bianca Maria, ed. Iconografia romana imperiale. Da Severo Alessandro a M. Aurelio Carino (222-285 d.C.) Roma, "L'Erma" di Bretschneider, 1958. 309p. 60 pl. on 30 l. (Quaderni e quide di archeologia, 2)

A basic reference work, comprehensive and scholarly, on Roman imperial portrait sculpture of the 3d century A.D.
Contents: pt. I, Bibliografia, Fonti e testimonianze; pt. II, Iconografia. Indexes of persons, museums, and illustrations. Annotated bibliography, p.7-19. Continued by Calza, R. *Iconografia romana imperiale. Da Carausio a Giuliano (287-363 d.C.)* (K65).

K68   García y Bellido, Antonio. Esculturas romanas de España y Portugal. Madrid, Consejo Superior de Investigaciónes Científicas, 1949. 2v. il., plates.
Contents: v.1 text; v.2 plates.
A corpus of Roman sculpture in Spain and Portugal; includes portraits, deities, sarcophagi, steles, reliefs, bronzes, etc. Indexes of museums, p.479-85; places, p.487-89; names, p.491-93.

K69   Hamberg, Per Gustaf. Studies in Roman imperial art with special reference to the state reliefs of the second century. Uppsala, Almqvist & Wiksell, 1945. 202p. 41 plates. (Repr.: Chicago, Argonaut; Roma, "L'Erma" di Bretschneider, 1968; Venezia, Filippi.)
Trans. from the Swedish.
A scholarly study of the great official reliefs of the 2d century A.D.
Contents: (1) The significance of a distinction between different modes of representation; (2) Studies in the grand tradition of imperial representation; (3) The columns of Trajan and Marcus Aurelius and their narratve treatment; (4) Convention and realism in the battle scene. Bibliography and list of abbreviations, p.193-202.

K70   Inan, Jale, and Rosenbaum, Elisabeth. Roman and early Byzantine portrait sculpture in Asia Minor. London, Published for the British Academy of Oxford Univ. Pr., 1966. xxv, 244p. 187 plates (incl. map).
"The present book is intended to be a survey of Roman and early Byzantine portrait-sculpture in Asia Minor comprising the period from the beginning of Roman rule in Asia Minor to about the time of Justinian (A.D. 565)."—*Pref.* Includes mostly freestanding portraits from museums in western Anatolia. Consists of an introductory essay, a catalogue prepared with meticulous scholarship, good recent photographs (311 portraits, 186 plates). Abbreviations and bibliography, p.xix-xxiv. Indexes: museums index, topographical index, chronological tables of portraits of private individuals, non-imperial portraits listed in the catalogue, general index.

K71   Kekule von Stradonitz, Reinhard. Die antiken Terrakotten, im Auftrag des Archäologischen Instituts des Deutschen Reichs hrsg. von Reinhard Kekule von Stradonitz. Berlin und Stuttgart, Spemann, 1880-1911. 4v. in 6. 254 plates (5 col.)
A monumental work on ancient terracottas. v.3 is particularly valuable.
Contents: Bd. 1, Die Terracotten von Pompeji, bearb. von H. von Rohden, nach Zeichnungen von L. Otto u.A.; Bd. 2, Die Terracotten von Sicilien, bearb. von R. Kekule, mit LXI Tafeln, gezeichnet und radirt von L. Otto und mit vielen Abbildungen im Text; Bd. 3, Die Typen der figürlichen

Terracotten, bearb. von F. Winter, 2v.; Bd. 4, Architektonische römische Tonreliefs der Kaiserzeit, bearb. von H. von Rohden, unter Mitwirkung von H. Winnefeld, 2v.

K72    Riis, Poul Jørgen. Tyrrhenika: an archaeological study of the Etruscan sculpture in the archaic and classical periods. Copenhagen, Munksgaard, 1941. xvi, 216p. il., 24 plates (incl. map).
"The first attempt to recognize local, regional styles in Etruscan sculpture."—E. Richardson (I133). Dansk resumé, p.[213]-16; Bibliographical footnotes.

K73    Ryberg, Inez Scott. Rites of the state religion in Roman art. [Rome] American Academy in Rome, 1955. 227p. 47 plates. (American Academy in Rome. Memoirs, v.22)
A significant contribution to the study of Roman imperial art. Constitutes a "survey of the monumental reliefs which represent religious rites," thus providing "an illuminating commentary on the development of religious concepts, above all on the gradually evolving concept of the emperor and his relation to gods and men."—*Author's pref.*
Bibliography, p.[213]-16.

K74    Strong, Donald Emrys. Roman imperial sculpture; an introduction to the commemorative and decorative sculpture of the Roman Empire down to the death of Constantine. London, Tiranti, 1961. vii, 104p. plates (144 figs.) (Chapters in art, 35)
An introductory text (79p.) on the relief sculpture of Imperial Rome is followed by a catalogue of the most important works. 144 illustrations. Select bibliography; no index.

K75    Strong, Eugénie Sellers. Roman sculpture from Augustus to Constantine. London, Duckworth; N.Y., Scribner, 1911. 408p. 130 plates, tables. (Repr.: N.Y., Hacker, 1971.)
The pioneer survey in English. The revised Italian edition (K76) is more useful to scholars.
   Comparative chronological tables of the first three centuries (arranged by centuries) at the beginning. Index: pt. 1, Museums and localities containing works of art, p.397-401; pt. 2, Principal subjects and authorities, p.402-8.

K76    _____. La scultura romana da Augusto a Costantino; traduzione italiana di Giulio Giannelli dall'opera interamente rifatta dall'autrice. Firenze, Alinari, 1923-26. 2v. il., plates.
Italian translation and extensive revision by the author of *Roman sculpture*, 1911 (K75). The illustrations are larger and inserted in the text.
   Contents: v.1, Da Augusto a Traiano; v.2, pt. 1, Da Traiano a Costantino; pt. 2, L'arte del ritratto in Roma. Indexes: (1) Museums and places v.2, p.423-27; (2) Names and subjects v.2, p.427-31.

K77    Toynbee, Jocelyn M. C. The Hadrianic school: a chapter in the history of Greek art. Cambridge, Univ. Pr., 1934. xxxi, 254p. 59 plates. (Repr.: Rome, "L'Erma" di Bretschneider, 1967.)

A fundamental study of Hadrianic art, presented both as a continuation of the Hellenistic tradition of Rome, and as a conscious return to Greek classical and Hellenistic forms. Largely limited to examples of coins, medals, and relief sculpture. Well written, erudite. Bibliographical footnotes.
   Contents: Introduction; pt. I, Coin types; pt. II, Relief-sculpture; Summary; Appendix I, List of extant statues and reliefs signed by artists of the Aphrodisian school; Appendix II, List, with bibliography, of historical reliefs attributed to Hadrian.

# EARLY CHRISTIAN — BYZANTINE

K78    Beckwith, John. Coptic sculpture, 300-1300. London, Tiranti, 1963. vii, 56p. plates. (Chapters in art, 37)
The only study of Egyptian sculpture during the Christian centuries. Presents the controversial thesis that Coptic sculpture can be explained without recourse to theories of Oriental influence.
   Contents: Historical outline; The problem of Alexandrian style; Coptic sculpture up to the Arab conquest; Conclusion. General bibliography, p.43-45.

K79    Bréhier, Louis. La sculpture et les arts mineurs byzantins. Paris, Editions d'art et d'histoire, 1936. 109p. 96 plates. (Repr.: London, Variorum, 1973.)
A brief but important text. Preface by A. Grabar. The 96 collotype plates are accompanied by scholarly notes. Bibliography, p.[104].

K80    Deichmann, Friedrich Wilhelm. Repertorium der christliche-antiken Sarkophage. Hrsg. von Friedrich Wilhelm Deichmann. Bearb. von Giuseppe Bovini und Hugo Brandenburg. Wiesbaden, Steiner, 1967. 1v. in 2. plates.
The 1st volume of a repertory of Early Christian sarcophagi. A 2d volume, listing those in other parts of Italy and the East, is projected. Arrangement by location in museum, collection, church, or catacomb. For each gives full documentation. Illustrations of each in plate volume. Includes bibliographies.
   Contents: 1. Rom und Ostia: Textband. Tafelband. 1. Sarcophagi.

K81    Goldschmidt, Adolph, and Weitzmann, Kurt. Die byzantinischen Elfenbeinskulpturen des X.-XIII. Jahrhunderts. Berlin, Cassirer, 1930-34. 2v. il., 156 plates, diagrs.
"Hrsg. vom Deutschen Verein für Kunstwissenschaft." A scholarly corpus of reproductions of Byzantine ivories with bibliographies and indication of size.
   Contents: v.1, Kästen; v.2, Reliefs. "Auflösung der Literaturabkürzungen" at beginning of each volume. Indexes of personal names, iconography, place of origin and preservation, private collections, and illustrations.

K82    Grabar, André. Sculptures byzantines de Constantinople, IVe-Xe siècle. Paris, Maisonneuve, 1963.

245

139p. 74 plates. (Institut Français d'Archéologie d'Istanbul. Bibliothèque archéologique et historique XVII)

The 1st volume of a scholarly work on Byzantine sculpture. Continued by *Sculptures byzantines du moyen âge II (XIe-XIVe siècle)*, published in 1976 (K83). Illustrated, mostly with selected works in public collections of Istanbul. Scholarly notes; no bibliography. The index for both volumes is in v.II (K83), p.[159]-64.

K83 _____. Sculptures byzantines du moyen âge II (XIe-XIVe) siècle. Paris, Picard, 1976. 167p. 144 plates. (Bibliothèque des Cahiers archéologiques, XII)

This study and catalogue continue the author's examination of Byzantine sculpture, the 1st volume being *Sculpteurs byzantines de Constantinople IVe-Xe siècle* (K82). Together these comprise the only comprehensive work on the subject.

The introductory essay reviews the problems and the state of research. This is followed by a catalogue of carefully selected examples from collections in Istanbul and other cities of the Byzantine world. Each work is illustrated in the plate section. Bibliographical references in the catalogue entries. "Index pour les deux volumes," p.[159]-64.

K84 Volbach, Wolfgang Fritz. Elfenbeinarbeiten der Spätantike und des frühen Mittelalters. Dritte vollständig überarbeitete und erweiterte Auflage. Mainz, Zabern, 1976. 156p. 116 plates. il.

First published in 1916 as *Katalog 7* of the Römische-Germanisches Zentralmuseum, Mainz; 2d. ed. 1952 (also *Katalog 7* of the Museum).

This catalogue of late antique and Early Christian ivories is frequently cited in scholarly bibliographies.

The new ed. includes catalogue entries for additional pieces (mostly small), and new photographs. "The bibliography relating to this branch had also to be increased to such an extent that a new edition was imperative. Important exhibitions (Ravenna, Paris, Athens) facilitated further comparisons between the various pieces, and further light has been shed on unresolved problems by the author's sojourns in Egypt, Russia, Turkey and Greece. New discoveries have contributed their share to clarifying questions of chronology and the various schools. The localization of many pieces at the present day also required to be verified: many changes occurred during the war, some pieces appear to have been lost, older collections have been dispersed and the items are not to be seen in other collections or museums." — *Pub. notes.*

K85 Wilpert, Josef. I sarcofagi cristiani antichi. Roma, Pontificio Istituto di Archeologia Cristiana, 1929-36. 3v. il. and atlas of cclxvi pl. 2v. (Monumenti dell'antichità cristiana, I)

_____. Volume terzo. Supplemento. 1936.

An extremely important corpus of material on early Christian sarcophagi, with excellent collotype plates.

Contents: (1) Il precetto del Signore: Docete omnes gentes baptizantes eos; (2) Il buon pastore; (3) San Pietro; (4) Le rappresentazioni del Vecchio Testamento; (5) Le rappresentazione del Nuovo Testamento.

Bibliographical footnotes. "Indice analitico," v.2, p.363-81: (1) Nomi; (2) Luoghi; (3) Cosi più notevoli. "Indice topografico," v.3, p.63-72. v.3 also has an index of its plates and text illustrations. "Indice delle tavole" at beginning of the two plate volumes.

SEE ALSO: Inan, J., and Rosenbaum, E. *Roman and early Byzantine portrait sculpture in Asia Minor* (K70).

# ISLAMIC

K86 Kühnel, Ernst. Die islamischen Elfenbeinskulpturen, VIII-XIII Jahrhundert. Berlin, Deutscher Verlag tur Kunstwissenschaft, 1971. ix, 105p. 65 text fig., 112 plates (496 il.)

A corpus and catalogue of Islamic ivories, prepared by a foremost authority on Islamic art. This catalogue is the 7th and last in the series: Goldschmidt, Adolph. *Die Elfenbeinskulpturen* (K90). Like the others it meets the highest standards of scholarship. Extensive bibliography, p.[99]-103. Each piece is illustrated.

SEE ALSO: Féhervári, G. *Islamic metalwork* (P457); Mayer, L. A. *Islamic metalworkers and their works* (P458); _____. *Islamic woodcarvers and their works* (E183).

# CAROLINGIAN — GOTHIC

K87 Barasch, Moshe. Crusader figural sculpture in the Holy Land; Twelfth century examples from Acre, Nazareth and Belvoir Castle. New Brunswick, N.J., Rutgers Univ. Pr. [1971]. 237p. il.

A scholarly study of surviving Crusader sculptures in the Holy Land, some of which have been recently discovered. New illustrations. Bibliography, p.227-34. Index, p.235-37.

K88 Bauch, Kurt. Das mittelalterliche Grabbild. Figürliche Grabmäler des 11. bis 15. Jahrhunderts in Europa. Berlin, de Gruyter, 1976. [376]p. 460 il.

An art historical survey of medieval figural sculpture on tombs. Traces the type from its origins in 12th-century Germany, through the French Gothic and extension to England and Italy, and finally the transformation and dissolution of figural tomb sculpture in the late Gothic period. Extensive documentation.

K89 Boccador, Jacqueline, and Bresset, Édouard. Statuaire médiévale de collection. Zug, Clefs du temps, 1972. 2v. 320, 352p. 600 il. (100 col.)

Traces in beautiful illustrations and text the evolution of nonmonumental European sculpture of the Middle Ages from its origins through the Gothic period. Emphasizes the development of the iconography and symbolism of the various

types (Madonna and Child, enthroned Madonnas, the Christ figure, the crucifixion, etc.).

Bibliography, v.2, p.347-49.

K90 Goldschmidt, Adolph. Die Elfenbeinskulpturen. Berlin, Cassirer, 1914-26. 4v. il., plates, Half title: (Denkmäler der deutschen Kunst, hrsg. vom Deutschen Verein für Kunstwissenschaft II. Sektion Plastik, 4. Abt., [Bd. 1-4.]) (Repr.: Berlin, Deutscher Verlag für Kunstwissenschaft, 1969-75.)

v.1-2 "Unter Mitwirkung von P. G. Hübner und O. Homburger." A monumental corpus of reproductions of ivories from the 8th through the 13th centuries, with bibliographies and indication of size.

Contents: Bd. 1-2, Aus der Zeit der karolingischen und sächsischen Kaiser, VIII.-XI. Jahrhundert (1914-18); Bd. 3-4, Aus der romanischen Zeit XI.-XIII. Jahrhundert (1923-26). Each volume contains indexes of names, iconography, places of origin and preservation, private collections, and illustrations.

The series is continued with Bd. 7: E. Kühnel, *Die islamischen Elfenbeinskulpturen VIII-XIII Jahrhundert,* 1971 (K86).

K91 Müller, Theodor. Sculpture in the Netherlands, Germany, France, and Spain: 1400-1500; trans. from the German by Elaine and William Robson Scott. Harmondsworth; Baltimore, Penguin [1966]. xviii, 262p. col. front., 192 plates, maps. (The Pelican history of art, Z25)

An art historical survey of late Gothic sculpture in the Low Countries, Germany, France, and Spain. Includes key works in Hungary, Czechoslovakia, Poland, Scandinavia, and Portugal. The first treatment of these regions together. Important as an introduction and as a research tool. Bibliographical references in foreword, notes, and bibliography.

K92 Porter, Arthur Kingsley. Romanesque sculpture of the pilgrimage roads. Boston, Marshall Jones, 1923. 10v. 1,527 plates. (Repr.: N.Y., Hacker, 1969.)

A monumental corpus of illustrations valuable for research in medieval sculpture. The short text (a study of the influence of Cluny and the pilgrimage to Compostella upon the formation of Romanesque and Gothic sculpture) has been superseded.

Contents: v.1, Text and index; v.2-10, plates: v.2, Burgundy; v.3, Tuscany and Apulia; v.4, Aquitaine; v.5, Catalonia and Aragon; v.6, Castile, Asturias, Galicia; v.7, Western France; v.8, Auvergne and Dauphine; v.9, Provence; v.10, Ile de France.

v.1 begins with a chronological chart in which are placed, side by side, the documented dates of Romanesque sculpture in all parts of Europe. Selected bibliography, p.343-56 and a comprehensive index, p.361-85, at end of text volume.

K93 Vöge, Wilhelm. Bildhauer des Mittelalters; gesammelte Studien. Vorwort von Erwin Panofsky. Berlin, Mann, 1958. xxxi, 254p. il., port.

A selection of articles by a great historian of medieval sculpture. Still fundamental. See review by W. Sauerländer in *Zeitschrift für Kunstgeschichte,* v.22 (1959), p.49-53. "Bibliographie der Schriften von Wilhelm Vöge," p.245-48; "Ortsverzeichnis," p.252-57.

# RENAISSANCE — BAROQUE

K94 Brinckmann, Albert Erich. Barock-Bozzetti. English-German ed. Frankfurt am Main, Frankfurter Verlags-Anstalt [1923-25]. 4v. il., plates.

A well-illustrated collection of Baroque sculpture sketches. "A vast and still important collection of material."—R. Wittkower (I359). Sizes of the *bozzetti* are given.

Contents: v.1-2, Italian sculptors; v.3, Netherlandish and French sculptors; v.4, German sculptors. Indexes of plates, figures, and places at end of each volume.

K95 _____. Barockskulptur; Entwicklungsgeschichte der Skulptur in den romanischen und germanischen Ländern seit Michelangelo bis zum 18. Jahrhundert. Berlin, Akademische Verlagsgesellschaft Athenaion [1919]. 2v. il., 17 plates. (Handbuch der Kunstwissenschaft, III. Abt., 2. Bd.)

A history of Baroque sculpture from Michelangelo to the 18th century in the Latin and Germanic countries. Very out-of-date.

Bibliography: v.1, p.212; v.2, p.405. Indexes: of works of art, v.2, p.407-15; of names, v.2, p.415-25.

K96 Schottmüller, Frida. Bronze Statuetten und Geräte. Mit 142 Abbildungen im Text. 2. Verm. Aufl. Berlin, Schmidt, 1921. 204p. il. (Bibliothek für Kunst- und Antiquitäten-Sammler, Bd. XII)

1st ed. 1917.

A good treatment of both the history and technique of small bronzes—statuettes and vessels.

Contents: pt. 1, Künstlerische Voraussetzungen; pt. 2, Material und Technik; pt. 3, Geschichte der Kleinkunst in Bronze; pt. 4, Kunstsammlungen (p.179-91). Bibliography, p.[192]-201. Index of artists, p.202-4.

K97 Weihrauch, Hans R. Europäische Bronzestatuetten, 15.-18. Jahrhundert. Braunschweig, Klinkhardt & Biermann [1967] 539p. 576 il.

The most important work on small bronzes; valuable to the collector and the art historian. Covers the greatest period of European bronze statuettes—the 15th through 18th centuries.

Contents: Bronze und Technik des Bronzegusses; Mittelalter; Neuzeit; Italien; Deutschland und die Niederlande; Frankreich; Das 18. Jahrhundert -ein Epilog; Die Kleinbronze als Sammelobject. Anmerkungen, p.495; Literatur, p.517-18; Kunstlerverzeichnis, p.519-24; Sachverzeichnis, p.525-32; Ortsverzeichnis, p.533-39.

SEE ALSO: Keutner, H. *Renaissance to Rococo sculpture* (K5); Pope-Hennessy, J. *The Frick Collection,* v.3-4 (I1).

## NEOCLASSICAL — MODERN

**K98** Berckelaers, Ferdinand Louis. The sculpture of this century [by] Michel Seuphor [pseud. of F. L. Berckelaers. Trans. from the French by Haakon Chevalier]. N.Y., Braziller, 1960. 372p. il.

An informative, well-illustrated survey of 20th-century sculpture consisting of 23 chapters on individual sculptors and movements. Biographies, p.225-[350], give information on European and American modern sculptors. Bibliography, p.353-55.

**K99** Berman, Harold. Bronzes; sculptors & founders, 1800-1930. [1st ed.]. Chicago, Abage [1974]. 224p. il.

"This book will be especially valuable to collectors and investors who have searched in vain for published materials dealing with available bronzes of this 1800 to 1930 period."—*Foreword.* Includes 129p. of photographic illustrations of bronzes. Each illustration is accompanied by an entry which gives sculptor, date (when known), size, country where cast, description, founder's mark, and in some cases signature of the artist. Indees of founders and sculptors.

A second volume covering additional artists working between 1800 and 1930 is in preparation.

*see also: Devaux: Univers des bronzes 1978! Good!*

**K100** Elsen, Albert Edward. Origins of modern sculpture: pioneers and premises. N.Y., Braziller [1974]. ix, 179p. il.

Available in paperback.

An enlarged and altered version of the introduction to the author's *Pioneers of modern sculpture* (K101), originally published in 1973. Includes bibliographical references.

*EC 730.0944 D488 U58 1976*

*see also EC 730.0944 R395 A265 1985*

*Renard, J-C. L'âge de la fonte... 1800-1914*

**K101** _____. Pioneers of modern sculpture. [Catalogue of an exhibition held at the] Hayward Gallery, London, 20 July-23 Sept. 1973. Introductory essay by Albert E. Elsen. London, Arts Council of Great Britain [1973]. 151p. il.

"The purpose of the exhibition and essay is to clarify the cause and nature of the revolution between the eighteen nineties and 1918 that resulted in modern sculpture."—*Foreword.*

In his provocative, art historical essay, Elsen relates the innovative sculptural forms to the changing ideas of the period. Bibliographical references in notes. The catalogue (p.101-48) is divided into three sections: Salon; Pioneers; Reliefs. Alphabetical arrangement by sculptor within each section.

An enlarged and altered version of the introduction, entitled *Origins of modern sculpture* (K100), was published by Braziller, N.Y., 1974.

**K102** Giedion-Welcker, Carola. Contemporary sculpture, an evolution in volume and space. Rev. and enl. ed. N.Y., Wittenborn [1961]. xxxi, 400p. il., ports. (Documents of modern art, v.12)

Trans. of *Modern Plastik.*

1st ed., *Modern plastic art,* Zurich, 1937; 2d ed., *Contemporary sculpture, an evolution in volume and space,* N.Y., Wittenborn, 1956 (contains original essay, 248p. of il., and bibliography by B. Karpel).

The best general reference work on 20th-century sculpture. This 3d ed. contains approx. 300 pages of plates. The text consists of commentary beneath plates which are arranged according to type of sculptures. Bibliography, p.355-94.

**K103** Hammacher, Abraham Marie. The evolution of modern sculpture; tradition and innovation. N.Y., Abrams [1969]. 385p. il. (part col.), plates.

Although not a comprehensive survey, this work traces the main lines of the development of sculpture from the late 19th century to mid-20th through informed, perceptive discussions of the major problems of source, style, and critical response. The emphasis is on European sculptors and the relationship of their works to those of the 19th century and earlier. Well illustrated.

Classified bibliography, p.364-73.

**K104** Maillard, Robert, ed. New dictionary of modern sculpture. [Trans. from the French by Bettina Wadia]. N.Y. Tudor [1971]. 328p. il.

Trans. of *Nouveau dictionnaire de la sculpture moderne.*

1st ed. 1960, with title: *Dictionary of modern sculpture.*

An alphabetical listing of 472 modern sculptors. The articles, signed by initials, were written by 34 specialists. List of contributors, p.[7]. For each artist gives vital statistics and a brief discussion of the work, style etc. Over 500 illustrations in the text. No bibliography.

**K105** Read, Herbert. A concise history of modern sculpture. London, Thames & Hudson; N.Y., Praeger [1964]. 310p. il. (part col.)

Available in paperback.

A brief, stimulating survey of 20th-century sculpture which outlines the major movements and masters from Picasso, Brancusi, Duchamp, and Moore to Nevelson, Paolozzi, and Chamberlain. Well illustrated with 340 reproductions of works.

Text references, p.279-82. Selected bibliography, p.283-85.

**K106** Rheims, Maurice. La sculpture au XIXe siècle. Paris, Arts et métiers graphiques [1972]. 431p. il. (part col.)

English ed.: *Nineteenth century sculpture,* N.Y., Abrams, 1976.

Examines 19th-century European and American sculpture in its political, social, and cultural context. Emphasis is on French sculpture; especially important for French academic sculptors. Lavishly illustrated. Bibliography, p.417-18, is classified by country.

Contents: Introduction; Néo-classicisme; Romantisme; David d'Angers; Réalisme au art positiviste; Carpeaux; Le

symbolisme; Préraphaélisme; Art nouveau; L'art en fusion. Rodin et ses disciples; Approche du XXe. Expressionnisme. Retour à l'hellénisme; Le monde du travail; Sculpture historiciste dans la rue; La sculpture décorative à l'époque de l'éclectisme; Le portrait; La caricature; L'art animalier; La sculpture et la religion; L'art funéraire; La sexualité, le sensualisme; La niaiserie, le kitsch; L'insolite; Les matières précieuses. La sculpture d'appartement.

K107  Trier, Eduard. Form and space; sculpture of the twentieth century. Rev. ed., with 245 il. [Trans. from the German by C. Ligota and Francisca Garvie]. N.Y., Praeger [1968]. 339p. plates, il. (part col.)
Not a history of the stylistic evolution of 20th-century sculpture, rather a study of some of the problems of modern sculpture. Its primary aim is "to plot in word and image the typical features of 20th-century sculpture, bringing out connections and oppositions."—*Foreword.*
Contents: (I) The problem of form (Kernel sculpture; Opening up of volume; Sign in space; Constructions; Mobile sculpture; Relief; Excursus; Conglomerates and 'recognized' sculpture); (II) The problem of meaning; (III) The problem of purpose; (IV) Form and space: Variations 1967; (V) Closing remarks: Form and space.
Biographical index of artists, p.321-[40], gives biographical data and references on 189 European and American sculptors.

SEE ALSO:  Licht, F. *Sculpture, 19th and 20th centuries* (K5).

*EC
30.944
311*

*Recueil gén. d. monument sculptés
en France pend. le Haut Moyen Age
v. 1-4...*

# WESTERN COUNTRIES

## France

K108  Aubert, Marcel. Le Bourgogne, la sculpture. Paris, van Oest, 1930. 3v. 204 plates.
Issued in 18 parts, 1927-30.
A corpus of pictures of sculpture in Burgundy. Short introduction; notes on the plates.
"Table des noms de personnes," p.75-77. "Table des noms de lieux," p.78-80. "Table chronologique des édifices," p.81-83. "Table des planches," p.84-88, is a numerical listing which amounts to a geographical arrangement.

K109  Boccador, Jacqueline. Statuaire médiévale en France de 1400 à 1530. [Zug, Les Clefs du temps, 1974]. 2v. 341p.; 358p. il. (part col.)
An analytical history of French sculpture of the period 1400-1530, supported by over 800 illustrations.
Contents: v.1. (I) Sources naturalistes de la statuaire de la fin du moyen âge en France. Les tendances de la sculpture dijonnaises après Claus Sluter; (II) Les ateliers toulousains après 1400. Les ateliers rouergats après 1400. Les ateliers du choeur d'Albi à la fin du moyen âge. Les ateliers dijonnais après 1400. Les ateliers d'Autun après 1450; (III) Influence des ateliers dijonnais. Carte géographique des lieux cités; v.2. (I) Quelques exemples de sculptures post-slutériennes;

(II) Les ateliers de la Loire et du Bourbonnais à fin du moyen âge; (III) La sculpture à Troyes à la fin du moyen âge; (IV) Les figures mystiques de la fin du moyen âge; (V) Morphologie régionale. Tableau récapitulatif historique. Bibliographie sommaire, p.356-58.

K110  Borg, Alan. Architectural sculpture in Romanesque Provence. Oxford, Clarendon, 1972. x, 144p. il. (Oxford studies in the history of art and architecture)
An outstanding example of modern creative scholarship. Largely through stylistic analysis and dating of nave capitals and other architectural sculpture in Provence, the author has revised the whole history of 11th- and 12th-century sculpture of the region, proving that it was not provincial. Also outlines general historical background, origins, influences, and problems. Bibliographical footnotes in the text. Bibliography, p.[133]-42. Many good photographs.

K111  Focillon, Henri. L'art des sculpteurs romans, recherches sur l'histoire des formes. 2d ed. Paris, Presses Universitaires de France, 1964. 279p. il.
1st ed., Paris, Leroux, 1931.
A fundamental work by a great scholar and teacher. Examines and relates all aspects of Romanesque sculpture—function, iconography, religion, spirit, style, changes of style. Documentation in footnotes. Clear illustrations.

*8/75/84*

K112  Forsyth, William H. The entombment of Christ: French sculptures of the fifteenth and sixteenth centuries. Cambridge, Mass., Published for the Metropolitan Museum of Art by Harvard Univ. Pr., 1970. xx, 216p. 273 il., map.
An important study of 15th- and 16th-century French monumental sculptures depicting the entombment of Christ. Classified by region, style, and iconography. The scholarly text is followed by a catalogue (p.171-90), an appendix of selected documents (p.191-201), a selective bibliography (p.203-9), and a detailed index (p.211-16). Good illustrations.

K113  Katzenellenbogen, Adolf. The sculptural programs of Chartres Cathedral: Christ, Mary, Ecclesia. Baltimore, Johns Hopkins Pr. [1959]. xiv, 149p. plates.
Paperback ed.: N.Y., Norton, 1964.
A specialized study which is also important as a contribution to the general knowledge of iconography and other aspects of Gothic sculpture. The sculptural programs of Chartres are studied in terms of form, the literary, theological, and liturgical sources, and with relation to the political and cultural milieu. Full documentation in "Notes," p.103-38; Bibliography, p.139-43. Excellent black-and-white illustrations.

K114  Koechlin, Raymond. Les ivoires gothiques français. Paris, Picard, 1924. 2v. and portfolio (2p. 1., ccxxi pl.) (Repr.: Paris, Nobele, 1968.)
A basic corpus of illustrations of French ivory carvings of the 13th, 14th, and 15th centuries. The examples are well documented.

Contents: Les ivoires religieux; Les ivoires profanes. Appendixes: (1) Ivoiriers nommés dans les comptes, p.531–40; (2) Ivoires gothiques français datés, ou signalés antérieurement au XIXe siècle, p.541–42; (3) Catalogues: I, De collections privées; II, De ventes, p.543–44. Bibliographical footnotes.

K115   Lami, Stanislas. Dictionnaire des sculpteurs de l'école française. Paris, Champion, 1898-1921. 8v. (Repr.: Nendeln, Liechtenstein, Kraus, 1970.)
A fundamental reference and research tool. Arranged alphabetically by the name of the sculptor. For each gives biographical information, a list of works arranged chronologically with dates of completion (whenever possible), prices, engraved copies, and holding museums. The bibliographies include regional histories and references to local documents.

Contents; From Middle Ages to the reign of Louis XIV (1v., 1898); Sculptors under the reign of Louis XIV (1v., 1906); 18th century (2v., 1910-11); 19th century (4v., 1914-21).

see p. 248 for French foundries

K116   Mirolli, Ruth. Nineteenth century French sculpture: monuments for the middle class. [Catalogue by Jane Van Nimmen and Ruth Mirolli. Louisville, Ky., 1971]. 244p. il.
The catalogue of an exhibition held at the J. B. Speed Museum, Louisville, Ky., in 1971.

A notable contribution to the study of the neglected field of 19th-century French sculpture. "Ruth Butler Mirolli's introductory essay is the finest brief study of French sculpture from the Revolution to Rodin available today in any language. It focuses less on problems of style than on the institutional aspects of sculpture: its public role . . .; the mechanism of state patronage; the continuous debate on the nature of sculpture; changes in subject matter and techniques." —H. W. Janson, *Art quarterly* 36:412 (Winter 1973).

Following the introductory essay is the catalogue of works by 28 sculptors, arranged alphabetically. Each entry includes a full description, bibliographical references, and sometimes quotations from contemporary critical commentaries. Bibliographical note, p.26.

K117   Rupprecht, Bernhard. Romanische Skulptur in Frankreich. Aufnahmen von Max und Albert Hirmer. München, Hirmer, 1975. 150p. [144] leaves of plates, numerous il. (some col.), map.
An important new book on Romanesque sculpture in France. The first part is an art historical introduction to the subject, topical in approach. Bibliographical notes. This is followed by a corpus of superb plates (272 il.), and "Dokumentation," a catalogue section with full documentation for each work illustrated (includes citations of literature). Indexes of places, persons, and subjects.

The catalogue and plates are arranged as follows: Das 11. Jahrhundert; Toulouse und Languedoc; Der Westen; Conques und die Auvergne; Burgund; Mittelfrankreich; Pyrenäen; Provence.

K118   Sauerländer, Willibald. Gothic sculpture in France, 1140-1270. Trans. by Janet Sondheimer. Photos. by Max Hirmer. N.Y., Abrams [1973]. 527p. il. (part col.)
Trans. of *Gotische Skulptur in Frankreich 1140-1270.*

An indispensable book, limited to the most important period of French Gothic sculpture. The introduction is an elucidating review of basic problems of style and iconography; the magnificent plates are characteristic of Hirmer's work; and the scholarly documentation of individual monuments summarizes the present state of knowledge on monumental Gothic sculpture in France.

Contents: (1) Opus Francigenum; (2) Categories and functions; (3) The sculptors and their methods; (4) Subject matter; (5) Methods of representation. Bibliography, p.515–22.

K119   _____. Von Sens bis Strassburg. Ein Beitrag zur kunstgeschichtlichen Stellung der Strassburger Querhausskulpturen. (Mit 232 Abbildungen auf 75 Tafeln). Berlin, de Gruyter, 1966. 152p. 38 1. il.
An essential work by an outstanding specialist in the field of Gothic sculpture. Using new comparisons, the author refutes the traditional idea that there was a simple line of stylistic development from the early Gothic of the Cathedral of Sens to its late phase in Strasbourg.

Contents: (I) Die Frage nach der Herkunf des Strassburger Bildhaueratliers in der bisherigen Forschung; (II) Sens und Strassburg. Vermutungen über das ursprüngliche Fassadenprogramm von St. Etienne in Sens. (III) Sens und Chartres. Die Herkunft des Meisters der Königskopfe. (IV) Die Querhausportale von Chartres und der Stilwandel in der französischen Hüttenplastik zu Beginn des 13. Jh. (V) Die Nachfolgewerke in Burgund. (VI) Strassburg um 1220 "Literaturverzeichnis," p.143–48; "Ortsregister," p.149–51. Well illustrated (232 figs.).

K119a  Souchal, François. French sculptors of the 17th and 18th centuries: the reign of Louis XIV: illustrated catalogue by François Souchal, with the collaboration of Françoise de la Moureyre, Henriette Dumuis. Trans. from the French by Elsie and George Hill. Oxford, Cassirer; London, distr. by Faber and Faber, v.1- , 1977- .
Contents: v.1, Andre-Frémin.
The first of 3v. to be devoted to French sculptors in the reign of Louis XIV. Part of a projected series of publications on French sculptors from the Middle Ages to the late 19th century.

"Listing the artists by name in alphabetical order was the only practicable arrangement. Each catalogue is preceded by a short biography, followed by a bibliography . . . . Entries, presented in chronological order, contain all the details to be expected in a scientific catalogue, the size, material, signature, state of preservation, the date and circumstances in which the work was ordered, its initial price, its subsequent history and lastly its present location. Undated works are relegated to the end. In case of works which have disappeared reference is made to old reproductions. Last-minute additions and corrections are included in the appendix."—*Introd.* Each work is illustrated in the text. Full index.

K120 Świechowski, Zygmunt. Sculpture romane d'Auvergne. Illus. de l'auteur. Clermont-Ferrand, G. de Bussac, 1973. 422p. il. (Collection le bibliophile en Auvergne, 16)

Includes summary in Polish. Introduction by Louis Grodecki.

A scholarly survey of Romanesque sculpture in the Auvergne region.

Contents: (I) La sculpture dans l'architecture; (II) Les cycles; (III) Sujets particuliers médiévaux; (IV) Sujets particuliers antiques; (V) Les ateliers et leur chronologie. Bibliographical notes, topographical index, index of illustrations, table of contents. 519 good illustrations.

K121 Vitry, Paul. Documents de sculpture française, publiés sous la direction de Paul Vitry et Gaston Brière. Paris, Longuet [1906–13]. 2v. in 3. chiefly plates. (Repr.: N.Y., Arno, 1969.)

Title varies. 1st ed. 1904; 2d ed. 1906.

A collection of reproductions of French sculpture from the 12th through the 16th century, made mostly from originals rather than from casts. Arranged chronologically by period and then classified geographically or by subject. The three volumes include 332 plates which contain 2,055 documents "de statuaire et de décoration."

Contents: v.1, Moyen âge; v.2, Renaissance, 2v. Each volume contains a "table des planches" which lists the plates and gives sources of the photographs, and an index of place names. Each part of v.2 has an index of artists.

SEE ALSO: Claretie, J. *Peintres & sculpteurs contemporains* (M197); Müller, T. *Sculpture in the Netherlands, Germany, France, and Spain: 1400–1500* (K91); Mussat, A. *Le style gothique de l'ouest de la France* (J164).

## Germany and Austria

K122 Bange, Ernst Friedrich. Die deutschen Bronzestatuetten des 16. Jahrhunderts. Berlin, Deutscher Verein für Kunstwissenschaft, 1949. 165p., plates.

A profusely-illustrated scholarly work on German bronze statuettes of the 16th century. Includes bronzes from neighboring Holland and Austria.

The catalogue, p.113–50, is fully documented. Indexes: artists, people, places, and subjects; owners and locations of the works.

K123 Deutsche Plastik von der Frühzeit bis zur Gegenwart [von] Theodor Müller [et al.]. Aufnahmen von Helga Schmidt-Glassner. Königstein im Taunus, Langewiesche Nachf. Köster [1969]. 7v. in 1. il. (part col.) (Die Blauen Bücher)

Editor: Theodor Müller.

Bound together, the monographs in this recent popular series comprise an excellent, up-to-date survey of German sculpture. Each part is by a recognized scholar.

Contents: (1) Frühzeit (etwa von 900 bis 1250), by Erich Steingräber; (2) Früh- und Hochgotik (etwa von 1230 bis 1380), by Alexander Freiherr von Reitzenstein; (3) Spätgotik (etwa von 1380 bis 1530), by Alfred Schädler; (4) Renaissance (etwa von 1500 bis 1650), by Theodor Müller; (5) Barock und Rokoko (etwa von 1650 bis 1775), by Arno Schönberger; (6) Das neunzehnte Jahrhundert, by Gert von der Osten; (7) Das zwanzigste Jahrhundert, by Gert von der Osten. Many excellent illustrations. Each section has a short bibliography.

K124 Feulner, Adolf, and Müller, Theodor. Geschichte der deutschen Plastik. München, Bruckmann [1953]. 655p. 523 il., 12 col. plates. (Deutsche Kunstgeschichte. Bd. 2)

A standard, well-illustrated history of German sculpture from its origins to the early 20th century. Somewhat narrowly confined to stylistic developments in Germany alone. Indexes of names and places; no bibliography. v.2 of *Deutsche Kunstgeschichte* (I298).

K125 Fründt, Edith. Sakrale Plastik; mittelalterliche Bildwerke in der Deutschen Demokratischen Republik. Fotos von Ulrich Frewel. Berlin, Union, 1965. 245p. p.[45]–[192] plates (part col.), map.

A succinct, well-illustrated survey of German medieval religious sculpture in present-day East Germany.

Contents: Einleitung: Das elfte und zwölfte Jahrhundert; Bildwerke der Spätromanik; Die ritterliche Klassik; Hochgotische Plastik; Der frühe bürgerliche Realismus; Die Spätgotik als Ausklang.

"Anmerkungen," p.197–[244], gives information on works illustrated, arranged alphabetically by location, including dimensions, frequently date, material, and references. "Literatur," p.245, is classified (Allgemeines Darstellungen, Romanik, Gotik, Bibliographien).

K126 Grzimek, Waldemar. Deutsche Bildhauer des zwanzigsten Jahrhunderts; Leben, Schulen, Wirkungen. München, Moos [1969]. 327p. il., plates, ports.

A well-illustrated survey of 20th-century German sculpture divided into four main periods. An introductory essay and sections on individual sculptors comprise each of the period divisions.

Contents: (1) Die naturalistisch-barocke Bildhauerschule und die Entdeckung der neuzeitlich-tektonischen Bildhauerei; (2) Die zweite Periode neuzeitlich-tektonischer Bildhauerei; Die Formverdeutlichung durch eine Zwischengeneration; (3) Die dritte Periode tektonischer Plastik und die Entdeckung ihrer Variationsmöglichkeiten; (4) Die vierte Periode tektonischer Plastik: Systematisierungen. Personenregister.

K127 Harvard University. William Hayes Fogg Art Museum. German and Netherlandish sculpture, 1280–1800, the Harvard collections, by Charles L. Kuhn. Cambridge, Harvard Univ. Pr., 1965. xiv, 146p. il., 85 plates.

Catalogue of the works in the Fogg Art Museum and the Busch-Reisinger Museum at Harvard Univ. Mostly of German and Austrian sculpture, with a few early Netherlandish

251

works. The documented entries are preceded by an art-historical essay. "Selected bibliography of German sculpture," p.35-40.

K128    Jantzen, Hans. Deutsche Bildhauer des dreizehnten Jahrhunderts, mit 147 Abbildungen. Leipzig, Insel-Verlag, 1925. 288p. 147 il. (Deutsche Meister, hrsg. von Karl Scheffler und Curt Glaser)

A scholarly treatment of 13th-century German sculpture of Strasbourg, Bamberg, Mainz, Magdeburg, and Naumburg. "Anmerkungen," p.271, contain bibliography. Index of illustrations, p.283-86.

K129    Paatz, Walter. Süddeutsche Schnitzaltäre der Spätgotik; die Meisterwerke während ihrer Entfaltung zur Hochblüte (1465-1500). Heidelberg, Winter, Universitätsverlag, 1963. 128p. 48 plates.

A scholarly study of the most important centers and masters of German late Gothic altarpieces. Includes excellent illustrations, extensive bibliographical footnotes, and an index of names and places mentioned in the text.

K130    Panofsky, Erwin. Die deutsche Plastik des elften bis dreizehnten Jahrhunderts. München, Wolff [1924]. 2v. il., plates. (Repr.: N.Y., Kraus, 1969.)

A basic work on German sculpture, 11th to 13th centuries. Excellent collotype illustrations.

Contents: v.1, Text; v.2, Plates. Allgemeinere Literatur: [v.1], p.[71] and bibliography in notes. Place index, v.1, p.179-81.

K131    Roh, Franz. Deutsche Plastik von 1900 bis Heute. [München] Bruckmann [1963]. 127p. 84 plates, figs.

A revised and expanded treatment taken from the sculpture section in the author's *Geschichte der Deutschen Kunst von 1900 bis zur Gegenwart* (I298). Includes an introductory essay on the historical development, biographical information, and statements by the sculptors. Excellent illustrations. Index, p.125-27.

K132    Volkelt, Peter. Die Bauskulptur und Ausstattungsbildnerei des frühen und hohen Mittelalters im Saarland. Saarbrücken, Institut für Landeskunde des Saarlandes, 1969. 600p. il., map. (Veröffentlichungen des Institutes für Landeskunde des Saarlandes, Bd. 16)

A listing of sculpture in the Saar region from the early medieval period until c.1250. Includes church furnishings, reliquaries, etc. "Katalog," p.377-427; "Literatur," p.428-80; "Abbildungen zum Katalog," p.481-600 (264 figures).

K133    Wesenberg, Rudolf. Frühe mittelalterliche Bildwerke; die Schulen rheinischer Skulptur und ihre Ausstrahlung. Düsseldorf, Schwann, 1972. 115p. 552 il. (part col.), plans.

A scholarly study of 10th- and 11th-century sculpture from the provinces of the Rhine. The survey of the schools and development of style (94p.) is followed by a documented catalogue of 72 works of Rhenish sculpture, indexes, and a corpus of 516 magnificent photographs.

K134    Wilm, Hubert. Die gotische Holzfigur: ihr Wesen und ihre Entstehung. 4. Aufl., mit 178 Abbildungen. Stuttgart, Metzler, 1940. 171p. il., plates.

Originally published in 1923 as *Die gotische Holzfigur: ihr Wesen und ihre Technik*. The first treatment of Gothic figure sculpture in wood. Bibliographical references included in "Anmerkungen." "Katalog der Abbildungen" gives size of sculpture. Place index: index of persons and subjects.

K135    _____. Gotische Tonplastik in Deutschland; mit 12 Abbildungen im Text und 207 Einzelabbildungen auf 120 Tafeln. Augsburg, Filser, 1929. 122p. il., 120 plates.

A scholarly work on Gothic terracotta sculpture in Germany. Well illustrated. Index of places, artists, and other names, subjects, and illustrations.

SEE ALSO:  Müller, T. *Sculpture in the Netherlands, Germany, France, and Spain: 1400-1500* (K91).

## Great Britain and Ireland

K136    Beckwith, John. Ivory carvings in early medieval England, with 270 il. [Greenwich, Conn.] New York Graphic Society [1972]. 167p. il. (part col.)

A scholarly survey of English ivory carvings from 700 to 1200 A.D. "An attempt has been made to discuss early medieval English ivory carvings in relation to illuminated manuscripts, metalwork, and monumental sculpture of the period and at the same time to provide a general historical and cultural background against which such an art could flourish."—*Pref.*

Contents: (1) The heroic age of the 7th and 8th centuries; (2) The 10th-century monastic reform and its aftermath; (3) The English genius in the 12th century; Notes to the text, p.111-15; General note on ivories, p.116; Catalogue, p.117-62; Index, p.163-66; List of illustrations, p.167.

K137    Crossley, Frederick Herbert. English church monuments A.D. 1150-1550; an introduction to the study of tombs & effigies of the mediaeval period. London, Batsford, 1921. x, 274p. il. (Repr.: London, Batsford, [1933].)

The standard work, still basic.

Contents: County index of illustrations; (1) General introduction: materials, provenance and makers of tombs and effigies; medieval contracts for tombs; colour decoration; (2) Architectural decoration of tombs and chantry-chapels; (3) Effigies and costume: Chronological series of illustrated effigies; Costume, civil; Costume, military; Brasses. Index and glossary of terms, p.257-74.

K138    Esdaile, Katherine Ada (McDowall). English church monuments. 1500 to 1840, with an introd. by Sach-

everell Sitwell. London, Batsford [1946]. viii, 144p. il., plates, ports.

"A sequel to Mr. Crossley's *English church monuments*" (K138)—*Pref.*

Contents: (1) Men and materials, etc. Patrons and portraits; (2) Types and influences; (3) Design and the craftsman; (4) The types portrayed, with notes on costume; (5) Epitaphs, with some contrasted verdicts. Index, p.140–44.

K139  Gardner, Arthur. English medieval sculpture. The original handbook rev. and enl. Cambridge [Eng.], Univ. Pr., 1951. viii, 351p. il. (Repr.: N.Y., Hacker, 1973.)

"The original handbook revised and enlarged with 283 photos." First published in 1935 with title: *A handbook of English medieval sculpture.*

Intended as a textbook. An abridgement of Prior and Gardner (K143) with additional photographs, additions, and a chronological rather than typological organization.

Bibliography, p.345–46. Index, p.347–52.

K140  Gunnis, Rupert. Dictionary of British sculptors. 1600–1851. New rev. ed. London [Murrays Book Sales] 1968. 515p. il., 32 plates, ports.

Earlier ed.: London, Odhams [1953].

Published in the U.S.: Cambridge, Harvard Univ. Pr., 1954.

Includes 1,700 sculptors who worked in Great Britain between 1660–1851. For each artist gives a short biography, a list of signed or documented works, and literature. Detailed information on artists whose biographies have not been previously published. Gives a quite complete list of the works of the more important sculptors; only the best works of minor artists and craftsmen are mentioned. The preface indicates sources consulted. Index of places, p.453–75; Index of names, p.477–514.

K141  Henry, Françoise. La sculpture irlandaise pendant les douze premiers siècles de l'ère chrétienne. 145 figures, 171 planches hors texte. Paris, Leroux, 1933. 2v. il., plates, map. (Études d'art et d'archéologie sous la direction d'Henri Focillon)

A scholarly work on Irish sculpture of the first 12 centuries of the Christian era.

Contents: v.1, Texte; v.2, Planches. "Répertoire bibliographique, comprenant l'index des croix et des sculptures d'églises," v.1, p.[199]–213. "Index des motifs ornementaux et thèmes iconographiques," v.1, p.[215]–16. "Index général," v.1, p.[217]–21. "Liste des abréviations bibliographiques," v.1, p.[223]–29. "Table des figures," p.[231]–34.

K142  Hunt, John. Irish medieval figure sculpture, 1200–1600: a study of Irish tombs with notes on costume and armour. With assistance and contributions from Peter Harbison; photos. by David H. Davison. Dublin, Irish Univ. Pr., [1974]. 2v. 357 il., fold. col. map.

Contents: v.1, Text and catalogue (550p.); v.2, Plates (340 il.).

The chronology of the effigies on the tombs was derived from a study of military, ecclesiastical, and civilian costume. Text divided as follows: Period I (1200–1350); Hiatus (1350–1450); Period II (1450–1570); Tomb-surrounds; Tombs in the Elizabethan style; Styles and workshops; Catalogue; Appendixes: Lost sculpture, Tomb-surrounds (List of iconographical and hagiographical subjects with details of attributes etc.), A list of Irish tombs with figure sculpture in the Elizabethan style prior to 1600.

Bibliographical references in catalogue; glossary; index. At end of v.2: Topographical index of plates.

K143  Prior, Edward Schröder, and Gardner, Arthur. An account of medieval figure-sculpture in England, with 855 photographs. Cambridge, Univ. Pr., 1912. xi, [1], 734p. il.

The pioneer survey of the field, still useful. Bk. 1 covers iconography and materials of the medieval sculptor; Bk. 2 covers the historical development from 650–1520; Bk. 3 treats the sepulchral effigies.

"Bibliography of English medieval sculpture," p.[105]–8. Index, p.[723]–34.

K144  Saxl, Fritz. English sculptures of the twelfth century. Ed. by Hanns Swarzenski. London, Faber and Faber [1954]. 183p. il., 99 plates.

"Fritz Saxl did not intend to give a historical survey. He was guided by a desire to awaken an interest in English Romanesque sculpture by presenting adequate reproductions of the few great monuments preserved in this country and thus reviving a sense of beauty."—*Pref.* Beautiful, well-chosen photographs with commentary by a great scholar. Bibliographical references in notes by Swarzenski.

K145  Stone, Lawrence. Sculpture in Britain: the Middle Ages. [2d ed.]. [Harmondsworth; Baltimore] Penguin [1972]. xxii, 297p. 192 plates. (The Pelican history of art, Z9)

1st ed. 1955.

A well-written, well-illustrated survey of British medieval sculpture which incorporates the latest findings and points the direction for further research.

Contents: pt. 1. Pre-conquest sculpture; pt. 2. Romanesque sculpture; pt. 3. 13th-century sculpture; pt. 4. Sculpture of the Decorated period; pt. 5. Late medieval sculpture. Notes, p.235–70; Bibliography, p.271–80.

K146  Whinney, Margaret Dickens. Sculpture in Britain: 1530 to 1830. [Harmondsworth; Baltimore] Penguin [1964]. xxii, 314p. 192 plates. (The Pelican history of art, Z23)

2d ed. 1975.

The standard, art historical survey, scholarly and well-written. Here for the first time the sculpture in Great Britain from the Renaissance to c.1830 is related to contemporary Italian, Flemish, and French development. Important material with bibliographical references in the notes. Full bibliography, p.281–84. Good new illustrations.

K147    Zarnecki, George. English Romanesque sculpture, 1066–1140. London, Tiranti, 1951. 40p. il. [Chapters in art, 17]

A compact outline of Anglo-Norman sculpture from the Norman Conquest to 1140 is followed by "Descriptive notes to the plates" and 82 illustrations, including lesser-known works. Suggestions for further reading, p.40. Continued by *Later English Romanesque sculpture, 1140–1210* (K148).

K148    _____. Later English Romanesque sculpture, 1140–1210. London, Tiranti, 1953. 67p. il. [Chapters in art, 22]

A companion volume to *English Romanesque sculpture, 1066–1140* (K147). The brief, authoritative survey of approx. 70 years of English sculpture is followed by descriptive notes to plates and 133 illustrations of excellent quality.

## Italy

K149    Avery, Charles. Florentine Renaissance sculpture. [London] Murray [1970]. [8], 274p. il.

"This book is intended to meet the need for a compact handbook to Florentine Renaissance sculpture for the use of students of art history and of those visitors to Florence whose curiosity is not satisfied by standard guidebooks."—*Pref.*

Written by a scholar. The scope extends from the background of late Gothic sculpture in central Italy to Giovanni da Bologna and the climax of the Florentine tradition. Illustrations in the text. Locations of principal sculptures in Florence, p.262; brief bibliography, p.268.

K150    Bravo, Carlo del. Scultura senese del Quattrocento. Firenze, Edam, 1970. 136p. 400 plates. (Collana di studi. 1)

A comprehensive history of Sienese sculpture of the 15th century. Up-to-date, scholarly, with a corpus of splendid recent photographs. Recommended for all students of Italian Renaissance art.

Contents: (I) Il tempo di Francesco di Valdambrino; (II) Il Vecchietta e Antonio Federighi; (III) Gli scultori dell'ultimo trentennio.

Bibliographical footnotes; bibliography, p.[109]–18, arranged by date of publication from before 1417 to 1969. Indexes of names and works of art arranged by place.

K151    Carli, Enzo. La scultura lignea italiana, dal XII al XVI secolo. Milano, Electa [1961]. 289p. il. (part mounted col.)

A survey of wooden sculpture in Italy from the 12th through the 16th centuries, written by a recognized specialist. This "bank publication" is illustrated (mostly in color) with 131 figures in the text and 90 full-page plates. Bibliography, p.119–22. Indexes: names, places and works, illustrations.

K152    Centro Italiano di Studi sull' Alto Medioevo, Spoleto, Italy. Corpus della scultura altomedievale. Con una premessa di Mario Salmi. Spoleto, Presso la sede del Centro di Studi, 1959–[74]. 5v. plates, maps.

The purpose of this corpus is to publish systematically all works of pre-Romanesque sculpture in Italy. Each volume has an introduction by a specialist, a corpus of illustrations, documented entries for the works illustrated, an index of plates, and a bibliography.

Contents: (1) La diocesi di Lucca, a cura di I. B. Barsali; (2) La diocesi di Spoleto, a cura di J. Serra; (3) La diocesi di Brescia, a cura di G. Panazza e A. Tagliaferri; (4) La diocesi di Genova, a cura di C. D. Bozzo; (5) La diocesi di Benevento, a cura di M. Rotili; (6) La diocesi di Torino, a cura di Silvana Casartelli Novelli; (7) La diocesi di Roma, a cura di Letizia Pani Ermini (3v.); (8) La diocesi dell' Alto Lazio: Bagnoregio, Bomarzo, Castro, Civita Castellana, Nepi, Orte, Sutri, Tuscania, a cura di Joselita Raspi Serra.

K153    Crichton, George Henderson. Romanesque sculpture in Italy. [London] Routledge & Paul [1954]. xx, 172p. 92 plates.

A useful handbook for the student and traveler. Well illustrated. Bibliography, p.161–63.

K154    Dizionario Bolaffi degli scultori italiani moderni. Torino, Bolaffi, 1972. xci, 415p. il.

The main section is devoted to "Scultori e ideatori plastici italiani dal 1900 ad oggi." Each entry gives biographical information, a photograph of the sculptor, one or more photographs of works, bibliographical references, holding museums and institutions, awards, exhibition data, and a price range.

"I grandi maestri della scultura" at the beginning of the volume is devoted to 20 of the leading international sculptors of the 20th century. Index of sculptors, p.411–13.

K155    Enggass, Robert. Early eighteenth-century sculpture in Rome. An illustrated catalogue raisonné. University Park, London, Pennsylvania State Univ. Pr., 1976. 2v. il.

The pioneer study of the little-explored area of early 18th-century sculpture in Rome. Covers Italian and foreign sculptors active in Rome from the late 17th century (after the death of Bernini) until the 1740s. Includes a few later works. The introduction, consisting of essays on the historical background and style, is followed by a catalogue of the works of 21 Italian and foreign sculptors, arranged according to the birthdate of the artist. For each gives a bio-bibliography and a list of his works in the city of Rome. Full documentation, including bibliographical references for each work and transcripts from archives. The plate volume contains 244 illustrations, about half of which were made from photographs taken for this book.

K156    Francovich, Géza de. Benedetto Antelami, architetto e scultore, e l'arte del suo tempo. Milano, Electa [1952]. 2v. il., plates, plans.

More than a monograph on Benedetto Antelami (c.1150–1233), this monumental work of meticulous scholarship is basic to research on the Romanesque sculpture of Lombardy.

Contents: v.1, Introduzione; (1) La scuola di Piacenza; (2) La corrente provenzaleggiante ed i maestri campionesi;

(3) Benedetto Antelami; (4) La scuola di Benedetto Antelami; Note aggiunte, p.467-76; Bibliografia, p.479-500; Indice delle illustrazioni, p.503-8; Indice generale, p.509-19. v.2, plates.

K157    Godfrey, Frederick M. Italian sculpture, 1250-1700. [1st American ed.]. N.Y., Taplinger; London, Tiranti, 1967. vi, 332p. il.

An excellent introductory handbook, recommended for the student and serious tourist. Perceptive comments on style. Selected bibliography, p.309-10; Biographical notes and index to sculptors, p.311-27; Index to sculptures, p.328-30; Index to places, p.331-32. Well illustrated.

K158    Haseloff, Arthur Erich Georg. Pre-Romanesque sculpture in Italy. Firenze, Pantheon [1930]. x, [1], 85, [1]p., 2 1. 80pl. (The Pantheon series) (Repr.: N.Y., Hacker, 1971.)

Trans. from the German by Ronald Boothroyd.

A sweeping overview of Italian sculpture, beginning with the late Roman sarcophagi to c.1000 A.D. Emphasizes Northern and Byzantine influences on the regional developments of Italy. Bibliography, p.73-77. Geographical index, p.79-82; General index, p.83-[86].

K159    Hubert, Gérard. Les sculpteurs italiens en France sous la Révolution, l'Empire et la Restauration, 1790-1830. Paris, Boccard, 1964. 196p. plates.

A companion to *La sculpture dans l'Italie napoléonienne* (K160). A scholarly, thorough treatment of the Italian sculptors who worked in France, particularly Paris, during the Revolution, Empire, and Restoration. Biographies of Italian sculptors who worked or exhibited in France. Indexes of artists, names of persons and works, places.

K160    ———. La sculpture dans l'Italie napoléonienne. Paris, Boccard, 1964. 531p. plates (225 figs.)

A detailed account of neoclassical sculpture in the Italian states from the late 18th century until c.1850, with particular focus on Canova and lesser-known sculptors of the Napoleonic period. Bibliographical references. Indexes of artists, names of persons and works, places. Continues *Les sculpteurs italiens en France* (K159).

K161    Lankheit, Klaus. Florentinische Barockplastik; die Kunst am Hofe der letzten Medici, 1670-1743. [München] Bruckmann [1962]. 381p. plates. (Italienische Forschungen, 3. F., 1 Bd.)

"One of the finest books ever written on a single period of sculpture, brilliant analytical text, meticulous and vast documentation, and lavish illustrations."—Molesworth and Brookes (K8).

Contents: (1) Die Grundlagen; (2) Künstler und Werke: Ciro Ferri, Giovanni Battista Foggini, Massimiliano Soldani Benzi, Die ubrigen Künstler; (3) Die Epoche und ihr Stil; Anmerkungen; Schriftquellen; Register: Verzeichnis der Künstler, Verzeichnis der Personen (ausser Künstlern), Verzeichnis der Orte und Werke, Katalog der Abbildungen.

Bibliographical references included in "Anmerkungen," p.206-20.

K162    Maclagan, Eric Robert Dalrymple. Italian sculpture of the Renaissance; the Charles Eliot Norton lectures for the years 1927-1928. Cambridge, Harvard Univ. Pr., 1935. 277p. il.

A general review by a scholar. Still listed in authoritative bibliographies. Index of artists, p.277-[78].

K163    Planiscig, Leo. Venezianische Bildhauer der Renaissance. Wien, Schroll, 1921. 652p. il. (Repr.: N.Y., Hacker, 1975.)

This fundamental work on Venetian sculpture of the Renaissance is again available. 711 illustrations.

Bibliographical index, p.51-[52]. Index of plates according to artist, p.55-64; of plates according to location of the work, p.65-[66].

K164    Pope-Hennessy, John. An introduction to Italian sculpture. 2d ed. London, N.Y., Phaidon, 1970-72. 3v. il.

The best introduction to Italian sculpture for the student and art lover. The scholarly notes are most valuable to the specialist. The scope of the 3v. ranges from Nicola Pisano to the followers of Bernini. Each volume has an authoritative introductory survey, a corpus of excellent black-and-white plates, notes on the plates and sculptors. Meticulous catalogues with full documentation of each work. Extensive up-to-date bibliography in notes. Brief bibliography in each volume. Indexes of plates and sculptors in each volume.

Contents: Pt. I, Italian Gothic sculpture (1st ed. 1955; 2d ed. 1972); Pt. II, Italian Renaissance sculpture (1st ed. 1963; 2d ed. 1971); Pt. III, Italian High Renaissance and Baroque sculpture (1st ed. 1963; 2d ed. 1970).

K165    Riccòmini, Eugenio. Ordine e vaghezza. Scultura in Emilia nell'età barocca. Fotografie di Paolo Monti e Corrado Riccòmini. Bologna, Zanichelli [1972]. 377p., incl. plates. il.

A survey of Baroque sculpture in Emilia (Parma, Modena, Bologna, etc.) from the beginning of the 17th century to the first decade of the 18th century. The critical text (p.1-42) is followed by a documentation of individual works (p.43-115) with biographical notices of artists, description of works, and references to literature and archival sources. Appendix of original documents (p.117-33). Excellent recent photographs, some in color. Critical bibliography, p.372-77.

K166    Salmi, Mario. Romanesque sculpture in Tuscany. Firenze, Rinascimento del Libro, 1928. 153p., 80 plates. (Studies of ancient and modern art, directed by Antonio Maraini)

A standard survey of Tuscan sculpture from its pre-Romanesque origins to the 13th century in Pisa, Lucca, and Lombardy. Indexes of artists, monuments, illustrations. General index. 248 illustrations, rather poor in quality.

K167    Scultura italiana. Milano, Electa [1966-68]. 5v. plates (part col.)

Each volume consists of a brief text by a specialist, a bibliography (with periodical literature), a general index, an index of illustrations, and a repertory of approx. 135

superb plates. Recent photographs, many in color, many details. For each gives location, material, size, and a brief art historical analysis.

An abridged version in English, *Twelve hundred years of Italian sculpture*, contains a translation of the essays and a selection of plates.

Contents: v.1, Dall'alto medioevo all'età romanica, di Rossana Bossaglia; v.2, Il Gotico, di Enzo Carli; v.3, Il Rinascimento, di Franco Russoli; v.4, Dal manierismo al rococò, di Valentino Martinelli; v.5, Dal neoclassicismo alle correnti contemporanei, di Carlo Pirovano.

K168 Semenzato, Camillo. La scultura veneta del Seicento e del Settecento. Con prefazione di Giuseppe Fiocco. [Venezia] Alfieri [1966]. 170p. 258 il. (Profili e saggi di arte veneta, 4)
"The first systematic attempt to master the *terra incognita* of Venetian Baroque sculpture: biographies and *oeuvre* catalogues."—R. Wittkower (I359). Bibliografia, p.153-55; Indice degli artisti e dei luoghi, p.157-64.

K169 Seymour, Charles. Sculpture in Italy, 1400 to 1500. Harmondsworth; Baltimore, Penguin [1966]. xxvi, 295p. il., plates (1 col.), maps. (Pelican history of art, Z26)
An innovative study whose central theme is that of major sculpture programmes and their role within the intellectual and social context of the city. Excellent bibliography divided as follows: (1) General; (2) Regions and monuments; (3) Individual sculptors; (4) Principal collections and exhibitions; (5) Periodical literature guide.

K170 Victoria and Albert Museum, South Kensington, Department of Architecture and Sculpture. Catalogue of Italian sculpture in the Victoria and Albert Musuem. [By] John Pope-Hennessy, assisted by Ronald Light-bown. London, H.M. Stationery Off., 1964. 3v. plates.
The catalogue of this large, important collection of Italian sculpture, compiled by an outstanding authority. Entries are examples of meticulous scholarship, with precise descriptions, latest attributions, provenance, bibliographical references, etc.
Contents: v.1, Text: 8th to 15th century; v.2, Text: 16th to 20th century; v.3, Plates. At end of v.2: Bibliographical abbreviations, p.700-8. All works illustrated in v.3: 736 figures, 426 plates.

K171 Wiles, Bertha Harris. The fountains of Florentine sculptors and their followers, from Donatello to Bernini. Cambridge, Harvard Univ. Pr., 1933. 163p. il., plates. (Repr.: N.Y., Hacker, 1971.)
This scholarly study of an important category of Italian sculpture is again available. Most of the fountains discussed are late Renaissance or early Baroque.
"Sources and bibliography," p.[109]-35. "Lost fountains," p.[136]-39. "Key to abbreviations," p.140-44. Index, p.147-63.

K172 Wolters, Wolfgang. La scultura venezia (1300-1460). Venezia, Alfieri, 1976. 2v. il.

A comprehensive history and catalogue of Venetian Gothic sculpture. Full documentation of the works listed and illustrated.
Contents: (1) Testo e catalogo, 351p., 46 black-and-white illustrations; (2) Tavole, 871 black-and-white illustrations.

SEE ALSO: Cicognara, L. *Storia della scultura dal suo risorgimento in Italia* (H85); Hill, G. F. *A corpus of Italian medals of the Renaissance before Cellini* (P565); Hill, G. F. *Medals of the Renaissance* (P566); Pope-Hennessy, J. *The Frick collection*, vol. III (I1).

## Latin America

K173 Navarro, José Gabriel. La escultura en el Ecuador (siglos XVI al XVIII). Madrid, Marzo, 1929. 195p. il., 28 plates.
At head of title: Real Academia de Bellas Artes de San Fernando. A study of sculpture produced from the 16th through the 18th century in Ecuador, with consideration of European and Oriental influences on the native Quito school.

K174 Weismann, Elizabeth (Wilder). Mexico in sculpture, 1521-1821. Cambridge, Harvard Univ. Pr., 1950. 224p. il.
A pictorial survey of three centuries of Mexican sculpture. Valuable for "Notes," p.189-219. Bibliography, p.220-22.

SEE ALSO: Wethey, H. *Colonial architecture and sculpture in Peru* (J260).

## Low Countries

K175 Rousseau, Henry. La sculpture aux XVIIe et XVIIIe siècles. Brussels, van Oest, 1911. 163p. 31 plates.
A summary sketch of sculpture in the Low Countries in the 17th and 18th centuries. Antiquated. Bibliography, p.158-60. "Table alphabétique des noms d'artistes," p.153-57.

SEE ALSO: Harvard University. William Hayes Fogg Art Museum. *German and Netherlandish sculpture, 1280-1800, the Harvard collections* (K127); Müller, T. *Sculpture in the Netherlands, Germany, France, and Spain: 1400-1500* (K91).

## Russia and Eastern Europe

K176 Homolka, Jaromír. Gotická plastika na slovensku. Fot. Tibor Honty. Resumé a zozn. vyobr. do ruš., angl. a nem. prel. Viera Sabíková. 1. vyd. Bratislava, Tatran, t. Tlač. SNP, Martin, 1972. 88, 435, [3]p. 248 il. (part col.)
A study of late Slovak Gothic sculpture, its major centers of creation, and its major sculptors. Outlines the development in Slovakia and establishes its place in the mainstream of Middle European arts.
Contents: Predhovor: Úvod (Bratislava; Košice; Banské Mestá; Spiš a Levoča; Bardejov a Sariš; Majster Pavol z

Levoče); Záver; Bibliografia; Katalóg. English summary, p.424-26. English list of illustrations, p.427-[29].

## Scandinavia

K177  Blindheim, Martin. Norwegian Romanesque decorative sculpture, 1090-1210. London, Tiranti, 1965. 72p. il. (Chapters in art)

A study of stone and wood ornamental sculpture in 12th-century Norwegian churches. Traces English and western European influences on artistic decoration in churches of the Romanesque period. Contains 221 illustrations.

Contents: Ch. 1, The oldest stone sculpture in Trondheim and its importance to the art of Trøndelag; Ch. 2, Southern influences; Ch. 3, The art of the woodcarver; Ch. 4, The main doorways of the stave churches; Ch. 5, The octagon in Trondheim; Bibliography, p.58-60; Index, p.61-64.

K178  Madsen, Herman, and Mortensen, Niels Th. Dansk skulptur. Odense, Skandinavisk bogforlag [1965]. 314p. il. (part col.)

A well-illustrated survey of Danish sculpture. No bibliography.

Contents: Fra oldtiden til wiedewelt, ved H. Madsen; Fra Bertel Thorvaldsen til Robert Jacobsen, ved N. T. Mortensen.

K179  Parmann, Øistein. Norsk skulptur i femti år Oslo, Dreyer, 1969. 321p. il.

A well-illustrated survey of Norwegian sculpture from c.1920 to c.1969. Includes a preliminary chapter on earlier Norwegian sculpture. Occasional references in footnotes. No bibliography.

K180  Stockholm. Statens Historiska Museum. Medieval wooden sculpture in Sweden. Stockholm, Almqvist & Wiksell [1964-(75)]. v. 1-(2, 4-5). il. (part col.)

When v.3 is published, v.1-3 will comprise a general survey of medieval wooden sculpture of all types in Sweden based largely on the collection in the Museum of National Antiquities. v.4-5 form a comprehensive catalogue of the Museum's collection. v.4 (1975) is a descriptive catalogue; v.5 (1964), the plate volume, reproduces the majority of the works in the collection, arranged chronologically in general and divided into sections corresponding to the chapters in the text volumes. The "List of objects" at the end of v.5 is arranged chronologically by place of origin, giving plate number, inventory number, kind of wood, and height of object. Bibliography in v.4, p.311-12. Corrections of v.5 in v.4, p.317.

Contents: v.1, Thordeman, Bengt. Attitudes to the heritage (1964); v.2, Andersson, Aron. Romanesque and Gothic sculpture (1966); v.3, Rydbeck, Monica. Late medieval sculpture (not published); v.4, The Museum collection: Catalogue (1975); v.5, The Museum collection: Plates (1964).

K181  Thorlacius-Ussing, Viggo, ed. Danmarks billedhugger-kunst fra oldtid til nutid, ved Johannes Brøndsted [et al.]. København, Hirschsprung, 1950. 499p. il.

A history of Danish sculpture, with each chapter written by a specialist. Bibliography, p.479-85. "Register over bildende kunstnere," p.487-90. "Person- og stedregister," p. 491-99.

## Spain and Portugal

Good scholarly surveys of Spanish sculpture of all periods are to be found in the volumes of the monographic series *Ars Hispaniae*. (I438). Examples: Durán Sanpere, A. and Ainaud de Lasarte, J. *Escultura gótica;* Gudiol Ricart, J. and Gaya Nuño, J. A., *Arquitectura y escultura románicas;* Azcárate, J.M. *Escultura del siglo XVI;* Gómez-Moren. M.E., *Escultura del siglo XVII.*

K182  Araujo y Goméz, Fernando. Historia de la escultura en España, desde principios del siglo XVI hasta fines del XVIII, y causas de su decadencia. Madrid, Tello, 1885. 640p.

An alphabetical and synoptical index of Spanish sculptors and foreigners who worked in Spain in the 16th and 17th centuries. Bibliography, p. [623]-30.

K183  Gómez-Moreno, Manuel. The golden age of Spanish sculpture. Notes on the plates by María Elena Gómez Moreno. 88 black-and-white photos by F.L. Kenett. 12 colour photos, by Paul Pietzsch. Greenwich, Conn., New York Graphic Society [1964]. 63p. 101 plates (part col.)

A survey of 16th- and 17th-century Spanish sculpture. Good illustrations with extensive explanatory notes on the works of such artists as Felipe Vigarny, Gregorio Fernandez, Juan Martinez Montañés, Alfonso Cano, and Pedro Roldán. No bibliography or index. Notes on the colour plates. p.29-35; notes on the monochrome plates, p.37-64.

K184  Pardo Canalis, Enrique. Escultores des siglo XIX. Madrid, Consejo Superior de Investigaciones Científicas, Instituto Diego Velázquez de Arte, 1951. 396p. il., 103 plates.

The 15 chapters of the text are devoted to individual sculptors. Documentation, p. 147-362; bibliographical sources, p.363-73, is divided into manuscripts and printed books. Index of names, p.379-93; index of illustrations, p.394-96.

K185  Pillement, Georges. La sculpture baroque espagnole. Biographies et bibliographie par Nadine Daniloff. paris, Michel [1945]. 174p. 80 plates.

A survey of Spanish Baroque sculpture. "Notices biographiques," p.127-62, give a page or so to each artist. Bibliography, p.[163]-67.

K186  Proske, Beatrice Irene (Gilman). Castilian sculpture, Gothic to Renaissance. Printed by order of the Trustees. N.Y. [Hispanic Society of America] 1951. 525p. il. (Hispanic notes & monographs; essays, studies, and brief biographies. Peninsular series)

A well-illustrated, scholarly treatment of Castilian sculpture. "References," p.499-509. Index, p.511-25.

K187  Santos, Reynaldo dos. A escultura em Portugal. Lisboa, n.p., 1948-50. 2v. il., plates (part col.)

A standard work on Portuguese sculpture from the Romanesque period to neoclassicism. v.1, Séculos XII a XV; v.2,

Séculos XVI a XVIII. Each volume has a rather brief text (with illustrations) followed by a corpus of plates. Bibliography, v.1, p.58.

K188  Weise, Georg. Die Plastik der Renaissance und der Frühbarock im nördlichen Spanien: Aragón, Navarra, die baskischen Provinzen und die Rioja, von Georg Weise, unter Mitwirkung von Ingrid Kreuzer, geb. Ossmann. Tübingen, Hopfer [c1957-59]. 2v. plates.

A monumental treatment of Renaissance and early Baroque sculpture in northern Spain, written by a recognized authority.

Contents: Bd. 1, Die Plastik der ersten Hälfte des 16. Jahrhunderts; Bd. 2, Die Romanisten. Includes bibliographies. Indexes of artists, places, and illustrations: v.1, p.96-100; v.2, p.125-31.

K189  _____. Spanische Plastik aus sieben Jahrhunderten. Reutlingen, Gryphius, 1925-[39]. 4v. in 5. il., plates. (Tübinger Forschungen zur Archäologie und Kunstgeschichte, Bd. 3, 6, 9)

A scholarly history of Spanish sculpture. Originally intended to cover the 12th to the 18th centuries.

The following volumes were published: Bd. II: Unter Mitwirkung von Hannschubert Mahn und Berthold Conrades. Bd. III has individual title page: Renaissance und Frühbarock in Altkastilien: (1) Halbbd., Die Spätgotik in Altkastilien und die Renaissanceplastik der Schule von Burgos; (2) Halbbd., Die Renaissanceplastik der Schulen von Valencia und Valladolid. Bd. IV, Die Plastik der Renaissance und des Frühbarock in Toledo und dem übrigen Neukastilien. v.2, pt. 1 (Text), v.3, pt. 2, and v.4 each has an index by place and artist. Profusely illustrated.

SEE ALSO:  Igual Úbeda, A. *Diccionario biográfico de escultores valencianos del siglo XVIII* (H212); Müller, T. *Sculpture in the Netherlands, Germany, France, and Spain: 1400-1500* (K91).

## Switzerland

K190  Joray, Marcel. La sculpture moderne en Suisse. Neuchâtel, Griffon [1955-67]. 3v. plates. (Collection L'Art suisse contemporain. no. 12,14)

A pictorial anthology of modern sculpture in Switzerland from c.1920 to 1966. Each volume includes introductory essays and sections of biographical data.

Contents: v.1, Antérieure à 1955; v.2, 1954 à 1959; v.3, 1959 à 1966.

## United States

### Bibliography

K191  Ekdahl, Janis. American sculpture; a guide to information sources. Detroit, Gale [1976]. xv, 260p. (Art and architecture information guide series, v.5)

Like its companion volume, *American painting* (M487), this guide promises to be a valuable key to research.

Contents: Sect. I, General research tools: (1) Bibliographies, library catalogs, and indexes (2) Sources of biographical information (3) Encyclopedias, dictionaries, and glossaries (4) Directories. Sect. II, History and aesthetics of American sculpture: (5) Surveys of American sculpture (6) Folk, primitive, and native carving (7) First school of American sculpture (8) American sculpture in the late 19th and early 20th centuries (9) Surveys of 20th-century American sculpture (10) Development of American preeminence in sculpture (11) American sculpture since 1960. Sect. III, Individual sculptors. Appendix: Public institutions with extensive collections of American sculpture. Author index; title index; subject index.

### Histories and Handbooks

K192  Andersen, Wayne. American sculpture in process: 1930-1970. Greenwich, Conn., New York Graphic Society, 1975. 256p. 208 il. (part col.)

The most comprehensive survey of modern American sculpture, beginning with the European-oriented works of the 1930s, through the growing independence of the 1940s and 1950s, the Abstract Expressionist movement, and finally the diverse developments of the 1960s (pop art, minimal art, earthworks, process art, etc.). The influential and progressive works of about 100 sculptors are examined.

Contents: (1) The thirties; (2) The forties; (3) The fifties in New York; (4) Chicago sculpture; (5) California sculpture; (6) Pop art and pop sculpture; (7) Minimal art and primary structures; (8) Earthworks and process art.

Bibliography (books, exhibition catalogues, articles, and major reviews), p.261-72.

K193  Ashton, Dore. Modern American sculpture. N.Y., Abrams [1969]. 54p. 80 plates (part col.), 28 il.

A brief authorative essay on the development of modern American sculpture, followed by a section of plates which reproduce works primarily of the fifties and sixties. No bibliography; a few references in the footnotes.

K194  Bishop, Robert. American folk sculpture. N.Y., Dutton [1974]. 392p. il. (part col.)

Primarily a pictorial anthology of over 700 illustrations of American folk sculpture. Brief commentaries. Includes, among others, sections on gravestones, weathervanes, scrimshaw, carousel sculpture, cigar store Indians, and decoys. Each section contains a short essay.

Bibliographical references in "Notes," p.387. Selected bibliography, p.388-89.

K195  Brewington, Marion Vernon. Shipcarvers of North America: Barre, Mass., Barre, 1962. xiv, 173p. il. (Repr.: N.Y., Dover, 1972.)

A well-written, scholarly study of ship carvers in the U.S. and Canada. Contains 135 illustrations.

Appendix: The figureheads of the frigate *Constitution*, p.121-38; Notes and references, p.139-45; Bibliography,

p.147-53; List of American shipcarvers, p.155-64; Index, p.165-73.

K196   Broder, Patricia Janis. Bronzes of the American West. Introd. by Harold McCracken. N.Y., Abrams [1974]. 431p. il. (part col.)

A comprehensive survey of western sculpture in bronze from the earliest period to the present. Also includes representative work of European sculptors. "Notes" with bibliography, p.390-96; "List of illustrations," p.397-404; "Index of American Western bronzes," p.405-20; "Index of monumental American Western bronzes (arranged by state and city)," p.421-29.

K197   Craven, Wayne. Sculpture in America. N.Y., Crowell [1968]. xx, 722p. 282 il.

The basic textbook of American sculpture from 17th-century gravestones, through the classic, romantic, and academic periods, to pop and minimal art. Includes a scholarly discussion of the art of William Rimmer. "It is hoped that the present book will stimulate an interest in and enjoyment of American sculpture, and restore it to the place it deserves as an integral part of the arts of the United States." — *Pref.* Bibliography, p.675-90.

K198   Gardner, Albert Ten Eyck. Yankee stonecutters; the first American school of sculpture, 1800-1850. N.Y., Pub. for the Metropolitan Museum of Art by Columbia Univ. Pr., 1945. 6p. 1., [3]-80p., 1 1., [81]-84p. front., xii pl. on 6 l.

Traces the rise of the first American school of sculptors in the early 19th century. "It has been the aim throughout this book to treat the subject as a part of the larger pattern of American life rather than to isolate it in a separate history of sculpture." — *Introd.* Includes chapters on patronage of sculptors, the artists themselves, and the influences on their lives and work. Biographical dictionary of American sculptors born between 1800-30, p.[60]-73. "Early nineteenth-century American sculpture in the collection of the Metropolitan Museum of Art," p.[75]. Bibliography, p.[76]-80.

K199   Ludwig, Allan I. Graven images; New England stonecarving and its symbols, 1650-1815. Middletown, Conn., Wesleyan Univ. Pr. [1966]. xxxi, 482p. il., maps.

A study of religious symbols in New England art. "The book is essentially a copiously illustrated essay on one aspect of Puritanism, rather than a work of easy reference." — W. M. Whitehill (A167). Contains 256 good plates.

Contents: Introduction; (1) Puritan religion; (2) Iconography; (3) Sources and definitions of the major New England styles; Conclusions; Notes, p.433-54; Bibliographical note, p.455-59; Maps, p. 461-68; Index, p.469-82.

K200   New York. Metropolitan Museum of Art. American sculpture. a catalogue of the collection [by] Albert Ten Eyck Gardner. [N.Y.] Distributed by the New York Graphic Society. Greenwich, Conn. [1965]. xii, 192p. il.

The catalogue of the important collection of 354 pieces of American sculpture in the Metropolitan Museum of Art.

Represents the works of 176 sculptors dating from the early 19th century to mid-20th century. Arranged chronologically by sculptor's dates. Each entry includes brief biographical information, description and discussion of work, replicas, exhibitions, and references.

K201   Taft, Lorado. The history of American sculpture. New ed., with a supplementary chapter by Adeline Adams. N.Y., Macmillan, 1930. xiii, 622p., incl. il., 15 plates (incl. front.)

A pioneer work by a famous American sculptor. Covers American sculpture from its beginnings (1750-1850) through 1903. Very out-of-date. Bibliography, p.607-18; index of sculptor's names, p.619-20.

K202   Tashjian, Dickran, and Tashjian, Ann. Memorials for children of change; the art of early New England stonecarving. Middletown, Conn., Wesleyan Univ. Pr. [1974]. xv, 309p. 161 il.

A detailed, sensitive study of the 17th- and 18th-century carved gravestones of New England which emphasizes the gravestones "as works of art within their cultural context." — *Pref.* Beautifully illustrated.

Contents: Introduction: Puritan attitudes toward art; (1) Rituals for God and history; (2) Symbolic modes of Christian metamorphosis; (3) Emblems of mortality; (4) Figures of angels; (5) Portraits in stone and spirit; (6) The unfolding of imagery; (7) Tableau, allegory, and typology; (8) The icons of Essex County; (9) The John Stevens Shop of Newport; The gravestone considered: Toward an American art; The epitaphs. Notes, p.[286]-96, include bibliographical references. Selected bibliography, p.[297]-99.

K203   Thorp, Margaret (Ferrand). The literary sculptors. Durham, N.C., Duke Univ. Pr., 1965. x, 206p. il., ports.

A largely biographical study of mid-19th century American sculptors who worked in Italy and drew their subject matter from classical literature or from contemporary romantic writers.

Contents: (1) The causes of literary sculpture; (2) Rome and the Caffé Greco — Thomas Crawford, William Wetmore Story; (3) Florence and the Caffé Doney — Horatio Greenough, Hiram Powers; (4) "The White, Marmorean Flock"; (5) The exception: William Rimmer; (6) The *Nudo*; (7) Wounded Indians, *Armed Freedom,* the *Libyan Sibyl* — John Rogers, Erastus Dow Palmer; (8) Patrons, public and private; (9) Philadelphia, 1876; Notes, p.181-85; Appendix, p.186-97; Selected bibliography, p.198-202; Index, p.203-6.

K204   Tuchman, Maurice. American sculpture of the sixties. [Los Angeles]. Distr. by the New York Graphic Society, Greenwich, Conn. [1967]. 258p. il. (part col.)

The book-catalogue of an exhibition at the Los Angeles County Museum of Art and the Philadelphia Museum of Art.

Presents a survey of the most significant achievements in American sculpture in the 1960s.

Contents: Introduction; Critical essays (by Lawrence Alloway, Wayne Andersen, Dore Ashton, John Coplans,

Clement Greenberg, Max Kozloff, Lucy Lippard, James Monte, Barbara Rose, Irving Sandler; Artists' statements (excerpts from published articles and interviews by 35 sculptors); Catalog of the exhibition (166 works by 79 sculptors); Illustrations (165 works).

General bibliography, p.236, arranged chronologically. Selected group exhibitions with reviews, p.237-39. Biographies and bibliographies, p.240-56. Glossary of terms, p.257.

K205  Whitney Museum of American Art, New York. 200 years of American sculpture [by] Tom Armstrong, Wayne Craven, Norman Feder, Barbara Haskell, Rosalind E. Krauss, Daniel Robbins, Marcia Tucker. [N.Y.] David R. Godine, in association with the Whitney Museum of American Art [1976]. 350p. 353 il., 68 col. plates, ports.

A book-catalogue issued in conjunction with an exhibition shown at the Whitney Museum of American Art, N.Y., in 1976.

A beautifully designed catalogue which contains a wealth of information on American sculpture from the works of the American Indians to the advanced forms of the 1970s. Artists' biographies and bibliographies, p. [255]-323, give excellent biographical sketches and bibliographies on 139 sculptors.

Contents: (1) Aboriginal art, by Norman Feder; (2) Images of a nation in wood, marble, and bronze: American sculpture from 1776 to 1900, by Wayne Craven; (3) The innocent eye: American folk sculpture, by Tom Armstrong; (4) Statues to sculpture: from the nineties to the thirties, by Daniel Robbins; (5) Magician's game: decades of transformation, 1930-1950, by Rosalind E. Krauss; (6) Two decades of American sculpture: a survey, by Barbara Haskell; (7) Shared space: Contemporary sculpture and its environment, by Marcia Tucker.

Selected bibliography (general references, American Indian sculpture, American folk sculpture, sculpturing techniques), by Libby W. Seaberg, p.[249]-53.

## ORIENTAL COUNTRIES

K206  Brundage, Avery. The Avery Brundage Collection [of the] Asian Art Museum of San Francisco. Chinese, Korean, and Japanese sculpture. René-Yvon Lefebvre d'Argencé, ed. in charge; Diana Turner, ed. With contributions by Fred A. Cline, Yoshiko Kakudo, Clarence F. Shangraw, Sylvia Chen-Shangraw, Terese Tse, and Alexander C. Soper. Tokyo, N.Y., Kodansha [1974]. 459p. 228 plates (part col.), maps.

The first of a series of catalogues of the Avery Brundage Collection of Asian art. Includes an introductory survey of Chinese, Korean, and Japanese sculpture, by René-Yvon Lefebvre d'Argencé, p.11-28, and a comparative chronology, p. 29. The catalogue of sculpture is in three parts: (1) China, p.31-[349], plates 1-187; (2) Korea, p.[351-59], plates 188-192; Japan, p.[361-429], plates 193-228. Each section includes a chronology and a map. Each entry gives full descriptive

and critical information and bibliographical references. Inscriptions, p.431-38. Selected glossary of terms, p.439-42. Bibliography, p.443-51.

## China

K207  Barnard, Noel. Bronze casting and bronze alloys in ancient China. [Canberra] Published by the Australian National Univ. and Monumenta Serica [1961]. 336p. il., plates. (Monumenta Serica. Monograph series. 14)

A detailed study of the casting processes of ancient Chinese bronzes. Takes into account research carried on in China. Excellent illustrations, line drawings, charts.

Contents: Bronze casting and the literary evidence; Bronze casting techniques in the light of iron foundry practice; Origins and technique of bronze casting; Sectional moulds and the significance of 'sectionalism'; Analyses of bronzes; Study of patina and corrosive effect.

Appendix A: Further notes on the nature of casting by the direct process in ancient Chinese bronzes, p.243. Appendix B: Notes on the *cire-perdue* method of casting bronze, p.294.

Bibliography, p.[307]-24.

K208  Freer Gallery of Art, Washington, D.C. The Freer Chinese bronzes, by John Alexander Pope, Rutherford John Gettens, James Cahill, Noel Barnard. Wash., Smithsonian Institution, 1967-69. 2v. (v.1, 457p.; v.2, 257p.). il., maps, plates (part col.) (Freer Gallery of Art, Wash., D.C. Oriental studies, 7)

A superb catalogue of 122 Chinese ceremonial bronze vessels in the collection of the Freer Gallery. Does not include small bronze objects. Meets the highest standards of scholarly publication. "Not only does it provide a selective sampling of the Chinese bronze caster's art from the An-Yang period of the Shang dynasty down to Han times, it also covers the history of bronze collecting in the West. Not only does it include a good many vessels of the highest quality, it also has some examples of indifferent and even downright poor workmanship ... While more than 100 of the bronzes are genuine products of their times, some 15 vessels are clearly later copies, imitations, or interpretations of archaic types, and at least two others are doubtful."—*Introd., v.1.*

v.1, the *Catalog,* gives for each bronze a preliminary description of its shape, decoration, and appearance (including date, indication of inscription, dimensions, accession number); a discussion of the style and chronology of the piece; and technical observations. The catalogue contains 177 text illustrations (81 are inscriptions) on 117 plates (8 color). The bibliography, p.621-29, lists works in Western languages and works in Chinese and Japanese. List of Chinese characters and general index at end.

v.2, *Technical Studies* by R. J. Gettens, supplements the technical observations that appear in each entry in v.1 and provides detailed scientific analyses of the pieces in the collection. Contents of v.2: (I) Bronze: Constituents and beginnings; (II) Bronze in ancient China; (III) Composition; (IV) Fabrication; (V) Metallographic structure; (VI) Inscriptions; (VII) Radiography; (VIII) Patina and corrosion; (IX) Fillings, inlays, and incised decor; (X) False patina and

repairs. Appendix I: The validity of the analytical data. Appendix II: Published analyses of illustrated bronzes. The bibliography, p.243–51, lists works in Western languages, works in Chinese and Japanese, and special publications.

Publication of v.3, *Epigraphic Studies* by N. Barnard, has been canceled.

K209    Loehr, Max. Relics of ancient China from the collection of Dr. Paul Singer. N.Y., Asia Society, 1965. 170p. il. (part col.)
The catalogue of an exhibition shown in the Asia House Gallery in 1965. Short historical sections by Loehr comprise an outline of the present [i.e. 1965] state of knowledge and research in the earliest periods of Chinese art.

Selected bibliography, p.168–70.

K210    _____. Ritual vessels of Bronze Age China. N.Y., Asia Society [1968]. 183p. il. (part col.)
The catalogue of an exhibition at the Asia House Gallery in the fall of 1968.

"Our exhibition is concerned with the artistic aspects of the bronzes. It attempts to make their stylistic sequence intelligible, especially that of the early phases, Shang and Western Chou. Of the eighty pieces exhibited, no less than forty are assigned to the Shang period; twenty to Western Chou; the remaining twenty, to Eastern Chou and Han.... With but few exceptions the exhibition consists entirely of vessels, so that the same types may be seen in several versions, typifying consecutive stylistic stages."—*Introd.*

Inscriptions, p.177–80; Bibliography, p.181–83.

K211    Matsubara, Saburō. Zōtei Chugoku Bukkyo Chokokushi Kenkyū (Chinese Buddhist sculpture—a study based on bronze and stone statues other than works from cave temples). Rev. ed. Tokyo, Yoshikawa, Kōbunkan, 1966. 306p. il., 312p.
Text and captions in Japanese; title pages in Japanese and English.

An encyclopedic survey of Chinese Buddhist sculpture in bronze and stone, drawn largely from Japanese collections. Omits works in cave temples.

K212    Mizuno, Seiichi. Bronze and stone sculpture of China, from the Yin to the T'ang dynasty. Trans. by Yuichi Kajiyama and Burton Watson. Tokyo, Nihon Keizai, 1960. 38p., 77p. 153 il., 130 plates (10 col.)
Text in Japanese with English preface, summary, and list of illustrations. Most of the plates represent works shown in an exhibition of ancient Chinese sculpture held in Tokyo in 1959.

The volume as a whole is intended as a complete survey of Chinese sculpture from the earliest times; the English summary is confined to Buddhist sculpture.

K213    _____. Bronzes and jades of ancient China. Trans. by J. A. Gauntlett. Tokyo, Nihon Keizai, 1959. 100p. 168 plates (part col.)
An outline study of Chinese bronzes and jades. Text in Japanese, with English summary.

Technical descriptions of works illustrated in "List of plates" and "List of figures."

K214    Munsterberg, Hugo. Chinese Buddhist bronzes. Rutland, Vt., Tokyo, Tuttle [1967]. 192p. il.
The basic work in English on Chinese Buddhist bronzes. Preliminary chapters on the introduction of Buddhist imagery into China and materials and techniques are followed by eight chapters on various types and aspects of Buddhist bronzes. Works of each type are described in chronological order, with dated pieces as fixed points of reference. Also contains chapters on inscriptions and dates, and collections, auction prices, and forgeries.

Appendix I: Major dated Chinese Buddhist bronzes; Appendix II: List of museums and art galleries. Selected bibliography, p.183–85.

K215    Rudolph, Richard C. Han tomb art of West China: a collection of first- and second-century reliefs [by] Richard C. Rudolph in collaboration with Wen Yu. Berkeley, Univ. of California Pr., 1951. 67p. 100 figs.
A study of bas-reliefs in stone and clay of the Han period in the Szechwan province of western China. Reproduces rubbings from one hundred reliefs, with detailed description and interpretation of each. Excellent, brief introduction.

Glossary, p.45-47. Bibliography, p.49-63, subdivided into western European, Chinese, and Japanese language sources.

K216    Sirén, Osvald. Chinese sculpture from the fifth to the fourteenth century; over 900 specimens in stone, bronze, lacquer and wood, principally from northern China. With descriptions and an introductory essay. London, Benn; N.Y., Scribner, 1925. 4v. il. (incl. plans), 623 plates. (Repr.: N.Y., Hacker, 1970)
The emphasis is on Buddhist sculpture. Plates are arranged chronologically and divided into provincial groups within the chronological framework.

Contents: v.1, Text; v.2–4, Plates.

K217    Soper, Alexander Coburn. Literary evidence for early Buddhist art in China. Ascona, Switzerland, Artibus Asiae, 1959. 296p. (Artibus Asiae. Supplementum. 19)
A translation of those parts of Ōmura Seigai's monumental history of Chinese sculpture (*Shina Bijutsu-shi, Chōso-hen,* Tokyo, 1915) particularly relevant to the study of Six Dynasties Buddhist art. Seigai's work "remains unique ... as an anthology of source material on Chinese sculpture, an inexhaustible mine of quotations from texts or inscriptions, usually contemporary with the monuments themselves."—*Introd.* The author-translator's conclusions from the translated texts are summarized in a separate section.

Appendix: The best-known Indian images. Contains bibliographical footnotes.

K218    Swann, Peter C. Chinese monumental art. Photos. by Claude Arthaud and François Hébert-Stevens. N.Y., Viking [1963]. 276p. il. (part col.), maps.
Valuable for fairly recent photographic documentation of some less well-known art in China. The text provides an intelligent general background, with enlightening analyses of the illustrations.

**K219**   Tokiwa, Daijo, and Sekino, Tadashi. Shina Bukkyō Shiseki (Buddhist monuments in China). Tokyo, Society for the Study of Buddhist Monuments, 1925–38. 11v. plates, plans.

Japanese title: *Tze-nah Foh Kiauh sze chich*. Five plate volumes; six text volumes, published in portfolio. Texts in Japanese and English.

A compilation of plates of Buddhist monuments in China grouped according to site, with accompanying descriptions and commentaries.

**K220**   Watson, William. Ancient Chinese bronzes. London, Faber and Faber [1962]. 117p. il., 107 plates.

"This book describes the artistic bronzes of ancient China from the beginning of bronze-founding in the middle of the second millennium B.C. to the end of the second century A.D. This period includes the Shang, Chou and Han dynasties."—*Introd.*

Contents: (1) Introduction; (2) Ritual vessels; (3) Ornament; (4) Inscriptions on the vessels; (5) Vessels; A note on bronze technique.

Bibliography, p.104-6. Bibliographical references in "Notes" p.107-14.

**K221**   Weber, George W. The ornaments of late Chou bronzes; a method of analysis. New Brunswick, N.J., Rutgers Univ. Pr. [1973]. 631p. il.

Not a survey of or an introduction to late Chou bronzes. "This study is directed toward the visual isolation and definition of ornaments of the Chinese ritual bronzes of the sixth to the fifth century B.C., with the objective of establishing a method of analysis for their distribution and dating."—*Pref.* The major portion of the book is given over to the catalogue, divided into sections on ornaments, embellishments, bands, and special features. The catalogue is illustrated with hundreds of diagrammatic renderings of bronze ornaments by the author; each example considered is meticulously and exhaustively described.

Notes, p.609-16, include numerous references. List of Chinese terms, p.617-23. Bibliography (in English and Chinese), p.625-31.

## India and Nepal

**K222**   Bachhofer, Ludwig. Early Indian sculpture. Paris, Pegasus; N.Y., Harcourt [1929]. 2v. 161 plates. (Repr.: N.Y., Hacker, 1972.)

A standard, older work. Contains 124p. of introductory text and section of 162 excellent plates.

Bibliography, v.1, p.125-28.

**K223**   Barrett, Douglas. Early Cola bronzes. Bombay, Bhulabahai Memorial Institute [1965]. viii, 46p. 102 plates.

A pictorial survey of early Cola bronzes, with a concise, authoritative text. Provides the first systematic study of the history of early Cola art. Includes bibliographical footnotes.

**K224**   Freer Gallery of Art, Washington, D.C. The Freer Indian sculptures. Catalogue by Ashwin Lippe. Washington, Smithsonian Institution, 1970. xv, 54p. map, 55 plates (4 col.) (Freer Gallery of Art, Wash., D.C. Oriental studies, 8)

The catalogue of the Freer Gallery's collection of Indian sculpture. Though small, this collection of rare and exceptional pieces is of considerable importance to scholars and connoisseurs.

Contents: Introduction; (I) Barhut stupa railing; (II) Gandhara frieze; (III) Durga from Java; (IV) Chola Parvati; (V) Pala Vishnu; (VI) Sena Vishnu; (VII) Orissa ivory.

Bibliography, p.47-49. References in footnotes.

**K225**   Harle, J. C. Gupta sculpture; Indian sculpture of the fourth to the sixth centuries A.D. Oxford, Clarendon, 1974. 57p. 149 plates.

A scholarly study of the origins and development of Gupta temple sculpture in stone and terracotta from 320 A.D. to 550. Works illustrated include both the familiar and the recently discovered. Documentation and references in the footnotes.

Contents: Introduction; Eastern Mālwā and Central India; Mathurā; The eastern Madhyadésa and Sārnāth; The periphery: Ajantā and Western India; The late Gupta style; Terracottas. Bibliographical note, p.32. Notes on the plates, p.33-57.

**K226**   Kramrisch, Stella. Indian sculpture. London, N.Y., Oxford Univ. Pr.; Calcutta, Y.M.C.A. Pub. House, 1933. 240p. 116 il. on 50 plates, map.

"Not an outline of the history of Indian sculpture but rather stylistical investigations of Indian sculpture as conditioned by the Indian craftsman."—*Pref.*

Contents: (1) Ancient Indian sculpture; (2) Classical sculpture; (3) Medieval sculpture; (4) Essential qualities of Indian plastic art; (5) Explanation of plates. Bibliography, p.[225]-28. Index of names and subjects.

**K227**   Pal, Pratapaditya. The arts of Nepal. Part 1, Sculpture. Leiden/Köln, Brill, 1974. 186p. 300 plates. (Handbuch der Orientalistik: 7. Abt., Kunst und Archäologie; 3. Bd.; Innerasien, 3. Abschnitt; Tibet, Nepal, Mongolei, 2. Lfg.)

Based on the author's thesis, *Sculpture and painting of Nepal*, Cambridge Univ., 1965. The 1st volume of a planned 3v. work; the 2d volume will be on painting, the 3d on architecture.

This volume is devoted exclusively to the stone and bronze sculpture of "the valley of the Bagnati, the cradle of Nepali culture."—*Pref.* An important aspect of the work is the establishment of a chronological framework for Nepalese sculpture by means of a method which can be applied to the study of Indian sculpture.

Contents: Introduction; (I) Corpus of datable material; (II) Early sculpture and stylistic problems; (III) Vaisnava sculpture; (IV) Saiva sculpture; (V) Buddhist sculpture; (VI) Female form and miscellaneous sculpture; (VII) Narrative reliefs and images of energy; Conclusion. Bibliogra-

phy, p.168–69. List of illustrations, p. 177–86. 300 plates at end.

**K228** _____. Bronzes of Kashmir. N.Y., Hacker, 1975. 225p. 130 il.

A scholarly study of the history and stylistic development of Kashmiri bronzes produced over a period of 600 years.

Contents: Introduction; Brahmanical bronzes; Buddhist bronzes; Stylistic analysis; Sources and influences; Conclusion. Well illustrated. Includes notes and selected bibliography.

SEE ALSO: Barrett, D. *Early Cola architecture and sculpture, 866–1014 A.D.* (J348).

## Japan

For English-language works on Japanese sculpture see also the two series: *Arts of Japan* (I550) and *Heibonsha survey of Japanese art* (I552).

**K229** Davey, Neil K. Netsuke, a comprehensive study based on the M. T. Hindson collection. Pref. by W. W. Winkworth. N.Y. and London, Sotheby Parke-Bernet [1974]. 564p. il. (part col.), plates.

The most comprehensive work published on netsuke, covering the period from mid-16th century to the Meiji revolution of 1868. The introduction provides a concise history of netsuke art and a thorough discussion of the various techniques and materials used by netsuke carvers. The major portion of the book is given to the catalogue of the M. T. Hindson Collection, sold at Sotheby's, London, in seven sales from June 1967 to June 1969, and supplemented by examples from other collections. Also includes sections on lacquer artists, metalworkers, unclassified artists, unknown artists, unsigned and unattributed ivory and wood netsuke, and various materials. All entries are fully described with provenance, carver or attributed carver, and references. Superbly illustrated with over 1,200 black-and-white photographs and a few color reproductions of netsuke.

Subject index, p.441–44. Glossary of Japanese terms, p.445–46. Index of known artists, p.449–555, is a list of all known *netsukeshi* (3,425 names) in Western alphabet and Japanese characters. Prices, p.[557]–64, in pounds sterling and U.S. dollars.

**K230** Hurtig, Bernard. Masterpieces of netsuke art: one thousand favorites of leading collectors. N.Y., published for the International Netsuke Collectors Society [by] Weatherhill [1973]. 245p. 1,091 col. il.

A pictorial compendium of 1,000 examples of netsuke drawn from more than 20 outstanding private collections and reproduced in 1,091 color illustrations. Not intended as an historical or technical work but as a visual reference for the collector and amateur. Entries provide brief descriptions, with title or subject, material, and carver if signed.

Bibliography, p.233. Index of carvers, p.235–38. Glossary-index, p.239–45.

**K231** Masterpieces of Japanese sculpture. Photographed by Yasukichi Iris [and others]. Introd., text and commentaries by J. Edward Kidder, Jr. Tokyo, Bijutsu Shuppan-sha; Rutland, Vt., Tuttle [1961]. 328p. 199 plates (part col.)

Trans. of *Nihon no chōkoku,* Tokyo, 1960, based on *Album of Japanese sculpture,* Tokyo, 1952–53.

Primarily a volume of plates, with introductory text and notes on the plates. Appendix A, Buddhist iconographical terms; Appendix B, Biographical, geographical, and historical terms. Bibliography, p.310–14.

**K232** Miki, Fumio. Haniwa, the clay sculpture of proto-historic Japan. English adaptation by Roy Andrew Miller. Rutland, Vt., Tuttle, 1960. 160p. il. (part col.)

Valuable as a study of the subject, especially of the Haniwa costumes, and for the excellent illustrations. This English ed. unfortunately omits the full inventory of all known Haniwa sculptures and their sites, included in the Japanese ed. of 1958.

**K233** Ueda, Reikichi. The netsuke handbook, adapted from the Japanese by Raymond Bushell. Rutland, Vt., Tuttle [1961]. 325p. il. (part col.)

An adaptation into English of "the only comprehensive work on the subject of netsuke written by a Japanese ...."—*Adaptor's pref.* Pt. 1 comprises chapters on the history of netsuke, their functions, materials, and regional characteristics as well as other aspects. Pt. 2 is an index of netsuke carvers (p.213–311). Bibliography, p.313–14.

**K234** Warner, Langdon. The craft of the Japanese sculptor. N.Y., McFarlane, and Japan Society of New York, 1936. 55p. 86 l. 85 plates.

Primarily a collection of plates illustrating Japanese sculpture from about A.D. 552–1867, with brief comments. An introductory text traces the development of techniques.

**K235** _____. Japanese sculpture of the Tempyo period: masterpieces of the eighth century. Ed. and arr. by James Marshall Plumer. Cambridge, Harvard Univ. Pr. [1959]. 165p. il. and portfolio (217 plates)

Text and plates published together in 1v. ed., 1964.

Pt. I of the text volume is a sensitive analysis and appreciation of the sculpture of the Tempyo period. Pt. II consists of technical descriptions and commentaries on the plates. Bibliography, p.155–56.

**K236** Watson, William. Sculpture of Japan, from the fifth to the fifteenth century. London, The Studio [1959]. 216p. chiefly il.

Attempts to present "a brief description of the styles and historical and religious background of Japanese sculpture from earliest times until the end of its latest creative phase, which lasted until about A. D. 1500."—*Pref.* Reliable for specific data in brief text. Exemplary selection of illustrations.

## Southeast Asia

K237  Boisselier, Jean. La sculpture en Thailande. Légendes par Jean-Michel Beurdeley. Photos de Hans Hinz. Paris, Bibliothèque des arts [1974]. 270p. il. (part col.), maps.

English ed.: *The heritage of Thai sculpture*, N.Y., Weatherhill [1975].

A comprehensive survey of the major stylistic periods and regions. Superb reproductions. Contents, pt. 1, Caractères généraux: Introduction; (1) Les constantes; (2) Les techniques et leurs impératifs; pt. 2, Les écoles: Introduction; (1) Les premières images; (2) L'école de Dvâravatî; (3) L'école de Srîvijaya; (4) L'école de Lopburi; (5) L'école de Sukhothai; (6) L'école du Lan Na; (7) L'école d'Ayuthya; (8) L'école de Thonburi et de Bangkok. Appendixes: (I) L'image du Buddha; (II) Les Roues de la Loi.

Notes et références bibliographiques, p.216–20. Légendes de l'illustration, p.221–36 (includes commentary with identification, dimensions, provenance, present location, on 145 text illustrations). Glossaire, p.237–41. Bibliographie, p.242–44. Tableaux chronologiques, p.249–63 (India, Ceylon, Southeast Asia, Thailand, and China from the 6th century B.C. through the 19th).

K238  _____. La statuaire khmère et son évolution. Saigon, École Française d'Extrême-Orient, 1955. 2v. (v.1, 322p.; v.2, 114 plates). (École Francaise d'Extrême-Orient, Hanoi, Indo-China. Publications. v. 37)

The basic, scholarly study of the chronology, development, and independent characteristics of Khmer sculpture from the 6th century to the 15th.

Contents, v.1: Introduction; pt. 1, La statuaire humaine et l'évolution de ses principaux éléments: (1) Le costume; (2) La parure; (3) La technique des images; pt. 2, (1) Caractère des divers styles de la statuaire; (2) Arguments en faveur de la chronologique proposée; (3) L'Ancienne chronologique et notre étude; (4) La statuaire khmère et les arts extérieures; Appendixes: Les bronzes; Les problèmes non résolus; L'évolution de la statuaire et les donnés historiques; Conclusion; Notes et références bibliographiques; Index (index des noms d'auteurs; index des références archéologiques et historiques). Contents, v.2: Plates.

K239  Bowie, Theodore Robert. The sculpture of Thailand. Theodore Bowie, editor, M.C. Subhadradis Diskul [and] A.B. Griswold. Photos. by Brian Brake. [N.Y.] Asia Society. (Distr. by New York Graphic Society [1972]). 137p. il. (part col.)

The catalogue of an exhibition held at the Asia House Gallery, N.Y., and other museums in 1972.

Provides an excellent introductory summary of the stylistically diverse sculpture of Thailand. Includes 80 catalogue entries with detailed descriptions and commentaries. Superbly illustrated.

Contents: Introduction by Theodore Bowie; "Images of the Buddha" by A. B. Griswold; Chronology; Map; Catalogue and plates; Notes by M. C. Subhadradis Diskul; Appendix. Selected bibliography, p.136–37.

K240  Giteau, Madeleine. Khmer sculpture and the Angkor civilization. [Trans. by Diana Imber]. N.Y., Abrams [1966]. 301p. il. (part col.), map, plans.

An informative introduction to Khmer stone, bronze, and wood sculpture treated in its social, historical, and religious context. Well-reproduced plates in the catalogue, p.[199]–247. The 135 catalogue entries include commentary, provenance, present location, dimensions, and date.

Glossary, p.249–53; Bibliography, p.255–56; Plan of the Great Square of Angkor Thom, p.259; Map of Cambodia, p.260; Plan of the monuments at Angkor, p.263; Comparative chronology, p.267–98 (Cambodia, South East Asia, India, China and the Far East, the West, the Middle East).

K241  Salmony, Alfred. Sculpture in Siam. London, Benn, 1925. xvi, 51p. map, 70 plates (Repr.: N.Y., Hacker, 1972.)

An early history of the evolution of sculpture in Siam.

Contents: Introduction; (1) Preliminaries; (2) Ligor; (3) Prapatom; (4) Sawankolok; (5) Lopburi; (6) Pitsanulok; (7) Sukothai; (8) Ayuthia; (9) Soil, race, religion; (10) Chronology and development; (11) Form and material; (12) Appreciation. Table of dates and localities, p.47. Literature and abbreviations, p.49–50.

# PRIMITIVE

## Africa

### Bibliography

For the most important bibliographies of African sculpture see: *Primitive art* in *Worldwide art book bibliography* (A56); *Primitive art bibliographies* (A179).

K242  Osundina, Oyeniyi. Bibliography of Nigerian sculpture. Univ. of Lagos Library, 1968. 35p.

Classified by the following subjects: General; Stone carving; Brass casting; Mud; Bronze casting; Wood carving; Ivory carving; Terracotta; Plastic; Cement. Author-title index and sources consulted.

### Histories and Handbooks

K243  Allison, Philip. African stone sculpture. N.Y., Praeger [1968]. vii, 71p. plates (99 figs.), maps.

A significant work in which the aim is "to illustrate and describe representative and outstanding examples of traditional stone sculpture from Africa south of the Sahara, and to record briefly what little is known of the culture which produced them."—*Introd.*

Excellent bibliography, p.65–69.

K244  Carroll, Kevin. Yoruba religious carving: pagan and Christian sculpture in Nigeria and Dahomey. Fore-

word by William Fagg. N.Y., Praeger [1967]. xi, 172p. il. (part col.)

"Authoritative ... Deals with the effort to keep traditional style alive by applying it to Christian themes. Presents an important account of traditional Yoruba religion. Especially valuable for studies of the careers of three Yoruba carvers and individual stylistic development, which give insight into the important question of the relation between personal and tribal styles."—*Primitive Art* (A56, GA64).

Bibliography, p.69.

K245  Cornet, Joseph. Art of Africa: treasures from the Congo. [London] Phaidon [1971]. 365p. 74 il., 108 col. plates, 4 maps.

Trans. by Barbara Thompson of *Art de l'Afrique noire au pays du fleuve Zaïre,* Brussels, Arcade, 1971.

Contents limited to sculpture produced within the political boundaries of the present Republic of Zaïre. Distinguished for the many color reproductions of outstanding pieces, but disappointing for oversimplifications and inconsistencies of the text. Excellent, extensive bibliography of more than 650 entries, p.331-54.

K246  Dark, Philip John Crosskey. An introduction to Benin art and technology. Oxford, Clarendon, 1973. 114p. 206 il. on 80 plates, maps.

A sound, basic study of Benin art synthesizing detailed formal, ethnographic, and historical information accumulated from field work and examination of works.

Contents: (1) Chronology; (2) A Western view of some principal forms of Benin art; (3) The context of Benin art; (4) Artists, artisans, and craftsmanship; (5) Designs and designing; Lists of collections of Benin art.

Bibliography, p.83-85. Extensive notes on the plates, p.[87]-109, give for each piece Benin Scheme visual file number, dimensions, location or collection, commentary, references. Bibliographical references in footnotes.

K247  Elisofon, Eliot. The sculpture of Africa; 405 photographs. Text by William Fagg. Pref. by Ralph Linton. Design by Bernard Quint. N.Y., Praeger [1958]. 256p. il., map.

Excellent photographs; informative introductory text. An evaluation of the literature on African sculpture is included in the "Bibliographical notes," p.252-54.

K248  Fagg, William. Nigerian images. Photos. by Herbert List. London, Lund Humphries [1963]. 124p. 145 plates, map.

This "book began as a kind of commemorative volume for the series of exhibitions of Nigerian art (Fagg organized) ... in 1960-62 in Great Britain, Germany and Switzerland."

Through a selection of beautifully reproduced illustrations, attempts to give "a reasonably balanced account [of ancient and recent Nigerian art] from the artistic, ethnological and historical points of view."—*Pref.*

Glossary, p.11-14.

K249  Kjersmeier, Carl. Centres de style de la sculpture nègre africaine. Paris, Morancé; Copenhague, Illums,

1935-38. 4v. 236 plates. (Repr. in 1v.: N.Y., Hacker, 1967.)

The first attempt to classify African sculpture into tribal styles. Although largely superseded by later research, it is still valuable for documentation on the sculptures reproduced.

Each volume contains a section of "Notes et bibliographie" and a "Liste des illustrations," giving tribe, function of piece, height, provenance, collector, collection, text page reference, and plate number. v.4 contains a "Liste des tribes dont la sculpture est traitée dans les volumes I–IV" and a "Liste des musées dont les collections de sculptures nègres africaines ont été visitées et étudiées par l'auteur."

K250  Sydow, Eckart von. Afrikanische Plastik. Aus dem Nachlass hrsg. von Gerdt Kutscher. N.Y., Wittenborn [1954]. 176p. 144p. of il., maps.

Originally planned as v.2 of the author's *Handbuch der afrikanischen Plastik* (K251). Still valuable for its illustrations.

Contents: (1) Allgemeine Betrachtung; (2) Die Plastik in Sudan, Nord-Kongo, Ost- und Südzentral-Afrika; (3) Nachträge zur westafrikanischen Plastik.

Includes bibliographies, mostly at the end of chapters. "Erlauterungen zum Tafelteil," p.157-73, gives size. "Verzeichnis der Schriften von Eckart von Sydow," p.174-77.

K251  ———. Handbuch der afrikanischen Plastik. v.1. Die westafrikanischen Plastik. Berlin, Reimer und Vohsen, 1930. 494p. 10 plates.

A systematic survey on the sculpture of Senegambia, Sierra Leone, Liberia, Ivory Coast, Gold Coast, South Togo, Southern Nigeria, the Cameroons, French Equatorial Africa, the Lower Congo, South Belgian Congo, and Northern Angola. v.1 of a planned work; v.2, *Afrikanische Plastik* (K250) completed by Gerdt Kutscher and published posthumously.

K252  Trowell, Margaret. Classical African sculpture, [3d ed.]. London, Faber & Faber; New York, Praeger [1970]. 101p. 48 plates, maps.

1st ed. 1954.

"An introduction to the subject ... The book shows its age by presenting some theories no longer generally accepted & relatively little new information or insights are offered. Usually cited as a standard work."—*Primitive Art* (A56, GA42).

Contents: (1) The appreciation of African art; (2) The function of the craftsman and his art; (3) Geography, history and social pattern; (4) A brief critique of African sculpture.

Bibliography, p.97.

K253  Willett, Frank. Ife in the history of West African sculpture. N.Y., McGraw-Hill [1967]. 232p. il., map, plan, plates (part col.)

"Deals primarily with the bronze, terra-cotta and stone sculpture of Ife ... It includes an extensive exposition of works in these and other media from elsewhere, by means of which Willett attempts to set the art of Ife in perspective and to show its place ..."—Review by A. Rubin, *Art bulletin* 52:348 (Sept. 1970). Based partially on the author's field research.

Bibliography, p.216-26.

K254  Williams, Denis. Icon and image; a study of sacred and secular forms of African classical art. London, Lane; [N.Y.] New York Univ. Pr. [1974]. xiv, 331p. il.
A study of the aesthetic values and iconographical relationships inherent in the sculpture of the major Nigerian schools through an examination of their significant forms.

Contents: pt. 1, The forms of the cult object; pt. 2, Iron and the gods; pt. 3, Copper, bronze, gold; pt. 4, Summary and conclusions.

Notes and references, p.303–15. Bibliography in three parts: (A) Literary sources (a classified listing of books and articles); (B) Museums, sites, and shrines (museums in Europe, Africa, the U.S.; sites and shrines in Africa); (C) Local and oral traditions. General index.

K255  Wingert, Paul Stover. The sculpture of Negro Africa. N.Y., Columbia Univ. Pr., 1950. 96p. il., plates, map.
A survey of the sculpture of four geographical regions: West Africa, Cameroon, Central Africa, East Africa. Within each region, major art-producing areas are defined and tribal styles characterized.

"African Negro sculpture in American collections," p.79–81, lists and describes significant museum collections. Bibliography, p.[83]–96.

## The Americas

K256  Easby, Elizabeth Kennedy, and Scott, John F. Before Cortes: Sculpture of Middle America. Catalogue by Elizabeth Kennedy Easby and John F. Scott. Foreword by Thomas P. F. Hoving. Pref. by Dudley T. Easby, Jr. [N.Y.] Metropolitan Museum of Art, (Distributed by New York Graphic Society [1970].) 322p. il. (part col.), maps.
The catalogue of a centennial exhibition at the Metropolitan Museum of Art from Sept. 30, 1970, through Jan. 3, 1971.

An excellent catalogue of over 300 sculptures in stone, clay, wood, gold, jade, and bone from Mexico, Central America, and the West Indies dating from c.1500 B.C. Each chapter includes an essay on the historical context and aesthetic qualities of the works.

Contents: (1) High cultures of Middle America; (2) The beginnings of sculpture; (3) Olmec leaders, sculptors, and lapidaries; (4) Post-Olmec and Izapan art; (5) The western fringe; (6) Urban Teotihuacán; (7) Gulf coast sculpture in clay and stone; (8) Zapotec tombs and offerings; (9) The Maya realm; (10) The wealth of the Indies; (11) Toltec imperial art and its heirs; (12) The Aztecs: the last empire.
Bibliography, p.319.

## Oceania

K257  Cox, J. Halley, and Davenport, William H. Hawaiian sculpture. Honolulu, Univ. Pr. of Hawaii, 1974. ix, 198p. il.
The authors' aim is to present an "analysis of Hawaiian sculpture in all its technical and stylistic complexity and in its social and cultural relationship."—*Foreword.* Following introductory essays on the historical, cultural, and stylistic aspects of Hawaiian sculpture is a descriptive catalogue of all extant pieces presently known. Bibliographical references and illustrations are included for most entries. "The Summary of collections," p.118, lists locations of known sculptures. Bibliography, p.195–97.

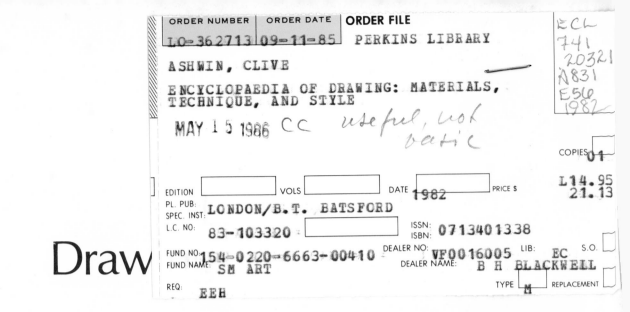
# Draw

Works concerned with the history and technique of drawing are listed in this chapter. Those in the section General Works include significant exhibition catalogues and the important inventory catalogues of major collections. Regional subdivisions correspond generally to those in chapter I, Histories and Handbooks.

## GENERAL WORKS

L1   Bibliothèque Nationale, Paris. Département des Estampes. Inventaire général des dessins des écoles du nord, par Frits Lugt, avec la collaboration de J. Vallery-Radot. [Paris] Editions des Bibliothèques Nationales de France, 1936. iii, 87p. 84 plates on 43 l.
A scholarly catalogue of the German, Dutch, Flemish, and English drawings in the collection of the Bibliothèque Nationale, which includes among others important sheets by Rembrandt and Dürer. The first of a series of inventory catalogues.
   Contents: Écoles allemande et suisse (entries 1-137); Écoles des Pays-Bas: flamande et hollandaise (entries 138-295); École anglaise (entries 296-301). Entries are arranged chronologically within sections. Each entry includes description, commentary, and often references.
   "Index des artistes, des portraits et des noms de lieu," p.85-[88].

L2   Bjurström, Per. Drawings in Swedish public collections. Stockholm, Nationalmuseum, 1972-(76). v.1-(2) il. (part col.)
The first 2v. of a projected series of 7v. of catalogues of European drawings in Swedish public collections, the majority of which are in the collection of the Swedish Nationalmuseum, Stockholm. v.1, German drawings, contains reproductions of and detailed information on 660 drawings by about 150 draughtsmen from Germany, Austria, and Switzerland, dating from c.1460 to c.1880. v.2, French drawings of the 16th and 17th centuries (including sheets by Poussin, Callot, Claude, and Le Brun), contains 787 drawings. Additional drawings

on the versos and comparative works are also reproduced in both volumes. v.2 does not include the theatre drawings or most of the decorative and architectural drawings in the Nationalmuseum's collection.
   Further volumes of the series will catalogue 18th- and 19th-century French drawings, Italian drawings, and Dutch and Flemish drawings.

L3   British Museum. Dept. of Prints and Drawings. A handbook to the drawings and watercolours in the Department of Prints and Drawings, British Museum, by A. E. Popham. London, Printed by order of the Trustees, 1939. 144p. 8 plates.
The British section was written by Edward Croft-Murray and part of the Netherlands section by A. M. Hind (*Pref.*). Still considered the best introductory handbook in English on the subject of drawings.
   Appendixes: (1) The growth of the British Museum collection; (2) Collections of drawings; (3) Reproductions of drawings. Bibliographical footnotes.

L4   Byam Shaw, James. Drawings by old masters at Christ Church, Oxford. Oxford, Clarendon, 1976. 2v. (v.1, xi, 445p., 139 il.; v.2, 890 plates).
A critical catalogue of the nearly 2,000 drawings of all schools in the collection at Christ Church, Oxford. Most were bequeathed by General John Guise in 1765. The approximately 1,200 drawings of the Italian school comprise the most important part of the collection.
   Contents, v.1: List of abbreviated titles, p.[ix]-x; Exhibitions, p.[xi]; Introduction, p.[1]-24; Excursus: Two notes on General John Guise, p.[25]-31; The Catalogue: Florentine School; Sienese School; Artists working chiefly in Rome; Venetian School; Bolognese School; Lombard and Emilian Schools; Genoese School; Neapolitan School; Uncertain Schools; Netherlandish School; German and Swiss Schools; French School; English School; Spanish School. Appendixes: (I) Secondary series; (II) The Ridolfi albums. Catalogue entries include artist or attribution, date of work, medium, description, provenance, exhibitions, bibliographical references, and commentary.
   Indexes of artists' names, related works, and selected subjects.

L5     De Tolnay, Charles. History and technique of old master drawings, a handbook. N.Y., Bittner [1943]. 155p. plates. (Repr.: N.Y., Hacker, 1973.)

"The present work may be conceived as in some respects a complement to Meder [L23] .... In the selection of plates, the attempt was made to illustrate by means of characteristic and qualitatively outstanding examples the development of European drawing."—*Pref.*

Covers roughly late 14th to the late 19th centuries.

Contents: (1) Survey of the theories of drawing; (2) Methods of construction; (3) Creative processes and categories of drawing; (4) The origins of Renaissance and modern drawing; (5) Principal methods of treatment; (6) Survey of the development of drawing; (7) Materials and techniques; (8) Survey of the development of great public and private collections.

Includes bibliographical references in "Notes," p.87–100. Catalogue, p.103–49, usually gives dimensions. Index of names, p.151–55, gives persons, collections, codices, and reproductions.

L6     Disegni dei maestri. A cura di Walter Vitzthum. Milano, Fabbri [1970–(71)]. 16v. il., plates.

A series of well-illustrated volumes by recognized authorities on various periods and schools of drawing. Each volume includes an historical summary, a two-part catalogue of drawings reproduced in black and white and in color, a general bibliography, and index of artists. For each drawing gives location, inventory number, techniques, provenance, bibliography, and commentary.

Contents: (1) Forlani Tempesti, Anna. *Capolavori del rinascimento. Il primo Cinquecento toscana* (1970); (2) Pignatti, Terisio. *La scuola veneta* (1970); (3) Fossi Todorow, Maria. *L'Italia dalle origini a Pisanello* (1970); (4) Pérez Sánchez, Alfonso E. *Gli spagnoli da El Greco a Goya* (1970); (5) Béguin, Sylvie M. *Il Cinquecento francese* (1970); (6) Sérullaz, Maurice. *L'Ottocento francese* (1970); (7) Gerszi, Teréz. *Capolavori del rinascimento tedesco* (1970); (8) Kuznetsov, I. I. *Capolavori fiamminghi e olandesi* (1970); (9) Vitzthum, Walter. *Il barocco a Napoli e nell'Italia meridionale* (1970); (10) Gere, John A. *Il manierismo a Roma* (1971); (11) Rosenberg, Pierre. *Il Seicento francese* (1971); (12) Johnston, Catherine. *Il Seicento e il Settecento a Bologna* (1971); (13) Bacou, Roseline. *Il Settecento francese* (1971); (14) not published (?); (15) Russoli, Franco. *Il Novecento* (1971); (16) Monbeig-Goguel, Catherine. *Il manierismo fiorentino* (1971).

L7     Eisler, Colin. The seeing hand: a treasury of great master drawings. New York, Harper [1975]. 263p. il., col. plates.

An informal, lavishly illustrated survey of the art of drawing by type of depiction. Each section of drawings reproduced is preceded by an introductory essay. Each drawing is accompanied by a catalogue entry giving location, description, provenance, bibliography, and brief commentary.

Contents: (1) Portraits; (2) Landscape; (3) Figures; (4) Animals; (5) Allegory, myth, and fantasy; (6) Religious subjects; (7) Genre; (8) Still life; (9) Ornament and architecture. A note on graphic techniques and conservation, p.[260–62]. Bibliography, p.263.

Many of the reproductions are from the series *I Disegni dei maestri* (L6).

L8     Florence. Galleria degli Uffizi. Gabinetto dei Disegni e delle Stampe. Cataloghi, no. [1]– . Firenze, Olschki, etc., 1951– . il.

A series of catalogues of exhibitions of drawings and prints organized by the Uffizi, primarily from the Uffizi's unparalleled collections. All catalogues follow a uniform format, with scholarly essays, full catalogue entries, bibliographies, and reproductions.

Examples: [1] Mostra di disegni d'arte decorativa (1951); [4] Mostra di disegni veneziani del Sei e Settecento (1953); [5] Mostra di disegni dei primi manieristi italiani (1954); [7] Mostra di disegni chiaroscuri italiani dei secoli XVI, XVII, XVIII (1956); [9] Le incisioni di A. Dürer (1957); [13] Mostra di disegni di Michelangelo (1962); [17] Mostra di disegni del Vasari e della sua cerchia (1964); [25] Mostra dei disegni italiani della collezione Santarelli (1967); [30] Da Dürer a Picasso (1969); [34] Mostra di disegni italiani del XIX secolo (1971); [38] Mostra di disegni italiani di paesaggio del Seicento e del Settecento (1973).

L9     Leporini, Heinrich. Die Künstlerzeichnung; ein Handbuch für Liebhaber und Sammler ... mit 169 Abbildungen im Text. Berlin, Schmidt, 1928. 405p. 169 il. (Bibliothek für Kunst- und Antiquitäten-Sammler, Bd. XXX)

An older, general survey of drawings. Contents: (1) Einführung; (2) Die Entwicklung der Handzeichen; (3) Der Sammler. "Literatur und Reproduktionen," p.[390]–98.

L10    Mongan, Agnes, ed. One hundred master drawings. Cambridge, Harvard Univ. Pr., 1949. 208p. il.

Presented in honor of Paul J. Sachs. "Seventy master drawings," a loan exhibition at the Fogg Museum of Art, Nov. 1948–Jan. 1949, held on the occasion of the 70th birthday of Paul J. Sachs, and 30 additional drawings from the Museum's collections.

Reproductions of drawings with descriptive text by various experts. Bibliographical references given for each drawing.

"Books frequently cited," p.203–4. "Glossary of materials," p.205–7.

L11    Moskowitz, Ira, ed. Great drawings of all time. N.Y., Shorewood [1962]. 4v. 1,107 plates (part col.)

A compilation of reproductions of master drawings, with text and commentaries by an international team of experts. Drawings are reproduced in as near actual size as possible.

Contents: v.1, Italian, 13th through 19th century; v.2, German, Flemish, and Dutch, 13th through 19th century; v.3, French, 13th century to 1919; v.4, Oriental, Spanish, English, American, and contemporary. Eight-page bibliography at end of v.4.

L12    Paris. Musée National du Louvre. Cabinet des Dessins. Expositions du Cabinet des Dessins. Paris, Editions des Musées Nationaux, 1951– . v.1– . il.

A series of excellent exhibition catalogues of drawings and prints, written primarily by the curatorial staff of the Cabinet

des Dessins. The catalogues generally follow a uniform format, with scholarly essays, full entries, bibliographies, and reproductions.

Examples: [5] Collection Carle Dreyfus (1953); [23] Dessins romains du XVIIe siècle, artistes italiens contemporains de Poussin (1959); [38] Dessins français du XVIIIe siècle. Amis et contemporains de P.-J. Mariette (1967); [41] Maîtres du blanc et noir au XIXe siècle, de Prud'hon à Redon (1968); [50] Dessins français de 1750 à 1825 dans les collections du Musée du Louvre: le néo-classicisme (1972).

L13 _____. _____. Great drawings of the Louvre Museum. New York, Braziller [1968]. 3v. col. plates.

Popular anthologies of color reproductions of outstanding drawings in the Louvre. Each volume contains a brief introductory essay, an index of artists, a plates section of 100 drawings, a concordance, an index of former owners and benefactors, and a chronological listing of publications and exhibitions of the Cabinet des Dessins of the Louvre. Each drawing is accompanied by a catalogue entry giving technique, provenance, bibliography, and critical discussion.

Contents: v.1, The French drawings, by Maurice Sérullaz, with the collaboration of L. Duclaux and G. Monnier; v.2, The German, Flemish, and Dutch drawings, by Roseline Bacou, with the collaboration of A. Calvet; v.3, The Italian drawings, by Roseline Bacou, with the collaboration of F. Viatte.

L14 Rosenberg, Jakob. Great draughtsmen from Pisanello to Picasso. Cambridge, Harvard Univ. Pr., 1959. xxvi, 142p. 256 plates.

"Presented as a series of eight lectures under the auspices of the Lowell Institute in Boston in January, 1956."

Provides an introduction to the field of drawings through essays on eight of the most historically significant draughtsman from the 15th to the 20th century.

Contents: Pisanello, Leonardo, Raphael, Dürer, Rembrandt, Watteau, Degas, Picasso. A rev. ed. (1974) includes additional essays, on Michelangelo by Rosenberg, on Goya by Phillip Hofer.

Selected bibliography, p. 141–42.

L15 Schönbrunner, Joseph, and Meder, Joseph. Handzeichnungen alter Meister aus der Albertina und anderen Sammlungen. Wien, Gerlach & Schenk [etc., 1896–1908]. 12v. 1,438 plates (part col.).

A corpus of 1,438 reproductions of master drawings in the collection of the Albertina, Vienna, and other collections in Frankfurt, Budapest, Florence, Oxford, Prague, Stockholm, and Liechtenstein. Includes an index of artists.

L16 Sterling and Francine Clark Art Institute, Williamstown, Mass. Drawings from the Clark Art Institute: a catalogue raisonné of the Robert Sterling Clark Collection of European and American drawings, 16th through 19th centuries, at the Sterling and Francine Clark Art Institute, Williamstown. By Egbert Haverkamp-Begemann, Standish D. Lawder, and Charles W. Talbot, Jr. New Haven, Yale Univ. Pr., 1964. 2v. il. plates (part col.)

A lavishly produced catalogue of 368 drawings in the collection of the Clark Art Institute. Approx. two-thirds of the drawings are 19th-century French. "Each drawing has been subjected to the most scrupulous examination. Besides the usual data, we are given, in the case of the most significant drawings, a succinct discussion of technique, style, date, and related versions (engraved, drawn, painted)."—R. Pickvance, *Burlington magazine* 108:42 (Jan. 1966).

Includes bibliographical references.

L17 Tietze, Hans. European master drawings in the United States. N.Y., Augustin [1947]. 326p. il. (Repr.: N.Y., Hacker, 1973.)

A collection of reproductions of drawings with descriptive text for each, including bibliographical references. "List of reference books," p.[1]. Index of places, p.323–24.

L18 Vienna. Albertina. Beschreibender Katalog der Handzeichnungen in der graphischen Sammlung Albertina; herausgegeben von Alfred Stix. Wien, Schroll, 1926–41. 6v. il. (Repr. v.1: Wien, Schroll, 1971.)

Critical catalogues of the incomparable collection of old master drawings in the Albertina.

Contents: v.1, Die Zeichnungen der venezianischen Schule, bearbeitet von Alfred Stix und L. Frölich-Bum (1926); v.2, Die Zeichnungen der niederländischen Schulen des XV. und XVI. Jahrhunderts, bearbeitet von Otto Benesch (1928); v.3, Die Zeichnungen der toskanischen, umbrischen und römischen schuleri, bearbeitet von Alfred Stix und L. Frölich-Bum (1932); v.4–5, Die Zeichnungen der deutschen Schulen bis zum Beginn des Klassizismus, bearbeitet von Hans Tietze und E. Tietze-Conrat, Otto Benesch, Karl Garzaralli-Thurn-lackh (1933); v.6, Die Schulen von Ferrara, Bologna, Parma und Modena, der Lombardei, Genaus, Neapels und Siziliens, bearbeitet von Alfred Stix und Anna Spitzmüller (1941).

L19 _____. _____. Master drawings in the Albertina: European drawings from the 15th to the 18th century, by Otto Benesch in collaboration with Eva Benesch. Greenwich, Conn., New York Graphic Society [1967]. 379p. 262 plates (25 col.)

Trans. into English from the German by R. Rickett and M. Schön, and revised for this ed. by F. Stampfle and R. Kraemer.

A beautifully produced volume of reproductions of drawings from the Albertina collections in which "consideration was given not only to the interests of the layman but also to those of the expert, who will find many an unpublished sheet along with everything requisite for its scholarly discussion in the commentary and bibliographical notes ...."—*Pref.*

Contains an introductory chapter, "The drawings collection of the Albertina," discussing its history and its role in research and education.

Plates, p.[33]–[316]; catalogue and bibliography, p.317; index of artists, p.377.

L20 Yale University. Art Gallery. European drawings and watercolors in the Yale University Art Gallery, 1500–1900, by E. Haverkamp-Begemann and Anne-Marie S. Logan. New Haven, Pub. for the Yale Univ. Art Gallery by Yale Univ. Pr., 1970. 2v. 69 il., 321 plates.

A catalogue of the drawings of the French, German, British, Italian, Dutch, and Flemish schools in the collection of the Yale Univ. Art Gallery. Accomplished with the highest standards of scholarly research and book production. v.I is a catalogue of approx. 1,000 drawings, the most important of which are thoroughly described. v.II contains reproductions of the most significant drawings.

SEE ALSO: *Inventaire des collections publiques françaises* (I2); *Master drawings* (Q234); Meder, J. *The mastery of drawing* (L23); *Old master drawings* (Q259); Sachs, P. *Modern prints & drawings* (N51); Royal Institute of British Architects. Sir Banister Fletcher Library. *Catalogue of the drawings collection ...* (J59).

## TECHNIQUES

L21    Blake, Vernon. The art and craft of drawing; a study both of the practice of drawing and of its aesthetic theory as understood among different peoples and at different epochs; especial references being made to the construction of the human form from the practical draughtsman's point of view. London, Oxford Univ. Pr., Milford, 1927. 414p., il., plates, diagrs. (Repr.: N.Y., Hacker, 1971.)
An older standard work. Contents: (1) Introduction; (2) Relations between composition and drawing; (3) Technical methods; (4) Mass equilibrium; (5) Perspective; (6) The main masses of the human body; (7) Values; (8) Anatomy and form; (9) Construction of the human frame; (10) Landscape drawing; (11) "Primitive" drawing; (12) Conclusion.
Index, p.405–11. Anatomical index, p.413–[15].

L22    Lavallée, Pierre. Les techniques du dessin, leur évolution dans les différentes écoles de l'Europe. 2. éd. revue et corrigée. Paris, van Oest, Éditions d'art et d'histoire, 1949. 110p. plates.
A useful handbook by a recognized authority. Poor illustrations.
Contents: (1) La plume; (2) Le pinceau; (3) Les pointes de métal; (4) Le fusain; (5) Les pierres; (6) Le pastel; (7) Le crayon de graphite ou mine de plomb; (8) Les supports du dessin; (9) Les techniques dans l'histoire du dessin. Bibliography, p.99–103. Includes bibliographical footnotes.

L23    Meder, Joseph, and Ames, Winslow. The mastery of drawing. N.Y., Abaris [1978]. 2v. 720p. 70 il., 315 plates.
A translation and expansion of Meder's classic work on the technical aspects of master drawings, *Die Handzeichnung; ihre Technik und Entwicklung,* first published in 1919. Ames extends the coverage in text and illustrations beyond Meder's cut-off of c.1800 to include full consideration of drawings in the 19th and 20th centuries. Contains bibliography and index.

L24    Watrous, James. The craft of old-master drawings. Madison, Univ. of Wisconsin Pr., 1957. 170p. il.

An authoritative, comprehensive manual devoted to the "tools, materials, formulas, recipes, workshop procedures, and photographic enlargements" of methods applied to the art of drawing. Superb illustrations of examples and results from laboratory experiments and studio applications. Written for "contemporary artists, scholars, and students of drawings."
Contents: pt. 1, The fine drawing media: (1) Metalpoint drawing; (2) Chiaroscuro drawings; (3) Pen drawing; (4) Inks for drawing; pt. 2, The broad drawing media: (5) Chalks, pastels, and crayons; (6) Charcoal and graphite. Appendix: (1) Commercial and noncommercial sources of materials; (2) List of masterworks cited. References and notes, p.154–63.

SEE ALSO: De Tolnay, C. *History and technique of old master drawings* (L5); Plenderleith, H. J. *The conservation of prints, drawings, and manuscripts* (N72).

## WESTERN COUNTRIES

### Canada

L25    Toronto. Royal Ontario Museum. Canadian watercolours and drawings in the Royal Ontario Museum. [Catalogue comp. by] Mary Allodi. Toronto, The Royal Ontario Museum, 1974. 2v. 430 il. (part col.)
The catalogue of the collection of 18th- and 19th-century Canadian watercolors and drawings in the collection of the Royal Ontario Museum. "As a whole the collection tells the story of exploration and military campaigns, of immigration and settlement, of the shaping of the landscape and the building of cities, of industry and trade and leisure activities. It is a painted history of Canada."—*Introd.* Works by 193 identified and 80 unidentified artists are included. Along with Canadian views, the collection contains 380 views of the U. S., a few views of the West Indies and Europe, and about 100 portraits and named figure studies. Each entry gives artist when known, life or working dates, title or subject, technique, dimensions, inscriptions, inventory number, and frequently brief comments.
Contents: v.1: Introduction, by Mary Allodi; Notes on procedure; Abbreviations; Artists A to K (entries 1–1345); vol. 2: Artists K to Y (entries 1346–2220); Anonymous artists; Geographical index; Subject index.

### France

L26    Berlin. Kunstbibliothek. Die französischen Zeichnungen der Kunstbibliothek Berlin. Kritischer Katalog. Bearb. von Ekhart Berckenhagen. Mit 1045 Abb. Berlin, Hessling, 1970. 476p. of il. with text.
A critical catalogue of the collection of French drawings in the Berlin Kunstbibliothek, especially rich in architectural and decorative drawings. Includes sheets by approx. 350 different draughtsmen from the 16th to the 19th century. Noteworthy for reproducing many significant drawings.

Many attributions and the methods of attribution have been severely criticized. See review by Anthony Blunt, *Burlington magazine* 114:178-80 (Mar. 1972).

L27 Institut Néerlandais, Paris. Le dessin français de Claude à Cézanne dans les collections hollandaises completé d'un choix d'autographes des artistes exposés. [Paris] 1964. 2v. (v.1, 176p.; v.2, 168 plates).
The catalogue of an exhibition shown at the Institut Néerlandais, Paris, and the Rijksmuseum, Amsterdam, in 1964 to honor the 80th birthday of Frits Lugt.

The catalogue, written by Carlos van Hasselt, includes 207 drawings and autographs by 59 French artists from Claude to Cézanne. Entries include technical description, collection, bibliography, and critical discussion. All drawings are reproduced in the plate volume (v.2).

L28 Paris. Musée National du Louvre. Inventaire général des dessins du Musée du Louvre et du Musée de Versailles. École française par Jean Guiffrey [et] Pierre Marcel. v.I-(XII). Paris, Librairie centrale d'art et d'architecture, 1907-(75). (12)v. il., plates.
An inventory of the collection of French drawings in the Louvre and at Versailles. Arranged alphabetically by artist. Contents, v.1-(12): Adam, Jean-Victor through Ozanne, Pierre.

For each drawing gives brief description, medium, dimensions, and inventory number. Often includes inscriptions, signature, monograms, collectors' marks, watermarks, and references. Many drawings reproduced. Facsimiles of watermarks and index at end of each volume.

L29 Windsor Castle. Royal Library. The French drawings in the collection of His Majesty the King at Windsor Castle, by Anthony Blunt. Oxford and London, Phaidon, 1945. 166 [2]p. il., plates.
A critical catalogue of the collection of French drawings at Windsor Castle. The collection is strong in 17th-century drawings, especially by Poussin and Claude Lorraine; the 16th, 18th, and 19th centuries are less well represented.
Bibliography, p.[14].
Corrections and additions to this catalogue are included in *The German drawings ... and supplements ...* (L37).

SEE ALSO: Bjurström, P. *Drawings in Swedish public collections* (L2); Moskowitz, I. *Great drawings of all time* (L11); Paris. Musée National du Louvre. *Great drawings of the Louvre Museum* (L13); Sterling and Francine Clark Art Institute. *Drawings* (L16); Windsor Castle. Royal Library. *The German drawings* (L37).

## Germany and Austria

L30 Aurenhammer, Gertrude. Die Handzeichnung des 17. Jahrhunderts in Österreich. Wien, Schroll [1958]. 181p. plates (81 figs.) (Studien zur österreischen Kunstgeschichte. [Bd. 1])
An excellent general study of a relatively unexplored field. Divided geographically into four centers of importance:

the Tirol; Austria above and below the Enns; inner Austria; Salzburg. Includes an iconographical index.

L31 Bernhard, Marianne. Deutsche Romantik: Handzeichnungen. Hrsg. von Marianne Bernhard. Nachw. von Petra Kipphoff. [München] Rogner & Bernhard [1973]. 2v. 2016p. il.
A comprehensive catalogue of the drawings of 61 German artists of the Romantic period. Based primarily on the holdings of public and private collections in Germany, Austria, and Switzerland. The section on each draughtsman includes a biographical chronology, a critical essay, reprints of important writings by or about the draughtsman, descriptive catalogue entries with bibliographical references, a concise bibliography, and reproductions of drawings.

Contents: Bd. 1, Carl Blechen (1798-1840) bis Friedrich Olivier (1791-1859); Bd. 2, Johann Friedrich Overbeck (1798-1869) bis Christian Xeller (1784-1872). Indexes at the end of Bd. 2: Standortregister; Personenregister; Inhalt (a list of draughtsmen included).

L32 Frankfurt am Main. Städelsches Kunstinstitut. Katalog der deutschen Zeichnungen: alte Meister. Bearbeitet von Edmund Schilling. München, Prestel [1973]. 3v. 307 plates.
A critical catalogue of the German drawings of the 15th through the 18th centuries in the collection of the Städelsches Kunstinstitut, Frankfurt am Main.

Contents, Bd. 1, *Text,* bearb. von Edmund Schilling: Einleitung; Geschichte der Sammlung; Zeichnungen des 15. und 16. Jahrhunderts; Zeichnungen des 17. Jahrhunderts; Zeichnungen des 18. Jahrhunderts. Includes 2,222 catalogue entries. Each part of the catalogue is arranged alphabetically by draughtsman, with descriptions and references. Bd. 2: *Tafeln* 1-213, bearb. von Edmund Schilling und Kurt Schwarzweller. Contains 677 illustrations on 213 plates, which correspond to catalogue entries in Bd. 1. Bd. 3: *Ergänzungsband,* bearb. von Kurt Schwarzweller. Contains 969 illustrations on plates 214-307, and indexes of artists, persons, iconography, places, and a concordance.

L33 Garzaralli-Thurnlackh, Karl. Die barocke Handzeichnung in Österreich. Zürich, Amalthea [1928]. 98p. 118 plates on 59 l.
A survey of Austrian Baroque drawings, with 65 pages of text. Includes bibliographical footnotes. Index of artists, p.76-94, gives brief information for each artist.

L34 Harvard University. Busch-Reisinger Museum of Germanic Culture. German master drawings of the nineteenth century. [Cambridge, 1972]. 1v. unpaged. 93 il.
The catalogue of an exhibition organized at the Busch-Reisinger Museum, Harvard Univ.; also shown at the Metropolitan Museum of Art, N.Y., and other museums in 1972-73.

Selected from the holdings of 29 public and private collections, the 93 drawings in the catalogue illustrate "the complete range of the German nineteenth century—beginning with the Romantics and the Nazarenes and concluding with Jugendstil and Impressionist artists."—*Acknowledgments.*

Introductory essay by John David Farmer. The catalogue is arranged alphabetically by draughtsman. Each entry includes biographical information, title of drawing, date, technique, dimensions, inscriptions and signatures, provenance, lending institution, and critical comments.

L35   Nüremberg. Germanische Nationalmuseum. Die deutschen Handzeichnungen. Nürnberg, Verlag des Germanischen Nationalmuseums, 1968-(69). (2)v. il. (Kataloge des Germanischen Nationalmuseums Nürnberg)
The first 2v. of the projected 4v. of catalogues of the collection of German drawings in the National Museum, Nuremberg. Very well produced, with excellent plates.
   v.1, Die Handzeichnungen bis zur Mitte des 16. Jahrhunderts, bearb. von Fritz Zink (1968). 178 entries arranged chronologically, with some topographical subdivisions. Bibliography, p.8-9. Full indexes.
   v.2, Die Handzeichnungen des 18. Jahrhunderts, bearb. von Monika Heffels (1969). 465 entries arranged alphabetically by artist, covering roughly the period 1685 to 1810. Bibliography, p.8-10. Full indexes.

L36   Paris. Musée National du Louvre. Inventaire général des dessins des écoles du nord, publié sous la direction de L. Demonts. Ecoles allemande et suisse, par Louis Demonts. v.1-2. Paris, Musées Nationaux, 1937-38. 2v. plates.
A critical catalogue of the holdings of German drawings in the Louvre. Contains 836 fully described entries.
   Contents: v.1, Première période, maîtres nés avant 1550, A-P; v.2, Fin de la première période, maîtres nés avant 1550, R-Z et anonymes et Deuxième période, maîtres nés après 1550.

L37   Windsor Castle. Royal Library. The German drawings in the collection of Her Majesty the Queen at Windsor Castle, by Edmund Schilling, and supplements to the catalogues of Italian and French drawings, with a history of the Royal Collection of drawings, by Anthony Blunt. London, Phaidon [1972]. 239p. 176 il.
A complete critical catalogue of the small collection of German drawings at Windsor Castle. The larger part of the volume deals with corrections and additions to the earlier catalogues of the Italian and French drawings in the collection (L60, L29).
   Bibliographical references included in individual entries.

SEE ALSO:   Bibliothèque Nationale, Paris. Département des Estampes. *Inventaire général des dessins des écoles du nord* (L1); Bjurström, P. *Drawings in Swedish public collections* (L2); Moskowitz, I. *Great drawings of all time* (L11); Paris. Musée National du Louvre. *Great drawings of the Louvre Museum* (L13); Vienna. Albertina. *Beschreibender Katalog* (L18).

## Great Britain

L38   British Museum. Dept. of Prints and Drawings. Catalogue of British drawings. Vol. I: XVI & XVII centuries, by Edward Croft-Murray & Paul Hulton.

Supplemented by a list of foreign artists' drawings connected with Great Britain, by Christopher White. London, Trustees of the British Museum, 1960. [2v.] plates (part col.)
The first volume of a projected new catalogue of British drawings in the British Museum. v.I consists of a text volume and a plate volume. "The present Catalogue, if such a term can be held adequate for a work in which there are biographical notices of every artist included containing quite new information ... is ... a model of thorough and exact scholarship; while Mr. Croft-Murray's Introduction ... is not only learned but eminently readable. It traces the development of Portraiture, Landscape, Natural History, Figure Subjects, and other varieties from the Middle Ages ... to the end of the seventeenth century ...."—Review by Ralph Edwards, *Connoisseur,* Dec. 1961, p.323.
   "List of works referred to in an abbreviated form," p.588-97.

L39   Henry E. Huntington Library and Art Gallery, San Marino, Calif. Early British drawings in the Huntington Collection, 1600-1760 by Robert R. Wark. San Marino, Huntington Library, 1969. 231p. 15 il. (p.[65]-[224]) plates.
A beautifully produced catalogue of early British drawings in the Huntington Library collection, marked by astute scholarship and judicious attributions in the catalogue entries.

L40   Pierpont Morgan Library. English drawings and watercolors, 1550-1850, in the collection of Mr. and Mrs. Paul Mellon. N.Y., The Pierpont Morgan Library, 1972. 107p. 150 plates (part col.)
The catalogue of an exhibition at the Pierpont Morgan Library, 13 April to 28 July 1972.
   150 drawings were "chosen to illustrate the achievement of English draughtsmanship over three hundred years, from the middle of the sixteenth century to the beginning of Victorian England and Pre-Raphaelite art."—*Foreword.*
Contents: Foreword, by Charles Ryskamp; Introduction, by Graham Reynolds; Bibliography, xvii-xx; Abbreviations; [Catalogue] by John Baskett and Dudley Snelgrove; Plates.

L41   Windsor Castle. Royal Library. English drawings; Stuart and Georgian period in the collection of His Majesty the King at Windsor Castle, by A.P. Oppé. London, Phaidon [1950]. 215p. 117 il.
A critical catalogue of the drawings by British artists and foreign artists born, with a few exceptions, before 1786, and working in England. The introductory essay, p.9-16, gives the history of the collection.
   Contents of catalogue: Drawings by members of the royal family (nos. 1-16); Drawings by known artists (nos. 17-711); Anonymous drawings (nos. 712-53). Appendix: Portrait sketches by the Dightons. Concordances; Index of persons and subjects; Index of places.
   Also includes a supplement to *The drawings of Paul and Thomas Sandby,* Oxford, Phaidon, 1947.

SEE ALSO:   Bibliothèque Nationale, Paris. Département des Estampes. *Inventaire général des dessins des écoles du nord* (L1) Moskowitz, I. *Great drawings of all time* (L11).

# Italy

L42    Berenson, Bernhard. I disegni dei pittori fiorentini. [Ed. riv. e ampliata dall'autore. L'hanno coadiuvato Nicky Mariano e Luisa Vertova Nicolson. Traduzione della dott. Luisa Vertova Nicolson] Milano, Electa [1961]. 3v. plates (part col.)

1st ed., *The drawings of the Florentine painters,* 1903, published by Murray, London; Dutton, N.Y. in 2v. 2d rev. ed., 1938, Univ. of Chicago Pr., in 3v. Repr. of 2d ed., Greenwood Pr., Westport, Conn., 1970.

The 3d ed. (in Italian only) of this brilliant, monumental work records Berenson's last thoughts concerning drawings. It incorporates 15 appendixes of the 2d ed. into the text, and adds 200 new items to the catalogue. Fewer drawings are reproduced here than in the 2d ed.; illustrations of related works are given. Indicates inventory numbers of drawings and paintings. Bibliography, v.2, p.[v]-xi, is updated.

Contents: v.1, Text (an introduction and 12 chapters on groups of related artists or one artist, as with Leonardo da Vinci and Michelangelo); v.2, Catalogue; v.3, Plates. For a detailed critical analysis of the 3d ed., see the review by Philip Pouncey, *Master drawings,* v.2, no.3, 1964, p.278.

L43    British Museum. Dept. of Prints and Drawings. Italian drawings in the Department of Prints and Drawings in the British Museum. London, Published by the Trustees of the British Museum, 1950-(67). 4v. in 7 plates.

A series of volumes intended to comprise a complete, illustrated catalogue of the Italian drawings in the British Museum. Models of scholarly accuracy and thoroughness. All significant drawings are reproduced.

Popham, A. E., and Pouncey, Philip. *The 14th and 15th centuries* (1950). 2v. v.[1], catalogue; v.[2], plates; Wilde, Johannes. *Michelangelo and his studio* (1953). xx, 142p., plates; Pouncey, Philip, and Gere, J. A. *Raphael and his circle: Giulio Romano, G. F. Penni, Perino del Vaga, Giovanni da Udine* [and others] (1962). 2v. v.[1], catalogue; v.[2], plates; Popham, A. E. *Artists working in Parma in the 16th century: Correggio, Anselmi, Rondani, Gatti, Gambara, Orsi, Parmigianino, Bedali, Bertoja* (1967). xiii, 139p.

Each catalogue contains a "List of works referred to in abbreviated form."

L44    Degenhart, Bernhard, and Schmitt, Annegrit. Corpus der italienischen Zeichnungen: 1300-1450. Teil I: Süd und Mittelitalien. Berlin, Mann, 1968. 4v. 635p. 443 plates.

Describes exhaustively in 635 entries about half of the surviving drawings from Southern and Central Italy of the period 1300-1450. Projected volumes are to cover drawings from Northern Italy (1300-1450) and Italian drawings of the medieval period. When complete, the corpus will comprise a vast survey of draughtsmanship in Italy from the Middle Ages through the mid-15th century and will become the foremost reference work for further research.

Contents: v.1-2, Catalogue; v.3-4, Plates. Appendixes: (1) Methoden Vasaris bei der Gestaltung seines "Libro"; (2) Das "Römische Skizzenbuch" des Gentile da Fabriano, seine Erweiterung in Gentiles Nachfolge, seine spätere Auflösung und Rekonstruktion; (3) Baldinuccis System des Sammelns und Klassifizierns von Zeichnungen; (4) Wasserzeichen. Bibliography, v.2, p.[666]-92, includes items through 1968.

L45    Disegno italiano. Collana diretta da Luigi Grassi. [Venezia] Sodalizio del libro [1959-(72)]. plates.

"Sotto gli auspici dell'Istituto di Storia dell'Arte della Facoltà di Magistero dell'Università di Roma."

A series of well-illustrated volumes on various periods and aspects of Italian drawings. The format of all volumes is generally the same, with introductory essays, a discussion of principal collectors and collections, and a plates section followed by a catalogue of the drawings illustrated. The value of the texts and the quality of reproductions in the volumes vary, but the series provides useful summaries of the more specialized literature in the field.

Volumes published: (1) Ivanoff, Nicola. I disegni italiani del Seicento: Scuole veneta, lombarda, ligure, napoletana [1959]; (2) Grassi, Luigi. I disegni italiani del Trecento e Quattrocento: Scuole fiorentina, senese, marchigiana, umbra [1961]; (3) Forlani, Anna. I disegni italiani del Cinquecento: Scuole fiorentina, senese, romana, umbro marchigiana e dell'Italia meridionale [1962]; (4) Pignatti, Terisio. I disegni veneziani del Settecento [1966]; (5) Roli, Renato. I disegni italiani del Seicento: Scuole emiliana, toscana, romana, marchigiana e umbra [1969]; (6) Chiarini, Marco. I disegni italiani di paesaggio dal 1600 al 1750 [1972].

L46    Drawings from New York collections. [N.Y.] Metropolitan Museum of Art and Pierpont Morgan Library. (Distr. by New York Graphic Society, Greenwich, Conn. [1965-(71)].) 3v. plates.

Excellent catalogues accompanying a series of exhibitions organized jointly by the Metropolitan Museum of Art and the Pierpont Morgan Library, designed to "display the resources of collections of master drawings located in New York City and its environs."—*Foreword, v.1.* The series as a whole is intended to encompass "the drawings of Western European artists from the Italian Renaissance to the end of the 19th century." Exhibitions organized and catalogues written by Felice Stampfle and Jacob Bean.

To date, three exhibitions and catalogues have been devoted to Italian draughtsmen: (1) The Italian Renaissance [1965]; (2) The seventeenth century in Italy [1967]; (3) The eighteenth century in Italy [1971]. Catalogue entries arranged chronologically by birth dates of artists. Each entry includes full technical description, informative discussion and stylistic analysis, provenance, bibliography, and exhibitions. All drawings are reproduced.

Selective bibliography in "Works cited in an abbreviated form" at beginning of each catalogue.

L47    Düsseldorf. Städtisches Kunstmuseum. Handzeichnungen. Düsseldorf (1967). 1v. il. (Düsseldorf. Städtisches Kunstmuseum. Kataloge 3)

v.1, Die Handzeichnungen von Andrea Sacchi und Carlo Maratta, by Ann Sutherland Harris and Eckhard Schaar. The 1st volume of a projected comprehensive catalogue of the Düsseldorf Kupferstichkabinett, praised as "the basis

273

for all further studies of the drawings of Sacchi and Maratta."
—Review by Peter Dreyer, *Master Drawings,* v.7, no. 2, Summer, 1969, p.173.

The 1st section, by Harris, catalogues the rich collection of Sacchi drawings, including a critical essay and fully detailed entries. The 2d section, by Schaar, catalogues the large group of Maratta drawings. Exceptionally excellent organization and presentation of material by both authors.

L48   Edinburgh. National Gallery of Scotland. Catalogue of Italian drawings [by] Keith Andrews. Cambridge, Published for the Trustees of the National Gallery of Scotland at the Univ. Pr., 1968. 2v. 200 plates (1,158 figs.)

The first catalogue of a proposed new series of catalogues of the drawings collection of the National Gallery of Scotland. Entries are arranged alphabetically by artist, with the following subdivisions: attributed, ascribed, studio, circle, copy, follower, imitator. The alphabetical section is followed by a catalogue of anonymous drawings, divided into schools and centuries. Contents: v.1, Text; v.2, Plates. Every Italian drawing in the collection is illustrated, with the exception of direct copies or fragments.

"List of works referred to in abbreviated form," p.xv–xvi.

L49   Fischel, Oskar. Die Zeichnungen der Umbrer; mit neun Tafeln in Lichtdruck, einer Tafel in Kornätzung und mit 343 Textabbildungen. Berlin, Grote, 1917. 280p. il., plates.

"Sonderdruck aus dem Jahrbuch der Kgl. preuss. Kunstsammlungen, 1917, Heft 1 und 2 und Beiheft."

An early scholarly study of Umbrian drawings, with a critical catalogue.

L50   Florence. Galleria degli Uffizi. Gabinetto dei Disegni e delle Stampe. I grandi disegni italiani degli Uffizi di Firenze. Introduzione di Anna Forlani Tempesti. Schede di Anna Maria Petrioli Tofani. Milano, Silvana [1973?]. 306p. 51 il., 100 col. plates.

A pictorial anthology, with authoritative commentaries, of 100 great Italian drawings in the collection of the Uffizi. The plates section is preceded by an introductory essay, "Il Gabinetto dei Disegni e delle Stampe degli Uffizi," p.74–74, which includes 51 black-and-white illustrations and notes, p.71–74, with references.

Bibliography, p.83–97.

L51   Hadeln, Detlev, *Freiherr* von. Venezianische Zeichnungen der Hochrenaissance. Berlin, Cassirer, 1925. 39p. 65 plates.

Reproductions of Venetian drawings of the Renaissance, with introductory text.

L52   _____. Venezianische Zeichnungen des Quattrocento. Berlin, Cassirer, 1925. 66p. 91 plates.

Reproductions of 15th–century Venetian drawings, with brief text.

L53   _____. Venezianische Zeichnungen der Spätrenaissance. Berlin, Cassirer, 1926. 31p. 104 plates.

Reproductions of late Renaissance Venetian drawings, with introductory text.

L54   Italy. Ministero dell'Istruzione Pubblica. Indici e cataloghi. I disegni delle biblioteca italiane. [Roma] Istituto Poligrafico dello Stato, 1959–(69).

Series of catalogues of the drawings collections of Italian libraries. All drawings discussed are reproduced.

v.1, *I disegni italiani della Biblioteca Reale di Torino.* Catalogo a cura di Aldo Bertini. [1958]. 86p. il. Contains 700 brief catalogue entries for drawings of the 15th through 18th centuries. Includes bibliographical references.

v.2, *I disegni de G. B. Piazzetta nella Biblioteca Reale di Torino.* Catalogo a cura di D. Maxwell White e A. C. Sewter. Testo italiano in collaborazione con Maria Pia Nazzari di Calabiani. [1969]. 100p. il.

L55   Oxford University. Ashmolean Museum. Catalogue of the collection of drawings in the Ashmolean Museum, by K. T. Parker. Volume II: Italian schools. Oxford, Clarendon, 1956. xx, 575p. plates.

Available in paperback.

A masterful catalogue of the collection of Italian drawings in the Ashmolean Museum, Oxford. Especially rich in sheets by Michelangelo and Raphael. Indispensable for study in the field.

Includes 1,118 entries for drawings arranged in chronological sections of the 15th through the 19th centuries. Entries give biographical information, detailed descriptions, references, and collections. 240 drawings are reproduced.

L56   Paris. Musée National du Louvre. Cabinet des Dessins. Inventaire général des dessins italiens. Paris, Éditions des Musées Nationaux, 1972–(74). v.1–(2). il.

A new series of inventory catalogues of the collection of Italian drawings in the Cabinet des Dessins of the Louvre. Volumes include introductory essays with biographical and critical information on the artists and/or periods covered, fully detailed catalogue entries for all drawings, and reproductions of almost all works catalogued.

Volumes published or announced: (1) Vasari et son temps; maîtres toscans nés après 1500, morts avant 1600, par Catherine Monbeig-Goguel (1972); (2) Dessins de Stefano della Bella, 1610–64, par Françoise Viatte (1974); Dessins des Carrache, par Roseline Bacou (in preparation).

L57   Pignatti, Terisio. I grandi disegni italiani nelle collezioni di Venezia. A cura di Terisio Pignatti. Milano, Silvana [1974?]. 314p. il., 100 col. plates.

A pictorial anthology, with authoritative commentaries, of 100 great Italian drawings in Venetian collections. The plates section is preceded by five introductory essays: Introduzione; Gallerie dell'Accademia, p.9–28; Fondazione Giorgio Cini, p.29–35; Museo Correr, p.37–53; Il disegno a Venezia, p.55–93. Notes, p.94–97, include references.

Bibliography, p.98–103.

L57a   Thiem, Christel. Florentine Zeichner des Frühbarock. München, Bruckmann [1977]. 423p. 308 il.

(part col.) (Kunsthistorische Instituts in Florenz. Italienische Forschungen. Ser. 3, Bd. 10)
A scholarly study of Florentine draughtsmen working in the period 1580–1640. A series of brief introductory essays is followed by a section of plates. The main text is a catalogue of the important drawings of 51 artists. For each artist the catalogue includes a biography, a critical discussion of his drawings, extensive bibliography, and detailed entries.
"Abkürzungen der häufiger zitierten Literatur," p.413–17; "Verzeichnis der Zeichnungs-Sammlungen nach Orten in alphabetischer Reihenfolge," p.419; "Künstlerregister," p.420–22.

L58    Tietze, Hans, and Tietze-Conrat, Erica. The drawings of the Venetian painters in the 15th and 16th centuries. N.Y., Augustin [1944]. 398p. 200 plates on 100 l. (Repr.: N.Y., Collectors editions, 1970).
"A companion piece to Bernhard Berenson's book on the drawings of the Florentine painters [L42]."—Introd. A scholarly corpus of Venetian drawings, arranged alphabetically by draughtsman.
Contents: Catalogue, p.31–365; General index, p.369–77; General place index, p.378–88. Place index of drawings, p.389–96; List of illustrations, p.397–98. Bibliographical references in "Signs and abbreviations," p.xiii–xvi.

L59    Vienna. Albertina. Italian drawings in the Albertina. Ed. by Walter Koschatzky, Konrad Oberhuber [and] Eckhart Knab. Greenwich, Conn., New York Graphic Society [1971]. 321p. 56 il., 100 col. plates.
Italian ed.: I grandi disegni italiani dell'Albertina di Vienna. Milano, Silvana [1972].
A selection of great Italian drawings in the collection of the Albertina, reproduced and accompanied by authoritative essays and commentary. Introductory essays: The Albertina: the importance and history of the collection, by Walter Koschatzky; The early Renaissance drawings, by Konrad Oberhuber; Seicento and Settecento, by Eckhart Knab. Notes to essays include bibliographical references. Commentary facing color reproductions includes biographical information, description, provenance, references, and brief discussion.
Abbreviations and selected bibliography, p.105–13.

L60    Windsor Castle. Royal Library. The Italian drawings at Windsor Castle. London, Phaidon [1948–(1968–69)]. il., plates.
General editor of series: Anthony Blunt.
A series of excellent catalogues of the Italian drawings in the Royal Library, Windsor Castle—one of the richest, most comprehensive collections of Italian drawings in the world.
Catalogues of specific areas by various authors: (1) Pope-Hennessy, John. The drawings of Domenichino. [1948]; (2) Parker, K. T. The drawings of Antonio Canaletto. ]1948]; (3) Popham, A. E. and Wilde, J. The Italian drawings of the XV and XVI centuries. [1949]; (4) Wittkower, Rudolf. The drawings of the Carracci. [1952]; (5) Blunt, Anthony. The drawings of G. B. Castiglione and Stefano della Bella. [1954]; (6) Kurz, Otto. Bolognese drawings of the XVII & XVIII centuries. [1955]; (7) Blunt, Anthony, and Croft-Murray,

Edward. Venetian drawings of the XVII & XVIII centuries. [1957]; (8) Blunt, Anthony, and Cook, H. L. The Roman drawings of the XVII & XVIII centuries. [1960]; (9) Clark, Kenneth. The drawings of Leonardo da Vinci. 2d ed., rev. with the assistance of C. Pedretti [1968–69] (3v.).
In each catalogue an introduction is followed by the catalogue entries and a section of plates. Many drawings are reproduced either as text illustrations or in the plates. Included are various indexes, concordances, bibliographies, and bibliographical references in footnotes and in individual entries.
Additions and corrections to the Italian drawings catalogues, by Anthony Blunt, comprise a large part of the volume The German drawings . . . and supplements to the catalogues of Italian and French drawings. (L37).

SEE ALSO:  Bjurström, P. Drawings in Swedish public collections (L2); Moskowitz, I. Great drawings of all time (L11); Paris, Musée National du Louvre. Great drawings of the Louvre Museum (L13); Vienna. Albertina. Beschreibender Katalog (L18); Windsor Castle. Royal Library. The German drawings (L37).

## Latin America

See: Catlin, S. L. and Grieder, T. Art of Latin America since Independence (I363); Image of Mexico (E122).

## Low Countries

L61    Berlin. Staatliche Museen. Kupferstichkabinett. Die niederländischen Meister; beschreibendes Verzeichnis sämtlicher Zeichnungen. Bearbeitet von Elfried Bock und Jakob Rosenberg. Berlin, Bard, 1930. 2v. plates.
A critical inventory catalogue of the Netherlandish drawings of the 15th century through the 18th century in the Kupferstichkabinett of the Staatliche Museen, Berlin. Entries include description, commentary, and sometimes references.
Contents, v.1: Vorwort, by Max Friedländer; Die Meister des XV. Jahrhunderts; Die Meister des XVI. Jahrhunderts; Die Meister des XVII. und XVIII. Jahrhunderts; Unbekannte des XVII. und XVIII. Jahrhunderts; Nachtrag. v.2: 220 plates.

L62    Bernt, Walther. Die niederländischen Zeichner des 17. Jahrhunderts. Zwei Bände mit 705 Abbildungen. Mit einem Geleitwort von J. Q. van Regteren Altena. München, Bruckmann [1957–58]. 2v. il.
A corpus of 17th-century Netherlandish drawings. A standard work, which forms a companion to the author's work on 17th-century Netherlandish painters (M416). Arranged alphabetically by draughtsman, with biographical information and bibliography for each. Gives dimensions, technique, and collection of each drawing reproduced.

L63    British Museum. Dept. of Prints and Drawings. Catalogue of drawings by Dutch and Flemish artists preserved in the Department of Prints and Drawings in the British Museum, by Arthur M. Hind. London, Printed by order of the Trustees, 1915–32. 5v. plates.

275

An inventory catalogue of the important collection of Dutch and Flemish drawings in the British Museum. Entries include detailed descriptive and critical information. All volumes contain indexes of artists and subjects.

Contents: v.1, Drawings by Rembrandt and his school; v.2, Drawings by Rubens, Van Dyck and other artists of the Flemish school of the XVII century; v.3, Dutch drawings of the XVII century (A–M); v.4, Dutch drawings of the XVII century (N–Z and anonymous); v.5, by A. E. Popham, Dutch and Flemish drawings of the XV and XVI centuries.

L64    Budapest. Szépmüvészeti Múzeum. Netherlandish drawings in the Budapest Museum. Sixteenth-century drawings. An illustrated catalogue. Compiled by Teréz Gerszi. [Trans. from the Hungarian manuscript by Mari Kuttna]. Amsterdam, Van Gendt; N.Y., Schram, 1971. 2v. il.

A critical catalogue of 319 Netherlandish drawings in the Budapest Museum. The majority of the drawings are of the 16th century, a few from the end of the 15th century, and some of c.1600 and the early 17th century. Entries are arranged alphabetically by artist in v.1. Each entry includes dates of artist, title/subject of drawing, technique, dimensions, inscriptions, watermark, provenance, and references. v.1 also contains 22 reproductions of comparative material. v.2 contains 331 reproductions of the drawings catalogued, including some drawings on versos. Watermarks, index to subjects, and general index in v.1.

Further volumes on the German and Italian drawings in the collection are planned.

L65    Hasselt, Carlos van. Dessins de paysagistes hollandais du XVIIe siècle, de la collection particulière conservée a l'Institut Néerlandais de Paris. [Bruxelles, Bibliothèque Royale de Belgique] 1968. 2v. il., plates.

The catalogue of an exhibition shown at the Bibliothèque Albert Ier, Brussels; the Musée Boymans-van Beuningen, Rotterdam; the Institut Néerlandais, Paris; and the Musée des Beaux-Arts, Bern, in 1968–69.

An excellent catalogue of 182 17th-century Dutch landscape drawings from an unnamed private collection; provides a comprehensive survey of the field. Each entry includes biographical information, description, watermark, provenance, and often references. Contents, v.1: Introduction, p.v–vii, by J. G. van Gelder; Catalogue, by C. van Hasselt; Filigranes, p.[183]–200. Indexes: Liste des abréviations; Liste des dessinateurs; Registre de collectionneurs précédents. v.2: Planches.

L66    _____. Dessins flamands du dix-septième siècle; Collection Frits Lugt, Institut Néerlandais, Paris. [Gand, Erasmus, 1972. 196p. 128 plates (part col.)]

The catalogue of an exhibition held at the Victoria and Albert Museum, London; the Institut Néerlandais, Paris; the Musée des Beaux-Arts, Bern; and the Bibliothèque Albert Ier, Brussels in 1972.

Includes 125 17th-century Flemish drawings from the collection of Frits Lugt. The catalogue is arranged alphabetically by artist, with extensive, detailed entries (including references) for all drawings.

Contents: In memoriam Frits Lugt, p.ix–xv, by J. G. van Gelder; Introduction, p.xvii–il, by R.-A. d'Hulst; Catalogue; Filigranes, p.[173]–87. Indexes: Liste des abréviations; Liste des dessinateurs; Registre de collectionneurs précédents.

L67    Institut Néerlandais, Paris. Dessins flamands et hollandais du dix-septième siècle. Collections: Musées de Belgium; Musée Boymans-van Beuningen, Rotterdam; Institut Néerlandais, Paris. Paris [1974]. vi, 205p. 132 plates.

The catalogue of an exhibition organized as part of a cultural exchange by Belgium and the Netherlands with the Soviet Union. Catalogue composed by A. W. F. M. Meij and J. Giltay of the Boymans-van Beuningen Museum, and by M. van Berge and C. van Hasselt.

Includes 125 17th-century Flemish and Dutch drawings from collections notably rich in the field. Arranged alphabetically by artist. Entries include biographical information, detailed descriptive and critical notes, exhibitions, and references. Indexes of lenders, artists, former collections, and exhibitions.

L68    Munich. Staatliche Graphische Sammlung. Die niederländischen Handzeichnungen des 15.-18. Jahrhunderts, bearbeitet von Wolfgang Wegner. Band I. Berlin, Mann, 1973. 2v. 456 plates.

A superb inventory catalogue of 1,551 Netherlandish drawings (15th-18th centuries) in the Staatliche Graphische Sammlung, Munich.

Bd. 1, *Textband,* is arranged alphabetically by artist within subdivisions: 15. und 16. Jahrhundert; 17. Jahrhundert; Rembrandt; Unbekannte 17. Jahrhundert; 18. Jahrhundert. Extensive bibliography p.214–[29]. "Wasserzeichen," p.[230]; "Konkordanz," p.231–[35]; "Konkordanz der Rembrandt-Zeichnungen," p.236–[37]. Indexes of artists, places and collections, portraits, and views.

Bd. 2, *Tafelband,* contains approx. 1,500 excellent illustrations on 456 plates.

L69    Paris. Musée National du Louvre. Inventaire général des dessins des écoles du Nord, publié sous la direction du Cabinet des Dessins. Maîtres des anciens Pays-Bas nés avant 1550, par Frits Lugt. Paris, Musées Nationaux, 1968. xiv, 147 (16p.). 203 plates, map.

A catalogue of the Netherlandish drawings in the Louvre by artists born before 1550. The final volume of the series of inventory catalogues of the Dutch and Flemish schools and the culminating achievement of the author.

Introduction, p.iii–xii. The Catalogue includes 722 entries, with detailed information given for each. "Liste des abréviations," p.xiii–xiv. "Index des noms d'artistes" and "Filigranes" at the end.

L70    _____. _____. Inventaire général des dessins des écoles du Nord, publié sous les auspices du Cabinet des Dessins. École flamande, par Frits Lugt. Paris, Musées Nationaux, 1949. 2v. plates.

A scholarly catalogue of the Flemish drawings in the collection of the Louvre.

Entries are arranged alphabetically by draughtsman. Contents: v.1, A–M; v.2, N–Z et anonymes. Each entry

includes description and commentary. "Liste des abréviations" at the beginning of v.1. "Filigranes" at the end of both volumes.

L71 _____. _____. Inventaire général des écoles du nord, publié sous la direction de L. Demonts. École hollandaise, par Frits Lugt. Paris, Morancé, 1929-33. 3v. il., plates.

Imprint varies: v.2-3, Paris, Musées Nationaux.

A scholarly catalogue of the Dutch drawings in the Louvre. Entries are arranged alphabetically by draughtsman. Contents: v.1, A-M; v.2, N-Z et anonymes; v.3, Rembrandt, ses élèves, ses imitateurs, ses copistes. Each entry includes brief description, commentary, and sometimes collection and references.

"Liste des abréviations" at the beginning of v.1, "Filigranes" at the end of all 3v. "Table des élèves et imitateurs de Rembrandt" at the end of v.3.

SEE ALSO: Bibliothèque Nationale, Paris. Département des Estampes. *Inventaire général des dessins des écoles du nord* (L1); Bjurström, P. *Drawings in Swedish public collections* (L2); Moskowitz, I. *Great drawings of all time* (L11); Paris Musée National du Louvre. *Great drawings of the Louvre Museum* (L13); Vienna. Albertina. *Beschreibender Katalog* (L18).

## Spain

L72 Angulo Iñiguez, Diego, and Pérez Sánchez, Alfonso E. A corpus of Spanish drawings. London, Miller [1975-(77)]. v.1-(2). il.

A corpus of Spanish drawings from 1400-1800 which will most likely become the standard work in the field. To be complete in seven or eight volumes.

Contents: v.1, 1400-1600 (208p., 524 il.); v.2, Madrid, 1600-50. v.1 includes more than 500 drawings by 57 identified and numerous anonymous artists. Drawings by identified artists are arranged alphabetically by draughtsman; drawings by anonymous artists are arranged iconographically according to subjects. Entries contain biographical information and dimensions, medium, condition, and critical analysis of each drawing.

L73 Florence. Galleria degli Uffizi. Gabinetto dei Disegni e delle Stampe. Mostra di disegni spagnoli. Introduzione e catalogo di Alfonso E. Pérez Sánchez. Firenze, Olschki, 1972. 123p. 104 plates. (*Its* [Catalogo critico] 37)

An exhibition catalogue of 132 Spanish drawings in the collection of the Uffizi Gallery, the most important collection of Spanish drawings outside Spain. Includes an introductory essay by Pérez Sánchez and a catalogue of drawings by 46 known and anonymous draughtsmen from the 16th through the 18th centuries. Each entry gives draughtsman's dates, title or subject, inventory number, dimensions, technique, provenance, bibliography, and commentary.

"Bibliografia delle opera abbreviate del testo," p.118-20, lists literature chronologically from 1715 to 1971. "Concordanze," p.121-22, is a concordance of inventory and catalogue numbers. "Indice degli autori dei disegni," p.123.

L74 Madrid. Museo Nacional de Pintura y Escultura. Catálogo de dibujos. Madrid, El Museo, 1972-(75). v.1-(2). il.

Inventory catalogues of the Spanish drawings in the Prado, the most important collection of Spanish drawings in the world.

v.1, *Dibujos españoles siglos XV-XVII* (192p., 64 il.), by A. E. Pérez Sánchez, includes 360 drawings of the 15th through the 17th centuries (300 with attributions, the remainder anonymous); approximately one-third are published for the first time.

v.2, *Dibujos españoles siglo XVIII, A-B* (175p., 199 il.), by Rocío Arnaez, is the 1st volume of a complete catalogue of the 18th-century drawings, the majority of which in this volume are by Francisco Bayeu.

Entries include biographical data, full descriptions, critical commentaries, and often bibliographical references. Each volume has a bibliography and indexes.

L75 Mayer, August Liebmann. Handzeichnungen spanischer Meister; 150 Skizzen und Entwürfe von Künstlern des 16. bis 19. Jahrhunderts; ausgewählt und hrsg. von August L. Mayer, N.Y., Hispanic Society of America, 1915. 2v. 150 plates.

Also published in a Spanish ed.: *Dibujos originales de maestros españoles.* N.Y., Hispanic Society of America, 1920.

A collection of reproductions of Spanish drawings from the 16th to the 19th centuries, compiled by a pioneering scholar of Spanish art. A list of plates is at the beginning of v.1.

L76 Spain. Junta para Ampliación de Estudios e Investigaciones Científicas. Centro de Estudios Históricos. Dibujos españoles. Material reunido por el Centro de Estudios Históricos, y publicado por F. J. Sánchez Cantón, Madrid, Hauser y Menet [193- ]. 5v. 435 plates.

At head of title: Ministerio de Instruccion Pública y Bellas Artes.

A collection of 435 reproductions of Spanish drawings from manuscript illuminations of the 10th century through sheets of the 17th century.

Contents: v.1, Siglos X-XV; v.2, Siglo XVI y primer tercio del XVII; v.3, Siglo XVII; v.4, Alfonso Cano; v.5, Siglo XVII.

SEE ALSO: Moskowitz, I. *Great drawings of all time* (L11).

## Switzerland

L77 Ganz, Paul. Handzeichnungen schweizerischer Meister des XV.-XVIII. Jahrhunderts. Im Auftrage der Kunstcomission unter Mitwirkung v. Prof. D. Burckhardt & Prof. H. A. Schmid, hrsg. von Dr. Paul Ganz. 1.-3. Serie. Basel, Helbing & Lichtenhahn [1904-08]. 3v. 180 plates (part col.)

Issued in 12 parts, each part containing 15 plates with descriptive text. v.3: . . . unter Mitwirkung v. verschiedenen Fachgenossen.

Reproductions of drawings by 81 Swiss artists. At the end of each volume an "Übersicht der Tafeln . . . nach Meistern geordnet." v.3 contains a cumulative index for all 3v.

277

**L78** Hugelshofer, Walter. Swiss drawings; masterpieces of five centuries. Introd. and notes by Walter Hugelshofer. Organized by the Pro Helvetia Foundation. Wash., Smithsonian Institution Pr., 1967. 176p. il. (Smithsonian publication, 4716)

The catalogue of an exhibition circulated by the Smithsonian Institution Traveling Exhibition Service to the National Gallery of Art, Wash., D.C.; the Pierpont Morgan Library, N.Y.; and other museums in the U.S.

The introductory essay, p.9–17, is a survey of the history of Swiss drawing from the 16th through the 20th centuries. The catalogue includes 126 drawings by 38 artists, and gives biographical information, technique, dimensions, lending institution or collection, and commentary for each. Each drawing is reproduced.

SEE ALSO: Bibliothèque Nationale, Paris. Département des Estampes. *Inventaire général des dessins des écoles du nord* (L1); Bjurström, P. *Drawings in Swedish public collections* (L2); Bernhard, M. *Deutsche Romantik: Handzeichnungen* (L31); Paris. Musée National du Louvre. *Inventaire général des dessins des écoles du nord* (L36).

## United States

**L79** Bolton, Theodore. Early American portrait draughtsmen in crayon. N.Y., Sherman, 1923. 111p. (Repr.: N.Y., Kennedy Graphics, 1970; Charleston, S. C., Garnier, 1969.)

A companion volume to *Early American portrait painters in miniature* (M492).

Includes American draughtsmen and foreign artists working in America up to 1860. Lists portraits drawn in black crayon, colored crayons or pastels, black lead pencil, and several in ink.

Index—Names of the artists, p.101–2; Index—Names of the sitters, p.103–11.

**L80** Boston. Museum of Fine Arts. M. and M. Karolik Collection. M. & M. Karolik collection of American water colours & drawings, 1800-1875. Boston, Museum of Fine Arts, 1962. 2v. il., col. plates, ports.

Catalogue of an exhibition held at the Museum of Fine Arts, Boston, 1962-63. Comp. by Henry P. Rossiter.

Contains useful information for the study of 19th-century American draughtsmen and watercolorists. Introductory essay gives an account of early drawing societies. v.1 is a catalogue of drawings, watercolors, prints, and sculpture by anonymous and known academic artists; v.2 is a catalogue of works by visiting foreign artists, artists of Civil War subjects, and folk artists. Both volumes contain appendixes listing known artists represented, known sitters, places represented, and subjects represented. Bibliography, v.1, p.328 and v.2, p.345.

**L81** Cummings, Paul. American drawings; the twentieth century. N.Y., Viking [1976]. 207p. il.

A broad survey of American drawing in the 20th century. An introductory essay, p.9–15, is followed by reproductions of and commentaries on the drawings of 118 artists, arranged chronologically, beginning with William Merritt Chase (1849-1916) and ending with Richard Serra (born 1939).

Contents, p.[7–8], is a list of artists included. Bibliography, p.205.

**L82** Stebbins, Theodore E., Jr. American master drawings and watercolors; a history of works on paper from colonial times to the present. With the assistance of John Caldwell and Carol Troyen. N.Y., Harper [1976]. 464p. 360 il. (part col.)

Issued also in a paperback ed. in conjunction with an exhibition at the Whitney Museum of American Art, N.Y., in 1976-77; published in association with The Drawing Society, Inc.

An excellent history of American draughtsmanship and one of the major contributions to American art scholarship inspired by the Bicentennial year. "This book represents the first attempt to survey the whole field of American drawings and watercolors from the late sixteenth century depictions of Indian life by John White and Jacques Le Moyne to the rich and eclectic products of our own day, some four hundred years later. Our effort has been to examine the major American draftsmen with some care, while also bringing to life many astonishing accomplishments by little-known artists; stylistic and formal developments are analyzed, as are the collecting and exhibition of drawings, and the artistic milieu in which they served."—*Introd.*

"Notes," p.411–19, include bibliographical references. "List of illustrations," p.421–34, gives draughtsman, title, date, technique, dimensions, and collection. Classified bibliography, p.437–53: (A) General bibliography; (B) Artists' bibliography.

SEE ALSO: Moskowitz, I. *Great drawings of all time* (L11).

The bibliographies of painting are listed at the beginning of each subdivision in the chapter. Entries for dictionaries, encyclopedias, and exhibition catalogues are with general literature, periods, or styles, and with specific countries or regions. Only the general biographies of painters have been isolated, having been placed under the category "Painters." Other entries are interfiled with histories and handbooks in the most appropriate subcategories.

Mosaics has been classified with the literature of painting. On the other hand, books on enamels and stained glass are entered in the chapter on decorative and applied arts.

# BIBLIOGRAPHY

M1   Donati, Lamberto. Bibliografia della miniatura. Firenze, Olschki, 1972. 2v. ix, 1211p. (La Bibliofilia. Biblioteca di bibliografia italiana. [n.]69)
A comprehensive, classified bibliography of Western manuscript painting. No annotations; indicates reviews.

Contents: (I) Generali; (II) Cronologia (Antichità-XX sec.); (III) Scuole; (IV) Miniatori; (V) Soggetti; (VI) Varia; (VII) Collezioni; (VIII) Titolari; (IX) Esposizioni.

# COLLECTIONS AND INVENTORIES

For guides to the printed censuses and catalogues of manuscripts in the great libraries of the world see E. Sheehy, *Guide to reference books* (AA181–AA193), and P. Kristeller, *Latin manuscript books before 1600* (M5).

M2   Amsterdam. Rijksmuseum. All the paintings of the Rijksmuseum in Amsterdam: a completely illustrated catalog by the Department of Paintings of the Rijksmuseum, Pieter J. J. van Thiel, director [et. al.]. Amsterdam, Rijksmuseum; Maarssen, Schwartz, 1976. 911p. il.
Trans. of *Alle schilderijen van het Rijksmuseum te Amsterdam.*

An illustrated catalogue of the approx. 5,000 items in the collections of the Department of Paintings of the Rijksmuseum. For each entry (listed alphabetically by artist) gives an illustration; inventory number and title; additional information concerning the subject and relation to other works; support, dimensions, idiosyncrasies of format and technique, signature, date, inscriptions; provenance and present location; literature.

M3   Braam, Frederik A. van. Art treasures in the Benelux countries. v.1, The Netherlands. Comp. by Fred. A. van Braam, assisted by Hans Klinkenberg [Paris? 1958]. 635p. plates.
A pioneer work, though incomplete, listing alphabetically by artist 5,947 paintings of European schools and periods in public and private collections in the Netherlands. For each picture gives a short description, dimensions, notes on its provenance, sometimes its condition, and bibliographical references. The attributions are not the author's but his compilation from material by other scholars.

M4   Buchthal, Hugo, and Kurz, Otto. A hand list of illuminated Oriental Christian manuscripts. London, The Warburg Institute, 1942. 120p. front. (Repr.: N.Y., Kraus, 1968.)
Half title: Studies of the Warburg Institute, ed. by Fritz Saxl, v. 12.

A comprehensive index of Eastern Christian manuscripts with miniatures, 6th-15th centuries. Locations throughout the world. Arranged by holding institution within the geographical sections. For each gives date, brief identifying description, and references.

Contents: (A) Syriac manuscripts; (B) Arabic manuscripts; (C) Coptic manuscripts; (D) Nubian manuscripts; (E) Ethiopic manuscripts; (F) Armenian manuscripts; (G) Georgian manuscripts. "Books and articles," p.110–16; "Chronological index," p.117–19.

M5   Kristeller, Paul Oskar. Latin manuscript books before 1600; a list of the printed catalogues and unpublished inventories of extant collections. New ed. rev. N.Y., Fordham Univ. Pr. [1960]. 234p.
"First published in *Tradito: studies in ancient and medieval history, thought and religion.* 6: 227-317 and 9: 393-418."

A listing of early Latin manuscripts located in public collections of Europe, the U.S., and Canada. Especially valuable to art historians doing research in the area of manuscript illumination.

Contents: Section A. Bibliography and statistics of libraries and their collections of manuscripts; Section B. Works describing manuscripts of more than one city; Section C. Printed catalogues and handwritten inventories of individual libraries, by cities. Cross-references; no index.

M6   London. National Gallery. Catalogues. London, National Gallery, 1945-. il. atlases of plates.

These catalogues of a great public collection, initiated by Martin Davies in 1945, are in a sense pioneer works; they set the high standard of scholarly entries and visual documentation which we have come to expect in catalogues of museums. Indispensable for research. Each work is fully documented, with a summary of the latest research and complete bibliography.

The following have been published: Davies, M. *Early Netherlandish school,* 2v., 1945–47, 2d ed. (1955), 3d ed. (1968); _____. *The British school,* 1946, 2d ed. (1959); _____. *French school,* 2v., 1946–50, 2d ed. (1957), 3d ed. (1970–); _____. *The earlier Italian schools,* 3v., 1951–53. 2d rev. ed. (1961–  ); Gould, C. *The 16th-century Venetian school, 1959;* _____. *The 16th-century Italian schools* (excluding the Venetian), 1962; Levey, M. *The 18th-century Italian schools,* 2v., 1956, later ed.: *The 17th and 18th century Italian schools,* 1971; _____. *The German school* (all German and Austrian pictures in the Gallery, and pictures which may be claimed as Swiss.), 2v., 1959–60; Maclaren, N. *The Spanish school,* 2v., 1952, 2d ed., rev. by A. Braham (1970); _____. *Dutch school, XVII-XIX centuries,* 3v., 1958-60; Martin, G. *The Flemish school, circa 1600–circa 1900,* 1970; *Summary catalogue, 1958; Summary catalogue* (Supplement), 1972; Acquisitions, 1953–62. (Catalogue of the Exhibition of Acquisitions, 1953–62, held in 1963.) [1963].

M7   _____. _____. Illustrated general catalogue. London, National Gallery, 1973. [5], 842p. il.

A 1v. reference guide to over 2,000 paintings in the National Gallery. "The catalogue aims to include all paintings (and the few sculptures) belonging to the National Gallery at the time of going to press, together with a few pictures on long loan from other national museums."—*Note.* Arranged alphabetically by painters. Gives biographical data for each painter. Gives for each painting a reference number, medium, dimensions, a reproduction, and brief commentary.

Numerical index, p.[825]–42.

M8   Oxford., Oxford University, Bodleian Library. Illuminated manuscripts in the Bodleian Library, Oxford [comp. by] Otto Pächt and J. J. G. Alexander. Oxford, Clarendon, 1966-73. 3v. plates (col. fronts.)

Lists 3,000 Western illuminated manuscripts in the Bodleian Library, arranged and classified according to country of origin and date, including important unknown manuscripts and notes on collectors.

Contents: v.1, German, Dutch, Flemish, French, and Spanish Schools; v.2, Italian school; v.3, British, Irish, and Icelandic schools, with addenda to v.1 and 2.

M9   Samuel H. Kress Foundation. Paintings from the Samuel H. Kress Collection. London, Phaidon, 1966-[77]. (Complete catalogue of the Samuel H. Kress Collection)

*Italian schools,* by Fern (Rusk) Shapley: v.1, Italian schools, 13th-15th century; v.2, Italian schools, 15th-16th century; v.3, Italian schools, 17th-18th century. Includes only those paintings located in the· National Gallery, Wash., D. C. Arranged by regional school within each volume. For each artist gives brief biography and a chronological list of paintings with location, measurements, provenance, and bibliographical references. Each painting is illustrated. Indexes of changes of attribution, iconography, previous owners, numerical index, places, and artists.

European paintings, excluding Italian, in the collection are included in the volume *Paintings: European schools excluding Italian,* by Colin Eisler. London, Phaidon, 1977, 640p., 488 il., 16 col. plates. Catalogues and reproduces 317 works from the German, Early Netherlandish, Flemish, Dutch, Spanish, and French schools.

M10   Vienna. Nationalbibliothek. Die illuminierten Handschriften und Inkunabeln der Österreichischen Nationalbibliothek. (Fortsetzung des beschreibenden Verzeichnisses der illuminierten Handschriften der Nationalbibliothek in Wien) Hrsg. von Otto Pächt. Wien, Österreichischen Akademie der Wissenschaften, 1974-. (Österreichische Akademie der Wissenschaften. Philosophisch-Historische Klasse. Denkschriften, Bd. 118- . Veröffentlichungen der Kommission für Schrift- und Buchwesen des Mittelalters, Reihe 1)

In progress.

A new series of catalogues of the illuminated manuscripts in the Austrian National Library. Supplements the earlier series *Die illuminierten Handschriften und Inkunabeln du Nationalbibliothek in Wien,* ed. by J. Schlosser and H. J. Hermann, Leipzig, 1923-38.

Like the earlier volumes, these catalogues are being prepared by outstanding scholars. Full documentation, completely illustrated.

Contents: Bd. 1, *Französische Schule I,* by Otto Pächt and Dagmar Thoss (2v.), 1974; Bd. 2, *Französische Schule II,* by Otto Pächt and Dagmar Thoss (2v.), 1977; Bd. 3, *Holländische Schule,* by Otto Pächt and Ulrike Jenni, (2v.), 1975.

M11   Wickhoff, Franz, ed. Beschreibendes Verzeichnis der illuminierten Handschriften in Österreich. 1-8 Bd. Leipzig, Hiersemann, 1905-38. 22v. il., facsims., plates (part col.) (Publikationen des Instituts für Österreichische Geschichtsforschung)

v.1-7 ed. by Franz Wickhoff (v.4-7 "fortgesetzt" von Max Dvořák);. v.8 ed. by Julius Schlosser and Hermann Julius Hermann. Some volumes issued in parts.

A monumental, scholarly work dealing with the manuscripts in various Austrian libraries. Well illustrated with collotypes.

Contents: Bd. 1, *Die illuminierten Handschriften in Tirol,* von H. J. Hermann; Bd. 2, *Die illuminierten Handschriften in Salzburg,* von H. Tietze; Bd. 3, *Die illuminierten Hand-*

*schriften in Kärnten,* von R. Eisler; Bd. 4, *Die illuminierten Handschriften in Steiermark:* t.1, *Die Stiftsbibliotheken zu Admont und Vorau,* von P. Buberl; Bd. 5, *Die illuminierten Handschriften der Rossiana in Wien-Lainz,* von H. Tietze; Bd. 6, *Die illuminierten Handschriften in Dalmatien,* von H. Folnesics; Bd. 7, *Die illuminierten Handschriften im österreichischen Küstenlande, in Istrien und der Stadt Triest,* von H. Folnesics; Bd. 8 (Neue Folge I-VII), *Die Handschriften und Inkunabeln der Nationalbibliothek in Wien:* |t.I| *Die frühmittelalterlichen Handschriften des Abendlandes,* von H. J. Hermann; t.II (N. F. Bd. 2), *Die deutschen romanischen Handschriften,* von H. J. Hermann; t.III (N. F. Bd. 3), *Die romanischen Handschriften des Abendlandes, mit Ausnahme der deutschen Handschriften,* von H. J. Hermann; t.IV (N. F. Bd. 4), *Die byzantinischen Handschriften,* von Paul Buberl und Hans Gerstinger, 2v.; t.V (N.F. Bd. 5), *Die italienischen Handschriften des Dugento und Trecento,* von H. J. Hermann, 3v.; t.VI (N.F. Bd. 6), *Die Handschriften und Inkunabeln der italienischen Renaissance,* von H. J. Hermann, 4v.; t.VII (N.F. Bd. 7), *Die westeuropäischen Handschriften und Inkunabeln der Gotik und der Renaissance, mit Ausnahme der niederländischen Handschriften,* von H. J. Hermann, 3v.

Neue Folge, Bd. I-VII: Publikationen des zweiten Kunsthistorischen Instituts der Universität Wien, in Verbindung mit dem Österreichischen Institut für Geschichtsforschung. Contains bibliographies. Each volume has elaborate indexes.

SEE ALSO: Frick Collection. *Catalogue,* v.1-2 (I1); *Inventaires des collections publiques françaises* (I2); *The James A. Rothschild collection at Waddesdon Manor* (P19); Wrightsman, C. B. *The Wrightsman collection* (P31).

# PAINTERS

Only general works are listed here. Entries for the lives of painters of individual countries and specific periods are to be found in those sections. Early sources are listed in the chapter on sources and documents.

M12 Aeschlimann, Erardo, and Ancona, Paolo d'. Dictionnaire des miniaturistes du moyen âge et de la renaissance dans les différentes contrées de l'Europe. Avec 155 planches dont 7 en couleurs. 2. éd. rev. et augm. contentant un index ordonné par époques, régions, écoles. Milan, Hoepli, 1949. 239p. plates (part col.) (Repr.: Nendeln, Liechtenstein, Kraus, 1969.)
1st ed. 1940.

A basic dictionary of miniature painters of the Middle Ages and the Renaissance. Does not include copyists, calligraphers, patrons, amateurs, or others allied to miniature painting. Many entries are signed and include biographical references. Index of periods, subdivided by countries, p.|221|-39.

M13 Bradley, John William. A dictionary of miniaturists, illuminators, calligraphers, and copyists, with references to their works and notices of their patrons, from the establishment of Christianity to the eighteenth century. Comp. from various sources, many hitherto inedited. London, Quaritch, 1887-89. 3v. (Repr.: N.Y., Burt Franklin, 1968.)

An old dictionary which gives a brief account of the work of each miniaturist, illuminator, calligrapher, or copyist listed. Sources are usually indicated. The appendix, p.425-40, is a list of supplementary names.

M14 Champlin, John Denison, and Perkins, Charles C., editors. Cyclopedia of painters and paintings. With more than two thousand illustrations. N.Y., Scribner, 1885-87. 4v. il., plates. (Repr.: Port Washington, Kennikat, 1969.)

An old standard biographical dictionary of painters. Entries include biographical data, lists of paintings with locations, descriptions of paintings, and engravings after paintings. Entries often include a line-drawing portrait of the artist and a reproduction of his signature. Now largely superseded by later works.

Bibliography, v.1, p.xix-xxxvi.

M15 Darmon, J. E. Dictionnaire des peintres miniaturistes sur vélin, parchemin, ivoire et écaille. Paris, Morancé |1927|. 123p. 8 plates.

A selective dictionary of painters of miniatures on vellum, parchment, ivory, and shells, primarily French 18th- and 19th-century artists. The works of more important miniaturists are listed chronologically. Includes numerous entries for "Anonymes."

M16 Foster, Joshua James. A dictionary of painters of miniatures (1525-1850) with some account of exhibitions, collections, sales, etc., pertaining to them. Ed. by Ethel M. Foster. London, Allan, 1926. 330p. ports. (Repr.: N.Y., Burt Franklin, 1968.)

"This book is an amplification of the list of artists reputed to have painted miniatures, from the days of Holbein down to the middle of the nineteenth century, which was printed in my work entitled *Miniature painters, British and foreign* |1903|."—*Author's Pref.* Includes biographical and critical information on portrait miniaturists; information on provenance and ownership; and details of auction sales or other disbursements of works. Sources mentioned in preface, p.xii-xiii; abbreviations, p.xv.

M17 Jakovsky, Anatole. Peintres naïfs: a dictionary of primitive painters. N.Y., Universe |1967|. 398p. il., plates (part col.) ports.
2d ed.: Basel, Basilius, 1976.

A dictionary of over 300 naive painters. Gives for each a biographical sketch, bibliographical references, list of exhibitions, photograph of the artist, and a reproduction of one or more of the artist's works. Text in English, German, French. Also includes an introductory essay on so-called primitive, or naive, painting.

M18   Kindlers Malerei Lexikon [die Herausgeber: Germain Bazin, et al.]. Zürich, Kindler [1964-71]. 6v. il. (part col.)

An excellent dictionary of painters from antiquity to the present. Incorporates modern research and scholarship. v.1-5 contain signed articles on painters written by an international team of specialists. Bibliographies are given for each painter. Includes approx. 1,000 reproductions of signatures and 1,200 color and 3,000 black-and-white reproductions of works. v.6, "Begriffe und Register," contains a "Sachwörtbuch der Weltmalerei" and a comprehensive index to all 6v. The "Sachwörtbuch" has articles on movements, schools, terminology, and periods. Longer articles are signed, and many include bibliographies.

M19   Lampe, Louis. Signatures et monogrammes des peintres de toutes les écoles; guide monogrammiste indispensable aux amateurs de peintures anciennes. Bruxelles, Castaigne, 1895-98. 3v.

Classified by subject: portraits, history, genre, pastoral scenes, horses and battles, animals, landscape, marine scenes, views of cities and architecture, interiors of churches, bas-reliefs, lighting effects, fires, moonlight, still life, musical instruments, plants and insects, fruits and flowers. For each artist gives full name, soubriquets, place and date of birth and death, masters, signatures and marks.

Contents: v.1, Portraits; v.2, Histoire; v.3, Genres divers.

M20   Pavière, Sydney Herbert. A dictionary of flower, fruit, and still life painters. Leigh-on-Sea, Lewis [1962-64]. 4v. il.

A comprehensive dictionary of flower, fruit, and still life painters of all schools and countries. Dictionary arrangement lists artists alphabetically, regardless of nationality or century, and gives school, dates, brief important facts of the artist's life, collections, exhibitions, sources of reproductions, auctions, and literature. The dictionary is followed by a representative examples of selected artists' works; not all artists listed are illustrated.

Contents: v.1, 15th-17th centuries; v.2, 18th century; v.3, pt. 1, 19th century (1786-1840, artists born in this inclusive period); v.3., pt. 2, 19th century (1841-85, artists born in this inclusive period).

M21   Schidlof, Leo. The miniature in Europe in the 16th, 17th, 18th and 19th centuries. [English ed.]. Graz, Austria, Akademische Druck-u. Verlagsanstalt, 1964. 4v. plates (part col.), ports.

A comprehensive dictionary of European miniature painters from the 16th through the 19th centuries. Includes introductory sections in v.1 on the miniature in various countries (England, France, Austria and Hungary, Germany, Scandinavia, Spain, etc.). Entries give dates, place of birth and death, summary discussion, references to sales. The reproductions are in plate volumes.

Contents: v.1, A-L; v.2, M-Z; v.3, Plates 1-329 (A-K); v.4, Plates 330-641 (L-Z). Abbreviations, p.vii-ix.

SEE ALSO:  **Bryan, M.** *Bryan's dictionary of painters and engravers* (E38).

# HISTORIES AND HANDBOOKS

M22   Blanc, Charles, ed. Historie des peintres des toutes les écoles. Paris, Renouard, 1861-70. 14v. il.

A standard work of the 19th century, still referred to by scholars of the 20th century.

For each school usually gives a short historical summary, followed by chapters devoted to the principal artists, with their portraits, signatures, and reproductions of their works. Minor masters are sometimes in the appendix. In most cases, alphabetical and chronological lists of artists are at end of volume.

Contents: v.1, École allemande, 1875; v.2, École anglaise, 1863; v.3, École bolognaise, 1874; v.4, École espagnole, 1869; v.5, École flamande, 1868; v.6, École florentine, 1870; v.7-9, École française, 3v., 1862-65; v.10-11, École hollandaise, 2v., 1861; v.12, Écoles milanaise, lombarde, ferraraise, génoise et napolitaine [1875]-76; v.13, École ombrienne et romaine, 1870; v.14, École vénitienne, 1868.

M23   Clark, Kenneth McKenzie. Landscape into art. Rev. ed. N.Y., Harper, 1976. xix, 147p. plates.

1st published in 1949. Available in paperback, Boston, Beacon, 1969.

A classic introduction to the development of landscape painting. Based on lectures given at Oxford University.

Contents: (I) The landscape of symbols; (II) The landscape of fact; (III) Landscape of fantasy; (IV) Ideal landscape; (V) The natural vision; (VI) The northern lights; (VIII) The return to order; Epilogue.

M24   Gaunt, William. Everyman's dictionary of pictorial art. London, Dent; N.Y., Dutton [1962]. 2v. il. (part col.)

"The aim of this work is to provide in concise form and within the limits of 250,000 words and 1,000 illustrations a handy reference to painters and periods, forms and techniques of pictorial art in all parts of the world where pictorial art has flourished from the earliest times to the present."—*Introd.* Includes approximately 1,200 entries on individual artists as well as entries on art forms, media, descriptions of famous works, galleries, museums, periods, styles, schools, theories, and techniques.

Contents, v.1: Systematic list of entries, p.ix-xx; Text, A-I. v.2: Text, J-Z. Appendixes: (A) Supplementary list of British artists; (B) Supplementary list of American artists. Index of illustrations, p.377-91.

M25   Pochat, Götz. Figur und Landschat: eine historische Interpretation der Landschaftsmalerei von der Antike bis zur Renaissance. Berlin, N.Y., de Gruyter, 1973. 559p. il.

A scholarly art historical study of man with relation to landscape in European painting from antiquity to the latter part of the 16th century. Extensive footnotes, full bibliography of sources and other literature. Indexes of illustrations, subjects, names, and places. 163 illustrations.

M26   Sterling, Charles. Still life painting from antiquity to the present time. [Rev. ed. Trans. by James

Emmons]. N.Y., Universe [1959]. 167p. il. (part col.)

1st ed. 1952, Paris, Tisne, as *La nature morte de l'antiquité à nos jours.*

An excellent survey of still-life painting from antiquity to the present. Bibliographical notes; extensive bibliography, p.151–[58]. Index, p.159–[65].

M27 Williamson, George Charles. The history of portrait miniatures. London, Bell, 1904. 2v. 104 (i.e., 107) plates.

"The object of the author has been to compile a comprehensive account of the art of miniature portrait painting as exhibited in the great collections of England and the Continent, and to narrate the history of the chief exponents of the art."—*Pref.*

A standard work on portrait miniatures. Covers the period 1531–1860. Appendixes: (1) Extracts from Norgate's manuscript in the Bodleian Library; (2) Extracts from King's manuscript in the British Museum entitled "Miniatura."

"Notable collectors and the chief collections" v.2, p.123–47. "The literature of the subject" v.2, p.148–60. Index, v.2, p.183–211. Index of artists whose works are illustrated, v.1, p.xxi–xxii; of collections from which the illustrations are taken, v.1, p.xxiii–xxiv; of portraits illustrated, v.1, p.xxv–xxix.

# TECHNIQUES

M28 Albers, Josef. Interaction of color. New Haven and London, Yale Univ. Pr., 1963. Text volume 80p.; 80 folders (color plates) with commentary of 48p.

A record of Albers's experimentation in the study of color based upon his work as a practicing artist and influential teacher. "The aim of such study is to develop—through experiences—by trial and error—an eye for color. This means, specifically, seeing color action as well as feeling color relatedness."—*Introd.* The 80 folders of color screenprint plates correspond to the 25 chapters of exercises in the text volume and are accompanied by a booklet of commentary.

Also published in an inexpensive ed. in reduced format: *Interaction of color,* New Haven, Yale Univ. Pr., 1971, xiv, 74p., il. (8 col.)

M29 Bazzi, Mario. The artist's methods and materials. Trans. by Francesca Priuli. London, Murray [1960]. xv, 228p. il. (part col.)

"The object of this manual is to make available a ready reference to basic recipes, both ancient and modern, which will be easy to consult."—*Introd.*

Contents: pt. 1, The artist's materials: (1) Surfaces for easel pictures and their preparation; (2) Grounds for mural painting; (3) Pigments; (4) Glues and oils; (5) Resins, balsams, gums and waxes; (6) Varnishes and varnishing; (7) Gilding; (8) Pastels; (9) Miniatures; (10) Watercolour painting; (11) Tempera painting; (12) Painting in oils; (13) Encaustic painting; (14) Fresco painting; (15) Mural oil painting and other decorations. Notes, p.198–205, include references. Glossary of terms not explained in the text, p.205–7.

Bibliography, p.207–28, arranged chronologically by period, partially annotated.

M30 Bradley, Morton C. The treatment of pictures. Cambridge, Mass., Art Technology, 1950. 304p. il.

Issued in loose-leaf format.

"Useful only as a handbook for competent conservators and curators and for students working under their direction"—*Pref.* Includes descriptions of various processes and formulas, a glossary, and index.

M31 Constable, William George. The painter's workshop. London, N.Y., Oxford Univ. Pr., 1954. 148p. 25 plates.

A general work on painting techniques written for the layman.

Contents: (1) Introductory; (2) Workshop organization and equipment; (3) The physical structure of a painting; (4) Painting processes: wax; pastel; water-colour; (5) Painting processes: fresco; (6) Painting processes: tempera; the metals in painting; (7) Painting processes: oil painting; (8) Preliminaries to making a painting; (9) The restorer's contribution.

Bibliography, p.[137]–39, classified by chapter.

M32 Doerner, Max. The materials of the artist and their use in painting, with notes on the techniques of the old masters; trans. by Eugen Neuhaus. Rev. ed. N.Y., Harcourt [1949]. xvi, 435p. il.

1st ed. 1934. Based on the author's lectures at the Academy of Fine Arts, Munich.

"This book is an attempt to communicate the dependable knowledge in the field of technique to the practicing artist. It is not intended as a course of instruction in painting."—*Pref.*

Contents: (1) The preparation of grounds for easel pictures; (2) Pigments; (3) Binding media of oil painting; (4) Painting in oils; (5) Tempera painting; (6) Pastel painting; (7) Painting in water colors; (8) Mural painting; (9) Techniques of the old masters; (10) The restoring of easel pictures. Bibliography, p.[415].

M33 Eastlake, Charles Locke. Materials for a history of oil painting. London, Brown, Green, and Longmans, 1847–69. 2v.

Reprint published under title: *Methods and materials of the great schools and masters,* N.Y., Dover, 1960.

"Eastlake seems to have extracted from the most important sources available, in several languages, every piece of information of interest concerning the methods and materials of the great schools and masters"—Ruhemann (M44), p.388.

M34 Gettens, Rutherford John, and Stout, George L. Painting materials, a short encyclopedia. With an introd. by Edward W. Forbes. N.Y., Van Nostrand, 1942. 333p. il. (Repr.: N.Y., Dover, 1966.)

Originally published as separate sections in *Technical studies in the field of fine arts* (Q333) from 1936–41. Contents: (1) Mediums, adhesives, and film substances; (2) Pigments and inert materials; (3) Solvents, diluents, and detergents; (4) Supports; (5) Tools and equipment; (6) Glossary, p.325–33. Items are arranged alphabetically within the six chapters.

Illustrated with a few line drawings. Bibliography at the end of each chapter.

283

M35   Hiler, Hilaire. Notes on the technique of painting. With a pref. by Sir William Rothenstein. N.Y., Watson-Guptill [1969]. 347p.
1st ed. 1934; reprinted 1947 and 1948. 2d ed. 1954. This ed. seems only slightly rev.
   "Written for painters, with ease and charm. Good introduction stressing the importance of technique, method and beautiful 'matière'."—Ruhemann (M44), p.401.
   Contents: Introduction; (1) Suggestions on the technique of painting; (2) Colour and pigments; (3) Vehicles and media; (4) The ideal studio; (5) Conservation of paintings. Appendixes: (I) Notes; (II) Pigments at a glance. Glossary, p.[335]-40.
   Bibliography, p.[304]-34.

M36   Hours-Miedan, Madeleine. A la découverte de la peinture par les méthodes physiques. [Paris] Arts et métiers graphiques [1957]. 147p. il.
A well-illustrated study and discussion of conservation and restoration techniques of painting. Contents: (I) La lumière et ses applications dans l'étude et la conservation des peintures; (II) À la recherche de l'invisible; (III) Le rôle des méthodes physiques dans l'étude des chef-d'oeuvre.
   Notes techniques, p.[134-37]. Bibliographie choisie, p.[139-44].

M37   International Museum Office. Manual on the conservation of paintings. [Paris] International Museums Office [1940]. 296p. il. (Publications of the International Institute of Intellectual Co-operation [League of Nations])
Also published in French: *Manuel de la conservation et de la restauration des peintures*, Paris, 1939. First published as a single issue of *Mouseion*, XLI-XLII (1938).
   "This handbook was the direct outcome of the International Conference on picture conservation and restoration held in Rome in 1930 ... It was written by an international group of specialists including G. L. Stout, H. J. Plenderleith and H. Ruhemann. With its emphasis on the importance of proper environment and on systematic examination of condition before treatment, it is perhaps the first modern textbook on the subject to be published."—Ruhemann, (M44), p.402.

M38   Keck, Caroline K. A handbook on the care of paintings. N.Y., Published for the American Association for State and Local History by Watson-Guptill [1965]. xii, 136p. 82 il.
A useful handbook on the subject, written by a well-known conservator. Contents: (1) Preliminary survey; (2) Anatomy of paintings: pastel, watercolors, gouache; (3) Anatomy of paintings: oil on fabric and solid supports; (4) Laboratory examination and treatment; (5) Conservation priorities and procedures.
   Appendix: Glossary of terms; Diagrams explaining some varieties of structural deterioration in painting; Sources of supply; The Frick Art Reference Library; Sources of further information (Bibliography); Recommended conservators for paintings; Recommended conservator for paper; Notes on portable fire extinguishers.

M39   Maroger, Jacques. The secret formulas and techniques of the masters. Trans. from the French by Eleanor Beckham. N.Y., London, Studio [1948]. 200p. il.
A popularized, unscholarly survey of old master techniques, written by a former technical director of the laboratory of the Louvre.
   Bibliography, p.195-96. Index of painters, p.197-200.

M40   Mayer, Ralph. The artist's handbook of materials and techniques. 3d ed., rev. and expanded. N.Y., Viking [1970]. xv, 750p. il.
1st ed. 1940.
A basic, comprehensive handbook of artists' materials and techniques. Although directed primarily to painters, it is also useful to art historians for the identification and description of terminology and procedures.
   Contents: (1) Introductory notes; (2) Pigments; (3) Oil painting; (4) Tempera painting; (5) Grounds for oil and tempera paintings; (6) Water color and gouache; (7) Pastel; (8) Encaustic painting; (9) Mural painting; (10) Solvents and thinners; (11) Gums, casein, glues, waxes; (12) The new materials; (13) Chemistry; (14) Conservation of pictures; (15) Miscellanous notes; (16) Appendix; (17) Bibliographies.
   Information on printmaking techniques is included in chapters 12, 13, and 15. Chapter 15 also contains "Notes on sculptors' materials—clay, metals, stones, woods, cement, etc." The Appendix includes sections on formulas, weights and measures, a glossary of terms, retail sources of some materials, and other technical data.
   Bibliographies: general, painting techniques, picture frames, sculpture, drawing, color, lettering, etc. General index.

M41   Merrifield, Mary Philadelphia. Original treatises, dating from the XIIth to XVIIIth centuries on the arts of painting, in oil, miniature, mosaic, and on glass; of gilding, dyeing, and the preparation of colours and artificial gems; preceded by a general introduction; with translations, prefaces, and notes. London, Murray, 1849. 2v. il. (Repr.: New York, Dover, 1967; includes a new introduction and a glossary of technical terms by S. M. Alexander.)
"Since its appearance in 1849, the *Original Treatises* has been the only publication and English translation of most of the compilations and manuals it contains; it has become one of the standard reference texts in the technology of painting from the Middle Ages to the seventeenth century."—*Introd. to the Dover ed.* Texts arranged chronologically. General index at the end of v.2.

M42   Munsell, Albert Henry. A color notation. An illustrated system defining all colors and their relations by measured scales of hue, value, and chroma. Introd. by Royal B. Farnum. 10th ed. (ed. and rearranged). Baltimore, Munsell Color Co., 1946. 74p. il., 3 col. plates, diagrs.
1st ed. 1905.
The principal work of the best-known American color theorist, Albert H. Munsell (1858-1918).
   Contents: (1) Color notation; (2) Color score; (3) Color arrangements. Appendixes: (A) Author's notes on relation

of color to science and general education; (B) Notes on various applications and advantages of the Munsell Color System and some of the more recent developments relating to it. Traditional color names, p.59-64. Glossary of color terms, p.65-70.

M43 Pope, Arthur. The language of drawing and painting. Cambridge, Harvard Univ. Pr. [1949]. 162p. il., [72] plates (part col.)
"A revision and rearrangement of ... [the author's] two earlier books, *The painter's terms* and *The painter's modes of expression.*"—Pref.
Contents: (1) The terms of drawing and painting; (2) Modes of representation. Appendixes: (1) Design in tone relations; (2) The emotional significance of different general tonalities; (3) The question of preference for individual tones; (4) A hybrid mode of drawing an illustration in Winchester MSS. Bibliographical note, p.160-62.

M44 Ruhemann, Helmut. The cleaning of paintings: problems and potentialities. With bibliography and supplementary material by Joyce Plesters, and foreword by Sir Philip Hendy. N.Y., Praeger [1968]. 508p. plates, 101 il. (6 col.)
A detailed, comprehensive work on the techniques and ethics of cleaning paintings, written for a wide range of readers by a conservator well-known for his work on the restoration of paintings in the National Gallery, London. Very well illustrated.
Contents, pt. I, Background: (1) Autobiographical and historical notes; (2) The restorer and his training; (3) The exhibition of cleaned pictures at the National Gallery; pt. II, Technique and ethics of restoration: (4) Anatomy of a painting; (5) Science and restoration; (6) Preservation and consolidation; (7) Technique and ethics of cleaning; (8) Technique and ethics of retouching; (9) Varnishes and varnishing. Appendixes: (A) Institutions; (B) Concerning cleaning: Technical reports; (C) Varnish recipes; (D) Useful articles reprinted.
Superb bibliography, p.361-481, classified into 31 sections and extensively annotated.

M45 Stout, George Leslie. The care of pictures. N.Y., Columbia Univ. Pr., 1948. 125p. il., 24 plates. (Repr.: N.Y., Dover, 1975.)
A sound introduction.
Contents: (1) Construction of pictures; (2) Surface blemishes; (3) Defects in paint or drawing; (4) Ground; Weakness and damage; (5) Flaws in the support; (6) Housing, handling, and moving. Appendixes: (A) Record abstracts of repair treatment; (B) Special means of examination.
Bibliography, p.[115]-20.

M46 Thompson, Daniel Varney. The materials of medieval painting; with a foreword by Bernhard Berenson. New Haven, Yale Univ. Pr., 1936. 239p.
Reprint published under title: *Materials and techniques of medieval painting.* N.Y., Dover, 1956. Also published by Dover in paperback, 1958.

A basic study of the materials and techniques of medieval painting. Especially useful for the art historian. Contents; (1) Carriers and grounds; (2) Binding media; (3) Pigments; (4) Metals.

M47 _____. The practice of tempera painting. Illustrated by Lewis E. York. New Haven, Yale Univ. Pr.; London, Milford, Oxford Univ. Pr., 1936. 141p. il., plates, diagrams.
Paperback ed.: N.Y., Dover, 1960.
An old, but still useful, study of the art of tempera painting with general background and step-by-step descriptions of the technique. Illustrations accompany the instructions. Valuable to artists interested in the medium and for art historians. The appendix, "Tempera practice in the Yale Art School," by Lewis E. York, discusses the use of tempera in the 1930s. Index, p.[139]-41.

M48 Wehlte, Kurt. The materials and techniques of painting. Trans. by Ursus Dix. N.Y., Van Nostrand [1975]. 678p. il. (part col.), 48 leaves of plates.
Trans. of *Werkstoffe und Techniken der Malerei.*
A thoroughly comprehensive, extremely detailed reference work on the materials and techniques of easel and wall painting. Contents: (1) Technical principles; (2-5) Wall painting; (6-9) Easel painting; (10-11) Special techniques; (12) The examination of paintings; (13) Glossary, p.647-48; (14) Color theory, p.653-71. Detailed table of contents, p.7-24. Well illustrated. Bibliography, p.649.

# PREHISTORIC

M49 Bandi, Hans-Georg [and others]. The art of the Stone Age: forty thousand years of rock art. 2d ed. London, Methuen; N.Y., Crown, 1970. 287p. il. (part col.), maps. (Art of the world, 5)
Trans. from the German by Ann E. Keep. 1st English ed. 1961.
A well-illustrated introductory study containing sections by six scholars on prehistoric rock pictures. Contents: Introduction; Franco-Cantabrian rock art; Franco-Cantabrian art stations with dates of discovery; The rock art of the Spanish Levant; The rock art of the Maghreb and Sahara; The rock art of South Africa; The rock art of Australia. Includes a chronology and a glossary. Classified bibliography, p.268-71.

M50 Breuil, Henri. Quatre cents siècles d'art pariétal: les cavernes ornées de l'âge du renne. Réalisation [de] Fernand Windels. Montignac, Centre d'Étude et de Documentation Préhistoriques [1952]. 413 p. 531 il. (2 col.), maps.
The translation of the English ed., *Four hundred centuries of cave art,* Montignac [1953], has been strongly criticized.
Valuable as a collection of illustrations of the cave art which Breuil studied for many years in Europe, primarily in France and northern Spain.
Bibliography, p.408-11.

# ANCIENT

M51   Swindler, Mary Hamilton. Ancient painting from the earliest times to the period of Christian art. New Haven, Yale Univ. Pr., 1929. 488p. il., plates (part col.), maps.

An old work, still unique in the breadth of its scope. Considers prehistoric, Egyptian, Oriental, Cretan, Greek, Etruscan, Pompeian, Graeco-Roman, and Roman painting. Includes chronological tables and a tentative chronology of some of the most important vase-painters.

Detailed, classified bibliography, p.[433]-70. Glossary, p.471-72.

## Egypt

M52   Davies, Nina M. (Cummings). Ancient Egyptian paintings selected, copied, and described by Nina M. Davies, with the editorial assistance of Alan H. Gardiner. Chicago, Univ. of Chicago Pr., 1936. 3v. il., 104 col. plates (part double).

Special publication of the Oriental Institute of the University of Chicago: James Henry Breasted, ed. A deluxe publication with fine color reproductions of Egyptian paintings from c.2700 B.C. to c.100 B.C. Includes bibliographies; dimensions are given in the text volume.

Contents: v.1-2, Plates; v.3, Descriptive text. General index, v.3, p.201-6; Index of localities, p.207; Index of personal names, p.207-9.

M53   Mekhitarian, Arpag. Egyptian painting. [Trans. by Stuart Gilbert. N.Y.] Skira [1954]. 164p. 151 mounted col. il. (The Great centuries of painting) (Repr.: N.Y., Skira/Rizzoli, 1978.)

A survey of Egyptian tomb painting from the 1st through the 30th dynasty. Emphasizes Theban paintings of the New Kingdom.

SEE ALSO:   Smith, W. S. *A history of Egyptian sculpture and painting in the Old Kingdom* (I46).

## Crete, Mycenae, Greece

M54   Arias, Paolo Enrico. A history of 1000 years of Greek vase painting. Text and notes by P..E. Arias. Photos by Max Hirmer. [Trans. and rev. by B. Shefton] N.Y., Abrams [1962]. 410 p. col. il., plates.

An introductory essay is followed by 240 black-and-white and 52 color illustrations with commentaries. "Admirable photographs and erudite notes."—R. M. Cook (M66). Includes bibliographical references.

M55   Beazley, *Sir* John Davidson. Attic black-figure vase-painters. Oxford, Clarendon, 1956. 851p.

"A monumental catalogue by painters of 10,000 pieces."—R. M. Cook (M66). Painters are arranged roughly chronologically. Divided into two sections: Painters of large vases, p.1-417; Painters of small vases, p.418-663. Supplemented by *Paralipomena* (M57).

Indexes: (1) Proveniences; (2) Mythological subjects; (3) Collections; (4) Publications; (5) Painters, potters, groups, classes.

M56   _____. Attic red-figure vase-painters. 2d ed. Oxford, Clarendon, 1963. 3v. lvi, 2,036p.

"The indispensable catalogue by painters of 21,000 red-figure and white-ground pieces."—R. M. Cook (M66). Extends coverage well into the 4th century B.C. "The arrangement of the painters is roughly chronological; but groups of painters are kept together."—*Instructions*. Full documentation, including bibliographical reference. Supplemented by *Paralipomena* (M57).

Contents: (I) Early red-figure pot-painters; (II) Early red-figure cup-painters; (III) Late archaic pot-painters; (IV) Late archaic cup-painters; (V) Early classic painters of large pots; (VI) Early classic painters of smaller pots; (VII) Early classic cup-painters; (VIII) Early classic skyphos-painters; (IX) Classic pot-painters; (X) Classic painters of smaller pots; (XI) Classic painters of white lekythoi; (XII) Classic cup-painters; (XIII) Classic skyphos-painters; (XIV) Classic painters of stemmed plates; (XV) Late-5th-century pot-painters; (XVI) Late-5th-century painters of small pots; (XVII) Late-5th-century painters of white lekythoi; (XVIII) Late-5th-century cup-painters; (XIX) 4th-century pot-painters; (XX) 4th-century painters of cups and stemlesses.

Appendixes: (I) The head vases; (II) Signatures of potters; (III) Fragmentary signatures; (IV) Kalos-names; Addenda. Indexes, in v.3: (I) Proveniences; (II) Mythological subjects; (III) Collections (IV) Publications; (V) Artists.

M57   _____. Paralipomena: additions to Attic black-figure vase-painters and to Attic red-figure vase-painters. 2d ed. Oxford, Clarendon, 1971. xix, 679p.

Supplements *Attic red-figure vase-painters* (M56) and *Black-figure vase-painters* (M55) with additions and new attributions. Painters arranged roughly chronologically.

Indexes: (1) Proveniences; (2) Mythological subjects; (3) Collections; (4) Publications; (5) Artists.

M58   Beazley, John Davidson, and Jacobsthal, Paul, eds. Bilder griechischer Vasen. Berlin-Wilmersdorf, Keller, 1930-39. 13v. 390 plates.

A classic series of monographs on individual Greek vase-painters and classes of vase-painting by preeminent scholars in the field. Each volume contains scholarly text, excellent reproductions, and bibliographies.

Contents: Hft. 1, Hahland, W. *Vasen um Meidias,* 1930; Hft. 2, Beazley, J. D. *Der Berliner Maler,* 1930; Hft. 3, Schefold, K. *Kertscher Vasen,* 1930; Hft. 4, Beazley, J. D. *Der Pan-Maler,* 1931; Hft. 5, Ducati, P. *Pontische Vasen,* 1932; Hft. 6, Beazley, J. D. *Der Kleophrades-Maler,* 1933; Hft. 7, Payne, H. G. G. *Proto-korinthische Vasenmalerei,* 1933; Hft. 8, Webster, T. B. L. *Die Niobidenmaler,* 1935; Hft. 9, Technau, W. *Exekias,* 1936; Hft. 10, Diepolder, H. *Der Penthesilea-maler,* 1936; Hft. 11, Rumpf, A. *Sakonides,* 1937; Hft. 12, Trendall, A. D. *Frühitaliotische Vasen,* 1938; Hft. 13, Smith, H. R. W. *Der Lewismaler (Polygnotos II),* 1939.

Five of these thirteen volumes are reprinted in the original German editions and four in revised English-language editions in the new series *Bilder griechischer Vasen* (M59).

M59 _____. _____. Mainz, Zabern, 1974. 9v. plates
· (Forschungen zur antiken Keramik. Erste Reihe)
A series of monographs on individual Greek vase-painters
and classes of vase-painting which consists of five German
edition reprints and four revised English-language editions
of the original *Bilder griechischer Vasen* series (M58). Each
volume contains a scholarly text, reproductions, and bibliog-
raphies. These volumes remain the basic scholarly studies
in the field.

Contents: Hft. 1, Beazley, J. D. *The Berlin Painter* (the
previously unpublished English text of 1930; rev. during
1944 and 1947); Hft. 2, Beazley, J. D. *The Pan Painter* (the
previously unpublished English text of 1931; revised during
1944 and 1947); Hft. 3, Beazley, J. D. *The Kleophrades
Painter* (the previously unpublished English text of 1933;
rev. during 1944 and 1948); Hft. 4, Diepolder, H. *Der Pen-
thesilea-maler* (repr. of 1936 German ed.); Hft. 5, Hahland,
W. *Vasen um Meidias* (repr. of 1930 German ed.); Hft. 6,
Payne, H. G. G. *Protokorinthische Vasenmalerei* (repr. of
1933 German ed.); Hft. 7, Rumpf, A. *Sakonides* (repr. of
1937 German ed.); Hft. 8, Smith, H. R. W. *Der Lewismaler*
(repr. of 1939 German ed.); Hft. 9, Trendall, A. D. *Early
South Italian vase-painting* (previously unpublished English
text of 1938; rev).

This series is continued by a new series *Kerameus* (For-
schungen zur antiken Keramik), Mainz, Zabern (M62).

M60 Boardman, John. Athenian black figure vases. N.Y.,
Oxford Univ. Pr., 1974. 252 p. 383 il.
The aim is "to give a history of the art full and detailed
enough for connoisseur and student, supported by pictures
numerous enough to demonstrate the quality of the work of
the finest artists as well as the appearance of the work by
less competent painters, and to add an account of the
subsidiary decoration and the figure scenes ... The account
of the styles of Athenian black figure painting is based on
Sir John Beazley's brilliant work in distinguishing painters
and groups" (M55). — *Pref.*

Contents: (1) Introduction; (2) Early Athenian black
figure; (3) Kleitias, Siana cup painters and others; (4) The
mid century and after; (5) The age of red figure; (6) The
latest black figure; (7) Panathenaic vases; (8) Odds and ends;
(9) Shapes, names and functions; (10) Relative and absolute
chronology; (11) General decoration; (12) Scenes of reality;
(13) Scenes of myth. Chronological chart, p.234. Notes
and bibliographies, p.235–41, include general works and
works classified by chapters. Index of artists and groups,
p.249–50; Index of mythological subjects, p.251–52; General
index.

M61 _____. Athenian red figure vases; the archaic period;
a handbook. London, Thames & Hudson, 1975. 252p.
462 il.
A companion volume to the author's *Athenian black figure
vases* (M60).

A history of Athenian red figure vases of the archaic period
from the invention of the technique c.530 B.C. through two
succeeding generations of painters. Very well illustrated.
Written for the student and the scholar.

Contents: (1) Introduction, (2) The first generation, (3)
The late archaic painters, (4) Mannerists and others, (5)
Shapes and dates, (6) General decoration, (7) Scenes of
reality, (8) Scenes of myth. Notes and bibliographies, p.236–
41. Index of artists and groups; Index of mythological
subjects; General index.

M62 Boardman, John, and Cohn, Herbert A. Kerameus.
Mainz, Zabern, 1974– . 17v. plates. (Forschungen
zur antiken Keramik. Zweite Reihe)
A new series of monographs on vase-painters and classes of
pottery. Each volume will contain a scholarly text, repro-
ductions of all recognized and attributed works as complete
as possible, and bibliographies. Following a plan envisioned
by the late J. D. Beazley, the foremost scholar in the field,
this series will complement and continue the two *Bilder
griechischer Vasen* series (M58, M59).

Volumes to be published: Hft. 1, Mommsen-Scharmer,
H. *Der Affecter,* 1974; Hft. 2, Lezzi-Hafter, A. *Der Schuwalow-
Maler,* 1975; Cook, R. M. *Clazomenian sarcophagi;* Board-
man, J. *The Northampton and Campana groups;* Hemelrijk,
J. M. *Caeretan hydriai;* Stibbe, C. M. *"Pontische" Vasenmaler;*
Kurtz, D. C. *Psiax and Paseas;* von Bothmer, D. *Euphronios;*
Boardman, J. *Epiktetos;* Lullies, R. *Der Kleophrades-Maler;*
Robertson, M. *The Berlin Painter;* Knauer, E. R. *Der
Triptolemosmaler;* Robertson, M. *The Syleus Painter and
his origins;* Shefton, B. B. *Hermonax;* Kurtz, D. C. *The
Achilles Painter;* Lezzi-Hafter, A. *Der Eretria-Maler und
sein Kreis;* Shefton, B. B. *The Pronomos Painter and his
circle.*

M63 Buschor, Ernst. Griechische Vasen. [Neuausg.
durchgesehen und im Anhang überarb. von Martha
Dumm] München, Piper [1969]. 293p. il.
1st ed. 1913.

An older, though standard, survey. "Good illustrations
and good, though rather mystical, account."—R. M. Cook
(M66).

M64 Cambitoglu, Alexander, and Trendall, A. D. Apulian
red-figured vase-painters of the plain style. [N.Y.]
Archaeological Institute of America, 1961. xv, 103p.
41 plates. (Monographs on archaeology and fine arts,
10)
"An attempt to provide a basis for the classification of the
vases of the 'Plain' style from the beginning of the fabric
with the painter of the Berlin Dancing Girl and Sisyphus
painter down to the third quarter of the fourth century."—
*Introd.* Includes all vases known to the authors which can
be attributed to individual painters, as well as many vases
closely related stylistically to individual artists.

Contents: (1) The Sisyphus group; (2) The Ariadne group;
(3) The Eumenides group; (4) The Rehearsal group; (5) The
Tarporley Painter and his school; (6) The Hoppin group;
(7) The Lecce group. Museum index, p.87–98; subject index,
p.99–103.

Supplemented by "Addenda to Apulian red-figure vase-
painters of the plain style," by Alexander Cambitoglu and
A. D. Trendall in *American journal of archaeology* 73:423–
33 (Oct. 1969).

**M65**   Coldstream, John Nicolas. Greek geometric pottery; a survey of ten local styles and their chronology. London, Methuen [1968]. xxxix, 465p. 64 plates, map. (Methuen's handbooks of archaeology)

"A fundamental, though not final, conspectus."—R. M. Cook (M66). Arranged topographically and chronologically. Photographic illustrations of nearly 500 geometric vases.

Contents: (1) Introduction: (2) Attic geometric; (3) Corinthian geometric; (4) Argive geometric; (5) Protogeometric survivals in Thessaly, Skyros, Euboea, and the Cyclades; (6) Thessalian geometric; (7) Cycladic and Euboean geometric; (8) Boeotian geometric; (9) Laconian geometric; (10) West Greek geometric; (11) Cretan geometric; (12) East Greek geometric; (13) Absolute chronology; (14) Historical conclusions.

Bibliography, classified by chapter (exclusive of site publications), p.391–94. Glossary of linear motifs, p.395–97. Indexes: Sites, collections, general.

**M66**   Cook, Robert Manuel. Greek painted pottery. [2d ed. London] Methuen [1972]. xxiv, 390p. il. (Methuen's handbooks of archaeology)

Probably the most comprehensive, authoritative handbook on all aspects of Greek vase painting from the Protogeometric style through the Hellenistic period.

Contents: (1) Introduction; (2) The protogeometric style; (3) The geometric style; (4) The orientalizing and black-figure styles; (5) The red-figure style; (6) Hellenistic pottery with painted decoration; (7) Black-painted and relief wares; (8) Shapes; (9) Technique; (10) Inscriptions; (11) Chronology; (12) The pottery industry; (13) Uses for other studies; (14) Practical comments; (15) The history of the study of vase-painting.

"Uses for other studies" acknowledges the significance of the content of vase paintings. "Practical comments" provides information to the student of vases on handling, examination, taking notes, drawing and photographing, cleaning, mending, and collecting.

Abbreviations, p.328–30. Excellent, annotated bibliography, p.331–59. Note on museums, p.360–64, indicates principal source of each collection and published, illustrated catalogues; Note on sites, p.365. Glossary of terms not already explained, p.366–72. Well-chosen illustrations.

**M67**   Corpus vasorum antiquorum. Paris, Champion [etc.] 1922– il., plates (part col.)

At head of title: Union Académique Internationale. Issued in portfolio form. Imprint varies.

An international series approaching 200 fascicles of about 50 plates each. Each fascicle is devoted to vases in a specific museum and is written by a specialist. Series for Austria, Belgium, Cyprus, Denmark, France, Germany, Great Britain, Greece, Italy, Low Countries, Norway, Poland, Rumania, Spain, Switzerland, U.S., and Yugoslavia. "The quality of text and illustrations is uneven, but generally the more recent fascicules are better."—R. M. Cook (M66).

————. Konkordanz zum Corpus vasorum antiquorum by Jan W. Crous. Rome, "L'Erma" di Bretschneider, 1942. 244p.

Concordances of the first 74 fascicles to 1940. Arranged by countries, museums, collections, and especially, groups of vases, i.e., Attic black-figure, Italo red-figure, etc.

**M68**   Noble, Joseph Veach. The techniques of painted Attic pottery. N.Y., Published by Watson-Guptill Publications in collaboration with the Metropolitan Museum of Art [1965]. xvi, 217p. 261 il., col. plates, diags., tables.

"A comprehensive and generally reliable compendium."—R. M. Cook (M66). Excellent illustrations of the forming and decorating of vases.

Contents: (1) Forming the vases; (2) The Greek black glaze; (3) Decorating the vases; (4) Firing the vases; (5) Conclusion. Appendixes: (I) Dating and localization; (II) Condition, repair, and photography; (III) The poem entitled "Kiln."

**M69**   Pfuhl, Ernst. Masterpieces of Greek drawing and painting. Tr. by J. D. Beazley. N. Y., Macmillan [1955]. 151p. 126p. of il. (part col.)

1st ed. 1926. The 1955 ed. includes an appendix by Beazley listing the attributions of the vases illustrated, p.146–47.

"Intended neither as a guide to the study of vases nor as a history of Greek painting. It is ... a collection, though not an arbitrary one, of masterpieces of Greek painting and drawing ... The plates contain a selection from the 800 reproductions in my three-volume work *Malerei und Zeichnung der Griechen*."—Pref.

Bibliography, p.144–45. "List of artists of the Attic vases illustrated," by Beazley, p.146–47.

**M70**   Richter, Gisela Marie Augusta. Attic red-figured vases; a survey. Rev. ed. New Haven, Yale Univ. Pr., 1958. xx, vii, 209p. 129 il.

At head of title: Metropolitan Museum of Art.
1st ed. 1946.

A basic, chronological survey of Attic red-figured vases. Examples discussed are drawn largely from the collection in the Metropolitan Museum of Art. Contents: Introduction (General; Ornaments; Shapes; Inscriptions; Chronology; Technique); (I) Early style, about 530–500 B.C.; (II) Ripe archaic style, about 500–475 B.C.; (III) Early free style, about 475–450 B.C.; (IV) Free style, about 450–420 B.C.; (V) Late 5th-century style, about 420–390 B.C.; (VI) The 4th century.

Bibliography, p.[vii]–xii. Notes, p.[165]–200 include references to more specialized literature.

**M71**   Richter, Gisela Marie Augusta, and Milne, Marjorie J. Shapes and names of Athenian vases. N.Y. [Plantin] 1935. xxiii, 32pl., 11. il., plates. (Repr.: Wash., McGrath, 1973.)

The standard work on the shapes and names of Attic vases. "Gives evidence for conventional names, bibliography and illustrations of the principal Attic shapes from the mid sixth to the mid fourth century."—R. M. Cook (M66).

**M72**   Robertson, Martin. Greek painting [Geneva] Skira [1959]. 193p. col. il., map. (The Great centuries of painting)

An authoritative account of Greek painting from its beginnings in the Bronze Age through the Hellenistic period as reflected primarily in painted vases. Excellent color illustrations. Selected bibliography, briefly annotated, p.183.

M73 Stibbe, C. M. Lakonische Vasenmaler des sechsten Jahrhunderts v. Chr. Amsterdam, London, North-Holland, 1972. 2v. il. (Studies in ancient civilization. New series, v.1)

A detailed, analytical survey of Laconian potters and vase painters of the 6th century B.C. Illustrated with 98 line drawings in the text volume (v. 1) and photographic reproductions on 132 plates in the plate volume (v.2).

Contents: Abkürzungen und Bibliographie, p.xi–xiv; Terminologie, p.xv; Einleitung; (I) Formgruppen; (II) Der Naukratis-Maler; (III) Der Boreaden-Maler; (IV) Der Arkesilas-Maler; (V) Der Jagd-Maler; (VI) Der Reiter-Maler; (VII) Die kleineren Maler; Exkurs über die Regierungszeit Arkesilas' II; Veröffentlichungen einzelner Gefässe; Katalog. Index of museums and General index. Includes numerous references in the footnotes.

M74 Trendall, Arthur Dale. The red-figured vases of Lucania, Campania and Sicily. Oxford, Clarendon, 1967. 2v. xxix, 812p. 256 plates. (Oxford monographs on classical archaeology)

The fundamental work on the subject. Assigns and classifies stylistically approx. 5,000 pieces, accompanied by extensive commentaries.

Contents: v.1, General introduction and bibliography, p.[xxvii]–xxix; Bk. I. Lucanian (pt. 1. Early Lucanian, c.440–370 B.C.; pt. 2. Later Lucanian); Bk. II. Campanian (pt. 1. The origins of Campanian red-figure; pt. 2. Capua I; pt. 3. Capua II; pt. 4. Cumae); Bk. III. Sicilian (pt. 1. The Lentini-Manfria and Borelli groups; pt. 2. The Etna groups; pt. 3. The Lipari group); Appendixes. Contents: v. 2, Indexes: (I) Subject and general; (II) Greek inscriptions; (III) Collections; (IV) Concordance with CVA (Corpus vasorum antiquorum) and other publications; (V) Sites; (VI) Vase painters and groups; List of plates; Plates.

———. 1st suppl. [London] 1970. xiv, 144p. 29 plates. (Univ. of London. Institute of Classical Studies. Bulletin supplement no. 26)

SEE ALSO: Rumpf, A. *Malerei und Zeichnung*, in *Handbuch der Archäology* (I35); Weitzmann, K. *Ancient book illumination* (M84).

## Etruria and Rome

M75 Beazley, John Davidson. Etruscan vase-painting. Oxford, Clarendon, 1947. xvi, 351p. 42 plates. (Oxford monographs on classical archaeology, v.1) (Repr.: N.Y., Hacker, 1976.)

The standard scholarly work on Etruscan vase painting. "List of abbreviations," p.xiii–xvi. Bibliographical footnotes. General index, p.311–16. Index of collections, p.317–38. Index of publications, p.339–51.

M76 Borda, Maurizio. La pittura romana. Milano, Società Editrice [1958]. xxx, 430p. il., 21 col. plates.

A general survey of ancient Roman painting, including decoration and ornament. Bibliography, p.397–413.

M77 Dawson, Christopher M. Romano-Campanian mythological landscape painting. New Haven, Yale Univ. Pr.; London, Milford, Oxford Univ. Pr., 1944. xvi, 233 [2] p. 25 pl. on 13 l. (Yale classical studies, no. 9) (Repr.: Roma, "L'Erma" di Bretschneider, 1965.)

An important study of Romano-Campanian landscape painting. Treats art historical style and the mythological subjects. Organized by topic, e.g. Greek landscape painting, Italian origins, composition, relationship to the theater, perspective, continuous narration, etc. Chapter 3 is a catalogue of the mythological paintings discussed in the following chapters. Scholarly notes with references to classical and modern sources. Bibliography, p.210–13. List of classical authors cited or quoted, p.226–31.

M78 Dorigo, Wladimiro. Late Roman painting. Foreword by Sergio Bettini. Trans. from the Italian by James Cleugh and John Warrington. N.Y., Praeger [1971]. xxviii, 345p. il. (part col.)

Italian ed.: Milan, Feltrinelli, 1966. 1st English ed.: London, Dent, 1970.

A scholarly art historical study of late Roman painting which covers mosaics, inlays, manuscript illustrations, and textile designs as well as panels executed in the Roman Empire by pagan and Christian artists between the 1st century B.C. and the 6th century A.D. Conclusions concerning the crises of the civilization are based on a critical analysis of the art. Presents new ideas on individual artists through stylistic analysis. General bibliography, p.308–21. Indexes of names, places, and subjects. Well illustrated.

M79 Maiuri, Amedeo. Roman painting. [Trans. by Stuart Gilbert. Geneva, Skira, 1953]. 153p. mounted col. il. (The Great centuries of painting)

A good survey of Roman painting, written for the general reader. Valuable for the color illustrations.

Bibliography, p.149–50.

M80 Monumenti della pittura antica scoperti in Italia. Roma, Istituto Poligrafico dello Stato [1937– ]. Sez. I; Sez. III– . il. folio.

In progress. A monumental work, projected as a complete documentation of all the ancient paintings in Italy. Each fascicle consists of a portfolio of all illustrations of one site, and an accompanying booklet of text prepared by a scholar. Includes bibliography. The completed work will be divided into three broad sections: "I. Pittura etrusca; II. Pittura osco-lucana; III. Pittura ellenistico-romana, e pittura più propriamente 'romana'."—*Pub. notes.*

Contents: Programma, by G. E. Rizzo [1936]; Sez. I. Tarquinia: (1) La pittura delle tombe delle Leonesse e dei Vasi Dipinti, by P. Ducati [1937]; (2) Le pitture della tomba della "Caccia e Pesca," by P. Romanelli [1939]; (3–4) Le pitture delle tombe degli Augiri e del Pulcinella, by G. Becatti and F. Magi [1955]; (5) Le pitture della tomba del Tifone, by M. Cristofani (1971); Sez. I. Clusium: Le pitture delle tome arcaiche, by R. Bianchi Bandinelli (1939); Sez. III. Centuripae. (1) Ritratti de età ellenistica, by G. E. Rizzo; Sez. III. Roma: (1) Le pitture della "Casa dei Grifi" (Palatino), by G. E. Rizzo (1936); (2) Le pitture dell' aula isiaca di Caligola

(Palatino), by G. E. Rizzo (1936); (3) Le pitture della "Casa di Livia" (Palatino), by G. E. Rizzo; (5) Le pitture del Colombario di Villa Pamphili, by G. Bendinelli [1941]; Sez. III. (B) Pompei: (1) Le pitture della "Casa del Citarista," by O. Elia [1937]; (2) Le pitture delle Case di "M. Fabius Amandio," del "Sacerdos Amandus," e di "P. Cornelius Teges" (Reg. I, Ins. 7), by A. Maiuri [1938]; (3-4) Le pittura del Tempio di Iside, by O. Elia [1941]; Sez. III. (C) Ostia: Ritratti di età ellenistica, by G. E. Rizzo; Sez. III. (D): (1-2) Le pitture delle Case delle Volte Dipinte e delle Pareti Gialle, by B. M. Felletti Maj [1961]; (3) Le pitture della Casa delle Muse, by B. M. Felletti Maj and P. Moreno; (1968); (4) Le pitture della Caupona del Pavone, by C. Gasparri (1970); Sez. III. (D) Ercolano: (1) Le pitture della Casa dell' Atrio a Mosaico, by G. Cerulli Irelli (1971); (2) Le pitture della Casa del Colonnato Tuscanico, by M. Manni (1974).

M81  Pallottino, Massimo. Etruscan painting. Trans. by M. E. Stanley and Stuart Gilbert. Geneva, Skira [1952]. 138p. mounted col. il., map. (The Great centuries of painting)
A readable survey of Etruscan painting, written by a famous etruscologist. Beautiful color illustrations.

M82  Peters, Wilhelmus Johannes Theodorus. Landscape in Romano-Campanian mural painting. Assen, Van Gorcum, 1963. 240p. plates.
A scholarly study of landscape in Roman mural decoration from shortly before 80 B.C. to the eruption of Vesuvius in 79 A.D. Bibliographical references in Notes; Bibliography with abbreviations, p.217-24.

M83  Schefold, Karl. La peinture pompéienne. Essai sur l'évolution de sa signification. Édition revue et augmentée. Traduction de J. M. Croisille. Bruxelles, Latomus, 1972. 282p. 56 plates.
1st ed. *Die Wände Pompejis*, Berlin, 1957.
   The 2d ed. in French has minor changes in the text, a more detailed analysis of the frieze in the Villa of the Mysteries, and a few revisions of dates. The bibliography has been brought up to date in the notes, in the list of abbreviations, and in the brief bibliographical essay of the *avant-propos*.
   A basic art historical survey of Pompeian wall painting — the forms, space, and subject matter. Scholarly, well organized, well written. Bibliographical footnotes; Bibliography. Clear illustrations.
   Contents: Introduction. L'énigme de la peinture romaine; (1) La conception de la décoration murale; (2) La conception des motifs picturaux; (3) Sens et forme de le peinture romaine.

M84  Weitzmann, Kurt. Ancient book illumination. Cambridge, published for Oberlin College and the Department of Art and Archaeology of Princeton Univ. by Harvard Univ. Pr., 1959. xiv, 166p. il., 64 plates. (Martin classical lectures, v.16)
An historical sketch of classical book illumination which concentrates on the most important ancient texts. Complements *Illustrations in roll and codex* (M107). Divided into types of illustrated books: Scientific and didactic treatises, epic poetry, dramatic poetry, literary and prose texts. The

author concludes that "the reconstruction of classical book illumination serves a dual purpose: on the one hand, to fill a gap in the history of Hellenistic-Roman art, and, on the other, to gather the most diversified material with which to build a strong foundation for a history of the illustration of the Bible and other Christian texts."—*p.135*. Abbreviations and bibliographical notes, p.137-57. Well illustrated.

SEE ALSO:  Charleston, R. J., *Roman pottery* (P287); Galassi, G. *Roma o Bisanzio* (M89); L'Orange, H. P., and Nordhagen, P. J. *Mosaics* (M90); Weitzmann, K. *Illustrations in roll and codex* (M107).

# MOSAICS

This section contains entries for those books in which mosaics are treated as a major art form akin to painting. With a few exceptions, the literature is concerned with Roman, Early Christian, and Byzantine mosaics.

M85  Anthony, Edgar Waterman. A history of mosaics. Boston, Sargent [1935]. 332p. 80 plates. (Repr.: N.Y., Hacker, 1968.)
The standard general history, covering mosaics from their earliest period until the early 20th century. Poor illustrations. Glossary, p.316. Bibliography, p.299-314. Index, p.317-33.

M86  Berchem, Marguerite van, and Clouzot, Étienne. Mosaïques chrétiennes du IVme au Xme siècle. Dessins de Marcelle van Berchem. Genève, "Journal de Genève," 1924. lxii, 253p. il., plates (1 col.) (Repr.: Rome, "L'Erma" di Bretschneider, 1965.)
A general study of Christian mosaics from the 4th to the 10th century. The halftone illustrations are not good by present standards.
   Contents: Introduction. (1) L'art de la mosaïque chrétienne, (2) Le costume, (3) La technique, p.ix-lix; Notices, p.1-253, arranged by century and then by monument. Bibliography, p.254. No index.

M87  Corpus des mosaïques de Tunisie, v.1- . Margaret A. Alexander & Mongi Ennaifer, co-directors. Tunis, Institut National d'Archéologie et d'Arts; Wash., D.C., Dumbarton Oaks Center for Byzantine Studies, 1973- .
Published in fascicles. A thorough inventory of Roman and Early Christian mosaics in Tunisia. Catalogue prepared by specialists. Full documentation. Recent photographs.
   Contents, v.1, Région de Ghar el Melh (Porto Farina), Atlas archéologique de la Tunisie, feuille 7: (1) Utique, Insulae I-II-III; (2) Utique, les mosaïques *in situ* en dehors des Insulae I-II-III; (3) Utique, les mosaïques sans localisation precise et El Alia.

M88  Demus, Otto. The mosaics of Norman Sicily. London, Routledge & Paul, 1950. 478p. 120 plates.

"The best general work . . . also important for the influence of the Sicilian mosaics on the art of certain other parts of Europe."—F. Bologna (M306).

Contents: (1) Monuments; (2) Iconography; (3) The development of style. Includes bibliographical references. Index of names, p.458-65. Iconographical index, p.466-71. General index, p.472-78.

M89  Galassi, Giuseppe. Roma o Bisanzio, i mosaici di Ravenna e le orgini dell'arte italiana. Roma, Libreria dello Stato, anno VIII [1930]-53. 2v. 425 il., 166 plates (19 col.)

A well-illustrated work on Byzantine mosaics considered as the origin of Italian artistic culture.

Contents: v.1, I mosaici di Ravenna e le origini dell'arte italiana; v.2, Il congedo classico e l'arte nell'alto medio evo. Each volume has an index of places and works, and v.2 an index of persons.

M90  L'Orange, H. P., and Nordhagen, P. J. Mosaics. Trans. by Ann E. Keep. London, Methuen [1966]. 92p. il. (part col.)

1st ed., Oslo, Dreyer, 1958, entitled *Mosaikk, fra antikk til middelalder*.

A general introduction for the student and general reader. Treats the development of mosaics of the ancient world and the medieval period. Well illustrated, with many details. Bibliography, p.82-83. Indexed.

M91  Matthiae, Guglielmo. Mosaici medioevali delle chiese di Roma. [Roma] Libreria dello Stato [1967]. 2v. vii. 444p. plates (part col.), atlas.

A corpus of the Christian mosaics in the churches of Rome, from late antiquity to Giotto. Arranged chronologically by work; for each gives history and documentation. Indexes of names, iconography, at end of text volume. Bibliography, p.425-26. Superb visual documentation in the atlas volume: 68 color plates, 345 black-and-white illustrations. List of plates. Includes bibliographies.

M92  Mosaici antichi in Italia. Roma, Istituto Poligrafico dello Stato, 1967- . il.

Published under the auspices of the Consiglio Nazionale delle Ricerche.

In progress, being published by region. A documented corpus of the ancient mosaics in Italy. Text by scholars. Many illustrations in color.

Contents: Regione 1, Roma: Reg. X Palatium, by M. L. Morricone Matini (1967); Antium, by V. S. Scrinari and M. L. Morricone Matini (1975); Regione 7, Baccano: Villa Romana, by G. Becatti, et al. (1970); Pavimenti di Signino Repubblicani di Roma, by M. L. Morricone Matini (1971); Regione 8, Ravenna: I, by Fede Berti (1976).

M93  Oakeshott, Walter Fraser. The mosaics of Rome: from the third to the fourteenh centuries. Greenwich, Conn., New York Graphic Society [1967]. 288p. 244 il., 33 col. plates, plan, diagrs.

An important scholarly survey which incorporates recent research on Early Christian and medieval mosaics of Rome.

Contents: (I) The technique of medieval mosaics in Rome; (II) The antique or classical period; (III) The 'Byzantine' works of the 6th, 7th, and 8th centuries; (IV) The late 8th and early 9th centuries; (V) Romanesque art in Roman mosaics; (VI) Byzantinism in Rome in the first half of the 13th century; (VII) The Roman renaissance as expressed in mosaics. Appendixes: (I) Sta. Maria di Grottoferrata; (II) The 'monograms' on the cloaks worn by figures represented in the mosaics. Bibliography, p.380-85. Indexes: General; Themes and subjects; Churches and other buildings containing Christian mosaics.

The excellent illustrations (with many color plates) provide a corpus which supersedes Wilpert (M109).

M94  Parlasca, Klaus. Die Römischen Mosaiken in Deutschland. Berlin, de Gruyter, 1959. vii, 156p. il., plates. (Römisch-Germanische Forschungen, 23)

An inventory of Roman mosaics in the Rhine region and southern Germany from the 1st to 4th century A.D. Well documented. 104 plates and 16 figures in the text.

M95  Stern, Henri. Recueil général des mosaïques de la Gaule. Publié sous les auspices de l'Académie des Inscriptions et Belles Lettres. Paris, Centre National de la Recherche Scientifique, 1957-(67). v.1-(2). plates, maps. (Gallia; fouilles et monuments archéologiques en France métropolitaine. Supplément. 10).

Based on the Academy's *Inventaire des mosaïques de la Gaule et de l'Afrique*, Paris, 1909-15.

A comprehensive, systematic catalogue of mosaics of the Roman provinces. Entries include full technical descriptions and bibliographical references. Published in parts.

Contents, v.1, Province de Belgique: pt. 1, Partie ouest (1957); pt. 2, Partie est (1960); pt. 3, Partie sud (1963). v.2, Province de Lyonnaise: pt. 1, Lyon (1967). v.3-4 to cover provinces of Narbonne and Aquitaine.

SEE ALSO:  Wilpert, J. *Die römischen Mosaiken und Malerein der kirchlichen Bauten vom IV. bis XIII* (M109).

# EARLY CHRISTIAN—BYZANTINE

M96  Corpus der byzantinischen Miniaturenhandschriften (CBM). Unter dem Patronat der Österreichischen Akademie der Wissenschaften, Wein, Bd. 1- . Stuttgart, Hiersemann, 1977- . il. (part col.)

Herausgegeben von Prof. Otto Demus; Redaktion Dr. Irmgard Hutter.

A monumental corpus of Byzantine illuminated manuscripts in the great libraries, projected in at least 20v. Prep. and ed. by two well-known art historians in the field of Byzantine art.

Published so far: Bd. 1, Handschriften der Bodleian Library, Oxford. Erster Teil (two or more are forthcoming), 1977.

M97  Felicetti-Liebenfels, Walter. Geschichte der byzantinischen Ikonenmalerei von ihren Anfängen bis zum

Ausklange unter Berücksichtigung der maniera greca und der italo-byzantinischen Schule. Olten, Urs-Graf, 1956. 139p. il., 136 plates (part col.)

A thorough treatment of Byzantine icon painting from its beginning to its last manifestations. Well illustrated. "Anmerkungen," p.105–17; "Allgemeines Register," p.118–26; "Ikonographisches Register," p.127–29; "Namenregister," p.131–33.

M98    Gerstinger, Hans. Die griechische Buchmalerei, mit 22 Abbildungen in Textband und 28 Tafeln nach Originalen der Nationalbibliothek in Wien. Wien, Österreichischen Staatsdruckerei, 1926. v, [1].p., 1 l., 52 p., 2 l. plates, and atlas ([3]p., xxviii pl.)

An important work on Greek illuminated manuscripts, illustrated with paintings from manuscripts in the Austrian National Library, Vienna. Bibliography, p.42. Detailed indexes of names, manuscripts, and subjects, p.49–52.

M99    Grabar, André. Byzantine painting; historical and critical study. [Trans. by Stuart Gilbert. Geneva] Skira [1953]. 200p. mounted col. il., map. (The Great centuries of painting)

A survey of Byzantine art which traces the development of mosaics, frescoes, and manuscript illuminations in Constantinople, Greece, Yugoslavia, and Italy. Written by a well-known authority in the field.

Contents: (1) Byzantine painting: introduction; (2) Critical study: 5th and 6th century mosaics, mosaics and frescoes in Rome, the mural paintings at Castelseprio, mosaics of the Middle Ages, the mosaics of Venetia, the mosaics of Sicily, Constantinople: the church of Kahrieh Djami, frescoes in the Balkans and Greece, 11th to 14th century, painting in books, icons; Bibliography, p.194; Index of names and subjects, p.195–96; 105 color plates of mosaics, frescoes, illuminations, and paintings in enamel.

M100   L'illustration des psautiers grecs de moyen-âge. Préf. de André Grabar. Publié avec le concours du Centre National de la Recherche Scientifique. Paris, Klincksieck, 1966–(70). v.1–(2). plates. (Bibliothèque des cahiers archéologiques. 1, 5)

Scholarly contributions to the field. Precise descriptions, analyses of style, complete bibliographies. Well indexed. Adequate, but numerous, black-and-white plates.

Contents: (1) Pantocrator 61, Paris grec 20, British Museum 40731, par Suzy Dufrenne; (2) Londres, Add. 19.532, par Sirapie Der Nersessian.

M101   Lazarev, Viktor Nikitich. Storia della pittura bizantina. Edizione italiana rielaborata e ampliata dall'autore. Torino, Einaudi, 1967. xli, 497p. 176 plates. (Biblioteca di storia dell'arte, 7)

Trans. from the Russian ed., 1947–48. Revised and enlarged by the author to include recent research. A completely new edition of this very important history of Byzantine painting, indispensable for research in Byzantine art. Richly illustrated (576 figs.).

Bibliography, p.[xxxv]–xli.

M102   Omont, Henri. Miniatures des plus anciens manuscrits grecs de la Bibliothèque Nationale du VIe au XIVe siècle. Paris, Champion, 1929. 66p. 136 plates.

A collection of 136 plates representing 10 important Greek manuscripts in the Bibliothèque Nationale, with a scholarly text describing the plates. "Répertoire alphabétique des principaux personnages mentionnés et des principales matières contenues dans les notices des planches," p.61-62.

M103   Pelekanidis, Stylianos M. The treasures of Mount Athos: illuminated manuscripts. Miniatures, headpieces, initial letters. [By] S. M. Pelekanidis [and others. Publishers: George A. Christopoulous, John C. Bastias. Trans.: Philip Sherrard. Athens] Ekdotikē Athenon [1974– ]. v.1– plates (col.)

Trans. of *Hoi thysauroi tou Hagiou Orous: eikonographē-mena cheirographa.*

The 1st of a projected 4v. which, taken together, will form a comprehensive catalogue of the enormous collection of Byzantine illuminated manuscripts from Mount Athos. Superb full-color reproductions of miniatures from 84 manuscripts from the Protaton and the monasteries of Dionysiou, Koutloumousiou, Xeropotamou, and Gregoriou. Each group of manuscripts is preceded by a brief history of the monastery from which they are taken.

The catalogue entries are neither as full nor as precise as those by Kurt Weitzmann in *The Monastery of Saint Catherine at Mount Sinai* (M108). Brief bibliography and glossary of terms at end.

M104   Restle, Marcell. Byzantine wall painting in Asia Minor. [Photos. by Jeannine Le Brun. Trans. from the German by Irene R. Gibbons]. Greenwich, Conn., New York Graphic Society [1967]. 3v. il., maps (part fold.), plans (part fold.), plates (part col.)

An attempt to bring together all material on Byzantine wall paintings in Asia Minor (mostly Cappadocia). Introduced by an historical analysis of style which excludes iconography (v.1). Lavishly produced, with a large corpus of plates.

Contents: v.1, Text: Cappadocia and Lycaonia, Western Asia Minor, Nicaea and Trebizond, Pictures of Cappadocian scenes, Catalogue of paintings, Byzantine wall painting techniques, Notes, Indexes (monuments, manuscripts, iconographical index), Maps. Bibliography, v.1, p.9–12; v.2–3, Plates. At end of v.2–3: "Classification of subjects"; "List of illustrations."

M105   Rice, David Talbot. Byzantine painting: the last phase. N.Y., Dial, 1968. 223p. il. (part col.), map.

A general study of the survival and revival of the Byzantine tradition of painting during its last phase, between the Christian conquest of Constantinople in 1204 and the fall of Byzantium to the Turks in 1453. Recommended for the student. Bibliographical notes. Excellent color and black-and-white illustrations.

M106   A treasury of icons, from the Sinai Peninsula, Greece, Bulgaria, and Yugoslavia, sixth to seventeenth centuries, by Kurt Weitzmann, Manolis Chatzidakis, Krsto

Miatev, and Svetozar Radojčić. N.Y., Abrams [1968]. xiv, 220p. plates (part col.)

Trans. by Robert Erich Wolf of *Ikone sa balkana,* Belgrade, Jugoslavija.

A collection of four independent studies on the icons of four Balkan regions, written by recognized scholars in the various fields covered. Each essay is followed by notes, a list of icons discussed and reproduced, and a section of plates.

Contents: (I) Weitzmann, Kurt. Sinai Peninsula: Icon painting from the 6th to the 12th century; (II) Chatzidakis, Manolis. Greece: Icon painting from the 12th to the 16th century; (III) Miatev, Krsto. Bulgaria: Icon painting from the 9th to the 17th century; (IV) Radojčic, Svetozar. Yugoslavia: Icon painting from the 13th to the 17th century.

Catalogue of illustrated icons, p.lxxix, contains commentaries on icons reproduced. Bibliography of illustrated icons, p.xcviii–[cv]. Bibliographical notes on the authors, p.[cvi].

M107 Weitzmann, Kurt. Illustrations in roll and codex; a study of the origin and method of text illustration. Princeton, Princeton Univ. Pr., 1970. x, 261p. il., plates, facsims.

1st ed. 1947. The later ed. has an addenda (p.233–61) following the index.

A basic introduction to book illustration of late antiquity and the Early Christian era. Important for an understanding of the role of the manuscript in medieval art. See also *Ancient book illumination* (M84).

Contents: (1) The general relation between literature and the representational art, (2) The physical relation between the miniature and the text, (3) The relation between the miniature and the text with regard to content, (4) The relation between text criticism and picture criticism, (5) The cycle of miniatures as the basic unit of the illustrated book.

M108 ———. The Monastery of Saint Catherine at Mount Sinai, the icons . . . with photographs by John Galey. Princeton, Princeton Univ. Pr., 1976- . v.1- . il.

The 1st volume of a catalogue raisonné of the rich collection of icons in Saint Catherine's monastery at Mount Sinai. "This book is the most outstanding single contribution to the study of pre-iconoclastic Byzantine art to appear in this century. It will cause a revolution in the history of art-historical writing in the Byzantine field. It allows the reader to gain for the first time an adequate idea of the characteristics of early Byzantine art, in Constantinople as well as in the provinces." —H. Buchthal in *Pub. notes.*

The catalogue entry for each icon gives physical description (including a note on restoration), iconography, stylistic commentary with color description, and bibliographical references. Index. The corpus of plates consists of superb illustrations made from new photographs, with many details and several in color.

Contents: v.1, From the 6th to the 10th century (266p., 138 plates, 38 color plates).

M109 Wilpert, Josef. Die römischen Mosaiken und malereien der kirchlichen Bauten vom IV. bis XIII. Jahrhundert. 2. Aufl. Freiburg im Breisgau, Herder, 1917. 4v. 542 il., 300 col. plates.

1st ed. 1916.

A monumental work with an excellent text. v.3 is mostly halftone plates; v.4 has excellent collotypes.

Contents of v.1–2: Bk. 1, Allgemeine Untersuchungen zur konstantinischen, nachkonstantinischen und mittelalterlichen Monumentalkunst Roms; Bk. 2, Die hervorragendsten kirchlichen Denkmäler mit Bilderzyklen; Bk. 3, Untersuchungen über einzelne Darstellungen; Bk. 4, Tafelgemälde; Bk. 5, Schlussbetrachtungen.

Bibliographical footnotes. "Verzeichnis der Textbilder," v.1, p.xxxiv–xlviii. "Namen und Sachregister zu den Textbänden," v.2, p.1207–21. "Topographisches Verzeichnis der Tafeln und Textbilder," v.2, p.1223–25. "Verzeichnis der Tafeln" at the beginning of each plate volume.

M110 Zimmermann, Ernst Heinrich. Vorkarolingische Miniaturen. Berlin, Selbstverlag des Deutschen Vereins für Kunstwissenschaft, 1916. xii, 329p. plates. 4 portfolios of plates. (Deutscher Verein für Kunstwissenschaft. Denkmäler deutscher Kunst. III. Sektion. Malerei. 1. Abt.)

A scholarly work on pre-Carolingian manuscripts, with a corpus of reproductions. The text volume gives a detailed description, with bibliography, for each plate included in the atlases.

Bibliography, p.[328]–29. Index of manuscripts, arranged alphabetically by location, p.311–21. Index of scribes, writers, and collections, p.324–26.

SEE ALSO: Cames, G. *Byzance et la peinture romane de Germanie* (M220); *Storia della miniatura. Studi e documenti* (R60).

# ISLAMIC

M111 Arnold, *Sir* Thomas Walker. Painting in Islam, a study of the place of pictorial art in Muslim culture. Oxford, Clarendon, 1928. 159p. 64 plates (part col.) (Repr.: N.Y., Dover, 1975.)

An important work which aims to indicate the place of painting in the Islamic world.

"A chapter of biography," p.138–49. Bibliographical footnotes. Index of manuscripts, p.153. General index, p.155–59.

M112 Arnold, *Sir* Thomas Walker, and Grohmann, Adolf. The Islamic book; a contribution to its art and history from the VII-XVIII century. Paris, Pegasus; N.Y., Harcourt, 1929. 130p. il., 104 plates (part col.)

A major contribution to the field.

Contents: Pt. 1, The early Islamic period from the VII-XII century, by A. Grohmann; Pt. 2, The period from the XIII-XVIII century, by Sir T. W. Arnold; Notes and references. "Table of papyri, manuscripts and other pieces discussed in the text," p.117–19. Bibliography, p.116. Index of subjects, persons, and places, p.121–31.

M113  Binyon, *Sir* Laurence; Wilkinson, J. V. S.; and Gray, Basil. Persian miniature painting, including a critical and descriptive catalogue of the miniatures exhibited at Burlington House, January-March 1931. London, Oxford Univ. Pr., 1933. 113 plates (part col.)
An important catalogue of a major exhibition. The introductions to the different periods of Persian miniature painting were written by the foremost scholars of the time. Richly illustrated.
    Appendixes: (1) Dūst Muhammed's account of past and present painters; (2) Mīrzā Muhammed Hydar Doughlāt on the Herāt school of painters; (3) The Album from the Gulistan Museum. Bibliography, p.193-95. Index, p.199-212.

M114  The Chester Beatty Library, Dublin. A catalogue of the Persian manuscripts and miniatures, by A. J. Arberry, M. Minovi, and E. Blochet. Ed. by J. V. S. Wilkinson and A. J. Arberry. Dublin, Hodges, Figgis, 1959-62. 3v. plates, facsims.
The catalogue of a remarkable collection of Persian manuscripts, 398 in all, ranging in date from the 13th to the 19th centuries. The entries are arranged chronologically. For each gives subject and arrangement, binding, writing and paper, date and scribe, illumination and illustration, seals and inscription. Each work is illustrated with one or more figures. Indexes at end of v.3: (I) Titles; (II) Authors; (III) Scribes and calligraphers; (IV) Former owners.

M115  Ettinghausen, Richard. Arab painting. [Geneva] Skira. [Distributed by World Pub. Co., Cleveland, 1962]. 208p. il. (part col.), map. (Treasures of Asia, 4) (Repr.: N.Y., Skira/Rizzoli, 1977.)
An art historical survey of the phases of Arab painting throughout the medieval world of Islam. An enthralling, well-written story for the scholar and general reader alike. Written by a foremost specialist.
    Begins with the Umayyad monuments (691-750) and ends with the "last ventures" after 1350. The color plates are of high Skira quality.
    Contents: (1) Early phases of the pictorial arts; (2) The flowering of the art of the book; (3) The beginning of the end; (4) Beyond the material world; (5) The final phase. Bibliography, index of manuscripts, general index, list of illustrations.

M116  Fondazione Giorgio Cini. Venice. Istituto Venezia e l'Oriente. Muslim miniature paintings from the XIII to XIX century from collections in the United States and Canada. Catalogue of the exhibition by Ernst J. Grube, with the collaboration of Alberta Maria Fabris. Venezia, Pozzi, 1962. xxviii, 139p. plates (part col.) (Fondazione Giorgio Cini, Venice. Istituto di Storia dell'Arte. Cataloghi di mostre, 18)
An excellent catalogue of a major loan exhibition of Muslim miniatures. Includes a bibliography, p.[xi]-xxii.

M117  Gray, Basil. Persian painting. [N.Y.] Skira. [Distr. by World Pub. Co., Cleveland, 1961]. 191p. col. illus., map. (Treasures of Asia, 2) (Repr.: N.Y., Skira/ Rizzoli, 1977.)

An excellent historical survey of Persian painting by a leading authority. Provides a stimulating introduction for the student and general reader as well as a reliable reference tool for the scholar. Index of manuscripts. Bibliographic notes. "Bibliography, a select list of Western authorities," p.173-[74]. Excellent color plates.

M118  Grube, Ernst J. Islamic paintings from the 11th to the 18th century in the collection of Hans P. Kraus. N.Y., H. P. Kraus [1972?]. 291p. il. 54 col. plates.
The catalogue of a major collection of 252 Islamic paintings. According to Grube the Kraus Collection is one of the few private collections which contributes to knowledge of the field with significant works of the known schools as well as new, unique paintings. Each work is fully documented and illustrated. Bibliography, p.17-[21].
    Contents: The early Islamic period, 10th to 14th century; The Mongol period in Persia, late 13th and 14th century; The Timurid period in Persia, late 14th and 15th century; The Safavid period in Persia, 16th to 18th century; The Ottoman period in Turkey, 16th and 17th century; The Mughal period in India, 16th to 18th century.

M119  Martin, Fredrik Robert. The miniature painting and painters of Persia, India and Turkey, from the 8th to the 18th century. London, Quaritch, 1912. 2v. il., 275 plates (4 col.)
v.1 describes various schools, techniques, etc.; a list of painters, p.111-36, arranged chronologically, includes some of their works; a chart of synchronology gives names and dates of outstanding artists in various countries. v.2 contains the black-and-white plates.
    Bibliography, v.1, p.143-44. Index, v.1., p.[149]-56, also includes names of artists.

M120  Robinson, Basil William, ed. Islamic painting and the arts of the book [by] B. W. Robinson, Ernst J. Grube, G. M. Meredith-Owens, R. W. Skelton. With an introd. by Ivan Stchoukine. Ed. by B. W. Robinson. London, Faber and Faber [1976]. 322p, il., plates (44 col.) (Keir Collection)
A scholarly, detailed catalogue of the important Keir Collection of Islamic miniature paintings and illuminated manuscripts. Includes primarily Persian paintings as well as Turkish and Indian Islamic works. Catalogue sections are written by four specialists in their respective fields. Entries include artist, dimensions, provenance, description and commentary, and references.
    Contents: pt. I, Fostat fragments, by Ernst J. Grube; pt. II, Pre-Mongol and Mamluk painting, by Ernst J. Grube. Notes to parts I and II; pt. III, Persian and pre-Mughal Indian painting, by B. W. Robinson; pt. IV, Ottoman Turkish painting, by G. M. Meredith-Owens; pt. V, Indian painting of the Mughal period, by R. W. Skelton; pt. VI, Illumination and calligraphy, by B. W. Robinson; pt. VII, Unilluminated manuscripts, by B. W. Robinson, pt. VIII, Book-covers and lacquer, by B. W. Robinson. Bibliography and abbreviations to parts III to VIII.
    Indexes of artists; of calligraphers and scribes; of texts and subjects illustrated.

M121 Stchoukine, Ivan. La peinture turque d'après les manuscrits illustrés. Ouvrage publié avec l'aide du Centre National de la Recherche Scientifique. Paris, Geuthner, 1966-71. 2v. il. (Institut Français d'Archéologie de Beyrouth. Bibliothèque archéologique et historique, t.84, t.93)

Pt. 1 cosponsored by the Centre National de la Recherche Scientifique and the Fogg Museum of Art, Harvard University.

The only comprehensive work on Turkish miniature painting during the Ottoman Empire. Scholarly, with complete documentation. Each volume includes a discussion of the historical milieu, a catalogue of the illustrated manuscripts, an essay on the evolution of the forms, and concluding remarks. Full bibliographies, alphabetical lists of the manuscripts, general indexes, indexes of painters and calligraphers, tables of plates, detailed tables of contents. Well illustrated (black-and-white) with 112 plates in pt. 1 and 96 in pt. 2.

Contents: pt. 1, De Sulaymān I$^{er}$ à ʿOsmān II, 1520-1622; pt. 2, Dē Murād IV à Mustafā III, 1623-1773.

M122 _____. Les peintures des manuscrits de Shāh ʿAbbās I$^{er}$ à la fin des Ṣafavīs. Paris, Geuthner, 1964. 262p. 88 pl. (Institut Français d'Archéologie de Beyrouth. Bibliothèque archéologique et historique, t.76)

A study of manuscript painting in Muslim Persia from c.1587 to 1722, the last flowering. Arranged according to the plan of the earlier works with an historical introduction, a catalogue of selected manuscripts, an analysis of the forms, and a discussion of the art historical development. 88 plates.

Bibliography, p.[229]-33. "Index des manuscrits," p.[235]-37; Index of painters, index of caligraphers, general index, table of plates.

M123 _____. Les peintures des manuscrits Safavis de 1502 à 1587. Paris, Geuthner, 1959. 233p. 88 plates. (Bibliothèque archéologique et historique, t.67)

An important art historical study and catalogue of manuscripts in Moslem Iran during the dynasty of the Safavis in the 16th century. Indexes of manuscripts, painters, calligraphers, and a general index. Bibliography, p.[201]-5.

Contents: Le milieu historique; Les manuscrits (arranged by school); Le paysage; Les animaux; Le décor architectural; L'image humaine, La composition et la couleur; L'évolution.

M124 _____. Les peintures des manuscrits tîmûrides. Paris, Impr. Nationale, 1954. vi, 176p. 88 plates. (Bibliothèque archéologique et historique, t.60)

An art historical study of manuscript painting in Moslem Iran from 1381 to 1510, with a catalogue of the important manuscripts. Written by the leading scholar in the field. Indexes of manuscripts, painters, and calligraphers, and general index. Bibliography, p.iii-vi.

Contents: (I) Les témoignages littéraires; (II) Les manuscrits (detailed documentations of individual works in each region); (III) Le paysage; (IV) Le décor architectural; (V) Les animaux; (VI) L'image humaine; (VII) La composition et la couleur.

M125 Welch, Anthony. Artists for the Shah: late sixteenth-century painting at the Imperial Court of Iran. New Haven and London, Yale Univ. Pr., 1976. xvi, 233p. il. (part col.)

A contribution to scholarship in the field of Persian painting. "Mr. Welch has chosen as his subject, and made his own special preserve, the Court painting produced between the middle sixteenth century and the early years of Shah ʿAbbas. This rather difficult and confused half-century, bridging the stylistic gap between Sultan Muhammad and Riza-i ʿAbbasi, has been lightly skated over by most of our authorities ... This is a great achievement and merits our gratitude." — B. W. Robinson in *Apollo* 105:505 (June 1977).

Consists of the historical background; a detailed discussion of three major painters: Siyavsh the Georgian, Sadiqi Bek, Riza; a study of the patronage; and a concluding summary chapter.

# CAROLINGIAN—GOTHIC

M126 Anthony, Edgar Waterman. Romanesque frescoes. Princeton, Princeton Univ. Pr., 1951. 208p. 500 plates. (Repr.: Westport, Conn., Greenwood, 1971.)

"This book is an attempt to write a concise history of mural painting in western Europe from the end of the Early Christian period until Gothic times." — *Pref.*

The introduction outlines the early styles and iconography from antiquity to the 9th century, and summarizes the general characteristics of Romanesque frescoes. Covers Italy, Germany, France, Belgium, Spain, Switzerland, England, Denmark, and South Sweden.

Bibliographical footnotes. Bibliographical abbreviations, p.204. Index of places, p.205-8.

M127 Boeckler, Albert. Abendländische Miniaturen bis zum Ausgang der romanischen Zeit. Berlin und Leipzig, de Gruyter, 1930. 133p. 106 plates (incl. facsims.)

An account of Romanesque illuminated manuscript paintings from the Carolingian period to the middle of the 13th century. Includes important manuscripts in American libraries. Bibliography, p.[124]-27. Index of manuscripts, p.128-33; index of plates, p.105-23.

M128 Buchthal, Hugo. Miniature painting in the Latin Kingdom of Jerusalem. With liturgical and paleographical chapters by Francis Wormald. Oxford, Clarendon, 1957. xxxiv, 163p. 155 plates.

A well-illustrated scholarly survey of miniature painting from the second quarter of the 12th century to the end of the 13th century in the Crusader Kingdom of Jerusalem. Bibliographical footnotes. Catalogue of manuscripts, p.155-56; General index, p.157-63.

M129 Demus, Otto. Romanesque mural painting. Photos by Max Hirmer. [Trans. from the German by Mary Whittall]. N.Y., Abrams [1970]. 654p. maps, plates (part col.)

Trans. of *Romanische Wandmalerei,* 1968.

An erudite study of Romanesque mural painting in Italy, France, Spain, England, Germany, and Austria. "My chief

concern as author ... has been to demonstrate the great variety of Romanesque form and its development in relation to changes in its function."—*Foreword.*

Contents: (1) General survey, p.13-157; (2) Plates (102 in color) and documentary sections, p.159-637; Bibliography, p.639-48; Index, p.649-54.

M130 Dodwell, Charles Reginald. Painting in Europe, 800 to 1200. Harmondsworth; Baltimore, Penguin [1971]. xxviii, 261p. il., 4 maps, 240 plates. (The Pelican history of art)

This volume in the distinguished Pelican series is an authoritative survey on medieval painting in the countries of Continental Europe, with emphasis on manuscript illumination and mural painting.

Contents: Introduction; Roman mosaics of the 9th century; The Carolingian renaissance; The Ottonian renaissance; French painting and the traditions of the West; Spain: manuscript-painting; Painting in Italy; Byzantine influences on the crusading kingdoms and Sicily; Byzantium and Germany in the 11th and 12th centuries; Byzantium and France in the 12th century; Spanish wall paintings and panel paintings; Transitional. Bibliographic notes. Good bibliography, p.237-41.

M131 Dupont, Jacques, and Gnudi, Cesare. Gothic painting. [Trans. by Stuart Gilbert. Geneva] Skira [1954]. 215p. mounted il. (part col.) (The Great centuries of painting)

A general study of Gothic painting. Includes paintings, tapestries, stained-glass windows, illuminations, and miniatures from Italy, France, Germany, Spain, England, and Bohemia. Works of lesser-known artists are also represented. 110 color reproductions. Bibliography, p.203-5. Index of names and subjects, p.206-9.

Contents: The Gothic age, by J. Dupont; Italian painters of the Gothic age, by C. Gnudi; Court art, by J. Dupont; Italian manifestations of International Gothic art, by C. Gnudi.

M132 Grabar, André, and Nordenfalk, Carl. Early medieval painting from the fourth to the eleventh century: Mosaics and mural painting, by André Grabar. Book illumination, by Carl Nordenfalk. Trans. by Stuart Gilbert. [N.Y.] Skira [1957]. 241p. il. (part mounted, part col.), map. (The Great centuries of painting)

Trans. of *Le haut moyen âge, du quatrième au onzième siècle: mosaïques et peintures murales.*

A concise survey of early medieval painting. The section on book illumination by Nordenfalk is an especially good introduction to the field. Well illustrated with tipped-in color plates. Poor translation. Bibliography, p.223-25.

M133 Köhler, Wilhelm Reinhold Walter. Die karolingischen Miniaturen, im Auftrage des Deutschen Vereins für Kunstwissenschaft. Berlin, Cassirer, 1930-[71]. Bd. 1-[4²]. il. in text and portfolios of plates.

In progress. Bd. 4: Wilhelm Köhler und Florentine Mütherich.

The definitive work on Carolingian miniatures. Important art historical text, meticulous scholarship, full documentation of individual manuscripts. Each volume consists of a text and a separate atlas of plates.

Contents: Bd. 1, Die Schule von Tours: [pt.] 1, Die Ornamentik; [pt.] 2, Die Bilder; Bd. 2, Die Hochschule Karls des Grossen. Hierzu ein Tafelband; Bd. 3, [pt.] 1, Die Gruppe des Wiener Krönungs-Evangeliars; [pt.] 2, Metzer Handschriften. Hierzu ein Tafelband; Bd. 4, [pt.] 1, Die Hofschule Kaiser Lothars; [pt.] 2, Einzelhandschriften aus Lotharingien.

M134 Leroquais, Victor. Les bréviaires manuscrits des bibliothèques publiques de France. Paris [Macon, Protat] 1934. 5v., atlas of xiiip. 140 plates (facsims.)

An introductory text (133p.) treating breviaries and their development is followed by entries for 913 manuscripts arranged by the holding institution. v.4, also contains: (1) Additions and corrections (nos. 915-1034), descriptions of manuscripts erroneously listed as breviaries in the *Catalogue général des manuscrits des bibliothèques de France;* (2) Supplement to missal manuscripts (nos. 1035-45) supplementing the author's *Les sacramentaires et les missels* (M138); (3) List of breviary manuscripts arranged alphabetically by the libraries and archives where they are located; (4) List of churches and abbeys to which they are attributed. v.5 consists of a general index, and errata and addenda.

M135 _____. Les livres d'heures, manuscrits de la Bibliothèque Nationale. Paris [Macon, Protat] 1927. 2v. Atlas of 130 plates.

_____. Supplément aux livres d'heures, manuscrits de la Bibliothèque Nationale (acquisitions récentes et donation Smith-Lesouëf). Mâcon, Protat. 1943. 72p. 40 plates.

Consists of 85 pages of introductory text on books of hours, followed by a description of 313 manuscripts and 24 in the supplement, arranged by collection number.

v.2 contains: "Quelques prières des livres d'heures," p.305-50; "Additions et corrections," p.351-52; "Table des livres d'heures manuscrits de la Bibliothèque Nationale par ordre numérique," p.355-70; "Table par ordre chronologique des livres d'heures manuscrits auxquels sont empruntées des planches du tome III," p.371-72. "Table générale," p.373-403.

M136 _____. Les pontificaux manuscrits des bibliothèques publiques de France. Paris [Macon, Protat] 1937. 3v. and portfolio of xiii p. 140 facsims.

A general introduction of 154p. covering pontifical manuscripts in general, followed by a description of 233 manuscripts arranged according to location. Additions and corrections (nòs. 234-50) and manuscripts, which are not pontificals but sacramentaries, breviaries and missals, etc., v.2, p.429-62.

v.3 contains: (1) List of pontifical manuscripts arranged alphabetically by the public libraries where they are located; (2) List of churches of abbeys to which they are attributed; (3) General index; (4) Errata and addenda.

M137 _____. Les psautiers, manuscrits latins des bibliothèques publiques de France. Paris [Macon, Protat] 1940–41. 2v. and portfolio atlas of xiiip. 140 plates.
An introductory text of 136p. dealing with psalters, followed by a description of 472 psalters arranged alphabetically by the libraries and archives where they are preserved, v.2, p.293–322. Additions, v.2, p.323–29. Errata and addenda, v.2, p.517–18. General index, v.2, p.331–515.

M138 _____. Les sacramentaires et les missels, manuscrits des bibliothèques publiques de Frànce. Paris, 1924. 3v. and atlas of xiip. 125 plates (facsims.)
A general introduction of 47p. and a description of 914 sacramentaries and missals, arranged chronologically.
v.3 contains: Additions and corrections, p.284–88; List of manuscripts arranged alphabetically by libraries and archives where they are preserved, p.289–310; List of sacramentaries and missals alphabetically listed by the churches and abbeys with which they are associated, p.311–32; List of manuscripts from which are drawn the plates in v.4, p.333–34. General index v.3, p.335–425.

M139 Leroy, Jules. Ethiopian painting in the late Middle Ages and during the Gondar dynasty. N.Y., Praeger [1967]. 60 (136)p. 14 mounted il. (part col.), 54 plates (51 col.)
A scholarly work, written by a leading authority on the subject. Accompanied by 60 excellent plates. Good translation by Claire Pace. "Bibliographical notes," p.43–45.

M140 The library of illuminated manuscripts. N.Y., Braziller, 1969– .
A monographic series of facsimiles of famous illuminated manuscripts. Each work is prefaced by a critical introduction and commentaries on the plates by an outstanding scholar. Beautiful plates.
Published so far: *The Hours of Catherine of Cleves,* introd. by John Plummer, 1966; *The Très Riches Heures of Jean, Duke of Berry,* pref. by Millard Meiss, introd. by Jean Longnon and Raymond Canzelles, 1969; *The Master of Mary of Burgundy,* introd. by J. J. G. Alexander, 1970; *The Grandes Heures of Jean, Duke of Berry,* introd. by Marcel Thomas, 1971; *The Hours of Etienne Chevalier,* introd. by Claude Schaefer, pref. by Charles Sterling, 1971; *The Visconti Hours,* introd. by Millard Meiss, commentaries by Edith W. Kirsch, 1972; *The Rohan Master,* introd. by Millard Meiss, commentaries by Marcel Thomas, 1973; *The Belles Heures of Jean, Duke of Berry,* introd. by Millard Meiss, 1974; *King René's Book of Love (Le Cueur d'amours Espris),* introd. by F. Unterkircher, 1975.

M141 Metzger, Mendel. La Haggada enluminée. I: Étude iconographique et stylistique des manuscrits enluminés et décorés de la Haggada du XIIIe au XVIe siècle. Préface par René Crozet. Leiden, Brill, 1973. xxix, 518p. 481 fig. on 83 plates. (Études sur le Judaïsme médiéval, tome II, 1)
A most complete iconographic and stylistic study of over 70 illuminated manuscripts of the Haggadah dating from the 13th through the 16th centuries. Divided into three sections: Iconography, decoration, and style. Three types of manu-

scripts are examined: Manuscrits *saferades.* Manuscrits *ashkenazes,* and Manuscrits de rite grec. The bibliography is a specialized work on Jewish art, its liturgical, historical, and doctrinaire context in the manuscripts.

M142 Randall, Lillian M. C. Images in the margins of Gothic manuscripts. Berkeley, Univ. of California Pr., 1966. viii, 235p. 156p. of il. (California Studies in the history of art, 4)
A comprehensive, iconographic index of the marginal illustrations in 226 Gothic illuminated manuscripts which range in date from the mid-13th century to the second half of the 14th century. The manuscripts culled from marginalia are English and Continental, for the most part French and Franco-Flemish in origin, and consist of scenes depicting humans, animals, or hybrids in some sort of activity. All in all, an incredible *tour de force* which provides the specialist with a valuable iconographic tool and others with a related sequence of delightful designs and images.
Contents: Introduction: Selective bibliography; Key to abbreviated manuscript references; List of manuscripts according to libraries; Guide to the use of the index. "Index of subjects," p.43–235, is an alphabetical listing by theme. Many cross-references. The 738 illustrations in alphabetical sequence follow the order of subject entries.

M143 Robb, David M. The art of the illuminated manuscript. South Brunswick and N.Y., Barnes [1973]. 356p. il. (part col.)
The first survey (in English) of the illuminated manuscript as an art form. Valuable to students for an introduction to major schools of manuscript painting. Begins with the origins and early forms of manuscript illumination and ends with an epilogue on illumination in the 15th century. Necessarily selective, yet reasonably comprehensive.
Appendix: "A brief description of some types of liturgical, service, and devotional manuscript books," p.331–34. Bibliography, p.337–45. An adequate number of illustrations, but many are poor in quality.

SEE ALSO: *Storia della miniatura. Studi e documenti* (R60).

# RENAISSANCE—BAROQUE

M144 Cuttler, Charles D. Northern painting from Pucelle to Bruegel: fourteenth, fifteenth, and sixteenth centuries. N.Y., Holt [1968]. xii, 500p. 682 il., 32 col. plates.
Available in paperback.
A good text for a college course in Northern painting. Brings together painting from the various countries, concentrates on significant work, and summarizes recent opinions on the major problems. "Selected bibliography and notes," p.486–91. Many illustrations.

M145 Levey, Michael. Rococo to revolution; major trends in eighteenth-century painting. London, Thames &

Hudson; N.Y., Praeger [1966]. 252p. 154 il. (part col.)

Available in paperback.

Based on the author's lectures as Slade Professor of Art, Cambridge.

Not a history of 18th-century painting but a collection of six stimulating essays which trace the major trends in European painting from the birth of Watteau to the death of Goya.

Contents: Introduction; (1) Intimations of Rococo; (2) The importance of Watteau; (3) High Rococo; (4) Natural reactions; (5) Nature and the antique; (6) Goya; Epilogue. Bibliography, p.240–41.

M146  Mather, Frank Jewett. Western European painting of the Renaissance. N.Y., Tudor, 1948. 873p. plates.

First published in 1939.

A general survey intended to supplement the author's *History of Italian painting.* Appendix contains "Historical illustrations" (excerpts from documents and sources). "Bibliography and notes," p.785–99. Index, p.849–73.

M147  Réunion des Musées Nationaux, Paris. Le XVIe siècle européen, peintures et dessins dans les collections publiques françaises. Paris, Petit Palais, octobre 1965-janvier 1966. [Préfaces par André Chastel et Michel Laclotte]. 2e édition. Paris, Réunion des Musées Nationaux, 1965. xxiv, 328p. il.

Editors: A. Canan and P. Quoniam.

The catalogue of a major loan exhibition of 16th-century paintings and drawings from various museums, churches, and libraries throughout France. The largest of four exhibitions on the 16th century held simultaneously in Paris. Particularly rich in Italian art. The catalogue is an important research tool which presents new material and the latest thinking on art historical problems relating to the 16th century. The documented entries by 13 specialists are examples of meticulous scholarship. Each work is illustrated. Full bibliography, p.301–15.

M148  Ringbom, Sixten. Icon to narrative; the rise of the dramatic closeup in fifteenth-century devotional painting. Åbo, Åbo Akademi, 1965. 233p. plates. (Acta Academie Aboensis. Ser. A: Humaniora: Humanistiska vetenskaper, socialvetenskaper, teologi, v.31, nr. 2)

A brilliant scholarly study of the changing form and content in 15th century religious painting with relation to the changing liturgy and devotional literature. The title states the principal theme.

Divided into 2 parts: (I) The icon. The devotional image; (II) The narrative. Excellent bibliography.

SEE ALSO:  Pigler, A. *Barockthemen* (F15).

# NEOCLASSICAL—MODERN

M149  Berckelaers, Ferdinand Louis. Abstract painting: fifty years of accomplishment from Kandinsky to the present

[by] Michel Seuphor [pseud.]. [Trans. from the French by Haakon Chevalier.] N.Y., Abrams [1962]. 320p. 530 il. (382 col.)

Primarily a pictorial anthology of the works of 20th-century painters noted as abstractionists. Although the selection of illustrations and the historical premises are unbalanced, the volume serves handily as a reference for reproductions.

Bibliography, p.320

M150  _____. A dictionary of abstract painting, preceded by a history of abstract painting [by] Michel Seuphor [pseud.]. [Trans. from the French by Lionel Izod, John Montague, and Francis Scarfe]. N.Y., Tudor [1957]; London, Methuen [1958]. [305]p. il. (chiefly col.)

Original French ed.: *Dictionnaire de la peinture abstraite,* Paris, Hazan, 1957. Contains brief biographical entries for over 500 artists and 200 small color illustrations. The emphasis is on French artists.

Contents: pt. 1, History of abstract painting, p.1–[88]; Appendixes (with manifestos by Severini, Malevich, and Mondrian), p.91–[104]; Chronological table of abstract art p.[106–13]; pt. 2, Dictionary of abstract painting, p.117–[294]. Bibliography, p.297–[305]; some entries include bibliographical references.

M151  Boetticher, Friedrich von. Malerwerke des neunzehnten Jahrhunderts. Beitrag zur Kunstgeschichte. Dresden, Boetticher, 1891-1901. 2v. in 4. (Repr.: Hofheim, Schmidt & Günther [1969].)

A basic dictionary of 19th-century painters of all nationalities. Biographical information is generally brief, but painters may be found here not listed elsewhere. Valuable for lists of paintings and prints included in most entries; dimensions and locations of paintings are often given.

M152  Coke, Van Deren. The painter and the photograph; from Delacroix to Warhol. [Rev. and enl. ed.]. Albuquerque, Univ. of New Mexico Pr. [1972]. 324p. 568 il.

A rev., enl. ed. of the 1964 exhibition catalogue issued under the same title.

"Essentially a history, pictorial and verbal, of various ways in which artists of many countries have used photographs directly or indirectly in their work since the perfection of photography in 1837."—*Pref.* Extremely well illustrated.

Contents: (1) Portraits: 19th century; (2) Portraits: 20th century; (3) Genre: 19th century; (4) Genre: 20th century; (5) Stop-action photography; (6) Photographic exaggerations of face and figure; (7) Landscapes; (8) Mixed media; (9) Fantasy and protest; (10) Photographs as catalysts; (11) Conclusion.

Notes, p.305–15, include bibliographical references.

M153  Dictionary of modern painting. General editors: Carlton Lake and Robert Maillard. [Trans. from the French by Lawrence Samuelson and others. 3d ed., rev. and enl.]. N.Y., Tudor [1964]; London, Methuen [1964]. 416p. il. (part col.)

Trans. and revision of *Dictionnaire de la peinture moderne,* Paris, Hazan [1954].

Contains articles on artists, movements, writers, critics, schools, and places for the period 1850–1950 (the only living painters included matured before World War II). Longer articles are signed with the initials of the contributors, who are listed at the front of the volume. Illustrated with small color and black-and-white reproductions.

M154 Haftmann, Werner. Painting in the twentieth century. [Trans. by Ralph Manheim. Newly designed and expanded ed.]. N.Y., Praeger [1966]. 2v. il. (part col.)
Available in paperback ed. Translation and revision of *Malerei im 20. Jahrhundert.* 2d ed., München, Prestel, 1957.

A sound general history of painting in Europe and the U.S. from Impressionism to post-World War II art. The author concentrates on artists' aesthetic theories, intentions, and methods rather than analyses of individual works.

Contents: v.1, An analysis of the artists and their work: Bk.1, The turning point in art; Bk. 2, Towards Expressionism; Bk.3, The magical experience of reality, the experience of the absolute; Bk.4, Towards a comprehensive style, art between the wars; Bk. 5, The contemporary scene, art since 1945. Short biographies of artists, p.379–425, includes references. Indexes of names and subjects.

v.2, A pictorial survey, contains 1,011 reproductions of works (50 in color), with brief essays on the following: Introduction; The ideas underlying modern painting; Matisse and Fauvism; German Expressionism; Cubism; Orphism; Futurism; The Blaue Reiter; Towards concrete painting; Magic in the material thing; Pittura metafisica; Painting between the wars: France; Painting between the wars: Italy; Painting between the wars: Germany; Aspects of painting in Belgium; Painting in Mexico; Painting in the U.S.; The painting of the present day. List of plates, p.403–18.

M155 Herbert, Robert L. Neo-Impressionism. [N.Y.] Solomon R. Guggenheim Museum [1968]. 261p. il. (part col.)
The catalogue of an exhibition held at the Solomon R. Guggenheim Museum, N.Y., in 1968.

Provides an excellent survey of the Neo-Impressionist movement, emphasizing the two main periods of activity and influence, 1886–92 and 1902–09. Includes an introductory essay, p.[14–26], and a detailed catalogue of 175 paintings, preparatory studies, and drawings by the Neo-Impressionist painters and by artists whose mature painting styles evolved through a Neo-Impressionist period. Contents of catalogue: Neo-Impressionists in France (14 painters); Contemporaries in France (9 painters); Neo-Impressionism in Belgium (5 painters); Neo-Impressionism in Holland (5 painters); The Fauve period (7 painters); The Cubist period and after (8 painters). A biographical sketch, with bibliography, is given for each artist. Entries include medium, dimensions, early exhibitions, collection, and commentary.

Contents of Documentation section: Exhibitions and chronology; Bibliography (general and archives and documents), p.[250]–51.

M156 Loevgren, Sven. The genesis of modernism; Seurat, Gauguin, Van Gogh, and French Symbolism in the 1880's. Rev. ed. Bloomington, Indiana Univ. Pr. [1971]. xiii, 241p. 28 il.

First published in *Figura; studies edited by the Institute of Art History, Univ. of Uppsala,* no. 11, 1959.
"An important study of the major ideas central to the development of modern painting." (Chipp, I238, p.632)
Contents: (1) In search of a style; (2) L'Ile des Iridées; (3) La lutte et le rêve; (4) La nuit étoilée. Appendix: Letter from Gauguin to Willumsen. Bibliography, p.197–204. Notes, p.205–36, include bibliographical references.

M157 Meier-Graefe, Julius. Modern art; being a contribution to a new system of aesthetics; from the German by Florence Simmonds and George W. Chrystal. London, Heinemann; N.Y., Putnam, 1907. 2v. il., *1908* 209 plates. (Repr.: N.Y., Arno, 1968.) *2 v.*
Trans. of *Entwicklungsgeschichte der modernen Kunst,* Stuttgart, 1904. 2d ed., Munich, 1927. *+ 3. ed. 1966. 2 v.*

A pioneering history of modern painting, with some consideration of sculpture, from the late 18th century to the beginning of the 20th century. Although the scholarship is dated, the work is still valid for its basic insights and significant for being the first history to give dominance to artists of the modernist tradition. Index in v.2, p.327–37.

M158 Norman, Geraldine. Nineteenth-century painters and painting: a dictionary. Berkeley, Univ. of California Pr., 1977. 256p. 469 il. (30 col.).
A well-illustrated dictionary of approx. 700 painters, movements, and institutions of the 19th century. Entries on painters include biographical and critical information, honors and prizes, locations of works, and bibliography.

M159 Paris. Grand Palais. Le symbolisme en Europe. [Paris, Éditions des Musées Nationaux, 1976]. 274p. il. (part col.)
The catalogue of an exhibition shown at the Museum Boymans-van Beuningen, Rotterdam; the Musées Royaux des Beaux-Arts de Belgique, Brussels; the Staatliche Kunsthalle, Baden-Baden; and the Grand Palais, Paris, in 1975 and 1976.

Includes 266 Symbolist paintings, drawings, and prints by 88 artists, both well-known (i.e. Gustave Moreau, Redon, Khnopff, Denis, Klimt, Burne-Jones) and lesser-known, especially those of Eastern Europe and Russia. The catalogue is arranged alphabetically by artist, with a biographical sketch and portrait of each. Entries give description, commentary, exhibitions, bibliography, provenance, and collection. All works are reproduced. Introductory essays; Hofstätter, Hans H. L'Iconographie de la peinture symboliste; Russoli, Franco. Images et langages du symbolisme; Lacambre, Geneviève. Le symbolisme en Europe—notes d'histoire.

Chronological list of important Symbolist exhibitions (1859–1975), p.258–63. Bibliography, p.264–68. Portraits of artists, p.271. List of artists in the exhibition, p.273.

M160 Raynal, Maurice. History of modern painting. Geneva, Skira [1949–50]. 3v. col. il. (Painting, colour, history)
A 1v. abridgment, *Modern painting,* pub. 1953. The text of each volume is by Raynal and others; v.1–2 trans. by Stuart Gilbert; v.3 trans. by Douglas Cooper. Historical and biographical notes by Jean Leymarie and others.

v.1: From Baudelaire to Bonnard, is on the period 1858–84. Discusses "the problems of impressionism in a rather journalistic manner but accompanied by numerous chronological charts, biographical notices, a bibl., etc., all very well arranged. Many ill., sometimes too vivid in color, but well selected."—(John Rewald, M161, p.617). v.2: Matisse, Munch, Rouault. v.3: From Picasso to Surrealism.

Each volume contains a "Selected bibliography" and a general index.

M161  Rewald, John. The history of Impressionism. 4th, rev. ed. N.Y., The Museum of Modern Art. (Distr. by New York Graphic Society, Greenwich, Conn. [1973].) 672p. il. (part col.), maps.
1st ed. 1946; 2d rev. ed. 1955; 3d rev. ed. 1961.

The definitive history of the Impressionist movement from 1855–86. "The richness of its documentation, and the clarity with which it traces the complex interrelationships between the Impressionist painters, provide a model against which any writer on the subject has to measure himself. The book's function is primarily documentary and biographical, and the discussion of the artists' paintings takes second place to its superbly engineered historical narrative." (Unsigned review of 4th ed. in the *Times Literary Supplement,* May 3, 1974, p.464.)

List of participants in the various group shows, p.591. Biographical chart, p.[592–607]. The up-to-date bibliography, p.608–53, is annotated and arranged chronologically within the following classifications: General; Bazille; Caillebotte; Cassatt; Cézanne; Degas; Gauguin; Guillaumin; Manet; Monet; Morisot; Pissarro; Renoir; Sisley.

M162  _____. Post-Impressionism from Van Gogh to Gauguin. [2d ed.]. N.Y., The Museum of Modern Art. (Distr. by Doubleday, Garden City, N.Y. [1962].) 619p. il. (part col.), maps.
3d. rev. ed. 1978; 1st ed. 1956.

A superbly documented history of the post-Impressionist period, covering the years 1886–93. With Van Gogh's arrival in Paris as the point of departure, the author reconstructs the history of the period by focusing on the leading painters and showing the other painters revolving around them.

Biographical chart, p.540–49. Participants in the exhibitions of the independents, 1884–93, p.550. The bibliography, p.551–602, is critically annotated and arranged chronologically within three sections: pt. I, General; pt. II, Individual artists, critics; pt. III, Neo-Impressionism; pt. IV, Literary symbolism.

M163  Rookmaaker, Hendrik Roelof. Synthetist art theories; genesis and nature of the ideas on art of Gauguin and his circle. Amsterdam, Swets and Zeitlinger, 1959. xi, 284p. (Repr. as *Gauguin and 19th century art theory,* Amsterdam, Swets and Zeitlinger, 1972.)
"An extensive study and analysis of the ideology of Gauguin and the Synthetist movement, including numerous texts of the period, many of which are annotated." (Chipp, I238, p.632).
Classified bibliography, p.243–57.

M164  Sutter, Jean. The Neo-Impressionists. Ed. by Jean Sutter, with contributions by Robert L. Herbert [and others. Trans. from the French by Chantal Deliss]. Greenwich, Conn., New York Graphic Society [1970]. 232p. il. (part col.)
A collection of essays by various authors on the major and minor French and Belgian Neo-Impressionist painters.

Contents: Introduction; George Seurat; Seurat's theories; Paul Signac; Henri Edmond Cross; Charles Angrand; Albert Dubois-Pillet; Lucien Pissarro; Louis Hayet; Hippolyte Petitjean; Lagny-sur-Marne; Cavallo-Pédazzi; Maximilien Luce; Léo Gausson; Henri Delavallée; Gustave Perrot; Les Vingt; Anna Boch; Frantz Charlet; Alfred William Finch; Georges Lemmen; Dario De Regoyos; Jan Toorop; Théo van Rysselberghe; Henry van de Velde; Guillaume Vogels; The Société des Artistes Indépendants.
Classified bibliography, p.221–23.

M165  Venturi, Lionello. Les archives de l'impressionisme. Lettres de Renoir, Monet, Pissarro, Sisley et autres. Mémoires de Paul Durand-Ruel. Documents. Paris, N.Y., Durand-Ruel, 1939. 2v. plates, facsims. (Repr.: N.Y., Burt Franklin, 1968.)
Letters and documents related to Impressionism. Bibliography. "La critique de l'impressionisme de 1863 à 1880," v.2, p.273–342. Index and table of contents at end of v.2.

SEE ALSO:  Monographs in *Documents of modern art* (I239), *Documents of 20th-century at* (I240); Levey, M. *Rococo to revolution* (M145).

# WESTERN COUNTRIES

## Australia

M166  Smith, Bernard William. Australian painting, 1788–1970. [2d ed.]. Melbourne, N.Y., Oxford Univ. Pr. [1971]. 483p. il. (part col.)
A generously illustrated, critical history of Australian painting. "A note on books and periodicals," p.459–61.

## Canada

M167  Harper, J. Russell. Painting in Canada, a history. 2d ed. Toronto, Buffalo, Univ. of Toronto Pr. [1977]. 463p. 173 il.
1st ed. 1966 contained 378 illustrations (70 col.).

The author's aim was "to write a history that would present for the general public an accurate, documented survey of Canada's very considerable aesthetic achievement in painting, one that also incorporated the scholarship and research that had been done on the subject to date."—*Pref.* Well illustrated.

Contents: pt. 1, The French colony, 1665–1759; pt. 2. The English colonial period, 1759–1867; pt. 3, The new Dominion, 1867–1910; pt. 4, Nationalism and internationalism after 1910. Notes, p.435–38, include bibliographical references.

Biographies, p.403–31, give brief biographical data. Selected bibliography, p.439–43.

M168 _____. A people's art: primitive, naïve, provincial, and folk painting in Canada. Toronto, Univ. of Toronto Pr. [1974]. x, 176p. 112 il., 26 col. plates.

The first serious consideration of the folk or "vernacular" painting of Canada, from the 17th century to modern times. Well illustrated. Index of artists. Includes bibliographical references.

M169 Reid, Dennis. A concise history of Canadian painting. Toronto, Oxford Univ. Pr., 1973. 319p. il. 35 col. plates.

A comprehensive, concise account of the history of Canadian painting from the French colonial period to the mid-1960s. "This guide to looking at the work of Canadian painters was written in the belief that of all the arts in Canada, painting is the one that most directly presents the Canadian experience." —*Pref.*

Bibliography discussed in the preface.

## France

M170 Dimier, Louis, and Réau, Louis. L'histoire de la peinture française depuis les origines jusqu'à David. Paris, van Oest, 1925–27. 5v. plates.

Each of the volumes contains a bibliography and a table of plates, but no index. The whole forms a history of French painting from its origin to the beginning of the 19th century. Still an important work.

Contents: v.1, L. Dimier, *Histoire de la peinture française des origines au retour de Vouet, 1300 à 1627* (1925); v.2–3, L. Dimier, *Histoire de la peinture française du retour de Vouet à la mort de Lebrun, 1627 à 1690* (1926–27); v. 4–5, L. Réau, *Histoire de la peinture française au XVIIIe siècle* (1925–26).

M171 New York. Metropolitan Museum of Art. A catalogue of French paintings. By Charles Sterling. Cambridge, published for the museum by Harvard Univ. Pr., 1955–[67]. 3v. il., maps.

v.2 and 3, by C. Sterling and Margaretta M. Salinger, have imprint: Metropolitan Museum of Art, distibuted by New York Graphic Society, Greenwich, Conn.

A complete catalogue of the French holdings of the Museum. In each volume painters are arranged in chronological order; each has a brief biography, plus information on the work's provenance, medium, material, and dimensions.

Contents: v.1, 15th to 18th centuries; v.2, 19th century; v.3, 19th and 20th centuries.

M172 Paris. Musée National du Louvre. Catalogue des peintures. Paris, Éditions des Musées Nationaux, 1972– . v.1 (École française). 423p.

A *catalogue sommaire,* no illustrations. Lists the approx. 6,000 paintings of the French School conserved in the Louvre and the Jeu de Paume. The paintings are listed alphabetically by artist. Gives titles, measurements, signatures, inscribed

or documented dates, inventory numbers, provenance, and occasional bibliographical references. Anonymous works are classed at the end by century. v.2 will include the paintings from all countries other than France and an index. Eventually the catalogue will be completed by including the many paintings owned by the Louvre but placed in provincial museums or public buildings.

For more detailed entries, with illustrations, see (M173), (M174), and (M175) of the *Répertoire illustré des peintures conservées par le Musée du Louvre.*

M173 _____. _____. Catalogue illustré des peintures: école française, XVIIe et XVIIIe siècles, par Pierre Rosenberg, Nicole Reynaud, Isabelle Compin. Paris, Éditions des Musées Nationaux, 1974. 2v. il.

According to the preface these 2v. (illustrated summary catalogues of the collection of 17th- and 18th-century paintings in the Louvre) complete the *Catalogue illustré des peintures* (previously entitled *Répertoire illustré des peintures,* see M174, M175). The project was begun in 1958.

For each painting gives inventory number, medium, dimensions, date, signature, provenance, etc., and a reproduction. Includes indexes and a concordance with older catalogues of the collection.

M174 _____. _____. Peintures: École française, XIVe, XVe, et XVIe siècles, par Charles Sterling et Hélène Adhémar, avec la collaboration de Nicole Reynaud et Lucienne Colliard. Paris, Éditions des Musées Nationaux, 1965. 66p. il., 262 plates (9 col.)

A volume of the *Catalogue général des peintures du Louvre (Répertoire illustré des peintures conservées par le Musée du Louvre).* An illustrated *catalogue sommaire.*

The catalogue of 14th-, 15th-, and 16th-century paintings in the Louvre. Works included are those of French artists and foreign artists who worked in France during this period. Includes the illuminated manuscripts in the Cabinet des Dessins. Documented entries for each work with selected bibliography. Each work is illustrated with many details. Concordance, list of historic personnages, index, and list of donors at end.

M175 _____. _____. Peintures: École française, XIXe siècle, par Charles Sterling et Hélène Adhémar. Paris, Éditions des Musées Nationaux, 1958–61. 4v. il. (part col.)

A *catalogue sommaire,* with illustrations, of the 19th-century paintings in the Louvre. These volumes constitute part of the *Répertoire illustré des peintures conservées par le Musée du Louvre.* Dictionary arrangement by painter, with factual information and provenance for the individual works. A small illustration of each work is provided. At the end of v.4: tables of concordance with older catalogues, and indexes of donors and subjects.

Contents: (I) A–C; (II) D–G; (III) H–O; (IV) P–Z.

### Carolingian-Gothic

M176 Branner, Robert. Manuscript painting in Paris during the reign of St. Louis. Berkeley, Univ. of California

Pr., 1977. il. (part col.) (California studies in the history of art, no. 18)

This last work of a great art historian is the result of seven years of research in the field of French 13th-century manuscript illumination. The study promises to be an original approach which will open up many new avenues in the field of Gothic art.

M177 Blum, André, and Lauer, Philippe. La miniature française aux XVe et XVIe siècles, avec un avant-propos de comte A. de Laborde. Ouvrage accompagné de la reproduction de 173 miniatures dont une planche en couleurs. Paris, van Oest, 1930. vii, 128p., 100 plates.

List of manuscripts, classed by cities and libraries, p.107–8. List of plates, p.109–22. Alphabetical index to the commentary, p.123–28.

Contains 54 pages of text; commentary on the plates by P. Lauer.

M178 Deschamps, Paul, and Thibout, Marc. La peinture murale en France au début de l'époque gothique, de Philippe-Auguste à la fin du règne de Charles V, 1180–1380. Paris, Centre Nationale de la Recherche Scientifique [1963]. 258p. il. (part col.), 151 plates (12 col.)

A comprehensive scholarly survey of French mural painting of the early Gothic period. The author treats all aspects of the subject—iconography, foreign influences, technique, and stylistic development. Bibliographic footnotes. The extensive corpus of good plates provides visual documentation of existing murals throughout France. Index of places, list of illustrations. No general index.

M179 _____. La peinture murale en France; le haut moyen-âge et l'époque romane. Paris, Plon [1951]. vii, 178p. il., 72 plates, map.

A comprehensive scholarly survey of French mural painting from the era of the Capetian dynasty to the reign of Philippe-Auguste (1180); continued by the authors' *La peinture murale en France au début de l'époque gothique* (M178). The authors establish new dates for murals previously thought to have been much earlier. The numerous paintings of the 12th century, especially those in the west of France, are presented in approximate chronological order. All aspects of the subject are presented—iconography, foreign influences, technique, and stylistic development. Numerous black-and-white illustrations and figures. Bibliographical footnotes.

M180 Laclotte, Michel. L'École d'Avignon; la peinture en Provence aux XIVe et XVe siècles. Paris, Gonthier-Seghers [1960]. 129p. 44 mounted col. il.

A concise up-to-date review of painting in Provence during the Babylonian Captivity. Presents new thinking on problems of Italian influence. Well written and well illustrated with color plates. Useful chronological tables.

M181 Martin, Henry. La miniature française du XIIIe au XVe siècle. Ouvrage accompagné de 134 reproductions de miniatures, dont 4 planches en couleurs. Paris, van Oest, 1923. 118p. 104 plates (4 col.)

A survey of French Gothic illumination. 84p. of text; description of plates, p.85–105. Includes bibliographical references.

M182 Meiss, Millard. French painting in the time of Jean de Berry; the Boucicaut Master. With the assistance of Kathleen Morand and Edith W. Kirsch. London, Phaidon, 1968. 384p. il. (some col.), facsims., plates, indexes. (National Gallery of Art: Kress Foundation studies in the history of European art, no. 3)

The 2d part of the work by Meiss (see the 1st pt., M183). Includes history, a catalogue of manuscripts, scholarly notes, and bibliography, p.154–59. Also has corrections to previous volumes. 497 illustrations with index.

M183 _____. _____; the late fourteenth century and the patronage of the duke. London, Phaidon, 2d ed. 1969. 2v. il., plates (part col.) (National Gallery of Art: Kress Foundation studies in the history of European art, no. 2)

1st ed. 1967.

The 1st part of a monumental survey of French painting (primarily manuscript illumination) of the late 14th and early 15th centuries, projected in 4 parts. The last published project of a great art historian. Indispensable for reference and research. A review of the art historical development is followed by manuscripts arranged by city and holding collection. Full documentation with meticulous scholarship. Bibliographical references in catalogue, scholarly notes, a separate bibliography, and an index. v.2 has 845 illustrations, 12 in color, with an index.

M184 _____. _____; the Limbourgs and their contemporaries. With the assistance of Sharon Off Dunlop Smith and Elizabeth Home Beatson. N.Y., Braziller [1974]. 2v. il. (some col.) (The Franklin Jasper Walls lectures, 1972)

A continuation of the extensive survey of French painting in the late Gothic period. The art historical discussion is followed by a scholarly catalogue of the manuscripts and panel paintings, notes, and bibliography. The separate plate volume is an important corpus of 898 illustrations, 35 in color.

M185 Mesuret, Robert. Les peintures murales du sud-ouest de la France, du XIe au XVIe siècle, Languedoc, Catalogne septentrionale, Guienne, Gascogne, comté de Foix. Paris, Picard, 1967. 312p. il., 40 plates, 57 text figures, 4 maps.

An inventory and thorough study of medieval mural painting in the southwestern part of France. Intended as a companion volume to Roques (M188).

Contents: (I) La technique et la décoration picturales; (II) Le style; (III) Les documents (on painters and lost paintings); (IV) Les peintures existantes: catalogue chronologique. "Répertoire des notices," p.125–281, is a catalogue of the paintings by place. For each work gives descriptive notes, discussion of research, and a full bibliography.

General bibliography and indexes at end. Recent photographic documentation.

M186 Porcher, Jean. Medieval French miniatures. [Trans. from the French by Julian Brown]. N.Y., Abrams [1960?]. 275p. il. (part col.), col. plates.
Trans. of *L'enluminure française.*

A good survey of French Romanesque and Gothic illumination, written by a foremost authority. The manuscripts discussed represent major stages of development, having been chosen to give the reader a broad impression of the history of French illumination. Copiously illustrated (90 black-and-white figures in the text, 92 excellent color plates) with miniatures, paintings, and sculpture, mostly from public collections in France. The text is followed by a useful "bibliographical commentary" and explanatory notes, p.85-[94].

M187 Ring, Grete. A century of French painting, 1400-1500. N.Y., Phaidon, 1949. 251p. il. (part col.), map, plates, geneal. table.

An important, well-illustrated work on aristocratic painting in France during the 15th century. Still the best introduction. Contents: Introduction: General, survey of literature, patrons and sitters, artists and their work; Plates; Catalogue (338 works); Biographical notes on the painters; Index of places; Table of patrons and their artists.

M188 Roques, Marguerite. Les peintures murales du sud-est de la France, XIIIe au XVIe siècle. Préf. de Paul Deschamps. Paris, Picard, 1961. 444p. il., 64 plates, 2 fold. maps, diagrs., facsims., plans.

An inventory of mural painting in the southeastern part of France. For each work gives description, state of research, and bibliographical references. General bibliography, p.[413]-24.

M189 Sterling, Charles. La peinture française: les peintres du moyen âge. Paris, Tisné [1942]. 85, 76p. 150 plates (22 mounted col.)

Pt. 1 consists of 76p. of text by a recognized authority describing the various schools and trends of medieval painting; notes, p.77-85; a list of important exhibitions; followed by 150 plates, several in color. Pt. 2 consists of "Répertoire de tableaux française du moyen âge," p.3-66, in which the works of the 14th and 15th centuries are treated separately, each divided into (1) pictures legitimately considered as French, and (2) those whose French character is spurious or questionable. This section also contains individual commentaries on the plates reproduced. Sizes of the paintings are given. Bibliography, p.71-[77], at end.

M190 Troescher, Georg. Burgundische Malerei; Maler und Malwerke um 1400 in Burgund, dem Berry mit der Auvergne und in Savoyen mit ihren Quellen und Ausstrahlungen. Berlin, Mann [1966]. 2v., maps, plans, 224 plates.

A study of Burgundian painting, c.1400, in the courts of France. Important for research in all of the arts excepting architecture. "Textband": Burgund; Berry und Auvergne; Savoy und der Alpenrand. Copious scholarly notes with bibliographical references in "Anmerkungen," p.373-[421]. Indexes of bibliographical abbreviations, painters, places,

and subjects. "Tafelband" consists of a valuable corpus of 730 illustrations and an index to the plates and figures.

M191 Varille, Mathieu. Les peintres primitifs de Provence. Paris, Rapilly, 1946. 230p.
A delightful little dictionary of painters, illuminators, embroiderers, and glassmakers who worked in Provence from 1250-1550. "Essai de bibliographie," p.[9]-13.

SEE ALSO: *Die illuminierten Handschriften und Inkunabeln der Österreichischen Nationalbibliothek,* Bd. 1, *Französiche Schule* (M10).

## Renaissance — Modern

M192 Béguin, Sylvie M. L'École de Fontainebleau: le maniérisme à la cour de France. Paris, Gonthier-Seghers [1960]. 155p. mounted col. il. (Collection "Écoles de la peinture")
A good introduction to the works of the artists of the Fontainebleau school. Well-documented text; 43 color plates of paintings, stucco decorations, and drawings. "Though intended mainly for the general public, this elegantly produced little volume is informed by copious eruditions." —Hugh Honour, *Connoisseur,* Oct. 1962. Bibliography, p.149-51.

M193 Boime, Albert. The Academy and French painting in the nineteenth century. [London, N.Y.] Phaidon [1971]. ix, 330p. 161 il.
A thorough examination and reevaluation of the Academy and its role in the development of 19th-century French painting. Concentrates on the period 1830-80. An extremely valuable addition to the literature in the field.
Contents: (I) The crystallization of French official art; (II) The curriculum of the private ateliers: practice; (III) The curriculum of the private ateliers: masters; (IV) The academic sketch; (V) The sketch in practice; (VI) The copy; (VII) The academic landscape: traditional procedure; (VIII) The academic 'étude': generative procedure; (IX) The aesthetcs of the sketch.
Notes, p.[187]-220, include bibliographical references. Bibliography, p.[221]-28: Archives; General sources.

M194 Bouret, Jean. The Barbizon School and 19th century French landscape painting. Greenwich, Conn., New York Graphic Society [1973]. 271p. 292 il. (45 col.)
Trans. of the *L'École de Barbizon et le paysage français au XIXe siècle,* Neuchâtel, Ides et Calendes [1972].
A general, well-illustrated history of the Barbizon painters. Notes, p.244-45, contain bibliographical references. Biographical notes, p.246-57, are brief biographical sketches, which include "only those ninteenth-century painters who were members of the original Barbizon group or who were influenced by the group, or who worked in the region." List of illustrations, p.261-68.
Bibliography, p.258-60, includes general works and works on individual artists.

**M195** Châtelet, Albert, and Thuillier, Jacques. French painting, from Fouquet to Poussin. [Trans. from the French by Stuart Gilbert. Geneva] Skira [1963]. 243p. mounted col. il. (Painting, color, history)

A well-written survey of French painting from Jean Fouquet (born c.1420) to Nicolas Poussin (1594-1665). Concentrates on important themes and major artists. The art historical development in France is tied to its European context. Excellent bibliography, p.229-32. Well illustrated with good color plates.

Contents: The ducal workshops; A perfect equipoise: the secret and the strength of Fouquet; Provençal painting from Charonton to Froment; The resistance to Italy; The Italians at Fontainebleau; The portrait from the Clouets to the Dumonstiers; French and Flemish artists at Fontainebleau; The great generation of the 17th century.

**M196** Chennevières-Pointel, Philippe, *marquis* de. Recherches sur la vie et les ouvrages de quelques peintres provinciaux de l'ancienne France. Paris, Dumoulin, 1847-62. 4v., 4 plates. (Repr.: Geneva, Minkoff, 1973.)

The fundamental work on the history of French provincial art from the 16th to the 19th century. Includes long biographies of the artists, discussions of artistic theory, information on published sources and the publication of early works, and material on provincial academies. Each volume has its own index. v.IV is a monograph on Hilaire Pader of Toulouse and a translation of the book of proportions by J. P. Lomasse.

**M197** Claretie, Jules. Peintres & sculpteurs contemporains; portraits gravés par L. Massard. Paris, Librairie des bibliophiles, 1882-84. 2v. il., 32 ports.

A collection of 32 biographies of artists, written by a member of the artistic circle in Paris during the latter part of the 19th century. Personal, chatty, most informative.

Contents: sér. 1, Artistes décédés de 1870-80; sér. 2, Artistes vivants en janvier 1881. An engraved portrait of each artist accompanies the text.

**M198** Dimier, Louis. Histoire de la peinture de portrait en France au XVIe siècle, accompagnée d'un catalogue de tous les ouvrages subsistant en ce genre, de crayon, de peinture à l'huile, de miniature, d'émail, de tapisserie et de cire en médaillons. Paris, van Oest, 1924-26. 3v. plates, ports.

v.1 is a history of portrait painting in France in the 16th century, illustrated with 64 plates. v.2 contains the catalogue, which lists all the works of portraiture painted in France in the 16th century, arranged as follows: (1) Original pencil sketches; (2) Copies in crayon; (3) Original paintings; (4) Painted copies; (5) Miniatures; (6) Prints when they bear witness of a lost work.

v.3 consists of a "Catalogue des ouvrages de second main," "Additions et corrections," p.273-78, and "Errata," p.279. Bibliography, p.281-89. "Table analytique de la première partie," p.291-310. "Table des musées, cabinets, etc. ainsi que les publications, auxquelles on renvoie dans cet ouvrage," p.311-30. "Table alphabétique des portraits catalogués dans cet ouvrage," p.331-57. "Table des matières" at end of each volume.

————. Supplément. Douze crayons de François Quesnel. Paris, van Oest, 1927. 12p., 6 plates.

**M199** ————. Les peintres français du XVIIIe siècle; histoire des vies et catalogue des oeuvres. Ouvrage publié sous la direction de M. Louis Dimier, avec la collaboration de nombreux savants et spécialistes. Paris, van Oest, 1928-30. 2v. 128 plates.

A fundamental work on French painters and paintings of the 18th century which has not been superseded.

The 2v. contain chapters on 35 individual artists of the 18th century, written by various authors. For each artist gives a biography, a catalogue of his works (including paintings, drawings and engravings, and tapestries) and a bibliography. Dimensions of the works are given in the catalogue.

"Additions au tome premier," p.393-96, at end of v.2.

**M200** Dorival, Bernard. Les étapes de la peinture français contemporaine. [Paris] Gallimard, 1943-48. 3v.

A general survey of French painting from Impressionism to World War II. A projected 4th volume of illustrations has not been published.

Contents: v.1, De l'impressionisme au fauvisme, 1883-1905; v.2, Le fauvisme et le cubisme, 1905-11; v.3, Depuis le cubisme, 1911-44.

Bibliographical notes: v.1, p.[275]-84; v.2, p.[347]-61; v.3, p.[325]-38. Index of artists for all 3v. in v.3, p.339-51.

**M201** Elderfield, John. The "Wild Beasts": Fauvism and its affinities. [N.Y.] The Museum of Modern Art. (Distr. by Oxford Univ. Pr., N.Y. [1976].) 167p. il. (part col.)

Published in conjunction with an exhibition shown at the Museum of Modern Art, N.Y.; San Francisco Museum of Art; and the Kimball Art Museum, Fort Worth, in 1976.

An excellent general study of Fauvism and the principal artists associated with Fauvist painting. Contents: Introduction; The formation of Fauvism; The Fauvist world; The pastoral, the primitive, and the ideal; Postscript: Fauvism and its inheritance. Bibliographical references included in Notes, p.149-60. Bibliography (general references and references on individual artists), p.161-66.

**M202** Faré, Michel. Le grand siècle de la nature morte en France: le XVIIe siècle. Paris, Société Française du Livre, 1974. 411p. il. (part col.)

An authoritative survey of French still life of the 17th century. Bibliographic notes, list of exhibitions, bibliography, indexes of illustrations and artists. Good illustrations with many in color.

Contents: Introduction; Les peintres de la réalité; Les peintres de l'Académie et les décorateurs; Nature morte et décor viant; Conclusion.

**M203** Florisoone, Michel. Le dix-huitième siècle: la peinture française. Paris, Tisné, 1948. 145p. 160 plates (part col.)

A brief but important art historical survey of French painting of the 18th century. The author critically examines all developments—the continuity and revivals of 17th-century realism and the academic, romantic, and revolutionary

trends. Notes with bibliographical references, p.119-[22]. "Notices sur les peintures dont les oeuvres sont reproduits dans ce livre," p.127-[33]; "Note bibliographique," p.135-[36]; "Index alphabétique des peintres, dessinateurs, graveurs et décorateurs ayant vécu entre 1690 et 1785 cités dans ce livre," p.137-[44].

**M204** French painting 1774-1830, the age of revolution. [Detroit Institute of Arts, Metropolitan Museum of Art, N.Y.; distributed by Wayne State Univ. Pr., Detroit, 1975]. 712p. il. (part col.)

The English language ed. of the catalogue of an exhibition shown at the Grand Palais, Paris; the Detroit Insititue of Arts; and the Metropolitan Museum of Art, New York, in 1974 and 1975. The title of the French exhibition and its accompanying catalogue, *De David à Delacroix: la peinture française de 1774 à 1830,* reflects homage paid to Walter Friedlaender's seminal work (M205). The exhibition shown in Detroit and New York was reduced in size from the version shown in Paris, but the English catalogue is a translation of the entire French catalogue, with a few revisions.

A major study and reassessment of French painting of the period 1774-1830, between the death of Louis XV and the fall of Charles X. The four catalogue essays correspond to the distinct political divisions of the period: Painting under Louis XVI, 1774-89, by Frederick J. Cummings, p.31-43; Painting during the Revolution, 1789-99, by Antoine Schnapper, p.101-17; Painting under Napoleon, 1800-14, by Robert Rosenblum, p.161-73; Painting during the Bourbon Revolution, 1814-30, by Robert Rosenblum, p.231-44. Each essay is followed by a section of black-and-white plates.

The catalogue section, p.309-682, is arranged alphabetically by painter and includes full, detailed entries on 206 works by 123 artists. List of exhibitions, p.685-88. Bibliography, p.689-706. List of lenders, p.708-10. Index to artists in the exhibition, p.711-12.

**M205** Friedlaender, Walter F. David to Delacroix. Trans. by Robert Goldwater. Cambridge, Harvard Univ. Pr., 1952. xii, 136p. 83 il.

1st German ed. 1930; paperback ed., N.Y., Schocken, 1968.

A classic work on "the historical structure" of French painting of the late 18th century through the first half of the 19th century.

Contents: Introduction: the ethical and formal bases of classicism in French painting; (1) Classicism and minor trends in the art of David; (2) Ultraclassicists and anticlassicists in the David following; (3) Protobaroque tendencies in the period of classicism; (4) The transformation of classicism in the art of Ingres; (5) Early Baroque and Realism in the art of Gericault; (6) Romantic high Baroque in the art of Delacroix.

**M206** Hautecoeur, Louis. Littérature et peinture en France du XVIIe au XXe siècle. 2d ed. Paris, Colin, 1963. 359p. il.

1st ed. 1942.

A history of the symbiotic relationship of literature and painting, artists and writers in France. Written by a distin-

guished scholar. Literary references and other bibliography in the text and footnotes.

Contents: (1) Des origines au XIXe siècle; (2) Le romantisme; (3) L'art social; (4) L'art pour l'art; (5) Le naturalisme; (6) Le symbolisme; (7) La peinture pure.

**M207** Herbert, Robert L. Barbizon revisited. [Boston, 1962]. 208p. il. (part col.)

The catalogue of an exhibition held at the California Palace of the Legion of Honor, San Francisco; the Toledo Museum of Art; the Cleveland Museum of Art; and the Museum of Fine Arts, Boston, in 1962 and 1963.

Provides an excellent, well-illustrated study of the Barbizon painters. Includes an introductory essay, p.15-68, a detailed chronology, p.75-82, and a catalogue of 113 paintings and drawings by eight of the principal Barbizon painters and five Impressionist painters whose works were influenced by Barbizon predecessors. Contents of catalogue: Corot (20 works); Daubigny (16 works); Diaz (9 works); Dupré (8 works); Jacque (4 works); Millet (24 works); Rousseau (20 works); Troyon (8 works); Barbizon heritage (5 works).

Bibliography (general and individual artists), p.71-73.

**M208** Jean, Marcel. The history of Surrealist painting. With the collaboration of Arpad Mezei. Trans. from the French by Simon Watson Taylor. N.Y., Grove [1960]. 383p. 380 il. (36 col.)

Trans. of *Histoire de la peinture surréaliste,* Paris, Éditions du Seuil [1959].

A well-illustrated, comprehensive survey of Surrealist painting. Includes bibliographical footnotes.

**M209** Leymarie, Jean. French painting, the nineteenth century. [Trans. from the French by James Emmons. Geneva] Skira. [Distr. in the U.S. by World Pub. Co., Cleveland, 1962.] 229p. col. il. (Painting, color, history)

An authoritative, if somewhat sketchy, survey of French painting in the 100-year period from David's *Oath of the Horatii* of 1784 to Seurat's *Bathing at Asnières* of 1884.

Contents: (1) The classical nostalgia; (2) Romantic exaltation; (3) The rise of landscape painting; (4) The battle of realism; (5) The Impressionist revolution.

Classified bibliography, p.215-[18]: General; Neoclassicism; Romanticism; Orientalism; Landscape; Realism; Impressionism; Monographs.

**M210** Locquin, Jean. La peinture d'histoire en France de 1747 à 1785; étude sur l'évolution des idées artistiques dans la seconde moitié du XVIIIe siècle. Paris, Laurens, 1912. xii, 344p. 32 plates. (Repr.: Paris, ARTHENA: Association pour la Diffusion de l'Histoire de l'Art, 1978.)

A basic work on royal patronage, academic doctrine, history painting, and the painters in France from 1747-85. Based on archival research.

Contents: Première partie: L'action administrative; La peinture d'histoire et la direction générale des bâtiments du roi. Deuxième partie: La doctrine et l'enseignement; Formation théorique et pratique du peintre d'histoire dans la

seconde moitié du XVIIIe siècle. Troisième partie: Les hommes, les inspirations, les oeuvres. Bibliographie (excellent for sources), p.291-310; Index alphabétique, p.311-22; Table des gravures, p.333-35; Table des matières, p.337-44.

M211 Rosenberg, Pierre. The age of Louis XV: French painting 1710-1774. [Toledo, Ohio] Toledo Museum of Art [1975]. xv, 94p. [62] leaves of plates (some col.)

An important catalogue of a loan exhibition held at the Toledo Museum of Art, the Art Institute of Chicago, and the National Gallery of Canada in 1975 and 1976. Attempts to view 18th-century French painting in its totality as it was observed and appreciated by contemporaries. Most illustrations are black-and-white, some color. Contains the most up-to-date bibliographical references, including notes on work as yet unpublished, p.87-94.

M212 Rosenthal, Léon. Du romantisme au réalisme; essai sur l'évolution de la peinture en France de 1830 à 1848. Paris, Laurens, 1914. iv, 436p. plates.

An important early study of the social conditions, artistic ideas, painters and painting in France in the period between the Revolution of 1830 and 1848. Still fundamental, though sparsely illustrated. Preceded by the author's *La peinture romantique* . . . (M213).

Tableau synchronique, p.402-7; Indications bibliographiques, p.[409]-21; Index alphabétique.

M213 ———. La peinture romantique; essai sur l'évolution de la peinture française de 1815 à 1830. Paris, Fontemoing [1900?]. x, 336p.

An early study of the development of French Romantic painting. Continued by the author's *Du romantisme au réalisme* . . . (M212).

Contents: (I) Avant le combat; (II) La bataille; (III) Les précurseurs du réalisme; (IV) Le romantique; (V) La résistance; (VI) Autour du combat. Appendixes: (I) Principales productions des Salons de la Restauration; (II) Principales oeuvres de la période de la Restauration, à Paris.

Bibliographie générale sommaire, p.[ix]-x. Index alphabétique des artistes.

M214 Sloane, Joseph C. French painting between the past and the present; artists, critics, and traditions, from 1848 to 1870. Princeton, Princeton Univ. Pr., 1951. 241p. 90 il. on plates. (Princeton monographs in art and archaeology, 27)

Reprinted in hardcover and paperback editions: Princeton, Princeton Univ. Pr., 1973.

An important study of French painting during the Second Empire in the light of the criticism of the time. "The purpose of the following account of certain ideas and events connected with the history of French painting in the middle years of the last century is to examine a crucial historical moment when the art of France, as well as that of Europe generally, was passing from the well-charted waters of tradition into the hitherto untraveled channels of modern expression; it was, in truth, a period lying between the past and the present."—*Introd.*, p.3.

The Appendix, p.217-26, is a list of critics and writers, giving biographical data and significant writings, mentioned in the text. Bibliography, p.227-35.

M215 Thuillier, Jacques, and Châtelet, Albert. French painting, from Le Nain to Fragonard. [Trans. from the French by James Emmons. Geneva] Skira [1964]. 275p. mounted col. il. (Painting, color, history)

The first three chapters are by J. Thuillier, the last three by A. Châtelet.

This historical survey of French painting from the death of Richelieu in 1642 to the Revolution is the best introduction for the student and the general reader. Arranged by topic within each chapter; concentrates on a few significant works. Beautiful color plates in text. Excellent selective bibliography; general index.

Contents: The painters of reality; The founders of the Academy; The painters of Louis XIV; From the grand monarch to Louis XV; The age of the Pompadour; Under the eye of Diderot.

SEE ALSO: Paris. Salon. *Catalogues of the Paris Salon 1673-1881* (H146); Smith, J. *A catalogue raisonné of the works of the most eminent Dutch, Flemish and French painters* (M428).

## Germany and Austria

M216 Andrews, Keith. The Nazarenes; a brotherhood of German painters in Rome. Oxford, Clarendon, 1964. xvii, 148p. 81 plates (10 col.)

An introductory study of the Nazarene painters who worked in Rome at the beginning of the 19th century. Noteworthy for presenting material in English previously available only in German. "An attempt has been made to indicate the religious and literary sources from which the artists' ideas sprang, and to see them within the European tradition, showing the influence they underwent and the influence they had, in their turn, on some of their contemporaries in Italy, France, and especially in Britain."—*Foreword*.

Contents: (I) Background and beginnings; (II) The revival of medieval art; (III) The brotherhood of St. Luke; (IV) Rome; (V) Germany; (VI) The aftermath; (VII) The influence of the Nazarenes; (VIII) Conclusion. Short biographical notes on the chief artists, p.[134]-37. Classified bibliography, p.[138]-41. Index of collections and general index.

M217 Becker, Wolfgang. Paris und die deutsche Malerei 1750-1840. München, Prestel [1971]. 507p. 241 plates. (Studien zur Kunst des neunzehnten Jahrhunderts, Bd. 10)

A major contribution to research in neglected aspects of 18th- and 19th-century European painting. Supported by a mass of facts gleaned from innumerable sources, the author demonstrates the profound influence of artistic activity in Paris in the period 1750-1840 on German painters who went there to study and to work. The documentation is based on lists of students of the Paris Academy, the annual reports of the École des Beaux-Arts, exhibition records, and other data on student-painters.

Contents of text (115p.): Einleitung; Zum Genrebild des 18. Jahrhunderts; Zur Landschaftsmalerei des 18. Jahrhunderts; Zur Bildnismalerei des 18. Jahrhunderts; Zur Malerei antiker Geschichte und Mythologie im 18. Jahrhundert; Das Musée Napoléon; Zum Bildnis der David-Schule; Zur Geschichts-und Schlachtenmalerei des 19. Jahrhunderts; Zur Landschaftsmalerei des 19. Jahrhunderts; Zur Genremalerei des 19. Jahrhunderts; Schluss. Anmerkungen zum Text, p.[116]-72, include 903 footnotes with specialized bibliographical references.

The plate section contains 241 well-reproduced and intelligently juxtaposed illustrations.

Contents of *Dokumentation,* Liste 1: Deutsche Maler in Paris 1736-1839, p.[335]-72, includes 324 painters with data on their working periods in Paris; Schüler- und Besucherdichte; Das Verhältnis von Paris- zu Romanfenthalt; Anmerkungen zu Liste 1, includes 1,779 footnotes. Liste 2: Werke deutscher Maler in Paris, p.[441]-55; Ehrungen deutscher Maler in Paris; Anmerkungen zu Liste 2, includes 744 footnotes.

Anhang: Literaturbericht und Literaturauswahl, p.[474]-84, is a classified bibliography of general works; Abbildungsverzeichnis, p.[485]-99.

M218 Benesch, Otto. German painting, from Dürer to Holbein. [Trans. from the German by H. S. B. Harrison. Geneva] Skira. (Distr. in the U.S. by World Pub. Co., Cleveland) [1966]. 197p. col. il. (Painting, color, history)

Based on a lecture course given at the Univ. of Vienna in 1959 and 1960; the author's final completed work before his death in 1964.

A scholarly study of German painting from the late 15th century through the first quarter of the 16th century. Contents: (1) Chiliasm 1490-1500; (2) The search for the new form and the microcosm; (3) The age of the great altarpieces; (4) The spell of nature; (5) Doctrine; (6) The formation of the character portrait; (7) Cosmic perspectives.

Bibliography, by Eva Benesch, p.182-[88]: Source works; Early literature; General works; History of art; Individual studies and articles; Museum and exhibition catalogues.

M219 Bloch, Peter, and Schnitzler, Hermann. Die ottonischer Kölner Malerschule. Bearb. von Peter Bloch und Hermann Schnitzler. Düsseldorf, Schwann [1967-69]. 2v. il. (part col.), plates.

A scholarly study and catalogue of the manuscripts produced at the scriptorium of Cologne, one of the leading centers of Ottonian manuscript illumination in the late 10th and early 11th centuries.

v.1 is a *Katalog* of 20 manuscripts grouped in 5 classes: (A) Die malerische Gruppe; (B) Die malerische Sondergruppe; (C) Die reiche Gruppe; (D) Die strenge Gruppe; (E) Ein Nachzügler. Includes summary discussions, detailed descriptions, histories, dates, and bibliographies for all entries; also includes 26 color plates in the catalogue proper and 504 plates of black-and-white illustrations at the end.

Contents of v.2, *Textband:* (I) Die Malerschule und ihre Voraussetzungen; (II) Die Anordnung der Bilder, Zierseiten und Initialen; (III) Die ornamentale Ausstattung der Hand-

schriften; (IV) Die Bilder; (V) Zusammenfassung. Contains 673 black-and-white illustrations. Abbildungsverzeichnis, p.161-82. Verzeichnis der Handschriften nach ihre Bibliotheksorten, p.183-89. Personenregister, p.191-92.

M220 Cames, Gérard. Byzance et la peinture romane de Germanie, rapports de l'art grec posticonoclaste à l'enluminure et à la fresque ottoniennes et romanes de Germanie dans les thèmes de majesté et les Évangiles. Paris, Picard, 1966. xvi, 361p. 331 il., plates.

A detailed, scholarly study of Byzantine sources for Ottonian and Romanesque illumination in Germany. The emphasis is on the influences of iconographical sources.

Contents: (A) Étude iconographique; (B) Étude du style; (C) Étude du coloris; (D) Recueils des modèles et traités de peinture: leur rôle dans le rayonnement de l'art byzantin posticonoclaste en Germanie, fin du Xe-Ire moitié du XIIIe siècle.

Bibliography, p.301-11, includes books and articles. Index général; Index des manuscrits; Table des revues; Tables des tableaux synoptiques. Includes extensive documentation and bibliographical references in footnotes.

M221 Deusch, Werner Richard. Deutsche Malerei des dreizehnten und vierzehnten Jahrhunderts, die Frühzeit der Tafelmalerei. Berlin, Genius [1940]. 29p. 96 plates.

A pictorial survey of German painting of the 13th and 14th centuries, with a useful bibliography and brief text.

"Katalog der Kunstwerke und Abbildungen," p.21-29, gives sizes and approx. dates of works reproduced. Bibliography, p.18-20.

M222 _____. Deutsche Malerei des fünfzehnten Jahrhunderts, die Malerei der Spätgotik. Berlin, Wolff [1936]. 31p. 104 plates.

A pictorial anthology with brief text on 15th-century German painting.

"Katalog der Künstler und Abbildungen," p.20-31, gives data on artists and paintings reproduced, including dimensions. "Schrifttum," p.17-19. "Alphabetisches Künstlerverzeichnis," p.31.

M223 _____. Malerei der deutschen Romantiker und ihrer Zeitgenossen. Berlin, Wolff [1937]. 31p. 100 plates (part col.)

A pictorial survey of the German Romantic period (c.1800-40), with brief introductory text and bibliography.

"Katalog der Künstler und Abbildungen," p.20-31. "Schrifttum," p.15-19.

M224 Finke, Ulrich. German painting from Romanticisim to Expressionism. London, Thames & Hudson; Boulder, Colo., Westview [1975]. 256p. 162 il. (12 col.)

A well-illustrated history of 19th and early 20th century painting in Germany. Valuable for presenting material in English previously available only in German. Includes bibliography.

M225 Fischer, Otto. Geschichte der deutschen Malerei. 3. Aufl. München, Bruckmann [1956]. 494p. il. (part col.) (Deutsche Kunstgeschichte. Bd. 3)
A standard survey of German painting from the early Middle Ages through the 19th century. No bibliography.

M226 Gmelin, Hans Georg. Spätgotische Tafelmalerei in Niedersachsen und Bremen. [München, Berlin] Deutscher Kunstverlag, 1974. 699p. il., 5 col. plates. (Veröffentlichungen der Niedersächsischen Landesgalerie Hannover)
A detailed, critical study and catalogue of the late Gothic panel paintings (c.1450-1530) from the German Bundesländer Niedersachsen and Bremen. The catalogue of 217 entries includes biographical data on painters, technical descriptions, reconstructions of dismembered altarpieces (with reproductions of all known parts), a critical discussion, and extensive bibliographical references. Extremely well illustrated.

Contents: Einleitung; Kunstzentren und Landschaften; Katalog; Spätgotische Wandmalerei auf Leinwand und Holz. Verzeichnisse: Ortsverzeichnis; Ikonographisches Verzeichnis; Künstlerverzeichnis; Abkürzungen.

M227 Goldschmidt, Adolf. German illumination. Firenze, Pantheon [1928]. 2v. 200 plates. (Repr.: N.Y., Hacker, 1970.)
Trans. of Die deutsche Buchmalerei, Firenze, Pantheon, 1928.

On older, standard survey of German illumination; valuable for both its brief text and excellent illustrations. Contents: v.1, Carolingian period; v.2, Ottonian period. Bibliographies: v.1, p.xv-xvii; v.2, p.xv-xvii.

M228 Grimschitz, Bruno. Austrian painting from Biedermeier to modern times. [Trans. from the German text by Friedrich Jasper.] Wien, Wolfrum, 1963. 43p. 124 plates (82 col.)
The 2d volume of the trilogy, Austrian painting from the Vienna Congress to the present day (see also M229).

Primarily a visual survey of Viennese painting from the mid-19th century to the time of Kokoschka. Introductory essay, p.9-43.

The "Illustrations" section includes 124 reproductions with commentary, biographical data, and description of each on facing pages. Index of names.

M229 _____. The old Vienna school of painting. [Trans. from the author's German text.] Wien, Wolfrum [1961]. 38p., 124 plates (part col.)
The 1st volume of the trilogy, Austrian painting from the Vienna Congress to the present day (see also M228).

Primarily a visual survey of Viennese painting in "the decades of its flowering, from the Vienna Congress to the revolutionary years of 1848." — p.7. Introductory essay, p.7-38.

The "Illustrations" section includes 124 reproductions with commentary, biographical data, and description of each on facing pages. Index of persons.

M230 Hamann, Richard. Die deutsche Malerei vom Rokoko bis zum Expressionismus. Leipzig und Berlin, Teubner [1925]. 472p. 362 il., 10 col. plates.
An old general history of German painting from the 18th century to the Expressionist movement of the 20th.

M231 Heise, Carl Georg. Norddeutsche Malerei; Studien zu ihrer Entwicklungsgeschichte im 15. Jahrhundert von Köln bis Hamburg. Leipzig, Wolff, 1918. 192p. 100 plates.
A collection of studies of north German painting in the 15th century. Contents: Köln, Westfalen, Niedersachsen, Hamburg. Indexes of artists and works of art. List of plates, p.183-92.

M232 Hofmann, Werner. Modern painting in Austria. [Trans. from the German text.] Wien, Wolfrum [1965]. 208p., 100 col. plates.
The 3d volume of the trilogy, Austrian painting from the Vienna Congress to the present day (see also M228, M229).

A survey of 20th-century painting in Vienna; text and illustrations are integrated. Captions for illustrations and biographical data of painters are given in right-hand columns of text pages opposite illustrations. Index of persons.

M233 Landolt, Hanspeter. German painting: the late Middle Ages, 1350-1500. Trans. by Heinz Norden. [Geneva] Skira. [Distr. in the U.S. by World Pub. Co., 1968]. 167p. col. il. (Painting, color, history)
A broad survey of German painting in the period 1350-1500. "The goal was not to give a little bit of everything but to present only what is crucial and significant, and that from as many aspects as possible."—Author's pref. Beautifully illustrated, including details. The Appendix, p.149-53, reproduces entire works shown only in color details in the text.

Contents: (1) Background and frame of reference; (2) The royal court of Bohemia and its impact on art; (3) The "soft style"; (4) The great realists; (5) Divergent trends about mid-century; (6) The incursion of the Netherlandish influence; (7) The Netherlandish influence grows homespun; (8) Sunset and dawn.

Classified bibliography, by Elisabeth Landolt, p.155-[60]: General works; Regional schools and centers; Monographs.

M234 Schäfer, Georg. Der frühe Realismus in Deutschland, 1800-1850; Gemälde und Zeichnungen aus der Sammlung Georg Schäfer, Schweinfurt. Ausstellung im Germanischen Nationalmuseum Nürnberg, 23. Juni-1. Oktober 1967. [Redaktion und Gestaltung: Konrad Kaiser. Schweinfurt, Sammlung G. Schäfer, 1967]. 463p., incl. plates (part col.)
The book-catalogue of an exhibition of a private collection of paintings and drawings by German artists whose works were exhibited primarily in the first half of the 19th century. Provides an excellent introduction to and survey of the period. Includes essays by various authorities on artists and artistic activities in Munich, Vienna, Dresden, Hamburg, Southwest Germany, and Berlin.

The detailed catalogue includes 288 works by 126 artists, each of which is reproduced. An appendix contains a selection of contemporary writings by artists and critics on the art of the time. Bibliography, p.159-60.

M235 Scheidig, Walter. Die Geschichte der Weimarer Malerschule 1860-1900. Weimar, Böhlaus, 1971. 152p. 188 il. (8 col.)

A well-documented study of the important art school at Weimar, founded in 1860 and associated with such painters as Lenbach, Böcklin, Liebermann, Buchholz, and Rohlfs. Provides a survey of the artistic background before the school's establishment (1774-1860) and a chronological history of the school and its major artists to 1900.

The notes, p.[107]-23, give bibliographical references. "Verzeichnis der Abbildungen" lists artists alphabetically with their works reproduced (including title, date, technique, dimensions, location). "In Weimar ausgestellte Werke" lists artists alphabetically and works chronologically. "Namen-verzeichnis" at the end.

M236 Schmied, Wieland. Malerei nach 1945 in Deutschland, Österreich und der Schweiz. Mit Beiträgen von Peter F. Althaus, Eberhard Roters und Anneliese Schröder. [Frankfurt-am-Main, Berlin, Wien] Propyläen [1974]. 336p. [64] leaves of plates; 434 il. (part col.)

Introductory essays on painting after 1945 in W. Germany, E. Germany, Austria, and Switzerland are followed by a plates section of 434 illustrations. The main portion of the book is given to the "Bio-Bibliographie," p.83-311, which includes biographical information on approx. 300 artists, with prizes, one-man shows, bibliographical references, a critical statement (often by the artist), a portrait and signature reproduction, and a work illustrated for each artist. Includes artists who worked for long periods outside their native countries (Albers, Ernst, Le Corbusier, Lindner, Hofmann, etc.).

Verzeichnis der Abbildungen auf den Bildtafeln und in der Bio-Bibliographie, p.315-27; Verzeichnis wichtiger Ausstellungen, p.329; Bibliographische Hinweise, p.330; Personenregister, p.333-36.

M237 Selz, Peter. German Expressionist painting. Berkeley, Univ. of California Pr. [1957]. xx, 379p. 37 il., 180 plates (part col.)

Paperback ed.: Berkeley, Univ. of California Pr.

The basic, scholarly history of German Expressionist painting from its roots to the beginning of World War I. The major German painters and the associations which they formed are considered in detail, along with painters who were not properly German (Kandinsky, Jawlensky, Schiele, Klee, and Feininger) but whose work formed an essential ingredient in the growth of Expressionism. The important role of Expressionist printmaking is presented within the total development of the movement. Excellent illustrations.

Contents: pt. 1, Development in German esthetics relevant to the Expressionist movement; pt. 2, Panorama of German art around 1900; pt. 3, Die Brücke; pt. 4, Expressionist trends in Vienna; pt. 5, The development of Expressionism

in Munich; pt. 6, The prewar years. Appendixes: (A) *Chronik der Brücke*, by E. L. Kirchner; (B) Chief periodicals dealing with the German Expressionist movement; (C) List of most important German and foreign participants in the major group exhibitions.

Bibliographical references included in Notes, p.[327]-53. Bibliography, p.[354]-70, classified into books, articles, exhibition catalogues, and unpublished material.

M238 Stange, Alfred. Deutsche Malerei der Gotik. Berlin, Deutscher Kunstverlag, 1934-61. 11v. plates. (Repr.: Nendeln, Leichtenstein, Kraus, 1969 [11v. in 4]).

The definitive work on German painting from c.1250-1500. Comprises a thorough examination of the panel painting, wall painting, and book illumination of the period. Each volume contains an index.

Contents: (1) Die Zeit von 1250 bis 1350; (2) Die Zeit von 1350 bis 1400; (3) Norddeutschland in der Zeit von 1400 bis 1450; (4) Südwestdeutschland in der Zeit von 1400 bis 1450; (5) Köln in der Zeit von 1450 bis 1515; (6) Nordwestdeutschland von 1450 bis 1515; (7) Oberrhein, Bodensee, Schweiz und Mittelrhein in der Zeit von 1450 bis 1500; (8) Schwaben in der Zeit von 1450 bis 1500; (9) Franken, Böhmen und Thüringen-Sachsen in der Zeit von 1400 bis 1500; (10) Salzburg, Bayern und Tirol in der Zeit von 1400 bis 1500; (11) Österreich in der ostdeutsche Siedlungsraum von Danzig bis Siebenbürgen in der Zeit von 1400 bis 1500.

M239 _____. Kritisches Verzeichnis der deutschen Tafelbilder vor Dürer. [München] Bruckmann [1967-70]. 2v. (v.1, 267p.; v.2, 268p.) (Bruckmanns Beiträge zur Kunstwissenschaft)

A critical inventory of German panel paintings before Dürer. Paintings are grouped by regions and schools; within each region the painters and workshops are arranged chronologically. Whenever possible, the works of individual masters are listed chronologically. Works are dated only when the date is certain.

Contents, Bd. 1: Abkürzungen, p.11; Abkürzungen der Literatur durch Verfassernamen, p.12-13; Ausstellungskataloge, p.14; (I) Köln; (II) Niederrhein; (III) Westfalen; (IV) Hamburg; (V) Lübeck und das wendische Quartier; (VI) Niedersachsen. Includes 844 paintings. Bd. 2: Abkürzungen, p.9; Abkürzungen der Literatur durch Verfassernamen, p.10-11; Museumskataloge, p.12-13; Ausstellungskataloge, p.13-15; (I) Oberrhein; (II) Bodensee; (III) Schweiz; (IV) Mittelrhein-Hessen; (V) Ulm; (VI) Augsburg; (VII) Allgäu; (VIII) Nördlingen; (IX) Von der Donau zum Neckar. Includes 1,089 paintings.

Indexes of artists and places in both volumes.

M240 _____. Malerei der Donauschule. 2., überarb. u. erw. Ausg. München, Bruckmann, 1971. 319p. 288 il. (part col.)

1st ed. 1964.

A scholarly study of the painters of the Danube School, including, among others, the Altdorfers, Lucas Cranach the Elder, and Wolf Huber; based on over 40 years of research in the field. The 2d ed. takes into account material presented in the exhibition and its accompanying catalogue, *Die*

*Kunst der Donauschule, 1490-1540* (I301). Very well illustrated.

The main text is followed by a catalogue of works by the painters of the Danube School, and includes commentaries and numerous bibliographical references. Index of names and subjects. Bibliography, p.137.

M241 Swarzenski, Georg. Die Regensburger Buchmalerei des X. und XI. Jahrhunderts; Studien zur Geschichte der deutschen Malerei des frühen Mittelalters. Leipzig, Hiersemann, 1901. 228p. 35 plates, 101 facsims., reduced. (Denkmäler der süddeutschen Malerei des frühen Mittelalters, Teil 1) (Repr.: Stuttgart, Hiersemann, 1969.)

A scholarly study of manuscript illumination of the Regensburg school in the 10th and 11th centuries. Index, p.219-28.

M242 _____. Die Salzburger Malerei von den ersten Anfängen bis zur Blütezeit des romanischen Stils; Studien zur Geschichte der deutschen Malerei und Handschriftenkunde des Mittelalters. Leipzig, Hiersemann, 1908-13. 219p. and atlas of 135 plates. (Denkmäler der süddeutschen Malerei des frühen Mittelalters, Teil 2). (Repr.: Stuttgart, Hiersemann, 1969.)

A scholarly study of manuscript illumination of the Salzburg school. v.2 contains an index of plates.

The "Register," p.207-19 is in four parts: (1) Handschriftliche Denkmäler; (2) Kunstdenkmäler mit Ausschluss der Handschriften; (3) Namen und Persönlichkeiten; (4) Ortsverzeichnis; (5) Sachregister.

M243 Tintelot, Hans. Die barocke Freskomalerei in Deutschland, ihre Entwicklung und europäische Wirkung. München, Bruckmann [1951]. 336p. il., 8 col. plates, maps.

A detailed study of German frescoes of the Baroque period and of their influences on painting throughout Europe. Bibliographical references in "Anmerkungen," p.307-32. "Künstlerverzeichnis," p.333-35.

M244 Vogt, Paul. Geschichte der deutschen Malerei im 20. Jahrhundert. [Köln] DuMont Schauberg [1972]. 528p. 377 il. (62 col.)

Paperback ed. in reduced format issued 1976.

A comprehensive, well-illustrated history of 20th-century German painting from Impressionism to the art of the 1960s. The emphasis is on Expressionist painting, including the integral role of printmaking by the artists linked to the movement.

Contents: (I) Deutsche Malerei um 1900; (II) Der Aufbruch der Jugend; (III) Das Jahrzehnt des Weltkrieges; (IV) Die Malerei der zwanziger Jahre; (V) Die Malerei zwischen 1930 und 1945; (VI) Deutsche Malerei nach 1945. "Verzeichnis der Abbildungen," p.500-6. "Ausgewählte Bibliographie, zusammengestellt von Uta Gerlach-Laxner," p.507-22: (I) Allgemeine Bibliographie zur Malerei des 20. Jahrhunderts; (II) Bibliographie einzelner Stilgruppen und- Strömungen in der Malerei des 20. Jahrhunderts; (III) Bibliographie der

einzelnen Künstler (181 artists). "Namenverzeichnis," p.524-28.

M245 Worringer, Wilhelm. Die Anfänge der Tafelmalerei. Leipzig, Insel, 1924. 349p. 126 il. (Deutsche Meister)

An important early study of 14th and 15th century German painting. List of plates, p.348-50, and table of contents. No index.

SEE ALSO:   Akademie der Künste, Berlin. *Die Kataloge der Berliner Akademie-Ausstellungen 1786-1850* (H150).

## Great Britain and Ireland

M246 Baker, Charles Henry Collins. British painting, with a chapter on primitive painting by Montague R. James. London, The Medici Society [1933]. xxxvi, 319p. 152 plates (12 col.), ports.

An historical survey of British painting from the medieval period to 1900, written by a recognized scholar. "The best short history of the whole field."—E. Waterhouse. (M287).

Appendixes: (1) List of some characteristic works, p.231-69 (arranged alphabetically by artist); (2) List of miniatures in principal collections by N. Hilliard. Isaac and Peter Oliver, the two Hoskins, and Samuel Cooper, p.270-75; (3) List of principal British paintings in American collections, p.276-88.

Bibliography, p.xxxv-xxxvi. Index, p.289-319. List of illustrations, p.ix-xxiii.

M247 Piper, David, ed. The genius of British painting. London, Weidenfeld and Nicolson; N.Y., Morrow, 1975. 352p. il. (part col.)

A series of essays on the subject of British painting from the medieval period to the 1970s. Written by British scholars. Together these studies form an excellent, up-to-date history of painting in Great Britain. 336 illustrations in the text. Bibliography of books and articles classified by period, p.337-41.

Contents: (1) The Middle Ages, by Jonathan Alexander; (2) Tudor and early Stuart painting, by David Piper; (3) Painting under the Stuarts, by Oliver Millar; (4) The 18th century, by Mary Webster; (5) The romantics, by Alan Bird; (6) The Victorians, by Alan Bowness; (7) The 20th century, by Grey Gowrie.

M248 Wilenski, Reginald Howard. English painting. [4. ed., rev.]. London, Faber and Faber [1964]. 320p. 182 plates (6 col.)

1st ed. 1933.

A popular historical survey by a well-known author.

### Early Christian — Gothic

M249 Alexander, J. J. G., *ed.* A survey of manuscripts illuminated in the British Isles. London, Harvey Miller; Boston, New York Graphic Society, 1975- . v.1- .

An historical survey of British illumination from the 6th to the 16th centuries. In progress, to appear in 6v. each written by a specialist.

Contents: v.1, Insular manuscripts from the 6th to the 9th century, by J. J. G. Alexander (1977); v.2, Anglo-Saxon manuscripts 900–1066, by E. Temple (1976); v.3, Romanesque manuscripts 1066–1190, by C. M. Kauffmann (1975); v.4, Early Gothic manuscripts 1190–1285, by Nigel Morgan (1979); v.5, Gothic manuscripts 1285–1385, by Lucy Freeman Sandler (1979); v.6. Later Gothic manuscripts, by Kathleen Scott (in preparation).

Each volume will include a scholarly introduction, a corpus of approx. 350 illustrations, and a catalogue of illuminated manuscripts with full documentation. v.3, the first volume published, has a catalogue of 106 manuscripts, with illustrations for each. Promises to be an invaluable reference work which meets the highest standards of modern scholarship.

M250 Caiger-Smith, A. English medieval mural paintings. Oxford, Clarendon, 1963. 190p. plates (1 col.)
An attempt to include and relate together "not only the styles and types of wall-paintings, but also the interpretations of subjects, the patrons and painters responsible for the works, and the controversies and iconoclasm which put an end to them."—*Introd.*

Contents: Romanesque paintings; The early Gothic period; The late Gothic period; The Last Judgement; The moralities; The lives of Christ and the Virgin; Patrons and painters 1170–1500; The destruction of images; The materials and technique of wall-painting. "A selective catalogue of surviving English wall paintings," p.129–82. Bibliography, p.[183]–84; index, p.185–90.

M251 Dodwell, Charles Reginald. The Canterbury school of illumination, 1066–1200. Cambridge, Univ. Pr., 1954. xv, 139p. il., 73 plates.
A scholarly study of the development of manuscript illumination at Canterbury in the years following the Norman Conquest. Well illustrated.

Contents: Introduction: Before the Conquest; (1) The Norman incursion; (2) The continuity of Anglo-Saxon illumination; (3) The development of Romanesque; (4) The Eadwine Psalter; (5) The great Bibles; (6) Sources of Romanesque decoration; (7) Byzantine influences; (8) The second half of the 12th century. Appendixes: (1) Norman manuscripts in England; (2) The Inhabited Scroll in British Museum Ms. Arundel 60; (3) A short note on the Rochester Books, (4) A hand list of manuscripts illuminated at Canterbury between 1050–1200. Bibliography, p.125–29.

M252 Masai, François. Essai sur les origines de la miniature dite irlandaise. Bruxelles, Éditions "Érasme," 1947. 146p. 64 plates (Publications de Scriptorium, v.1)
A scholarly study of the origins of Irish miniatures. "Tables des planches," p.141–45. Bibliography, p.6–8.

M253 Millar, Eric George. English illuminated manuscripts from the Xth to the XIIIth century. Paris, van Oest, 1926. xii, 145p. 100 plates, tables.

A standard work on English illumination. Contains 37p. of text, description of the plates, p.69–103, and "Hand list of English illuminated manuscripts," p.105–28. Bibliographical references and footnotes. Index, p.129–35. List of plates, p.137–45.

Continued by *English illuminated manuscripts of the XIVth and the XVth centuries* (M254).

M254 ———. English illuminated manuscripts of the XIVth and the XVth centuries. Paris, van Oest, 1928. xi, 106p. 100 plates.
A standard work consisting of a corpus of 100 illustrations and a brief text. "Hand list of English illuminated manuscripts," p.79–94. Contains bibliographical references. Index p.95–98.

M255 Oakeshott, Walter Fraser. The sequence of English medieval art, illustrated chiefly from illuminated manuscripts, 650–1450. London, Faber and Faber [1950]. xi, 55p. il., 56 plates (part col.), map.
This short survey of English medieval art by a foremost scholar is the best introduction to the field. Based primarily on illuminated manuscripts rather than wall painting.

Contents: A short survey of the field, p.1–29; Notes, p.30–31; Appendix I, The Book of Durrow and the Northumbrian style; Appendix II, The representation of the human figure in Northumbrian manuscripts, and in manuscripts produced in the South, 675–825; List of plates in chronological order (with detailed descriptive notes), p.42–51. Indexes of books, persons, and subjects represented, p.53–55.

M256 Rickert, Margaret Josephine. Painting in Britain: the Middle Ages. 2d ed. Harmondsworth; Baltimore, Penguin [1965]. xxix, 275p. 201 plates (part col.), maps. (The Pelican history of art. Z5)
1st ed. 1954.

The standard historical survey of British medieval painting. Scholarly, well-organized, with helpful historical outlines at the beginning of each chapter and summaries at the end. The introduction has a chart showing interrelationships of medieval schools of art.

Contents: (1) Hiberno-Saxon art in the 7th, 8th, and 9th centuries; (2) Anglo-Saxon art from the late 9th to the middle of the 11th century; (3) Pre-Romanesque art (1050–c.1110); (4) Romanesque art of the 12th century; (5) The 13th century; (6) The East Anglican period; (7) The International style (1350–c.1420); (8) The end of the Middle Ages; (9) Evaluation. Glossary (with drawings), p.209; Notes, p.215; Bibliography, p.252–58; General index, p.259; Index of manuscripts, p.271.

M257 Saunders, O. Elfrida. English illumination. Firenze, Pantheon [1928]. 2v. 129 plates (incl. facsims.) (Repr. of 1928 ed.: N.Y., Hacker, 1969.)
"Issued in the U.S. by the David McKay company, Philadelphia." A standard book on English manuscript miniatures.

v.1 contains 120p. of text and plates 1–50. v.2 contains plates 51–129. Bibliography, v.1, p.[121]–24. Index of manuscripts, v.1, p.125–28. General index, v.1, p.129–32.

M258  Tristram, Ernest William. English medieval wall painting. Prepared with the assistance of the Courtauld Institute of Art and published on behalf of The Pilgrim Trust. [London] Milford, Oxford, Univ. Pr., 1944-50. 2v. in 3. plates (part col.)

An important work. Each volume has a scholarly text, a chapter on technique, one on iconography which includes a list of subjects depicted, a detailed catalogue of the paintings with full documentation, and an index to the text chapters.

Contents: v.1, The 12th century, with a catalogue by E. W. Tristram, comp. in collaboration with W. G. Constable; v.2, The 13th century, with a catalogue by E. W. Tristram, comp. in collaboration with Monica Bardswell, [pt. 1] text, [pt. 2] plates. Includes bibliographies.

M259  _____. English wall painting of the 14th century. Ed. by Eileen Tristram, with a catalogue by E. W. Tristram comp. in collaboration with Monica Bardswell, London, Routledge & Paul [1955]. xi, 311p. 64 plates.

A scholarly treatment of English wall paintings of the 14th century, concentrates on churches. The author was involved in restoration of most of the works discussed. Well illustrated in black and white.

Contents: Pt. 1. (I) General considerations and the iconographic scheme; (II) Westminster: the abbey and palace; (III) 14th-century wall-paintings of the more "elaborate" type; (IV) 14th-century wall-paintings of the "simpler" type; (V) The allegories and moralities; Bibliography (chapters I-V); Pt. 2. The catalogue; Abbreviations used in the bibliography of the catalogue; Appendixes: (A) List of subject-paintings of lesser interest, whether extant or recorded; (B) List of places with remains of strictly decorative painting of lesser interest, either extant or recorded; (C) Tabulation of items in accounts for the decoration of St. Stephen's Chapel, Westminster Palace; (D) List of painters working between 1300-1400 in London and elsewhere; (E) List of places which have or once had 14th-century wall-paintings, arranged under countries; (F) Iconographic list; (G) List of drawings by E. W. Tristram and Monica Bardswell in the Victoria and Albert Museum: from wall-paintings of the 14th century; Index (for chapters I-V).

## Renaissance — Modern

M260  Auerbach, Erna. Tudor artists; a study of painters in the Royal service and of portraiture on illuminated documents from the accession of Henry VIII to the death of Elizabeth I. [London] Univ. of London, Athlone Pr., 1954. xvi, 222p. 53 plates (part col.)

Appendixes: (1) Warrants and other documents, p.140-43; (2a) Biographical notes on serjeant painters, p.144-49; (2b) Biographical notes on other painters, p.150-94; (3) Analytical table of decorations on plea rolls, p.195-203. Bibliography, p.204-11. Index, p.212-22.

M261  Bell, Quentin. Victorian artists. Cambridge, Harvard Univ. Pr., 1967. xiv, 111p. il., plates (123 figs.)

"This book has been made out of eight lectures, delivered at Oxford during the Spring of 1965. . . . What I attempted to do was to offer some general considerations concerning the Victorian period and a partial adumbration of its historical shape."—*Pref.*

An excellent review of painting between c.1837 to c.1910, especially good for the discussion of the Pre-Raphaelites and painting technique. Bibliography, p.96-103.

M262  Caw, *Sir* James Lewis. Scottish painting, past and present, 1620-1908. Edinburgh, Jack. 1908. xiii, 503p. 76 plates (incl. front., ports.) (Repr.: Bath, Kingsmead, 1975.)

A standard work on the subject, with emphasis on the painting of the 19th century. Has been largely superseded by Irwin (M277).

Contents: (I) The past, 1620-1860; (II) The present, 1860-1908. Résumé and conclusion: the subjective, emotional, and technical characteristics of Scottish painting. Index, p.497-503.

M263  Croft-Murray, Edward. Decorative painting in England, 1537-1837. London, Country Life, 1962-70. 2v. il.

A scholarly, well-illustrated work on "painting as the decorative complement to architecture in the adornment of ceilings, walls and woodwork, during a period ranging from the Tudors to the accession of Queen Victoria."—*Introd. Note, v.1.*

Contents: v.1, Early Tudor to Sir James Thornhill; v.2, The 18th and early 19th centuries. Each volume contains a catalogue with biographical information on the artists and a list of their works. Bibliography, v.1, p.277-91; v.2, p.327-45. Each volume contains an index.

M264  Cummings, Frederick J. Romantic art in Britain; paintings and drawings, 1760-1860. Catalogue [by] Frederick J. Cummings [and] Allen Staley. Essays [by] Robert Rosenblum, Frederick Cummings [and] Allen Staley. [Philadelphia, n.p., 1968]. 335p. il., ports.

The catalogue of a major loan exhibition of British paintings and drawings shown at the Detroit Institute of Arts and the Philadelphia Museum of Art in 1968. Preface: British art and the Continent, by Robert Rosenblum; Romanticism in Britain, 1760-1860, by Frederick Cummings; British landscape painting, 1760-1860, by Allen Staley. In the catalogue section the artists are arranged by birth date. For each work gives size, date, stylistic description, provenance, exhibitions, bibliographical references, and a small illustration. Alphabetical list of artists at end.

M265  Day, Harold A. E. East Anglian painters. Eastbourne, Eastbourne Fine Art [1967-69]. 3v. il., plates, ports.

Contains biographical chronologies, brief critical analyses, museum holdings, and exhibition and sales records for East Anglian painters of the 18th and 19th centuries. v.1 is devoted to painters who lived primarily in Suffolk; v.2 and 3 include Norwich School painters.

M266  Fisher, Stanley W. A dictionary of watercolour painters, 1750-1900. London, Foulsham [1972]. 245p. [16]p. il.

The great majority of the 3,000 watercolor painters listed lived and worked in Great Britain between 1750–1900; some worked well into the 20th century. Not limited to British painters but includes many of foreign birth who worked in Britain for some time. For each gives brief biographical information, types of subjects usually painted, number of works exhibited, and the names of galleries in which typical examples may be found. Dictionary is preceded by a short introductory essay on the development of watercolor painting in Britain. Bibliography, p.241–45.

M267 Foskett, Daphne. A dictionary of British miniature painters. N.Y., Praeger [1972]. 2v. 1,069 il. (100 col.)
A comprehensive dictionary of miniature painters who were born in Great Britain or worked there between 1520–1910. Contains over 4,000 artists' names, thereby doubling Long's list (M278). For each artist includes biographical information, artistic merit, characteristics, signatures, and details of certain important works. v.2 consists of the monochrome illustrations. Selected bibliography, v.1, p.592–96.

M268 Fredeman, William Evan. Pre-Raphaelitism; a bibliocritical study. Cambridge, Harvard Univ. Pr., 1965. xix, 327p. il., facsims., ports.
This work includes an introduction which defines Pre-Raphaelitism (both literary and visual), a survey of Pre-Raphaelite scholarship, a partially annotated bibliography of primary and secondary sources (up until early 1964), and a detailed index. Four-part bibliography: Sources of bibliography and provenance; Bibliography of individual figures; Bibliography of the Pre-Raphaelite Movement; Bibliography of the Pre-Raphaelite illustrations.

M269 Gilbey, *Sir* Walter. Animal painters of England from the year 1650; a brief history of their lives and works, illustrated with specimens of their paintings, chiefly from wood engravings by F. Babbage. London, Vinton, 1900–11. 3v. plates (fronts., ports.)
v.1–2 contain chapters on 51 painters (in alphabetical order) with an "Index to paintings and engravings" at the end of each volume. v.3 contains material on 46 additional painters. Accompanying the discussion of each artist is a list of his works.

M270 Grant, Maurice Harold. A chronological history of the old English landscape painters (in oil) from the XVIth century to the XIXth century (describing more than 800 painters.) [New rev. and enl. ed.]. Leigh-on-Sea, Lewis [1957–61]. 8v. il., plates, ports.
1st ed., London, privately published by the author, 1926, in 2v.
The eight volumes include the lives and works of more than 800 English landscapists from 1545–1880. Approx. 900 black-and-white illustrations. Intended as an aid to the collector and connoisseur rather than the art historian. The paintings are described more fully than the lives of the artists. Artists are arranged chronologically. Appendixes list the artists regionally (Scottish, Welsh, Londoners, etc.), amateurs, women, water colorists, and painters who did landscapes. Index of painters at the end of each volume.

M271 _____. A dictionary of British landscape painters from the 16th to the early 20th century. 2d ed. Leigh-on-Sea, Lewis, [1970]. 236p.
1st ed. 1952.
A dictionary of over 4,000 landscape painters who worked in England, whether natives or of foreign birth. Also lists artists who painted landscape backgrounds and details in other types of paintings. Entries give brief descriptions of the landscape subjects preferred by the painter, exhibitions at the Royal Academy, British Institution, and others, and museums and galleries which own paintings or drawings. No illustrations, no bibliography.

M272 Graves, Algernon. The British Institution, 1806–1867; a complete dictionary of contributors and their works from the foundation of the Institution. London, Bell, 1908. 617p. (Repr.: Bath, Kingsmead, 1969 [of the 1875 ed.].)
Records works by all the artists who exhibited at the British Institution during its existence. For each painting gives the year of exhibition, dimensions, and selling price. Includes sculptors who exhibited during this period.

M273 _____. A century of loan exhibitions, 1813–1912. London, Graves, 1913–15. 5v. (Repr.: N.Y., Burt Franklin, 1966?)
Includes the most important public exhibitions of the 100-year period in London and the provinces. Arranged alphabetically by artist, then by gallery or museum. For each painting gives the gallery where exhibited, year, number and title, size, and owner.
Index of portraits, p.2309–2440; Index of owners, p.2443–2608; List of exhibitions analyzed in the century of loan exhibitions with the different years, p.2609–10.

M274 Hardie, Martin. Water-colour painting in Britain. Ed. by Dudley Snelgrove with Jonathan Mayne and Basil Taylor. London, Batsford [1967–68]. 3v. plates (col. front.)
An important reference work on British watercolors from their origins to those painted during the reign of Queen Victoria. The lives and works of hundreds of artists are documented; separate chapters are devoted to major painters and groups of painters of each period. Each volume contains over 200 clear illustrations.
Contents: v.1, The 18th century; v.2, The Romantic period; v.3, The Victorian period. An index of artists mentioned in the text is given at the end of each volume. v.3 contains a full general index, p.339–96, and an extensive bibliography, p.283–323.

M275 Herrmann, Luke. British landscape painting of the 18th century. London, Faber and Faber [1973]. 151p. il. (part col.)
A broad introductory survey of British landscape painting; includes works in oil and watercolor, topography but not marine painting. Well illustrated with numerous monochrome plates, and with some color. A 2d volume on British landscape of the 19th century in preparation.

Contents: (I) The beginnings, and the rise of the classical tradition; (II) The topographical tradition; (III) The discovery of Italy; (IV) The tradition of the Netherlands, and the rise of the picturesque. "References to books on individual artists, articles in periodicals, and museum collections and exhibition catalogues are given in the footnotes."—*p.133.* Select bibliography, p.133–[34]; General index and Topographical index included.

M276 Hilton, Timothy. The Pre-Raphaelites. London, Thames & Hudson, 1970; N.Y., Abrams [1971]. 216p. il. (part col.)

A critical history of the Pre-Raphaelite movement. Illustrations include nearly all the key Pre-Raphaelite paintings. Includes bibliographical references.

M277 Irwin, David, and Irwin, Francina. Scottish painters at home and abroad, 1700–1900. London, Faber and Faber, 1975. 512p. il. (part col.)

An important, up-to-date survey of Scottish painting, the first in 70 years, which makes "a deliberate attempt to re-set Scottish painting in its broader context of British and European art."—*Introd.* Biographical sketches of the painters discussed (some more detailed than others); a complete treatment. The black-and-white plates at the end of the volume, some never before reproduced, are representative examples of those artists discussed; some color plates in the text. Extensive notes, p.411–[52]. Bibliography, p.453–[77], is divided: (1) General works: contemporary; (2) General works: later; (3) Individual artists. The bibliography is most complete and up-to-date; excellent for the contemporary sources of painters.

M278 Long, Basil Somerset. British miniaturists. London, Bles, 1929. xxxiii, 475p. col. front., ports. facsim.

A source book of the miniaturists who worked in Great Britain and Ireland between 1520–1860. For each gives biographical information, works which can be seen in public galleries as well as some in private collections, and references to reproductions. Largely superseded by Foskett (M267).

Contents: Notes on British miniature painting; List of abbreviations; List of illustrations; Lists of artists represented by illustrations; List of provincial towns and miniaturists who worked there; List of British miniaturists. Extensive bibliography.

M279 Mayoux, Jean-Jacques. English painting: from Hogarth to the Pre-Raphaelites. [Trans. from the French by James Emmons]; pref. by Sir Anthony Blunt. N.Y., St. Martins, 1975. 252p., 128 col. il.

Trans. of *La peinture anglaise* (Geneva, Skira, 1972).

A survey of the English school of painting from Hogarth to Turner. One of the great merits of the book is that it sees English art as forming part of that of the whole European community."—*Pref.* Superb plates, all color. Notes, p.259–[60], are bibliographic. Up-to-date bibliography properly divided: Documents and general works; works concerning periods or aspects of English painting; monographs on individual artists.

M280 Pavière, Sydney Herbert. A dictionary of Victorian landscape painters. Leigh-on-Sea, Lewis [1968]. 143p. 94 il., 48 plates.

Artists who died before 1850 and those born after 1870 have not been included in this dictionary. For each artist gives brief biographical information, collections containing examples of the artist's work, exhibitions, locations of illustrations reproduced, and a bibliography.

M281 Redgrave, Richard, and Redgrave, Samuel. A century of British painting. New ed. [by Ruthven Todd]. London, Phaidon, 1947. viii, 612p. il., plates.

1st ed. 1866; 2d ed. 1890.

The 1947 ed., which has been corrected and brought up-to-date, is based on the 2d ed. of 1890.

A chatty account of British painting from William Hogarth (1697–1764) to William Dyce (1806–64). Constitutes a valuable source of information on painters of the 19th century, in particular members of the Royal Academy in the London circle of the author. "Bibliographical index," p.593–612.

M282 Roget, John Lewis. A history of the 'Old Water-Colour' Society, now the Royal Society of Painters in Water Colours, with biographical notices of its older and of all deceased members and associates, preceded by an account of English water-colour art and artists in the eighteenth century. London, Longmans, Green, 1891, 2v. (Repr.: Clapton, Woodbridge, Suffolk, The Antique Collector's Club, 1972.)

A comprehensive history of the Old Water-Colour Society (founded in 1804) from 1805–55. The biographies of the members, the proceedings, and detailed lists of the exhibitions make this a rich resource for scholars and collectors.

M283 Staley, Allen. The Pre-Raphaelite landscape. Oxford, Clarendon, 1973. xxvi, 193, [108]p. il. (some col.) (Oxford studies in the history of art and architecture)

A survey of the Pre-Raphaelite landscape painters and their ideas about nature as reflected in their paintings. Includes a discussion of the relationship between Pre-Raphaelitism and the major French movements of Realism, Impressionism, and Symbolism. Chapters on Ford Madox Brown, John Everett Millais, William Holman Hunt, Thomas Seddon, George Price Boyce, John William Inchbold, John Brett, and William Dyce. Quality of the illustrations is uneven. Includes bibliographical references in the footnotes. Index.

M284 Strong, Roy Colin. The English icon: Elizabethan and Jacobean portraiture. London, Paul Mellon Foundation for British Art, [in association with] Routledge & Paul; N.Y., Pantheon [1969]. xvi, 388p. il. (part mounted col.), facsims., ports.

This critical work by the former Keeper of the National Portrait Gallery, London, is an account of Elizabethan and Jacobean easel painting from c.1540 to c.1620. The emphasis is on the art of the time in relation to its historical, social, ideological, and stylistic background. More than 360 paintings are grouped by artists or ateliers. Bibliography, p.355–58.

M285 Tate Gallery, London. The modern British paintings, drawings, and sculpture, by Mary Chamot, Dennis Farr & Martin Butlin. London, published by the Oldbourne Press by order of the trustees of the Tate Gallery, 1964-65. 2v. plates (some col.)

Two additional catalogues of the Tate Gallery collection are projected; the first for works of British artists born before 1765, the second for those born between 1765 and 1849.

These volumes include over 1,500 works of British artists born in or after 1850. The most reliable source of information on well-known contemporary artists. Brief entry for each artist; for each work includes facts, literature, collections, signatures, exhibitions. 58 illustrations of representative work. Numerical index and index of benefactors at end of v.2.

Contents: v.1, A-L; v.2, M-Z.

M286 Taylor, Basil. Painting in England, 1700-1850: collection of Mr. and Mrs. Paul Mellon [exhibited at the] Virginia Museum of Fine Arts, Richmond, Virginia, 1963. [Catalogue by Basil Taylor. Richmond, 1963]. 2v. il. (part col.), ports.

On spine of both volumes: *English Painting 1700-1850. The Mellon Collection.*

A 2v. catalogue of a major exhibition of a great private collection of English paintings, drawings, and prints from the period 1700-1850. Divided into four parts: landscapes; portraits, "conversation pieces," and scenes of contemporary life; animal and sporting pictures; religious, historical, and mythological works. Brief introductory text in v.1, which contains an alphabetical listing, by category and artist providing attributions, medium, dimensions, provenance, exhibitions, and references. Small reproductions of selected works and a concordance so that this volume can be used with v.2, which provides larger illustrations of selected works; only the title and artist (with date and size only) are given.

M287 Waterhouse, Ellis. Painting in Britain 1530-1790. 3d ed. Harmondsworth; Baltimore, Penguin, 1969. xv, 275p. il., 193 plates. (Pelican history of art, Z1)

1st ed. 1953; 2d ed. 1962.

A condensed, well-written, authoritative survey of British painting from the period of Henry VIII and Holbein to the end of the 18th century. Bibliographical notes. Valuable bibliography with critical comments, p.250-56.

Contents: (1) Painting under the Tudors; (2) Painting under the Stuarts, up to the Revolution of 1688; (3) The age of Kneller and English Baroque; (4) Hogarth and the precursors of the classical age; (5) The classical age.

M288 Williams, Iolo Aneurin. Early English watercolours, and some cognate drawings by artists born not later than 1785. London, Connoisseur, 1952. xxii, 266p. 200 plates. (Repr.: Bath, Kingsmead, 1970.)

An important survey of English watercolors. Erudite and interesting. Begins with a chapter on the 16th and 17th centuries; Ch. XI treats the Old Water-Colour Society; ch. XII is entitled "A note on amateurs." Includes lesser-known artists and figure painters. 200 plates. Bibliographical references in footnotes.

M289 Wood, Christopher. Dictionary of Victorian painters; with guide to auction prices and index to artists' monograms. [Woodbridge] Antique Collectors' Club, 1971. xvi, 435p. il.

A standard reference work. Gives detailed biographical information and a comprehensive bibliography for each Victorian painter listed. 300 illustrations.

Contents: Introduction; Exhibitions and galleries; Letters after artists' names; Bibliographical abbreviations; Books; Price revisions; Dictionary; Illustrations; Monogram index.

SEE ALSO:  Baker, J. *English stained glass* (P433).

## Greece

M290 Lydakis, Stelios. Geschichte der griechischen Malerei des 19. Jahrhunderts. München, Prestel [1972]. 380p. 110 il. on 80 plates. (Materialien zur Kunst des neunzehnten Jahrhunderts. Bd. 7)

A general history of Greek painting in the 19th century. Especially useful for its dictionary of Greek painters and graphic artists of the 16th to the 20th century, which includes bibliographical references.

Contents: Einleitung der Epochen neugriechischer Kunst; Einführung in die Geschichte der neugriechischen Kunst; Die 'Münchner Gruppe'; Die Ausserhalb der 'Münchner Gruppe' stehenden Maler; Die graphischen Künste; Schlusswort. Anmerkungen, p.165-212, include bibliographical references. Lexikon der griechischen Maler und Graphiker (16.-20. Jahrhundert), p.213-71. Literaturverzeichnis, p.357-[71].

## Italy

Italian painting is subdivided as follows: (1) General (2) Early Christian-Gothic (excluding mosaics); (3) Late-Gothic-Renaissance; (4) Baroque-Modern.

The abundant source material is listed in the chapter, Sources and Documents. See the index for a breakdown into regional schools.

M291 Carli, Enzo. La pittura senese. Milano, Electa [1955]. 315p. il. (part col.)

An authoritative historical survey of Sienese painting and painters, from the so-called "primitives" before the 13th century, to Sodoma and Beccafumi in the 16th century. Written by the director of museums in Siena. Index of artists, illustrations, and locations of paintings. "Orientamenti bibliografici," p.309-14, is a valuable critical commentary on the sources and published literature on Sienese art during its greatest period.

M292 Causa, Raffaello. Pittura napoletana dal XV al XIX secolo. Bergamo, Istituto Italiano d'Arti Grafiche [1957]. 102p. 63 col. il.

An excellent survey of Neapolitan painting from the 15th through the 19th century. Illustrated in color. "Bibliografia sommaria (1938-57)," p.100-2.

M293 Colnaghi, *Sir* Dominic Ellis. A dictionary of Florentine painters from the 13th to the 17th centuries. Ed. by P. G. Konody and Selwyn Brinton. London, John Lane [1928]. viii, 286p. front. (port.)

An authoritative dictionary of Florentine painters which provides the English-speaking student with a reliable reference tool. The essays are based largely on Florentine guild records and early sources. Most of the principal works of each artist are listed. Short bibliographies are given at the end of each article.

M294 Crowe, *Sir* Joseph Archer, and Cavalcaselle, Giovanni Battista. A history of painting in Italy: Umbria, Florence, and Siena, from the second to the sixteenth centuries. Ed. by Langton Douglas. [2d ed.] London, Murray, 1903-14. 6v. plates. (Repr. of 1903 ed.: N.Y., AMS Pr., 1972).

This is another edition of *A new history of painting in Italy, from the II to the XVI century*, originally pub. 1864; Italian ed. pub. in Florence in 1875-1908.

The old standard survey of Central Italian painting for the English-speaking reader. Should not be undervalued.

M295 DeWald, Ernest Theodore. Italian painting, 1200-1600. N.Y., Holt [1961]. 613p. il. (Repr.: N.Y., Hacker, 1978.)

An excellent survey of Italian painting from 1200-1600. Written by a recognized scholar as an introduction for the English-speaking student and general reader. Well organized by period, with many subheadings within each chapter; easy to read with clear explanations of background, styles, terms, etc. Small black-and-white illustrations in text. Bibliography at the end of each chapter. Appendix: A general bibliography in English; Glossary; The making of a 14th century painting; General index; Index of works of art by cities.

M296 Edgell, George Harold. A history of Sienese painting. N.Y., MacVeagh, Dial, 1932. xxviii, 1 1., 302p. front. (map), plates, facsims.

A readable history of Sienese painting from Guido da Siena to the early 16th century. Antiquated, but still the most comprehensive introduction for the English-speaking student. Many illustrations, the majority from the Pinacoteca in Siena. Bibliographical footnotes.

M297 Faldi, Italo. Pittori viterbesi di cinque secoli. Rome, Bozzi, 1970. xv, 398p. il.

Sponsored by Cassa di Risparmio della Provincia di Viterbo.

A history of painting and painters from the city of Viterbo from the 14th century to the end of the 18th century, with an introduction on the development of Viterban painting in the 12th and 13th centuries. Handsomely produced, with a corpus of excellent, recent photographs. Bibliography, p.85-88.

M298 Fredericksen, Burton B., and Zeri, Federico. Census of pre-nineteenth-century Italian paintings in North American public collections. Cambridge, Harvard Univ. Pr., 1972. xxii, 678p.

Valuable, comprehensive lists and keys to the locations of pre-19th–century Italian paintings in the U.S. and Canada. "The list gives the artist's name (with variations), his dates, and in parentheses, the century in which he is categorized .... For each of the artist's known paintings, arranged alphabetically according to their present location, is given the institution, the accession number (if used), and the title." —*Introd.* The most convenient source of reproductions (publications of museums, journals, monographs) is listed. Many cross-references. Contents: pt.1, Index of artists; pt.2 Index of subjects (divided into sections of religious and secular subjects, portraits and donors, unidentified subjects, and fragments); pt.3, Index of collections; Appendixes. (A) Paintings not included. (B) The Samuel H. Kress Collection. (C) Register of places. (D) Key to works cited in pt.1.

M299 Marle, Raimond van. The development of the Italian schools of painting. The Hague, Nijhoff, 1923-38. 19v. il., plates. (Repr.: N.Y., Hacker, 1970.)

A monumental work on Italian painting from the 6th through the 15th centuries. Most important for the many illustrations. Still indispensable as a reference tool although the art historical text has been superseded. v.19 has detailed indexes of the entire work.

Contents: v.1, From the 6th until the end of the 13th century; v.2, The Sienese school of the 14th century; v.3, The Florentine school of the 14th century; v.4, The local schools of north Italy of the 14th century; v.5, The local schools of central and southern Italy of the 14th century; v.6, Iconographical index; v.7, Late Gothic painting in north Italy of the 15th century; v.8, Gentile, Pisanello and late Gothic painting in central and southern Italy; v.9, Late Gothic painting in Tuscany; v.10, The Renaissance painters of Florence in the 15th century—1st generation; v.11, The Renaissance painters of Florence in the 15th century—2d generation; v.12-13, The Renaissance painters of Florence in the 15th century—3d generation; v.14, The Renaissance painters of Umbria; v.15, The Renaissance painters of central and southern Italy; v.16, The Renaissance painters of Tuscany; v.17-18, The Renaissance painters of Venice; v.19, General index.

v.6 consists of Iconographical index to v.1-5. v.19, General index, contains an index by place (for larger towns the material is divided into: Churches and monasteries, public collections, public buildings and streets, private collections); also an artist index which includes the names of the artist, his dates, and "where possible an indication of the site of his activity."

M300 New York. Metropolitan Museum of Art. Italian paintings: a catalogue of the collection of the Metropolitan Museum of Art [by] Federico Zeri, with the assistance of Elizabeth E. Gardner. (Distr. by New York Graphic Society, Greenwich, Conn., 1971-[73].)

Published so far: *Florentine school* (234p. 135 plates) 1971; *Venetian school* (114p., 107 plates), 1973. Two other volumes are in preparation, one on the North Italian schools, another on the Sienese, Central, and Southern Italian schools.

These catalogues meet the highest standards of modern scholarship. The documented entries incorporate recent research and new attributions. For each artist gives brief factual information; the entry for each painting gives descriptive data, problems with critical opinions, extensive bibliographical references, exhibitions, and provenance. Each painting is illustrated. At end of each volume: Books and periodicals abbreviated, index of former owners, and index.

M301  Torriti, Piero, et al. La pittura a Genova e in Liguria dagli inizi al primo Novecento. Genova, SAGEP, 1970-71. 2v. il.

Companion volumes of essays (totaling 17) by specialists which together form an authoritative review of Genoese painting from its origins to the early 20th century. v.1: La pittura a Genova e in Liguria degli inizi al Cinquecento (376p., 221 il., 44 col.); v.2, La pittura a Genova e in Liguria dal Seicento al primo Novecento (556p., 320 il., 58 col.). Includes biographies and bibliographies.

M302  Zampetti, Pietro. A dictionary of Venetian painters. Leigh-on-Sea [Eng.] Lewis [1969-71]. 4v. plates.

Prepared by a foremost scholar of Venetian art. For each painter gives biographical information, principal works, and essential bibliography. Well illustrated. Short introductory essay to each volume. At beginning of v.1-2: List of artists in chronological order. At end of each volume: Illustrations (arranged chronologically—showing the development of style in Venetian painting).

Contents: v.1, 14th and 15th centuries; v.2, 16th century; v.3, 17th century; v.4, 18th century.

SEE ALSO: *Paintings from the Samuel H. Kress Collection. Italian schools* (M9).

### Early Christian — Gothic (excluding mosaics)

M303  Ancona, Paolo d'. La miniatura fiorentina (secoli XI-XVI). Florence, Olschki, 1914. 2v. 110 plates (1 col.

A standard work on Florentine illumination. Contents: v.1, 109p. of text and good plates; v.2, the descriptive catalogue and indexes.

Bibliography, v.2, 3d preliminary leaf. Indexes: Codexes, p.889-900; Works, p.901-9; Subjects (figures and scenes in the miniatures, places, and people), p.911-30; Miniaturists, calligraphers and copyists, p.931-34; Plates, p.935-41.

M304  _____. La miniature italienne du X au XVIe siècle. Traduction de M. P. Poirier. Paris, van Oest, 1925. 128p. 97 plates (part col.)

A standard history of Italian miniature painting, written by an authority. Well illustrated, well documented. Index of manuscripts, p.97-107, arranged by place. Index of miniaturists, p.111-16. List of plates, p.119-28.

M305  Berg, Kent. Studies in Tuscan twelfth-century illumination. Oslo, Bergen, Tromsö Universitetsforlaget [1968]. 220p. 69 plates.

A scholarly study of the development of the schools of Romanesque Tuscan illumination, from the late geometrical period to the 12th century. Poorly illustrated. Catalogue of manuscripts, p.223-[326]. Index, p.327-[43].

M306  Bologna, Ferdinando. Early Italian painting; Romanesque and early medieval art. [Princeton, N.J.] Van Nostrand [1964]. 227p. col. il.

Trans. of *La pittura italiana della origine*.

A review of Italian painting from the Beneventan style (c.762-800) to Pietro Cavallini (c.1250-c.1300). Provides the serious student with a summary of the historiography and present state of research in the field. Important critical bibliography, p.[217]-24. Sumptuously illustrated with 100 color plates.

M307  Carli, Enzo. Pittura medievale pisana. Milano, Martello [1958-61]. 3v. il., plates.

A history of Pisan painting from its origins to the end of the 13th century. Authoritative, written by a recognized scholar and a native of Pisa. Not intended to be the definitive work. Concentrates on the major works of the artists. Good bibliographies at the end of each volume. Well illustrated with 106 plates in v.1 and 224 plates in each of the 2d and 3d volumes.

Contents: (1) Pittura medievale pisana; (2) (in 2v.) v.1, Dal maestro di S. Torpe al Trionfo della Morte; v.2, La seconda metà del secolo.

M308  Garrison, Edward B. Italian Romanesque panel painting; an illustrated index. Florence, Olschki, 1949. 266p. il. (Repr.: N.Y., Hacker, 1976.)

Covers panels from the 11th century to the early 14th century. The main section is entitled "Preliminary notice on panels and crucifixes." Includes a list of photographers (including negative collections), school and painter index, list of dated panels, of falsely attributed panels, place index. For each panel gives: (1) place history; (2) description; (3) inscriptions; (4) measurements; (5) condition; (6) attribution and dating; (7) bibliography; (8) photographic negatives. Panels are grouped according to shape, with a short notice preceding each group. Each panel is given a serial number, and almost all are illustrated. Bibliography, p.247-53.

M309  _____. Studies in the history of medieval Italian painting. Florence, "L'Impronta," 1953-62. 4v. il., plates.

Each issue contains about four long, detailed, scholarly articles written and published by E. B. Garrison. Excellent illustrations. General index, v.IV, p.421-443. Index of manuscripts, p.445-51.

M310  Matthiae, Guglielmo. Pittura romana del medioevo. Roma, Palombi [1965-66]. 2v. plates (part col.)

An historical review of medieval Roman painting and mosaics, written by a recognized scholar. Begins with the paintings in the catacombs and ends with the work of Giotto in Rome.

Contents: v.1, La pittura dal secolo quarto al sesto; La pittura dal secolo sesto all'ottavo; La pittura dal secolo ottavo al decimo; v.2, La pittura dal secolo XI alla metà del XII; La pittura dalla metà del secolo XII alla metà del XIII; La pittura nella seconda metà del secolo XIII. Many illustrations, some in color.

M311  Rotili, Mario. La miniatura gotica in Italia. Napoli, Libreria scientifica editrice, 1968-69. 2v. plates.
A review of Italian illumination of the 13th and 14th centuries. The introduction summarizes past studies and the present state of research. Includes a list of the Gothic manuscripts in Italian libraries. Each volume has indexes of artists, places and works, illustrations, and a table of contents. Bibliographical references in chapter notes; general bibliography, v.2, p.47-54. Adequate illustrations.

M312  Salmi, Mario. Italian miniatures. 2d ed., rev. and enl. [Trans. by Elisabeth Borgese-Mann. Milton S. Fox, ed.]. N.Y., Abrams [1956]. 214p., il. (part mounted col.), (p.[81]-197 col. plates).
Trans. of *La miniatura italiana.* Milano, Electa [1956].
A good introduction to the important schools of Italian manuscript painting, written by a recognized authority. Presents the art historical problems for future research. Splendidly illustrated. Excellent bibliography, p.190-202.

M313  Toesca, Pietro. La pittura e la miniatura nella Lombardia dai più antichi monumenti alla metà del Quattrocento. Torino, Einaudi [1966]. lxi, 278p., facsims., plates. (Biblioteca di storia dell'arte, 6)
1st ed. 1912.
A scholarly, well-illustrated treatment of painting in Lombardy. This new edition incorporates minor corrections, most of which were already noted by the author in an errata list. Introd. by Enrico Castelnuovo, "Scritti di Pietro Toesca," p.[lvii]-lxi. Bibliographical footnotes are those of the 1912 ed.; "Bibliografia aggiuntiva," by Enrico Castelnuovo, p.[239]-67.

SEE ALSO: Demus, O. *The mosaics of Norman Sicily* (M88); Matthiae, G. *Mosaici medioevali delle chiese di Roma* (M91); Oakeshott, W. F. *The mosaics of Rome* (M93).

## Late Gothic — Renaissance

M314  Ancona, Paolo d'. Umanesimo e rinascimento, con 16 tavole in rotocalco e 716 figure. 3. ed. riveduta e aggiornata, con la collaborazione di Maria Luisa Gengaro. Torino, Unione Tipografico-Editrice Torinese, 1948. 726p. il., plates. (Storia dell'arte classica e italiana, v.3)
A survey of Renaissance art and humanism in Italy. Well organized, with many illustrations of rather poor quality. Bibliography, p.653-82. Index of artists, p.683-90; of places and monuments, p.691-726.

M315  Antal, Frederick. Florentine painting and its social background; the bourgeois republic before Cosimo de' Medici's advent to power: XIV and early XV centuries. London, Kegan Paul [1948]. 388p. 160 plates. (Repr.: Boston, Boston Book & Art Shop, 1965.)
Paperback ed.: N.Y., Harper & Row, 1975.
A scholarly history of Florentine painting during a period of social upheaval. Marxist in its argument that the development of style and subject matter was directly influenced by changes in the social and political power of the various classes of society. Includes bibliographies. Index of persons.

M316  Baroni, Costantino, and Ludovici, Sergi Samek. La pittura lombarda del Quattrocento. Messina, D'Anna [1952]. 282p. 103 plates.
A standard history of painting in Lombardy during the 15th century. Contains a wealth of information but does not pretend to be complete. Well documented with many references to sources and published literature. An adequate number of rather poor illustrations.

M317  Baxandall, Michael. Painting and experience in fifteenth century Italy; a primer in the social history of pictorial style. Oxford, Clarendon, 1972. viii, 165p. il., (part col.)
Available in paperback, 1974.
A unique study of the interrelationships between social history and art history in Italy during the 15th century; written for those with "general historical curiosity." Bibliographic references, p.155-61; Index of names, p.163-65.
Contents: (I) Conditions of trade (facts of the picture trade); (II) The period eye (style as determined by social, religious, and commercial experience); (III) Pictures and categories (16 concepts of judgment used by lay critics of the period).

M318  Berenson, Bernhard. The Italian painters of the Renaissance. [London] Phaidon [1952]. 488p. (p.[208-478] il.), 16 col. plates.
Paperback ed.: N.Y., Phaidon, 1968.
A revised and more lavishly illustrated ed. of the title published in 1930 (Oxford, Clarendon). The text was originally published as separate essays in *The Venetian painters of the Renaissance,* 1894; *The Florentine painters of the Renaissance,* 1896; *The Central Italian painters of the Renaissance,* 1897; *The North Italian painters of the Renaissance,* 1907.
Index, p.481-88, includes plate references but is not as detailed as the one in the 1930 ed.

M319  _____. Italian pictures of the Renaissance, a list of the principal artists and their works with an index of places. Oxford, Clarendon, 1932. 723p.
An Italian ed. trans. by E. Cecchi was pub. in 1936. Arranged alphabetically by artist. This list is not only a combination of the lists in the 4v. of *Renaissance painters* but it includes many more artists and many more pictures than the earlier editions.
The original editions were: *Venetian painters* (1894, 1895, 1897); *Florentine painters* (1896, 1900, 1909); *Central Italian*

*painters* (1897, 1909); *North Italian painters* (1907). These were pub. in French in 1926 and in German in 1923.

The essays from these 4v. were likewise published in 1v. by Clarendon (Oxford, 1932) and subsequently in an illustrated ed. by Phaidon in 1952 and 1968.

For each artist gives: dates and teachers; a list of his paintings arranged alphabetically under the name of the city where they are located; dates of the pictures when known. Index of places, p.609-723.

M320 _____. _____. Central Italian and North Italian schools. [London] Phaidon [1968]. 3v. il. (some col.)
Paperback ed.: London, N.Y., Phaidon, 1968.
Revision by Luisa Vertova.

A new rev. ed. of Berenson's famous list (v.1), with a valuable corpus of illustrations (v.2-3). Incorporates recent scholarship, corrects errors. Topographical index.

M321 _____. _____. Florentine school. [London] Phaidon [1963]. 2v. 1,482 il.
A new rev. and illustrated ed. of Berenson's list of Florentine painters from Cimabue to the Mannerists. Incorporates recent attributions and scholarship. A posthumous ed.; however, the revisions had been completed by Berenson with the aid of Nicky Mariano.

Bibliographical references augmented by recent literature. Topographical index, v.2, p.3-39.

M322 _____. _____. Venetian school. London, Phaidon [1957]. 2v. 1,336 il. (part col.)
A new and extensively revised ed. of the author's famous list of Venetian painters (M319). This ed. corrects errors and incorporates the latest attributions and scholarship; profusely illustrated with many new photographs. Bibliographical references. Topographical index, v.2, p.1-44.

M323 Bologna, Ferdinando. I pittori alla corte angioina di Napoli, 1266-1414, e un riesame dell'arte nell'età fridericiana. Roma, Bozzi, 1969. xiv, 398p., incl. 33 mounted plates. 199 plates. (Saggi e studi di storia dell'arte, 2)
A detailed treatment of painting in the Angevine court of Naples, with a summary of southern Italian art during the previous period of Frederick II. The introduction reviews the history of research; scholarly notes with many bibliographical references at the end of each chapter. "Saggio di bibliografia," p.359-72, arranged by date from 1333-34 to 1969. Detailed index. 561 black-and-white illustrations, 34 color plates.

M324 Borsook, Eve. The mural painters of Tuscany, from Cimabue to Andrea del Sarto. With 120 illustrations. London, Phaidon [1960]. 167p. (p.37-124 il.). 1 col. plate.
An excellent visual survey of mural painting in Tuscany from c.1300 to 1500, with a concise introduction on history, design, and technique. The emphasis is on the design of the murals in relation to the architecture of the room. Useful for both the specialist and nonspecialist.

The photographs (more than half new) are followed by a catalogue of the 32 works illustrated. For each gives the history, scheme, technique, present condition, and bibliography. General bibliography, p.126; Glossary, p.167; Appendix of plates. Index of artists, p.179.

M325 Briganti, Giuliano. Italian Mannerism. [Trans. from the Italian by Margaret Kunzle. Princeton, N.J.] Van Nostrand [1962]. 166p. 100 col. il.
Trans. of *La maniera italiana.*
A stimulating, well-written introduction to the history of Mannerist painting in Italy, by a prominent specialist in the field. Good bibliography classified by sources; concept; Mannerists in general; the 1st, 2d, and 3d Mannerist periods; and exhibitions. Illustrated with 100 color plates, including details.

M326 Canova, G. Mariani. La miniatura veneta del Rinascimento 1450-1500. Venezia, Alfieri, [1969]. 315p., incl. 112 plates. (Profili e saggi di arte veneta, 7)
An exemplary catalogue of 143 illuminated manuscripts from Venice made during the last half of the 15th century. Valuable documentation. Includes notices of the artists with lists of their works, authentic and attributed. Splendid color plates. Bibliography, p.[169]-74.

M327 Carli, Enzo. Sienese painting. Greenwich, Conn., New York Graphic Society [1956]. 77p. il., plates (part col.) (The Great masters of the past, 7)
Trans. of *Les primitifs siennois.*
A good introduction to Sienese painting for the English reader. "Its purpose is to furnish a summary view of the whole development by singling out the most characteristic masters of the glorious epoch that ran from the middle of the 13th century to the dawn of the 16th century."—*Foreword.* The brief scholarly text is followed by many excellent color plates. Arranged by artist. No bibliography.

M328 Castelfranchi, Vegas Liana. International Gothic in Italy. [Trans. from the Italian by B. D. Phillips and rev. by Talbot Rice.] [Leipzig] Edition Leipzig, 1966. 171p. (p.[61-160] col. plates).
(Also distr. by Thames & Hudson, London, 1968.)
Trans. of *Il gotico internazionale in Italia.*
A good summary of the International Style in Italy, beginning with its background (c.1330) and ending with the final phase in the mid-15th century. Clarifies the relationship to the French school. Also provides an historical review of the interpretations of scholars and a critical bibliographic essay. Illustrated with 100 splendid color plates.

M329 Cavalcaselle, Giovanni Battista. La pittura friulana del Rinascimento. A cura di Giuseppe Bergamini. Presentazione di Decio Gioseffi. 201 illustrazioni in nero e 4 tavole a colori. Vicenza, Pozza, 1973. xxiii, 339p. 91 plates. (Saggi e studi di storia dell'arte, 15) (Pubblicazioni della Deputazione di Storia Patria per il Friuli, 5)
The first publication of a manuscript written by a pioneer art historian in 1876. Intended as an inventory of paintings

by artists from the earliest period to the end of the 16th century in the region of Friuli-Venèzia Giulia. Consists of the lives of the artists and the inventory. Introduction, additional notes incorporating recent research, new attributions, as well as additional bibliography by G. Bergamini. An appendix of lost works by G. V. Valentinis. Bibliography (up-to-date); indexes of places, artists and writers; illustrations, many recent.

M330   Crowe, *Sir* Joseph Archer, and Cavalcaselle, Giovanni Battista. A history of painting in north Italy, Venice, Padua, Vicenza, Verona, Ferrara, Milan, Friuli, Brescia, from the fourteenth to the sixteenth century. London, Murray, 1871. 2v. plates.
2d ed., N.Y., Scribner; London, Murray, 1912, 3v., ed. by Tancred Borenius. Repr. of 1912 ed.: N.Y., AMS Pr., 1972. The 1871 ed. has one index at end of v.2; the 1912 ed. has indexes of artists and places at end of v.3. The 1871 ed. is illustrated with line drawings; the 1912 ed. is illustrated with Alinari photographs.

An important pioneer work on North Italian painting, the collaboration of an English historian and an Italian connoisseur. Contains material still useful to art historians.

M331   Freedberg, Sydney Joseph. Painting in Italy, 1500–1600. Harmondsworth; Baltimore, Penguin, 1971. xix, 554 p. 300il., col. plate. (Pelican history of art, Z35)
Revised paperback ed. 1975.

An excellent survey of 16th-century Italian painting, recommended for all students of Italian art. Concentrates on the major artists and presents a clear picture of their stylistic development. An adequate number of illustrations, some mediocre in quality.

Bibliographical references in end notes, p.467–514; classified bibliography, p.515–27.

M332   _____. Paintings of the High Renaissance in Rome and Florence. Cambridge, Harvard Univ. Pr., 1961. 2v. 644p. 700 il. in v.2.
Paperback ed., Harper, 1972.

Essentially concerned with the history of classical painting of Rome and Florence of the early 16th century. Detailed stylistic analyses. Most difficult to read, yet rewarding for the advanced student. Richly illustrated.

Contents: (1) Introduction: the genesis of High Renaissance classical style; (2) The formation of the classical vocabulary; (3) The maturity of the classical style in Rome; (4) The maturation of classical style in Florence; (5) Climax, crisis, and dissolution of the classical style in Rome; (6) Climax and crisis in Florence and the generation of Florentine Mannerism; (7) Epilogue, the ascendancy of Mannerism.

M333   Fremantle, Richard. Florentine Gothic painters from Giotto to Masaccio; a guide to painting in and near Florence 1300–1450. London, Secker & Warburg, 1975. xxv, 665p. 1,335 il., maps.
This monumental work by a recognized scholar promises to become indispensable for both ready reference and advanced research on Florentine painters and painting of

the Gothic period. Extensive bibliographies (in text) incorporating the most recent scholarship are given for each painter.

Contents: Painters (listed chronologically); Painters (listed alphabetically); Appendixes: (A) A visual reference list of painters: (1) who worked in or near Florence just *before* and just *after* the period covered in this compilation; (2) who worked *during* the period covered in or near Florence, but either about whom almost nothing is known, or for whom reproductions are easily available, p.567–[606]; at the end of Appendix A is a list of extant dated paintings, arranged chronologically, by unknown hands. For most of these painters a single work or part of a work is reproduced, p.[607–14]; (B) Glossary, p.617–[19]; list of saints appearing in this work and their usual symbols, p.619–[23]; (C) Page references to Offner's *Corpus* and Berenson's *Florentine Lists*, p.625–[26]; (D) (I) A chronological list of known dated works. 1300–1450, p.629–[31]; (II) Three lists by artists of: (1) Signed works, p.631–[32]; (2) dated works, p.632–[34]; (3) signed and dated works, p.635; (III) A list, by year, 1300–1450, including: (1) dated works; signed and dated works; (2) documented works; (3) some works dated by Berenson, Marcucci, and Offner, p.636–[42]; (E) Maps of the area around Florence, in the provinces of Florence, Pistoia, Arezzo, Siena, and Pisa, p.645–[59]. List of photographers, p.661. Topographical list of locations of paintings reproduced, p.663–[65].

M334   Longhi, Roberto. Officina ferrarese 1934, seguita dagli Ampliamenti 1940 e dai Nuovi ampliamenti 1940-55. Firenze, Sansoni, 1956. 270p. plates (16 col.) (His *Opere complete*, v.5)
Still the basic critical work for Renaissance painting of the Ferrarese school. Includes bibliographical references.

M335   Matalon, Stella. Affreschi lombardi del Trecento. Introd. di G. A. dell'Acqua; testo di S. Matalon. Milano, Silvana [1964]. xxiv, 501p. (p.[1]–[350], [413]–[54] plates (part col.)).
A survey of 14th-century frescoes in Lombardy, comprehensive in scope, lavishly produced, with a large corpus of superb illustrations. Includes bibliographies, p.481–87.

M336   Mazzini, Franco. Affreschi lombardi del Quattrocento. Introd. di G. A. dell'Acqua, testo di F. Mazzini. [Milano, Cassa di Risparmio] 1965. 684p. il.
At head of title: Cassa di Risparmio delle Province Lombarde.
A companion volume to *Affreschi lombardi del Trecento* (M335).

M337   Meiss, Millard. Painting in Florence and Siena after the Black Death. Princeton, N.J., Princeton Univ. Pr., 1951. xiv, 194p. 169 il.
Paperback ed. (N.Y., Harper, 1964) is entitled *Painting in Florence and Siena after the Black Death; the arts, religion, and society in the mid-fourteenth century*. The "Index supplement," p.195, lists new ownership of various paintings.

A classic work by a great art historian. In this scholarly treatment of Florentine and Sienese painting from about 1350–70, marked changes in style and subject matter are

related to the social, economic, and political crises after the Black Death. Contents: The new form and content; The two cities at mid-century; Guilt, penance, and religious rapture; The Spanish Chapel; Texts and images; The Madonna of Humility; Boccaccio. Appendixes: Chronological table; Facts about painters; Some recent criticism of Orcagna; A new polyptych by Andrea da Firenze. Extensive bibliographical footnotes. Well illustrated.

M338 Murray, Peter. An index of attributions made in Tuscan sources before Vasari. Florence, Olschki, 1959. 163p. (Pocket library of "Studies" in art, v.12)
Of singular importance for any research in Tuscan art before Vasari. Dictionary arrangement lists artists and works attributed to them with explanatory notes. "This *Index* has two purposes: first, to provide a convenient corpus of the works attributed to any one of the Early Renaissance masters up to the moment of the appearance of Vasari's *Vite* in 1550, so that the importance of tradition may be estimated, and, second, to give a clearer idea of the filiation of the sources among themselves. This latter function may reveal interesting relationships and lines of descent which it is difficult to see in any other way. It may also provide a useful check on the known expansionist tendency of Vasari, especially in his second edition."—*Introd.*

M339 Oertel, Robert. Early Italian painting to 1400; [trans. from the German by Lily Cooper]. London, Thames & Hudson [1968]. 376p. il. (some col.)
Trans. of *Die Frühzeit der italienischen Malerei.*
A survey of significant works of Italian painting from the early medieval period to the end of the 14th century. "Its theme in broad terms is the prelude to Giotto, the extent of his historical significance . . . and his wide stylistic influence."—*Foreword.* Especially valuable as a summary of historiography, problems, and recent research. Extensive bibliography in notes. Well illustrated.

M340 Offner, Richard. Studies in Florentine painting, the fourteenth century. N.Y., Sherman, 1927. 8 p.l., 143p. 1 l. front., plates. (Repr.: N.Y., Schram, 1972.)
An important collection of critical essays on Florentine painters and painting of the 14th century, written by a famous scholar. Required reading for the student specializing in Italian Renaissance art. "An outline of a theory of method," p.127-36, adumbrates the author's critical method of research in art history. Index of artists and authors and periodicals, index of places.

M341 Offner, Richard, and Steinweg, Klara. A critical and historical corpus of Florentine painting. N.Y., Institute of Fine Arts, New York Univ., (Distr. by J. J. Augustin, N.Y., Locust Valley, [1930]- .)
Section III. The 14th century. v.1-8 in 9, 1930-58. Section IV. The 14th century. v.1-[6], 1960-[78].
A monumental work by a great art historian; fundamental for research in early Florentine painting.
Originally projected as a repertory of all Florentine painting from its origins to the late 15th century. Only sections on the 14th century have been published. These incorporate

the wealth of material and photographs collected by Richard Offner with the assistance of Klara Steinweg. The *Corpus* lists virtually every painting in each period covered; for each there is a formidable critical apparatus—history, descriptions, problems, bibliography, etc.—and a picture of each work. Each volume has a supplement to one or more preceding volumes, bringing the information up-to-date; each has indexes of artists, places, and illustrations. General bibliography for Section III, v.1, p.3-14; General bibliography for Section IV, v.1, p.xvii-xxv. A final volume of the series which will survey all unpublished sections is in preparation.

M342 Os, H. W. van, and Prakken, Marian. The Florentine paintings in Holland 1300-1500. Maarssen, Schwartz [1974]. 120p. il.
A catalogue of 64 early Florentine paintings in public and private collections in the Netherlands. Contains both famous and little-known works as well as anonymous pieces. Discussions of the paintings include iconography, original function, possible reconstructions, and attribution and dating. Includes bibliographies.

M343 Pallucchini, Rodolfo. La pittura veneziana del Trecento. Venezia, Istituto per la Collaborazione Culturale [1964]. xiv, 287p. plates (32 col.) (Storia della pittura veneziana)
The major reference work for Venetian painting of the 14th century. Contains an abundance of material, grouped by artists. 711 illustrations, 32 color plates. Full bibliography, p.[231]-42.

M344 Pope-Hennessy, John. Sienese Quattrocento painting. Oxford, Phaidon; N.Y., Oxford Univ. Pr., [1947]. 33p. 93 (i.e. 91) plates, il.
A brief authoritative text and a pictorial anthology of the significant work of 12 Sienese artists who flourished in the 15th century.
Contents: Text, p.7-24; Notes on plates, p.25-33; Index of collections, 2p. at end of volume.

M345 Procacci, Ugo. Sinopie e affreschi. Milano, Electa [1961]. 271p. col. il., plates.
An important reference work on *sinopie* uncovered and rediscovered in Italy during and after World War II. The majority of these date from the late 13th century to the mid-15th century. A few are later.
Introductory essay with descriptive notes and bibliography, p.7-[48]; Comments on the plates, p.49-70. The plates (144 in all, most are in color) include several comparisons of *sinopie* and finished paintings. Following the illustrations is a comprehensive catalogue of existing Italian *sinopie* p.211-46, arranged alphabetically by region, and consisting of brief descriptive entries with bibliography. Appendix of 52 illustrations relative to the catalogue; index.

M346 Ricci, Corrado. North Italian painting of the Cinquecento: Piedmont, Liguria, Lombardy, Emilia. Firenze, Pantheon; N.Y., Harcourt. [1929]. viii, 68p. 84 plates. (Repr.: N.Y., Hacker, 1976.)

321

Standard pictorial survey of 15th-century painting from northern Italy. Brief text, a cursory overview.

M347 Schubring, Paul. Cassoni; Truhen und Truhenbilder der italienischen Frühenaissance, ein Beitrag zur Profanmalerei im Quattrocento. 2. verm. Aufl. Leipzig, Hiersemann, 1923. xii, 492p. 16 plates, atlas of 10p., 210 plates.
1st ed. 1915.

This fundamental study and corpus of pictures of Italian *cassoni* and their panel paintings promises to remain indispensable for research in Italian Renaissance art for many more years. The scholarly text traces the history of the wooden chests and analyzes them by types of subjects portrayed in the painted scenes. Illustrations of 959 *cassoni.* Each is described and documented in the catalogue. Detailed indexes.

Contents: Text, p.1-216; Katalog, p.|219|-418; Anhang, p.|419|-31; Literaturverzeichnis, p.|432|-41; Anhang I, Fest, datierbare Cassoni, Deschi und Letti, p.|442|; Anhang II, Bottega-Buch des Marco del Buono und des Apollonio di Giovanni, Florenz, 1446-63, p.|443|-50; Anhang III, Antonio Averlino Filaretes Mythologien an der Bronzetür von St. Peter in Rom un die in Sforzinda erwähnten mythologischen Stoffe, p.|451|-53.

Indexes: (1) Inhalt, p.|454|-58; (2) Ortsregister, p.|459|-63; (3) Register der Meister und Schulen, p.|464|-67; (4) Autoren-Register, p.|468|-72; (5) Geschlechter-Register, p.|473|-79; (6) Mythus, Sage und antike Historie, p.|480|-87; (7) Ergänzendes Sachregister, p.|488|-90; (8) Verzeichnis der Abbildungen des Textesbandes, p.|491|-92.

M348 Schulz, Juergen. Venetian painted ceilings of the Renaissance. Berkeley, Univ. of California Pr., 1968. 244p. diagrs., 117 plates (241 figs.) (California studies in the history of art, no. 8)

An historical study of the decorative schemes of all of the known Venetian painted ceilings of the 16th century. Represents a step forward in the research on Titian, Tintoretto, Veronese, and lesser-known artists. "Introduction," p.3-58, sketches the development of the systems; "A catalogue of the painted ceilings of the Renaissance in metropolitan Venice," p.[59]-143, lists 67 painted ceilings. Fully-documented entries, each with history, notes on the artists, iconography, and references to literature. Bibliographical references in notes. 151 illustrations.

M349 Smyth, Craig Hugh. Mannerism and *maniera.* Locust Valley, N.Y., J. J. Augustin |1963|. xi, 88p. plates (Walter W. S. Cook alumni lecture. 1961)

A classic historiographical essay on Mannerism and *maniera*—the use of the words, the changing concepts, and the art historical problems—along with a summary of the characteristics of selected Italian postclassical paintings which can be called Mannerist. The brief text (p.1-30) is followed by exhaustive documentation in notes (p.31-88) which provide a valuable critical bibliography. Illustrated with plates of rather poor quality.

M350 Turner, A. Richard. The vision of landscape in Renaissance Italy. Princeton, N.J., Published for the Department of Art and Archaeology, Princeton Univ. |by| Princeton Univ. Pr., 1966. xviii, 219p. plates (158 figs.)
Paperback ed. 1974.

Ten critical essays on the style, philosophy, mood, etc., of the landscape in paintings of major Italian artists from Leonardo da Vinci to Annibale Carracci. The introduction summarizes early Renaissance ideas on the landscape. Intended for the nonspecialist, yet it should be in the library of all students of Italian Renaissance art. Perceptive commentaries on style. Well documented with literary references and passages.

"Selected bibliography of general studies on Renaissance landscape painting," p.213.

M351 Voss, Hermann. Die Malerei der Spätrenaissance in Rom und Florenz; mit 247 Abbildungen. Berlin, Grote, 1920. 2v. il.

A basic scholarly survey of late Renaissance and Mannerist painting in Florence and Rome. Has not been superseded. Many illustrations in the text. Bibliography, index of names and subjects, index of places, at end of v.2.

Contents: Bd. 1, Das Erbe Raffaels und Michelangelos in römischen Malerei; Der Ausgang der Florentiner Hochrenaissance; Bd. 2, Ausbreitung und Überwindung des Manierismus in Florenz; Der Manierismus in Rom und Mittelitalien; Bibliographie, p.599-604; Namen- und Sachverzeichnis, p.605-9; Ortsverzeichnis, p.610-20.

M352 White, John. The birth and rebirth of pictorial space. 2d ed. rev. London, Faber and Faber, 1967. iii. 289p. 64 pl., diagr.
1st ed. 1957.

A scholarly study of pictorial space in Italian art of the 13th, 14th, and 15th centuries, valuable for the art historian and advanced student. Compares Italian pictorial space to that in contemporary French manuscript illumination and to perspective in ancient painting and sculpture, Chinese and Islamic art. The discussion of varying degrees of realism, methods, and theories of perspective is based on careful analysis of the works. Sparse but good illustrations, including diagrams. Extensive notes with bibliographical references at the end of each chapter.

M353 Zampetti, Pietro. Paintings from the Marches: Gentile to Raphael; trans. |from the Italian| by R. G. Carpanini. London, Phaidon, 1971. 277p. il. (some col.) (Distr. in U.S. by Praeger, N.Y.)
Orig. pub. as *La pittura marchigiana da Gentile a Raffaello,* Milano, Electa, 1969.

An excellent scholarly study of painting by the Renaissance artists from the Adriatic region of the Marches. Includes a wealth of material on lesser-known Italian painters. Divided into 5 sections: Fabriano school; S. Severino school; Camerino school; Crivelli school; and the artists from Urbino. Good translation. 187 black-and-white illustrations, 40 color plates. Bibliography. Index.

SEE ALSO:  Klesse, B. *Seidenstoffe in der italienischen Malerei des 14. Jahrhunderts* (P673); Thiem, G., and Thiem,

C., *Toskanische Fassaden-Dekoration in sgraffito und fresco, 14. bis 17. Jahrhundert* (J246).

## Baroque — Modern

M354  Ballo, Guido. Pittori italiani dal futurismo a oggi. [Roma] Mediterranee [1956]. 238p. il. (col.)
English ed. trans. by Barbara Wall (London, Thames & Hudson; N.Y., Praeger [1958]) lacks the extensive bibliography.

An historical review of modern Italian painting from Futurism to the mid-20th century. The critical, often poetic, text presents the author's conception of a "line" of cultural and historical development in modern Italy. See the author's *La linea dell'arte italiana dal simbolismo alle opere moltiplicate* (I321). Chronological survey, p.221–29. Bibliography, p.230–34. Lavishly produced with beautiful color plates.

M355  Bologna. Mostra Biennale d'Arte Antica, 1962. L'Ideale classico del Seicento in Italia e la pittura di paesaggio; catalogo. Testi critici di Francesco Arcangeli [et al.]. Pref. di Germain Bazin. Saggio introduttivo di Cesare Gnudi. 8 settembre–11 novembre 1962. Bologna, Palazzo dell'Archiginnasio. 2. edizione, riveduta e corretta. Bologna, Alfa [1962]. xviii, 458p. plates.
Editor: Cesare Gnudi.

The catalogue of a major exhibition with the theme of 17th-century classicism in Italy. Includes paintings and drawings of Italian artists as well as the French masters, Nicolas Poussin and Claude Lorraine. Each work is documented and illustrated. Important essays by various scholars on the individual artists, short critical biographies, bibliographical notes, and notes on the drawings. Index of places and names of works exhibited.

M356  Donzelli, Carlo. I pittori veneti del Settecento. Firenze, Sansoni, 1957. xii, 328p. il. (part mounted col.)
An alphabetical listing of about 220 18th-century Venetian painters. For each artist gives a short biography, a list of works, and a full bibliography. 384 illustrations. Index of artists, p.291–95. General bibliography, p.296–328.

M357  Donzelli, Carlo, and Pilo, Giuseppe Maria. I pittori del Seicento veneto. Firenze, Sandron [1967]. 522p. il., plates.
A dictionary of 270 Venetian painters of the 17th century. Gives biographical information and lists both existing and lost works. Bibliography, p.443–99. Indexes of names and illustrations.

M358  Drudi Gambillo, Maria, ed. Archivi del futurismo; raccolti e ordinati da Maria Drudi Gambillo e Teresa Fiori. Roma, De Luca [1958–62]. 2v. il. (Archivi dell'arte contemporanea)
A collection of documents dealing with the Futurist movement—manifestos, letters, articles, etc. "Elenco delle opere" gives short biographical information and lists of works of the principal artists. "Regesti" is a chronological register of documents. Bibliography, v.I, p.495–[553] and v.II, p.501–12.

M359  Fiori, Teresa. Archivi del divisionismo. Raccolti e ordinati da Teresa Fiori. Saggio introduttivo di Fortunato Bellonzi. Roma, Officina Edizioni, 1969. 2v. plates. (Archivi dell'arte contemporanea)
A collection of documents and illustrations dealing with the Italian Divisionists' artistic *risorgimento*. Emphasizes the relationship between the Divisionists and Futurists. "The present volumes have provided the groundwork for another important chapter in the overall history of Neo-Impressionism."—Marianne Martin. *Art bulletin*, Dec. 1971. Contents: v.1, Documents; v.2, A catalogue of the paintings and plates. Bibliography, v.1, p.459–537; Indexes, v.1, p.541–52.

M360  Haskell, Francis. Patrons and painters; a study in the relations between Italian art and society in the age of the Baroque. London, Chatto & Windus, 1963. xix, 454p. 64 plates (incl. ports.)
Paperback ed.: N.Y., Harper, 1971.

An important study of art patronage in Italy during the 17th and 18th centuries, beginning with the Rome of Urban VIII and ending with the last phase in Venice (c.1798). Based on original sources; indispensable for research. Also a fascinating, well-written story.

Contents: (I) Rome; (II) Dispersal; (III) Venice. Scholarly footnotes. Appendixes of excerpts from documents. Good bibliography, p.396–421.

M361  Levey, Michael. Painting in XVIII century Venice. London, Phaidon [1959]. 225p. 107 il., 8 col. plates.
The best introduction to the last great period of Venetian painting. Includes the historical background in Venice, art patronage, and art criticism of the time. Lively text, enjoyable reading. Chapter notes include bibliography. Bibliography, p.219. Well illustrated in the text.

Contents: Introduction; (1) The history painters; (2) Landscape painting; (3) The view painters; (4) Genre; (5) Portrait painting; (6) The presiding genius of Giambattista Tiepolo. Notes; bibliography; index.

M362  Luciani, Lidia, and Luciani, Franco. Dizionario dei pittori italiani dell'800. Firenze, Vallecchi, 1974. xxxviii, 428p. [56] leaves of plates.
A biographical dictionary of 19th-century Italian painters. Includes a biographical sketch and bibliography for each. General bibliography, p.419.

M363  Martini, Egidio. La pittura veneziana del Settecento. Venezia, Marciane [1964]. 658p. (p.[311–634] plates). il. (33 col.)
"A provocative, scholarly work, written by a restorer who has an unmatched knowledge of Venetian painting"—R. Wittkower (I359). The introductory essay is a critical-historical survey of 18th-century Venetian painting. The extensive notes deal with problems of style, dating, and attributions. Well illustrated.

M364   Maxon, John, and Rishel, Joseph J., eds. Painting in Italy in the eighteenth century: Rococo to Romanticism. An exhibition organized by the Art Istitute of Chicago, the Minneapolis Institute of Arts, and the Toledo Museum of Art. Chicago, 1970. 251p. il. (part co.), maps, ports.

The catalogue of a major loan exhibition. Critical biographies of each artist, meticulous catalogue entries, up-to-date bibliographies, and an illustration for each work exhibited. "Technical note," by Marigene H. Butler, is a scientific analysis of the materials and techniques of two representative paintings. Index of artists.

M365   Pallucchini, Rodolfo. La pittura veneziana del Settecento. [701 illustrazioni in nero e 35 tavole a colori. 1. ed.]. Venezia, Istituto per la Collaborazione Culturale [1960]. viii, 323p. plates (part col.) (Storia della pittura veneziana)

The fundamental reference tool in the field of 18th-century Venetian painting. Each chapter, from the first—*l'avvento del rococò*—to the last—*le estreme voci del rococò*—is subdivided by artist. For each gives a critical essay with reliable information. Extensive bibliography (from 1700-1958), p.[267]-323. 701 black-and-white illustrations, 35 color plates.

M366   Pérez Sánchez, Alfonso E. Pintura italiana del s. XVII en España. Madrid [Universidad de Madrid, Fundación Valdecilla] 1965. 619p. 253 plates.

"First serious attempt to catalogue and illustrate all Italian Seicento paintings in Spain."—R. Wittkower (I359). Important for the history of Italian Baroque painting and 17th-century Spanish painting.

Bibliografía, p.[575]-605. "Apéndice: Papas del siglo XVII; Embajadores de España cerca de la Santa Sede; Virreyes de Nápoles." "Indice alfabético de pintores; Indice topográfico; Indice iconográfico; Indice general."

M367   Quinsac, Annie Paule. La peinture divisionniste italienne; origines et premiers développements, 1880-1895. Paris, Klincksieck, 1972. 295p. 47 plates.

A general study of Italian Divisionism, with emphasis on its relationship to French Divisionism. Bibliography, p.[205]-22.

M368   Roli, Renato. Pittura bolognese 1650-1800. Dal Cignani ai Gandolfi. Bologna, ALFA, 1977. 740p. il.

A scholarly study of all aspects of Bolognese painting from 1650 to 1800. Comprehensive photographic illustrations classified by subject, p.[325]-740.

Contents: (I) Vita, cultura e pittura a Bologna: registro dei tempi; (II) Mecenati e pittori; (III) Tendenze della pittura bolognese nell'età barocca; (IV) La grande decorazione; (V) Traccia per i pittori di figura (quadri di "storia" e chiesastici); (VI) La "bottega": maestri e allievi; (VII) Iconografia; (VIII) Il ritratto e la "testa di carattere"; (IX) La scena di genere; (X) Il paesaggio; (XI) Prospettive e "rovine"; (XIII) La "natura morta".

"Regesti biografici, bibliografia e cataloghi delle opere," p.221-300, is an alphabetical listing of artists with principal dates, works, and bibliographical notes. General bibliography, p.301-6.

M369   Somaré, Enrico. Storia dei pittori italiani dell'Ottocento. Milano, "L'Esame," 1928. 2v. plates (part col.), ports. (part col.) (Repr.: Milan, Cisalpino, 1971.)

The basic historical survey of 19th-century Italian painting. Contents: v.1, Introduzióne generale; Neoclassici; La nuova scuola lombarda; Pittori veneti; Pittori piemontesi; Pittori liguri; Pittori emiliani; v.2, La nuova scuola toscana, Pittori dell'Italia centrale, La nuova scuola napoletana. Extensive bibliographies at the end of each section. v.1 has 333 plates (21 in color); v.2 has 308 plates (18 in color). Includes bibliographies.

M370   Storia della pittura italiana dell'Ottocento. [Coordinamento di Mario Monteverdi. Milano] Bramante, 1975. 3v. 1,210 il., 227 col. plates.

A comprehensive, well-documented study of 19th-century painting in Italy. Lavishly illustrated.

Contents, v.1, by Mario Monteverdi: Introduzione; I "lumi" della vigilia; Neoclassicismo e aspetti accademici del primo romanticismo italiano; Sviluppi della pittura romantica in Italia; Il movimento antiaccademico dei macchiauioli; Da Napoli nuovi stimoli creativi; La scapigliatura. v.2: Monteverdi, Mario. La pittura italiana dell'Ottocento; Penny, Nicholas B. L'attività degli artisti inglesi nell'Italia dell'Ottocento (text in Italian and English); Henze, Anton. Pittori tedeschi del XIX secolo in Italia (text in Italian and German); Le Cannu, Marc. I pittori francesi del XIX secolo e l'Italia (text in Italian and French). v.3: Testimonianze e documenti, a cura di Gino Traversi; Dizionario biografico, a cura di Maria Teresa Fiorio, Marcella A. Riccobon, Cecilia Bonatti; Bibliografia ragionata, a cura di Gemma Verchi. Indice dei nomi.

M371   Voss, Hermann. Die Malerei des Barock in Rom. Berlin, Propyläen [1925]. 690p. plates.

A scholarly treatment of the Baroque period in Rome, from Caravaggio to Mengs and neoclassicism. "The basic study without which no work in the field can be undertaken."—R. Wittkower (I359).

Well illustrated. Bibliographical footnotes. Index of artists and their works.

M372   Waterhouse, Ellis Kirkham. Italian Baroque painting. 2d ed. London, Phaidon, 1969. 237p. 198 il.

1st ed. 1962. Available in paperback.

A survey of Italian Baroque painting which concentrates on a selection of significant works. The best introduction for the student and general reader. Written by a leading scholar; witty, enjoyable reading, easy to understand. 198 illustrations in the text. Bibliography, p.228-29.

M373   _____. Roman Baroque painting: a list of the principal painters and their works in and around Rome: with an introductory essay. [Oxford] Phaidon, 1976. 163p. il.

1st ed. 1937.

An excellent, readable survey of painting in Rome from the late 16th century to the end of the 17th century; followed by a critical bibliographical note and lists of the works of painters "who executed important commissions for the decoration of churches or palaces in Rome after the accession of Urban VIII in 1623, and who were born before 1660." —*Note* to the lists. These lists (p.49-121), which are arranged by artist and include many lesser-known painters, are indispensable for the study of Roman Baroque painting. 81 illustrations. Bibliographical notes, p.39-45; Topographical index, p.157-63.

## Latin America

M374  Acquarone, Francisco, and Queiroz Vieira, A. de. Primores da pintura no Brasil com uma introdução historica e textos explicativos. Rio de Janeiro [Edição dos Autores, 1942]. 2v. col. plates.

A survey of 19th-century painting in Brazil from the "Coroaçao de Pedro I" to the early 20th-century Impressionists. Each of the 20 sections consists of 8 color plates and a page of biographical information on the artist with critical discussion of his work. No index or table of contents.

M375  Boulton, Alfredo. Historia de la pintura en Venezuela. Caracas, Manaure [1964-72]. 3v. il., plates (part col.)

A comprehensive, very well-illustrated history of painting in Venezuela from the beginning of the colonial period to the present.

Contents, v.1, *Epoca colonial* (1964); pt. 1, Siglos XVI y XVII; pt. 2, Siglo XVIII. Catálogo biográfico de pintores, p.279-406, includes 140 painters arranged alphabetically, with biographical data and lists of works; v.2, *Epoca nacional de Lovera a Reveron* (1968): pt. 1, De la colonia a la independencia; pt. 2, El academicismo y la estabilidad Guzmancistá; pt. 3, El circulo de bellas artes; v.3, *Epoca contemporanea* (1972): Prólogo; El pintor en su tiempo; La instrucción artística; Las noticias, los comentarios, la crítica; El Museo de Bellas Artes, los salones anuales; Las principales tendencias después del Círculo.

Each volume contains excellent bibliographies of published and unpublished works and various indexes.

M376  Giraldo Jaramillo, Gabriel. La pintura en Colombia. [1. ed.]. México, Fondo de Cultura Económica [1948]. 248p. il., 49 plates. (Colección Tierra Firme, 36)

A general survey of painting in Colombia. Includes the colonial period, the republican period, moderns, and contemporaries. Bibliography, p.182-84. Indexes of names and illustrations.

M377  Kelemen, Pál. Peruvian colonial painting, a special exhibition. The Collection of the Stern Fund and Mr. and Mrs. Arthur Davis, with an additional selection from the Brooklyn Museum. Introd. and catalogue by Pál Kelemen. [Norfolk? Conn., 1971]. 112p. 65 il.

The catalogue of an exhibition of 46 works of the Cuzco School shown at the Brooklyn Museum and other museums in the U.S. in 1971-72.

"The introduction is a discussion of the pre-Columbian and Spanish influences on the iconography and style of Peruvian painting. Frequently painted subjects and saints are cited. The catalogue commentary includes aesthetic evaluation of the works and notes on the sources for the subject matter. An essay entitled *Technological notes* discusses native colors and methods of preparing canvases as well as suggestions for restoration techniques in dealing with colonial works from 200 to 400 years old. The works shown date from the 17th to early 19th cs. [Author]."—*RILA*, Demonstration issue, p.43, no. 547.

Bibliography, p.109-10. References to paintings in the Brooklyn Museum, p.111-12.

M378  Laroche, Ernesto. Algunos pintores y escultores. [Montevideo] Ministerio de Instrucción Pública y Previsión Social, República Oriental del Uruguay, 1939. xl, 214p. il., plates, ports.

Gives biographical and critical information on about 20 19th-century Uruguayan artists and includes a portrait and reproductions of works of each.

M379  Lira, Pedro. Diccionario biográfico de pintores. Santiago de Chile, Esmeralda, 1902. 552p.

An old biographical dictionary of Latin American painters, most useful for information on Chilean artists. "Primero apéndice: Los pintores vivos," p.[453-539]. "Segundo apéndice: Pintores chilenos vivos en 1901," p.[541]-51.

M380  Myers, Bernard S. Mexican painting in our time. N.Y., Oxford Univ. Pr., 1956. 283p. 124 il.

A history of Mexican painting in the first half of the 20th century. Emphasizes the importance of mural painting of the period.

Contents: (I) Background for a new art; (II) A culture in revolution; (III) The Obregón period: 1920-24; (IV) Diego Rivera: through 1924; (V) José Clemente Orozco: through 1924; (VI) David Alfaro Siqueiros: through 1924; (VII) The Calles period: 1924-34; (VIII) Rivera: 1924-34; (IX) Orozco: 1924-34; (X) Siqueiros: 1924-34; (XI) Mural versus easel painting: 1924-34; (XII) The Cárdenas period: 1934-40; (XIII) Orozco: 1934-40; (XIV) Siqueiros: 1934-40; (XV) Rivera: 1934-40; (XVI) The Mexican school of painting: 1934-40; (XVII) The war and postwar periods; (XVIII) Orozco: 1940-49; (XIX) Siqueiros: since 1940; (XX) Rivera: since 1940; (XXI) Mexican painting today.

Bibliography, p.269-76.

M381  Reis, José Maria dos. História da pintura no Brasil, prefácio de Oswaldo Teixeira . . . (312 ilustrações). São Paulo, Editôra LEIA, 1944. 409p., incl. il., plates.

A well-illustrated general history of Brazilian painting. Bibliography, p.[391]-97. Indexes of names and illustrations.

M382  Robertson, Donald. Mexican manuscript painting of the early colonial period: the Metropolitan schools.

325

New Haven, Yale Univ. Pr., 1959. xix, 234p. 88 plates. (Yale historical publications. History of art. 12)
The first art historical study of Mexican manuscript painting of the early colonial period, from the conquest in 1521 to c.1600. Not a comprehensive survey, but a limited study of a group of significant examples from the Central Valley of Mexico.

Contents: Introduction; (1) Mixtec pre-conquest manuscript style; (2) The pre-conquest painters and the books; (3) The early colonial painters and their books; (4) The early colonial manuscript style; (5) The school of Mexico-Tenochtitlán: the first stage; (6) The school of Mexico-Tenochtitlán: the second stage; (7) The school of Texcoco; (8) Tlateloleo; (9) The manuscripts of Sahagún; (10) Cartography and landscape; (11) The Techialoyan codices; Conclusion. Appendixes: (A) Catalogues and bibliographic studies; (B) Codex Magliabecchian and related material.

Exhaustive bibliography, p.203-22: pt. 1, General; pt. 2, Reproductions.

M383  Rodríguez, Antonio. A history of Mexican mural painting. Trans. from the Spanish and German by Marina Corby. N.Y., Putnam [1969]. 517p. 312 il., plates (56 col.)
Because of its unbalanced, flawed text, this work should be used primarily for its many reproductions of Mexican mural paintings. Bibliographical references included in Notes, p.[494]-500.

M384  Romera, Antonio R. Historia de la pintura chilena. Santiago de Chile, Editorial del Pacifico [1951]. 223p. il.
A general survey of painting in Chile. Poorly illustrated. Bibliography, p.199-212.

M385  Romero Brest, Jorge. La pintura brasileña contemporanéa. Buenos Aires, Poseidón [1945]. 7-112p. il., plates (part col.)
A survey of contemporary Brazilian painting to time of publication. "Notas," p.35-37, contains bibliography. Short biographical notices, p.39-47. Index of reproductions.

M386  Soria, Martin S. La pintura del siglo XVI en Sud America. Buenos Aires, Univ. de Buenos Aires. Instituto de Arte Americano e Investigaciones Estéticas, 1956. 125p. 82 il. on plates.
A scholarly study of 16th-century painting in S. America. Bibliographical footnotes.

M387  Toussaint, Manuel. Pintura colonial en México. [1. ed.]. México, Imprenta universitaria, 1965. xvi, 307p. plates, 438 figs. (24 col.)
At head of title: Universidad Nacional Autónoma de México, Instituto de Investigaciones Estéticas.
"First major history of Mexican paintings from the early 16th century to the early 19th century by the pioneer student of modern art history in Mexico. Through initialed notes, it has been revised and brought up to date in many details by Xavier Moyssén. . . . Includes as appendices 14 archival documents on colonial painters and a 12-page 'Nómina de los Pintores . . .' listing the names of painters who worked in Mexico with indication of their dates, when known and bibliographic references . . ."—*Handbook of Latin American Studies*, v.28, 1966, p.37, no. 207.
Bibliography, p.277-78.

## Low Countries

Dutch and Flemish painting is divided as follows: (1) General; (2) Early Netherlandish (through the 16th century); (3) Baroque-Modern.

M388  Bautier, Pierre, et al. Dictionnaire des peintres [nés avant 1900]. Préface de Paul Fiernes. Bruxelles, Larcier [1951]. 694p. (Petits dictionnaires des lettres et des arts en Belgique, no. 4)
A dictionary of Belgian painters who were born before 1900 as well as artists who were born in Belgium and worked elsewhere. For each artist gives dates, description of style, most important works, and bibliography. Some entries are signed by the contributors.

M389  Fromentin, Eugène. The masters of past time; Dutch and Flemish painting from Van Eyck to Rembrandt. [Trans. by Andrew Boyle. Ed. by H. Gerson]. London, Phaidon, 1948. xvi, 389p. 96 plates.
Original French ed. 1876.
A literary classic and a masterpiece of perceptive art criticism. "Notes on the plates," p.[353]-77, and "selected bibliography," p.[381]-83, by person. Index of names, p.385-87; of collections, p.388-89.

M390  Genaille, Robert. Dictionnaire des peintres flamands et hollandais. Paris, Larousse, 1967. 256p. il.
A dictionary arrangement which is a complete, concise history of Dutch and Flemish painting. Scholarly entries provide information on the minor as well as the great masters. Contains useful synoptic tables. Particularly helpful for 19th- and 20th-century painters.

M391  Hoogewerff, Godefridus Joannes. De noord-nederlandsche schilderkunst, door G. J. Hoogewerff. 's Gravenhage, Nijhoff, 1936-47. 5v. il. (incl. facsims.)
A comprehensive work on the history of painting in the northern part of the Netherlands from the Ottonian period to the end of the 16th century. Bibliographical footnotes.
v.5 is an index volume containing synopses of previous volumes, a list of works of artists mentioned, iconographical index, topographical index, and index of personal names.

M392  Lassaigne, Jacques. Flemish painting. [Trans. by Stuart Gilbert. N.Y.] Skira [1957-58]. 2v. mount. col. il. (Repr.: N.Y., Skira/Rizzoli, 1977.)
An excellent introduction to the painting of Flanders. Illustrated with superb color plates. Contents: v.1, The century of Van Eyck, by Jacques Lassaigne, 181p. Bibliography, p.171-[73]; v.2. From Bosch to Rubens, by Jacques Lassaigne and Robert L. Delevoy, 202p. Bibliography, p.187-[93].

M393 Lewis, Frank. A dictionary of Dutch and Flemish flower, fruit, and still life painters, 15th to 19th century. Leigh-on-Sea, Lewis, 1973. 83p., 48 1. il. (part col.)

An alphabetical listing of flower, fruit, and still-life painters of the Low Countries. Includes many lesser-known artists. Brief entries with the minimum of biography. At end the plates of representative works are arranged chronologically in order to show stylistic development of the genres.

M394 Leymarie, Jean. Dutch painting. [Trans. by Stuart Gilbert. Geneva, N.Y.] Skira [1956]. 213p. il. (mounted col.)

A broad survey of Dutch painting from Geertgen tot Sint Jans to Vermeer. Recommended for the beginning student. The good bibliography, p.201-4, includes a list of exhibitions to 1956. Index of names, p.205-[10]. Excellent color plates.

M395 Paris. Musée National du Louvre. Département des peintures, des dessins et de la chalcographie. Catalogue raisonné des peintures du moyen-âge, de la renaissance et des temps modernes: Peintures flamandes du XVe et XVIe siècle, par Edouard Michel. Paris, Éditions des Musées Nationaux, 1953. xv, 309p. and atlas (xi p., 68 plates).

A catalogue raisonné of the Flemish paintings of the Louvre, based on the earlier catalogue by Louis Demonts of 1922; a major revision and enlargement. For each artist gives a summary biography and bibliography. For each painting gives: (1) A pictorial description determining the appearance and character of the painting; (2) A summary study of the painting's theme, stating precisely the origins and iconographical evolution; (3) A list of studies relating to the work considered.

M396 Puyvelde, Leo. La peinture flamande à Rome. Bruxelles, Librarie encyclopédique, 1950. 239p. 96 plates.

A scholarly treatment of Flemish painting in Rome from the 15th century to the end of the 18th century. The text is first divided by century, then by the individual artists. Well illustrated.

Bibliographical footnotes. Index of names and places, p.225-36.

M397 Speth-Holterhoff, S. Les peintres flamands de cabinets d'amateurs au XVII siècle. [Bruxelles] Elsevier [1957]. 230p. 75 il., 6 col. plates. (Les Peintres flamands du XVII. siècle, 7)

A unique study of collectors, collecting, taste, and style in Flanders during the 17th century, based on a study of the paintings depicting *cabinets d'amateurs*—rooms of private collectors which housed their paintings, statues, decorative arts, curios, etc. Three *annexes* of documents. Bibliographical notes. Index of artists, p.225-27.

M398 Wilenski, Reginald Howard. Flemish painters, 1430-1830. N.Y., Viking [1960]. 2v. plates (part col.)

A standard work; especially useful as a library reference tool. "This book purports to take students of art history to the point where work in a specialized art-historical library becomes unavoidable."—*Note to specialist students.*

v.I, pt. 1, "Flemish painters, notes on their lives, circumstances and production (1430-1830)" is arranged chronologically by sovereign; pt. 2, "A dictionary of Flemish painters," (p.481-694) gives dates of birth and death, types of subjects portrayed, travels, signed examples, and coded bibliographical references. "Bibliographical index to the dictionary," p.695-724. Bibliography entitled "Notes on literature," p.725-59.

## Early Netherlandish (through 16th century)

M399 Blum, Shirley Neilsen. Early Netherlandish triptychs: a study in patronage. Berkeley and Los Angeles, Univ. of California Pr., 1969. xv, 176p. 80 il., 11 plates (8 col.) (California studies in the history of art, no. 13)

A new approach to the study of Flemish triptychs. Stresses the role of the donor, the occasion for the commission, and the intended physical setting, as well as style and iconography. Not a comprehensive survey of the triptych form or a general survey of patronage. Includes only those works with complete documentation; thus Robert Campin and Jan van Eyck are examined only in general terms. Begins with the emergence of the form with Rogier van der Weyden, c.1440, and continues to the dissolution of the form with Gerard David, c.1510. Inadequate color plates are balanced by the abundant black-and-white illustrations including excellent visual comparisons and views and plans of the buildings for which the triptychs were made. Bibliographical references in notes, p.115-[62], as well as a bibliography including recent scholarship, p.163-[70].

M400 Byvanck, Alexander Willem. La miniature dans les Pays-Bas septentrionaux, traduit du néerlandais par Mlle. Adrienne Haye. Paris, Éditions d'art et d'histoire, 1937. 185p., 100 plates.

A good general history of illumination in the northern Low Countries. "This book sums up many earlier articles on the subject,"—L. M. J. Delaissé (M403). Contains 108p. of text followed by "Notices des manuscrits dont sont tirées les miniatures," p.117-61. Bibliographical references in notes. "Liste des miniaturistes," p.166. Bibliography, p.167-70. Index of plates, p.171-85.

M401 Byvanck, Alexander Willem and Hoogewerff, Godefridus Joannes. La miniature hollandaise dans les manuscrits des 14e, 15e, et 16e siècles. La Haye, Nijhoff, 1922-25. 91p. 112 il., and 2 portfolios of 240 plates.

Also published in Dutch.

The text volume has general title on cover only, dated 1925, while title page bears the date of 1926.

A basic scholarly work on Dutch manuscript illumination. Text volume contains: Introduction, p.xv-xxv; Notes descriptives des manuscrits, p.1-74 (with bibliographical references); Liste des manuscrits étudiés, p.75-78 (arranged

327

by location); Liste des autres manuscrits mentionnés, p.79; Principaux livres et mémoires auxquels se réfère le présent ouvrage, p.80; Index alphabétique des reproductions, d'après les sujets, p.82–84; Index alphabétique des noms, etc., figurants dans l'introduction et dans les notices descriptives, p.85–88; Liste de figures, p.89.

**M402** Conway, William Martin, *Baron,* The Van Eycks and their followers. London, Murray, 1921. xix, 529p. 24 plates. (Repr.: N.Y., AMS Pr., 1976.)
A history of Flemish painting up to and including Bruegel. Out-of-date, yet still important as an informative and stimulating introduction for the student. Several illustrations on each plate. General index, p.523–29. Index of works of art, p.509–22.

**M403** Delaissé, L. M. J. A century of Dutch manuscript illumination. Berkeley, Univ. of California Pr., 1968. xii, 102p. [79]p. of il. (part col.) (California studies in the history of art, 6)
The best art historical study of Dutch manuscript painting from its early period in the late 14th century to the late 15th century. Written by the leading scholar in the field. Well illustrated, partly in color. Bibliographic footnotes.
Contents: (I) The political and spiritual milieu; (II) The illuminated manuscripts; (III) Dutch style; (IV) Dutch presence abroad; (V) Postscript (The complementary fragment of the Hours of Catherine of Cleves recently acquired by the Pierpont Morgan Library); (VI) Conclusions. Selected bibliography, p.97–98.

**M404** Franz, Heinrich Gerhard. Niederländische Landschaftsmalerei im Zeitalter des Manierismus. Graz, Akademische Druck- u. Verlagsanstalt, 1969. 2v. il. 43 plates (part col.) (Forschungen und Berichte des Kunsthistorischen Institutes der Universität Graz, 2)
A comprehensive study of Dutch and Flemish landscape painting in the latter part of the 16th century. Presents new information on lesser-known artists (including short biographies), good analyses of style, and a great number of illustrations. v.2 is a corpus of 530 illustrations. Bibliography in v.1, p.[339]–53.

**M405** Friedländer, Max J. Early Netherlandish painting. Preface by Erwin Panofsky. Comments and notes by Nicole Veronée-Verhaegen. Trans. by Heinz Norden. Leiden, Sijthoff; Brussels, Connaissance; N. Y., Praeger, 1967–76. 14v. in 16. il.
Editors: N. Veronée-Verhaegen, H. Pauwels, G. Lemmens, S. Herzog.
In progress.
German ed.: *Die altniederländische Malerei.* Berlin, Cassirer, 1924–37.
A new English ed. (with comments, notes, and new illustrations) of a fundamental work on early Netherlandish painting.
"This new edition, translated from the German, brought up-to-date in some respects and augmented by about 2,000 new illustrations, will not so much revive . . . as make more

easily accessible, more useful and, if only by comparison with the original, more pleasurable, one of the few uncontested masterpieces produced by our discipline."—Erwin Panofsky, *Note to the reader,* v.1.
Each volume has Editor's note, Notes, and Index of Plates.
Contents by volume: (1) The Van Eycks—Petrus Christus; (2) Rogier van der Weyden and the Master of Flémalle; (3) Dieric Bouts and Joos van Gent; (4) Hugo van der Goes; (5) Geertgen tot Sint Jans and Jerome Bosch; (6a) Hans Memlinc and Gerard David; (6b) Hans Memlinc and Gerard David; (7) Quentin Massys; (8) Jan Gossart and Bernart van Orley; (9a) Joos van Cleve, Jan Provost, Joachim Patenier; (9b) Joos van Cleve, Jan Provost, Joachim Patenier; (10) Lucas van Leyden and other Dutch masters of his time; (11) The Antwerp Mannerists, Adriaen Ysenbrandt; (12) Jan van Scorel and Pieter Coeck van Aelst; (13) Antonis Mor and his contemporaries; (14) Pieter Bruegel.

**M406** _____. From Van Eyck to Bruegel. Ed. and annot. by F. Grossmann. [Trans. from the German by Marguerite Kay. 3d ed. London] Phaidon [1969]. x, 409p. il. (part col.)
Trans. of *Die frühen niederländischen Maler von Van Eyck bis Bruegel.* 1st ed. 1916; 2d ed. 1923; Eng. trans. of 2d ed. 1956.
Available as a 2v. Phaidon paperback ed.
Brilliant stylistic analyses by a great art historian and connoisseur. Not a textbook. The editing and annotation of this 3d ed. brings the material up to date with new attributions and scholarship as well as the current locations of the works discussed.

**M407** Löhneysen, Hans-Wolfgang von. Die ältere niederländische Malerei; Künstler und Kritiker. Eisenach, Röth [1956]. 556p. plates (part col.)
A useful reference work on early Netherlandish painters. Dictionary arrangement; for each artist gives an outline biography, a discussion of his work, and a selection of critical excerpts from the writings of art historians, critics, and other authors, from the 16th through the 19th centuries.
Bibliography, p.522. "Bibliographisches Verzeichnis des Arbeitsmaterials," p.523–36. Index of people, places, and subjects, p.537–52; Index of illustrations, p.554–56.

**M408** Panofsky, Erwin. Early Netherlandish painting, its origins and character. Cambridge, Harvard Univ. Pr., 1953. 2v. plates. (Charles Eliot Norton lectures, 1947–48)
Paperback ed.: N.Y., Harper, 1971.
A scholarly work, now a classic. Concentrates on Hubert and Jan van Eyck, the Master of Flémalle, and Rogier van der Weyden. See the important review by Julius S. Held in *Art bulletin* 37:205–34 (Sept. 1955).
Contents: v.1, Text; ("Notes," p.[361]–511); v.2, Plates. Bibliography, v.1, p.513–[35]; Index, v.1, p.537–[73].

**M409** Les Primitifs flamands: I. Corpus de la peinture des anciens Pays-Bas méridionaux au quinzième siècle. no. 1–[13]. Anvers, De Sikkel, 1951–[73]. [Publica-

numbers added. "Pictures are cataloged under the names given them by their owners . . . . Pictures falsely attributed to masters have been deliberately omitted."—*Pref.* At end of each volume is an index of public and private collections and owners.

Contents: Bd. 1. Jan Steen, Gabriel Metsu, Gerard Dou, Pieter de Hooch, Carel Fabritius, Johannes Vermeer; Bd. 2. Aelbert Cuyp, Phillips Wouwerman; Bd. 3. Frans Hals, Adriaen van Ostade, Isaack van Ostade, Adriaen Brouwer; Bd. 4. Jacob van Ruisdael, Meindert Hobbema, Adriaen van der Velde, Paulus Potter; Bd. 5. Gerard Ter Borch, Caspar Netscher, Godfried Schalcken, Pieter van Slingeland, Eglon Hendrick van der Neer; Bd. 6. Rembrandt, Nicolas Maes; Bd. 7. Willem van der Velde (II); Johannes van der Cappelle, Ludolf Bakhuyzen, Aert van der Neer; Bd. 8. Jan van Goyen, Jan van der Heyden, Johannes Wijnants; Bd. 9. Johannes Hackaert, Nicolaes Berchem, Karel du Jardin, Jan Both, Adam Pijnacker; Bd. 10. Frans van Mieris, Adriaen van der Werff, Willem van Mieris, Rachel Ruysch, Jan van Huysum.

M424 Legrand, Francine Claire. Les peintres flamands de genre au XVIIe siècle. Bruxelles, Meddens, 1963. 282p. il. (Les peintres flamands du XVIIᵉ siècle, 8, 2. sér.)

A comprehensive survey of Flemish genre painters of the 17th century (excepting Brouwer and Teniers). The classification is arranged by genre subject of the paintings. "The evolution of themes is often described and it is thus possible to discern the constants and the variants in the sixteenth and seventeenth centuries."—A. P. De Mirimonde, *Gazette des beaux-arts*, v.64, Oct. 1964.

M425 Preston, Rupert. The seventeenth century marine painters of the Netherlands. Leigh-on-Sea, Lewis, 1974. viii, 103p., [47] leaves of plates, il., facsims. 600 copies printed.

A useful reference book on 17th-century marine artists of the Netherlands. Offers documentary and visual information on which to base attributions. 91 illustrations.

Contents: Introduction; Index of 17th-century Netherlands marine artists; Alphabetical list and biographical details of painters; Appendixes: History, Ship details, Flags, Signatures. Recommended bibliography, p.102.

M426 Riegel, Alois. Das holländische Gruppenporträt. Wien, Österreichischen Staatsdr. 1931. 2v. 88 plates.

"A basic work. It is not necessary to accept the author's ideas about Dutch *Kunstwollen* to profit from his keen observations on the history of Dutch group portraits from Geertgen tot Sint Jans to Rembrandt."—Rosenberg, Slive, Kuile (I388).

"Vorwort des Herausgegebers," by Karl M. Swoboda; "Nachwort" (v.1, p.283-92) and "Bibliographie" (v.1, p.293-98), by Ludwig Münz.

M427 Rooses, Max. Dutch painters of the nineteenth century. With biographical notes. With six etchings by Ph. Zilcken, six photogravure plates, and over 200 other illustrations. Trans. by F. Knowles, London, Low, Marston, 1898-1901. 4v. il., plates.

Also published in a French ed. This work consists of a series of articles by various well-known writers on the life and works of the most celebrated Dutch painters of the 19th century, with a summary of the entire school by Rooses.

Each volume contains the essays and reproductions for 12 painters. No index, but artists are listed on the spines of the volumes.

M428 Smith, John, dealer in pictures, London. A catalogue raisonné of the works of the most eminent Dutch, Flemish and French painters; in which is included a short biographical notice of the artists, with a copious description of their principal pictures; a statement of prices at which such pictures have been sold at public sales on the continent and in England; a reference to the galleries and private collections in which a large portion are at present; and the names of the artists by whom they have been engraved; to which is added a brief notice of the scholars and imitators of the great masters of the above schools. London, Smith, 1829-42. 9v. plates. (Repr. for Sands and Co., London and Edinburgh, 1908 in an ed. of 1,250 copies.)

An important early work which was revised and brought up-to-date by Hofstede de Groot (M423), contains descriptions of the works of 33 Dutch, 4 Flemish, and 3 French artists.

"Antiquated, but of interest as the first catalogue raisonné of the works of many of the principal Dutch painters. The basis for Hofstede de Groot's monumental catalogue published in the following century."—Rosenberg, Slive, Kuile (I388).

Contents by volume: (1) Gerard Dow, Peter van Slingelandt, Francis van Mieris, William van Mieris, Adrian van Ostade, Isaac van Ostade, Philip Wouwermans; (2) Peter Paul Rubens; (3) Anthony van Dyck and David Teniers; (4) Jan Steen, Gerard Terburg, H. E. vander Neer, Peter de Hooge, Gonzales Cocques, Gabriel Metsu, Gaspar Netscher, A. vander Werf, Nicolas Maes, Godfrey Schalcken; (5) Nicholas Berghem, Paul Potter, Adrian vander Velde, Karel du Jardin, Albert Cuyp, John vander Heyden; (6) Jacob Ruysdael, Minderhout Hobbema, John and Andrew Both, John Wynants, Adam Pynaker, John Hackaert, William vander Velde, Ludolph Backhuyzen, John van Huyzum, Rachel Ruisch; (7) Rembrandt van Rhyn; (8) Nicholas Poussin, Claude Lorraine, Jean Baptiste Greuze; (9) Supplement.

M429 Stechow, Wolfgang. Dutch landscape painting of the seventeenth century. 2d ed. London, Phaidon, 1968. ix, 494p. 369 il. (National Gallery of Art. Kress Foundation studies in the history of European art, 1) 1st ed. [1966].

A comprehensive work by a leading scholar. Arranged by type of landscape: pt. 1, The Dutch scene (chapters on dunes and country roads, panoramas, rivers and canals, woods, winter, the beach, the sea, and the town); pt. 2, Foreign lands (chapters on imaginary scenes, Tyrol and

Scandinavia, the Italian scene and other foreign scenes); pt. 3, Nocturnes. Well illustrated. Selected bibliography includes a list of recent exhibition catalogues.

## New Zealand

M430 Docking, Gilbert Charles. Two hundred years of New Zealand painting. Wellington, Reed [1971]. 212p. 148 il. (part col.)

A generously illustrated survey of New Zealand painting, for the most part in New Zealand collections. "Begins with the arrival in 1769 of the commissioned artist Sydney Parkinson, who sailed on Cook's first voyage, and concludes with paintings produced in 1969."—*Introd.* List of illustrations, p.7-10, arranged alphabetically by painter. Notes, p.207-9, include bibliographical references.

## Russia and Eastern Europe

M431 Alpatov, Mikhail Vladimirovich. Drevnerusskaīa ikonopis'. Early Russian icon painting. Moscow, Iskusstvo, 1974. 331p. 203 col. plates.

Text and notes to plates in parallel Russian and English.

An authoritative survey, compiled and written by a renowned Soviet scholar. The introductory essay, p.6-[61], presents concisely the major problems of style and interpretation of early Russian icon paintings.

The plates section of 203 color reproductions of icons painted on single themes at different periods is divided into the following categories: (I) Russian and Byzantine icons; (II) Iconographical canon and artistic creativity; (III) 11th-12th-century icon painting (pre-Mongol period): Kiev, Vladimir, Novgorod; (IV) Icon painting of the period of the Mongol oppression; (V) Theophanes the Greek and his time; (VI) Andrei Rublev and his time; (VII) The iconostasis as an artistic ensemble; (VIII) 15th-century Novgorodian icon painting; (IX) Pskov; (X) 15th- 16th-century local schools; (XI) Dionysius and his time; (XII) First half of the 16th century; (XIII) Second half 16th and 17th century. The notes to the plates, p.291-[324], gives for each painting reproduced title or subject, origin, date, dimensions, present location, commentary, and bibliography.

List of plates, p.325-31.

M432 Benois, Aleksandr Nikolaevich. Istoriīa russkoī zhivopisi v XIX veke. S.-Petersburg, Znanie, 1902. 285p. il., plates.

Issued in parts, 1901-02.

An old standard history of 19th-century Russian painting. Follows the development of national traditions from the earliest Russian art through the introduction of foreign influences in the time of Peter the Great, and the gradual freedom from these influences. A significant part of the book deals with the painting associated with the publication *Mir iskusstva.* Bibliography, p.[275]-85.

M433 _____. The Russian school of painting, with an introduction by Christian Brinton. N.Y., Knopf, 1916. 199p. 32 plates.

Trans. by A. Yarmolinsky.

A popular introductory survey of Russian painting of the 18th and 19th centuries. No index, bibliography, or footnotes.

M434 Dvořáková, Vlasta. Gothic mural painting in Bohemia and Moravia, 1300-1378 [by] Vlasta Dvořáková [and others. Trans. from the Czech by Roberta Finlayson-Samsour and Iris Unwin]. London, N.Y., Oxford Univ. Pr., 1964. 160p. 198p. of il., 52 plates (part col.), map.

A series of 11 scholarly essays by Czech art historians on the iconography and stylistic development of 14th-century mural painting in Bohemia and Moravia. Includes a fully documented catalogue of extant paintings, with notes on restoration. Very well illustrated with overall views of decorative schemes, single works, and details.

Bibliography, p.153-60 (464 entries). Iconographical index.

M435 Farbman, Michael S., ed. Masterpieces of Russian painting . . . reproductions of Russian icons and frescoes from the XI to the XVIII centuries; text by A. I. Anisimov, Sir Martin Conway, Roger Fry, and Prof. Igor Grabar. London, Europa [1930]. 124p. il., 20 col. plates.

An illustrated record of the exhibition of Russian icons at the Victoria and Albert Museum, Nov. 1929.

Contents: (1) History of Russian icon painting, by Sir Martin Conway; (2) Russian icon painting from the West European point of view, by Roger Fry; (3) Russian icon painting: its bloom, over-refinement, and decay, by A. I Anisimov; (4) Scientific restoration of the historic works of art, by Igor Grabar; (5) Descriptions of icons and notes on iconography and style.

"Chief places in Russia where icons are preserved," p.[125]. Bibliography, p.[125].

M436 Felicetti-Liebenfels, Walter. Geschichte der russischen Ikonenmalerei in den Grundzügen dargestellt. Graz, Akademische Druck- und Verlagsanstalt, 1972. x, 361p. (p.214-340 plates). (Forschungen und Berichte des Kunsthistorischen Institutes der Universität Graz, 3)

A comprehensive, scholarly study of the major periods, artists, and techniques of Russian icon painting. Well illustrated with 384 illustrations.

Abkürzungen der Buchtitel, p.186. Anmerkungen, p.187-202. Verzeichnis der Abbildungen, p.203-11. Namen- und Ortsregister; Sachregister; Ikonographisches Register.

M437 Grabar, André. La peinture religieuse en Bulgarie; préface de Gabriel Millet. Paris, Geuthner, 1928. 396p. il., map, portfolio of 14p. and 64 plates. (Orient et Byzance, études d'art médiéval. 1)

A scholarly study of Bulgarian religious painting, based on the author's thesis at the Univ. of Strasbourg. Bibliography, p.[vii]-xvi. "Index des monuments," p.[363]-76. "Index iconographique," p.[377]-84.

The portfolio contains "Table explicative des planches," "Index des monuments," and "Index iconographique."

M438 Hamann-Mac Lean, Richard Heinrich Lauglan, and Hallensleben, Horst. Die Monumentalmalerei in

Serbien und Makedonien vom 11. bis zum 14. Jahrhundert. Giessen, Schmidt, 1963- . v.1, 3. il. (part col.), map, plans. (Osteuropastudien der Hochschulen des Landes Hessen. Reihe 2: Marburger Abhandlungen zur Geschichte und Kultur Osteuropas, Bd. 3, 5)

A scholarly study of the stylistic development and iconography of late Byzantine wall painting in Yugoslavia. v.1, the *Bildband*, is in two parts: (1) a collection of photographs of wall paintings dating from those of Saint Sophia at Ohrid (mid-11th century) to Dečani (1327-35); (2) a section of drawings which place paintings in their proper distribution within church decorative schemes. v.3, *Die Malerschule des Königs Milutin; Untersuchungen zum Werk einer byzantinischen Malerwerkstatt zu Beginn des 14. Jahrhunderts,* is a detailed study of the important atelier of painters who worked under the sponsorship of King Milutin.

M439 Kondakov, Nikodim Pavlovich. The Russian icon. Prague, Seminarium Kondakovianum, 1928-33. 4v. 216 plates (part col.)

An earlier standard work.

Contents: v.1-2, plates; v.3-4, text. v.1 contains 65 color plates with captions in French, German, English, Czech, and Russian; v.2 contains 136 black-and-white plates with descriptive text; v.3-4 have texts in Russian with French summaries and also include a few plates.

Bibliography, v.3, p.[xi-xx]. v.4 includes general and iconographical indexes in Russian only.

M440 ———. The Russian icon. Trans. by Ellis H. Minns. Oxford, Clarendon, 1927. 226p. il., map, 63 (i.e. 65) plates (3 col.) on 48 l.

An abbreviated English ed. of the author's larger work (M439).

"Inscriptions and lettering, names of saints etc." p.xxi-xiii. "Sketch map of Russia, table of Russian history," p.xxiv-xxvi. Bibliography, p.xix-xx, and bibliographical footnotes. General and iconographical indexes.

M441 Lazarev, Viktor Nikitich. Old Russian murals and mosaics from the XI to the XVI century. {Trans. from the original Russian manuscript by Boris Roniger and revised by Nancy Dunn. London] Phaidon [1966]. 290p. 176 il. (part col.), 89 figs.

A comprehensive survey of Russian murals and mosaics, written by a renowned authority. Includes photographs and discussions of works destroyed in World War II. "Notes to the text," p.213-24, give references to paintings discussed but not reproduced. "Descriptive notes on the murals and mosaics," p.225-69, give detailed descriptions of works reproduced, with references.

The bibliography, p.271-[77], includes a general section and references classified by location on 28 individual works and groups of works.

M442 Lukomskiĭ, Georgiĭ Kreskent'evich. History of modern Russian painting (Russian painting of the past hundred years) (1840-1940). Trans. from the Russian by G. K. London; N.Y., Hutchinson [1945]. 184p. plates.

A brief general survey. Appendixes: (I) Biographies: Short biographical details about the more outstanding Russian painters, p.57-63; (II) List of the names of 19th-20th-century painters (especially 1870-1920), p.64-66; (III) List of the names of painters of the 20th century (1920-45), p.67; (IV) List of the names of painters-foreigners, who worked in Russia in the 18th century until the beginning of the 19th century, p.68. Bibliography is mentioned in a note, p.14.

M443 Millet, Gabriel. La peinture du moyen âge en Yougoslavie (Serbie, Macédoine et Monténégro). Paris, Boccard, 1954-(69). Fasc. 1-(4). il., plates.

A series of volumes on the various periods and areas of Yugoslav medieval mural painting from the 11th to the 15th centuries. Each volume contains an introductory text, a list of monuments included, an iconographical index, and a section of plates which reproduce decorative schemes in church interiors, entire wall paintings, and details of wall paintings. Fascicles 1-3 issued in portfolio. To be complete in five fascicles.

Bibliographical footnotes included in introductory texts; bibliographies for each monument, or church, given in the lists of monuments.

M444 Moscow. Gosudarstvennaia Tret'iakovskaia gallereia. Katalog drevnerusskoĭ zhivopisi XI-nachala XVIII v.v; [opyt istoriko-khudozhestvennoi klasifikatsii. By V. I. Antonova & N. E. Mneva. Red. L. M. Tarasov] Moscow [Iskusstvo] 1963. 2v. il., plates (part col.)

Text in Russian.

The catalogue of 1,053 Russian icon paintings in the Tretyakov Gallery, Moscow. v.1 includes an historical summary of Russian icon painting and an overview of the gallery's holdings, by V. I. Antonova. The main text of both volumes is devoted to the catalogue, which is arranged chronologically by schools. Each entry gives full technical and critical descriptions. Diagrams of the original arrangement of paintings from dismembered iconostases are sometimes given. Includes bibliographies and bibliographical footnotes. Each volume has an iconographical index and a list of plates.

Contents: v.1, Catalogue nos. 1-341, XI-nachalo XVI veka (394p., 256 plates); v.2. Catalogue nos. 342-1053, XVI-nachalo XVIII veka (702 p., 179 plates).

M445 Muratov, Pavel Pavlovich. L'ancienne peinture russe. Traduction du manuscrit russe, par André Caffi. Rome, Stock, 1925. 181p. il.

A general survey of Russian painting to the beginning of the 17th century. Contents: (1) Introduction; (2) Les origines; (3) La peinture russe du XIe et du XIIe siècles; (4) Le XIIIe et le XIVe siècles; (5) De Roubliow à Denys; (6) La peinture russe au XVIe siècle; (7) La fin. Bibliographical footnotes.

M446 Okunev, Nikolai Aleksandrovich. Monumenta artis serbica. Prague, Institutum Slavicum, 1928-37. 4v. plates.

Contains introductory essays in Czech on Serbian painting from the 13th to the 15th centuries. All volumes have short texts followed by one color plate and four black-and-white plates. v.1 has parallel texts in French and German; v.2–4 have texts in French, German, and Russian.

M447   Onasch, Konrad. Icons. London, Faber and Faber [1963]. 423p. il., 151 col. plates.
Trans. by M. V. Herzfeld of *Ikonen,* Gutersloh, Mohn, 1961.

A comprehensive survey of Russian icon painting, ranging from the well-known *Our Lady of Vladimir* to obscure examples of 18th-century folk art. Incorporating recent research in the field, the author concentrates on the relationship of the icon with liturgy and hagiography. Very well illustrated.

Contents: Introduction, p.9–35; Synoptical table, p.36; Plates, p.[39]–[339]; Notes to the plates, p.341–[408]; Bibliography, p.409–13; List of icons, p.414–17; Name index, p.417–18; Word index, p.419–[24] (a glossary of terms and techniques).

M448   Schweinfurth, Philipp. Geschichte der russischen Malerei im Mittelalter. Mit 8 Lichtdrucktafeln und 169 Abbildungen. Haag, Nijhoff, 1930. 506p. 169 il., 8 plates.
A comprehensive study of medieval Russian painting, with special emphasis on the influence of Byzantine art on the development of the Russian styles.

Includes bibliographical footnotes. "Register," p.499–506. "Verzeichnis der Abbildungen," p.483–97, gives sources of photographs and titles and locations of paintings.

M449   Stefănescu, I. D. Contribution a l'étude des peintures murales valaques. (Transylvanie, district de Vâlcea, Târgoviste, et région de Bucarest.) Paris, Geuthner, 1928. 90p. 10 plates. (Orient et Byzance; études d'art médiéval. III)
A study of mural paintings from before the 17th century through the first third of the 19th century. Includes a chapter on paintings restored in the 19th century and destroyed paintings.

"Tableau chronologique des princes ayant régné en Valachie," p.75–76. "Bibliographie," p.77–78. "Index des monuments," p.79–80. "Index iconographique," p.81–86.

M450   _____. L'évolution de la peinture religieuse en Bucovine et en Moldavie; depuis les orignes jusqu'au XIXe siècle. Paris, Geuthner, 1928. 334p. il. and atlas of 8p. and 96 plates. (Orient et Byzance; études d'art médiéval. II)
University of Paris thesis. A scholarly study of religious painting in Bucovina and in Moldavia. "Bibliographie," p.[309]–11. "Index des monuments," p.313–14. "Index iconographique," p.315–22. "Table des planches," p.323–27. Plate volume contains "Index des monuments" and "Index iconographique."

M451   _____. L'évolution de la peinture religieuse en Bucovine et en Moldavie depuis les origines jusqu'au

XIXe siècle. Nouvelles recherches, étude iconographique. Paris, Geuthner, 1929. 192p. il., diagr. and atlas 8p. and 60 plates (2 col.) (Orient et Byzance; études d'art médiéval. VI)
Complements the author's previous work on the subject (M450), and takes into account evidence derived from the cleaning of paintings. "Bibliographie," p.[171]–72, includes references not in the earlier volume. "Tableau des monuments décorés de Moldavie," p.[173]. "Index des monuments," p.[175]–76. "Index iconographique," p.177–84, contains "Les monuments décorés" and "L'iconographie." The plate volume contains "Table des planches," "Index des monuments," and "Index iconographique."

M452   Stuart, John. Ikons. London, Faber and Faber [1975]. 176p. il. (part col.), 80p. of plates, map.
Not a comprehensive history but a scholarly study of various aspects of Russian icon painting, with concentration on the development of the local schools. Considerable attention is given to problems of technique.

Contents: (1) The spiritual dimension of the ikon; (2) The aesthetics of the ikon; (3) The writing of an ikon; (4) From the linear style of the 11th century to the paleologue style of the early 14th century; (5) The Byzantine heritage in Russia and Theophan the Greek; the 'Syzdal' tradition, Rublyov, and Dionisiy; (6) The ikon-painting of Novgorod; (7) The ikon-painting of Pskov; (8) Ikon-painting in North Russia; (9) Ikon-painting in 16th-century Muscovy; (10) The Cretan schools of ikon-painting; (11) Stroganov painting: the dominance of decorative elements circa 1580–1660; (12) The lure of naturalism: Russian ikon-painting after 1650; (13) Later abstract ikon-painting in Russia. Appendix: The ikon related to oil painting and engraving: metaphysical, sensual, and rational art forms.

Classified bibliography, p.155–70: (1) Iconography and technique; (2) Byzantine aesthetics and orthodox theology; (3) Historical background to the eastern Roman empire, modern Greece, and the Balkans; (4) Greek ikons; (5) Ikons of the Balkans; (6) Historical background to Russia; (7) Russian ikons.

SEE ALSO:  Amiranashvili, S. *Medieval Georgian enamels of Russia* (P450); Pisarskaja, L. V. [et. al.]. *Russkie emali XI–XIX* (P451).

## Scandinavia

M453   Been, Ch. A. Danmarks malerkunst, billeder og biografier...kapitlerne indledede af Emil Hannover. Kobenhavn, Nordiske forlag, 1902–03. 2v. in 1. il.
A survey in three chapters of Danish painting from the mid-18th century to the end of the 19th, followed by artists' biographies arranged chronologically. Well illustrated. "Inholdsfortegnelse" at the beginning of v.1 is an index of artists.

M454   Erdmann, Domenico. Norsk dekorativ maling fra reformasjonen til romantikken. Oslo, Dybwad, 1940. 323p. il.

A history of Norwegian decorative paintings from the Reformation to the romantic period. German summary, p.285-311. Bibliographical references in "Noter," p.312-18.

M455 Lindblom, Andreas Adolf Fredrik. La peinture gothique en Suède et en Norvège; étude sur les relations entre l'Europe occidentale et les pays scandinaves. Publ. par l'Académie Royale des Belles-lettres, d'Histoire et d'Archéologie de Stockholm. Stockholm, Wahlstrom & Widstrand; London, Quaritch, 1916. 252p. il., plans, 50 plates.
Trans. by Mlle. C. Harel. A study of Gothic painting in Sweden and Norway. Notes, p.234-43. "Index iconographique," p.245-48. "Index des localités des oeuvres d'art traités dans ce travail," p.249-52.

M456 Madsen, Herman. 200 danske malere og deres vaerker. København, Pioras, 1946. 2v. il.
A survey of Danish painting through the works of 200 painters. At the beginning of each volume is an alphabetical listing of the painters discussed in the 2v., followed by a chronological listing of the painters discussed in that particular volume. "Ordforklaring" (Glossary) at end of v.2, p.381-88.

M457 Madsen, Karl Johan Vilhelm, ed. Kunstens historie i Danmark. [København] Jacobsen, 1901-07. 430p. il.
A history of Danish painting from the Middle Ages to the 20th century. Contains seven sections, each of which is written by a specialist. Well illustrated.

M458 Nordisk målerkonst; det moderna måleriets genombrott. Författare: Preben Wilmann [et. al.; Stockholm] Ehlin [1951]. 95p. il., 40 col. plates.
A succinct, well-illustrated survey of modern painting in Scandinavia. Contents: Danmark, av P. Wilmann; Finland, av A. Lindström; Island, av B. T. Björnsson; Norge, av L. Østby; Sverige, av C. Derkert.
"Konstnärsregister" by L. Widding gives brief information on each artist. "De vanligaste konsttermerna" by L. Widding is a glossary of terms. The list of plates, p.[5-7], includes dates for each artist, and the sizes and locations of paintings reproduced.

M459 Østby, Leif. Modern Norwegian painting. Oslo, Mittet, 1949. 261p. 1 il. (p.41-167, col. plates).
A pictorial survey of modern Norwegian painting with an introductory text outlining movements and influences. Biographical notes, p.251-[59].

M460 Plahter, Leif Einar; Skaug, Erling; and Plahter, Unn. Gothic painted altar frontals from the Church of Tingelstad. Materials, technique, restoration. Oslo, Universitetsforlaget, 1974. 106p. il., 2 plates, diagrs. (Medieval art in Norway. v.1)
A detailed study of the conservation and restoration of three 13th-century altar frontals formerly in the church of Tingelstad, Hadeland, now in the Universitetets Oldsaksamling (University Museum of National Antiquities), Oslo. Although the work is written primarily for the conservator

and specialist, it is extremely important for the history of painting techniques and for the history of medieval painting in Scandinavia. The volume is the first in a series which is to include further scholarly studies in other fields of medieval art in Norway.
Contents: Section I. Tingelstad I. Madonna and Child and scenes from the life of St. Mary; Section II. Tingelstad II. The Passion of Christ; Section III. Tingelstad III. The legend of St. Egidius; Section IV. Conclusion; Section V. Analyses. Notes, p.101-2. List of illustrations, p.103-4. Bibliography, p.105. General index.

M461 Söderberg, Bengt G. Svenska kyrkomålningar från medeltiden. Stockholm, Natur och kultur [1951]. x, 282p. il., 168 plates (4 col.)
A survey of the most significant wall paintings wholly or partially preserved in churches in Sweden and dating from the beginning of the 12th century to the middle of the 17th century. Includes important chapters on major foreign influences on Swedish painting. Very well illustrated.
Contents: (I) Kyrkomålningar och pieteten; (II) Konstområden, stiftare och mästare; (III) Romanska stil; (IV) Romanska målningar; (V) Gotisk stil; (VI) Mäster Sigmunder och den sachsiska stilen. Från Dädesjö till Bringetofta; (VII) Arkitektonisk-ornamentala målarskolor 1250-1350; (VIII) Parisisk höggotik i Södra Råda och engelsk i Björsäter; (IX) Spridda strömningar i 1300-talets figurmåleri; (X) Fyra stora. Fogdö—Othem—V. Sallerup—Tensta; (XI) Vadstenaskolans upphov; (XII) Fromhetens målare och passionsexpressionisten. Risingemästaren—Passionsmästaren; (XIII) Målaren Nils Håkansson och hans krets; (XIV) Allmogemålaren Amund; (XV) Vadstenaskolan i Mälardalen; (XVI) Sengotisk stil; (XVII), Målaren Johannes Ivan; (XVIII) Målaren Peter; (XIX) Albertus Pictor; (XX) Till medeltidens slut; (XXI) Det danska Skåne.
Anmärkningar och litteraturhänvisningar, p.273-79, include bibliographical references. Iconographical index and index of persons.

M462 Stenstadvold, Håkon. Norske malerier gjennem hundre år. 3 revid. utg. With an English summary. [Oslo] Dreyer [1949]. 157p. 23 col. il., 55 col. plates.
1st ed. 1943.
A survey of Norwegian painting from the mid-19th century to the mid-20th.
English summary, p.151-55. Table of illustrations, p.156-57, gives dates of artists and of paintings reproduced. "Lesning om norsk kunst," p.146-47.

M463 Wennberg, Bo Göte. Svenska målare i Danmark under 1700-talet. Lund, Gleerup [1940]. 353p. 76 plates on 38 l.
"Utgivet med anslag från Längmanska kulturfonden." A scholarly study of Swedish artists who worked in Denmark. Includes catalogues of works of artists. "Källor och literatur," p.339-45. "Personregister," p.346-52.

M464 Wennervirta, Ludvig. Goottilaista monumentaalimaalausta Länsi-suomen ja Ahvenanmaan kirkoissa.

Helsinki [Puromiehen] 1930. 279p. il (Suomen mui-
naismiustoyhdistyksen aikakauskirja, XXXVIII:1)
A scholarly study of monumental Gothic painting in the
churches of West Finland and Åland.
"Kirjallisuutta," p.[272]-76. "Phyimyksiä" (Index), p.277.
"Die gotische Monumentalmalerei in den Kirchen von
Westfinnland and Åland," p.[243]-71 is a German summary
of the text.

M465 ———. Suomen keskiaikainen kirkkomaalaus. Por-
voo, Söderstrom [1937]. 258p. 135 il., 73 plates.
A scholarly study of painting in the medieval churches of
Finland. "Die mittelaltarliche Kirchenmalerei in Finnland,
übersetzt von Rita Öhquist," p.[223]-48 is a German summary
of the text.
"Chronologische Tabelle," p.247-48.

M466 Zahle, Erik, ed. Danmarks malerkunst fra middelalder
til nutid. [4th ed.] København, Hirschsprung, 1956.
350p. il. (part col.)
1st ed. 1937.
"Udgivet med tilskud fra Ny Carlsbergfondet." A general
survey of Danish painting from the Middle Ages to the
mid-20th century. Includes articles by Poul Nørlund, Otto
Andrup, Christian Elling, Leo Swane, Jørn Rubow, Henrik
Bramsen, Haavard Rostrup, Poul Uttenreitter, Erik Zahle,
and Svend Eriksen.
"Litteratur om dansk malerkunst" and "Danmarks offent-
lige malerisamlinger."

M467 Zibrandtsen, Jan. Moderne dansk maleri. With an
English version. [2. revid. udg.] København, Gylden-
dal, 1967. 416p. il., plates.
A comprehensive, well-illustrated survey of Danish painting
from the late 19th century to the 1960s. "English version,"
p.329-[95], is an English summary of the 11 chapters of text
in Danish.
Billedortegnelse, p.397-[404], lists reproductions by
painters alphabetically. Kunstnerregister, p.405-[8]. Littera-
turhenvisninger, p.409-[16], arranged by chapters.

## Spain and Portugal

For an authoritative survey of Spanish painting see the
volumes in the series *Ars Hispaniae* (I438). Those volumes
dealing exclusively, or primarily, with painting are: Angulo
Iñiguez, D. *Pintura del Renacimiento* (1954); ———. *Pintura
del siglo XVII* (1971); Cook, W. W. S., and Gudiol Ricart, J.
*Pintura e imaginería románicas* (1950); Domínguez Bordona,
J., and Ainaud, J. *Miniatura, grabado, encuadernación* (1962);
Gudiol Ricart, J. *Pintura gótica* (1955).

M468 Angulo Iñiquez, Diego, and Pérez Sánchez, Alfonso
E. Historia de la pintura española. Madrid, Consejo
Superior de Investigaciones Científicas, Instituto
Diego Velázquez, 1969-[72].
Contents: v.I. Escuela madrileña del primer tercio del siglo
XVII, 1969. 395p., 308 plates; v.II. Escuela toledana de la
primera mitad del siglo XVII, 1972. 399p., 308 plates.

The first 2v. of a very important new corpus of Spanish
painting, written by two outstanding scholars in the field.
These 2v., dealing with paintings from Madrid and Toledo
during the first third of the 17th century, initiate the ambitious
project of a complete repertory of Spanish paintings. Also
intended as a continuation of the monumental work of C. R.
Post (M481). Volumes on the paintings of the latter part of
the 16th century, a period not covered by Post, are scheduled
to appear next.
In each volume the material is alphabetically arranged
by artist. For each painter gives an authoritative discussion
of his life and style, a chronology of significant dates, and a
numbered list of his works. Full documentation, with size,
provenance, literature, etc.
Good illustrations of virtually all of the documented and
certain works. Full bibliographies. Topographical, icono-
graphic, and general indexes. A remarkable reference work.

M469 Bosque, A. de. Artistes italiens en Espagne du XIVme
siècle aux rois catholiques. Paris, Éditions du temps,
1965. 493p. il. (part mounted col.) (Panoramique, 8)
A unique study of the work of Italian artists in Spain and the
influence of Italian art on Spanish art from the 14th century
to the early 16th century. The historical background outlines
the links between the two countries. Excellent illustrations.
Scholarly notes at the end of each chapter; bibliography,
p.471-92.
Contents: (1) Liens entre l'Espagne et l'Italie, (2) Les
courants siennois et florentins en Espagne au XIVe et au
XVe siècles, (3) Les peintres du Cardinal Borgia, (4) Influ-
ences italiennes à Valence au début du XVIe siècle, (5) La
sculpture italienne en Espagne, (6) La sculpture italienne
de la Renaissance en Espagne.

M470 Bottineau, Yves. L'art de cour dans L'Espagne de
Philippe V, 1700-1746. Bordeaux, Féret [1961?]. 687p.
128 il., ports., maps, plans. (Bibliothèque de l'École
des Hautes Études Hispaniques, fasc. 29)
A brilliant, well-written account of art and cultural life in
the court of Spain during the first half of the 18th century.
Scholarly, based largely on research with sources and docu-
ments. List of sources and a full bibliography of older works,
published texts, and modern studies.

M471 Domínquez Bordona, Jesús. Spanish illumination.
Firenze, Pantheon [1929]. 2v. 160 plates (incl. facsims.)
(Repr.: N.Y., Hacker, 1970.)
v.1 covers Visigothic illumination through the 12th century
and Romanesque illumination in Catalonia; v.2 covers
Spanish miniature painting from the 13th through the 16th
century. List of manuscripts, v.2, p.73-77, arranged by
location. Bibliography, v.2, p.78-85. Alphabetical index,
v.2, p.87-100.

M472 Franca, José Augusto. A arte em Portugal no século
XIX. Lisboa, Bertrand [1966]. 2v. il., col. plates, plans,
ports.
An important study of 19th-century Portuguese painting.
Contents, v.1: Primeira parte (1780-1835) (O Neoclassi-
cismo); Segunda parte (1835-80) (O Romantismo). Índices:

Gravuras foro texto (a cores); Gravuras no texto. v.2: Terceira parte (1880–1910) (O Naturalismo); Quarta parte (depois de 1910). Notas (for both volumes), p.[367–452], include bibliographical references. Quadro cronológico, p.[453]–71. Índices: Onomástico; Gravuras foro do texto (a cores); Gravuras no texto. Detailed table of contents at end of both volumes.

M473  Gaya Nuño, Juan Antonio. La pintura española del siglo XX. [Madrid] Ibérico Europea [1970]. 437, [5]p. il. (part col.), ports. (part col.)

A panoramic survey of 20th-century Spanish painting—its chronology and general art historical development, with perceptive stylistic analyses of representative individual works. Written by a leading scholar. Well illustrated with several hundred figures, mostly in color. The illustrations are not numbered; there is no index. Bibliography, p.439–42. Alphabetical index of painters, but no general index.

M474  Gudiol y Cunill, Josep G. Els primitius. Barcelona, Babra, 1927–55. 3v. il., plates. (La pintura mig-eval catalana)

A good treatment of early medieval Catalan painting, profusely illustrated.

Contents: (1) Els pintors: la pintura mural; (2) La pintura sobra fusta; (3) Els llibres illuminats. "Notes documentals sobre els pintors primitius" v.1, p.57–84. Includes bibliographies. An alphabetical index and an index of illustrations at end of each volume. v.3 also has an index of manuscripts.

M475  Kuhn, Charles Louis. The Romanesque mural painting of Catalonia. Cambridge, Harvard Univ. Pr., 1930. xvi, [1], 102p. 63 plates, fold, map.

Still the basic work in English on Catalonian wall painting.

Pt.1 "contains a detailed study of the monuments and an attempt to establish a definite chronology for the more important ones. Those of less significance have been relegated to a separate chapter and are arranged in alphabetic order regardless of date. The second section contains a consideration of more general problems such as technique, iconography, origins of style and division of the paintings into stylistic and geographic groups"—*Pref.*

Map shows the geographic distribution of the frescoes. Bibliographical footnotes. Index, p.99–103.

M476  Lafuente Ferrari, Enrique. Breve historia de la pintura española. 4. ed., rev. y ampliada. Madrid, Tecnos, 1953. 657p. 248 plates (part col.)

1st ed., Madrid, Unión poligráfica, 1934.

Considered to be a good brief history of Spanish painting. Bibliography, arranged by chapters, p.[537]–56. At end: synoptical tables of Spanish painting and indexes of persons, places, and illustrations, p.611–52.

M477  Larco, Jorge. La pintura española moderna y contemporánea. Texto y selección gráfica de Jorge Larco. Prólogo de Juan Antonio Gaya Nuño. Madrid, Castilla [1964–65]. 3v. mounted col. il., 402 plates.

An art historical survey of Spanish painting in the 19th and 20th centuries, from Goya to Tapiès. Lavishly produced

with superb illustrations of paintings from collections throughout the world. Color plates in text volumes. No footnotes. Bibliography: v.3, p.[35]–[39]. Indexes of names and illustrations.

Contents: v.1. De Goya al impresionismo; v.2. De Nonell al informalismo; v.3. Repertorio gráfico (a corpus of 403 black-and-white plates).

M478  Lassigne, Jacques. Spanish painting. Trans. by Stuart Gilbert. [Geneva, N.Y.] Skira [1952]. 2v., 141 col. il., map. (Painting, colour, history, v.6,8.) (Repr.: N.Y., Skira/Rizzoli, 1977.)

An historical survey of Spanish painting, Romanesque to modern. Written by a well-known scholar. Biographical and bibliographical notices by A. Busuioceanu are at the end of each volume. Indexes of names. Good Skira color plates.

Contents: v.I, Introduction; Romanesque art in Spain; The primitives; The Renaissance; El Greco. v.II, Introduction; El Greco and his age; The spirit of Toledo; The world of Velasquez; Goya; Picasso.

M479  Mayer, August Liebmann. Historia de la pintura española. 2 ed. Madrid, Espasa-Calpe, 1942. 556p. il., plates (part col.)

Originally pub. in German. 1st ed. 1928. 3d ed. of 1947 has same paging as the 2d ed.

An old standard history of Spanish painting from the Romanesque period to the early 19th century. Bibliography, p.[541]–44. Index of artists, p.545–56.

M480  Moreno Galván, José Maria. The latest avant-garde. Trans. by Neville Hinton. Greenwich, Conn., New York Graphic Society [1972]. 273p. il. (color).

Trans. of *La última vanguardia.*

A study of Spanish painting since 1956, concentrating on "nonformalism," a term coined by the author. The excellent color plates alone can generate interest in the exciting new work from contemporary Spain. Useful biographical appendix, p.251–67. Short bibliography, p.275.

M481  Post, Chandler Rathfon. A history of Spanish painting. Cambridge, Mass., Harvard Univ. Pr., 1930–66. 14v. in 20. il., ports. (Repr.: Nendeln, Liechtenstein, Kraus, 1970–73.)

v.13–14 ed. by H. E. Wethey.

A monumental history of Spanish painting up to the later Renaissance in Castile. Contents: v.I, pt. 1, Pre-Romanesque style; pt. 2, The Romanesque style; v.II, pt. 3, The Franco-Gothic style; pt. 4, The Italo-Gothic and International styles; v.III, pt. 4 continued; v.IV, pt. 1–2, The Hispano-Flemish style in northwestern Spain; v.V, The Hispano-Flemish style in Andalusia; v.VI, pt. 1–2, The Valencian school in the late Middle Ages and early Renaissance; v.VII, pt. 1–2. The Catalan school in the late Middle Ages; v.VIII, pt. 1–2, The Aragonese school in the late Middle Ages; v.IX, pt. 1–2, The beginning of the Renaissance in Castile and Leon; v.X, The early Renaissance in Andalusia; v.XI, The Valencian school in the early Renaissance; v.XII, pt. 1–2, The Catalan school in the early Renaissance; v.XIII, The schools

337

of Aragon and Navarre in the early Renaissance; v.XIV, The later Renaissance in Castile.

Includes bibliographies. General bibliography at beginning of v.1 and additional ones before each index. Index for v.1-3 at end of v.3, subsequently one at end of each volume (not each part). Each index divided into names and places.

M481a Rodríguez-Moñino, Antonio. Los pintores badajoceños del siglo XVI: noticias documentos. Badajoz, 1956. 160p. il.
Notes and documents relating to 16th-century painters of Badajoz province.

M482 Schlunk, Helmut, and Berenguer, Magin. La pintura mural asturiana de los siglos IX y X. Traducido del alemán por María de los Angeles Vázquez de Parga. Madrid, Sanchez Cuesta, 1957. xxii, 188p. il., plans, 50 plates (33 col.)
An erudite work on the pre-Romanesque mural paintings in six Asturian churches noted for their overall "painted architecture" and rich ornamental patterns. Written by the foremost scholar for this period of Spanish art. For each gives a summary of the architecture of the church, a description of the paintings, and a discussion of antecedents and style. Bibliographical footnotes. Indexes of persons, places, ornamental motifs; Plans and drawings in text, plates. German summary, p.173-81. General index.

## Switzerland

M483 Bovy, Adrien. La peinture suisse de 1600 à 1900. Bâle, Birkhaeuser, 1948. 194p. il. (part col.) (Art suisse: collection de dix monographies, t.4)
A brief, general survey of Swiss painting.
"Bibliographie sommaire," p.182. "Index des noms d'artistics," p.183-89. "Table des illustrations," p.190-93.

M484 Deuchler, Florens; Roethlisberger, Marcel; and Lüthy, Hans. La peinture suisse du moyen âge à l'aube du XXe siècle. [Genève] Skira [1975]. 199p. il. (part col.)
A beautifully illustrated survey of Swiss painting from the Middle Ages to the beginning of the 20th century, written by three authorities. Contents: Deuchler, F. Art suisse ou art en suisse?—Les débuts de la peinture; Roethlisberger, M. L'affirmation de l'art suisse—XVe siècle et renaissance; Roethlisberger, M. De l'ère baroque au siècle des lumières; Lüthy, H. Conscience et sentiment d'une patrie de la fin du XVIIIe à l'aube du XXe siècle.
Classified bibliography, p.183-[85] (general; by chapter and individual painters). Index of names and places, p.187-[92]. List of illustrations, p.193-[99].

M485 Ganz, Paul. La peinture suisse avant la renaissance. Trans. par Paul Budry. Paris, Budry, 1925. 156p. il., 120 plates.
French ed. of 300 copies. German ed.: Zürich, Berichthaus, 1924.

A survey of Swiss painting before the Renaissance. Each plate is preceded by a sheet giving a brief description, the dimensions, and location of the painting reproduced.
Contents: Table et sommaire des chapitres, p.xi-xii; Table des planches, p.xiii-xvii; Table des illustrations, p.xvii-xxiii; Index des noms et des lieux cités, p.xix-xxiii; Remarques et appendices, p.[149]-56, are bibliographical footnotes.

M486 Neuweiler, Arnold. La peinture à Genève de 1700 à 1900. Genève, Jullien [1945]. 9-233p. il.
Edition of 500 copies.
Introduction, "La peinture genevoise," by Adrien Bovy. A survey of Genevan painting from Jean Petit to the beginning of the 20th century.
"Répertoire général des artistes genevois ou ayant séjourné à Genève (peintres, dessinateurs, miniaturistes, peintres sur émail) nés avant 1881," p.155-200. "L'enseignement des beaux-arts à Genève—Un résumé chronologique de l'histoire des écoles d'art à Genève depuis le XVIIIe siècle, suivi d'une liste complète des professeurs ayant enseigné dans des écoles"; "La liste complète des lauréats des concours de la Société des Arts"; "Quelques renseignements sur les fausses attributions."
"Bibliographie sommaire," p.230. "Index et abréviations," p.231. "Index des illustrations" p.232-33.

SEE ALSO:   Schmied, W. *Malerei nach 1945 in Deutschland, Österreich und der Schweiz* (M236); Stange, A. *Kritisches Verzeichnis der deutschen Tafelbilder vor Dürer* (M239).

## United States

### Bibliography

M487 Keaveney, Sydney Starr. American painting; a guide to information sources. Detroit, Gale [1974]. xiii, 260p. (Art and architecture information guide series, v.5)
A classified, fully annotated bibliography of American painting. Concentrates on reliable, recent literature. Includes a few exhibition catalogues and periodical articles. Omits illustrators, cartoonists, and artists who worked predominately in a medium other than painting. Bibliographies are noted.
Contents: (1) General reference sources—Bibliographies and library catalogs, Indexes and directories, Biographical dictionaries and indexes, Dictionaries and encyclopedias; (2) General histories and surveys of American painting; (3) Early painting in America: Colonial painting; (4) 19th-century American painting; (5) Modern painting: the 20th century; (6) Individual artists; (7) Sources: Early writings on American art; (8) Periodicals; (9) Major publishers of books on American painting; (10) Some important library research collections for the study of American painting; (11) National art organizations relating to the field of American painting; (12) Museums with important collections of American paintings.

## Histories and Handbooks

M488 Ashton, Dore. The New York School; a cultural reckoning. N.Y., Viking [1973]. x, 246p. 52 il.
English ed. pub. under title: *The life and times of the New York School: American painting in the twentieth century.* London, Adams and Dart, 1972.

A survey of the development of Abstract Expressionism as the predominant collective force of American art from the Depression to the mid-1950s. The emphasis is on the theoretical background, critical reception, and social milieu of the movement rather than on stylistic development. References at the end are notes by chapter.

M489 Barker, Virgil. American painting, history and interpretation. N.Y., Macmillan, 1950. 717p. il.
A basic introductory survey of American painting, now somewhat superseded by more recent writings.
Bibliographical references in Notes, p.669-92. Index, p.639-717, includes "Owners of the paintings mentioned in this book," p.714-17.

M490 Belknap, Waldron Phoenix. American colonial painting: materials for a history. Cambridge, Mass., Belknap Press of Harvard Univ. Pr., 1959. xxi, 377p. il., plates.
Prepared for publication by Charles Coleman Sellers.

The scholarly materials and fragments of a proposed history of the beginnings and early development of American painting. Includes previously published articles and unpublished research, incomplete at the time of the author's death. Especially important are Belknap's writings on the painters Feke and Smibert and his research on the relationships between English mezzotint portraits and American portrait paintings.
Contents: (I) The identity of Robert Feke; (II) Problems of identification in 17th- and 18th-century portraiture; (III) New York painters and patrons: The genealogical approach; (IV) Painters and craftsmen; (V) Notes on colonial portraits; (VI) The discovery of the English mezzotint as prototype of American colonial portraiture; (VII) New York portraits. Catalogue of prints and paintings, p.279-322. Bibliographical footnotes.

M491 Black, Mary, and Lipman, Jean. American folk painting. N.Y., Potter [1966]. xxiv, 244p. 215 il. (part col.)
A pictorial survey of American folk painting from the colonial period through the first half of the 20th century. "The purpose of this book is to present the folk artist as he appeared in his time and place and as his work is appraised today."—*Introd.*
Bibliography, p.233-40.

M492 Bolton, Theodore. Early American portrait painters in miniature. N.Y., Sherman, 1921. x, 180p.
A biographical dictionary of American portrait miniaturists. "The present volume lists as many of the portrait painters in miniature, both native Americans and foreign painters working in America, from the earliest times until 1850, as it has been possible to enumerate. It includes not only ivory miniatures but small portraits in oil and water color as well."—*Pref.*

M493 Born, Wolfgang. American landscape painting; an interpretation. New Haven, Yale Univ. Pr., 1948. 228p. il. (Repr.: Westport, Conn., Greenwood, 1970.)
An historical interpretation of the development of landscape painting in America, written as "a history of ideas rather than a biographical account of a school of painters."—*p.2.*
Contents: (I) The European heritage; (II) Sentiment of nature; (III) The panoramic style; (IV) With fresh eyes; (V) Painters of tone and light; (VI) Toward a technocratic landscape.
Bibliographical references included in Notes, p.[217]-21. List of illustrations, p.[vii]-xiii gives dimensions of paintings.

M494 Boston. Museum of Fine Arts. American paintings in the Museum of Fine Arts, Boston. [Catalogue, by Barbara Neville Parker and Arianwen Howard]. Boston, Museum of Fine Arts. (Distributed by New York Graphic Society, Greenwich, Conn., 1969]. 2v. plates.
A catalogue of 1,049 American paintings in the Boston Museum of Fine Arts, especially important for its collection of early American paintings (including 60 works by Copley, about 50 by Stuart, and 15 by Allston). "Presents an historical and harmonious stylistic panorama of American painting from the late 17th century to the middle of the 20th century."—*p.xi.* Includes 334 paintings in the Karolik Collection, 233 of which were previously published in greater detail in *M. and M. Karolik Collection of American paintings, 1815-1865* (M495). The catalogue (v.1) is arranged alphabetically by artist. Paintings within each artist's oeuvre are arranged chronologically. The 613 paintings reproduced in v.2 are arranged chronologically by date of painting. Each entry gives biographical data, title of painting, description, medium, dimensions, signature and/or inscriptions, previous collections, purchase funds, references, exhibitions, and reproductions.
Paintings in the collection not in the catalogue, p.292-96. Indexes: Titles of paintings; Collections.

M495 _____. _____. M. and M. Karolik Collection. M. and M. Karolik Collection of American paintings, 1815 to 1865. Cambridge, Pub. for the Museum of Fine Arts, Boston [by] Harvard Univ. Pr., 1949. lx, 544p. 233 il.
A catalogue of 233 American paintings dating from 1815-65 in the Karolik Collection, the second major gift presented to the Boston Museum of Fine Arts by the Karoliks (see also I471). An important reference work which also provides a survey of American painting for the period. The catalogue is arranged alphabetically by artist. Paintings within an artist's oeuvre are arranged chronologically. All paintings are reproduced. Biographies are given for each artist, some of which are of considerable length when information was not more fully available elsewhere. Each entry includes technical and documentary data, and topographical, historical, and biographical references. Preliminary drawings are sometimes reproduced. "Trends in American painting 1815-1865," by John I. H. Baur, p.xv-lvii, is an excellent brief survey.

Appendixes: (1) Artists represented in the collection in order of date of birth; (2) Artists mentioned other than those represented in the collection; (3) Dated pictures in order of date; (4) Places, portraits, and subjects represented in the collection; (5) Former private owners of pictures in the collection.

The 233 paintings are also catalogued in somewhat abbreviated form in *American paintings in the Museum of Fine Arts, Boston* (M494).

M496 Boyle, Richard J. American Impressionism. Boston, New York Graphic Society, 1974. 240p. 175 il., 46 col. plates.

The most comprehensive, if not definitive, treatment of American Impressionist painting. In addition to giving a survey of the movement's development in America and defining the American contribution to the style, the author investigates the particular influences and precedents of French painting. Very well illustrated.

Bibliography, p.233–36.

M497 Brown, Milton W. American painting, from the Armory Show to the Depression. Princeton, Princeton Univ. Pr., 1955. xii, 243p. il.

Reissued 1970.

An important study of American painting from the Armory Show of 1913 to the beginning of the Depression in 1929. "This study is concerned with the origins, nature and development of modern art movements in this country and their interaction with the already established tradition of realism. It is concerned not only with this struggle of styles but also with the relationship of these artistic developments to the changing social conditions which determined them."— *Introd.*

Contents: Revolt; The Armory Show; Interlude; Post War; Modernism; Compromise; Realism. Footnotes, p.197–99, include bibliographical references. Extensive classified bibliography, p.201–37, arranged chronologically within categories.

M498 Burroughs, Alan. Limners and likenesses; three centuries of American painting. Cambridge, Harvard Univ. Pr., 1936. 246p. plates, ports. (Harvard-Radcliffe fine arts series) (Repr.: N.Y., Russell and Russell, 1965.)

An attempt to define the national characteristics and qualities of American painting through its development from the 17th century to the 20th. Illustrated with 192 black-and-white reproductions of works.

Bibliography, p.[223]–26, and in Notes.

M499 Frankenstein, Alfred. After the Hunt: William Harnett and other American still life painters, 1870–1900. Rev. ed. Berkeley, Univ. of California Pr., 1969. xvi, 200p. 137 il. (1 col.) (California studies in the history of art. 12)

1st ed. 1953.

A detailed study of the *trompe l'oeil* style of late 19th-century painting in America, and a major contribution to scholarship in American art.

Contents: The problem and its solution; Still life with mug, pipe, and antique vase. William Harnett; Arbitrary juxtaposition, unrelated objects. John Frederick Peto; Entirely with the brush and with the naked eye. John Haberle; The second circle; The third circle; William Michael Harnett: A critical catalogue; List of owners: Genuine Harnetts.

Bibliographical footnotes.

M500 Gerdts, William H., and Burke, Russell. American still-life painting. N.Y., Praeger [1971]. 263p. il. (part col.)

A comprehensive survey of still-life painting in America, most noteworthy for its wealth of facts and names which provides a rich source for further research. Despite the lack of definition of individual painters' achievements, the work is exemplary for reviving forgotten artists and their paintings and for providing references to obscure and scattered materials.

Contents: (1) Antecedents and beginnings; (2) The Peale dynasty; (3) Other early 19th-century still life; (4) Non-professional still life: (5) The flood tide at mid-century; (6) 19th-century flower painters; (7) Still life by landscape painters and other specialists; (8) The influence of Ruskin and the Pre-Raphaelites on American still life; (9) Fish and game still life; (10) Trompe l'oeil: William Michael Harnett and his followers; (11) "Hard edge" fruit and vegetable painters; (12) Some regional still-life schools: Fall River, Providence, Springfield; (13) Still life by poets and visionaries of the late 19th century; (14) The influence of Munich and Paris; (15) Still life by the American Impressionists; (16) 20th-century still life.

The extensive Notes, p.237–55, include numerous bibliographical references. Bibliography, p.257–59.

M501 Isham, Samuel. The history of American painting ... with 12 full-page photogravures and 121 illustrations in the text. New ed. with supplemental chapters by Royal Cortissoz. N.Y., Macmillan, 1927. 608p., incl. plates.

Originally pub. in 1905 as v.3 of *The history of American art,* ed. by J. C. Van Dyke.

A pioneering work, long considered the standard work, now largely superseded by more recent studies.

Bibliography, compiled by Henry Meier, p.593–600. Index of painters' names, p.601–5. Index to supplementary chapters (p.561–592), p.607–8.

M502 Lipman, Jean, and Winchester, Alice, comps. Primitive painters in America, 1750-1950; an anthology. N.Y., Dodd, 1950. 182p. il. (part col.) (Repr.: Freeport, N.Y., Books for Libraries, 1971.)

An anthology of essays by ten authors, most of which are devoted to a single artist. Contents: (I) Winchester, Alice. Why American primitives?; (II) Little, Nina Fletcher. Primitive painters of the 18th century; (III) Lipman, Jean. Eunice Pinney; (IV) Dods, Agnes M. Ruth Henshaw Bascom; (V) Bye, Arthur Edwin. Edward Hicks; (VI) Lipman, Jean. Mary Ann Willson; (VII) _____. Rufus Porter; (VIII) Sherman, Frederic Fairchild. James Sanford Ellsworth; (IX) Robinson, Frederick B. Erastus Salisbury Field; (X) Little,

Nina Fletcher. William Matthew Prior; (XI) Lipman, Jean. Deborah Goldsmith; (XII) Spinney, Frank O. Joseph H. Davis; (XIII) Little, Nina Fletcher. Thomas Chambers; (XIV) Clarke, John Lee, Jr. Joseph Whiting Stock; (XV) Sniffen, Harold S. James and John Bard; (XVI) Lipman, Jean. Joseph H. Hidley; (XVII) Jacobson, Margaret E. Olaf Krans; (XVIII) Lipman, Jean. Paul Seifert; (XIX) Janis, Sidney. 20th-century primitives; (XX) Lipman, Jean. Record of primitive painters (a list of American primitive painters which gives the painter's name, working location, date, subject or type of work, and medium).

M503 Little, Nina Fletcher. American decorative wall painting, 1700-1850. Sturbridge Village, in cooperation with Studio Publications, N.Y., 1952. 145p. il. (part col.)

Paperback ed.: N.Y., Dutton, 1972.

An important study of the various techniques and styles of American wall painting, primarily in New England. In two parts: (I) Painted woodwork; (II) Painted plaster walls. Very well illustrated with photographs of paintings *in situ,* reproductions of easel paintings showing painted walls, and details of wall paintings.

Appendixes: Biographical lists of panel, chimneyboard, and wall painters; Checklist of pictorial panels; Selective bibliography (classified), p.138-40.

M504 Neumeyer, Alfred. Geschichte der amerikanischen Malerei: von der kolonialen Frühzeit bis zur naiven Malerei im 18. und 19. Jahrhundert. München, Prestel [1974]. 310p. 164 plates (14 col.)

"Forschungsunternehmen der Fritz Thyssen Stiftung, Arbeitskreis Kunstgeschichte. Sonderband."

A scholarly study of early American painting from the colonial period through the naïve painting of the 18th and 19th centuries. Contents: (I) Die Kunst der kolonialen Frühzeit; (II) Maler und Gemalte in der Frühzeit; (III) Malerei als Handwerk; (IV) Copley, "The most elegant art of painting"; (V) Benjamin West, der Maler des Erhabenen; (VI) Die Eroberung des sichtbaren Gegenstandes. Von Ralph Earl bis John Trumbull; (VII) Naive Malerei im 18. und 19. Jahrhundert. Bibliographical references in Anmerkungen, p.148-68. Bibliography, p.169-73.

M505 New York. Metropolitan Museum of Art. American paintings, a catalogue of the collection [by] Albert Ten Eyck Gardner [and] Stuart P. Feld. [New York, 1965]. v.1- . il.

A catalogue of more than 1,250 American paintings by approx. 625 artists in the collection of the Metropolitan Museum of Art. v.1 of a projected 3v. catalogue. Includes only oil paintings by artists born by 1875. The catalogue is arranged chronologically by birth date of painters; works within a painter's oeuvre are arranged chronologically. Almost all paintings are reproduced and discussed individually. Entries give biographical, historical, and documentary data; problems of attribution, style, date, and references are often included. Contents, p.v-vi, is a list of painters in the catalogue. Unattributed works are listed in their approximate chronological positions. General index, p.287-92.

M506 Novak, Barbara J. American painting of the nineteenth century; realism, idealism and the American experience. N.Y., Praeger [1969]. 350p. il. (part col.)

A brilliant work which constitutes a major contribution to the field of American art studies.

"This volume has two main purposes. First it is an attempt to isolate more specifically certain characteristics in American art that we can with some degree of confidence denote as American.... The second purpose is didactic. ...My aim has been to provide an intermediary literature of intensive essays on some of the key figures, and I have deliberately omitted many interesting artists."—*Pref.*

Contents: (1) Prolegomena to the 19th century; (2) Washington Allston; (3) Thomas Cole; (4) Asher B. Durand; (5) Luminism; (6) Fitz Hugh Lane; (7) Martin Johnson Heade; (8) William Sidney Mount; (9) George Caleb Bingham; (10) Winslow Homer; (11) Thomas Eakins; (12) Albert Pinkham Ryder; (13) William Harnett; (14) The painterly mode in America; (15) Epilogue.

"Brief biographies of eighteenth- and nineteenth-century artists," p.319-34, are biographical sketches of 48 American artists, with bibliographies for each. Classified bibliography, p.335-39.

M507 Park, Esther Ailleen. Mural painters in America. Part I. A biographical index. Pittsburg, Kansas State Teachers College, 1949-

"Period covered is from 1800 through June 1947, with references to some 259 books, to 178 magazine titles (over 500 volumes) and to 1,544 artists."—*Pref.* Includes artists who painted one or more murals in the U.S.

The Biographical index, p.19-182, gives for each artist listed life dates, references in books and periodicals, and reproductions in periodicals. Part II, which was to have been a geographical index, has not been published.

M508 Richardson, Edgar Preston. Painting in America, from 1502 to the present. N.Y., Crowell [1965]. 456p. il. (part col.)

The basic textbook survey of painting in America from the artist-explorers of the 16th century to the post-World War II Abstract Expressionists. Bibliography, p.425-35.

A rev. and updated ed. of the author's *Painting in America; the story of 450 years,* N.Y., Crowell [.1956]. An abridged ed. with a new concluding chapter published as *A short history of painting in America; the story of 450 years,* N.Y., Crowell [1963].

M509 Sandler, Irving. The New York school; the painters and sculptors of the fifties. N.Y., Harper [1978]. xi, 366p. 225 il., 8 col. plates.

A sequel to the author's *The triumph of American painting; a history of Abstract Expressionism* (M510). Takes as its primary point of departure the "second-generation" gesture painters, whose work followed "in the vein of de Kooning, Hofmann, Kline, and Guston. "—*Introd.*

Contents: (1) The milieu of the New York school in the early fifties; (2) The community of the New York school; (3) The colonization of gesture painting; (4) Frankenthaler, Mitchell, Leslie, Resnick, Francis, and other gesture painters;

(5) Gestural realism; (6) Rivers, Hartigan, Goodnough, Müller, Johnson, Porter, Katz, Pearlstein, and other gestural realists; (7) Assemblage: Stankiewicz, Chamberlain, Di Suvero, and other junk sculptors; (8) The Duchamp–Cage aesthetic; (9) Rauschenberg and Johns; (10) Environments and happenings: Kaprow, Grooms, Oldenburg, Dine, and Whitman; (11) Hard-edge and stained color–field abstractions, and other non-gestural styles: Kelly, Smith, Louis, Noland, Parker, Held, and others; (12) The recognition of the second generation; (13) The new academy; (14) Circa 1960: a change in sensibility. Appendixes: (A) First-generation painters, dates and places of birth; (B) Second-generation artists, dates and places of birth, art education, and one-person shows in New York, 1950-1960.

Bibliography (books, exhibition catalogues, periodicals), p.326-44.

M510 _____. The triumph of American painting; a history of Abstract Expressionism. N.Y., Praeger [1970]. xv, 301p. il., 24 col. plates.

The first critical history of the Abstract Expressionist school of New York painters. Based largely on conversations and interviews with the leading artists, as well as on documents, statements, public letters, records, symposia, and lectures. "This book focuses on the milieu in which the Abstract Expressionists flourished from roughly 1942 to 1952; their ideas and how they developed; and on a close analysis of the works of fifteen artists, who were singled out for discussion in depth because they had evolved distinctive styles by 1952 and because they had been generally recognized by their fellow artists as significant."—*Introd.*

Contents: Introduction; (1) The great Depression; (2) The imagination of disaster; (3) Arshile Gorky; (4) The myth-makers; (5) William Baziotes; (6) A new vanguard emerges; (7) The gesture painters; (8) Jackson Pollock; (9) Willem de Kooning; (10) Hans Hofmann; (11) The color-field painters; (12) Clyfford Still; (13) Mark Rothko; (14) Barnett Newman; (15) Adolph Gottlieb; (16) Robert Motherwell; (17) The Abstract Expressionist underground surfaces; (18) Ad Reinhardt; (19) The later gesture painters; (20) The Abstract Expressionist scene, 1950-52: Success and dissolution.

Biographies, p.277-80, include biographical data and lists of one-man shows for 15 artists. Classified bibliography, p.281-98: General bibliography (books, articles, exhibition catalogues); Bibliography by artist (statements, books, articles, exhibition catalogues). General index.

M511 Smithsonian Institution. National Collection of Fine Arts. Directory to the Bicentennial inventory of American paintings executed before 1914. N.Y., Arno, 1976. 211p.

A reference guide to the inventory of pre-1914 American paintings comp. at the National Collection of Fine Arts. Gives "the most exhaustive listing yet published of identified American artists active into the 20th century and of institutional collections with holdings in American art."—*ARLIS/NA newsletter,* April 1977, p.104.

Indexes of artists, collections, subjects. "Sources," p.[197]-211, include survey sponsors, individual contributors, and bibliography.

M512 Williams, Hermann Warner. Mirror to the American past; a survey of American genre painting: 1750-1900. Greenwich, Conn., New York Graphic Society [1973]. 248p. il. (part col.)

"This study is not presented as a definitive history of genre painting in America. A selective survey of our genre painting from its genesis late in the eighteenth century up to the close of the nineteenth century, it brings together in roughly chronological order many—by no means all—of the practitioners of this form of painting."—*Pref.* The works of almost 150 artists are discussed in a broad survey which touches on the various problems and meanings of genre painting, a neglected field of American art.

Very well illustrated, often with reproductions of little-known works. Valuable for its extensive bibliography by Alice Farley Williams, p.229-40, and for references to obscure material in the "Notes," p.241-44.

M513 Wilmerding, John. A history of American marine painting. [Salem, Mass.] Peabody Museum of Salem, Mass.; Boston, Little [1968]. xxiii, 279p. 186 plates (18 col.)

The first comprehensive study of marine painting in the U.S. If not superseded, will most likely be expanded and revised. Valuable as well as a guide to further research in several areas of American painting.

Contents: (I) The contribution of portrait painting; (II) The folk art tradition; (III) The contribution of history painting; (IV) The Hudson River School: First generation; (V) The Hudson River School: Second generation; (VI) The inheritance of French romantic painting; (VII) The Dutch marine tradition; (VIII) English-American artists; (IX) Independents; (X) The establishing of a style; (XI) The style established; (XII) Wind, sail, and steam; (XIII) The great age; (XIV) Toward new directions.

Bibliography and notes, p.257-68.

# ORIENTAL COUNTRIES

M514 Fontein, Jan, and Hickman, Money L. Zen painting & calligraphy; an exhibition of works of art lent by temples, private collectors, and public and private museums in Japan, organized in collaboration with the Agency for Cultural Affairs of the Japanese government. Boston, Museum of Fine Arts. (Distr. by New York Graphic Society, Greenwich, Conn. [1970]). liv, 173p. il. (part col.)

The catalogue of an exhibition held at the Boston Museum of Fine Arts in 1970.

The 71 works in the exhibition were selected "to show the broad scope and distinctive characteristics of Ch'an art in China and Zen art in Japan," with a "wide range of works dating from the Sung and Yüan periods in China and the Kamakura, Muromachi, and later periods in Japan, including *chinso* portraits; paintings of patriarchs and eccentrics, of landscapes, birds, animals, and plants; and calligraphy by eminent monks."—*Foreword.* The catalogue, p.1-167, con-

tains 71 entries with detailed descriptions and commentaries.

Chronology, p.xii; Introduction, p.xiii–liv; Glossary, p.169. Index.

M515  Martin, Fredrik Robert. The miniature painting and painters of Persia, India, and Turkey, from the 8th to 18th century. London, Quaritch, 1912. 2v. il., 275 plates (4 col.) (Repr.: London, Holland, 1971.)

v.1 contains the text which describes various schools, techniques, etc.; a list of painters, p.111–36, arranged chronologically, with some works; and a synchronological chart giving names and dates of prominent artists (in parallel columns: Europe, Egypt, Persia, Transoxiana, India, China). v.2 contains the plates.

Bibliography, v.1, p.143–44. Index, v.1, p.[149]–56, also includes names of artists.

## Central Asia

M516  Andrews, Frederick Henry. Wall paintings from ancient shrines in Central Asia; recovered by Sir Aurel Stein; described by Fred H. Andrews. Pub. under the orders of the Government of India. London, Oxford Univ. Pr., 1948. 128p. il., map, plans, portfolio of 32 plates (part col.)

An important collection of reproductions of wall paintings of Central Asia. Index, p.113–28.

M517  Bussagli, Mario. Painting of Central Asia. [Trans. from the Italian by Lothian Small] [Geneva] Skira [1963]. 135p. col. il., map.

An authoritative survey of the tradition of painting in Central Asia from the early centuries of Christianity through the 10th century. An introductory chapter is followed by six chapters which discuss various specific aspects: (1) The beginning of painting in Central Asia, Mirān; (2) The aesthetics of light; (3) Pjandžikent and the influence of Sogdiana; (4) The school of Khotan; (5) The main centres on the northern caravan route; (6) The Turfān group.

Bibliography, p.127–28, arranged chronologically by date of publication. Includes Oriental language and Soviet references.

M518  Tucci, Giuseppe. Tibetan painted scrolls. Roma, Libreria dello Stato, 1949. 2v. xv, 798p. il., portfolio (256 plates [part col.])

Trans. from the Italian by Virginia Vacca.

A classic study of the painted scrolls of Tibet. Contents: pt. 1, Historical, cultural, and religious background; pt. 2, Evolution and character of Tibetan tankas; pt. 3, Description and explanation of the tankas; pt. 4, Sources and documents.

Genealogical tables, p.706–8. Tibetan texts, p.745–63.

## China

### Bibliography

M519  Laing, Ellen Mae Johnston. Chinese paintings in Chinese publications, 1956–1968; an annotated bibliography and an index to the paintings. [Ann Arbor, Univ. of Michigan, Center for Chinese Studies] 1969. ii, 308p. (Michigan papers in Chinese studies, 6)

An annotated bibliography of books published between 1956 and 1968 which contain reproductions of Chinese paintings in Chinese public or private collections and a detailed index to the paintings reproduced. Continues Sirén's "Annotated lists of paintings and reproductions of paintings by Chinese artists" in *Chinese painting: leading masters and principles* (M548). The index, following Sirén's scheme, is arranged by dynasty, then alphabetically by artist.

M520  Lovell, Hin-cheung. An annotated bibliography of Chinese painting and related texts. Ann Arbor, Univ. of Michigan, 1973. 141p. (Michigan papers in Chinese studies, no. 16)

A critical review and evaluation of the 108 titles in John C. Ferguson's *Li-tai chu-lu hua mua* (Catalogue of the recorded paintings of successive dynasties), Nanking, Univ. of Nanking, 1934, with a supplement of 22 additional texts. Entries are arranged chronologically as far as possible by compilation date. Includes for each entry the name of the compiler; the title of the text; compilation date whenever possible; the number of *chüan* in the text; a cross-reference to the numbering system used by Ferguson; and citation of most recent, accessible edition. An invaluable reference work for the serious student and scholar of Chinese painting.

Index of names and Index of titles.

### Histories and Handbooks

M521  Boston. Museum of Fine Arts. Portfolio of Chinese paintings; Yüan to Ch'ing periods. [With a descriptive text by Kojiro Tomita and Hsien-Chi Tseng]. Boston, Museum of Fine Arts, 1961. 1 1., 178 plates (part col.)

A sequel to *Portfolio of Chinese paintings (Han to Sung periods)* (M522). Descriptive text in English and Chinese issued in two pamphlets. Translations of inscriptions included in descriptions.

M522  _____. _____. Portfolio of paintings in the Museum (Han to Sung periods); [with] a descriptive text by Kojiro Tomita. Cambridge, Mass., pub. for the Museum of Fine Arts, Boston, by Harvard Univ. Pr., 1933. 20p. 144 plates.

A compendium of large, excellent plates reproducing paintings in the museum's collection. Full descriptions for each plate, in English and Chinese.

M523  Cahill, James. Chinese painting. [Geneva] Skira [1960]. 211p. col. il. (Repr.: N.Y., Skira/Rizzoli, 1977.)

Excellent color illustrations; authoritative text. "The text . . . presents the paintings against a background of the aesthetic and critical ideas current in their respective periods and schools, and so is intended as an aid to such understanding."—*Author's pref.*

Selected bibliography, p.199–[200].

343

M524 _____. Chinese painting, XI–XIV centuries, N.Y., Crown [1960]. 40p. il., 27 plates (part col.)
A very brief but excellent introduction to Chinese painting. Each of the paintings reproduced is discussed in the "Description of plates," p.24–39, which included information adapted from the text of the Japanese ed. of the book by Kei Kawakami.
Bibliography, p.40.

M525 _____. Fantastics and eccentrics in Chinese painting. N.Y., Asia Society, 1967. 122p. il. (part col.)
The catalogue of an exhibition shown in the Asia House Gallery in 1967.

A scholarly catalogue of 39 paintings, 6 natural and semi-natural objects, 4 ceramic pieces, and 2 carvings of the late Ming and early Ch'ing dynasties, representing works by "masters of the fantastic and bizarre, creators of distinctive kinds of pictorial calligraphy ... as well as 'abstractionists' and some that fit into none of these categories, and whose individualism lies in an entirely personal quality of vision."—*Introd.*
Bibliography, p.122.

M526 _____. A history of later Chinese painting, 1279–1950. N.Y., Tokyo, Weatherhill [1976–(78)]. [v.1–(2)]. il. (part col.), maps.
A series of five volumes which, when complete, will comprise a history of Chinese painting from the 13th century through the first half of the 20th century.

Contents of volumes published to date: v.1, *Hills beyond a river: Chinese painting of the Yüan Dynasty, 1279–1368* (1976): (I) The beginnings of Yüan painting; (II) Conservative trends in landscape painting; (III) Landscape painting of the late Yüan; (IV) Figures, birds and flowers, bamboo and plum. Bibliography, p.183–87. v.2; *Parting at the shore: Chinese painting of the early and middle Ming Dynasty, 1368–1580* (1978): (1) The early Ming "academy" and the Che school; (II) The beginnings of the Wu school: Shen Chou and his predecessors; (III) The later Che school; (IV) Some nonconformist painters of Nanking and elsewhere; (V) The Soochow professional masters; (VI) Wen Ching-ming and his followers: the Wu school in the 16th century. Bibliography, p.265–68.
Notes in both volumes include references.

M527 Ch'en, Chih-mai. Chinese calligraphers and their art. [Melbourne] Melbourne Univ. Pr.; London, Cambridge Univ. Pr. [1966]. 286p. il.
An historical survey and consideration of calligraphy as an art form. Written more for the general reader than for the specialist. No bibliography.

M528 Contag, Victoria, and Chi-Ch'ien, Wang. Seals of Chinese painters and collectors of the Ming and Ch'ing periods, reproduced in facsimile size and deciphered. Rev. ed. with supplement. Hong Kong Univ. Pr., 1966. 726p.
1st ed. in German, 1940.

A corpus of photographic reproductions of seal impressions on Chinese paintings. Includes nearly 9,000 of these from the 1st ed., plus a supplement with new information and examples. Useful for determining the authenticity of paintings.

M529 Crawford, John M., Jr. Chinese calligraphy and painting in the collection of John M. Crawford, Jr. [Ed. by Lawrence Sickman]. N.Y., [Pierpont Morgan Library] 1962. 302p. 51 plates (part col.)
A thorough, detailed catalogue of an important private collection of Chinese painting and calligraphy. Sumptuously produced. Introductory essays by recognized scholars. Excellent reproductions.

Contents: Chinese chronology; List of calligraphy and painting; Introduction by Lawrence Sickman; Chinese painting, by Max Loehr; Chinese calligraphy, by Lien-Sheng Yang; Calligraphy and painting in the collection; Glossary of Chinese terms; Chinese characters for names and terms; Chinese titles of calligraphy and painting. Bibliography, p.191–96.

M530 Ecke, Gustav. Chinese painting in Hawaii in the Honolulu Academy of Arts and in private collections. [Honolulu] Pub. by the Univ. of Hawaii Pr. for the Honolulu Academy of Arts, 1965. 3v. il., plates (part col.)
A beautifully-produced 3v. work which presents significant points of Chinese painting from the Sung through the Ch'ing dynasties, based largely on hand scrolls and hanging scrolls in Hawaiian collections. In addition to outlining the history of Chinese painting, the author attempts to interrelate Chinese and Western ideals in painting and to explain the basic principles of Chinese painting in terms of Western experience.

Contents: v.1: pt. I. Imponderabilia; pt. II. Avenue of approach; pt. III. Painters and calligraphers; pt. IV. Selected bibliography; pt. V. Plates I–XL. v.2: Plates XLI–LIII. v.3: Plates LIV–LXII.

M531 Ecke, Yu-ho. Chinese calligraphy. [Philadelphia] Philadelphia Museum of Art, 1971. [n.p.] il.
The catalogue of an exhibition shown at the Philadelphia Museum of Art, the Nelson Gallery-Atkins Museum, and the Metropolitan Museum in 1971 and 1972.

Aesthetic and technical bases and the development of the art of calligraphy over a period of 3,000 years are discussed and illustrated in the introductory essay.

"Calligraphy on oracle bones, bronzes, and wood, examples preserved by engraving in stone and reproduced for students and connoisseurs by the process known as 'rubbing,' as well as actual writing are presented in this exhibition."—*Foreword.*

M532 Freer Gallery of Art, Washington, D.C. Chinese figure painting, by Thomas Lawton. Wash., Smithsonian Institution, 1973. x, 236p. 111 il., 19 col. plates. (50th anniversary exhibition, v.2)
The book-catalogue of an exhibition at the Freer Gallery of Art in 1973.

Not a comprehensive history but an important contribution to the study of Chinese figure painting for which no basic

or pointers indicating their probable degree of authenticity."—*Pref.* Bibliography for these lists, p.7-13.
Bibliography to p.2, v.4-5, v.4, p.235-40.

M549 _____. A history of early Chinese painting. London, The Medici Society [1933]. 2v. 226 plates.
Limited ed. of 525 copies. Contents: (I) From the Han to the beginning of the Sung period; (II) From the Sung to the end of the Yüan dynasty.

Bibliography, divided into Chinese books and foreign books, v.1, p.xix-xxii. Indexes at end of v.2 are divided into Index of Chinese names and terms, and Index to foreign names and terms.

M550 _____. A history of later Chinese painting. London, The Medici Society. 1938. 2v. 242 plates. (Repr.: N.Y. Hacker, 1978)
Limited ed. of 525 copies. Contents: (I) From the end of the Yüan period to the end of the Wan Li reign, c.1350-1620; (II) From the end of the Ming period to the end of the Ch'ien Lung reign, c.1620-1796.

Each volume contains a "List of paintings and reproductions of works by painters active mainly in that period and covered in the volume." v.1 includes an extensive bibliography in both Oriental and Western languages, p.[193]-200. v.2 includes an index to Chinese names and terms, and an index of foreign names.

M551 Sullivan, Michael. The birth of landscape painting in China. Berkeley, Univ. of California Pr., 1962. 213p. il.
A scholarly study of the early development of Chinese landscape painting.

Contents: (1) Pictorial art and the attitude toward nature in antiquity; (2) the Han dynasty; (3) The Six dynasties; (4) Summary. Bibliographical references included in "Notes."

M552 Whitfield, Roderick. In pursuit of antiquity; Chinese paintings of the Ming and Ch'ing dynasties from the collection of Mr. and Mrs. Earl Morse. With an addendum by Wen Fong. [Princeton] Art Museum, Princeton Univ. & Rutland, Vt., Tuttle [1969]. 240p. il. plates (part col.)
The catalogue of an exhibition of paintings by Wang Hui and other Ming and Ch'ing masters, held at the Art Museum of Princeton Univ. in 1969. "It is the hope of this exhibition, the first to explore an individual Far-Eastern painter and his circle, that it will not only help to re-create a major artistic personality but also to define the nature of the Orthodox movement in seventeenth-century Chinese painting."—*Foreword.*
Selected bibliography, p.239-40.

SEE ALSO: Oriental Sources and Documents (H216-H225); Soper, A. C. *Literary evidence for early Buddhist art in China* (K217).

## India

M553 Archer, William George. Indian paintings from the Punjab Hills; a survey and history of Pahari miniature

painting. Foreword by Sherman E. Lee. London and N.Y., Sotheby Parke Bernet, 1974. 2v. plates, map.
A monumental study and catalogue of the miniature paintings produced in the 35 feudal states and courts of northern India in the 17th, 18th, and 19th centuries. Superbly documented and illustrated; sensitively written. The author identifies and classifies the local schools in v.1, and surveys exhaustively each of the schools alphabetically by state of origin. "Such a reconstruction includes a consideration of the geography, scenery and religion of each state, its history—with special emphasis on rulers, their marriage alliances, wars and political relationships—a list of royal portraits, and finally a discussion of the possible implications for local painting of all these varied factors and circumstances."—*Introd.*

Pertinent literature on each school is reviewed and evaluated. Each section concludes with a detailed catalogue of significant examples of the local style; includes bases for attributions, bibliographical references, transcribed and translated inscriptions, and discussion of subject matter. The catalogue section contains the complete holdings of the Victoria and Albert Museum, one of the largest and finest collections of paintings of the Punjab Hills. v.2 contains 335p. of reproductions (over 900), grouped according to the catalogue arrangement in v.1.

Bibliography, v.1, p.427-31. Glossary, p.432-36. Concordance: Victoria and Albert Museum (Indian Section) numbers and Catalogue numbers. Indexes: (I) Rulers and personages; (II) Artists; (III) Ragas and raginis; (IV) General.

M554 _____. Paintings of the Sikhs. London, H.M.S.O., 1966. xxiii, 284p. col. front., maps. (Victoria and Albert Museum. Monograph no. 31)
Fulfills "two aims: to catalogue Sikh pictures in the Victoria and Albert Museum . . . a collection unrivalled in scope and quality . . . and, at the same time, to provide the basic materials necessary for its study."—*Pref.*

Contents: Introduction; (I) The Sikhs; (II) The Punjab Hills; The Punjab Plains. Notes, p.71-75, include references. General bibliography, p.76-78. Bibliography: Paintings of the Sikhs, p.79-103, listed chronologically, includes excellent annotations. Biographical notes, p.104-13.

Catalogue of Sikh paintings in the Victoria and Albert Museum, p.[115]-91: (I) Gouaches; (II) Sketches; (III) Glass; (IV) Ivories; (V) Woodcuts. Concordance, p.275-76. Glossary, p.277-78.

M555 Asia House, New York. Gods, thrones, and peacocks; northern Indian painting from two traditions: fifteenth to nineteenth centuries, by Stuart Cary Welch and Milo Cleveland Beach. [N.Y., Asia Society]. (Distr. by Abrams [1965].) 129p. plates (part col.), map.
The catalogue of an exhibition shown at the Asia House Gallery, N.Y., the Baltimore Museum of Art, and the Munson-Williams-Proctor Institute, Utica, N.Y., in 1965 and 1966.

The exhibition was "intended to bring out the variety, power, and charm of later northwestern Indian miniature painting, as shown in a selection of pictures from several

347

collections, and to trace, within the scope of these collections, the relationship between two main streams of tradition, one indigenous, the other foreign. Our primary purpose, however, is to demonstrate that in fact these paintings can seldom be divided according to this criterion."—*Introd.* The catalogue of 84 works is preceded by 3 essays: The Rajput tradition; The age of the Muslim sultans; The Mughal age: a period of synthesis.

Bibliography: Rajput painting, p.127-29.

M556  Barrett, Douglas, and Gray, Basil. Painting of India. [Genève] Skira [1963]. 213p. col. il., map. (Treasures of Asia, 5) (Repr.: N.Y., Skira/Rizzoli, 1978)
A very well illustrated general survey of painting in India, written by two leading authorities.
Index of manuscripts, p.197-[200]. Bibliography, p.195-96.

M557  Beach, Milo Cleveland. Rajput painting at Bundi and Kota. Ascona, Artibus Asiae, 1974. xiii, 58p., [60] leaves of plates. (Artibus Asiae. Supplementum. 32)
"The purpose of this study, limited in scope, is to investigate one group of closely related schools, centered on the states of Bundi and Kota; and to extract those works for which definite evidence of provenance is available, placing them in a relative sequence, defined by means of dated paintings."—*Introd., p.3.*
Contents: Introduction; Painting at Bundi; Painting at Uniara; Painting at Kota; Painting at Raghugarh; Postscript. Appendixes: (A) Bundi genealogy; (B) Kota genealogy; (C) Uniara genealogy; (D) Raghugarh genealogy; (E) Major inscribed paintings from Bundi; (F) Major inscribed paintings from Kota; (G) Major inscribed paintings from Uniara; (H) Major inscribed paintings from Raghugarh.
Bibliography, p.57-58.

M558  Brown, Percy. Indian painting under the Mughals, A.D. 1550 to A.D. 1750. Oxford, Clarendon, 1924. 204p. 72 plates (part col.) (Repr.: N.Y., Hacker, 1975.)
An older, basic survey of Mughal miniature painting. Contents: Introduction; Pt. I. Historical: (I) The Persian and Indian traditions; (II) Babur; Humayun; Akbar; (III) Jahangir the aesthete; (IV) Shah Jahan; Aurangzeb, and the decline. Pt. II. Descriptive: (V) Akbar's school of book illustrators; (VI) The Meridian; (VII) Portraiture; (VIII) European influences; (IX) Methods and materials. Appendixes: (A) List of painters and their principal works; (B) List of collections of Indian pictures; (C) Bibliography, p.200-1.

M559  Coomaraswamy, Ananda Kentish. Rajput painting; being an account of the Hindu paintings of Rajasthan and the Panjab Himalayas from the sixteenth to the nineteenth century described in their relation to contemporary thought. London, N.Y., Oxford Univ. Pr., 1916. 2v. il., 77 plates (part col.) (Repr.: N.Y., Hacker, 1975.)
A classic, monumental work. v.1, Text; v.2, Plates. Contents: (1) The Rajput schools; (2) Subject matter of Rajput paintings; (3) Allied arts and the present day. No bibliography or index.

M560  Ebeling, Klaus. Ragamala painting. Basel, Kumar [1973]. 305p. il., col. plates.
The most comprehensive study of the various schools and styles of Ragamala miniature painting of northern India and the Deccan. Fully documented and well illustrated.
Contents: (I) History of Ragamala painting; (II) Pictorial raw material; (III) Iconographic traditions; (IV) Regional schools and styles; (V) Ragamala texts A-W; (VI) Set notes; (VII) Visual dictionary.
Glossary, p.10-11. The set list, p.18-25. List of collections, p.297-98. Bibliography, p.298-99.

M561  Gangoly, Ordhendra Coomar. Masterpieces of Rajput painting, selected, annotated and described in relation to original Hindi texts from religious literature. Calcutta, Manager-"Rupam" [1926?]. 104p. 52 plates (part col.)
Edition of 210 copies. "An attempt to co-relate the subject matter of the pictures to their literary sources."—*Pref.* Useful primarily for the reproductions.

M562  Ghosh, Amalananda, ed. Ajanta murals; an album of eighty-five reproductions in colour. Illustrated text by Ingrid Aall, A. Ghosh, M. N. Deshpande, Dr. B. B. Lal. Photographs by S. G. Tiwari. New Delhi, Archaeological Survey of India [1967]. x, 71p. il., col. plates, maps.
A pictorial survey of the Ajanta murals and sculpture. Includes authoritative accompanying texts written by archaeologists.
Contents: Introduction, by A. Ghosh; Ajanta: an artistic appreciation, by I. Aall; The caves: their historical perspective, by M. N. Deshpande; The caves: their sculpture, by M. N. Deshpande; The murals: their theme and content, by M. N. Deshpande; The murals: their art, by I. Aall; The murals: their composition and technique, by Dr. B. B. Lal; The murals: their preservation, by Dr. B. B. Lal.
Bibliography, p.60-62.

M563  Khandalavala, Karl. Pahārī miniature painting. Bombay, New Book Co. [1958]. xvi, 409p. il., plates (part col.), map.
A comprehensive study of Pahārī miniatures. Classifies and dates the various schools of Pahārī painting which the author relates to their historical, cultural, and religious background. Well illustrated.
Contents: (1) A brief survey of Indian painting; (2) The background of Pahārī painting; (3) The development of Pahārī painting and its classification; (4) Technique and analysis; (5) The dreamland of the hills. Appendixes: (I) Poets whose verses appear on Pahārī miniatures; (II) Pahārī painters and genealogies of artist-families; (III) Brief historical information. Important collections of Pahārī paintings, p.389-90.
Bibliography, p.378-87. Bibliographical references in footnotes.

M564  Kramrisch, Stella. A survey of painting in the Deccan. London, The India Society, 1937. 234p. 24 plates.
An important study of Indian painting in the Deccan, written by a foremost scholar.

Contents: (1) Ajanta; (2) Elura; (3) Vijayanagar; (4) The last phase. Appendix: Catalogue of paintings from Golconda and Hyderabad in the collection of Sir Akbar Hydari, on loan in the Prince of Wales Museum, Bombay, p.189–98. Bibliographical references in the "Notes."

M565 Rowland, Benjamin, and Coomaraswamy, Ananda Kentish. The wall-paintings of India, Central Asia & Ceylon; a comparative study of Benjamin Rowland with an introductory essay on the nature of Buddhist art by Ananda K. Coomaraswamy, with a foreword by A. Townshend Johnson and colour plates by F. Bailey Vanderhoef, Jr. Boston, Printed at Merrymount Pr., 1938. 94p. 36 plates (30 col.)
Edition of 500 copies printed. Color plates issued in portfolio; black-and-white plates in text volume.

# Japan

M566 Akiyama, Terukazu. Japanese painting. [Geneva] Skira. (Distr. by the World Pub. Co., Cleveland, 1961].) 216p. col. il., 2 maps. (Treasures of Asia. 3) (Repr.: N.Y., Skira/Rizzoli, 1977)
Original text in French; English trans. by James Emmons.
A general survey of painting in Japan. Beautifully illustrated. Contents: (1) Pre-Buddhist painting; (2) The introduction of Buddhist paintings and the assimilation of the T'ang style from China (7th and 8th centuries); (3) Buddhist painting of Japanese inspiration (9th to 13th century); (4) The formation of the national style in secular art (9th to 12th century); (5) The great age of scroll painting (12th to 14th century); (6) The renewed influence of Chinese art and the development of monochrome painting (13th to 16th century); (7) The golden age of mural painting (16th and 17th centuries); (8) Decorative painting of the Sōtatsu-Kōrin school (17th to 19th century); (9) Genre painting and the masters of the Japanese print (17th to 19th century); (10) Trends of modern painting (17th to 19th century).
Chronological table, p.195–97. Selected bibliography of books and articles on Japanese painting in Western languages, p.[200]. List of colorplates and contents at end.

M567 Cahill, James Francis. Scholar painters of Japan: the Nanga school. [N.Y.] Asia Society. (Distr. by New York Graphic Society [1972].) 135p. il.
The book-catalogue of an exhibition held at the Asia House Gallery, New York, and the University Art Museum, Univ. of California, Berkeley, in 1972.
The first comprehensive study in a Western language of Nanga painting and its principal artists. Contents: (1) Introduction; (2) The begininnings of Nanga; (3) Ikeno Taiga and his followers; (4) Yosa Buson and his followers; (5) Uragami Gyokudō; (6) Mokubei and Chikuden; (7) The spread of Nanga. The catalogue gives for each of the 60 works artist, the artist's dates, title/subject, technique, dimensions, references, collection.
Bibliography, p.134.

M568 Freer Gallery of Art, Washington, D.C. Ukiyo-e painting. Wash., Smithsonian Institution, 1973. xv, 319p. il. (part col.) (50th anniversary exhibition, v.1)
The book-catalogue of an exhibition at the Freer Gallery of Art in 1973.
An excellent catalogue of 118 Ukiyo-e paintings drawn from the outstanding collection of approx. 500 paintings and studies of this school in the Freer Gallery. The catalogue entries give detailed descriptions and commentaries.
Catalogue numbers in numerical order, p.[307]; Accession numbers in numerical order, p.[309]; List of artists, p.311; Date chart, p.313. Classified bibliography, p.315–19: General literature on Ukiyo-e; Book illustration; Works on individual artists; Catalogue of collections; Specialized works; Periodicals.

M569 Grilli, Elise. The art of the Japanese screen. N.Y., Walker/Weatherhill. In collaboration with Bijutsu Shuppan-sha, Tokyo [1970]. 275p. il. (part col.)
"The purpose of this book ... is to present the general reader and art connoisseur with a brief survey of the history and general aesthetic principles of Japanese screen art."—*Pref.* Beautifully illustrated.
Contents: pt. 1, Six master works of Japanese screen painting; pt. 2, The screen as a medium in Japanese art; pt. 3, A brief history of Japanese screens; pt. 4, Supplementary plates. Appendixes: (1) An outline of screen development in Japan; (2) Genealogy of the Kano family; (3) Genealogy of the Hon'ami family; (4) Genealogy of the Ogata family; (5) Documents: Sotatsu; (6) Documents: Korin; (7) Chronology: Korin.
Glossary, p.266–68. Bibliography, in English and Japanese, p.269–71.

M570 Hillier, Jack Ronald. Catalogue of the Japanese paintings and prints in the collection of Mr. & Mrs. Richard P. Gale. With an introd. by Richard P. Gale. [London] Pub. by Routledge & Paul for Minneapolis Institute of Arts, 1970. 2v. xvi, 567p. plates (part col.)
A scholarly, beautifully produced catalogue of an important collection of later Japanese art. The collection comprises primarily works of the genre and Ukiyo-e masters.
Bibliography, v.2, p.549–54.

M571 _____. The Harari collection of Japanese paintings and drawings. Catalogue comp. by J. Hillier. London, Lund, Humphries; Boston, Boston Book and Art Shop [1970–73?]. 3v. plates (part col.)
A catalogue of the important Harari Collection of Japanese paintings and drawings, comp. and written by a foremost authority. Especially strong in works by Hokusai and his pupils, which comprise about one-fourth of the collection; the remainder of the collection consists mainly of works by Tokugawa masters, particularly Ukiyo-e and nonconformists. Beautifully produced and illustrated.
v.1, *Genre and Ukiyo-e school,* includes an introductory essay, p.vii–x, which outlines the history of Japanese painting. List of artists for v.1–3, p.v–vi. v.2, *Hokusai and his school and Hiroshige.* Bibliography, p.353–54. Glossary, p.355–56.

v.3, *Kanō, decorative, Nanga and Maruyama/Shijō schools, independents, fans of various schools.* Bibliography, p.569.

M572 _____. The uninhibited brush; Japanese art in the Shijō style. [London] Moss [1974]. xxvi, 378p. 287 il. (part col.)

A beautifully illustrated, sensitively written study of the Shijō school of Japanese painting, the first in a Western language. Concentrates on the period from the end of the 18th century to the 1830s. "Does not purport to be an exhaustive account of the Shijō movement, but it encompasses the intricate and complex process that led up to the 'ultimate' in Shijō during what may be thought of as the 'vital years'."—*p.4.* Takes into account the important role of woodblock prints in albums, books, and as separate sheets.

Contents: Introduction; (1) Forerunners: Maruyama Ōkyo and others; (2) Buson and Goshun; (3) Rosetsu: the supreme eccentric; (4) Genki, Nangaku, Ōzui, and Ōju; (5) Soken, Sōkyū, and Shūho; (6) Keibun, Toyohiko, Gitō, and Tōyō; (7) Other Ōkyo followers: Nantei, Kohsū, Kōkei, Bummei, Naokata, Rankō; (8) Chō Gesshō and the art of *haiga*; Ōishi Matora; (9) Suiseki, Nagaharu, Kagen, and Shōnen; (10) The Kishi school: Ganku, Gantai, Minwa, Shōdō, Renzan, and Yokoyama Kazan; (11) Kawamura Bumpō and his pupil Kihō; (12) The Mori family: Sosen, Shūhō, Tetsuzan, Yūsen, and Ippō; (13) Anthologies; (14) Kōin, Kōchō, Nikka, Ōshin, Donshū, and Yachō; (15) The ultimate in Shijō: Nanrei and Chinnen; (16) Seiki, Hōen, Kanei, Raishō, Bunrin, Seiyō, Hanzan, and Kansai; Epilogue.

List of plates, p.xi–xxvii, gives artist, title/subject, medium, date, signature, seal, dimensions, and collection. Bibliography, p.367-68.

M573 Japanese ink paintings from American collections: the Muromachi period. An exhibition in honor of Shūjirō Shimada. Ed. by Yoshiaki Shimizu and Carolyn Wheelwright. [Princeton] The Art Museum, Princeton Univ. (Distr. by Princeton Univ. Pr. [1976].) 300p. il.

"We are presenting, in this exhibition, a group of important works, some only recently discovered, as evidence for certain artistic trends of the Muromachi period. Since major gaps hinder a faithful selection of Japanese stylistic evolution from the fourteenth through the sixteenth centuries, these paintings should be viewed in relation to the larger development of Muromachi art history."—*Pref.*

Foreword by Wen C. Fong. The catalogue includes essays by various scholars on each of the 37 paintings exhibited. Artists' signatures and seals, p.271-77. Chronological charts (Chinese historical periods/Japanese historical periods; the Muromachi period), p.278-79. Bibliography: Sources in Japanese and Chinese, p.280-89; Sources in Western languages, p.289.

M574 Murase, Miyeko. Byōbu: Japanese screens from New York collections. [N.Y.] Asia Society [1971]. 134p. il. (part col.)

The catalogue of an exhibition in the Asia House Gallery in the winter of 1971.

Excellent illustrations accompany full, scholarly catalogue entries for 26 screens. The introductory essay briefly surveys and analyzes various types of screens, with most attention given to the byōbu.

Bibliography, p.134.

M575 Nihon emakimono zenshu. Japanese scroll paintings. Ed. by Kadokawa Shoten under the supervision of Ichimatsu Tanaka. Tokyo, Kadokawa, 1958- . v.1- . il. (Part col.)

Text in Japanese with English summaries.

A series of volumes of excellent reproductions of Japanese scroll paintings. Volumes include introductory essays by various scholars and commentaries on the illustrations.

Publication of a rev. ed. of the series in 30v. was begun in 1975.

M576 Okudaira, Hideo. Emaki: Japanese picture scrolls. Tokyo and Rutland, Vt., Tuttle [1962]. 241p. il., plates (part col.)

Abbreviated English trans. of *Emaki,* Tokyo, 1957.

A series of color plates followed by text tracing the development of *emakimono* from the 8th through the 12th and 13th centuries. "Explanation of the thirty principal *emaki*" gives brief notes on 30 of the most important scrolls in chronological order. "List of *emaki* and their English titles" includes almost all extant scrolls, with dates, collections, and attributions.

M577 Rosenfield, John M.; Cranston, Fumiko E.; and Cranston, Edwin A. The courtly tradition in Japanese art and literature: selections from the Hofer and Hyde collections. [Cambridge] Fogg Art Museum, Harvard Univ., 1973. 316p. il. (part col.)

The catalogue of an exhibition shown at the Fogg Art Museum, Harvard Univ., the Japan House Gallery, N.Y., and the Art Institute of Chicago in 1973 and 1974.

A major exhibition of Japanese calligraphy and paintings of religious and narrative subjects. Traces the aristocratic traditions of Japanese art and culture. Beautifully illustrated.

Contents: Note on the Hofer collection; Note on the Hyde Japanese collection; Introduction; Buddhist graphic arts; Japanese literature; Narrative painting. Each of the 99 catalogue entries gives detailed description, critical discussion, and references.

"Major artists, authors, and patrons," p.299-310, gives dates and biographical sketches for 50 figures included.

M578 Tanaka, Ichimatsu; Doi, Tsuguru; and Yūzō, Yamane, eds. Shōheki-ga zenshū [Corpus of paintings on partitions and doors]. Tokyo, Bijutsu Shuppan-sha, 1966- . 10v. il. (part col.), plans.

Title transliterated; complete text in Japanese.

A series of 10v. on Japanese paintings on partitions and doors. Beautifully illustrated. Contents: (1) the Chishakuin; (2) the Tenkyūin of Myōshinji; (3) Daikakuji; (4) Nagoya Castle; (5) the Sambōin of Daigoji; (6) Nishi Honganji; (7) Kenninji; (8) the Shinjuan of Daitokuji; (9) Chinonin; (10) the main building, Hombō, of Nanzenji.

M579 Toda, Kenji. Japanese scroll painting. Chicago, Univ. of Chicago Pr. [1935]. 167p. il., 19 plates (part col.), map.

Pt.1 is an historical discussion of Japanese scrolls. Contents, pt.2: (1) Items of identification of a scroll; (2) The making of a scroll; (3) Chronological table; (4) Bibliography, p.144–42; (5) Transliteration, measurement, illustrations.

"List of important works of Japanese scroll painting," p.144–49. Appendix: Titles of the scrolls, p.153–54; Bibliographical list, p.154–58; Eras, p.158–59; Buddhist temples and Shinto shrines, p.159–60; Bibliographical list, p.160. Miscellaneous, p.160–64, in Japanese and Roman alphabet.

M580 Tokyo. Institute of Art Research. Index of Japanese painters. Tokyo, The Society of Friends of Eastern Art, 1941. 156p. table. (Repr.: Rutland, Vt., Tuttle [1958].)

"The index contains about 600 names, with short biographies of painters who are familiar in the reproductions and the articles which have been published for the past several years in important publications of the country."—*Pref.* Names given in Japanese characters after the English forms. At end of volume: (1) List of albums of reproductions (no place, date, or publisher given); (2) List of names of places (giving pre-Meiji and modern form in alphabetical order according to pre-Meiji names); (3) Explanation of schools; (4) Table of schools (a chart).

## Southeast Asia

M581 Boisselier, Jean. Thai painting. Trans. by Janet Seligman. Tokyo, N.Y., Kodansha [1976]. 270p. il. (part col.)

Trans. of *La peinture en Thaïland,* Fribourg, Office du livre, 1976.

A comprehensive survey of the history, techniques, and iconography of the various forms of Thai painting from the 14th century to the 20th century. Beautifully illustrated.

Contents: pt. 1, General character, techniques and schools; pt. 2, Themes. Appendixes: (I) Some of the techniques used in decorative art; (II) Albums of iconographical models and manuals of design. Notes and bibliographical references, p.236–40. Glossary, p.241–45. Maps and plans, p.246–51. Chronological tables, p.253–59.

Bibliography, p.260–61.

SEE ALSO: Roberts, L.P. *A dictionary of Japanese artists* (E184).

# PRIMITIVE

## Bibliography

M582 Dawdy, Doris O. Annotated bibliography of American Indian painting. N.Y., Museum of the American Indian, 1968. 27p. (N.Y., Museum of the American Indian, Heye Foundation. Contributions, 21)

A comprehensive bibliography of books and periodical literature on the painting of the North American Indians.

## Histories and Handbooks

M583 Dunn, Dorothy. American Indian painting of the Southwest and Plains areas. [Albuquerque] Univ. of New Mexico Pr., 1968. xxvii, 429p. il. (part col.)

An authoritative, well-illustrated study of American Indian painting in two areas, with emphasis on development since the late 19th century.

Bibliography, p.385–414.

# N.
# Prints

This chapter includes works on the history and technique of prints, both Western and Oriental. References in the related fields of book illustration and posters are limited to a few basic works, and no attempt has been made to cover these fields comprehensively. The arrangement is by form, followed by country or region.

## BIBLIOGRAPHY

N1    Beall, Karen F. Kaufrufe und Strassenhändler/Cries and itinerant trades. Eine Bibliography/A bibliography. Deutsch von Sabine Solf/Trans. into German by Sabine Solf. Mit 343 Abbildungen auf 152 Seiten/With 343 illustrations on 152 pages. Hamburg, Hauswedell [1975]. 563p. il.

A bibliography of street cries and itinerant trades depicted in prints. Includes "only *series* of criers whether on a single sheet of paper, in a set of individually printed engravings, lithographs, etc., or in portfolios and books with title pages and texts."—*p.9.* Arranged by nationality, then by city, with entries in chronological order. Gives description (medium, size), references, and collection. Complete text in German and English.

Contents: Introduction; Abbreviations; China; Denmark; Germany; England; France; Iberian peninsula; Indonesia; Italy; Latin America; The Netherlands and Belgium; Austria; Russia; Switzerland; Turkey; The United States of America; Conclusion; Bibliography; Sources of illustrations.

N2    Bourcard, Gustave. Graveurs et gravures, France et étranger: essai de bibliographie, 1540-1910. Paris, Floury, 1910. 320p.

Includes books and periodical articles on engravers and engraving.

N3    Colin, Paul. La gravure et les graveurs. Bruxelles, van Oest, 1916-18. 2v. (Repr.: N.Y., Garland, 1978.)

A classed bibliography listing 610 items in v.1, with important items starred. Under each group or class, books are listed chronologically according to language. Alphabetical author index at end of volume.

v.2, *Les monographies,* contains 2,659 entries listed alphabetically by name of artist and chronologically under the artist. List of periodicals with bibliographical information, p.305-25. Author index, p.327-44.

Errata and addenda to v.1 at end of v.2.

N4    Duplessis, Georges. Essai de bibliographie contenant l'indication des ouvrages relatifs à l'histoire de la gravure et des graveurs. Paris, Rapilly, 1862. 48p. (Repr.: Osnabrück, Illmer, n.d.)

A classed bibliography begun as a catalogue of the author's own collection.

Sources were Weigel's *Kunstcatalog* (A55) and the bibliographies of M. P. Chéron in the *Gazette des beaux-arts* (Q174).

N5    Levis, Howard Coppuck. A bibliography of American books relating to prints and the art and history of engraving. London, Chiswick, 1910. 79p.

"The basis of this Bibliography is the manuscript catalogue of my own collection of books relating to engraving in America and American books relating to the art and history of engraving."—*Pref.*

N6    _____. A descriptive bibliography of the most important books in the English language relating to the art & history of engraving and the collecting of prints. London, Ellis, 1912. 571p. il. (Repr.: London, Dawson, 1974.)

Intends "to describe the most important, interesting or rare books in the English language on the subject (together, of course, with some which are unimportant), and show their development and the relation between them."—*Introd.*

_____. Supplement and index, by Howard C. Levis. London, Ellis, 1913. 141p. il.

N7    Lewine, J. Bibliography of eighteenth century art and illustrated books: being a guide to collectors of illustrated works in English and French of the period. London, Low, Marston & Co., 1898. xv, [1], 615p. 35 plates. (Repr.: Amsterdam, Hissink, 1968.)

A bibliography of 18th-century English and French illustrated books. Arranged alphabetically by author. Occasional commentaries. Index of authors and subjects.

**N8**   Mason, Lauris, comp. Print reference sources: a select bibliography, 18th-20th centuries. Assisted by Joan Ludman. Millwood, N.Y., Kraus-Thomson, 1974. ix, 246p.
2d ed. 1979.

A bibliography of references on almost 1,300 printmakers, including catalogues raisonnés, oeuvre-catalogues, exhibition catalogues, dealers' catalogues, checklists, and articles in books and periodicals. Because the references are not critically annotated and complete citations are not often given, the work's usefulness is limited.

**N9**   New York Public Library. The Research Libraries. Prints Division. Dictionary catalog of the Prints Division. Boston, Hall, 1975. 5v.

The dictionary catalogue of the Prints Division of the New York Public Library which records on approx. 83,000 cards the holdings of literature in books and periodicals on prints and printmaking in the Library. Includes references to works of historical and technical nature on Western and Far Eastern prints and book illustration and to a selective group of illustrated books containing original graphic work and scrapbooks on prominent American cartoonists, such as Nast, Keppler, and Rogers. Also includes references to the Library's unique clipping files on individual artists, galleries, dealers, organizations, and on some subjects.

Supplemented annually by the *Bibliographic guide to art and architecture* (A69).

**N10**   Riggs, Timothy. [A bibliography of oeuvre-catalogues. Sponsored by the Print Council of America.]. Publisher and publication date to be announced.

An exhaustively researched bibliography of all known oeuvre-catalogues of printmakers and of catalogues of prints after artists. Critical information given for each entry. In addition to true catalogues, articles supplying additions and corrections to previously published catalogues are included, as well as reviews of the more significant catalogues. Gives references to comprehensive catalogues such as Bartsch (N13).

# GENERAL WORKS

**N11**   Adhémar, Jean. Graphic art of the 18th century. [Trans. from the French by M. I. Martin]. London, Thames & Hudson; N.Y., McGraw-Hill [1964]. 254p. il. (part col.)

A good, general introduction to the principal aspects of 18th-century graphic art in Europe. Presents few new observations.

Bibliography, p.237-40.

**N12**   Bartsch, Adam von. The illustrated Bartsch; Le peintre-graveur illustré. General editor: Walter L. Strauss. N.Y., Abaris, 1979- . v.1- . il.

A series of volumes of illustrations to Bartsch's *Le peintre graveur* (N13), with annotations by print specialists. Supersedes and expands the series of illustration volumes to the Italian volumes of Bartsch begun and announced for publication by Pennsylvania State Univ. Pr. (N112). Only the illustration volume to Bartsch, v.12, *Italian chiaroscuro woodcuts* (1971), ed. by Caroline Karpinski, was published in the series as originally announced. The new series proposes to include the Netherlandish and German volumes of Bartsch, and will thus overlap the two Hollstein series (N98 and N126), as well as the Italian volumes. Each volume is published in two parts: (A) An illustration volume, with illustrations of all prints listed by Bartsch; (B) A text volume, with illustrations of prints attributed subsequent to Bartsch, and detailed commentary.

**N13**   _____. Le peintre graveur. Vienne, Degen, 1803-21. 21v. plates. (Repr.: N.Y., Schram; Nieuwkoop, De Graaf, 1970; Hildesheim, Olms, 1970.)

Also reprinted: Leipzig, Barth, 1854-76; Würzburg, Verlagsdruckerei Wurzburg, G.m.b.H., 1920. Continued and supplemented by Robert-Dumesnil (N87), which includes French engravers only; Rudolph Weigel, *Suppléments au peintre-graveur de Adam Bartsch,* Leipzig, Weigel, 1843; Andresen (N91); J.P. van der Kellen, *Le peintre-graveur hollandais et flamand,* Utrecht, Kemink, 1873; Passavant (N44); and Baudi de Vesme (N113), which is limited to Italian engravers.

The foundation work for the modern systematic study of Dutch, Flemish, German, and Italian painter-engravers through the 17th century. Although now outdated in many instances, subsequent oeuvre-catalogues and histories refer to Bartsch almost universally, and for some lesser artists, Bartsch remains the only, or most important, source. For each printmaker, a general essay, descriptions of prints, and often an alphabetical list of works are given.

Contents: v.1-5, [Niederlaender]; v.6-11, Les vieux maîtres allemands; v.12, Les clairs-obscurs des maîtres italiens; v.13, Les vieux maîtres italiens; v.14, Oeuvres de Marc-Antoine et de ses deux principaux élèves Augustin de Venise et Marc de Ravenne; v.15, Estampes de différents graveurs anonymes qui semblent être de l'école de Marc-Antoine Raimondi; v.16-18, Peintres ou dessinateurs italiens: Maîtres du seizième siècle; v.19-21. Peintres ou dessinateurs italiens; Maîtres du dix-septième siècle.

At the end of some volumes is an alphabetical list of artists.

v.11 is an index to v.6-11; v.21 contains an index to catalogues of prints in v.1-21.

A series of volumes of illustrations to Bartsch has begun publication (Bartsch, *The illustrated Bartsch,* N12).

**N14**   Beraldi, Henri. Les graveurs du XIXe siècle; guide de l'amateur d'estampes modernes. Paris, Conquet, 1885-92. 12v.

The fundamental dictionary and inventory catalogue of the works of 19th-century printmakers, primarily French. Includes short biographies of the artists, critical comments, and lists of prints, which for some artists remain the most complete catalogues.

N15    Bland, David. A history of book illustration: the illuminated manuscript and the printed book. [2d ed.] Berkeley, Univ. of California Pr., 1969. 459p. 404 il. (part col.)

The most comprehensive one-volume presentation of the history of book illustration.

Contents: The beginnings in roll and codex; Medieval illumination in the West; Oriental illumination and illustration; From the introduction of printing until c.1520; From c.1520 to the end of the 17th century; The 18th century; The 19th century; The 20th century.

Bibliography, p.437-41.

N16    Bologna. Pinacoteca Nazionale. Gabinetto delle Stampe. Catalogo generale della raccolta di stampe antiche. Bologna, Associazione per le Arti "Francesco Francia" [1973-(77)]. v.1- . plates.

At head of title: 1973- , Soprintendenza alle gallerie di Bologna, Associazione per le Arti "Francesco Francia."

A series of inventory catalogues of the collection of prints in the Gabinetto delle Stampe, Pinacoteca Nazionale, Bologna. When complete, the volumes will include all of the approx. 40,000 prints conserved in the collection. Each volume reproduces hundreds of prints. Each entry gives the engraver, whenever possible the designer, subject/title, dimensions, technique, watermark, collectors' marks, inscriptions, condition, and references to Bartsch.

Contents: Sezione I. Incisori tedeschi dal sec. XV al sec. XIX (2v.); Sezione II. Incisori fiamminghi dal sec. XV al sec. XIX (1v.); Sezione III. Incisori bolognesi ed emiliani dal sec. XV al sec. XIX (v.1, 1973; v.2, 1974; v.3, 1975); Sezione IV. Incisori toscani, dal sec. XV al XVIII (1v., 1976); Sezione V. Incisori veneti dal sec. XV al sec. XIX (1v.); Sezione VI. Incisori liguri e lombardi dal sec. XV al sec. XVIII (1v., 1977); Sezione VII. Incisori romani e napoletani dal sec. XVI et XIX (2v.); Sezione VIII. Incisori francesi dal sec. XVI al sec. XIX (3v.); Sezione IX. Ritrattistica dal sec. XVI al sec. XIX (4v.); Sezione X. Stampe con soggetti antichi sec. XVII (1v.); Sezione XI. Stampe in libri antichi sec. XVIII (4v.); Sezione XII. Stampe varie sec. XIX (2v.).

N17    Boston. Museum of Fine Arts. The artist & the book: 1860-1960 (in Western Europe and the United States). [Exhibition held at the Museum of Fine Arts, May 4-July 16, 1961 in association with the Dept. of Printing and Graphic Arts, Harvard College Library. Catalogue by Eleanor M. Garvey. Boston, 1961]. 232p. il. (part col.)

Reissued 1972.

The indispensable work for the period covered. "This exhibition is to show, primarily, what major artists of Western Europe and the United States have contributed in book form during the last hundred and, especially, the last sixty 'explosive' years."—*Introd.*

Books are listed alphabetically by artist, with title, author, publisher, printer, dimensions, description of edition, and references.

Bibliography, p.222-27.

N18    Bourcard, Gustave. A travers cinq siècles de gravures, 1350-1903. Catalogue descriptif et annoté, avec des notes biographiques et références, des estampes célèbres, rares ou curieuses de écoles allemande, française, hollandaise et flamande, italienne et anglaise. Paris, Rapilly, 1903. li, 638p. il. (Repr.: Amsterdam, Hissink, 1971.)

Original ed. of 250 copies.

A standard survey of prints from the 14th century to the beginning of the 20th century. Contains indexes of engravers and engravings discussed. Bibliography, p.619-38.

N19    Castleman, Riva. Prints of the twentieth century: a history. With illustrations from the collection of the Museum of Modern Art, N.Y., The Museum of Modern Art. (Distr. by Oxford Univ. Pr., New York [and] Toronto [1976].) 216p. 179 il. (part col.)

The best general survey of 20th-century printmaking. A welcome addition to the literature in the field. "The book, which attempts to illuminate the most important points in the history of printmaking in the twentieth century, is illustrated with works exclusively from the Museum's collection. Although there may be examples that would more succinctly characterize a movement, period or artist, those prints that have been reproduced are chosen from a collection that has no peer for its variety, breadth and quality in the period it covers (circa 1885 to the present)."—*Pref.*

Contents: (1) Introduction: some 19th-century influences; (2) Expressionism in France and Germany up to World War I: Fauves, Die Brücke, Der Blaue Reiter; (3) Cubism and early abstract movements; (4) Postwar Expressionism and nonobjective art in Germany; (5) Dada and Surrealism; (6) Independent directions: the School of Paris and the revival of lithography; (7) Picasso after Cubism; (8) Between the wars: Mexico, the U.S., Japan; (9) Printmaking after World War II: the persistence of Expressionism and Surrealism; (10) The flourishing of lithography in the U.S.A.; the prints of Pop art; (11) New modes of expression: Op, Kinetic, Concrete, Conceptual.

Notes on the text, p.207-8, include references. Glossary of printmaking terms, p.209-10. Bibliography (General reference and monographs), p.210-14.

N20    Cohen, Henry. Guide de l'amateur de livres à gravures du XVIIIe siècle. 6. éd., rev., cor. et considérablement augm. par Seymour de Ricci. Paris, Rouquette, 1912. 2v. front., plates.

1st ed. 1870.

The standard reference on 18th-century books illustrated with engravings. Entries are fully described. Avant-propos, p.[i]-vi, by Seymour de Ricci. Préface, p.[vii]-xxvi, by Baron R. Portalis.

Supplément, p.]1076]-1110. Errata, p.[1114]-15. Indexes at end of p.2: Table des ouvrages cités, p.[1118]-91; Table alphabétique des noms d'artistes, p.[1192]-1247.

N21    Darmon, J. E. Dictionnaire des gravures en couleurs, en bistre et en sanguine du XVIIIe siècle, des écoles française et anglaise, en circulation dans le commerce des estampes, avec leurs prix. Nouv. éd., rev., corr. et

augm. Montpellier, Barral, 1929. 142p. (Repr.: N.Y., Garland, 1978.)

1st ed. (Paris, 1920) published as the joint work of J. E. Darmon and Granger. A dictionary of 18th-century French and English engravers.

N22    Davenport, Cyril James Humphries. Mezzotints. London, Methuen; N.Y., Putnam, 1903. 208p. il., 40 plates. (Repr.: N.Y., Garland, 1978.)

Contains a technical description of the process and an historical survey, still not superseded. An index to the plates, preceding the text, contains small line drawings of each plate and gives dimensions, date, publisher and printer, and often prices, together with brief notes on the sitters and subjects.

"List of the more important works on mezzotints, as well as of books containing valuable references to them," p.xv-xviii.

N23    Delteil, Loÿs. Manuel de l'amateur d'estampes du XVIIIe siècle; orné de 106 reproductions hors texte. Paris, Dorbon-Aîné [1910]. 447p. 107 plates.

A detailed study of 18th-century prints devoted primarily to French works. Similar to Delteil (N24).

Bibliography, p.[361]-64. "Table des noms d'artistes et des estampes cités," p.[371]-442.

N24    _____. Manuel de l'amateur d'estampes des XIXe et XXe siècles (1801-1924) avec 158 reproductions hors texte. Paris, Dorbon-Aîné [1925]. 2v. plates.

v.1 and part of v.2 contain a history of 19th- and 20th-century printmaking similar in format to Delteil (N23). The text is followed by "Liste des principaux ouvrages relatifs à la gravure aux XIXe et XX siècles," v.2, p.[547]-56; "Table alphabétique des principales ventes publiques, avec noms des propriétaires, mentionnés au cours du Manuel . . .," v.2, p.[559]-61; "Table des noms d'artistes et des titres d'estampes cités," v.2, p.[565]-629.

_____. 700 reproductions d'estampes des XIXe et XXe siècles pour servir de complément au Manuel de l'amateur d'estampes. Paris, Dorbon-Aîné [1925]. 2v. plates.

Plates, arranged chronologically, supplement the text of the *Manuel.*

N25    _____. Le peintre-graveur illustré (XIXe et XXe siècles). Paris, Chez l'auteur, 1906-30. 31v. il. (Repr.: N.Y., Collectors editions, Da Capo, 1969.)

Catalogues raisonnés of prominent graphic artists, primarily French, of the 19th and early 20th centuries. Includes for each printmaker a biographical sketch, a portrait, and a catalogue of his prints. Brief descriptions and various states of the works are given; sales and prices and provenance are indicated. Each work is illustrated.

Contents: t.1, J. F. Millet, Th. Rousseau, Jules Dupré, J. Barthold Jongkind; t.2, Charles Meryon; t.3, Ingres, Delacroix; t.4, Anders Zorn; t.5, Corot; t.6, Rude, Barye, Carpeaux, Rodin; t.7, Paul Huet; t.8, Eugène Carrière; t.9, Degas; t.10-11, Toulouse-Lautrec; t.12, Gustave Leheutre; t.13, C.-F. Daubigny; t.14-15, Goya; t.16, Raffaëlli; t.17, Pissarro, Sisley, Renoir; t.18, Géricault; t.19, Henri Leys,

Henri de Brackeleer; James Ensor; t.20-29, Daumier; t.30, Albert Besnard; t.31, Jean Frélaut.

The 1969 reprint ed. includes an additional volume (v.32), comprising an Appendix and Glossary, prepared under the supervision of Herman J. Wechsler.

N26    Duplessis, Georges, and Bouchot, Henri. Dictionnaire des marques et monogrammes de graveurs. Paris, Rouam, 1886-87. 3v. (Repr.: N.Y., Garland, 1978.)

Arranged in dictionary form. Mark or monogram is identified by a few lines giving name of artist, dates, etc.

General alphabetical index at end of v.3.

N27    Eichenberg, Fritz. The art of the print; masterpieces, history, techniques. N.Y., Abrams [1976]. 611p. 654 il., 95 col. plates.

A comprehensive, nonscholarly survey of the history and techniques of printmaking "addressed to the working artist, to art students, and to teachers, but it is intended to be of help to the collector, the curator, the dealer, and the general public interested in prints."—*Pref.* Written by a well-known American printmaker. Particularly useful as a visual survey.

Contents: (I) Antecedents of the print; (II) The relief print; (III) The intaglio print; (IV) The lithograph; (V) The silkscreen print, or serigraph; (VI) The monotype; (VII) Workshops; (VIII) Paper. Sections on the various print techniques include "Notes" by printmakers known for their work in the techniques. Section VIII, on paper, includes a chapter, "Care and preservation of works of art on paper," by Douglass Howell.

Contributors, p.573-80. Glossary, p.[581]-89. Classified bibliography, p.[590]-95.

N28    Das frühe Plakat in Europa und den USA; ein Bestandskatalog hrsg. von Lise Lotte Möller, Heinz Spielmann [und] Stephan Waetzoldt für Kunstbibliothek Staatliche Museen Preussischer Kulturbesitz Berlin [und] Museum für Kunst und Gewerbe Hamburg. Berlin, Mann [1973-(76)]. v.1-(2). il., (part col.)

At head of title: Forschungsunternehmen "19. Jahrhundert" der Fritz Thyssen Stiftung.

To be complete in 8v.

A series of scholarly studies and catalogues of posters of the second half of the 19th century and early 20th century in Europe and the U.S. The catalogues list all posters available in the public collections of the Federal Republic of Germany and West Berlin. The catalogues are arranged alphabetically by artist and include reproductions of many posters facing the text pages where they are described.

Each volume includes introductory essays on the historical development of posters (with English summaries), a chronological table, a biographies section, a bibliography, and an index.

Contents: Bd. 1. Grossbritannien. Vereinigte Staaten von Nordamerika, von R. Malhotra und C. Thon (1973); Bd. 2. Frankreich und Belgien, von K. Popitz, A. von Saldern, H. Spielmann, und S. Waetzoldt (1976); Bd. 3. Österreich (not published); Bd. 4-7. Deutschland (not published); Bd. 8. Die übrigen europaischen Staaten (not published).

N29   Heinecken, Karl Heinrich von. Dictionnaire des artistes, dont nous avons des estampes, avec une notice détaillée de leurs ouvrages gravés. t.1–4. Leipsig. Breitkopf, 1778–90. 4v. (Repr.: N.Y., Johnson, 1970.)
v.1–4, A–Diziani only. No more published.

A dictionary of artists, including painters, engravers, architects, sculptors, goldsmiths, and amateurs, after whose works engravings were made or who made engravings. Biographical information is given for each artist; bibliographical references and portrait references are sometimes included.

N30   Heller, Joseph. Handbuch für Kupferstichsammler; oder, Lexicon der Kupferstecher, Maler-Radirer und Formschneider aller Länder und Schulen nach Massgabe ihrer geschätztesten Blätter und Werke. Auf Grundlage der 2. Aufl. von Heller's Pract. Handbuch für Kupferstichsammler neu bearb. und um das Doppelte erweitert von Dr. Phil A. Andresen. Leipzig, Weigel, 1870–73. 2v. (Repr.: Hildesheim, Olms, 1975; N.Y., Garland, 1978.)
A standard reference work for engravers of all countries. "Alphabetisches Verzeichnis" v.2, p.835–949.

———. Ergänzungsheft zu Andresen-Wessely's Handbuch für Kupferstichsammler, enhaltend die seit 1873 erscheinenen hervorragenden Blätter nebst zahlreichen Nachträgen zum Hauptwerke. Bearb. von J. E. Wessely. Leipzig, Weigel, 1885. 120p. (Repr.: N.Y., Garland, 1978.)

N31   Hind, Arthur Mayger. A history of engraving & etching from the 15th century to the year 1914; being the 3d and fully rev. ed. of "A short history of engraving and etching." With frontispiece in photogravure and 110 illustrations in the text. London, Constable; Boston, Houghton Mifflin, 1923. 487p. il.
Paperback ed.: N.Y., Dover, 1963.

A standard, comprehensive history of engraving and etching, written by a foremost scholar and former curator of prints of the British Museum.

Appendixes: (1) Classified list of engravers, p.343–92; (2) General bibliography, p.393–419; (3) Index of engravers and individual bibliography, p.420–87.

N32   ———. An introduction to a history of woodcut, with a detailed survey of work done in the fifteenth century. With frontispiece and 483 illustrations in the text. London, Constable; Boston, Houghton Mifflin, 1935. 2v. il. (Repr.: N.Y., Dover, 1963; Magnolia, Mass., Peter Smith.)
A standard work by a well-known authority.

Contents: v.1, Processes and materials; General historical survey; The origin of woodcut, with a survey of single cuts before the period of book-illustration; Block-books; v.2, Book-illustration and contemporary single cuts in Italy, the Netherlands, France, French Switzerland, England, Spain, and Portugal.

List of illustrations, v.1, p.xv–xl. Indexes, v.2: (I) Designers and engravers of woodcuts, p.760–66; (II) Printers and publishers of books, p.767–82; (III) Books illustrated with woodcuts, p.783–814; (IV) Prints mentioned or reproduced, p.815–33; (V) Subjects discussed in the text, p.834–38.

N33   Hofer, Philip. Baroque book illustration: a short survey from the collection in the Department of Graphic Arts, Harvard College Library. Cambridge, Harvard Univ. Pr., 1951. 43p. 149 figs. (Reissued by Harvard Univ. Pr., 1970.)
An excellent visual outline of the complicated mass of 17th-century illustrated books.

Divided into short sections on individual European countries or areas.

N34   Hofstätter, Hans H. Jugendstil: Druckkunst [von] Hans Hofstätter, unter Mitarbeit von W. Jaworska und S. Hofstätter. Baden-Baden, Halle, [1968]. 295p. il. (part col.)
A general survey of European *Jugendstil* graphic production, primarily book illustration. Contains a short introductory essay concerning various aspects of the style and individual sections on work done by the most prominent artists in France, England, Belgium and Holland, Scandinavia, Germany, Italy, Vienna, and Eastern Europe. Includes reproductions of works and bibliography for each artist.

A classified bibliography, p.287–91.

N35   Ivins, William Mills. Prints and visual communication. Cambridge, Harvard Univ. Pr.; London, Routledge & Paul [1953]. 190p. il. (Repr.: N.Y., Da Capo, 1968; Cambridge, Mass., MIT Pr., 1970?)
A classic work on the history and development of printed pictures as they responded to cultural changes and requirements.

N36   Kunzle, David. History of the comic strip. Berkeley, Univ. of California Pr. [1973]. v.1 (480p.)– . il. (part col.)
v.1, The early comic strip; narrative strips and picture stories in the European broadsheet from c.1450 to 1825. The first volume of a three-volume comprehensive history of the comic strip; extremely well illustrated. "This book is intended as a history or pre-history of an artistic phenomenon which is part pictorial and part literary, and known to the English-speaking world variously as 'comic strip,' 'comic,' 'comic book,' 'strip cartoon,' and 'the funnies.'"—*Introd.*

Contents: pt. I. Politics; pt. II. Personal morality; pt. III. Hogarth and the Hogarthians; pt. IV. Conclusion. Collections of broadsheets, p.[431]. Catalogue, p.[433]–61. Bibliography, p.[463]–66; bibliographical references in footnotes.

N37   Laran, Jean. L'estampe ... avec la collaboration de Jean Adhémar et Jean Prinet. Préf. de Jean Vallery-Radot. Paris, Presses Universitaires de France, 1959. 2v. plates (part col.)
An authoritative, well-illustrated history of printmaking from the beginning of the 15th century to the mid–20th century.

Contents: v.1: Introduction; (I) Les premiers bois d'accident; (II) L'aurore de la taille-douce; (III) Dürer et son temps; (IV) L'épanouissement du métier classique; (V) L'eau-

forte de peintre et Rembrandt; (VI) La gravure du XVIIIe siècle; (VII) L'estampe en Chine et en Japon, par Jean Buhot; (VIII) Introduction à l'histoire de l'estampe moderne; (IX) Le burin et l'eau-forte au XIXe siècle; (X) La lithographie au XIXe siècle; (XI) Le bois au XIXe siècle; (XII) L'estampe après 1900. v.2: Plates.

Classified bibliography, p.[263]-72. "Index des noms de personnes et de lieux, des termes techniques et des sujets," p.[273]-414, is a biographical dictionary, a geographical dictionary, and glossary of technical terms and subjects related to the history of printmaking. "Table des planches," p.[415]-26, arranged by chapters, gives title, technique, date, bibliographical references, collection, and text reference for each print reproduced.

N38    Le Blanc, Charles. Manuel de l'amateur d'estampes, contenant le dictionnaire des graveurs des toutes les nations dans lequel sont décrites les Estampes rares, précieuses et intéressantes avec l'indication de leurs différents états et des prix auxquels ces Estampes ont été portées dans les ventes publiques, en France et à l'Étranger. Paris, Bouillon, 1854-89. 4v. (Repr.: Amsterdam, Hissink, 1970-71, 4v. in 2; N.Y., Garland 1978.)

A standard, international listing of engravers and their works. Arranged alphabetically by artist. Coverage less comprehensive toward end of alphabet.

N39    Lehrs, Max. Geschichte und kritischer Katalog des deutschen, niederländischen und französischen Kupferstichs im XV. Jahrhundert. Wien, Gesellschaft für vervielfältigende Kunst, 1908-34. 9v. il., and 9 atlases of 284 plates. (Repr.: Nendeln, Liechtenstein, Kraus, 1969.)

Original ed. of 140 copies.

The basic catalogue of 15th-century northern European engravings; indispensable for work in the field. The main text contains general information on each engraver, with an iconographically arranged listing of each engraver's works, which includes dimensions, bibliographical references, and collections for each engraving. Text and plates are coordinated by number.

Contents by volume: (1) Die Primitiven; (2) Der Meister E. S.; (3-4) Die Anonymen; (5-6) Martin Schongauer und seine Schule; (7) Die niederländischen Monogrammisten und der Meister P. W. von Köln; (8) Der Meister des Hausbuches und die Oberdeutschen Stecher; (9) Israhel van Meckenem.

Indexes in each text volume: (1) Artists and their works reproduced, arranged iconographically; (2) Subjects; (3) Places; (4) Bibliographical abbreviations; (5) Watermarks. "Konkordanz nach Geisberg," v.9, p.[505]-9. Cumulative artist index for the 9v. in v.9, p.511-15.

The illustrations of the German and Netherlandish engravings, with condensed captions and notes in English translation, are included in Lehrs, *Late Gothic engravings of Germany & the Netherlands* (N40). 250 of the engravings in Lehrs, plus 11 additional engravings undescribed in Lehrs, are listed, illustrated, and described in the catalogue *Fifteenth century engravings of Northern Europe* (N59).

N40    _____. Late Gothic engravings of Germany & the Netherlands. 682 copperplates from the "Kritischer Katalog." With a new essay "Early engraving in Germany and the Netherlands," by A. Hyatt Mayor. N.Y., Dover [1969]. 367p.

"Contains all the illustrations from the *Geschichte und kritischer Katalog* ... (N39). The captions and notes in the present volume are condensed translations of portions of the text volume, prepared specially for this edition. Other new features ... are the Publisher's Note, List of Illustrations, Index of Artists and Index of Subjects ...."—*Pref.*

N41    Lippmann, Friedrich. Engravings and woodcuts by old masters (sec. xv-xix) reproduced in facsimile under the direction of Dr. Friedrich Lippmann. London, Quaritch, 1899-1900 [i.e., 1904]. 5v. plates (part col.), facsims.

Originally published in ten parts, 1889-1900, with provisional titles and indexes. Permanent titles and indexes were compiled under the direction of Lippmann and J. Springer. Published in an ed. of 80 complete copies.

A collection of excellent reproductions of engravings, with brief commentary on each engraver in the contents.

Contents: v.1, Italian and Spanish schools; v.2, German school (engravings on metal); v.3, Netherlandish school (engravings on metal); v.4, German and Netherlandish schools (engravings on wood); v.5, French and English schools.

N42    Mayor, A. Hyatt. Prints & people; a social history of printed pictures. [N.Y.] The Metropolitan Museum of Art. (Distr. by New York Graphic Society [1971].) 1v. unpaged. 752 il.

An informal survey of the history of printmaking from the Chinese invention of paper to the present. The text comprises a commentary on the more than 700 illustrations especially chosen to emphasize the innovations which have expanded, revised, and refined the roles and possibilities of printed images.

"Terms and abbreviations found on prints" is a two-page list with succinct definitions or translations of terms. The index numbers refer to the illustrations and to discussions adjacent to the illustrations; dates for printmakers and their working locations are given in the index.

N43    Musper, Heinrich Theodor. Der Holzschnitt in fünf Jahrhunderten. Stuttgart, Kohlhammer [1964]. 400p. 324p. (part col.)

A comprehensive survey of woodcuts from the late 15th century to the early 20th century. Well illustrated.

Contents: (I) Frühe Einblattdrucke; (II) Die Blockbücher; (III) Buchschmuck am Ende des Mittelalters; (IV) Dürer und Cranach; (V) Burgkmair und die Augsburger; (VI) Altdorfer und die Donauschule; (VII) Baldung und die Schweizer; (VIII) Niederländer und Niederdeutsche; (IX) Tizian und italienische Zeitgenossen; (X) Der Clairobscurholzschnitt; (XI) Rubens und Lievens: (XII) Neubeginn; (XIII) Die Romantik; (XIV) Rethel und Menzel; (XV) Daumier und Doré; (XVI) Die Humoristen; (XVII) Der reproduzierende Holzstich; (XVIII) Der Flächenholz-

schnitt. Classified bibliography, p.393–96. Index of names at the end.

N44    Passavant, Johann David. Le peintre-graveur. Contenant l'histoire de la gravure sur bois, sur métal et au burin jusque vers la fin du XVI siècle. L'histoire du nielle avec complément de la partie descriptive de l'Essai sur les nielles de Duchesne aîné. Et un catalogue supplémentaire aux estampes du XV. et XVI. siècle du Peintre-graveur de Adam Bartsch. Leipsic, Weigel, 1860–64. 6v. in 3. (Repr.: N.Y., Burt Franklin, 1966; Nieuwkoop, De Graaf, 1970.)
A standard reference work for the study of engraving; still important for supplementing Bartsch (N13). Bibliographical footnotes. An index of artists and a table of monograms are included in each volume.
    Contents: t.1, Histoire de la gravure sur bois et sur métal jusque vers la fin du XVIe siècle. Histoire de la gravure au burin jusque vers la fin du XVIe siècle. Nielles. Supplément; t.2, Gravures au burin allemandes du XVe siècle. Gravures au burin néerlandaises du XVe siècle; t.3, Catalogue des estampes néerlandaises du XVI siècle. Catalogue des estampes de la haute et de la basse Allemagne du XVIe siècle; t.4, Suite du Catalogue des estampes allemands du XVIe siècle; t.5–6, Gravures italiennes.

N45    Pennell, Joseph and Robins, Elizabeth. Lithography and lithographers. London, Unwin, 1898. 279p.
The first serious attempt in English of a history of lithography; still useful.

N46    Portalis, Roger. Les dessinateurs d'illustrations au dix-huitième siècle. Paris, Morgand et Fatout [1877]. 2v. (Repr.: Amsterdam, Hissink, 1970.)
Contents: v.1, Binet-Martinet; v.2, Martini-Watelet. Appendice, p.[655]–735. Table alphabétique des noms et des ouvrages cités, p.[737]–85.

N47    Portalis, Roger, and Beraldi, Henri. Les graveurs du dix-huitième siècle. Paris, Morgand et Fatout, 1880–82. 3v. (Repr.: N.Y., Burt Franklin, 1970.)
An important reference work for the study of 18th-century prints. Over 400 artists arranged alphabetically; for each is given biographical information, a general discussion of his work, and a chronological listing of the engravings.
    "Table générale des graveurs" in v.3, p.[736]–79.

N48    Prideaux, Sara Treverbian. Aquatint engraving; a chapter in the history of book illustration; illustrated by an original aquatint, two collotype plates, and numerous half-tone plates. London, Duckworth [1909]. 434p. 24 plates. (Repr.: London, Foyle, 1968.)
1st ed. 1909. Gives a brief description of the process and a history of its development and usage. Has not been replaced.
    Appendixes: Books published before 1830 with aquatint plates, p.325–57; Biographical notices of engravers whose names appear on the plates, p.358–71; Artists whose names appear on the plates, p.372–73; Publications by Ackermann with aquatint plates, p.374–78; List of books containing illustrations by T. Rowlandson, based on 'Rowlandson the caricaturist,' by J. Grego, p.379–87; Engravers and the books they illustrated, p.388–405; List of authorities, p.406–7.

N49    Roger-Marx, Claude, Graphic art of the 19th century. N.Y., McGraw-Hill [1962]. 254p. il. (part col.)
Trans. of La gravure originale au XIXe siècle.
    A popular survey of the development of graphic art in the 19th century, with emphasis on French contributions. Many illustrations, in color and black and white. No bibliography.

N50    Rosenthal, Léon, and Adhémar, Jean. La gravure. 2. éd. rev. et augm. Paris, Laurens, 1939. 488p. il. (Manuels d'histoire de l'art)
1st ed. 1909; 2d ed. rev. and updated by J. Adhémar.
    A general history of printmaking. Includes bibliographies at the end of each chapter and a general bibliography.

N51    Sachs, Paul Joseph. Modern prints & drawings; a guide to a better understanding of modern draughtsmanship. Selected and with an explanatory text by Paul J. Sachs. N.Y., Knopf [1954]. 261p. il.
"A picture book with brief comments about prints and drawings made in modern times."—Introd. Biographies, p.247–58. Bibliography, p.259–61.

N52    Schreiber, Wilhelm Ludwig. Handbuch der Holz- und Metallschnitte des XV. Jahrhunderts. Manuel de l'amateur de la gravure sur bois et sur métal au XVe siècle. 3. Aufl. Vollständiger Neudruck des Gesamtwerkes. Stuttgart, Hiersemann; Nendeln, Liechtenstein, Kraus, 1969–76. 11v. il.
This 3d ed. of Schreiber's Handbuch is a reprint of the 8v. Handbuch, 1926–30 (N53), and v.4–5 of the original Manuel (N54), plus a new plate volume, which is a rev. ed. of the plate volumes (v.6–8) of the Manuel (see below).
    The indispensable study and catalogue of the single-leaf and block-book woodcuts and metalcuts of the 15th century. Entries are arranged iconographically, with descriptions, indication of size, bibliographical references, reproductions, dates, and collections. The numbering of the Manuel is retained; additions are included within the sequence by means of intercolated letters.
    Contents by volume: (1) Holzschnitte mit Darstellungen aus dem Alten and Neuen Testament, den apokryphen Evangelien und biblischen Legenden; (2) Holzschnitte mit Darstellung der Heiligen Dreifaltigkeit, Gottvaters, Jesu Christi und der Jungfrau und Gottesmutter Maria; (3) Holzschnitte mit Darstellungen der männlichen und weiblichen Heiligen; (4) Holzschnitte, darstellend religiös-mystische Allegorien, Lebensalter, Glücksrad, Tod, Kalender, Medizin, Heiligtümer, Geschichte, Geographie, Satiren, Sittenbilder, Grotesken, Ornamente, Porträts, Wappen, Bücherzeichen, Münzen; (5) Metallschnitte (Schrotblätter) mit Darstellungen religiösen und profanen Inhalts; (6) Teigdrucke, Weisslinienschnitte, Holzschnittexte ohne Bilder. Nebst Monogrammenregister, Liste der Passepartout-Bordüren, Attributen der Heiligen; (7) Der Formschnitt. Seine Geschichte, Abarten, Technik, Entwicklung und seine ikonologischen Grundlagen; (8) Nachträge zu den vorhergehenden Bänden.

Generalübersicht des gegenwärtig bekannten Bestandes öffentlicher und privater Sammlungen im Inland und Ausland; (9) Catalogue des livres xylographiques et xylo-chirographiques, indiquant les différences de toutes les éditions existantes. Avec des notes critiques, bibliographiques et iconologiques (*Manuel,* v.4); (10) Catalogue des incunables à figures imprimés en Allemagne, en Suisse, en Autriche-Hongrie et en Scandinavie. Avec des notes critiques et bibliographiques (*Manuel,* v.5); (11) (Tafelband) Der Einblattholzschnitt und die Blockbücher des XV. Jahrhunderts. Ausgewählt, eingeleitet und beschreiben von H. Th. Musper. (Völlig neubearbeitet und stark erweiterte Ausgabe von Band VI–VIII des *Manuel de l'amateur de la gravure sur bois . . .*).

N53 \_\_\_\_\_. \_\_\_\_\_. \_\_\_\_\_. Stark vermehrte und bis zu den neuesten Funden ergängte Umarbeitung des Manuel de l'amateur de la gravure sur bois et sur métal au XVe siècle. Leipzig, Hiersemann, 1926–30. 8v.

The indispensable study and catalogue of single-leaf woodcuts and metalcuts of the 15th century. v.1–6 constitute a revision and amplification of v.1–3 of the earlier *Manuel* (N54). The *Handbuch* also includes a text volume on the history and technique of the relief print (v.7) and a supplementary volume (v.8). v.4–5 of the *Manuel,* on blockbooks, and the plate volumes (v.6–8) were not reissued with the *Handbuch.*

Entries are arranged iconographically, with descriptions, indication of size, bibliographical references, reproductions, dates, and collections. The numbering of the *Manuel* is retained; additions are included within the sequence by means of intercolated letters.

For contents and reprint information, see Schreiber, *Handbuch* (N52).

N54 \_\_\_\_\_. Manuel de l'amateur de la gravure sur bois et sur métal au XVe siècle. Berlin, Cohn, 1891–1911. 8v. in 9. il., 121 plates (part col.) on 104 l.

v.4–5: Leipzig, Harrassowitz. v.1–4, 6–8, limited ed. of 300 copies; v.5, 400 copies.

Reprint: See Schreiber, *Handbuch* (N52).

Supplanted by Schreiber's *Handbuch* (N53), except for v.4–5, which were not revised, and v.6–8, the plates, which were not reissued.

Contents: t.1, Catalogue des gravures xylographiques se rapportant à la Bible, l'histoire apocryphe et légendaire, la Sainte Trinité et la Sainte Vierge; t.2, Catalogue des gravures xylographiques se rapportant aux saints et saintes, sujets religieux, mystiques et profanes, calendriers, alphabets, armoiries, portraits et suivi d'une spécification des impostures; t.3, Catalogue des gravures sur métal et des empreintes en pâte, suivi d'un supplément provisoire, d'une clef des attributs des saints et d'une liste des marques et monogrammes; t.4, Catalogue des livres xylographiques et xylochirographiques, indiquant les différences de toutes les éditions existantes; t.5, Catalogue des incunables à figures imprimés en Allemange, en Suisse, en Autriche-Hongrie et en Scandinavie (2 pts.); t.6, Atlas de fac-similés de gravures sur bois et sur métal et d'empreintes en pâte; t.7, 8, Facsimilés des livres xylographiques.

N55 Strauss, Walter L. Chiaroscuro: the clair-obscur woodcuts by the German and Netherlandish masters of the XVIth and XVIIth centuries; a complete catalogue with commentary. Greenwich, Conn., New York Graphic Society [1973]. xx, 393p. il.

A catalogue raisonné of all known surviving chiaroscuro woodcuts made in the 16th and 17th centuries by German and Netherlandish printmakers. Includes about 180 two-color illustrations of chiaroscuro woodcuts, with complete entries for each, giving title/subject, date, dimensions, references, states, commentary, collections, and footnotes with references. A useful reference work for the scholar, collector, and cataloguer.

Repositories, p.xvi; Exhibitions (1900–73), p.387; Bibliography, p.388–90.

N56 Strutt, Joseph. A biographical dictionary; containing an historical account of all engravers, from the earliest period of the art of engraving to the present time; and a short list of their most esteemed works. With cyphers, monograms, and particular marks. London, printed by J. Davis for R. Fauldner, 1785–86. 2v. il.

"An essay on the art of engraving with a full account of its origin and progress": v.1, p.1–29, and v.2, p.1–16. Table of monograms at end of each volume.

N57 Stubbe, Wolf. Graphic arts in the twentieth century. N.Y., Praeger [1963]. 318p. il. (part col.)

English ed. of *Die Graphik des zwanzigsten Jahrhunderts,* Berlin, Rembrandt [1962].

A pictorial survey of 20th-century graphic art. "Biographies," compiled by Kurt Sternelle, p.[251]-306.

N58 Twyman, Michael. Lithography, 1800–1850; the techniques of drawing on stone in England and France and their application in works of topography. London, N.Y., Oxford, 1970. 302p. 88 plates.

"Not intended to be a comprehensive history of lithography. It is a study of the various techniques used by artists in England and France for making drawings on stone, and of the use made of these methods in topographical and landscape prints."—*Introd.* Invaluable for research in early lithography.

Bibliography: (a) Literature on the history and techniques of lithography, 1801–20, p.257–62, arranged chronologically; (b) Sources for the early history and techniques of lithography, p.263–71; (c) General, p.272–77.

N59 United States. National Gallery of Art. Rosenwald Collection. Fifteenth century engravings of Northern Europe. Catalogue by Alan Shestack. Wash., D.C., National Gallery of Art [1967]. unpaged. 267 il.

The second in a series of catalogues of exhibitions drawn from the National Gallery's holdings (see also N60, N119); all but nine prints are from the Lessing J. Rosenwald Collection. A major book-catalogue devoted to Northern European engravings of the 15th century. Includes an introduc-

tory essay by Alan Shestack and entries on the 261 prints in the exhibition. Entries are arranged by engraver, in general following Lehrs' *Geschichte* (N39). In the catalogue proper, a brief essay on each engraver is followed by the entries for each engraving, giving date, Lehrs reference, dimensions, provenance, bibliographical references, and critical discussion.

A selected bibliography precedes the catalogue.

N60    _____. _____. _____. Fifteenth century woodcuts and metalcuts from the National Gallery of Art. Catalogue prepared by Richard S. Field. Wash., D.C., National Gallery of Art [1965?]. unpaged. 365 il.

The first in a series of catalogues of exhibitions drawn from the print holdings of the National Gallery, the major portion of which was formed from the Lessing J. Rosenwald Collection (see also N59, N119). Provides a detailed, scholarly survey of woodcuts and metalcuts created during the 15th century in Germany, Flanders, France, Switzerland, and Italy. Includes an introductory essay by Richard S. Field and entries on the 365 prints in the exhibition. Entries are arranged iconographically following Schreiber's *Handbuch* (N53). Each entry gives origin of print with date, Schreiber reference, dimensions, description, provenance, bibliographical references, and critical discussion.

A selected bibliography precedes the catalogue.

N61    Weber, Wilhelm. A history of lithography. N.Y., McGraw-Hill [1966]. 250p. il. (part col.)

English translation and conflation into 1v. of original 2v. German ed. pub. in 1961 and 1964 as *Saxa loquuntur: Steinereden,* Munich, Moos.

A general, but scholarly, history of lithography, emphasizing developments in the first half of the 19th century.

N62    Wend, Johannes. Ergänzungen zu den Oeuvreverzeichnissen der Druckgrafik. Band 1: Das deutschsprachiges Schrifttum. Leipzig, Zentralantiquariat der DDR, 1975. 521p. (Ergänzendes Handbuch zu den Oeuvreverzeichnissen der Druckgrafik, 1)

Attempts to supplement the latest standard catalogues raisonnés of Western printmakers from the 15th to the 20th centuries. Includes over 3,000 prints listed previously in auction catalogues, periodical literature, and other sources. Arranged alphabetically by printmaker, with source and description given for each print. A valuable aid to research despite some omissions and duplications of references already included in standard works.

SEE ALSO:  Brulliot, F. *Dictionnaire des monogrammes, marques figurées, lettres initiales, noms abrégés etc. avec lesquels les peintres, dessinateurs, graveurs et sculpteurs ont designé leurs noms* (E54); Florence, Galleria degli Uffizi, Gabinetto dei disegni e delle Stampe. *Cataloghi* (L8); Goldstein, F. *Monogramm-Lexikon...* (E56); Heller, J. *Monogrammen-Lexicon...* (E57); Nagler, G. K. *Die Monogrammisten...* (E58); Paris, Musée National du Louvre. Cabinet des Dessins, *Expositions du Cabinet des Dessins* (L12); Ris-Paquot, O. E. *Dictionnaire encyclopédique...* (E59).

# TECHNIQUES

N63    Antreasian, Garo Z., and Adams, Clinton. The Tamarind book of lithography: art & techniques. Los Angeles, Tamarind Lithography Workshop; N.Y., Abrams, 1971. 464p. il. (part col.)

Available in paperback.

A comprehensive, invaluable work on the art and techniques of lithography. Practical processes are clearly described in text and illustrations.

Contents: pt. 1, Drawing a lithograph; Processing the stone; The artist and the printer; Proofing and printing; After the edition is printed; Metal-plate, color, and transfer lithography; pt. 2, The chemistry of lithography; Materials and equipment; Inks; Paper; The printing press; The inking roller; Special processes; The lithography workshop.

Appendix A: Sources of supply, p.441–47. Appendix B: Bibliography, p.449–53. The bibliography is annotated and classified: (1) technical works; (2) history; (3) publications of the Tamarind Lithography Workshop.

N64    Auvil, Kenneth W. Serigraphy; silk screen techniques for the artist. Englewood Cliffs, N.J., Prentice-Hall [1965]. 165p. il.

A thorough handbook on the various techniques of silk-screen printing.

Contents: The medium; Equipping the studio; Preparing for stencil application; Image formulations; Stencil techniques; Color mixing; Printing; Cleaning and maintenance; The finished print.

Bibliography, p.158.

N65    Brunner, Felix. A handbook of graphic reproduction processes; a technical guide including the printmaking processes for art collectors and dealers, librarians, booksellers, publishers, artists, graphic designers and the printing trade. [4th ed.] N.Y., Hastings, [1972]. 380p. 440 il. (part col.)

Title page and text in English, German, and French. A detailed reference work on reproduction techniques and the means of their identification. Includes information on original graphic art; the techniques of letterpress; the techniques of intaglio; silk-screen process; lithography and the techniques of planographic printing; the identification of printing processes, etc. Excellent reproductions; full index.

N66    Burch, Robert M. Colour printing and colour printers: with a chapter on modern processes by W. Gamble. N.Y., Baker & Taylor, 1911. 281p. plates (part col.)

Now outdated but still useful for the early history of color printing. Written more for the historian than for the printmaker.

N67    Chieffo, Clifford T. Silk-screen as a fine art; a handbook of contemporary silk-screen printing. N.Y., Reinhold [1967]. 120p. il. (part col.)

"This book, concerned essentially with the techniques of silk-screen printing, is intended for painters and other artists who have already developed their own image and language

of expression in another medium, as well as for printmakers, teachers, and students."—*Pref.*

N68 Dolloff, Francis W., and Perkinson, Roy L. How to care for works of art on paper. [2d ed.] Boston, Museum of Fine Arts [1977]. 48p. 11 il.

1st ed. 1971.

An excellent, practical guide. Contents: (1) The history of papermaking; (2) The enemies of paper; (3) Matting and framing; (4) A note on restoration; Materials and services; Programs in art conservation.

Bibliography, p.46–48.

N69 Heller, Jules. Printmaking today, a studio handbook. 2d ed. N.Y., Holt [1972]. viii, 344p. il. (part col.)

1st ed. 1958.

"In *Printmaking Today* it has been my purpose to offer for college students and generally interested adult readers an introduction to the fine art of making prints that would, in handbook form, be comprehensive and systematic in its presentation of the materials and processes fundamental to original, creative work in lithography, woodcut, intaglio, and screen printing, as well as in the major variants and combinations thereof."—*Pref.* Well illustrated with reproductions of prints, photographs of studio procedures, line drawings of tools, etc.

Contents: pt. I, The planographic process; pt. II, The relief process; pt. III, The intaglio process; pt. IV, The stencil process; pt. V, Workshops, equipment, and materials.

Appendixes: Checklist of equipment and supplies; Sources for printmaking supplies; Films related to prints and printmakers; Bibliography; Glossary. Index.

N70 Ivins, William Mills. How prints look; photographs with a commentary. N.Y., [Metropolitan Museum of Art] 1943. 164p. il. *New ed. 1987*

At head of title: The Metropolitan Museum of Art.

"This book is an elementary introduction to the appearances (the outward and visible signs) of prints. It is not a history, and it contains no technical recipes or instructions for print making. Most of the time spent over it should be given to looking at pictures."—*Introd.* Still basic.

N71 Peterdi, Gabor. Printmaking: methods old and new. Rev. ed. N.Y., Macmillan [1971]. xxxix, 342p. il., 4 col. plates.

1st ed. 1959.

A well-illustrated handbook of practical information on traditional and contemporary printmaking techniques by a well-known printmaker; emphasizes works on metal.

Bibliography, p.330–31.

N72 Plenderleith, Harold James. The conservation of prints, drawings, and manuscripts. [Oxford] Pub. for the Museums Association by Oxford Univ. Pr., 1937. 66p. il., incl. charts, plates, diagrs.

Contents: (1) Materials and their permanence; (2) Mounting, storage, and exhibition; (3) Deterioration and reconditioning; (4) An outline of practical methods of cleaning and repair.

N73 Ross, John, and Romano, Clare. The complete printmaker: the art and technique of the relief print, the intaglio print, the collograph, the lithograph, the screen print, the dimensional print, photographic prints, children's prints, collecting prints, print workshop. N.Y., Free Pr., [1972]. 306p. il. (part col.)

A comprehensive handbook of all major printmaking techniques. Clear, concise texts describe the various techniques; supplemented by over 400 photographs of working procedures, reproductions of prints, and diagrams.

Section XII, "Sources and Charts," includes lists of U.S. and Canadian sources of supplies for printmaking, books on photo techniques, a screen printing information chart, papers for printmaking, domestic and foreign suppliers of etching presses, and new lithographic presses.

Classified bibliography, p.295–97.

N74 Zigrosser, Carl, and Gaehde, Christa M. A guide to the collecting and care of original prints. N.Y., Crown [1965]. 120p. il., diagrs.

Sponsored by the Print Council of America.

An excellent guide for both beginning and experienced collectors. Contains chapters explaining the various techniques and terminology of printmaking and the relationship between artists and the print market. Chapter 7, "The care and conservation of fine prints," is by Christa M. Gaehde.

# WATERMARKS

N75 Briquet, Charles Moïse. Les filigranes. Dictionnaire historique des marques du papier dès leur apparition vers 1282 jusqu'en 1600, avec 39 figures dans le texte et 16,112 facsimilés de filigranes. Deuxième édition. Leipzig, Hiersemann, 1923. 4v. il., plates, facsims. (Repr.: N.Y., Hacker, 1968.)

A history of watermarks, arranged alphabetically by the descriptive titles of the marks. Bibliography, v.1, p.[viii]–x.

N76 Churchill, William Algernon. Watermarks in paper in Holland, England, France etc., in the XVII and XVIII centuries and their interconnection. Amsterdam, Hertzberger, 1935. 94, cdxxxiip. il., facsims. (Repr.: Amsterdam, Hertzberger, 1967.)

The text consists primarily of lists of papermakers, arranged by country; the plates reproduce 578 watermarks, corresponding to numbers given in the lists.

N77 Heawood, Edward. Watermarks, mainly of the 17th and 18th centuries. Hilversum, Holland, The Paper Publications Soc., 1950. 3p. 1., 11–154p., 1 1. 533 pl. (Monumenta chartae papyraceae historiam illustrantia. [v.]1.)

300 copies printed.

Preface by the general editor, E. J. Labarre.

A basic compilation of watermarks, primarily of the 17th and 18th centuries.

## WESTERN COUNTRIES

### France

N78   Adhémar, Jean, ed. Imagerie populaire française, par Jean Adhémar, Michèle Hébert, J. P. Seguin, Elise J. P. Seguin [et] Philippe Siguret. [Milan] Electa [1968]. 227p. 57 il., 121 plates (part col.), facsims.

A well-illustrated survey of aspects of *imagerie populaire* in France from the 15th through the 19th century.

N79   Bailly-Herzberg, Janine. L'Eau-forte de peintre au dix-neuvième siècle: La Société des Aquafortistes (1862–1867). Préface de Jean Adhémar. Paris, Laget, 1972. 2v. il.

An invaluable study of the revival of the art of etching in the second half of the 19th century in France through the activities of the Société des Aquafortistes. Meticulously documented; superbly illustrated. v.1 comprises critical analyses and detailed discussions of five years of publishing enterprises by the Société. Bibliography, p.279–85. v.2 is a "Dictionnaire de la Société des Aquafortistes," listing participating members and their works. Includes indexes of names, titles of etchings, and topographies.

N80   Baudicour, Prosper de. Le peintre-graveur français continué, ou Catalogue raisonné des estampes gravées par les peintres et les dessinateurs de l'école française nés dans le XVIIIe siècle, ouvrage faisant suite au Peintre-graveur français de M. Robert-Dumesnil. Paris, Bouchard-Huzard; Leipzig, Weigel, 1859–61. 2v. fold. geneal. table. (Repr.: Paris, Nobele, 1967; Hildesheim, Olms; N.Y., Garland, 1978.)

A supplement to Robert-Dumesnil (N87), extending the treatment through the 18th century. Biographical sketches of the artists are followed by detailed descriptions of their works.

Each volume has both chronological and alphabetical lists of artists included.

N81   Bocher, Emmanuel. Les gravures françaises du XVIIIe siècle; ou Catalogue raisonné des estampes, vignettes, eaux-fortes, pièces en couleur, au bistre et au lavis, de 1700 à 1800. Paris, Librairie des bibliophiles, 1875–82. 6v. (Repr.: N.Y., Garland, 1978.)

Oeuvre catalogues of six French printmakers of the 18th century: Lavreince, Baudouin, Chardin, Lancret, A. de Saint-Aubin, J. M. Moreau le jeune.

N82   Courboin, François. Histoire illustrée de la gravure en France. Paris, Le Garrec, 1923–28. 4v. 3 portfolios of plates. (Repr.: N.Y., Garland, 1978.)

An illustrated history of French engraving. Includes an introductory historical survey and biographical information on each artist, with identification of works reproduced.

Contents: v.1, Des origines à 1660; v.2, De 1660 à 1800; v.3, XIXe siècle; v.4, Table générale, donnant les noms des personnes et les titres des estampes et des ouvrages imprimés compris dans les trois tomes.

N83   Courboin, François, and Roux, Marcel. La gravure française; essai de bibliographie. Paris, Le Garrec, 1927–28. 3v. (Repr.: N.Y., Garland, 1978.)

A classed bibliography including books and periodical articles.

v.1 covers various subjects; v.2, biographical material on individual artists; v.3, index.

N84   Didot, Ambroise Firmin. Les graveurs des portraits en France. Catalogue raisonné de la collection des portraits de l'école française appartenant à A. F. D. Paris, Firmin-Didot, 1875–77. 2v. (Repr.: Nieuwkoop, De Graaf, 1970.)

Arranged alphabetically by engraver. For each engraved portrait provides the sitter's name, title or occupation, dates, and description.

"Table des personnages," v.2, p.[509]; "Table des peintres, dessinateurs, sculpteurs et architectes d'après lesquels les portraits ont été gravés," v.2, p.[541].

N85   Leymarie, Jean. The graphic works of the Impressionists: Manet, Pissarro, Renoir, Cézanne, Sisley. Catalogue by Michel Melot. N.Y., Abrams; London, Thames & Hudson [1972]. 353p. 445 il. (17 col.)

A trans. by Jane Brenton from the French: *Les graveurs des impressionistes: Manet, Pissarro, Renoir, Cézanne, Sisley.* Paris, Arts et métiers graphiques, 1971.

An excellent catalogue of the prints of five of the major Impressionist painters. Catalogue entries include title, date, technique, dimensions, references, collection of impression reproduced, and comments. All prints are reproduced in black and white or in color. The introduction, by Leymarie, p.[5]–29, is a critical-historical account of printmaking by the Impressionists.

A companion volume devoted exclusively to the prints of Degas has also been published: Adhémar, Jean. *Degas: the complete etchings, lithographs, and monotypes.* N.Y., Viking; London, Thames & Hudson [1975]. A trans. by Jane Brenton from the French: *Edgar Degas: gravures et monotypes.* Paris, Arts et métiers graphiques, 1972.

N86   Paris. Bibliothèque Nationale. Département des Estampes. Inventaire du fonds français: graveurs du XVIe siècle. 2v. Paris, Le Garrec & Bibliothèque Nationale, 1932–38. (Repr.: Paris, Bibliothèque Nationale, 1971.)

v.1 by André Linzeler; v.2 by Jean Adhémar. Contents: v.1, Androuet du Cerceau-Leu; v.2, Levert-Woeiriot, anonymes, supplément.

———. ———. ———. Inventaire du fonds français: graveurs du XVIIe siècle. v.1–(7). Paris, Bibliothèque Nationale, 1939–(76).

All volumes available in original or reprint editions.

v.1–6 by Roger-Armand Weigert; v.7 by Weigert and Maxime Préaud. Contents: v.1–6, Alix-Leclerc.

———. ———. ———. Inventaire du fonds français: graveurs du XVIIIe siècle. v.1–(14). Paris, Le Garrec & Bibliothèque Nationale, 1930/31–(77).

All volumes available in original or reprint editions.

v.1–8 by Marcel Roux; other volumes by Edmond Pognon,

N95   Geisberg, Max. Bilder-Katalog zu Max Geisberg. Der deutsche Einblatt-Holzschnitt in der ersten Hälfte des XVI. Jahrhunderts: 1600 verkleinerte Wiedergaben, herausgegeben von Hugo Schmidt. München, Schmidt [1930]. 299p. il.

A summary or key to Geisberg's *Einblatt-Holzschnitt* (N96).

N96   _____. Der deutsche Einblatt-Holzschnitt in der ersten Hälfte des XVI. Jahrhunderts. München, Schmidt [1923-29]. 3v. 1,600 mounted plates (part col.)

Rev., English ed.: N.Y., Hacker, 1974 (N97).

Issued in portfolio.

_____. Übersicht über die in der ersten Hälfte des Werkes veröffentlichen Holzschnitte. München, Schmidt, 1926. 89p. incl. plates.

Interleaved.

_____. Die Gesamtverzeichnisse. München, Schmidt [1930]. 52, [85]p. il., 3 facsims.

"Die Titel der häufiger zitierten Bücher," p.15.

A monumental corpus of more than 1,600 reproductions of German single-leaf woodcuts of the first half of the 16th century. An essential reference work for the study of northern Renaissance art, although it is now partially superseded by Hollstein *German engravings . . .* (N98).

Contents of index volume: "Konkordanz," p.10-14, which refers from the alphabetical listing to the table of contents; "Das Verzeichnis der Schnitte," p.16-48, which lists plates alphabetically by artist, numbered consecutively with indication of the volume in which they are found; "Verzeichnis der Holzschnitte nach Darstellungsgegenständen geordnet," p.49-52, which lists plates according to broad subjects; "Inhaltsverzeichnis," p.[55-139], a table of contents listing plates as they appear in the volumes.

N97   _____. The German single-leaf woodcut: 1500-1550. Rev. and ed. by Walter L. Strauss. [N.Y.] Hacker, 1974. 4v. il.

At head of title: Max Geisberg. Based on Geisberg's *Der deutsche Einblatt Holzschnitt in der ersten Hälfte des 16. Jahrhunderts* (N96), and the *Bilder-Katalog zu Max Geisberg* (N95), edited by Hugo Schmidt.

A revision and translation of Geisberg's fundamental work (N96). Includes some reorganization of material, adds references to more recent catalogues and a few prints beyond current catalogues, and eliminates a few superseded references. Bibliography, v.1, p.ix-xiii.

N98   Hollstein, F. W. H. German engravings, etchings and woodcuts, c.1400-1700. Amsterdam, Hertzberger [1954-(78)]. v.1-(11), 16-(22). il.

Similar in format and kind of information to Hollstein's *Dutch and Flemish etchings . . .* (N126), and likewise indispensable to work in the field. Projected to include "some eight thousand of the more important prints of the German School."—*Introd.* An index volume is planned.

Contents by volume: (1) Aachen-Altdorfer; (2) Altzenbach-B. Beham; (3) Hans Sebald Beham; (4) Beischlag-Brosamer; (5) Brucker-Coriolanus; (6) Cranach-Brusse; (7) Albrecht and Hans Dürer; (8) Dürr-Friedrich; (9) Frölich-Gentsch; (10) Georg-Graf; (11) Urs Graf; (16) Kandtpaltung-Bartolomeus II Kilian; (17) Lucas Kilian-Philipp Kilian; (18) Philipp Kilian (cont.)-Wolfgang Kilian; (19) Kirchmaier, after-Küsel; (20) Maria Magdalena Küsel-Johann Christoph Laidig; (21) Lang-Leinberge; (22) Leipolt-Lorch.

N99   Strauss, Walter L., ed. The German single-leaf woodcut: 1550-1600. [N.Y.] Hacker, 1975. 3v. xv, 1429p. approx. 1,200 il.

A sequel to *The German single-leaf woodcut: 1500-1550* (N97), which is the editor's revision and translation of Geisberg's *Der deutsche Einblatt Holzschnitt in der ersten Hälfte des XVI. Jahrhunderts* (N96). Includes reproductions of and documentation on hundreds of German single-leaf woodcuts of the second half of the 16th century.

N100  Winkler, Rolf Arnim. Die Frühzeit der deutschen Lithographie; Katalog der Bilddrucke von 1796-1821. München, Prestel, 1975. 467p. il. (Materialien zur Kunst des 19. Jahrhunderts, Bd. 16)

An extremely well-documented study and catalogue of the beginnings of German lithography. This work will doubtless be regarded as the standard reference in the field for years to come.

Contents: Einführung (p.7-15); Einleitung zum Katalog; Anmerkungen (includes bibliographical references); Abkürzungen zum Katalog; Katalog I. Teil: Verfasser (entries 1-952 on lithographers giving for each biographical data and catalogue of works, with references); Katalog II. Teil: Folgen (entries 953-9676 on series of lithographs giving titles, full descriptions, and references); Tafeln (Abb. 1-107); Lithographisches Wörterbuch (detailed definitions of terms pertaining to lithography); Anhang: Masse, Papierformate, Geldwert, Texte; Literaturverzeichnis (p.439-40); Personenregister; Sachregister.

SEE ALSO:  Lehrs, M. *Geschichte und kritischer Katalog . . .* (N39).

## Great Britain

N101  Abbey, John Roland. Life in England in aquatint and lithography, 1770-1860; architecture, drawing books, art collections, magazines, navy and army, panoramas, etc., from the library of J. R. Abbey; a bibliographical catalogue. London, priv. print. at the Curwen press, 1953. 427p. il., plates (Repr.: Folkestone, Dawsons of Pall Mall, 1972.)

Original ed. of 400 copies.

_____. Scenery of Great Britain and Ireland in aquatint and lithography, 1770-1860, from the library of J. R. Abbey; a bibliographical catalogue. London, priv. print. at the Curwen press, 1952. 399p. il., plates. (Repr.: Folkestone, Dawsons of Pall Mall, 1972.)

Original ed. of 500 copies.

_____. Travel in aquatint and lithography, 1770-1860, from the library of J. R. Abbey; a bibliographical catalogue. London, priv. print. at the Curwen press, 1956-57. 2v. il., plates. (Repr.: Folkestone, Dawsons of Pall Mall, 1972.)

Original ed. of 400 copies.

Catalogues of the unequalled Abbey Collection of English Coloured Books. Invaluable reference works for the study of British illustration and typography. The collection is limited to books printed in England, with exceptions in the last two *Travel* volumes, in which are included a few books printed in America bearing English publishers' titles or imprints and a few early books published in Australia and India.

Each catalogue contains indexes of artists and engravers, authors, printers, publishers and booksellers, and titles.

**N102** Bushnell, George Herbert. Scottish engravers; a biographical dictionary of Scottish engravers and of engravers who worked in Scotland to the beginning of the nineteenth century. With a chronological index. London, N.Y., Oxford Univ. Pr., 1949. 60p.

Contains "Some details of the lives and works of 243 engravers" and is "an unofficial supplement to Bryan" (E38). Each entry notes sources and whether the engraver is in Bryan or the *Dictionary of national biography.* List of abbreviations of sources, p.xi–xii.

**N103** Hammelmann, Hanns. Book illustrators in eighteenth-century England. Ed. and completed by T. S. R. Boase. New Haven and London, published for the Paul Mellon Centre for Studies in British Art (London) Ltd. by Yale Univ. Pr., 1975. 120p. 45 il.

A ten-page introductory essay on book illustration in the 18th century is followed by a dictionary of 263 artists who worked as illustrators in England between 1700–1800. Each entry gives biographical information and a chronological list of books illustrated. Also includes a chronological list of plates unsigned by the designers. Index of authors and titles and general index.

**N104** Hind, Arthur Mayger. Engraving in England in the sixteenth & seventeenth centuries; a descriptive catalogue with introductions. Cambridge, Univ. Pr., 1952–(64). v.1–(3). plates.

Contents: v.1, The Tudor period; v.2, The reign of James I; v.3, The reign of Charles I . . . compiled from the notes of the late A. M. Hind by Margery Corbett & Michael Norton.

General introductions precede the catalogues of each part. The catalogues are arranged by artist and give information and bibliographical notes followed by a list of works grouped by type. Detailed descriptions and dimensions are given.

In v.1 the Catalogue is followed by: General bibliography; A note on Humphrey Dyson's collection of Elizabethan proclamations; A note on 'Grangers'; Chronological list of engravers working in England from Henry VIII (1540) to the Revolution (1689); Notes on printers, printsellers and publishers; Notes on the most important collections available for study; On the arrangement of collections of engraved portraits: A note for museums and collectors; Index, p.329–[34]; Plates.

v.2 is arranged similarly to v.1 but the Catalogue is followed by: Anonymous engravers, including some foreign prints of English interest, by known as well as anonymous engravers; Corrections and additions to Part I; Index, p.407–13; Plates.

The Catalogue of v.3 is followed by anonymous engravers and general and subject indexes.

**N105** Hodnett, Edward. English woodcuts 1480–1535. 1st ed., reprinted; with additions and corrections. [Oxford, Univ. Pr.] 1973. (1), xv, 483, xvii, 82p. il.

1st ed. 1935.

A scholarly study and catalogue of woodcuts used to illustrate English printed books of the period 1480–1535. Includes a comprehensive bibliography of illustrated books of the period, a detailed catalogue of approximately 2,500 woodcuts, a list of facsimiles, and an index of woodcuts by size.

**N106** Laver, James. A history of British and American etching. London, Benn, 1929. 195p. 84 plates.

"A volume in which might be traced the evolution of etching in England from its beginnings, the story of its development carried down to the present day, and the many common characteristics of the British and American Schools emphasized."—*Pref.*

Extensive bibliography in two parts: (I) General and technical, arranged chronologically, 1593–1928; (II) Monographs, arranged alphabetically by artist, then chronologically.

**N107** McLean, Ruari. Victorian book design & colour printing. 2d ed. London, Faber and Faber, 1972. xii, 241p. il. (part col.)

Covering primarily developments in London between 1837–90, the "subject is the design of books as a *whole,* not book illustration."—*Foreword to lst ed.*

Bibliographical footnotes.

**N108** Ray, Gordon N. The illustrator and the book in England from 1790 to 1914. [N.Y.] The Pierpont Morgan Library [and] Oxford Univ. Pr. [1976]. xxxiii, 336p. il., plates (2 col.)

Published in conjunction with an exhibition at the Pierpont Morgan Library in March and April of 1976.

"The first comprehensive and detailed study of English book illustration between 1790 and 1914. It attempts in essay and illustration and by full bibliographical descriptions to give a comprehensive view of that time when England's illustrated books were as fine as any in the world."—*Pref.* The "Introduction for collectors," p.xiii–xxxiii, gives a summary of study in the field and the history of the formation of the author's collection, upon which the exhibition and catalogue were based. The 333 entries in the Catalogue section are arranged chronologically in general; formal bibliographical descriptions of the Catalogue were written by Thomas V. Lange.

Appendix: 100 outstanding illustrated books published in England between 1790 and 1914, p.313–15. Bibliography, p.317–25. Index of artists; Index of authors and titles.

**N109** Rostenberg, Leona. English publihers in the graphic arts, 1599–1700: a study of the printsellers & publishers of engravings, art & architectural manuals, maps & copy-books. With a preface by A. Hyatt

Mayor. N.Y., Burt Franklin, 1963. 128p. il. (Burt Franklin bibliography and reference series no. 42)
An invaluable study of a neglected field; especially useful for the bibliography of 17th-century books on art and architecture.

Contents: (1) The background; (2) The Stuart monarchy; (3) The Commonwealth; (4) The Restoration; (5) Résumé; (6) Bibliography of art & architectural books published in England, 1598-1700; (7) Sources.

N110   Russell, Charles E. English mezzotint portraits and their states from the invention of mezzotinting until the early part of the 19th century. London, H. & T. Smith; N.Y., Minton, Balch, 1926. 2v. plates.
v.1 is a quarto volume of plates; v.2 is the text volume with subtitle: Catalogue of corrections of and additions to J. Chaloner Smith's *British mezzotint portraits* (N111).

Contents, v.2: Engravers, p.1-425; Engraver not ascertained, p.426-85; Appendix of earliest specimens, p.486-88; Errata, p.489-98; Corrections of J. Chaloner Smith's indexes, p.499-500; Index of painters, p.501-4; Index of personages, p.505-25; Index of fancy and other names, p.526.

N111   Smith, John Chaloner. British mezzotint portraits; being a descriptive catalogue of these engravings from the introduction of the art to the early part of the present century. Arranged according to the engravers; the inscriptions given at full length; and the variations of state precisely set forth; accompanied by biographical notes. London, Southeran, 1883. 4v. in 5. il., diagrs., and portfolio of 2 plates, 123 ports. (Repr.: N.Y., Garland, 1978.)
"Intends to describe all mezzotint portraits published in England, Ireland, and Scotland, down to the early part of the present century."—*Notes.*

The arrangement is alphabetical by names of engravers, then by names of persons represented. "Authors and works principally consulted," p.xiv-xvii.

## Italy

N112   Bartsch, Adam von. Le peintre graveur illustré; illustrations to Adam Bartsch's Le peintre graveur, volumes XII-(XXI). General editor: A. Hyatt Mayor. Volume I: Italien chiaroscuro woodcuts (Bartsch Vol. XII), ed. by Caroline Karpinski. University Park, Pennsylvania State Univ. Pr. [1971]. xxi, 209p. il.
The only volume published in an announced series of volumes of illustrations to the Italian volumes of Bartsch's *Le peintre graveur* (N13). "Primarily intended as a visual reference to Bartsch's catalogue; thus Bartsch's order and numeration have been retained ... and the caption for each print has been taken from Bartsch's entry for that print."—*Foreword. p.ix.* A projected accompanying volume of critical notes has not been published.

"Adam von Bartsch: an introduction to his life and work," by Walter Koschatzky, p.xi-xxi. Index of designers; Index of printmakers.

The series, *Le peintre graveur illustré,* as announced by Pennsylvania State Univ. Pr. and now cancelled, has been announced again for publication by Abaris Books, beginning in 1979. This new series is to include illustration volumes to the Netherlandish and German volumes of Bartsch, as well as Italian (see Bartsch, *The illustrated Bartsch,* N12).

N113   Baudi di Vesme, Alessandro. Le peintre-graveur italien: ouvrage faisant suite au Peintre-graveur de Bartsch. Milan, Hoepli, 1906. 542p. (Repr.: Turin, Bottega d'Erasmo, 1963; N.Y. Garland, 1978.)
The basic work on late 16th-century through 18th-century Italian engravers and engraving. Includes 61 painter-engravers giving a biographical sketch and list of engravings for each. Supplements Bartsch (N13). "Table des graveurs," p.541-42.

N114   Catalogo nazionale Bolaffi della grafica. N. 1-(5). 1969-(1973/1974). [Torino] Bolaffi [1970-(74)]. v.1-(5). il. (part col.)
An annual dictionary of contemporary Italian printmakers. Includes for each printmaker biographical data and reproductions of prints made during the year covered, with title, technique, dimensions, size of edition, and price for each print. Each volume contains indexes of printmakers, print publishers, galleries, and a cumulative index of printmakers included in all volumes published.

N115   Hind, Arthur Mayger. Early Italian engraving, a critical catalogue with complete reproduction of all the prints described. London, Quaritch; N.Y., Knoedler & Co., 1938-48. 7v. il., plates. (Repr.: Nendeln, Liechtenstein, Kraus, 1970 (7v. in 4).)
The original edition was limited to 375 copies for sales and 30 lettered copies not on the market. Pt.2 limited to 275 copies and bears imprint: Pub. for the National Gallery, Wash., D.C.

A section of short articles on each artist containing biographical and bibliographical information is followed by a list of works with descriptions of their various states, dimensions, collections, watermarks, inscriptions, and bibliographical references. Each text volume also contains a section on watermarks and a concordance to Bartsch (N13), Passavant (N44), and the British Museum catalogue, and an index of artists and subjects.

Contents: pt. 1, Florentine engravings and anonymous prints of other schools. v.1, Catalogue, v.2-4, Plates; pt. 2, Known masters other than Florentine monogrammists and anonymous. v.5, Catalogue, v.6-7, Plates.

General bibliography, v.1, p.xv-xxii. List of collections and mode of references in the catalogue, v.1, p.xxiii-xxvi. Additions and corrections to pt. 1 in v.5, p.307-13.

N116   Kristeller, Paul. Early Florentine woodcuts. With an annotated list of Florentine illustrated books. London, Paul, Trench, Trubner, 1897. 184p. 123 plates. (Repr.: Nieuwkoop, De Graaf, 1970.)
The primary emphasis is on book illustration rather than on separate woodcuts. An introductory essay precedes the list of illustrated Florentine books of the 15th and 16th centuries.

Index of printers and publishers, p.181-84.

*see also Essling,
Livres à figures venitiens... 15e-16e s..
Repr. 1908... f 011.7*

N117  Servolini, Luigi. Dizionario illustrato degli incisori italiani moderni e contemporanei. Milano, Görlich [1955]. 871p. il., plates (part col.)
A dictionary of modern Italian engravers, with bibliography for each artist.

N118  Toschi, Paolo. Stampe popolari italiane dal XV al XX secolo. Milano, Electa [1964]. 258p.
A well-illustrated survey of *imagerie populaire* in Italy treated categorically rather than chronologically.

Contents: Introduzione, Tematica sacra; Epica e storia; Ciclo dell'anno; Stampe satiriche e moraleggianti; Allegorie e proverbi; Tematica animalesca; Canto, danza, musica et teatro; Giochi; Cantastorie: Libretti e fogli volanti.

Bibliography, p.241-44. "Principali collezioni di stampe popolari," p.245.

N119  United States. National Gallery of Art. Early Italian engravings from the National Gallery of Art. Wash., D.C., National Gallery of Art, 1973. xxviii, 578p. il.
A catalogue published in conjunction with an exhibition, *Prints of the Italian Renaissance,* drawn primarily from the Lessing J. Rosenwald Collection in the National Gallery. The third in a series of catalogues on prints in the National Gallery (N59, N60). The catalogue entries were written by Jay A. Levenson, Konrad Oberhuber, and Jacquelyn L. Sheehan. Introduction, p.xiiii-xxvi, by Konrad Oberhuber.

A monumental work which encompasses the entire range of 15th- and early 16th-century Italian engravings. Includes a representative survey of niello prints and a consideration of Italian woodcuts in the appendixes. The catalogue proper is arranged in 28 sections on individual known and anonymous engravers. Each section includes a critical essay on the engraver and detailed, fully documented entries. Extensive references in footnotes. Extremely well-illustrated with reproductions of prints catalogued and comparative material.

Contents: (I) Maso Finiguerra; (II) Baccio Baldini; (III) Anonymous fine manner; (IIII) Francesco Rosselli; (V) Antonio Pollaiuolo; (VI) Masters of the Tarocchi; (VII) Anonymous Northeast Italian; (VIII) Andrea Mantegna; (VIII) Mantegna School; (X) Giovanni Antonio da Brescia; (XI) Zoan Andrea; (XII) Giovanni Pietro da Birago; (XIII) Leonardo da Vinci; (XIIII) Cristofano Robetta; (XV) Benedetto Montagna; (XVI) Master I•I•CA; (XVII) Jacopo de' Barbari; (XVIII) Girolamo Mocetto; (XVIIII) Giulio Campagnola; (XX) Domenico Campagnola; (XXI) Master of the Beheading of St. John the Baptist; (XXII) Giovanni Battista Palumba, the Master I.B. with the Bird; (XXIII) Master of 1515; (XXIIII) Nicoletto da Modena; (XXV) Lorenzo Costa; (XXVI) Jacopo Francia; (XXVII) Master NA•DAT with the Mousetrap; (XXVIII) Master IRs; (XXVIIII) Anonymous 16th century.

Appendixes: (A) Copper engraving plates; (B) Niello prints; (C) Woodcuts; (D) Concordance with Hind; (E) Watermarks.

Bibliography in Abbreviations, p.xxvii-xxviii.

SEE ALSO:  Bologna. Pinacoteca Nazionale. Gabinetto delle Stampe. *Catalogo generale della raccolta di stampe antiche* (N16).

## Latin America

N120  Haab, Armin. Mexican graphic art. [English version: C. C. Palmer] N.Y., Wittenborn [1957]. 126p. il. (part col.)
A pictorial survey of Mexican prints, with a brief introductory text.

Index, p.103-26, contains brief biographies and portraits of printmakers. List of artists, p.127.

N121  Haight, Anne Lyon, ed. Portrait of Latin America as seen by her print makers; Retrato de la América latina hecho por sus artistas gráfico. N.Y., Hastings House [1946]. 36p. plates.
Contains a short biographical sketch on each artist included.

SEE ALSO:  Catlin, S. L., and Grieder, T. *Art of Latin America since independence* (I363); Fernández, J. *A guide to Mexican art . . .* (I369); *Image of Mexico . . .* (E122).

## Low Countries

N122  Burchard, Ludwig. Die holländischen Radierer vor Rembrandt, mit beschreibenden Verzeichnissen und biographischen Übersichten. 2. durch 12 Tafeln und ein alphabetisches Register verm. Ausg. Berlin, Cassirer, 1917. 183p.
Biographical notes on and descriptions of the work of about 15 engravers before Rembrandt.

"Katalog der Radierungen," p.121-76. "Alphabetisches Verzeichnis der zitierten Künstler und öffentlichen Sammlungen," p.177-83.

N123  Conway, William Martin. The woodcutters of the Netherlands in the fifteenth century. In three parts: I. History of the woodcutters. II. Catalogue of the woodcuts. III. List of the books containing woodcuts. Cambridge, Cambridge Univ. Pr., 1884. 359p. (Repr.: Nieuwkoop, De Graaf, 1961, in cooperation with Olms, Hildesheim.)
The standard early study.

Contents of parts I and II: (1) Woodcuts from the blockbooks; (2) Louvain, Utrecht, and Bruges (1475-84); (3) Leeu's early workmen at Gouda and Antwerp (1480-91); (4) The Haarlem woodcutter and his school (1483-1500); (5) Foreign woodcuts used by Leeu and others (1485, 1491); (6) Zwolle (1484-1500); (7) Delft (1477-98); (8) Brussels and Louvain (1484-96); (9) Gouda, Deventer, Leyden, and Schoonhoven (1486-1500); (10) Late Antwerp woodcuts (1487-1500).

N124  Delen, Adrien Jean Joseph. Histoire de la gravure dans les anciens Pays-Bas et dans les provinces belges, des origines jusqu'à la fin du XVIIIe siècle. Paris, Bruxelles, van Oest, 1924-35. v.1-2². 172 plates.
v.2 pub. Paris, Les Éditions d'art et d'histoire; last volume published.

Reprint of v.1-2² pub. as *Histoire de la gravure dans les anciens Pays-Bas et dans les provinces belges, des origines jusqu'à la fin du XVIe siècle.* Paris, Nobele, 1969.

Contents: v.1, Des origines à 1500; v.2, Le XVIe siècle, Les graveurs-illustrateurs, Les graveurs d'estampes.

N125   Dutuit, Eugène. Manuel de l'amateur d'estampes . . . contenant: Un aperçu sur les plus anciennes gravures . . . sur les livres xylographiques . . . un essai sur les nielles ou gravures d'orfèvres; [et le Manuel de] Les écoles . . . flamande et hollandaise. Paris, Lévy, 1881–88. 4v. in 5. (Repr.: Amsterdam, Hissink, 1971.)
Only four of the eight proposed volumes ever published. Remains standard for some printmakers.
    Contents: v.1, pt. 1, Introduction générale: Les plus anciennes gravures connues avec date. Livres xylographiques. Atlas; v.1, pt. 2, Introduction générale: Nielles; v.4–6. Écoles flamande et hollandaise.

N126   Hollstein, F. W. H. Dutch and Flemish etchings, engravings and woodcuts, c.1450–1700. Amsterdam, Hertzberger [1949–(78)]. v.1–(20). il.
v.17–20 pub. Amsterdam, Vangendt.
    Completion of Hollstein's work is now an undertaking of Karel G. Boon, Director of the Print Room, Rijksmuseum, and his staff.
    Projected to 25v. and an index volume. "Every print of importance or of interest from the point of view of the history of art will be illustrated. . . . Between the catalogues of the works are given, also in alphabetical order, complete lists of those prints which have been engraved after paintings and drawings by well-known artists. The numbers in brackets . . . refer to Wurzbach [E135] . . . ." — *Introd.*
    Arranged alphabetically by names of artists, with brief biographical notes. Projected to contain illustrations of about 10,000 of the important prints of the Dutch and Flemish schools when all volumes are completed. Dimensions are given, and all known states of each print are cited.
    Contents by volume: (1) Abry-Berchem; (2) Berckheyde-Bodding; (3) Boekhorst-Brueghel; (4) Brun-Coques; (5) Cornelisz-Dou; (6) Douffet-Floris; (7) Fouceel-Gole; (8) Goltzius-Heemskerck; (9) Heer-Kuyl; (10) L'Admiral-Lucas van Leyden; (11) Leyster-Matteus; (12) Masters and monogrammists of the 15th century; (13) Monogrammists of the 16th and 17th century; (14) Meer-Ossenbeeck; (15) Van Ostade-De Passe; (16) De Passe (continued); (17) Pauli-Rem; (18) Rembrandt, text; (19) Rembrandt, plates; (20) Renesse-Ryssen.

N127   Meyer, Maurits de. Imagerie populaire des Pays-Bas: Belgique, Hollande. [Milan] Electa [1970]. 216p. 175 il. (part col.)
First published with title: *Stampe popolari dei Paesi Bassi*, in a trans. from the French. German ed.: *Populäre Druckgraphik Europas: Niederlande, vom 15. bis zum 20. Jahrhundert*, München, Callwey [1970].
    A generously illustrated survey of *imagerie populaire* in the Low Countries. Covers religious and devotional popular images, as well as nonsecular images and playing cards from the earliest examples to the present.
    Bibliography, p.201–3.

N128   Nijhoff, Wouter. Nederlandsche houtsneden, 1500–1550, reproducties van oude Noord-en Zuid-Nederlandsche houtsneden op losse bladen met en zonder tekst in de oorspronkelijke grootte uitgegeven door Wouter Nijhoff. 's Gravenhage, Nijhoff, 1931–39. 101p. 414 plates.
A collection of reproductions of Dutch woodcuts with descriptive text and bibliographical references. p.[1]–6 of the plate volume contain a table of contents, with titles arranged by artist, and indication of location; p.7–8, index of artists and monogrammists and titles of anonymous works.

N129   Waller, François Gerard. Biographisch woordenboek van Noord Nederlandsche graveurs, uitgegeven door beheerders van het Wallerfonds en bewerkt door W. R. Juynboll; met 61 portretten in lichtdruk. 's Gravenhage, Nijhoff, 1938. 551p. il., 60 ports., geneal. tables. (Repr.: Amsterdam, Israël, 1974.)
A biographical dictionary of north Netherlandish engravers including modern artists. For each artist gives media, dates, and bibliography. List of abbreviations indicating equivalents in Dutch, French, English, German, Italian, and Spanish, p.xvi–xix. Bibliography, p.498–544; Chronological list of sources, p.545–51. Appendix A, Engravers and etchers of whom no prints are known. Appendix B, Publishers of prints and maps.

SEE ALSO:  Lehrs, M. *Geschichte und kritischer Katalog . . .* (N39).

## Russia

N130   Claudon-Adhémar, Catherine. Stampe popolari russe. Milano, Electa, 1974. 202p. 190 il. (part col.)
German ed.: *Populäre Druckgraphik Europas/Russland.* München, Callwey, 1975.
    A beautifully illustrated survey of Russian *imagerie populaire* from 1564 to the beginning of the 20th century.

N131   Duchartre, Pierre-Louis. L'imagerie populaire russe et les livrets gravés, 1629–1885. Paris, Gründ [1961]. 188p. il., 8 col. plates.
Contents: pt. 1, Les origines de la gravure en Russie; pt. 2, Principaux thèmes traités par l'imagerie populaire russe.
    Annotated bibliography, p.186–87.

N132   Rovinskiĭ, Dimitriĭ Aleksandrovich. Podrobnyĭ slovař russkikh graverov XVI–XIX vv. S.-Peterburg, Tipografiía Imperatorskoĭ Akademii Nauk, 1889. 2v. il., plates.
A dictionary of Russian engravers. Contents: t.1, A–I; t.2, K–F.

## Scandinavia

N133   Clausen, V. E. Stampe popolari scandinave. [Traduzione a cura di Marisa Bianchi, Milano]. Electa [1973]. 216p. 201 il. (part col.)

Trans. of *Folkelig grafik i Skandinavien,* København, Berg, 1973.

German ed.: *Skandinavien: vom 15. bis z. 20. Jahrhundert,* München, Callwey, 1973

A well-illustrated survey of Scandinavian *imagerie populaire.*

Bibliography, p.205-6. Index of names and places.

N134  Sallberg, Harald, ed. Svensk grafik från tre sekler; en översikt omfattande tiden från 1700–talets mitt till våra dagar. Redaktion Harald Sallberg [och] Gunnar Jungmarker. Stockholm [Realförlaget, 1957]. 468p. il., col. plates.

A very well-illustrated survey of Swedish printmaking from 1700 to the mid-20th century. Contents: Jungmarker, Gunnar. Svensk grafik från sjuttonhundratalets mitt till inemot arton hundratalets slut; Holmér, Folke. Decennierna kring sekelskiftet 1900; Sandström, Sven. Första världskrigets tid och decenniet därefter; Lindhagen, Nils. Den yngre samtida grafiken; Bergmark, Torsten. Färggrafik.

Bibliography, p.461-62. Index of artists, p.463-[69].

N135  Sthyr, Jørgen. Dansk grafik 1500-1910. København, Forening for Voghaandvaerk, 1943-49. 2v. il.

A chronological survey of Danish graphic art. v.1, 1500-1800; v.2, 1800-1910. Includes bibliographies.

## Spain

SEE: Domínguez Bordona, J. and Ainaud, J. *Miniatura, grabado, encuadernación* (I438).

## Switzerland

N136  Scheidegger, Alfred. Die schweizer Künstlergraphik 1450-1900. Bern, Bentelli, 1974. [180]p. 142 il. (part col.)

A survey of Swiss printmaking from the mid-15th century to the end of the 19th century in the context of developments in other European countries.

Bibliography, p.192.

v.2, on Swiss printmaking of the 20th century, is in preparation.

*see also: 769.924 C976/1984 2v Currier + Ives cat. rais.*

## United States

N137  Fielding, Mantle. American engravers upon copper and steel. Biographical sketches and check lists of engravings; a supplement to David McNeely Stauffer's American engravers. Philadelphia, Priv. printed, 1917. 365p. ports. (Repr.: N.Y., Burt Franklin, n.d.)

Similar in format to Stauffer (N142), which it supplements. Contains notes, a check list, and a section (p.298-316) on unknown and unsigned engravings. Subject index, p.321-65.

N138  New York (City) Museum of Graphic Art. American printmaking, the first 150 years. Pref. by A. Hyatt Mayor. Foreword by Donald H. Karshan. Introd. by J. William Middendorf II. Text by Wendy J. Shadwell. [N.Y., 1969]. 180p. il. (part col.), facsims., maps, ports.

The catalogue of a traveling exhibition in 1969-71; the majority of the prints included were from the collection of Mr. and Mrs. J. William Middendorf II.

"This catalogue for the first time reproduces all of the most important prints dealing with what is now the United States during the period when our outlook was still British [i.e. 1670-1820]."—*Pref.*

The prints are listed chronologically, with full descriptions and references. Some biographical information on printmakers is included.

Bibliography, p.175-78.

N139  New York Public Library. American historical prints, early views of American cities, etc., from the Phelps Stokes and other collections, by I. N. Phelps Stokes and Daniel C. Haskell. N.Y., The New York Public Library, 1933. xxxiii, 235p. plates. (Repr.: Detroit, Gale 1974.)

Deluxe ed. pub. 1932.

Primarily a catalogue of the I. N. Phelps Stokes Collection of American historical prints in the Prints Division of the New York Public Library; basic for research in the growth and development of American cities and invaluable as a source for its wealth of facts and references on American printmaking from its Anglo-American beginnings to the third quarter of the 19th century. Includes some watercolors as well as prints. The catalogue is arranged chronologically by date of depiction. Approx. 235 works are reproduced in black and white. Artist-engraver index; Subject-place index.

A fully revised and completely rewritten ed. by Gloria-Gilda Deák is in preparation.

N140  Peters, Harry Twyford. America on stone; the other printmakers to the American people; a chronicle of American lithography other than that of Currier & Ives, from its beginning, shortly before 1820, to the years when the commercial single-stone hand-colored lithograph disappeared from the American scene. A prologue, being a survey of the field as a whole, followed by the alphabetical list of the artists, lithographers, publishers and craftsmen who built up America on stone in lithographs. [Garden City, N.Y., Doubleday, 1931]. 415p. (Repr.: N.Y., Arno, 1976.)

Still very useful; excellent plates and illustrations.

"Checklist of books, pamphlets, and articles," p.413-15.

N141  Princeton University. Library. Early American book illustrators and wood engravers, 1670-1870; a catalogue of a collection of American books illustrated for the most part with woodcuts and wood engravings. With an introductory sketch of the development of early American book illustration by Sinclair Hamilton. With a foreword by Frank Weitenkampf. Princeton, 1958-68. 2v. il.

*compl. ut at PL EC has v. 1 only*

An invaluable reference work of information on early American book illustrators and printmakers for the period 1670-1870.

The Catalogue in v.I (1958; reissued 1968) lists 1,302 books in two parts: pt.I, American book illustration prior to the 19th century; pt. II, American book illustration in the 19th century. Pt.I is arranged chronologically; pt.II alphabetically by illustrator. Includes indexes of illustrators and engravers, authors, and titles. v.II (1968) is a supplement which extends the number of entries to 2,004.

N142   Stauffer, David McNeely. American engravers upon copper and steel. N.Y., Grolier Club, 1907. 2v. il., plates, ports. (Repr.: N.Y., Burt Franklin, n.d.)
Remains the basic work. Supplemented by Fielding (N137).

Contents: pt. 1, Biographical sketches, illustrated (containing notes on about 700 American artists, arranged alphabetically), and "Index to engravings described with checklist numbers and names of engravers and artists," p.317-91; pt. 2, Checklist of the works of the earlier engravers, covering only "the plates of men who were actually engraving in this country before 1825, though all the work found of any man coming within this classification is covered by the lists." —*Pref.*

N143   United States. Library of Congress. Prints and Photographs Division. American prints in the Library of Congress; a catalog of the collection. Comp. by Karen F. Beall and the staff of the Prints and Photographs Division of the Library of Congress. With an introd. by Alan Fern and a foreword by Carl Zigrosser. Baltimore, published for the Library of Congress by Johns Hopkins Pr. [1970]. 568p. il.
An excellent catalogue of the Library's holdings. Lists approx. 1,250 artists, with 12,000 entries for individual prints. Brief, biographical notes.
Geographical index, p.549-59; Name index, p.560-67. Bibliography, p.541-47.

*PLV*   N144   Weitenkampf, Frank. American graphic art. New ed., rev. & enl. N.Y., Macmillan, 1924. 328p. il., plates. (Repr.: N.Y., Johnson, 1970.)
1st ed. 1912. A pioneering work which has not been replaced.

SEE ALSO:  Laver, J. *A history of British and American etching* (N106).

## ORIENTAL COUNTRIES

### China

See: British Museum. Dept. of Prints and Drawings. *A catalogue of Japanese and Chinese woodcuts . . .* (N148); Loehr, Max. *Chinese landscape woodcuts . . .* (M541); Museum für Ostasiatische Kunst (West Berlin). *Katalog der chinesischen und japanischen Holzschnitte . . .* (N159).

### Japan

N145   Art Institute of Chicago. The Clarence Buckingham collection of Japanese prints. [Chicago, 1955]-65. 2v. il. (part col.)
Meets the highest standards of published catalogues; complete descriptions and excellent illustrations.
Contents: v.[1], The primitives, catalogue by Helen C. Gunsaulus; v.2, Harunobu, Koryūsai, Shigemasa, their followers and contemporaries, catalogue by Margaret O. Gentles.
Arranged chronologically by artist. Gives for each print "a detailed description of the subject matter, a reading in Japanese and English of all titles, series, poems, and inscriptions as well as the exact signatures of the artists and publishers. . . . The Japanese terms for the sizes of prints are given with the actual measurements in inches. . . . The prints of each artist are numbered chronologically." —*Introd.* Includes bibliographies.

N146   Blakemore, Frances. Who's who in modern Japanese prints. N.Y., Tokyo, Weatherhill [1975]. 263p. 270 il.
A useful index and dictionary of over 400 modern Japanese printmakers. Gives for each printmaker dates, principal media used, memberships in organizations, and international exhibitions. Describes and illustrates the work of 104 leading artists in the main dictionary. Includes an introductory essay, "The Japanese print: a historical survey," p.9-12.

N147   Binyon, Laurence, and Sexton, J. J. O'Brien. Japanese colour prints. [2. ed.] Ed. by Basil Gray. London, Faber and Faber; Boston, Boston Book and Art Shop [1960]. 230p. il., 48 plates (part col.) (Repr.: London, Sawers, 1979.)
1st ed. 1923.
A standard work; superseded somewhat by more recent research. Its principal value consists of the tables of publishers' and censors' seals, actors' *mon*, and chronological tables for dating. "The text of the first edition has been reprinted with very few changes. Some conclusions from recent research which modify statements in the text are noted in footnotes; some dates have been corrected. Some titles have been added to the Bibliography, mainly to the western literature of the subject." —*Pref. to 2d ed.*

N148   British Museum. Dept. of Prints and Drawings. A catalogue of Japanese and Chinese woodcuts preserved in the Sub-Department of Oriental Prints and Drawings in the British Museum, by Laurence Binyon. [London] Printed by order of the Trustees, 1916. lii, 605 (1)p. 31 plates (1 col.)
An early catalogue of the Japanese and Chinese woodcuts in the collection of the British Museum. Still one of the most useful reference works on Japanese prints from the earliest examples to the beginning of the Meiji period in 1868. The small supplementary section on Chinese woodcuts is likewise valuable for providing material in a field in which too little of a general nature has been published.
Contents: Introduction, p.[ix]-xxvi; Table of artists, arranged according to schools, p.xxvii-xxviii; Note A. On

the dating of Japanese woodcuts, p.xxix–xxxv; Note B. Was there a second Kiyonobu? p.xxxv–xxxviii; Note C. States, variations, reprints, forgeries, p.xxxviii–xliii; Note D. Pigments, p.xliii–xliv; Select bibliography, p.xlv–xlvi (I. Works on Ukiyo-yé and the colour print; II. Works on particular masters; III. Exhibition catalogues; IV. Sale catalogues; V. General); Corrections and additions; Comparative table of chronology p.xlix–l; List of illustrations; Catalogue of Japanese woodcuts; Stencil-prints; Catalogue of Chinese woodcuts; Index of artists; Signatures of artists; General index.

N149   Chibbett, David. The history of Japanese printing and book illustration. Tokyo, N.Y., Kodansha [1977]. 264p. 102 il. (part col.)

A concentrated history of Japanese printing based largely on Japanese language sources and a comprehensive, detailed survey of Japanese printed book illustration up to 1868. Authoritatively written; well illustrated.

Contents: pt. I, The history of Japanese printing: (1) The printed book; (2) The introduction of printing and printing techniques; (3) The age of Buddhist domination of printing; (4) The movable type room; (5) Publishing in the Edo period. Pt. 2, The history of printed book illustration: (6) Early Buddhist illustration; (7) Book illustration and the Tosa school; (8) The ukiyo-e schools; (9) The Kanō school; (10) The Kōrin, Nanga, Maruyama, Shijō and Kishi schools. Appendixes: Glossary, p.229–36; Bibliography, p.237–38; Index of artists; Index of book titles; General index.

N150   Hatanaka, T., ed. Japanese woodcut book illustrations, c.1250–1704. N.Y., Abaris, 1979. v.1–(4). 2,140p. 1,000 il.

A series of volumes which contain reproductions of and critical commentary on Japanese woodcut book illustrations from Buddhist works of the 13th century to the Ukiyo-e and other schools of the 18th and 19th centuries. v.1–4 cover the period c.1250–1704; future volumes will deal with 18th- and 19th-century illustrations.

Each volume includes introductory essays, commentary on each illustration, bibliographical references to Western and Japanese literature, indexes, and a glossary.

N151   Hillier, Jack Ronald. The Japanese print: a new approach. London, Bell [1960]. 184p. il.

Paperback ed.: Rutland, Vt., Tuttle, 1975.

"Although this book deals comprehensively with the Japanese print, tracing its development chronologically, giving due weight to technical as well as aesthetic considerations . . . , a new and rather oblique approach has been adopted. . . . It is by accounts of the work of a relatively small number of typical artists that I have tried to show something of the scope and achievement of the art of the Ukiyo woodblock print in Japan, by the example of the few rather than the catalogue of the whole."—*Pref.*

Select bibliography, classified, p.171–74. Short glossary of Japanese words, p.175–79.

N152   Ishida, Mosaku. Japanese Buddhist prints. English adaptation by Charles S. Terry. N.Y., Abrams for Kodansha [1964]. 195p. il., plates.

First published as v.1 of *Nijon hanga bijutsu zenshū*, Tokyo, Kodansha, 1961–62.

"This book presents a broad selection of prints dating from the twelfth century to the sixteenth, together with a general discussion of them by an editorial staff composed of both art historians and active print artists."—*Pref.* Includes Buddhist images as script illustrations, scroll illustrations, and as paper and fan decorations. Contains 32 excellent color plates with commentaries and 162 black-and-white illustrations. Glossary, p.193–95.

N153   Kikuchi, Sadao. A treasury of Japanese wood block prints: ukiyo-e. Trans. by Don Kenny. N.Y., Crown [1969]. 423p. 1,500 il., 100 col. plates.

An introductory essay on the history and various types of ukiyo-e prints is followed by a section of 100 color plates and a section of 1,500 black-and-white illustrations of prints. Both sections are arranged as follows: Early prints; Beautiful women; Actors; Sumō wrestlers; Landscapes; Flowers and birds.

Comparative sizes of prints, p.6. List of color prints, p.7–8. List of black-and-white prints, p.9–27. Notes to color prints, p.401–23, give artist, title, description, collection, and brief discussion. Glossary, p.423.

N154   Lane, Richard Douglas. Masters of the Japanese print, their world and their work. London, Thames & Hudson; Garden City., N.Y., Doubleday [1962]. 319p. il. (part col.)

An introductory study of the history and technique of Japanese prints, which are treated as integral to Japan's artistic tradition.

N155   Ledoux, Louis Vernon. Japanese prints of the primitive period, in the collection of Louis V. Ledoux; catalogue by the owner, with 20 plates in full color and 30 in half-tone. N.Y., Weyhe, 1942. [182]p., incl. plates.

_____. Japanese prints by Harunobu & Shunshō in the collection of Louis V. Ledoux; catalogue by the owner, with 8 plates in full color and 44 in half-tone. N.Y., Weyhe, 1945. [152]p., incl. plates.

_____. Japanese prints, Bunchō to Utamaro, in the collection of Louis V. Ledoux; catalogue by the owner, with 20 plates in full color and 39 in half-tone. N.Y., Weyhe, 1948. [192]p., incl. plates.

_____. Japanese prints, Sharaku to Toyokuni, in the collection of Louis V. Ledoux; catalogue by the owner, with 16 plates in full color and 45 in half-tone. Princeton, Princeton Univ. Pr., 1950. 1v. unpaged. plates.

_____. Japanese prints, Hokusai and Hiroshige, in the collection of Louis V. Ledoux; catalogue by the owner, with 8 plates in full color and 44 in half-tone. Princeton, Princeton Univ. Pr., 1951. 1v. unpaged. plates.

Superb catalogues of one of the great collections of Japanese prints, now dispersed. Written with scholarly thoroughness and sensitive understanding; excellent reproductions in black and white and color.

Each volume contains "A list of books and catalogues mentioned in the text."

N156   Masterworks of ukiyo-e. Tokyo and Palo Alto, Kodansha, 1968–70. 11v. col. il.

A series of well-illustrated monographs primarily on well-known Japanese printmakers, written by Japanese authorities. Each volume provides a reliable introduction to its subject.

Contents by volume: (1) Suzuki, Juzo. Sharaku (1968); (2) Suzuki, Juzo, and Oka, Isaburo. The Decadents (Kunisada, Kuniyoshi, Eisen) (1969); (3) Narazaki, Muneshige, and Kikuchi, Sadao. Utamaro (1968); (4) (not published?) (5) Narazaki, Muneshige. Hokusai (1968); (6) ———, Hiroshige (1968); (7) ———. Kiyonaga (1969); (8) ———. Hokusai: Sketches and paintings (1969); (9) ———. Hiroshige: The 64 stations of the Tokaido (1969); (10) ———. Studies in nature: Hokusai-Hiroshige (1970); (11) Takahashi, Seiichirō. Harunobu (1968).

N157   Michener, James Albert. Japanese prints: from the early masters to the modern. With notes on the prints by Richard Lane. With the cooperation of the Honolulu Academy of Arts. Tokyo, Rutland, Vt., Tuttle [1959]. 287p. il. (part mounted col.)

Addressed primarily to the collector. Valuable chiefly for reproductions of prints from a famous collection.

"List of artists and prints," p.6–8. Bibliography, p.283–84.

N158   Mody, N. H. N. A collection of Nagasaki colour prints and paintings, showing the influence of Chinese and European art on that of Japan. [1. Tuttle ed.] Rutland, Vt., Tuttle [1969]. xxxiv, 10, [3]p., 250 plates (part col.)

First published in an ed. of 200 copies: London, K. Paul, Trench, Trubner & Co., Ltd., and Kobe, Japan, J. L. Thompson & Co., Ltd., 1939.

Foreword to this ed. by Carl M. Boehringer.

Provides a visual survey of Nagasaki-ye and Nagasaki paintings. Introductory survey, p.xxvii–xxxii, in two parts: (1) Nagasaki-ye; (2) Paintings of the Nagasaki and other schools. Description and sometimes commentary for each plate. Index.

N159   Museum für Ostasiatische Kunst (West Berlin). Katalog der chinesischen und japanischen Holzschnitte im Museum für Ostasiatische Kunst Berlin. Bearb. von Steffi Schmidt. Berlin, Hessling [1971]. 442p. 135 plates (36 col.)

At head of title: Staatliche Museen Preussischer Kulturbesitz.

A well-illustrated catalogue of 1,116 Chinese woodcuts (the earliest examples from the 9th and 10th centuries) and Japanese woodcuts from their beginnings to the 20th century in the collection of the Museum für Ostasiatische Kunst, West Berlin. Also includes books with woodcuts. Introductory essays trace the development and styles of the art of the Chinese and Japanese woodcut.

The catalogue is in two parts: [pt. 1] Chinesische Holzschnitte, p.25–36 (entries 1–4); [pt. 2] Japanische Holzschnitte, p.39–403 (entries 5–1,116). Each entry gives full documentation, critical evaluation, and bibliographical references.

"Liste der verwendeten Abkürzungen," p.404–12. "Glossar," p.413–18. "Liste der im Katalog aufgeführten Serien- und Albentitel," p.419–24. "Motiv-Index," p.425–33. "Alpha-betische Liste der Künstlernamen," p.434–37. "Verzeichnis der Bildtafeln," p.438–40.

N160   Narazaki, Muneshige. The Japanese print: its evolution and essence. English adaptation by C. H. Mitchell. [1. ed.] Tokyo, Palo Alto, Kodansha [1966]. 274p. 107 mounted col. il.

107 excellent color plates with commentary for each print. "This book is the first full presentation in English of the Japanese print by a modern Japanese authority on the subject. . ." —Adaptor's Pref.

"On collecting Japanese prints," p.249–55, and Bibliography, p.257–67, by C. H. Mitchell.

N161   Petit, Gaston. 44 modern Japanese print artists. Tokyo and San Francisco, Kodansha, 1973. 2v. 494p. 358 plates (90 col.)

A selection of prints made since 1960 by 44 contemporary Japanese printmakers. Each artist is represented by about two color and six black-and-white plates. Technical data is given in a supplementary booklet. Among the artists included are Hara Takeshi, Amano Kazumi, Mori Yoshitoshi, Ikeda Masuo, and Ay-o.

N162   Philadelphia Museum of Art. The theatrical world of Osaka prints; a collection of eighteenth and nineteenth century Japanese woodblock prints in the Philadelphia Museum of Art, by Roger Keyes and Keiko Mizushima. [Philadelphia] 1973. 334p. il. (part col.)

A superb exhibition catalogue; the authoritative work on Osaka prints. The introductory essay provides informative accounts of "The social setting of the Japanese woodblock print," and "The Kabuki theater." "The essay discusses in a general way the differences between printmaking in Osaka and Edo, gives a brief history of the Osaka style, and touches briefly on kabuki theater, the constant subject of Osaka prints. The eighty plates recapitulate the history of the school and should give the reader an idea of the particular excellence of the Osaka style."—Authors' pref.

The main section of the catalogue consists of 80 plates (10 col.) which are accompanied by critical discussions and descriptive information. The annotated catalogue, arranged by printmaker, includes 180 supplementary illustrations. List of artists, p.261–80 (in Japanese characters and Western alphabet). Signature facsimiles, p.281–89. List of actors, p.290–97. Concordance of names, p.298–313. Appendixes, p.314–20. Bibliography, p.321–31. Glossary, p.332–34.

N163   Statler, Oliver. Modern Japanese prints; an art reborn. With an introd. by James A. Michener. Rutland, Vt., Tuttle [1956]. 209p. il. (part col.)

A selective survey of individual modern artists and groups.

N164   Stern, Harold P. Master prints of Japan: ukiyo-e hanga. N.Y., Abrams, in association with UCLA Art Council and UCLA Art Galleries, Los Angeles [1969]. 324p. il., plates.

Issued on the occasion of an exhibition held at the Art Galleries of the Univ. of California, Los Angeles.

An excellent, carefully researched catalogue of 163 Japanese prints. Bibliography, p.314–16.

N165 Stewart, Basil. Subjects portrayed in Japanese colour-prints, a collector's guide to all the subjects illustrated, including an exhaustive account of the Chushingura and other famous plays, together with a causerie on the Japanese theatre; illustrated with reproductions of over 270 prints from the author's collection and other sources: 22 in colour. London, Paul, Trench, Trubner, 1922. [382]p. il., plates (part col.) (Repr.: N.Y. Garland, 1978.)

A revision and enlargement of the author's *Japanese colour-prints and the subjects they illustrate* (1920). Japanese printmaking, the collecting of Japanese prints, and the works of notable artists and schools are discussed in the introductory texts (pt.I). Followed by a detailed survey of subjects illustrated: (pt. II) Subjects of illustration (1) landscape; (pt. III) Subjects of illustration (2) figure-studies; (pt. IV) Actor-portraits and theatrical subjects; (pt. V) Historical subjects, legends and stories.

Appendixes: (1) The dating of Japanese prints: chronological table: Numerals, p.331–39; (2) Notes, p.340–53; (3) List of Ukiyoye artists (with brief commentary), p.354–63; (4) Reproductions of artists' signatures, publishers' seals, and actors' crests, p.364–76; (5) Bibliography, p.377.

List of illustrations, p.ix–xiv. Glossary, p.xv–xvi. Index at the end.

N166 Tokyo. National Museum. Illustrated catalogues of Tokyo National Museum: ukiyo-e prints. [Tokyo, 1960–63]. 3v. plates (3,926 figs.).

Contents in Japanese and English. Useful as an index to the complete collection of prints of the Tokyo National Museum. Includes a small reproduction and brief description of each print.

N167 Vever, Henri. Japanese prints and drawings from the Vever Collection, by Jack Hillier. London, Sotheby Parke Bernet, 1976–7. 3v. 1,034p. 973 il. [74] col. plates.

The catalogue of one of the most important collections of Japanese prints and drawings ever formed. Many thousands of the prints are now in the collection of the Tokyo National Museum. Approx. 1,000 remaining prints, many of which were sold in two sales at Sotheby's in 1974 and 1975, while others were retained by the present owner, are catalogued and illustrated. The prints are "arranged chronologically and those in series have been placed in their correct order. Brief notes on the artists, their style of work and environment, as well as on the development of the woodblock print in Japan, link each section. The name of the artist is also shown in Japanese characters,"—*Pub. notes.*

Glossary and index, v.3, p.1,013–27. Bibliography, v.3, p.1,029–34.

SEE ALSO: *Heibonsha survey of Japanese art* (I552); Hillier, J. R. *Catalogue of the Japanese paintings and prints in the collection of Mr. & Mrs. Richard P. Gale* (M570); _____. *The Harari collection of Japanese paintings and drawings* (M571); _____. *The uninhibited brush; Japanese art in the Shijō style* (M572); Rosenfield, J., Cranston, F., and Cranston. E. *The courtly tradition in Japanese art and literature; selections from the Hofer and Hyde collections* (M577).

# O.
# Photography

This section was compiled by Julia Van Haaften.

Photography is a discipline with many disparate and wide-ranging aspects. The titles selected for inclusion here are among the most important for research in the history of photography as an expressive and communicative medium. They include bibliographies, dictionaries, handbooks, and general period and regional histories. Following the editorial practice in other chapters, monographs on individual photographers have not been listed, although biography is covered in the section on photographers. The arrangement is by form, chronology, and country.

## BIBLIOGRAPHY

O1    Boni, Albert, ed. Photographic literature; an international bibliographical guide to general and specialized literature on photographic processes, techniques, theory, chemistry, physics, apparatus, materials & applications, industry, history, biography, aesthetics, etc. Hastings on Hudson, N.Y., Morgan & Morgan [1962]. 335p.
        _____. 1st supplemental volume (1960–70). Hastings-on-Hudson, N.Y., Morgan & Morgan [1972]. 535p.
An essential reference work which includes publications of all types, dating from 1727; frequently annotated. Primarily technical but with useful sections on individual photographers, bibliography, history, aesthetics, illustrated books, and photographic processes. Author indexes.

O2    Camera Club, New York. Library. Catalogue of the photographic library of the Camera Club, N.Y., 1902. 78p.
Largely superseded, but still useful for early photographic literature. Contains a separate list of periodicals.

O3    Columbia University. Library. Epstean Collection. A catalogue of the Epstean Collection on the history and science of photography and its applications especially to the graphic arts. N.Y., Columbia Univ. Pr., 1937. 109p. il.

_____. Accessions May 1938–December 1941, with addenda 1942; author and short title index. [N.Y. Columbia Univ. Pr.], 1942. 29 1. (Repr.: Pawlet, Vt., Helios, 1972.)
A classified list of books emphasizing technical history and practice, but useful to the historian for the sections on biography, aesthetics, and periodical literature. Author, title indexes.

O4    International Museum of Photography at George Eastman House, Rochester, N.Y. [Catalog of the library]. Boston, Hall.
Publication scheduled for 1982; 7v. projected in 2 parts: author/title and subjects. Possibly the most complete photography library in the world; includes exhibition catalogues, albums, and periodicals as well as monographs and technical manuals.

O5    Lewis, Stephen; McQuaid, James; and Tait, David. Photography source and resource; a source book for creative photography. [State College, Pa.] Turnip Pr. [1973]. 214p.
Information on diverse aspects of current American photo activity, with a bibliography of 139 theses in photography. Also has sections listing public collections (indexed by photographer) and galleries specializing in photography.

O6    Royal Photographic Society of Great Britain. Library catalogue: Pt. 1. Author catalogue. London, 1939. 48p.
        _____. Pt. 2. Subject catalogue. London, 1952. 105p.
        _____. Supplement to author catalogue 1939. London, 1952. 41p.
The technical emphasis is similar to the Epstean Collection (O3); brief history and biography sections.

O7    Société Française de Photographie. Catalogue de la bibliothèque. Paris, Gauthier-Villars, 1896. 56p.
A list of publications, primarily continental; useful for 19th-century exhibitions, annuals, and periodicals as well as history and biography; technical works predominate. Arranged alphabetically by author.

## DICTIONARIES AND ENCYCLOPEDIAS

O8    The Focal encyclopedia of photography. [Rev.] desk
      ed. N.Y., McGraw-Hill [1969]. 2v. (1,699p.) il.
A useful quick reference work. Although the majority of
entries are on technical topics of little interest to the historian,
many other articles cover theory, antiquated processes,
and biography. ✓ 1965 ed

O9    Jones, Bernard E. Encyclopedia of photography.
      London, Cassell, 1911. 572p. il. (Repr.: N.Y., Arno,
      1974.)
A very useful reference for 19th-century processes, apparatus,
studio practice, and biography. More detailed than the *Focal
encyclopedia* (O8) in its coverage of early formulas and
operation of equipment.

## PHOTOGRAPHERS

✓ O10    Beaton, Cecil, and Buckland, Gail. The magic image;
      the genius of photography from 1839 to the present
      day. London, Weidenfeld and Nicolson [1975]. 304p.
      il.
Arranged chronologically by photographer, the approx. 200
selected entries include short biographical notes, bibliog-
raphy, collection citations, and at least one illustration. Useful
especially for photographers of this century. Contains a
short essay by Beaton and brief appendixes on commercial,
architectural, fashion, press, and stage photography. Glos-
sary, p.302-3.

O11    Lloyd, Valerie. Photography: the first eighty years.
      London, Colnaghi, 1976. 262p. il.
Exhibition catalogue; very useful for brief biographies and
work history of nearly 100 prolific and noted photographers
to 1914.

O12    Lyons, Nathan, ed. Photographers on photography;
      a critical anthology. Englewood Cliffs, N.J. Prentice-
      Hall [1966]. 190p. 62 il.
Statements by 39 photographers from the turn of the century
to the 1960s presenting "points of view which have contributed
to the development of contemporary photographic ex-
pression."—*Pref.* Valuable for its "Biographical notes &
selected bibliography," p.177-90.

O13    Mann, Margery, and Noggle, Anne. Women of
      photography; an historical survey. San Francisco,
      San Francisco Museum of Art [1975]. 128p. 500 il.
A chronologically arranged survey of the work of 50 women
photographers; includes biographical notes and two historical
essays. "Selected bibliography" arranged by photographer.

O14    Mathews, Oliver. Early photographs and early photog-
      raphers; a survey in dictionary form. London, Reed-
      minster [1973]. 198p. 252 il.

A biographical dictionary (approx. 300 entries) of photog-
raphers to c.1914 keyed to the illustrations (p.6-44). Un-
fortunately lacks references to sources of information.
Includes a guide to market values of photographs, books,
and albums.

O15    Naef, Weston J. The collection of Alfred Stieglitz;
      fifty pioneers of modern photography. N.Y., The
      Metropolitan Museum of Art; Viking [1978]. 529p.
      735 il.
Major survey and scholarly catalogue of this important
collection; includes extensive bibliographies and notes
concerning biography, collections, and exhibitions for each
of 50 alphabetically arranged modern masters who figured
in the Photo-Secession, *Camera work* (Q128), or later.
"General bibliography," p.496-522; detailed index. Published
to accompany a 1978 exhibition.

O16    Newhall, Beaumont, and Newhall, Nancy. Masters
      of photography. N.Y., Braziller, 1958. 192p. il.
An anthology which covers sixteen major figures; gives a
good biography and critical bibliography for each. Many
illustrations. "Selected bibliography," p.189.

O17    Sipley, Louis Walton. Photography's great inventors;
      selected by an international committee for the
      International Photography Hall of Fame. Philadelphia,
      American Museum of Photography [1965]. 170p. il.
Biographical sketches and portraits of innovators in the
technology of photography from its origins to recent times.
Bibliography, p.151-54.

## HISTORIES AND HANDBOOKS

O18    Aperture history of photography series, no. 1- .
      [Millerton, N.Y., Aperture [1977-  ].
An excellent introductory series of uniform, small-format
monographs on individual photographers, mostly American
and Western European. Primarily 20th century, e.g. Robert
Frank, Walker Evans, Weegee, although earlier photogra-
phers are included, e.g. Frank M. Sutcliffe. Essays by the
photographer or a recognized writer vary slightly in length.
Each volume has about 40 reproductions plus bibliography,
chronology, exhibition history, and/or archives list.

O19    Baier, Wolfgang. Quellendarstellungen zur Geschichte
      der Fotografie. Halle, VEB Fotokinoverlag [1964].
      703p. 313 il.
Primarily a narrative of technological history connecting
numerous sources which are reprinted in original German
or in translation from their original languages. Keyed to a
list of 225 publications: "Liste der Bücher und Zeitschriften,"
p.552-57.

O20    Braive, Michel F. The photograph; a social history.
      N.Y., McGraw-Hill; London, Thames & Hudson
      [1966]. 367p. il.

Trans. by David Britt from *L'âge de la photographie; de Niépce à nos jours.* Bruxelles, Éditions de la Connaisance [1965].

A lively, well-illustrated history, international in scope. "Bibliographical note," p.363-64, includes films on photography.

O21   Chini, Renzo. Il linguaggio fotografico. Torino, Società editrice internazionale [1968]. 181p. 224 il. (Coordinamento grafico n. 33-34)

An important work on the problem of photographic visualization and its role in expression and communication. Illustrations are accompanied by notes and biography with references to collections. Especially strong on contemporary European work. Classed bibliography, p.101-7.

O22   Coke, Van Deren, ed. One hundred years of photographic history; essays in honor of Beaumont Newhall. Albuquerque, Univ. of New Mexico Pr. [1975]. 180p. il.

Scholarly essays on the history, aesthetics, and styles of photography, dedicated to the preeminent American photographic historian. Some of the essays are illustrated. Index, p.176-80.

O23   Eder, Josef Maria. Die Geschichte der Photographie. Halle, Knapp, 1932. 1,108p. 376 il.

Trans. without illustrations, by E. Epstean, *History of photography.* N.Y., Columbia Univ. Pr., 1945. 860p.

Primarily a history of technology with a German emphasis; also contains international biography and social history. As bibliography, the chapter "Photographische Fachliteratur, Fachgesellschaften und Bildungsstätten" is valuable.

O24   _____. ed. Quellenschriften zu den frühesten Anfängen der Photographie bis zum XVIII. Jahrhundert. Halle a.d. S., W. Knapp, 1913. 187p. il. (Repr.: N.Y., Arno, 1979.)

Reprints original text, usually in Latin, with German translations, of eight seminal discoveries leading to the understanding and use of photographic chemistry.

O25   Gassan, Arnold. A chronology of photography; a critical survey of the history of photography as a medium of art. Athens, Ohio, Handbook Co. [1972]. 373p. il.

A highly readable survey of the socio-aesthetic history of photography considered as an art form. Index, p.228-30, followed by a portfolio of 154 selected images, and a detailed chronology which includes births, deaths, and principal events, p.[295]-369. Bibliography, p.370-73.

O26   Gernsheim, Helmut. Creative photography; aesthetic trends 1839-1960. London, Faber and Faber [1962]. 258p. 244 il.

An outstanding history of photography as a means of artistic expression. "Short biographies of photographers illustrated," p.231-47. Excellent bibliography with comments, p.251-54.

O27   Gernsheim, Helmut, and Gernsheim, Alison. A concise history of photography. N.Y., Grosset & Dunlap [1965]. 314p. il.

Good coverage and balance of American, British, and continental photography from its beginnings to the 1960s, in a small paperback format. See also *The History of photography* (O28). Annotated bibliography, p.291-94.

O28   _____. The history of photography; from the camera obscura to the beginning of the modern era. N.Y., McGraw-Hill [1969]. 599p. 390 il.

1st ed. 1955.

The standard history and reference work on photography. This 2d ed. has a larger format, broader geographical coverage, updated information on technology, and more discussion of the artistic trends of the 20th century. Annotated bibliography, p.580-81; comprehensive lists of photographic journals, annuals, and societies for the first ten years, p.584-88; bibliographic footnotes.

O29   The history of photography. Woodbridge, Conn., Research Publications. Consulting editor: Beaumont Newhall.

In preparation. A large scale microfilm republishing series drawing on the international literature collections of the International Museum of Photography at George Eastman House, the New York Public Library, and the Epstean Collection at Columbia University; it will include approx. 125 periodical titles, primarily American and European, and, in a second section, over 2,000 monograph and pamphlet titles to 1920 ranging from rare technical manuals and handbooks to illustrated aesthetic tracts. Some overlap with *The literature of photography* (O33) and *The sources of modern photography* (O40).

O30   Kahmen, Volker. Art history of photography. N.Y., Viking [1975]. 232p. 453 il.

Trans. of *Fotografie als Kunst,* Berlin, Wasmuth, 1973; British edition entitled *Photography as art,* London, Studio Vista, 1975.

The short philosophical and political text introduces the reproductions arranged by theme or subject; valuable for its wide range and diversity. Bibliography, p.53-55.

O31   Lécuyer, Raymond. Histoire de la photographie. Paris, Baschet, 1945. 451p. il. (part col.)

A well-illustrated history with a French emphasis. "Notes bibliographiques," p.435-[44].

O32   Life library of photography. N.Y., Time-Life [1970- ].

A continuing series with excellent texts and illustrations covering history, theory, special subjects, and conservation. Each has a selected bibliography. Examples: *The camera* (1970); *Color* (1970); *The great themes* (1970); *The print* (1970); *Photography as a tool* (1970); *Caring for photographs* (1972); *Frontiers of photography* (1972).

O33   The literature of photography. N.Y., Arno, 1973. Advisory editors: Peter C. Bunnell and Robert A. Sobieszek.

A facsimile reprint series of 62 titles of major importance; includes 19th-century technical manuals, aesthetic treatises, histories, and handbooks. Examples: P. L. Anderson, *The fine art of photography* (1919); P. H. Delamotte, *The practice of photography* (1855); B. E. Jones, ed., *Cassell's cyclopaedia of photography* (1911); H. B. Pritchard, *About photography and photographers* (1883).

O34   London. Science Museum. The Science Museum collection by David Bowen Thomas. London, Her Majesty's Stationery Office, 1969. 113p. il.
A guide to the equipment and photographs in the oldest museum of photographic history. British emphasis.

O35   Lothrop, Eaton S., Jr. A century of cameras from the collection of the International Museum of Photography at George Eastman House. Dobbs Ferry, N.Y., Morgan & Morgan [1973]. 150p. il.
Not a survey history of the development of the camera, this very selective catalogue of 130 chronologically arranged entries covers cameras which have been important in the history of photographic image making from 1839–1940. While limited to examples from a specific collection, the descriptions are useful for the historian of photography because "the full history of photography cannot be assessed . . . without an understanding of the technology that produced the results." —*Introd.* References to source literature accompany most entries; index, p.148–50.

O36   Newhall, Beaumont. The history of photography from 1839 to the present day. [4th rev. and enl. ed. N.Y., Museum of Modern Art in collaboration with George Eastman House, 1964]. 215p. il.
Originated as an exhibition catalogue of the Museum of Modern Art, New York; reprinted as a book in 1938, and rewritten in 1940. A new edition is in preparation.
   Essential companion to Gernsheim (O28). A sensitive account of the history of photographic vision discussing technology only ". . . in so far as it affects the photographer." —*Foreword.* Bibliography, p.[205]–10, concentrates on individual photographers.

O37   _____, ed. On photography; a source book of photo history in facsimile. Watkins Glen, N.Y., Century House [1956]. 192p. il.
Similar in intent to Buddemeier (O47). Beginning with Daguerre, this collection of reprints from English and American sources ranges from announcements of technical innovation to personal statements of aesthetic theory by leading 20th-century photographers.

O38   Pollack, Peter. The picture history of photography; from the earliest beginnings to the present day. Rev. and enl. ed. N.Y., Abrams [1969]. 701p. il.
1st ed. 1958; abridged ed. 1977.
   A broad historical survey consisting of illustrations with informative captions and a brief text. Bibliography, p.698–701.

O39   Skopec, Rudolf. Dějiny fotografie v obrazech od nejstarších dob k dnešku. Praha, Orbis, 1963. [502]p. il.
German trans.: *Photographie in Wandel der Zeiten,* Prag, Artia [1964]. 302p.
   An illustrated, international history useful for East Europe and Russia. Bibliography, p.489–[93].

O40   The sources of modern photography. N.Y., Arno, 1979. Advisory editors: Peter C. Bunnell and Robert A. Sobieszek.
Facsimile reprint series of 67 titles in 52v. Expands the editors' 1973 reprint series, *The literature of photography* (O33) by containing equally important technical manuals, aesthetic treatises, and histories published in French, German, and, only in some instances, English. Examples: L. D. Blanquart-Évrard, *La photographie* (1870); Niépce de Saint Victor, *Recherches photographiques* (1855); T. P. Kravets, ed., *Documents on the history of the invention of photography* (1949); W. Gräff, *Es kommt der neue Fotograf!* (1929).

O41   Stenger, Erich. The march of photography. London, N.Y., Focal Pr. [1958]. 304p.
Trans. of *Siegeszug der Photographie in Kultur, Wissenschaft, Technik,* 1950. It is the 2d ed. of *Die Photographie in Kultur und Technik,* 1938, which was trans. by E. Epstean as *The history of photography,* 1939.
   A wide-ranging topical survey useful for socio-cultural and aesthetic background. Lacks the illustrations of the original German editions.

O42   Szarkowski, John. Looking at photographs; 100 pictures from the collection of the Museum of Modern Art. Greenwich, Conn., New York Graphic Society [1973]. 215p. il.
A selection of significant photographs from the extensive collection of the Museum of Modern Art. Each is reproduced with an accompanying analytical text. Index to the photographers, p.215.

O43   _____. The photographer's eye. N.Y., Museum of Modern Art [1966]. [156]p. il.
A clear introduction to the visual and philosophical factors involved in looking at and taking photographs. Numerous reproductions illustrate concepts essential to photography and reinforce the interdependence between the revelations of the photographic image and the choices of the photographer.

O44   Union Centrale des Arts Décoratifs, Paris. Un siècle de photographie de Niépce à Man Ray. Paris [1965]. 156p. il.
An extensive catalogue of an important exhibition of works in French public and private collections. Short essays and index to long catalogue notes. Classed bibliography, p.106–20.

SEE ALSO:  Coke, V. D. *The painter and the photograph* (M152); Scharf, A. *Art and photography* (I260).

## 19th CENTURY

O45 The Arts Council of Great Britain. 'From today painting is dead': the beginnings of photography. [London, 1972]. 60p. il., 50 pl.
A catalogue by D. B. Thomas of a major exhibition held at the Victoria and Albert Museum, which covers photography in Great Britain and France up to the 1880s. No index; the topical divisions provide access to detailed notes for the over 900 entries. Bibliography, p.17.

O46 Bossert, Helmuth Theodor, and Guttmann, Heinrich. Aus der Frühzeit der Photographie 1840-70; ein Bildbuch nach 200 Originalen. Frankfurt-am-Main, Societäts-Verlag, 1930. 12p. 199 plates.
Brief text with many rarely reproduced photographs from Europe, America, and Great Britain. Bibliography, p.[4].

O47 Buddemeier, Heinz. Panorama, Diorama, Photographie; Entstehung und Wirkung neuer Medien im 19. Jahrhundert: Untersuchungen und Dokumente. [München] Fink, 1970. 352p. (Theorie und Geschichte der Literatur und der schönen Künste, Bd. 7)
A very thorough compendium, with scholarly commentary, of international sources and documents recording the interest, attitudes, and reactions of the artistic community to the developments leading to photography and its acceptance as an art form. "Verzeichnis der Dokumente und Quellen," p.345-47; "Historische Darstellungen und Abhandlungen," p.348.

O48 Darrah, William Culp. The world of stereographs. Gettysburg, Pa., Darrah [1976]. 246p. 301 il.
The most detailed, useful survey of this popular type of photograph. Expands and revises Darrah's *Stereo views* (O97) to cover stereos internationally from about 1851. A substantial section is devoted to regional and subject analysis as an aid to identification. "Alphabetic checklist and index of stereographers cited with approximate dates of stereo activity," p.213-36; bibliography, p.238-42.

O49 Gernsheim, Helmut, and Gernsheim, Alison. L. J. M. Daguerre; the history of diorama and the daguerreotype. 2d rev. and enl. ed. N.Y., Dover [1968]. 226p. 118 il.
Much more extensive coverage of daguerreotype history than the monographic title might imply. Includes long chapters on the diffusion of the daguerreotype to Great Britain, America, and throughout Europe. Equally valuable for the early relationship between painting and dioramas, and later, photography. Numerous appendixes include documents, lists of manuals, and books illustrated from daguerreotypes. Selected bibliography, p.207-9.

O50 Jussim, Estelle. Visual communication and the graphic arts; photographic technologies in the nineteenth century. N.Y., London, Bowker, 1974. 364p. 119 il.
A scholarly work on photographic and photomechanical processes and their effects on graphic arts and publishing in the areas of illustration, documentation, and artistic expression. Revises and extends the theories set forth by Ivins in *Prints and visual communication* (N35). Limited to American developments in photomechanical media and their influences on the careers of Howard Pyle, William Hamilton Gibson, and Frederic Remington. Notes, p.311-29; Bibliography, p.331-37.

O51 Mathews, Oliver. The album of carte-de-visite and cabinet portrait photographs 1854-1914. London, Reedminster [1974]. 148p. [211] il.
Surveys history, producers, and subjects of two types of the most commonly known and widely-disseminated early photographs. International list of photographers and firms specializing in these fields, p.82-141. Lacks sources and dates.

O52 Newhall, Beaumont. Latent image; the discovery of photography. Garden City, N.Y., Doubleday, 1967. 148p. il.
A concise technical history of the discovery and development of the first photographic processes: daguerreotype and calotype. Bibliography and source notes, p.139-44.

O53 Potonniée, George. Histoire de la découverte de la photographie. Paris, Montel, 1925. 319p. 99 il.
Trans. by E. Epstean: *History of the discovery of photography.* N.Y., Tenant and Ward, 1936. 272p. (Repr.: N.Y., Arno, 1974.)
A well-documented history of primary importance, valuable for the numerous references and citations from unpublished texts. Bibliographical footnotes.

O54 Scharf, Aaron. Pioneers of photography; an album in words and pictures. [N.Y.] Abrams [1976]. 189p. il.
Published in London for the British Broadcasting Corporation in 1975.
A collection of essays on several innovators in 19th-century photographic technology and/or aesthetics. Well illustrated. Bibliography, p.189.

O55 Thomas, David Bowen. The first negatives; an account of the discovery and early use of the negative-positive photographic process. London, Her Majesty's Stationery Office, 1964. [42]p. il.
An informative history of the process prefiguring modern photography. "Selected bibliography," p.[40].

O56 Welling, William. Collector's guide to nineteenth century photographs. N.Y., Macmillan; London, Collier Macmillan [1976]. 204p. il.
A wide-ranging collection of information about different types of 19th-century photographs and about the photographers who made them. North American and British emphasis but includes major figures on the continent. Lists important societies and photographic publishers. Bibliography and notes, p.187, 191-94.

## 20th CENTURY

O57 Ades, Dawn. Photomontage. N.Y., Pantheon; London, Thames & Hudson [1976]. 112p. 171 il.
A survey of the kind of art using photographic imagery, whether collaged or rephotographed from a composite piece. Includes Dadaists, Constructivists, and their successors. Illustrations have lengthy captions which supplement the three chapters of text. Bibliographical notes, p.24.

O58 Doty, Robert. Photo-Secession; photography as a fine art. [Rochester] The George Eastman House [1960]. 104p. il. (Eastman House monograph no. 1)
The history of the movement founded in 1902 by Alfred Stieglitz that championed photography as an independent medium and art form. Bibliography; exhibition schedule; membership list, p.99-[104].

O59 Gidal, Nachum. Modern photojournalism: origin and evolution, 1910-1933. Trans. by Maureen Oberli-Turner. N.Y., Macmillan [1973]. 96p. il. (Photography: men and movements, 1)
First pub. Lucerne and Frankfurt-am-Main, Bucher, 1972.
   A history of the origins of modern photojournalism which concentrates on Germany and Great Britain. Many rare illustrations, but poorly reproduced. Bio-bibliographies of the photographers, p.91-93. Index, p.96.

O60 Green, Jonathan, ed. Camera work: A critical anthology. N.Y., Aperture [1973]. 376p. il.
A selection from the 50 issues of the influential journal of photography and modern art. The photographs are reproduced on high-quality stock. Biographies, p.334-43; bibliography, p.344-52; index of selected names and subjects, p.353-60; chronological article index, p.361-70; photographers and artists index, p.371; chronological plate index, p.372-76. Indexes include the complete edition of *Camera work* (Q128).

O61 Hannover. Kestner-Gesellschaft. Künstlerphotographien im XX. Jahrhundert. Hannover, 1977. 232p. il.
Well-illustrated exhibition catalogue of the work of major European art photographers of this century; also includes photographs by artists better known in more traditional media. Each photographer accompanied by a bio-bibliography.

O62 Lyons, Nathan. Photography in the twentieth century. N.Y., Horizon Press in collaboration with the George Eastman House, Rochester, N.Y., [1967]. 143p. mostly il.
Provides a "visual anthology of the picture making concern of photographers in the Twentieth Century."—*Introd.* Photographs from the George Eastman House collection.

O63 Petruck, Peninah R., ed. The camera viewed; writings on twentieth-century photography. N.Y., Dutton [1979]. 2v. il.
An annotated selections of 38 interpretive essays by well-known critics and photographers on important figures, aesthetic aspects, or related philosophical considerations in modern photography. Volumes divide at World War II; contents range from *Camera work* to Susan Sontag. Excellent introduction to the literature of modern photography criticism.

O64 Roh, Franz, and Tschichold, Jan. Foto-auge; 76 Fotos der Zeit. Stuttgart, Akademischer Verlag, 1929. 18p. 76 il. (Repr.: N.Y., Arno, 1973.)
A collection of Surrealist, Constructivist, and related photographs of the twenties in Europe and the U.S. Text in German, French, and English.

O65 Société Française de Photographie. Une invention du XIXe siècle: expression et technique; la photographie: collections de la Société Française de Photographie. Paris, Bibliothèque Nationale, 1976. 153p. il.
Catalogue of a major exhibition from the Society's historical collections; 346 entries, including photographs, publications, and apparatus, primarily French. Bibliographical notes in many entries; most are illustrated.

O66 Steinert, Otto. Subjective Fotographie; ein Bildband moderner europäischer Fotografie. Bonn, Auer [1952]. 40p. 112 il.
Covers 20th-century photography which relies on and exploits the control of the individual artist in image making. Biographical notes, p.36-40.

O67 Thornton, Gene. Masters of the camera; Stieglitz, Steichen & their successors. N.Y., Holt [1976]. 251p. il.
Based on an exhibition organized by the American Federation of Arts. Traces the history of the dichotomy between fine art photography and that which serves documentary, journalistic, or commercial purposes. Numerous illustrations. Essay with biographical notes, p.8-25.

# WESTERN COUNTRIES

## Australia

O68 Cato, Jack. The story of the camera in Australia. Melbourne, Georgian House [1955]. 187p. il.
An informal but detailed account of photographers active in Australia beginning with the introduction of the daguerreotype in 1841.

## Canada

O69 Greenhill, Ralph. Early photography in Canada. Toronto, Oxford Univ. Pr., 1965. 173p. 130 il.
An informative survey of Canadian photographers and their work before 1885. Bibliographical footnotes.

## France

O70    Besson, George. La photographie française. Paris, Braun & Cie [1936]. unpaged. 88 il.
Text in French and English. Short essay relating photographic practice in France to c.1880 and concluding with a discussion of aesthetic evolution since that date. Excellent selection of rarely reproduced photographs.

O71    Christ, Yvan. L'age d'or de la photographie. [Paris] Vincent, Fréal [1965]. 107p. 160 il.
A general history of French photography before 1900. "Tableau chronologique," p.98-103; "Bibliographie sommaire," p.105-6, includes books containing illustrations of 19th-century photographs.

O72    Freund, Gisèle. La photographie en France aux dix-neuvième siècle; essai de sociologie et d'esthétique. Paris, La Maison des amis des livres, 1936. 154p. il.
Original German text not published until 1968: *Photographie und bürgerliche Gesellschaft; eine kunst-soziologische Studie,* München, Rogner & Bernhard.
   A study of portrait photography's influence on popular culture and notions of the nature of art in 19th-century France. Larger bibliography in the French ed., p.145-54.

O73    Jammes, Andre, and Sobieszek, Robert. French primitive photography. [N.Y., Aperture, 1970]. unpaged. il.
Published as *Aperture* XV, no. 1, Spring, 1970, a catalogue accompanying an exhibition at the Philadelphia Museum of Art in 1969. Includes essays and detailed catalogue of 246 items by major and unknown French photographers up to the 1860s. References in catalogue and 1p. of selected bibliography.

## Great Britain

O74    Baynes, Ken, ed. Scoop, scandal and strife; a study of photography in newspapers. [N.Y.] Hastings [1974]. 144p. il.
A discussion of primarily British pictorial journalism and the rise of a mass media audience.

O75    Buckland, Gail. Reality recorded; early documentary photography. Greenwich, New York Graphic Society [1974]. 128p. il.
A survey of early travel, war, and illustrative photography by British photographers. Bibliography, p.126-27.

O76    Gernsheim, Helmut. Masterpieces of Victorian photography. London, Phaidon [1951]. 107p. il.
A survey of early photography in Great Britain which discusses its relationship with contemporaneous painting. Biographical notes on photographers, p.98-107.

O77    Jeffrey, Ian, and Mellor, David. The real thing; an anthology of British photographs 1840-1950. [London] Arts Council of Great Britain [1975]. 124p. [80] il.
Topical arrangement introduced by two historical essays. Notes contain bibliography.

O78    Ovenden, Graham. Pre-Raphaelite photography. London, Academy [1972]. 111p. mostly il.
Despite poor reproduction quality, this survey of rarely published photographs is important for the period.

O79    Strasser, Alex. Victorian photography; being an album of yesterday's camera-work. London, N.Y., Focal Pr. [1942]. 120p. il.
The historical narrative emphasizes master photographers through the 1880s and includes numerous excerpts from contemporary literature. Chronological chart, p.20-21; biographical notes, p.113-19.

O80    Worswick, Clark, and Embree, Ainslee. The last empire; photography in British India 1855-1911 [Millerton, N.Y., Aperture, 1976]. [150p.] il.
Published to coincide with an exhibition at Asia House in N.Y. in 1976. Contains an essay on photography history in colonial India and reproduces work by British colonial photographers. No index. Bibliography, p.[148-49].

## Latin America

O81    Coloquio Latinoamericano de Fotografía, 1st, Mexico City, 1978. Hecho en latinoamerica; memorias. Mexico City, Consejo Mexicano de Fotografía, A. C., 1978. 100p.
Significant collection of essays on the history and criticism of contemporary Latin American photography; presented at the first Latin American photography conference in 1978 See also (O84), the catalogue of a concurrently held exhibition.

O82    Fernandez Ledesma, Enrique. La gracia de los retratos antiguos. Mexico City, Ediciones Mexicanas, 1950. 156p. il.
Mexican portraits of the daguerreotype and collodion eras. "Nomina de los mas notables daguerreotipistas . . . 1845 a 1880," p.149-56.

O83    Ferrez, Gilberto, and Naef, Weston J. Pioneer photographers of Brazil, 1840-1920 [N.Y.] The Center for Inter-American Relations, 1976. 143p. il.
Contains scholarly essays and portfolios, with biographical notes, of works by 15 early Brazilian photographers. Published to accompany an exhibition in N.Y. in 1976. Bibliography, p.142.

O84    Mexico City, Museo de Arte Moderno. Hecho en latinoamerica; primera muestra fotografía a latino-americana contemporanea. México, Consejo Mexicano de Fotografía, A. C., 1978. il.
Catalogue of a major contemporary Latin-American photography exhibition held concurrently with the first Coloquio Latinoamericano de Fotografía; see (O81). Includes over 125 photographers, each with reproductions and biogra-

phical statement. Introductory texts in Spanish, French, and English.

## Low Countries

O85    Coppen, Jan., ed. Een camera vol stilte; Nederland in het begin van de fotografie 1839–1875. Amsterdam, Meulenhoff [1976]. unp. 317 il.

Well-illustrated narrative introduction to this period. Despite the absence of a index, bibliography, or list of photographers, the text is useful for its wealth of detail. Major photography collections located in the Netherlands are listed in the section on illustration sources.

O86    Magelhaes, Claude. Nederlandse fotographie; de erste 100 jaar. Utrecht, Bruna [1969]. 28p. 100 il.

Published to accompany a traveling exhibition, this brief survey covers the work of Dutch photographers. Bibliography, p.xxviii.

O87    Magelhaes, Claude, and Roosens, Laurent. De Fotokunst en België 1839–1940. Deurne-Antwerpen, Het Sterckshof, Afdeling Foto en Film, 1970. unp. 121 il.

Plate captions form a running narrative history containing biographical and historical information. Published to accompany the first major exhibition of Belgian photography. Essays in Flemish, French, English, and German. "Beknopte bibliografie," one page.

## New Zealand

O88    Knight, Hardwicke. Photography in New Zealand; a social and technical history. Dunedin, McIndoe [1971]. 196p. il.

A scholarly history of photography in New Zealand from the daguerreotype and calotype processes through about the 1920s. Has three appendixes including a guide to collections of historical photographs in New Zealand. Contains a directory of New Zealand photographers to 1900. Bibliography, p.179.

## Russia

O89    Morosov, Sergeĭ Aleksandrovich. Russkaĭa khudozhestvennaĭa fotografia, 1839–1917. Moscow, 1955. 181p. il.

Text in Russian. Narrative coverage of photographic interest, personalities, and activity before the Revolution. No index. Bibliography, p.179–82. (The 1961 ed. is a small paperback with poor reproductions and no bibliography.)

O90    Tupitzin, I. K. Soviet art photography. Moscow, Foreign languages publishing house [195–?]. 14p. 149 il.

Covers news and portrait photography as well at photography intended as art. Text in Russian, English, French, German, and Spanish.

## Scandinavia

O91    Ochsner, Bjørn. Fotografiet i Danmark 1840–1940; En kulturhistorisk billedbog. København, Forening for Boghaandvaerk, 1974. 10p. 172 il.

Brief essay on the history of photography in Denmark beginning with the introduction of the daguerreotype. Numerous illustrations in chronological order with informative captions. No index. Bibliography, p.10.

## South Africa

O92    Bensusan, A. D. Silver images; history of photography in Africa. Cape Town, Timmins, 1966. 146p. il.

Covers photographic activity in colonial Africa since 1841. References, p.111–31.

## Switzerland

O93    Photographie in der Schweiz von 1840 bis heute. Teufen, Niggli [1974]. 316p. il.

Published by the Stiftung für Photographie in Zürich. 23 essays on different subjects or aspects of Swiss photography. Short biographical notes, p.308–14.

## United States

O94    Andrews, Ralph Warren. Photographers of the frontier west; their lives and works, 1875 to 1915. Seattle, Superior [1965]. 182p. il.

Contains a series of essays on several themes in western photography and individual photographers including Curtis and Genthe.

O95    ———. Picture gallery pioneers, 1850 to 1875. Seattle, Superior [1964]. 192p. il.

Covers portrait and some landscape photographic activity in the American west and discusses the work of major photographers. "Photographers of the west," p.189, a list by locality.

O96    Current, Karen, and Current, William R. Photography and the old west. [N.Y.] Harry N. Abrams, Inc. in association with the Amon Carter Museum of Western Art [1978]. 272p. il.

Nineteen photographers working from the 1860s to the 1920s in the American west are represented by high quality reproductions and bio-critical text. Complements and continues Naef (O101). Chronology, p.256–63; Bibliographic notes; "Selected bibliography," p.264–68.

O97    Darrah, William Culp. Stereo views; a history of stereographs in America and their collection. [Gettysburg, Pa., Times and News, 1964]. 255p. il.

Contains explanations of different types of processes and prints. Valuable for a checklist of photographers and producers of stereographs. Annotated bibliography, p.247–50.

O98   Doty, Robert, ed. Photography in America. N.Y., Random House for the Whitney Museum of American Art. [1974]. 255p. il.
A survey of the work of major American photographers. Arranged chronologically; primarily illustrations.

O99   Hurley, F. Jack. Portrait of a decade; Roy Stryker and the development of documentary photography in the thirties. Baton Rouge, Louisiana State Univ. Pr. [1972]. 196p. il.
Useful for illustrations, biographical information, and discussion of different social and aesthetic attitudes of American documentary photographers. Bibliography, p.189-93.

O100   Jenkins, Reese V. Images and enterprise; technology and the American photographic industry 1839 to 1925. Baltimore and London, Johns Hopkins Univ. Pr. [1975]. 371p. il. (Johns Hopkins studies in the history of technology)
Expanded version of the author's dissertation, a history of the business and economics of photographic technology. Emphasizes cameras, plates, and related apparatus and their use and distribution. Complements Taft (O107) and Welling (O109). Bibliographic footnotes; "Primary sources of information," p.353-57.

O101   Naef, Weston, and Wood, James N. Era of exploration; the rise of landscape photography in the American west, 1860-1885. Boston, New York Graphic Society [1975]. 260p. 126 plates.
Published for an exhibition at the Albright-Knox Art Gallery and the Metropolitan Museum of Art. A good introduction and excellent illustrations accompany bio-critical studies of the five major photographers of the period. Notes and selected bibliography, p.251-58.

O102   Newhall, Beaumont. The daguerreotype in America. 3d. rev. ed. N.Y., Dover, 1976. 175p. il.
Historical survey concentrating on daguerreotypists and their work. Valuable for biography section, p.139-56. Bibliography, p.169-70.

O103   Rinhart, Floyd, and Rinhart, Marion. American Daguerreian art. N.Y., Potter [1967]. 135p. 89 il.
Complements Newhall (O102); brief, but valuable for biography section, p.112-32, and for discussion of daguerreotype cases and frames. Selected bibliography, p.133-34.

O104   Rudisill, Richard. Mirror image; the influence of the daguerreotype on American society. Albuquerque, Univ. of New Mexico Pr. [1971]. 342p. 202 plates.
A scholarly examination of the American attitude toward portraiture and the popularity of the daguerreotype. Discusses practitioners and present collections of American daguerreotypes. Annotated bibliography, p.239-55.

O105   Stryker, Roy Emerson, and Wood, Nancy. In this proud land; America 1935-1943 as seen in the FSA photographs. Greenwich, Conn., New York Graphic Society [1973]. 191p. 189 il.
Beautifully reproduced selections from Farm Security Administration photographs—the origins of the American documentary tradition. "Archives" and "Selected readings," p.89.

O106   Szarkowski, John, and Pratt, Davis. The photographer and the American landscape. N.Y., Museum of Modern Art [1963]. 48p. il.
Brief essay with reproductions and portrait biographies with bibliography for 19 American landscape photographers.

O107   Taft, Robert. Photography and the American scene; a social history, 1839-1889. N.Y., Macmillan, 1938. 456p. il. (Repr.: N.Y., Dover, 1964.)
The standard detailed history, useful for biography, societies, and publications. Bibliography and notes, p.453-516.

O108   Tucker, Anne, ed. The woman's eye. N.Y., Knopf, 1973. [170]p. il.
Takes up the questions of women's vision and function as artists. Diverse examples in portfolios and biographical essays on ten American photographers. Bibliography for each, p.[170].

O109   Welling, William. Photography in America; the formative years, 1839-1900. N.Y., Crowell [1978]. 431p. il.
A chronological history especially useful for technological invention and practice in the U.S., and for details about individual commercial photographers' studio methods. Its detailed use of American photo periodicals is helpful as a rudimentary index to such literature. Supplements but does not replace Taft (O107). Bibliography p.403-4.

## ORIENTAL COUNTRIES

### China

O110   Worswick, Clark, and Spence, Jonathan. Imperial China; photographs 1850-1912. N.Y., Pennwick Pub. and Crown Pub. [1978]. 151p. il.
Worswick's chronological essay covers both foreign and Chinese cameramen working in China. Published to accompany an exhibition organized by the Asia House Gallery, N.Y., and the American Federation of Arts, 1978. "Index of commercial and amateur photographers of China, 1846-1912" and "Sources," p.150-51.

## Japan

O111   Japanese Historical Society. One hundred years of photography, 1840–1945. Tokyo, Hebonsha [1971]. 516p. 696 il.

Text in Japanese. Monumental survey of Japanese photography; includes a year-by-year international chronology with additional illustrations; biography and bibliographical notes.

A complementary volume, *The history of Japanese photography, 1945–70,* was announced for future publication.

O112   Szarkowski, John, and Yamagishi, Shoji, eds. New Japanese photography. N.Y., Museum of Modern Art [1974]. 112p. il.

Numerous reproductions of work by major post-war Japanese photographers Biographical notes, p.105–12, include portraits.

# P.
# Decorative and Applied Arts

This chapter is classified first by general works, then by the principal types of the decorative and applied arts. These sections are classified further, whenever expedient, into periods and regional subdivisions.

## BIBLIOGRAPHY

P1      Chafer, Denise, ed. The arts applied. A catalogue of books. London, Weinreb [1975]. 319p. il.

An annotated sales catalogue (B. Weinreb, no. 29) of the 1,979 entries of books and original drawings on the decorative arts. Subjects included are furniture, interior design, murals, mosaics, ceilings, exhibitions, ceramics, metalwork, jewelery, textiles, vases, and ornament. Precise cataloguing and descriptive annotations by Denise Chafer and Hugh Pagan make this catalogue useful to scholars and collectors. The listing includes a great many early works and suites of ornamental engravings. Well illustrated. Index, p.309-19.

P2      Ehresmann, Donald L. Applied and decorative arts: a bibliographic guide to basic reference works, histories, and handbooks. Littleton, Colo., Libraries Unlimited, 1977. 232p.

A classified, annotated bibliography of 1,240 works on the applied and decorative arts. More useful to the beginning student and interested layman than to the scholar.

Includes the following sections: General; Ornament; Folk art; Arms and armor; Ceramics; Clocks; Watches and automata; Costume; Enamels; Furniture; Glass; Ivory; Lacquer; Leather and bookbinding; Medals and seals; Metalwork; Musical instruments; Textiles; Toys and dolls.

Comprises a companion volume to the author's *Fine arts: a bibliographic guide to basic reference works, histories, and handbooks* (A35).

P3      Lackschewitz, Gertrud. Interior design and decoration; a bibliography. Comp. for the American Institute of Decorators. N.Y., New York Public Library, 1961. 86p.

A classified bibliography of interior design and decoration. "Each of the books listed is thought to have some reference value, either for its historical accuracy, for its handiness of orientation, or for its technical data or sound theory or good illustrations."—*Compiler's note*. Includes brief annotations when titles are not self-explanatory. Gives New York Public Library class mark locations.

Arranged in six main sections: (I) History of architecture and the decorative arts (general and classed by periods); (II) Interior design and decoration from the Middle Ages to the 19th century (general and classed by countries); (III) 20th-century forms and concepts of design; (IV) Theory and practice of interior design and decoration; (V) Decorative elements, materials, and accessories (walls and ceilings; textiles and tapestries; carpets, rugs, and floorcoverings, etc.); (VI) Periodicals and periodical indexes. Appendix: Bibliographies. Author index.

P4      Paris. Bibliothèque Forney. Catalogue d'articles de périodiques, arts décoratifs et beaux-arts. Paris, Bibliothèque Forney; Boston, Hall, 1972. 4v.

"The collection contains at present 1,350 titles: 325 are current publications, 245 are in French and about 100 are in 20 foreign languages. From 1919 to 1950, only particularly relevant articles were selected and analyzed. Since 1950, periodical holdings have been systematically catalogued and since 1960 references from foreign publications have been added."—*Pref.* "Liste de périodiques," v.1, p.ix-xxii.

Most important for the decorative arts. Supplements the *Répertoire d'art et d'archéologie* (A14) and the *Art index* (A3).

P5      _____. _____. Catalogue matières: arts-décoratifs, beaux-arts, métiers, techniques. Paris, Société des Amis de la Bibliothèque Forney, 1970-74. 4v.

1st supplement: t.1, A-K, 1979; t.2 (to be pub. in 1980).

The subject catalogue of this great library specializing in the decorative arts, crafts, and techniques. Comprises approx. 100,000v. and 1,347 titles of periodicals. The scope of the collection also includes books on costume, theater, architecture, painting, sculpture, and prints. An author index is projected.

Contents: t.I. A-Che (1970); t.II. Chi-Kyo (1971); t.III. L-Pei (1972); t.IV. Pek-Zuy (1974).

P6     Paston, Herbert S. Interior design: a guide to information sources. Detroit, Gale, publication announced. (Gale Information Guide Library. Art and architecture)

A classified, annotated bibliography on interior design.

SEE ALSO: *Decorative arts*, v. IV, no. 2 of *Worldwide art book bibliography* (A56); Paris. Bibliothèque Forney. *Catalogue des catalogues de ventes d'art* (C21).

# DIRECTORIES

P7     British antiques yearbook. 1968/69- . London, Antiques yearbooks, 1968- . il.

Current editors: Marcelle d'Argy Smith and E. Dick.

Annual. Companion to the *International antiques yearbook* (P9).

A guide to the British antiques trade. Contains names and addresses of London dealers (antique dealers, picture dealers, booksellers) and of provincial dealers in England, Wales, Scotland, Northern Ireland, and Eire. Includes lists of commercial packers and suppliers. Indexes.

P8     Guide Européen de l'antiquaire, de l'amateur d'art et du bibliophile. 1949/1951- . Paris, Guide Emer, 1949- . Biannual.

Current editor: Marc Roy. Title varies 1949/51, *Guide de l'antiquaire de décorateur et de l'amateur d'art*; 1951/53, *Guide de l'antiquaire, de l'amateur d'art et du décorateur*. Frequently referred to as Guide Emer.

An international guide to the antique and art trade, with more concentrated coverage of France. Recent editions are in six sections: (1) Antiquaires, négociants en objets d'art, galeries de tableaux, brocanteurs de Paris; (2) Antiquaires et brocanteurs, négociants en objets d'art, galeries de tableaux de province; (3) Antiquaires, négociants en objets d'art, galeries de tableaux, brocanteurs, ventes publiques d'Europe; (4) Antiquaires et négociants en objets d'art d'Europe, classés par spécialités; (5) Antiquariat, libraires d'ancien et de bibliophile d'Europe; (6) Techniciens et fournisseurs. Includes extensive advertising.

P9     International art and antiques yearbook. 1949/50- London [etc.], Tantivy Pr.; Antiques yearbooks, 1949- . il.

Annual. Title varies: 1949/50-1961/62, *The Antiques yearbook, encyclopaedia & directory*. Companion to *British Antiques Yearbook* (P7).

An annual guide to antique dealers, art galleries, and antiquarian booksellers in Australia, Austria, Belgium, Canada, Denmark, France, Germany, Great Britain, Holland, Italy, Japan, Malta, Norway, Portugal, Spain, Sweden, Switzerland, the U.S. and other countries. Arranged alphabetically by country, then by city. Includes sections on packers and shippers, auctioneers and sale rooms, international antique fairs, antique and art periodicals, antique dealers associations, and street maps. Specialist index and index to dealers.

# GENERAL HISTORIES, DICTIONARIES AND ENCYCLOPEDIAS, COLLECTIONS

P10    Aprà, Nietta. Dizionario enciclopedico dell'antiquariato. Presentazione, revisione e integrazione a cura di Guido Gregorietti. Milano, Mursia, 1969. xix, 572p. il., plates (Dizionari enciclopedici. 1)

A general dictionary of terms relating to the decorative arts and of artists connected with them (including some painters, sculptors, printmakers, and architects). Illustrated with photographs, line drawings, and reproductions of signatures and marks. Bibliographical references included in some entries.

"Elenco degli antiquari italiani e calendario delle fiere antiquarie d'Europa" in pocket.

P11    Bernasconi, John R. The collectors' glossary of antiques and fine arts. With over 100 il., including reproductions from the books of Chippendale, Sheraton, and Hepplewhite. [Rev. ed.] London, Estates Gazette [1963]. xvi, 587p. il.

A handbook of concise definitions, tables, and lists of terms relating to the decorative and applied arts. Includes sections on furniture, silver, gold, pewter, porcelain and pottery, glass, clocks and watches, paintings, prints, jewelry, fabrics, carpets and rugs, coins, medals, arms and armor, musical instruments, heraldry, symbols, mythological divinities, saints, monastic orders, and Roman numerals.

Glossary of general and miscellaneous terms, not included in previous specialized sections, p.497-521. Silver, tables of date letters, p.522-71.

P12    Boger, Louise Ade, and Boger, H. Batterson. The dictionary of antiques and the decorative arts; a book of reference for glass, furniture, ceramics, silver, periods, styles, technical terms, etc. N.Y., Scribner [1967]. ix, 662p. il. (part col.)

1st ed. 1957. This ed. includes a supplementary section of nearly 700 terms on the decorative arts of the 19th and 20th centuries.

A useful dictionary of concise definitions of terms and subjects relating to the decorative arts. Aimed primarily at the collector and general reader.

Classified bibliography, p.559-66. Supplementary bibliography, p.661-62.

P13    Bossert, Helmuth Theodor. Geschichte des Kunstgewerbes aller Zeiten und Völker im Verbindung mit zahlreichen Fachgelehrten. Herausgegeben von Dr. H. Th. Bossert. Berlin, Wasmuth, 1928-35. 6v. il., plates (part col.)

A comprehensive history of applied arts throughout the world from the Ice Age to the early 20th century. Consists of contributions by experts. Richly illustrated. Bibliography at the end of each chapter. Table of contents and subject index at end of v.6.

P14    The complete color encyclopedia of antiques. Comp. by the Connoisseur, London; ed. by L. G. G. Ramsey;

pref. by Bevis Hillier. 2d ed. London, The Connoisseur; N.Y., Hawthorn, 1975. 704p. il. (part col.)
1st ed. pub. in 1962 as *The complete encyclopedia of antiques,* London, The Connoisseur and N.Y., Hawthorn. Material in this volume was adapted from *The concise encyclopedia of antiques,* London, The Connoisseur, and N.Y., Hawthorn, 1954–61, 5v. (P15); and *The concise encyclopedia of American antiques,* ed. by Helen Comstock, N.Y., Hawthorn, 1958, 2v. (P54).

A comprehensive guide to European and American antiques, arranged within broad subject areas. Contents: (1) The aesthetic movement; the arts and crafts movement; Art Nouveau; Art Deco, etc.; (2) Antiquities; (3) Arms and armour; (4) Barometers, clocks, and watches; (5) Carpets and rugs; (6) Coins and medals; (7) Ethnographica; (8) Furniture; (9) Glass; (10) Jewelry; (11) Metalwork; (12) Mirrors; (13) Needlework and embroidery; (14) Pottery and porcelain; (15) Prints; (16) Scientific instruments; (17) Silver.

List of museums and galleries, p.679–86, arranged under the main subject headings. Classified bibliography, p.669–78. General index.

P15     The Connoisseur. The concise encyclopedia of antiques. Editor, L. G. G. Ramsey, London, The Connoisseur, N.Y., Hawthorn, 1954–61. 5v. il.

A comprehensive encyclopedia of Western decorative arts and Oriental decorative arts treated primarily from a Western point of view. Each section is written by an authority in the field. Sections include an essay, generally a glossary of terms and biographies, and a bibliography.

Covers furniture, glass, ceramics, pewter, silver, jewelry, clocks and watches, arms and armor, book collecting, needlework, Oriental carpets and rugs, portrait miniatures, prints, coins and medals, and many other subjects.

A list of museums and galleries in Great Britain, Europe, and the U.S. in which representative collections are located are listed under the main subject areas covered in v.3, p.261–77. Each volume contains an index of names and places; comprehensive index to all 5v. is at the end of v.3.

Material in these volumes is adapted to form part of the contents of the 1v. *Complete color encyclopedia of antiques* (P14).

P16     Fleming, John, and Honour, Hugh. Dictionary of the decorative arts. N.Y., Harper [1977]. 896p. il.

Pub. in Great Britain as *The Penguin dictionary of decorative arts,* London, Lane, 1977. A companion volume to the *Penguin dictionary of architecture* (J26).

The best comprehensive dictionary of the primary forms of Western decorative arts. Contains approx. 4,000 entries on "furniture and furnishings—i.e. movable objects other than paintings and sculpture—in Europe from the Middle Ages onwards and in North America from the Colonial Period to the present day . . . [Includes] definitions of stylistic and technical terms; accounts of materials and processes of working and embellishing them; biographies of leading craftsmen and designers; and brief histories of the more notable factories in which objects for household use and decoration have been made."—*Foreword.* Illustrated with more than 1,000 reproductions of works.

Bibliography given at the end of some entries. Ceramic marks, p.881–89. Hall-marks on silver, p.[890]–92. Makers' marks on silver and pewter, p.[893]–95.

P17     Havard, Henry. Dictionnaire de l'ameublement et de la décoration depuis le XIIIe siècle jusqu'à nos jours. Nouv. éd. entièrement refondue et considérablement augm. Paris, Quantin, Librairies-imprimeries réunies [1894]. 4v. il., plates (part col.)
1st ed. 1887–90.

A monumental work of scholarship in the French encyclopedic tradition. Still valuable for research, particularly in the history of French decorative arts. Encompasses all of the decorative arts. Based on a scientific examination of records, e.g. personal inventories, archives, letters, etc. References to sources in the text. Many illustrations in the text; chromolithographic plates.

P18     Honour, Hugh. Chinoiserie; the vision of Cathay. [London] Murray [1961]. viii, 294p. il., plates (4 col.) (Repr.: N.Y., Harper, 1973.)

A very good story of the "vision of Cathay" and its formal expression in the European style called "chinoiserie." Authoritative, witty, delightful to read. Treats mostly decorative arts (including decorative painting) of the 17th and 18th centuries. Chapter VI is on the Anglo-Chinese garden; the last chapter summarizes the later Chinese survival and Japonaiserie. Well illustrated with a "catalogue of illustrations." Ample bibliography in the text and catalogue.

P19     The James A. de Rothschild Collection at Waddesdon Manor. [Fribourg] Office du Livre [London, National Trust for Places of Historic Interest or Natural Beauty, 1967–(75)]. [v.1–(7)]. il., plates (part col.)
Ed. of series: Anthony Blunt.

A series of excellent catalogues of the collection of fine and decorative arts at Waddesdon Manor. Each catalogue presents extensive documentation and bibliographical references. Entries include detailed descriptions and analytical commentaries. Very well illustrated.

Contents by volume: (1) Waterhouse, Ellis K. *Paintings.* 334p. (1967); (2) Eriksen, Svend. *Sèvres porcelain.* 339p. (1968); (3) Hodgkinson, Terence. *Sculpture.* 308p. (1970); (4) Charleston, R. J., and Ayers, John. *Meissen and other European porcelain. Oriental porcelain.* 316p. (1971); (5) Blair, Claude. *Arms, armour and base-metalwork.* 531p. (1974); (6) De Bellaigne, Geoffrey. *Furniture, clocks and gilt bronzes.* 2v. 903p. (1974); (7) Grandjean, Serge; Piacenti, Kirsten Aschengreen; Truman, Charles; and Blunt, Anthony. *Gold boxes and miniatures of the eighteenth century.* 367p. (1975).

P20     Morant, Henry de. Histoire des arts décoratifs, des origines à nos jours. Suivie de le design et les tendances actuelles, par Gérald Gassiot-Talabot. [Paris] Hachette [1970]. 574p. il. col. plates.

A unique one-volume survey of the decorative arts from antiquity to the early 20th century. The last chapter, written by Gérald Gassiot-Talabot, is a critical essay on contemporary design. Intended as a manual for art students and amateurs.

Geographical and chronological arrangement with sub-divisions by medium. The various arts are represented by good-sized photographs and drawings in the text (769 in all) and a few color plates. Contains a comprehensive bibliography.

Répertoire des artistes, p.487–[509]; Répertoire des musées, p.510–[23]; Bibliographie, p.525–[39]; Index des noms cités, p.540–[52]; Table des illustrations, p.553–[74].

P21　New York. Metropolitan Museum of Art. Decorative art from the Samuel H. Kress Collection at the Metropolitan Museum of Art: the tapestry room from Croome Court, furniture, textiles, Sèvres porcelains, and other objects. By Carl Christian Dauterman, James Parker, and Edith Appleton Standen. London, Phaidon Pr. for the Samuel H. Kress Foundation [1964]. 303p. 245 il.

Added title-page: "Complete catalogue of the Samuel H. Kress Collection."

The definitive *catalogue raisonné* of the museum's Kress Collection of decorative arts. Includes valuable information on the *marchands merciers*. Detailed discussion of the Adam tapestry room from Croome Court, 18th-century furniture, textiles, Sèvres porcelains, and other objects. Handsomely illustrated. Bibliography, p.285–89; Index, p.293–303.

P22　Osborne, Harold, ed. The Oxford companion to the decorative arts. Oxford, Clarendon, 1975. xiv, 865p. 460 il.

A companion volume to the *Oxford companion to art* (E14).

A comprehensive dictionary of the "major crafts whose origin goes back to prehistoric times such as leather-working, glass-making and so on; crafts which have arisen since the dawn of history such as bell-founding, paper-making, clock-making, typography, landscape gardening, photography; and specialised or luxury crafts such as arms and armour, enamels, lacquer, jewellery, toys, lace-making and embroidery. . . . Includes both general articles on particular crafts and articles or groups of articles devoted to particular periods of cultures (ancient Egypt, Greek and Roman Antiquity, Africa, Pre-Columbian America, Russia and so on)."—*Pref.* Comp. and written by a team of experts. Illustrated with 60 line drawings and 400 photographic reproductions. Many cross-references.

The bibliography, p.851–65, contains 940 numbered items; numerical references to items in the bibliography are listed at the end of entries.

P23　Phillips, Phoebe, ed. The collectors' encyclopedia of antiques. Associate editors: David Coombs [and] Joseph Butler. Drawings by Christopher Evans. N.Y., Crown [1973]. 703p. il. (part col.)

A comprehensive encyclopedia of the applied arts, with emphasis on the 18th and 19th centuries. "Our purpose has been to provide a survey of the main collecting fields, together with some of the more important minor crafts. The editorial arrangement has been devised and constructed to be of the greatest practical use to collectors."—*Introd.* Articles are written by a team of specialists and are signed. Contributors, p.13–14.

Arranged in 16 sections: Arms and armour; Bottles and boxes; Carpets and rugs; Ceramics; Clocks, watches and barometers; Embroidery and needlework; Furniture; Glass; Jewellery; Metalwork; Musical instruments; Netsuke and inro; Pewter; Scientific instruments; Silver; Toys and automata. Each section includes a separate table of contents, an introduction, a discussion of historical and technical aspects, a glossary, material on maintenance and repair, bibliography, a list of collections in Great Britain and the U.S., and an index.

A general index is at the end.

P24　The Random House collector's encyclopedia, Victorian to Art Deco. N.Y., Random [1974]. 302p. il. (part col.)

British ed.: *The collector's encyclopedia,* London, Collins, 1974.

A companion volume of *The Random House encyclopedia of antiques* (P25).

A one-volume encyclopedia of the decorative arts from 1851–1939.

Ceramic marks, p.[292]–94. Silver date letters, p.[295]. The bibliography, p.[297]–302, is classified and includes English-language books only.

P25　The Random House encyclopedia of antiques. Introd. by John Pope-Hennessy. [1st American ed.] N.Y., Random [1973]. 400p. il. (part col.), maps.

British ed.: *Collins encyclopedia of antiques,* London, Collins, 1973.

A comprehensive one-volume encyclopedia of over 5,000 entries on the decorative arts limited, for the most part, to the period from the early 15th century to 1875. "This book is addressed primarily to collectors, and for this reason the categories of works of art that are generally available for purchase are dealt with more fully than others which may be of greater value but are less readily procurable."—*Introd.* Does not cover prints, book bindings, coins, medals, dolls, toys, needlework, militaria, or ethnographica.

Ceramic marks, p.[385]–87. Silver date letters, p.[388]–90. The bibliography, p.[391]–98, is classified and includes English-language books only.

P26　Savage, George. Dictionary of antiques. N.Y., Praeger [1970]. ix, 534p. il., col. plates.

A dictionary of more than 1,500 entries on antiques. "This Dictionary has been devised primarily to help both collectors and dealers in antiques of one kind or another to date and attribute those specimens which come their way."—*Pref.* Contains approx. 700 illustrations.

Classified bibliography, p.[503]–34. Appendix of marks, p.479–99.

P27　Stoutenburgh, John Leeds. Dictionary of arts and crafts. N.Y., Philosophical Library, 1956. 259p.

A useful dictionary of short, precise definitions of technical terms relating primarily to crafts rather than to the decorative arts.

P28  Studio dictionary of design and decoration. [Ed.:
Robert Harling. Rev. and enl. ed.]. N.Y., Viking
[1973]. 583p. il.
Pub. in Great Britain as the *Dictionary of design and
decoration,* London, Collins, 1973. "Originated as a series
by Robert Harling, editor of *House and Garden,* which was
published in the magazine over a number of years."

A well-illustrated, general dictionary of the various aspects
of design, including architecture and the decorative arts.
Contains biographies of major designers and craftsmen.
Entries range in length from succinct definitions to articles
of several pages. No bibliography.

P29  Untermyer, Irwin. The Irwin Untermyer Collection.
[Catalogues]. Cambridge, published for the Metro-
politan Museum of Art by Harvard Univ. Pr., 1956-
69. 6v. il., plates (part col.)
The catalogues of an important private collection of deco-
rative arts, now part of the collection of the Metropolitan
Museum of Art. Introductory essays provide historical
surveys. Notes and commentaries on pieces reproduced in
the plates are detailed and include marks, ex-collections, and
references. Volumes also include general bibliographies.

Contents (text by Yvonne Hackenbroch unless indicated
otherwise): v.1, *Meissen and other continental porcelain,
faience and enamel.* xxix, 264p. 159 plates (part col.) (1956);
v.2, *Chelsea and other English porcelain, pottery and enamel.*
xxx, 286p. 346 il. (part col.) (1957); v.3, *English furniture,
with some furniture of other countries.* Introd. by John
Gloag. Notes and comments by Y. Hackenbroch. lxv, 95p.
359 plates (part col.); v.4, *English and other needlework,
tapestries and textiles.* lxxxi, 80p. il., 183 plates (part col.);
v.5, *Bronzes, other metalwork and sculpture.* Introd. by Y.
Hackenbroch. lxv, 64p. 27 il., 201 plates (1962); v.6, *English
and other silver.* 115p. il., plates, facsims. (1963; rev. ed.
1969).

P30  Whiton, Augustus Sherrill. Interior design and
decoration. 4th ed. Philadelphia, Lippincott [1974].
vi, 699p. il.
Editions for 1937-44 pub. under title *Elements of interior
decoration;* for 1951-63 under title *Elements of interior
design and decoration.*

A textbook survey of historical and practical aspects of
interior design and decoration; not entirely reliable for its
historical information. Contents: pt. 1, Period decoration
and furniture; pt. 2, Contemporary design; pt. 3, The basic
interior; pt. 4, Design materials and accessories; pt. 5, Interior
planning.

Bibliographies at the ends of chapters; glossaries at the
ends of some chapters. Glossary of decorative art terms,
p.669-86. General index.

P31  Wrightsman, Charles Bierer. The Wrightsman Collec-
tion, by F. J. B. Watson. [N.Y.] Metropolitan Museum
of Art. (Distr. by New York Graphic Society, Green-
wich, Conn. [1966-70].) 5v. il., plates (part col.), map,
facsims., plans.

A lavishly illustrated catalogue of the Wrightsman Collection
of 18th-century furniture and decorative works of art at
the Metropolitan Museum of Art in New York. Each piece
is illustrated and described in great detail by an expert in
the field. v.5 treats the Wrightsman collection of painting
and sculpture, some of which is 19th century. Extensive
bibliographies and documentation.

Contents: v.I, *Furniture: menuiserie; Furniture: ébéni-
sterie,* by F. J. B. Watson. v.II, *Gilt bronze and mounted
porcelain, carpets and chimneypieces.* Appendix: Savonnerie
carpets, p.523-[32]; Saint-Cyr embroidery, p.532; Biogra-
phies of craftsmen: Furniture makers, p.533-[62]; Bronze-
workers, designers, goldsmiths, sculptors, etc. p.562-[73];
Glossary, p.574-[95]; Bibliography, p.596-[635]; Index,
p.637-[71], by F. J. B. Watson. v.III, *Furniture and gilt
bronze, continued from v.II; Gold boxes,* by F. J. B. Watson;
*Porcelain and enamel boxes; Silver and silver gilt; Book-
bindings, etc.* by Carl Christian Dauterman; Biographies of
goldsmiths, p.293-[306]; Glossary, p.307-[14]; Bibliog-
raphy (by subject), p.315-[22]; Index of craftsmen, p.323-
[28]; General index, p.329-[48]. v.IV, *Meissen porcelain;
Sèvres and other French porcelain; Chelsea and other
English porcelain; Oriental porcelain,* by Carl Christian
Dauterman; Biographies of craftsmen, p.429-[40]; Glos-
sary, p.441-[48]; Bibliography, p.449-[57]; Index of crafts-
men, p.459-[63]; General index, p.464-[86]. v.V, *Paintings,
drawings,* by Everett Fahy; *Sculpture,* by Sir Francis Watson;
*Introductions,* by John Walker, Sir John Pope-Hennessy;
Index, p.419-[55].

# ANCIENT

P32  Strong, Donald, and Brown, David, eds. Roman crafts.
[London] Duckworth; N.Y. New York Univ. Pr.
[1976]. 256p. 390 il., 12 col. plates.
A series of introductory studies of ancient Roman decorative
and applied arts, written by authorities in the respective
fields. The essays emphasize the development of the craft
techniques involved, rather than related economic conditions
and social background.

Contents: (1) Silver and silversmithing, by David Sherlock;
(2) Bronze and pewter, by David Brown; (3) Enamelling, by
Sarnia A. Butcher; (4) Jewellery, by Reynold Higgins; (5)
Minting, by David Sellwood; (6) Pottery, by David Brown;
(7) Pottery lamps, by D. M. Bailey; (8) Terracottas, by
Reynold Higgins; (9) Glass, by Jennifer Price; (10) Iron-
making, by Henry Cleere; (11) Blacksmithing, by W. H.
Manning; (12) Woodwork, by Joan Liversidge; (13) Textiles,
by J. P. Wild; (14) Leatherwork, by J. W. Waterer; (15)
Marble sculpture, by Donald Strong and Amanda Claridge;
(16) Stuccowork, by Roger Ling; (17) Wall painting, by
Pamela Pratt; (18) Wall and vault mosaics, by Frank Sear;
(19) Floor mosaics, by David S. Neal.

Bibliographies at the end of each essay.

## ISLAMIC

**P33**   Kühnel, Ernst. The minor arts of Islam. Trans. from the German by Katherine Watson. Ithaca, Cornell Univ. Pr. [1971]. viii, 255p. il. (part col.), facsims. (part col.)

1st German ed. 1925; 2d rev. German ed. 1963.

Trans. of *Islamische Kleinkunst.*

The basic guide to the decorative arts of Islam. Useful both as an introduction and as a handbook for the specialist. Arranged by technique—books, pottery, metalwork, glass and crystal, ivory, wood, stone, and stucco. Several misspellings and misprints. The appendix gives the formula for converting Muslim into Christian dates. "Public collections of Islamic art," p.244-46. "Select bibliography," with brief notes, p.247-50 (not in order). Well illustrated.

**P34**   Migeon, Gaston. Les arts plastiques et industriels. Deuxième édition. Paris, Picard, 1927. 2v.

Half title: *Manuel d'art musulman.*

1st ed. 1907.

"Still indispensable as a single comprehensive handbook on all Islamic decorative arts, with many illustrations in the text."—E. Kühnel, *The minor arts of Islam* (P33).

**P35**   New York. Metropolitan Museum of Art. A handbook of Muhammadan art, by Maurice Sven Dimand. 3d ed., rev. and enl. N.Y., 1958. xi, 380p. il., map.

1st ed. 1930 under title *A handbook of Mohammedan decorative arts;* 2d ed. 1947.

A survey of Islamic art based on the extensive collections in the Metropolitan Museum of Art. Gives historical background and a discussion on the origins of the style. Covers the painting, sculpture, calligraphy, illumination, bookbinding, ceramics, carving, metalwork, glass, textiles, and rugs of several countries. A chronology follows the text. Bibliography, p.332-48.

**P36**   Wulff, Hans E. The traditional crafts of Persia; their development, technology, and influence on Eastern and Western civilizations. Cambridge, MIT Pr. [1966]. xxiv, 404p. il. (part col.)

An important study of the crafts of Persia. Treats metalworking, woodworking, ceramics, textiles, leather, building, and agricultural crafts. Illustrated with photographs and drawings. Bibliography, p.305-14; "Review of relevant literature," p.315-29; and a glossary of technical terms, p.331-404.

## RENAISSANCE — MODERN

**P37**   Encyclopédie des arts décoratifs et industriels modernes au XXème siècle. Paris, Office central d'éditions et de libraries [1927?]. 12v. il. (Repr.: N.Y., Garland, 1977. 12v.)

An important source for the study of early 20th-century decorative arts, industrial arts, and architecture, in particular

*l'art moderne.* Documents the Exposition Internationale des Arts Décoratifs, Paris, 1925. Valuable for both the illustrations and text.

Contents by volume: (1) Préface: Evolution de l'art moderne. L'esprit nouveau dans les arts décoratifs et industriels. Evolution au XXe siècle. Vue d'ensemble; (2) Architecture et décoration fixe. Décoration sculptée. Décoration peinte; (3) Décoration fixe de l'architecture: Art et industrie de la pierre, du bois, du métal, de la céramique et de la verrerie; (4) Le mobilier et son ensemble. Art et industrie du bois et du cuir dans l'ameublement. Hygiène, art et lumière. Matières et techniques. Mobiliers luxeux et usuels. Art colonial; (5) Accessoires du mobilier. Tabletterie, maroquinerie, ferronerie, incrusteurs, émailleurs, laqueurs, orfèvres, graveurs sur acier, horlogers, armuriers, bronziers, fondeurs, médailleurs, doreurs et argenteurs. Vaisselle et cristallerie.; (6) Art et industries des textiles. Tissus, lampas, brocards, brochés. Papiers peints et imprimés; (7) Le livre. Art et industrie du livre. Le papier. Impression, illustrations, brochage, cartonnage, reliure. Édition et librairie. Fondeurs de caractères. Imprimeurs, illustrateurs, relieurs, éditeurs, livres de luxe, bibliophiles; (8) Jeux et jouets. Instruments et appareils de sport. Appareils scientifiques. Instruments de musique et de radio. Moyens de transports: chemins de fer, autos, avions, navires, etc. . . ; (9) La parure. Accessoires du vêtement: bas, gants, chaussures, chapeaux, lingerie, dentelles, mode, fleurs et plumes, parfumerie, bijouterie, joaillerie; (10) Théâtre, Introduction. Arts du theatre. Photographie. Cinématographie; (11) Rue et jardin. Plans de villes, aménagements urbains. Décor et mobilier de la rue. Décor publicitaire. Arts des jardins. Parc et jardins. Arbres et arbustes. Plantes et fleurs. Décors et mobiliers du jardin; (12) Enseignement. Enseignement professional, artistique, technique. Travail de la pierre, du bois, du métal, de la céramique, du verre, des textiles, du papier et des matières végétales ou animales (produits de replacement).

**P38**   Thornton, Peter. Seventeenth-century interior decoration in England, France and Holland. New Haven and London, published for the Paul Mellon Centre for Studies in British Art by Yale Univ. Pr., 1978. xii, 427p. il. (some col.)

An authoritative study of Baroque furniture and interior decoration in England, France, and Holland. Based on research with inventories. Underscores the importance of the French contribution.

Contents: (I) France and the aristocratic tradition; (II) The spread of the French ideal; (III) The architectural framework; (IV) The upholsterer's task; (V) The upholsterer's materials; (VI) The upholsterer's furnishings; (VII) Beds, cloths of estate and couches; (VIII) Upholstered seat furniture; (IX) Tables and cup-boards; (X) Other furniture and decorative features; (XI) Lighting; (XII) Specific rooms and their decoration.

Scholarly notes with bibliographical references: "Notes to the text," p.336-99; "Notes to the plates," p.400-14. Good index with many cross-references. Illustrated with 314 figures and 17 color plates in the text.

SEE ALSO:   Schmutzler, R. *Art nouveau* (I261).

## WESTERN COUNTRIES

### Canada

P39   Lessard, Michel. Complete guide to French-Canadian antiques. Illustrated by Huguette Marquis. Trans. by Elisabeth Abbott. N.Y., Hart [1974]. 255p. il.
Trans. of *Encyclopédie des antiquités du Quebec; trois siècles de production artisanale.* Montreal, Éditions de l'homme [1971].

A popular guide to French-Canadian antiques, intended primarily for collectors. Introductory chapters on collecting and French and Anglo-American influences on French-Canadian antiques are followed by sections on furniture, wooden objects, ceramics, glass, lamps and lighting devices, ironwork, silver, pewter, tools, toys, firearms, papers, books, etc.

Classified bibliography, p.248–51. Glossary, p.8–10.

P40   Webster, Donald Blake, ed. The book of Canadian antiques. Toronto, Montreal, N.Y., London, McGraw-Hill Ryerson [1974]. 352p. il. (part col.)

A collection of 21 essays by 17 authors on the various areas of Canadian antiques. Although the volume is directed primarily to the collector, it also provides the most comprehensive, authoritative survey for the student and historian of Canadian decorative arts.

Contents: French-Canadian furniture; Quebec sculpture and carving; Furniture of English Quebec; Nova Scotia furniture; New Brunswick furniture; Ontario furniture; Ontario-German decorative arts; Silver; Pewter and copper; Treenware and wooden utensils; Toys and games; Guns and gunmakers; Decorative ironwork; Tools of the trades; Pottery—earthenware and stoneware; 19th-century British ceramic imports; Glass and the glass industry; Handweaving and textiles; Prints and early illustrations; Books and broadsides; Photography and photographers. Dating and identification, p.337–38. Restoration and care, p.338–39. The problem of fakery, p.339–41. Antiques as an investment, p.341–42. Museums with Canadian antique collections, p.347–49.

Classified bibliography, p.343–46.

### France

P41   Eriksen, Svend. Early neo-classicism in France: the creation of the Louis Seize style in architectural decoration, furniture and ormolu, gold and silver, Sèvres porcelain in the mid-eighteenth century. Trans. from the Danish and ed. by Peter Thornton. London, Faber and Faber, 1974. 432p. plates (part col.)

A major scholarly contribution to art historical research in French decorative arts and architecture. Contains an astonishing amount of material (culled from sources and archives) pertinent to all aspects of the period of Louis XVI. Handsomely produced. Illustrations of all works discussed in the text, with a separate catalogue of the 499 illustrations. "Select biographies," p.145–225, is an alphabetical arrangement of biographies of artists, patrons, craftsmen, etc., each

with a bibliography. Other bibliographical references in footnotes. "Appendixes," p.226–77, consists of a selection of letters, extracts from sources and documents. Each has the French text and an English translation.

P42   Kimball, Sidney Fiske. The creation of the Rococo. [Philadelphia] Philadelphia Museum of Art, 1943. xvii, 242p. plates. (Repr.: N.Y., Norton, 1964.)
French ed., Paris, Picard, 1949, *Le style Louis XV; origine et évolution du rococo.* Traduit par Jeanne Marie. Has numerous additions and bibliographic footnotes.

The basic pioneer work on the Rococo style with special attention to its creation during the last years of Louis XIV and the Regency period. Treats the Rococo as a French style only distantly related to Italian Baroque. A difficult book for the student and general reader, most rewarding for the specialist. Many illustrations of uneven quality.

P43   Savage, George. French decorative art, 1638–1793. N.Y., Praeger [1969]. xi, 188p. il. (part col.)

A brief introduction to the field of French furniture and decorative art for the English-speaking reader. Covers the period from the building of Versailles to the French Revolution. Bibliography, p.179–[80].

P44   Vial, Henri; Marcel, Adrien; and Girodie, André. Les artistes décorateurs du bois; répertoire alphabétique des ébénistes, menuisiers, sculpteurs, doreurs sur bois, etc., ayant travaillé en France aux XVIIe et XVIIIe siècles. Paris, Bibliothèque d'art et d'archéologie, 1912–22. 2v.

A fundamental reference work. Arranged alphabetically by name of artist or artisan who worked in wood. Bibliographical references, v.1, p.xxvi–xxvii.

Contents: v.1, A–L; v.2, M–Z and Supplément.

P45   Viollet-le-Duc, Eugène Emmanuel. Dictionnaire raisonné du mobilier français de l'époque carlovingienne à la renaissance. Paris, Morel, 1868–75. 6v. il., 114 plates, maps.

"Remarkable survey of mediaeval furnishings, household objects, costume and armour, based on Viollet's encyclopedaic knowledge and his feeling for the Gothic and perception even when mistaken."—D. Chafer, *The arts applied* (P1).

Contents: t.1, Meubles; t.2, Ustensiles. Orfèvrerie. Instruments de musique. Jeux, passe-temps. Outils, outillages; t.3–4, Vêtements, bijoux de corps, objets de toilette; t.5–6, Armes de guerre, offensive et défensives. Dictionary arrangement under the above given headings. Each volume has an alphabetical index; inclusive index in last volume.

SEE ALSO:   *Louis XV* . . . (I282).

### Germany and Austria

P46   Kohlhaussen, Heinrich. Geschichte des deutschen Kunsthandwerks. München, Bruckmann [1955]. 591p. 543 il., 16 col. plates. (Deutsche Kunstgeschichte. Bd. 5)

A scholarly, well-illustrated survey of German applied and decorative arts. Classified bibliography, p.577–80.

SEE ALSO: *Augsburger Barock* (I292).

## Great Britain

P47    The Connoisseur. The Connoisseur period guides to the houses, decoration, furnishing, and chattels of the classic periods, ed. by Ralph Edwards & L. G. G. Ramsey. N.Y., Reynal, 1957–58. 6v. il. (part col.), ports, facsims.
Contents: (1) The Tudor period, 1500–1603; (2) The Stuart period, 1603–1714; (3) The early Georgian period, 1714–60; (4) The late Georgian period, 1760–1810; (5) The Regency period, 1810–30; (6) The early Victorian period, 1830–60. Includes bibliographical references and indexes.

P48    Naylor, Gillian. The Arts and Crafts movement; a study of its sources, ideals and influence on design theory. London, Studio Vista [1971]. 208p. il.
A study of the various aspects of the Arts and Crafts movement; written for the general reader. Brings together sources and information on the leading figures and their influence on the development of design in the 20th century. Bibliography, p.195–98, includes recent literature. Illustrations vary in quality.

SEE ALSO: Aslin, Elizabeth. *The aesthetic movement* (I306).

## Italy

P49    Fossati, Paolo. Il design in Italia. 1945–1972. Torino, Einaudi, 1972. xiv, 255p. 101 plates (part col.)
A well-documented summary of the work of ten creative Italian designers of the post-war period, with an historical introduction on space in Italian design. Reviews only machine-produced objects; includes innovative solutions for the design of interior and exterior spaces with prefabricated elements. The ten designers are Franco Albini, Bruno Munari, Carlo Scarpa, Ernesto N. Rogers, Marco Zanuso, Ettore Sottass, Achille Castiglioni, Alberto Rosselli, Roberto Sambonet, and Enzo Mari. For each gives a descriptive chapter with footnotes. "Compasso d'oro (1954–70)" is a chronological listing of milestone works in the history of modern design. "Schede per i designers" gives biographies and a list of the designs and projects of each artist. Good bibliography of Italian books and periodicals.

SEE ALSO: Amici dei Musei di Roma. *Il Settecento a Roma* (I319); Detroit. Institute of Arts. *The twilight of the Medici . . .* (I327); Malle, L. *Le arti figurative in Piemonte dalle origini al periodo romantico* (I339); *Storia di Milano* (I351); Viale, V., ed. *Mostra del barocco piemontese* (I357).

## Latin America

See: Cossió del Pomar, F. *Arte del Perú colonial* (I365); Fondo Editorial de la Plástica Mexicana. *The ephemeral and the eternal of Mexican folk art* (I370).

## Low Countries

See: Detroit. Institute of Arts. *Flanders in the fifteenth century . . .* (I379).

## Scandinavia

P50    Møller, Viggo Sten. Dansk kunstindustri. København, Rhodos [1969–70]. 2v. (v.1, 214p.; v.2, 195p.) il.
A well-illustrated history of Danish applied and decorative arts in the period 1850–1950. Includes a summary in English and bibliographical footnotes.
    Contents: Bind 1. 1850–1900; Bind 2. 1900–1950.

P51    Zahle, Erik. A treasury of Scandinavian design; [the standard authority on Scandinavian-designed furniture textiles, glass, ceramics, and metal]. N.Y., Golden Pr. [1961]. 299p. il. (part col.)
Trans. of *Hjemmets brugskunst; kunsthåndvaerk og kunstindustri i Norden,* København, Hassing, 1961.
    A well-illustrated survey of contemporary design of Scandinavia. Introductory sections on individual countries are followed by the illustrations section, which comprises the main portion of the book.
    Biographies, p.265–[96], include designers of furniture, glass, ceramics, interiors, etc.

SEE ALSO: Anker, P., and Andersson, A. *The art of Scandinavia* (I423).

## Spain and Portugal

See: *Ars Hispaniae*, v.20, Alcoles, S. *Artes decorativas en la España cristiana, siglos XI–XIX* (I438); Santos, R. *Oito séculos de arte portuguesa; história e espírito* (I456); Smith, R. C. *The art of Portugal, 1500–1800* (I458).

## United States

P52    Christensen, Erwin Ottomar. The Index of American design. Introd. by Holger Cahill. N.Y., Macmillan, 1950. xviii, 229p. 378 il. (part col.) (Repr.: N.Y., Macmillan, 1959.)
A representative selection of 378 illustrations which document American crafts and folk arts. These have been selected from the Index of American Design at the National Gallery of Art. Includes examples of toys, signs etc. as well as furniture, silver, textiles, glass, and ceramics.
    Bibliography, p.219–21. Index, p.223–29.

P53    Clark, Robert Judson, ed. The Arts and Crafts movement in America, 1876–1916. [Princeton] Princeton Univ. Pr., [1972]. 190p. 295 il.
The catalogue of an exhibition shown at the Art Museum, Princeton Univ.; the Art Institute of Chicago; and the Renwick Gallery of the National Collection of Fine Arts in 1972–73.
    An excellent book-catalogue which surveys the American Arts and Crafts movement in five scholarly essays and 295 catalogue entries. Includes furniture, glass, textiles, metalwork, books, and pottery.

Contents: Introduction; Chronology; (1) The Eastern seaboard, by Robert Judson Clark and others; (2) Chicago and the Midwest, by David A. Hanks; (3) The Pacific coast, by Robert Judson Clark; (4) The Arts and Crafts book, by Susan Otis Thompson; (5) Art pottery, by Martin Eidelberg. Other contributors include Mary Laura Gibbs, Karen L. Graham, Howard John Iber, Thomas L. Sloan, and Roberta Waddell Wong. Selected bibliography, p.187-90.

P54    Comstock, Helen, ed. The concise encyclopedia of American antiques. [2d ed.] N.Y., Hawthorn [1965]. 848p. il., maps.
1st ed. 1958 (2v.).

An authoritative encyclopedia of American decorative and applied arts. Articles are written by experts in the respective fields; each article includes an essay, usually a glossary of terms and biographies, and a bibliography.

Covers furniture, silver, pewter, wrought iron, pottery and porcelain, glass, needlework, quilts, prints, carpets and rugs, stamps, and other specialized subjects. An index of names and places is at the end.

Material from this volume makes up part of the contents of *The complete color encyclopedia of antiques* (P14).

P55    Hornung, Clarence Pearson. Treasury of American design; a pictorial survey of popular folk arts based upon watercolor renderings in the Index of American Design, at the National Gallery of Art. Foreword by J. Carter Brown. Introd. by Holger Cahill. N.Y., Abrams [1972]. 2v. xxvii, 846p. il. (part col.)
A pictorial survey of American crafts and folk art from c.1700 to the late 19th century. Representative specimens based on the watercolor renderings in the Index of American Design at the National Gallery of Art. The illustrations, many of which are in color, are accompanied by brief descriptions. The comprehensive index allows for easy use as a reference tool.

P56    Williamson, Scott Graham. The American craftsman. N.Y., Crown [1940]. xiv. 239p. plates, maps, facsims.
A survey of American crafts and craftsmen. Includes houses and housebuilders, furniture makers, craftsmen in clay, makers of glass, silversmiths, weavers, ironmasters, pewterers, bookbinders, etc. Checklists of craftsmen arranged according to their trade, p.191-218. Bibliographies, p.219-32, have useful critical notes.

SEE ALSO:   *The arts in America: the colonial period* (I468); *The arts in America: the 19th century* (I469); Bishop, R. *American folk sculpture* (K194); Boston. Museum of Fine Arts. M. and M. Karolik Collection. *Eighteenth-century American arts . . .* (I471); Brewington, M. V. *Shipcarvers of North America* (K195); *The Britannica encyclopedia of American art* (E169); Lipman, J., and Winchester, A. *The flowering of American folk art, 1776-1876* (I479).

# ORIENTAL COUNTRIES

## China

P57    Feddersen, Martin. Chinese decorative art; a handbook for collectors and connoisseurs. London, Faber and Faber [1961]. 286p. il. 8 col. plates.
Trans. by Arthur Lane of 2d German ed., *Chinesisches Kunstgewerbe.* "Intended to give the collector of Chinese applied art a survey of the most important documents in his particular field, and to communicate the results of recent research."—*Pref. to the 1st ed.* The 2d ed. is updated with the results of more recent research.

Contents: (1) Historical survey; (2) Ceramics; (3) Metalwork (excluding mirrors); (4) Bronze mirrors; (5) Jade; (6) Ivory, bone, horn, tortoiseshell, mother-of-pearl, amber; (7) Glass; (8) Textiles; (9) Iconography; (10) Marks.

Extensive classified bibliography, p.253-72.

P58    Jenyns, Soame, and Watson, William. Chinese art: the minor arts. N.Y., Universe [1963-65]. 2v. il.
Companion volumes to *Chinese art: bronze, jade, sculpture, ceramics* (I517).

Superb collections of plates for the various branches of the minor arts; each section preceded by a general introductory essay.

Contents: v.1, Gold, silver, bronze, cloisonné, Cantonese enamel, lacquer, furniture wood; v.2, Textiles, glass and painting on glass, carvings in ivory and rhinoceros horn, carvings in hardstones, snuff bottles, inkcakes and inkstones.

Bibliographical references in "Notes."

SEE ALSO:   Great Britain. Arts Council. *The arts of the Ming dynasty* (I513); Kuo li ku kung po wu yüan. Taiwan. *Masterpieces of Chinese art in the National Palace Museum* (I515); Lion-Goldschmidt, D., and Moreau-Gobard. J. C. *Chinese art: bronze, jade, sculpture, ceramics* (I517); Medley, M. *A handbook of Chinese art for collectors and students* (I518).

## Japan

P59    Feddersen, Martin. Japanese decorative art: a handbook for collectors and connoisseurs. Trans. by Katherine Watson. London, Faber and Faber, 1962. 296p. il. (part col.)
1st German ed., *Japanisches Kunstgewerbe,* 1960.

A comprehensive, well-documented study of the most important forms of Japanese decorative art. The first chapter gives an historical survey from prehistoric through modern times, followed by chapters on ceramics, metalwork, lacquer, netsuke, textiles, leather, basketry, and iconography. Excellent classified bibliography, p.267-83.

P60    Hauge, Victor, and Hauge, Takako. Folk traditions in Japanese art. Introduction and catalogue by Victor and Takako Hauge. Tokyo, N.Y., Kodansha, in cooperation with the International Exhibitions Foundation, Washington, D.C., and with the Japan Foundation [1978]. 272p. il. (part col.).

The book-catalogue of an exhibition shown at the Cleveland Museum of Art, the Japan House Gallery, N.Y., and the Asian Art Museum of San Francisco.

A beautifully illustrated, well-documented survey which gives "the broadest representation of Japanese folk cultural materials on the level of art yet assembled for exhibition." — *Pref.* The introduction, p.13–32, is followed by the section of illustrations, p.34–224, arranged by types of works: Paintings, prints and sculpture; Ceramics; Textiles; Lacquer, wood and metal; Other crafts. The catalogue gives detailed descriptions and commentaries for each of the 231 entries. Glossary, p.265–66. Classified bibliography, p.267–71.

P61   Munsterberg, Hugo. The folk arts of Japan. Rutland, Vt., and Tokyo, Tuttle [1958]. 168p. il. (part col.)
An intelligent, attractive introduction to the principal and lesser folk arts of Japan.

Contents: (1) The spirit of Japanese folk art; (2) Pottery; (3) Baskets and related objects; (4) Lacquerware, woodenware, metalwork; (5) Toys; (6) Textiles; (7) Painting and sculpture; (8) Peasant houses; (9) The contemporary folkart movement.

P62   Yamada, Chisaburoh F., ed. Decorative arts of Japan. Tokyo, Kodansha [1964]. 262p. col. il.
"The present volume is designed to present a historical survey of Japan's decorative arts through a series of full-color reproductions of carefully selected masterpieces." —*Pref.* Contains an introductory essay and sections on ceramics, metalwork, lacquerware, and textiles. Descriptive and critical comments accompany each illustration.

SEE ALSO:  *Arts of Japan* (I550); *Heibonsha survey of Japanese art* (I552); Tokyo. National Museum. *Pageant of Japanese art* (I563); Ueno, N., ed. *Japanese arts and crafts in the Meiji era* (I564).

## PRIMITIVE

See:  Sieber, R. *African textiles and decorative arts* (P686).

## ORNAMENT

### Bibliography

P63   Berlin. Staatliche Kunstbibliothek. Katalog der Ornamentstichsammlung der Staatlichen Kunstbibliothek, Berlin. Berlin, Verlag für Kunstwissenschaft, 1936–39. 782p. il. (Repr.: N. Y., Burt Franklin [1958].)
Published in 12 parts 1936–39. Introd. by Hermann Schmitz. 1st ed., 1894, ed. by Peter Jessen (2,638 entries).

Indispensable for reference work with prints, decorative arts, and early architectural books.

A classified bibliography of ornamental prints (5,435 entries), primarily in series form, which comprised the decorative arts collection of the Berlin State Library and its predecessors. This library was largely destroyed in World War II.

Divided into nine general categories: (1) General collections; (2) Handicrafts; (3) Architecture; (4) Interior decoration; (5) Plastic arts; (6) Nature; (7) Symbolical works; (8) Painting; (9) Calligraphy and printing arts.

P64   Debes, Dietmar. Das Ornament; Wesen und Geschichte. Ein Schriftenverzeichnis. Leipzig, Seemann [1956]. 101p.
A classified bibliography of the literature of ornament. 2,026 entries. Includes books and periodical articles. Indexes of authors, artists, geographical names, and subjects.

### Histories and Handbooks

P65   Bauer, Hermann. Rocaille; zur Herkunft und zum Wesen eines Ornament-Motivs. Berlin, de Gruyter, 1962. 87p. il., 44 plates, figs. (Neue Münchner Beiträge zur Kunstgeschichte, Bd. 4)
A unique scholarly study of the genesis of *rocaille* and its development as a form of Rococo decoration in France and Germany. Based on original sources. Full critical notes with bibliography. Well illustrated.

P66   Berliner, Rudolf. Ornamentale Vorlage-Blätter des 15. bis 18. Jahrhunderts. Leipzig, Klinkhardt & Biermann, 1924–26. x, 182p. Atlas of 450 plates in 4v.
An important corpus of decorative engravings, 15th to the end of the 18th century. Invaluable for identifying prints. Scholarly notes, list of literature cited, indexes of artists, publishers, and the collections from which the illustrations were reproduced.

*[handwritten: New ed. 745.4494 B515 O74 1981 3v.]*

P66a   Bossert, Helmuth Theodor. ed. Ornament in applied art, 122 color plates reproducing over 2,000 decorative motives from the arts of Asia, primitive Europe, North, Central and South America, Africa, Oceania and from the peasant arts of Europe; with an introduction and catalogue by H. Th. Bossert. N.Y., Weyhe, 1924. 35p. 122 col. plates.
"Main consideration has been devoted to the pre-classic, occidental, Islamic, Asiatic and ancient American cultures during the period of their highest development, as well as to those of native peoples and European folk art."—*Introd.* Plates are very good collotypes and halftones in color. "Description of plates," p.1–24, gives location of objects; Index, p.25–26, lists plates by type of work or medium. Also includes a list of names and a list of plates.

Similar compendiums of color illustrations of folk ornament throughout the world are: Bossert, Helmuth Theodor, *Folk art of Asia, Africa, and the Americas*, N.Y., Praeger, 1964; _____. *Folk art of Europe*, N.Y., Praeger, 1964. The brief introductions are translated from earlier German editions.

P67    Evans, Joan. Pattern: a study of ornament in western Europe from 1180 to 1900. Oxford, Clarendon, 1931. 2v. il., plates. (Repr.: N.Y., Hacker, 1974.)

A scholarly history of ornament from the Gothic period to the 20th century. The patterns are treated in the context of the history of civilization, as "a *speculum minus* of human life, darkly reflecting the web of man's thought and feeling." —*Introd.* Concentrates on the Western countries with the greatest change; includes architectural details, relief sculpture and painted figures which are part of a decorative scheme. Scholarly notes.

Contents: v.1, The mistress art; Speculum Naturae; The mark of the individual; Literature and decoration; The romance of distance; v.2, The new age; The Far East; Les amateurs; The return to antiquity; The return to nature; The romance of the past; The age of theory. Index, v.2, p.201-49.

P68    Guilmard, Désiré. Les maîtres ornemanistes, dessinateurs, peintres, architectes, sculpteurs et graveurs; écoles française, italienne, allemande, et des Pays-Bas (flamande & hollandaise). Ouvrage renfermant le répertoire général des maîtres ornemanistes avec l'indication précise des pièces d'ornement qui se trouvent dans les cabinets publics et particuliers de France, de Belgique etc. Publication enrichie de 180 planches tirées à part et de nombreuses gravures dans le texte donnant environ 250 spécimens des principaux maîtres et précédé d'une introduction par M. le baron Davillier. Paris, Plon, 1880-81. xvi, 560p. il., facsim. and atlas of 180 plates. (Repr.: Amsterdam, Emmering, 1968.)

An important reference tool for research with prints, architecture and the decorative arts. Old, not complete, but still valuable. v.1 is a listing of the *maîtres ornemanistes,* arranged chronologically within geographical divisions by school (French, Italian, German, Low Countries, English). Under each artist is a list of his published designs, mostly suites of engravings. An index of motifs and one of artists follow each school. v.2 is a corpus of the decorative designs.

P69    Hamlin, Alfred Dwight Foster. A history of ornament. N.Y., Century [1916]-23. 2v. il., 92 plates (part col.) (Repr.: N.Y., Cooper Square, 1973.)

A standard, still valuable handbook, illustrated by line drawings in the text and plates. Contents: v.[1] Ancient and medieval; v.[2] Renaissance and modern. Bibliographies at the end of each chapter. Index at the end of each volume.

P70    Jessen, Peter. Meister der Ornamentstichs; eine Auswahl aus ver Jahrhunderten. Berlin, Verlag für Kunstwissenschaft [1922-24]. 4v. 800 plates.

A collection of 800 plates of reproductions of ornament engravings. Each volume of 200 plates includes a brief introductory essay and a list of artists.

Contents: Bd. 1, Gotik und Renaissance; Bd. 2, Das Barock; Bd. 3, Das Rokoko; Bd. 4, Der Klassizismus.

P71    _____. Der Ornamentstich. Geschichte der Vorlagen des Kunsthandwerks seit dem Mittelalter. Berlin, Verlag für Kunstwissenschaft, 1920. 384p. 223 il.

A comprehensive history of engraved ornament from the Middle Ages to the 19th century.

Contents: Wesen und Geltung des Ornamentstichs; Der Goldschmiedsstich der Spätgotik; Italien im 15. und 16. Jahrhundert; Die deutsche Frührenaissance; Rollwerk und Maureske in Frankreich; Der flämische Rollwerkstil; Deutsches Roll- und Schweifwerk; Phantastereiern und Knorpelwesen der deutschen Spätrenaissance; Der Modelbücher; Das italienische Barock; Das Barock in den Niederlanden; Das Zeitalter Ludwigs XIV; Das deutsche Barock; Das Rokoko in Frankreich; Deutsches Rokoko; Vom Barock zum Klassizismus in England; Die Rückkehr zur Antike in Italien; Der Stil Ludwigs XVI; Der Zopfstil in Deutschland; Der Empire-Stil; Der Ausgang im 19. Jahrhundert.

Index of artists and publishers.

P72    Jones, Owen. The grammar of ornament. Illustrated by examples from various styles of ornament. London, Quaritch, 1910. 157p. il., 111 plates (part col.) (Repr.: N.Y., Van Nostrand Reinhold, 1973.)

1st ed. 1856. Contributions by J. B. Waring, J. O. Westwood, and M. Digby Wyatt.

A splendid corpus of historic ornament from all over the world; first produced during the Arts and Crafts movement in England. Illustrates the scientific study of color and theory of the geometric construction of ornament. The beautiful chromolithographs are still used by designers as sources of pattern and color. Bibliography at end of sections.

Contents: (1) Ornament of savage tribes; (2) Egyptian ornament; (3) Assyrian and Persian . . . ; (4) Greek; (5) Pompeian; (6) Roman; (7) Byzantine; (8) Arabian; (9) Turkish; (10) Moresque ornament from the Alhambra; (11) Persian; (12) Indian; (13) Hindoo; (14) Chinese; (15) Celtic; (16) Medieval; (17) Renaissance; (18) Elizabethan; (19) Italian; (20) Leaves and flowers from nature.

P73    Meyer, Franz Sales. Handbook of ornament; a grammar of art, industrial and architectural designing in all its branches for practical as well as theoretical uses. N.Y., Hessling [1892]. xiv, 548p. il. (Repr.: N.Y., Dover, 1957.)

1st ed. in 1888.

A standard handbook of ornament, still useful. Descriptive notes on the emblems; includes a section of alphabets. Indexed.

P74    Speltz, Alexander. Styles of ornament, exhibited in designs and arranged in historical order with descriptive text. A handbook for architects, designers, painters, sculptors, wood-carvers, chasers, modellers, cabinetmakers and artistic locksmiths as well as also for technical schools, libraries, and private study. Trans. from the 2d German ed. by David O'Conor. N.Y., Grosset & Dunlap [1935]. vii, 647p. 400 il. (Repr.: N.Y., Dover, n.d.)

1st German ed. 1904. 2d ed. 1906. Also published by A. Speltz. *Das farbige Ornament aller historischen Stile*, Leipzig [1914-23]. 180 mounted color plates.

A pictorial handbook of ornament from prehistoric times to the middle of the 19th century. Still useful. "List of reference books," p.[627]-29. "Index of illustrations according to subject and material," p.[630]-47.

# COSTUME

## Bibliography

P75 Colas, René. Bibliographie générale du costume et de la mode; description des suites, recueils, séries, revues et livres français et étrangers relatifs au costume civil, militaire et religieux, aux modes, aux coiffures et aux divers accessoires de l'habillement. Paris, Colas, 1933. 2v. (Repr.: N.Y., Hacker, 1969.)

Contains 3,131 items on costume and fashion listed alphabetically by author or main entry. For each item gives bibliographical information, approx. size, and a description of the contents.

Important bibliographies are listed in the preface. Index of proper names and anonymous titles, p.1122-1411. "Table méthodique" (68p.).

P76 Hiler, Hilaire, and Hiler, Meyer. Bibliography of costume, a dictionary catalogue of about eight thousand books and periodicals, ed. by Helen Grant Cushing, assisted by Adah V. Morris. N.Y., Wilson, 1939. 911p. (Repr.: N.Y., Blom, 1967.)

Lists "approximately 8,400 works on costume and adornment, including books in all languages."—*Pref.* Arranged in dictionary form with author, editor, engraver, illustrator, subject, and title entries in one alphabet.

"Costume and ideologies," p.xi-xxxix.

P77 Lipperheide, Franz Joseph, *Freiherr* von. Katalog der Lipperheideschen Kostümbibliothek. [2. völlig neubearb. und verm. Aufl.] neubearb. von Eva Nienholdt und Gretel Wagner-Neumann. Berlin, Mann, 1965. 2v. xix, 1166p. il.

At head of title: Stiftung Preussischer Kulturbesitz, Staatliche Museen Berlin, Kunstbibliothek.

1st ed., Berlin, Lipperheide, 1896-1905, 2v. (issued in parts). Repr. of 1st ed.: N.Y., Hacker, 1963; London, Edwards, 1965.

A greatly expanded ed. of the indispensable catalogue of the Lipperheide collection, today comprising about 12,000 books and 30,000 prints relating to the history of costume. The catalogue is arranged systematically in 25 sections. Examples: (A) Allgemeines Trachtenkunde; (B) Die Tracht im Altertum; (C) Die Tracht im Mittelalter und in der Neuzeit; (D) Deutschland; (L) Asien; (M) Afrika, Amerika, Australien; (Q) Kriegstracht; (U) Tanz, Masken und Theater. Entries give complete, detailed bibliographical information, including number and type of plates and frequently annotations.

Konkordanz zur 1. Auflage, v.2, p.1071-[88]. Verzeichnis der Autoren und Titel, v.2, p.1089-1161. Schlagwortregister, v.2, p.1163-[67].

P78 Monro, Isabel Stevenson, and Cook, Dorothy E. Costume index; a subject index to plates and to illustrated texts. N.Y., Wilson, 1937. x, 338p.

An index to plates in 615 titles, comprising 942 volumes. Detailed indexing under countries and localities and under special types of costume and costume details. Major classifications are subdivided chronologically. List of books indexed (p.295-338) indicates location of books in a number of libraries.

_____. Supplement. N.Y., Wilson, 1957. vii, 210p.

## Directories

P79 Centro Internazionale delle Arti e del Costume, Venezia; International Centre of Arts and Costume, Venice. Guida internazionale ai musei e alle collezioni pubbliche di costumi e di tessuti. Venezia, 1970. xix, 594p.

An international listing of 736 museums and public collections of costumes. Complete text in Italian, French, and English. Gives for each entry address, curator, brief description of collection, and bibliography, including published catalogues of the collection.

P80 Huenefeld, Irene Pennington. International directory of historical clothing. Metuchen, N.J., Scarecrow, 1967. 175p.

Contains listings of collections of historical clothing in North America (pt. I) and Europe (pt. II) based on questionnaires mailed to over 2,000 institutions. Both parts subdivided: (A) Institutions alphabetized geographically; (B) Institutions alphabetized by title; (C) Institutions alphabetized by clothing and clothing accessory; (D) Clothing terms listed by category, century, and institution.

## Histories, Handbooks, Dictionaries and Encyclopedias

P81 Allemagne, Henry René d'. Les accessoires du costume et du mobilier depuis le treizième jusqu'au milieu du dix-neuvième siècle. Ouvrage contenant 393 phototypies, reproduisant plus de 3,000 documents. Paris, Schemit, 1928. 3v. plates. (Repr.: N.Y., Hacker, 1970 (3v. in 2).)

A large compendium of illustrations with text. Includes costume accessories and various other works of the decorative and applied arts which date from the 13th through the 19th centuries.

Contents: (1) La parure et la toilette; (2) Menus objets mobiliers; (3) Outils, instruments et appareils de précision; (4) La table et la cuisine.

"Table analytique," (index) v.3, p.511-50. "Table méthodique," (table of contents) v.3, p.[551]-63. "Bibliographie," v.3, p.[565]-67.

P82 Arnold, Janet. A handbook of costume. [London] Macmillan [1973]. 336p. 240 il.

Primarily a handbook for the student of costume history. Reviews primary sources, discusses the conservation and exhibition of historical costumes, and lists and describes costume collections in Great Britain. Illustrated partially with the author's line drawings.

Bibliographies at the end of each chapter. Comprehensive bibliography, p.[217]-32.

P83    Bell, Quentin. On human finery. 2d ed., rev. and enl. London, Hogarth Pr.; N.Y., Schocken, 1976. 239p. 64 il., 4 col. plates.
1st ed. 1947.

A stimulating, theoretical work on the changes of fashion, the forces which cause change, and the role of fashion within society.

Contents: (I) Sartorial morality; (II) Sumptuosity; (III) The nature of fashion; (IV) Theories of fashion; (V) The mechanism of fashion; (VI) Revolution; (VII) Vicarious consumption—archaism; (VIII) Recent history; (IX) Deviations from Veblen.

Appendixes: (A) Fashion and the fine arts; (B) A brief survey of fashion from the 15th to the 20th century. Bibliography, p.[9]-10.

P84    Boehn, Max von. Modes and manners. Trans. by Joan Joshua. Illustrated with reproductions of contemporary paintings. London, Harrap; Philadelphia, Lippincott, 1932-35. 4v. il., col. plates. (Repr.: N.Y., Blom, 1971.)

Describes fashions within their social context from antiquity through the 18th century. Contents: (1) From the decline of the ancient world to the Renaissance; (2) The 16th century; (3) The 17th century; (4) The 18th century.

P85    Boucher, François Léon. 20,000 years of fashion: the history of costume and personal adornment. [Trans. by John Ross]. N.Y., Abrams [1967?]. 441p. 1,150 il. (346 col.)

Trans. of *Histoire du costume en occident, de l'antiquité à nos jours,* Paris, Flammarion [1965]. Pub. in England as *A history of costume in the West,* London, Thames & Hudson, 1967.

An excellent reference work for the interested layman as well as the specialist. "This work does not claim to be a complete and exhaustive history of costume in all periods and all countries; it sets out to define, within a limited area, the essential characteristics of the forms taken by costume in the Western world, to discover the conditions in which these forms evolved and the causes behind the changes they underwent, and to trace the lines along which innovation spread and interpenetrated."—*Pref.* Very well illustrated.

Contents: Introduction; (I) Prehistoric costume; (II) Costume in the ancient East; (III) Crete and its costume; (IV) The Mediterranean countries; (V) Europe from the 5th century B.C. to the 12th century A.D.; (VI) Europe between the 12th and 14th centuries; (VII) Costume in Europe from the 14th to the early 16th century; (VIII) The 16th century; (IX) The 17th century; (X) The 18th century; (XI) From the French Revolution to the early 20th century; (XII) Costume fashions from 1920; Conclusion.

Glossary, p.425-36. General bibliography, p.423. Bibliographies at the end of each chapter.

P86    Brun, Wolfgang, and Tilke, Max. A pictorial history of costume; a survey of costume of all periods and peoples from antiquity to modern times including national costume in Europe and non-European countries. N.Y., Praeger [1955]. 74p. 200 plates (128 col.)

Reissued 1973.

Trans. of *Das Kostümwerk.* A pictorial survey useful for quick visual reference. "The color plates are facsimiles from the originals colored by Max Tilke. The monochrome plates have been produced partly from Tilke's drawings and partly from engravings and photographs in the Lipperheide Kostümbibliothek,"—*Pref.* Index of plates, p.73-74.

P87    Calasibetta, Charlotte Mankey. Fairchild's dictionary of fashion. Ed. by Ermina Stimson Goble, Lorraine Davis. N.Y., Fairchild [1975]. xiv, 693p. il., plates (part col.)

A quick-reference dictionary of succinct definitions of terms relating to the history and practical aspects of fashion of all periods. Concentration is on modern trends, terminology, and the fashion industry. Within the principal alphabetical sequence are listed broad categories with related terms following in alphabetical order. Includes cross references to categories and an "Index to categories," p.xiii-xiv. Illustrated with line drawings and photographic reproductions.

The "Designers appendix," p.547-98, contains biographical sketches of leading contemporary designers arranged alphabetically under countries in which the designers' main work was done. "Designers portraits," p.599-693. No bibliography.

P88    Davenport, Millia. The book of costume. N.Y., Crown, 1948. 2v. 958p. il. (part col.) (Repr.: N.Y., Crown, 1962.)

"A chronological survey of dress through the ages. Each segment—civilization or century—has been given an historical summary and an outline of changes in its dress. These are followed by a picture section, which is subdivided by centuries and by countries, as regional differentiations become well established."—*Introd.*

Index, v.2, p.946-58. Appendix in v.2 contains bibliographies with annotations.

P89    Evans, Mary. Costume throughout the ages. [Rev. ed.] Philadelphia and N.Y., Lippincott [1950]. 360p. il.
1st ed. 1930.

A concise textbook survey of costume. Includes bibliographies at the ends of chapters and a general bibliography, p.318-29.

P90    Kelly, Francis Michael, and Schwabe, Randolph. Historic costume; a chronicle of fashion in Western Europe, 1490-1790. 2d ed., rev. & enl. London, Batsford; N.Y., Scribner, 1929. xv, 305p. il., plates (part col.) (Repr.: N.Y., Blom [1968].)
1st ed. 1925.

An older work *"primarily* intended as a practical guide for the artist, actor, film producer, etc."—*Pref.* Contents: (I) The Italianate tendency (1490-1510); (II) Puffs and slashes: the German element (1510-45); (III) Spanish bombast (1545-1620); (IV) Long locks, lace, and leather (1620-55); (V) Effects of the "Grand Règne" (1655-1715); (VI) Paniers, powder, and queue (1715-90). A Patterns section

includes diagrams of the cut-out pieces and construction of a cloak with hanging sleeves, a Spanish cape, a bodice and stomacher, a doublet and breeches, etc.
Bibliography, p.299–302. Index (and glossary).

P91 Kybalová, Ludmila. The pictorial encyclopedia of fashion by Ludmila Kybalová [and others]. Trans. by Claudia Rosoux. [Foreword by James Laver]. N.Y., Crown [1968]. 604p. 995 il., 32 col. plates.
A comprehensive one-volume encyclopedia of costume from the 4th millenium B.C. to the 1960s. Arranged in two main sections: (1) 4,000 years in the history of fashion; (2) Glossary of the various garments and accessories of fashion (hairstyles and their accessories, beards, headgear, collars, ties, etc.). Illustrated with reproductions of historical examples in all media.
No bibliography. Index of artists and general index.

P92 Laver, James. The concise history of costume and fashion. N.Y., Abrams [1969]. 288p. 315 il. (58 col.)
A well-illustrated, compact survey of Western dress from antiquity to the mid-20th century. Authoritative and readable.
Contents: (1) How it all began; (2) Greeks and Romans; (3) The Dark Ages and the Middle Ages; (4) The Renaissance and the 16th century; (5) The 17th century; (6) The 18th century; (7) From 1800 to 1850; (8) From 1850 to 1900; (9) From 1900 to 1939; (10) The last 30 years.
Select bibliography, p.277. List of illustrations, p.278–85.

P93 Leloir, Maurice. Dictionnaire du costume et de ses accessoires, des armes et des étoffes des origines à nos jours. Achevé et réalisé sous la direction de André Dupuis. Préface de Georges G.-Toudouze. Paris, Gründ [1951]. xi, 435p. il., 7 col. plates.
A standard, comprehensive dictionary of costume. Contains more than 2,000 articles and 3,500 black-and-white illustrations. Many cross-references. No bibliography.

P94 Lester, Katherine Morris, and Oerke, Bess Viola. Illustrated history of those frills and furbelows of fashion which have come to known as: accessories of dress; drawings by Helen Westermann. Peoria, Ill., Manual Arts Pr. [1940]. 587p. il.
Cover title: Accessories of dress.
Still useful, perhaps, for ready reference. Contents: (1) Accessories worn at the head; (2) Accessories worn at the neck, shoulders, and waist; (3) Accessories worn on the feet and legs; (4) Accessories worn on the arm and hand; (5) Accessories carried in the hand; (6) Accessories used on the costume (embroidery, lace, fur, etc.).
Bibliography, p.577–79; references at the end of each chapter.

P95 Norris, Herbert. Church vestments; their origin and development; illustrated with 8 pages of photographs and with 8 colour plates, and black and white drawings by the author. London, Dent [1949]. 190p. il., plates (part col.)
A popular survey of the various types of church vestments. Brief historical data, p.xv.
Bibliography, p.xiii–xiv.

P96 Payne, Blanche. History of costume, from the ancient Egyptian to the twentieth century. Drawings by Elizabeth Curtis. N.Y., Harper [1965]. xiii, 607p. il.
A comprehensive survey of Western costume.
Contents: Introduction: the origin of clothing; (1) Egypt; (2) Mesopotamia; (3) The Bronze Age in Denmark; (4) Crete and Greece; (5) Etruscans and Romans; (6) The Byzantine Empire; (7) Western Europe to the 12th century; (8) 12th and 13th centuries; (9) The 14th century; (10) Men's costume of the 15th century; (11) Women's costume of the 15th century; (12) High Renaissance: Men's costume of the 16th century; (13) High Renaissance: Women's costume of the 16th century; (14) The Baroque period: Men's costume of the 17th century; (15) The Baroque period: Women's costume of the 17th century; (16) 18th-century fashions for men; (17) Women's costume of the 18th century; (18) Men's wear in the 19th century; (19) Women's fashions of the 19th century.
Pattern drafts for 30 costumes reproduced to scale, p.539–90. Bibliography, p.591–94.

P97 Picken, Mary (Brooks). The fashion dictionary; fabric, sewing, and apparel as expressed in the language of fashion. Rev. and enl. N.Y., Funk & Wagnalls [1973]. xii, 434p. il., plates.
A rev., expanded ed. of the author's *Language of fashion*, N.Y., Funk & Wagnalls, 1939. 1957 ed. entitled: *The fashion dictionary; fabric sewing and dress*, N.Y., Funk & Wagnalls.
Gives definitions and descriptions of more than 10,000 terms; useful for quick reference. Illustrated with more than 750 line drawings and 207 small photographic reproductions.
Index of illustrations at the end.

P98 Planché, James Robinson. A cyclopedia of costume or dictionary of dress; including notices of contemporaneous fashions on the Continent; a general chronological history of the costumes of the principal countries of Europe, from the commencement of the Christian era to the accession of George the Third. London, Chatto and Windus, 1876–79. 2v. il., 50 plates (part col.)
Still useful, especially for the illustrations. Contents: v.1, The dictionary; v.2, A general history of costume in Europe. Index, v.2, p.435–48.

P99 Racinet, Albert Charles Auguste. Le costume historique. Cinque cents planches, trois cents en couleurs, or et argent, deux cents en camaïeu. Types principaux du vêtements et de la parure, rapprochés de ceux de l'intérieur de l'habitation dans tous les temps et chez tous les peuples, avec de nombreux détails sur le mobilier, les armes, les objets usuels, les moyens de transport, etc. Recueil pub. sous la direction de M. A. Racinet, avec des notices explicatives, une introduction générale, des tables et un glossaire. Paris, Firmin-Didot, 1886. 6v. 500 plates (part col.)
v.1 contains explanatory text with an introduction. v.2-6 contain plates with descriptive text, which were published in 20 fascicles 1877–86. "Bibliographie du costume," v.1, p.113–24. "Glossaire," v.1, p.125–62.

**P100**   Rubens, Alfred. A history of Jewish costume. Foreword by James Laver. London, Funk & Wagnalls; N.Y., Crown, 1967. xvi, 221p. il. (part col.)

The standard general history of Jewish costume, written by a foremost authority. Contents: (1) Origins and distinctive features; (2) The Eastern world and the influence of Islam; (3) The Western world—the effects of tradition and restrictive laws; (4) Poland and Russia; (5) The Western world—the effects of emancipation and assimilation; (6) Rabbinical dress. Appendixes: (1) The costume of the high priest: Extracts from Exodus and Josephus; (2) Extracts from sumptuary laws and dress regulations; (3) Documents relating to the wearing of the yellow hat in the Comtat Venaissin.

Notes, p.205-7, include references. Bibliography, p.208-11. List of illustrations, p.212-14. Glossarial index, p.215-21.

**P101**   Squire, Geoffrey. Dress art and society, 1560-1970. London, Studio Vista, 1974. 176p. il. (part col.)

Not an historical survey but a study of "fashionable European dress of the past as an essential manifestation of changing patterns in thought and belief. . . . This book attempts to redress what seems a common oversight by discussing fashionable dress as both an aesthetic experience, and as an essential expression of that generalized personality which emerges from a period."—*p.9.* Very well illustrated.

Contents: The eye of the beholder; Style in the dress of thought; Clothes make the man, but man makes his clothes; Mannerism; The two faces of Baroque 1600-1700; Rococo 1690-1770; Neo-classicism 1750-1815; From romance to materialism 1800-60; In all directions 1860 and after.

Bibliography, p.173.

**P102**   Wilcox, Ruth Turner. The dictionary of costume. N.Y., Scribner [1969]. 406p. il.

A nonscholarly dictionary of concise definitions of terms relating to costume in all countries and periods. Illustrated with numerous line drawings. No references to bibliography.

## Ancient

**P103**   Bieber, Margarete. Entwicklungsgeschichte der griechischen Tracht von der vorgriechischen Zeit bis zum Ausgang der Antike. 2. durchgesehene Aufl. besorgt von Felix Eckstein. Berlin, Mann. 1967. 61p. 12 il., 56 plates.

1st ed. 1934.

A brief survey of the development of Greek dress from Egyptian antecedents to Greco-Roman times. Very well illustrated. This ed. includes updated bibliographies in each section and revised illustrations.

Contents: Einleitung: Die Technik der Gewandherstellung. Geschichte der griechschen Kleidung; (I) Der vorgriechische Zeit; (II) Die archaische Zeit; (III) Die klassische Zeit; (IV) Die hellenistische Zeit; (V) Die griechische-römische Zeit; (VI) Modell und Kunstwerk bei griechischen Gewandstatuen.

Zeittafel, p.53-[54]. Quellennachweise für die Abbildungen, p.55-[60]. Sachregister.

**P104**   ____. Griechische Kleidung. Berlin, de Gruyter, 1928. 100p. 25 il., 64 plates. (Repr.: Berlin, de Gruyter, 1975.)

A systematic, scholarly study of the various articles of clothing represented in ancient Greek works of art. Illustrated with reproductions of vase paintings, sculptures, and modern reconstructions.

Contents: Einleitung; Systematik der griechischen Gewänder; Übersicht über die Systematik mit Beispielen; Beschreibung der Tafeln—(I) Peplos; (II) 1. Chiton der Fräuen; 2. Chiton der Männer; (III) 1. Mantel der Fräuen; 2. Mantel der Männer; (IV) Modellaufnahmen; (V) Haartrachten; (VI) Schmuck; (VII) Fussbekleidung.

Terminologie, p.[93]-94, gives terms in Greek with German equivalents and succinct definitions. Bibliography, p.[95]. Verzeichnis der Textabbildungen, p.[96]. Verzeichnis der Vorlagen für die Tafeln, p.[97]-100.

**P105**   Houston, Mary Galway. Ancient Egyptian, Mesopotamian & Persian costume and decoration. 2d ed., with nine plates, and over two hundred drawings in the text. London, Black [1954]. 190p. il., 9 col. plates. (A technical history of costume, 1) (Repr.: London, Black, 1972.)

1st ed. 1920.

"The costumes illustrated in this volume have been considered primarily from the technical point of view, that is, their *construction* has been carefully studied."—*Introd.*

Classified bibliography, p.188-90.

**P106**   ____. Ancient Greek, Roman and Byzantine costume and decoration. 2d ed., with eight plates in colour, and over two hundred drawings in the text. London, Black, 1947. 182p. il., 8 col. plates. (A technical history of costume, 2) (Repr.: London, Black, 1968.)

1st ed. 1931.

Emphasizes the technical aspects and construction of Greek, Roman and Byzantine costume.

Classified bibliography, p.179-82.

## Early Christian — Gothic

**P107**   Bock, Franz. Geschichte der liturgischen Gewänder des Mittelalters; oder, Entstehung und Entwicklung der kirchlichen Ornate und Paramente in Rücksicht auf Stoff, Gewebe, Farbe, Zeichnung, Schnitt und rituelle Bedeutung nachgewiesen und durch 110 Abbildungen in Farbendruck. . . . Mit einem Vorworte von Dr. Georg Müller. Bonn, Henry & Cohen, 1859-71. 3v. in 2. plates (part col.) (Repr.: Graz, Akademische Druck- und Verlagsanstalt, 1970.)

A detailed history of church vestments, their color, design, materials, and liturgical significance. Well illustrated. Index of names, v.2, p.[363]-79.

**P108**   Houston, Mary Galway. Medieval costume in England & France; the 13th, 14th and 15th centuries. With eight plates in colour and 350 drawings in black and white. London, Black, 1939. 228p. il., 8 col. plates.

(A technical history of costume, 3) (Repr.: London, Black, 1950.)

A broad survey which emphasizes the technical aspects of costume. Includes patterns of costumes. Glossary of medieval terms for costume, p.219-26.

Bibliography, p.227-28.

SEE ALSO: Houston, Mary Galway. *Ancient Greek, Roman and Byzantine costume and decoration* (P106).

## Renaissance — Modern

P109 Boehn, Max von. Modes & manners of the nineteenth century as presented in the pictures and engravings of the time, by Dr. Oskar Fischel and Max von Boehn; trans. by M. Edwardes, with an introduction by Grace Rhys. London, Dent; N.Y., Dutton, 1927. 4v. il., plates (part col.) (Repr.: N.Y., Blom, 1970.)

First published 1909; rev. and enl. 1927. Published in German, French, and English editions. The quality of the illustrations is best in the German ed. Contents: (1) 1790-1817; (2) 1818-42; (3) 1843-78; (4) 1879-1914. No index.

A supplementary volume, published in 1929, covers lace, fans, gloves, walking sticks, parasols, jewelry, and trinkets.

P110 Braun-Ronsdorf, Margarete. Mirror of fashion; a history of European costume, 1789-1929. [Trans. from the German by Oliver Coburn]. N.Y., McGraw-Hill [1964]. 270p. 415 il., 28 col. plates.

British ed. pub. as *The wheel of fashion (1789-1929)*, London, Thames & Hudson.

"This book surveys the history of costume from 1789 to 1929, taking as reference the old fashion plates (which provide almost the only unbroken record of the development of fashion) and also of some surviving garments actually worn during the period, and their often attractive accessories." —*Introd.*

Contents: Introduction; From robe to chemise dress; Romantic bourgeois; The age of the crinoline; The return of the bustle; Cul de Paris; Reaction and reform; La garçonne. Notes on the illustrations, p.233-59, and Notes on the colour plates p.261-63, give concise descriptions.

Bibliography (General; Illustrated museum catalogues; Fashion magazines), p.265.

P111 Ewing, Elizabeth. History of twentieth century fashion. London, Batsford [1974]. x, 243p. il.

A broad survey of women's fashion in the 20th century. Illustrated with photographs of actual dresses, fashion advertisements, and line drawings.

List of illustrations, p.vi-x. Bibliography, p.237-39.

P112 Holland, Vyvyan. Hand coloured fashion plates, 1770 to 1899. London, Batsford [1955]. 200p. 129 il., 4 col. plates.

Not a history of costume but a survey of hand-colored plates issued with periodicals wholly or partially devoted to women's fashion. Valuable for lists of periodicals which contained fashion plates.

General index.

P113 Laver, James, ed. Costume of the western world. London, Harrap; N.Y., Harper, 1951. v.3. 390p. plates (28 col.)

Only v.3 published: *Fashions of the Renaissance in England, France, Spain and Holland.* Originally intended to be complete in 6v.

Contents: Early Tudor, 1485-1558, by James Laver; The last Valois, 1515-1590, by André Blum; Elizabethan and Jacobean, 1558-1625, by Graham Reynolds; Dominance of Spain, 1550-1660, by Brian Reade; Great age of Holland, 1600-1660, by F. van Thienen; Early Bourbon, 1590-1643, by André Blum. Illustrations are drawn from contemporary sources.

Bibliographies at the ends of sections.

P114 Leloir, Maurice. Histoire du costume de l'antiquité à 1914. Paris, Ernst, 1933-49. v.8-12. il., plates (part col.)

All published. At head of title: Ouvrage publié sous la direction de M. Maurice Leloir, et sous le patronage de la Société de l'Histoire du Costume. Préface de M. Henri Lavedan.

Contents: v.8, Epoque Louis XIII (de 1610 à 1643); v.9, Epoque Louis XIV (première partie) de 1643 à 1678; v.10, Epoque Louis XIV (2me partie) 1678-1715. Epoque Régence 1715-1725; v.11, Epoque Louis XV 1725 à 1774; v.12, Epoque Louis XVI et révolution 1775 à 1795. Illustrated with line drawings in the text and color plates. Includes bibliographies in each volume.

## Western Countries

### Great Britain

P115 Buck, Anne Mary. Victorian costume and costume accessories; foreword by Hugh Wakefield. London, Jenkins; N.Y., Nelson [1961]. 215p. il.

A handbook of English women's costume in the period 1837-1900, with brief discussions of men's and children's clothing. Especially valuable for descriptions of the construction of dresses. Well illustrated with contemporary portraits, line drawings, and photographs of live models in Victorian dresses from the Gallery of English Costume at Platt Hall, Manchester, where the author serves as keeper.

Bibliography (Fashion magazines; Other periodicals; Contemporary writings; Modern writings; Museum publications), p.208-9.

P116 Cunnington, Cecil Willett, and Cunnington, Phillis. Handbook of English costume in the eighteenth century. With illus. by Barbara Phillipson and Phillis Cunnington. Rev. ed. London, Faber and Faber [1972]. 453p. il. (1 col.)

1st ed. 1957.

A basic handbook of 18th-century men's, women's, and children's costume in England. Copiously illustrated with line drawings after historical examples. Sources of illustrations, p.435-42.

Glossary of materials, p.416-21. Prices of materials, p.422-25. Sources (bibliography), p.426-34, arranged within primary sources and secondary sources.

P117     _____. Handbook of English costume in the nineteenth century. Illustrations by Phillis Cunnington, Cecil Everitt [and] Catherine Lucas. 3d ed. London, Faber and Faber, 1970. 617p. 260 il., plates.

1st ed. 1959.

An authoritative handbook of women's and men's costume of the 19th century in England. Illustrated with line drawings after contemporary originals. Includes a "Glossary of materials" and "Sources of illustrations."

Classified bibliography, p.588-93.

P118     _____. Handbook of English costume in the seventeenth century. With illus. by Barbara Phillipson and Phillis Cunnington. 3d ed. London, Faber and Faber; Boston, Plays, 1972. 229p. il. (1 col.)

1st ed. 1955.

A handbook of practical and historical information on English men's and women's costume in the 17th century. Illustrated with line drawings after historical examples. Sources of illustrations are given.

Sources (bibliography), p.207-12, include primary (unpublished and published) and secondary material.

P119     _____. Handbook of English costume in the sixteenth century. [2., new and rev., ed.]. Illus. by Barbara Phillipson with additions by Catherine Lucas and Phillis Cunnington and others from contemporary sources. London, Faber and Faber [1970]. 244p. il. (1 col.)

1st ed. 1954.

A handbook of practical and historical information on men's, women's, and children's costume in 16th-century England. Illustrated with line drawings after original sources. "Decoration," p.13-16, is a section of descriptions of items of decoration (aiglets, lace, panes, etc.).

Glossary of materials, p.212-27. Bibliography of primary and secondary sources, p.228-34. Sources of illustrations, p.235-38.

P120     _____. Handbook of English mediaeval costume. With illus. by Barbara Phillipson and Catherine Lucas. 2d ed. London, Faber and Faber; Boston, Plays [1969]. 210p. il. (part col.), plates.

1st ed. 1952.

A basic handbook of historical and practical information on all types of costume from the 9th through the 15th centuries in England.

Classified bibliography, p.190-94.

P121   Cunnington, Cecil Willett; Cunnington, Phillis; and Beard, Charles. A dictionary of English costume, 900-1900. London, Black [1960]. vi, 281p. il.

A dictionary of concise descriptions and definitions of terms relating to all aspects of English costume from 900 to 1900.

Glossary of materials, p.241-80. Obsolete colour names (prior to 1800), p.281.

P122   Cunnington, Phillis Emily, and Lucas, Catherine. Occupational costume in England: from the eleventh century to 1914. With chapters by Alan Mansfield. London, Black, 1967. 427p. col. front., il., 64 plates.

An authoritative survey by type of English occupational costume. Includes chapters on workers on the land; seamen and fisherfolk; miners, coal carriers, navvies, etc.

Bibliography, p.[395]-403. Sources of figures, p.[404]-14. A list of museums with "specimens or pictures illustrative of occupational costume," p.403.

P123   Cunnington, Phillis, and Mansfield, Alan. English costume for sports and outdoor recreation: from the sixteenth to the nineteenth centuries. London, Black [1969]. 388p. il., plates (part col.)

A survey by type of English costume for sports and outdoor recreation. Includes chapters on costume for cricket, tennis, angling, cycling, bathing and beachwear, skating, climbing, picnics, and others.

General bibliography, p.[363]-66. Sources of figures, p.[367]-75.

P124   Mansfield, Alan, and Cunnington, Phillis. Handbook of English costume in the twentieth century, 1900-1950. Illus. by Valerie Mansfield. London, Faber and Faber [1973]. 371p. 222 il., 1 col. plate.

A handbook of practical and historical information on English women's and men's costume in the first half of the 20th century. "It deals with costume not fashion, and during the years when France was incontestably the leader in the fashion world does not talk of Paris, rarely refers to London and places the emphasis on the provinces with a strong preference for East Anglia."—Madge Garland, *Apollo* 99:73, Jan. 1974. Illustrated with line drawings after original examples.

Bibliography, p.[359]-60.

## Italy

P125   Birbari, Elizabeth. Dress in Italian painting, 1460-1500. London, Murray, 1975. 114p. 115 il.

A pioneering study "based almost entirely on the minute observation of photographs of pictures, portraits and frescoes of the period. By selecting small detailed photographs, it has proved possible to illustrate types of men's shirts and women's chemises, of lacings and fastenings as well as of outer garments."—J. L. Nevinson, *Connoisseur* 189:244, July 1975.

No bibliography.

P126   Cappi Bentivegna, Ferruccia. Abbigliamento e costume nella pittura italiana. [Introd., testi didascalici e annotazioni alle tavole di Ferruccia Cappi Bentivegna]. Roma, Bestetti [1962-64]. 2v. il., plates (part col.)

A visual survey of Italian costume from the 15th to the 19th century, as reflected and documented in painting. The text is limited to brief commentaries and notes on the illustrations, which are included in separate booklets inserted at the ends of both volumes.

Contents: v.1; Il Quattrocento; Il Cinquecento; v.1; Il Seicento; Il Settecento. Indexes of names and places in both volumes.

P127  Levi Pisetzky, Rosita. Storia del costume in Italia. [Milano] Istituto Editoriale Italiano [1964-69]. 5v. il. (part col.)

At head of title: Fondazione Giovanni Treccani degli Alfieri.

A monumental history of Italian costume from the fall of the Roman Empire through the 19th century. The essential reference for art historians, costume specialists, cultural historians, and theatrical designers who work in the field. Replaces virtually all previous studies.

Contents: v.1 [349p., 210 il. (92 col.).]: Il costume dopo la caduta dell'impero d'occidente; Il costume dei goti e il costume romano alla fine del V e durante il VI secolo; Il periodo bizantino del VI secolo; Il periodo longobardo e gli ultimi domini bizantini; Il periodo carolingio; Il periodo ottoniano; Il secolo XI; Il secolo XII; Il secolo XIII. v.2 [516p., 215 il. (79 col.)]: Il Trecento; Il Quattrocento. v.3 [499 p., 219 il. (76 col.)]: Il Cinquecento; Il Seicento. v.4 [432p., 226 il. (75 col.)]: Il Settecento. v.5 [535p., 211 il. (92 col.)] L'Ottocento.

Indexes of illustrations in each volume. Numerous bibliographical references in the footnotes.

## United States

P128  Earle, Alice (Morse). Two centuries of costume in America, MDCXX-MDCCCXX. N.Y., Macmillan, 1903. 2v. il., plates. (Repr.: N.Y., Blom [1968]; N.Y., Dover [1970]; Rutland, Vt., Tuttle [1971].)

"The first systematic survey, and a very entertaining example of early scholarship which still contains a vast amount of important data and critical commentary. The text, however, must be checked against later research. Many of the plates are European, or, if American, the attribution and dating may not be acceptable."—Warwick (P130).

P129  McClellan, Elisabeth. History of American costume, 1607-1870; with an introductory chapter on dress in the Spanish and French settlements in Florida and Louisiana. N.Y., Tudor, 1937. 661p. il., plates (part col.) (Repr.: N. Y., Tudor, 1969.)

Reprint combines material presented in the author's two earlier works: *Historic dress in America, 1607-1800*, Philadelphia, Jacobs. 1904; *Historic dress in America, 1800-1870*, Philadelphia, Jacobs, 1910.

A standard work on American costume. More than 750 illustrations. "A serious attempt to survey the whole period. There are many entertaining and informative references in the text. The redrawings by Sophie B. Steele, carefully identified in the titles of the plates, are represented without indicating the provenance in any way that is readily visible. The rapid viewer may too easily assume that all examples are of American origin."—Warwick (P130).

Glossary for 1607-1800, p.615-30. Glossary for 1800-1870, p.631-40. Authorities consulted, p.[655]-61.

P130  Warwick, Edward; Pitz, Henry C.; and Wyckoff, Alexander. Early American dress: the colonial and revolutionary periods. N.Y., Blom [1965]. 428p. il., plates, maps. (The History of American dress, v.2)

A rev. ed. by Wyckoff of the 1st ed. of 1929; published as v.2 of a proposed 5v. comprehensive work, *The History of American dress*.

"In *Early American Dress* our main concern will be all the articles of clothing, of any function, which people have worn in America in all the manifold activities of their existence—dress from head to heel, and skin-deep."—*p.27.*

Contents: (I) The European background; (II) Virginia: 1607-75; (III) The New England background: 1620-75; (IV) The Dutch in New York: 1623-75; (V) Growth and change in the colonies: 1675-1775; (VI) Pennsylvania (and the Quakers); (VII) The Revolution and the new republic: 1775-90; (VIII) Children in North America: 1585-1790; (IX) Frontier life. Illustrated with numerous line drawings and reproductions of portraits of the colonial and revolutionary periods.

Excellent classified bibliography, p.389-98, partially annotated.

## Oriental Countries     *good on china too!*

P131  Chandra, Moti. Costumes, textiles, cosmetics & coiffure in ancient and mediaeval India. Delhi, Oriental Publishers on behalf of the Indian Archaeological Society, 1973. xxxii, 248p. vip. il., 14 plates.

A general history which covers the period from the 1st century B.C. through the Sultanic period. Illustrated with numerous line drawings and photographic reproductions.

Bibliographical references in footnotes.

P132  Dar, Shiv Nath. Costumes of India and Pakistan; a historical and cultural study. With 142 illustrations including 4 in full colour. Bombay, Taraporevala [1969]. xiv, 244p. 44 plates (part col.)

"The purpose of this work is to present in a systematised manner the mass of facts relating to the various forms of clothing and toilet observed by the peoples of India and Pakistan throughout the ages and to consider how far these forms have been influenced by the forces of art, sex and superstition."—*Pref.*

Contents: Pt. I, Historical background: (1) Preliminary survey; (2) Far vistas; (3) Medieval conflict; (4) Mogul renaissance; (5) The aftermath; (6) The triumphant West. Pt. II, Analytical review: (7) The pageant of clothes; (8) The fine art of clothing; Dress in the arts; (10) Clothing in magic and religion; (11) The erotics of dress; (12) The future of clothes. Appendix: The philosophy of clothes. Vocabulary, p.[231]-34, lists vernacular names of dresses and ornaments.

Extensive notes, p.[185]-229, include references to books and articles listed in the bibliography, p.[235]-38.

P133  Fairservis, Walter Ashlin, Jr. Costumes of the East. Costumes photographed by Thomas Beiswenger; Drawings by Jan Fairservis. Riverside, Conn., Chatham. [Distr.. by Viking, N.Y.]. Published in association with The American Museum of Natural History [1971]. 160p. il. (part col.)

A well-illustrated, brief survey of Eastern costume; based on the collection of the American Museum of Natural His-

tory, N.Y. Written from the point-of-view of the anthropologist rather than the art historian.

Contents: (I) Costume and the West; (II) The Asian setting; (III) The circles of ethnohistory: A. Balkans, Caucasus, Ukraine; B. Near East; C. Iran (Persia) and Afghanistan; D. Central Asia; E. India and Pakistan; F. The high borderlands. Kashmir, Nepal, Sikkim, and Bhutan; G. Tibet; H. Southeast Asia; I. China; J. Japan and Korea; K. Southeast Siberia, Manchuria, Hokkaido, and Bonins; L. Siberia. Costumes in the Museum collection, p.153.

Bibliography, p.154.

P134 Minnich, Helen Benton, and Nomura, Shojiro. Japanese costume and the makers of its elegant tradition. Rutland, Vt., Tuttle [1963]. 374p. il. (part col.)
Authoritative text; excellent illustrations.

Contents: (1) Background for a picture; (2) The legendary period; (3) Asuka; (4) Nara; (5) Heian-Fujiwara; (6) Kamakura; (7) Ashikaya-Muromachi; (8) Azuchi-Momoyama; (9) Early Tokugawa; (10) Yuzen-Zorne; (11) Genroku and late Edo; (12) Meiji to modern. Includes five appendixes and a glossary. Bibliography, p.[361]-64, subdivided into books in English and French and books in Japanese.

## Primitive

### Bibliography

P135 Eicher, Joanne Bubolz. African dress; a select and annotated bibliography of Subsaharan countries. [East Lansing] African Studies Center, Michigan State Univ., 1969. xi, 134p. map.
A partially annotated bibliography of 1,025 English-language references to dress in all areas of Subsaharan Africa. Contents: General; West Africa; Central Africa; South Central Africa; East Africa; Southern Africa.

Map, p.xii. Author index.

SEE ALSO: Sieber, R. *African textiles and decorative arts* (P686); Thompson, R. F. *African art in motion* (I597).

# FURNITURE

P136 Aronson, Joseph. The new encyclopedia of furniture. N.Y., Crown [1967]. ix, 484p. il., 16 col. plates.
Earlier editions published under the title: *The encyclopedia of furniture*, N.Y., Crown, 1938, 1941, 1965.

A useful popular work with numerous cross-references. Bibliography, p.467-79. Glossary of designers and craftsmen, p.480-84.

P137 Bajot, Édouard. Encyclopédie du meuble du XVe siècle jusqu'à nos jours. Recueil de planches contenant des meubles de style de toutes les époques et de tous les pays, depuis le XVe siècle ... classées par ordre alphabétique. Avec une notice historique;

2000 meubles de style reproduits à grande échelle. Paris, Schmid [1901-09]. 20 pts. in 8v. 600 plates.
A corpus of illustrations of furniture containing 2,000 pieces classified and arranged in alphabetical order. At the beginning of v.1 is a "Notice," a short paragraph describing the different pieces of furniture represented; and a "Table analytique des planches" which lists all of the plates arranged by type of furniture.

P138 Boger, Louise Ade. The complete guide to furniture styles. Enl. ed. N.Y., Scribner [1969]. xii, 500p. il.
1st ed. 1959.

A useful handbook for furniture styles of all periods and countries in Europe, America, and the Far East. The most complete coverage is of English furniture. Intended for the English-speaking reader. Detailed index. Bibliography, p.423-29.

P139 Feulner, Adolf. Kunstgeschichte des Möbels seit dem Altertum. Berlin, Propyläen [1927]. 654p. il.
A basic history of furniture from the Middle Ages through the Biedermeier period, with many illustrations, some of which are from paintings. Bibliography, p.613-[17]. Index of illustrations, p.618; Index, p.635-55.

P140 Gloag, John. Guide to furniture styles: English and French, 1450 to 1850. Illustrated by Maureen Stafford. N.Y., Scribner [1972]. 232p. il.
A study of the relationship between French and English furniture design between 1450 and 1850. 16 chronological sections alternate between the English and French styles.

Contents: (1) The Gothic tradition; (2) The Renaissance in France; (3) Elizabethan and Jacobean; (4) The ébénistes and the Baroque; (5) Puritan austerity: Carolean luxury; (6) The magnificent style; (7) The William and Mary and Queen Anne styles; (8) The Rococo style; (9) Resurgence of English Baroque; (10) Chippendale and mid-Georgian style; (11) English Rococo and the Chinese taste; (12) The 'Gothick taste'; (13) The Louis XVI and directoire styles; (14) The Adam, neoclassical style; (15) The French Empire style and its successors; (16) Regency to early Victorian. Index, p.231-32.

P141 _____. A short dictionary of furniture, containing over 2,600 entries that include terms and names used in Britain and the United States of America. With over 1,000 illustrations reproduced from contemporary sources or drawn by Ronald Escott [and others. Rev. and enl. ed.]. London, Allen and Unwin [1969]. 813p. il.
1st ed. 1952.

A greatly enlarged ed. of a widely-used furniture dictionary European or Oriental terms are included only when relevant to English or American furniture. The beginning sections treat the history of furniture terminology and the social origins of furniture design.

Contents: (1) The description of furniture; (2) The design of furniture; (3) Dictionary of names and terms; (4) Furniture makers in Britain and America; (5) Books and periodicals on furniture and design; Periods, types, materials, and craftsmen from 1100-1950. Bibliography, p.779-83.

P142 Hayward, Helena, ed. World furniture; an illustrated history [by] Douglas Ash [and others]. N.Y., McGraw-Hill, 1965. 320p. il., col. plates.

"The purpose of this book is to illustrate the history of furniture as an art in relation to its background, and to trace the various styles in which it developed."—*Introd.* A collection of essays by various authors, arranged first by period (from the Egyptian, Greek, and Roman to the 20th century) and then arranged by sections pertaining to specific countries.

Contents: (1) Egypt, Greece, Rome; (2) Byzantine and early medieval; (3) Gothic; (4) Renaissance; (5) The 17th century; (6) The 18th century; (7) The 19th century; (8) The Far and Middle East; (9) The 20th century. Short appendix on primitive furniture, p.306-7; Glossary, p.308-11; Reading list, p.312; Index, p.315-20.

P142a The history of furniture. Introduction by Sir Francis Watson. London, Oris; N.Y., Morrow, 1976. 344p. col. il.

A series of essays by specialists which form a popular, readable history of furniture from antiquity to the 1970s. All illustrations are in color.

Contents: Ancient and medieval furniture, by James Wheeler; Europe's Renaissance, by Geoffrey Beard; The Baroque age, by Gervase Jackson-Stops; The Rococo style, by John Kenworthy-Browne; Neoclassical reaction, by Jonathan Bourne and Lucinda Fletcher; Nineteenth century, by Ian Grant; Arts and Crafts and Art Nouveau, by Ian Bennett; Art Deco, by Martin Battersby; Furniture to the present day, by Penny Ratford.

Illustrated glossary, p.313-29; Collections, p.330-31; Bibliography, p.332-35.

P143 Jervis, Simon. Printed furniture designs before 1650. [London] The Furniture History Society, 1974. viii, 54p. 449 plates.

A valuable compendium of 16th- and early 17th-century designs for furniture, based on extensive research in the major libraries and print collections of Europe. Brief introduction with bibliographical essay and documentation; "Commentary on the illustrations" (arranged chronologically) consists of a reliable critical apparatus for each work; "Index of proper names," p.[51]-54; and 449 reproductions of early woodcuts and engravings, including prints from treatises on perspective used by the furniture makers.

P144 Mercer, Eric. Furniture, 700-1700. London, Weidenfeld & Nicolson [1969]. 183p. il. (16 col.), 128 plates.

A history of European furniture which emphasizes the relationship between styles and social and domestic changes. Deals primarily with medieval and Renaissance furniture in England, Italy, Germany, France, and Spain.

Uses a wide variety of visual and documentary sources. Well illustrated.

P145 Praz, Mario. An illustrated history of furnishing from the Renaissance to the 20th century. [Trans. from the Italian by William Weaver]. N.Y., Braziller [1964] 396p. 400 il. (part col.) incl. ports.

Also published in London by Thames & Hudson, 1964, as *An illustrated history of interior decoration, from Pompeii to Art Nouveau.*

A unique pictorial history of European interiors from the Renaissance to the first decade of the 20th century. Illustrated with paintings, drawings, and engravings (400 in all) of scenes which recapture the spirit of the rooms and their inhabitants. The introduction is brilliantly written, personal and nostalgic; the commentaries for the individual pictures are perceptive, authoritative, with many quotations from literature. Scholarly notes with bibliographical references.

P146 Schmidt, Robert. Möbel; ein Handbuch für Sammler und Liebhaber. 7. verm. und verb. Aufl. Braunschweig, Klinkhardt & Biermann [1953]. 303p. 239 il. (Bibliothek für Kunst und Antiquitäten-freunde, 5)

A convenient, reliable handbook of European furniture from the early Middle Ages through the period of the Empire and Biedermeier styles. Bibliography, p.299-301.

P147 Sironen, Marta Katrina, comp. Manual of the furniture arts and crafts. Comp. by A. P. Johnson and Marta K. Sironen; ed. by William J. Etten. Grand Rapids, Mich., Johnson, 1928. xxxv, 899p. il.

Contents: (1) Narrative of furniture; (2) Origin and identification of design; (3) Technical description of the furniture periods and styles; (4) Furniture woods; (5) Veneers and plywood; (6) Furniture machinery; (7) Furniture construction; (8) Furniture finished and finishing; (9) Furniture upholstery; (10) Furniture transportation; (11) Furniture as an industry; (12) Furniture museums in the U.S.; (13) Code of selling ethics; (14) Biography; (15) Bibliographies: Furniture craftsmen, architects, and artisans to the twentieth century with brief biography, p.659-82; Annotated bibliography of furniture books, p.685-745; Bibliography of furniture books (listed according to subject matter), p.745-80; Glossary of furniture words and terms, comp. by D. D. Warner, p.781-840. Alphabetical index, p.841-99.

P148 Verlet, Pierre, ed. Styles, meubles, décors, du moyen âge à nos jours. Paris, Larousse [1972]. 2v. 825 il. (part col.)

A survey of furniture and interior decoration from the Renaissance to the 20th century, with an introduction summarizing medieval furniture and decoration. Consists of authoritative contributions by an international team of experts. Well illustrated, including many beautiful color plates.

Contents: v.1, Renaissance, Baroque, Louis XIV, Louis XV; v.2, Louis XVI, Empire et XIXe siècle. "Notices" (v.2, p.[226]-54) give brief biographies of the artists mentioned in the text. Bibliography, p.[255]-[56].

SEE ALSO: The scholarly periodical *Furniture history* (Q173), which features excellent book reviews and bibliographies.

## Ancient

P149  Baker, Hollis S. Furniture in the ancient world: origins & evolution 3100–475 B.C. With an introd. by Sir Gordon Russell. N.Y., Macmillan [1966]. 351p. col. front., il., 16 col. plates, tables, diagrs.
"The first really comprehensive treatment of ancient furniture from the beginning through the first part of the Greek period."—Dorothy Kent Hill, *Archaeology* 20:235 (June 1968). Of interest to historians, students, designers, and interior decorators. Contents: (1) Egypt; (2) The Near East; (3) The Aegean.

P150  Richter, Gisela Marie Augusta. The furniture of the Greeks, Etruscans and Romans [London] Phaidon [1966]. vi, 369p. 693 il.
Rev. ed. of earlier work entitled *Ancient furniture* (1926).
An authoritative survey of types of furniture from the Mycenaean era to the Roman empire. Includes documentation based on literary sources and inscriptions. Indispensable for research. Contains an appendix and a short bibliography on linear perspective in representations of Greek and Roman furniture. Abundantly illustrated. Selected bibliography, p.341–43. Index of localities, p.361–69.
Contents: (1) Introduction; (2) Aegean furniture; (3) Greek furniture; (4) Etruscan furniture; (5) Roman furniture; (6) Furnishings; (7) Technique; Appendix.

## Medieval

P150a  Eames, Penelope. Furniture in England, France and the Netherlands from the twelfth to the fifteenth century. London, Furniture History Society, 1977. xxiv, 303p. [72] leaves of plates.
Pub. simultaneously as *Furniture history* XIII (1977).
An award-winning survey of medieval furniture in England, France, and Holland. "Dr. Eames sets surviving masterpieces of medieval furniture in a convincing perspective. Her monograph will inspire not only students of furniture but social historians, art historians and all medievalists, in short everyone endowed with cultural curiosity."—Christopher Gilbert, *Ed. note.*
Pt. 1 treats types of furniture—armoires, buffets and dressoirs, beds and cradles, chests, and seating. Pt. 2 is a discussion of style and technique. Pt. 3 is the conclusion. Nine appendixes reproduce pertinent documents.
Scholarly critical apparatus, with bibliographical footnotes and a comprehensive bibliography. Many illustrations.

## Western Countries

### Canada

P151  Dobson, Henry, and Dobson, Barbara. The early furniture of Ontario & the Atlantic provinces: a record of the pieces assembled for the Country heritage loan exhibition from private collections across Canada. Foreword by Dorothy Duncan. Toronto, Feheley, 1976. approx. 200p. chiefly il.
"This catalogue greatly contributes to an understanding of Canadian country furniture ... it makes clear many of the subtle differences between forms produced in the early nineteenth century by country craftsmen in the United States, and similar forms, which they often inspired, that were produced in Canada. ... The emphasis is on furniture of early English Canada. The influence of Chippendale, Hepplewhite, Sheraton, and later Neoclassical designers are discussed in a brief foreword."—J. B. Barnes, *Antiques* 109:196 (Jan. 1976).
Well illustrated with black-and-white photographs. Divided into sections dealing with different types of furniture.

P152  Palardy, Jean The early furniture of French Canada. Trans. from the French by Eric McLean. [2d rev. ed.]. Toronto, Macmillan of Canada; N.Y., St. Martin's Pr., 1965. 413p. il., map, 11 col. plates.
1st ed. 1963.
A comprehensive survey of French-Canadian furniture from the 17th century to the first half of the 19th century. A valuable source of basic information on the historical and technical aspects of furniture styles. Register of woodworkers, cabinetmakers, locksmiths. Bibliography, p.401–2.

## France

### Bibliography

P153  Viaux, Jacqueline. Bibliographie du meuble (mobilier civil français). Paris, Société des Amis de la Bibliothèque Forney, 1966. 589p.
A bibliography of periodical articles concerning French civil furniture from the medieval period to the present. Complements the earlier bibliographies of Marquet de Vasselot (P482) and (P647).
Classified as follows: (I) Généralités; (II) Meubles par époque; (III) Meuble régional; (IV) Artistes du meuble; (V) Expositions; (VI) Musées; (VII) Collections; (VIII) Inventaires; (IX) Techniques; (X) Corporations. The articles within each chapter are arranged by date of publication. Each chapter is preceded by an informative bibliographic essay.
Index of periodicals analyzed, periodicals cited, pieces of furniture, names of artists, collectors, and places, and names of authors. Holdings in major French libraries are noted.

### Histories, Handbooks, Collections

P154  Boutemy, André. Meubles français anonymes du XVIIIe siècle. Analyses stylistiques et essais d'attribution de meubles français anonymes du XVIIIe siècle. Bruxelles, Éditions de l'Université de Bruxelles [1973]. 260p. 142 il. (Université Libre de Bruxelles. Faculté de philosophie et lettres. [Travaux]: 56)
The author traces the origin of several works in the public collections of Europe and the U.S. by means of penetrating stylistic analyses of the details of unstamped pieces of French furniture and comparisons with similar signed works. Also a contribution to research on the development of characteristic 18th-century furniture types such as the

*bonheur-du-jour*, the *commode*, and the *table mécanique*. Scholarly notes. Bibliography, p.253–57.

P155 Champeaux, Alfred de. Le meuble. Nouv. éd. Paris, Maison Quantin, 1885. 2v. il.
_____. Portfeuille des arts décoratifs. Paris, Calavas [1889–98]. 10v. in 5. 960 plates.
A pioneer handbook which marked the beginning of the scientific study of furniture; still fundamental. The portfolio volumes are important for the illustrations.
Contents: (I) Antiquité, moyen âge et renaissance; (II) XVIIe, XVIIIe et XIXe siècles.

P156 Frégnac, Claude, ed. French cabinetmakers of the eighteenth century. Foreword by Pierre Verlet. [Paris] Hachette [1965]. 341p. il. (part col.) (Collection Connaissance des arts: "Grands artisans d'autrefois")
Trans. of *Les ébénistes du XVIIIe siècle français.*
Essays written by Jean Meuvret; biographies, captions, and appendixes by Claude Frégnac.
An authoritative, reliable book for the beginner. From 4–16p. on each artisan. Excellent representative pictures. No bibliography.
Contents: The cabinetmakers and their history in the century of a gentle way of life; The evolution of taste during the Regency; The evolution of taste during the reign of Louis XV; The evolution of taste during the reign of Louis XVI; Manufacturing technique; Varieties of furniture; The stamps of the Paris masters.

P157 Grandjean, Serge. Empire furniture, 1800 to 1825. London, Faber and Faber, 1966. (Distr. in the U.S. by Taplinger, N.Y.) 120p. col. front., 99 plates (3 col.), table. (Faber monographs on furniture)
The first comprehensive study of Empire furniture in English, written by a *conservateur* in the Louvre who specializes in 19th-century decorative arts. Indispensable for research on the style, the artists, the materials, and techniques. Two appendixes of documents. Bibliography, p.112–14. Well illustrated.

P158 Jarry, Madeleine. Le siège français. Photos by Pierre Devinoy. [Fribourg, Suisse] Office du Livre [1973]. 366p. il.
1st ed. 1948.
A pictorial history of French seat furniture from the Carolingian period to Art Deco. Considers the social and economic framework and the architectural setting as well as style. Excellent illustrations.

P159 Ledoux-Lebard, Denise. Les ébénistes parisiens du XIXe siècle, 1795–1870; leurs oeuvres et leurs marques. [2. éd., rev., corr., augm.] Paris, Nobele, 1965. xxii, 599p. 128 plates.
An extensive revision of the 1951 ed.; the material has been expanded and brought up-to-date, and the scope has been extended to 1870. Arranged in dictionary form. For each cabinetmaker gives biographical information, commissions, exhibitions, descriptions of furniture, marks (when known), etc. Extensive bibliographical footnotes. Based on original

research in archives and 19th-century publications. Photographs of 308 pieces with an index. Bibliography, p.[567]–84.

P160 Nicolay, Jean. L'art et la manière des maîtres ébénistes français au XVIIIe siècle. Paris, Le Prat [1956–59]. 2v. plates (2 col.), fold. map, facsims.
A reference handbook on French furniture and cabinetmakers of the 18th century. Brings together much new material; some errors and questionable attributions.
Contents: [t.1.] Les truquages, comment reconnaître l'authenticité des meubles anciens; [t.2.] 688 estampilles et marques au feu.

P161 Ricci, Seymour de. Louis XIV and Regency furniture and decoration. N.Y., Helburn [1929]. xxiii, 215p. il.
Trans. by W. E. Walz.
An early work, still important for the good illustrations.

P162 _____. Louis XVI furniture. London, Heinemann [1913]. xvii, 256p. il.
A pioneer work. Good illustrations of pieces not to be found elsewhere.

P163 Salverte, François, *comte* de. Les ébénistes du XVIIIe siècle; leurs oeuvres et leurs marques. 5. éd., rev. et augmentée [par le comte Hubert de Salverte]. Paris, Nobele, 1962. xviii, 365p. 87 plates, port. facsim.
1st ed. 1923; 2d ed. 1927, is the only one with a bibliography; 4th ed., 1953, contains the integral text of the 2d ed., rev. and corrected by the author's wife. This ed. has been expanded to include cabinetmakers from other European countries. The names of the craftsmen are arranged in dictionary form. For each gives signatures, brief biographies, and information on their work. Documentation in footnotes. Appendice: "Liste de marques abréviatives trouvées sur des meubles du XVIIIe siècle," p.[333]–40. Index, p.[341]–58.

P164 Theunissen, André. Meubles et sièges du XVIIIe siècle; menuisiers, ébénistes, marques, plans et ornementation de leurs oeuvres. Paris, Éditions "Le Document" [1934]. 194p. il., 64 plates (part col.) facsims., diagrs.
An important and useful reference book, well illustrated by plates and drawings of details, with many facsimiles of signatures in the section devoted to artists.
Contents: Tableau synoptique donnant le classement alphabétique et chronologique des ébénistes du XVIIIe siècle, Meubles et sièges du XVIIIe siècle classés par ordre alphabétique d'auteurs, p.1–179; Fac-similé d'une facture de Chartier, ébéniste et de Morel, maître-sculpteur marbrier, en 1775, Marques d'inventaires, Marques et monogrammes de châteaux, Marques diverses, p.181–95; Listes des marbres utilisés au XVIIIe siècle; Description (planche en couleurs).
Bibliography, p.[199]–[201]. Index of 4p. Glossary of 4p.

P165 Verlet, Pierre. L'art du meuble à Paris au XVIIIe siècle. 2d éd. Paris, Presses Universitaires de France, 1968. 126p. il. ("Que sais-je?", no. 775)

1st ed. 1958.

The essential beginner's book for a general background of the history of 18th-century French furniture and the context in which it was produced. Written by the leading authority on the subject. Bibliography, p.127.

P166   _____. French royal furniture; an historical survey followed by a study of forty pieces preserved in Great Britain and the United States. [Trans. from the original French manuscript by Michael Bullock]. London, Barrie and Rockliff [1963]. 210p., plates (part col.)
This 3d volume in the series on French royal furniture (see P169) gives the English-speaking reader a valuable introduction to its manufacture, principal designers and craftsmen, its dispersal and rediscovery, as well as the methodology of furniture research. The catalogue of 40 pieces preserved in Great Britain and the U.S. is fully documented with notes from archives. Each work is illustrated. Glossary, comp. by F. J. B. Watson, p.191-99.

P167   _____. La maison du XVIIIe siècle en France: société, décoration, mobilier. Paris, Boschet, 1966. 309p. 228 il.
English trans.: *The eighteenth century in France: society, decoration, furniture.* Trans. by George Savage. Rutland, Vt., Tuttle, 1967.

A general book by the foremost authority on French furniture. The author studies the furniture and decoration of the upper-class homes as an integral part of 18th-century French society. Arranged by topic: French society of the 18th century; the distribution and decoration of the *appartements;* the types of furniture and *objets d'art.* Based on original research with documents. The last part consists of the inventories of three well-furnished houses.

P168   _____. Les meubles français du XVIIIe siècle. Paris, Presses Universitaires de France, 1954. 2v. il. (part col.) (L'Oeil du connaisseur)
A specialized study of the 18th-century French furniture which distinguishes and emphasizes the traditional distinctions between the *menuisiers* and *ébénistes.* Especially valuable for discussions of techniques, and for considerations of the problems of reproductions and fakes.

Contents of both volumes: v.1, *Menuiserie* and v.2, *Ébénisterie* in three parts: (1) Généralites et techniques; (2) Écoles et styles; (3) Collections et collectionneurs. v.1 also contains: Bibliographie, p.95-98 (critical, annotated); Liste des menuisiers, p.99-103; Estampilles, p.105-13; Table des illustrations, p.115-25 (includes commentaries). v.2 also contains: Bibliographie, p.101-2; Liste des ébénistes, p.103-9; Estampilles, p.111-19; Table des illustrations, p.121-33.

P169   _____. Le mobilier royal français; meubles de la couronne conservés en France. Paris, Éditions d'art et d'histoire, 1945-[56]. 2v. plates.
The first 2v. in a 3v. series on French royal furniture, written by the foremost authority in the field, (see also P166). Based on documentary evidence. Each volume contains extensive notes on 40 individual pieces of royal furniture preserved in

French public and private collections. Includes a study of the archives of the Royal Garde-Meuble. Each piece is illustrated.

P170   Wallace Collection, London. Wallace Collection catalogues. Furniture: text, with historical notes and illustrations, by F. J. B. Watson. London, Printed for the Trustees, by W. Clowes, 1956. lxvi, 360p. il., 120 plates.
The catalogue of a major collection of French decorative arts. Consists of a valuable introduction to French furnishings, a scholarly catalogue of the individual pieces, and an extensive critical bibliography, p.274-338. A rev. ed. with new information is in preparation.

P171   Watson, Francis J. B. Louis XVI furniture. London, Tiranti, 1960. vi, 162p. il., plates. (Chapters in art, v.30)
Reissued: London, Academy Editions; N.Y., St. Martin's 1973.

A book "concerned solely with those 'moveable articles' made principally of wood which were the creations of the Parisian guild of *menuisiers-ébénistes* during a period which extends from about 1760 to the French revolution"—*Pref.*

The excellent text traces the development of the style, the evolution of forms, technique, the Parisian guilds, and individual makers and manufacturers. Corpus of 242 plates; full notes for each illustration. Glossary of French terms arranged under English headings. Brief bibliography (p.95) supplements the critical bibliography in the author's *Wallace Collection catalogues* (P170).

SEE ALSO:   Duvaux, L. *Livre-journal de Lazare Duvaux, marchand-bijoutier ordinaire du roy 1748-1758* (H94); Vial, H. M.; Marcel, A.; and Girodie, A. *Les artistes décorateurs du bois* (P44).

## Germany and Austria

P172   Himmelheber, Georg. Biedermeier furniture. Trans. and ed. by Simon Jervis. London, Faber and Faber [1974]. 115 [84]p. il. (Faber monographs on furniture)
An authoritative analysis of Biedermeier furniture, the first to appear in English. Written by the curator of furniture at the Bayerisches Nationalmuseum, Munich. 115 excellent illustrations. Many of the captions give dimensions, provenance, and bibliographical references. Bibliography, p.104-5.

Contents: (1) Towards a definition of the Biedermeier style; (2) The formal vocabulary of the Biedermeier style; (3) Sources of the style; (4) Regional characteristics and regional cabinet-makers; (5) Upholstery; (6) Craftsmanship in Biedermeier furniture; (7) The Aftermath. Appendix: The introduction of freedom to trade in Bavaria.

P173   Kreisel, Heinrich, and Himmelheber, Georg. Die Kunst des deutschen Möbels; Möbel und Vertäfelungen des deutschen Sprachraums von den Anfängen bis zum Jugendstil. München, Beck [1968-73]. 3v. il., plates (part col.)

Contents: Bd. (1) Von den Anfängen bis zum Hochbarock, by H. Kreisel; Bd. (2) Spätbarock und Rokoko, by H. Kreisel; Bd. (3) Klassizismus/Historismus/Jugendstil, by G. Himmel-heber.

A cornerstone work in the field of furniture scholarship. Most comprehensive, the scope ranges from the throne of Charlemagne to the *Jugenstil* movement at the end of the 19th century. Based on meticulous examination of inventories and documents. Exhaustive descriptive notes with bibliographical references; v.3 has a bibliography section, p.287. v.1-2 have indexes of artists and artisans; places; and persons and subjects; v.3 has a detailed general index to that volume. Many excellent black-and-white illustrations; some superb color plates.

## Great Britain

P174  Aslin, Elizabeth. Nineteenth century English furniture. London, Faber and Faber [1962]. 93p. il., plates (part col.) (Faber monographs on furniture)
A study of the evolution of 19th-century furniture which analyzes the Gothic and Rococo revivals and traces the influence of architects, designers, and critics. "A scholarly survey of a depth and precision that has been confined in the past almost exclusively to furniture of earlier periods." —C. Musgrave, *Burlington magazine* 105:570 (Dec. 1963). 139 plates.

Contents: Introduction: Early Victorian furniture; Exhibitions and their influence; Marble, metal, papier mâché, and new methods of decoration; Woodcarving; William Morris and Company; Art furniture and the aesthetic movement; The Arts and Crafts; Art Nouveau; Cabinet-makers—A brief guide; Bibliography, p.89-[90].

P175  Cescinsky, Herbert, and Gribble, Ernest R. Early English furniture and woodwork. London, Routledge, 1922. 2v. col. front., il., plans.
A history of oak furniture and woodwork from the beginning of the 14th century to the end of the 17th century. Well illustrated. Each volume contains an index.

Contents: v.1, The dissolution of monasteries; The early woodworker: his life, tools and methods; The plan of the early Tudor house; The development of the English timber roof; Gothic woodwork and colour decoration; Timber houses, porches and doors; The English staircase; Wood panellings and mantels; Bedsteads and their development; v.2, The development of the chest and standing cupboard; The progression of English oak tables; The development of the English oak chair; Walnut chairs from 1660 to 1700; English marqueterie; Domestic clocks; English lacquer work.

P176  Coleridge, Anthony. Chippendale furniture: the work of Thomas Chippendale and his contemporaries in the Rococo taste: Vile, Cobb, Langlois, Channon, Hallett, Ince and Mayhew, Lock, Johnson and others, *circa* 1745-65. London, Faber and Faber; N.Y., Potter [1968]. 229p. 194 plates, 423 figs. (3 col.), facsims. (Faber monographs on furniture)

A well-informed, readable survey which incorporates recent research. "The aim of this book is to discuss, in some detail, the history of English furniture and its design from about 1745 to about 1765. These twenty years may be taken to cover the short period in the evolution of furniture design in this country when the imported Rococo style, in its fully developed form, was all the rage."—*Introd.* Bibliography, p.216-19.

P177  Edwards, Ralph. The shorter dictionary of English furniture; from the Middle Ages to the late Georgian period. London, Country Life [1964]. 684p. il., port.
Condensed and rev. ed. of *The dictionary of English furniture,* by P. Macquoid and R. Edwards (P187).

This authoritative dictionary of English domestic furniture should be on all art reference shelves. "In condensing the text I have sought to retain all important historical and literary references (even adding some which seemed of special interest), while confining descriptive detail mainly to the captions."—*Foreword.* 850 entries; 1,900 illustrations.

P178  Edwards, Ralph, and Jourdain, Margaret. Georgian cabinet-makers, c.1700-1800. New and rev. [i.e. 3d ed.] London, Country Life, 1955. 247p. 233 il., ports.
1st ed. 1944; 2d ed. 1946.

A listing of 105 famous 18th-century cabinetmakers. Authoritative entries. "The aim of this book is to state briefly what is known of the careers of leading cabinet-makers of the 18th century, and to assemble a corpus of furniture which can be assigned to them individually." —*Introd.* Bibliographical footnotes.

Contents: Cabinet-makers, joiners, and carvers; Lesser-known and minor cabinet-makers, joiners, and carvers; Appendix: extracts from the Great Wardrobe accounts; Illustrations, p.121-240; Index, p.241-47.

P179  Fastnedge, Ralph. English furniture styles from 1500 to 1830. Baltimore, Penguin [1967]. xxiii, 320p. il.
A useful, comprehensive, authoritative survey of English furniture from 1500 to 1830. Includes glossaries of makers, woods, and special terms. 64 plates and 100 line drawings.

Contents: (1) The period of oak (from the early 16th century to the end of the Commonwealth; (2) The early walnut period (1660-90); (3) The later walnut period (1690-1720); (4) Lacquer furniture with some mention of gilt and silvered furniture and gesso; (5) The early Georgian period (1720-40); (6) The pre-'director' period (1740-54); (7) The post-'director' period; (8) Robert Adam—the classical revival; (9) Hepplewhite: 'The cabinet-maker and upholsterer's guide,' 3d ed., 1794; (10) Thomas Sheraton (1751-1806); (11) The Regency period; Index, p.313-21.

P180  ———. Sheraton furniture. London, Faber and Faber [1962]. 125p. 100 plates (4 col.) (Faber monographs on furniture)
A history of late 18th-century furniture which traces the influence of Thomas Sheraton's *The cabinet-maker and upholsterer's drawing-book* on furniture making during the eighties and nineties.

Contents: Introduction; Thomas Sheraton; 'The drawing book'; Some contemporary makers; Woods and decorative processes; The furniture of 'The drawing book'.

P181   Fowler, John Stewart, and Cornforth, John. English decoration in the 18th century. London, Barrie and Jenkins [1974]. 288p. il. (part col.)
Published in the U.S.: Princeton, Pyne [1974].
A discussion of all topics related to 18th-century English interior decoration, including society, fashion, paintings, etc. Based on archival and literary sources. Bibliographical references in notes, p.271–83, plus selected bibliography, p.267–79. Indexes of names, houses, subjects, p.284–88.
Contents: (1) The concept of the decorator; (2) The quicksands of style and fashion; (3) The uses of houses and their arrangement; (4) The practice of the upholsterer; (5) Colour and the painter's craft; (6) The treatment of floors; (7) Lighting and heating; (8) Attitudes to pictures and picture hanging; (9) Ladies' amusements; (10) Care and housekeeping; (11) A matter of balance.

P182   Hayward, Charles Harold. English period furniture. Rev. and enl. ed. London, Evans, 1971. 271p. 16 plates, figures.
1st ed. 1936.
A standard history of English furniture from the Tudor period to the Victorian era. Divides the styles into three types: those produced by the carpenter, by the cabinet-maker, and by the designer.
"*English period furniture* has stayed the course over thirty years and it still appeals to those who want reliable knowledge of construction, and techniques communicated in a modest, unpretentious way."—Rev. by Geoffrey Beard, *Furniture history* 8:94 (1972).
Many figures in the text and good photographic plates. No bibliography. Index, p.266–70.

P183   Heal, *Sir* Ambrose. The London furniture makers from the Restoration to the Victorian era, 1660–1849; a record of 2500 cabinet makers, upholsterers, carvers and gilders, with their addresses and working dates, illustrated by 165 reproductions of makers' trade-cards. With a chapter by R. W. Symonds on the problem of identification of the furniture they produced, illustrated by some hitherto unpublished examples of authenticated pieces. London, Batsford [1953]. xx, 276p. il., facsims. (Repr.: N.Y., Dover, 1972.)
Contents: Sources of references, p.xix; Selected list of cabinet-makers, upholsterers, carvers, and gilders working in London between 1660–1840 with reproductions of a selection of trade-cards in use during the period, p.3–212; Old English furniture and its makers, the problem of identification with examples of authenticated pieces, p.213–62; Notes on the illustrations referred to in the foregoing section, p.265–76.
Supplemented by: Agius, Pauline, "Cabinet-makers not in 'Heal', or eighteenth- and nineteenth-century trade cards of furniture makers in the John Johnson Collection of printed ephemera," *Furniture history*, 10:82–84 (1974).

P184   Hope, Thomas. Household furniture and interior decoration; classic style book of the Regency period. With a new introd. by David Watkin. N.Y., Dover [1971]. xiii, 140p. il., plan, port.
A facsimile reprint of the 1807 ed. An important record of English Regency design. A short bibliography follows the introduction by David Watkin.

P185   Jourdain, Margaret. Regency furniture, 1795–1830. Rev. and enl. by Ralph Fastnedge. London, Country Life [1965]. 116p. il., col. plates.
1st ed. 1934.
A reliable reference work, now a classic. The revisions consist of a new section on the Gothic taste, and new chapters on the later Regency period and the work of French craftsmen in London.

P186   Macquoid, Percy. A history of English furniture. With plates in colour after Shirley Slocombe, and numerous illustrations. London, Lawrence & Bullen, 1925–28. 4v. col. fronts. (v.1, 3), il., col. plates.
1st ed. 1904–08 (Repr.: N.Y., Dover, 1972.)
An old, standard work, parts of which are out-of-date and need revision.
Contents: v.1, The age of oak; v.2, The age of walnut; v.3, The age of mahogany; v.4, The age of satinwood. Each volume has its own index.

P187   Macquoid, Percy, and Edwards, Ralph. The dictionary of English furniture from the Middle Ages to the late Georgian period. [2d ed.] rev. and enl. by Ralph Edwards. London, Country Life [1954]. 3v. il. (part col.)
Originally published in 1904. "This work is intended to give the reader an insight into the history of English domestic furniture and its place in the changing social habits of the people of this island."—*Introd.* Some articles are almost entirely new; most are signed and noted when revised. More emphasis on individual cabinet-makers and many new illustrations. Contents: v.1, Aca-Cha; v.2, Che-Mut; v.3, Nai-Zuc.
Condensed and rev. version of this work: Edwards, Ralph. *The shorter dictionary of English furniture; from the Middle Ages to the late Georgian period* (P177).

P188   Musgrave, Clifford. Adam and Hepplewhite and other neo-classical furniture. London, Faber and Faber, 1966. 223p. col. front., 99 plates (incl. 3 col.) (Faber monographs on furniture)
A survey of neoclassical furniture up to about 1790. "Attention has been paid especially to the evolution of the principal types of furniture during the Adam and Hepplewhite periods as expressed in the work of the principal cabinet-makers."—*Introd.*
Contents: Introduction; The Adam revolution; Adam's furniture designs and the development of his style; Adam and the French; Adam and Chippendale; Furniture in the Adam houses; Hepplewhite and the Adam dissemination; The Adam craftsmen; Types of furniture; Materials and processes.
Bibliography, p.175–78.

P189 _____. Regency furniture, 1800 to 1830. 2d rev. ed. London, Faber and Faber, 1970. 157p. il., 100 plates (some col.)

1st ed. 1961.

The author considers historical, social, and psychological influences on the development of English furniture during the Regency period. Bibliography, p.149-52.

P190 Symonds, Robert Wemyss, and Whineray, B. B. Victorian furniture. London, Country Life [1962]. 232p. plates (1 col.)

A broad survey of Victorian furniture design and its usage in the home, written by an expert. Valuable chapters on cabinet-making practices and techniques; extensively illustrated.

P191 Tomlin, Maurice. English furniture; an illustrated handbook. London, Faber and Faber, 1972. 180p. 247 il. (8 col.)

A guide to English furniture from the Middle Ages to 1970. The emphasis is on the period from the Restoration to the Regency. For each style gives general characteristics, newly introduced techniques, and the leading cabinetmakers of the time. Bibliography; index.

P192 Ward-Jackson, Peter W. English furniture designs of the eighteenth century. London, H. M. Stationery Office, 1958. viii, 68p. 278 plates (366 figs.)

"In this book an attempt is made to illustrate the history of English furniture in the eighteenth century by a new method, using contemporary designs instead of photographs of furniture."—*Pref.*

Contents: (1) General introduction: The purpose of furniture designs; Furniture designs in the 17th century; The furniture of the Palladian age; The Rococo style; Chippendale & the Chinese and Gothic taste; The neo-classical revival; (2) Catalogue of the illustrations and notes on the artists; Index of designers; (3) The illustrations; Appendix; Bibliography, p.viii.

## Italy

P193 Broscio, Valentino. Il mobile italiano. Roma, Editalia [1971]. 246p. 199 il., 24 col. plates.

A pictorial survey of Italian furniture by type, with a brief introductory summary and commentary on the illustrations.

Contents: Breve storia del mobile italiano, p.13-46; Piccolo dizionario del mobile, p.49-56; I cassoni e le cassepanche; Gli stipi e i secrétaires; Le credenze, gli armadi, le librerie, le vetrine; I cassettoni; Le *consoles;* I tavoli, i tavolini, le scrivanie; Le sedie e gli sgabelli; Le poltrone; I divani; Le culle e i letti; I mobili diversi. Bibliography, p.237.

P194 Ghelardini, Armando. Il mobile italiano dal medioevo all'Ottocento. Milano, Bramante [1970]. [154]l. il. (part col.)

A visual survey (563 il.), with brief descriptive text, of Italian furniture from the Middle Ages through the 19th century.

Contents: Cassoni e cassepanche; Credenze e cantonali; Cassettoni e cassettoncini; Cassettoni con alzata; Tavoli; Scrivanie; Armadi, librerie e vetrine; Ante e porte; Stipi e medaglieri; Letti; Mensole; Specchiere; Panche e divani; Seggiole e poltrone; Mobili diversi. "Indice delle illustrazioni" at the end.

P195 Levy, Saul. Lacche veneziane settecentesche. [Milano] Görlich [1967]. 2v. 25p. 2 col. fronts., 496 col. plates.

A luxury publication with a few pages of text and almost 500 superb color plates illustrating Venetian lacquered furniture of the 18th century. Arranged by type of furniture.

Contents: (1) Poltrone, divani, sedie e panche. Cassettoni, credenze, comodini. Scrittoi e cassettoni a ribalta. Cassettoni a ribalta con alzata. Armadi. Tavoli da parete, tavolini e trespoli; (2) Specchiere e cornici. Porte. Strumenti musicali e accessori. Miscellanea. Bibliographical notes; bibliography, v.1, p.24.

P196 _____. Mobile veneziano del Settecento. Milano, Görlich, 1975. 2v. il. (part col.)

Authoritative text based on *Mobile veneziano del Settecento* by Giuseppe Morazzoni (Milano, Görlich, 1958). Over 400 good illustrations, mostly in color. Bibliography, v.1, p.30.

P197 Mobili regionali italiani. Milano, Görlich, 1969- .

An unnumbered monographic series; each volume covers the furniture of a region of Italy. Good illustrations and brief reliable texts.

Examples: Alberici, Clelia. Il mobile lombardo (1969); Cantelli, Giuseppe. Il mobile umbro (1973); Lizzani, Goffredo. Il mobile romano (1970); Miotti, Tito. Il mobile friulano (1970).

P198 Morazzoni, Giuseppe. Il mobile genovese, a cura della Associazione "Amici di Genova." Milano, Alfieri, [1948]. cxxiv, 117p. 319 il.

A basic survey of Genoese furniture from the Gothic period to about 1850, written by a leading furniture historian. Based on research with sources. Well illustrated.

P199 _____. Il mobile neoclassico italiano. Milano, Görlich [1955]. 61p. 335p. of il.

An authoritative survey of neoclassical furniture (1768-c.1820) from Rome, Turin, Genoa, Parma, Naples, Milan, and Venice. Excellent visual documentation. "Alcune caratteristiche del mobile neoclassico," p.48-56; "Album neoclassici," p.57-[62], is a listing of collected engravings of Italian neoclassical furniture. Bibliographical footnotes.

P200 Odom, William Macdougal. A history of Italian furniture from the fourteenth to the early nineteenth centuries. Garden City, N.Y., Doubleday, 1918-19. 2v. il. (Repr.: N.Y., Archive Pr., 1966.)

An old luxury publication, still the basic history of Italian furniture with the most extensive corpus of illustrations (352 il. in v.1; 513 in v.2).

Contents: v.1; (1) Italian Gothic. The 14th and early 15th centuries; (2) The early Renaissance. The second half of the 15th century; (3) The high Renaissance. The first half of the 16th century; (4) The late Renaissance. The second half of the 16th century; v.2; (1) The Baroque style. The 17th century; (2) The Rococo styles. The first half of the 18th century; (3) The classic revival. The second half of the 18th century; (4) The Empire style. The early 19th century.

P201   Puglia, Raffaello del, and Steiner, Carlo. Mobili e ambienti italiani dal gotico al floreale. Testo storico introduttivo a cura di Raffaello del Puglia; testo descritto e catalogazione a cura di Carlo Steiner. Milano, Bramante [1963]. 2v. il. (part col.)
A splendid picture book (621 il.) with an introductory text (p.11-100) outlining the history of Italian furniture from the Gothic period to the *floreale* style of the 20th century. "Tavole e testo descrittivo," p.101-502; index of illustrations at end of v.2. No bibliography.

P202   Schottmüller, Frida. Furniture and interior decoration of the Italian Renaissance ... with 590 illustrations. N.Y., Brentano, 1921. 246p. il.
A useful collection of pictures, with 31p. of preliminary text. Its purpose was "to illustrate the culture of the home in the time of the Italian Renaissance, the decoration of the rooms and the nature of the single objects of furniture." —*Foreword.* "Explanatory," p.241-46, gives brief information about the illustrations, including size. Bibliographical footnotes.

## Low Countries

P203   Amsterdam. Rijksmuseum. Catalogus van meubelen en betimmeringen. 3. druk. Amsterdam, Rijksmuseum, 1952. 374p., plates.
The catalogue of the furniture collection of the Rijksmuseum. Especially rich in Dutch and Flemish pieces and colonial furniture from Indonesia and other former Dutch colonies. Scholarly descriptive entries with bibliographical references. Indexes of places and persons. List of technical terms.

P204   Philippe, Joseph. Le mobilier liégeois (Moyen âge-XIXe siècle). Liège, Bénard et Central réunies, 1962. 243p. 129 plates (part col.) (Collection consacrée à l'art mosan, v.2)
A history of furniture in Liège and the Meuse region. Contents: [pt.1] Le mobilier mosan et liégeois avant le XVIIIe siècle; [pt.2] Le mobilier liégeois et mosan du XVIIIe siècle. Bibliographical notes; bibliography, p.94-100. Indexes of native artists, foreign artists, types of furniture, materials, and owners. Well illustrated.

P205   Singleton, Esther. Dutch and Flemish furniture. N.Y., McClure, Phillips, 1907. 338p. 63 plates.
An old, standard work on Dutch and Flemish furniture from the Middle Ages through the 19th century. Index, p.329-38.

P206   Wall, Victor. Het hollandsche koloniale barokmeubel; bijdrage tot de kennis van het ebbenhouten meubel omstreeks het midden der XVIIde en het begin der XVIIIde eeuw. Antwerpen, De Sikkel, 's Gravenhage, Nijhoff, 1939. xvi, 231p il.
A thorough scholarly treatment of Dutch colonial furniture of the Baroque period. 138 good illustrations in the text. Bibliographical notes: bibliography, p.223-31.

## Scandinavia

P207   Stockholm. Nordiska Museet. Nordiska Museets möbler från svenska herremanshem; utgivna av Sigurd Wallin. Stockholm, Nordiska Museets Förlag, 1931-35. 3v. il., plates (part col.)
A catalogue of the rich collection of Swedish furniture and related decorative art in the Nordiska Museet. The pieces date from the Renaissance to the early 19th century. Consists of many good illustrations with descriptive text. At end of v.3: List of plates, index of artisans, and bibliography, p.lxvii-lxxi.
Contents: Del 1, 1500- och 1600-talen, Vasatiden och den Karolinska tiden, Renässans och Barock; Del 2, 1700-talet, Frihetstiden och Gustaf III:s tid, Senbarock, Rokoko och Gustavinsk stil; Del 3, 1800-talet, Gustav IV Adolfs-Karl XIV Johans tid, Sengustaviansk och Karl-Johans-stil.

## Spain

P208   Burr, Grace Hardendorff. Hispanic furniture, from the fifteenth through the eighteenth century. 2d ed., rev. and enl. N.Y., Archive Pr., 1964. 231p. 201 il.
1st ed. 1941.
The best work on Spanish furniture in English, based on research in the archives and collection of the Hispanic Society, N.Y. The emphasis is on domestic furniture of the 16th and 17th centuries. Many examples from American collections. Notes, with bibliographical references. Bibliography, p.215-19.
Contents: (I) Spanish Gothic furniture; (II) The Renaissance; (III) The 17th century; (IV) The 18th century; (V) Colonial furniture; (VI) The Hispanic Society Collection.

P209   Byne, Arthur, and Stapley, Mildred. Spanish interiors and furniture; photographs and drawings by Arthur Byne, with brief text by Mildred Stapley. N.Y., Helburn [1921-22]. 4v. plates. (Repr.: N.Y., Dover, 1969.)
Still important for the corpus of 400 pictures.

P210   Feduchi, Luis M. Spanish furniture, N.Y., Tudor [1969]. 313p. 268 il. (part col.)
In Spanish, English, French, and German.
A survey of Spanish furniture from the Iberian and Roman period to Gaudi and Art Nouveau in the 20th century. Written by the foremost authority. Splendid pictures, many in color. The parallel texts in five languages make it almost impossible to read. Bibliography, p.308-13 (repeated five times).

P211   Lozoya, Juan Contreras y López de Ayala, *marqués* de. Meubles de estilo español, desde el gótico hasta el siglo XIX con el mueble popular. Selección de ilustraciones por José Claret Rubira. Barcelona, Gili, 1962. 451p. (incl. 408 plates).

A brief introduction is followed by the many plates of measured drawings, designs, patterns, and details of Spanish furniture. Bibliography, p.451.

## United States

P212   Andrews, Edward Deming, and Andrews, Faith. Shaker furniture, the craftsmanship of an American communal sect; photographs by William F. Winter. New Haven, Yale Univ. Pr.; London, Milford, Oxford, Univ. Pr., 1937. 133p. 48 plates (incl. front.) on 25 l. (Repr.: N.Y., Dover [1946].)

A study of the cultural background, craftsmanship, and craftsmen of Shaker furnitures.

Contents: (1) Shaker craftsmanship; its cultural background; (2) Shaker furniture; its essential character; (3) The craftsmen of the sect; (4) Shaker houses and shops; (5) Conclusion; Plates; Appendixes: (A) The Shaker chair industry; (B) Notes on Benjamin and Isaac Youngs, Shaker clockmakers; (C) Notes on construction, materials, and finishes; Bibliography, p.121-26.

P213   Bjerkoe, Ethel Hall, and Bjerkoe, John Arthur. The cabinetmakers of America. Foreword by Russell Kettell, illustrated with photographs and drawings. [1st ed.]. Garden City, N.Y., Doubleday, 1957. 252p. il., plates.

A biographical dictionary of American cabinetmakers. Illustrated by line drawings and halftone plates. "Cabinetmaking as it developed in America," p.1-17. Glossary, p.241-46. Bibliography, p.249-52.

P214   Boston, Museum of Fine Arts. American furniture in the Museum of Fine Arts, Boston [by] Richard H. Randall, Jr. Boston [1965]. xvii, 276p. il.

A scholarly catalogue of 218 pieces of American furniture in the collection of the Museum of Fine Arts in Boston, exclusive of the Martha and Maxim Karolik donations (I471). "The attempt of this catalogue is to group the pieces as closely as possible in date sequence, where many of their histories have been of benefit, and to allow the quixotic juxtapositions of style to appear."—*Introd.* Bibliography, p.xvii-[xviii]; General index, p.267-73; Index of donors and former owners, p.274-76.

P215   Comstock, Helen. American furniture: seventeenth, eighteenth, and nineteenth century styles. N.Y., Viking [1962]. 336p. il.

Treats the subject of American furniture from the point of view of design characteristics of styles from Jacobean to early Victorian. Emphasizes the individuality of American furniture styles against the European background. 665 illustrations.

Contents: (1) Jacobean—William and Mary: 1640-1720; (2) Queen Anne: 1720-55; (3) Chippendale: 1755-90; (4) Classical period: 1790-1830; (5) Early Victorian: 1830-70; Notes, p.312-18; Selected bibliography, p.319-24; Index, p.327-36.

P216   Fales, Dean A. American painted furniture: 1660-1880. Robert Bishop, illus. and design ed. Cyril I. Nelson, general ed. [1st ed.]. N.Y., Dutton, 1972. 229p. il.

A survey of the development of early American painted furniture. "As a whole, American painted furniture shows the coming together of people from other lands and the eventual emergence of a national style in the nineteenth century."—*Pref.*

Contents: (1) Early colonial; (2) Late colonial; (3) Federal; (4) American Empire; (5) 19th century; (6) Cultural patterns; (7) Victorian. Notes, p.285-89; Bibliography, p.289-93; Index, p.295-98; Index of owners of furniture illustrated, p.299.

P217   Henry Francis du Pont Winterthur Museum. American furniture, Queen Anne and Chippendale periods, in the Henry Francis du Pont Winterthur Museum, by Joseph Downs. Foreword by Henry Francis du Pont. N.Y., Viking [1967]. 470p. 411 il., 10 col. plates (A Winterthur book)

A detailed catalogue of the Queen Anne and Chippendale furniture in the great collection of Winterthur. Companion volume to *American furniture, the Federal period* (P218). "A pioneering look into the social as well as the artistic history of the American cabinetmaker's art."—Frank L. Horton, *Art bulletin* 50:292 (Sept. 1968). Bibliographies included.

P218   _____. American furniture, the Federal period, in the Henry Francis du Pont Winterthur Museum, by Charles F. Montgomery. Foreword by Henry Francis du Pont. With photos. by Gilbert Ash. N.Y., Viking [1966]. 497p. 524 il., 27 col. plates.

An indispensable research tool for the study of American furniture. Companion volume to *American furniture, Queen Anne and Chippendale periods* (P217). The introductory text, which discusses styles, methods of production, woods used, upholstery, and room decoration, is followed by the catalogue of 491 pieces of furniture from 1788-1825. Bibliography, p.484-89; Index, p.490-97.

P219   Hornor, William Macpherson. Blue book, Philadelphia furniture, William Penn to George Washington, with special reference to Philadelphia-Chippendale school. Philadelphia, n.p., 1935. xv p., 2 l., 340p. incl. front., il. plates, facsims.

Now rare. "Based on original research, this is an intensive study of one of the most important productive centers."—M. Rogers, *American interior design.*

"Philadelphia craftsmen, 1783-86," p.[317]-26. "Articles by the author relating to American furniture, the fine arts, and colonial mansions," p.[315]-16.

P220   Kirk, John T. American chairs; Queen Anne and Chippendale. N.Y., Knopf, 1972. 208p. il.

An excellent technical, aesthetic, and historical analysis of Queen Anne and Chippendale chairs produced in Philadelphia and Massachusetts. Written by an expert in the field. Nicely illustrated with many clear details.

P221 Lockwood, Luke Vincent. Colonial furniture in America. 3d ed. Supplementary chapters and one hundred and thirty-six plates of new subjects have been added to this edition, which now includes over a thousand illustrations of representative pieces. N.Y., Scribner, 1926. 2v. fronts. il. (Repr.: N.Y., Castle, 1957.)
A basic reference work for the student of American furniture. Comprehensive visual documentation.

Contents: v.1, Introduction; Chests; Chests of drawers, cupboards and sideboards; Desks and scritoires; Looking-glasses; Supplementary chapter. v.2, Chairs; Settees, couches, and sofas; Tables; Bedsteads; Clocks; Supplementary chapter; Index, p.345–52.

P222 Lyon, Irving Whitall. The Colonial furniture of New England; a study of the domestic furniture in use in the 17th & 18th centuries. [2d ed.]. Boston, 1892. 285p. plates.
A study of carved oaken furniture of New England. 113 illustrations. Contents: Chests, cupboards; Chests of drawers; Desks; Chairs; Tables; Clocks. Appendix, p.265–70; Index, p.271–85.

P223 McClelland, Nancy Vincent. Duncan Phyfe and the English Regency, 1795–1830. Foreword by Edward Knoblock. N.Y., Scott [1939]. xxix, 364p. il., plates.
A scholarly account of the life and work of Duncan Phyfe. Includes chapters about his competitors and brief histories of many of his customers. Bibliography, p.341–46.

P224 Miller, Edgar George. American antique furniture, a book for amateurs. N.Y., Barrows [1937]. 2v. il.
Paperback ed.: N.Y., Dover, 1966.
Important for pictures. The book is composed of many illustrations, arranged by type of furniture (beds, chairs, etc.) with explanatory remarks showing the changes in style in successive periods. The majority of the illustrations have been chosen to represent the kind of pieces found in private homes rather than in museums. "Museums and collections in New England open to the public," p.1065–71. Index to both volumes, p.1080–1106.

P225 Nutting, Wallace. Furniture treasury (mostly of American origin). All periods of American furniture with some foreign examples in America, also American hardware and household utensils. Five thousand illustrations with descriptions on the same page. N.Y., Macmillan, 1948. 2v. il. (Repr.: N.Y., Macmillan, 1962.)
An old, standard work, useful for pictures. Contains photographs of 5,000 examples of furniture (arranged by type, i.e., beds, chairs, etc.) and utensils to the end of the Empire period.
Dimensions are usually indicated, as well as the owner of the piece. A 19-page index at end of v.2.

P226 Otto, Celia Jackson. American furniture of the nineteenth century. N.Y., Viking [1965]. 229p. il., 3 col. plates.
"This book is an attempt to make an accurate record of the furniture evolutions of the nineteenth century in America." —*Introd.* Attempts to show how furniture styles were influenced by social and historical developments. 481 illustrations.
Contents: Introduction; The Classic period; The Empire period; The Restauration period; The Rococo period; The Renaissance period; The eighties and nineties. Index, p.225–29.

P227 Singleton, Esther. The furniture of our forefathers. With critical descriptions of plates by Russell Sturgis. N.Y., Doubleday, 1901. 8 pt. in 2v. il. (Repr.: N.Y., Blom, 1970, of 1913 1v. ed. pub. by Doubleday.)
A pioneer work. Covers U.S. furniture and home interiors from colonial times to the end of the Victorian era. Includes technical as well as historical information about American furniture.

SEE ALSO: Gowans, A. *Images of American living: four centuries of architecture and furniture as cultural expression* (J314).

## Oriental Countries

P228 Ecke, Gustav. Chinese domestic furniture; one hundred and sixty-one plates illustrating one hundred and twenty-two pieces of which twenty-one are in measured drawings. Peking, Vetch, 1944. 2v. in 1. il., 161 plates. (Repr.: Rutland, Vt., Tuttle, 1963.)
A valuable collection of plates and measured drawings of Chinese furniture. Short introductory text. Measurements of the pieces are given in the list of plates. Bibliography, v.1, p.35–[40].

P229 Ellsworth, Robert Hatfield. Chinese furniture: hardwood examples of the Ming and early Ch'ing dynasties. N.Y., Random [1971]. 299p. il., plates (part col.)
The most thoroughly researched investigation to date of the various intricate forms of joinery and metal mounts of Chinese furniture. Superb illustrations and line drawings.
Contents: (1) Historical background; (2) Ming evidence for the dating of Chinese furniture; (3) Woods known to have been used in Chinese furniture; (4) Chinese joinery; (5) Metal mounts; (6) Chinese furniture of the Ming and Ch'ing dynasties; notes on the construction of the illustrated pieces; (7) The change in seating surfaces and its importance in the dating of Chinese furniture; (8) Conservation and restoration. Appendix A: "Random talks on chairs and stools and method of arrangement," by Chia-chun Chu, trans. by Z. Z. Li. Appendix B: The P'an tombs of the Ming dynasty.
Annotated bibliography, p.297–99.

P230 Kates, George Norbert. Chinese household furniture, from examples selected and measured by Caroline

F. Bieber and Beatrice M. Kates; photographs by Hedda Hammer Morrison. [1st ed.]. N.Y. and London, Harper [1948]. 125p. il., plates. (Repr.: N.Y., Dover [1962].)

A brief survey of the various types of Chinese furniture.

Contents: Origins and development: growth of Western interest; The Chinese tradition; What the West noticed; Native appraisals; Problems of dating; The woods employed; Historical evolution; Cupboards in general; Wardrobes; Smaller cupboards; Open cupboards; Dressers, Tables; Small tables; Writing tables; Side tables; Altar tables; Lute tables, etc.; The built-in *K'ang*; *K'ang* furniture; The bed; The stool; The chair; Various chests, boxes, etc.; Traditional design; Furniture arrangement; Conclusion.

Bibliographical references included in Notes to the text, p.60–63; Bibliography, p.125.

# CLOCKS AND WATCHES

## Bibliography

P231  Baillie, Granville Hugh. Clocks and watches; an historical bibliography. With a foreword by Sir Harold Spencer-Jones. London, N.A.G. Pr. [1951]. 414p. il.

An extremely important bibliography, with annotations. Arranged chronologically, from 1344 to 1799. Name index, p.369–92; subject index, p.393–414.

P231a  Tardy. Bibliographie générale de la mesure du temps, suivie d'un essai de classification technique et géographique; pref. de Paul Ditischeim, documentation réunie par Tardy. Paris [1947]. 352p.

A useful compilation of books and periodical literature on clocks, watches, and other types of timepieces.

## Histories, Handbooks, Dictionaries and Encyclopedias, Collections

P232  Baillie, Granville Hugh. Watches: their history, decorations and mechanism. London, Methuen [1929]. 383p. 75 plates (part col.)

Still the best book on watches treated from an artistic point of view. Annotated bibliography, p.xvi–xxiii. "The chronology of watches," p.349–67. Index, p.369–83.

P233  _____. Watchmakers and clockmakers of the world. 3d ed. London, N.A.G. Pr. [1951]. xxxv, 388p. maps. (Repr.: London, N.A.G., 1963).

1st ed. 1929; 2d ed. 1947.

The most important list of its type. An alphabetical list of watch and clockmakers who flourished up to 1825. For each artisan gives city, dates, type of clock or watch. Supplemented by: Loomes, Brian. *Watchmakers and clockmakers of the world* (P239a).

P234  Baillie, G. H., Clutton, C., and Ilbert, C. A., eds. Britten's old clocks and watches and their makers. A historical and descriptive account of the different styles of clocks and watches of the past in England and abroad containing a list of nearly fourteen thousand makers. 8th ed. London, Methuen [1973]. 532p. il. (part fold.)

First published as *Former clock and watchmakers and their work,* 1894. 1st ed., *Old clocks and watches,* 1899; 2d ed. 1904; 3d ed. 1911; 4th ed. 1920; 5th ed. 1922; 6th ed. 1933; 7th ed. 1956.

A new and substantially rev. ed. of Britten's fundamental work in horology. Includes appendixes: (I) Glossary of technical terms, (II) Hallmarks, (III) Bibliography, (IV) List of former clock and watchmakers. Indexed.

P235  Basserman-Jordan, Ernst von. The book of old clocks and watches. 4th ed. fully rev. by Hans von Bertele. N.Y., Crown [1964]. xii, 522p. il. (part col.)

German ed., *Uhren,* Braunschweig, Klinkhardt & Biermann, 1961.

A broad historic treatment of clocks and watches, useful to the connoisseur, collector, and amateur. Very good illustrations. Most valuable for German clocks. Long bibliography, p.495–503. Index, p.504–22.

P236  Clutton, Cecil, and Daniels, George. Watches. London, Batsford; N.Y., Viking [1965]. xvi, 159p. il.

A good general book on watches. Covers the period from the mid-16th to the mid-20th century. Emphasizes technical developments.

Contents: Pt. I, Historical; Mechanical 1500–1750; The precision watch 1750–1830; The modern watch 1830–1960. Pt. II, Performance of early watches. Pt. III, Technical. Pt. IV, Biographical notes, contains biographies of "makers or men who in some way advanced or influenced the progress of watchmaking."—*p.127.*

P237  Daniels, George, and Clutton, Cecil. Clocks and watches: the collection of the Worshipful Company of Clockmakers. London, Sotheby Parke Bernet, 1975. 160p. il. (part col.)

A new catalogue, superseding G. H. Baillie's 1949 catalogue of the collection, known to be one of the finest in the world. The entries are divided into three main categories: Watches, clocks, and miscellaneous. Each section has an historical and technical introduction. 200 of the pieces (out of 684) are illustrated. An essential reference work for horologists and collectors.

P238  Lloyd, Herbert Alan. The collector's dictionary of clocks. London, Country Life; South Brunswick, N.J., Barnes [1964]. 214p. il. (1 col.)

A well-illustrated dictionary of clocks of all types and clock makers. Bibliography, p.204–6; "Dictionary of horological terms," p.207–9.

P239  _____. Old clocks. 4th ed., rev. and enl. London, Benn [1970]. 216p. il.

1st ed. 1951; 2d ed. 1958; 3d ed. 1964.

413

A good general historical survey, useful for both the beginner and the expert. Good illustrations. Short bibliography, p.169-70; Appendix I, "Giovanni de Dondi's horological masterpiece 1364," p.171-201; Appendix II, "The original Greenwich clocks," p.202-5; "Note on symbols of measure in horology," p.206; Glossary, p.207-10; Index, p.211-16.

P239a Loomes, Brian. Watchmakers and clockmakers of the world; volume 2. London, N.A.G. [1976]. xiii, 263p.

Supplements G. H. Baillie, *Watchmakers and clockmakers of the world* (P233). Adds approx. 35,000 entries to Baillie's list, which brings the total number in both volumes to over 70,000. "This book contains entries of three distinct types; Firstly, makers from about 1820 to about 1875 (later in some instances) . . . ; Secondly, I have included any makers of any period who were men not known to Baillie; Thirdly, I have included some makers listed by Baillie where further information has since come to light that either extends the working period of the maker or occasionally corrects an error."—*Pref.*

P240 Wood, Edward J. Curiosities of clocks and watches from the earliest times. With a new introd. by Richard Good. [Wakefield, Eng.] EP Publishing, 1973. x, 443p. il.
1st ed. 1866.
    A history of European clocks and watches from their early appearance to c.1866. Documentation from inventories. Covers England and continental Europe with emphasis on England.

## Western Countries

### France

P241 Develle, Edmond. Les horlogers blésois au XVIe et au XVIIe siècle. Blois, Rivière, 1913. 373p. 18 plates.
2d ed. 1917.
    The definitive work on the clockmakers of Blois.

P242 Edey, Winthrop. French clocks. N.Y., Walker [1967]. 83p. il. (part col.) (Collectors' blue books)
An introduction to French domestic clocks produced from the Renaissance to the 18th century, written by an expert in the field. The last chapter contains advice to collectors. Good illustrations.

P243 Tardy. Dictionnaire des horlogers français, documentation réunie par Tardy. Avec l'apport des travaux de Paul Brateau. Paris, Tardy, 1971-72. 2v. il. (Collection Tardy. 125, 127)
The most comprehensive list of French clockmakers. An alphabetical listing of 23,000 names; includes 1,020 photographs, drawings, engravings, marks, signatures, and portraits.
Contents: v.1, A-K, v.2, L-Z.

P244 _____. La pendule française, des origines à nos jours; documentation recueillie auprès de nos penduliers. Paris, 1961-64. 3v. il. (Collection Tardy. 104, 106, 110).
Important for illustrations; unreliable attributions and dating.
    Pt. I: De l'horloge gothique à la pendule Louis XV; Pt.II: Du Louis XIV à nos jours; Pt. III: Provinces et étranger; Table alphabétique des horlogers et artistes dont les oeuvres sont reproduites; Adresses d'horlogers d'art, d'antiquaires et de réparateurs; Principaux musées possédant des pièces d'horlogerie.

P245 Thiout, Antoine. Traité de l'horlogerie mécanique et pratique. Suivi des lettres de Massoteau de Saint-Vincent et Julien Le Roy et de la réponse d'Antoine Thiout. Paris, Moette, 1741. 2v. (Repr.: Paris, Éditions du Palais Royal, 1972. 2v. in 1.)
The standard French technical work of the 18th century.

P246 Vial, Eugène, and Côte, Claudius. Les horlogers lyonnais de 1550 à 1650. Paris, Rapilly, 1927. vii, 253p. 12 plates.
The only book on watchmakers in Lyons, the great center in the 16th and 17th centuries. Still important.

### Germany

P247 Maurice, Klaus. Die deutsche Räderuhr: zur Kunst und Technik des mechanischen Zeitmessers im deutschen Sprachraum. München, Beck, 1976. 2v. il., col. plates.
A comprehensive, scholarly history of German mechanical clocks from the 13th to the 19th century.
    Contents, v.l, Text: I. Symbolische Bedeutung und Indikationen der Räderuhr; II. Monumentale astronomische Uhren; III. Planetarische Uhren; IV. Gehäuse und Werktypen des 16. Jahrhunderts; V. Zentren des Uhrmacherhandwerks bis zur Mitte des 17. Jahrhunderts; VI. Die technische Entwicklung von 1658-1815; VII. Die Uhren im 18. Jahrhundert; VIII. Produktion und Präzision in der Uhrenherstellung im 19. Jahrhundert; Personenregister; Sachregister. v.2 contains detailed descriptions and commentaries on the 18 color plates and 1,166 black-and-white illustrations.
    Bibliographical references in margin notes.

### Great Britain

P248 Cescinsky, Herbert. The old English master clockmakers and their clocks, 1670-1820. N.Y. and Toronto, Stokes [1938]. xii, 182p., il. (incl. ports.)
A good general history of English clockmaking and clock types. Many illustrations. No bibliography. Glossary of terms, p.[171]-79.

P249 Symonds, Robert Wemyss. A book of English clocks. Rev. ed. London, Penguin [1950]. 79p. il., 64 plates.
An especially good survey, particularly for the beginner.

## Italy

P250 Morpurgo, Enrico. Dizionario degli orologiai italiani (1300-1880). [Roma] "La Clessidra," 1950. 239p.
A dictionary of Italian clock and watchmakers active from 1300-1880.
Bibliography of 156 items, p.215-18. References at the ends of entries are keyed to the bibliography.

## Low Countries

P251 Morpurgo, Enrico. Nederlandse klokken- en horlogemakers vanaf 1300. Amsterdam, Scheltema & Holkema, 1970. 152p. il.
A dictionary of Dutch clock and watchmakers active from 1300 to the 20th century.
Bibliography, p.148-52.

P251a Sellinck, J. L. Dutch antique domestic clocks, c.1670-1870, and some related examples. Leiden, Kroese, 1973. vii, 367p.
A catalogue of the collection in the Oegstgeest Museum of Clocks. Among the subjects covered are clock movements made prior to Huygen's patent in 1657, Hague clocks, clockmaking in Amsterdam and Haarlem, Zaandam clocks, Groninger *stoelkloks,* Frisian *stoelkloks,* long-case clocks and *staartkloks.*
Bibliography, p.365.

## Scandinavia

P251b Sidenbladh, Elis Theodor. Urmakare i Sverige under äldre tider, anteckningar. 2., revid. och kompletterade uppl. Stockholm, Nordiska Museet, 1947. 256p. il. (Nordiska Museets handlingar, 28)
A dictionary of Swedish clock and watchmakers.
Bibliography, divided into published works and archival materials, p.15-17.

## Spain

P251c Montañés Fontenla, Luis. Relojes españoles. 2. ed., refundida y puesta al día, de Capítulos de la relojería en España, Relojes olvidados y Museo Español de Antiqüedades. Con "narracion" y "saludo" previos de Camilo José Cela. Madrid, Prensa Española, 1968. xvi, 352p. 145 plates (1 col.)
A scholarly history of Spanish clocks and clockmaking. Contents in four main sections: Relojes fuera de serie; La relojería en la corte; Panorama de la relojería en el Noroeste; Relojería popular catalana; Otros relojes y relojeros españoles.
Bibliographical references in footnotes. "Bibliografía básica," arranged chronologically, p.189-92. "Papeles de Simancas referidos a la Real Escuela de Relojería," p.193-96. "Bibliografía particular de esta edición," p.198. Index of names.

## Switzerland

P251d Jacquet, Eugène, and Chapuis, Alfred. Technique and history of the Swiss watch, by Eugène Jacquet and Alfred Chapuis with the co-operation of G. Albert Berner and Samuel Guye. London, N.Y., Spring, 1970. 272p. il., col. plates.
A comprehensive, authoritative history of watchmaking in Switzerland. Emphasizes technical rather than stylistic developments.
Contents: (1) The beginnings of watch-making in Switzerland; (2) The introduction of the watch industry to the Jura, and its development; (3) The 18th century; (4) Decoration of the watch and of the movement from 1700 to 1850; (5) The commerce of watch-making; (6) The 19th century and the beginnings of the mechanical manufacture of the watch; (7) Chronometry; (8) The later evolution of the modern watch; (9) Development of the Swiss watch industry from 1945 to 1968.
Index of Swiss watchmakers and other craftsmen up to 1900, p.268-72.

## United States

P252 Drepperd, Carl William. American clocks and clockmakers. 2d enl. ed. Boston, Branford, 1958. 312p. (52p. suppl.) il.
1st ed. 1947.
A facsimile reprint of the original ed. with a 52p. supplement listing additional clockmakers. Deals only with clocks produced and used in colonial America. Includes a list of 3,000 artisans, with their dates. Good illustrations. Glossary, p.295-312; bibliography, p.312.

P252a Yale University. Art Gallery. The American clock, 1725-1865; the Mabel Brady Garvan and other collections at Yale University. Essay and technical notes by Edwin A. Battison. Commentary by Patricia E. Kane. Foreword by Charles F. Montgomery. Introd. by Derek de Solla Price. Greenwich, Conn., New York Graphic Society [1973]. 207p. il.
An excellent catalogue of 41 clocks from the Garvan Collection and 7 clocks from other collections in the Art Gallery, Yale Univ. Catalogue in three parts: (1) Tall clocks (nos. 1-36); (2) Shelf clocks (nos. 37-44); (3) Wall clocks (nos. 45-48). Individual entries include place and date of manufacture, types of wood, dimensions, description, condition, provenance, and comments. Glossary, p.202.
Annotated bibliography, p.204-5.

## Oriental Countries

P253 Mody, N. H. N. A collection of Japanese clocks. London, Paul, Trench, Trubner, 1932. 46p. 136 plates.

415

(Repr.: Rutland, Vt., Tuttle, 1967, entitled *Japanese clocks.*)
The standard book on the subject, still unique. Short text (also in Japanese) introduces the plates, which are described in detail.

SEE ALSO: Kurz, O. *European clocks and watches in the Near East* (R73).

## POTTERY AND PORCELAIN

### Bibliography

P254 Campbell, James Edward, ed. Pottery and ceramics: a guide to information sources. Detroit, Gale [1978], xi, 241p. (Art and architecture information guide series, v.7)
"This bibliography is intended for the use of researchers, students, and individuals who have some basic knowledge of ceramic history and/or some technical knowledge of ceramic materials. . . . While answering the reference needs of a very broad range of readers, my text should be of principal benefit to the ceramic historian, collector, and artist."—*Pref.*
Contents: (1) Reference works; (2) General histories, dictionaries, and encyclopedias; (3) Ancient and Pre-Columbian ceramics; (4) Eastern ceramics; (5) Western ceramics: Greece to the Middle Ages; (6) Western ceramics: The Middle Ages to the 20th century; (7) Ceramics of the United States, Canada, and Mexico; (8) Contemporary world ceramics; (9) Ceramic collections; (10) Ceramic marks; (11) Technical works on ceramic materials and processes; (12) Ceramic periodicals; (13) Ceramic organizations and societies; (14) Museum collections in the United States. Author index; Title index; Subject index.

P255 Champfleury, Jules Fleury Husson. Bibliographie céramique; nomenclature analytique de toutes les publications faites en Europe et en Orient sur les arts et l'industrie céramiques depuis le XVIe siècle jusqu'à nos jours. Paris, Quantin, 1881. 352p.
A classified bibliography. Does not include Greek, Roman, or Gallo-Roman ceramics.
Pt. 1, "Bibliographie générale," arranged alphabetically by author. Pt. 2, "Bibliographie des ouvrages sur le céramique publiés chez les divers peuples," arranged by countries and then subdivided according to a scheme shown in the table of contents, p.35–52. Items in pt. 2 are annotated.

P256 Solon, Louis Marc Emmanuel. Ceramic literature: an analytical index to the works published in all languages on the history and the technology of the ceramic art; also to the catalogues of public museums, private collections, and of auction sales, in which the descriptions of ceramic objects occupy an important place; and to the most important price-lists of the ancient and modern manufactories of pottery and porcelain. London, Griffin, 1910. 660p.

Contents: pt. 1, Author list with annotations; pt. 2, Classified list of the same works, p.475–649.
Bibliography, p.623–26.
————. List of books on the history and technology of the ceramic art. A supplement to ceramic literature. (Ceramic Society, Stoke-on-Trent, Eng. *Transactions,* VI, 1911–12, p.[65]–104. London, 1911.)

## Histories, Handbooks, Dictionaries and Encyclopedias, Collections

P257 Barber, Edwin Atlee. The ceramic collectors' glossary. N.Y., Printed for the Society, 1914. 119p. il. (Repr.: N.Y., Da Capo, 1967.)
At head of title: The Walpole Society.
"It is not claimed that the list of terms here presented is exhaustive; rather has it been considered sufficient to limit the number to those which are most likely to be needed in the work of cataloguing public and private collections." —*Pref.* Includes primarily English language terms.

P258 Boger, Louise Ade. The dictionary of world pottery and porcelain. N.Y., Scribner [1971]. viii, 533p. il. (part col.)
A collector's guide to ceramics, arranged in dictionary format. Includes line drawing illustrations and reproductions of marks in the margins. Photographs, p.385–[484], in general arranged chronologically. Notes on the photographs, p.485–524.
Classified bibliography, p.525–33.
Part of the material in this volume first appeared in the author's *Dictionary of antiques and the decorative arts* (P12).

P259 Burton, William. A general history of porcelain. With thirty-two plates in colour and eighty in black and white. London, N.Y., Cassell, 1921. 2v. il., plates (part col.)
A comprehensive survey of Chinese, Japanese, Persian, Italian, Spanish, Portuguese, French, English, German, Norwegian, Swedish, and other European porcelains. Bibliography, v.2, p.207–8.

P260 Caiger-Smith, Alan. Tin-glaze pottery in Europe and the Islamic world; the tradition of 1000 years in maiolica, faience & delftware. London, Faber and Faber [1973]. 236p. 189 il., 23 col. plates.
The only comprehensive work on the subject. Traces the "tin-glaze tradition from 9th-century Iraq to lustre wares of Southern Spain, Majolica, North European Delft, *faience fine,* 19th-century peasant survivals and 20th-century sophisticated revivals . . . Mr. Caiger-Smith writes from the viewpoint of a working potter."—Gerald Reitlinger, *Burlington magazine* 116:543–44, Sept. 1974. Very well illustrated.
Appendixes: (A) Blended clay-bodies; (B) Glaze recipes; (C) Lead poisoning; (D) Dutch glaze recipes; (E) Practical comments. Bibliography, p.[226]–28.

P261 Chaffers, William. Marks and monograms on European and Oriental pottery and porcelain. The British section ed. by Geoffrey A. Godden. The European and Oriental sections ed. by Frederick Litchfield & R. L. Hobson. 15th rev. ed. London, Reeves [1965]. 2v. il.

A standard handbook. v.1 covers continental Europe and the Orient; v.2 is concerned with the pottery and porcelain of Great Britain.

v.1 contains bibliographies at the end of some regional sections. Bibliography on British pottery and porcelain, v.2, p.328-32. "Notes on the auction prices of ceramics," v.2, p.[339]-45. "Quotations from auctioneers' catalogues of sales of representative specimens of English ceramics during fifty-five years," v.2, p.[343]-81. "Advice to collectors," by Frederick Litchfield, v.2, p.[382]-86.

Index to both volumes at the end of v.2.

P262 Charles, Rollo. Continental porcelain of the eighteenth century. London, Benn [1964]. 198p. 76 plates (12 col.), map.

A brief survey of 18th-century continental porcelain. Intended primarily for the collector.

Contents: (1) Porcelain in the 18th century; (2) The materials; (3) Making and decorating porcelain; (4) The porcelain trade; (5) Porcelain figures; (6) Meissen: Boettger; (7) Meissen: Herold; (8) Meissen: Kaendler; (9) Meissen: 1750 onwards; (10) Independent decorators; (11) Vienna; (12) Höchst; (13) Fürstenberg; (14) Berlin; (15) Nymphenberg; (16) Frankenthal; (17) Ludwigsburg; (18) Other factories in Germany; (19) Switzerland; (20) Rouen and St. Cloud; (21) Chantilly; (22) Mennecy; (23) Vincennes-Sèvres: History; (24) Vincennes-Sèvres: Productions; (25) Tournai; (26) Other French factories; (27) Holland; (28) Scandinavia and Russia; (29) Medici porcelain; (30) Venice and North Italy; (31) Doccia; (32) Capodimonte, Madrid, Naples.

Bibliography, p.187.

P263 Charleston, Robert J., ed. World ceramics, an illustrated history. N.Y., McGraw-Hill [1968]. 352p. 1,019 il., col. plates, maps, facsims.

A comprehensive, introductory survey of Western and Eastern ceramics from antiquity to modern times; various sections written by leading authorities in their respective fields.

Contents: Introduction, by R. J. Charleston; (I) The ancient world; (II) The Far East; (III) The lands of Islam; (IV) Europe: the lead-glaze tradition and salt-glazed stoneware; (V) Europe; the tin-glaze tradition; (VI) European porcelain; (VII) Staffordshire and the rise of industrialism; (VIII) The modern world; (IX) The primitive world. Glossary of terms, p.345; Glossary of marks, p.346-47.

Bibliography, p.8.

P264 Cox, Warren E. The book of pottery and porcelain. 3,000 illustrations. Pictures selected by the author. Lay-outs by A. M. Lounsberg. Rev. ed. N.Y., Crown [1970]. 2v. (xvi, 1158p.) il., maps.

1st ed. 1944.

A reliable, comprehensive survey of Western and Eastern pottery and porcelain. Contains illustrations for over 3,000 examples. "Definitions," v.1, p.xiii-xvi. "The marks of potteries and porcelains," v.2, p.1079-1150, includes an index of marks arranged geographically and a section of reproductions of marks.

P265 Cushion, J. P., and Honey, W. B. Handbook of pottery and porcelain marks. [3d ed., rev.]. London, Faber and Faber; Boston, Boston Book and Art Shop [1965]. 477p. maps. (The Faber monographs on pottery and porcelain)

1st ed. 1956.

"Comprehensive and detailed reference work of pottery and porcelain marks, including many 19th and 20th century marks not recorded previously, arranged alphabetically by country. Text gives brief history of ceramic arts in each country; entries include dates of marks, types of ware, names of proprietors if known and chronological sequence of marks. Invaluable reference tool."—*Decorative arts,* A56, H5.

General index, p.451-77.

P266 Danckert, Ludwig. Handbuch des europäischen Porzellans. 3. durchgesehene und erweiterte Auflage. München, Prestel, 1974. xiv, 357 (115)p. il.

1st ed. 1954; 2d ed. 1967. Also published in a French ed.: *Manuel de porcelaine européenne,* Fribourg, Office du Livre.

A comprehensive handbook of marks on European porcelain. Contents in two main sections: (I) Lexikon der Stichworte (über 2,000 Stichworte), p.1-330. Anhang I, Sèvres-Künstler mit Signaturen. Anhang II, Nachtrag: (II) Katalog der Porzellan Marken (über 3500 Marken).

Bibliography, p.ix-xiv.

P267 Ducret, Siegfried. Keramik und Graphik des 18. Jahrhunderts; Vorlage für Maler und Modelleure. Mit 422 Abbildungen. Braunschweig, Klinkhardt & Biermann [1973]. vii, 215p. 422 il. on 157 plates, facsims.

A brief study of 18th-century German, Dutch, and French prints used as sources of painted decoration on porcelain and models for porcelain figures. Introductory texts are followed by excellent reproductions of porcelains and their sources of print designs.

Contents: (1) Einleitung; (2) Das Farbenarcanum; (3) Der Motivraub; (4) Vorlagen für Maler und Modelleure; (5) Schlussbetrachtung.

Notes, p.37-38, include bibliographical references.

P268 Eberlein, Harold Donaldson, and Ramsdell, Roger Wearne. The practical book of chinaware. With 202 halftone illustrations including 13 in full color, and numerous drawings. Rev. ed. Philadelphia, Lippincott [1948]. 320p. il., 120 plates (part col.)

1st ed. 1925.

An introductory work primarily for the collector. "Attempts to present the essential facts regarding china or porcelain from the beginning of its manufacture to 1840. This book deals only with such china as the person of average means can expect to have, either by way of inherited ownership or by purchase."—*Foreword.*

Bibliography, p.307-10.

P269   Graesse, Johann Georg Theodor, and Jaennicke, E. F. Führer für Sammler von Porzellan und Fayence, Steinzeug, Steingut usw. Umfassendes Verzeichnis der auf älterem und neuerem Porzellan, Fayence, Steingut usw. befindlichen Marken. Umgearb. von E. Zimmermann. Letzte Neubearbeitung von Arthur Behse und Luise Behse. 21. Aufl. Braunschweig, Berlin, Klinkhardt & Biermann [1967]. 736p. il.
Originally pub. in French: Dresden, Schönfeld, 1864.

An old standard handbook of pottery and porcelain, updated through numerous revisions. Arranged by countries. Also published in French editions as: *Graesse-Jaennicke, guide de l'amateur de porcelaines et de faïences*.
Bibliography, p.709-16.

P270   Haggar, Reginald G. The concise encyclopedia of continental pottery and porcelain. London, Deutsch; N.Y., Hawthorn [1960]. 533p. il., plates (part col.), facsims. (Reissued: N.Y., Praeger, 1968.)
A useful handbook of European pottery and porcelain production. A companion volume to the author's *Concise encyclopedia of English pottery and porcelain* (P332).

Contents: A selection of impressed and incised marks, p.16-17; The concise encyclopedia of continental pottery and porcelain, p.[21]-520.
Extensive classified bibliography, p.523-33.

P271   Hannover, Emil. Pottery and porcelain, a handbook for collectors. Ed. with notes and appendixes by Bernard Rackham. London, Benn, 1925. 3v. il., col. plates, maps.
Trans. of *Keramisk Haandbog*, 1921-24.

A standard earlier work. Contents: (1) Europe and the Near East, earthenware and stoneware [tr. by B. Rackham]; (2) The Far East [tr. by W. W. Worster]; (3) European porcelain [tr. by W. W. Worster].

Each volume contains bibliography and indexes: (1) persons and private collections; (2) countries, places, factories, and public collections; (3) subjects, technique, and terminology.

P272   Hillier, Bevis. Pottery and porcelain, 1700-1914: England, Europe and North America. N.Y., Meredith [1968]. 386p. il., plates (part col.) (The Social history of the decorative arts)
An erudite, readable survey of European and American pottery and porcelain produced in the period 1700-1914. Emphasizes the social and economic aspects in the development of ceramics rather than stylistic factors. Imaginatively illustrated.

Contents: (1) Social status of the potter; (2) The end of the Baroque; (3) Porcelain; (4) The Rococo; (5) Folk pottery; (6) Wedgwood neo-classicism and the Industrial Revolution; (7) The French Revolution; (8) North America; (9) Marketing; (10) Revival—Gothic and otherwise; (11) Artist potter in England; (12) Collectors; (13) Repairs, reproductions, and fakes; (14) Art Nouveau.
Notes, p.341-60, include references. Bibliography, p.361-68.

P273   Hofmann, Friedrich Hermann. Das Porzellan der europäischen Manufakturen im XVIII Jahrhundert; eine Kunst- und Kulturgeschichte. Berlin, Propyläen [1932]. 537p. il., (incl. plans, facsims.), 24 plates (part col.)
A scholarly, comprehensive history of European porcelain in the 18th century. Includes a section of facsimile reproductions of marks.
General index.

P274   Honey, William Bowyer. European ceramic art, from the end of the Middle Ages to about 1815. London, Faber and Faber [1952-63]. 2v. il., plates (part col.)
v.1, 1st ed., 1949. v.1, 2d ed., 1963, *Illustrated historical survey*, text rev. by Arthur Lane.

v.1 consists of an introductory survey, p.17-47, with references in the margins to the plates. v.2, *A dictionary of factories, artists, technical terms, etc.*, contains an "account [in dictionary form] of the meaning and significance of the words and names likely to be met with in the study of European ceramic art."—*Pref.* Includes information on factories, types of ceramic wares, artists, techniques, and collectors; often includes marks and bibliography.
General bibliography, v.2, p.17-27. Index to marks, p.683-788.

P275   Jedding, Hermann. Europäisches Porzellan. Band I. Von den Anfängen bis 1800. 2. korrigierte Aufl. München, Keyser [1974-]. v.1. (504p.) il. (part col.)
1st ed. 1971.

A comprehensive reference volume on European ceramics from their origins to 1800. Contents in four parts: (I) Einführung (a nine-page survey); (II) Lexikon A-Z, Künstler—Manufakturen—Fachwörter; (III) Bildlexikon: Deutschland; Belgien; Dänemark; England; Frankreich; Italien; Niederlande; Russland; Schweden; Schweiz; Spanien; (IV) Anhang: Markenindex; Berühmte Porzellan-Sammlungen; Spitzenpreise für Porzellan auf internationalen Auktionen 1965-70; Literaturhinweise, p.IV/36-7.

"Lexikon" entries include reproductions of marks, references to illustrations, and often bibliography.

P276   Minghetti, Aurelio. Ceramisti. Milano, E. B. B. I., Istituto Editoriale Italiano B.C. Tosi [1939]. 451p. il., plates (part col.), facsims. (Enciclopedia biografica e bibliografica "Italiana," serie XLI)
A dictionary of ceramics makers from the 11th century to the 20th century. Bibliographical references at the end of most entries.

P276a   Neuwirth, Waltraud. Porzellanmaler Lexikon, 1840-1914. Braunschweig, Klinkhardt & Biermann [1977]. 2v. il. (part col.) (Bibliothek für Kunst- und Antiquitätenfreunde. Bd. 49)
A dictionary of European porcelain painters working from 1840-1914. An introductory historical survey of the period (p.1-87) is followed by the dictionary of porcelain painters. Entries include biographical data, references, and sometimes reproductions of marks and illustrations of pieces.

Contents: v.1, Aaron-Juuel; v.2, Kabareau-Zwintscher. "Abkürzungsverzeichnis für den Quellennachweis (gleichzeitig Bibliographie)," v.1, p.89-95. "Markentafeln," v.2, p.371-84.

P277 Savage, George, and Newman, Harold. An illustrated dictionary of ceramics; defining 3,054 terms relating to wares, materials, processes, styles, patterns, and shapes from antiquity to the present day. With an introductory list of the principal European factories and their marks, comp. by John Cushion. London, Thames & Hudson [1974]. 319p. il. (part col.)
"This book is primarily a dictionary of terms—nouns, verbs, adjectives, and descriptive names and phrases—encountered in the world of ceramics. This dictionary ... deals with potting, painting, and pieces, rather than with potteries, places, and people."—*Pref.* Includes terms which relate to both Western and Eastern ceramics and which range in date from antiquity to the present. Extensive cross-referencing.
Principal European factories and their marks, p.[7-18].

P278 Schnorr von Carolsfeld, Ludwig. Porzellan der europäischen Fabriken. 6. von Erich Köllmann völlig neu bearb. Aufl. Braunschweig, Klinkhardt & Biermann, 1974. 2v. (v.1, 372p.; v.2, 336p.). 478 il. (68 col.) (Bibliothek für Kunst- und Antiquitätenfreunde, Bd. 3, 4)
At head of title: Ein Handbuch für Sammler und Liebhaber.
1st ed. 1912, and subsequent editions published as: *Porzellan der europäischen Fabriken des 18. Jahrhunderts.*
A well-illustrated, general history of European porcelain. Concentrates on the development of porcelain in the 18th century and gives fullest treatment to German centers of production.
Contents: v.1, Meissen; Wien; Berlin; Fürstenberg; Höchst. v.2, Frankenthal; Ludwigsburg; Nymphenburg; Die kleinen deutschen Porzellanfabriken; Böhmen; Hausmaler; Französisches Porzellan; Schweizer Porzellan; Englisches Porzellan; Italienisches und spanisches Porzellan; Holländisches Porzellan; Belgisches Porzellan; Dänisches Porzellan; Schwedisches Porzellan; Russisches Porzellan; Polen; Ungarn.
Bibliographies and indexes at the ends of both volumes. Bibliographical references in notes sections.

## Techniques

P279 Leach, Bernard Howell. A potter's book; with introductions by Soyetsu Yanagi and Michael Cardew. London, Faber and Faber [1940]. xxvii, 293p. il., plates (part col.) (Repr.: N.Y., Transatlantic Arts, 1970.)
A fundamental work on the design and technique of Eastern and Western pottery, written by a distinguished British potter. Well illustrated with diagrams and plates. Appendix: Potter's terms, tools and materials, p.261-63.

P280 Parsons, Claudia Sydney Maria, and Curl, F. H. China mending and restoration. London, Faber and Faber [1963]. 435p. il.
A detailed work on the techniques of mending and restoring china. "This book is written not only for the beginner and semi-experienced, but also for the professional mender." —*p.19.*
Contents: pt. 1, Riveting; pt. 2, Restoring; pt. 3, Overpainting, gilding and glazing; pt. 4, Glass repair. Information on tools and equipment is given at the end of each part.
Classified bibliography, p.421-26.

P281 Rhodes, Daniel. Clay and glaze for the potter. [Rev. ed.]. Philadelphia, Chilton [1973]. xix, 330p. il. (part col.)
1st ed.: N.Y., Greenberg [1957].
A handbook of detailed technical information on the materials and methods used in firing and glazing pottery. Illustrated with historical examples as well as contemporary pieces to demonstrate techniques.
Bibliography, p.325.

P282 Searle, Alfred Broadhead. An encyclopedia of the ceramic industries, being a guide to the materials, methods of manufacture, means of recognition, and testing the various articles produced in the clay-working and allied industries. Arranged in alphabetical order for rapid reference. London, Benn, 1929-30. 3v. il., tables, diagrs.
More useful for technical than for historical information.
Works of reference, with symbols, v.1, p.xi-xxvii.

## Ancient

### Western Asia

P283 Amiran, Ruth. Ancient pottery of the Holy Land; from its beginnings in the Neolithic period to the Iron Age. With the assistance of Pirhiya Beck and Uzza Zevulum. [New Brunswick, N.J.] Rutgers Univ. Pr., 1970. 305p. il., map.
Trans. from the Hebrew.
A chronological arrangement of pottery from the 6th century B.C. to c.586 B.C. Classification by shape and size. Intended for archaeologists. Many bibliographical references.

### Classical World

#### Greece

P284 Edwards, G. Roger. Corinthian Hellenistic pottery. Princeton, The American School of Classical Studies at Athens, 1975. 254p. 86 plates. (Corinth; results of excavations conducted by the American School of Classical Studies at Athens, v.7, pt. 3)
A comprehensive study, the main purposes of which are the presentation, classification, and the establishment of the chronology of Hellenistic Corinthian pottery. "The pottery studied in this volume is Corinthian only, or what is believed

to be Corinthian: shape series or other entities believed to have been in production at Corinth during the Hellenistic period, or rather a part of it, from the time of Alexander the Great to the time of the destruction of Corinth by Mummins in 146 B.C."—*p.[1]*.

Contents: General introduction; Conspectus of the pottery; The pottery (vessels for food, vessels for drink, vessels for other purposes, etc.); Deposits and chronology. Concordance I: Corinth inventory numbers: Publication numbers or page references. Concordance II: Publication references: Publication numbers or page references. Index I: Graffiti, dipinti, and moulded inscriptions. Index II: General index. Extensive bibliographical references.

P285   Lacy, A. D. Greek pottery in the Bronze Age. London, Methuen [1967]. xv, 303p. col. front., il., 4 col. plates, 4 maps.
A concentrated study of Bronze Age pottery in Crete, mainland Greece, and the Cyclades. Contents: (1) The Neolithic era, 6600-3000 B.C.; (2) The Minoan era, 3000-1100 B.C.; (3) The Helladic era; (4) The Mycenaean era, 1580-1100 B.C.; (5) The Cyclades and Cycladic pottery in the Bronze Age; (6) The Dorian invasion, 1200-1100 B.C.
Unclassified bibliography, p.288-90.

P286   Lane, Arthur. Greek pottery. [3d ed.]. London, Faber and Faber [1971]. 64p. 96 plates (8 col.) (Faber monographs on pottery and porcelain.)
"A book for amateurs (taken in the best sense) but written by an expert, and with excellent, carefully chosen illustrations."—J. H. Young, *American journal of archaeology* 73:385. Bibliography, p.91-61.

SEE ALSO:   Entries under Painting—Ancient—Crete, Mycenae, and Greece (M54-M74).

*Rome*

P287   Charleston, R. J. Roman pottery. London, Faber and Faber [1955]. xv, 48p. il., 100 plates (4 col.)
The basic survey of the principal types of Roman pottery; written by an authority on ceramics rather than an archaeologist.
Contents: (1) Introduction; (2) Red-gloss pottery; (3) Glazed pottery; (4) 'Coarse' pottery. Table of shapes, p.40. Bibliography classified within chapter subjects, p.41-4. Bibliographical references in footnotes. General index.

P288   Hayes, J. W. Late Roman pottery. London, The British School at Rome, 1972. 477p. il., plates, maps.
"The fine tablewares produced and used in the Mediterranean provinces of the Empire between the second and the seventh century A.D., in part the red-slipped products of North African factories and the various imitations of them which were dominant throughout the period, constitute the main subject of this study."—*Introd.*
Contents: (I) Introduction; (II) African red slip ware; (III) Other African wares; (IV) African lamps; (V) Çandarli ware; (VI) 'Late Roman C' ware; (VII) Cypriot red slip ware; (VIII) Egyptian red slip wares; (IX) Gaulish 'T.S.

grise'; (X) Other late Roman wares; (XI) Distribution; Conclusion. Appendixes: (1) Late Roman pottery: site bibliography, p.428-45; (2) African red slip ware: concordance of vessel forms, p.446-48; (3) Late Roman pottery; concordance of stamp types on main wares, p.449-50. Maps: (A) 1-18, distribution by sites; (B) 19-36, approximate main areas of distribution; (C) 37-40, site locations. Select bibliography and abbreviations, p.xix-xxv.

## Islamic

P289   Butler, Alfred Joshua. Islamic pottery; a study mainly historical. London, Benn, 1926. xxv, 179p. 92 plates (part col.)
A scholarly history of Islamic pottery to the 16th century. Especially valuable for its treatment of Egyptian lustre ware, as well as of the pottery of Spain, North Africa, Persia, and Turkey. Excellent plates. Bibliography, p.xxi-xxiv.

P290   Fehérvári, Géza. Islamic pottery; a comprehensive study based on the Barlow Collection; with a foreword by Sir Harry Garner. London, Faber and Faber [1973]. 191p. il. (part col.), 120 plates, map.
A catalogue and study of the Barlow Collection of Iranian and Turkish Islamic pottery, the more than 300 pieces of which are now divided among several institutions and individuals. In order to present a comprehensive survey, nine pieces from outside the Barlow Collection are included.
Contents in three main sections: (I) The early Islamic period; (II) The medieval Islamic period; (III) The later Islamic period.
Bibliography, p.181-83. Bibliographical references in footnotes.

P291   Freer Gallery of Art, Washington, D. C. Ceramics from the world of Islam, by Esin Atil. Wash., D.C., Smithsonian Institution, 1973. viii, 225p. il. (part col.), map. (Fiftieth anniversary exhibition, v.3)
The book-catalogue of an exhibition shown at the Freer Gallery of Art in 1973.
Following an 11p. introductory essay are 101 detailed catalogue entries for ceramic pieces, most of which are from Iran. "The main concern of this catalogue is to present a number of pieces which have not been previously published or studied and to provide a complete physical description of each object with the hope that such information may assist future studies."—*Pref.* Entries include bibliographical references and references to comparative pieces.
Appendixes: (I) Notes on the inscriptions; (II) Notes on the colors of paste. Bibliographical references in footnotes.

P292   Grube, Ernst J. Islamic pottery of the eighth to the fifteenth century in the Keir Collection. London, Faber and Faber [1976]. 378p. il., col. plates.
A scholarly study of 264 pieces of Islamic pottery of the 8th to the 15th century in the Keir Collection, one of the most important collections formed in recent years. Catalogue information about each object is given in the notes to the illustrations, and each object is discussed in the main text.

"Objects are grouped together according to their affiliation with countries, schools of ceramic-making and type of decoration, and the general problems posed by these groups as well as by individual pieces within each group have been made the principal subject of the discussion. Questions of iconography, stylistic development, and the meaning of both the form and the decoration of ceramic objects have taken precedence over the discussion of attributions, dates and the identification of technical details."—*Introd.*

The extensive bibliography, p.[305]-74, is in two main sections: pt. I, General bibliography; pt. II, Classified bibliography. "This bibliography is also a first step in an attempt to create an annotated, critical bibliography of the subject which will list everything published and will give a detailed account of each individual publication. Such a bibliography ... is in active preparation at the Oriental Institute in Naples."—*A note on the bibliography,* p.[305].

P293  Lane, Arthur. Early Islamic pottery: Mesopotamia, Egypt and Persia. London, Faber and Faber [1947]. xi, 52p. [100] plates (part col.) (Faber monographs on pottery and porcelain)

Reissued subsequent to 1947 in slightly revised editions.

Remains the best general survey of Islamic pottery from its beginnings to c.1300. The author's *Later Islamic pottery* (P294) is a sequel to this work.

Contents: (1) The Islamic scene; (2) The Umayyad caliphs (661–750 A.D.): the sources of Islamic ornament: and earlier contributions to the potter's technique; (3) First contacts with China: the Abbasid school of Mesopotamia in the 9th and 10th centuries; (4) Painted wares of the Samarkand region and Persia; (5) Egyptian lustre-painted and carved pottery of the Fatimid period (969–1171); (6) Common pottery: the ceramic underworld of Islam; (7) The Saljuq Turks and the new epoch of pottery in Persia; (8) Saljuq carved, moulded, and silhouette-painted pottery: 12th–13th centuries; (9) Persian and Mesopotamian lustre-painted wares: 12th–13th centuries; (10) The 'Minai' and 'Lajvardina' painted wares of Persia: 12th–14th centuries; (11) Underglaze painting: Egypt, Mesopotamia, and Persia: 12th–13th centuries.

Bibliography, p.49.

P294  _____. Later Islamic pottery: Persia, Syria, Egypt, Turkey. 2d ed. [rev. by Ralph Pinder-Wilson]. London, Faber and Faber, 1971. xvi, 133p., 100p. [8] l. il. (part col.), map. (Faber monographs on pottery and porcelain)

1st ed. 1957.

Continues the author's *Early Islamic pottery* (P293).

Contents: (1) The 14th-century Mongol style; (2) 15th-century blue-and-white; (3) Turkish pottery; (4) Persia: Safavid period (1502-1722) and later; (5) Late Persian polychrome wares; (6) Late Persian blue-and-white; (7) Late Persian lustre-painted ware; (8) Late Persian monochrome wares; (9) Marks.

Appendix: Extracts from contemporary writers referring to late Persian pottery. Classified bibliography, p.124-27; bibliographical references in footnotes.

P295  Wilkinson, Charles Kyrle. Nishapur: pottery of the early Islamic period. [N.Y.] Metropolitan Museum of Art. (Distr. by New York Graphic Society, Greenwich, Conn. [1973].) xlii, 374p. il. (part col.), map.

A detailed study and catalogue of the pottery of the ancient city of Nishapur up to the early 13th century excavated by the Metropolitan Museum of Art in 1935–40 and 1947, along with a few examples from other traceable sources. "The intention is to present, in as practical a manner as possible, a sufficient body of authentic material to represent truly what was used in Nishapur in ancient times."—*Introd.* Superbly illustrated with photographic reproductions and numerous line drawings.

Catalogue entries are arranged by types of wares: (1) Buff ware; (2) Color-splashed ware: (3) Black on white ware; (4) Polychrome on white ware; (5) Slip-painted ware with colored engobe; (6) Opaque white ware and its imitations; (7) Opaque yellow ware; (8) Ware with yellow-staining black; (9) Monochrome ware; (10) Chinese wares; (11) Alkaline-glazed ware and its molds; (12) Unglazed ware.

Bibliography, p.371-74.

# Western Countries

### Canada

P296  Collard, Elizabeth. Nineteenth-century pottery and porcelain in Canada. Montreal, McGill Univ. Pr., 1967. xx, 441p. il.

An indispensable, detailed study of the limited native production of pottery and porcelain in Canada in the 19th century, set against the far greater quantities of imported wares. Based on an extensive and meticulous examination of original sources.

Contents: The tide of imports: toils and hazards; How pottery and porcelain were sold; The earthenwares; The porcelains; Printed earthenware with Canadian views and emblems; Canadians compete. Appendixes: (A) Concerning marks; (B) A check of 19th-century Canadian potters.

Notes, p.407-30, contain bibliographical references.

P297  Webster, Donald Blake. Early Canadian pottery. Greenwich, Conn., New York Graphic Society [1971]. 256p. il. (part col.)

A well-illustrated survey of pottery in Canada from the colonial period through the 19th century. Intended primarily for the collector.

Contents: (1) The production of earthenware; (2) Quebec—the French period; (3) Quebec—the late 18th and 19th centuries; (4) Ontario earthenware; (5) Earthenware of the maritimes; (6) Miniatures, toys and whimseys; (7) Salt-glazed stoneware; (8) Manufacturing—Rockingham and yellow-ware; (9) Whiteware and porcelain; (10) The archaeology of potteries.

Glossary, p.247-48. Bibliography, p.249-50.

**France**

P298    Chavagnac, Xavier Roger Marie, *comte* de, and
Grollier, Gaston Antoine, *marquis* de. Histoire des
manufactures françaises de porcelains, précédée
d'une lettre de M. le marquis de Vogüé. Paris, Picard,
1906. 966p. il.

An old standard work. "Liste par ordre alphabétique des
propriétaires, chefs d'atelier, décorateurs, peintres et
marchands de Paris," p.814-55. "Table alphabétique des
noms," p.859-86. "Table des marques," p.887-966.

P299    Dauterman, Carl Christian. Sèvres. N.Y., Walker
[1969]. 84p. 52 il., 2 col. plates. (Collector's blue
books)

An excellent brief study of Sèvres porcelain manufacture
from its beginnings in 1738 to present times. Bibliography,
p.[65].

P300    Fourest, Henry Pierre, and Giacomotti, Jeanne.
L'oeuvre de faïenciers français du XVIe à la fin du
XVIIIe siècle. [Paris] Hachette [1966]. 327, [5]p. il.
(part col.) (Collection Connaissance des arts "Grands
artisans d'autrefois")

An historical survey of French faïence from the 16th century
to the end of the 18th century. Superbly illustrated with the
finest examples of representative types from European and
American collections. Includes illustrations of many
comparative works and sources of decoration designs.

Contents: Les origines de la faïence française; Le style
Louis XIV; Le style Louis XV—La faïence de grand feu; Le
style Louis XV—La faïence de petit feu; Répertoire des
principales manufactures françaises avec leurs marques.

Bibliography, p.[328-29].

P301    Giacomotti, Jeanne. French faience. [Trans. by
Diana Imber]. N.Y., Universe Books [1963]. 267p.
il., col. plates.

Trans. of *Faïences françaises,* Fribourg, Office du Livre,
1963.

An historical outline of the development of French faïence
through the 17th and 18th centuries. Many of the pieces
illustrated are from provincial French museums, as well as
from private collections and foreign museums. Superb
illustrations.

Contents: Pt. 1, Faience in France, origins and technique;
Primitive faience; Nevers and the Loire Valley; Rouen and
Normandy; Brittany; Paris and the surrounding factories;
The northern and eastern districts; The central region;
Provence; The south-east region; The south-west region;
Charente; Pt. 2, Strasbourg; Niderviller; Marseille; Aprey;
Meillonas; Sceaux.

Bibliography, p.258. Marks, p.259-63.

P302    Honey, William Bowyer. French porcelain of the
18th century. 2d ed. London, Faber and Faber, 1972.
xv, 79, [104]p. il. (8 col.) (Faber monographs on pot-
tery and porcelain)

1st ed. 1950.

An introductory survey of 18th-century French porcelain
and its centers of production with primary emphasis on the
earlier soft-pastes.

Contents: Introduction; Rouen; Saint-Cloud; Chantilly;
Mennecy, Sceaux and Bourg-la-Reine; Vincennes and
Sèvres; Other soft-pastes: Tournay, Arras and Saint-Amand-
Les-Eaux; Strasburg and other factories in the east of
France; Paris and miscellaneous factories making hard-paste;
Forgeries; Marks; Miscellany.

Bibliography, p.70-71.

P303    Lane, Arthur. French faïence. 2d ed. London, Faber
and Faber; N.Y., Praeger [1970]. xi, 51p., il. (8 col.),
104 plates. (The Faber monographs on pottery and
porcelain)

1st ed. 1948.

A brief, authoritative survey; useful primarily to the
exclusively English language reader.

Contents: (1) The technical nature of faïence; (2) The
medieval beginnings; (3) Italian modes in the 16th century;
(4) 'Faïence blanche' made for common use; (5) Nevers in
the 17th century; (6) Faïence as a fine art; a prelude to the
18th century; (7) Rouen and the factories of the north; (8)
Moustiers and Marseilles: the factories of the south; (9)
Strasburg and the factories of eastern France; (10) Aprey,
Meillonas, and Sceaux.

Bibliography, p.45.

P304    Paris. Musée des Arts Décoratifs. Répertoire de la
faïence française, publié à l'occasion de "L'Exposition
retrospective de la faïence française" au Musée des
Arts Décoratifs, sous la direction de Dr. Chompret
... Jean Bloch ... Jacques Guérin, Paul Alfassa.
Paris, Lapina, 1933-35. 6v. 610 plates in 5 portfolios
and 1v. of text.

A corpus of excellent plates which illustrate French faïence
from the 16th to the beginning of the 19th centuries. Includes
notes on factories, arranged alphabetically by place. Sizes
of pieces illustrated are given on guard sheets. Contents:
v.1-5, Plates; v.6, Text.

Bibliography, p.287-88.

P305    Les porcelainiers du XVIIIe siècle français. Préf. de
Serge Gauthier. [Conçu et réalisé par Claude Frégnac,
photos de Jean-Pierre Sudre et Michel Nahmias. Paris]
Hachette [1964]. 333, [3]p. il. (part col.), facsims.
(Collection Connaissances des arts "Grands artisans
d'autrefois")

A pictorial survey of 18th-century French porcelain, superbly
illustrated with pieces from European and American
collections. Texts are written by authorities in the respective
fields covered.

Contents: Introduction, d'André Sergène; La manufacture
de Rouen et les débuts de la porcelaine française, texte de
Roger-Armand Weigert; La manufacture de Saint-Cloud,
texte de Roger-Armand Weigert; La manufacture de
Chantilly, texte de Philippe Chapu; La manufacture de
Mennecy, texte de Georges Poisson; La manufacture de
Vincennes puis de Sèvres, texte de George Poisson; La
manufacture de Vincennes puis de Sèvres, texte de Philippe

Chapu; Les manufactures de Strasbourg et de Niderviller, texte de Jacques Fischer; Les manufactures de Limoges et de Paris, texte de Jeanne Giacomotti; Répertoire des principales manufactures de porcelaine française avec leurs marques.

Bibliography, p.[334].

P306 Verlet, Pierre; Grandjean, Serge; and Brunet, Marcelle. Sèvres. Paris, Le Prat [1953]. 2v. plates (part col.)

The essential work on the most important French porcelain factory. Includes complete descriptions and commentaries on each piece reproduced in the plates.

Contents, v.1: Le XVIIIe siècle (I. Historique; II. La technique; III. Les oeuvres; IV. Le style; V. Le succès et ses conséquences), par P. Verlet; Les XIXe et XXe siècles, par S. Grandjean. Bibliography, v.1, p.231-33. Expositions, p.233.

v.2, Les marques de Sèvres, par M. Brunet: Marques d'origine; Table systématique; Liste alphabétique.

SEE ALSO: *The James A. de Rothschild Collection at Waddesdon Manor.* [v.2] Eriksen, Svend. *Sèvres porcelain* (P19); Wrightsman, C. B. *The Wrightsman Collection.* v.IV Dauterman, C. C. *Meissen porcelain . . .* (P31).

## Germany and Austria

P307 Ducret, Siegfried. Fürstenberg Porzellan. Braunschweig, Klinkhardt & Biermann [1965]. 3v. il., col. plates, facsims.

A monumental history and study of porcelain manufactured and decorated in Fürstenberg in the second half of the 18th century.

v.1, *Geschichte der Fabrik,* contains brief chapters on various aspects of porcelain manufacture in Fürstenberg beginning in the mid-18th century. "Verzeichnis der Bedienten, Künstler und Arbeiter nach Jahren geordnet," v.1, p.237-56. "Die Künstler und Fabrikanten nach ihren Spezialität aufgeführt," v.1, p.257-60. "Alphabetisches Verzeichnis der Künstler und Fabrikanten von 1746-1800," v.1, p.261-93. "Die Archivalien und ihr Inhalt," p.294-302. "Literatur," v.1, p.309. "Anmerkungen," v.1, p.310-11. v.2, *Geschirre,* contains three introductory chapters (A. Die Formen; B. Die Bemalung; C. Das Stichverzeichnis) which are followed by a section of 343 illustrations of porcelains and sources of design for decoration. v.3, *Figuren,* includes sections on the principal figure makers. "Fürstenberger Porzellan am Auktionsmarkt," v.3, p.249-51. "Die Marken und die eingeritzten Zeichen," v.3, p.257-62.

P308 _____. German porcelain and faience. [Trans. by Diana Imber]. N.Y., Universe Books [1962]. 466p. 180 plates (56 col.)

An important contribution to the study of German ceramics which emphasizes aesthetic and technical achievements in such manufacturing centers as Meissen, Nymphenberg, Berlin, Cassel, Dresden, and Nuremberg. Also includes Vienna and Zürich. 180 pieces are superbly reproduced, with commentaries and descriptions on facing pages.

Contents: pt. 1, The porcelain factories; pt. 2, Faience. Porcelain marks, p.445-49; Faience marks, p.450-51. Bibliography, p.452-[56].

P309 _____. Meissner Porzellan, bemalt in Augsburg, 1718 bis um 1750. Braunschweig, Klinkhardt & Biermann [1971-72]. 2v. il. (v.1, 395 il., 14 col. plates; v.2, 316 il., 16 col. plates)

A lavishly illustrated study and survey of decorated Meissen porcelain painted in Augsburg in the period 1718-c.1750, the principal painters of porcelain decoration, and the sources of decoration designs. Includes English, French, and Italian summaries of the brief texts and notes on the many plates.

Contents: v.1, *Goldmalereien und bunte Chinoiserien:* (1) Einleitung; (2) Die Familie Aufenwerth; (3) Die Familie Suter; (4) Bezugsquellen für weisses Porzellan; (5) Hat auch Meissen radierte Goldchinesen im Stil Augsburgs gemalt?; (6) Der radierte Golddekor; (7) Die Goldmalereien des Johann Aufenwerths; (8) Der Goldmalereien des Abraham Seuter; (9) Die Goldmalereien des Bartholomäus Seuter; (10) Andere radierte Golddekore; (11) Die Lüsterzeichen; (12) Anna Elisabeth Wald, eine geborene Aufenwerth; (13) Bunte Chinesen von Bartholomäus Seuter; Anmerkungen, p.51-52 (include references); Archivalen und Literatur, p.81; v.2, *Bunte Augsburger Hausmalereien:* (1) Einleitung und Rückblick; (2) Die bemalten Fayencen des Bartholomäus Seuter; (3) Johann Aufenwerth; (4) Sabina Hosennestel-Aufenwerth; (5) Anna Elisabeth Wald-Aufenwerth; (6) Abraham Seuter; Anmerkungen, p.33-34 (include references).

P310 Hayward, John Forrest. Viennese porcelain of the Du Paquier period. London, Rockliff [1952]. 218p. 76 plates (4 col.)

A scholarly study of Viennese porcelain of the first half of the 18th century. Contains five appendixes of specialized material.

Bibliographical note, p.175-76. Bibliographical references in notes at ends of chapters.

P311 Honey, William Bowyer. Dresden china; an introduction to the study of Meissen porcelain [new ed.] London, Faber and Faber; N.Y., Pitman [1954]. 219p. il., 64 plates.

1st ed. 1934.

"This book [is] intended to serve as an introduction to the study of Meissen porcelain of the 18th century. . . . Its purpose is to provide no more than a clear and brief account, unencumbered with confusing detail, of the history and production of the great Saxon factory."—*Pref.* Marks, p.162-73. Notes, p.178-207.

Bibliography, p.175-77.

P312 _____. German porcelain. London, Faber and Faber [1947]. xv, 56p. il., plates (part col.) (The Faber monographs on pottery and porcelain)

Reissued 1967.

A very concise survey in which the author's intention is "to describe in its setting this vital and original German porcelain of the eighteenth century, and distinguish it, as

far as may be done in writing and with photographs, from the endless later imitations by which it has all too often been vulgarised."—*Foreword*. The introductory text, p.1-36, outlines the major centers of production and their wares. Marks, p.37-47.

Classified bibliography, p.49-51.

P313 Hüseler, Konrad. Deutsche Fayencen, ein Handbuch der Fabriken, ihrer Meister und Werke. Stuttgart, Hiersemann, 1956-58. 3v. plates, maps.

A comprehensive survey and handbook of German faïence. Contents: v.1, (1) Geschichte der deutschen Fayence-fabriken; (2) Vom innern Betrieb der Fayencefabriken; (3) Fayence; (4) Bilagen; v.2, (5) Die künstlerische Entwicklung der deutschen Fayence im 17. und 18. Jahrhunderts; (6) Einzelne Künstler; (7) Verschiedenes; v.3, (8) Biographisches Lexikon, p.369-433; (9) Bibliographie (Handbücher; Austellungs-kataloge; Sammlungs- und Auktionskataloge; Vorbilderwerke; Einzelne Landschaften; Die einzelnen Fabriken; Einzelne Meister; Verschiedenes) p.437-99 (10) Marken, p.543-78.

v.1-2 contain plates sections at the ends; v.3 ends with a section of 67 plates of reproductions of marks.

P314 Klein, Adalbert. Deutsche Fayencen; ein Handbuch für Sammler und Liebhaber. Braunschweig, Klinkhardt & Biermann [1975]. xi, 367p. 374 il., 16 col. plates. (Bibliothek für Kunst- und Antiquitäten-freunde, Bd. 20)

A well-illustrated regional survey of German faïence from its 16th-century origins through its development in the 17th and 18th centuries. Includes reproductions of marks of some pieces illustrated.

Contents: Einführung; Frühe Fayencen im deutschen Kulturbereich; Hanau und Frankfurt; Berlin und Nord-westdeutschland; Thüringen und Sachsen; Der Westen; Süddeutschland–Nördlicher Teil; Süddeutschland–Südlicher Teil; Der Südwesten; Norddeutschland; Der Nordosten; Deutsche Fayencemaler; Fayencetechnik–Die Manufaktur; Kachelöfen; Zur Beurteilung von Fayencen.

Bibliography, p.362-63. Bibliographies at ends of sections within chapters. "Anmerkungen," p.365-66, include references.

P315 Neuwirth, Waltraud. Wiener Keramik: Historismus, Jugendstil, Art Déco. Braunschweig, Klinkhardt & Biermann, 1974. xiv, 508p. il. (part col.), plates.

A detailed, scholarly study of ceramics produced in Vienna between 1864 and 1938. Superbly illustrated. Pt. 1, "Die Situation der Wiener Keramik im späten 19. Jahrhundert," is a brief summary of ceramic production in the late 19th century. "Wiener Porzellanmaler und Institute für Porzellan-malerei in der zweiten Hälfte des 19. Jahrhunderts," p.19-24, gives career data chronologically. Pt. 2, "Der Wiener Manufaktur Friedrich Goldscheider," covers the period from 1885 to past mid-20th century. Pt. 3 comprises the main portion of the volume, "Künstler- und Firmenmo-nographien in alphabetischer Reihenfolge," p.99-456, which lists individual artists and workshops active in the

period from the late 19th century to 1938. "Marken, Zeichen, Signaturen," p.457-90, includes reproductions of marks, etc.

Bibliography, p.491-93.

P316 Pauls, Emil. Porzellan des 18. Jahrhunderts. Meissen, Höchst, Frankenthal, Ludwigsburg. Hrsg. und ein-geleitet von Peter Wilhelm Meister. [Photos: Hans Hinz]. Frankfurt a. M., Osterrieth [1967]. 2v. plates (part col.)

At head of title: Sammlung Pauls, Riehen, Schweiz.

A detailed, lavishly illustrated catalogue of one of the most important private collections of 18th-century German porcelain. Contents, Bd. 1: Einführung, p.13-60; Teil I. Meissen; Künstlerverzeichnis, p.61-64; Geschirr 1715-30; Geschirr 1731-50; Geschirr mit Hausmalerei; Figuren 1715-30; Figuren 1731-50; Figuren ab 1750. Bd. 2: Teil II. Höchst; Teil III. Frankenthal; Teil IV. Ludwigsburg; Künstlerverzeichnis, p.30-31; Verzeichnis der aufgesuchten Museen, p.32.

Bibliographical references included in footnotes in introduction in Bd. 1. Classified bibliography, p.268-69. Verzeichnis der für die Bearbeitung des Buches benutzten Kataloge, p.270-76.

P317 Rückert, Rainer. Meissener Porzellan, 1710-1810; Ausstellung im Bayerischen Nationalmuseum, Mün-chen. Katalog bearb. von Rainer Rückert. München, Hirmer [1966]. 208p. il., 319 plates (31 col.)

The catalogue of an exhibition of 1,187 pieces of Meissen porcelain from the 100-year period of its greatest flourishing. Includes the fullest, most comprehensive documentation on Meissen to date; summarizes and advances research in the field.

Bibliography, p.44-51.

P318 Savage, George. 18th-century German porcelain. Foreword by H. Weinberg. London, Rockliff; N.Y., Macmillan [1958]. xxiv, 242p. col. front., 150 plates.

A survey of 18th-century German porcelain and its major centers of production. Valuable to the exclusively English-language reader. Index of marks, p.221-25.

Selected bibliography, p.226-27.

P319 Treskow, Irene von. Die Jugendstil-Porzellane der KPM; Bestandskatalog der Königlichen-Manufaktur Berlin 1896-1914. München, Prestel [1971]. 338p. 299 il., 500 figs., 55 col. plates. (Materialien zur Kunst des 19. Jahrhunderts. Bd. 5)

A comprehensive history and catalogue of the porcelain production of the Königlichen Porzellan-Manufaktur, Berlin, in the period 1896-1914. Detailed documentation based on an exhaustive examination of primary sources and extant pieces. The catalogue of 222 entries on works by more than 100 artists follows the historical survey of the Berlin porcelain production from the mid-18th century to the start of World War I. Extremely well illustrated with photographs of porcelain pieces, comparative materials, and reproductions of decoration designs. The appendix contains a valuable section of artists' biographies, with references.

Anmerkungen, p.120-31, include bibliographical references. Verzeichnis der verwendeten Literatur, p.332-34.

P320  Vienna. Österreichisches Museum für Angewandte Kunst. Österreichische Keramik des Jugendstils: Sammlung d. Österr. Museums f. Angewandte Kunst, Wien [by] Waltraud Neuwirth; [hrsg. vom Österr. Museum f. Angewandte Kunst; graf. Gestaltung, Leopold Netopil; Farbaufn. u. Schwarzweissfotos, Ludwig Neustifter]. München, Prestel, 1974. 516p. 312 il. (29 col.) (Materialien zur Kunst des 19. Jahrhunderts. Bd. 18)

A detailed, fully illustrated catalogue of the collection of Austrian Jugendstil ceramics in the Museum für Angewandte Kunst, Vienna. Complete catalogue entries include reproductions of marks and signatures. Also contains biographies of artist-craftsmen, extensive notes, and references.

Bibliography, p.504-5.

SEE ALSO: *The James A. de Rothschild Collection at Waddesdon Manor.* [v.4] Charleston, R. J., and Ayers, John. *Meissen and other European porcelain. Oriental porcelain* (P19).

## Great Britain

P321  Barrett, Franklin Allen, and Thorpe, Arthur L. Derby porcelain, 1750-1848. London, Faber and Faber, 1971. xv, 206p. il. (part col.)

A comprehensive study of Derby porcelain.

Contents: (1) Andrew Planché 1750-56; (2) William Duesburg I 1756-69; (3) Chelsea-Derby period 1770-84 (i) Introduction; (4) Chelsea-Derby period 1770-84 (ii) Figures; (5) Chelsea-Derby period 1770-84 (iii) Useful and decorative wares; (6) The later figures 1786-1848; (7) Useful and decorative wares 1786-1848. Appendixes: (I) Biographies of work people employed at the factory; (II) Factory marks and workmen's marks; (III) The pattern books; (IV) Physical characteristics and chemical composition; (V) Extracts from contemporary manuscripts; (VI) Chelsea-Derby sale catalogues; (VII) Articles of agreement; (VIII) List of groups and single figures; (IX) List of figures attributed to Andrew Planché.

Bibliography, p.199-200. Bibliographical references in footnotes.

P322  Charleston, Robert J., ed. English porcelain, 1745-1850. London, Benn; Toronto, Univ. of Toronto Pr. [1965]. 183p. 182 il. (12 col.), 76 plates.

An authoritative volume on the manufacture of English porcelain, with separate chapters on individual factories, by a team of expert contributors. The discussions of styles, materials, and techniques are supplemented by a list of marks and an index of public collections of English porcelain.

Bibliography, p.171-72; bibliographical references in footnotes.

P323  Cushion, J. P. Pocket book of British ceramic marks, including index to registered designs, 1842-83. [3d ed.]. London, Faber and Faber [1976]. 431p. facsims.
1st ed. 1959.

A pocket guide to marks on ceramics produced in Great Britain and Ireland. Continental marks are included in the author's *Handbook of pottery and porcelain marks* (P265). "The marks here recorded are restricted to true factory marks and those others which by their frequent occurence, or in other ways are of actual use in helping to identify the place and period of manufacture of a piece."—*Pref.* Arrangement is alphabetical by cities, then subdivided into factories or owners. Most of the marks are reproduced.

Contents of marks section: England (other than Staffordshire); Staffordshire; Isle of Wight, Channel Islands, Isle of Man and N. Ireland; Scotland; Wales; Ireland; Addendum of recent changes, new material, etc.

Appendixes: (A) Patent office registration mark; (B) Index of names and dates of manufacturers, retailers, wholesalers and others who registered designs from 1842-83. Historical note and methods of marking, p.13-15. Notes on wares made in Great Britain and Ireland, p.16-19.

General index.

P324  Garner, Frederick Horace, and Archer, Michael. English delftware. 2d enl. and rev. ed. London, Faber and Faber, 1972. xxi, 105, [144]p. il. (part col.)
1st ed. 1948.

A comprehensive summary of and guide to English delftware. The standard work.

Contents: (1) Origins and method of manufacture; (2) 17th-century delftware; (3) An introduction to 18th-century delftware; (4) The attribution of 18th-century delftware from Lambeth, Bristol, and Liverpool; (5) The history of the London pot-houses; (6) The history of the Brislington and Bristol pot-houses; (7) The history of the Liverpool pot-houses; (8) The Wincanton pot-house and its delftware; (9) The Irish pot-houses and their delftware; (10) The Glasgow pot-house and its delftware; (11) The manufacture of delftware in America. Appendixes: (A) Cross-sections of the more common plates, dishes, and saucers; (B) Elections recorded on English delftware.

Classified bibliography, p.83-86.

P325  Godden, Geoffrey A. British porcelain; an illustrated guide. London, Barrie and Jenkins; N.Y., Potter. (Distr. by Crown, N.Y. [1974].) 451p. il. (part col.)

A companion volume to the author's *British pottery* (P326).

A collector's and beginning connoisseur's pictorial guide to British porcelain produced from the mid-18th century to c.1900. Includes sections on the principal British porcelain factories, arranged alphabetically. The introduction, p.13-20, is essentially an outline to the main body of the work. Brief chronological survey, p.21-29.

Classified bibliography, p.446-48.

P326  _____. British pottery; an illustrated guide. London, Barrie and Jenkins, 1974; N.Y., Potter. (Distr. by Crown, N.Y. [1975].) 452p. il. (part col.)

A companion volume to the author's *British porcelain* (P325).

A generously illustrated guide to British pottery from the late 17th century to the 20th century. Sections on various types of pottery are arranged chronologically. Intended primarily for the collector.

Bibliography, p.445-47.

P327 _____. Encyclopaedia of British pottery and porcelain marks. London, Jenkins; N.Y., Bonanza [1964]. 765p. il., map.

A companion volume to the author's *Illustrated encyclopaedia of British pottery and porcelain* (P328). Some of the material in this volume appears also in the author's *Handbook of British pottery and porcelain marks,* London, Jenkins; N.Y., Praeger, 1968.

An encyclopedia of more than 4,400 marks on British pottery and porcelain which range in date from 1650 to the present. The marks section is arranged alphabetically by name of potter or pottery; entries include address, period of production, and types of wares produced. Map showing the location of the principal pottery centres, p.15. Types of ceramic marks (photographic plates) between p.16 and 17. Appendix: Unidentified or problem marks in alphabetical sequence. Postscript, recent marks, p.745.

Selected bibliography, p.741-44. Index of monograms; Index of signs and devices.

P328 _____. An illustrated encyclopaedia of British pottery and porcelain. London, Jenkins; N.Y., Bonanza [1966]. xxvi, 390p. 679 il., 16 col. plates.

A companion volume to the author's *Encyclopaedia of British pottery and porcelain marks* (P327). "Illustrates over two thousand documentary examples of English ceramic art, so that this book, which is virtually an illustrated encyclopaedia of marked specimens, cannot only be used in conjunction with the *Encyclopaedia of British Pottery and Porcelain Marks* but it can be equally useful as a companion to the new revised 15th edition of Chaffer's *Marks and Monograms* [P261] . . . or to any other mark book and also to all general ceramic reference books from such nineteenth-century classics as Jewitt's *Ceramic Art of Great Britain* to such modern works as *English Porcelain 1745-1850,* edited by R. J. Charleston (1965) [P322]."—*Pref.* Historical summary and glossary, p.xi-xxvi. The main portion of the volume is devoted to a section of illustrations of pieces arranged alphabetically by manufacturer's name.

Selected bibliography, p.385.

P329 _____, ed. The illustrated guides to pottery and porcelain. London, Barrie & Jenkins; N.Y., Praeger [1969-71]. 7v. il., plates (part col.), maps.

A series of authoritative volumes on English pottery and porcelain manufacturers intended "to provide a wide selection of illustrations (especially chosen to show key shapes, styles of decoration, or other identifying characteritics) rather than long, textual explanations."—*Editorial pref.* Texts consist of historical summaries and appendixes of specialized materials. Addressed primarily to the collector. Individual bibliographies in each volume; bibliographical references in footnotes.

Contents by volume: (1) Godden, Geoffrey A. *The illustrated guide to Lowestoft porcelain.* xv, 164p. [1969];

(2) Sandon, Henry. *The illustrated guide to Worcester porcelain, 1751-1793.* xvii, 96p. [1969]; (3) Smith, Alan. *The illustrated guide to Liverpool Herculaneum pottery, 1796-1840.* xvi, 142p. [1970]; (4) Rice, Dennis G. *The illustrated guide to Rockingham pottery and porcelain.* xx, 194p. [1971]; (5) Godden, Geoffrey A. *The illustrated guide to Mason's patent ironstone china and related wares—stone china, new stone, granite china—and their manufacturers.* xiv, 175p. [1971]; (6) Mountford, Arnold R. *The illustrated guide to Staffordshire salt-glazed stoneware.* xxi, 88p. [1971]; (7) Shinn, Charles, and Shinn, Darrie. *The illustrated guide to Victorian Parian china.* xv, 125p. [1971].

P330 _____. Victorian porcelain. Foreword by Hugh Wakefield. London, Jenkins [1961]. 222p. il.

A reliable introductory survey of the principal English porcelain factories and their products of the Victorian period. Lists of the most important ceramic artists, with dates and specialities, and lists of factory marks are at the ends of some chapters.

Contents: (1) The international exhibitions; (2) Coalport; (3) Copeland; (4) Derby; (5) Minton; (6) Worcester; (7) The Parian body; (8) Pâte-sur-pâte; (9) The smaller factories; (10) Notes on dating.

Bibliography, p.215-16.

P331 Honey, William Bowyer. English pottery and porcelain. 6th ed.; rev. by R. J. Charleston. London, Black, 1969. xvi, 287p. il., 24 plates.

1st ed. 1933.

A standard survey. "The purpose of this book is to provide a concise history of English ceramic art, that is to say, an account of the sequence of the various kinds of distinctively English wares, of their authorship or derivation, and more especially of their aesthetic charm—of those qualities in fact which make their study and collection worth while." —*Pref. to the 1st ed.*

Contents: pt. 1, Earthenware and stoneware to the end of the 18th century; pt. 2, English porcelain of the 18th century; pt. 3, 19th-century pottery and porcelain. Collecting, p.243-58.

Bibliography, p.271-77. Appendix, p.259-69, includes notes which revise and update the original ed., with new references.

P332 Mankowitz, Wolf, and Haggar, Reginald G. The concise encyclopedia of English pottery and porcelain. London, Deutsch; N.Y., Hawthorn [1957]. xv, 312p. il., plates (part col.), facsims. (Reissued: N.Y., Praeger, 1968.)

A handbook of information on English pottery and porcelain factories, manufacturers, artists, processes, materials, terminology, and marks. A companion volume of R. G. Haggar's *Concise encyclopedia of continental pottery and porcelain* (P270).

Contents: A selection of impressed and incised marks, p.xiv-xv; The concise encyclopedia of English pottery and porcelain, p.1-249. Appendixes: (1) Names of potters, pottery firms, pot-dealers, and outside decorators taken from directories, p.250-75; (2) Engravers for pottery and porcelain, p.276-89. (3) Books and articles giving lists of names of potters and pottery craftsmen etc., p.290-92; (4) British

and American museums where pottery and porcelain may be studied, p.293-96; (5) British potters on foreign soil, p.297-99.

Classified bibliography, p.300-11.

P333    Oxford University. Ashmolean Museum. English delftware pottery in the Robert Hall Warren Collection, Ashmolean Museum, Oxford [by] Anthony Ray. With a pref. by Nigel Warren. London, Faber and Faber; Boston, Boston Book and Art Shop [1968]. 248p. 118 il., 8 col. plates.

A detailed, scholarly catalogue of an important collection of English delftware. An historical introduction on the production of delftware is followed by the catalogue, which is arranged by style of decoration.

Catalogue contents: (I) 'English maiolica'; (II) Royal delftware; (III) History in English delftware; (IV) Armorial delftware; (V) Delftware with various inscriptions; (VI) Delftware with religious themes; (VII) Delftware with landscapes and figures; (VIII) Delftware decorated with animals, birds and fish; (IX) Delftware with floral decoration; (X) Delftware with 'Oriental' decoration; (XI) Delftware decorated with various ornamental motifs; (XII) Tiles. Catalogue entries give description, attribution, date, dimensions, shape, glaze, provenance, and references to comparative material.

Appendixes: (I) Analysis of the Warren Collection according to probable or possible attribution; (II) Dated pieces in the Warren Collection; (III) Table of marks; (IV) Shapes of plates and dishes.

Bibliography, p.240-42. Bibliographical references in footnotes.

P334    Rackham, Bernard. Medieval English pottery. 2d ed., rev. London, Faber and Faber, 1972. xvi, 96p. il., plates (part col.)

1st ed. 1947.

A brief, authoritative survey of English pottery produced in the "period between the Norman Conquest and the Reformation."—*p.1.*

Bibliography, p.33-35; bibliographical references in footnotes.

P335    Watney, Bernard. English blue and white porcelain of the eighteenth century. 2d ed. London, Faber and Faber [1973]. xxii, 145, [97]p. il. (8 col.) (The Faber monographs on pottery and porcelain)

1st ed. 1963.

An introductory study; addressed primarily to the collector. Includes discussions of the techniques of manufacture, the principal centers of production, and the stylistic development of English blue and white china of the 18th century.

Contents: Introduction; (1) Cobalt; (2) Bow; (3) Limehouse, Lund's Bristol and Worcester; (4) The first two Staffordshire china factories; (6) Derby; (7) Lowestoft; (8) Caughley; (9) Plymouth, Bristol and New Hall.

Classified bibliography, p.138-40; bibliographical references in footnotes.

## Italy

P336    Ballardini, Gaetano. Corpus della maiolica italiana. [Roma] Libreria dello Stato [1933-38]. 2v. plates (part col.)

At head of title: Bollettino d'arte. Pubblicazione annuale n. 1-2.

A corpus of reproductions of dated examples of Italian maiolica. Contents: v.1, Le maioliche datate fino al 1530; v.2, Le maioliche datate dal 1531 al 1535. Notes sections in both volumes include bibliographical references. Indexes of collections and illustrations at the end of both volumes.

P337    Berlin. Museen. Kunstgewerbemuseum (West). Majolika: spanische und italienische Keramik vom 14. bis zum 18. Jahrhundert [von] Tjark Hausmann. Berlin, Mann, 1972. 422p. 315 il. (29 col.) (*Its* Kataloge, 6)

A detailed catalogue of an important collection of Spanish and Italian maiolica. Very well illustrated.

The catalogue is arranged chronologically by centuries, then by principal centers of production. Each entry gives detailed descriptive and technical information. "Form-Profile," p.[412]-15, includes 36 profile drawings of the most important types. "Abkürzungen häufig zitierter Literatur," p.416-17. "Konkordanz der Inventar- und Katalog-Nummern"; "Verzeichnis der Namen."

P338    Conti, Giovanni. L'arte della maiolica in Italia. Milano, Bramante [1973?]. 387p. plates (part col.)

A superbly illustrated survey of Italian maiolica; presents a synthesis of research in the field and extensive archival documentation. The introductory essay, which includes numerous footnotes with references, is followed by a section of 181 illustrations which accompany the text.

"Regesto di notizie storiche sulla maiolica italiana," p.97-182, lists documents, statutes, letters, references to dated pieces, and many bibliographical references chronologically from 1115 to 1908. "Repertorio iconografico," p.[183-375], is a section of 517 illustrations.

Bibliography, p.[377]-87, arranged chronologically, 1758-1972.

P339    Cora, Galeazzo. Storia della maiolica di Firenze e del contado secoli XIV e XV. Firenze, Sansoni, 1973. 2v. (v.1, 505p.; v.2, 365 plates [94 col.])

A lavishly produced, monumental history of maiolica manufactured in Florence and its neighboring countryside in the 14th and 15th centuries. Based on exhaustive archival research, a systematic examination of excavated sherds, and an extensive study of examples in public and private collections. The text volume (v.1) includes information on over 650 potters, many of whom were previously unidentified; the various types of wares are classified within lists of decorative patterns. v.2 includes a section of reproductions of 265 patterns.

Statistica dei vasai di Firenze, p.409-13. Documenti, p.413-44. Schede delle illustrazioni, p.445-82. Classifica

delle maioliche di Firenze e del contado del XIV e del XV secolo, p.483–88. Indice analitico dei nomi citati nel testo.

Bibliografia, p.491–95. Bibliographical references in margin notes.

A study of the later development of Florentine maiolica is in preparation.

P340   Giacomotti, Jeanne. Catalogue des majoliques des musées nationaux: Musées du Louvre et de Cluny, Musée National de Céramique à Sèvres, Musée Adrien-Dubouché à Limoges. Paris, Éditions des Musées Nationaux, 1974. xvii, 500p. il., 1 col. plate.

A detailed, scholarly catalogue of approx. 1,500 pieces of Italian maiolica in French national museums. The classification is based on that established by Ballardini (P336). Catalogue entries include descriptions, identification of sources, measurements, inventory number, provenance, bibliography. Almost all pieces are reproduced. Introductory essays precede each catalogue section.

Contents: Introduction, by Pierre Verlet, p.iii–xiv; pt. 1. XIVe et XVe siècles: Faïences primitives et naissance de la majolique classique ou "stile severo"; pt. 2. Premier tiers du XVIe siècle: Début de l'art de la renaissance proprement dit ou "stile bello"; pt.3. Première moitié du XVIe siècle: Apogée de l'art de la renaissance, du "stile bello" et du décor historié ou "a istoriato"; pt. 4. Milieu et deuxième moitié du XVIe siècle: Diffusion du décor historié et naissance d'un nouveau style ornemental "a raffaellesche"; pt. 5. Du milieu du XVIe au milieu du XVIIe siècle: Diffusion du style ornemental et goût pour la faïence blanche; pt. 6. XVIIe et XVIIIe siècles: Prolongements de l'art de la majolique classique.

Ouvrages cités en abrégé (bibliography), p.xv–xvii.

P341   Lane, Arthur. Italian porcelain, with a note on Buen Retiro. London, Faber and Faber [1954]. xvi, 79p. il., 100 plates (4 col.) (The Faber monographs on pottery and porcelain)

A brief, authoritative survey of the neglected field of Italian porcelain. Contents: (1) The Medici porcelain (1575–87) and other early experiments; (2) Venice: the Vezzi factory; (3) Later Venetian factories; (4) Vinovo (1776–1820) and other north-western factories; (5) Doccia; (6) The Bourbon factories.

Classified bibliography, p.74–75; bibliographical references in footnotes.

P342   Liverani, Giuseppe. La maiolica italiana sino alla comparsa della porcellana europea. Milano, Electa; London, McGraw-Hill [1958]. 264p. 52 il., 84 col. plates.

A broad survey of Italian maiolica which summarizes authoritatively the results of study in the field. Beautifully illustrated with examples from European and American collections.

Indice degli artisti, delle botteghe e delle officine; Indice delle cose, dei luoghi, delle persone e dei soggetti; Indice delle raccolte; Indice delle illustrazioni; Indice generale.

Bibliography, p.61–[62].

P343   Morazzoni, Giuseppe. Le porcellane italiane. [Nuova ed.] Testo di Saul Levy. Milano, Görlich [1960]. 2v. 397 plates.

1st ed.: *Le porcellane italiane,* presentazione di Roberto Papini. Milano, Roma, Tumminelli, 1935.

A pictorial survey, with introductory texts, of Italian porcelain from the late 16th century to its flourishing in the 18th century. Illustrated with pieces in public and private collections.

Contents of text, v.1: Le porcellane de' Medici; Le manifatture venete; Le manifatture del Piemonte; Doccia; Le manifatture romane; Le fabbriche borboniche; Le porcellane lombardi dell'Ottocento. The second pt. of v.1 and all of v.2 are composed of plates.

Bibliography, v.1, p.[137–38]; bibliographical references in footnotes.

P344   Rackham, Bernard. Italian maiolica. [2d ed.]. London, Faber and Faber [1963]. xvi, 35p. 100 plates (4 col.)

1st ed. 1952.

An authoritative introductory survey of Italian maiolica. Contents: (1) Historical setting. Origins. Technique; (2) Aesthetics of maiolica; (3) Local distribution of the potteries. Development of design. The early wares. Tuscany and Faenza; (4) The early Renaissance. Introduction of lustre; (5) The pictorial school. Castel Durante and Urbino; (6) Sgraffiato ware; (7) Later maiolica: 1550–1800.

Bibliography, p.32–33.

P345   Victoria and Albert Museum, South Kensington. Department of Ceramics. Catalogue of Italian maiolica, by Bernard Rackham. London, pub. under the authority of the board of education, 1940. 2v. plates.

A scholarly, detailed catalogue of the collection of Italian maiolica in the Victoria and Albert Museum. Entries give full descriptions, date, plate reference, measurements, provenance, and bibliographical references. Shapes are indicated by numerical references to the series of profile-drawings v.1, p.[456–57].

Contents, v.1, Text: (I) Primitive maiolica of various types, mostly of uncertain origin; (II) Florentine wares of the 15th century; (III) Faenza maiolica of the 15th century; (IV) Maiolica of the 15th century made at Forli or perhaps at Faenza; (V) Miscellaneous maiolica of the 14th and 15th centuries; (VI) Tiles of the 15th century; (VII) Maiolica of the early Renaissance style; (VIII) Maiolica of early *istoriato* type and contemporary decorative wares; (IX) Maiolica of later *istoriato* type and contemporary wares; (X) Maiolica of the *bianchi di Faenza* class and the *stile compendiario;* (XI) Maiolica showing Chinese influence and miscellaneous contemporary wares; (XII) Maiolica in the revived *istoriato* manner and other late Baroque wares; (XIII) Maiolica made under the influence of Meissen and other porcelain; (XIV) *Sgraffiato* wares; (XV) Wares with manganese-brown glaze. Index of numbers, p.[458]–66. General index.

v.2 contains 1,441 illustrations on 222 plates.

Bibliography, v.1, p.xix–xxiii.

## Low Countries

P346  Neurdenberg, Elisabeth, and Rackham, Bernard. Old Dutch pottery and tiles; trans. with annotations by Bernard Rackham. London, Benn, 1923. 155p. 69 plates (part col.)

A scholarly study of the subject.

Contents: (1) Introduction; (2) The process of manufacture; (3) Dutch red earthenware and tiles; (4) Dutch maiolica of the 16th and 17th centuries; (5) Dutch tiles; (6) Dutch tile-pictures; (7) Delft earthenware: its origins and study; (8) Blue-and-white Delft. De Keizer, Pijnacker, Frijtom and other potters and pottery-painters of the 17th century; (9) Samuel van Eeenhoorn and Rochus Hoppesteyn; (10) Lambertus van Eeenhorn and Louwijs Fictoor; (11) Blue-and-white and purple Delft of the 18th century; (12) Polychrome Delft of the *grand feu*. Lambertus van Eeenhorn and Louwijs Fictoor; (13) The "rose" factory. Verhaast and other 17th-century potters; (14) Delft ware with coloured ground. Imitations of foreign earthenware; (15) *Grand feu* polychrome ware of the 18th century; (16) The beginnings of muffle-kiln painting. Hoppesteyn, Pijnacker, and others; (17) The muffle-kiln. The influence of porcelain technique; (18) The red teapots of Delft; (19) The decline; (20) The place of Dutch earthenware in the history of European pottery.

Appendix: List of marks of Delft potters in 1764, p.145-46. Bibliography, p.147-48.

## Russia and Eastern Europe

P347  Csányi, Károly. Geschichte der ungarischen Keramik, des Porzellans, und ihre Marken. [Übersetzt von Thomas Mátrai]. Budapest, Fonds für bildende Künste, 1954. 159p. il., 79 plates.

A history of the various types of Hungarian pottery and porcelain from medieval earthenware to modern products.

Contents: (I) Die mittelalterlichen Tongefässe in Ungarn und ihre Marken; (II) Die Habankeramik und ihre Meistermarken; (III) Die Fayencen von Ungarn und ihre Marken; (IV) Die ungarischen Steingutfabriken und ihre Marken; (V) Die ungarischen Porzellane und ihre Marken; (VI) Die Marken der neueren Fayence-, Steingut-, Porzellan- und bleiglasierten Erzeugnisse.

Markentafeln, p.67-116, include reproductions of 935 marks. Erklärung der Marken, p.117-23.

Classified bibliography, p.124-26.

P348  Post, Marjorie Merriweather. Russian porcelains; the Gardner, Iiusupov, Batenin ... factories, by Marvin C. Ross. With a foreword by Marjorie Merriweather Post. Norman, Univ. of Oklahoma Pr. [1968]. xxviii, 427p. il., plates (86 col.) (The collections of Marjorie Merriweather Post)

A well-illustrated, fully documented catalogue of all the Russian porcelains in the Post Collection at Hillwood, Wash., D.C., except those pieces manufactured at the Imperial Porcelain Factory. Based on research in Russian collections and Russian publications. Provides a great deal of material

for the first time in a language other than Russian. Includes individual sections on the various factories; each section contains an introduction, illustrations, catalogue entries, and a bibliography. Bibliographies list the important books, articles, and catalogues in Russian, as well as those in Western languages.

The marks on Russian porcelains at Hillwood, p.417-27.

A second volume on porcelains from the Imperial Porcelain Factory is announced in the preface.

## Scandinavia

P349  Grandjean, Bredo L. Kongelig Dansk porcelain, 1775-1884. København, Thaning & Appel, 1962. 310p. il.

A scholarly history of the production of the Royal Danish Porcelain Factory during the period 1775-1884. Well illustrated.

Contents: (I) Historie og administration; (II) Teknik; (III) Kunstnerne og produktionen; (IV) Katalog; (V) Porcelaenets forjandling; (VI) Maerker; (VII) Bilag; (VIII) Litteraturhenvisninger, p.301-[3] (classified); (IX) Noter, p. 305-[8] (include references); (X) Personenregister.

## Spain and Portugal

P350  González Martí, Manuel. Cerámica del Levante español, siglos medievales. Barcelona [etc.] Editorial Labor, 1944-52. 3v. il. (part col.), plates (part col.), plans.

A detailed, scholarly study. Very well illustrated.

Contents: v.1, Loza; v.2, Alicatados y azulejos; v.3, Azulejos, "socarrats," y retablos. Bibliographies: v.1, p.645-47; v.2, p.721-23; v.3, p.671-72. Each volume contains detailed indexes (museums, collections, archives and libraries, potters, etc.).

SEE ALSO:  *Ars Hispaniae*, v.10, *Cerámica y vidrio*, por J. Ainaud de Lasarte (I438); Berlin. Museen. Kunstgewerbemuseum (West). *Majolika: spanische und italienische Keramik* . . . (P337).

## Switzerland

P351  Ducret, Siegfried. Die Zürcher Porzellanmanufaktur und ihre Erzeugnisse im 18. und 19. Jahrhundert. Zürich, Füssli [1958-59[. 2v. il., col. plates.

A detailed, fundamental study of 18th- and 19th-century porcelain produced in Zürich. Based on extensive archival research and the meticulous examination of innumerable pieces by the leading connoisseur in the field.

Contents: Bd. 1. Geschirre; Bd. 2. Die Plastik. Notes sections in both volumes include bibliographical references.

## United States

P352  Barber, Edwin Atlee. Marks of American potters. With facsimiles of 1000 marks, and illustrations of

rare examples of American wares. Philadelphia, Patterson and White, 1904. 174p il. (Repr.: Southampton, N.Y., Cracker Barrel Pr. [1971?]; repr. with *The pottery and porcelain of the United States* [P353]: N.Y., Feingold & Lewis, 1976.)

Still useful. Contents: Pennsylvania potteries; New Jersey potteries; New York potteries; New England potteries; Ohio potteries; Potteries of the Southern states; Potteries of the Western states.

Index, p.169–74.

P353 _____. The pottery and porcelain of the United States; and historical review of American ceramic art from the earliest times to the present day, to which is appended a chapter on the pottery of Mexico. 3d ed., rev. and enl., with 335 illustrations. N.Y., Putnam, 1909. 621p. il. (Reprint of 1st ed.: Watkins Glen, N.Y., Century House Americana, 1971. Reprint ed. has an updated bibliography, p. 407–35; repr. with *Marks of American potters* [P352]: N.Y., Feingold & Lewis, 1976.)

1st ed. 1893.

Still standard. "The main purpose of this work is to furnish an account of such of the earlier potteries as, for any reason, possesses some historical interest, and of those manufactories which, in later days, have produced works of originality or artistic merit." —*Pref.*

American marks and monograms, p.392–414.

P354 Evans, Paul. Art pottery of the United States: an encyclopedia of producers and their marks. N.Y., Scribner [1974]. 353p. il., col. plates.

A scholarly historical survey and handbook of American art pottery — "earthenware, stoneware and porcelain — produced primarily for aesthetic, decorative purposes." —*p.1.* Covers the period between the Centennial exhibition of 1876 and the Great Depression. The main portion of the book consists of chapters on individual art potteries arranged alphabetically by name of pottery. Marks are listed in the last paragraph of each chapter.

Appendixes: (I) Geographical listing of art potteries; (II) Vital statistics of significant art pottery figures; (III) Expositions involving art pottery of the U.S.; (IV) Bibliography of principal reference works, p.345. Bibliographical references in notes sections at the ends of chapters.

## Oriental Countries

P355 Garner, *Sir* Harry. Oriental blue and white. [3d ed.]. London, Faber and Faber; N.Y., Praeger [1970]. 86p. il. (part col.)

1st ed. 1954. Main text for 3d ed. unaltered; revisions appear in the prefaces to the 2d and 3d ed.

An authoritative study of oriental blue and white porcelains.

Contents: (1) Introduction; (2) Origin of blue and white; (3) The late 14th and early 15th centuries; (4) Classical reigns of the 15th century; (5) The 16th century; (6) The end of the Ming dynasty; (7) The reign of K'ang Hsi; (8)

Yung Chêng and subsequent reigns of the Ch'ing dynasty; (9) Provincial Chinese blue and white; (10) Korean blue and white; (11) Japanese blue and white; (12) The dating and attribution of oriental blue and white. Appendix: marks. Bibliography, p.83–84, includes additional bibliography for the 3d ed.

P356 Honey, William Bowyer. The ceramic art of China, and other countries of the Far East. London, Faber and Hyperion Pr. [1945]. 238p. il. (incl. map.) 192 plates.

Surveys the ceramic art of China, Indo-China, Korea, and Japan. Bibliography p.218–26.

P357 Koyama, Fujio. 2000 years of oriental ceramics. N.Y., Abrams; London, Thames & Hudson [1959]. 409p. plates (part col.)

French ed., *Céramique ancienne de l'Asie: Chine, Japon, Corée, Asie du Sud-Est, Proche-Orient*, Fribourg, Office du Livre.

Invaluable for outstanding illustrations of pieces in Japanese collections, many in color. Approximately two-thirds of the book is devoted to Chinese and Japanese ceramics. Each section is preceded by an informative, introductory essay.

Bibliography p.379.

P358 Oriental ceramics, the world's great collections. [Honorary supervisors, Fujio Koyama and John A. Pope. Tokyo, Kodansha, 1975-   .]. v.1-   . il., col. plates.

Texts in English and Japanese.

A series of 12 expensively-produced volumes which contain glossy color and black-and-white reproductions of outstanding pieces of oriental ceramics in some of the world's most renowned collections. Each volume includes a very brief introductory text, a list of color plates, a section of 90 to 100 color plates, a section of about 300 black-and-white illustrations, and notes on the plates. Each volume is compiled by a leading authority, who is generally the curator in charge of the collection represented.

Contents by volume: (1) Tokyo National Museum; (2) National Museum of Korea, Seoul; (3) Museum Pusat, Jakarta; (4) Iran Bastan Museum, Teheran; (5) The British Museum, London; (6) Victoria & Albert Museum, London; (7) Percival David Foundation of Chinese Art, London; (8) Musée Guimet, Paris; (9) Museum of Far Eastern Antiquities, Stockholm; (10) The Freer Gallery of Art, Wash., D.C.; (11) Museum of Fine Arts, Boston; (12) The Metropolitan Museum of Art, N.Y.

## China

P359 Beurdeley, Cécile and Michel. A connoisseur's guide to Chinese ceramics. Trans. by Katherine Watson. [Drawings by Danica Peter]. New York, Harper [1975?]. 317p. il. (part mounted col.), diagrs., maps, plates.

Trans. of *La céramique chinoise,* Fribourg, Office du Livre [1974]. Also published as *Chinese ceramics,* London, Thames & Hudson, 1974.

A superbly illustrated survey of Chinese ceramics from their beginnings to the early 20th century. Contents: (I) Neolithic period; (II) The Shang-Yin period; (III) The Zhou (Chou) period; (IV) The Qin (Ch'in) and Han periods; (V) Period of the Six dynasties; (VI) The Sui dynasty; (VII) The Tang (T'ang) dynasty and the Five dynasties; (VIII) The Song (Sung) and Jin (Chin) dynasties; (IX) The Liao dynasty; (X) The Mongol Yuan (Yüan) dynasty; (XI) The Ming dynasty; (XII) From Ming to Qing (Ch'ing). Transitional period; (XIII) The Qing (Ch'ing) dynasty; (XIV) Export ware; (XV) Chinese porcelain of the 19th and early 20th centuries. Appendixes, p.285-304: The transcription of Chinese; Glossary; Materials, etc.

Excellent bibliography, p.305-10, arranged by chapter groups, includes books, catalogues, and articles in Western languages and in Chinese.

P360    Beurdeley, Michel. Porcelain of the East-India Companies. [English trans. by Diana Imber]. London, Barrie and Rockliff [1962]. 220p. il. (part col.)

"This work is a study of form and decoration in Chinese export porcelain, and includes the history of the Companies which brought it to Europe, with an examination of the varying characteristics which their nationalities imposed." —*Introd.* A comprehensive work; excellent illustrations.

Bibliography, p.212-13.

P361    Dexel, Thomas. Frühe Keramik in China; die Entwicklung der Hauptformen vom Neolithikum bis in die T'ang-Zeit. Braunschweig, Klinkhardt & Biermann [1973]. 84p., [48], 80p. of il.

A scholarly study of the development of early forms of Chinese ceramics. Contents: Die neolithische, erste archaische Phase der Gefässform; Die bronzezeitliche, zweite archaische Phase der Gefässform; Die Übergangphase von der archaischen zur klassischen Gefässform; Die erste klassische Phase der Gefässform; Beschreibung zu den Umrisszeichnungen. Umrisszeichnungen (48 Tafeln mit je 12 Zeichnungen). Bildtafeln (80 Tafeln mit 212 Abbildungen). Zeittafel, p.81.

Classified bibliography, p.82-84.

P362    [Fondation Alfred et Eugénie Baur-Duret]. The Baur Collections. Chinese ceramics, by John Ayers. Genève, Collections Baur [1968-74]. 4v. il., plates (part col.)

Lavish catalogues of an outstanding private collection of Chinese ceramics, most of which are previously unpublished. All pieces are reproduced. Catalogue entries are expertly written, with full technical descriptions and many references to comparable pieces already published elsewhere.

Contents: v.1, T'ang and Sung, with Korean and Thai wares (1968); v.2, Ming porcelain, and other wares (1969); v.3, Monochrome-glazed porcelains of the Ch'ing Dynasty (1972); v.4, Painted and polychrome porcelains of the Ch'ing Dynasty (1974).

The complete Baur Collections will eventually be published in approx. 12v. These include v.5, *Chinese jades and other hardstones* (P710) and v.6, *Netsuke* (announced for publication at the end of 1977). Remaining volumes will catalogue Japanese sword furniture, Japanese ceramics, and Japanese lacquer.

P363    Gompertz, G. St. G. M. Chinese celadon wares. London, Faber and Faber [1958]. xviii, 72p. 100 plates (4 col.)

"The prime objective of this book is . . . to provide a synthesis of views on the principal celadon wares and to illustrate these by a selection of representative examples drawn from collections in England and elsewhere." —*Pref.*

Contents: Introduction; (1) The origin of celadon; (2) Yüeh ware; (3) Some unidentified celadons —from T'ang to Sung; (4) Ju and other northern wares; (5) Southern Kuan; (6) Lung-Ch'üan ware; (7) Celadon of the Yüan and Ming periods; (8) The Ch'ing celadons.

Bibliography, p.69-70.

P364    Gray, Basil. Early Chinese pottery and porcelain. London, Faber and Faber [1953]. 48p. 101 plates (part col.)

An expertly rendered introduction to the early ceramics of China from the Shang dynasty to the Southern Sung and Yuan periods.

Bibliography, p.46.

P365    Gulland, W. G. Chinese porcelain, with notes by T. J. Larkin. 2d ed. London, Chapman & Hall, 1902. 2v. il., plates.

1st ed. 1898.

Still useful. "Chronological table," v.2, p.[xvii]-xxiv. "Authorities," v.1, p.[xiii]-xiv; v.2, p.[xxxvii]-xxxviii.

P366    Hobson, Robert Lockhart. Chinese pottery and porcelain; an account of the potter's art in China from primitive times to the present day. London, N.Y. [etc.] Cassell, 1915. 2v. il. 134 plates (part col.)

A standard work on the subject despite its age. Contents: (1) Pottery and early wares; (2) Ming and Ch'ing porcelain. Bibliography, v.1, p.xxvii-xxx.

P367    _____. The wares of the Ming dynasty. London, Benn, 1923. 240p. plates (part col.) (Repr.: Rutland, Vt., and Tokyo, Tuttle [1962]; N. Y., Dover, 1978)

Remains a useful account of the Ming dynasty wares. Somewhat out-of-date for attributions and chronologies. "The purpose of this book is to explain and illustrate as many varieties of Ming as possible. The text is based primarily on information obtained from Chinese sources and the occasional notes made by Europeans who visited China in the Ming period." —*Pref.*

P368    Howard, David Sanctuary. Chinese armorial porcelain; with a foreword by Sir Anthony Wagner. London, Faber and Faber, 1974. xiii, 1,034p. il. (49 col.), plates.

A monumental study and systematic classification of Chinese armorial porcelain. "This lavishly-produced book, illustrat-

ing pieces from nearly 2,000 services and describing nearly 1,000 more... is likely to remain the standard work for many years to come."—Michael Sullivan, *Times literary supplement,* Nov. 1, 1974, p.1222. The major portion of the work consists of a dictionary-catalogue of porcelain services painted between 1695 and 1820 arranged by styles A–Y, with detailed descriptions of coats of arms.

Contents: Introduction; (1) The Honourable East India Company; (2) Canton; (3) The porcelain and its painting; (4) The armigerous families; (5) Heraldry and Chinese painters; (6) Collections and the saleroom; (7) The classification of styles; Illustrated services, styles A to Y, p.161–800; An alphabetical list of services not illustrated, p.801–71. Includes 14 appendixes of specialized supplementary material.

Selected bibliography, p.1003–5. Index of services; General index.

P369   Jenyns, Soame. Later Chinese porcelain: the Ch'ing dynasty, 1644–1912. 4th ed. London, Faber and Faber, 1971. xvi, 111p. il. (part col.)
1st ed. 1951.

A study of Ch'ing dynasty porcelain which emphasizes the wares produced for the Chinese market rather than for export.

Contents: Introduction; (1) The letters of Père d'Entrecolles from Ching-Tê Chên; (2) The period of transition, 1620–83; (3) The directorship of Ts'ang Ying-Hsüan and the years that followed, 1683–1726; (4) The directorship of Nien Hsi-Yao, 1726–36; (5) The directorship of T'ang Ying (1736–49 or 1755); (6) The period of decline, 1749 ( or 1753)–1912; (7) The porcelain of the provincial kilns. Appendixes: (I) Ku Yüeh Hsüan (Ancient moon terrace); (II) The *nien hao,* hall-marks, and marks of commendation; (III) Ch'ing dynasty reign marks and dates.

Bibliography, p.102–3.

P370   _____. Ming pottery and porcelain. London, Faber and Faber [1953]. xi, 160p. 124 plates (4 col.)
A scholarly historical survey of Ming ceramics; incorporates the author's revisions and refinements of previous attributions and chronologies. The introduction presents an excellent account of the historiography of Chinese ceramics in general, and Ming in particular. The main text follows the development of Ming wares chronologically from the transition period of Yüan to Ming through the 17th century and the production of export wares. Appendix: Ming dynasty reign marks and dates, p.155.

Bibliography, p.156–57; bibliographical references in footnotes.

P371   Kuo li ku kung po wu yüan. Porcelain of the National Palace Museum. Comp. by the joint board of directors of the National Palace Museum and the National Central Museum. Hong Kong, Cafa, 1961–69. 3v. in 33. col. plates.
Compendia of color plates of the outstanding pieces of porcelain from the Sung to the Ch'ing dynasties in the collection of the National Palace Museum, Taipei (Taiwan),

formerly at Peking. Descriptive catalogue entries in Chinese and English given for each piece reproduced.

Contents: v.1, Sung dynasty: (1) Ju ware; (2) Chün ware; (3) Kuan ware; (4) Lung-Ch'üan ware; (5) Ko ware (2v.); (6) Southern Sung Kuan ware (3v.); (7) Ting ware (2v.) v.2, Ming dynasty: (1) Blue and white ware (7v.); (2) Underglaze red ware; (3) Enamelled ware (3v.); (4) Monochrome ware (2v.). v.3, Ch'ing dynasty: (1) Fine-enamelled ware, K'ang-Hsi period (A.D. 1662–1722); (2) Fine-enamelled ware, Yung Chêng period (A.D. 1723–35) (2v.); (3) Fine-enamelled ware, Ch'ien-Lung period (A.D. 1736–95) (2v.); (4) Blue and white ware (2v.); (5) Enamelled ware (2v.).

P372   Le Corbeiller, Clare. China trade porcelain: patterns of exchange; additions to the Helena Woolworth McCann Collection. Foreword by John Goldsmith Phillips. [N.Y.] Metropolitan Museum of Art [1974]. 134p. il. (part col.)
Documents pieces added to the McCann Collection of the Metropolitan Museum of Art; comprises a sequel to John Goldsmith Phillips's *China-trade porcelain* (P376). The Introduction, p.[1]–11, includes notes with references. The main portion of the text consists of the 52 catalogue entries, with commentaries, notes, and reproductions of comparative material and design sources.

Works cited in abbreviated form, p.125.

P373   London University. Percival David Foundation of Chinese Art. Illustrated catalogue. London [Percival David Foundation of Chinese Art] 1953–(73). v.1–(6). il.
A series of scholarly catalogues of the superb collection of Chinese ceramics of the Percival David Foundation. Contents: v.1, Tung, Ju, Kuan, Chün, Kuang-tung & glazed I-hsing wares, by S. Yorke Hardy (1953); v.2, Ch'ing enamelled wares, by Lady David (1958); v.3, Porcelains decorated in underglaze blue and copper red, by Margaret Medley (1963); v.4, Ting Yao and related white wares, by Hin-Chueng Lovell (1964); v.5, Ming polychrome wares, by Margaret Medley (1966); v.6, Ming and Ch'ing monochrome, by Margaret Medley (1973).

P374   Lunsingh Scheurleer, D. F. Chinese export porcelain; chine de commande. London, Faber and Faber; N.Y., Pitman, 1974. 256p. 360 il. (8 col.), maps.
Trans. of *Chine de commande,* Hilversum, W. de Haan, 1966.

An authoritative collector's handbook on Chinese porcelain of the 17th through 19th century made expressly for export to the West. Generously illustrated with line drawings of details, decorative motifs, and marks, color and black-and-white photographic reproductions of porcelains of all types, and of comparative materials. The text includes sections concerning the development and nature of trade relations between China and the West, the growth of interest in Chinese porcelain in the West, and the various kinds of porcelain exported.

Appendix: Collections in the Netherlands. Classified bibliography, p.233–43.

P375 Medley, Margaret. The Chinese potter: a practical history of Chinese ceramics. London, Phaidon; N.Y., Scribner [1976]. 288p. 215 il., 8 col. plates, maps.
"The aim of the following study is to present an up-to-date history of Chinese ceramics in terms of their technical development .... An attempt is also made to set the ceramics against the social and economic background, and to relate the whole subject in the wider, world picture." —*Pref.*

Contents: (1) The basic technology; (2) The period of discovery and innovation; (3) Development and variations. Reign marks, p.277–78. Glossary, p.279–81.

Notes, p.268–76, include bibliographical references. Classified bibliography, p.282–84.

P376 Phillips, John Goldsmith. China-trade porcelain; an account of its historical background, manufacture, and decoration, and a study of the Helena Woolworth McCann Collection. Cambridge, Mass., pub. for the Winfield Foundation and the Metropolitan Museum of Art [by] Harvard Univ. Pr., 1956. 234p. il. (part col.), maps on end papers.
An historical survey of China trade porcelain; based on the Helena Woolworth McCann Collection, now divided among the Metropolitan Museum, the Boston Museum of Fine Arts, and several other institutions. Supplemented and complemented by Clare Le Corbeiller's *China trade porcelain* (P372).

Bibliography, p.222–24.

P377 Sullivan, Michael. Chinese ceramics, bronzes and jades in the collection of Sir Alan and Lady Barlow. London, Faber and Faber [1963]. 173p. il., 164 plates (4 col.)
A noteworthy catalogue of an outstanding collection, particularly rich in early ceramics. The catalogue is divided into 20 sections: 18 sections on ceramics, 1 on bronzes, 1 on jades. Each catalogue section is preceded by a brief introductory essay. Also contains a chronological table and a general introduction. Excellent plates.

Bibliography, p.165–70.

P378 Valenstein, Suzanne G. A handbook of Chinese ceramics. N.Y., Metropolitan Museum of Art. (Distr. by New York Graphic Society, Boston, [1975].) xii, 251p. il.
An excellent introductory survey, based on the collection of more than 4,500 pieces in the Metropolitan Museum of Art. "A synopsis of the historical and technological background of Chinese ceramic art as a frame of reference against which the Museum's collection can be better enjoyed." —*Foreword,* by Wen Fong.

Contents: Early periods; Shang dynasty; Chou dynasty; Ch'in and Han dynasties; Six dynasties; Sui dynasty; T'ang dynasty; Five dynasties; Northern Sung, Chin and Southern Sung dynasties; Yüan dynasty; Ming dynasty; Ch'ing dynasty; The 20th century. Map, p.[x–xi]. Chronology, p.xii. Glossary, p.247–48. Bibliography, p.249–51. Notes, p.244–46, include references.

SEE ALSO: Kuo li ku kung po wu yüan. Taiwan. *Masterpieces of Chinese art in the National Palace Museum* v.3, *Porcelain* (I515).

## Japan

P379 Jenyns, Soame. Japanese porcelain. London, Faber and Faber [1965]. 351p. 124 plates (part col.)
A critical study of the history and expert assessment of the state of investigation of Japanese porcelain. Contents: (1) The export trade and its influence on the Japanese porcelain kilns; (2) The Imari and other Arita wares; (3) The early blue and white porcelain of Japan; (4) Sakaida Kakiemon and the first enamelled porcelain; (5) The Kutani wares of Kaga and some related kilns; (6) The porcelain of Nabeshima, Hirado and some less important factories; (7) Chinese porcelain made for the Japanese market and the work of Japanese studio potters in the Chinese tradition.

Includes valuable appendixes. Bibliography, p.321–23.

P380 _____. Japanese pottery. London, Faber and Faber; [1971]. 380p. plates (part col.)
The most important study in the field to date. Contents: (1) The prehistoric and protohistoric unglazed tomb wares; (2) Japanese pottery of the Nara (672–780) and Heian (781–1184) periods; (3) The six old kilns of Japan; (4) The rise of the pottery of the *cha-no-yu*; (5) The Mino wares; (6) The potteries founded by the Koreans; (7) and (8) The pottery of Yamashiro; (9) The work of some minor potters and kilns; The dating and attribution of Japanese pottery. Appendixes: (I) Extracts from the diary of Edward Morse; (II) Toshiro and his successors; (III) A list of pieces by Ninsei, Kengan, Chojiro, and Koetsu, illustrated in *Toki Zenshu.*

Bibliography, p.348–50.

P381 Kidder, Jonathan Edward. Prehistoric Japanese arts: Jōmon pottery. With contributions by Teruya Esaka. Tokyo and Palo Alto, Calif., Kodansha [1968]. 308p. il., col. plates.
Intended as "a full and representative survey of the latest material and research on Jōmon culture." —*Pref.* Excellent illustrations, map, and charts.

Contents: Earliest Jōmon; Early Jōmon; Middle Jōmon; Late Jōmon; Latest Jōmon; Notes on decorative techniques; Jōmon design incidence chart; List of collections; Carbon 14-dated sites; Jōmon chronology; Jōmon shape incidence chart; Map of archaeological sites; Archaeological site list; Jōmon shape development chart. Bibliography and notes, p.296–300.

P382 Koyama, Fujio. The heritage of Japanese ceramics. Trans. and adapted by John Figgess. With an introd. by John Alexander Pope. N.Y., Tokyo, Weatherhill/Tankosha [1973]. 252p. plates (part col.)
Originally pub. as *Nihon Toji no Dente,* Kyoto, Tankosha, 1967.

Pt. 1 contains six chapters and sections of plates with commentaries which comprise a general history of Japanese ceramics. Pt. 2 is a photo essay with commentaries on

Japanese kiln sites, potteries, and potters. Appendix: Locations of ceramic sites and kilns, p.241–47.

Selected bibliography, p.248.

P383    Miller, Roy Andrew. Japanese ceramics, by Roy Andrew Miller, after the Japanese text by Seiichi Okuda and others. With photos by Manshichi Sakamoto, Tazaburo Yoneda, and Yoshihiko Maejima. Tokyo, Toto Shuppan. (Distr. by Tuttle, Rutland, Vt. [1960].) 240p. il., 105 plates (19 col.), map.

A well-illustrated introduction to the history of Japanese ceramics from their origins to modern times. Contents: (1) Early earthenware; (2) Early pottery; (3) Medieval wares from the "Six old kilns"; (4) Mino and allied pottery; (5) Karatsu and allied pottery; (6) Raku ware; (7) Early Japanese porcelains; (8) The Arita porcelains; (9) Ninsei and his heirs.

Index with Japanese characters for proper names and ware designations, p.237–40.

SEE ALSO:    *Arts of Japan*, v.2, Sato, M. *Kyoto ceramics*; v.3, Fujioka, R. *Tea ceremony utensils* (I550); [Fondation Alfred et Eugénie Baur-Duret]. The Baur Collections (P362); *Heibonsha survey of Japanese art*, v.15, Hayashi, T. *Japanese art and the tea ceremony*, v.29, Mikami, T. *The art of Japanese ceramics* (I552); Lee, S. E. *Tea taste in Japanese art* (I556).

## Korea

P384    Asia House, New York. The art of the Korean potter: Silla, Koryŏ, Yi. [N.Y.] Asia Society. (Distr. by New York Graphic Society [1968].) 131p. il., plates (part col.), map.

The catalogue of an exhibition of 106 pieces of Korean pottery from American collections, selected by Robert P. Griffing Jr., and shown in the Asia House Gallery, N.Y., in 1968. The introductory essay, p.13–54, surveys the main outlines of the Korean potter's art. Catalogue entries give dynasty, date, dimensions, collection, brief description, and reference to illustration.

Chronology, p.12. Map, p.18. Footnotes in introduction include bibliographical references.

P385    Gompertz, G. St. G. M. Korean celadon and other wares of the Koryŏ period. London, Faber and Faber [1963]. xvii, 102p. il., 102 plates (part col.), map.

An excellent study of the forms and decoration of Korean ceramics of the Koryŏ period (A.D. 918–1392). Followed by the author's *Korean pottery and porcelain of the Yi period* (P386).

Contents: Introduction: the aesthetic approach; (1) The history of Koryŏ wares; (2) Early Koryŏ celadons and their relationship with Yüeh ware; (3) Hsü Ching's record of Koryŏ ceramic wares; (4) The Koryŏ celadon glaze; (5) Celadon roof-tiles for a royal pavilion; (6) Koryŏ inlaid celadon ware; (7) Black Koryŏ ware; (8) Koryŏ white porcelain; (9) Cyclical year-marks, iron painting, gilding and copper-red. Chronological summary, p.xvii. Note on Koryŏ pottery kilns and implements, p.89. Sketch map showing Koryŏ kiln sites, p.90.

Bibliography, p.91–6, classified into sections of books and catalogues in Western languages and Japanese. Includes a "note on historical sources utilized."

P386    _____. Korean pottery and porcelain of the Yi period N.Y., Praeger [1968]. xx, 106p. il., 128 plates (8 col.), maps.

The basic scholarly study of the later Korean ceramics of the Yi period (1392–1910); a sequel to the author's *Korean celadon . . .* (P385). "It is the first book in English on this subject, and it sums up the extensive knowledge derived from Japanese and Korean sources, as well as knowledge acquired at first hand from several visits to Korean kiln sites." –*Foreword.*

Contents: Introduction: the aesthetic approach; (1) The history of Yi wares; (2) Punch'ŏng ware; (3) Early Yi bowls; (4) White porcelain; (5) Painted decoration in underglaze iron and copper; (6) Blue-and-white porcelain; (7) Black-glazed and other wares; (8) The potter's craft and pottery kilns, etc. in the Yi period Korea. Appendix: Korean pottery wares which have been identified from their special names, uses and shapes. Chronological summary p.xix–xx.

Classified bibliography of books, catalogue articles and other references included in footnotes. Korean and literary sources, p.95–97.

P387    Kim, Chewon, and Gompertz, G. St. G. M., editors. The ceramic art of Korea. London, Faber and Faber [1961] 222p. incl. 100 plates (part col.)

A brief introductory survey followed by 100 plates reproducing ceramic pieces, with technical notes and historical comments for each. Plates are arranged chronologically by dynasty.

SEE ALSO:    [Fondation Alfred et Eugénie Baur-Duret]. The Baur Collections (P362).

## Southeast Asia

P388    Frasché, Dean F. Southeast Asian ceramics: ninth through seventeenth centuries. [N.Y.] The Asia Society in association with John Weatherhill [1976]. 144p. il., plates (part col.), maps.

The catalogue of an exhibition at the Asia House Gallery, N.Y., in 1976.

Documents the first major exhibition of Southeast Asian ceramics and provides the most comprehensive study of the field. Introductory essay, "Southeast Asia: its land and its people," p.13–19. The catalogue is in three sections: Khmer ceramic art (13 pieces); The ceramics of Thailand (43 pieces); The ceramics of Viet Nam (51 pieces).

Map of Southeast Asia, p.20; Map of kiln sites and monuments, p.21. Bibliography, p.142–43; bibliographical references included in notes at the end of introductions to catalogue sections.

P389    Spinks, Charles Nelson. The ceramic wares of Siam. Bangkok, The Siam Society, 1965. vii, 196, 52p. il., col. plates, maps.

A detailed, pioneering work. Gives an "account of the ceramic wares of Siam of the 14th and 15th centuries and of the Thai wares of the kilns of northern Thailand of the 15th and 16th centuries." —*Pref.*

Contents: (I) The coming of the Thai; (II) Sukhodaya's relations with the Yüan court; (III) Chinese ceramic influences at Sukhodaya; (IV) The Chalian monochromes; (V) The rise of the Svargaloka kilns; (VI) Svargaloka monochromes; (VII) Svargaloka painted wares; (VIII) Svargaloka figurines; (IX) The ceramic export trade; (X) Unconventional use of ceramics; (XI) The later kilns of northern Siam; (XII) The rediscovery of Thai ceramics; (XIII) Thai kiln construction and potting methods; (XIV) A simplified grammar of Thai ceramic forms; (XV) Bibliography, p.177-90.

Bibliographical references in footnotes.

SEE ALSO: [Fondation Alfred et Eugénie Baur-Duret]. The Baur Collections (P362).

## Primitive

P390   Bushnell, Geoffrey Hext Sutherland, and Digby, Adrian. Ancient American pottery. London, Faber and Faber; N.Y., Pitman [1956?]. xii, 51p. 84 plates (part col.), maps. (The Faber monographs on pottery and porcelain)

A brief introductory survey of pre-Columbian pottery from its origins in the 2d millennium B.C. to the beginning of the 16th century. Includes only the products of the better-known areas.

Contents: (1) Introduction; (2) The Southwest of the U.S.; (3) The pottery of Central America; (4) South America.

Classified bibliography, p.47-48.

# GLASS

## Bibliography

P391   Duncan, George Sang. A bibliography of glass (from the earliest records to 1940). With a foreword by W. E. S. Turner. Ed. by Violet Dimbleby. Subject index prepared by Frank Newby. London, Dawsons of Pall Mall for the Society of Glass Technology, Sheffield [1960]. viii, 544p.

A comprehensive annotated bibliography of glass, comprising over 16,000 entries from the earliest records to 1940. Includes references to books, periodicals, pamphlets and catalogues, as well as to pertinent literary sources. Detailed subject index, p.505-44.

SEE ALSO: "A check list of recently published articles and books on glass," in each annual volume of *Journal of glass studies* (Q207), 1959- , lists the literature of the previous year under the following categories: general, technology, regions, periods, countries, and types. Includes stained glass.

## Histories, Handbooks, Dictionaries and Encyclopedias, Collections

P392   Beard, Geoffrey. International modern glass. London, Barrie & Jenkins, 1976. 264p. il. (part col.)

A brief authoritative review of modern glass from 1870-1974. The concise historical introduction is followed by a compendium of 344 good illustrations arranged by subject.

"A select list of a glass manufacturers" (p.209-15) gives short descriptions of major glass-making centers in Europe and the U.S., including names of principal designers and bibliographical references. "A select list of designers" (p.216-53) gives thumbnail biographies, whenever possible, of approx. 300 glass designers with exhibitions and bibliography. Glossary, p.257-58. Classified bibliography, p.254-56.

P393   Düsseldorf. Kunstmuseum. Das Glas des Jugendstils. Katalog der Sammlung Hentrich im Kunstmuseum Düsseldorf, [von] Helga Hilschenz. [2. durchgeschene Aufl.] München, Prestel [1973]. 535p. il. (part col.) (Materialien zur Kunst des 19. Jahrhunderts, Bd. 8)

A complete catalogue of the Hentrich Collection of Art Nouveau glass in the Kunstmuseum Düsseldorf. One of the most important glass collections. Complements Neuwirth (P408). Extensive bibliographical references in notes. The catalogue of 458 pieces includes detailed descriptions and bio-bibliographies of the major artists. Each piece is illustrated.

"Glastechnisches Glossar," p.[508]-13. "Ausgewählte allgemeine Bibliographie," p.[514]-20. "Signaturentafeln," p.522-29. "Orts- und Namenregister," p.[530]-35.

P394   Elville, E. M. The collector's dictionary of glass. London, Country Life [1961]. 194p. il. (col. front.)

A well-illustrated dictionary of glass from the earliest times to the present. Intended for the collector; some inaccuracies. Treats British glass more fully than that of other countries. The introduction traces the history of glass up to the Venetian period. Subsequent development is covered in the dictionary. Some entries on technology and types. Selected bibliography, p.193-94.

P395   Grover, Ray, and Grover, Lee. Art glass nouveau. Rutland, Vt., Tuttle [1967]. 231p. 423 col. il.

A lavishly illustrated survey of Art Nouveau glass, described according to shape, color, and texture or finish. Detailed descriptions of each type. All of the pieces are reproduced in color. Includes an ownership list, a list of museums, and a bibliography.

P396   _____. Carved and decorated European art glass. Rutland, Vt., Tuttle [1970]. 244p. 423 col. il.

A lavishly produced survey of carved and decorated glass created during the late 19th and early 20th centuries. Like the authors' earlier *Art glass nouveau* (P395), this volume concentrates on design. Supported by superb color illustrations. Bibliography, p.239. Index, p.241-44.

P397   Haynes, Edward Barrington. Glass through the ages
[Rev. ed.]. Baltimore, Penguin [1964]. 309p. il.
1st ed., 1948.

A useful work which provides a good introduction to the
history and technology of glass. The rev. ed. corrects errors
and expands the treatment of 18th-century English glass.
Small clear illustrations. Bibliographies at the end of each
chapter. Index, p.301-[10].

Contents: (I) The glass of the Eastern world: (1) Begin-
nings, (2) The first four centuries, (3) The second four
centuries, (4) The empty ages, (5) The rise and fall of Venice,
(6) The revival in Western Europe, (7) German glass, (8)
Gilding the lily, (9) Glassmaking in England, (10) Jacobite
glass, (11) Commemorative glass; (II) English glasses of the
18th century.

P398   Kämpfer, Fritz, and Beyer, Klaus G. Glass: a world
history; the story of 4000 years of fine glass-making.
Trans. and rev. by Edmund Launert. Greenwich,
Conn., New York Graphic Society [1967]. 315p. il.
(part col.)
Rev. trans. of *Viertausend Jahre Glas*. Dresden, Verlag der
Kunst, 1966.

A pictorial history of glass intended for the beginner and
the general reader. 248 illustrations, 40 in color. Biblio-
graphical references in the catalogue notes. Glossary,
p.296-[315]. No general bibliography or index.

P399   Kolthoff, Benedict. Glass terminology: A German-
English glossary. 3d ed., rev. The Hague, van Goor
Zonen, 1967. xiv, 106p. il., 8 plates.
1st ed. 1963; 2d ed. 1966.

A dictionary of glass terminology. Includes all aspects of
glassmaking. "The present edition is not intended to be a
duplication of existing works but offers many terms, defini-
tions and data not found in other books. Therefore, it should
be regarded as a glass supplement to the available litera-
ture." – *Foreword*. Many of the entries are abbreviations
commonly found in the literature. Excellent bibliography,
p.97-103.

P400   Krug, Helfried. Glassammlung Helfried Krug. Besch-
reibender Katalog mit kunstgeschichtlicher Ein-
führung von Brigitte Klesse. München, Müller; Bonn,
Habelt [1965-73]. 2v. (v.1, 363 p.; v.2, 316p.) 762 il.,
plates (part col.)

A lavishly illustrated, detailed catalogue, in two parts, of an
important German collection, comp. by a distinguished
scholar. v.2 was pub. in conjunction with an exhibition in
the Overstolzenhaus, Cologne, mounted by the International
Congress of Glass in 1973. Both volumes include introduc-
tory essays on the major centers of glass production espe-
cially in Germany, but also in the Netherlands, Russia, and
other European countries. The Catalogues in both volumes
contain sections on glass from many regions which dates
from antiquity through the 19th century.

Bibliographies: v.1, p.363-[64]; v.2, p.315-16.

P401   Moore, Hannah Hudson. Old glass; European and
American. With two hundred and sixty-five illustra-
tions. N.Y., Stokes, 1924. xvi, 394p. il.

Reissued 1931, 1935, 1938 (as a new ed.), 1939, 1941, 1943,
1945, 1946.

A standard survey of the development of European and
American glassmaking. Contents: pt. 1, European glass; pt.
2, American glass. "American glass factories," p.369-82.

P401a   Newman, Harold. An illustrated dictionary of glass;
2,442 entries, including definitions of wares, materials,
processes, forms, and decorative styles, and entries
on principal glass-makers, decorators, and design-
ers, from antiquity to the present. With an introduc-
tory survey of the history of glass-making by Robert
J. Charleston. [London] Thames & Hudson [1977].
351p. 625 il. (17 col.)

"Intended primarily to define terms relating to glass and
glassware, such as the constituent elements, the methods of
production and decoration, and the styles in various
regions and periods, and also to describe some pieces that
bear recognized names. —*Pref*. Well illustrated; numerous
cross-references. Some entries give bibliography.

P402   Paris. International Council of Museums. Comité
international pour les musées et collections du verre.
Répertoire international des musées et collections
du verre; International repertory of glass museums
and glass collections. Liège [Musée du Verre] 1966.
216p.

An international directory of glass museums and museums
with collections of glass. Arranged by continent, then coun-
try, city, and museum. Includes for each listing address of
museum, director's name, departments with glass collections,
curator or curators, origins of collections, size of collections,
collections on display, periods and geographical regions
represented, and bibliography.

P403   Polak, Ada Buch. Glass: its tradition and its makers.
N.Y., Putnam [1975]. 224p. il.

A well-illustrated social and economic history of glass from
the Middle Ages to c.1870. Bibliographical references at
end of each chapter. Extensive bibliography, p.[211]-21.

P404   _____. Modern glass. London, Faber and Faber
[1962]. 94p. 100 plates (4 col.) (Faber monographs
on glass)

A readable account of the aesthetic nature of modern glass,
written by a well-known scholar for the connoisseur and the
collector. "This book sets out to deal with one quantitatively
very small branch of modern glass-making —namely glass
vessels where particular aesthetic qualities in the material,
or decorative methods peculiar to glass, have been exploited
with a genuine artistic purpose."—*p.19*. A useful list of
glass marks is included. Bibliography, p.89-90. Index,
p.91-94.

Contents: (1) Fin-de-siècle, (2) Functionalism: 1915-40,
(3) Neo-Functionalism: 1945-60.

P405   Schlosser, Ignaz. Das alte Glas; ein Handbuch für
Sammler und Liebhaber. Braunschweig, Klinkhardt
& Biermann [1956]. 301p. il., 6 col. plates. (Bibliothek
für Kunst- u. Antiquitäten-freunde, Bd. 36)

A handbook of old glass, written for the collector and connoisseur. Covers Egypt to the Renaissance in Venice. Well illustrated. Bibliography, p.294–95.

P406 Schmidt, Robert. Das Glas. 2d ed. Berlin, de Gruyter,
O    1922. viii, 419p. 233 fig. (Handbücher der K. Museum zu Berlin, Bd. 14)
1st ed., Berlin, Reimer, 1912.

A "superior and encompassing view of glass history in general and German glass in particular." –Duncan, *Bibliography of Glass* (P391). Bibliography, p.408–9.

P407 Victoria and Albert Museum. South Kensington.
Glass; a handbook for the study of glass vessels of all
O    periods and countries & a guide to the museum collection, by W. B. Honey. London, pub. under the authority of the Ministry of Education, 1946. xii, 169p. 72 plates.

An excellent introductory handbook to the study of glass; based on the important collection of the Victoria and Albert Museum.

Contents: (I) Introduction; (II) Ancient Egyptian glass; (III) Roman glass; (IV) Mediaeval European and Islamic glass; (V) Venetian glass; (VI) German and Bohemian glass; (VII) English glass; (VIII) Netherlandish glass; (IX) French glass; (X) Spanish glass; (XI) Chinese glass; (XII) Scandinavian and American glass.

General bibliography, p.[xi]–xii; bibliographical references in footnotes. Subject index; Numerical index.

P408 Vienna. Österreichisches Museum für Angewandte
Kunst. Das Glas des Jugendstils: Sammlung d. Österr.
Museums f. Angewandte Kunst, Wien [von] Waltraud
Neuwirth. München, Prestel, 1973. 435p. il. (part col.), map. (Materialien zur Kunst des 19. Jahrhunderts; Bd. 9)

An excellent catalogue of an important collection of Art Nouveau glass. The 272 objects are superbly illustrated within the extensively documented catalogue. The catalogue is preceded by an historical and technological introduction. This work and Helga Hilschenz's catalogue of Jugendstil glass in the Kunstmuseum, Düsseldorf (P393) form the finest documentation of Jugendstil glass in German countries.

"Terminologie und Technologie," p.88–96; "Künstler-biographien," p.98–101; "Marken, Zeichen, Signaturen," p.400–20; "Bibliographie," p.422–24; "Orts- und Namen-register," p.425–32; "Sachregister," p.433–35.

P409 Weiss, Gustav. The book of glass. Trans. by Janet
Seligman. N.Y., Praeger [1971]. 353p. il., plates (part col.), maps.
German ed.: *Ullstein Gläserbuch*, Berlin, Ullstein, 1966.

A scholarly introduction to the history and technology of glass from its beginnings to the present. Good bibliography. Well illustrated.

Contents: Glass in history; From the earliest beginnings to the Carolingian period; From the early Islamic period to the present day; Technique and history of glassmaking. Appendix; "Glasshouses: the sites," p.333–40. Index and glossary, p.341–45. Bibliography, p.346–50.

## Techniques

SEE: Parsons, C. S. M., and Curl, F. H. *China mending and restoration* (P280); Theophilus. *The various arts* (H19).

## Ancient

P410 Brooklyn Institute of Arts and Sciences. Museum.
Department of Ancient Art. Ancient Egyptian glass
and glazes in the Brooklyn Museum [by] Elizabeth
Riefstahl. [Brooklyn, 1968]. xv, 114p. il., 13 col.
plates. (Wilbour monographs, 1)

A valuable guide to 93 of the most significant pieces in the comprehensive collection of the Brooklyn Museum. Most useful to specialists. Includes bibliographical references.

P411 Corning, New York. Museum of Glass. Glass from
the ancient world. The Ray Winfield Smith Collec-
O    tion, 1957. Corning, N.Y., The Corning Museum of
Glass [1957]. 298p. il.

The catalogue of an outstanding collection of ancient glass in the Corning Museum. Each piece is illustrated and fully documented. Bibliography, p.287–98. No index.

P412 Kisa, Anton Carel. Das Glas im Altertum. Leipzig,
Hiersemann, 1908. 3v. il., plates (6 col.) (Hiersemanns
Handbücher. Bd. III) (Repr.: Rome, "L'Erma" di
Bretschneider, 1968.)

Still a standard reference work on ancient glass, covering Egypt, the Near East, Greece, Rome, and the early civilizations of Western and Northern Europe. Chapters on sculptured glasses, glass mosaics, enamels, etc. Index at end of v.3, p.[969]–78. Bibliographical references in footnotes.

P413 Neuberg, Frederic. Ancient glass. Trans. from the
German by Michael Bullock and Alisa Jaffa. Lon-
don, Barrie & Rockliff; [Toronto] Univ. of Toronto
Pr. [1962]. ix, 110p. col. illus., plates, maps.

A comprehensive treatment of ancient glass vessels and jewelry. Well illustrated.

Contents: (I) The material; (II) Shape and decoration; (III) Glass beads; (IV) Egypt; (V) Mesopotamia and Syria; (VI) Palestine and the Jews; (VII) Greece and Rome; (VIII) The western Roman Empire; (IX) The eastern Roman Empire; (X) Final thoughts. Comparative time chart, p.98–99. List of references, p.103–5. Bibliography, p.106–7.

## Western Countries

### France

P414 Barrelet, James. La verrerie en France de l'époque
gallo-romaine à nos jours. Paris, Larousse [1953].
O    206p. plates, maps.

A basic, comprehensive survey of French glassmaking. The appendixes have a glossary of terms, short biographies of glassmakers, and an index of centers. Bibliography, p.[189]–92. Well illustrated; notes on the plates.

**P415**  Bloch-Dermant, Janine. L'art du verre en France, 1860–1914. Lausanne, Denoël, [1974]. 200p. il. (part col.), facsims.

A scholarly study of the development of Art Nouveau glass in France. Illustrations throughout the text; facsimiles of the artists' marks. Excellent color reproductions.

Contents: Introduction; Les techniciens et le renouveau; Les influences orientales et les recherches de formes nouvelles; Les successeurs de l'art de Rousseau; L'école de Nancy; Emile Gallé; Les frères Daum; Sources d'inspiration; Les frères Muller; La pâte de verre. Glossaire, p.196–98; Bibliographie, p.199–200.

## Germany and Austria

**P416**  Corning, New York. Museum of Glass. German enameled glass: the Edwin J. Beinecke Collection and related pieces [by] Axel von Saldern. Corning Museum of Glass, Corning, N.Y., 1965. 474p. il. (part col.), map. (The Corning Museum of Glass monographs, v.2)

The catalogue of a major collection of German enameled glass and other related pieces in the Corning Museum. Covers the 16th, 17th, and 18th centuries. The catalogue of 167 items is preceded by a scholarly introductory text. Bibliographical references in footnotes. Includes an extensive bibliography.

Contents: Introduction; Glass production from the 15th to the 18th centuries; Terminology; Venetian-type glass; Themes; Regions; Catalogue. Appendix: Examples of glasses with religious scenes; Examples of guild and profession glasses, p.446–48. Selected bibliography, p.449–61.

**P417**  Pazaurek, Gustav Eduard. Gläser der Empire- und Biedermeierzeit. Leipzig, Klinkhardt & Biermann, 1923. 412p. il.

An old standard survey of German and Austrian glass of the early 19th century. Well illustrated.

SEE ALSO:  Schmidt, R. *Das Glas* (P406).

## Great Britain

**P418**  Davis, Derek C. English and Irish antique glass. London, Barker [1964]; N.Y., Praeger [1965]. 152p. il., plates.

A compact survey of the history of glassmaking in England and Ireland in the 18th and 19th centuries. Includes chapters on the styles, techniques, and types of glassware produced. Appendixes: (1) Glass terminology; (2) Important dates in glass history; (3) Collections on display; (4) Glasshouses; (5) Glass paperweights.

Selected bibliography, p.145–46.

**P419**  Thorpe, William. A history of English and Irish glass. London, The Medici Society, 1929. 2v. xv, 372p. il. (part col.) (Repr.: London, Holland, 1971.)

A fundamental history of glass in Great Britain and Ireland from the 13th century to 1845. Still a basic work.

Contents: v.I: (1) The principles of technique; (2) The age of adoption; (3) The age of assimilation; (4) The Ravenscroft revolution; (5) The age of design; (6) The age of ornament; (7) The Anglo-Irish revival: Cut glass. Appendixes: (I) On abjects, orts, and imitations; (II) Thomas Betts's acounts; (III) Cardiff Ms. 5.21; (IV) Special types. Terminology, p.335–40. Select bibliography, p.341–49. Index to v.I and II, p.351–72. v.II.: Plates with notes.

**P420**  Wakefield, Hugh. Nineteenth century British glass. London, Faber and Faber [1961]. 64p. 100 plates (4 col.) (Faber monographs on glass)

An important survey of 19th–century British glass which presents the results of extensive primary research in the field. Based on securely dated and attributed pieces.

Contents: (1) Introduction; (2) Cut glass; (3) Earlier coloured glass and novelties; (4) Engraved glass; (5) Later fancy glass; (6) Mould-brown and press-moulded glass. Marks, p.60–61.

Bibliography of six items, p.61. Bibliographical references in footnotes.

**P421**  Warren, Phelps. Irish glass; the age of exuberance. N.Y., Scribner [1970]. 155p. 107 plates (part col.)

A detailed study of all types of glass produced in Ireland at the end of the 18th and the beginning of the 19th centuries. Well illustrated with clear plates.

Appendixes: (A) Glossary of Irish cutting terms most frequently used in the text; (B) A note concrning vessels with notched rims; (C) Excerpt from *A Frenchman in England, 1784*, François de la Rochefoucauld; (D) Facsimile of the formulae by John Hill; (E) A note on 'Waterford' chandeliers and other lighting fixtures; (F) Excerpt from Sir Tomason's Memoirs; (G) An historical note on the Marquess of Bute's collection. Bibliography, p.150–51.

**P422**  Wills, Geoffrey. Victorian glass. London, Bell, 1976. xi, 96p. il., 80 plates.

A brief accout of English Victorian glass.

Contents: (1) The 1840s; (2) The Great Exhibition; (3) The influence of Venice; (4) Etching and cameo-carving; (5) Premoulded and other late varieties; (6) Nailsea-type glass. The Appendix, "Victorian glass manufacture and decoration," includes a discussion of various technical processes and a glossary of terms associated with glassmaking.

Bibliography, p.[85]–6.

## Italy

**P423**  Corning, New York. Museum of Glass. Three great centuries of Venetian glass; a special exhibition, 1958. Corning, N. Y. [1958]. 116p. il.

The catalogue of an exhibition of 128 pieces of Venetian glass from various public and private collections. The introductory essay, p.9–26, and the catalogue entries provide an

authoritative survey of Venetian glassmaking in the 15th, 16th, and 17th centuries. The catalogue includes a section of comparative materials (paintings, sculptures, furniture, enamels, ceramics, prints, fabrics).

Bibliography, p.114-16. Bibliographical references included in catalogue entries.

P424  Mariacher, Giovanni. Italian blown glass, from ancient Rome to Venice. [Trans. by Michael Bullock and Johanna Capra]. London, Thames & Hudson; N.Y., McGraw-Hill [1961]. 245p. il., 84 col. plates.
Trans. of *Il vetro soffiato da Roma antica a Venezia.*

A sumptuous pictorial survey of Italian blown glass from antiquity to that made at Murano in the early 19th century. Condensed historical review by a well-known authority on Venetian glass.

Bibliography, p.61-62.

## Low Countries

P425  Chambon, Raymond. L'histoire de la verrerie en Belgique du IIme siècle à nos jours. Préf. de G. Faider-Feytmans. Bruxelles, Librarie encyclopédique, 1955. 331p. 77 plates.
A comprehensive book on Belgian glass, based on archival research. Not for the beginner. Illustrated with 150 examples from Belgian collections. Detailed index. Full bibliography, p.261-82.

## Spain and Portugal

P426  Frothingham, Alice Wilson. Spanish glass. London, Faber and Faber; N.Y., Yoseloff [1964]. 96p. 100 plates (4 col.), map. (Faber monographs on glass)
An authoritative survey of Spanish glass which summarizes and brings previous works up-to-date. Scholarly notes.

Contents: (1) Medieval Spanish glass: Romanesque and Gothic periods; (2) Cataluña and neighboring regions; (3) Southern Spain: Almería, Granada, Sevilla; (4) Castilla: Cadalso, Recuenco, Nuevo Baztán and other glass centres of the region; (5) The royal factory of La Granja de San Ildefonso. Map of glass centres in Spain, p.88-89; Bibliography, p.90-92; Index, p.93-96. Well illustrated.

SEE ALSO: *Ars Hispaniae*, v.10, *Cerámica y vidrio*, por J. Ainaud de Lasarte (I438).

## United States

P427  McKearin, George Skinner, and McKearin, Helen. American glass. 2000 photographs, 1000 drawings by James L. McCreery. N.Y., Crown [1950]. xvi, 634p. il., plates, facsims.
1st ed. 1941; 2d ed. 1948.

A standard survey which treats all aspects of American glass. Extensive illustrations and tables of mold charts. "Chronological chart of American glass houses," p.583-613. Glossary, p.xv-xvi. Bibliography, p.615-17.

P428  _____. Two hundred years of American blown glass. Garden City, N.Y., Doubleday, 1966. xvi, 382p. 115 plates (part col.)
1st ed. 1950.

A general history of the subject, including "notes on the modern renaissance of the art of glass." Bibliography, p.361-66.

P429  Revi, Albert Christian. American Art Nouveau glass. [Camden, N.J.] Nelson [1968]. 476p. il. (part col.)
A general history of Art Nouveau glass in America; covers the major companies and artists. Well illustrated. Catalogues of glass manufacturers included in an appendix. Bibliography, p.463-64. Index, p.465-76.

P430  _____. American pressed glass and figure bottles. N.Y., Nelson [1964]. xi, 446p. il., diagrs.
An historical survey of the varieties of American pressed glass and figure bottles. The chapters list the contributions of the individual companies. Illustrated with line drawings and photographs. Bibliography, p.413. Index of patterns, p.425-46.

P431  Wilson, Kenneth M. New England glass and glassmaking. N.Y., Crowell [1972]. 401p. 365 il.
A comprehensive history of the development of New England's glassmaking industry from the 17th century to the present day. Small clear illustrations.

Contents: Heritage of New England glass-importation; 17th- and 18th-century glassmaking attempts in New England; 19th-century New England window glasshouses; 19th-century Connecticut bottle glasshouses; 19th-century New Hampshire bottle glasshouses; 19th-century Massachusetts bottle glasshouses; The flint glass industry in New England. Bibliographical notes follow the text. "Chronological list of New England glasshouses and products," p.[379]-83. Bibliography, p.[385]-86.

## Oriental Countries

P432  Blair, Dorothy. A history of glass in Japan. [Tokyo, N.Y., Kodansha, 1973]. 479p. plates (part col.)
"A Corning Museum of Glass monograph."

A monumental book, by the foremost Western authority on Japanese glass, which advances research in the field and serves as the starting point for future research. The historical survey begins with the Jōmon period (c.10,000 B.C. to c.250 B.C.) and ends with the modern period (c.1970). Documentation in footnotes. Excellent plates, many in color. Notes to the plates (240 entries), p.327-417, with bibliographical references; Supplementary notes (92 entries), p.419-47. Appendix: Chemical considerations, by R. H. Brill, p.448-57; Bibliography, p.461-69; Index-Glossary, p.470-79. Also has chronologies and maps.

439

# STAINED GLASS

**P433** Baker, John. English stained glass. Introd. by Herbert Read. Photos by Alfred Lammer. N.Y., Abrams [1960]. 244p. il., plates (part mounted col.)

A pictorial history of stained glass in England, written by a restorer of ancient glass paintings. Good illustrations. Bibliography, p.242–43.

**P434** Corpus vitrearum medii aevi. Pub. with the co-operation of the Comité Internationale d'Histoire de l'Art. 1956– . il. plates (part col.)

In most cases sponsored by the national organization for art historians within the individual country. The publisher for individual volumes also varies with the country.

"The Corpus Vitrearum Medii Aevi, an international organization of scholars was founded in 1949 with the monumental task of compiling a complete inventory of surviving medieval stained-glass panels according to their present location in Europe or America. The Corpus intends to publish about ninety volumes, including thirty devoted to French and eighteen to German stained glass .... Each will have an introduction treating the history, style, and iconography of the glass, and a catalogue with provenance, dating, state of preservation, and bibliography for each panel."—D. Schimansky in *New York Metropolitan Museum of Art bulletin* (Dec.–Jan. 1971–72), p.109.

For an annotated bibliography of the volumes published to 1970, see L. Grodecki in *Revue de l'art* 10:97 (1970).

Published so far:

Corpus vitrearum medii aevi. Belgique.

v.1, Helbig, J. *Les vitraux médiévaux conservés en Belgique, 1200–1500.* Brussels, 1961; v.2, _____. *Les vitraux de la première moitié du XVIe siècle. Province d'Anvers et Flandre.* Brussels, 1968; v.3, Helbig, J., and Vanden Bemden, Y. *Les vitraux de la première moitié du XVIe siècle: Brabant et Limbourg.* Brussels, 1974.

_____. Deutschland.

v.1, Wentzel, H. *Die Glasmalereien in Schwaben von 1200–1350,* 1958; v.4, Rode, H. *Die mittelalterlichen Glasmalereien der Kölner Domes.* Berlin, 1974.

_____. España.

v.1, Nieto Alcaide, V. M. *Las vidrieras de la Catedral de Sevilla.* Madrid, 1969; v.2, Nieto Alcaide, V. M. *Las vidrieras de la Catedral de Granada.* Madrid, 1973.

_____. France.

v.1, Grodecki, L.; Lafond, J.; and Verrier, J. *Les vitraux de Notre Dame et de la Sainte-Chapelle de Paris.* Paris, 1959; v.4 (2), Lafond, J. *Les vitraux de l'église Saint-Ouen de Rouen.* Avec la collaboration de F. Perrot et de P. Popesco. Paris, 1970; Série études: (1) Les vitraux de Saint Denis, 1. Paris, 1976.

_____. Great Britain.

v.1, Newton, P. *The county of Oxford.* London, 1977. Supplementary volume: Wayment, H. *The windows of King's College Chapel.* Cambridge, London, 1972; Occasional papers: Newton, R. G. *The deterioration and conservation of painted glass.* London, 1974.

_____. Italia.

v.1, Marchini, G. *Le vetrate dell' Umbria.* Rome, 1973.

_____. Österreich.

v.1, Frodl-Kraft, E. *Die mittelalterlichen Glasgemälde in Wien,* Wien, 1962; v.2, _____. *Die mittelalterlichen Glasgemälde in Niederösterreich.* Wien, 1972.

_____. Schweiz.

v.1, Beer, E. J. *Die Glasmalereien der Schweiz vom 12. bis Beginn des 14. Jahrhunderts.* Basel, 1956; v.3, _____. *Die Glasmalereien der Schweiz aus dem 14. und 15. Jahrhundert ohne Königsfelden und Berner Münsterchor.* Basel, 1965.

_____. Skandinavien.

Andersson, S. M.; Christie, C. A.; Nordman, C. A.; and Roussell, A. *Die Glasmalereien des Mittelalters in Skandinavien.* Stockholm, 1964.

_____. Tschechoslowakei.

Matous, F. *Mittelalterliche Glasmalerei in der Tschechoslowakei.* Prag. 1975.

**P435** Drake, Wilfred James. A dictionary of glasspainters and "glasyers" of the tenth to eighteenth centuries. N.Y., The Metropolitan Museum of Art, 1955. x, 224p. il.

A dictionary of European glasspainters, designers, glasyers, and glassmakers. Includes for each artist, whenever possible, his name, dates, location of works, reproduction of signature, and reference. The "Geographical key," p.161–204, lists artists by country and then by century of activity.

Appendixes: (I) Glassmakers (makers of white and coloured window glass); (II) Designers of stained glass (known to have designed stained glass but not, as far as is known, glasspainters); (III) Signatures of glasspainters not yet identified.

Bibliography, p.221–24.

**P436** Frodl-Kraft, Eva. Die Glasmalerei. Entwicklung, Technik, Eigenart. Wien und München, Schroll [1970]. 140p. il. (part col.)

An excellent introductory book on the technique, history, and conservation of stained-glass painting, written by a well-known specialist. Good illustrations, many of lesser-known works. Full bibliography, p.135–37. Indexed.

**P437** Lafond, Jean. Le vitrail. Paris, Fayard, 1966. 127p. (Je sais, je crois; encyclopédie du catholique au XXme siècle, 127. 12. ptie.; Les arts chrétiens)

A brief, authoritative introduction to medieval stained glass.

**P438** Lee, Lawrence; Seddon, George; and Stephens, Francis. Stained glass. With photos by Sonia Halliday and Laura Lushington. London, Beazley; N.Y., Crown, 1976. 207p. il. (some col.)

A wide-ranging survey of stained glass which promises to be valuable to both the student and general reader. Covers its history from the beginning to the present; contains topical essays on historical and philosophical background, the relationship of stained glass windows to church architecture, and iconography; includes a section on techniques and restoration. Excellent photographic illustrations, in color and black and white, conveniently placed in the text. Gazetteer, p.195–98 (arranged by city and building); Glossary, p.199; Bibliography, p.207.

Contents: The world of stained glass, by Lawrence Lee; The history of stained glass, by George Seddon; How a stained-glass window is made and restored, by Francis Stephens.

P439 Marchini, Giuseppe. Italian stained glass windows. London, Thames & Hudson, [1957]. 264p. p.[71]-[231] plates (part col., incl. plans), mounted il. (1 col.), 4 col. transparency plates.

Trans. of *Le vetrate italiane.*

A general history of Italian stained glass. The introduction contains a brief history of the technique of stained glass. Excellent reproductions of the windows discussed; many color plates. Diagrams and plans of the churches showing the location of the windows in relation to the church. Bibliographical references included in "Notes," p.233-[55]. Bibliography, p.256, lists only the "more essential works." Includes Index of persons.

Contents: Introduction; Assisi; The Sienese school; Pisa; The Florentine school; Bologna; Venice; Lombardy; Marcillat; Other 16th-century stained glass.

P440 Paris, Musée des Arts Decoratifs. Le vitrail français. Paris, Deux mondes [1958]. 336p. il., plates (part col.)

A sound, well-illustrated survey of French stained glass from its beginnings to the present. Also discusses aesthetics, techniques, and restoration. Each chapter is written by a specialist, e.g. Marcel Aubert, Louis Grodecki. Bibliography, p.313-14; notes, p.315-27, also contain bibliography; "Index général," p.329-36.

P441 Witzleben, Elisabeth von. French stained glass; trans. from the German by Francisca Garvie. London, Thames & Hudson, 1968. 264p. il., 47 col. plates.

Trans. of *Licht und Farbe aus Frankreichs Kathedralen.*

A well-presented volume on French stained glass. Excellent color plates; numerous black-and-white illustrations. The author has "laid greater emphasis on [the glass of] Alsace and Lorraine than previous books since from the second half of the thirteenth century the stained glass of Strasbourg became an important vehicle for western canons of form, while it also evolved a native style whose influence extended through South Germany as far as Austria."—*Pref.* The introduction presents a brief essay on the symbolic aspects of light and the development of the technique of stained glass. Historical survey gives a concise treatment of the windows discussed.

Contents: Introduction; Historical survey; Notes (contain bibliographical references), p.85-[87]; The plates, p.89-[255]; List of color plates; List of black-and-white plates; Bibliography, p.260-[61]. Bibliography contains standard and most recent scholarship only.

# ENAMELS

## Bibliography

P442 McClelland, Ellwood Hunter. Enamel bibliography and abstracts, 1928 to 1939, inclusive, with subject and coauthor indexes. Columbus, Ohio, American Ceramic Society, 1944. 352p.

A bibliography of all aspects of enamels and enameling. Subject index, p.312-35, lists numerous entries under art on p.314. Index to coauthors, p.351-52.

## Histories and Handbooks

P443 Gauthier, Marie-Madeleine. Émaux du moyen âge occidental. Cartes et dessins de Geneviève Mottel. Fribourg, Office du Livre [1972]. 443p. il. (part col.), plans, maps.

A comprehensive history of medieval enamels in the West, from the end of the 8th century to the International Style of the 15th century. A handsomely produced luxury edition, written by the foremost scholar in the field. Summarizes and advances the state of research.

"Phases are differentiated by the type of metal support: gold, silver, copper; metals cloisonné, champlevé, cut in low relief, and planed. Techniques are employed singly or in combination, by anonymous and known masters whose style is related to that of manuscript illuminators. Modes of execution, iconography, epigraphy, palette and style characterize the workshops situated in the orbit of the Franco-German empire: in Lombardy, Sicily, Northern Spain, the Limousin, Rhine and Meuse valleys, England, Lower Saxony, Denmark; then in Tuscany, Catalonia, the German Alps, Cologne, Paris, London, Burgundy, Flanders and the Loire Valley"—Author, *RILA,* Dem. issue, 1973, no. 324.

Bibliography, p.425-39.

P444 Molinier, Émile. Dictionnaire des émailleurs depuis le moyen âge jusqu'à la fin du XVIIIe siècle; ouvrage accompagné de 67 marques et monogrammes. Paris, Rouam, 1885. 113p. il.

Contents: Dictionnaire, p.7-93; Essai d'une bibliographie des livres relatifs à l'histoire des émaux, p.93-104; Liste des principales collections publiques ou privées renfermant des émaux, p.105-13.

P445 Walters Art Gallery, Baltimore. Catalogue of the painted enamels of the Renaissance. [by] Philippe Verdier. Baltimore, Walters Art Gallery, 1967. xxvii, 423p. 215 il. (part col.)

A scholarly catalogue of Renaissance enamels in the Walters Art Gallery and the indispensable work for research in the field. "Particular attention has been paid to tracing the graphic sources of the Limoges enamellers through the portfolios of prints and illustrated books which they had at their disposal . . . ." *Introd.*

The catalogue lists and illustrates 215 works: Netherlandish (no. 1); Italian (nos. 2-14); Limoges (nos. 15-215). For each gives a summary of research, technique, condition, exhibitions, provenance, and bibliography. Index.

P446 Wessel, Klaus. Die byzantinische Emailkunst vom 5. bis 13. Jahrhundert. Recklinghausen, Bongers [1967]. 213p. plates. (part col.) (Beiträge zur Kunst des christlichen Ostens, Bd. 4)

Eng. ed.: *Byzantine enamels from the fifth to the thirteenth century.*

A survey of Byzantine enamels. The introductory historical sketch is followed by a catalogue of 66 works. Documented catalogue entries. Faulty translation in the English ed. Good illustrations, Bibliography, p.203. Indexes of location, iconography, persons, authors, and illustrations.

SEE ALSO:  Lipinsky, A. *Oro, argento, gemme e smalti* (P465).

## Techniques

P447  Day, Lewis Foreman. Enamelling, a comparative account of the development and practice of the art. London, Batsford, 1907. xxv, 222p. 115 il.
A practical book for the artist and craftsman; covers the various techniques. A brief historical background is given. Illustrated with line drawings and some photographs.

SEE ALSO:  Maryon H. *Metalwork and enamelling* (P472).

## Western Countries

### France

P448  Gauthier, Marie Madeleine. Émaux limousins champlevés des XIIe, XIIIe, & XIVe siècle. Préface de Pierre Verlet. Paris, Le Prat, [1950]. 164p. plates (part col.)
A lucid, well-written introduction to Limoges enamels, with 64 beautiful illustrations of pieces shown in the exhibition held in Limoges in 1948. "Notices descriptives des objets représentés," p.151-[60]. Bibliography, p.161-62.
Contents: (1) Les techniques; (2) L'évolution du décor; (3) Remarques sur le style et l'iconographie des émaux limousins.

P449  Marquet de Vasselot, Jean Joseph. Les émaux limousins de la fin du XVe siècle et de la première partie du XVIe; étude sur Nardon Pénicaud et ses contemporains. Paris, Picard, 1921. 412p. and atlas of 85 plates.
The standard reference work on Limoges enamels and enamellers of the late Gothic period.
Contents: Introduction (discussion of various schools), p.1-210; Liste des émaux (catalogue), p.211-364. Appendixes: (1) Documents relatifs à Nardon et à Jean Fer Pénicaud; (2) Liste des émailleurs limousins; (3) Le groupe violet. Bibliography, p.[385]-96. Index, p.[403]-9.

SEE ALSO:  Marquet de Vasselot, J. J. *Bibliographie de l'orfèvrerie et de l'émaillerie françaises* (P482).

### Russia and Eastern Europe

P450  Amiranashvili, Shalva IA sonovich. Medieval Georgian enamels of Russia. [Trans. by François Hirsch and John Ross] N.Y., Abrams [1964]. 126p. mounted col. il.
Also published in a French ed.: Paris, Cercle d'art [1962].
A condensed survey of Georgian and ancient Russian enamels from the 7th to the 12th century A.D., with a catalogue of the cloisonné enamels on gold in the Georgian National Museum of Fine Arts, Tiflis. The author, Director of the Museum, intended the book for both scholars and the general public. Treats Georgian enamels as a development of local tradition, distinct from that of Byzantium and the art which spread from the East. Describes technique, style, and iconography of the individual icons, medallions, manuscript bindings, crosses, reliquaries, etc. in the collection. Sumptuously produced, with 122 beautiful color plates.
Bibliography, p.125-26.

P451  Pisarskaja, Ljudmila Vasil'evna; Platonova, Nina Georgievna; and Ul'Janova, Bella Lazarevna. Russkie emali XI-XIX VV. iz sobranij Gosudarstvenny Muzeev Moskovskovskogo Kremlja, Gosudarstvennogo Istoriceskogo Muzeja, Gosudarstvennogo Ermitaza [Russian enamels of the 11th-19th cs. from the collections of the State Kremlin Museums, the Historical Museum, and the Hermitage]. Moscow, Iskusstvo, 1974. 239p. il. (127 col.)
"121 pieces, arranged chronologically, are catalogued and illustrated in color. Each entry is in Russian and French." —Staff, *RILA,* 1975, v.1, no.1-2, p.613.

## Oriental Countries

P452  Garner, *Sir* Harry. Chinese and Japanese cloisonné enamels. London, Faber and Faber [1962]. 120p. 102 plates (part col.)
A scholarly history and analysis of cloisonné enamels of China and Japan. Excellent illustrations of a wide range of examples.
Contents: The nature of enamels; The early history of enamels in the West; Chinese enamels in the pre-Ming period; Methods of assessment; Chinese enamels of the 15th century; The Ching-t'ai myth; The 16th century; The traditional period; The Ch'ing dynasty; Japanese cloisonné enamels.
Appendix 1: Marks on cloisonné enamels; Appendix 2: Split wires in Chinese cloisonné enamels. Bibliography, p.114-16.

SEE ALSO:  Kuo li ku kung po wu yüan. Taiwan. *Masterpieces of Chinese art in the National Palace Museum,* v.[7] *Enamel ware* (I515).

# METALWORK

P453 Clouzot, Henri. Les arts du métal; métaux précieux, le bronze et le cuivre, le fer, les armes, la parure. Paris, Laurens, 1934. 524p. 270 il.

A broad survey of Western and Oriental metalwork from antiquity to the beginning of the 20th century.

"Bibliographie sommaire," p.[485]-94. "Index des noms cités," p.495-511.

P454 Haedeke, Hanns-Ulrich. Metalwork. Trans. by Vivienne Menkes. N.Y., Universe Books [1969]. 227p. 265 il. (16 col.)

A comprehensive survey of the development and uses of copper, bronze and brass, iron, and pewter from antiquity to modern times. Well illustrated.

Notes, p.199-211. Classified bibliography, p.213-18: General; Copper; Brass and bronze; Arms and armour; Cutlery; Iron and steel; Pewter.

P455 Perry, John Tavenor. Dinanderie; a history and description of mediaeval art work in copper, brass and bronze. N.Y., Macmillan; London, Allen, 1910. 238p. 71 il., 24 plates.

A comprehensive, introductory survey of the coppersmith's art. Illustrated with line drawings and photographic reproductions. Contents: Pt. 1, Introductory: (I) General view; (II) Dinant and the Mosan towns; (III) The origins; (IV) The materials; (V) The processes. Pt. 2, Historical: (VI) The schools; (VII) Germany; (VIII) The Netherlands; (IX) France; (X) England; (XI) Italy and Spain. Pt. 3, Descriptive: (XII) Preliminary; (XIII) Portable altars; (XIV) Pyxes, ciboria and monstrances; (XV) Shrines; (XVI) Reliquaries; (XVII) Crosses; (XVIII) Censers; (XIX) Candlesticks and lightholders; (XX) Crosiers; (XXI) Holy water vats; (XXII) Lecterns; (XXIII) Book-covers; (XXIV) Fonts; (XXV) Ewers and water vessels; (XXVI) Bronze doors; (XXVII) Sanctuary rings or knockers; (XXVIII) Bells; (XXIX) Tombs; (XXX) Monuments.

Bibliography, p.221-22. General index.

## Techniques

P456 Braun-Feldweg, Wilhelm. Metal; design and technique. Trans. by F. Bradley. N.Y., Van Nostrand Reinhold [1975]. 296p. il.

Trans. of *Metall—Werkformen und Arbeitsweisen*, Ravensburg, Maier, 1968.

A layman's guide to the various forms of metalwork and their techniques. Contents: (1) Metalcrafts in the past and present; (2) Objects; (3) Raw materials; (4) Techniques of forming; (5) Decorating techniques; (6) Metallic raw materials and expendable materials; (7) Calculation of alloys; (8) Precious stones; (9) Historical and stylistic survey; (10) Basic terms of heraldry.

Classified bibliography, p.287-88: Gold and silver; Iron and steel; Techniques; Enamel; Coining, steel- and punch engraving; Style, form and design; Heraldry; Gemmology.

Indexes: Artists and manufacturers; Historical examples; General.

SEE ALSO: Maryon, H. *Metalwork and enamelling* (P472).

## Islamic

P457 Fehérvári, Géza. Islamic metalwork of the eighth to the fifteenth century in the Keir Collection. With a foreword by Ralph Pinder-Wilson. London, Faber and Faber [1976]. 143p. 181 il., 12 col. plates.

A scholarly catalogue and study of 171 objects in the Keir Collection of Islamic metalwork. Although the collection does not include pieces in all important areas, this work provides a much-needed introduction to the field for which no comprehensive work exists.

Contents: Introduction; (I) Islamic metalwork from the 7th to the end of the 10th century; (II) Metalwork in Egypt, Sicily, and Spain between the 7th and the 12th centuries; (III) Metalwork in Iran and Central Asia between the early 11th and late 13th centuries; (IV) Metalwork of Upper Mesopotamia and Northern Syria during the 13th century; (V) Metalwork in Syria and Egypt from the late 12th to the middle of the 13th century; (VI) Metalwork in Iran from the late 13th to the end of the 15th century; (VII) Metalwork of Syria and Egypt from the middle of the 13th to the end of the 15th century; (VIII) Problem pieces.

Bibliography, p.[135]-38. Bibliographical references in footnotes.

P458 Mayer, Leo Ary. Islamic metalworkers and their works. Geneva, Kundig, 1959. 126p. 15 plates.

Contains a brief explanatory introduction and an alphabetical "Roll of metalworkers," p.[19]-91, including bibliographical references. "Chronological list of metalworkers," p.[101]-5. Bibliography, p.[107]-26.

## Western Countries

P459 British Museum. Dept. of British and Medieval Antiquities. Anglo-Saxon ornamental metalwork 700-1100 in the British Museum, by David McKenzie Wilson. With appendices by R. L. S. Bruce-Mitford and R. I. Page. [London] 1964. 248p. il. (British Museum. Dept. of British and Medieval Antiquities. Catalogue of antiquities of the later Saxon period. 1)

"This catalogue lists all the objects in the British Museum of precious metal or decorated bronze, made in an Anglo-Saxon context in the period between 700 and 1100. Objects of iron inlaid or embellished with precious metal are also included."–p.1. Complemented by the catalogue of the important collection of Anglo-Saxon metalwork in the Ashmolean Museum (P463). Each of the 155 entries includes detailed description and analysis, and frequently bibliography. Each object is illustrated photographically; many line drawings of details are included to emphasize certain points.

443

The catalogue proper is preceded by introductory chapters: (1) The collection of Anglo-Saxon ornamental metalwork in the British Museum; (2) The art of the metalworker; (3) The classification of the objects. Appendixes: (A) The inscriptions, by R. I. Page; (B) Iconography of the Fuller brooch (no. 153), by R. L. S. Bruce-Mitford; (C) Anglo-Saxon ornamental metalwork 700–1100, outside the British Museum – a hand-list.

Excellent bibliography, p.220–33. Index verborum; General index.

P460  Collon-Gevaert, Suzanne. Histoire des arts du métal en Belgique. [Bruxelles, Palais des Académies, 1951]. 476p. and atlas of 109 plates. (Académie Royale des Sciences, des Lettres et des Beaux-Arts, Brussels. – Classe des beaux-arts. Mémoires. Collection in 8°. t.7)

A comprehensive, scholarly history of the arts of metalwork in Belgium from the Bronze Age (2000–900 B.C.) to the 19th century. Glossary, p.419–45.

Bibliographical references in footnotes; Extensive bibliographies at the ends of chapters. General index.

P461  Gentle, Rupert, and Feild, Rachael. English domestic brass, 1680–1810, and the history of its origins. Foreword by Graham Woods. London, Elek; N.Y., Dutton, 1975. 232p. 350 plates.

A comprehensive history of brassmaking and brass manufacturers of domestic wares from 1680–1810. Well illustrated. Bibliography, p.87.

P462  Kauffmann, Henry J. American copper and brass. [Camden, N.J.] Nelson, 1968. 288p. il., plans.

A popular work, directed to the collector rather than to the scholar. "This survey with its listing of makers' names is designed to help the reader to make reasonably positive identification or attribution of objects in his possession or of some he expects to buy, to enrich his knowledge of the way the objects were made and used, and to lead him to a fuller understanding of American copper and brassware." –*Pref.*

Contents: (I) The metals – copper and brass; (II) The trades – the coppersmith and the brass founder; (III) Products of the coppersmith; (IV) Products of the brass founder; (V) William Bailey – a craftsman; (VI) Documented list of coppersmiths; (VII) Documented list of brass founders. Bibliography, p.282–83.

P463  Oxford. University. Ashmolean Museum. A catalogue of the Anglo-Saxon ornamental metalwork 700–1100 in the Department of Antiquities, Ashmolean Museum, by David A. Hinton. Oxford, Clarendon, 1974. xii, 81p. 56 il., 20 plates.

A detailed catalogue of the small but important collection of ornamental metalwork in the Ashmolean Museum. The only other collection of equal importance is that of the British Museum, whose catalogue this work complements (P459). A lengthy description is given for each of the 40 pieces catalogued, along with details of accession, and bibliography. Each object is shown in line drawings and photographic reproductions.

Bibliography, p.71–76. Index of countries; Index of inscriptions; Classification index; General index.

# Gold and Silver

## Histories and Handbooks

P464  Link, Eva Maria. The book of silver. Trans. [from the German] by Francisca Garvie. London, Barrie and Jenkins; N.Y., Praeger [1973]. 301p. il. (16 col.), maps.

Trans. of *Ullstein Silberbuch; eine Kunst- und Kulturgeschichte des Silbers,* Berlin, Ullstein, 1968.

A reliable introduction to the history of Western silver from ancient times to the present. Well illustrated with numerous line drawings and photographic reproductions. Bibliography, p.291–96.

P465  Lipinsky, Angelo. Oro, argento, gemme e smalti: technologia delle arti dalle origini alla fine del medioevo, 3000 a.C.–1500 d.C. Firenze, Olschki, 1975. xvi, 516p. il. (Arte e archeologia, 8)

A comprehensive history of gold, silver, gems, and enamel of all types from their origins to the end of the Middle Ages.

Contents: (I) L'uomo ed i metalli preziosi nelle religioni, nella vita sociale, nell'economia; (II) I giacimenti auriferi ed argentiferi nel mondo antico e medievale, Italia compresa; (III) I metodi dell'estrazione e dell'affinamento; (IV–V) Le diverse technologie della lavorazione artistica; (VI) Le gemme note nell'antichità, nelle religioni e folklore; loro provenienza e lavorazione; (VII) Gli smalti, inventati nell'ambiente mediterraneo e la loro differenziata evoluzione.

Extensive bibliographies for each section.

P466  Okie, Howard Pitcher. Old silver and old Sheffield plate, a history of the silversmith's art in Great Britain and Ireland, with reproductions in facsimile of about thirteen thousand marks. Tables of date letters and other marks. American silversmiths and their marks. Paris marks and Paris date letters with a description of the methods of marking employed by the Paris guild of silversmiths. Hallmarks, and date letters when used, of nearly all the countries of Continental Europe, reproduced in facsimile. A history of old Sheffield plate and a description of the method of its production, with the names and marks, in facsimile, of every known maker. With twelve full-page illustrations. N.Y., Doubleday, 1928. 420p. il., plates.

An old standard work. The "purpose [of the book is] of enabling the reader to establish the origin and authenticity of antique silver and 'old Sheffield plate.'" –*Foreword.*

General index.

P467  Rosenberg, Marc. Der Goldschmiede Merkzeichen. 3. erweiterte und illustrierte Aufl. Frankfurt am Main, Frankfurter Verlags-Anstalt, 1922–28. 4v. il., 117 plates. (Repr.: Florence, Centro Di, n.d.)

1st ed. 1890; 2d ed. 1911.

A standard comprehensive work on goldsmiths' and silversmiths' marks, which has not been totally superseded by more recent compilations. Contents: v. 1-3, Deutschland; v. 4, Ausland und Byzanz. Arranged alphabetically by city, then by artist. For each silversmith gives dates, cites examples of his work, and reproduces marks. Includes size of works and bibliography.

Index of marks and names at the end of each volume.

P468  Tardy. Les poinçons de garantie internationaux pour l'argent. [8. éd.] Paris, Tardy [1968]. 495p. il., facsims.
A handbook of silver hallmarks arranged by country, then by city. Table of contents in English as "Index," p.[484]-86, and in French, "Table des matières," p.[487]-89. "Table alphabétique des lieux cités," p.[389]-404.

Bibliography, p.[478]-82, classified by country.

P469  _____. Les poinçons de garantie internationaux pour l'or. 6e éd., réunie par Tardy. Paris, Tardy, 1967. 326p. il., facsims.
A handbook of gold hallmarks arranged by country. "Table des matières," p.[317]-24. "Index analytique des poinçons contenus dans le volume," p.[309]-18.

P470  Wyler, Seymour B. The book of old silver, English, American, foreign; with all available hallmarks including Sheffield plate marks. N.Y., Crown [1937]. 447p. il., plates.
Numerous printings.

Contains a series of 19 brief chapters on various aspects concerning British, American, and continental European silversmithing and types of silver. The main portion of the book, p.165-443, is devoted to methods of identifying hallmarks and to sections of hallmarks on the silver of England, Scotland, Ireland, Sheffield, America, France, Germany, and other European countries. Detailed indexes.

Bibliography, p.444. General index.

### Techniques

P471  Brepohl, Erhard. Theorie und Praxis des Goldschmieds. Mit 347 Bildern. 3., neubearb. Aufl. Leipzig, Fachbuchverl. [1973]. 512p. il.
A detailed manual on the techniques of goldsmiths' work. Contents: Historische Einleitung; (1) Werkstoffe; (2) Arbeitstechniken; (3) Herstellung einzelner Teile von Schmuckstücken.

Bibliography, p.500, is limited to a few technical works.

P472  Maryon, Herbert. Metalwork and enamelling; a practical treatise on gold and silversmiths' work and their allied crafts. Line drawings by Cyril Pearce. 5th rev. ed. N.Y., Dover [1971]. xii, 335p. il., plates.
1st ed. 1912.

"In this book I have discussed metalworking and enamelling, as practised to-day, primarily from the practical and technical point of view. And, where evidence exists for some more primitive methods of working, employed by the craftsmen of early Sumeria, Egypt, China or Europe, where

I felt that they were likely to prove of value to a modern worker, I have given details of those methods." —*Author's pref.*

Contents: (I) Materials and tools; (II-V) Soldering; (VI-VII) Filigree and other small work; (VIII-X) The setting of stones; (XI) Raising; (XII) Spinning; (XIII-XIV) Repoussé work; (XV) Mouldings; (XVI) Twisted wires; (XVII) Hinges and joints; (XVIII) Metal inlaying and overlaying; (XIX) Niello; (XX) Japanese alloys and stratified fabrics; (XXI-XXVII) Enamelling; (XXVIII-XXXII) Metal casting; (XXXIII) Construction; (XXXIV) Setting out; (XXXV) Polishing and colouring; (XXXVI) The making and sharpening of tools; (XXXVII) Design; (XXXVIII) Benvenuto Cellini; (XXXIX) Assaying and hallmarking; (XL) Various tables and standards; (XLI) Gauges. Workshop first aid, p.325-26.

Bibliography, p.318.

### Ancient

P473  Strong, Donald Emrys. Greek and Roman gold and silver plate. Ithaca, N.Y., Cornell Univ. Pr. [1966]. xxviii, 235p. il., 68 plates.
The basic scholarly handbook on the history, stylistic development, functions, and techniques of Greek and Roman plate from the Bronze Age to the 5th century A.D. Includes references in the writings of ancient historians and poets.

Contents: (1) General background; (2) The Bronze age; (3) Archaic Greece and Etruria; (4) Classical Greece, 480-330 B.C.; (5) The Hellenistic age: early Hellenistic, 330-200 B.C.; (6) The Hellenistic age: late Hellenistic, after 200 B.C.; (7) The Roman empire; (8) The Roman empire: 1st century A.D.; (9) The Roman empire: 2d and 3d centuries A.D.; (10) The Roman empire: 4th and 5th centuries A.D. Appendixes: (I) The treasure of Trier; (II) List of decorated drinking-cups of the Hellenistic-Roman class; (III) Analyses of ancient silver plate; (IV) The finds from Dherveni. Bibliography in "Abbreviations," p.xix-xxiv and in footnotes. Index of sites; Index of museums and private collections.

SEE ALSO:  Hoffmann, H., and Davidson, P. F. *Greek gold; jewelry from the age of Alexander* (P601).

### Early Christian -- Byzantine

P474  Dodd, Erica Cruikshank. Byzantine silver stamps. With an excursus on the Comes Sacrarum Largitionum by J. P. C. Kent. Wash., Dumbarton Oaks Research Library and Collection, 1961. xix, 283p. il., 103 plates, map. (Dumbarton Oaks studies. 7)
A study of the archaeological evidence and a detailed catalogue of all known silver stamped with Byzantine hallmarks. "Before progress can be made in solving stylistic and iconographic problems pertaining to Byzantine silver, all available information regarding the stamps must be marshalled systematically. It is to this task that the present study is devoted. Concerned solely with the stamps, it is

intended to provide a basis for future research in broader fields." — *Pref.*

Contents: pt. I. Classification and analysis of the stamps; pt. II. The question of provenance and controls; pt. III. Catalogue of stamped objects. List of stamped objects and illustrations, p.xv-xix.

Indexes: (I) List of stamped objects according to present location; (II) List of stamped objects according to place of discovery. Tables (in pocket): (I) Imperial bust types; (II) Imperial monograms; (III) Secondary monograms; (IV) Inscribed names; (V) *Comites Sacrarum Largitionum* in the 6th and 7th centuries.

References cited in abbreviations, p.279-80. Bibliographical references in footnotes.

―――――. ―――――. Supplement I: New stamps from the reigns of Justin II and Constans II. (Dumbarton Oaks papers. no. 18 (1964), p. [237]-48)

## Renaissance — Modern

P475   Grandjean, Serge. L'orfèvrerie du XIXe siècle en Europe. Paris, Presses Universitaires de France, 1962. viii, 161p. il., 32 plates (part col.)

A brief, introductory survey of European gold and silver of the 19th century.

Contents: Pt. 1, Généralités et techniques; (1) Le XIXe siècle et l'orfèvrerie en Europe; (2) Poinçons et technique; (3) Les principaux types d'objets. Pt. 2, Le style et ses particularités: (1) L'évolution générale du style; (2) Les particularités. Pt. 3, Collections et collectionneurs: (1) Le marché et les collections; (2) Les principales collections publiques.

Liste des principaux orfèvres, p.131-37, arranged by countries. Tableaux des principaux poinçons, p.139-52, arranged by countries. Table des illustrations, p.153-61, gives descriptions and comments. Bibliographie méthodique, p.121-29.

P476   Hayward, John Forrest. Virtuoso goldsmiths and the triumph of Mannerism, 1540-1620. [London] Sotheby Parke Bernet, Rizzoli [1976]. 751p. 739 il. on plates, 24 col. plates.

A monumental study of European goldsmiths' art in the period 1540-1620, when Mannerism was the pervasive stylistic influence. "This book is primarily concerned with secular plate . . . . [It is] less concerned with the detailed study of the work of individual makers than with stylistic evolution as a whole." — *Introd.* Superbly illustrated with the finest surviving pieces in European and American collections, design sources, and comparative materials. A major contribution to the study of goldsmiths' work, as well as to the study of the mannerist style.

Contents: Pt. 1, Text: (1) The study of silver; (2) Patrons, goldsmiths, and guilds; (3) The craft of the goldsmith; (4) The Renaissance; (5) The Renaissance goldsmiths; (6) Mannerism; (7) Italy; (8) France; (9) Spain and Portugal; (10) South Germany; (11) Erasmus Hornick; (12) North and Western Germany, Switzerland, Saxony; (13) The Habsburg family dominions: Hungary and Poland; (14) The Nether-

lands; (15) England; (16) The goldsmith as armourer and base metal worker. Pt. 2, Catalogue of plates, contains descriptions and analytical discussion of works reproduced in the color and black-and-white plates. Pt. 3, Monochrome plates.

Bibliography, p.[729]-31. Notes at the end of each chapter include references. Index of goldsmiths, artists, and craftsmen; Index of museums and collections; General index.

## Western Countries

*Canada*

P477   Derome, Robert. Les orfèvres de Nouvelle-France: Inventaire descriptif des sources. Ottawa, Galerie Nationale du Canada, 1974. x, 243p. (Documents d'histoire de l'art canadien, no. 1)

Published in conjunction with an exhibition (and its accompanying catalogue (P481) ) at the National Gallery of Canada in 1974.

A compilation of source materials relating to French-Canadian silver of the 17th and 18th centuries. Contents: Introduction; Inventaire descriptif des sources — Notice explicative: description du document; Abréviations, sigles et symboles; Première partie: Orfèvres: Inventaire descriptif des sources concernant les orfèvres de Nouvelle France; Deuxième partie: Présumés orfèvres: Inventaire descriptif des sources concernant des personnages de Nouvelle-France dont l'activité d'orfèvre ne peut être provée avec certitude.

Classified bibliography, p.225-37. Index of names and marks.

P478   Langdon, John Emerson. Canadian silversmiths, 1700-1900. Toronto [Printed by the Stinehour Press with the Meridan Gravure Co.] 1966. xx, 249p. il., facsims., 77 plates.

"The object of this work is threefold: to make available additional material on the silversmiths listed in *Canadian Silversmiths & Their Marks 1667-1867* [P479] . . . ; to record and list the workers active in the last half of the nineteenth century; and, where possible, to show the identification marks used on Canadian silver made during the period 1700 to 1900." — *Pref.* Contents: Historical sketch; Alphabetical list of makers and their marks. Appendixes: (I) Series of date-letters used by Henry Birks & Sons; (II) Punch-marks used by Robert Hendery and Hendery and Leslie; (III) Key to punch-marks used by Robert Hendery and Hendery and Leslie; (IV) Imitation hall-marks used by Robert Hendery and Hendery and Leslie.

Bibliography, p.231-33, classified in sections on the silver of England, France, the U.S., South Africa, and Canada. Bibliographical references included in biographical material in the list of makers. Index of general material; Index of silversmiths' initials.

P479   ―――――. Canadian silversmiths and their marks, 1667-1867. Lunenburg, Vt., Priv. print., Stinehour Pr. [1960]. 190p. il., facsims.

A handbook of biographical data on and information concerning the works of approx. 800 Canadian silversmiths

and related craftsmen during the 200-year period before Confederation in 1867. Contents: Quebec silversmiths; Nova Scotia and New Brunswick silversmiths; Ontario silversmiths. Appendixes: Hendery and Leslie; Marking of Canadian silver; Notes on marks; Forms of Canadian silver.

Bibliography, p.175-79, classified in sections on English, French and German, American, and Canadian silver.

P480 _____. Guide to marks on early Canadian silver, 18th and 19th centuries. Toronto, Ryerson Pr. [1968]. viii, 104p. il.

A pocket guide which includes all of the marks described in *Canadian silversmiths and their marks, 1667-1867* (P479) and *Canadian silversmiths, 1700-1900* (P478) and a few additional marks. Marks are listed alphabetically by maker.

P481 Trudel, Jean. Silver in New France. [Ottawa, National Gallery of Canada, for the corporation of the National Museums of Canada, 1974]. vii, 237p. il., maps.

Also pub. in a French ed. Pub. in conjunction with an exhibition at the National Gallery of Canada in 1974.

A detailed study of French-Canadian silver produced in the major centers of Montreal and Quebec in the period 1543-1760. Includes documentation on over 160 pieces of primarily ecclesiastical types. The introductory essay is followed by reproductions, with detailed captions, of all pieces. Index of silversmiths; Index of illustrations.

Bibliography, p.231-33.

SEE ALSO: Clayton, M. *The collector's dictionary of the silver and gold of Great Britain and North America* (P501).

## France

### BIBLIOGRAPHY

P482 Marquet de Vasselot, Jean Joseph. Bibliographie de l'orfèvrerie et de l'émaillerie françaises. Paris, Picard, 1925. 293p. (Société Française de Bibliographie. Publications [12])

A classified bibliography of more than 2,700 books and articles on the history of French goldsmithing and enamels.

Contents: (1) Généralités; (2) Technique; (3) Métier (Organization of work, teaching, and competitions); (4) Poinçons; (5) Modèles, sujets; (6) Époques; (7) Localités; (8) Musées; (9) Expositions; (10) Collections privées; (11) Trésors; (12) Artistes; (13) Objets.

Index of authors, persons, and places.

### HISTORIES, HANDBOOKS, DICTIONARIES AND ENCYCLOPEDIAS, COLLECTIONS

P483 Beuque, Émile. Dictionnaire des poinçons officiels français et étrangers, anciens et modernes de leur création (XIVe siècle) à nos jours. Préface de M. Lucien Puy. Paris, Courtois, 1925-28. (Repr.: Paris, Nobele [1962].)

At head of title: Platine, or & argent.

A dictionary of the hallmarks on French and other European platinum, gold, and silver from the 14th century to the early 20th century. Both volumes are in two parts: pt. 1, Figurines et objets; pt. 2, Lettres, chiffres, et signes. Each hallmark is reproduced and identified. Hallmarks in v.2 are primarily from after 1789.

At the ends of both volumes: Table nominative des poinçons; Table des poinçons classés par pays; Table des poinçons particuliers à chaque ville.

P484 Beuque, Émile, and Frapsauce, F. Dictionnaire des poinçons des maîtres-orfèvres français du XIVe siècle à 1838. Préface de M. La Clavière. Paris, 1929. 344p. il. (Repr.: Paris, Nobele, 1964.)

A dictionary of 3,000 hallmarks of French goldsmiths from the 14th century to 1838. Reproduces and describes each hallmark. Contents in three parts: pt. 1, Symboles avec initiales; pt. 2, Symboles sans initiales; pt. 3, Poinçons losangiques.

"Table des poinçons particuliers à chaque ville" at the end.

P485 Carré, Louis. A guide to old French plate. [Trans. from the French. 1st ed. repr.]; with a foreword by Maurice Bouvier-Ajam. London, Eyre & Spottiswoode [1971]. xxviii, 270p. il., 32 plates.

1st ed. 1931. Trans. of *Guide de l'amateur d'orfèvrerie française.*

A concise handbook of French gold and silver plate and their marks. Contents: Pt. I, The marks on French plate from the 13th century to the end of the 18th century; Bk. I, The three kinds of marks; Bk. II, Glossary of marks; Pt. II, The marks of French plate from the law of 19 Brumaire, year VI, until the present time; Bk. I, The standards and marks; Bk. II, Glossary of marks. Pt. I constitutes an abridgment of the authors's *Les poinçons de l'orfèvrerie française du quatorzième siècle jusqu'au début du dix-neuvième siècle* (P486).

Index of marks, p.221-70.

P486 _____. Les poinçons de l'orfèvrerie française du quatorzième siècle jusqu'au début du dix-neuvième siècle. Paris, Carré, 1928. 355p. il., 14 plates. (Repr.: N.Y., Burt Franklin, 1968.)

A comprehensive guide to French gold and silver plate and their marks from the 14th century to the beginning of the 19th. Pt. I of the author's *A guide to old French plate* (P485) in an abridgment of the work. Appendix: Poinçons de garantie en usage du 19 juin 1798 au 9 mai 1838, p.332-36.

Index of marks, p.336-55.

P487 French master goldsmiths and silversmiths from the seventeenth to the nineteenth century. Pref. by Jacques Helft. N.Y., French & European publications [1966]. 333p. il. (part col.) (The Connaissance des arts collection "Grands artisans d'autrefois")

Trans. of *Les grands orfèvres de Louis XIII à Charles X.*

A survey of French gold- and silversmiths' work from the 17th to the 19th century. Lavishly illustrated with pieces from European and American collections. Includes many illustrations of comparative works.

Contents: Introduction, by Jean Babelon; The age of Louis XIV and its splendors, by Yves Bottineau; The triumph of rocaille, by Yves Bottineau; The return to antiquity, by Yves Bottineau; The splendors of the imperial epoch, by Olivier Lefuel; The hallmarks of Paris from 1600 to 1838. Bibliography, p.333.

P488   Havard, Henry. Histoire de l'orfèvrerie française. Paris, May & Metteroz, 1896. 472p. il., 40 plates (part col.)

A comprehensive history of French gold- and silversmiths' work from antiquity through the 19th century. Includes chapters on enamelling and jewelry.

Bibliographical references in footnotes. No index.

P489   Helft, Jacques. Le poinçon des provinces françaises. Paris, Nobele, 1968. xxiv, 612p. il., plates, facsims.

The basic reference work on the marks on goldsmiths' and silversmiths' work produced in the French provinces from around the middle of the 17th century to the 19th century. Marks are arranged alphabetically according to *jurisdictions;* marks are reproduced for the most part photographically or from line drawings. Includes about 400 superb illustrations of pieces.

Contents: Introduction, p.ix–xi; Remarques techniques, p.xiv–[xvii]; Glossaire, p.xviii–[xix]; Abréviations, p.xx; Table des jurisdictions, p.xxi; Table des plaques d'insculpations (pl. I à XIX); Table des villes, p.xxii–[xxiii]; Tableau générale des dénominations et figures des poinçons de la marque d'or et d'argent, de la régie de J.-B. Fouache, p.xxiv; Table générale des dénominations et figures des poinçons de la marque d'or et d'argent, de la régie de H. Clavel, p.xxvii; Tableau générale des poinçons de 1809 à 1838, p.[3]; Carte des généralités (limites approximatives des jurisdictions), p.[4–5]; Jurisdictions, p.7–422; Index des devises, symboles, millésimes, p.443–78; Index des lettres A à Z, p.479–524; Illustrations (pl. XX à XCIII), p.525–600; Liste de planches, p. 601–4; Liste des photographies, p.605.

Bibliographie, p.606–7.

P490   Jourdan-Barry, Raymond. Les orfèvres de la généralité d'Aix-en-Provence du XIVe siècle au début du XIXe siècle. Paris, Nobele [1974]. xiii, 483p. 666 il. maps.

"Covers goldsmiths' professional organization; lists Goldsmiths by name, town and initials and hall-marks by town and master; classifies 124 objects from various collections by subject." —Staff, *RILA*, v.2, no.1, 1976, no. 485.

Bibliography, p.475–78.

P491   New York. Metropolitan Museum of Art. Three centuries of French domestic silver; its makers and its marks, by Faith Dennis. N.Y., 1960. 2v. il., maps.

Based on an exhibition at the Metropolitan Museum in 1938.

The fundamental study and survey of domestic silver produced in Paris and the provinces from the 17th century to the early 19th century. Superbly illustrated with examples from American and European public and private collections, the most important of which are now in the permanent collection of the Metropolitan. v.2 contains photographic reproductions of over 2,000 silver marks.

"The book has been arranged for easy reference to individual makers, which are grouped alphabetically within their respective guilds. Paris craftsmen are given first. The provincial goldsmiths appear under the names of the towns in which they worked, and the towns are grouped alphabetically under the jurisdiction of the various supervisory mints, also arranged alphabetically. In order that the evolution of style may be traced a chronological table is provided in Volume II in which all of the pieces illustrated are listed by number according to date." —*Author's pref.*

Contents, v.1: Introduction, by Preston Remington, p.13–24; Illustrations of the Paris silver, p.27–247 (381 pieces); Illustrations of the provincial silver, p.251–367 (104 pieces); v.2: Introduction, p.9–23; The marks on the Paris silver, p.27–118; The marks on the provincial silver, p.121–76; Chronological table of the Paris and provincial silver, p.179–80; Goldsmiths' marks by first initial, p.181–83; Devices used in the silver marks, p.184–87; Illegible marks, p.[188].

Classified bibliography, v.2, p.189–92. General index.

P492   Nocq, Henry. Le poinçon de Paris, répertoire des maîtres-orfèvres de la jurisdiction de Paris depuis le moyen-âge jusqu'à la fin du XVIIIe siècle. Paris, Floury, 1926–30. 5v. il., plates (part col.) (Repr.: Paris, Laget, 1967.)

The standard work on the goldsmiths of Paris from 1292 to the end of the 18th century. Includes 5,511 goldsmiths; contains 876 reproductions of goldsmiths' marks and 240 illustrations of various types of the goldsmiths' art. Contents: v.1, A–C; v.2, D–K; v.3, L–R; v.4, S–Z; v.5, Supplément (errata et addenda).

v.4 also contains: Résumé chronologique, p.129–[96]; Brèves indications, p.197–[200]; Liste des gardes, p.201–[19]; Poinçons des fermiers, p.220–[42]; Itinéraire des gardes, p.243–[55]; Notice sur les orfèvres de la généralité de Paris, p.256–[82]; Principales sources de l'histoire des orfèvres de Paris, p.283–[90].

v.5 also contains: Poinçons de maîtres rangés d'après les initiales dans l'ordre alphabétique, p.[35]–65; Poinçons dans lesquels la dernière lettre n'est pas l'initiale du nom de famille, tel qu'il s'écrit habituellement, p.[66]–71; Table des différents, p.[73]–96.

P493   Ris-Paquot, Oscar E. Dictionnaire des poinçons, symboles, signes figuratifs, marques et monogrammes des orfèvres français et étrangers, fermiers généraux, maîtres des monnaies, contrôleurs, vérificateurs, etc. Paris, Laurens, 1890. 382p.

Includes 1,557 monograms and hallmarks.

Contents: pt. 1, Statuts et privilèges du corps des marchands orfèvres et joyailliers de la ville de Paris; pt. 2, Armorial de la corporation des orfèvres de France; pt. 3, Poinçons et marques figuratives ou symboliques; pt. 4, Dictionnaire des noms des fermiers généraux, contrôleurs, maîtres des monnaies, orfèvres, villes dont les poinçons, symboles, signes figuratifs, marques et monogrammes sont contenus dans l'ouvrage.

P494 Thuile, Jean. Histoire de l'orfèvrerie du Languedoc de Montpellier et de Toulouse. Répertoire des orfèvres depuis de moyen-âge jusqu'au début du XIXe siècle. Paris, Schmied, 1964-69. 3v. il., plates.

An exhaustive historical survey and biographical dictionary of the goldsmiths and silversmiths of Languedoc from the Middle Ages to the beginning of the 19th century. Contents; v.1, A à C; v.2, D à L; v.3, M à Z.

### Germany and Austria

P495 Braun, Joseph. Meisterwerke der deutschen Goldschmiedekunst der vorgotischen Zeit. München, Riehn und Reusch, 1922. 2v. il. (Sammelbände zur Geschichte der Kunst und des Kunstgewerbes, hrsg. von Adolf Feulner, Bd. VIII)

Both volumes include 12-13p. of introductory text, plates, and a catalogue. Contents: v.1, 9.-12. Jahrhundert; v.2, 12. und 13. Jahrhundert.

Bibliography: v.1, p.11; v.2, p.1.

P496 Heuser, Hans-Jörgen. Oberrheinische Goldschmiedekunst im Hochmittelalter. Berlin, Deutscher Verlag für Kunstwissenschaft [1974]. 250p. 731 il. on 104 plates (2 col.), map.

A comprehensive, scholarly study of the goldsmith's art in the major creative centers of the Upper Rhine region during the Gothic period (1200-1350). The catalogue includes 117 entries on pieces ranging from minor fragments to elaborate reliquaries, giving for each present location, references to illustrations, place of origin, date, detailed description and commentary, and references. Very well illustrated.

Contents: (1) Strassburg um 1200; (2) Strassburger Siegel und Verwandtes; (3) Der Onyx von Schaffhausen und die staufischen Kronenteile in Stockholm; (4) Eine Deckelschale mit Strassburger Beschau; (5) Die Johannes-Werkstatt in Freiburg; (6) Freiburger Ateliers seit der Jahrhundertwende; (7) Meister Konrad von Hausen in Konstanz; (8) Der Goldschmied des Katharinentaler Konventsiegels; (9) Das Ziborium von Klosterneuburg; (10) Versenktes Relief und Email in der Hochgotik; (11) Die grossen Meister in Konstanz seit der Jahrhundertwende; (12) Werkstätten zwischen Breisgau und Bodensee; (13) Die sogenannten "Wiener" Schmelze des 14. Jahrhunderts; (14) Konstanz oder Zürich; (15) Zürcher Siegel und andere Goldschmiedearbeiten aus der Stadt; (16) Basel. Der Münsterschatz und Siegel der Stadt; (17) Membra disiecta; (18) Werkkatalog; (19) Siegelkatalog; (20) Urkunden; (21) Abgekürzt zitierte Literatur; (22) Register.

P497 Kohlhaussen, Heinrich. Nürnberger Goldschmiedekunst des Mittelalters und der Dürerzeit, 1240 bis 1540. [Hrsg. vom Deutschen Verein für Kunstwissenschaft]. Berlin, Deutscher Verlag für Kunstwissenschaft [1968]. 589p. 738 il., 5 col. plates.

A detailed, scholarly study and catalogue of approx. 500 pieces of Nuremberger goldsmiths' work produced from 1240-1540. Each section is devoted to a particular type of work and includes a catalogue of those works of that type known to the author. Superbly illustrated.

Contents: Nürnberger Siegel um 1240-1530; Reliquienträger des 14.-16. Jahrhundert und Verwandtes; Nürnberger Buchbeschläge 14.-16. Jahrhundert; Frühe Kelche um 1330-1430; Greifenklauen, Strausseneier; Glattwandige Gefässe; Späte Kelche zwischen 1430 und 1530; Monstranzen; Reliquiare um 1500; Dürer und die Tischbrunnen; Silberschiffe; Das gebruckelte Gefäss; Der Einbruch von Naturformen, Dürer und die Krug-Werkstatt; Melchior Baier d. Ä. und Peter Flötner; Der Meister ME um 1535; Weitere Goldschmiede nach Ludwig Krug und neben Melchior Baier; Die Meister; Die Beschau; Die Meistermarke; Signaturen; Beziehungen; Vergleichende Übersicht (Zusammenfassung).

Register (von Dr. Ursula und Matthias Mende): Personenregister; Ortsregister; Sachregister. Bibliographie, p.532-34.

P498 Scheffler, Wolfgang. Berliner Goldschmiede; Daten, Werke, Zeichen. Mit 137 Abbildungen. Berlin, Hessling, 1968. xxii, 647p., 17 l. of il.

The indispensable reference work on goldsmithing in Berlin from its beginnings to the mid-19th century. Based on extensive archival research and inspection of church registers. Includes approx. 2,700 goldsmiths and lists of coinmakers, engravers, amber cutters, pearl drillers, and related craftsmen. The catalogue includes about 1,800 works, with assay marks and corresponding letters. 467 makers' marks are identified, half of which are reproduced.

Index of names; Index of masters' marks and firms' marks.

P499 _____. Goldschmiede Niedersachsens; Daten, Werke, Zeichen. Berlin, de Gruyter, 1965. 2v. xi, 1258p. il., plates, map.

An exhaustive work on the goldsmiths of Lower Saxony. Amplifies and replaces much of the material in Rosenberg (P467). Arranged alphabetically under 145 cities and then by goldsmiths. The index includes approx. 4,800 names of goldsmiths. For each goldsmith it includes dates, cites works, and reproduces marks.

Contents: v.1, Aerzen-Hamburg; v.2, Hameln-Zellerfeld. Register der Goldschmiedezeichen (45 plates of goldsmiths' marks) and Namenregister at the end of v.2.

Bibliography, p.ix-x.

SEE ALSO: *Augsburger Barock* (I292)

### Great Britain

P500 Chaffers, William. Hall marks on gold & silver plate, illustrated with revised tables of annual date letters employed in the assay offices of England, Scotland and Ireland. 10th ed. Extended and enl., and with the addition of new date letters and marks, and a bibliography. Also incorporating makers' marks from "Gilda aurifabrorum," ed. by Major C. A. Markham. London, Reeves, 1922. lix, 395p. il., plates.

3d ed. 1868.

An old standard work. Contains material on English goldsmiths and silversmiths, table of statutes and ordinances, table of marks, chronological list of English plate, London gold- and silversmiths, provincial assay offices, etc.

Bibliography, p.[373]-83. General index.

P501   Clayton, Michael. The collector's dictionary of the silver and gold of Great Britain and North America. Foreword by A. G. Grimwade. Feltham, London, Country Life, 1971. 350p. 730 il., 48 col. plates.

A comprehensive dictionary of the goldsmiths' and silversmiths' art in Great Britain, the U.S., and Canada from the Middle Ages to the end of the 19th century. Contains articles on types of pieces, biographies, descriptions, and succinct definitions of terms. Includes few references to marks. Articles often include bibliographies.

Classified bibliography, p.345-49: (I) Plate of the British Isles; (II) Plate of the U.S.A.; (III) Plate of Canada; (IV) Varia; (V) Design sources.

P502   Ensko, Stephen G. C., and Wenham, Edward. English silver 1675-1825. N.Y., Ensko [1937]. 109p. il.

A useful handbook for the identification of marks on English silver. "An effort has been made to describe, concisely, the changes in style and form that have taken place in English silver during the period 1675 to 1825, and the sources from which those changes sprang."—*Foreword.* Assay marks, p.99-109.

Bibliography, p.14-15.

P503   Fallon, John Padraic. Marks of London goldsmiths and silversmiths, Georgian period (c.1697-1837). Newton Abbott, David & Charles; N.Y., Arco [1972]. 420p. 1,130 il.

A useful handbook of the hallmarks of over 300 of the principal London silversmiths and goldsmiths registered from c.1697 to 1837. "Unless otherwise stated, all makers' marks illustrated in the book are accurate drawings of those entered in the records at the Goldsmiths' Hall, London."—*Introd.* Entries include biographical data and succinct comments on works.

Bibliography, p.16.

P504   Grimwade, Arthur G. London goldsmiths, 1697-1837: their marks and lives from the original registers at Goldsmiths' Hall and other sources. London, Faber and Faber [1976]. ix, 728p. il.

The most important contribution to scholarship in the study of English silver since the publication of Jackson's *English goldsmiths and their marks* (P507). Pt. 1, the Marks, lists and reproduces 3,469 marks registered at the London Goldsmiths' Hall between 1697 and Queen Victoria's accession in 1837, and 440 unregistered marks copied from surviving pieces. Also includes the marks of provincial goldsmiths who registered them at the Goldsmiths' Hall, and the marks of goldworkers, watchcasemakers, bucklemakers, hiltmakers, and other specialists.

Pt. 2, the Lives, is a biographical dictionary of about 2,500 goldsmiths, which gives biographical and career data and previously unrecorded details on the goldsmiths listed.

P505   Hayward, John Forrest. Huguenot silver in England, 1688-1727. London, Faber and Faber, 1959. xx, 89p. 96 plates.

An authoritative study of English Huguenot silver. Contents: (1) The Huguenot style; (2) The Huguenot goldsmiths in England; (3) Goldsmiths and the hallmark; (4) List of plate and vessels commonly in use; (5) Silver furniture; (6) Engraving on silver; (7) The cost of plate.

Appendix: Entries related to purchases of silver, extracted from the diaries of John Hervey, First Earl of Bristol, 1688-1727. Bibliography, p.85.

P506   Heal, *Sir* Ambrose. The London goldsmiths, 1200-1800; a record of the names and addresses of the craftsmen, their shop-signs and trade cards, comp. ... from the records of the Goldsmiths' company and other contemporary sources; pub. under the patronage of the Worshipful Company of Goldsmiths of London. Cambridge, Univ. Pr., 1935. 279p. 80 facsims. (Repr.: Newton Abbot, David & Charles, 1972.)

A standard reference work. "List of London goldsmiths' shop-signs," p.49-89, gives about 1,500 shop-signs, with dates. "A list of the London goldsmiths, jewellers, bankers and pawnbrokers up to the year 1800, setting out their names, addresses, and dates," p.93-275, includes nearly 7,000 names.

P507   Jackson, *Sir* Charles James. English goldsmiths and their marks; a history of the goldsmiths and plate workers of England, Scotland, and Ireland; with over thirteen thousand marks reproduced in facsimile from authentic examples of plate, and tables of date-letters and other hallmarks in the assay offices of the United Kingdom. 2d ed. rev. and enl. London, MacMillan, 1921. 747p. il., plates, tables. (Repr.: N.Y., Dover, 1964.)

1st ed. 1905.

An invaluable standard reference work. Arranged geographically with chapters on goldsmiths from London, York, Exeter, Chester, Sheffield, Glasgow, Dublin. Index, p.719-47.

P508   _____. An illustrated history of English plate, ecclesiastical and secular, in which the development of form and decoration in the silver and gold work of the British Isles, from the earliest known examples to the latest of the Georgian period, is delineated and described, with a coloured frontispiece, seventy-six photogravure plates and fifteen hundred other illustrations. London, Country Life, 1911. 2v. il., 76 plates. (Repr.: N.Y., Dover, 1969.)

An invaluable standard work. "Chronological list of illustrations," v.1, p.[xxix]-xxxviii. Bibliography is in the preface. Index, v.2, p.1065-85.

P509   Oman, Charles Chichele. Caroline silver, 1625-1688. London, Faber and Faber, 1970. xix, 73p. 97 plates (1 col.)

While not a comprehensive survey of Caroline silver, this work contains the author's important discoveries and new insights in the field.

Contents: (I) The artistic climate; (II) The crown and the goldsmiths; (III) Trends and techniques; (IV) Brief lives of some eminent goldsmiths; (V) Dining room plate; (VI)

Plate about the house. Appendix: The service of plate given to the Duchess of Portsmouth.

Bibliography, p.66–67. Bibliographical references in footnotes. General index, p.69–71; Index of goldsmiths and their marks, p.72–73.

**P510** _____. English church plate, 597–1830. London, Oxford Univ. Pr., 1957. xxx, 326p. 328 il., 200 plates.
"Authoritative work on neglected subject concentrates on developments in the form and decoration of Anglican and Roman Catholic church silver in light of changes in liturgical ritual and the political and social situation in general. Objects discussed are from the provinces of Canterbury and York and are of English manufacture."—*Decorative arts,* A56, HM27.

Bibliography (general works, collections of documents, etc., local inventories), p.[291]–97. Appendixes: (1) List of medieval chalices and patens; (2) List of Edwardian communion cups; (3) Quantities and distribution of the communion cups and paten-covers made by the Elizabethan goldsmith IP; (4) List of Anglican 17th-century Gothic chalices; (5) List of the identifiable goldsmiths who worked for the Catholic Recusants down to the introduction of the *Britannia Standard* in 1697. Index of persons and subjects; Index of extant pieces of plates.

**P511** _____. English domestic silver. 7th ed. London, Black, 1968. xii, 240p. 135 il., 32 plates.
1st ed. 1934.

The standard brief history of English domestic silver. Written especially for the collector, with extended discussion of fakes, hallmarks, and heraldic engraving.

Bibliography, p.233–34.

**P512** Reddaway, Thomas Fiddian. The early history of the Goldsmiths' Company, 1327–1509. Prepared for publication with additional material including the first volume of the Company's Ordinances and Statutes, The Book of Ordinances, 1478–83, by Lorna E.M. Walker. [London] Arnold, 1975. xxx, 378p. 17 plates.

A detailed history of the first 200 years of the London Goldsmiths' Company. Based on a meticulous examination and analysis of the Company's records.

Contents: (1) The Company established; (2) London in 1341; (3) The years of consolidation, 1341–92; (4) The second charter (1392) and its results; (5) Years of prosperity, 1404–44; (6) 15th-century problems; (7) New beginnings, 1478–1509. Appendixes: (I) The Book of Ordinances; (II) Biographical notes; (III) Assay and touch: the background to the reforms of 1478; (IV) Wardens of the Company.

Classified bibliography, p.342–49 (Manuscript sources; Printed sources; Secondary authorities).

**P513** Rowe, Robert. Adam silver, 1765–1795. London, Faber and Faber; N.Y., Taplinger [1965]. 94p. 118 il., 97 plates.

A study of the manufacture of English silver (designed by Robert Adam) in the second half of the 18th century and

created in the neoclassical style influenced by his designs. Bibliography, p.89.

**P514** Wardle, Patricia. Victorian silver and silver-plate. N.Y., Universe Books, 1963. 238p. 22 il., 69 plates.

A brief survey of Victorian silver from 1837–1901.

Contents: (1) 1837–50; (2) Sheffield plate; (3) Electro-plate; (4) The Society of Arts, Henry Cole and Felix Summerly; (5) The Great Exhibition of 1851; (6) Silver sculpture; (7) 1851–62; (8) The International Exhibition of 1862; (9) Racing trophies and testimonials; (10) Armstead, Morel Ladeuil and Wilms; (11) 1862–80; (12) Christopher Dresser; (13) 1880–1901; (14) New developments in the 1890s. Appendix I, Marks on silver and silver-gilt; Appendix II, Registery marks. Bibliography, p.227–28.

*Italy*

**P515** Bulgari, Costantino G. Argentieri, gemmari e orafi d'Italia; notizie storiche e raccolta dei loro contrassegni con la riproduzione grafica dei punzoni individuali e dei punzoni di stato. Roma, Turco [1958–70]. 3 parties en 4v. il., plates (part col.), ports. (part col.), facsims.

The most important reference work on Italian silversmithing, jewelry, and goldsmithing. Valuable not only to collectors and connoisseurs but to students of painting and sculpture. Includes hundreds of facsimile reproductions of individual goldsmiths' and silversmiths' marks and of the official regional marks, and biographical dictionaries of goldsmiths, silversmiths, and gem engravers.

Contents: pt. 1. Roma (2v.); pt. 2. Latium, Umbria; pt. 3. Marche, Romagna. Indexes of marks.

**P516** Catello, Elio. Argenti napoletani dal XVI al XIX secolo. Prefazione di Bruno Molajoli. [Napoli] Giannini, 1973. 452p. il. (part col.)

A detailed, comprehensive study of Neapolitan goldsmiths' work. Contents: La corporazione degli orefici; L'argenteria a Napoli; La punzonatura; Gli argentieri. Very well illustrated.

Notes, p.183–96, include bibliographical references. Bibliography, p.425–28. Indexes: Indice dei punzoni; Indice delle illustrazioni; Indice dei nomi; Indice dei luoghi.

**P517** Fornari, Salvatore. Gli argenti romani. Roma, Edizioni del Tritone, 1968. 316p. il.

A comprehensive, well-illustrated survey of Roman goldsmiths' work. Contents: (I) Premessa. Argenteria pagana e cristiana; (II) Storia degli statuti. Instituzione dell'Università degli Orefici. Nascita del "Nobil Collegio degli Orefici e Argentieri di Roma"; (III) Capolavori poco noti del Quattrocento e Cinquecento romano. Celebri dinastie di orefici e argentieri del Rinascimento al Seicento; (IV) Argenteria romana dei secoli quattordicesimo e quindicesimo. Tesori romani a Lisbona; (V) Sviluppi e varietà degli argenti romani settecenteschi. Gusto neoclassico nell'argenteria del primo Ottocento; (VI) Giulio Romano ed altri grandi ideatori di argenterie; (VII) Gli argenti inediti fra il 1700 e il 1870.

Bibliography, p.315–16.

*Latin America*

P518   Anderson, Lawrence Leslie. The art of the silver-
smith in Mexico, 1519-1936. N.Y., Oxford Univ. Pr.,
1941. 2v. il., plates. (Repr.: N.Y., Hacker, 1975.)
Also pub. in Spanish: N.Y., Oxford Univ. Pr., 1941.

The major study of the mining, smelting, legislation, crafts-
men, marks, and stylistic development of Mexican silver.
Dimensions of pieces are given under the illustrations.

Contents: v.1, Text; v.2, Plates. Appendix I, List of silver-
smiths in Mexico; Appendix II, Ordinances relative to the
silversmith's art. Bibliography, v.1, p.[435]-51.

P519   Taullard, Alfredo. Platería sudamericana. Buenos
Aires, Peuser, 1941. 285p. il., plates.

An historical survey of gold- and silversmithing in South
America. Contains a considerable amount of detailed
information within the brief texts.

Contents: Platería prehispánica; Las minas del Perú, el
cerro de Potosí; Platería peruana; Platería religiosa; La
tarja de Potosí, y lámina de Oruro; La platería en el virrei-
nato del Río de la Plata; El mate; Platería del apero gaucho;
Las minas de Chile, Atacama, La Rioja y otras regiones;
Platería pampa; Platería araucana; Láminas (387 il.); Nómina
de plateros (Época colonial; Época independiente), p.279-83.

Bibliography, p.7-8; bibliographical references in foot-
notes.

*Low Countries*

P520   Citroen, K. A. Amsterdam silversmiths and their
marks. Amsterdam, Oxford, North-Holland, 1975.
xxv, 255p. (North-Holland studies in silver, v.1)

A dictionary of 1,253 makers' marks on the gold and silver
produced in Amsterdam between 1550 and 1800. For each
identified maker, entries include biographical information,
dates, descendants, type of objects in which the maker
specialized, and his associations with fellow-craftsmen. Title
page and introductory material in English; dictionary infor-
mation in Dutch.

Dutch-English glossary, p.[xxiv-xxv]. Index of makers'
marks, p.243-53. Unidentified makers' marks, p.254.

P521   Colman, Pierre. L'orfèvrerie religieuse liégeoise du
XVe siècle à la révolution. Liège, 1966. 2v. plates,
facsims. (Liège. Université. Faculté de philosophie
et lettres. Bibliothèque. Publications exceptionnelles,
2)

A monumental study of the ecclesiastical silver produced
in Liège. All types of church plate are considered in detail;
the catalogue section documents 927 pieces.

Contents, v.1: (I) Le "bon métier" des orfèvres de la cité
de Liège; (II) Les poinçons de l'orfèvrerie liégeoise; (III)
Les orfèvres liégeois; (IV) La demande d'orfèvrerie reli-
gieuse liégeoise; (V) Mesures de conservation; (VI) Pertes;
(VII) Les oeuvres; (VIII) Thèmes iconographiques; (IX)
Styles; (X) Techniques; (XI) Modèles; (XII) Mérites esthé-
tiques. v.2: Table des illustrations (244 il.); Répertoire
chronologique; Répertoire par dénominations; Répertoire
par poinçons onomastiques; Répertoire iconographique;
Index général des poinçons onomastiques liégeois; Index
des noms de lieux et de personnes.

Abréviations et sigles, v.1, p.[5]-12, include bibliographi-
cal references. Bibliographie, v.1, p.[19]-32: Manuscrits;
Imprimés.

P522   Frederiks, J. W. Dutch silver from the Renaissance
until the end of the eighteenth century. The Hague,
Nijhoff, 1952-61. 4v. il., plates.

The definitive history of Dutch silver; indispensable for
work in the field. Almost all pieces described are shown in
the superb illustrations. Catalogue sections are arranged
geographically, then alphabetically by masters. Detailed
catalogue entries include descriptions, analytical discus-
sion, and references.

Contents: v.1, Embossed plaquettes, tazze and dishes: (I)
The Renaissance style; (II) The period of transition; (III)
The Baroque style; (IV) The 18th century. xvii, 540p., 467
il. (1952). v.2, Wrought plate of North and South-Holland:
(I) Print engravers; (II) Silversmiths. xxxiv, 211p., 624 il. on
313 plates (1958). v.3, Wrought plate of the central, northern,
and southern provinces. xii, 157p., 450 il. on 332 plates
(1960). v.4, Embossed ecclesiastical and secular plate. xxxvi,
179p., [352] il. on 334 plates (1961).

Individual volumes include indexes of masters, indexes
of sources of design, indexes of representations, indexes of
objects. Lists of abbreviations at the beginning of each vol-
ume give bibliographical references.

P523   Gans, M. H., and Duyvene de Wit-Klinkhamer, Th.
M. Dutch silver. Trans. by Oliver von Oss. London,
Faber and Faber [1961]. 97p. of il., map.

An authoritative survey of Dutch silver intended for the
student or collector with limited previous knowledge on
the subject. Less scholarly than Frederiks (P522).

Bibliography, p.89-93.

P524   Meestertekens van Nederlandse goud- en zilver-
smeden. 's Gravenhage, Staatsdrukkerij- en uitgeverij-
bedrijf, 1963-67. 2v. facsims.

A handbook of marks on Dutch gold and silver for the
period 1814-1966. Contents, v.1, In gebruik Geweest van
1814-1963: De Geschiedenis van de Waarborging van pla-
tina, gouden en zilveren werken, p.vii-xii; Handleiding voor
het gebruik, p.xiii-xiv; Meestertekens, p.Mt 1-604; Naam-
lijst Meestertekens, p.Mt 607-78; Importeurstekens, p.It
1-13; Naamlijst Importeurstekens, p.It 17-19; Herkennings-
tekens van essaieurs van de Dienst van de Waarborg, p.Et
1-22; Naamlijst essaieurs p.Et 25-26; Essaieurstekens
gevoerd door handelsessaieurs, p.HEt 1-2; Naamlijst handel-
sessaieurs, p.HEt 5. v.2, In gebruik na 1 Januari 1963, issued
with three supplements in loose-leaf format.

P525   Voet, Elias, Jr. Nederlandse goud- en zilvermerken.
Met afbeeldingen tussen de tekst en 3 platen. 4. druk,
bewerkt door P. W. Voet. 's Gravenhage, Nijhoff,
1966. xii, 77p. il.
1st ed. 1937.

A useful handbook of Dutch gold and silver marks, comp.
by a leading authority. The author's other works include
more detailed studies of the hallmarks of Haarlem, 1928;
Amsterdam, 1912; Friesland, 1932; and The Hague, 1941.

*Russia and Eastern Europe*

P526  Gol'dberg, Tamara Grigor'evna. Russkoe zolotoe i serebrīanoe delo. Moscow, Nauk, 1967. 307p. 104 il., 5 col. plates.

Text in Russian. Added title page in French: *L'orfèvrerie et la bijouterie russes aux XV–XX siècles.* Summary (18p.), captions, and list of illustrations in French.

A comprehensive study of Russian goldsmithing, silversmithing, and jewelry from the 15th century to the mid-20th century. The first general work on the subject in more than 50 years. The French summary provides an excellent account of aspects of interest to non-Russian readers and gives a survey of the principal centers of production and of the major craftsmen. Includes reproductions of 2,601 marks, with names of goldsmiths in Russian only.

Bibliography, p.289-[95].

P527  Köszeghy, Elemér. Magyarországi ötvösjegyek, a középkortól 1867-ig. Merkzeichen der Goldschmiede Ungarns, vom Mittelalter bis 1867. Budapest, Királyi magyar egyetemi nyomoda, 1936. xxiv, 408p. il., 30 plates.

A handbook of Hungarian goldsmiths' marks from the 15th century to 1867. Includes reproductions of approx. 2000 marks, arranged alphabetically by cities.

Markenregister, p.373-98: (a) Monogramme; (b) Figürliche Marken; (c) Zahlen. Verzeichnis der Goldschmiedenamen, p.399-408.

SEE ALSO:  Histories and Handbooks — Oriental Countries — Central Asia (I498–I507).

*Scandinavia*

P528  Boesen, Gudmund, and Bøje, Chr. A. Old Danish silver. [Trans. by Ronald Kay]. Copenhagen, Hassing, 1949. 35, [8]p. il., 210 plates.

Trans. of *Gammelt dansk søln til bordburg,* København, Hassing, 1948.

A pictorial survey of Danish domestic silver from c.1550–1840. The introductory essay discusses the uses and stylistic development of Danish silver and the techniques of the goldsmith's art. The section of photographs is arranged chronologically under types of objects: Tankards, beakers and goblets, wine jugs, coffee- and chocolate pots, teapots, teakettles, etc. The illustrations include descriptions and commentaries.

Marks, names of private owners, and bibliography, p.[36-41]. Index to names of goldsmiths, p.[42-43].

P529  Bøje, Christen Anton. Dansk guld og søln smedemaerker før 1870. Illustreret folkeudg. redigeret af Bo Bramsen. København, Politikens forlag, 1954. 438p. il., facsims.

Reissued 1962. A popular ed. of the author's work first published in 1946.

A comprehensive handbook of Danish gold and silver marks before 1870. Introductory material in Danish and English. "This book contains all the approximately 3,600

known and identified Danish silver marks which were registered by the late Chr. A. Boje."—*Pref.*

Contents: Stamps of pureness; Copenhagen; The provinces; Old devices; Register.

P530  L'Or des Vikings, exposition du Musée des Antiquités Nationales de Suède, Bordeaux, Musée d'Aquitaine, 1969. [Traduit du suédois]. Bordeaux, Musée d'Aquitaine, 1969. xvi, 308p. il., plates, maps.

The catalogue of an exhibition drawn for the most part from the collection of the National Museum of Antiquities, Stockholm, as well as from French museums.

Includes a series of scholarly essays on various historical and technical aspects of the gold jewelry and gold objects produced by Viking craftsmen. Detailed catalogue entries include descriptions, commentaries, and reproductions of works.

Bibliographies at the end of essays. Bibliographie sommaire, p.265-68: (I) References des ouvrages cités en abrégé; (II) Bibliographie des ouvrages in extenso.

P531  Svenskt silversmide, 1520–1850. Stockholm, Nordisk rotogravyr [1941-63]. 4v. in 5. il., plates.

A monumental work on Swedish domestic and ecclesiastical silver of all types from 1520–1850. Magnificently illustrated with the finest examples of representative types from each period covered. Includes reproductions of thousands of marks.

Contents: v.1, Renässans och barock, 1520–1700, av Olle Källström och Carl Hernmarck. 248p., text il. and 519 il. on plates. 2v. (1941); v.2, Senbarock, Frederik I:s stil och rokoko, 1700–1780, av Carl Hernmarck, Åke Stavenow och Gustaf Munthe. 245p., text il. and 695 il. on plates (1943); v.3, Gustaviansk stil, empire och romantik, 1780–1850, av Carl Hernmarck och Erik Andrén. Äldre guldsmedsteknik, av Bengt Bengtsson. 315p., text il., and 714 il. on plates (1945); v.4, Guld- och Silverstämplar, av Erik Andrén, Brynolf Hellner, Carl Hernmarck, och Kersti Holmquist. 791p., il. (1963). v.4 contains 9,092 reproductions of marks by 3,604 craftsmen and biographies of 3,211 goldsmiths; v.4 is arranged by city or town, then alphabetically by goldsmith. v.3-4 include English summaries of text. Indexes in v.3: Guldsmeder och konstnärer; Bilder med angivna mått. Indexes in v.4: Register över stadsstämplar; Register över provins- och åldermansstämplar; Register över mästarestämplar; Register över mästare.

v.1-3 contain bibliographies and numerous bibliographical references in notes sections.

*Spain and Portugal*

P532  Johnson, Ada Marshall. Hispanic silverwork. With 266 illustrations. N.Y., Hispanic Society, 1944. xx, 308p. il. (Hispanic notes and monographs; essays, studies and brief biographies issued by the Hispanic Society of America. Catalogue series)

A comprehensive, scholarly history of Spanish silver.

Contents: (I) Gothic silverwork in the 14th century; (II) Gothic silverwork in the 15th century; (III) Renaissance silverwork; (IV) 17th-century silverwork; (V) 18th- and 19th-

century silverwork; (VI) Catalogue of silverwork in the collection of the Hispanic Society of America, p.147-283.

Bibliography, p.294-300; bibliographical references included in Notes, p.284-94.

P533   Victoria and Albert Museum, South Kensington. Eng. Golden age of Hispanic silver, 1400-1655; [comp. by] Charles Oman. London, Her Majesty's Stationery Office, 1968. xlvii, 71p. 180 plates (280 il.)

A thorough, detailed catalogue of the Spanish and Portuguese silver of the period 1400-1665 in the collection of the Victoria and Albert Museum. The catalogue is arranged stylistically according to regions. Entries include description, marks (with reproductions), exhibitions, commentary, and bibliography.

Bibliography, p.59-62. Index of town marks, p.63; Index of goldsmiths and assayers, p.65; Index of goldsmiths' works referred to in the text, p.67-68; Numerical index, p.69-[71].

*United States*

P534   Avery, Clara Louise. Early American silver. N.Y., London, Century [1930]. 378p. il., 63 plates. (Repr.: N.Y., Russell & Russell, 1968.)

A standard work which traces the "development of styles of early American silver from the Stuart period, through the William and Mary to high-standard, Rococo, etc., in relation to English silver of the same period, concentrating on Massachusetts silver but also treating silver from other New England states, New York, Virginia, Pennsylvania and South Carolina, and emphasizing regional differences."—*Decorative arts*, A56, HM11.

"Bibliographical note," p.361-64.

P535   Boston. Museum of Fine Arts. American silver, 1655-1825, in the Museum of Fine Arts, Boston, by Kathryn C. Buhler. Boston. (Distr. by New York Graphic Society, Greenwich, Conn. [1972].) 2v. xx, 708p. il.

A detailed catalogue of more than 600 pieces of American silver by more than 150 known makers in the collection of the Museum of Fine Arts, Boston, which is unsurpassed in examples of New England manufacture. The catalogue is arranged geographically, then chronologically by makers' dates under place of origin. Entries include biographical information, description of piece, marks, commentary, history, notes, references, exhibitions, and one or more illustrations.

Contents: v.1: Introduction; Short title index; Massachusetts.; v.2: Massachusetts (cont.); New Hampshire; Connecticut; Rhode Island; New York; Philadelphia; Addenda; Appendix; Index; Errata.

P536   Currier, Ernest M. Marks of early American silversmiths, with notes on silver, spoon types & list of New York City silversmiths 1815-1841. Illustrated with many of [the author's] drawings. Ed. with introductory note by Kathryn C. Buhler. Portland, Me., Southworth-Anthoensen Pr.; London, Quaritch, 1938. 179p. il., plates, facsims. (Repr.: Harrison, N.Y.,

Green, 1970; Watkins Glen, N.Y., American Life Foundation, distr. by Century House, 1970.)

A compilation of silversmiths' marks, arranged by name of maker. Silversmiths of New York City 1815-1841 with their dates, p.173-76.

Bibliography, p.177-79.

P537   Ensko, Stephen G. C. American silversmiths and their marks. N.Y., Ensko, 1927-48. 3v. il., plates. (Repr. of v.2 (1937): Southampton, N.Y., Cracker Barrel [1969?].)

Still a standard work for the collector. v.1 contains a list of silversmiths arranged by states and marks of silversmiths, p.175-98. v.2: Standard and assay marks, p.16-17; Identified marks, p.19-79; Unidentified marks, p.80-82. v.3: (1) Names of early American silversmiths, 1650-1850, p.11-146; (2) Marks of early American silversmiths, 1650-1850, p.149-252; (3) Locations of silversmiths' shops, p.253-71.

Bibliographies: v.1, p.xi; v.2, p.8; v.3, p.281-85.

P538   French, Hollis. A list of early American silversmiths and their marks, with a silver collectors' glossary. N.Y., Walpole Society, 1917. ix, 164p. il. (Repr.: N.Y., Da Capo, 1967.)

An early compilation of American silversmiths' marks. The glossary, p.133-64, is still useful for basic definitions.

P539   Hood, Graham. American silver; a history of style, 1650-1900. N.Y., Praeger [1971]. 255p. 292 il.

An introductory survey of American silver, written for the beginning student and interested layman. "Each chapter is arranged so that the dozen or so most important pieces from the period are discussed first, summarizing, as it were, the attainments of the particular style. . . . Virtually all pieces illustrated here are from public collections where they are readily accessible and available for study."—*Pref.*

Contents: (1) Society, silversmiths, and their wares; (2) The 17th century; (3) Baroque silver of the William and Mary period; (4) Queen Anne silver; (5) Fully developed Rococo silver; (6) The classical taste of the early republic; (7) The Empire style; (8) Later 19th-century styles.

Classified bibliography, p.247-50.

P540   Rainwater, Dorothy T. Encyclopedia of American silver manufacturers. N.Y., Crown [1975]. 222p. il.

Previous ed. of 1966 pub. under title: *American silver manufacturers.*

A useful guide to manufacturers of American silverware from the mid-19th century to c.1920. Most of the illustrated trademarks are from 1896-1915 editions of *Trade-marks of the jewelry and kindred trades,* issued by the Jewelers' Circular. Manufacturers are listed alphabetically by name, with reproductions of marks and pertinent data.

Glossary, p.210-14. Bibliography, p.217-22.

P541   Turner, Noel D. American silver flatware, 1837-1910. South Brunswick, Barnes [1972]. 473p. il.

A comprehensive survey and handbook of American silver flatware of the Victorian and Edwardian periods.

Glossary, p.409-11. Classified bibliography, p.413-22. General index.

P542  Yale University. Art Gallery. American silver: Garvan and other collections in the Yale University Art Gallery, by Kathryn C. Buhler and Graham Hood. New Haven, Yale Univ. Pr., 1970. 2v. il.

A fully detailed, superbly illustrated catalogue with over 1,000 entries (including marks, provenance, description, commentary, bibliography, exhibitions) of the distinguished collections of American silver in the Yale Univ. Art Gallery. Arranged geographically by state and by silversmith.

Contents: v.1, New England; v.2, Middle Colonies and the South. Glossary, v.1, p.xiii-xiv; v.2, p.vii-viii. Short titles (bibliography, exhibitions, museums), v.1, p.xv-xviii; v.2, p.ix-xii. Reproductions of marks, v.1, p.321-32; v.2, p.275-87.

SEE ALSO:  Clayton, M. *The collector's dictionary of the silver and gold of Great Britain and North America* (P501).

## Oriental Countries

P543  Forbes, Henry A. Crosby; Kernan, John Devereux; and Wilkins, Ruth S. Chinese export silver, 1785 to 1885. Milton, Mass., Museum of the American China Trade, 1975. xvi, 303p. 304 il., 1 col. plate, map.

An exhaustive study of Chinese export silver, primarily as it related to the English and particularly the American markets. "The overall purpose of this study is to bring together what is presently known about the silver. The writers have not included descriptions of every known example; this would have meant unnecessary duplication. We have aimed, rather, by including representative examples by each maker, to indicate the variety of forms, decoration, and styles."—*p.3.* Excellent illustrations.

Contents: Pt. 1, Silver: a new category of Chinese export art: (I) Definition and scope; (II) Loss and recovery. Pt. 2, Historical background: (III) The indigenous tradition; (IV) Sources of silver; (V) Fineness and cost; (VI) Demand; (VII) Manufacturing centers; (VIII) Packaging, supply, and delivery. Pt. 3, Identification: (IX) Style; (X) Form; (XI) Technique, structural elements, and decoration; (XII) Makers; (XIII) Marks. The Descriptive Catalogue lists 299 pieces alphabetically by makers. The Plates section is grouped by types of objects.

Appendixes: (I) Chinese dynasties and epochs mentioned in the text; (II) Analyses of Chinese export silver; (III) List of Chinese export silversmiths 1785-915; (IV) Problems in translating makers' names.

Bibliography, p.261-76, classified and frequently annotated. Index of makers and marks. General index.

P544  Kempe, Carl. Chinese gold & silver in the Carl Kempe collection. A catalogue by Bo Gyllensvärd. [Stockholm, 1953]. 255p. il.

The catalogue of a comprehensive collection of Chinese gold and silver objects, from late Chou to Ch'ing. Outstanding as a pioneer attempt "to outline the history of Chinese precious metal craft, illustrated by photographs and drawings." —*Introd.* The introduction discusses general stylistic problems and presents the broad historical evolution; the catalogue contains detailed descriptions of 175 individual pieces. Extensive bibliography, p.54-59.

P545  Roth, Henry Ling. Oriental silverwork, Malay and Chinese. A handbook for connoisseurs, collectors, students and silversmiths. London, Truslove & Hanson, 1910. 3p. 1, 300p. il., maps. (Repr.: Kuala Lumpur, Univ. of Malaya Pr., 1966.)

A pictorial survey of 170 examples of Malay and Chinese silverwork. Arranged by types: Betrothal cups, betel nut holders, vases and cups, chelpas or tobacco boxes, Chinese caskets, water bowls, lime box, etc. Description and commentary on pages facing illustrations.

Index. No bibliography.

## Iron

### Histories and Handbooks

P546  Ffoulkes, Charles John. Decorative ironwork from the eleventh to the eighteenth century. London, Methuen [1913]. xxvi, 148p. 80 il., 31 plates.

Includes examples of European hinges, grills, locks, door handles, chests, clocks, and other types. Names of smiths and ironworkers, p.141-44.

P547  Gloag, John, and Bridgwater, Derek. A history of cast iron in architecture. With a foreword by Sir Charles Reilly. London, Allen & Unwin [1948]. xx, 395p. 507 il., 6 col. plates.

A well-illustrated history of the decorative and constructional functions of cast iron in architecture. Includes bibliographies.

P548  Hoever, Otto. Wrought iron; encyclopedia of ironwork. [Trans. from the German by Ann C. Weaver. 2d American ed. N.Y.]. Universe Books [1962]. xxxiiip. il., 320 plates.

Trans. of *Das Eisenwerk; die Kunstformen des Schmiedeeisens vom Mittelalter bis zum Ausgang des 18. Jahrhunderts.* [4. inhaltlich unveränderte Aufl.]. Tübingen, Wasmuth [1961]. Also pub. in England as: *A handbook of wrought iron from the Middle Ages to the end of the eighteenth century.* London, Thames & Hudson [1962]. 1st American ed.: *An encyclopedia of ironwork* ... N.Y., Weyhe, 1927.

A pictorial survey of European ironwork, with a brief history of wrought iron manufacture. Contents: (1) Introduction: ornamental ironwork; (2) Gothic; (3) Late Gothic and Renaissance; (4) Baroque and classicism.

P549  Robertson, E. Graeme, and Robertson, Joan. Cast iron decoration: a world survey. N.Y., Watson-Guptill [1977]. 336p. il., plates.

A comprehensive pictorial survey of cast iron ornamentation, with introductory texts which outline the use of cast iron in nonstructural, architectural contexts throughout the world. Includes an excellent selection of reproductions of designs and design sources, and photographic illustrations of buildings and details of cast iron elements. References to plates are given in text margins.

Contents: (1) Introduction; (2) The British Isles; (3) The continent of Europe; (4) U.S.A. (5) Australia and New Zealand; (6) Empires and influences. Glossary, p.321–23. Classified bibliography, p.324–31. General index.

## Western Countries

### France

P550  Allemagne, Henry René d'. Les anciens maîtres serruriers et leurs meilleurs travaux. Paris, Gründ, 1943. 2v. il., plates.

A comprehensive survey of the works of Parisian locksmiths and ironworkers, which include not only locks but also grills, railings, hinges, gates, keys, door knockers, and various types of ornamental ironwork.

v.1, text, covers the history of locksmithing and ironworking and the types of ironwork produced. v.2 contains the plates.

Illustration also included in text volume.

P551  Blanc, Louis. Le fer forgé en France. La régence; aurore, apogée, déclin. Oeuvres gravées des anciens maîtres serruriers, architectes, dessinateurs et graveurs. Paris et Bruxelles, van Oest, 1930. 24p. 96 plates.

A pictorial survey of French engraved designs for wrought ironwork of the Regency period. A sequel to the author's *Le fer forgé en France aux XVIe et XVIIe siècles* (P552). "Notices biographiques," p.[9]–19, give biographies of nine of the most important masters of the period. "Table des sujets reproduits," p.[23–24].

P552  _____. Le fer forgé en France aux XVIe et XVIIe siècles; oeuvres gravées des anciens maîtres, serruriers, architectes, dessinateurs et graveurs. Paris, van Oest, 1928. 27p. 96 plates.

A compendium of plates of French engraved designs of wrought ironwork of the 16th and 17th centuries. Followed by the author's *Le fer forgé en France. La régence; aurore, apogée, déclin* (P551). "Notices biographiques," p.[9]–23, give brief biographies of 20 leading artists. "Table par noms d'auteurs dans l'ordre chronologique," p.25. "Table des sujets reproduits," p.[26]–27.

P553  Frank, Edgar Black. Old French ironwork; the craftsman and his art. Cambridge, Mass., Harvard Univ. Pr., 1950. xiv, 221p. il., 96 plates.

Trans. of *Petite ferronnerie ancienne*, Paris, SELF, 1948.

A study of small pieces of French ironwork: locks, keys, hinges, bolts, padlocks, caskets, tinder boxes, sewing accessories, knives, seals, candlesticks, etc.

Bibliography, p.217–18.

### Great Britain

P554  Ayrton, Maxwell, and Silcock, Arnold. Wrought iron and its decorative use. London, Country Life [1929]. 196p. il., plans.

A well-illustrated survey of English architectural wrought iron to the mid-18th century. Includes sections on Tijou, the smiths of Wales, the West of England, and the Midlands. Bibliography, p.188.

P555  Gardner, John Starkie. English ironwork of the XVIIth and XVIIIth centuries; an historical and analytical account of the development of exterior smithcraft ... with 88 collotype plates from photographs chiefly by Horace Dan, architect, and upwards of 150 other illustrations. London, Batsford [1911]. xxxvi, 336p. il., 88 plates. (Repr.: N.Y., Blom, 1970.)

A fundamental work on 17th- and 18th-century English ironwork, comp. and written by a practicing designer of decorative ironwork who was largely responsible for forming the important collection of ironwork in the Victoria and Albert Museum.

Contents: Medieval ironwork; The evolution of gates; Railings, balustrades, balconies, stair-ramps and grilles; Lampholders, brackets, signs and vanes; List of smiths and designers, p.321–23. General index to the text, p.324–36. Brief subject list of examples illustrated, p.xv–xviii. Topographical list of examples illustrated, p.xix–xxvi.

P556  Lister, Raymond. Decorative and wrought ironwork in Great Britain. London, Bell [1957]. xii, 265p. il.

An introduction to the history and techniques of British decorative wrought ironwork. Contents: (1) Introductory; (2) Technique; (3) Architectural wrought ironwork; (4) Domestic ironwork; (5) The blacksmith, Appendix: 'Old Clem' celebrations and blacksmiths' lore.

Annotated, classified bibliography, p.245–56; bibliographical references in footnotes.

### Italy

P557  Ferrari, Giulio. Il ferro nell'arte italiana; centosettante tavole reproduzioni in parte inedite di 368 soggetti del medio evo, del rinascimento, del periodo barocco e neoclassico raccolte e ordinate con texto explicativo. 3. ed. aumentara. Milano, Hoepli [1927]. 197p. 160 plates.

1st ed. 1910.

Primarily a picture book of photographic illustrations of Italian architectural ironwork from the Middle Ages to the early 19th century. "Indice" is a list of illustrations.

### Spain and Portugal

P558  Byne, Arthur, and Byne, Mrs. Mildred (Stapley). Spanish ironwork. With one hundred and fifty eight illustrations. [N.Y.] Hispanic Society, 1915. 143p. il., plates. (Hispanic Society publications, no. 89)

An informal survey of the various types of Spanish ironwork, with greatest attention given to the *rejas*. Contents: Introduction; (I) Spanish ironwork previous to the Gothic period; (II) Gothic rejas and pulpits; (III) Gothic hardware and domestic-utensils; (IV) The development of the Renaissance reja; (V) Renaissance church rejas; (VI) Smaller Renaissance productions; (VII) The last of Spanish ironwork.

"Catalogue of ironwork in the collection of the Hispanic Society of America," p.[137]-43, is merely a list of 180 pieces, with no notes or descriptions. No bibliography.

### United States

P559    Kauffmann, Henry J. American ironware, cast and wrought. Rutland, Vt., Tuttle [1966]. 166p. 210 il.
"A pictorial survey of objects made of iron in America and the trades that produced them."—*Introd.* Written primarily for the collector rather than the scholar.

   Contents: (1) The blast furnace; (2) The forge; (3) The iron foundry; (4) The blacksmith; (5) The whitesmith; (6) The farrier; (7) The edge toolmaker; (8) The cutler; (9) The locksmith; (10) The gunsmith; (11) The nailer; (12) The wheelwright; (13) The tinsmith.
   Bibliography of 7 items, p.148.

P560    Sonn, Albert H. Early American wrought iron, with 320 plates from drawings by the author. N.Y., Scribner, 1928. 3v. il., 320 plates.
A pictorial survey.
   Bibliography, v.3, p.243-44. General index for all three volumes, v.3, p.247-63.

## Medals

P561    Armand, Alfred. Les médailleurs italiens des quinzième et seizième siècles. 2d éd. rev., corrigée et considérablement augmentée. Paris, Plon, 1883-87. 2v. and suppl. (Repr.: Bologna, Forni, 1966.)
1st ed. 1879. A compilation of 2,600 Italian medals of the 15th and 16th centuries. Pt. 1 includes the work of approx. 178 medalists whose names, initials, or marks are known. Under each artist medals are arranged alphabetically, with a description and reference to a reproduction. Locations of unpublished medals are given. Pt. 2 includes anonymous medalists.
   A 3d volume contains a supplement and indexes. Bibliography in prefaces of v.1, p.17-18, and v.3, p.8. v.2-3 contain indexes of persons represented and legends inscribed on medals. An alphabetical list of medalists referred to in v.1-2 in v.2, p.307-31.

P562    Forrer, Leonard. Biographical dictionary of medalists; coin, gem, and seal-engravers, mint-masters, etc., ancient and modern, with references to their works B.C. 500-A.D. 1900. London, Spink, 1902-30. 8v. il., 6 plates. (Repr.: N.Y., Burt Franklin, 1971.)
The standard reference work. Sources are given at the end of most entries.
   Contents: v.1-6, A-Z; v.7, A-L, Supp.; v.8, M-Z, 2d Supp. Bibliography: v.1, p.xxxix, xlviii and v.8, p.[368]. Index of illustrations, v.8, p.369-461.

P563    Habich, Georg, ed. Die deutschen Schaumünzen des XVI. Jahrhunderts, hrsg. mit Unterstützung der Bayerischen Akademie der Wissenschaften und der Notgemeinschaft der Deutschen Wissenschaft im Auftrag des Deutschen Vereins für Kunstwissen-

schaft. München, Bruckmann [1929-34]. v.1^{1-2}, 2^{1-2}, and index in 5v. il., 334 plates.
No more published. A scholarly corpus of German medals of the 16th century; arranged by medalists and schools. Includes bibliographies.

P564    _____. Die Medaillen der italienischen Renaissance. Stuttgart und Berlin, Deutsche Verlags-Anstalt [1923] 168p. il., 100 plates.
A basic work on Italian Renaissance medals. Excellent plates. Short bibliography, p.xii. Indexes: "Tafelrückweis," p.151-59; "Verzeichnis der Medailleure," p.160-61; "Verzeichnis der auf den Medaillen dargestellten Personen," p.162-67.

P565    Hill, *Sir* George Francis. A corpus of Italian medals of the Renaissance before Cellini. London, British Museum, Printed by order of the Trustees, 1930. 2v. il., 201 plates.
Describes and classifies medals produced in Italy from 1390 to about 1530. "Fundamental study of the great Renaissance medallists before Cellini, including Pisanello and Matteo de'Pasti."—Molesworth and Brookes (K8).
   Contents: v.1, Text; v.2, Plates. List of museums and collections v.1, p.xv-xvi. List of the more important catalogs of auction sales consulted, v.1, p.xvii. Bibliography, v.1, p.xii-xiv.

P566    _____. Medals of the Renaissance. Revised and enlarged by Graham Pollard. London, British Museum, 1978. 230p. 32 plates.
1st ed. 1920.
   A general survey of Renaissance medals from Italy, Germany, France, England, and the Netherlands. Expertly revised through greatly expanded notes, new references and bibliography, and a thorough index. "The most reliable and certainly the most enjoyable introduction to its field."—Ulrich Middeldorf in *Apollo* 108:358-59, Nov. 1978.

P567    Lenormant, François. Monnaies et médailles. Nouv. éd. Paris, Quantin [1885?]. 328p. il. (Bibliothèque de l'enseignement des beaux-arts)
A reissue of the 1st ed. 1883.
   An old general survey of coins and medals from antiquity to the 19th century. Appendixes: (1) Liste des médailleurs italiens des XVe et XVIe siècles dont on possède des oeuvres signées, p.319-22; (2) Médailleurs et graveurs monétaires français depuis la renaissance, p.323-24; (3) Table des matières, p.[327]-28.

P568    U.S. National Gallery of Art. Renaissance medals: from the Samuel H. Kress Collection at the National Gallery of Art; based on the catalogue of Renaissance medals in the Gustave Dreyfus Collection, by G. F. Hill, rev. and enl. by Graham Pollard. London, Phaidon, for the Samuel H. Kress Foundation [1967]. x, 307p. 1,209 il., 628 plates.
This important catalogue, based on an unpublished catalogue which documents the core of the collection, has "a triple purpose; it makes available for the first time one of the masterpieces of the art historical literature of the years

457

between the two world wars, . . . it constitutes a companion to historical studies, and it provides a comprehensive survey of a now neglected aspect of Renaissance art."—*Pref.* Additions and reattributions are noted in a table. A bibliography with abbreviations precedes the catalogue, which includes bio-bibliographical information on the artists and their medals. Each entry is accompanied by excellent reproductions of the obverse and reverse of the medal. Some coins are included. Concordance with Armand, p.273–77. Index of inscriptions, p.278–92. General index, p.293–99; of persons, p.300–5; of artists concerned with medals, p.306–7.

P569  Weber, Ingrid. Deutsche, niederlandische und französische Renaissanceplaketten, 1500–1650: Modelle für Reliefs an Kult-, Prunk- und Gebrauchsgeständen. München, Bruckmann, 1975. 2v. v.1, 443p., 41 (56) il.; v.2, 1,058 il. on 302 plates.

A catalogue and comprehensive survey of Renaissance plaquettes produced in Germany, the Netherlands, France, and Spain. Within chronological sections, the catalogue entries are arranged first by place of production, then by plaquette designer. Entries for designers include biographical data and bibliographical references. Entries for each plaquette include description, dimensions, collection or collections, references, and often critical discussion. Plaquettes are illustrated in v.2.

Contents, v.1: 15. Jahrhundert; 1. Hälfte 16. Jahrhundert; 2. Hälfte 16. Jahrhundert; 17. Jahrhundert. Register, p.419–43 (Künstler und Kunsthandwerker, Orts-Register, Personen- und Sachregister).

SEE ALSO:  Pyke, E. J., *A bibliographical dictionary of wax modellers* (K11).

## Pewter

### Bibliography

P570  Denman, Carolyn. A bibliography of pewter. Boston, Pewter Collectors' Club of America [1945]. 21p. (Bulletin, no. 15)

A fundamental bibliography of books and periodical articles on the history and techniques of pewter. Contents: General, American, English, Scotch, Continental, Asiatic, and modern. List of museums containing collections, p.20–21.

### Histories and Handbooks

P571  Haedeke, Hanns Ulrich. Zinn; ein Handbuch für Sammler und Liebhaber. Mit 498 Abbildungen, darunter mehreren Markentafeln und einer Farbtafel. 2., erw. Aufl. Braunschweig, Klinkhardt & Biermann [1973]. 368p. il., col. plate. (Bibliothek für Kunst- und Antiquitätenfreunde. Bd. 16)

1st ed. 1963.

A comprehensive survey of European ecclesiastical and domestic pewter from antiquity to the Art Nouveau period. More scholarly than the usual collector's handbook. Very well illustrated.

Contents: (I) Vorkommen, Gewinnung; (II) Die Verarbeitung des Zinns; (III) Die Zünfte; (IV) Zinn in Vorgeschichtlicher Zeit und der Antike; (V) Mittelalter; (VI) Renaissance und Manierismus; (VII) Das Zinngerät der deutschen Landschaften; (VIII) Klassizismus und Biedermeier; (IX) Historismus und Jugendstil; (X) Das Zinngerät ausserhalb Deutschlands; (XI) Das Sammeln von Zinn.

Notes, p.351–[56], include references. Bibliography, p.357–61.

P572  Mory, Ludwig. Schönes Zinn: Geschichte, Formen und Probleme. [Die Bildtaf. "Stempelmarken" u. "Regionale Krug- u. Kannentypen" bearb. Hildegard Mory]. 5. durchges. Aufl. München, Bruckmann, 1975. 336p. il. (part col.), maps.

1st ed. 1961.

A pictorial survey of pewter from its origins to the 20th century. Includes well-illustrated discussions of pewter-making techniques and reproductions of many marks. Bibliography, p.317–18.

### Western Countries

P573  Boston. Museum of Fine Arts. Dept. of American Decorative Arts and Sculpture. American pewter in the Museum of Fine Arts, Boston. Photographs by Daniel Farber. Boston, Museum of Fine Arts. (Distr. by New York Graphic Society [1974]) xiii, 119p. il.

A catalogue (342 entries) of the collection of American pewter in the Museum of Fine Arts, Boston. "The finest examples of holloware (pitchers, flagons, tankards, teapots, etc.) are illustrated."—*Pref.* Introduction, by Jonathan Fairbanks, p.viii–xiii.

Contents: Maine; Vermont; Massachusetts; Connecticut; Rhode Island; New York; Pennsylvania; Maryland; Unknown makers.

Selected bibliography, p.119; bibliographical references in footnotes.

P574  Cotterell, Howard Herschel. Old pewter, its makers and marks in England, Scotland and Ireland; an account of the old pewterer & his craft, illustrating all known marks and secondary marks of the old pewterers, with a series of plates showing the chief types of their wares. London, Batsford [1929]. 432p. il., 76 plates, facsims. (Repr.: Rutland, Vt., Tuttle, 1963.)

An essential reference work on British pewter. Historical introduction, p.1–19. Alphabetical list of pewterers, p.145–344; Initialled marks, p.345–83; Obscure marks, p.384–89. Includes 5,374 pewterers.

Bibliography, p.423. General index, p.425–32. Index to devices, p.391–415; to hallmarks, p.416–21.

P575  Hatcher, John, and Barker, T. C. A history of British pewter. London, Longman, 1974. xii, 363p. il., [16] leaves of plates.

A comprehensive, well-documented history. "Our attention is devoted to the main use of tin-rich alloys, namely pewter-

ware, and to the vast range of tableware and household utensils that were made by pewterers, including plates, dishes, salt-cellars, basins, porringers, spoons, ewers, flagons, cups, tankards, candlesticks, chamberpots, teapots, coffeepots, pepperpots, and inkpots. . . . In this study emphasis has been placed not only upon the industry and its gilds, but also upon the consumption and distribution of pewter, and upon its role in the household."—*Introd.* Illustrated with line drawings and photographic reproductions.

Contents: Pt. 1, Pewter before 1700, by J. Hatcher: (1) From early times to the Norman Conquest; (2) The Middle Ages; (3) The 16th and 17th centuries; (4) Pewterers' gilds and the regulation of the industry; (5) Manufacturing and marketing. Appendix A, Data extracted from London Company records: 1451-1700. Appendix B, The retail price of pewterware, before 1700. Pt. 2, Pewter in modern Britain, by T. C. Barker: (6) The decline of pewter; (7) The Company and the craft.

Extensive classified bibliography (Manuscript sources; Printed primary sources; Printed secondary sources; Unpublished secondary sources), p.323-40. Bibliographical references in footnotes.

P576   Hintze, Erwin. Die deutschen Zinngiesser und ihre Marken. Leipzig, Hiersemann, 1921-31. 7v. (Repr.: Aalen, Zeller, 1964-65.)

A monumental work on German pewter and pewter marks. Contents: v.1, Sächische Zinngiesser; v.2, Nürnberger Zinngiesser; v.3, Norddeutsche Zinngiesser; v.4, Schlessische Zinngiesser; v.5-7, Süddeutsche Zinngiesser: (1) Aalen-Kronach; (2) Kunzelsau-Sulzbach; (3) Tauberbischofsheim bis Zwiesel, mit Anhang Elsass, Österreich, Schweiz, Ungarn.

Indexes in each volume: (1) Meisterverzeichnis; (2) Register der Marken: a, Vereinigte Stadt- und Meisterzeichen; b, Stadtzeichen; c, Meisterzeichen; d, Qualitätszeichen für Probezinn, Lauterzinn, Feinzinn, Englisch Zinn; (3) Verzeichnis der Eigentümer.

P577   Jacobs, Carl. Guide to American pewter. Illus. by Marion B. Wilson. N.Y., McBride, 1957. 216p. il., plates, facsims.

Still useful to the collector, although prices recorded are far out-of-date. Arranged alphabetically by name of pewterer. Characteristic pewter forms, p.205-16.

P578   Kerfoot, John Barrett. American pewter. With illustrations from photographs by the author of specimens in his own collection. Boston and N.Y., Houghton Mifflin, 1924. xxiii, 239p. plates. (Repr.: Detroit, Gale, 1976.)

A standard survey of American pewter, now partially superseded by more recent works.

P579   Laughlin, Ledlie Irwin. Pewter in America, its makers and their marks. Boston, Houghton Mifflin, 1940-71. 3v. il., 115 plates.

Imprint varies: v.3, Barre, Mass., Barre, 1970. Repr. of v.1-2: Barre, Mass., Barre, 1969.

The definitive work on American pewter. Fully documented with a wealth of factual information on American

pewter and pewterers, reproductions of almost all known marks, and superb illustrations of representative pieces. v.3 supplements and corrects v.1-2 and follows, in general, the same arrangement of material as in the original volumes.

Contents: v.1, Introduction; The European background; Problems of the colonial pewterer; The business of a pewterer; The marks on pewter; Pewter-making in America; Household pewter; Ecclesiastical pewter; The pewterers of Massachusetts Bay; The Rhode Island pewterers; The pewterers of the Connecticut Valley. v.2: The pewterers of New York City; Albany pewterers; The pewterers of Pennsylvania; The pewterers of the South; The initialed porringers; Unidentified American touches; The Britannia period; Dethroned pewterers; Fakes; The cleaning and care of pewter. Appendixes: (I) Checklist of American makers of pewter, Britannia, or block tin; (II) Representative inventories of American pewter shops. Index of symbols and initials in the early touch-marks; Index of makers of pewter shown in plates; General index.

Bibliography, v.2, p.163-[92], is exhaustive and classified in detail. Bibliography, v.3, p.233-55.

P580   Montgomery, Charles F. A history of American pewter. N.Y., Praeger [1973]. 246p. il.

An authoritative, readable history of American pewter which traces its development within its cultural context from the early colonial period through the 18th and 19th centuries. Valuable to the scholar as well as the collector.

Contents: (1) Pewter in everyday life; (2) The American pewterer and his craft; (3) Connoisseurship; (4) Church pewter: baptismal basins, beakers, chalices, flagons, and communion tokens; (5) Lighting: candlesticks, lamps, and sconces; (6) Drinking vessels: mugs and tankards; (7) Pitchers; (8) Plates, dishes, and basins; (9) Porringers; (10) Spoons and ladles; (11) Utensils for tea and coffee; (12) "Any uncommon thing in pewter." Pewterers and Britannia makers and their marks represented in *A History of American Pewter,* p.215-29. Public collections of American pewter, p.230-31. Plates and dishes in the Winterthur Museum, p.232-34. The composition of American pewter and Britannia objects, p.235-39. Cleaning old pewter, p.240.

Critical bibliography, p.241-42. Notes, p.205-14, include references.

P581   Schneider, Hugo. Zinn. Olten und Freiburg im Breisgau, Walter [1970]. 396p. il., facsims.

A fully illustrated catalogue of the collection of Swiss pewter in the Schweizerische Landesmuseum, Zürich. All marks are reproduced and dimensions are given for each piece.

Contents: Profanes Zinn; Sakrales Zinn; Werkzeuge. Anhang: Meisterregister; Ortsregister.

Two further volumes are projected: *Geschichte des schweizerischen Zinngiesserhandwerkes* and *Die Zinngiesser der Schweiz und ihre Marken.*

P582   Tardy. Les étains français. Avant-propos de M. B. Douroff. Paris [1957-64]. 4v. in 3. 1,117p. il., map.

Facing title of v.1: La Chambre syndicale de la poterie d'étain et des industries qu'y s'y rattachent présente.

A comprehensive reference work on French pewter. v.1, *Lois générales. Paris,* contains a general historical and technical survey of French pewter; v.1 also includes a listing of Parisian pewterers and their marks, with reproductions of the marks and photographs of works. v.2-3, *Les provinces,* cover pewterers working in about 1,600 French towns other than Paris. Altogether, approx. 7,800 pewterers and 1,825 marks are identified. v.4, *Notes complémentaires et tables générales.*

P583    Tischer, Friedrich. Böhmisches Zinn und seine Marken, mit 1258 Abbildungen von Zinngiessermarken und 16 Tafeln. Leipzig, Hiersemann, 1928. 329p. 1,258 il., 16 plates, facsims.

A scholarly history of and reference work on Bohemian pewter and its marks. Covers the works of both German and Czech pewterers.

Bibliography, p.xiv-xv. Indexes: Places, p.vii-xi; Masters, p.295-304; Marks, p.309-26; Coats of arms of owners, p.327-29.

# GEMS AND JEWELRY

## Histories and Handbooks

P584    Black, J. Anderson. The story of jewelry. With an introduction by Edward Lucie-Smith. N.Y., Morrow, 1974. 400p. il. (part col.)

Pub. in Great Britain under title: *A history of jewels,* London, Orbis. First pub. in Italian trans. under title *Storia dei gioielli.*

A popular, generally reliable history of jewelry from prehistory to the 20th century. Over 500 color illustrations. Appendixes: (A) Royal regalia and other great collections; (B) Gemstones—their physical properties and occult significance; (C) Glossary of techniques and technical terms.

Bibliography, p.384-85.

P585    Evans, Joan. A history of jewellery, 1100-1870. [2d ed.]. London, Faber and Faber; Boston, Boston Book and Art Shop [1970]. 224p. il., 204 plates (12 col.)

1st ed. 1953.

The standard historical survey. "The present book surveys a field limited in time from the end of the eleventh century to the middle of the nineteenth, and limited in space to the more civilised parts of Europe. It begins when the cycle of European economic life once more made it possible for artistic creation to break through the shackles of tribal tradition; it ends in 1870.... It is as a decorative art that jewellery is here considered, and as an art confined to ornaments actually worn upon the person."—*p.39.*

Contents: (I) The early Middle Ages; (II) The Gothic period; (III) The later Middle Ages; (IV) The early Renaissance; (V) The later Renaissance; (VI) The 17th century; (VII) The 18th century; (VIII) 1789-1870.

Extensive bibliography, p.185-200. Bibliographical references in footnotes.

P586    Gere, Charlotte, European and American jewellery, 1830-1914. London, Heinemann, 1975. 240p. 250 il. (64 col.)

American ed. pub. as *American and European jewelry,* N.Y., Crown, 1975.

"Survey of the period, from the aftermath of the French revolution through the Victorian era to the age of the great international exhibitions. Includes an account of the emergence of identifiable American style and the early awareness by Americans of the commercial possibilities of a large jewelry industry. Contains over 120 biographical entries of jewelers and designers, both firms and individuals."—Staff, *RILA,* 1976, v.2, no. 1, p.2158.

Contents: pt. 1, Fashions and styles (1830-50, 1851-75, 1876-1914); pt. 2, Materials, techniques and marks; pt. 3, Jewellers and designers. Glossary, p.231-32. Bibliography, p.233-34.

P587    Hinks, Peter. Nineteenth century jewellery. London, Faber and Faber, 1975. 120p. 202 il. (8 col.)

The first comprehensive work on the subject. "Covers Revolutionary, Napoleonic, post-Napoleonic, midcentury, Second Empire, High Victorian and Fin de Siècle styles of jewelry, as well as the Arts and Crafts Movement, Art Nouveau, peasant and mourning jewelry, collecting, and an appendix of the gold and silver marks of ten countries. The development of the great centers of manufacture both in Europe and America is traced."—Staff, *RILA,* 1976, v.2, no. 1, p.2178.

P588    Lanllier, Jean, and Pini, Marie-Anne. Cinq siècles de joaillerie en Occident. Préf. de G. Boucheron. [Fribourg] Office du Livre; Paris, Bibliothèque des arts [1971]. 336p. 310 il. (59 col.)

"Jewelry with precious stones is studied from the Renaissance to the present. The 15th c. is chosen as the starting point because it marks a notable evolution in technique contemporary with the extension of the political and commercial relations of Europe with the rest of the world...." —M.-A. Pini, *RILA,* Demonstration issue, no. 149.

Contents: (I) Connaissance de la joaillerie; Le diamant; Le rubis; Le saphir; L'émeraude; La perle; Les émaux; Annexe (réglement); (II) La renaissance; (III) L'âge classique; (IV) Le XIXe siècle; (V) Le XXe sièclel (VI) Bijou d'artistes.

Bibliography, p.327-28.

P589    Smith, Harold Clifford. Jewellery. London, Methuen; N.Y., Putnam [1908]. 409p. il., 54 plates (3 col.) (The connoisseur's library, gen. ed.: C. Davenport) (Repr.: Wakefield, EP, 1973.)

A general history of jewelry from the Egyptian period to the beginning of the 20th century. Jewelry of the 16th and 17th centuries receives the fullest treatment. Bibliography, p.371-79.

P590    Steingräber, Erich. Antique jewellery, its history in Europe from 800 to 1900. [Trans. by Peter Gorge]. London, Thames & Hudson [1957]. 191p. 341 il., (6 col.)

Also pub. as *Antique jewelry*, N.Y., Praeger, 1957. Trans. of *Alter Schmuck; die Kunst des europäischen Schmuckes*, München, Rinn [1956].

An authoritative survey of Western jewelry. Bibliography, p.185–86.

SEE ALSO: Lipinsky, A. *Oro, argento, gemme e smalti* ... (P465).

## Ancient

P591  Antike Gemmen in deutschen Sammlungen. München, Prestel [1968–(75)]. v.1–(5). plates.
A series of catalogues of Phoenician, Achaemenidian, Sassanidian, Minoan, Greek, Etruscan, Roman, and Early Christian gems in German collections. Catalogue entries contain detailed descriptions, bibliographical references, analytical discussion, and references to comparative material. Illustrated with superb photographs of the original gems and of plaster casts.

Contents: Bd. I. Staatliche Münzsammlung München. Teil 1, Griechische Gemmen von minoischer Zeit bis zum späten Hellenismus, bearb. von Elfriede Brandt, mit einer Geschichte der Münchener Sammlung von Harald Küthmann (1968). Teil 2, Italische Gemmen, etruskisch bis römisch-republikanisch, bearb. von Elfriede Brandt und Italische Glaspasten, vorkaiserzeitlich, bearb. von Evamaria Schmidt (1970). Teil 3, Italische und griechische Gemmen und Glaspasten der römischen Kaiserzeit sowie Nachträge, bearb. von Elfriede Brandt, Wendula Gercke, Antje Krug und Evamaria Schmidt (1972); Bd. II. Stiftung Preussischer Kulturbesitz Staatliche Museen Berlin, Antikenabteilung. Antike Gemmen von frühminoischer Zeit bis zur spätrömischen Kaiserzeit, bearb. von Erika Zwierlein-Diehl, die auch die Geschichte der Sammlung schrieb (1969); Bd. III. Braunschweig, Göttingen, Kassel, bearb. von Peter Gercke, Volker Scherf, Peter Zazoff, hrsg. von Peter Zazoff (1970); Bd. IV. Hannover, Kestner-Museum, Hamburg, Museum für Kunst und Gewerbe, bearb. von Margildis Schlüter, Gertrud Platz-Horster und Peter Zazoff, hrsg. von Peter Zazoff (1975); Bd. V. Gemmenbetrachtung und Glyptikforschung (Abschlussband), von Peter Zazoff.

P592  Becatti, Giovanni. Oreficerie antiche, dalle minoiche alle barbariche. Roma, Istituto poligrafico dello stato, 1955. 255p. il. (part col.), 169 plates (590 figs.)
A comprehensive historical and stylistic study of ancient jewelry from the second millenium B. C. to the 7th century A.D. Examples illustrated and described are drawn from public and private collections in Europe and the U.S. In two parts: text and descriptive catalogue.

Bibliography, p.229–34.

P593  Vienna. Kunsthistorisches Museum. Die antiken Gemmen des Kunsthistorischen Museums in Wien. München, Prestel, 1973- . v.1- . plates.
The 1st volume of a 3v. series of catalogues of ancient gems in Viennese collections. Catalogue entries include detailed descriptions, bibliographical references, analytical discussion, and references to comparative material. Illustrated with photographs of the original gems and of plaster casts.

Contents: Bd. I. Die Gemmen von der minoischen Zeit bis zur frühen römischen Kaiserzeit, bearb. von Erika Zwierlein-Diehl, mit einem Vorwort von Wolfgang Oberleitner. Photographiert von Isolde Luckert (1973).

## Egypt and Western Asia

P594  Aldred, Cyril. Jewels of the pharaohs; Egyptian jewelry of the dynastic period. Special photography in Cairo by Albert Schoucair. London, Thames & Hudson; N.Y., Praeger [1971]. 256p. il., plates (100 col.)
A very well illustrated study of the design and technical aspects of Egyptian jewelry.

Contents: (1) The recovery of ancient Egyptian jewellery; (2) The uses of ancient Egyptian jewellery; (3) The materials; (4) The craftsmen and their tools; (5) Techniques; (6) The forms; Epilogue. Chronological table, p.164. Notes on the plates, p.173–245, give detailed descriptions and commentaries. Sources of the illustrations, p.245. Notes on the text, p.250–51.

Classified bibliography, p.246–49: Catalogues and collections; Excavations and surveys; Technical studies; Studies in design; Literary sources; Miscellaneous.

P595  Maxwell-Hyslop, K. R. Western Asiatic jewellery, c.3000–612 B.C. London, Methuen [1971]. lxvi, 286p. il., plates (8 col.)
"This book, which is a pioneer attempt to examine synoptically ancient gold and silver jewellery from Western Asia, involves recourse to a wide range of specialist branches of learning beyond the purely archaeological. Tentative conclusions have, therefore, to be based on historical, metallurgical, linguistic, technological and archaeological evidence. . . . The volume forms the predecessor to R. A. Higgins's *Greek and Roman Jewellery* [P600] . . . and is a companion to A. Wilkinson's *Ancient Egyptian Jewellery* [P597]."
—*Pref.*

Contents: (1) Mesopotamia: the early dynastic period; (2) Mesopotamia: the Sargonid period, c.2370–2200 B.C.; (3) Anatolia, 2500–2000 B.C.; (4) The Guti-Gudea period, 3d dynasty of Ur to Isin and Larsa dynasties, 2250–1894 B.C.; (5) Babylonia, Mesopotamia, and Iran, 2017–1750 B.C.; (6) Anatolia, c.1950–1750 B.C.: Kültepe-Kanesh and the Assyrian *Kārum*; (7) Phoenicia, Syria, and Palestine, c.2000–1550 B.C. Asiatic-Cypriote relations, c.1550–1450 B.C.; (8) Syria and Palestine, c.1550–1300 B.C.; (9) Iran in the mid-second millennium B.C.; (10) The Kassite period in Babylonia and the mid-Assyrian period in Assyria; (11) Assyria and Iran: 12th to 7th centuries B.C.; (12) Urartu: 9th to 7th centuries B.C.; (13) North-west Iran: 8th to 7th centuries B.C.; (14) Palestine and Syria: 12th to 6th centuries B.C.; (15) Assyria and Iran: 9th to 7th centuries B.C. Chronological table I, c.3000–1000 B.C., p.liv–lv; Chronological table II, 1000–612 B.C., p.lvi–lvii. Map, p.lviii–lix.

461

Bibliography, p.271-73, arranged by chapters. Bibliographical references in footnotes. Index of sites; General index.

P596   Vilímková, Milada. Egyptian jewelry. Selection of illus. by Moh. H. Abdul-Rahman. Photography by Dominique Darbois. [Trans. by Iris Irwin]. London and N.Y., Hamlyn [1969]. 141p. col. il., col. plates.
An introductory survey of ancient Egyptian jewelry. Pieces illustrated and described are from the collection of the Cairo Museum.

Contents: (I) The beginnings; (II) The protodynastic period; (III) The Old Kingdom; (IV) The Middle Kingdom; (V) The New Kingdom; (VI) The late dynastic period; (VII) The end of Egyptian tradition; (VIII) Decoration in Egyptian jewellery; (IX) Materials and techniques.

Illustrations and catalogue, p.[57-134] include 94 pieces with description and brief commentary. List of abbreviations used in the notes, p.52. Notes, p.53-[56]. Chronological table, p.[135].

P597   Wilkinson, Alix. Ancient Egyptian jewellery. London, Methuen [1971]. lxi, 266p. il., plates (8 col.)
A comprehensive, scholarly study of the stylistic and technical development of Egyptian jewelry from the predynastic period to the end of the XXVIth dynasty (525 B.C.). Each section begins with an historical survey of the period and includes descriptions of the primary archaeological discoveries of that period. The work is a companion to K. R. Maxwell-Hyslop's *Western Asiatic jewellery*. (P595).

Contents: (1) Craftsmen; (2) Predynastic period; (3) Early dynastic period; (4) Old Kingdom; (5) Middle Kingdom; (6) New Kingdom: 1—17th-18th dynasties; (7) New Kingdom: 2—19th-20th dynasties; (8) 21st-22nd dynasties; (9) Kushite period; (10) Late period—23rd-26th dynasties; (11) Conclusion. Chronological list, p.lvii-lxi.

Abbreviations, p.xxxv-1; Additional bibliography, p.li-lvi; Notes, p.202-31, include bibliographical references. Index of museums; Geographical index; Index of personal names; General index.

**Classical World**

P598   Boardman, John. Archaic Greek gems: schools and artists in the sixth and early fifth centuries B.C. Evanston, Northwestern Univ. Pr., 1968. 236p. plates, il. (10 col.)
A scholarly study which determines "the origins and development of gem engraving in the Archaic Greek world by isolating the works of individual artists and studios, or by identifying common styles, and then relating them to each other and to the other arts of Archaic Greece."—*Pref.* Establishes relationships between Greek and Etruscan, Phoenician, Cypriot, and other Eastern glyptic arts. Includes extensive notes with bibliographical references and an index to collections and books.

P599   _____. Greek gems and finger rings: early Bronze to Classical. Photographs by Robert L. Wilkins.

London, Thames & Hudson; N.Y., Abrams [1970?]. 458p. il. (part col.)
"A history of gem engraving in Greek antiquity with its relationship to other arts and with the iconography of the engraved scenes.... The scheme of the book is ... to provide a narrative account of gem engraving from the Early Bronze Age in Greece to the Hellenistic period. This is closely linked to the illustrations which are chosen to represent all the important styles and motifs and which, for some periods, in fact present a very large part of the surviving material. Special attention is paid to the shapes of the gems and rings, to their materials and iconography.

"The authorities, ancient and modern, for statements in the text will be found either in the Lists of Illustrations, which include both description and further comment, or in the Notes on the Text."—*Pref.*

Contents: (I) Introduction; (II) Minoans and Mycenaeans; (III) The geometric and early archaic periods; (IV) Archaic gems and finger rings; (V) Classical gems and finger rings; (VI) Greeks and Persians; (VII) Hellenistic Greece and Rome; (VIII) Materials and techniques.

Summaries of gem and ring shapes, p.[384-85]. Extensive notes section, p.386-449, contains numerous references. Indexes: Abbreviations, p.450-51; Summary gazeteer of collections, p.452-53; Index to gems illustrated, p.457; General index.

P600   Higgins, Reynold Aleyne. Greek and Roman jewellery. London, Methuen [1961]. xlvii, 236p. 33 il., 68 plates (4 col.) (Methuen's handbooks of archaeology)
An excellent general handbook by a preeminent scholar on the wide-ranging subject of Greek and Roman jewelry. Directed toward the scholar and layman. Bibliography and site-lists, p.193-223, includes publications of major collections and jewelry finds on ancient sites. Very well illustrated.

P601   Hoffmann, Herbert, and Davidson, Patricia F. Greek gold; jewelry from the age of Alexander. Ed. by Axel von Saldern. [Mainz, Zabern, publisher and distributor for Europe, 1965]. xi, 311p. il. (part col.), map.
The catalogue of an exhibition at the Museum of Fine Arts, Boston, the Brooklyn Museum, and the Virginia Museum of Fine Arts, Richmond.

The indispensable work on the subject. "This catalogue deals with the stylistic, historic and iconographic elements of Hellenistic gold as well as the technology of Hellenistic goldworking."—*Pref.* Includes 138 groups of gold objects selected from European and American public and private collections; three quarters of the pieces were exhibited for the first time. The detailed catalogue is arranged by types: Diadems and wreaths; Earrings; Necklaces; Bracelets and armbands; Pins, brooches and fibulas; Belts; Thigh-bands; Medallion-discs; Pendants; Finger-rings; Treasure from Amphipolis; Treasure from Tarentum; Treasure from Palaiokastron; Ears of wheat. Very well illustrated.

Bibliographical references in the footnotes. Bibliographical abbreviations, p.297-300.

P602   Naples, Museo Nazionale. Jewelry and amber of Italy: a collection in the National Museum of Naples

[by] Rodolfo Siviero. N.Y., McGraw-Hill, 1959. 153p. il., 144 plates (part col.)

Trans. of *Gli ori e le ambre del Museo Nazionale di Napoli,* Firenze, Sansoni, 1954.

A detailed catalogue of 556 pieces of gold jewelry and 12 pieces of amber in the National Museum of Naples, which comprise one of the most complete collections of the Italic and Greco-Roman jeweler's art. Includes examples from all the civilizations in central and southern Italy from the 6th century B.C. to the 7th century A.D. Catalogue entries give identification of each piece, dimensions, provenance, inventory number, critical discussion, and bibliographical references. Text photographs reproduce jewelry in actual size; pieces are reproduced in enlargement in the plates.

Indexes of inventory numbers, places of provenance, black-and-white plates, and color plates.

P603  Richter, Gisela Marie Augusta. The engraved gems of the Greeks, Etruscans and Romans. [London, N.Y.] Phaidon [1968-71]. 2v. 250p.; 316p. il., plates (part col.)

A comprehensive study of the history, stylistic development, techniques, and materials of the engraved gems of the Greeks, Etruscans, and Romans. Contains excellent reproductions of the original gems in actual size and of cast impressions in enlargement. Contents: v.1, Engraved gems of the Greeks and the Etruscans: a history of Greek art in miniature; v.2, Engraved gems of the Romans: a supplement to the history of Roman art.

"Bibliography of the chief books and articles, from the Renaissance to modern times, on Greek, Etruscan, and Roman engraved stones and rings," v.1, p.327-32, and v.2, p.291-96. Indexes in v.1-2: Collections; Subjects; Persons and places.

## Western Countries

### Germany and Austria

P604  Hase, Ulrike von. Schmuck in Deutschland und Österreich, 1895-1914: Symbolismus, Jugendstil, Neohistorismus. München, Prestel, 1977. 430p. il., col. plates.

A history of the jewelry produced in Germany and Austria in the period 1895-1914. Includes over 900 catalogue entries and biographical notes on approx. 270 jewelers. Classified bibliography, p.423-25.

### Great Britain

P605  Armstrong Nancy J. Jewellery; an historical survey of British styles and jewels. Guildford, Lutterworth Pr., 1973. xiii, 286p. [52]p. plates. il. (part col.)

A broad history of jewelry, primarily in England, which "attempts to set its development in the context of historical events and political and social changes, and to remark on the more influential of the changes in the other decorative arts."—*Introd.*

Contents: (1) A background of belief; (2) A background of events; (3) The offshore islands; (4) Medieval England;

(5) The House of Tudor; (6) The House of Stuart; (7) Georgian glitter; (8) Neo-classical restraint; (9) Victorian sentimentality; (10) The Art Nouveau; (11) The twentieth century; (12) The present day. Appendixes: (A) On caring for jewels; (B) A career in the jewellery trade; (C) Valuations; (D) Mohs' scale; (E) The National Art Collections Fund; (F) The National Association of Decorative and Fine Arts Societies; (G) A list of addresses.

Bibliography, p.273-75.

P606  Oman, Charles Chichele. British rings, 800-1914. London, Batsford [1974]. x, 146p. 96p. of il., 4 col. plates.

A scholarly survey of rings made in England and Scotland during the period 800-1914. Contains illustrations of 815 rings (32 in color) with description of each. Indispensable for research in the field.

Contents: Pt. I, Rings, their materials and uses: Introduction; (1) The wearing of rings; (2) The makers & markings of rings; (3) Decorative rings; (4) Signet rings; (5) Love rings & rings given at weddings; (6) Investiture & ceremonial rings; (7) Religious, magical & medicinal rings; (8) Political & portrait rings; (9) Mourning rings; (10) Rings with miscellanous inscriptions & the rings of sergeants-at-law; (11) Scientific rings. Pt. II, Catalogue of illustrations. Appendixes: (I) Extracts from some Tudor inventories; (II) Surviving rings of sergeants-at-law.

Index of goldsmiths' marks; Index of religious invocation and of magical inscriptions; General index. Extensive notes at ends of chapters include bibliographical references.

### Italy

P607  Kris, Ernst. Meister und Meisterwerke der Steinschneidekunst in der italienischen Renaissance. Wien, Schroll, 1929. 2v. plates.

Reprint announced 1975.

The standard work on the history and technique of the glyptic arts of the Italian Renaissance. Begins with introductory chapters on techniques and the development of Burgundian-French gem engraving. The major portion of the text surveys gem engraving in Italy in the 15th and 16th centuries. "Kritisches Verzeichnis der abgebildeten Werke," p.[149]-93, gives descriptions and commentaries on the 658 illustrations of gem engraving on 200 plates in v.2.

"Verzeichnis der abgekürzt zitierten Literatur," v.1, p.195-96. "Künstlerregister" and "Verzeichnis der Standorte der abgebildeten Werke," at end of v.1.

SEE ALSO:  Bulgari, C. G. *Argentieri, gemmari e orafi d'Italia* ....(P515).

### Latin America

P608  Davis, Mary L., and Pack, Greta. Mexican jewelry. With drawings by Mary L. Davis. Austin, Univ. of Texas [1963]. xv, 262p. 145 il.

An introductory survey of Mexican jewelry from the precolonial period to the present. Contents: The jewelry of

463

Mexico; Pre-Hispanic background; The jewelry of the past; Religious jewelry; Jewelry of the people; *Charro adornos;* Present-day jewelry; Notes on jewelry making.
Classified bibliography, p.245–49.

## Low Countries

P609 Gans, M. H. Juwelen en mensen; de geschiedenis van het bijou van 1400 tot 1900, voornamelijk naar Nederlandse bronnen. Amsterdam, J. H. de Bussy, 1961. 479p. il. (part col.), plates.
A very well illustrated history of jewelry in the Netherlands from 1400–1900. Contents: (1) Bijou-geschiedenis. Inleiding; (2) Bourgondische Rijkdom; (3) Het Manierisme; (4) Hof en burgerij in Neerlands Gouden Eeuw; (5) De achttiende eeuw. Brillantflonkering; (6) Negentiende eeuws indivi-dualisme; (7) Diamant en mens. Lijst van inventarissen, p.361–63. Inventarissen, p.364–476.
Notes, p.182–85, include references. Bibliography, p.477–79.

## Russia and Eastern Europe

See: Gol'dberg, Tamara Grigor'evna. *Russkoe zolotoe i serebrūanoe delo* (P526).

## Scandinavia

See: *L'Or des Vikings . . .* (P530).

## Spain

P610 Muller, Priscilla E. Jewels in Spain, 1500–1800. N.Y., Hispanic Society of America, 1972. 195p. 282 il. (17 col.) (Hispanic Society of America, Hispanic notes and monographs. Peninsular series)
"Presents for the first time a fully documented account of jewels, jewelers and their patrons in the Iberian Peninsula from the reign of Ferdinand and Isabella to that of Charles IV and Maria Luisa of Parma. The text discusses the jewels, their makers and their owners, traces the vicissitudes of famed royal pieces, considers stylistic and iconographical aspects of secular and religious jewels, and examines pos-sible contributing influences from abroad (as for example those suggested by Pre-Columbian gold from Spanish America). Extant jewels, period portraits and many pre-viously unpublished jewelers' and inventory drawings accompany the text."—Author, *RILA,* Demonstration issue, 1973, no. 619. The indispensable work in the field. Beautifully illustrated.
Contents: (I) The reign of Ferdinand and Isabella; (II) Interlude: Spain and the New World; (III) The 16th century: Renaissance and Mannerism; (IV) The 17th century; (V) The 18th century.
Bibliography, p.181–84. References also given in notes.

## Primitive

See: Sieber, R. *African textiles and decorative arts* (P686).

# RUGS AND CARPETS

P611 Kendrick, Albert Frank, and Tattersall, Creassey Edward Cecil. Handwoven carpets, Oriental and European. With 205 plates of which 19 are in color. N.Y., Scribner, 1922. 2v. plates. (Repr.: N.Y., Dover, 1973.)
"In addition to carpets of the golden age, this work contains many late examples too, but little that is new in the way of research developments." E. Kühnel, in Bode-Kühnel (P617). Bibliography, v.1, p.193–94.
Contents: (1) Historical; (2) Technical: v.1, Text; v.2, Plates.

## Western Countries

P612 Jarry, Madeleine. The carpets of Aubusson. Leigh-on-Sea, Lewis [1969]. 65p. 92 plates.
A history of Aubusson carpets from the 18th century to the present, written by an expert in the field. Includes technical information. Black-and-white plates. No bibliography.

P613 ———. The carpets of the Manufacture de la Savonnerie. Trans. by C. Magdalino. Leigh-on-Sea, Lewis [1966]. 47p. plates.
A pictorial survey of carpets woven at the Manufacture de la Savonnerie, with a brief introduction on the historical origins and techniques. 96 plates with descriptive notes. The carpets illustrated range in date from 1675 to the mid-20th century. No bibliography.

P614 Mayorcas, Manda J. English needlework carpets; 16th to 19th centuries. Leigh-on-Sea, Lewis [1963]. 64p. il. 94 plates (part col.)
The only book on the subject. Good illustrations with full descriptive notes and bibliography. Index of owners.

P615 Tattersall, Creassey Edward Cecil. A history of British carpets from the introduction of the craft to the present day. New ed., rev. and enl. by Stanley Reed. Leigh-on-Sea, Lewis, 1966. iii, 139p. il., 176 plates (part col.), diagrs.
1st ed., Benfleet, Lewis, 1934.
A rev. ed. of the first scholarly history of British carpets. The 1st ed. is somewhat more authoritative, and includes more technical information. Bibliographical footnotes.

P616 Washington, D. C. Textile Museum. Catalogue of Spanish rugs, 12th century to 19th century, by Ernst Kühnel. Technical analysis by Louisa Bellinger. Wash., D.C., National Publishing Co., 1953. vii, 64p. xlv plates in portfolio (part col.)
A volume of the *catalogue raisonné* of the Textile Museum. Written by an outstanding scholar, with expert technical analyses by the curator of the Museum. For each piece gives history, style, provenance, and literature. Each rug is illustrated. Bibliography, p.59.

## Oriental Countries

P617 Bode, Wilhelm von, and Kühnel, Ernst. Antique rugs from the Near East. 4th rev. ed. Trans. by Charles Grant Ellis. London, Bell, 1970. 184p. 4 plates. il. (incl. 4 col.)
1st ed. 1902; 2d ed. 1914; 3d ed. 1922; 4th German ed. 1955; 4th ed. English trans. with revisions, 1958.

A pioneer manual for oriental carpet studies which has been kept up-to-date. The revised Bode-Kühnel provides the beginner with a readable introduction to the field, the specialist with a reliable basic handbook. Covers antique rugs from Turkey, the Caucasus, Egypt, Persia, and India. "The principal books on rugs" is a selective bibliography with annotations.

P618 Bogoliubov, Andreĭ Andreevich. Carpets of central Asia. Rev. ed. [Trans. from the Russian by Rudi Ritschel and from the French by J. M. A. Thompson]. Ed. by J. M. A. Thompson. Basingstoke, Crosby, 1973. [5] 26, [96]p. (2 fold.) il. (part col.), maps.
Original ed. 1908-09 with text in French and Russian, entitled *Kovrovyĭa izdĭeliĭa Srednĕĭ Azii.*

The first great book on Turkoman rugs. Now translated with smaller-scale reproductions of the 36 splendid chromolithographs, and black-and-white copies of the tempera paintings in the original work. J. M. A. Thompson has added an introduction on the pioneer work of Bogoliubov, additional notes to update the information in the text, a commentary on each illustration, and the bibliography since 1908.

P619 Dilley, Arthur Urbane. Oriental rugs and carpets: A comprehensive study. Rev. by Maurice S. Dimand. Philadelphia, Lippincott, [1959]. 290p. il. (part col.) maps.
1st ed. 1931, N.Y., Scribner.

A standard history of oriental rugs from the ancient Near East to China. M. S. Dimand has added a chapter on Spanish carpets. No bibliography; index, p.283-89.

Contents: (1) Rugs have a beginning; (2) Rugs of kings, caliphs, and shahs; (3) Persia's great rugs; (4) Persia's semiantique and modern rugs; (5) India's great rugs; (6) Rugs of Turkey; (7) Rugs of the Caucasus; (8) Western Turkestan, Afghanistan, Beluchistan rugs; (9) Chinese rugs; (10) Chinese Turkestan rugs; (11) Rugs of Spain; (12) Fibres and dyes; (13) The weaver's work; (14) The significance of names.

P620 Eiland, Murray L. Oriental rugs: A comprehensive guide. Greenwich, Conn., New York Graphic Society [1973]. 196p. il. (part col.), diagrs., map.
An introduction to the rugs of the Middle East and Central Asia (Persia, Turkey, Turkoman, and the Caucasus). Useful for the interested general reader. Bibliographical references in footnotes.

P621 Erdmann, Kurt. Oriental carpets. An account of their history. 3d ed. Trans. by Charles Grant Ellis. N.Y., Universe Books, 1965. 80p. il.
1st ed. 1960; 2d ed. 1962.

"Important as a short, but interesting discussion of some general problems, presenting the author's own ideas." — E. Kühnel in Bode-Kühnel (P617). The exhaustive bibliography, p.59-67, contains 550 titles of carpet literature.

P622 _____. Seven hundred years of Oriental carpets. Ed. by Hanna Erdmann and trans. by May H. Beattie and Hildegard Herzog. Berkeley, Univ. of California Pr. [1970]. 238p. 286 il., 20 col. plates.
Trans. of *Siebenhundert Jahre Orientteppich,* 1966.

A collection of 51 short essays by a foremost rug historian. Intended to be "more than a popular book but not quite a manual or complete history of the carpet." — *Foreword.*

Contents: The beginnings of carpet studies; Individual groups of carpets; Some collections and museums; The Berlin carpet collection; Peripheral problems; European production. "The development of carpet studies," p.36-37, is a discussion of the history and current state of research. "Illustrations, literature, and notes," p.219-33, documents the 280 illustrations; "Illustrations check list," p.234; "Index of carpets," p.235-36; "Index of museums and collections," p.237-38.

P623 Iten-Maritz, Johann. Turkish carpets. Tokyo, N.Y., Kodansha [1977]. 353p. 258 il. (179 col.), 8 maps.
Trans. of *Der anatolische Teppich,* Fribourg, Office du Livre, 1975.

A comprehensive, beautifully illustrated survey of the rugs produced in the various regions of Asia Minor. Written primarily from the point-of-view of the connoisseur and collector.

Contents: Introduction; The history of Turkish carpets; Carpet weaving in western Anatolia; Carpet weaving in central Anatolia; Carpet weaving in eastern Anatolia. The pronunciation of Turkish words, p.348.
Bibliography, p.349.

P624 Jacobson, Charles W. Oriental rugs: a complete guide. Rutland, Vt., Tuttle, 1962. 479p. il., plates.
Written by a dealer with long experience, this manual is considered to be a reliable source for the general buyer and collector of oriental rugs. Pt. 1 is a general discussion of rug centers, the designs, techniques, dyes, care, rug books, and advice to the purchaser. Pt. 2 is an alphabetical listing of the types of rugs, with notes on availability, where made, and characteristics. Pt. 3 contains 194 plates, some in color.

P625 Lorentz, H. A. A view of Chinese rugs from the seventeenth to the twentieth century. London & Boston, Routledge & Paul [1972]. 194p. 95 color plates, 60 black-and-white il., 1 map.
The first authoritative monograph on Chinese rugs. Treats the geographical and historical background, colors, patterns, symbols, chronology, techniques, sizes, and centers of production. Includes comparisons with the rugs of eastern Turkestan. Well illustrated (mostly in color); the captions give origin, date, pattern, and the page reference to the text.

P626  Martin, Fredrik Robert. A history of Oriental carpets before 1800. Vienna, Printed for the author in I. and R. State and Court Printing Office, 1908. 159p. il. (part col.), 33 plates (part col.)
Edition of 300 copies.

"Contains the greatest wealth of material of any rug book ever written. Unfortunately it appeared several decades too soon and it is of such lavish and monumental make-up that it was only within the reach of a few purchasers and because of its size could hardly be handled."—Erdmann, *Seven hundred years of Oriental carpets* (P622), p.377. Profusely illustrated, both in the text and by excellent plates. "Notes," p.147-52. List of text illustrations, p.153-57. List of plates, p.157. Index of principal names, p.158-59.

P627  New York. Metropolitan Museum of Art. Oriental rugs in the Metropolitan Museum of Art, by M. S. Dimand. With a chapter and catalogue of rugs of China and Chinese Turkestan by Jean Mailey. [N.Y.]; distr. by New York Graphic Society [Greenwich, Conn., 1973]. ix, 353p. il. (part col.), maps.

A scholarly catalogue of 236 oriental rugs in the great collection of the Metropolitan Museum of Art. Written by a well-known rug authority, aided by the associate curator of the textile collection. Each rug is illustrated in the catalogue with full documentation. Bibliographical notes follow each chapter. Bibliography, p.351-53.

P628  Schürmann, Ulrich. Caucasian rugs: a detailed presentation of the art of carpet weaving in the various districts of the Caucasus during the 18th and 19th century. Eng. trans. by A. Grainge. London, Allen & Unwin [1970]. 142p. il., figs., map.
1st German ed., Braunschweig, Klinkhardt & Biermann, 1966, with English captions.

An important introduction to rugs from the Caucasus region of Asia. Consists of technical and stylistic introduction followed by a catalogue with color illustrations. Arranged by region. Entries are in German and English.

P629  Vienna. Österreichisches Museum für Kunst und Industrie. Old Oriental carpets, issued by the Austrian Museum for Art and Industry; with text by Friedrich Sarre and Hermann Trenkwald, trans. by A. F. Kendrick. Vienna, Schroll, 1926-29. 2v. il., 120 plates (part col.), tables, diagrs.
A milestone publication based on the earlier pioneer works published by the Museum: *Orientalische Teppiche* published in 1892-96, and *Altorientalische Teppiche* published in 1908. Documentation and technical notes on each carpet. Magnificent illustrations, many of which are in color.

Contents: v.1, Carpets of the Austrian Museum for Art and Industry, by Hermann Trenkwald; v.2, The most important carpets in the older work, with the exception of those now in the Austrian Museum, as well as additional examples hitherto unknown or inadvertently published, by Friedrich Sarre and others. Bibliography, v.2, p.37-42, by Kurt Erdmann.

P630  Washington, D.C. Textile Museum. Cairene rugs, and others technically related, 15th century-17th century, by Ernest Kühnel. Technical analysis by Louisa Bellinger. Wash., National Publishing Co., 1957. vii, 90p. 50 plates (part col.), maps. (Catalogue raisonné, v.4)
Technical and historical documentation of the museum's collection of rugs produced in and near Cairo from the 15th to the 17th centuries. Each of the 33 rugs is illustrated.

SEE ALSO:  Viale, M., and Viale, V. *Arazzi e tappeti antichi* (P646).

# TAPESTRIES

## Bibliography

P631  Guiffrey, Jules Marie Joseph. La tapisserie. Paris, Picard, 1904. 128p. (Bibliothèque des bibliographies critiques, pub. par la Société des Études Historiques, 20)
A classified, partially annotated, bibliography of 1,083 references on the history and technique of tapestries. Includes books, periodical articles, and sales catalogues.
"Table alphabétique," p.109-28, is an index of names, places, and subjects.

## Histories, Handbooks, Collections

P632  Ackerman, Phyllis. Tapestry, the mirror of civilization. N.Y., Oxford Univ. Pr., 1933. xi, 451p. 48 plates. (Repr.: N.Y., AMS Pr. [1970].)
A comprehensive introductory survey of tapestries in the Western world. Useful primarily to the beginning student and the exclusively English-language reader.
Appendixes: (I) The technique and aesthetics of tapestry; (II) Guild regulations; (III) Some collectors and collections, p.318-42. Notes, p.343-429, include references.
Bibliography, p.431-33.

P633  Boccara, Dario. Les belles heures de la tapisserie. [Zoug (Suisse)] Les Clefs du temps [1971]. 233p. il. (part col.)
A lavishly illustrated survey of European tapestries. Contents: Le moyen âge; La renaissance; Les feuilles de choux; Le baroque et le siècle de Louis XIV; Les Tenières; Le XVIIIème siècle sous les règnes de Louis XV et Louis XVI.
Bibliography, p.223-30, arranged by chapters with references to tapestries reproduced.

P634  Boston. Museum of Fine Arts. Tapestries of Europe and of colonial Peru in the Museum of Fine Arts, Boston, by Adolph S. Cavallo. [Catalogue]. Boston [1967]. 2v. plates (part col.)
An excellent catalogue of the near-comprehensive collection of European tapestries in the Museum of Fine Arts,

Boston. Contains full, detailed entries and discussions of 66 tapestries; entries give designer and weaver, references to plates in v.2, place and date of manufacture, materials, dimensions, condition, description, related tapestries, provenance, exhibition, bibliography, and photograph negative numbers. Superbly illustrated with black-and-white and color plates, including a number of details.

Contents: v.1, Text: Introduction; pt. I. 1350–1500: South Germany, France & the Franco-Flemish territories (nos. 1–13); pt. II. 1475–1550: France & Flanders (nos. 14–26); pt. III. 1550–1700: Brussels, Enghien, Grammont, Paris, Germany, Denmark & Holland (nos. 27–43); pt. IV. 1650–1750: Rome, Brussels, London & Beauvais (nos. 44–55); pt. V. Peruvian tapestries of the colonial period (1532–1821) (nos. 56–66). List of exhibitions, p.207–9. Short title index, p.211–37. Indexes: Titles and subjects of individual tapestries and series of tapestries; Tapestry weavers and merchants; Directors and artistic directors of manufactories; Weaving centers; Cities, towns, manufactories; Collections and owners of tapestries. v.2: Plates.

P635    Göbel, Heinrich. Wandteppiche. Leipzig, Klinkhardt und Biermann, 1923–24. 3v. in 6. il., plates (part col.), facsims.

Remains an essential work on the history of tapestries. Well illustrated, including reproductions of marks.

Contents: Teil I, Die Niederlands; Teil II, Die romanischen Länder; Teil III, Die germanischen und slavischen Länder. The first volumes of Teilen I and II are text volumes; the second volumes contain plates. Teil III is divided geographically, with text and plates in both volumes.

Extensive bibliographies are arranged as footnotes. Indexes: (1) Manufacturers; (2) "Wandteppichfolgen"; (3) "Wirker und Wirkereihändler"; (4) Painters; (5) Historical personages; (6) Authors.

Teil I also published in English trans.: *Tapestries of the Lowlands,* trans. by Robert West [pseud.], N.Y., Brentano, 1924. (Repr.: N.Y., Hacker, 1974.)

P636    Guiffrey, Jules Marie Joseph; Müntz, Eugène; and Pinchart, Alexandre. Histoire générale de la tapisserie. Paris, Société Anonyme de Publications Périodiques, 1878–85. 25 pts. in 3v. il., 105 mounted plates (part col.) (Repr.: Osnabrück, Zeller, 1971.)

A standard older work; indispensable. Contents: pt. 1, Tapisseries françaises, par J. Guiffrey; pt. 2, Tapisseries italiennes, allemandes, anglaises. danoises, espagnoles, russes, etc., par E. Müntz; pt. 3, Tapisseries flamandes, par A. Pinchart.

P637    Heinz, Dora. Europäische Wandteppiche; ein Handbuch für Sammler und Liebhaber. Braunschweig, Klinkhardt & Biermann [1963– ]. v.1– . 232 il., 15 col. plates. (Bibliothek für Kunst- und Antiquitätenfreunde, Bd. 37)

An excellent survey of European medieval and Renaissance tapestries. Provides new insights into such problems as the relationships between tapestry designers and painters and miniaturists. Covers Franco-Flemish works, as well as those of German, Italian, Scandinavian, and British origin.

Contents: v.1, Von den Anfängen der Bildwirkerei bis zum Ende des 16. Jahrhunderts.

Classified bibliography, p.319–31.

A volume on later European tapestries was originally planned.

P638    Hunter, George Leland. The practical book of tapestries. With 8 illus. in colour and 220 in doubletone. Philadelphia and London, Lippincott, 1925. 302p. plates (part col.)

An older general work which covers the design and techniques of tapestries as well as their historical development from ancient Egypt to modern times. Public collections, p.277–78.

Bibliography, p.279–80.

P639    Inventaire général des monuments et des richesses artistiques de la France. Tapisserie; méthode et vocabulaire, by Nicole Viallet. Paris, Imprimerie nationale, 1971. xv, 148p. 184 il. (29 col.) (Inventaire général des monuments et des richesses artistiques de la France. Principes d'analyse scientifique, 1)

The most useful, authoritative reference work on the techniques, terminology, and methodology for the study of tapestries. Illustrated with details of tapestries, photographs of tapestry weaving in progress, and schematic drawings of techniques described.

Contents: Introduction; Bibliographie; (1) Définition du domaine de la tapisserie; (2) Méthode d'analyse; (3) Instructions pratiques pour la constitution d'un dossier d'inventaire; (4) Vocabulaire méthodique; Illustrations; Index des illustrations; Index alphabétique.

Bibliographie, p.[2]–5, is classified as follows: Ouvrages de référence; Ouvrages concernant la tapisserie sur métier: Tapisserie européenne; Tapisserie copte; Tapisserie péruvienne; Tapisserie orientale; Ouvrages concernant la tapisserie au point. Includes bibliographical references in footnotes.

P640    Jarry, Madeleine. La tapisserie: art du XXème siècle. [Fribourg] Office du Livre [1974]. 357p. il., plates (part col.)

A lavishly-illustrated survey of tapestry production in the 20th century. Includes sections on several of the most important tapestry designers and the various countries in which tapestry-weaving has been a significant artistic activity in the 20th century. In three main parts: (I) Préliminaires d'un renouveau; (II) La renaissance de la tapisserie française; (III) La tapisserie—art mondial 1963–73.

"Notes bibliographiques," p.347–49, arranged by chapter; Bibliography, p.349. Glossary, p.350–51.

P641    _____. World tapestry from its origins to the present. [Iconographic documentation: Dominique Bergès and Marie-Thérèse May]. N.Y., Putnam [1969]. 358p. il. (part col.)

Trans. of *La tapisserie des origines à nos jours* [Paris] Hachette [1968].

A copiously illustrated popular survey of Western tapestry, the purpose of which is "to present tapestry as an important

creative expression and to show the great achievements which, during the course of centuries, have made it a major art form throughout the world."—*p.7*. The quality of the illustrations varies.

Contents: (I) The origins of tapestry; (II) Europe in the 14th century; (III) The Arras and Tournai workshops in the 15th century; (IV) Tapestry at the dawn of the Renaissance; (V) The 16th century: tapestry during the Renaissance; (VI) The 17th century: from Rubens to Le Brun; (VII) French workshops in the 18th century; (VIII) Tapestry outside of France in the 17th and 18th centuries; (IX) Tapestry in the 19th and 20th centuries: decline and revival.

Classified bibliography, p.349-54.

**P642**   Müntz, Eugène. A short history of tapestry. From the earliest times to the end of the 18th century. Tr. by Louisa J. Davis. London, N.Y., Cassel, 1885. 399p. il.

Trans. of 2d ed. of *La tapisserie*. 6th ed. of *La tapisserie*, Paris, Picard [189-?].

A standard early history, illustrated with line drawings. A guide for the amateur of tapestries (lists marks and monograms), p.367-85. List of the chief centres of manufacture, p.387-88. List of painters who designed cartoons for tapestry, or whose pictures were reproduced in tapestry, p.389-90. List of tapestry workers mentioned, p.391-92.

**P643**   New York. Metropolitan Museum of Art. Masterpieces of tapestry from the fourteenth to the sixteenth century; an exhibition at the Metropolitan Museum of Art. Foreword by Thomas Hoving. Introd. by Francis Salet. Catalogue by Geneviève Souchal. [Trans. by Richard A. H. Oxby]. [N.Y., Metropolitan Museum of Art, 1974]. 222p. il. (part col.)

Trans. of *Chefs-d'oeuvre de la tapisserie du XIVe au XVIe siècle;* the catalogue of the New York version of an exhibition first shown at the Grand Palais, Paris, Oct. 1973–Jan. 1974.

The introductory essay, p.11-23, outlines the development of Gothic and early Renaissance tapestries and the art historical problems involved in their study. The catalogue contains detailed entries on and analytical discussions of 97 tapestries and tapestry series. It is arranged as follows: 14th-century tapestries (nos. 1-5); Major 15th-century works (nos. 6-17); The *Hunt of the Unicorn* (nos. 18-24); Millefleurs tapestries (nos. 25-36); The *Lady with the Unicorn* (nos. 37-42); Choir tapestries (nos. 43-45); Heraldic tapestries (nos. 46-52); Scenes from daily life and allegories (nos. 53-74); Brussels-style tapestries (nos. 74-97).

Each entry concludes with bibliographical references.

**P644**   Schmitz, Hermann. Bildteppiche; Geschichte der Gobelinwirkerei. Berlin, Verlag für Kunstwissenschaft [1919]. 352p. il.

A general history of tapestry-weaving from the 15th through the 18th centuries in Germany, the Netherlands, and France. Also includes brief considerations of tapestries in Italy, England, Denmark, Sweden, Spain, and Russia. Tapestry marks in facsimile, p.333-37.

Bibliography, p.349-52. Index of names, p.345-49.

**P645**   Thomson, William George. A history of tapestry from the earliest times until the present day. 3d ed. with revisions ed. by F. P. & E. S. Thomson. [Wakefield] EP, 1973. xxiv, 596p. il., plates (part col.) 1st ed. 1906; 2d rev. ed. 1930.

The standard comprehensive work in English. Surveys the history and development of the tapestry-weaving art from pre-Christian, through Coptic, medieval, French, German, Flemish, Italian, Spanish, English, Irish, Scottish, and Swedish tapestries to the 20th century. Concentration is on the period from the 14th through the 17th centuries.

Contents of chapter 18: Tapestry marks; Appendixes: (I) Glossary of textile terminology; (II) Bibliography; (III) Where tapestries may be seen; (IV) Index additions and corrections; (V) 20th-century tapestry; Indexes: Socioeconomic; List of the chief centres of manufacture; Subject of tapestries; List of tapissiers and painters, merchants, founders, and directors of manufactories; List of owners, authorities, collections, and sales.

**P646**   Viale, Mercedes, and Viale, Vittorio. Arazzi e tappeti antichi: Arazzi [di] Mercedes Viale. Tappeti [di] Vittorio Viale. Torino, Industria [1952]. 247p. plates (part col.)

Contains authoritative, general surveys and studies of tapestries and carpets; based on an exhibition shown at the Museo Civico, Turin, in 1948.

The first part of the book includes brief sections on 20 principal European centers of tapestry production. Each section includes a general discussion and fully detailed entries on works reproduced in the plates. Bibliography is given at the end of each section. The second part contains sections on the carpets and rugs of Persia, the Caucasus, Egypt, Asia Minor, Turkestan, and France. General bibliography on carpets, p.168-69.

## Western Countries

### France

**P647**   Marquet de Vasselot, Jean Joseph, and Weigert, Roger-Armand. Bibliographie de la tapisserie, des tapis et de la broderie en France. Paris, Colin, 1935. 354p. (Archives de l'art français, pub. par la Société de l'Histoire de l'Art Français. Nouv. pér., t.XVIII) (Repr.: Paris, Nobele, 1969.)

A classified bibliography of more than 2,700 items; includes books and periodical articles published up to 1932. Covers tapestries, rugs, and embroidery in France; indispensable for study in these fields.

Contents: Tapisserie, p.3-240; Tapis, p.243-54; Broderie, p.257-313. Table alphabétique, p.317-46; Table des sujets representés, p.347-51.

This bibliography is supplemented in Weigert's *French tapestry* (P648), bibliography, p.191-98.

**P648**   Weigert, Roger Armand. French tapestry. Trans. by Donald and Monique King. London, Faber and Faber [1962]. 214p. plates (part col.)

Trans. of *La tapisserie française,* Paris, Laurens [1956].

A basic survey of the history and stylistic evolution of French tapestries from their beginnings to the 20th century. Technical information concerning tapestry weaving is limited to succinct definitions. Contents: (I) Generalities; (II) The origins and early history of tapestry in the West. The Paris workshops in the 14th century; (III) Franco-Flemish tapestry down to 1450; (IV) Franco-Flemish tapestry from 1450 onwards; (V) French tapestries of the 15th and early 16th centuries; (VI) The tapestries of the Renaissance; (VII) The Paris workshops in the 17th century. The Gobelins factory: 1662-1793; (VIII) The Beauvais factory in the 17th and 18th centuries; (IX) Aubusson and other factories in the 17th and 18th centuries; (X) The 19th and 20th centuries. Biographical notes on the principal weavers, contractors and designers, p.163-90, include bibliographical references.

Bibliography, p.191-98, supplements the earlier basic work of Marquet de Vasselot and Weigert (P647).

## Germany and Austria

P649  Kurth, Betty. Die deutschen Bildteppiche des Mittelalters. Wien, Schroll, 1926. 3v. il., 344 plates (part col.)

A scholarly history of German medieval tapestries. Invaluable for both the text and the excellent plates.

Contents, v.1, text: Die Technik; Vorgotische Bildwirkereien; Gotische Bildwirkereien; Katalog; Quellenanhang, p.281-99 (includes 56 items). The Katalog in v.1 gives detailed descriptions, commentaries, and extensive bibliographical references on tapestries reproduced in the plates in v.2-3.

Verzeichnis der Bildteppiche nach Aufbewahrungsorten; Verzeichnis der auf den Bildteppichen dargestellten Stoffe; Orts- und Namenregister.

## Italy

P650  Viale, Mercedes. Arazzi italiani [di] M. Viale Ferrero. Presentazione di Bruno Molajoli. [Milano, Electa editrice per conto della] Banca Nazionale del Lavoro [1961]. 259p. 38 il. (8 col.), 82 col. plates, facsims.

A scholarly survey of Italian tapestries; the best general account. The main portion of the book is composed of excellent plates, including many details in color. References to plates are given in text margins.

Contents: L'arazzo in Italia nel secolo XV; L'arazzo in Italia nel secolo XVI; L'arazzo in Italia nel secolo XVII; L'arazzo in Italia nel secolo XVIII. Glossario dei termini tecnici, p.71-72. Marche di manifatture e arazzieri, p.[73-74].

Bibliografia, p.75-[78]: (a) Opere generale; (b) Opere su argomenti particolari (per luoghi) (Bologna, Casale, Correggio, Ferrara, Firenze, Mantova, etc.).

## Low Countries

P651  Hulst, Roger Adolf d'. Flemish tapestries, from the fifteenth to the eighteenth century. Foreword by H.

Liebaers. Historical account by J. Duverger [Trans. from the Dutch by Frances J. Stillman]. N.Y., Universe Books [1967]. xxxi, 324p. plates (part col.)

A superbly illustrated survey of Flemish tapestries produced from the 15th to the 18th century. The introductory essay, p.ix-xxxi, traces the development of the tapestry-weaving industry in the southern Netherlands, set against the social background. The major portion of the book is composed of sections on 38 tapestries or tapestry series; each section includes an analytical essay and reproductions of the tapestry, with numerous details.

Selected bibliography, p.295; Bibliography on individual tapestries, p.296-303. General index.

P652  Ysselsteyn, Gerardina Trjaberta van. Geschiedenis der tapijtweverijen in de Noordelijke Nederlanden; bijdrage tot de geschiedenis der kunstnijverheid. Met 202 afbeeldingen en 140 afbeeldingen van merken. Leiden, N.V. Leidsche Uitgeversmaatschappij, 1936. 2v. (viii, 314p., 198 il.; xiii, 554, 1xxxvi p., 140 il.) il., plates.

An exhaustive history of tapestry-weaving in the northern Netherlands. Copiously illustrated. "English version," v.2, p.i-lxxxvi, is a partial English translation of the main text.

Bibliography, v.2, p.471-76; bibliographical references in footnotes.

## Oriental Countries

P653  Kuo li ku kung po wu yüan. [The collection of tapestry and embroidery in the National Palace Museum]. Tokyo, Gakken [1970]. 2v. in 4. il., col. plates.

A fully-illustrated catalogue of the collection of tapestries and embroideries in the National Palace Museum, Taiwan; comp. and written by the staff of the museum. Texts and commentaries in English, Chinese, and Japanese.

Contents: v.1, Tapestry (112p., 95 plates); v.2, Embroidery (96p., 55 plates).

# TEXTILES

## Bibliography

P654  Lawrie, Leslie Gordon. A bibliography of dyeing and textile printing, comprising a list of books from the sixteenth century to the present time [1946]. London, Chapman and Hall, 1949. 143p.

A specialized technical bibliography which could be useful to the art historian.

Contents: pt. 1, List of books printed from the 16th century until the present time in alphabetical order according to authors, p.17-100; pt. 2, Short-title list of works in chronological order, p.101-37. "Sources of information," p.10-12. Classified index, p.139-43.

## Histories and Handbooks

P655 Bühler, Alfred. Ikat, batik, plangi; Reservemusterungen auf Garn und Stoff aus Vorderasien, Zentralasien, Südosteuropa, und Nordafrika. Basel, Pharos-Verlag H. Schwabe [1972]. 3v. il. plates (part col.)
A scholarly, detailed study of the three principal types of reserve dyeing techniques of ikat, batik, and plangi used in the decoration of textiles from the Near East, Central Asia, Southeastern Europe, and North Africa.

Bibliographical references in "Anmerkungen," v.2, p.7–34; Bibliography, v.2, p.35–47. "Register" at end of v.2. v.3 contains plates.

P656 Falke, Otto von. Decorative silks. 3d ed. London, Zwemmer, 1936. 55p. il., 126 plates (10 col.)
1st ed., 1913, in German. 2d ed. (in English), N.Y., Helburn, 1922.

A picture book, with an essay by a great textile historian, the first to specialize in the study of silk-weaving. The text (47p.) traces the development of silk-weaving from the 4th century to 1800, with an introductory chapter on Oriental tapestries and early Greek woven patterns. 126 good plates.

P657 Flemming, Ernst Richard, and Jaques, Renate. Encyclopedia of textiles; decorative fabrics from antiquity to the beginning of the 19th century, including the Far East and Peru. Completely rev., with an introd. by Renate Jaques. London, Zwemmer; N.Y., Praeger [1958]. xxxp., 304 plates (16 col.)
Trans. of Flemming's *Das Textilwerk* by R. Jaques, with revision and new material.

The brief introduction is followed by a pictorial review of historic textile designs. List of sources.

P658 Hunter, George Leland. Decorative textiles; an illustrated book on coverings for furniture, walls and floors, including damasks, brocades and velvets, tapestries, laces, embroideries, chintzes, cretonnes, drapery and furniture trimmings, wall papers, carpets and rugs, tooled and illuminated leathers; with 580 illustrations, 27 plates in colour. Philadelphia and London, Lippincott, 1918. xxii, 457p. il. (part col.)
"This is the first comprehensive book on the subject to be published."—*Pref.* Profusely illustrated. Bibliography, p.438–[47]. Index and glossary, p.448–58.

P659 Migeon, Gaston. Les arts du tissu. Nouv. éd., revue et augmentée. Paris, Laurens, 1929. 468p. il.
1st ed. 1909.

A standard history of textiles. Numerous illustrations in the text. Bibliographies.

Contents: (1) Les tissus de soie décorée de laine et de coton; (2) Le broderie; (3) La tapisserie; (4) La dentelle.

P660 Robinson, Stuart. A history of dyed textiles: dyes, fibres, painted bark, batik, starch-resist, discharge, tie-dye, further sources for research. Cambridge, Mass., MIT Pr. [1969]. 112p. il. (part col.)
English ed.: London, Studio Vista, 1969.

A brief history and handbook of dyed and dye-patterned textiles. Provides reliable information on design, techniques, and the industry. "This book and its companion volume [P661] dealing with printed textiles are intended both as an outline history of decorated textiles and as comprehensive source books for further study of this topic."—*Pref.* Bibliographical footnotes. Classified bibliography (p.89–97) lists primarily books in English and the most useful numbers of the *CIBA review* for each subtopic. Includes another list of principal subjects in the *CIBA review.*

Contents: The ancient world; Further developments: 1377–1856; 19th and 20th centuries; Resist processes. Appendixes: (I) Notes and references for further reading; (II) Museums and centres with collections of textiles; (III) Libraries and booksellers; (IV) Educational aids.

P661 ———. A history of printed textiles. Cambridge, Mass., MIT Pr. [1969]. 152p. il. (part col.), maps.
English ed.: London, Studio Vista, 1969.

"This book is intended both as an outline history of printed textiles and as a comprehensive source book for the further study of this topic. My experience over a number of years in advising students preparing special studies upon decorated textiles has shown me how scattered is the necessary information in a wide variety of articles, journals and books, many of which are now out of print. As far as I know this, and its companion volume [P660] dealing with dyed textiles, are the first books to cover the subject in detail".—*Pref.*

A concise authoritative handbook. Bibliographical footnotes. Excellent classified bibliograhy, p.124–36, primarily of the literature in English, includes the listing of particular issues of *CIBA review* relevant to each specialized topic. Also includes a brief subject index to the contents of the *CIBA review.*

Contents: Origins; Great Britain: 1750 to the present day; Developments abroad. Appendixes: (1) Notes and references for further reading; (II) Museums and centres with collections of textiles; (III) Libraries and booksellers; (IV) Educational aids.

P662 Schmidt, Heinrich J. Alte Seidenstoffe; ein Handbuch für Sammler und Liebhaber. Braunschweig, Klinkhardt & Biermann, [1958]. 483p. 399 il., 16 col. plates, 2 maps. (Bibliothek für Kunst- und Antiquitäten-Freunde, v.10)
Covers silk weavings from the earliest preserved specimens to the period of 1800. Bibliography, p.434–49. Index of illustrations, p.465–78; subject index p.479–81.

P663 Textiles collections of the world. Editor: Cecil Lubell. N.Y., Van Nostrand Reinhold [1976–(77)]. v.1–(3). il., col. plates.
A series of generously illustrated guides to textile collections and compendia of source materials "chiefly directed to professional textiles designers, to producers of textiles, to craft workers in thread, and to students of textile design."—*Plan and purpose, v.1, p.[5].* Volumes consist of listings of textile collections and sections of color and black-and-white illustrations of textiles from the collection represent-

ed. Textile collections are arranged alphabetically by city, with address, telephone number, curators, and a description of the collection. Volumes also contain introductory essays on the traditions and histories of textile design of the various countries included.

Contents: v.1, U.S. & Canada; an illustrated guide to textile collections in U.S. and Canadian museums; v.2, United Kingdom — Ireland; an illustrated guide to textile collections in the United Kingdom and Ireland. v.3, France: an illustrated guide to textile collections in French museums. Indexes.

P664   Thornton, Peter. Baroque and Rococo silks. London, Faber and Faber [1965]. 209p. 124 plates (4 col.), diagrs.

The first thorough study of European figured silks of the Baroque and Rococo periods (c.1640–c.1770). The chronology and the art-historical developments are based on archival material, literary sources, and dated silks preserved in collections. Treats French, English, Swedish, and Italian centers of production. Bibliographical footnotes and bibliography. Detailed index. Excellent illustrations with annotations.

## Ancient

P665   Volbach, Wolfgang Fritz. Early decorative textiles. [Trans. from the Italian by Yuri Gabriel]. London, Hamlyn [1969]. 157p. 71 col. il.

Italian ed.: *Il tessuto nell'arte antica,* Milan, Fabbri, 1967.

An authoritative, if popular, review of ancient fabrics from the earliest known patterned textiles of Egypt to those of Byzantium in the 11th century A.D. Excellent color illustrations in the text, with informative captions. "List of illustrations," p.154–57.

## Early Christian-Byzantine (Coptic)

P666   Kybalová, Ludmila. Coptic textiles; photographs by K. and J. Neubert, English trans. by Till Gottheiner. London, Hamlyn, 1967.

A concise introduction to Coptic textiles. Takes into account the cultural and historical background as well as style. Good illustrations. Bibliography, p.48.

P667   Paris. Musée National du Louvre. Catalogue des étoffes coptes, par Pierre du Bourguet. Paris, Musées Nationaux, v.1-  . 1964-  . il., col. plates.

The first volume of a catalogue of the important collection of Coptic textiles in the Louvre. Written by a foremost authority on Early Christian art. Each piece is fully documented. Bibliographical references and bibliography at the end of the text section, p.43.

SEE ALSO: Volbach, Wolfgang Fritz. *Early decorative textiles* (P665).

## Islamic

P668   Reath, Nancy Andrews, and Sachs, Eleanor B. Persian textiles and their technique from the sixth to the eighteenth centuries, including a system for general textile classification. New Haven, Pub. for Pennsylvania Museum of Art by Yale Univ. Pr.; London, Milford, Oxford Univ. Pr., 1937. viii, 133p. il., plates.

A well-illustrated scholarly work.

Contents: Table of textile classifications; Introduction; pt. 1, (1) Distinctive Persian types; (2) Sasanian and early Islamic weaves; (3) Seljuk weaves; (4) 14th and 15th centuries; (5) Safavid weaves; (6) Post-Safavid weaves; (7) Conclusion; pt. 2. Definition of terms; pt. 3. Analyses of textiles; pt. 4. Diagrams and plates. Index.

P669   Washington, D. C. Textile Museum. Catalogue of dated tiraz fabrics: Umayyad, Abbasid, Fatimid, by Ernst Kühnel. Technical analysis by Louisa Bellinger. Wash., National Pub. Co., 1952. vii, 137p. il., 52 plates, maps. (Catalogue raisonné, 1)

A catalogue of 8th–11th-century fabrics (linen, cotton, mulham, and wool) primarily of Egyptian origin with tiraz inscriptions in the collection of the Textile Museum, Wash., D.C. The Catalogue is divided into three sections: Umayyad caliphs; Abbasid caliphs; Fatimid caliphs. Entries are arranged chronologically and include detailed description, commentaries, and references. An appendix documents fragments of less certain origin. Terms and symbols, p.4. Technical analysis, p.101–9. Chronological charts, p.110–17. Factories, p.116–20. Notes on the tiraz institution, p.121–28.

Bibliography, p.129–31.

## Western Countries

### France

P670   Clouzot, Henri. Painted and printed fabrics: the history of the manufactory at Jouy and other ateliers in France, 1760–1815. Notes on the history of cotton printing, especially in England and America by Francis Morris. New Haven, Yale Univ. Pr., 1927. xvii, 108p. front., il. (facsims.), 92 plates (part col.) (Repr.: N.Y., Arno, 1972.)

An important study of textile manufacturers in France. Still useful.

Contents: History of the manufactory at Jouy; Other important centers of cotton printing in France, 1760–1815; Notes on the history of cotton printing, especially in England and America. Appendix: List of centers of cotton printing in France, 1760–1815. Brief bibliography, p.[xv]–xvii. Index, p.97–108.

### Germany and Austria

P671   Jaques, Renate. Deutsche Textilkunst; in ihrer Entwicklung bis zur Gegenwart. Mit einem Geleitwort

471

von Hans Croon. Berlin, Rembrandt [1942]. 319p. il., 6 col. plates.

A well-illustrated treatment of German textiles from their beginnings to the early 20th century. Index of subjects and names, p.301-2. Index of places, p.313-18.

## Great Britain

P672   Henry Francis du Pont Winterthur Museum. Printed textiles; English and American cottons and linens, 1700-1850 [by] Florence M. Montgomery. N.Y., Viking [1970]. 379p. il. (part col.)

An exemplary study of English and early American printed textiles. The text consists of four chapters treating the export of English textiles to America, the designs, the fashion, manufacture, and the related fabrics made in America. The catalogue (p.111-359) lists over 400 pieces from the collection of the Winterthur Museum. Each example is fully documented and illustrated. "Reference notes" (bibliographical), p.104-10. Bibliography, p.361-71.

## Italy

P673   Klesse, Brigitte. Seidenstoffe in der italienischen Malerei des 14. Jahrhunderts. Mit 519 Zeichnungen der Autorin. Bern, Stämpfli, 1967. 524p. il., 12 plates. (Schriften der Abegg-Stiftung Bern, Bd. 1)

A monumental study of the designs in silks depicted in Italian paintings of the 14th century. The author finds that the Italian-patterned silks of the 14th century formed the basis for European silk design. The introductory text is an outline of design chronology, with a discussion of the major types of ornament—geometric, arabesque, "Chinese littlemaster," palmette, designs with figures, plant designs, those with Christian and heraldic symbols.

Detailed catalogue with full documentation of painting and fabrics arranged by type. Summary in German, French, Italian, and English, p.483. Bibliography, p.489-502. Illustrations of details of paintings in catalogue and a series of drawings of repeat patterns by the author.

P674   Podreider, Fanny. Storia dei tessuti d'arte in Italia (secolo XII-XVIII); prefazione di Paolo d'Ancona. Bergamo, Istituto Italiano d'Arti Grafiche, 1928. viii, 312p. il., plates (part col.), facsim.

A well-illustrated history of textiles in Italy from the 12th to the 18th century.

"Guida descrittiva per la visita delle collezioni de stoffe d'arte nei musei italiani," p.[303]-7. "Indice per materia in base alle illustrazione," p.308-12.

P675   Santangelo, Antonio. A treasury of great Italian textiles. [Trans. by Peggy Craig]. N.Y., Abrams [1964]. 239p. il. (part col.)

Trans. of *Tessuti d'arte italiane dal XII al XVII secolo.*

A history of the textile industry and fabric design in Italy from the 12th to the 18th century. Underscores the relationship of textile design to painting. Written by the director of the Museo di Palazzo Venezia, Rome. Most important

for the corpus of 100 beautiful plates; all of the pieces are documented. Bibliography, p.235-37.

## Spain and Portugal

P676   May, Florence Lewis. Silk textiles of Spain; eighth to fifteenth century. N.Y., Hispanic Society of America, 1957. ix, 286p. plates (166 figs., part col. ) (Hispanic notes and monographs; essays, studies and brief biographies issued by the Hispanic Society of America. Peninsular series)

The pioneer work on the early silks of Spain. Based on source material and the examination of the textiles in major collections of Europe and the U.S. Bibliographical footnotes and full bibliography (p.266-73). Excellent illustrations.

## United States

P677   Little, Frances. Early American textiles. N.Y., London, Century [1931]. xvi, 267p. plates, facsims.

A standard survey of American fabrics from the 17th century to the early 19th century. "Important dates in the history of American textiles," p.255-56. Bibliography, p.249-53.

Contents: (1) Beginnings; (2) The South in the 17th century (3) Early New England and the North; (4) Development of the industry; (5) The beginning of the machine age; (6) The story of American silk; (7) Spinning and weaving; (8) Embroidery in America; (9) Early cotton-printing in America; (10) Textiles used in early American houses.

P678   Safford, Carleton L., and Bishop, Robert. America's quilts and coverlets. N.Y., Dutton, 1972. 313p. il. (part col.)

A lavishly-illustrated survey of American bedcovers from the 18th century to the present. Historical background, function, and design are all considered. Bibliography. Index of cover names.

SEE ALSO:   Henry Francis du Pont Winterthur Museum. *Printed textiles; English and American cottons and linens. 1700-1850* (P672).

## Oriental Countries

P679   Irwin, John, and Brett, Katherine B. Origins of chintz. With a catalogue of Indo-European cotton-paintings in the Victoria and Albert Museum, London, and the Royal Ontario Museum, Toronto. London, H. M. Stationery Office, 1970. viii, 134p. 158 plates, 57 il., facsims., 2 maps, 8 col. plates.

The definitive work on Indo-European cotton-paintings. The text of 7 chapters treats the significance of chintz, the trade, technique and manufacture, designs, furnishing fabrics, and costume. Appendixes: (A) Beaulieu's account of the technique of Indian cotton-painting, c.1734. Introduced and with a commentary by P. R. Schwartz; (B) Father Coeurdoux's letters on the technique of Indian cotton-painting, 1742 and 1747. Introduced and with a commentary

by P. R. Schwartz. Comparison between the Coeurdoux and Beaulieu figures.; (C) The Roxburgh account of Indian cotton-painting: 1795. By P. R. Schwartz. Detailed catalogue of examples from the Victoria and Albert Museum and the Royal Ontario Museum. Precise documentation. Full bibliography, p.59–63. Not every work in the catalogue is illustrated.

P680 Irwin, John, and Hall, Margaret. Indian painted and printed fabrics. Bombay, Bastikar, pub. on behalf of the Calico Museum of Textiles, 1971. xxiv, 203p. plates (part col.) (Historic textiles at the Calico Museum, v.1)

The first volume of a series of catalogues to cover the collection of the Calico Museum in Ahmedabad, India. Limited to textiles made in India. Includes a section on the ritual fabrics for temples. Each piece is fully described and documented. Excellent illustrations (96 black-and-white plates, 13 color plates). Glossary; extensive bibliography; concordance of museum and catalogue numbers.

P681 Japan Textile Color Design Center. Textile designs of Japan. [Osaka, 1959–61]. 3v. plates (part col.) (Reissued in 1967.)

A monumental corpus of the textile designs of Japan. Comprehensive in scope; v.3 includes related designs of foreign textiles. Each volume contains an introductory text which outlines the development and characteristics of the designs; a description of the plates; an index of terms; and the corpus of superb illustrations (v.1, 184 plates; v.2, 175 plates; v.3, 168 plates). No bibliography.

Contents: v.1, Designs composed mainly in free style; v.2, Designs composed mainly in geometric arrangement; v.3, Designs of Ryukyu, Ainu, and foreign textiles.

P682 Langewis, Laurens, and Wagner, Frits A. Decorative art in Indonesian textiles. Amsterdam, C.P.J. van der Peet, 1964. 67p. il. plates (14 col.), map.

An introductory study and classification of Indonesian decorative textiles.

Bibliography, p.44–45. Map and classification, p.48–49. Description of the plates, p.51–67.

SEE ALSO: Bühler, A. *Ikat, batik, plangi* . . . (P655).

## Primitive

P683 Harcourt, Raoul d'. Textiles of ancient Peru and their techniques. Ed. by Grace G. Denny and Carolyn M. Osborne; trans. by Sadie Brown. Seattle, Univ. of Washington Pr., 1962. xvii, 186p. 117 plates. (Repr.: Seattle, Univ. of Washington, 1974.)

A rev. English ed. of *Les textiles anciens du Pérou*, Paris, 1934.

The basic scholarly study of ancient Peruvian textiles. The author describes in detail and analyzes all known techniques of Peruvian weaving, network, needle-made fabrics, plaiting, and embroidery. Very well illustrated with plates and diagrs.

Bibliography, p.141–46.

P684 Lamb, Venice. West African weaving. London, Duckworth, 1975. 228p. il. (part col.), maps.

A beautifully illustrated study based on extensive firsthand examination of examples of West African textiles both at their places of origin and in museum collections. The scope of the work is limited generally to "two of the main weaving traditions to be found in Ghana, those of the Asante and of the Ewe and Adangbe weavers of the Volta Region, not only for their own inherent interest but also as case studies which may throw some light on the entire West African narrow strip weaving complex."—*p.24*.

Contents: (1) Looms and weavers; (2) An historical survey; (3) Asante weaving; (4) Ewe weaving in the Volta Region; (5) Conclusions.

Bibliography, p.222–24. Bibliographical references in notes at ends of chapters.

P685 Plumer, Cheryl. African textiles; an outline of handcrafted sub-Saharan fabrics. [East Lansing] African Studies Center, Michigan State Univ., 1971. xiv, 146p.

"Presents the history of weaving—including the yarns, a discussion of looms and weavers, and a listing of the types of textiles and techniques of making them—trade, and a bibliography for each ethnic group."—Roslyn Walker Randall in Sieber (P686) p.30.

Bibliography, p.133–46.

P686 Sieber, Roy. African textiles and decorative arts. N.Y., Museum of Modern Art. (Distr. by New York Graphic Society, Greenwich, Conn. [1972].) 239p. il. (part col.), map.

Issued in conjunction with an exhibition shown at the Museum of Modern Art in 1972; the Los Angeles County Museum of Art; the M. H. de Young Memorial Museum, San Francisco; and the Cleveland Museum of Art in 1973.

An extended, well-illustrated essay which constitutes "an introduction to the rich and varied world of African textiles and decorative arts, particularly costumes and jewelry. . . . A general survey is intended: no style or geographical area of sub-Saharan Africa has been consciously ignored."—*p.10*.

Selected bibliography, by Roslyn Walker Randall, p.229–38, includes an evaluation of research in the field.

# EMBROIDERY AND NEEDLEWORK

## Bibliography

P687 Lotz, Arthur. Bibliographie der Modelbücher; beschreibendes Verzeichnis der Stick- und Spitzenmusterbücher des 16. und 17. Jahrhunderts. Leipzig, Hiersemann, 1933. xii, 274p. 108 plates (incl. facsims.) (Repr.: Stuttgart, Hiersemann, 1963.)

A scholarly bibliography of needlework pattern books published in the 16th and 17th centuries. Arranged by date within countries of origin: Germany, Italy, France, and England. Index of names and titles, p.261–71. Index of publishers, places of publication, and presses, p.272–74.

## Histories and Handbooks

P688   Antrobus, Mary (Symonds), and Preece, Louisa. Needlework through the ages; a short survey of its development in decorative art, with particular regard to its inspirational relationship with other methods of craftsmanship. London, Hodder and Stoughton, 1928. xxxiii, 413p. 103 plates (part col.)
A pictorial survey of the historical development of needlework. Bibliography, p.391–98. Index, 399–413.

P689   Bolton, Ethel Stanwood, and Coe, Eva Johnston. American samplers. [Boston] The Massachusetts Society of the Colonial Dames of America, 1921. 416p. col. front., il., cxxvi plates (part col.) (Repr.: Princeton, N.J., Pyne, 1973.)
The definitive reference work on early American samplers from the 17th century to 1830. Includes history of the designs and two registers of the samplers arranged alphabetically by maker (p.29–89; p.121–246); an anthology of sampler verse; a list of early schools; and a chapter on materials, designs, and stitches. Register of embroidered arms, p.403–8. No bibliography.

P690   Christie, Grace. English medieval embroidery, a brief survey of English embroidery dating from the beginning of the tenth century until the end of the fourteenth: together with a descriptive catalogue of the surviving examples. Oxford, Clarendon, 1938. xviii, 206p. il., 159 plates.
A general survey of English medieval embroidery; includes a corpus of the extant pieces.
    Appendix I: Some embroidery workers and purchases of embroideries recorded in medieval documents, p.31–37. Appendix II: Contemporary records of medieval embroideries, p.38–41. Descriptive catalogue, p.45–198, gives bibliographical references. Index of persons; Index of museums, libraries, treasuries and collections; General index.

P691   Farcy, Louis de. La broderie du XIe siècle jusqu'à nos jours d'après des spécimens authentiques et les anciens inventaires. Paris, Leroux, 1890. iv, 144p. 181 plates.
———. Supplément. no. 1. Angers, Belhomme, 1900. 35 plates.
———. Supplément. no. 2. Angers, Belhomme, 1919. 85 plates.
    An important history of embroidery, comparable to Guiffrey's *Histoire générale de la tapisserie* (P636). Bibliographical footnotes. Page and plate numbering varies.

P692   Harbeson, Georgiana Brown. American needlework; the history of decorative stitchery and embroidery from the late 16th to the 20th century. N.Y., Coward-McCann, 1938. xxxviii, 232p. plates (part col.), ports. (Repr.: N.Y., Bonanza, 1963.)
A readable survey of the many forms of needlework produced in America from the Colonial period to the early 20th century. Includes sections on American Indian em-

broidery and beadwork, stump work, crewel, quilting, samplers, gowns and waistcoats, lacework, Moravian needlework, embroidered maps and needlework rugs, flags and banners, as well as crewel upholstery and pictures from the Victorian era. Many good illustrations scattered throughout the text. Bibliography, p.225–26. Index, p.227–32.

P693   Johnstone, Pauline. The Byzantine tradition in church embroidery. London, Tiranti; Chicago, Argonaut, 1967. x, 144p., col. front., 115 plates.
A unique, scholarly survey of the ecclesiastical embroidery of the Greek Orthodox Church.
    Contents: (I) The Byzantine background; (II) Textiles and embroidery; (III) Vestments; (IV) Iconography; (V) Ornament; (VI) Inscriptions; (VII) Workers and workrooms; (VIII) Technique; (IX) Embroidery and history; (X) The pieces illustrated. Appendix: (I) Short list of vestments; (II) The alphabet. Bibliography, p.132–35. Index, p.136–44.

P694   Kendrick, Albert Frank. English needlework. 2d ed., rev. by Patricia Wardle. London, Black, 1967. xvi, 212p. 31 plates.
1st ed. 1933.
    An important work covering English embroidery from the Middle Ages through the 19th century, now expanded and brought up-to-date by Patricia Wardle. The selected bibliography includes recent works.

P695   Kroos, Renate. Niedersachische Bildstickereien des Mittelalters. Berlin, Deutscher Verlag für Kunstwissenschaft [1970]. 218p. 124 l. of il.
A detailed, scholarly study and catalogue of pictorial embroideries produced in Lower Saxony from the 12th through the first half of the 15th centuries. The catalogue includes 123 extremely well documented entries, giving for each references to illustrations, collection, subject, inscriptions, dimensions, technique, restorations, provenance, and bibliographical references. Superb black-and-white illustrations. Includes some comparative materials (manuscript illuminations, sculpture, stained glass).
    Abkürzungsverzeichnis für häufiger zitierte Literatur, p.[11]17. Quellenanhang, p.157–92 (250 entries, with bibliographical references). Namen- und Sachregister; Ikonographisches Register; Abbildungsverzeichnis.

P696   Schuette, Marie, and Müller-Christensen, Sigrid. A pictorial history of embroidery. [Trans. by Donald King]. N.Y., Praeger [1964]. xxiv, 336p. il. (part col.)
German ed., Tübingen, Wasmuth, 1963, pub. as *Das Stickereiwerk*.
    A catalogue of 464 fine examples of European needlework, with representative pieces from each period from the origins of embroidery to the beginnings of the 20th century. Includes a few examples of Islamic and Oriental embroidery. Comp. by authorities in the field. The catalogue is preceded by brief chapters on materials and techniques, and the history of embroidery.
    "The text aims to guide the reader through the illustrations, which are not always easy to interpret, and to help towards a more intimate appreciation of the embroideries. The

catalogue provides the facts about the individual objects; the bibliographical notes [are] restricted to the essential and the most recent literature."—*Foreword.*

P697    Wingfield Digby, George. Elizabethan embroidery. London, Faber and Faber [1963]. 151p. 84 plates (part col.).

The first book to be devoted to the embroidery of the Elizabethan period. Pt.1 focuses on the history of Elizabethan embroidery, the artisans, and the types of work. Pt. 2 is technical and is divided into costume work and embroidery for furnishings. Bibliographical references follow both sections. Bibliography, subdivided into books, catalogues, and articles, p.142–46. Well illustrated.

SEE ALSO:  Marquet de Vasselot, Jean Joseph, and Roger-Armand. *Bibliographie de la tapisserie, des tapis et de la broderie en France* (P647).

## Oriental Countries

SEE:  Kuo li ku kung po wu yüan. [The collection of tapestry and embroidery in the National Palace Museum] (P653); Kuo li ku kung po wu yüan. Taiwan. *Masterpieces of Chinese art in the National Palace Museum,* v. [13] *Silk tapestry and embroidery* (I515).

# LACE

P698    Clifford, Chandler Robbins. The lace dictionary. Pocket ed. including historic and commercial terms, native and foreign. N.Y., Clifford & Lawton [1913]. 156p. il.

A small dictionary of succinct definitions of terms associated with lace and brief articles on importat lace-making centers, types of lace, etc. Topical index, p.149–56.

P699    Laprade, *Mme.* Laurence de. Le poinct de France et les centres dentelliers au XVIIe et XVIIIe siècles; ouvrage ornè de quarante-trois illustrations, lettre-préface de M. Henry Lapauze. Paris, Laveur, 1905. xxxvi, 395p. il., plates.

A detailed history of French lace, its centers of production, and the lace trade in the 17th and 18th centuries. Contents: (I) Le poinct de France; (II) Les centres dentelliers; (III) Le commerce, les droits, les fraudes; (IV) Les marchands, dentelliers, lingers, passementiers. Appendix: Les fils à dentelle, p.369–84.

P700    May, Florence Lewis. Hispanic lace and lace making. N.Y. [The Hispanic Society, 1939]. xliii, 417p. il.

A well-illustrated volume treating all aspects of Spanish lace. Many details of the techniques complement the historical text. Bibliographical notes, p.387–99; References, p.400–5; Index, p.406–17. Maps on end papers.

P701    Moore, Hannah Hudson. The lace book, with seventy engravings showing specimens of lace, or its wear in famous portraits. N.Y., Stokes, 1904. 206p. 58 plates.

An old standard work. Includes sections on the development of lace, and on Italian, Flemish, French, Spanish, English, and Irish laces.

P702    Morris, Frances, and Hague, Marian. Antique laces of American collectors. N.Y., pub. for the Needle and Bobbin Club by William Helburn, 1920-26. 5v. plates.

A visual survey of lace making in Italy, France, and the Netherlands in the 16th, 17th, and 18th centuries; based on pieces in American collections. v.5, the text, contains an introductory essay on laces in the American colonies and on lace collecting in America. The main portion of v.5 is devoted to "Descriptive notes" on the 104 plates in v.1–4.

Bibliography, v.5, p.131–35; bibliographical references in footnotes.

P703    Palliser, Fanny M. History of lace; entirely revised, rewritten, and enlarged under the editorship of Margaret Jourdain and Alice Dryden. With 266 illustrations. [4th ed.] N.Y., Scribner, 1902. xvi, 536p. il.

1st ed. 1865.

Reprint (of 3d ed. of 1875): Detroit, Gale, 1973.

Remains a standard work on the history of lace. Glossary of terms, p.503–6; Index, p.507–36.

P704    Powys, Marian. Lace and lace-making. Drawings by the author. Boston, Branford, 1953. vii, 219p. il.

A well-illustrated and useful general book on lace; describes various types and how to distinguish them. Also gives directions for making, mending and cleaning lace.

"Pedigree of needlepoint laces," p.7. Index, p.217–19.

P705    Ricci, Elisa. Old Italian lace. Philadelphia, Lippincott, 1913. 2v. il., plates.

Trans. of *Antiche trine italiane raccolte e ordinate,* Bergamo, Istituto Italiano d'Arti Grafiche, 1908.

Well illustrated with a list of plates at the end of each volume.

Contents: v.1: (1) Modano or lacis, drawn-thread work, Buratto; (2) Punto e reticello; (3) Punto in aria; v.2, Bobbin lace: Venice, Genoa, Milan, Abruzzi.

P706    Schuette, Marie. Alte Spitzen, Nadel- und Klöppelspitzen; ein Handbuch für Sammler und Liebhaber. 4. neubearb. Aufl. Braunschweig, Klinkhardt & Biermann [1963]. 247p. 179 il. (Bibliothek für Kunst- und Antiquitätenfreunde. Bd. 6)

1st ed. 1914.

An excellent, comprehensive handbook of the history of lace, rev. and updated through periodic new editions.

Contents: Pt. 1, Technik der Spitze: Ursprung und Vorläufer der Spitze, die geknüpfte Spitze; Vorstufen der Nadelspitze; Nadelspitze; Klöppelspitze. Pt. 2, Geschichte der Spitze: Italien; Frankreich; Die Niederlande: Spanien; Deutschland, Österreich; England.

Anmerkungen, p.220-32, include references. Fachausdrücke, p.233-41. Classified bibliography, p.246-47.

P707  Vanderpoel, Emily Noyes. American lace and lace-makers, ed. by Elizabeth C. Barney Buel. New Haven, Yale Univ. Pr. 1924. xx, 14p. 110 plates.
A picture book with 14p. of introductory text. A description of each plate is on the verso of the previous plate.

P708  Wardle, Patricia. Victorian lace. N.Y., Praeger [1969]. 286p. il.
English ed., London, Jenkins, 1968.
A well-illustrated, detailed study of hand- and machine-made laces of the 19th century. Contents: (1) Fashions in lace in the 19th century; (2) France; (3) Belgium; (4) England; (5) Ireland; (6) Miscellaneous; (7) Machine-made lace in England; (8) Machine-made lace in France and elsewhere. Appendix: Basic techniques of lace-making, p.262-66; Classified bibliography, p.267-70.

P709  Whiting, Gertrude. A lace guide for makers and collectors; with bibliography and five-language nomenclature, profusely illustrated with half-tone plates and key designs. N.Y., Dutton [1920]. 415p. il.
A technical book with extensive bibliography, clear illustrations of various types of lace, and instructions for making them. "Explanation and nomenclature," p.36-68, lists in parallel columns terms in English, French, Italian, Spanish, and German. Bibliography, p.243-401.

## JADE

P710  [Fondation Alfred et Eugénie Baur-Duret]. The Baur Collections. Chinese jades and other hardstones, by Pierre-F. Schneeberger. Trans. by Katherine Watson. Genève, Collections Baur [1976]. 210p. il. (part col.)
v.5 of the catalogue of the Baur Collections; v.1-4, *Chinese ceramics* (P362). Text in English with a French summary.
A thoroughly detailed catalogue of the important Baur Collection of 129 jades, primarily of the Ch'ing Dynasty. Each piece is illustrated.

P711  Hansford, S. Howard. Chinese carved jades. Greenwich, Conn., New York Graphic Society; London, Faber and Faber [1968]. 131p. plates (part col.)
A scholarly study of the history, designs, and purposes of Chinese jades, drawn heavily from archaeological evidence.
Contents: (1) Introduction; (2) The material and its sources; (3) Progress of the craft; (4) Design, purpose and usage: Neolithic, Shang and Chou; (5) Design, purpose and usage: Han to Ch'ing; (6) Archaeology.
Excellent bibliography, p.112-20, contains many Chinese sources. Index of Chinese terms, p.123-26.

P712  Laufer, Berthold. Jade; a study in Chinese archaeology and religion. [2d ed., with a new foreword by the Chicago Natural History Museum], South Pasadena, Perkins; London, Routledge, 1946. xiv, 370p. il., col. plates. (Repr.: N.Y., Kraus, 1967.)

1st ed. 1912 (Chicago, Field Museum of Natural History, Pub. 154, Anthropological series v. 10)
An early study of Chinese jade.
Bibliography, p.355-60.

P713  Salmony, Alfred. Chinese jade through the Wei dynasty. N.Y., Ronald Pr. [1963]. 287p. 46 plates.
Published posthumously. Originally planned as a comprehensive history of Chinese jade; completed only through the Wei dynasty. The author's intention was "to replace arbitrary or intuitive attributions by controllable ones, and to lay a firm groundwork for a complete and substantiated jade chronology."—*Introd.*
Contents: (1) Introduction; (2) Pre-Anyang; (3) Shang; (4) Early western Chou; (5) Middle Chou; (6) Late eastern Chou; (7) Han; (8) Wei.
Bibliographical references in "Notes" at the end of each chapter.

P714  Wills, Geoffrey. Jade of the East. N.Y. Weatherhill [1972]. 196p. il. (part col.)
A well-illustrated survey of jade from Asia and New Zealand in all forms in which it has been carved. The emphasis is on Chinese jade.
Contents: Pt. 1, Chinese jade: (1) Origins of Chinese jade; (2) Early Chinese jade: Through the Yüan dynasty; Shapes and symbols; Decorations and patterns; (3) Later Chinese jade: Ming and Ch'ing dynasties. Pt. 2, Other Eastern jade: (4) Islamic jade; (5) Japanese and Korean jade; (6) New Zealand jade. Notes, p.187-89. Bibliography, p.191-92.

SEE ALSO:  Kuo li ku kung po wu yüan. Taiwan. *Masterpieces of Chinese art in the National Palace Museum*, v. [4], *Jade* (I515); Lion-Goldschmidt, Daisy, and Moreau-Gobard, J. C. *Chinese art: bronze, jade, sculpture, ceramics* (I517); Sullivan, Michael. *Chinese ceramics, bronzes and jades in the collection of Sir Alan and Lady Barlow* (P377).

## LACQUER

### Western Countries

P715  Holzhausen, Walter. Lackkunst in Europa; ein Handbuch für Sammler und Liebhaber, Braunschweig, Klinkhardt & Biermann [1959]. 320p. 208 il., 26 col. plates. (Bibliothek für Kunst und Antiquitätenfreunde. Bd. 38)
A comprehensive, authoritative history of European lacquerwork. Contents: Die Anfänge der Lackmalerei in Europa; Zwischenspiel; Die Blütezeit der Lackmalerei; Deutschland; Die Spätzeit der Lackmalerei; Variationen über das Thema Lackmalerei.
Notes, p.295-306, include references. Bibliography, p.307. Index of names.

P716  Huth, Hans. Lacquer of the West; the history of a craft and an industry, 1550-1950. Chicago, Univ. of Chicago Pr. [1971]. x, 158, [200]p. il. (part col.)

The most comprehensive, scholarly history of Western lacquer. "As presented here, the history of European and North American lacquer deals with decorated objects made of wood, papier-mâché, leather, and earthenware." —*p.1.*

Contents: (I) Lacquer in the 17th century; (II) Lacquer in the 18th century; (III) Lacquer in England and the North American colonies; (IV) Italian lacquer; (V) German lacquer; (VI) French lacquer; (VII) Lacquer in the Netherlands, Scandinavia, Russia; (VIII) The lacquer industry. Illustrations (list of colour plates and figures), p.[139]-49, gives maker, if known, date, and present location.

Bibliography, p.136-38, arranged chronologically. Extensive notes at ends of chapters include bibliographical references. General index.

## Oriental Countries

P717 Herberts, Kurt. Oriental lacquer; art and technique. [Trans. from the German by Brian Morgan. London] Thames & Hudson [1962]. 513p. 324 plates (104 col.), maps.
Trans. of *Das Buch der ostasiatischen Lackkunst,* Düsseldorf, Econ [1959].

The most comprehensive work on the techniques of Chinese and Japanese lacquerwork. The major portion of the book is composed of plates which illustrate lacquerwork of various types, with descriptions and commentaries on facing pages.

Contents: Carved lacquer; Dry lacquer; Incised lacquer; Inlaid mother-of-pearl; Various inlays; Togidashi; Hiramakie, Takamakie; Smooth grounds of coloured lacquer; Painted lacquer. "Towards an understanding," p.250-60, is an introductory historical survey. Key to the grouping of lacquer techniques, p.261-64. Alphabetical glossary of techniques and technical terms, p.[265]-392, defines about 400 terms. Note on the Japanese lacquer artists, by Werner Speiser, p.394-98. List of Japanese lacquer artists: Characters, names, literary sources, and dates, p.399-500.

Alphabetical bibliography, p.502-8; Chronological bibliography, p.510-13.

P718 Jahss, Melvin, and Jahss, Betsy. Inro and other miniature forms of Japanese lacquer. Rutland, Vt., Tuttle [1971]. 487p. plates, 245 figs. (part col.), 59 facsims.
A well-illustrated survey of the history and development of *inro* and other types of Japanese lacquered objects. Includes detailed descriptions of lacquering processes and decoration techniques.

Contents: (1) Characteristics of Japanese lacquer art; (2) History of Japanese lacquer; (3) Lacquer manufacture and techniques; (4) Miniature lacquer art forms; (5) The netsuke as an art form; (6) Subject matter of lacquer art; (7) Lacquer artists. A list of miniature lacquer artists, p.395-450. Signatures of lacquer artists, p.451-58.

Genealogical charts, p.459-68. Glossary, p.469-77. Bibliography, p.479-82.

P719 Ragué, Beatrix von. A history of Japanese lacquerwork. Trans. from the German by Annie R. de Wassermann. Toronto, Univ. of Toronto Pr. [1967]. xiii, 303p. [5] leaves of plates, il. (part col.)
Trans. of *Geschichte der japanischen Lackkunst,* Berlin, de Gruyter, 1967.

A scholarly history of the stylistic development of Japanese lacquerwork which incorporates the recent research of Japanese authorities. The survey is based on firmly dated works, which are related to significant undated examples. References are made to ceramics, metalwork, and textiles. Very well illustrated.

Contents: (1) Origins and apprentice years; (2) Early Heian period: the rise of an indigenous style; (3) 11th and 12th centuries: the golden age of Heian lacquerwork; (4) Kamakura period; (5) Muromachi period I: Nambokuchō period to the Higashiyama period; (6) Muromachi period II: from the end of the Higashiyama period to 1567; (7) Momoyama period; (8) Early Edo period; (9) Mid- and late Edo period; (10) From the Meiji period to the present day. Notes, p.247-65, include bibliographical references. List of dated lacquer objects, p.[273]-76. Glossary of more common Japanese descriptive terms, p.[277]. Japanese names and technical terms with their corresponding written characters, p.[279]-86. Period table, p.[287]. Japanese provinces (map), p.[289].

Bibliography, p.[267]-71.

SEE ALSO: Kuo li ku kung po wu yüan. Taiwan. *Masterpieces of Chinese art in the National Palace Museum,* v.[15] *Carved lacquer ware* (I515).

# WALLPAPER

P720 Entwisle, E. A. A literary history of wallpaper. London, Batsford [1960]. 211p. 102p. of plates (part col.)
A bibliography of the literature on wallpaper of all periods, with an anthology of over 600 extracts from sources.

P721 Olligs, Heinrich, ed. Tepeten. Ihre Geschichte bis zur Gegenwart. Braunschweig, Klinkhardt & Biermann [1969-70]. 3v. il. (part col.), plans, sample.
A monumental history of wallpaper and other decorative wall coverings from the medieval period to the present. Promises to be the definitive work on the subject. Consists of a series of essays by specialists; H. Olligs is the chief editor, and Josef Leiss is the major contributor. Superb visual documentation in the text: recent photographs, drawings, prints, technical diagrams, etc. Many color illustrations. Descriptive caption for each piece, with date. Each volume has indexes of names, places, and subjects. v.1-2 also have lists of illustrations; v.2 has a subject list of hand-printed wall coverings.

Contents: Bd. 1, Tapeten-Ihr Geschichte bis zur Gegenwart; Bd. 2, Fortzetzung Tapeten-Geschichte; Bd. 3 Technik und wirtschaftliche Bedeutung.

# Serials IV

# Q.
# Periodicals

This list was compiled and edited with the collaboration of Julia Van Haaften.

A growing interest in the history of art periodicals was kindled by the International Conference on Art Periodicals and the concurrent exhibition at the Victoria and Albert Museum in 1976. In conjunction with the conference and exhibition a book of essays was published: *The Art press: Two centuries of art magazines,* edited by Trevor Fawcett and Clive Phillpot.[1] Librarians of art research collections will find this pioneering review of various types of art magazines informative and enjoyable reading. The critical notes about important journals have been helpful in the final editing of this list.

This list contains most of the periodical titles in the Chamberlin precedent; the entries have been edited, revised, closed or updated, and reprints have been noted. Some of the old journals have only historiographic or sentimental value, others include key articles and documents which have not as yet been published elsewhere, still others are invaluable for current research.

Over 100 titles have been added, these having been chosen from approximately 300 contestants, old and new. The choices were based on language, the test of time, indexes, importance for research, adherence to the scope of this bibliography, and, above all, standards of quality. Journals in Western European languages predominate; the listing of Oriental and Eastern European titles is highly selective. For the identification and indexing of current art journals of Eastern Europe see *Bibliographie zur kunstgeschichtlichen Literatur in ost- und südosteuropäischen Zeitschriften* (A7).

The archaeological and general historical journals were selected with the art historian in mind. In keeping with the logic of Mary Chamberlin, museum bulletins have been excluded. Included, however, are other scholarly periodicals published by museums, those with a broader scope, such as the *Jahrbuch der Berliner Museen* and *The Art quarterly.* Coverage of architectural periodicals is selective, and only a few of the many photography magazines are listed here. Periodicals of advertising art are excluded, *Graphis* being the exception. Although some of the journals can be called avant garde, no attempt has been made to document those "little magazines" which are primary sources for the study of art and literature of the 19th and 20th centuries.

Open entries are given for all titles currently being published; with few exceptions the publishers and places are the current ones. Entries for those journals which have ceased publication have been closed, and the publishers covering the longest spans are given. Title changes, and major changes in frequency of publication are noted.

An attempt has been made to indicate where the various periodicals are indexed (see the abbreviations at end of annotations). However, the published periodical catalogues of libraries have not been noted. In the case of the *Art index,* dates are supplied when the whole span of a magazine is not indexed. For selective indexing of scholarly periodicals see also *RILA,* v.1, 1975– (A15), the new current bibliography which promises to become a fundamental research tool.

The indexes, with abbreviations, are listed below:

A. D. P.: Art/Design/Photo.

Ann. mag. subj. ind.: Annual magazine subject-index.

Art index: Art index.

ARTbib. curr.: ARTbibliographies current titles.

ARTbib. mod.: ARTbibliographies modern.

A. S. T. ind.: Applied science and technology index.

B. d. d. Z.: Bibliographie der deutschen Zeitschriftenliteratur.

B. d. f. Z.: Bibliographie der fremdsprachigen Zeitschriftenliteratur.

B. H. I.: British humanities index.

Bibl. de Belgique: Bibliographies de Belgique.

Br. tech. ind.: British technology index.

[1]Trevor Fawcett and Clive Phillpot, eds. *The Art press: Two centuries of art periodicals.* (Published for the Art Libraries Society on the occasion of the exhibition at the Victoria and Albert Museum and the International Conference on Art Periodicals.) London, Art Book, 1976, 63p. (Art documents number one) Contents: Introduction; Nineteenth-century periodicals, by Anthony Burton; Scholarly journals, by Trevor Fawcett; The Fin de siècle, by Hans Brill; Movement magazines—the years of style, by John A. Walker; Illustration and design, by Trevor Fawcett; Index to periodicals.

Bull. sig. 521: Bulletin signalétique 521: Sociologie-ethnologie.

Bull. sig. 525: Bulletin signalétique 525: Préhistoire.

Bull. sig. 526: Bulletin signalétique 526: Art et archéologie-Proche-Orient, Asie, Amérique.

Can. ind.: Canadian index.

Catholic ind.: Catholic index.

Chem. abs.: Chemical abstracts.

Dansk tids.-ind.: Dansk tidsskrift-index.

Eng. ind.: Engineering index.

Hague. K. Bibl.: Hague. Koninklijke Bibliotheek. *Repertorium op de Nederlandsche tijdschriften.*

Hum. ind.: Humanities index.

Ind. arts ind.: Industrial arts index.

Int. ind.: International index.

I. B. Z.: Internationale Bibliographie der Zeitschriftenliteratur aus allen Gebieten des Wissens.

Italy. Parl. Cam dei Deputati. Bibl.: Italy Parlamento. Camera dei Deputati. Biblioteca. *Catalogo metodico degli scritti contenuti nelle pubblicazione periodïche italiane e straniere.*

Italy. Prov. Gen. dello Stato: Italy. Provveditorato Generale dello Stato. *Pubblicazioni edite dallo stato o col suo concorso.*

LOMA: Literature on modern art.

Nijhoff: Nijhoff's index op de Nederlansche periodiken van algemeeneninhoud.

P. A. I. S.: Public affairs information service. *Bulletin.*

Poole's: Poole's index to periodical literature.

R. G.: Readers' guide to periodical literature.

Rel. per.: Index to religious periodicals.

Rép. d'art.: Répertoire d'art et d'archéologie.

Rép. bibl.: Répertoire bibliographique des principales revues françaises.

Rev. of revs.: Review of reviews.

S. S. H. I.: Social sciences and humanities index.

S. S. I.: Social sciences index.

Subj. ind.: Subject index to periodicals.

**Q1**    "AARP"; art and archaeology research papers, no. 1, June 1972- . London. Semiannual.
A forum for work in progress in the areas of art and archaeology from the Mediterranean to the Far East, including theses. Index to nos. 1-6 in no. 6 (1974). *ARTbib. curr.*

A I A journal. See: *American Institute of Architects, Journal.*

**Q2**    ARIS; art research in Scandinavia, v.1, 1969- . Lund, Sweden, Institutionen för Konstvetenskap i Lund. Annual.
A new periodical on modern art and theory. *ARTbib. curr.; ARTbib. mod.; I. B. Z.; LOMA.*

**Q3**    ARLIS newsletter, no. 1-26, Oct. 1969–Mar. 1976. London, Art Libraries Society. 4 times a year.
Superseded by *Art libraries journal* (Q72). Contains news notes and articles related to art library management, especially service, collection building, and organizational practice. Long reviews of reference works. Not illustrated. *A. D. P.; ARTbib. curr.*

**Q4**    ARLIS/NA newsletter, v.1, Nov. 1972- . Glendale, Calif., Art Libraries Society/North America. Bimonthly.
The official organ of ARLIS/NA. Directed to art librarians and curators of slides and photographs. Contains notes on art bibliography, signed book reviews, a visual resources section, and short articles concerned with the common problems of selection, classification, collection maintenance and operation, etc. *A. D. P.; ARTbib. mod.*

**Q5**    Académie des Inscriptions et Belles-Lettres, Paris. Commission de la Fondation Piot. Monuments et mémoires . . . , t.1, 1894- . Paris, Presses Universitaires de France. Annual, some variation.
Lengthy, scholarly articles on ancient, Byzantine, medieval, and Renaissance art, emphasizing archaeology. Index to 1894-1913 in t.20, pt. 2. *Art index, B. d. f. Z; Bull. sig. 525; Int. ind.; I. B. Z.*
———. Table alphabétique t.21-50 in v.50 (supplement).

**Q6**    Académie des Inscriptions et Belles-Lettres, Paris. Comptes-rendus des séances, 1-8, 1857-64; n.s., v.1-7, 1865-71; s.3, v.1, 1872; s.4, v.1-27, 1873-99; s.5, v.1, 1900- . Paris, Klincksieck. Quarterly; earlier years monthly with some variation; publisher varies.
Contains various papers on art subjects, i.e., objects in the Louvre, architectural monuments, etc. *B. d. f. Z.; Bull sig. 525, 526; I. B. Z.; Rép. bibl.*
———. Table des années 1857-1900. Paris, Picard, 1906. 232p.
———. Tables des années 1901-30. Paris, Picard, 1934. 229p.

**Q7**    Accademia Romana di Archeologia. Atti della . . . , ser.1-2, 30v., 1821-1921; ser.3, Memorie, v.1-8, no. 3, 1923-48; ser.3, Rendiconti, v.1, 1921/23- . Roma, Poliglotta Vaticana. Annual; frequency, publisher vary.
Useful primarily for Early Christian art, especially reports on recent excavations. *Indice generale dal 1821 al 1938* in v.14 of *Rendiconti,* which is indexed in *B. d. f. Z.; Rép d'art.*

**Q8**    Acta archaeologica Academiae Scientiarum Hungaricae, t.1, 1951- . Budapest, Akadémiai Kiadó. Irregular, 4 fasc. in 1v.
Published for the Academiae Scientiarum Hungaricae. Notes and articles on Hungarian archaeology, prehistoric through the Middle Ages. Signed book reviews, with a section on Hungarian art. Text also in English, French, German, or Russian, with summaries in other languages. *Bull. sig. 525, 526; I. B. Z.; Rép. d'art.*

Q9    Acta historiae artium Academiae Scientiarum Hunga-
      ricae, t.1, 1953/54- . Budapest, Magyar Tudományos
      Akadémia. Semiannual, 2 fasc. per issue.
A major scholarly periodical covering European art history
of all periods. Book reviews. Text in German, English,
French, Russian, and Italian, with summaries in other lan-
guages. Index to t.1-10 in t.10. *ARTbib. curr.; ARTbib.
mod.; I. B. Z.; Rép. d'art.*

Q10   African arts; a quarterly journal devoted to the plastic,
      graphic, literary, and performing arts of Africa, v.1,
      1967/68- . Los Angeles, African Studies Center,
      Univ. of California. Quarterly.
Prior to summer 1970, pub. also in French, *Arts d'Afrique.*
Book review section. *Art index* (1969- ); *ARTbib. curr.;
ARTbib. mod.*

Q11   Albertina Studien; Jahresschrift der Graphischen
      Sammlung Albertina, [Bd.] 1, 1963- . Wien, Kossatz.
      Annual, some years combined.
Editor: Walter Koschatzky.
    Scholarly articles dealing with the drawings and prints in
the collection, and related topics from the Renaissance
through the 18th century.

Q12   Alte und moderne Kunst, Jahrg. 1, 1956- . Wien,
      AMK-Verlag. Monthly, 1956-70; bimonthly, 1971-;
      publisher varies.
Covers painting, decorative arts, and architecture, with
emphasis on work in Austrian collections. Short book
reviews; exhibition and auction notices. *A. D. P.; ARTbib.
curr.; ARTbib. mod; LOMA; Rép. d'art.*

Q13   American Academy in Rome. Memoirs, v.1, 1917-.
      Rome. Annual; publisher varies.
Continues the *Supplementary papers* of the American
School of Classical Studies in Rome. Scholarly articles on
current research; some volumes are monographs. *Art index;
B. d. f. Z.; I. B. Z.*

Q14   The American architect, v.1-152, 1876-Feb. 1938.
      N.Y., Hearst Magazines. Monthly; frequency, pub-
      lisher, place vary.
Title varies; merged with *Architectural record* Mar. 1938.
Short articles on all aspects of American architecture. Short
book reviews. *Art index* (v.136-52); *B. d. f. Z.; Ind. arts
ind.; Poole's; Subj. ind.*
    Besides the regular editon the following were issued with
additional plates: Gelatine ed., 1885-88; Imperial ed., Mar.
1886-Dec. 1899; International ed., 1890-1908.
———. Decennial index of the photolithographic and other
illustrations, v.1, 1876-85. Boston, Ticknor, 1888.

Q15   The American art journal, v.1, 1969- . N.Y., Kennedy
      Galleries, Semiannual.
Covers all periods of American art; occasional articles on
broad theoretical problems of art scholarship. Signed book
reviews and a list, "Books on American art," in each issue.
*A. D. P.; Art index; ARTbib. curr.; ARTbib. mod.*

Q16   American art review, v.1, 1973- . Los Angeles,
      Kellaway. Bimonthly.
Covers American painting, sculpture, and prints from
Colonial times to 1950. Most reproductions are in color.
Some articles relate current institutional activities in
American art. *Art index* (1979- ); *ARTbib. curr.; ARTbib.
mod.*

Q17   American Institute of Architects. Journal, v.1,
      1944- . Wash. D.C., American Institute of Architects.
      Monthly.
Supersedes its *Quarterly bulletin* and *Octagon.* Now en-
titled *AIA journal.* Official organ of the American Institute
of Architects. Contains short articles on various pertinent
subjects and news notes in the field. Very brief book re-
views. *Art index; ARTbib. curr.; ARTbib. mod.; B. d. f. Z.;
Bull. sig. 521; Ind. arts ind.; Rép. d'art; Subj. ind.*

Q18   American journal of archaeology, ser.1, v.1-11,
      1885-96; ser. 2, v.1, 1897- . N.Y., Archaeological
      Institute of America. Quarterly; frequency, place
      vary. (Repr.: v.11 [1896] only, which is the index to
      ser.1, v.1-10 (1885-95), Wash., D.C., Carrollton Pr.;
      Ser.2, v.1-29 (1897-1925) and index to ser.2, v.1-10,
      N.Y., Johnson.)
Official journal of the Institute; contains articles on the
latest archaeological discoveries in the ancient world.
Signed reviews. 1899-1931 have an annual bibliography of
archaeological literature. v.1-51 contain summaries of
articles in other periodicals, succeeded in v.55-56 by "Ar-
chaeological bibliography.", Index, v.1-10 (1899); Index,
v.11 in appendix (1896); Indexes ser.2, v.1-10 (1897-1906);
v.11-70 (1907-66). *Art index* (Jan. 1929-Oct. 1950; Nov.
1968- ); *B. d. f. Z.; Bull. sig. 525, 526; Chem. abs.; Hum.
ind.; I. B. Z.; Poole's; Rep. d'art; Rev. of revs.; S. S. H. I.;
Subj. ind.*

Q19   American Research Center in Egypt. Journal, v.1,
      1962- . Princeton, N.J. Annual; place varies.
Publishes reports of excavations sponsored by the Center
and includes other scholarly articles on Egyptian studies
through Islamic times. Foldout plates; signed book reviews.

Q20   L'Amour de l'art, v.1-32, mai 1920-53. Paris, Cercle
      français d'art. Monthly, irregular; publisher varies.
In 1933 and 1934 issued in two parts. In 1933 pt. 1, *Histoire
de l'art contemporain,* consists of detailed chapters, universal
in scope, written by specialists. Good biographies and
bibliographies at end of each chapter. Pt. 2, *Bulletin mensuel*
(comprising *L'Amour de l'art*). In 1934 pt. 1 comprised
*Formes* and *L'Amour de l'art;* pt. 2 called *Revue mensuelle.*
v.20, no. 1-6, fév.-juil. 1939 have title *Prométhée. L'Amour
de l'art n.s.* Suspended 1940-avr. 1945 (and v.21-24 omitted in
numbering). Covers all aspects and periods of art, especially
modern. Well illustrated. From 1947- each issue is devoted
to a special subject. Signed reviews and notes on exhibitions,
sales, etc. Oct. 1927-Jan. 1952, short English summaries of
articles appeared as supplements. *Art index* (v.15-20, no.
9-10).

**Q21**    Anatolian studies; journal of the British Institute of Archaeology at Ankara, v.1, 1951- . London. Annual.
Reports of the Institute and summaries of its archaeological work precede scholarly, detailed articles describing excavations, inscriptions, and other findings. Indexes: v.1-10 (1951-60); v.11-20 (1961-70). *I. B. Z.; Rép. d'art.*

**Q22**    Annales archéologiques, t.1-27, mai 1844-72; t.28, 1881. Paris, Didron. Annual.
Suspended 1873-80. Treats medieval (mainly French) and Byzantine art and archaeology, with emphasis on iconography. Contains a few color plates. Bibliographical notes. Index, t.1-27; "Table analytique et méthodique" in t.28.

✓ **Q23**    Antichità viva; rassegna bimestrale d'arte, Anno 1, 1962- . Firenze, EDAM. Bimonthly, some issues combined.
Covers Italian art of all periods. English résumés, signed exhibition and book reviews. *ARTbib. curr.; ARTbib. mod; I. B. Z.; Rép. d'art.*

✓ **Q24**    Antike Kunst, Jahrg. 1, 1958- . Basel, Vereinigung der Freunde antiker Kunst. Semiannual.
Scholarly articles (in German, French, and English) on a wide range of classical subjects. Several thematic studies, many articles on ancient works in public and private collections. Also includes news notes. Publishes a *Beiheft* (R3), a monographic series, usually once a year, on similar subjects. Indexes: v.1-10 in v.14 (1971); v.11-15 in v.15 (1972). *Art index* (1969- ); *ARTbib. curr.; I. B. Z.; Rép. d'art.*

**Q25**    The Antiquaries journal; being the journal of the Society of Antiquaries, London, v.1, 1921- . London, Oxford Univ. Pr. Semiannual.
Supersedes the Society's *Proceedings*. Comprehensive coverage of the archaeology of Great Britain from prehistory through the Middle Ages. Numerous illustrations. Signed book reviews, "List of accessions" which functions as a book bibliography, and "Periodical literature," covering recent journals. *B. d. f. Z.; B. H. I.; Bull. sig. 525, 526; I. B. Z.; Rép. d'art.*

✓ **Q26**    Antiques, v.1, 1922- . N.Y., Editorial publications. Monthly; publisher varies.
Primarily devoted to American decorative and minor arts of the pre-modern period. Well-illustrated articles on historic houses. Also contains articles on American painters and sculptors. Signed book reviews, notes on exhibitions, notes on major museum acquisitions. Indexes; v.1-30 (1922-36); v.1-40 (1922-41); v.41-50 (1942-46); v.1-70 (1922-56); v.71-80 (1957-61); v.81-90 (1962-66); v.91-100 (1967-71). *Art index* (1969- ); *ARTbib. curr.; ARTbib. mod.; R. G.*

**Q27**    Antiquity; a quarterly review of archaeology, v.1, 1927- . Cambridge, Eng., Antiquity Publications. Quarterly; subtitle, publisher vary. (Repr.: v.1-35 [1927-61], N.Y., Johnson.)
Excavations and field reports on all areas of archaeology. Signed book reviews and "Book chronicle," a list of new publications. Index, v.1-25 (1927-51). *Art index; B. d. f. Z.; B. H. I.; Bull. sig. 525, 526; Hum. ind.; I. B. Z.; Rép. d'art.*

**Q28**    Aperture, v.1, April 1952- . Millerton, N.Y. Quarterly, irregular, 1952-75; bimonthly, 1976- ; publisher, place vary.
Through 1975 each issue was a portfolio of photographs, a monographic study of a particular artist, or a treatment of one theme with accompanying essays. Beginning in 1976 *Aperture* includes more studies concerning the history of photography as an art form. *A. D. P.; Art index* (1952-69; 1979- ); *ARTbib. curr.; ARTbib. mod.; LOMA.*

**Q29** ✓ Apollo; a journal of the arts, v.1, 1925- . London, Apollo Magazine. Monthly; subtitle, publisher vary. (Repr.: v.1-90 (1925-69), Nendeln, Liechtenstein, Kraus-Thomson, 1975-76.)
Current editor: Denys Sutton.
    A journal of the highest quality, with excellent articles directed to the art lover and the art historian. Concentrates on painting, the decorative arts, collections, and exhibitions. Some issues are devoted to a single theme. Brief notes of art events and sales. Signed short reviews. Well illustrated, with many color plates. *A.B.P.; Art index; ARTbib. curr.; ARTbib. mod.; LOMA.*

**Q30**    Archaeologia; or miscellaneous tracts relating to antiquity, v.1, 1773- . Oxford, Society of Antiquaries of London. Biennial, v.101, 1967- ; frequency varies 1932-66; annual 1773-1931.
The emphasis is on Greek, Roman, and British archaeology, with consideration of medieval and later subjects. Archival material frequently printed. *Art index; B. d. f. Z.; Bull. sig. 525; I. B. Z.; Poole's; Rép. d'art; Subj. ind.*
————. Index to the first fifteen volumes, 1809. 290p.
————. Index to Archaeologia . . . Volume XVI to XXX . . ., 1844. 309p.
————. Index. v.1-50, 1889. 806p.

**Q31**    The Archaeological journal, v.1, 1844- . London, Royal Archaeological Institute of Great Britain and Ireland. Annual; frequency varies.
Articles on archaeology and medieval art of Great Britain and Ireland. Reviews and proceedings of Institute meetings. *B. d. f. Z.; Bull. sig. 525; I. B. Z.; Rép. d'art; Subj. ind.*
————. Index, v.1-25, London, 1878. 303p.
————. Index, v.26-50, London, 1955. 287p.

**Q32**    Archäologische Mitteilungen aus Iran, Bd. 1-9, 1929-38; n.F., Bd. 1, 1968- . Berlin, Reimer. Annual, irregular. (Repr.: N.Y., Johnson, 1966.)
Scholarly treatment of art and texts of the ancient Near East. Plates accompanying 1st ser. pub. as *Iranische Denkmäler.* Neue Folge published by the Deutsches Archäologisches Institut, Abteilung Teheran. Indexed; *B. d. d. Z.; Bull. sig. 526; I. B. Z.*

**Q33**    Archäologischer Anzeiger, 1889- . Berlin, de Gruyter. Quarterly.
"Beiblatt zum Jahrbuch des Deutschen Archäologischen Instituts"; early years are part of Deutsches Archäologisches Institut. *Jahrbuch,* Bd. 4-82, 1889-1967. Contains reports of the Institut, proceedings of the Archäologische

Gesellschaft zu Berlin, notices, bibliographies, etc. *Art index* (1929-40, 1969- ); *B. d. d. Z.; Bull. sig. 525, 526; I. B. Z.; Rép. d'art.*

Q34 Archaeology; a magazine dealing with the antiquity of the world, v.1, March 1948- . N.Y., Archaeological Institute of America. Quarterly.
Fairly short, well-illustrated articles of a somewhat popular nature, and brief news notes. Signed reviews and list of books received. *Art index; B. d. f. Z.; Bull. sig. 525; Hum. ind.; I. B. Z.*

Q35 Archaiologika analekta ex Athenon / Athens annals of archaeology, etos 1, 1968- . Athēnai, General Inspectorate of Antiquities and Restoration. 3 times a year.
Well-illustrated, short articles on new research in Greek archaeology. Greek text with translations or summaries as well as occasional contributions in English, French, Italian or German. *Bull. sig. 525.*

Q36 Archaiologikē ephēmeris, [per. I] okt. 1837-60; per. II, v.1-17, 1862-74; per. III, 1883-1915; 1916- . Athens. Frequency varies, irregular; currently annual.
Title varies: 1837-60, 1883-1909, *Ephēmeris archaiologikē.* Not pub. July 1843-Oct. 1852, 1863-68, 1871, 1873, 1875-82. Text in Greek; treats Greek art and archaeology. Announcements of new books in various languages; signed reviews. *B. d. f. Z.; I. B. Z.; Rép. d'art.*

Q37 Architects' yearbook, v.1, 1945- . London, Elek. Biennial; irregular.
Each volume is a compilation of essays, original and reprinted, on a specific theme; each has a different editor. Many black-and-white illustrations and plans. *Art index* (1969- ); *ARTbib. curr.*

Q38 Architectura; Zeitschrift für Geschichte der Baukunst/Journal of the history of architecture, no. 1, 1971- . München, Berlin, Deutscher Kunstverlag. Semiannual.
An important new periodical in the field of architectural history. Scholarly articles by leading historians on all periods and styles. Lengthy signed book reviews. Articles in German and English. *Art index* (1979- ); *ARTbib. mod.*

Q39 Architectural forum, v.1-140, no. 2, 1892-Mar. 1974. N.Y., Whitney Publications. Monthly (10 nos. per yr.); publisher, place vary.
Title varies: v.1-25, *The Brickbuilder;* absorbed *The Architect's world* Oct. 1938. The major U.S. architectural periodical for generations. Articles cover contemporary architecture. Publication suspended Sept. 1964-Mar. 1965. Short book reviews. *Ann. mag. subj. ind.; Art index; ARTbib. curr.; ARTbib. mod.; A. S. T. ind.; I. B. Z.; Eng. ind.; I. B. Z.; LOMA; P. A. I. S.; R. G.; Subj. ind.*

Q40 Architectural history; journal of the Society of Architectural Historians of Great Britain, v.1, 1958- . London, Gabare. Annual.

Specialized articles by scholars on all periods of architecture, with major emphasis on British architecture and architects of the last 300 years. Valuable for championing the cause of preservation. Long signed book reviews. *Art index* (1979- ); *ARTbib. curr.; ARTbib. mod.; Rép. d'art.*

Q41 The Architectural record; an illustrated monthly magazine of architecture and the allied arts and crafts, v.1, July 1891- . N.Y., McGraw-Hill. Quarterly, 1891-1902; monthly, 1902- ; subtitle varies, dropped with v.71.
Incorporated *The American architect and architecture,* Mar. 1938. Articles and notes on architecture, building, housing, and urban planning. Directed to the practicing architect in the U.S. Great American architects series, no. 1-6, May 1895-July 1899, issued as extra nos. of the periodical. *Art index; ARTbib. curr.; A. S. T. ind.; B. d. f. Z.; Eng. ind.; P. A. I. S.; Poole's; Subj. ind.*
———. Index, 1891-1906. 16p.

Q42 The Architectural review, v.1, 1896- . London, Architectural Pr. Monthly; subtitle varies.
A lively, influential review of recent architecture, history, urban design, and theory supplemented by shorter notes on contemporary architectural developments. Several special issues were later published separately. The emphasis is on England. Well illustrated. Signed reviews, exhibition notes, and list of books received. *A.D.P.; Art index; ARTbib. curr.; ARTbib. mod.; B. d. f. Z.; B. H. I.; LOMA; Rép. d'art.*

Q43 The Architectural review, v.1-16; v.17, no. 1-4, Nov. 2, 1891-Apr. 1910; v.18-[28] (n.s. v.1-13), Jan. 1912-July 1921. Boston [Bates, Kimball & Guild, etc.] 8 numbers a year, Nov. 1891-Dec. 1898; monthly, Jan. 1899-1921; publisher, place vary.
Publication suspended May 1910-Dec. 1911 and Apr. 1914-Aug. 1915. Combined with *American architect* Aug. 31, 1921 under title *The American architect and The Architectural review.* Supersedes *Technology architectural review.* A well-illustrated general architectural periodical similar in format to *International studio.*

Q44 Architecture, v.1-73, Jan. 1900-May 1936. N.Y., Scribner. Monthly; publisher varies.
v.1-10 also numbered as whole no. 1-60. Combined with *American architect* June 1936. Emphasis is on U.S. architecture. Richly illustrated, especially valuable for the illustrations of buildings in New York. Occasional short book reviews. Index issued for every 2v. *Art index* (v.59-73, 1929-May 1936); *Ann. mag. subj. ind.; Ind. arts ind.; Subj. ind.*

Q45 L'Architecture d'aujourd'hui, année 1, 1930- . Boulogne (Seine). Bimonthly; frequency varies.
Articles on contemporary architecture throughout the world, with occasional issues devoted to a specific subject. Older issues have "Bibliographie" and "Revue des revues." English summaries. *Art index* (1948- ); *ARTbib. curr.; B. d. f. Z.; I. B. Z.; LOMA; Rép. d'art.*

Q46   Architecture plus; the international magazine of architecture, v.1-2, 1973-74 . N.Y., Informat. Monthly.

Informative articles on contemporary international architecture of all types—public, residential, business, etc. Also a news notes section on architects and new projects.

Q47   L'Architettura; cronache e storia, anno 1, magg./giugno 1955- . Roma, Etas-Kompass. Monthly.

Supersedes *Metron, architettura urbanistica.* Coverage is international in scope with emphasis on current architecture, urban design, and architectural history in Italy. Well illustrated with photographs, plans, and diagrams. Brief book reviews and convention notes. *Metron* indexed in July and Aug. 1956 issues of *Palladio.* Summaries in English, French, Spanish, and German. *Art index; ARTbib. curr.; B. d. f. Z.; I. B. Z.; Rép. d'art.*

Q48   Archives alsaciennes d'histoire de l'art, année 1-16, 1922-48. Strasbourg, Paris, Istra. Annual to 1936, one issue 1948. (Repr.: Année 1-16 (1922-48), Amsterdam, Swets & Zeitlinger, 1970.)

Covers documents of Alsatian art, architecture, and minor arts from medieval times, with some contemporary art. Ann. 16 has title: "Trois siècles d'art alsacien." Extensive signed book reviews. Ann. 15 contains "Sommaire des années" by volume number.

———. Table générale des matières, première à douzième année (1922-33). Strasbourg, 1934. 50p.

Archives de France. See: Sources and Documents (H131, H144).

Q49   Archives of American art. Journal, v.1, 1960- . Wash., D.C., Smithsonian Institution. Quarterly; place varies.

Title varies: May 1960-June 1962, *Bulletin*; Sept. 1962-Oct. 1963, *Quarterly bulletin.* Continues and complements an earlier series in *The Art quarterly* v.17-27. v. for 1960-69 issued by the Detroit Archives of American Art; 1970- , by the Archives as a division of the Smithsonian Institution. Reproduces material on file in the Archives; lists new acquisitions. Some issues devoted to one artist or theme. *A. D. P.; ARTbib. curr.; ARTbib. mod.*

Q50   Archives of Asian art, v.1, 1945/46- . N.Y., Asia Society. Annual.

Title varies: v.1-19, Chinese Art Society of America. *Archives.* Beginning with v.20, scope expanded to cover all Asian art. Scholarly articles and papers, many of which were first presented as lectures before the Society. Illustrated lists with short descriptions of objects acquired by American museums. *Art index* (1979- ); *ARTbib. curr.; ARTbib. mod.; Bull. sig. 526.*

Q51   Archivio storico dell'arte, anno 1-7, 1888-94; ser. 2, anno 1-3, 1895-97. Roma, Danesi. Monthly 1889-90; bimonthly 1891-97; publisher varies.

Superseded by *L'Arte* (Q78). Emphasis is on the Italian Renaissance, but includes contemporary art of Italy and other countries. Many contributions by well-known authori-

ties. Signed book reviews. Indexed with *L'Arte; Italy. Parl. Cam. dei Deputati Bibl.*

Q52   Archivo español de arqueología, t.14, no. 40, 1940- . Madrid, Instituto Español de Arqueología. Semiannual.

Continues in part *Archivo español de arte y arqueología.* Scholarly articles on Spanish archaeology, signed reviews, "Bibliografia." *Art index* (to 1968); *B. d. f. Z.; Bull. sig. 526; Rép. d'art.*

Q53   Archivo español de arte, t.14, no. 40, 1940- . Madrid, Consejo Superior de Investigaciones Científicas. Instituto Diego Velázquez. Bimonthly, t.14-18; quarterly, t.19- .

Continues in part *Archivo español de arte y arqueología.* Scholarly articles on Spanish art of all periods. Includes the basic current bibliography on Spanish art (A161). Signed reviews. *Art index; ARTbib. curr.; ARTbib. mod.; B. d. f. Z.; Bull. sig. 526; I. B. Z.; Rép. d'art.*

Q54   Archivo español de arte y arqueología, t.[1]-13, no. 1-39 (1925-37). Madrid, Centro de Estudios Históricos. 3 times a year.

This scholarly journal devoted to Spanish art and archaeology was continued in 1940 by two separate publications: *Archivo español de arte,* t.14, no. 40- (Q53), and *Archivo español de arqueología,* t.14, no. 40- (Q52). Contains signed book reviews and brief notices of pertinent periodical articles. *Art index; B. d. f. Z.*

Q55   Arkhitektura SSSR, 1933-1948; 1951- . Moskva. Monthly.

Publication suspended 1948-Oct. 1951. Issues for 1942-47 appeared irregularly. Organ of the Akademiĩa Arkhitektury SSSR, Soĩuz Sovetskikh Arkhitektorov & Upravlenie po delam Arkhitektury pri Sovete Ministrov RSFSR. The leading architectural periodical of Russia. Well illustrated. *ARTbib. curr.: Rép. d'art.*

Q56   Ars hungarica. Bulletin of the Institute of Art History of the Hungarian Academy of Sciences, 1973- . Annual.

Well-illustrated, scholarly, art historical articles on Hungarian art of all periods. French résumés.   *Rép. d'art.*

Q57   Ars islamica, v.1-15/16, 1934-51. Ann Arbor, Mich., Univ. of Michigan Pr. Semiannual. (Repr.: v.1-15/16 in 3v., N.Y., Kraus.)

Publication suspended 1949-50; pub. by the Research Seminary in Islamic Art Division of Fine Arts, Univ. of Michigan, and the Detroit Institute of Arts. Continued by *Ars orientalis* (Q58). Articles in English, with some in French and German, are contributed by specialists in Islamic arts and crafts. v.5 has supplements: "Preliminary materials for a dictionary of Islamic artists." v.8 is devoted to reviews of Pope's *Survey of Persian art.* "Literature on Islamic art, 1939-1945" pub. in v.13-14, 1948, p.[150]-79, and in v.15-16, 1951, p.[151]-211. Entries arranged by country of publication and comp. by scholars in each country. v.15-16 also

contains "Indices to 'Material for a history of Islamic textiles up to the Mongol conquest,' by R. B. Serjeant," p.[273]-305. Signed book reviews are included. Indexes: "Contents arranged according to subject," v.1-5 and v.1-10; v.1-16 (by author and subject) in v.15-16, p.[307]-28. *Art index.*

Q58    Ars orientalis; the arts of Islam and the East, v.1, 1954- . Wash., D.C., Freer Gallery of Art and the Univ. of Michigan Fine Arts Dept. Irregular.

Succeeds *Ars islamica* (Q57). Scholarly articles, copiously illustrated with plates, line drawings, and maps. Signed reviews and bibliographies. *Art index; Bull. sig. 526; I. B. Z.*

Q59    L'Art; revue bi-mensuelle illustrée, année 1-27, t.1-68, 1875-1907. Paris, Librairie de l'art. Bimonthly, 1884-94; monthly, 1901-07.

t.1-35 have subtitle: *Revue hebdomadaire illustrée.* Suspended 1894-1901. t.36-59 also called 2. sér., t.1-24; t.60-68 also 3. sér., t.1-9. Particular emphasis is on French art, including music and literature; long articles on the Salons. Long signed reviews, some illustrated. *Italy. Parl. Cam. dei Deputati Bibl.*

Q60    Art and archaeology; the arts throughout the ages. v.1-35, no. 3, July 1914-May/June 1934. Wash., D.C., Archaeological Society of Wash., D.C., Bimonthly, 1914-15, 1918-19, 1932-34; monthly, 1916-17, 1920-31; publisher, place vary.

Absorbed *Art and life,* May 1920. Contains popular treatments of the fine arts and archaeology, with shorter news notes and some signed book reviews. Includes non-technical material formerly covered in the *Quarterly bulletin* of the Archaeological Institute of America. *Ann. mag. subj. ind.; Art index (v.27-35, no. 3, 1929-34); B. d. f. Z.; R. G.; Subj. ind.*

Q61    Art and artists; international art guide, v.1, April 1966- . London, Hansom Books. Monthly.

Articles on contemporary artists. Signed book reviews and exhibition reviews. *A. D. P.; Art index (1969- ); ARTbib. curr.; ARTbib. mod.; LOMA.*

Q62    The Art bulletin, v.1, 1913- . N.Y., College Art Association of America. Irregular, 1913-18; quarterly, 1919- ; place varies. (Repr.: v.1-52 (1913-69), N.Y., Kraus.)

Publication suspended 1914-1916, Sept.-Dec. 1928. The official publication of the College Art Association. Contains long scholarly articles on topics of art history, as well as shorter notes. Lengthy signed book reviews. Indexes: v.1-20, 1938, 11p., by subject; *An index of v.I-XXX, 1913-1948,* 1950, 426p., also lists contents chronologically. *A. D. P.; Art index; ARTbib. curr.; ARTbib. mod.; B. d. f. Z.; Rép. d'art; Subj. ind.*

Q63    L'Art d'aujourd'hui, v.1-6, 1924-29. Paris, Morancé. Quarterly, v.1; annual, v.2-6.

Short articles on individual artists, with many valuable plates for the study of modern art. v.6 indexes artists covered in v.1-6 with plate numbers. *Rép. d'art.*

Q64    Art de France; étude et chroniques sur l'art ancien et moderne . . . , no. 1-4, 1961-64. Paris, Art de France. Annual.

A luxury format. The lavishly-illustrated articles by recognized scholars concentrate largely on French art and architecture from prehistory to the present. *Rép. d'art.*

Q65    Art et décoration; la revue de la maison, t.1-67, 1897-1938; n.s. no. 1-2, 1939; 3. sér. no. 1, 1946-50. Paris, Massin. 7 times a year; frequency, subtitle vary.

Suspended Aug. 1914-Apr. 1919, Feb. 1939-46. Absorbed *L'Art décoratif* Jan. 1922, *L'Architecture* July 1925, and *L'Architecte* July 1936. Covers modern art in general, architecture, and especially interior design and the decorative arts. Exhibition announcements and some book reviews. *Art index* (v.55-n.s. no. 2; no. 7-142, 1948-69); *B. d. f. Z.; I. B. Z.*
———. Table des matières contenus dans les 12 premières années. t.I-XXIV (1897-1908), Paris, 1910. 64p.

Q66    L'Art et les artistes, t.1-23, no. 5, avr. 1905-fév. 1919; n.s. t.1-38; no. 1-199, avr. 1919-juil. 1939. Paris. Monthly; subtitle varies.

During World War I (t.20-23) only special numbers were published. New ser., t.1-38, also called ann. 14-34. Fairly popular coverage of painting, sculpture, and prints, as well as some architectural and applied arts. Well illustrated. Various numbers are devoted to particular artists or subjects. *Art index* (n.s., v.18, March 1929- ); *B. d. f. Z.; Subj. ind.*

Q67    L'Art flamand & hollandais; revue mensuelle illustrée, t.1-22, 1904-14. Anvers, van Oest. Monthly.

Suspended 1915-20, for which years see *Onze kunst* (Q261). v.23, 1921, called *Revue d'art,* which continues to 1929. Articles are contributed by specialists on Dutch and Flemish art of all periods. Signed book reviews and a section of short reviews of exhibitions, news of the art world, and résumés of important articles in the field are included. Illustrated with black-and-white halftones; almost no color plates. *Bibl. de Belgique; Rép. d'art.*

Q68    Art in America, v.1, 1913- . N.Y., Art in America, Inc. Bimonthly, v.1-20, v.51- ; quarterly, v.21-50; title, place vary. (Repr.: v.1-38 (1913-50), N.Y., AMS Pr., 1971.)

Articles are on all aspects of American art, often by well-known scholars. Each issue of v.38-51 (Feb. 1950-Feb. 1963) is "devoted . . . to four special publications in the field of American art research, some in conjunction with coordinated exhibitions." Signed book reviews. *A. D. P.; Ann. mag. subj. ind.; Art index; ARTbib. curr.; ARTbib. mod.; B. d. f. Z.; I. B. Z.; LOMA; Rép. d'art; Subj. ind.*

Q69    Art international, v.1, 1956- . Lugano, Switzerland, Fitzsimmons. 10 times a year; place varies.

Supplies current information on international art events, i.e. calendars, competitions and prizes, auctions, art-world news, art books, reviews of exhibitions, etc. Not primarily a

journal of criticism or art history *A. D. P.; ARTbib curr.; ARTbib. mod.; LOMA; Rép. d'art.*

**Q70**   The Art journal, v.1-74, no. 1-884, Feb. 1839-Feb. 1912. London, Virtue. Monthly.
Title varies; v.1-10 called *The Art union; a monthly journal of the fine arts.* 1851-54 called n.s., v.3-6; 1855-61 called n.s., v.1-7; 1862-80 called n.s., v.1-19; 1881-1902 called n.s. (without volume numbers). An American ed. was also published with largely American emphasis in its articles. A popular review containing many very short pieces on a variety of subjects: museums, collections, exhibitions, types of art. Some book reviews.

**Q71**   Art journal, v.1. Nov. 1941- . N.Y., College Art Association of America. Quarterly.
Title varies: v.1-19, *College art journal;* supersedes *Parnassus.* Once the organ of the Association, it listed programs of meetings and abstracts of papers presented. Now it contains scholarly articles, and notes on teaching appointments, dissertations in progress, acquisitions, and exhibitions of colleges, universities, and museums. Signed book reviews and "Books received"; some articles on art education. *A. D. P.; Art index; ARTbib. curr.; ARTbib. mod.; B. d. f. Z.; I. B. Z.; LOMA; Rép. d'art.*

**Q72**   Art libraries journal, v.1, pt. 1, spring 1976- . London, Art Library Society. Quarterly.
Supersedes *ARLIS newsletter* (Q3). Articles, reviews, bibliographies for "documentation and librarianship of art and design throughout the world."

**Q73**   Art news, v.1, 1902- . N.Y., Art news. Semi-monthly to Feb. 1946; 10 times a year, 1946- ; publisher varies.
Title varies: Nov. 1902-Apr. 1904, *Hyde's weekly art news;* Nov. 1904-Feb. 1923, *American art news.* Earlier volumes contain general art history with an American emphasis; more recently a rather popular news magazine concerning American exhibitions, collections, individual works, and sales. Prior to Fall 1972 contained an international exhibition calendar and brief reviews of one-man shows. Signed book reviews. *A. D. P.; Art index; ARTbib curr.; ARTbib mod.; B. d. f. Z.; Bull. sig. 526; I. B. Z.; LOMA; R. G.; Rép. d'art.*

**Q74**   Art news annual, v.1-38, 1927-73. N.Y., Newsweek. Annual; publisher varies.
Assumed the volume numbering of *Art news annual* which was issued as a separate section of *Art news* (Q73), 1926-59, and *Portfolio,* 1959-62, which it superseded. Not published 1932-36, 1941-42.
Extensively illustrated articles by known scholars of all periods. Frequently devoted to one theme. Brief section on activity in the art world for the previous year. *A. D. P.; Art index; ARTbib. curr.; I. B. Z.; LOMA.*

**Q75**   The Art quarterly, v.1, winter, 1938-v.37, spring 1974. [Detroit] Detroit Institute of Arts; n.s., v.1, 1977- . N.Y., Metropolitan Museum of Art. Quarterly.
Editor (1969-74); 1977- : Jerrold Lanes.

An important art history journal with excellent articles on art of all periods. The new *Art quarterly,* under the same editiorial leadership, promises to continue its tradition of critical scholarship.
"Archives of American art," v.17-27, includes notes, archival material, and illustrations of recent important acquisitions of American museums. Acquisitions list continued but the archival material is now published in the *Journal of the Archives of American Art.* Beginning with v.9- , most issues have "Recent publications in the field of art." Occasional contributions in French and German. Signed book reviews. *A. D. P.; Art index; ARTbib. curr.; ARTbib mod.; B. d. f. Z.; Bull. sig. 526; I. B. Z.; LOMA; Rép. d'art.*

**Q76**   Art studies; medieval, Renaissance and modern. [v.1-8], Cambridge, Mass., Harvard Univ. Pr., 1923-[31]. Annual.
v.1-2 pub. by Princeton Univ. Pr. "Edited by members of the departments of the fine arts at Harvard and Princeton universities." v.1-5 are called "an extra number of the *American journal of archaeology.*"
Lengthy articles treat art in general; no book reviews are included. *Art index* (v.7-8); *B. d. f. Z.; Subj. ind.*

**Q77**   L'Art vivant, no. 1-234, 1925-juil. 1939. Paris, Larousse. Semimonthly, 1925-30; monthly, 1931-39.
1925-30 called t.1-6; 1931-39 not numbered. A popular review of contemporary French plastic art and "industries de luxe": fashion, decorative arts, etc.; also gives news of exhibitions and sales, with some longer articles devoted to contemporary painting and art of the old masters. *B. d. f. Z.*

**Q78**   L'Arte, anno 1-62, 1898-1963, Roma, Casa editrice de L'Arte, 1898-1963; nuova edizione anno 1-4, 1968-71. Milano, Istituto Editoriale Italiano; University Park, Pennsylvania State Univ. Pr. Bimonthly through 1935; 1936- frequency varies; 1968-71, quarterly.
All issues available on microfilm: Cambridge, Eng., Chadwyck-Healey; Teaneck, N.J., Somerset House.
v.33-62, 1930-63 called also *nuova ser.,* anno 1-28; vols. 71- , 1968- , called also *nuova edizione,* anno 1. v.63-70 never published. Supersedes *Archivio storico dell'arte* (Q51).
A major periodical of art history. Founded by Adolfo Venturi. "The early volumes of *L'Arte* tend to reflect Venturi's personal style of historical connoisseurship (in the line of Cavalcaselle), but within a decade or so the Crocean theory was finding rich application in the articles of Roberto Longhi or Lionello Venturi (Adolfo's son). The prominence now accorded to criticism among the younger art historians inevitably raised the issue of contemporary art — which most traditional scholars had preferred to ignore. For the first time art history was dragged into the polemics of modernism."—Trevor Fawcett, *The Art press,* p.17-18. 1898-1963 primarily on Italian art; 1968-71 international coverage with articles in various Western languages. Signed reviews, exhibition notes. In anno 8, 1905- of *Archivio . . .* classified summaries of articles and books on Italian art,

"Bollettino bibliografico." *Art index* (anno 32-43); *ARTbib. curr.; B. d. f. Z.; Rép. d'art.*

————. Archivio storico dell'arte (1888-97) e L'Arte (1898-1929) indice generale dei quarantadue volumi. Roma, 1930. 511p.

————. Indice dei fascioli dal 1944-57. 28p.

Q79    Arte antica e moderna, t.1-34/36, 1958-66. Firenze, Sansoni. Quarterly, issues frequently combined.
"Rivista degli Istituto di Archeologia e di Storia dell'Arte dell'Università di Bologna e dei Musei del Commune di Bologna." Scholarly articles on the history of Italian art and architecture from classical times to the Baroque period. Includes archival material; signed book reviews; some contributions in English. *Rép. d'art.*

Q80    Arte español; revista de la Sociedad Española de Amigos del Arte, año 1-44 (t.1-24), 1912-61. Madrid. Frequency varies; since 1947, 3 times a year.
Title varies: 1932-June 1936, *Revista española de arte.* An important, well-illustrated periodical concerning Spanish art from antiquity to the present. Book reviews, some signed. *B. d. f. Z.; Rép. d'art.*

Q81    Arte illustrata, no. 1-51, gennaio 1968-72. Milano, Algranti. Monthly, many issues combined.
Originally subtitled *Rivista d'arte antica e moderna, arti minori, critica e documentazione d'attualita' artistica.* International contributions to Italian art history; well illustrated, includes book and exhibition reviews. Text primarily in Italian or English. *A. D. P.; ARTbib. curr.; ARTbib. mod.; LOMA.*

√Q82    Arte lombarda; rivista di storia dell'arte, annata prima, 1955- ; nuova serie, 1975- . Milano, La Rete. Annual.
Volumes for 1967- issued by the Istituto per la Storia dell'Arte Lombarda. Semiannual 1955-70; annual 1971- . A scholarly journal with articles concerning the history of art in Lombardy. Handsomely produced with excellent illustrations. Text in French, German, English, and Italian. Includes archival material. Latest issues are hardbound. Includes exhibitions notes, notes of new books, and signed book reviews. *ARTbib. curr.; Rép. d'art.* Index, v.1-12 (1955-67) in v.13, 1968.

√ Q83    Arte veneta; rivista di storia dell'arte, anno 1, 1947- . Venezia, Alfieri. Quarterly, v.1-7; annual, v.8- . (Repr.: v.1-22 (1947-69), Amsterdam, Swets & Zeitlinger.)
Well-illustrated, scholarly articles on Venetian art of all periods, some archival material. Contains current bibliographies on Venetian art. Similar to *Arte lombarda. ARTbib. curr.; Rép. d'art.*

————. Indici analitici dal 1947 al 1951. Venezia. 103p.

Q84    Artes; monuments et memoires, v.1-8, 1932-40; [n.s.] v.1-2, 1965-66. Copenhagen, Haase. Annual; publisher varies.
Its scope was Danish art history and foreign art in Danish collections. In French, German, and Italian. *B. d. f. Z.; Rép. d'art.*

Q85    Artes de México, no. 1, 1953- . México, D.F., Universidad Nacional de México. Monthly, irregular.
Subtitle varies: no. 1-6, *Revista bimestral editada por el Frente Nacional de Artes Plásticas.* Handsomely produced; covers all periods and types of fine arts and folk arts in Mexico. Emphasis is on current developments. English and French summaries. *Art index* (to 1969); *ARTbib. curr.; ARTbib mod.; LOMA; Rép. d'art.*

Q86    Artforum, v.1, 1962- . N.Y., Charles Cowles. 10 times a year; place varies.
One of the most influential magazines of recent art. Important for the articles on contemporary art and artists, and modern art theory and criticism. Includes photography and film; exhibition reviews. *A. D. P.; Art index* (1969- ); *ARTbib. curr.; ARTbib. mod.; LOMA.*

————. Cum. index, v.1-6, 1962-68.

Q87    Le Arti, rassegna bimestrale dell'arte antica e moderna a cura della direzione generale delle arti, anno 1-5, ott./nov. 1938-43. Firenze, LeMonnier. Bimonthly.
Replaced *Bollettino d'arte* during the war years. Long articles by important scholars covering ancient art and Italian art of all periods, including modern. Contains an illustrated section concerning restoration of works of art in various Italian museums, a series of documents on Italian art edited by Pèleo Bacci, some articles on music, and limited material on the current theater. During the war years there was a section devoted to the war and the activities of prominent people. Signed book reviews. *Art index* (v.1-2); *Italy. Prov. Gen. dello Stato.*

Q88    Artibus Asiae, v.1, 1925/26- . Ascona, Switzerland, Artibus Asiae; N.Y., New York Univ., Institute of Fine Arts. Quarterly, some double nos. (Repr.: v.1-21 (1925/26-58), N.Y., Johnson.)
Suspended 1938-39; publisher varies. Current editor-in-chief: Alexander Coburn Soper.
Contains scholarly articles (in English, German, and French) on all areas of Asiatic art and archaeology. *"Artibus Asiae* considers as its main purpose the presentation of hitherto unknown excavations and objects as well as new theories concerning known material." Includes book reviews of varying lengths in the "Bibliographia" section. Also publishes a monographic series *Artibus Asiae. Supplementum* (R10); *Art index* (1948- ); *ARTbib. curr.; B. d. f. Z.; Bull. sig. 525, 526; I. B. Z.; Rép. d'art.*

Q89    L'Artiste; revue de l'art contemporain, [sér.1] v.1-15, 1831-38; sér.2, v.1-8, 1839-41; sér.3, v.1-5, 1842-44; sér.4, v.1-11, 1844-48; sér.5, v.1-16, 1848-56; sér.6, v.1-3, 1856-57; [sér.7] n.s. v.1-12, 1857-61; [sér.8] 1862-90; [sér.9] n.s. v.1-14, 1891-97; [sér.10] v.1-7, 1898-1904. Paris. Frequency and subtitle vary. (Repr.: sér.1-2, Geneva, Slatkine, 1972.)
The major 19th-century journal of French and other European art. Valuable for research; includes exhibition information and reviews.

Q90    Artists' proof; the annual of prints and print making, v.1–11, 1961–71. N.Y., Pratt Graphic Art Center. Annual; semiannual, no. 1–8 (also called v.1–5).
Very well produced volumes covering primarily contemporary printmakers and their techniques. Short articles. Each issue has at least one original print. Also surveys printmaking of a particular area or period. Reports on individual collections and workshops. Book reviews, lists, and news notes of exhibitions and individual artists. *Art index* (1969–71).

Q91    The Arts, v.1–18, no. 1, Dec. 4, 1920–Oct. 1931. N.Y., The Arts pub. corp. 10 times a year.
Hamilton Easter Field, ed. and pub., v.1–2; Forbes Watson, ed., v.3–18. Followed by *The Arts weekly*, Mar.–May 1932. Absorbed *Touchstone*, June 1921. A popular publication which contains some sound material. Its particular emphasis is on American art, but it also covers European exhibitions. Signed book reviews. Good illustrations. *Ann. mag. subj. ind.; Art index* (v.15–18); *Int. ind.*

Q92    Les Arts anciens de Flandre, t.1–6, 1905–14. Bruges, Association pour la Publication des Monuments de l'Art Flamand. Quarterly.
Useful for Flemish medieval, Renaissance, and later art. Also some articles on private collections.

Q93    Arts and architecture, v.1–84, 1911–no. 7/8, 1967. Los Angeles, Entenza. Monthly; frequency varies. Vol. numbers irreg.
Originally *The Pacific coast architect*; merged with *Pacific southland* to form *California arts and architecture*, v.35–61, 1920–44. Very useful for the study of American architecture of the West Coast. Some book reviews.

Q94    Arts & decoration, v.1–55, no. 2, Nov. 1910–Mar. 1942. N.Y., Adam Budge. Monthly; publisher, subtitle vary.
Absorbed *The Art world*, Mar. 1918; from May 1918–Jan. 1919 called *The Art world and Arts & decoration*. Combined with *The Spur* July 1941. A popular magazine of decorative arts which covers all aspects of gracious living, including decoration, gardens, the theater, etc. Occasional short reviews. *Ann. mag. subj. ind.; Art index* (v.31–55); *R. G.*

Q95    Arts asiatiques, t.1, 1954– . Paris, Presses Universitaires de France. Quarterly. (Repr.: v.1–8, Nendeln, Liechtenstein, Kraus-Thomson.)
Published for the Musée Guimet and the Musée Cernuschi. Replaces *Revue des arts asiatiques*. Scholarly articles by specialists on the art of India, Indo-China, and the Far East. Signed reviews. *Art index* (1979– ); *ARTbib. curr.; B. d. f. Z; Bull. sig. 525, 526; I. B. Z.*

Q96    Arts in society, v.1, 1958/60– . Madison, Wis., Research Studies and Development in the Arts, Univ. Extension, Univ. of Wisconsin. Quarterly, irregular. (Repr.: v.1–3 (1958/60–1964/66), N.Y., Johnson.)
Social commentary on contemporary art, architecture, and environmental planning. Most issues are thematic. Lengthy signed reviews. *A. D. P.; ARTbib. curr.; ARTbib. mod.; Hum. ind.; LOMA.*

Q97    Arts-loisirs, no. 1–1054, jan. 31, 1945–sept. 22, 1965; n.s., no. 1–88, sept. 29, 1965–juil. 1967. Paris. Weekly.
Continues *Beaux-arts; revue d'information artistique*. Title varies: no. 1–352, *Arts; beaux-arts, littérature, spectacles*; no. 353–n.s., no. 16, *Arts; spectacles*. Georges Wildenstein, director, no. 1–356. Newspaper of the art world, also covering books, films, and the theater. Some reviews. *Art index* (no. 53–177).

Q98    Arts magazine, v.1, Nov. 1926– . N.Y., Art Digest. 10 issues a year.
Title varies: 1926–54, *Art digest*; 1954–55, *Arts digest*; 1955–64 *Arts*; Subtitle varies. Absorbed *Argus* (San Francisco, 1927–29?). Brief authoritative articles and news notes of the people and events in the contemporary art world. Includes articles on the history of 19th- and 20th-century art. Calendar of exhibitions and reviews of gallery shows in major American cities. Also includes art news from abroad. Signed book reviews. *A. D. P.; Art index; ARTbib. curr.; ARTbib. mod.; LOMA.*

Q99    Artscanada, v.1, 1943– . Toronto, Society for Art Publications. Bimonthly, irregular.
Title varies: 1943–66, *Canadian art*. Covers Canadian art and Canadian Indian art. Includes several thematic double issues. Signed reviews. *A. D. P.; Art index; ARTbib. curr.; ARTbib. mod.; B. d. f. Z.; Can. ind.; LOMA.*

Q100    Ausonia; rivista della Società Italiana di Archeologia e Storia dell'Arte, anno 1–10, 1907–21. Roma, Loescher. Annual, sometimes in 2 fascicles.
Suspended 1916–18, 1920. More emphasis on archaeology than on art. Book reviews in "Recensioni" and "Bollettino bibliografico" (v.1–6) with classified review of periodicals. "Notiziario bibliografico (1915–21)" in v.10 has subject arrangement. *B. d. f. Z.; Italy. Parl. Cam. dei Deputati Bibl.*

Q101    Avalanche, no. 1–8, Fall, 1970–Fall, 1973(?). N.Y., Center for New Art Activities. Quarterly, irregular.
Valuable for European and American conceptual art and related movements. Well-illustrated interviews and coverage of art events. Each issue lists new publications in this area: artists' books, exhibition catalogues, and periodicals. *A. D. P.; ARTbib. curr.*

Q102    Baumeister; Zeitschrift für Architektur, Planung, Umwelt. Jahrg. 1, Okt. 1902– . München, Callwey. Monthly; subtitle, publisher, place vary.
Publication suspended Dec. 1944–May/June 1946.
Covers contemporary architecture of various countries, but the emphasis is on Germany. Most reviews are of technical and professional books. Summaries in English. *ARTbib. curr.; B. d. d. Z.; I. B. Z.; Rép. d'art.*

Q103    Beaux-arts; revue d'information artistique, année 1–10, 1923–32; n.s., année 71–80, 1932–44. Paris, Gazette des Beaux-Arts. Semimonthly, 1923–28, 1939–44; monthly, 1929–Sept. 1932; weekly to 1939. Subtitle varies.
In 1932 superseded *Chronique des arts* and assumed its numbering as a n.s. Continued by *Arts-loisirs* (Q97). Covers

art and museum news, sales, exhibitions, etc., primarily for France. Short book-review section. Combined with *Journal des arts* Dec. 1932. *Art index* (1929-June 1940); *B. d. f. Z.*

Q104  Le Beffroi; arts, héraldique, archéologie, t.1-4, 1863-73. Bruges, Gailliard. Annual.
Contains few illustrations but is useful for Flemish art, archaeology, heraldry, and archival information, especially for early Renaissance painting. Index, v.1-4.

Q105  Belvedere, 1-13 Jahrg., 1922-43. Zürich [etc.] Amalthea-Verlag. Monthly; irregular; subtitle, publisher, place vary.
Contains material of interest to collectors and news of sales and the art world, as well as scholarly articles (some still important) dealing mostly with medieval and Renaissance art, with many illustrations. v.5-10, 1924-26, issued in two parts. Second part called "Forum." In v.9-10 the parts are combined. Signed book reviews as well as listings of new publications in the field. *Art index* (v.8-13); *B. d. d. Z.*

Q106  Berytus; archaeological studies, v.1, 1934- . Beirut, American Univ. Annual, irregular, sometimes in two parts; publisher varies.
"Historical and archaeological studies on Syria and Lebanon from prehistoric to early Islamic times."—*Cover statement.* In English, French, or German. "Index v.1-10, 1934-52", in v.11, fasc. 2, 1955. *Art index* (1969- ); *B. d. f. Z.; Bull. sig. 526; Rép. d'art.*

Q107  Biblical archaeologist, v.1, 1938- . Cambridge, Mass., American Schools of Oriental Research. Quarterly.
Intended to "meet the need for a readable, non-technical, yet thoroughly reliable account of archaeological discoveries as they relate to the Bible."—*Editor.* Some book reviews, cumulative index every five years. *Art index; B. d. f. Z.; Bull. sig. 525, 526; I. B. Z.; Rel. Per.; Rép. d'art.*

Q108  La Biennale di Venezia; rivista trimestrale di arte, cinema, teatro, musica, moda, no. 1, 1950- . Venezia, Sansoni. Quarterly; frequency, publishers vary.
Publication suspended Oct. 1970-Nov. 1971, Jan. 1972. Devoted primarily to contemporary art and cultural life. English, French, and German summaries. July 1950-57 have "Bollettino dell'archivio storico d'arte contemporanea della Biennale" listing exhibits in Italy and of Italian art in other countries. This list continues as Archivio storico d'arte contemporanea della Biennale. *Bollettino. ARTbib. curr.; LOMA.*

Q109  The Bijutsu Kenkyu; the journal of art studies, no. 1, Jan. 1932- . Tokyo, Institute of Art Research. 6 times a year, earlier numbers were monthly.
Scholarly coverage of Japanese art and archaeology of all periods except modern. Japanese text with English and/or French summaries; title page in English. *ARTbib. curr.; Bull. sig. 526*

Q110  Bollettino d'arte, anno 1-14, 1907-20; ser.2, anno 1-10, 1921-31; ser.3, anno 25-32, 1931-38; ser.4-5,

anno 33, 1948- . Roma, Libreria dello Stato. Monthly, 1907-38; quarterly, 1948- ; subtitle varies.
Pub. by the Direzione Generale delle Antichità e Belle Arti. Supersedes *Gallerie nazionale italiane.* Suspended 1939-47, replaced by *Le Arti* for those years. Scholarly articles on Italian art of all periods, and classical art of the Mediterranean cultures. Museum notes and short book reviews in ser.4 and 5. *Art index* (1936-38, 1959- ); *ARTbib. curr.; B. d. f. Z.; Bull. sig. 526; Italy. Prov. Gen. dello Stato.; Rép. d'art.*

Q111  Bonner Jahrbücher des Rheinischen Landmuseums in Bonn (im Landschaftsverband Rheinland) und des Vereins von Altertumsfreunden im Rheinlande, v.1, 1842- . Annual.
Suspended 1943-47.
Continues Gesellschaft der Freunde und Förderer des Rheinischen Landmuseums in Bonn. *Bonner Jahrbücher.* Covers a wide range of subjects in the art and archaeology of the Rhineland, prehistorical through the Baroque period. Includes natural history. Lengthy signed reviews. *B. d. d. Z.; I. B. Z.; Rép. d'art.*

Q112  The British journal of aesthetics (British Society of Aesthetics), v.1, 1960- . London, Oxford Univ. Pr. Quarterly. (Repr.: v.1-14, 1961-74, Nendeln, Liechtenstein, Kraus.).
Scholarly articles on aesthetics, philosophy, sociology, and psychology of art. Signed book reviews; "Books received" list. *A. D. P.; Art index; ARTbib. curr.; ARTbib. mod.; B. H. I.; I. B. Z.; LOMA; Rép. d'art.*

Q113  British Museum yearbook, v.1- 1976- . London, British Museum publications.
v.1 is devoted to the classical tradition.
Supersedes the *British Museum quarterly.* Articles on art and archaeology, with particular reference to the museum's collections. "The *Yearbook* . . . contains a number of major articles specially written around a central theme by members of the Museum staff and outside authorities; short notes on a selection of recent acquisitions are included, and both articles and notes are fully illustrated."—R. Brilliant, *Art bulletin,* June, 1977, p.299-300.

Q114  British School at Athens. The annual . . . no. 1, session 1894/95- . London, Macmillan. Annual; publisher varies.
Scholarly articles and reports of excavations. Has supplementary papers. *Art index; B. d. f. Z.; B. H. I.; I. B. Z.; Rép. d'art, Subj. ind.*
_____. Index to nos. 1-16 (1912).
_____. Index to nos. 17-32 (193-?).

Q115  British School at Rome. Papers, v.1, 1902- . London, Macmillan. Annual. (Repr.: v.1-23 (1902-55), N.Y., Johnson.)
Scholarly papers on architecture, archaeology, inscriptions, etc. *B. d. f. Z.; B. H. I.; I. B. Z.; Rép. d'art; Subj. ind.*

Q116  Brussels. Institut Royal du Patrimoine Artistique, Brussels. Bulletin, t.1, 1958- . Bruxelles. Annual.

491

Name of institute also: Koninklijk Instituut voor het Kunst-patrimonium. Scholarly articles on all periods of art represented in Belgian collections, with emphasis on old masters and conservation. Text in Flemish and French, occasionally with English summaries. List of related publications at end of each volume. *Rép. d'art.*

Q117 Bulletin de correspondance hellénique, année 1, 1877- . Paris, Boccard. Semiannual; publisher, place vary. (Repr.: v.1-43 (1877-1917/19) Nendeln, Liechtenstein, Kraus-Thomson.)
Pub. suspended 1942-43. Scholarly articles on Greek art and archaeology. Includes some signed book reviews, news of excavations, and current publications lists. Pub. for the École Française d'Athènes. *Art index* (1929-59); *B. d. f. Z.; I. B. Z.; Rép. d'art.; Rép. bibl.*
_____. Table générale . . . (1877-86). Paris, 1889.
_____. Table quinquennale (1887-91). Paris, 1894.

Q118 Bulletin de l'art ancien et moderne, no. 1-819, 1899-1935 Paris [Petit]. Monthly, irregular, 1922-35; weekly, 1899-1914; semimonthly, 1919-21.
Pub. as a supplement to *Revue de l'art ancien et moderne.* (Q296). Suspended Aug. 1914-Nov. 1919. Covers art news, museum acquisitions, necrology, sales, exhibitions, etc., primarily for France. "Extrait des tables du 'Bulletin'" in index to v.27-71 of *Revue* . . . p.[193]-201. *Art index* (1929-35); *B. d. f. Z.* .

Q119 Bulletin monumental; revue trimestrelle, publiée avec la concours du Centre National de la Recherche Scientifique, t.1, 1834- . Paris., Musée des Monuments Français. Quarterly, v.91- ; frequency, subtitle vary. (Repr.: v.4-28 (1838-63), N.Y., Johnson, 1965.)
Not published 1835, 1900, 1915-19. Pub. for the Société Française d'Archéologie. An important publication on French medieval archaeology, art, and architecture. Lengthy signed reviews. Soc. Franç. d'Archéol. *Table alphabétique* . . . (1930) covers 1834-1925. *Art index* (1970- ); *ARTbib. curr.; Bull. sig. 525, 526; I. B. Z.; Int. index; Rép. d'art; Rép. bibl.*

Q120 Bullettino di archeologia cristiana, anno 1-7, genn. 1863-dic. 1869; 2. ser., anno 1-6, 1870-75; 3. ser., anno 1-6, 1876-81; 4. ser., anno 1-6, 1882-89; [5. ser., anno 1-4, 1890-94]. Roma, Salviucci [etc.]. Monthly, 1863-69; quarterly, 1870-94.
Superseded by *Nuovo bullettino di archeologia cristiana,* (Q257) 1895-1922. Good for early Christian art.
_____. Indici generali della prima serie . . . 1863-69. Roma, 1870. 70p.
_____. Indici generali per gli anni 1870-89 . . . Roma, 1876-91. 3v.

Q121 The Burlington magazine, v.1, 1903- . London, Monthly. (Repr.: v.1-110 (1903-68) and Index, Nendeln, Liechtenstein, Kraus-Thomson, 1970-74.)
A fundamental periodical, with authoritative contributions to all areas of art history. Also reports on sales, exhibitions, and correspondence. Signed reviews and "Publications received." Cumulative index: v.1-104 (1903-62). *A. D. P.; Art index* (v.54- ); *ARTbib. curr.; ARTbib. mod.; B. d. f. Z.; B. H. I.; Bull. sig. 526; Int. Ind.; LOMA; Rép d'art.*

Q122 Byzantinische Zeitschrift, Bd. 1, 1892- . München, Beck. Semiannual; frequency, publisher, place vary. (Repr.: v.1-41 (1892/94-1941), N.Y., Johnson.)
Not pub. 1920-22, 1942; suspended during the war years; v.23 (1914/19) and v.42 (1943/49). Scholarly articles concerning all aspects of Byzantine art and culture. Lengthy signed reviews and many shorter bibliographical notes. Indexes to the bibliographies in v.1-60 (1892-1967); *Dumbarton Oaks bibliographies based on Byzantinische Zeitschrift* (A93). *B. d. d. Z.; I. B. Z.; Rép. d'art.*
_____. General register . . . 1-13, 1892-1903 (1909).

Q123 Cahiers archéologiques, fin de l'antiquité et moyen âge, t.1, 1945- . Paris, Klincksieck. Annual, irregular; publisher varies.
Original research on art and archaeology from late antiquity through the Middle Ages. Index to v.1-10 in v.10; v.11-15 in v.15; v.16-20 in v.20. *Art index* (1979- ); *ARTbib. curr.; B. d. f. Z.; Bull. sig. 526; I. B. Z.; Rép. d'art.*

Q124 Cahiers d'art, année 1-33/35, 1926-60. Paris, Éditions "Cahiers d'art." Annual; frequency varies; pub. suspended 1941-43.
An important source for modern art; occasional articles on earlier art periods allied to contemporary movements; fine color plates, many are original lithographs. Includes music, film, etc. *Art index* (v.5-15, 23-35); *B. d. f. Z.; Rép. d'art.*

Q125 Cahiers de civilisation médiévale; Xe-XIIe siècle, année 1, 1958- . Poitiers, Centre d'Études Supérieures de Civilisation Médiévale, Université de Poitiers. Quarterly.
Scholarly coverage of the medieval period, primarily its literature, art, and architecture. Includes one of the most important current bibliographies on medieval art (A81). Extensive signed reviews. Indexes: v.1-5, 1958-62. *I. B. Z.; Rép. d'art.*

Q126 Cahiers de la céramique, du verre et des arts du feu, no. 1, 1955- . Sèvres (Seine-et-Oise), Société des Amis du Musée National de la Céramique. Quarterly, some issues combined; title varies.
A richly-illustrated periodical concerning the history and technology of French pottery and glass. Includes a separately-paged supplement, usually thematic. *ARTbib. curr.; Rép. d'art.*

Q127 Cahiers de l'art médiéval, v.1, 1947- . Strasbourg, Centre Alsacien d'Art Roman. Irregular, 3 issues per volume; publisher varies.
Title varies: v.1-4 (1947-62) *Les Cahiers techniques de l'art.* Scholarly, original studies of all of the arts. Includes analyses of medieval construction and iconography. Early issues contain reviews and bibliography.

Q128  Camera work; a photographic quarterly, no. 1-49/50, Jan. 1903-June 1917. N.Y., Stieglitz. Quarterly; irregular. (Repr.: Nendeln, Liechtenstein, Kraus-Thomson, 1970.)

Editor: Alfred Stieglitz.

Major articles on modern art and photography in America and Europe. Exquisite gravure prints and other reproductions. A critical anthology has been published: J. Green, ed. *Camera work* (Millerton, N.Y., Aperture, 1973), 376p. il. Contains indexes to the complete periodical by author, artist, and subject, plus chronological lists of articles and plates.

Q129  The Canadian architect, v.1, Jan. 1956- . Don Mills, Ontario, Southam. Monthly; publisher varies.

Covers current Canadian architecture, with articles on urban planning and interior design. *Art index* (1979- ); *Can. ind.*

Q130  Casabella; rivista di urbanistica, architettura e disegno industriale, anno 1-16, nos. 1-187, 1928-43; no. 199, 1953- . Milano, Domus. Monthly, irregular; title varies.

An excellent, well-illustrated magazine of urban design, architecture, and industrial design. Complements *Domus*. International in scope, with emphasis on contemporary Italy. Includes brief articles on architectural and city history. Gives news of conventions, competitions, and exhibitions. English "translations and digests" at the end of each issue. *Art index; ARTbib. curr.; LOMA.*

Q131  Centro Internazionale di Studi d'Architettura Andrea Palladio, Vicenza. Bollettino 1, 1959- . Annual, some years in two parts.

Scholarly articles on the architecture of Palladio, his contemporaries, and his successors in Italy and elsewhere. Numerous plates. *Rép. d'art.*

Q132  Chronique d'Égypt; bulletin périodique de la Fondation Egyptologique Reine Élisabeth, t.1, 1925- . Bruxelles, Musées Royaux d'Art et d'Histoire. Semiannual, irregular 1925-34.

Scholarly articles on Egyptian studies and excavations. Bibliography and more recently signed reviews. Text in English, French, German, and Italian. Index to v.1-10, 1925-37 [1937]. *Art index* (1928-47); *B. d. f. Z.; Bull. sig. 526; I. B. Z.; Rép. d'art.*

Q133  Cimaise; art et architecture actuels/present day art and architecture, année 1, 1954- . Paris. Bimonthly; issues frequently combined.

Handsomely produced; concentrates on contemporary European and American artists and their work. Includes exhibitions reviews and interviews with artists. *A. D. P.; ARTbib. curr.; ARTbib. mod.; LOMA; Rép. d'art.*

Q134  Commentari; rivista di critica e storia dell'arte, anno 1, 1950- . Roma, De Luca. Quarterly; some issues combined. (Repr.: v.1-20 (1950-69), Amsterdam, Swets & Zeitlinger.)

Scholarly articles on art of all periods. Signed book reviews 1950-54, later shorter reviews. *ARTbib. curr.; ARTbib. mod.; I. B. Z.; Rép. d'art.*

Q135  Congrès Archéologique de France. Session tenue à . . . par la Société Française d'Archéologie 1, 1834- . Paris, Musée des Monuments Français. Annual; publisher, place vary.

Each volume deals with monuments of a different French locality, giving scholarly and detailed descriptions of architecture, sculpture, inscriptions, etc. *Art index* (1969- ); *Rép. d'art.*

_____. Table alphabétique . . . 1834-1925 (1930).
_____. Table alphabétique . . . 1926-54 (1956).

Q136  Connaissance des arts. Paris, Société Française de Promotion Artistique. Monthly.

Title varies slightly. A glossy magazine with beautiful illustrations, primarily in color. The articles are directed to the art lover and collector. World coverage with a strong emphasis on French decorative arts and historic architecture. Notes of sales, exhibitions, and other art activities. *A. D. P.; Art index* (1969- ); *ARTbib. curr.; ARTbib. mod.; Bull. sig. 525, 526; LOMA; Rép. d'art.*

Q137  Connection; visual arts at Harvard, v.1-6, nos. 3, 1964-spring 1969. Cambridge, Mass. Every 3 weeks, Feb.-May 1964; quarterly, 1965-69; subtitle varies.

Issued by the students of the Graduate School of Design, Carpenter Center for the Visual Arts and Fogg Museum of Art, Harvard Univ. Students and scholars in art and related fields write on contemporary architecture, urban planning, design, and photography. Includes interviews with leading architects. Remarkable for its innovative treatment of environmental design.

Q138  The Connoisseur, v.1, 1901- . London, National magazine co. Monthly.

Current editor: William Allen.

Absorbed *International studio* 1931. A handsome, well-produced magazine, directed to the connoisseur, and useful to the art historian. Authorative articles on the decorative arts, painting, sculpture, architecture, interiors, etc. Some issues are devoted to single topics, such as the arts of a period, a country, or a great collection. News of sales; excellent, succinct book reviews by specialists. Indexes for v.1-12, 1901-05; v.13-14, 1906-09. *A. D. P.; Ann. mag. subj. ind.; Art index; ARTbib. curr.; ARTbib. mod.; B. d. f. Z.; B. H. I.; Bull sig. 526; Int. ind.; I. B. Z.; LOMA; Rép d'art; Rev. of revs.; Subj. ind.*

Q139  Copenhagen. Statens Museum for Kunst. Kunstmuseets aarsskrift, 1, 1914- . København, Langkjaersbogtrykkeri. Annual, some years combined.

Lengthy articles on Danish art and collections in Denmark. Since 1948, short résumés in French and English. *B. d. f. Z.; Dansk tids. -ind.; Rép. d'art.*

_____. Registre til Kunstmuseets aarsskrift I-XXX (1945).

493

Q140    Costume; the journal of the Costume Society, no. 1, 1967- . London, Victoria and Albert Museum. Annual.
Includes costume and fashion history, design and technique to the present day. New books list and signed reviews. *ARTbib. mod.*

Q141    Country life, v.1, 1897- . London, IPC magazines. Weekly.
Not an art periodical, but valuable for photographs and detailed descriptions of English country houses, their furnishings and collections. Also covers the minor arts in exhibitions, collections, and sales. v.81 lists country homes illustrated in v.1-81. Indexes published in July-Dec. 1933 and 1953. *ARTbib. mod.; B. H. I.; Subj. ind.*

Q142    Craft horizons, v.1, Nov. 1941- . N.Y., American Crafts Council. Bimonthly, Nov. 1951- ; frequency varies.
Title v.39, no. 3, June/July, 1979- , *American craft.*
    Authoritative coverage of all the crafts and individual craftsmen: potters, silversmiths, weavers, etc. Historical and contemporary approach, elegant layout. Reviews and calendars of current crafts exhibitons. *A. D. P.; Art index* (1948- ); *ARTbib. curr.; ARTbib. mod.; LOMA; R. G.*

Q143    Creative art; a magazine of fine and applied art, v.1-12, Oct. 1927-May 1933. [N.Y., Boni] Monthly.
v.1-8, no. 3 incorporate *The Studio* of London (v.94, no. 415-v.101, no. 456). Merged Jan. 1934 with *American magazine of art.* Mostly popular, with some scholarly contributions. Contains short signed book reviews. Deals mainly with contemporary art, but also includes some articles on the past and some emphasis on the American art world. Gallery notes. *Ann. mag. subj. ind.; Art index* (v.4-12).

Q144    La Critica d'arte, v.1-8, ott. 1935-50; n.s., no. 1, genn. 1954- . Firenze, Vallecchi. Bimonthly; frequency, subtitle, publisher vary.
Long scholarly articles, in general devoted to Italian and ancient art, occasionally to contemporary French and Italian art. Concentrates (for varying periods) on ancient art, medieval, Renaissance and modern. New series covers art of all periods. Unsigned book reviews. *ARTbib. curr.; ARTbib. mod.; B. d. f. Z.; LOMA: Rép. d'art.*

Q145    Dansk brugskunst; tidsskrift for kunsthåndvaerk og design, Årg. 1, 1928- . København, Landsforeningen dansk Kunsthåndvaerk. Bimonthly; frequency varies.
Title varies: 1928-47, *Nyt tidsskrift for kunstindustri;* 1948-67/68, *Dansk kunsthaandvaerk.* Danish crafts and industrial design; features individual craftsmen. Frequent historical articles. English captions and summaries. *Rép. d'art.*

Q146    Dedalo; rassegna d'arte, anno 1-13, fasc. 6., giugno 1920-giugno 1933. Milano-Roma, Bestetti e Tumminelli. Monthly.
One of the most important art history periodicals from the period between the wars. Has published some key articles.

"Commenti" contains notes on publications and exhibitions, and brief obituaries. *Art index* (v.10-13); *B. d. f. Z.*

Q147    Dekorativnoe Iskusstvo SSSR. (Soûz Khudozhnikov SSSR) Moscow. 1957- . Monthly.
The official organ of the Association of Soviet Artists. Contains articles on contemporary art, art theory and criticism, and the history of art and architecture in Russia and the countries of Eastern Europe. *Rép. d'art.*

Q148    Derrière le miroir, no. 1, 1946- . Paris, Maeght. 6 times a year, some nos. combined.
Each issue contains new work by an individual artist, arranged to coincide with exhibitions at Galerie Maeght. Generally includes original lithographs and excellent reproductions. *Derrière le miroir et affiches, catalogue 1* (1971) functions as an index. *ARTbib. curr.; LOMA.*

Q149    Design quarterly, no. 1, 1946- . Minneapolis, Walker Art Center. Quarterly, some issues combined.
Title varies: no. 1-28, *Everyday art quarterly;* no. 1-20 subtitled "A guide to well designed products." Each issue devoted to a different aspect of design in modern life, including urban planning. Yearly "Product review" issue. *ART index; ARTbib. curr.; ARTbib. mod.; LOMA.*

Q150    Deutsche Kunst und Denkmalpflege v.1-35, 1899-1933; n.F., 1-15, no. 7/8. 1934-42. Berlin, Deutscher Kunstverlag, 1952- .
Frequency varies. Title varies: 1899-Dec. 1922, *Die Denkmalpflege;* 1923-Dec. 1929, *Denkmalpflege und Heimatschutz;* 1930-32, *Die Denkmalpflege.* Absorbed *Heimatschutz* 1923, and *Zeitschrift für Denkmalpflege* 1930. Issues for 1952— also called v.46- of *Denkmalpflege und Heimatschutz* and v.18— of *Zeitschrift für Denkmalpflege.*
    Covers the monuments of German-speaking countries. Signed book reviews and bibliographies. *B. d. d. Z.*

Q151    Deutscher Verein für Kunstwissenschaft. Zeitschrift. Jahrg. 1-10, 1934-43; n.F., Bd. 1, 1947- . Berlin. Quarterly, original series irregular, n.s. issued in one or two fascicles a year.
Title varies n.F., Bd. 1-16, 1947-62, *Zeitschrift für Kunstwissenschaft.* Contains scholarly, well-illustrated articles on German art history, with occasional contributions on related Italian or Netherlandish art. *Art index* (1959- ); *ARTbib. curr.; B. d. d. Z.; I. B. Z.; Rép. d'art.*

Q152    Deutsches Archäologisches Institut. Jahrbuch, Bd. 1, 1886- . Berlin, de Gruyter. Quarterly, sometimes combined; title varies.
Supersedes the *Annali dell'Istituto di Corrispondenza Archeologica* (1829-85) and *Archäologische Zeitung* (1843-85). Scholarly articles by specialists, bibliographies. Indexes every ten years to 1935. *Art index* (1929-40, 1969- ); *B. d. d. Z.; Bull. sig. 526; Int. ind.; I. B. Z.; Rép. d'art.*

Q153 Deutsches Archäologisches Institut. Mitteilungen, Bd. 1-6, 1948-53. München, Bruckmann. Annual; publisher, place vary.
Superseded (as a merger) *Archäologisches Institut des Deutschen Reichs*. Pub. during the suspension of the Institute's *Athenische Abteilungen, Mitteilungen*, and its *Römische Abteilungen, Mitteilungen*. Scholarly treatment of archaeology in general. *B. d. d. Z.*

Q154 Deutsches Archäologisches Institut. Abteilung Baghdad. Baghdader Mitteilungen, Bd. 1, 1960- . Berlin, Mann. Biennial, irregular.
Scholarly treatment of the archaeology of Mesopotamia. Includes inscriptions, tablet archives, and related studies in cultural history. Occasional English text. Foldout maps and charts. *B. d. f. Z.; I. B. Z.; Rép. d'art.*

Q155 Deutsches Archäologisches Institut. Abteilung Istanbul. Istanbuler Mitteilungen, Bd. 1, 1933- . Tübingen, Wasmuth. Annual, some volumes biennial, irregular; suspended 1936-55.
Scholarly coverage of archaeology and art from prehistoric times through the Early Christian period. *Bull. sig. 526; I. B. Z.; Rép. d'art.*

Q156 Deutsches Archäologisches Institut. Abteilung Kairo. Mitteilungen, Bd. 14, 1956- . Mainz am Rhein, Zabern. Annual; irregular, sometimes in two parts.
Continues: Archäologisches Institut des Deutschen Reiches. Deutsches Institut für Ägyptische Altertumskunde, Cairo. *Mitteilungen;* suspended 1945-55. Egyptian studies and archaeology; research on new sites and inscriptions. Occasional articles in English. Foldout charts and plans. *B. d. d. Z.; Bull. sig. 526; I. B. Z.; Rép. d'art.*

Q157 Deutsches Archäologisches Institut. Abteilung Madrid. Madrider Mitteilungen, Jahrg. 1, 1960- . Heidelberg, Kerle. Annual.
Scholarly articles (in German, and occasionally in other languages) on art of the Iberian peninsula from prehistory through the Islamic period. Beginning in v.6 (1965), an international bibliography for the previous year on Spanish and Portuguese art and archaeology. *Rép. d'art.*

Q158 Deutsches Archäologisches Institut. Athenische Abteilung. Mitteilungen, Bd. 1, 1876- . Early years, quarterly; annual, 1914- ; publisher, place vary.
Not published 1943-52. Long scholarly articles on Greek art and archaeology. Indexed every five years to 1896. *Art index; B. d. d. Z.; Rép. d'art.*

Q159 Deutsches Archäologisches Institut. Römische Abteilung. Mitteilungen/Bullettino, Bd. 1, 1886- . Mainz am Rhein, Zabern. Frequency varies.
Supersedes *Bullettino* (1829-85). Not published 1945-52. Scholarly articles on Roman archaeology and art. Indexes published at irregular intervals. *Art index; B. d. d. Z.; Rép. d'art.*

Q160 La Diana; rassegna d'arte e vita senese, anno 1-9, 1926-34. Siena [etc.]. Quarterly.

Deals exclusively with Sienese art, with greatest emphasis on painting, but also includes music and literature. Long articles by well-known scholars. v.2 and 3 have lists of Sienese painters from the 13th to 15th centuries.

Q161 Domus; rivista di architettura, arredamento, arte, anno 1, 1928- . Milano, Domus. Monthly.
A well-illustrated magazine devoted primarily to architecture, interior design, and the decorative arts, with a few articles and notes on architectural history, the theater, film, and music. Book reviews. Some English, French, and German summaries. *A. D. P.; Art index; ARTbib. curr.; ARTbib. mod.; LOMA; B. d. f. Z.; Rép. d'art.*

Q162 Dresden. Staatliche Kunstsammlungen. Jahrbuch, 1959- . Dresden, Zentral Kunstbibliothek. Annual.
Concentrates on works in Dresden art museums, individually and through exhibition coverage. The first volume covers activities since 1945. *ARTbib. curr.; Rép. d'art.*

Q163 Eastern art . . . v.1-3, July 1928-31. Philadelphia, College Art Association. Quarterly, v.1; annual, v.2-3.
Contains articles by recognized authorities in the field and lists of museum accessions. v.1 includes sections "Book reviews" and "Oriental abstracts," which are brief reviews of the current literature. *Ann. mag. subj. ind.; Art index.*

Q164 École Française de Rome, Mélanges. Antiquité. École Française de Rome. Mélanges. Moyen-âge-temps moderne, année 1, 1881- . Paris, Boccard. Annual; frequency varies.
To t.82 called *Mélanges d'archéologie et d'histoire;* split with t.83/1 and t.83/2 (1971). Long scholarly articles valuable for Italian art from prehistoric through Renaissance periods. Beginning in 1971, modern periods included. Bibliographies and reviews in earlier volumes. Indexes to 1940 at ten-year intervals. Indexes: v.1-38 (1881-1920) with v.38; v.58-72 (1941-60), lv. *B. d. f. Z.; Bull. sig. 525; I. B. Z.; Rép. d'art; Rép. bibl.*

Q165 Emporium; rivista mensile d'arte e di cultura, v.1-140, 1895-1964. Bergamo, Istituto Italiano d'Arte Grafiche. Monthly.
A well-illustrated popular review of modern Italian art and culture. International exhibition notes, book reviews. *Art index* (v.69-107); *B. d. f. Z.; Italy. Parl. Cam. dei Deputati Bibl.*
———. Indice . . . v.1-50, 1895-1919.

Q166 L'Esprit nouveau; revue internationale illustrée de l'activité contemporaine, no. 1-28, Oct. 1920-Jan. 1925. Paris, Société des Éditions de l'Esprit Nouveau. Monthly, irregular. (Repr.: no. 1-28, N.Y., Da Capo, 1968-69.)
Eds.: Le Corbusier and Ozenfant. Important for early modern design, modern art theory, and criticism. Covered art, architecture, exhibitions, film, city planning, etc.

Q167 Far eastern ceramic bulletin, no. 1-43, 1948-60. Boston, Far Eastern Ceramic Group. Bimonthly,

July 1948-June 1949; quarterly, Sept. 1949-58; semi-annual, 1959-60; place varies. (Repr.: Amsterdam, Israël, 1974.)

No. 13-43 (Mar. 1951-60) also called v.3-11. Scholarly articles by authorities on history and technology in ceramics of the Far East from ancient to present time; includes bibliographies and lengthy commentary on exhibitions. Books reviewed also include technical manuals. Index no. 1-40 in no. 40.

Q168    Felix Ravenna; rivista di antichità ravennati, cristiane e bizantine, fasc. 1, 1911- . Ravenna, Istituto di Antichità Ravennati e Bizantine dell'Università di Bologna. Annual, 1969- ; frequency varies.

Scholarly treatment of Early Christian and Byzantine art of Ravenna and its region. Includes archival material, bibliographies, and signed reviews. "Indici" in facs. 16, "Indici" fasc. 17-24 in f. 24. *Rép. d'art.*

Q169    Flash art; international review of arts, no.1, 1967- . Milano. Monthly, some issues combined.

Current title: Flash art/Heute Kunst.

Exhibition, publication and gallery notes, interviews and articles on contemporary constructivist and conceptual art, in Italian, French and English, with some translations. *A. D. P.; ARTbib. curr.; ARTbib mod.*

Q170    Folia historiae artium, v.1, 1964- . Oddział w Krakowie, Komisja Teorii i Historii Sztuki, Polska Akademia Nauk. Annual.

Scholarly articles on the archaeology, art, and architecture of Poland for all periods. Large foldout charts and maps of excavations. French summaries and contents. *ARTbib. curr.; ARTbib. mod.; Rép. d'art.*

Q171    Formes; revue internationale des arts plastiques, no. 1-33, 1929-33. Paris, 10 times a year.

Appeared in both a French and an American ed. Reappeared for 1934 in *L'Amour de l'art*, année 15, 1934, pt. 2. Covers contemporary art of international scope and also some art of other periods. Well illustrated. Some book reviews, a few of which are signed. *Art index; B. d. f. Z.*

Q172    France. Comité des Travaux Historiques et Scientifiques. Bulletin archéologique, année 1, 1883- . Paris, Impr. Nationale. Annual.

Pub. for the Ministère de l'Instruction Publique et des Beaux-Arts. Supersedes *Revue des sociétés savantes*, 1856-81, and their *Bulletin historique et philologique*, 1882. Archaeology in general, especially French and North African. *B. d. f. Z.; Rép. d'art; Rép. bibl.*

_____. Tables générales, 1883-1915 (1923).

_____. Tables générales, 1916-40 (1952).

Q173    Furniture history; the journal of the Furniture History Society, v.1, 1965- . London, Annual.

A unique journal featuring contributions to furniture scholarship of all periods. Includes articles on social and historical background as well as on individual cabinetmakers.

The emphasis is British. Excellent illustrations, signed book reviews, and selective current bibliographies. *ARTbib. curr.; ARTbib. mod.*

Q174    Gazette des beaux-arts, t.1-25 (1.-10. année), 1859-68; 2. pér., t.1-38 (11.-30. année), 1869-88; 3. pér., t.1-40 (31.-50. année), 1889-1908; 4. pér., t.1-15 (51.-61. année), 1909-19; 5. pér., t.1-18 (62.-70. année), 1920-28; 6. pér., t.1- (71.- ), 1929- . Paris and N.Y. Monthly, irregular.

Repr.: Nendeln, Liechtenstein, Kraus-Thomson, sér.1, v.1-25 (1859-68); sér.2, v.1-38 (1869-88); sér.3, v.1-40 (1889-1908); sér.4, v.1-15 (1909-19); sér.5, v.1-18 (1920-28); sér.6, v.1-62 (1929-63); Gén. index sér.1-3; Tables générales des cinquante premières années de la Gazette des beaux-arts (1859-1908), 2v. 1911-15.

Founded by Charles Blanc in 1859. Suspended several times since 1870. 1942-48 published in English; 1948- bilingual with summaries. One of the oldest and most respected art periodicals. Authoritative articles on art of all periods. International board of editorial consultants. *La Chronique des arts* is a supplement covering sales, acquisitions, exhibitions, new literature, etc. Bibliographies and signed reviews. *A. D. P.; Art index (sér. 6 v.1- ); ARTbib. curr.; ARTbib. mod.; B. d. f. Z.; Bull. sig. 526; I. B. Z.; LOMA; Rép. d'art; Rép. bibl.; Subj. ind.*

_____. Tables générales . . . 1859-1908 (1910-15).

Q175    Gentsche bijdragen tot de kunstgeschiedenis (Ghent Universiteit. Hooger instituut voor kunstgeschiedenis en oudheidkunde), deel 1, 1934- . Antwerp. Frequency varies.

Scholarly articles on all aspects of art history in the Low Countries. Summaries in French and English. *Rép. d'art.*

Q176    Gesta, v.1, 1963- . N.Y., International Center of Medieval Art, The Cloisters, Fort Tryon Park. Semi-annual, irregular; some issues double; place varies.

1963 unnumbered. Issues for 1964 called no. 1 & 2 but they constitute v.2-3. v.1-4 issued by the Center under its earlier name: International Center of Romanesque Art. Supersedes *Bulletin trimestriel*. Scholarly articles on medieval art, architecture, sculpture, and illumination. "Studies and dissertations in medieval art recently completed or in progress (1963-67)" in v.7, p.62-64. v.15, 1-2 is a Festschrift, "Essays in honor of Sumner McKnight Crosby." *Art index (1969- ); ARTbib. curr. Rep. d'art. Index 1-10 in v.9-10, 1970-71.*

Q177    Goya; revista de arte, no. 1, julio/augusto 1954- . Madrid, Fundación Lázaro Galdiano. Bimonthly.

A well-illustrated journal covering all periods of painting, sculpture, and architecture. Book reviews, international exhibition notices and events. No. 60 (1964)- , has English summaries. *A. D. P.; Art index (1969- ); ARTbib. curr.; ARTbib. mod.; LOMA; Rép. d'art.*

Q178    Graphis; international journal of graphic art and applied art, v.1, 1944- . Zürich, Amstutz & Herdeg, Graphis Press. Bimonthly.

A profusely illustrated journal on the graphic and applied arts, i.e. posters, typography, cartoons, packaging, etc., with some articles on printmaking and art in general. In German, English, and French. Book reviews. *A. D. P.; Art index* (1949- ); *ARTbib. curr.; ARTbib. mod.; B. d. d. Z.; I. B. Z.; LOMA; Rép. d'art.* Cumulative index, 1944-53.

Q179 Die graphischen Künste, v.1-56, 1879-1933; n.F., v.1-5, no. 2, 1936-40. Baden bei Wein, Rohrens. Annual.

v.1-56 pub. in Wien, Gesellschaft für vervielfältigende Kunst. The emphasis is on graphic arts and book illustration. Includes important articles, checklists, and "Mitteilungen der Gesellschaft für vervielfältigende Kunst." v.24-55 contain "Anzeigen neuer Erscheinungen" covering illustrated books and the literature of the graphic arts including periodicals. Index to v.1-12 in v.12. *Art index* (v.52-56 and n.F., v.1-5, no. 2); *B. d. d. Z.*

Q180 Graz, Austria. Universität. Kunsthistorisches Institut. Jahrbuch, Bd. I. 1965- . Graz, Akademische Druck-und Verlagsanstalt. Annual; irregular.

Emphasizes Austrian and Eastern European art of all periods. Signed reviews. *ARTbib. curr.; I. B. Z.; Rép. d'art.*

Q181 Hesperia; journal of the American School of Classical Studies at Athens, v.1, 1932- . Princeton, N.J., Institute for Advanced Study. Quarterly; publisher, place vary. (Repr.: v.1-38 (1932-69), Amsterdam, Swets & Zeitlinger.)

Scholarly coverage of the work of the School and of excavations of the Agora in Athens and related subjects, Latin as well as Greek. *Art index* (1948- ); *B. d. f. Z.; Bull. sig. 525; I. B. Z.; Rép. d'art.*

———. Index, v.I-X (1946).

———. Index, v.XI-XX (1968).

Q182 Historic preservation, v.1, 1949- . Wash., D.C., National Trust for Historic Preservation. Quarterly, some issues combined.

Continues U.S. National Council for Historic Sites and Buildings. *Quarterly report.* Conservation of architectural and folk-art traditions with features on individual architects, buildings, and crafts. Signed book reviews. *Art index* (1969- ); *ARTbib. mod.; Rép. d'art.*

Q183 History of photography, v.1, Jan. 1977- . London, Taylor & Francis. Quarterly.

Scholarly, well-illustrated periodical devoted to "original findings and the assessment of their significance"—*Editorial statement.* Advisory board consists of photo experts of international repute. Scope is quite broad in that all aspects of photography history are welcome areas of inquiry, e.g.: technical discoveries, biography, equipment, questions of style, relatedness of the graphic arts, and conservation topics. Includes long book reviews as well as book notes and short history essays. *Art index* (1979- ).

Q184 Image; journal of photography and motion pictures of the International Museum of Photography at

George Eastman House, v.1, Jan. 1952- . Rochester, N.Y., Monthly, 1952-58, 1961; quarterly, 1959-60, 1972- .

Suspended 1962-71. International coverage of the history of photography. Exhibition reviews, "Books received" list; early issues have signed book reviews and yearly index. *A. D. P.; Art index* (1979- ); *ARTbib. curr.; ARTbib. mod.*

Q185 Indian Society of Oriental Art. Journal, v.1-19, June 1933-52/53; n.s. v.1, 1965/66- . Calcutta. Semiannual, v.1-8, then annual; n.s. is biennial.

Supersedes *Rupam.* A scholarly journal with well-illustrated articles devoted to Indian art and architecture. Signed book reviews. A table of names of Buddhist iconography in Sanskrit, Chinese, and Japanese, arranged in alphabetical order, according to Sanskrit, in v.6, p.57-62. *Bull. sig. 525.*

Q186 L'Information d'histoire de l'art; revue illustrée paraissant tous les deux mois pendant la période scolaire, année 1, nov./déc. 1955- . Paris, Baillière. 5 times a year; i.e. bimonthly during the school year.

Title varies: 1955-57, *L'Information culturelle artistique.* Brief articles and information on current research, including dissertations, in all areas of Western art and architecture. Signed book reviews. *ARTbib. curr.; Bull. sig. 525, 526; Rép. d'art.*

Q187 The Inland architect and news record; v.1-52, 1883-1908. Chicago, Western Association of Architects. Monthly. (Repr.: v.1-52; N.Y., Da Capo, 1972.)

Merged into *American architect and architecture* in 1909. Important source material for the architectural history of the Midwest.

Q188 The International studio. v.1-99, March 1897-Aug. 1931. N.Y., Lane. Monthly.

From 1897 to 1921 it forms the American ed. of *The Studio,* v.1 of *The International studio* corresponding to v.10 of *The Studio.* Part of each number was printed in England and joined with an American section. From 1922, produced entirely in America. Combined with *The Connoisseur* Sept. 1931. A well-illustrated, popular type of art journal covering all phases of art. Includes some book reviews. *Ann. mag. subj. ind.; Art index* (v.92-99); *B. d. f. Z.; Poole's; R. G.*

Q189 Iranica antiqua, v.1, 1961- . Leiden, Brill. Annual, sometimes in two parts.

v.6-8 subtitled "Mélanges Ghirshman I-III." Extensive coverage of the ancient history of Iran as revealed by recent research in art, archaeology, inscriptions, and numismatics. Text in French, English, or German; large foldout charts and diagrams. *Art index* (1969- ); *Bull. sig. 526; I. B. Z.; Rép. d'art.*

Q190 Iraq, v.1, 1934- . London, Published for the British School of Archaeology in Iraq (Gertrude Bell Memorial). Semiannual.

Suspended 1941-45. Scholarly articles on "Iraqi history, art, archaeology, religion, economic and social life . . . from

the earliest times down to about A.D. 1700."—*Editor's note.*
Includes excavation reports. *B. d. f. Z.; Bull. sig. 525, 526;
I. B. Z.*
_____. Index, v.1-30 (1943-68) in v.30.

Q191 Iskusstvo; organ Ministerstva Kultury SSSR i
       Org'Komiteta Soiuza sovetskikh khudozhnikov SSSR,
       v.1, 1933- . Moskva, Leningrad, Ogiz Izogiz. Bi-
       monthly to 1964; monthly, 1965- .
Articles on Soviet art, mainly contemporary. Profusely
illustrated, with bibliographies and news of the art world in
the Soviet Union. Contents page and captions also in French.
*ARTbib. curr.; I. B. Z.; Rép. d'art.*

Q192 Istituto Nazionale di Archeologia e Storia dell'Arte,
       Rome. Rivista, anno 1-9, 1929-42; n.s. 1, 1952- .
       Roma, "L'Erma" di Bretschneider. Originally 3 times
       a year; n.s. is annual.
Extensive scholarly coverage of art and archaeology in Italy.
Valuable for excavation reports, and Renaissance and Ba-
roque art. *B. d. f. Z.; I. B. Z.; Rép. d'art.*

Q193 It is; a magazine for abstract art, no. 1-6, spring
       1958-aut. 1965. N.Y., Second Half. 3 times a year;
       1961-64 not pub.
The writings of American abstract artists, and contemporary
art criticism. The emphasis is on the New York School.
Large black-and-white and color illustrations.

Q194 Italy. Istituto Centrale del Restauro. Bollettino, no.
       1, 1950- . Roma, Istituto Poligrafico dello Stato;
       Libreria dello Stato. Quarterly, combined, irregular.
Contains articles and shorter notices on preservation and
restoration of architecture, sculpture, painting; mostly Ita-
lian, but includes other countries. Scholarly approach with
extensive documentary illustration. Signed reviews and
English summaries. *Rép. d'art.*

Q195 Jahrbuch der Berliner Museen; Jahrbuch der preus-
       sischen Kunstsammlungen, n.F., Bd. 1, 1959- . Berlin,
       Mann. Annual, some years in two parts; pub. varies.
Continues the *Jahrbuch der preussischen Kunstsammlungen*
(Q199) 1880-1943/44. Issued by the Staatliche Museen zu
Berlin der Stiftung Preussischer Kulturbesitz. Lengthy articles
on works of art of all periods belonging to Berlin museums.
Very well illustrated; summaries in English. *Art index*
(1969- ); *ARTbib. curr.; B. d. d. Z.; I. B. Z.; Rép. d'art.*

Q196 Jahrbuch der Hamburger Kunstsammlungen, Bd. 1,
       1948- . Hamburg, Hauswedell. Annual, v.4, 1959- ;
       previously irregular.
Pub. by the Hamburger Kunsthalle and the Museum für
Kunst und Gewerbe, Hamburg. Articles on works in these
collections plus general art historical topics. A section on
exhibitions and an illustrated list of acquisitions for the pre-
vious year(s) at end of volume. *Art index* (1969- ); *ARTbib.
curr.; ARTbib mod.; B. d. d. Z.; I. B. Z.; Rép. d'art.*

Q197 Jahrbuch der kunsthistorischen Sammlungen in
       Wien, Bd. 1-36, 1883-1925; n.F., 1-13, 1926-44; Bd.

50, 1953- . Wien, Schroll. Annual, irregular. (Repr.:
v.1-34, N.Y., Johnson, 1970.)
Title varies: v.1-34, *Jahrbuch der kunsthistorischen Samm-
lungen des Allerhöchsten Kaiserhauses.* Long, well-illustra-
ted scholarly articles by specialists. Covers all media and
periods of art. Supplements issued before 1900. Index: v.1-
36 in v.36. *Art index* (n.F. 1-12, Bd. 58- ); *ARTbib. curr.;
B. d. d. Z.; Int. ind.; I. B. Z.; Rép. d'art.*

Q198 Jahrbuch der österreichischen Byzantinistik, 1,
       1951- . Wien, Böhlaus. Annual; publisher, place vary.
Contributions (in English, French, German, or Italian) by
internationally known scholars on Byzantine history and
art. Signed book reviews. Now pub. for the Kommission für
Byzantinistik der Österreichischen Akademie der Wissen-
schaften and the Institut für Byzantinistik der Universität
Wien.

Q199 Jahrbuch der preussischen Kunstsammlungen, Bd.
       1-64, 1880-1943/44. Berlin, Grote. Quarterly; pub-
       lisher varies. (Repr.: v.1-10 (1880-89), v.55-64
       (1934-43/44), N.Y., Johnson.)
A pioneering art history periodical. Contains long, scholarly,
well-illustrated essays concerning art history of various per-
iods and countries. Many are still basic to research today.
   "Amtliche Berichte aus den königlichen Kunstsamm-
lungen" appears at beginning of v.1-28. Thereafter it ap-
pears as a separate publication and contains articles deal-
ing with objects in the museum collections. From 1902-18
each volume has a supplement containing archival material.
Indexes published covering: v.1-10, 1891; v.11-20, 1900;
v.21-30, 1910, v.31-50, 1934 (Berlin, Grote). *Art index*
(v.50-61, no. 1.); *B. d. d. Z.; Int. ind.*

Q200 Jahrbuch für Antike und Christentum. Jahrgang 1,
       1958- . Münster, Aschendorff. Annual, some years
       combined.
Issued by the Franz Josef Dölger-Institut, Universität Bonn.
Scholarly articles on the classical and Early Christian world.
Lengthy, signed book reviews; some news notes. *Rép. d'art.*

Q201 Jahrbuch für Kunstwissenschaft, 1923-30. Leipzig,
       Klinkhardt & Biermann. Annual.
Superseded *Monatshefte für Kunstwissenschaft* (Q240).
Merged with *Repertorium für Kunstwissenschaft* and
*Zeitschrift für Kunstwissenschaft* to form *Zeitschrift für
Kunstgeschichte* (Q354). Scholarly articles on all types of
art and all periods. Long signed book reviews; classified
bibliography of current literature in the 1926 and 1928 vol-
umes. *Art index* (1929-30); *B. d. d. Z.*

Q202 Japan architect, v.1, 1925- . Tokyo, Shinkenchiku-
       sha. Monthly, some combined.
"International edition" of *Shinkenchiku;* continues the
numbering of *Shinkenchiku; new architecture in Japan,*
v.1-33. Well-illustrated articles on contemporary architecture
and building in Japan; text and summaries in English with
summaries in Spanish. *Art index* (1969- ); *ARTbib. curr.;
Rép. d'art.*

Q203 The Journal of aesthetics and art criticism, v.1, spring 1941- . Baltimore, The American Society for Aesthetics. Quarterly. (Repr.: v.1-30) (1941-72), N.Y., AMS Pr., (with new index).)

Scholarly research in the aesthetics of all the arts—visual, literary, and musical. Many signed book reviews; annual bibliography. Index: v.1-20 (1941-62). *A. D. P.; Art index; ARTbib. curr.; ARTbib. mod.; B. d. f. Z.; I. B. Z.; LOMA; Rép. d'art.*

Q204 The Journal of Asian studies, v.16, Nov. 1956- . Ann Arbor, Mich., Association for Asian Studies. 5 times a year. (Repr.: v.1-27 (1941-68), N.Y., AMS Pr.)

Continues the numbering of *Far Eastern quarterly* (1941-55). The Sept. issue of each volume is the "Bibliography of Asian studies" for the previous year, which continues "Far Eastern bibliography" of *Far Eastern quarterly,* which in turn supersedes the *Bulletin of Far Eastern bibliography* (1936-40). The bibliographies are classed by subjects for each Asian country and include "Arts" and "Archaeology" sections. The periodical itself has occasional articles on art. *Int. ind.; S. S. H. I.*

Q205 The Journal of Canadian art history; studies in Canadian art, architecture and the decorative arts/ Annales d'histoire de l'art canadien; études en art, architecture et arts décoratifs canadiens. v.1, spring 1974- . Montreal, Concordia Univ. Pr. Semiannual.

A well-produced journal of scholarly articles and shorter notes on topics in Canadian art and architectural history. Long signed book reviews and "Publications for review" list books on Canadian art history. Text in French or English, no translations or summaries. *Art index* (1979- ).

Q206 Journal of Egyptian archaeology, v.1, 1914- . London, The Egypt Exploration Society. Quarterly, 1914-28; semiannual, 1929-41; annual, 1942- .

Supersedes the *Archaeological report* published by the Egypt Exploration Fund. Primarily excavation reports, also includes bibliographies and Greek inscriptions. *Art index* (1941- ); *B. d. f. Z.; Bull. sig. 525; I. B. Z.; Subj. ind.*
_____. Index to v.1-20 (1914-34).
_____. Index to v.21-40 (1935-54) in v.40.

Q207 Journal of glass studies, v.1, 1959- . Corning, N.Y., Corning Museum of Glass. Annual.

Scholarly and technical articles covering all periods of glass production. Each volume includes a lengthy classed list of recent publications on glass. Also in German, French, or Italian with English summaries. Index v.1-15 (1959-73). *Art index* (1979- ); *ARTbib. curr.; Bull. sig. 526; I. B. Z.; Rép. d'art.*

Q208 The Journal of Hellenic studies; v.1, 1880- . London, The Council of the Society for the Promotion of Hellenic Studies. Annual. (Repr.: v.1-20, 1880-99; Nendeln, Liechtenstein, Kraus-Thomson.)

Wide variety of articles covering literature, archaeology, art, etc.; numerous signed book reviews and, lately, a list of "books received." Index to v.1-8 in v.8. *Art index* (1950- ); *B. d. f. Z.; Hum. ind.; I. B. Z.; Poole's; Subj. ind.*

_____. Index to v.9-16 (1898).
_____. Index to v.17-42 (1923).
_____. Index to v.43-60 (1941).

Q209 The Journal of Roman studies, v.1, 1911- . London, The Society for the Promotion of Roman Studies. Semiannual.

Scholarly, well-illustrated articles on Roman civilization, including much on Roman Britian. Proceedings of the Society, Reports, etc. are included. Numerous signed book reviews. Indexes: v.1-20 in v.20; v.21-40, (1955). *Art index* (1929-59); *B. d. f. Z.; Hum. ind.; Subj. ind.*

Q210 Kobijutsu; quarterly review of the fine arts, no. 1, 1963- . Tokyo, Sansai-sha. Quarterly.

Covers Japanese art, but includes art of the West. Similar to *Connoisseur* in format. English summaries of major articles.

Q211 The Kokka, no. 1, Oct. 1889- . Tokyo, Kokka. Monthly.

No. 1-337 (1889-1918) pub. in Japanese and English editions; no. 338- , a Japanese ed. only, with English summaries. Subtitle: an illustrated monthly journal of the fine and applied arts of Japan and other Eastern countries. Contains beautiful full-page black-and-white plates and colored tip-ins, representing Japanese and other Eastern arts. *ARTbib. curr.; B. d. f. Z.; Bull. sig. 526; I. B. Z.; Rép. d'art.*
_____. Index no. 1-148 (1889-1902) 1v. English text.
_____. Index no. 1-753 (1889-1954) 1v. Japanese text.

Q212 Konsthistorisk tidskrift; utgiven av Konsthistoriska Sällskapet genom Institutionen för Konstvetenskap vid Stockholms Universitet. Art review, pub. by The Society of History of Art, Stockholm. Quarterly; issued twice a year in double numbers; subtitle varies.

Current editor: Henrik Cornell.

The major Swedish journal of art history, ed. by the Society of History of Art, Stockholm Univ. Some articles are in German, French, and English; most in Swedish have English or German summaries. Book reviews; beginning with v.29 (1960), no. 3-4 of each volume contain "Svensk konsthistorisk bibliografi" which covers the preceding year. *Art index* (1969- ); *ARTbib. curr.; ARTbib. mod.; B. d. f. Z.; I. B. Z.; LOMA; Rép. d'art.*

Q213 Kritische Berichte zur kunstgeschichtlichen Literatur, v.1-7, 1927-37. Leipzig, Poeschel & Trepte. Quarterly, irregular; publisher vaires. (Repr.: Hildesheim, Olms, 1972.)

A periodical devoted to criticism of art historical literature, with long scholarly reviews written by specialists. While the first 5 volumes cover books only, v.6 contains some periodical literature. Includes a few articles which are not reviews. *B. d. d. Z.*

Q214 Kunst des Orients, Bd. 1, 1950- . Wiesbaden, Steiner. Every 4 years; irregular to 1963; semiannual, 1968- .

Scholarly articles (in German, English, or French) on Near Eastern art and architecture. Signed reviews, some exhibition

notices. *Art index* (1979– ); *ARTbib. curr.; B. d. d. Z.; I. B. Z.; Rép. d'art.*

Q215 Die Kunst und das schöne Heim; Monatsschrift für Malerei, Plastik, Graphik, Architektur und Wohn Kultur, Jahrg. 1, Okt. 1899– . München. Monthly; frequency varies.
Title varies: 1899-1944, *Die Kunst; Monatshefte für freie und angewandte Kunst,* 2v. a year. Odd-numbered v.1-59, *Die Kunst für Alle,* cover the fine arts; even-numbered v.2-60, *Dekorative Kunst.* Beginning v.61 (1930) odd volumes are *Freie Kunst* and even ones *Angewandte Kunst.* Suspended Oct. 1944-Apr. 1949. A well-illustrated, popular, international art journal, more recently concentrating on Germany. Exhibition notes, short reviews; lately, English summaries. *A. D. P.; Art index* (to 1941); *ARTbib. curr.; ARTbib. mod.; B. d. d. Z.; I. B. Z.; LOMA.*

Q216 Kunst und Künstler, Jahrg. 1-32, 1902-Juni 1933. Berlin, Cassirer, Monthly; subtitle varies.
An influential journal, valuable for research in 19th- and 20th-century European art. Popular, beautifully-illustrated, with many serious articles by well-known art historians. *Art index* (v.27-32); *B. d. d. Z.; Rép. d'art.*

Q217 Kunstchronik; Monatsschrift für Kunstwissenschaft, Museumwesen, und Denkmalpflege, Jahrg. 1, 1948– . Nürnberg, Carl. Monthly, sometimes combined. "Herausgegeben vom Zentralinstitut für Kunstgeschichte in München." Contains news of museums, exhibitions, institutes, congresses, research, obituaries, etc. International in scope. Perhaps the best source of information for current exhibitions. Signed reviews. Important for reviews of exhibition catalogues.
    "Nachweis ausländer Literatur" (1949-50) lists works in Western art and archaeology published outside Germany since 1939. *A. D. P.; ARTbib. curr.; ARTbib. mod.; B. d. d. Z; I. B. Z.; Rép. d'art.*

Q218 Kunsten idag., v.1-21, 1946/47-1973. Oslo, Per Rom. Quarterly.
Covers contemporary art and design in Norway and other countries; frequently thematic. English summaries. *A. D. P.* (1972); *ARTbib. curr.; ARTbib. mod.; Dansk tids.-ind; LOMA* (1969-71); *Rép. d'art.*

Q219 Kunsthistorisches Institut in Florenz. Mitteilungen, Bd. 1, 1908– . Berlin, Leipzig, Cassirer. Irregular to 1964; semiannual, 1965– ; publisher, place vary.
Scholarly articles on Italian art, including foreign artists who worked in Italy. Contains "Berichte über das Institut." *Art index* (v.3-6); *B. d. d. Z.; I. B. Z.; Rép. d'art.*

Q220 Das Kunstwerk; eine Zeitschrift über alle Gebiete der bildenden Kunst, Jahrg. 1, 1946– . Stuttgart, Kohlhammer; N.Y., Wittenborn. Monthly, 1957-66; bimonthly, 1966– ; irregular; subtitle, publisher vary.
Current subtitle: Zeitschrift für bildende Kunst.
    Well illustrated. Covers the art of all periods and countries; especially valuable for contemporary Germany and

Western Europe. Exhibition and book reviews, news notes. Some issues on one subject. *A. D. P.; Art index* (1960– ); *ARTbib. curr.; ARTbib. mod.; B. d. d. Z.; I. B. Z.; LOMA; Rép. d'art.*

Q221 Lalit kalā; a journal of Oriental art, chiefly Indian, no. 1/2, April 1955/March 1956– . New Delhi, Lalit Kalā Akadami. Semiannual, 1955-62; biennial, 1967– , irregular.
Suspended 1963-66; covers Indian art and archaeology as well as other Oriental art which influenced Indian art. Includes scholarly contributions, original research, news notes on museums and, until 1962 when *Lalit kalā contemporary* (Q222) began publication, contemporary art news. Signed reviews. *ARTbib. curr.*

Q222 Lalit kalā contemporary, no. 1, 1962– . New Delhi, Lalit Kalā Akadami. Semiannual.
Covers contemporary painting and sculpture in India, including exhibitions, interviews. The emphasis is on cultural heritage of India in modern life. *ARTbib. curr.; ARTbib. mod.*

Q223 Leonardo; art science and technology; international journal of the contemporary artist, v.1, 1968– . Oxford; Elmsford, N.Y., Pergamon. Quarterly.
Contains articles by an international range of artists, scientists, and art historians on the technological and aesthetic aspects of contemporary art. Text in English, some French summaries. Reviews of art and related technical books plus "Books received" list. *A. D. P.; Art index* (1979– ); *ARTbib. curr.; ARTbib. mod.; LOMA; Rép. d'art.*

Q224 Levant; journal of the British School of Archaeology in Jerusalem, v.1, 1966– . London. Annual.
Scholarly articles on the archaeology of Palestine and the surrounding area from the earliest times to 1800 A.D. *Bull. sig. 525, 526; Rép. d'art.*

Q225 Liturgical arts; a quarterly devoted to the arts of the Catholic church, v.1-40, no. 3, fall 1931-May 1972. N.Y., Liturgical Arts Society. Quarterly. (Repr.: v.1-20 (1931-52), Millwood, N.Y., Kraus, 1968.)
Articles cover fine and decorative arts in the Catholic church up to the present day; contributors are frequently well-known scholars. Occasional reviews of art books. *Art index* (1935-72); *Catholic ind.*

Q226 London. University. Warburg Institute. Journal of the Warburg and Courtauld Institutes, v.1, July 1937– . London. Quarterly, irregular, 1937-44, 1950-62; annual, 1945-49, 1963– . (Repr.: v.1-28, 1937-65, Nendeln, Liechtenstein, Kraus-Thomson.)
Title varies: July 1937-Apr. 1939, *Journal of the Warburg Institute.* An important scholarly journal of art history, with emphasis on iconography and iconology in art and literature. *Art index* (1947– ); *B. d. f. Z.; I. B. Z.; Rép. d'art; Subj. ind.*
_____. Index, v.1-37, 1937-74.

Q227  Lotus international, no. 1, 1964/65- . Milano, Alfieri. Annual; Sept. 1976, Quarterly; irregular, subtitle varies.

Well-illustrated articles on a wide range of contemporary architectural and planning subjects. Recent issues are concerned with environmental, social, and political considerations; no. 8 (1974) begins a three-part series on the problem of the house. Text in English, French, German, Italian, or Spanish. *Art index* (1979- ); *ARTbib. curr.*

Q228  Maandblad voor beeldende kunsten; tevens orgaan der "Vereeniging van Vrienden der Aziatische Kunst," jaarg. 1-26, 1924-50. Amsterdam, De Bussy. Monthly.

Well-illustrated, scholarly articles on all styles and periods of art. Much Oriental art is contained in the earlier volumes, and the "Bulletin" of the Vereeniging van Vrienden der Aziatische Kunst is included in jaarg. 6-21. Occasional signed book reviews. *B. d. f. Z.; Nijhoff.*

Q229  Magazine of art, v.1-46, no. 5, Nov. 1909-May 1953. Wash., D.C., The American Federation of Arts. 10 times a year.

Title varies: Nov. 1909-Dec. 1915, *Art and progress;* Jan. 1916-Aug. 1936, *American magazine of art.* Absorbed *Creative art* Jan. 1934. Covers American art, but not exclusively. Contains signed book reviews and notes of exhibitions. *Ann. mag. subj. ind.; Art index* (v.20-46); *B. d. f. Z.; Int. ind.; R. G.*

Q230  The Magazine of art, v.1-28, n.s., 1-2, 1878-July 1904. London, Paris, N.Y., Cassell. Monthly; publisher varies.

v.27-28 also appeared as n.s., v.1-2. Issued in both an American and an English ed.

  Contains material on some lesser English 19th-century artists and some descriptions of English country homes and landscape. Emphasis is on contemporary art and artists. Short notes on the art world: sales, exhibitions, and book notices and reviews. *Poole's; R. G.; Rev. of revs.*

Q231  Marburger Jahrbuch für Kunstwissenschaft, Bd. 1, 1924- . Marburg an der Lahn, Verlag des Kunstgeschichtlichen Seminars der Universität. Annual, irregular; publisher, place vary. Suspended 1949/50-1955.

Scholarly articles covering sculpture, painting, architecture, and the graphic arts of all periods; emphasis on the Middle Ages. Some text in English and French. *Art index* (Bd. 1-13); *B. d. d. Z.; I. B. Z.; Rép. d'art.*

Q232  Mārg; a magazine of the arts, v.1, 1946- . Bombay, Modern Artists and Architects Research Group. Quarterly; subtitle varies.

Covers all periods of Indian art, dance, music, photography, etc. Occasional issues are devoted to a theme or area. Early volumes have French summaries; exhibition notes. Also called *Pathway (Art of India)* in some issues. *Art index* (1968- ); *ARTbib. curr.; Rép. d'art.*

Q233  Marsyas, studies in the history of art, v.1, 1941- . N.Y., New York Univ. Pr. Biennial, irregular. (Repr.: v.1-4, 1941-1945/47. Millwood, N.Y., Kraus, 1974.)

Scholarly articles on all fields of art history, written by students at the Institute of Fine Arts, New York Univ. Lists Institute thesis titles and includes abstracts of theses and dissertations. Two supplementary *Festschriften* have been published: *Essays in honor of Karl Lehmann,* ed. by L. F. Sandler, 1964, 395p. *Essays in honor of Walter Friedlaender,* ed. by Marsyas, 1965, 194p. *Art index.*

Q234  Master drawings, v.1, spring 1963- . N.Y., Master Drawings. Quarterly.

The leading scholarly periodical devoted exclusively to Western European drawings since the Renaissance. Many plates at end of each volume. Lengthy, signed book reviews. *A. D. P.; Art Index; ARTbib. curr.; ARTbib. mod.; LOMA; Rép. d'art.*

Q235  Metro; international review of contemporary art, no. 1-12, 1960-67; n.s., no. 13-17, 1968-70(?). Milano, Alfieri. Semiannual; irregular, some issues combined.

Suspended 1969-70?; text in English, French, or Italian. Articles on international contemporary art movements and leading figures in the *avant-garde.* n.s. contains more criticism. *Art index* (1969- ); *ARTbib. curr.; LOMA.*

Q236  Metropolitan Museum journal, v.1, 1968- . N.Y., Metropolitan Museum of Art. Annual; v.5-8, 1972-73, are semiannual.

"Articles and shorter notes in all fields of art represented in the Museum . . . both by members of the staff and by other scholars."—*v.1, Foreword.* Concentrates on objects in the museum's collections but is not limited to them; some text in German or French with English summaries. Continues the *Metropolitan Museum studies* which ceased publication in 1936. *A. D. P.; Art index; Rép. d'art.*

Q237  Minotaure, année 1-6, no.1-12/13, juin 1933-mai 1939. [Paris, Skira]. 5 times yearly, no. 1-5; quarterly, no. 6-13. (Repr.: N.Y., Arno, 1968 (6v. in 4).)

Année 4-6 also called troisième série. No. 2 has special title: "Mission Dakar-Dijibouti, 1931-33." A major periodical covering contemporary artistic and literary trends and individuals; also treats primitive art and anthropology. Outstanding illustrations, including original prints. An index to the 13 numbers has been comp. by Julia Sabine of the Newark (N.J.) Public Library. *Rép. d'art.*

Q238  Monatshefte der kunstwissenschaftlichen Literatur, Jahrg. 1-3, Berlin, Meyer. Monthly, 1905-07.

A review of art literature with book reviews and bibliographies, which was superseded by *Monatshefte für Kunstwissenschaft* (Q240). Each number contains signed book reviews and a classed bibliography of recent books and periodical articles, dating from 1904. *B. d. d. Z.*

Q239  Monatshefte für Baukunst & Städtebau, Jahrg. 1-26, 1914-42. Berlin, Wasmuth. Monthly, publisher varies.

Title varies: *Wasmuths Monatshefte für Baukunst,* Jahrg. 1-14. Absorbed *Der Städtebau* Jan. 1930. Articles by scholars

on architecture of the past and present. In later issues emphasis is on contemporary architecture. Contains reviews and summaries of periodical articles. *Art index* (v.15-24); *B. d. d. Z; Subj. ind.*

Q240 Monatshefte für Kunstwissenschaft, Jahrg. 1-15, Jan. 1908-Sept. 1922. Leipzig, Klinkhardt & Biermann. Monthly.
Like *Monatshefte der kunstwissenschaftlichen Literatur* (Q238), with the addition of articles on European art history. Emphasis in the articles on German artists. Contains long signed book reviews and lists of periodical articles in the field. Superseded by *Jahrbuch für Kunstwissenschaft.* (Q201). *B. d. d. Z.*

Q241 Les Monuments historiques de la France; revue trimestrielle, année 1-4, fasc. 2, 1936-39; nouv. sér., v.1, 1955- . Paris, Caisse Nationale des Monuments Historiques et des Sites. Bimonthly, 1936-39; quarterly, 1955- .
Comprehensive articles on French architectural monuments and their conservation. Includes studies of armor, glass, and other objets d'art in the collections of these buildings. Signed book reviews and list of the organization's publications in each volume. *Rép. d'art.*

Q242 Mouseion, v.1-58, avr. 1927-46. Paris, Institut International de Coopération Intellectuelle. 3 times a year to v.4, no. 12; then quarterly; publisher, subtitle vary.
Publication suspended 1941-44. v.1-49/50 also called année 1-14. Contains material on various museums throughout the world, restorations, and archaeological techniques; also, notes on museum personnel, annual reports, etc. v.1-3 have English summaries; v.5 has supplements in English, German, Spanish, and Italian. Two supplementary series were pub.: *Information mensuelles,* mars 1932-sept. 1935, and *Supplément mensuel,* oct. 1935-46. Both the main publication and the supplements have reviews and bibliographies. *Art index* (ann. 1-14, no.2); *B. d. f. Z.; Rép. d'art.*
_____. Index to v.1-50 and the the supplements. [Paris, Office International des Musées, 1946]. 312p. Also pub. in v.51/52-53/54.

Q243 Münchner Jahrbuch der bildenden Kunst, Bd. 1-13, 1906-23; n.F., Bd. 1-13, 1924-39; 3. F., Bd. 1, 1950- . München, Prestel. Annual; frequency varies. (Repr.: Bd. 1-n.F., Bd. 13, N.Y., Johnson, 1970.)
Suspended 1939-50. Published by the Staatliche Kunstsammlungen and since 1950, with the Zentralinstitut für Kunstgeschichte, Munich. Scholarly articles on ancient, medieval, Renaissance, and modern art through the 18th century. News notes of the state museums. *Art index* (1929-39, 1969- ); *ARTbib. curr.; B. d. d. Z.; I. B. Z.; Rép. d'art.*

Q244 Musées de France, année 1-15, 1929-50. Paris, Direction des Musées Nationaux. Monthly.
Title varies: 1929-47, *Bulletin des musées de France.* Suspended 1939-45. Replaced by *La Revue des arts* (Q299). Official journal of the French museums, contains news and

articles on the collections. Short reviews up to 1929. *Art index* (1948-50); *B. d. f. Z.; Rép. d'art.*

Q245 Museum; a quarterly review/revue trimestrielle, v.1, 1948- . Paris and N.Y., UNESCO. Quarterly.
Supersedes *Mouseion.* Well-illustrated articles on museum management, operation, and exhibitions; international in scope. Text in French and English; summaries in Spanish and Russian. *Art index; ARTbib. curr; B. d. f. Z.; Bull. sig. 525, 526; Chem. Abst.; I. B. Z.; Rép. d'art; Subj. ind.*

Q246 Museum; revista mensual de arte español antiguo y moderna y de la vida artistica contemporanea, v.1-7, no. 11; 1911-36. Barcelona, Thomas. Monthly, later volumes very irregular.
Important for all periods of Spanish painting, sculpture, and church arts; well illustrated. Some book reviews and art notes. *Rép. d'art.*

Q247 The Museum news, 1, 1924- . Wash., D.C., American Association of Museums. 10 times a year.
A news magazine containing short feature articles and notes regarding American museums and their activities. Brief book reviews. Index to special articles, v.1-30, issued with v.30 (1953). *Art index* (1929-59, 1979-); *ARTbib. curr.; ARTbib. mod.*

Q248 Museum studies, v.1, 1966- . Chicago, Art Institute of Chicago. Annual.
Scholarly articles which concentrate largely on painting and sculpture (with emphasis on new acquisitions and restorations) in the museum's collections; also includes contributions on topics of much wider scope. *Art index* (1968- ); *Rép. d'art.*

Q249 The Museums journal, v.1, July 1901- . London, The Museums Association. Monthly to 1961; then quarterly.
Supersedes the Association's *Report on proceedings.* Contains articles on museums throughout the world, but concentrates on Great Britain. Recently has signed book reviews and short news items. "Indexes to papers read before the Museums Association 1890-1909" in v.9. *Art index; ARTbib. curr.; ARTbib. mod.; LOMA; Rép. d'art; Subj. ind.*

Q250 Museumskunde; Fachzeitschrift herausgegeben vom Deutschen Museumsbund, Bd. 1-17, 1905-Aug. 1924; n.F., Bd. 1-11, 1929-39; Bd. 29-41 (also called dritte Folge, Bd. 1-13), 1960-72. Berlin, de Gruyter. Annual, irregular, 1905-24; quarterly, 1929-39; three times a year, irregular, 1960-72.
Subtitle varies: 1905-39, *Zeitschrift für Verwaltung und Technik öffentlicher und privater Sammlungen;* Bd. 41 (1972) not pub. until 1975. Official organ of the Deutscher Museumsbund. Covers museum operation and collections throughout the world, with special emphasis on Germany. Includes bibliographies and, since 1960, book reviews in the museum field. Bd. 38 (1969) and 41, Heft 1-2 (1972) are monographs: G. Calov. *Museen und Sammler des 19. Jahrhunderts in*

*Deutschland,* and F. R. Zankl. *Das Personalmuseum.*
*ARTbib. curr.; B. d. d. Z.; I. B. Z.; Rép. d'art.*

Q251 Művészettörténeti értesítő, évf. 1, 1952- . Budapest,
Akadémiai Kaidó. Quarterly, some issues combined;
semiannual, 1952-55.
Issued by the Magyar régészeti, művészettörténeti és érem-
tani társulat. Long articles on Hungarian art throughout the
world and foreign art in Hungarian collections. Beginning
1955, yearly international bibliography on Hungarian art
history. Long signed book reviews, some German or Eng-
lish summaries. Table of contents also in Russian and
French. *Rép. d'art.*

Q252 Napoli nobilissima; rivista bimestrale di arti figurative,
archeologia e urbanistica, v.1-6, magg./giugno 1961-
sett./dic. 1967. Napoli, L'Arte tipografica. Bimonth-
ly, irregular.
Scholarly treatment of art and architecture in the city of
Naples and the surrounding area. Also covers non-Neapolitan
work in local collections. Short book reviews. *Rép. d'art.*

Q253 Nederlands Instituut te Rome. Mededelingen, deel
1-10, 1921-25; tweede reeks, deel 1-10, 1931-40;
derde reeks, deel 1-10, 1942-59; deel 31-35, 1961-
71; nova series, 1 (also called deel 36), 1974- .
's Gravenhage. Annual, irregular.
Suspended 1972-73; to 1971, issued by the Nederlands
Historisch Instituut te Rome. Pub. by the Ministerie van
Cultuur, Recreatie en Maatschappelijk Werk. A scholarly
publication in the area of Italian studies, valuable for arti-
cles on Italian art and archaeology and the relationship
between Dutch artists and Italy. In Dutch with some French
summaries; *nova* series also called *Papers.* Text in French,
German, and English. Beginning v.32- includes annual re-
ports of the Instituut. *Art index* (1929-47); *Rép. d'art.*
_____. Index deel 1-10 (1935).
_____. "Inhoudsopgave . . . Reeks 2 en III" in 3 reeks, deel
10 (1959).

Q254 Nederlands kunsthistorisch jaarboek, v.1, 1947- .
's Gravenhage, Daamen. Annual. (Repr.: v.1-20
(1947-69), Amsterdam, Swets & Zeitlinger.)
v.5- also called *Netherlands yearbook for history of art.* A
scholarly, well-illustrated periodical which examines all
phases of art history, emphasizing Netherlandish art. Also
in English, French, German, and Italian; English summaries
of the Dutch text. *Art index* (1969- ); *ARTbib. curr.; ARTbib.
mod.; B. d. f. Z.; I. B. Z.; Rép. d'art.*

Q255 Niederdeutsche Beiträge zur Kunstgeschichte, Jahrg.
1, 1961- . Köln, Seemann. Annual.
Current editor: Harald Seiler.
Each volume contains long articles on a broad range of
topics on German art and art in German collections from
antiquity to the 19th century. *I. B. Z.*

Q256 Nouvelles de l'estampes, [v.1], 1963- . Paris, Comité
de la Gravure Française et Cabinet des Estampes
de la Bibliothèque Nationale. 10 times a year, 1963-
71; bimonthly, 1972- .

Continuous numbering begins with no. [1], jan.-fev., 1972- .
Contains significant, scholarly articles on prints and
printmakers of all periods, with some concentration on
contemporary developments. Lists exhibitions in Paris, in
France by province, and internationally by city. Reports on
sales, museum acquisitions, new prints and editions, and
techniques. Short signed book reviews. *Rép. d'art.*

Q257 Nuovo bullettino di archeologia cristiana, anno 1-
28, 1895-1922. Roma, Libreria Spithöver. 4 (some
double) fascicles issued yearly; publisher varies.
Supersedes *Bullettino di archeologia cristiana* and was super-
seded by *Rivista di archeologia cristiana.* From 1898-1922:
Ufficiale per i resoconti della Commissione di archeologia
sacra sugli scavi e su le scoperte nelle catacombe romane.
Useful for material on Early Christian art and archaeology.
Contains reviews. *B. d. f. Z.; Rép. d'art.*

Q258 L'Oeil; revue d'art mensuelle, no. 1, 1955- . Lausanne,
Sedo. Monthly, some numbers combined.
A well-illustrated, popular periodical, with numerous color
plates. Wide range of articles; recently the emphasis has been
on contemporary interior design. Most of the articles end
with suggestions for further reading. Brief book reviews.
*A. D. P.; Art index* (1959- ); *ARTbib. curr.; ARTbib. mod.;
I. B. Z.; LOMA; Rép. d'art.*

Q259 Old master drawings; a quarterly magazine for stu-
dents and collectors, v.1-14, 1926-40. London, Bats-
ford. Quarterly. (Repr.: v.1-14, N.Y., Collectors
Editions, 1970).
Short articles by recognized scholars in the field; many
excellent halftone reproductions, with size and provenance.
*Art index; Rép. d'art.*

Q260 Old-time New England; the bulletin of the Society
for the Preservation of New England Antiquities,
v.1, May 1910- . Boston. Irregular, 1910-19; quar-
terly, 1919- .
Subtitle: "A quarterly magazine devoted to the ancient build-
ings, household furnishings, domestic arts, manners and
customs, and minor antiquities of the New England people."
Emphasis is on preservation of architecture and crafts. *Art
index; ARTbib. curr.*

Q261 Onze kunst; geillustreerd maandschrift voor beel-
dende en decoratieve kunsten, deel [1]-46, jaarg. 1-
25, 1902-juni 1929. Antwerpen, Burton; Amsterdam,
Veen. Semiannual. Subtitle, publisher vary.
None pub. 1921, 1923-24, 1927-June 1928. Supersedes *De
Vlaamsche school.* A journal of Flemish art which also
contains information about exhibitions of other art in Flan-
ders and the Netherlands. Contains book reviews and re-
views of periodicals. Index: v.1-20, 1902-11. *B. d. f. Z.;
Bibl. de Belgique; Hague. K. Bibl.*

Q262 Oppositions; a journal for ideas and criticism in
architecture, no. 1, Sept. 1973- . Cambridge, Mass.,
MIT Pr. Quarterly.

A handsome journal of architectural history and criticism, with contributions by leading authorities. Includes town planning and environmental design. Lengthy book reviews. *Art index* (1979– ).

✓ Q263 Oriental art; quarterly publication devoted to all forms of Oriental art, v.1–3, 1948–51; n.s., v.1, 1955– . London, Oriental Art magazine. Quarterly; subtitle varies.
One of the leading periodicals of Oriental art. Contains articles by specialists in all areas of Eastern art, as well as notes on museums and exhibitions throughout the world. Signed book reviews. Each issue has a bibliography of recent books and periodicals, classified by place. *Art index* (1959– ); *Bull. sig. 526; Rép. d'art; Subj. ind.*

Q264 Oriental Ceramic Society. Transactions, v.1, 1921/22– . London. Annual, recent years irregular; biennial, 1967/69– .
Papers presented by members of the Society (and occasionally by others) on all periods of Far Eastern ceramics and related topics such as Oriental porcelain in Western painting and individual collections.

Q265 Ostasiatische Zeitschrift, Jahrg. 1–28, Apr. 1912–1942/43. Berlin und Leipzig, de Gruyter. Quarterly, v.1–14; then 6 times a year; subtitle, publisher vary.
v.11–28 also called n.F., v.1–18. Suspended 1928. Includes articles on Eastern art in German, French, and English. Especially valuable for book reviews and bibliographies on Far Eastern art. Gives lists of periodical articles pertaining to Oriental studies in German and foreign periodicals. Includes sales notes and lists catalogues dealing with Oriental art. v.15– include "Mitteilungen der Gesellschaft für Ostasiatische Kunst." *Art index* (n.F., v.15–16); *B. d. d. Z.; Rép. d'art.*

✓ Q266 Österreichische Zeitschrift für Kunst und Denkmalpflege, Jahrg. 1, 1947– . Wien, Schroll. Bimonthly, 1947–54; quarterly, 1955– .
Title, 1947–51, "Österreichische Zeitschrift für Denkmalpflege." Pub. for the Bundesdenkmalamt of Austria. Covers art and architectural conservation in Austria in well-illustrated technical descriptions. Includes general articles and bibliographies of Austrian art and art in Austria. Signed book reviews. *ARTbib. curr.; I. B. Z.; Rép. d'art.*

Q267 Österreichisches Archäologisches Institut in Wien. Jahreshefte, Bd. 1, 1898– . Baden bei Wien, Roher. Annual, irregular.
Supersedes *Archäologisch-epigraphische Mitteilungen aus Österreich-Ungarn.* Contains scholarly articles on archaeological subjects and epigraphy. Has a separately paged "Beiblatt" or "Grabungen" with short articles and news notes on excavations. Index to Bd. 1–5 in Bd. 5, *Beiblatt;* Bd. 6–10 in Bd. 10, *Beiblatt.* Indexes to Bd. 19–20 and 21–22 issued as a combined volume. *Art index* (1929–39); *B. d. d. Z.; I. B. Z.; Rép. d'art.*

Q268 Oud-Holland; driemaandelijks tijdschrift voor Nederlandse kunstgeschiedenis. The quarterly for Dutch art history, jaar. 1, 1883– . Amsterdam, De Bussy. Irregular, 1883–97; bimonthly, 1923–25; quarterly, 1898–1922, 1926– ; subtitle, publisher vary. (Repr.: v.1–86 (1883–1971) and Index, v.1–60, Nendeln, Liechtenstein, Kraus, 1976– .)
Scholarly coverage of the entire range of Dutch art history, especially painting. Text in Dutch, German, French, or English; some English summaries. Signed book reviews. v.65, 1950– , "Mededelingen van het Rijksbureau voor Kunsthistorische Documentatie"; v.42–54: "Overzicht der literatuur betreffende Nederlandsche kunst," arranged by country of origin. *Art index; B. d. f. Z.; Hague. K. Bibl.; I. B. Z.; Nijhoff; Rép. d'art.*
    Indexes: v.1–40 in v.40; v.41–50 in v.50; v.1–60, C. Bille, *Oud-Hollands systematische inhoudsopgave van den 1sten-60sten jaargang, 1883–1943.* 1v.

Q269 Palestine exploration quarterly, v.1, 1869– . London, Palestine Exploration Fund. Quarterly, 1869–1941; semiannual, 1942– . (Repr.: 1869/70–1970, Folkstone, Kent, Eng.)
Wide scholarly coverage of archaeology in the Palestine area from prehistoric times through the Islamic period. Signed book reviews. *Art index* (1979– ); *B. d. f. Z.; Bull. sig. 525, 526; I. B. Z.; Rép. d'art.*

Q270 Palladio; rivista di storia dell' architettura, anno 1–5, 1937–41; n.s. 1, 1951– . Roma, Istituto Grafico Tiberino. Quarterly, 1951–58; semiannual, 1959–61; annual, 1962– ; publisher varies.
Scholarly coverage of architectural history from prehistoric times to the 20th century in Italy and elsewhere. Signed book reviews; n.s. has some summaries in English, French, and German of major articles. *Art index* (1969– ); *ARTbib. curr.; B. d. f. Z.; I. B. Z.; Rép. d'art.*

Q271 Pan. 1.–5. Jahrg., Heft 4; Apr./Mai 1895–Juli, 1900. Berlin. Fontane. 5v. in 6. Quarterly.
An important Art Nouveau periodical. Contains original prints. A detailed analysis of its contents has recently been published: *Bildende Kunst 1850–1914; Dokumentation aus Zeitschriften des Jugendstil* (A103).

Q272 Pantheon; internationale Zeitschrift für Kunst/International art journal, Jahrg. 1, 1928– . München, Bruckmann. Monthly, 1928–45; bimonthly, 1960– ; subtitle varies.
Absorbed *Cicerone* in 1931. Suspended publication 1945–59. A well-illustrated periodical with brief authoritative articles on Western art, and, to a lesser extent, on Oriental art. From Jahrg. 18, 1960, contains notes on sales and exhibitions in Europe and North America. *A. D. P.; Art index* (1928–39, 1969– ); *ARTbib. curr.; ARTbib. mod.; B. d. d. Z.; I. B. Z.; LOMA; Rép. d'art.*

Q273 Paragone; rivista mensile di arte figurativa e letteratura, fondata da Roberto Longhi, anno 1, 1950– . Florence, Sansoni. Monthly; subtitle, publisher vary.

Issued in two alternating sections, *Arte* and *Letteratura: Arte* is a general Italian art periodical including art of various countries and periods, exhibitions, and book reviews. Occasionally includes "Antologia di critici" which reprints art criticism in all areas of art history. *ARTbib. curr.; ARTbib. mod.; B. d. f. Z.; I. B. Z.; Rép. d'art.*

**Q274** Paris. Musée National du Louvre. Laboratoire de Recherche des Musées de France. Annales, 1970- . Paris, Conseil des Musées Nationaux. Annual.
Originally pub. by the Laboratoire pour L'Étude Scientifique de la Peinture as *Bulletin,* année 1-12, juin 1956-68. Devoted to studies involving the scientific examination and conservation of works of art. No. 1-5 issued as supplements to *La Revue des arts* (Q299), and *Musées de France* (Q244). First issue has a bibliography of works published by the laboratory, 1936-55. *Bull. sig. 526; Rép. d'art.*

**Q275** Parnassus, v.1-13, 1929-41. N.Y., College Art Association of America. 10 times a year.
Replaced by the *College art journal.* Contains articles, brief book reviews, exhibition notices, recent museum acquisitions, and programs of the College Art Association meetings. *Art index; B. d. f. Z.; Rép. d'art.*

**Q276** Perspecta; the Yale architectural journal, no. 1, summer 1952- . New Haven. Irregular.
Well-designed volumes pub. by students in the School of Architecture and Design, Yale Univ. Format varies from issue to issue but generally contains articles, interviews, and projects by leading architects, planners, historians, and others. Predominantly American. Emphasis is on new methods and viewpoints. *Art index* (1959- ); *ARTbib. curr.*

**Q277** The Portfolio; an artistic periodical, v.1-24, 1870-93. London, Seeley. Monthly; publisher varies.
Superseded by *The Portfolio; monographs on artistic subjects,* 1894-1907. Contains some useful articles on contemporary English art, written in a popular style. Includes material on the English countryside and places, book notices, and news of the English art world. *Poole's.*

**Q278** The Prairie school review, v.1, 1964- . Palos Park, Ill., Prairie School Pr. Quarterly.
Articles on the history of architecture and associated subjects in the American Midwest; concentrates on Sullivan, Wright, and their contemporaries. Signed book reviews and occasional bibliography. *Art index* (1969- ).

**Q279** Print collector; il conoscitore di stampe, Aug./Sept. 1970- , no. 1- . Milan, Salamon e Agustoni. 5 times a year.
Title varies: Aug./Sept. 1970-Nov./Dec. 1975, *I Quaderni del conoscitore di stampe;* also pub. in an English ed. as *Print collector; bimonthly review—the print: trends and developments,* aut./win. 1972-Sept./Oct. 1975, which included much of the same material as the Italian ed. Began publication in bilingual form Nov./Dec. 1975, discontinuing English ed. numbering and continuing Italian ed. numbering.

The emphasis is on information for the connoisseur and collector of prints for all periods. Includes scholarly articles, oeuvre catalogues and supplements to catalogues, notes, inquiries, book reviews, and auction prices. Annual indexes. *ARTbib. mod.*

**Q280** The Print collector's newsletter, v.1, Mar.-Apr. 1970- . N.Y., Print Collector's Newsletter. Bimonthly.
Each issue reports on two or three major printmakers or themes, historical and contemporary; also covers photography. Includes news notes, recent bibliography, lists of newly published portfolios and prints, book reviews, and detailed records of print sales. Lists print publishers and printmakers' representatives. Loose-leaf format. *A. D. P.; Art index* (1979- ); *ARTbib. curr.; ARTbib. mod.*

**Q281** The Print-collector's quarterly, v.1-30, Feb. 1911-Aug. 1951. N.Y., and London, Keppel [etc.] Quarterly; publisher, place vary. (Repr.: v.1-30 (selective), ind. 1-23, N.Y., Kraus.)
Combined with *Print, a quarterly journal of the graphic arts,* with v.30, no. 3. Suspended 1918-20, Oct. 1936-Feb. 1937, Apr. 1942-Nov. 1948. A profusely illustrated journal containing articles by recognized authorities on individual artists of all times. Contains book reviews in v.11-23. *Ann. mag. subj. ind.; Art index* (v.16-30); *B. d. f. Z.; Int. ind.; Subj. ind.*
_____. General index, v.I-XIII, 1911-26. London, Dent, 1927. 78p.
_____. Complete index, v.I-XXIII, 1911-36. London, Dent [1936]. [96]p.

**Q282** Print review, no. 1, 1973- . N.Y., Pratt Graphics Center and Kennedy Galleries. Semiannual.
Current editor: Walter L. Strauss.
An excellent new periodical which supersedes *Artists' proof* (Q90). Contains scholarly articles on all periods of prints and printmaking. Reports on recent museum acquisitions, signed book reviews. Issue no. 7 (1976) is a *Festschrift* for the late Wolfgang Stechow. *Art index* (1979- ).

**Q283** Progressive architecture; Pencil points, v.1, 1920- . Stamford, Conn., Reinhold. Monthly; place varies.
Title varies: 1920-45, *Pencil points.* In 1932, absorbed the *Monograph* series, formerly published separately as *The White pine series of architectural monographs,* which was retained in the periodical to 1941.
Covers design aspects of contemporary architecture as well as technical matters of interest to architects and engineers. Some book reviews. *Art index; ARTbib. curr.; A. S. T. ind.; B. d. f. Z.; Eng. ind.; I. B. Z.; LOMA; P. A. I. S.*

**Q284** Proporzioni; studi di storia dell'arte, 1-4, 1943-63. Firenze, Sansoni. Irregular.
Roberto Longhi, editor. Scholarly articles with emphasis on Italian art of all periods. Occasional articles in English or French.

505

Q285    Quadrum; revue internationale d'art moderne, no. 1-20, 1956-66. Bruxelles, L'Association pour la Diffusion Artistique et Culturelle. Semiannual.
Text in English, German, French, and Italian (with English and French summaries) by recognized authors. The well-designed layout enhances emphasis on contemporary art. Contains news notes on acquisitions, biography, and exhibitions, some reviews. Index to v.1-20 in v.20. *Art index* (1959-66); *Rép. d'art.*

RIBA journal. See: Royal Institute of British Architects, London. Journal.

Q286    Racar; revue d'art canadienne/Canadian art review, v.1, 1974- . Saskatoon, Society for the Promotion of Art History Publications in Canada. Semiannual.
A new journal devoted to the publication and promotion of art historical research by Canadian scholars. Text in French or English, no translations; signed book reviews.

Q287    Rassegna bibliografia dell'arte italiano . . . anno 1-19, 1898-1916. Ascoli Piceno, Tassi. Monthly; publisher, place vary.
Gives abstracts of books and periodical articles. Index at end of each volume. *Rép. d'art.*

Q288    Rassegna d'arte, anno 1-22, 1901-22. Milano, Alfieri & Lacroix. Monthly.
Title for anno 15-22: *Rassegna d'arte antica e moderna;* anno 14-22 also called n.s. v.1-9; 1901-13 include a section *Vita d'arte;* 1915 has subtitle *Vita d'arte (moderna).* Scholarly articles valuable for the study of Italian art, chiefly painting. Signed book reviews. New series is wider in scope; contains exhibition and art notes. *Italy. Parl. Cam. dei Deputati Bibl.; Rép. d'art.*

Q289    La Renaissance de l'art français et des industries de luxe, année [1]-23, n. 1, mars 1918-mars 1940. Paris, Les Éditions Nationales. Monthly; title, publisher vary.
A popular French journal, similar to *International studio.* The emphasis is on decorative arts; includes information on lesser-known French painters. Many illustrations. Contains notes on sales, acquisitions, exhibitions, and some book reviews. Frequently has English translations or summaries. *Art index* (v.12-22); *B. d. f. Z.*

Q290    Renaissance quarterly, v.1, 1948- . N.Y., Renaissance Society of America. Quarterly. (Repr.: v.1-23 (1948-70), Millwood, N.Y., Kraus.)
Title varies: v.1-19, *Renaissance news.* Not primarily an art periodical. Contains articles on all aspects of the cultural and intellectual life of the Renaissance. Extensive signed book reviews. Lists "Renaissance books" from national bibliographies with a "fine arts" section. *Art index* (1959-78); *Hum. ind.; I. B. Z.; Rép. d'art.*

Q291    Repertorium für Kunstwissenschaft, Bd. 1-52, 1876-1931. Berlin, de Gruyter. Irregular, 4-6 no. a year; publisher varies. (Repr.: v.1-52, Berlin, de Gruyter, 1968.)

v.36-45 also called n.F., Bd. 1-9. Merged with *Zeitschrift für bildende Kunst* and *Jahrbuch für Kunstwissenschaft* to form *Zeitschrift für Kunstgeschichte.* An important scholarly periodical. Book review section is arranged according to broad groups, *i.e.,* architecture, painting, sculpture, and contents of periodicals. Lists recent publications (both books and periodical articles) and also necrologies from 1876-1903. *Art index* (v.50-52); *B. d. d. Z.; Rép. d'art.*
————. Register zu Band I-XVI . . . Berlin und Stuttgart, Spemann, 1893. 164p.

Q292    Revue archéologique, année 1-16, 15 avril 1844-sept. 1859; n.s., année 1-23, t.1-44, jan. 1860-déc. 1882; sér.3, t.1-41, jan. 1883-déc. 1902; sér.4, t.1-24, jan. 1903-juin 1914; sér.5, t.1-36, jan. 1915-déc. 1932; sér.6, t.1, jan. 1933- . Paris, Presses Universitaires de France. Semiannual; frequency varies.
Pub. for the Centre National de la Recherche Scientifique. Valuable for its coverage of archaeology, especially that of Greece and Rome. News notes, bibliographies, extensive signed reviews. Indexes: v.1-10 in v.10; v.11-16 in v.16; n.s. 1860-69, lv.; 1870-90 in sér.3, t.23. *Art index; B. d. f. Z.; Bull. sig. 526; I. B. Z.; Rép. d'art; Rép. bibl.*
————. Table des années 1900-45, Paris, 1949.

Q293    Revue belge d'archéologie et d'histoire de l'art/ Belgisch tijdschrift voor oudheidkunde en kunstgeschedenis, t.1, 1931- . Bruxelles, L'Académie Royale d'Archéologie de Belgique. Quarterly; publisher, place vary.
Succeeds its *Bulletin* and *Annales* (1842-1930). Scholarly treatment of painting, sculpture, architecture, and archaeology. The scope is predominantly Flemish. Text mostly in French. *Art index* (1931-48, 1969- ); *ARTbib. curr.; ARTbib. mod.; B. d. f. Z.; Bibl. de Belgique; I. B. Z.; Int. ind.; Rép. d'art.*

Q294    La Revue d'art, t.23-30, 1921-29. Anvers, Burton. Monthly; subtitle, publisher, place vary.
Continues *L'Art flamand & hollandais* (Q67) and has same format. For 1915-20 see *Onze kunst* (Q261). Suspended Apr. 1921-Mar. 1922. Covers Flemish and Dutch art from Middle Ages to modern times. Includes list of recently published books. *B. d. f. Z.; Bibl. de Belgique; Rép. d'art.*

Q295    Revue de l'art. [no.] 1, 1968- . Paris, Flammarion. Quarterly; publisher varies.
At head of title: Secretariat d'État aux Universités, Centre National de la Recherche Scientifique, Revue publiée sous l'égide du Comité Français d'Histoire de l'Art, avec le concours du Secrétariat d'État à la Culture.
A new periodical which ranks with the older established scholarly journals of art history. The editorial board is comprised of distinguished French scholars and well-known art historians from other countries. Each issue includes an editorial, two or more long articles, and shorter contributions in "Notes et documents" or "Chroniques." Notes on exhibitions. English summaries. Attractive format; well illustrated. *Art index* (1979- ); *ARTbib. curr.; Rép. d'art.*

Q296 Revue de l'art ancien et moderne, t.1-71, avr. 1897
1937. Paris, Petit. Monthly, t.1-35, 1897-juin 1914;
t.36 covers juin. 1914-déc. 1919; 10 numbers a year,
t.37-71.
Suspended 1914-19. Has supplement: *Bulletin de l'art.*
Covers architecture, painting, sculpture (as well as some
music and dance) of all periods. Also contains short exhibi-
tion and art world notes, book reviews, and bibliographies.
*Art index* (v.56-71); *B. d. f. Z.; Rép. d'art; Rép. bibl.*
_____. Tables de 1897 à 1909. Paris, 1910. 150p.
_____. Tables, t.II (1910-1937). Paris, 1939. 210p.

Q297 Revue de l'art chrétien, t.1-64, jan. 1857-juin 1914.
Paris, Pringuet. Monthly, t.1-20; quarterly, t.21-39;
bimonthly, t.40-64; subtitle varies.
v.18-32 also called 2.sér., t.1-15; v.33-39, 3.sér., t.1-7;
v.40-54, 4.sér., t.1-15; v.55-64, 5.sér., t.1-10.
Contains articles on Christian architecture, artifacts, ar-
chaeology, and iconography in France and, to a lesser ex-
tent, in other European countries and the Holy Land. Signed
book reviews and précis of periodical articles. *Rép. bibl.;
Rép. d'art.*
_____. Table méthodique des articles publiés dans la
Revue . . . depuis l'origine (janvier 1857) jusqu'au 31 dé-
cembre 1881. 56p.
_____. Table analytique générale de la Revue . . . années
1883 à 1895. [Supplement to Nov. 1895 issue]
_____. Table alphabétique 1883-1909. Paris, Champion
[etc.], 1914. 112p.

Q298 Revue de l'histoire des religions; annales du Musée
Guimet, Paris, v.1, 1880- . Paris, Presses Universi-
taires de France. Bimonthly, 1880-1941; quarterly,
irregular 1942- . (Repr.: Nendeln, Liechtenstein,
Kraus, 1972, v.1-50.)
Includes articles on symbols and iconography as well as
histories of the activities of saints, some biblical archaeology,
and articles on primitive and Eastern religions. Signed
book reviews. Index 1-44 (1880-1901). *B. d. f. Z.; I. B. Z.;
Rép. d'art.*

Q299 La Revue des arts, année 1-10, 1951-60. Paris, Con-
seil des Musées Nationaux. Quarterly.
Replaces *Musées de France* (Q244). Scholarly articles and
notes on works in French museums. Lists current French
exhibitions. Continued by *La Revue du Louvre et des mu-
sées de France* (Q301). Supplement: Paris. Musée National
du Louvre. Laboratoire de Recherche Scientifique. *Bulle-
tin. Art index; B. d. f. Z.; Rép. d'art.*

Q300 Revue des arts asiatiques, année 1-13, mai 1924-
1939/42. Paris, Les Éditions d'art et d'histoire. 10
times a year to Mar. 1925; thence quarterly; publi-
sher varies.
Superseded in 1954 by *Arts asiatiques* (Q95). Subtitle varies:
v.5- . *Annales du Musée Guimet.* Scholarly articles on Orien-
tal art. Signed book reviews. Issues from Mar. 1925- con-
tain the "Bulletin" of the Association Française des Amis
de l'Orient. *B. d. f. Z.; Rép. d'art.*

Q301 La Revue du Louvre et des musées de France; chro-
nique des Amis du Louvre, t.11, 1961- . Paris, Con-
seil des Musées Nationaux. Quarterly.
Continues *La Revue des arts* (Q299). Well-illustrated, short
articles on works in French collections, new acquisitions,
and exhibitions. *A. D. P.; Art index; ARTbib. curr.; ARTbib.
mod.; Bull sig. 525, 526; I. B. Z.; Rép. d'art.*

Q302 Revue roumaine d'histoire de l'art, t.1, 1964- .
Bucarest, L'Académie de la République Socialiste
de Roumanie. Semiannual to 1969; in 1970 produced
in 2 series: 1.sér., arts plastiques, 2.sér., theatre,
musique, cinématographie; each series is annual.
Limited to Rumanian art history, contemporary and folk
art. Prior to 1970 the issues combined theater studies and
the visual arts. Signed book reviews. Chiefly in French with
occasional articles in English or German. *ARTbib. curr.;
ARTbib. mod.; Rép. d'art.*

Q303 Rivista d'arte, anno 1-36, 1903-61/62. Firenze, Olsch-
ki. Monthly, 1903-05; bimonthly, irregular, 1906-42;
annual, 1950-61/62; publisher varies. (Repr.: v.1-36
(1903-61/62), Amsterdam, Swets & Zeitlinger.)
Title in 1903: *Miscellanea d'arte.* Suspended 1908-11,
1913-16, 1917-29, 1943-49. Scholarly articles on Italian
art; the emphasis is on Tuscan painting. Lengthy signed
reviews, v.26- . Archival material included. "Bibliografia"
covers this field in book and articles; includes news notes.
*Art index* (1929-39); *B. d. f. Z.; Rép. d'art.*
_____. Index: v.1-24, 1903-42 (issued as v.25).

Q304 Rivista di archeologia cristiana, anno 1, 1924- .
Roma, Pontifico Istituto di Archeologia Cristiana.
Quarterly, many combined; publisher varies.
Supersedes *Nuovo bullettino di archeologia cristiana.*
Valuable for Early Christian archaeology; news notes and
book reviews. From 1929 through the 1960s includes a clas-
sified bibliography of books and articles on the subject.
*B. d. f. Z.; I. B. Z.; Rép. d'art.*

Q305 Rivista di estetica, anno 1-18(?), genn./apr. 1956-
73(?). Torino, Istituto di Estetica dell'Università di
Torino. 3 times a year; publisher, place vary.
First issue pub. by Istituto di Filosofia dell'Università di
Padova. Covers all aspects of aesthetics in Western arts and
literature. Includes lengthy abstracts of articles from other
journals. Book reviews and list of books received. *ARTbib.
curr.*

Q306 Roma. Università. Istituto di Storia dell'Architettura.
Quaderni, n.1-73/78, 1953-66. Roma. Bimonthly,
most numbers combined.
Not pub. 1959-60. Scholarly investigations of architecture
in Italy from the medieval period into the 19th century.
Well illustrated. *Rép. d'art.*

Q307 Römische Quartalschrift für christliche Altertums-
kunde und für Kirchengeschichte, Jahrg. 1, 1887- .
Quarterly; publisher, place vary.

Suspended publication 1939-53. v.48- issued by Deutsches Priesterkolleg am Campo Santo and the Römisches Institut der Görres-Gesellschaft. Not primarily an art periodical but covers Early Christian architecture, inscriptions, monuments, archaeology, etc., throughout the Mediterranean area. Signed reviews; few illustrations. v.15-46, "Anzeiger für christliche archäologie" contains bibliographical notes. *B. d. d. Z.; I. B. Z.; Rép. d'art.*

Q308 Römisches Jahrbuch für Kunstgeschichte, Bd. 1, 1937- . Tübingen, Wasmuth. Irregular; publisher, place vary.
Pub. under auspices of the Bibliotheca Hertziana in Rome. v.1-2 title: *Kunstgeschichtliches Jahrbuch der Bibliotheca Hertziana.* Suspended 1945-54. Long scholarly articles on Italian medieval, Renaissance, and Baroque art, emphasizing architecture. Occasional text in Italian. *Art index* (1968- ); *ARTbib. curr.; B. d. d. Z.; I. B. Z.; Rép. d'art.*

Q309 Roopa-lekhā, v.1-4, no.1-13, 1929-34; n.s., v.1-3. no. 1, July 1939-46; v.20, no. 1-2, 1948; v.22, 1948/49- . Delhi, All-India Fine Arts & Crafts Society. Semiannual; formerly quarterly, irregular.
Suspended 1935-June 1939; 1941-42; July 1943-45. Articles on Indian painting and arts in general, with balance between contemporary work and an historical approach. Many color plates and "Art notes," a news column. Recently, longer signed reviews. *ARTbib. curr.*

Q310 Royal Institute of British architects, London. Journal. 3d series, v.1, 1893/94- . London, Royal Institute of British Architects. Fortnightly during sessions of the Institute, monthly during recess, v.1-46; monthly, v.47- .
Preceded by *Transactions* and *Journal of proceedings* which combined in 1893 to form the *Journal* 3d series. The official journal of the Royal Institute of British Architects, it contains papers read at meetings and news notes. More recently, it emphasizes the professional and technical aspects of design and construction. *Art index; ARTbib. curr.; ARTbib. mod.; B. d. f. Z.; I. B. Z.; Rép. d'art; Subj. ind.*

Q311 Rūpam; an illustrated quarterly journal of Oriental art, chiefly Indian, no. 1-44, 1920-30. Calcutta, Gangoly. Quarterly.
Superseded by Indian Society of Oriental Art. *Journal.* Includes scholarly contributions on Indian and other Asiatic art; long signed reviews. No. 10, Apr. 1922, p.57-58, contains "Bibliography of Indian painting (not including Moghul)" by A. K. Coomaraswamy. *Art index* (no.38-44); *B. d. f. Z.; Rép. d'art; Subj. ind.*

Q312 Saggi e memorie di storia dell'arte, v.1, 1957- . Firenze, Olschki. Biennial; irregular.
Issued by the Istituto di Storia dell'Arte of the Fondazione Giorgio Cini. Scholarly articles on the history of Italian art and foreign artists who worked in Italy. Includes sources, letters, and other archival material. Articles in various European languages. *ARTbib. curr.; Rép. d'art.*

Q313 Schweizerisches Institut für Kunstwissenschaft. Jahrbuch, 1963- . Zürich. Annual, 1963-67; biennial 1968/69- .
Issued as *Jahresbericht,* 1963-65, and as *Jahresbericht und Jahrbuch,* 1966-67; from 1968 *Jahresbericht,* the Institute's annual report, has been published separately.
A scholarly journal with articles treating all subjects of the art history of Switzerland. Well illustrated. The volume for 1970-71 is a monograph: A. Knoepfli, *Schweizerische Denkmalpflege,* which also begins a series which from time to time will appear instead of the *Jahrbuch.* N.F. is entitled *Beiträge zur Geschichte der Kunstwissenschaft in der Schweiz.*

Q314 Sculpture international, v.1-3, no. 2/3, 1966-70. London, Sculpture publications. Quarterly; irregular; publisher varies.
Covers contemporary movements in sculpture and the work of individual sculptors, primarily American and British. Some articles have summaries in French, Russian, and Spanish. Includes exhibitions and brief book reviews. v.3, no. 2/3 contains an index for previous issues. *Art index* (1969-73 ); *LOMA.*

Q315 Scuola archeologica di Atene. Annuario della . . . e delle Missioni Italiane in Oriente, v.1-15/16, 1913-32/33; n.s. v.1, 1939- . Roma, Istituto Poligrafico dello Stato. Annual, some years combined, publisher varies.
Scholarly articles on classical Greek archaeology. Later years have color plates and foldout maps and charts. Includes "Atti della Scuola." *Art index* (1969- ); *B. d. f. Z.; I. B. Z.; Rép. d'art.*

Q316 Simiolus; Netherlands quarterly for the history of art, jaarg. 1, 1966/67- . Bussum, Fibula-Van Dishoeck. 3 times a year, 1966/67-1970/71; quarterly, 1971- ; publisher, place vary.
Subtitle, v.1-4: *Kunsthistorisch tijdschrift.* Covers history of art pertinent to the Netherlands. Contributions in Dutch, English, French, and German. Signed reviews. v.4 (1971), listing works published in 1969, begins a continuing annual bibliographical survey of books and articles in art history and related fields. *ARTbib. curr.; ARTbib. mod.; LOMA; Rép. d'art.*

Q317 Sociedad Española de Excursiones. Boletín; arte, arqueología, historia, año 1-58, marzo 1893-1954. Madrid, Hauser y Menet. Monthly, año 1-15, 1893-1907; quarterly, año 16-58, 1908-54; publisher varies.
Publication suspended 1936-39. Covers Spanish art, archaeology, history, and literature. Brief notices of pertinent books and longer signed reviews año 13-58. Indexes: 1893-1906 in año 14; 1893-1917 in año 25. *Art index* (v.37-44); *B. d. f. Z.*

Q318 Società Piemontese de Archeologia e di Belle Arti. Bollettino . . . anno 1-5, 1917-21; n.s., anno 1, 1947- . Torino, Società Tipografico Editrice. Quarterly, many combined, so that from 1964- , annual.

An important journal for Piedmontese art and architecture, excluding the modern period. Has a section "Segnalazione" with shorter essays. *Rép. d'art.*

Q319 Société d'Archéologie Copte. Bulletin, [t.]1, 1935- . Le Claire. Annual, irregular. (Repr.: v.1-5 (1935-39), Nendeln, Liechtenstein, Kraus.)
A journal of Early Christian archaeology and anthropology in Egypt. Contributions in English, French, or German, and occasionally Arabic. *I. B. Z.; Rép. d'art.*

Q320 Société de l'Histoire de l'Art Français, Paris. Bulletin, année 1-4, 1875-78; 1907- . Paris, Nobele. Quarterly, 1875-78, 1912-14; semiannual, 1920-25; annual, 1907-11, 1915-19, 1926- ; publisher varies.
Suspended 1879-1906; 1941-46. Contains news of the Society; publishes documents from French archives, including facsimiles and illustrations, in addition to articles of varying length. From 1907-35, lists works published by members. Later years have been published with the cooperation of the Centre National de la Recherche Scientifique. Index: 1875-78 in année 4, 1878. *B. d. f. Z.; I. B. Z.; Rép. d'art.*
_____. Répertoire des publications . . . (1875-1927), Paris, 1930.
_____. Répertoire des publications . . . (1928-56), Paris, 1958.

Q321 Société Nationale des Antiquaires de France. Bulletin, 1857- . Paris, Klincksieck. Annual.
Pub. for the Centre Nationale de la Recherche Scientifique. Continues *Annuaire de la Société.* 1857-67, 1869 issued as part of its *Mémoires;* 1858-67, 1869 also issued separately (1868 only issued separately); 1887-1908 pub. under one cover as *Bulletin et mémoires.* Contains the papers on French monuments given at the Society's meetings. Foldout charts and maps. No book reviews. *B. d. f. Z.; I. B. Z.; Rép. d'art.*

Q322 Society of Architectural Historians. Journal, v.1, 1941- . Philadelphia. Quarterly; place varies. (Repr.: v.1-25 (1941-66), N.Y., Johnson, 1972.)
Not published 1945. Official publication of the Society; v.1-4 published as the *Journal of the American Society of Architectural Historians.* A very important journal, with scholarly articles, signed reviews, and abstracts of papers presented at the annual meetings. v.1-8 have current bibliographies; later volumes contain "Book notes." *Art index* (1946- ); *ARTbib. curr.; ARTbib. mod.; I. B. Z.*
_____. Index, v.1-20 (1941-61). 1v., 1974, by Shirley Branner.

Q323 _____. Newsletter. Philadephia, v.1, no. 1, Sept., 1957- . Bimonthly.
Contains notices of the Society, news of its members and the various chapters, the activities of other organizations, notes on historic preservation, etc. The listings of articles, books, booklets, catalogues, and journals are especially valuable to historians and librarians.

Q324 Speculum; a journal of mediaeval studies, v.1, 1926- . Cambridge, Mass., Mediaeval Academy of America. Quarterly.
Though not an art periodical, its scholarly coverage of all phases of medieval life and culture is of interest to the art historian. Extensive signed reviews. Lists pertinent books, v.1- , and has bibliographies of periodical literature, v.9- . *Art index; ARTbib. curr.; B. d. f. Z.; Bull. sig. 526; Hum. ind.; Int. ind.; I. B. Z.; Rép. d'art; Subj. ind.*

Q325 Städel-Jahrbuch, Bd. 1-9, 1921-35/36; n.F., Bd. 1, 1967- . München, Prestel. Annual, irregular; publisher, place vary.
An important yearbook for German art. Articles deal mostly with objects in the Städelisches Kunstinstitut, but include works in other collections. Neue Folge contains a section on new acquisitions. *Art index* (v.6-9); *ARTbib. curr.; B. d. d. Z.; Rép. d'art.*

Q326 De Stijl; maandblad voor nieuwe kunst, wetenschap en kultuur, jaarg. 1-[8] (nos. 1-[90]), oct. 1917-jan. 1932. Leiden. Monthly, irregular; subtitle, place vary. (Repr.: Amsterdam, Athenaeum; Den Haag, Bakker; Amsterdam, Polak & Van Gennup, 1968. A final volume containing English translations of the Dutch text is in preparation.)
An influential journal, the publication of the "De Stijl" movement. Contains articles on theory, design, painting, applied arts and architecture. Text chiefly in Dutch or French. Not pub. Nov.-Dec. 1920, Jan.-Feb. 1923, 1929-31. *Form* (Cambridge, Eng.) no. 7 (March 1968) contains a complete index to *De Stijl.*

Q327 Storia dell'arte. Firenze, Nuova Italia editrice. 1/2, [genn./giugno] 1969- . Quarterly.
Directed by G. C. Argan. Each issue has two or three substantial articles which investigate an aspect of the history of art (primarily in Italy), and several shorter contributions to art historical research. The articles and notes are in various languages with summaries in English. *Rép. d'art.*

Q328 The Structurist, no. 1, 1960/61- . Saskatoon, Canada. Univ. of Saskatchewan. Annual.
Each number covers a different aspect of art from a Constructivist viewpoint. Frequently includes archival material and the work of contemporary constructivists. *Art index* (1979- ); *ARTbib. curr.*

Q329 Studi etruschi, v.1, 1927- . Firenze, Olschki. Annual; publisher varies.
At head of title: Istituto di Studi Etruschi ed Italici.
v.27, 1959- includes *Atti del Convegno di studi etruschi.* Covers all aspects of Etruscan civilization, with emphasis on archaeology and art. *B. d. f. Z.; Bull. sig. 525.*
_____. Indici (v.1-30), Firenze, 1968. 605p.

Q330 Studies in conservation; the journal of the International Institute for the Conservation of Historic and Artistic Works, v.1, Oct. 1952- . London.

Quarterly, irregular, some combined; publisher, place vary. (Repr.: v.1–4 (1952–59), N.Y., Johnson.) Supersedes *Technical studies in the field of the fine arts* (Q333); its early signed reviews cover material pub. since the demise of *Technical studies.* French summaries of articles; some French text with English summaries. *Art index* (1969– ); *ARTbib. curr.; Bull. sig. 526.*
————. Index, v.1–12.

**Q331**  Studio international; journal of contemporary art, v.1, April 1893– . London, Cory, Adams & MacKay. Monthly; subtitle, publisher vary.
Founded in London as *The Studio.* For the following years, an American ed. appeared concurrently: 1897–1921, *The International studio;* Oct. 1927–Mar. 1931, *Creative art; incorporating The Studio of London;* Apr. 1931–Feb. 1932, *Atelier;* Mar. 1932–Jan. 1939, *The London studio.* Separate editions ceased and were continued by: Feb. 1939–Apr. 1964, *The Studio;* May 1964– , *Studio international* which continues *The Studio* volume numbering (v.167– ). A well-illustrated review, it surveys all aspects of art. Since 1964 concentrates on contemporary American and European work. *A. D. P.; Art index; Ann. mag. subj. ind.; ARTbib. curr.; ARTbib. mod.; B. d. f. Z.; I. B. Z.; LOMA; Poole's; Rép. d'art; Subj. ind.*
————. General index to the first 21v. of *The Studio,* 1893–1901. London (1902).
————. Index: v.1–42. 1v.

**Q332**  Syria: revue d'art oriental et d'archéologie, t.1, 1920– . Paris, Geuthner. Quarterly, usually two issues combined. (Repr.: Paris, Geuthner, 1967.)
Pub. under the auspices of L'Institut Français d'Archéologie de Beyrouth, t.24, fasc. 3– . Covers Syrian art and archaeology, ancient and Islamic. Occasional articles in English. Many signed reviews. Indexes: v.1–10 in v.10; v.11–20 in v.20. *B. d. f. Z.; Bull. sig. 525, 526; I. B. Z.; Rép. d'art.*

**Q333**  Technical studies in the field of the fine arts, v.1–10, July 1932–Apr. 1942. Cambridge, Mass. Quarterly. (Repr.: N.Y., Garland, 1975.)
Continued by *Studies in conservation,* 1952– (Q330). Pub. for the Fogg Art Museum, Harvard Univ. Deals with scientific analysis and problems of restoration of works of art. Includes book reviews and abstracts of periodical articles. v.10 has author index of v.1–10. *Art index.*

**Q334**  Town planning review, v.1, 1910– . Liverpool, Univ. of Liverpool Press. Irregular, 1910–31, 1939–1943/47; semiannual, 1932–38; quarterly, 1949– . (Repr.: v.1–20 (1910–49), Nendeln, Liechtenstein, Kraus, 1974.)
Suspended publication 1948. Ed. at the Department of Civic Design (Town and Regional Planning and Transport Studies), the University of Liverpool. Perhaps the most important journal of town planning in English, with articles on all aspects of town planning, including methodology and history. Earlier issues were more history-oriented. Signed book reviews. *Art index* (1959– ); *B. H. I.; I. B. Z.; P. A. I. S.; S. S. I.*

**Q335**  U.S. National Gallery of Art. Kress Foundation studies in the history of art, 1967– . Wash., D.C., Annual; irregular.
Title varies: 1967–69, *Report and studies in the history of art.* Scholarly articles on works in the collection, conservation topics, artists, and broad historical periods. *Art index* (1967– ); *Rép. d'art.*

**Q336**  Urbanistica; organo ufficiale dell'Istituto Nazionale di Urbanistica, anno 1–28, n. 1–29, 1932–59; n. 30, 1960–77. Torino, Rivista Urbanistica. Quarterly, some issues combined; irregular; place varies.
A major journal in the field of regional and city planning. The emphasis is on the current development and planning of historic cities. Also important for the history of Italian cities. Splendidly illustrated, color maps; some issues are thematic. Summaries in English and French. Lists of recent books. Special issues on individual Italian cities. *Art index* (1959– ); *B. d. f. Z.; Rép. d'art.*

**Q337**  Il Vasari; rivista d'arte e di studi vasariani e cinquecenteschi, anno 1–21, 1927–63. Arezzo, Casa Vasari. Quarterly, irregular; frequency, subtitle, publisher vary.
Confined to Italian art of the 16th century, with special reference to Vasari. Includes much archival material; almost no illustrations. Suspended 1944–56.

**Q338**  Ver Sacrum; Organ der Vereinigung bildender Künstler Österreichs, v.1–6, 1898–1903. Wien, Gerlach & Schenk. Monthly.
The periodical of the Viennese Secession movement. Invaluable for source material and illustrations. A biographical anthology has been published: C. M. Nebehay, ed. *Ver Sacrum 1898–1903* (Wien: Tusch 1975) 321p., with indexes to the original publication by author, illustrator, and exhibitor.

**Q339**  Verve; revue artistique et littéraire, v.1–10, no. 1–37/38, 1937–60. Paris, Éditions de la revue *Verve.* One double no. a year, irregular; subtitle, publisher vary.
Suspended Sept./Nov. 1940–Oct. 1943. No. 1–6, 8 have articles on art of all periods, Eastern and Western. No. 7, 9–(except no. 27/28) are monographic and devoted to high quality color reproductions of illuminated manuscripts, original projects by contemporary French artists, etc. No. 1–8 published in English; no. 9–37/38 in French. *Art index* (v.5–9); *Rép. d'art.*

**Q340**  Victoria and Albert Museum yearbook, no. 1, 1969– . London. Annual, no. 1–2; biennial, no. 3– .
Scholarly articles, primarily on works in the museum collection. Excellent illustrations. *B. H. I.*

**Q341**  XXe [i.e. Vingtième] siècle, année 1–2, no. 1, mars 1938–39; no. 1, 1951– . Paris, Chroniques du jour. Semiannual; early years irregular.
An English ed. was pub. for v.1, no. 4–5/6. Covers contemporary art, and includes many articles by modern artists,

as well as interviews of artists. Beginning with 1957, each issue devoted to a specific theme: art and poetry, space, etc. Very well illustrated. Signed book and exhibition reviews. More recent issues have English summaries. *Art index* (1959- ); *ARTbib. curr.; ARTbib. mod.; LOMA; Rép. d'art.*

Q342 Vizantiĭski vremennik, v.1-25, 1894-1927; n.s. 1, 1947- . Moscow. Quarterly, v.1-25; n.s. is annual, irregular. (Repr.: Amsterdam, Hakkert, 1962).
Issued by the Institut Istorii Akademii Nauk SSSR. v.1-25 pub. in St. Petersburg (Petrograd) and Leipzig with added title in Greek: *Byzantina xponika.* Covers Byzantine studies; illustrations begin n.s., v.2- ; current bibliographies with long signed reviews. Index v.1-15 in v.16. *B. d. f. Z.; I. B. Z.; Rép. d'art.*

Q343 Waffen- und Kostümkunde; Zeitschrift der Gesellschaft für historische Waffen- und Kostümkunde, Bd. 1, 1959- . München, Deutscher Kunstverlag. Semiannual.
Also called "Dritte Folge" as it supersedes Gesellschaft für historische Kostüm- und Waffenkunde. *Mitteilungen* (1955-59) and *Zeitschrift für historische Waffenkunde* (1897-1944). Scholarly coverage of weapons and costumes in private and public collections. Occasional articles in English, Spanish, French, and Italian. Book reviews. *B. d. d. Z.; I. B. Z.; Rép. d'art.*

Q344 Wallraf-Richartz Jahrbuch, Bd. 1, 1924- . Köln, Dumont Schauberg. Annual; publisher, place vary.
Issued under the auspices of the Wallraf-Richartz Museum. Not published 1929, 1931-32, 1935, 1944-51. Title varies: v.9-13, *Westdeutches Jahrbuch für Kunstgeschichte;* with v.14- this becomes the subtitle. Scholarly contributions, mostly on German art, with some articles on the art of other European countries. Regional museum notes; signed book reviews v.14- . *Art index* (1930-36, 1969- ); *ARTbib. mod.; B. d. d. Z.; I. B. Z.; Rép. d'art.*
_____. Register . . . Bd. 1-30 (1966).

Q345 Walpole Society, London. The first (1912) volume of the Walpole Society, 1911/1912- . Glasgow, R. MacLehose, The Univ. Pr. Annual, irregular; publisher varies. (Repr.: v.1-43 (1912-71), Folkstone, Kent, Eng., Dawson.)
Publication delayed by up to three years for volumes published since World War II. Covers British art, especially painting, from the Middle Ages on, with emphasis on the 18th and 19th centuries. Some volumes are monographs. "Contents to volumes I to XLI" in v.42. *ARTbib. curr.; Rép. d'art; Subj. ind.*

Q346 Die Weltkunst; the world-art review; les beaux-arts du monde, Jahrg. 1, 1927- . München, Kunst und Technik. Twice monthly; weekly, 1927-38; subtitle, place vary.
Title varies: 1927-30, *Die Kunstauktion; deutsches Nachrichtenblatt des gesamten Kunstmarktes und Buchmarktes.* Suspended Sept. 1944-Mar. 1949. Reviews art sales,

primarily European; includes decorative arts as well as painting and sculpture. Regular coverage of major exhibitions and collections in Europe and North America; international auction calendar. *ARTbib. curr.; B. d. d. Z.; I. B. Z.; Rép. d'art.*

Q347 Wendingen; maandblad voor bouwen en sieren van Architectura et Amicitia, ser. 1-12, 1918-31. Santpoort, Mees. Monthly; publisher, place vary.
Not pub. 1922 and 1926. "Orgaan van het genootschap Architectura et Amicitia te Amsterdam." Articles cover modern architecture, sculpture and design in general, with emphasis on the *De Stijl* movement. Several issues are devoted to the work of individual architects; ser.7, no.3-9, form a separately paged and numbered monograph, *The life-work of the American architect, Frank Lloyd Wright . . . Aflev. 1-7.* (This part has been reprinted: N.Y., Horizon [1965]. 1v.) Text occasionally in French, German, or English.

Q348 Werk/Archithese. v.1, 1914- . St. Gallen, Zollikofer. Monthly; subtitle varies; publisher varies.
Continues *Werk/Oeuvre* and assumes its numbering.
   Title varies: *Das Werk* 1.-60. 1914-1973; *Werk/Oeuvre* 1973-76, v.61-63. The official organ of the Bund Schweizer Architekten, the Schweizerischer Werkbund, the Schwiezerisches Kunstverein, and the "Oeuvre." Covers contemporary architecture ad some fine and applied arts; in recent years, issues are thematic; ie., conservation, apartment buildings, schools. Signed book reviews; English and French summaries in early and recent issues. *A. D. P.; Art index* (1953- ); *ARTbib. curr.; B. d. d. Z.; LOMA; Rép. d'art.*

Q349 Wiener Beiträge zur Kunst- und Kulturgeschichte Asiens; Jahrbuch des Vereines der Freunde Asiatischer Kunst und Kultur in Wien, Bd. 1-11, 1925/26-1937. Wien, Krystall-Verlag. Annual.
Each volume contains three or four scholarly articles on various aspects of Oriental art or culture. Signed book reviews, v.4- . In 1936 a special publication was issued: *Sammlung Baron Eduard von der Heydt, Wien; Ordos-Bronzen, Bronzen aus Luristan und dem Kaukasus, Werke chinesischer Kleinkunst aus verschiedenen Perioden.* Bearbeitet von Viktor Griessmaier. 110p.

Q350 Wiener Jahrbuch für Kunstgeschichte, Bd. 1-14, 1907-20; n. F., Bd. 1, 1921/22- . Wien, Böhlaus. Annual, irregular.
Preceded by: Austria. Zentral-Kommission zur Erforschung und Erhaltung der Kunst- und historischen Denkmale. *Jahrbuch.* Title varies: *Kunstgeschichtliches Jahrbuch; Jahrbuch des Kunsthistorischen Institutes: Jahrbuch für Kunstgeschichte.* v.22 (1969)- pub. by both the Institut für Österreichische Kunstforschung des Bundesdenkmalamtes Wien and the Kunsthistorisches Institut at the Universität Wien. Long scholarly articles concentrating on Austrian art and collections; since the late 1950s includes all European countries and styles. *Art index* (1932-37); *ARTbib. curr.; B. d. d. Z.; I. B. Z.; Rép. d'art.*
_____. General register, 1903-12 (1913).

Q351  Wintherthur portfolio, v.1, 1964- . Charlottesville,
       Univ. Pr. of Virginia. Annual, irregular, quarterly,
       1980- .
Pub. for the Henry Francis du Pont Winterthur Museum.
Current publisher is Univ. of Chicago Pr., 1979- . Scholarly,
well-illustrated articles on American art history, concen-
trating on decorative arts and architecture to 1900 and
their roles in the cultural heritage of the country. *ARTbib.*
*curr.; ARTbib. mod.*

Q352  Zeitschrift für Aesthetik und allgemeine Kunst-
       wissenschaft, Bd. 1-37, 1906-43; Bd. 1, 1951- . Bonn,
       Bouvier. Quarterly, 1906-17, 1924-43; irregular,
       1918-23; annual, many years combined, 1951-65;
       semiannual, 1966- ; publisher, place vary.
Bd. 1-10 issued as *Jahrbuch für Aesthetik und allgemeine
Kunstwissenschaft.* Scholarly articles on art history, art
criticism, theory, and the aesthetics of the visual arts,
litarature, music, and the theater. Long signed reviews.
*ARTbib. curr; B. d. d. Z.; I. B. Z.; Rép. d'art.*
————. Table of contents . . . (1940).

Q353  Zeitschrift für bildende Kunst, Jahrg. 1-24, 1866-
       Sept. 1889; n.F., Jahrg. 1-33, Okt. 1890-1922; Jahrg.
       58-65, 1924/25-1931/32. Leipzig, Seemann. Monthly.
In 1932 merged with *Repertorium für Kunstwissenschaft* and
*Jahrbuch für Kunstwissenschaft* to form *Zeitschrift für
Kunstgeschichte.* Treats art in general, and includes book
reviews (sometimes signed), and classified bibliographies
of current books and articles. Has numerous good illus-
trations, with notes as to who made the plates and (usually)
an identification of the process employed. In late 1880s
and 1890s contains heliogravures made by Albert and
Hanfstaengl. Includes various supplements: Kunstchronik,
Kunstgewerbeblatt, Kunstmarkt and Kunstchronik, Mo-
natsrundschau, Kunstliteratur (from 1925-, and, reviewing
the literature of general art historical and archaeological
interest), Kunstchronik, and Kunstliteratur. Registers
published every four or six years. *Art index* (v.63-65);
*B. d. d. Z.*

Q354  Zeitschrift für Kunstgeschichte, Bd. 1, 1932- . Mün-
       chen, Berlin, Deutscher Kunstverlag. Bimonthly,
       1932-42; annual, 1949-52; semiannual, 1952-55;
       quarterly, 1956- ; publisher, place vary.
Forms "neue Folge von *Repertorium für Kunstwissenschaft,
Zeitschrift für bildende Kunst, Jahrbuch für Kunstwissen-
schaft.*" Suspended 1944-49. A very important journal,
with scholarly coverage of the whole field of art history.
Edited by art historians at the Institut für Kunstgeschichte,
Univ. of Munich. Articles in various languages. Long signed
reviews; v.12- , annual comprehensive bibliographies of
current art books and articles. *A. D. P.; Art index* (1932-41,
1959- ); *ARTbib. curr.; B. d. d. Z.; I. B. Z.; LOMA; Rép.
d'art; Subj. ind.*

Q355  Zeitschrift für schweizerische Archäologie und
       Kunstgeschichte, Bd. 1, 1939- . Zürich, Berichthaus.
       Quarterly, place, publisher vary.
The official journal of the Verband der Schweizerischen
Altertumssammlungen and the Gesellschaft für Schweizer-
ische Kunstgeschichte, pub. under the direction of the
Schweizerische Landesmuseum in Zürich. Supersedes
*Anzeiger für schweizerische Altertumskunde.* Exhaustive
treatments of Swiss art history and archaeology. Text in
French, German, and Italian, although earlier years are
mostly in German. Signed book reviews; reports each issue
on restoration and preservation work in various cantons.
*ARTbib. curr.; B. d. d. Z.; I. B. Z.; Rép. d'art.*

Q356  Zodiac; revue internationale d'architecture con-
       temporaine, v.1, 1957-(73). Milano, Edizioni di
       Comunità. Semiannual; irregular.
Publication suspended with no. 22, 1973. Pub. under the
auspices of L'Association pour la Diffusion Artistique et
Culturelle, Bruxelles, and Società Ing. C. Olivetti & C.,
Ivrea, Italy. Showcase publication for contemporary archi-
tecture, both projected and newly completed. Includes
technical, functional, and aesthetic criticism. Articles in
English, French, Italian, or German; English and French
translations as well; book reviews. *Art index* (1959- );
*ARTbib. curr.*

# R.
# Series

This listing of series is very selective, the choices having been made with the collection of a research library in mind. Continuing serials with wide-ranging subject matter are included; and in general, these have a scholarly bent. Most are numbered; most are irregular. Three important exhibition series are listed: Council of Europe exhibitions, Documenta, and the Venice Biennale.

Not included here are monographic series of an encyclopedic nature, for example, *Sources and Documents in the History of Art,* and *The Pelican History of Art.* These can be found with sources and histories and handbooks. For the most part general reprint series and publishers' series are excluded. Entries of periodicals are in the preceding section.

Representative titles in each series indicate scope and subject matter.

R1    The A. W. Mellon lectures in the fine arts, 1- . 1953- . (Bollingen series 35)
Publisher varies: N.Y., Pantheon; Princeton Univ. Pr.

Major monographs by outstanding scholars, based on annual lectures held at the National Gallery of Art, Wash., D.C.; publication dates are usually one to several years after the year in which the lectures were given. The topics range across the fields of painting, sculpture, architecture, iconography, criticism, psychology and the philosophy of art, and poetry. Examples: 2. K. Clark, *The nude; a study in ideal form,* 1956; 5. E. Gombrich, *Art and illusion: a study in the psychology of pictorial representation,* 2d ed., rev., [1961] 1965; 10. A. Grabar, *Christian iconography; a study of its origins.* 1968; 16. M. Praz, *Mnemosyne; the parallel between literature and the visual arts,* 1970; 22. J. Barzun, *The use and abuse of art,* 1974.

R2    Acta ad archaeologiam et artium historiam pertinentia, 1- . Roma, "L'Erma" di Bretschneider, 1962- .
At head of title: Institutum Romanum Norvegiae.

Studies on Roman and Italian art by Norwegian scholars. The articles and monographs are in English, French, or Italian. Examples: 3. P. J. Nordhagen, *The frescoes of John VII (A.D. 705-707) in S. Maria Antiqua in Rome,* 1968; 5. S. S. Larsen, *Christ in the Council Hall; studies in the religious iconography of the Venetian republic,* 1974.

R3    Antike Kunst. Beihefte, 1- . Berne, Franke, 1963- .
A series of reports on ancient and Early Christian art and archaeology, intended to supplement the periodical, *Antike Kunst* (Q24), with studies of new excavations and illustrated monographs on ancient works of art. Examples: 3. T. Klauser, *Frühchristliche Sarkophage in Bild und Wort,* 1966; 4. *Gestalt und Geschichte; Festschrift Karl Schefold,* 1967; 7. *Studien zur griechischen Vasenmalerei,* 1970; 8. C. Davaras, *Die Statue aus Astritsi,* 1972.

R4    Architectural Association, London. Papers, 1- . London, Lund Humphries, 1965- .
Occasional papers on various topics of architectural design and history. Directed primarily to the architect and student of architecture. Examples: 2. D. Sharp, *Sources of modern architecture: a bibliography,* 1967; 5. J. Posener, *From Schinkel to the Bauhaus,* 1972; 9. D. Macintosh, *The modern courtyard house,* 1972.

R5    Ars Asiatica: études et documents etc, 1-18. Paris, Bruxelles, van Oest, 1914-35.
A numbered series of volumes written by specialists on various subjects related to Far Eastern art. Many of the titles have been superseded. For a complete listing see Chamberlin (2380). Examples: 1. E. Chavannes and R. Petrucci, *La peinture chinoise au Musée Cernuschi,* 1914; 5. G. Coedès, *Bronzes khmèrs,* 1923; 8. N. J., Krom, *L'art javanais dans les musées de Hollande et de Java,* 1926; 9. L. Binyon, *Les peintures chinoises dans les collections l'Angleterre,* 1927; 17. A. Godard, *Les bronzes du Luristān,* 1931; 18. A. K. Coomaraswamy, *La sculpture de Bodhgayā,* 1935.

R6    Ars Suetica. Studier utg. av Konsthistoriska Institutionen vid Uppsala Universitet, 1- . Stockholm, Almqvist & Wiksell, 1966- . (Acta Universitas Upsaliensia)
Editor: Rudolf Zeitler.

A scholarly series on Swedish art, ed. by the Institute of Art History, Uppsala Univ. Summaries in English or German. Example: 1. A. Ellenius, *Karolinska bildidéer* (English summary entitled "Pictorial ideas on Swedish art of the Caroline period"), 1966.

**R7**   Art and architecture bibliographies, 1- . Los Angeles, Hennessey & Ingalls, 1973- .

An important series of bibliographies by art historians; these cover a wide range of topics. 1. H. Park, *A list of architectural books available in America before the Revolution*, rev. ed., 1973; 2. V. C. Smith, *Juan de Borgoña and his school*, 1973; 3. J. M. Spalek, *German Expressionism in the fine arts*, 1977; 4. R. Kempton, *Art Nouveau: an annotated bibliography*, 1977; 5. R. Sweeney, *Frank Lloyd Wright*, 1978.

**R8**   Art in context. London, Lane; N.Y., Viking, 1973- . Editors: John Fleming and Hugh Honour.

An unnumbered series of well-illustrated studies by specialists on individual works of art from the Renaissance to the 20th century. Excellent for students. Examples: E. Dhanens, *Van Eyck: The Ghent Altarpiece*, 1973; J. Golding, *Duchamp: The Bride Stripped Bare by Her Bachelors, Even*, 1973; H. Hibbard, *Poussin: The Holy Family on the Steps*, 1973; M. A. Lavin, *Piero della Francesca: The Flagellation*, 1972; B. Nicolson, *Courbet: The Studio of the Painter*, 1972; D. Posner, *Watteau: A Lady at her Toilet*.

**R9**   Art in its context; studies in ethno-aesthetics. Pub. with the aid of the Netherlands Organisation for the Advancement of Pure Research. Field reports, 1- . The Hague, Paris, Mouton, 1963- .

Well-illustrated ethnic studies, the results of primary scientific field-research into the artistic production of various groups. Examples: 1. C. A. Schmitz, *Wantoat; art and religion of the northeast New Guinea Papuans*, 1963; 2. J. H. Plokker, *Artistic self-expression in mental disease; the shattered image of schizophrenics*, 1964; 3. A. A. Gerbrands, *Wow-Ipits; eight Asmat woodcarvers of New Guinea*, 1967; 4. J. Hurault, *Africains de Guyane; la vie matérielle et l'art des noirs réfugiés de Guyane*, 1970.

———. Museum series, 1- . The Hague, Paris, Mouton, 1966- .

Scholarly research on the cultural symbols and forms of non-European art represented in museum collections. Examples: 1. F. Sierksma, *Tibet's terrifying deities; sex and aggression in religious acculturation*, 1966; 2. T. P. van Baaren, *Korwars and Korwar style; art and ancestor worship in north-west New Guinea*, 1968.

**R10**   Artibus Asiae. Supplementum, 1- . Ascona, Artibus Asiae, 1937- .

An irregular series of monographs dealing with the visual arts and culture of Asia. Supplements the periodical *Artibus Asiae* (Q88). Examples: 14. S. E. Lee and W. Fong, *Streams and mountains without end; a Northern Sung handscroll and its significance in the history of early Chinese painting*, 1955; 24. A. C. Soper, *Textual evidence for the secular arts of China in the period from Liu Sung through Sui (A.D. 420-618) excluding treatises on painting*, 1967; 32. M. C. Beach, *Rajput painting at Bundi and Kota*, 1974.

**R11**   Basler Studien zur Kunstgeschichte, 1-17, 1943-58. n. F. 1- , 1960- .

Original series, 1-17, 1943-58, pub. by Birkhäuser, Basel. Neue Folge, 1- , 1960- , pub. by Franke, Bern.

A numbered series of scholarly studies in art history. Chiefly dissertations by students of the Univ. of Basel. Examples: 15. P. Bloch, *Das Hornbacher Sakramentar und seine Stellung innerhalb der frühen Reichenauer Buchmalerei*, 1956; n. F. 5. B. Brenk, *Die romanische Wandmalerei in der Schweiz*, 1963; n. F. 8. *Gaetano Matteo Pisoni; Leben, Werk und Stellung in der Auseinandersetzung zwischen der Architektur des Spätbarocks und des Frühklassizismus*, 1967.

**R12**   Beiträge zur Kunst des Christlichen Osten, Bd. 1- . Recklinghausen, Bongers, 1964- .

Ed. jointly by the Ikonenmuseum, Recklinghausen, and the Gesellschaft der Ikonenkunst.

A numbered series of scholarly monographs on Early Christian and Byzantine art of the East. Examples: Bd. 1. R. Lange, *Die byzantinische Reliefikone*, 1964; Bd. 5. L. Budde, *Antike Mosaiken in Kilikien*, 1969- .

**R13**   Beiträge zur Kunstgeschichte (Berlin), Bd. 1- . Berlin, de Gruyter, 1968- .

Editors: Günter Bandmann, Erich Hubala, Wolfgang Schöne.

Scholarly studies embracing all areas of art historical research, for the most part revisions of dissertations by students of West German universities. Examples: 1. G. Hopp, *Edouard Manet: Farbe und Bildgestalt*, 1968; 4. W. Schlink, *Zwischen Cluny und Clairvaux; die Kathedrale von Langres und die burgundische Architektur des 12. Jahrhunderts*, 1970; 10. R. Kuhn, *Michelangelo. Die sixtinische Decke*, 1974.

**R14**   Beiträge zur Kunstgeschichte der Schweiz, Bd. 1- . Basel, Birkhäuser, 1970- .

Ed. by the Gesellschaft für Schweizerische Kunstgeschichte.

Scholarly monographic studies in the area of Swiss art history. Bd. 1. P. Felder, *Johann Baptist Bable, 1716-1799*, 1970.

**R15**   Biblioteca di storia dell'arte, 1- . Roma, Bulzoni, 1966- .

Publisher varies; earlier years, Torino, Einaudi. Monographs on Italian art and architecture, including reprints and translations of works in various languages into Italian. Examples: 1. G. C. Argan, *Studi e note dal Bramante al Canova*, 1970; 2. M. Fagiolo dell'Arco, *Il Parmigianino*, 1970; 7. V. N. Lazarev, *Storia della pittura bizantina* (trans. from Russian), 1967.

**R16**   Bibliothek für Kunst- und Antiquitätenfreunde, Bd. 1- . Braunschweig, Klinkhardt & Biermann, 1955- .

A numbered series of standard handbooks primarily for collectors of antiques and decorative arts. Usually reliable. Continues and often replaces volumes in the earlier series, *Bibliothek für Kunst- und Antiquitätensammler* (Chamberlin, 239). Examples: 6. M. Schuette, *Alte Spitzen: Nadel- und Kloppelspitzen*. 4th ed., 1963; 40. H. Himmelheber, *Negerkunst und Negerkünstler*, 1960; 45. P. Babendererde, *Dekorative Graphik*, 1968.

R17    Bibliothèque des cahiers archéologiques, t.1- . Paris, Klincksieck, 1966- .
Editors: André Grabar and Jean Hubert.

A series of scholarly studies concerning archaeology and the history of art in late antiquity and the Middle Ages. Intended as a supplement to the articles in *Cahiers archéologiques* (Q123). Examples: 1. S. Dufrenne, *L'illustration des psautiers grecs du moyen âge*, I, 1966; 8. A. Grabar, *Les manuscrits grecs enluminés de provenance italienne*, 1972; 10. N. Thierry, *Nouvelles églises rupestres de Cappadoce*, 1973.

R18    Bonner Beiträge zur Kunstwissenschaft, Bd. 1- . Düsseldorf, 1950- .
Publisher varies.

Scholarly studies in the general field of art history, for the most part revisions of theses submitted to the Kunsthistorisches Institut der Universität Bonn. Examples: 2. V. H. Elbern, *Der Karolingische Goldaltar von Mailand*, 1952; 10. K. Hoffmann-Curtius, *Das Programm der Fontana Maggiore in Perugia*, 1968.

R19    California studies in the history of art, 1- . Berkeley, Univ. of California Pr., 1962- .
General editor: Walter Horn.

An important series of full-scale monographs by outstanding authorities in their specialized fields. Examples: 2. J. S. Boggs, *Portraits by Degas*, 1962; 11. H. B. Chipp, *Theories of modern art; a source book by artists and critics*, 1968; 17. R. Branner, *Manuscript painting in Paris during the reign of St. Louis*, 1977.

R20    Collectonea artis historiae, 1- . München, Fink, 1972- .
Editor: Klaus Lankheit.

Each volume in the series is a collection of published essays by an outstanding art historian. Examples: 1. H. von Einem, *Goethe-Studien*, 1972; 4. H. G. Evers, *Gesammelte Schriften*, 1974; 5. L. H. Heydenreich, *Architekturstudien*, 1974.

R21    Council of Europe exhibitions, 1954- . Publisher varies according to the country where the exhibition was held.
Annual 1954-65, excepting 1957, 1963; biennial 1966-72.

Major loan exhibitions, each dealing with a specific period, style, or topic of European art. Splendid catalogues with illustrations and full documentation of the works exhibited. These catalogues are important contributions to research, having set new standards in documentation.

Contents: (1) Brussels. Palais des Beaux-Arts, *L'Europe humaniste*, 1954; (2) Amsterdam. Rijksmuseum, *De triomf van het manierisme: De europese stijl van Michelangelo tot El Greco*, 1955; (3) Rome. Palazzo delle Esposizione, *Il Seicento europeo: realismo, classicismo, barocco*, 1956; (4) Munich. Residenzmuseum, *Europäisches Rokoko/Le siècle du rococo*, 1958; (5) The Arts Council of Great Britain, *The Romantic movement*, 1959; (6) Paris. Musée National d'Art Moderne, *Les sources du XXe siècle/The*

*sources of the XXth century*, 1960; (7) Barcelona. Palacio Nacional de Montjuich and Santiago de Compostela, Palacio Gelmírez and the Cathedral and the Museum of the Cathedral, *El arte románico*, 1961; (8) Vienna. Kunsthistorisches Museum, *Europäische Kunst um 1400*, 1962; (9) Athens. Zappeion Megaron, *Byzantine art; an European art*, 1964; (10) Aachen. Rathaus, *Karl der Grosse/Charlemagne*, 1965; (11) Stockholm. National Museum, *Christina, drottning av Sverige/Christina, Queen of Sweden*, 1966; (12) Paris. Musée Nationale du Louvre. *L'Europe gothique, XIIe-XIVe siècles*, 1968; (13) Valetta, Malta. Palace and Museum of St. John's Co-cathedral, *The Order of St. John in Malta, with an exhibition of paintings by Mattia Preti*, 1970; (14) The Arts Council of Great Britain, *The age of Neo-classicism*, 1972; (15) Berlin, *Tendenzen der zwanziger Jahre*, 1977.

R22    Deutsches Archäologisches Institut. Jahrbuch. Ergänzungsheft, 1- . Berlin, de Gruyter, 1888- .
Publisher varies.

An irregular series of monographs by scholars, covering various subjects of ancient art and archaeology. Supplements the *Jahrbuch* (Q152). For a listing of the titles published from 1888 to 1955 see Chamberlin (2227). Later examples: 21. A. Greifenhagen. *Beiträge zur antiken Reliefkeramik*, 1963; 25. D. Arnold. *Die Polykletnachfolge*, 1969.

R23    Disegno. Studien zur Geschichte der Europäischen Handzeichnung, 1- . Berlin, de Gruyter, 1969- .
Each monograph contains a long essay, a catalogue of drawings, and numerous illustrations. Examples: 1. M. Roethlisberger, *Bartholomäus Breenbergh: Handzeichnungen*, 1969; 2. W. Schulz, *Lambert Doomer: sämtliche Zeichnungen*, 1974.

R24    Dumbarton Oaks colloquium on the history of landscape architecture, 1- . Wash., Dumbarton Oaks, 1971- .
The publication of papers read at the annual international conference on the history of landscape architecture. Each colloquium is concerned with a particular subject. Examples: 1. D. R. Coffin, ed. *The Italian garden*, 1972; 2. N. Pevsner, ed. *The picturesque garden and its influence outside the British Isles*, 1974. 3. E. B. MacDougall and F. H. Hazlehurst, *The French formal garden*, 1974.

R25    Figura, 1-12, 1951-59; n.s. 1- . Uppsala, Almqvist & Wiksell, 1959- .
Studies ed. by the Institute of Art History, Univ. of Uppsala.

A most important series of scholarly monographs in the fields of art history and criticism. Written in French, German, or English (the predominate language). Examples: 5. R. W. Zeitler, *Klassizismus und Utopia*, 1954; 9. T. Magnuson, *Studies in Roman Quattrocento architecture*, 1958; 11. S. Loevgren, *The genesis of modernism*, 1959; n.s. 3. F. Nordström, *Goya, Saturn, and Melancholy*, 1962; 7. P. Reuterswaerd, *Hieronymus Bosch*, 1970; 12. H. Omberg, *William Hogarth's portrait of Captain Coram*, 1974; 13. F. Nordström, *The Auxerre reliefs*, 1974.

R26   Fondazione Giorgio Cini, Venice. Centro di Cultura e Civiltà. Istituto di Storia dell'Arte. Cataloghi di mostre, 1- . Venezia, Neri Pozza, 1955- .
Important catalogues of exhibitions held in Venice and cities in the surrounding region. Examples: 2. T. de Marinis, *Rilegature veneziane del XV e XVI secolo,* 1955; 7. M. Mrozinska, *Disegni veneti in Polonia,* 1958; 14. O. Benesch, *Disegni veneti dell'Albertina di Vienna,* 1961; 20. L. Salmina, *Disegni veneti del museo di Leningrado,* 1964; 24. A. Schmitt, *Disegni del Pisanello e di maestri del suo tempo,* 1966; 25. A. Bettagno, *Disegni di una collezione veneziana del Settecento,* 1966; 32. T. Mullaly, *Disegni veronesi del Cinquecento, 1971. 33. P. Bjurström. Disegni veneti del Museo di Stoccolma,* 1974.

R27   Freer Gallery of Art. Oriental studies, 1- . Wash., D.C., Smithsonian Institution, 1933- .
A scholarly series on the antiquities, art, and literature of the Far East. Lavishly-produced with good illustrations. Examples: 4. G. D. Guest, *Shiraz painting in the 16th century,* 1949; 7. J. A. Pope, R. J. Gettens, J. Cahill, and N. Barnard, *The Freer Chinese bronzes,* 1967; 8. A. Lippe, *The Freer Indian sculptures,* 1970.

R28   Genoa, Università. Istituto di Storia dell'Arte. Quaderni, 1- . Genova, 1957- .
Scholarly studies on Genoese art and architecture and art works and collections in Genoa. *Nuova serie* issued only one number in 1965; regular numbering continues. Examples: 1. E. de Negri, *Galeazzo Alessi, architetto a Genova,* 1957; n.s. 1, E. Gavazza, *Lorenzo de Ferrari 1680-1744,* 1965; 5. C. D. Bozzo, *Sarcofagi romani a Genova,* 1968; 6. F. Sborgi, *Il Palazzo Ducale a Genova,* 1970.

R29   Geschichte und Theorie der Architektur, 1- . Basel, Stuttgart, Birkhäuser, 1968- .
Papers of the Institut für Geschichte und Theorie der Architektur at the Eidgenössische Technische Hochschule in Zürich.
   A numbered series on wide-ranging subjects of architectural history and theory, for the most part (but not exclusively) by Swiss architectural historians. Size varies. Examples: 4. C. Rowe and R. Slutzky, *Transparenz* (Le Corbusier Studien, 1), 1968; 13. P. Hofer, ed., *Hommage à Giedion,* 1971; 14. M. Frölich, *Gottfried Semper: zeichneriches Nachlass an der ETH Zürich, kritischer Katalog,* 1974.

R30   Giessener Beiträge zur Kunstgeschichte, 1- . Giessen, Schmitz, 1970- .
Pub. under the auspices of the Kunstgeschichtliche Seminar, Giessen University. Bd. 1, *Festschrift Günther Fiensch zum 60. Geburtstag,* 1970.

R31   Harvard-Radcliffe fine arts series. Cambridge, Mass., Harvard Univ. Pr., 1930-66.
Scholarly monographs devoted to various subjects in art history. Examples: C. R. Post, *A history of Spanish painting,* 14v., 1930-66; A. Burroughs, *Limners and likenesses: three centuries of American painting,* 1936; F. R. Grace, *Archaic sculpture in Boeotia,* 1939.

R32   History in the arts, 1- . Pub. by the Institute for the Study of Universal History through Arts and Artifacts. Watkins Glen, N.Y., Victoria, B.C., 1968- .
A monographic series of studies concerned with art and architecture as reflections of society and as factors in the creation of attitudes and institutions. Examples: 1. H. Kalman, *The railway hotels and the development of the château style in Canada,* 1968; 3. D. D. Egbert, *On arts in society: a Festschrift reader from the periodical writings of Donald Drew Egbert,* 1970; 4. A. Gowans, *On parallels in universal history discoverable in arts & artifacts: an outline statement,* 1972.

R33   Index of art in the Pacific Northwest, 1- . Seattle, Univ. of Washington Pr., 1970- .
A monographic series, pub. for the Henry Art Gallery, Univ. of Washington, and related to the major exhibitions of the gallery. Not limited to art of the region. Examples: 1. R. Bravmann, *West African sculpture,* 1970; 2. H. Rosenberg, *Barnett Newmann: Broken obelisk and other sculptures,* 1971; 4. M. Kingsbury, *Art of the thirties: the Pacific Northwest,* 1972; 7. I. Cunningham, *Imogen! Imogen Cunningham photographs, 1910-1973,* 1974.

R34   International Congress of the History of Art; Acts, 1st- . Publisher varies according to country, 1902- .
English, French, German, or Italian articles on the history of art. The papers presented at the Congress represent international scholarship of the highest caliber. Recent examples: (20th congress, 1961) M. Meiss, ed. *Studies in western art,* 3v., 1963; (21st congress, 1964) *Stil und Überlieferung in der Kunst des Abendlandes,* Bonn, 1967; (22nd congress, 1969) *Evolution général et développements régionaux en histoire de l'art,* Budapest, 1972.

R35   Italienische Forschungen, Bd. 1-2, 4-5, Berlin, Cassirer, 1906-12; Bd. 2. Folge 1-2, Leipzig, Seemann, 1925-26; Bd. 3. Folge 1-3, München, Bruckmann, 1954-62.
Bd. 3 never pub. Scholarly publications of the Deutsches Kunsthistorisches Institut, Florence. Early examples of German research in Italian art history; some of these studies have not been entirely superseded. Examples: 2. G. Poggi, *Il Duomo di Firenze,* 1909; 4. G. Ludwig, *Archivalische Beiträge zur Geschichte der venezianischen Kunst;* 5. W. Bombe, *Geschichte der Peruginer Malerei bis zu Perugino und Pintoricchio,* 1912; Ser. 2, 1, H. Posse, *Der römische Maler Andrea Sacchi,* 1925; Ser. 3, 2, K. Lankheit, *Florentinische Barockplastik,* 1962.

R36   The Johns Hopkins studies in nineteenth century architecture. Baltimore, Johns Hopkins Univ. Pr., 1968- .
General editor: Phoebe Stanton; Advisory editors: Peter Collins, Henry-Russell Hitchcock, William Jordy, and Sir Nikolaus Pevsner.
   An unnumbered series of scholarly works on 19th-century architecture (so far mostly American). Examples: P. Stanton, *The Gothic revival and American church architecture,* 1968; D. Hoffman, *The architecture of John Wellborn Root,* 1973; R. Alexander, *The architecture of Maximilian Godefroy,* 1974.

R37    Kassel (Germany). Documenta, Internationale Ausstellung. [Kataloge]. Köln, DuMont Schauberg, 1955-(77). v.[1-(5)] il., plates (part col.)

Catalogues of the largest international exhibition of contemporary art. Cover the full range of current art movements and trends. Each exhibition is generally thematic. The catalogues, written by an international team of experts, critics, and historians, contain the most detailed documentation available on contemporary art and artists.

Catalogues to date: (1) Documenta. Kunst des XX. Jahrhunderts (1955); (2) II Documenta. Kunst nach 1945 (3v.; 1959); (3) Documenta III. Malerei, Skulptur, Handzeichnungen (2v.; 1964); (4) 4. Documenta (2v.; 1968); (5) Documenta 5. Befragung der Realität: Bildwelten heute (1972); (6) Documenta 6 (1977).

R38    Klassiker der Kunst in Gesamtausgaben, 1-38. Stuttgart und Leipzig, Deutsche Verlags-Anstalt, 1904-37.

A prewar series of well-illustrated monographs on important painters and a few sculptors. Mostly antiquated, yet a few of the titles are still useful, and others are classics. Each has a section of works attributed to the artist or copies of lost works, a chronological index of the works, and a subject index. Many of the volumes were issued in French by Hachette, Paris, as the series *Classiques de l'art.* Examples: A. Rosenberg, *Rembrandt,* 1906; W. von Bode, *Botticelli,* 1926; G. Gronau, *Giovanni Bellini,* 1930; G. Gombosi, *Palma Vecchio,* 1937.

R39    Kunsthistorische Studiën van het Nederlands Instituut te Rome, 1- . Haag, Nijhoff, 1969- .

A continuation of Nederlands Historisch Instituut te Rome. *Studiën,* Haag, Nijhoff, 1931-42. (Chamberlin 2455).

A monographic series of scholarly studies on Italian art by Dutch scholars in Rome. Examples: 1. H. W. van Os, *Marias Demut und Verherrlichung in der sienesischen Malerei 1300-1400,* 1969; 3. A. W. A. Boschloo, *Annibale Carracci in Bologna; visible reality in art after the Council of Trent,* 2v., 1974.

R40    Madrider Forschungen, Bd. 1- . Berlin, de Gruyter, 1956- .

At head of title: Deutsches Archäologisches Institut. Abteilung Madrid.

Scholarly monographs on ancient and medieval art and archaeology in Spain. Examples: 2. C. Ewert, *Spanisch-islamische Systeme sich kreuzender Bögen,* 1968; 3. W. Schuele, *Die Meseta-Kulturen der iberischen Halbinsel,* 1969.

R41    Manchester studies in the history of art, 1- . Manchester, Manchester Univ. Pr., 1972- .

Each volume is a collection of essays or lectures by scholars on a particular topic or theme. Examples: U. Finke, *French 19th century painting and literature,* 1972; C. R. Dodwell, *Essays on Dürer,* 1973.

R42    Materialien zur Kunst des 19. Jahrhunderts, 1- , München, Prestel, 1973- .

A monographic series ed. by the research group "Neunzehntes Jahrhundert" of the Fritz Thyssen Stiftung. Subjects include all topics and media within the period of 19th- and early 20th-century art. Each volume is written by a specialist. Examples: 1. H. Voss, *Franz von Stuck 1863-1928,* 1973; 8. H. Hilschenz, *Das Glas des Jugenstils, Düsseldorf,* 1973; 14. D. E. Gordon, *Modern art exhibitions 1900-1916,* 1974.

R43    Monographs on archaeology and fine arts, 1- . N.Y., Published for the College Art Association of America by New York Univ. Pr., 1944- .

Also called the *CAA monographs.* A distinguished series of books on wide-ranging subjects in the history of art. Each monograph is written by an eminent American scholar. Examples: 8. B. R. Brown, *Ptolemaic paintings and mosaics and the Alexandrian style,* 1957; 11. M. Schapiro, *The Parma Ildefonsus* 1964; 16. J. Spector, *The murals of Eugene Delacroix at Saint-Sulpice,* 1967; 24. P. Fehl, *Classical monuments; reflections on the connection between art and morality in Greek and Roman sculpture,* 1972; 30. W. Cahn, *The Romanesque wooden doors of Auvergne,* 1974. For a complete listing see issues of the *Art bulletin.*

R44    Monumenta artis romanae, v.1- . Berlin, Mann 1959- .

Editor: Heinz Kähler.

Brief but important studies of individual works of Roman pictorial art and architecture. Examples: 2. J. Moreau, *Das Trierer Kornmarktmosaik,* 1960; 12. H. Kähler, *Die Villa des Maxentius bei Piazza Armerina,* 1973.

R45    Münchner Forschungen zur Kunstgeschichte. München, Prestel, 1967- .

Herausgegeben von den Bayerischen Staatsgemäldesammlungen.

An unnumbered series of oeuvre catalogues of artists who worked in Bavaria or whose work is well represented there. Examples: A. Dube-Heynig and W. D. Dube, *E. L. Kirchner: das graphische Werk,* 1967; S. Wichmann, *Wilhelm von Kobell 1766-1853,* 1970.

R46    Neue Münchner Beiträge zur Kunstgeschichte, Bd. 1- . Berlin, de Gruyter, 1961- .

Editor: Hans Sedlmayer.

An important series of scholarly studies in art history. Most are based on dissertations from the Zentralinstitut für Kunstgeschichte, Univ. of Munich. Examples: 1. C. L. Frommel, *Die Farnesina und Peruzzis architektonisches Frühwerk,* 1961; 5. P. Tigler, *Die Architekturtheorie des Filarete,* 1963; 9. K. Maurice, *Die französische Pendule des 18. Jahrhunderts,* 1967.

R47    New York City. Museum of Primitive Art. Lecture series, 1-3. (Distr. by University Publishers, N.Y., 1959-63.)

Each contains three lectures on special topics or single objects within a larger theme; some illustrations. Contents: 1. R. Redfield, M. J. Herskovits, G. F. Ekholm, *Aspects of primitive art,* 1959; 2. H. L. Movius, S. Kooijman, G. Kubler, *Three regions of primitive art,* 1961; 3. M. Mead, J. B. Bird, H. Himmelheber, *Technique & personality,* 1963.

R48   Norton critical studies in art history. N.Y., Norton, 1969- .
An unnumbered series. Also available in paperback. Each volume treats a famous work of art or achitecture. Each consists of an essay by the editor, extracts from documents (translated), critical analyses extracted from published literature, bibliography, and several illustrations. Especially valuable to students. Examples: R. Branner, ed. *Chartres cathedral*, 1969; C. Seymour, ed. *Michelangelo; The Sistine Chapel ceiling*, 1972; V. Bruno, ed. *The Parthenon*, 1974.

R49   Orbis artium. Utrechtse kunsthistorische studiën, v.1- . Utrecht, Haentjens Dekker Gumbert, 1957- .
Scholarly monographs on Dutch and Flemish art and architecture of all periods. Several are based on theses of Utrecht Univ. Substantial in size, handsomely produced. Examples: 3. A. B. Loosjes-Terpstra, *Moderne Kunst in Nederland 1900-1914*, 1959; 6. E. K. J. Reznicek, *Die Handzeichnungen von Hendrick Goltzius*, 1961 (an important catalogue raisonné); 11. V. Hefting, ed. *Johann Barthold Jongkind d'après sa correspondance* [1969].

R50   Outstanding dissertations in the fine arts. N.Y., Garland, 1st ser., 1975; 2d ser., 1976; 3d and 4th ser. announced 1978 and 1979.
These series consist of previously unpublished art history dissertations from American universities. Many are by authors who have since attained prominence. 34 are available in the 1st ser., 67 in the 2d. Examples from the 1st ser.: E. Fahy, *Some followers of Domenico Ghirlandajo;* L. Nochlin, *Gustave Courbet; a study of style and society;* E. C. Oppler, *Fauvism re-examined;* R. Pincus-Witten, *Occult symbolism in France;* R. Rosenblum, *The international style of 1800;* L. Steinberg, *Borromini's San Carlo alle Quattro Fontane.*

R51   Oxford studies in the history of art and architecture. Oxford Univ. Pr., 1971- .
Editors: Anthony Blunt, Francis Haskell, and Charles Mitchell.
An unnumbered series of scholarly works on various topics of inquiry in art and architecture. Examples: J. E. Lloyd, *African animals in Renaissance literature and art*, 1971; P. H. Walton, *The drawings of John Ruskin*, 1972; J. Wilde, *Venetian art from Bellini to Titian*, 1974.

R52   Princeton monographs in art and archaeology, 1- . Princeton, Princeton Univ. Pr., 1912- .
An important series of scholarly monographs in art history and archaeology. Examples: 27. J. C. Sloane, *French painting between the past and the present*, 1951, reissue, 1973; 31. R. Krautheimer, *Lorenzo Ghiberti*, 1956, reissue with corrections and new preface, 1970; 34. D. Coffin, *The Villa d'Este at Tivoli*, 1960, repr., 1971; G. K. Golinsky, *Aeneas, Sicily and Rome*, 1969. (Earlier examples in Chamberlin, 2469.)

R53   Probleme der Kunstwissenschaft, 1- . Berlin, de Gruyter, 1963- .
Editors: Hermann Bauer, et al.
Each volume is thematic and contains a group of essays by various scholars. Examples: 1. *Kunstgeschichte und Kunsttheorie im 19. Jahrhundert*, 1963; 2. *Wandlungen des Paradiesischen und Utopischen: Studien zum Bild eines Ideals*, 1966.

R54   Quellen und Schriften zur bildenden Kunst, 1- . Berlin, Hessling, 1966- .
An important series consisting of editions of lesser-known sources (including previously unpublished manuscripts) and collections of source material.
Contents: (1) G. B. Mola, *Breve racconto delle miglior opere d'architettura, scultura et pittura fatte im Roma et alcuni fuor di Roma*, 1966; (2) H. Philipp. *Tektonon Daidala; der bildende Künstler und seine Werk im vorplatonischen Schrifttum*, 1968; (3) P. M. Felini, *Trattato nuova delle cosa maravigliose dell'alma città di Roma...1610*, 1969; (4) Berlin. Königliche Akademie der Künste. *Die Kataloge der Berliner Akademie-Ausstellungen 1786-1850* (1971).

R55   Raccolta pisani di saggi e studi, 1- . Venezia, Neri Pozza, 1959- . Sponsored and ed. by Pisa Università, Istituto di Storia dell'Arte Medievale e Moderna.
Publisher varies: Milano, Edizioni di Comunità, 1965-66; Firenze, Marchi & Bertolli, 1967- .
An important monographic series dealing with subjects in art history from the Etruscan period to modern times. Most, not all, are on Italian art, in particular the art of Tuscany. Examples: 4. D. Corsi, *Statuti urbanistici medievali di Lucca, gli statuti delle vie e de' pubblici di Lucca nei secoli XIII-XIV*, 1960; 14. C. Laviosa, *Scultura tardo-etrusca di Volterra*, 1965; 28. A. Garzelli, *Sculture toscane nel Dugento e nel Trecento*, 1969; 35. A. R. Calderoni Masetti, *Spinello Aretino Giovane*, 1973.

R56   Römische Forschungen der Bibliotheca Hertziana, 1- , 1927- .
Pub. in Leipzig, 1927-38; beginning 1959- , printed by Schroll, Vienna and Munich, and Wasmuth, Berlin.
An extremely important scholarly series of full-scale monographs, sponsored by the Bibliotheca Hertziana (Max-Planck-Institut) in Rome. The subjects concern art in Italy during the Renaissance and Baroque periods. Examples: 1. E. Steinmann and R. Wittkower, *Michelangelo Bibliographie 1510-1926*, 1927 (Repr.: Hildesheim, Olms, 1967); 15. L. Schudt, *Italienreisen im. 17. und 18. Jahrhunderts*, 1959; 21. C. Frommel, *Der Römische Palastbau der Hochrenaissance*, 1973.

R57   Saggi e studi di storia dell'arte, 1- . Vicenza, Neri Pozza, 1959- .
A scholarly series of studies on art and artists of Venice and the Veneto. Handsomely produced, substantial in size. Examples: 1. G. Fiocco, *L'arte di Andrea Mantegna*, 2d ed., 1959; 7. E. Ruhmer, *Marco Zoppo*, 1966; 14. F. Vivian, *Il Console Smith mercante e collezionista*, 1971; 15. G. B. Cavalcaselle, *La pittura friulana del rinascimento*, 1973.

R58   Société Française d'Archéologie. Bibliothèque, 1- . Paris, Arts et métiers, 1971- .
Pub. under the auspices of Centre National de la Recherche Scientifique.

Studies of various French monuments of architecture. Works of original research, based on dissertations. Examples: 1. P. Kurmann, *La cathédrale Saint-Étienne de Meaux; étude architecturale,* 1971; 3. J. Gardelles, *Les châteaux du moyen âge dans la France du sud-ouest, la Gascogne anglaise de 1216 à 1327,* 1972.

R59   Stockholm studies in the history of art, 1- . Stockholm, Almqvist & Wiksell, 1956- . (Acta Universitatis Stockholmiensis)
A continuing monographic series of scholarly works by Swedish scholars on wide-ranging topics of art history. The texts are in Swedish, German, or English. Examples: 3. P. Reuterswald, *Studien zur Plastik,* 2v., 1958-60; 12. M. Lundquist, *Svensk konsthistorisk bibliografi,* 1967; 22. E. Forssmann, *Venedig in der Kunst und in Kunsturteil des 19. Jahrhunderts,* 1971.

R60   Storia della miniatura. Studi e documenti, 1- . Firenze, Olschki, 1962- .
Scholarly works on Italian miniatures and collections of illuminated manuscripts in Italy. 1. M. Levi D'Ancona, *Miniatura e miniatori a Firenze dal XIV al XVI secolo. Documenti per la storia della miniatura,* 1962. 2. M. L. Gengaro and G. Villa Guglielmetti, *Inventario dei codici decorati e miniati della Biblioteca Ambrosiana (sec. VII-XIII),* 1968. 4. M. Levi D'Ancona, *The Wildenstein collection of illuminations—the Lombard school,* 1971.

R61   Studia archaeologica, 1- . Roma, "L'Erma" di Bretschneider, 1961- .
Studies by Italian scholars in the field of classical archaeology and art. Examples: 1. S. de Marinis, *La tipologia del banchetto nell'arte etrusca arcaica,* 1961; 5. S. Nocentini, *Sculture greche, etrusche e romane del Museo Bardini in Firenze,* 1965; 12. F. Canciani, *Bronzi orientali e orientalizzanti a Creta nell'VIIIe-VII sec. a.C.,* 1970.

R62   Studien der Bibliothek Warburg, 1-24, Leipzig, Berlin, Teubner, 1922-32.
The earliest works of the great scholars at the Bibliothek Warburg in Hamburg, and later at the Warburg Institute, London. Several deal with problems of theory and iconology, in particular classical survivals and revivals. Continued by the same series published in London as *Studies of the Warburg Institute* (R73). Examples: E. Panofsky, *"Idea" ein Beitrag zur Begriffsgeschichte der alteren Kunsttheorie,* 1924; F. Saxl, *Antike Götter in der Spätrenaissance,* 1927; 9. F. Schmidt-Degener, *Rembrandt und der hollandische Barock;* 23. W. Stechow, *Apollo und Daphne,* 1932.

R63   Studien zur deutschen Kunstgeschichte, 1- . Strasbourg, Heitz, 1894- .
Current publisher: Baden-Baden, Heitz. Several volumes in the series have been reprinted by A. van Bekhoven in Naarden, Netherlands. v.1-8 and other selected titles reprinted by Koerner, Baden-Baden, 1971- .
   Bd. 331 is *General register zu Bd. 1 bis 330 (1894-1962),* 1962, 98p. (A listing of all volumes by number, indexes of authors, artists' names, and illustrations.)

A venerable series of monographs concerning art in Germany and German-speaking regions. Size varies, many under 100p. Recent examples: 352. G. Tschira van Oyen, *Jan Baegert, der Meister von Cappenberg,* 1972; 353. H. Gollob, *Renaissance-Probleme in Wiener Frühdruckinitialen,* 1973.

R64   Studien zur Kunst des 19. Jahrhunderts, Bd. 1- . München, Prestel, 1966- .
A collaboration of the Zentralinstitut für Kunstgeschichte, Munich, and the research group "Neunzehntes Jahrhundert" of the Fritz Thyssen Stiftung.
   Important scholarly contributions to art historical research in the art of the 19th and early 20th centuries. Handsomely-produced volumes with good illustrations. Examples: 1. L. Grote, ed. *Historismus und bildende Kunst,* 1966, 2d ed. 1968; 4. H. Lietzmann, *Bibliographie zur Kunstgeschichte des 19. Jahrhunderts,* 1968; 11. M. Steinbauer, *Die Architektur der Pariser Oper,* 1969; 28. R. Wagner-Rieger, and W. Krause, ed. *Historismus und Schlossbau,* 1975.
———. Sonderbände, 1971- .
   Examples: H. Börsch-Supan and K. W. Jähning, *Caspar David Friedrich,* 1973; A. Neumeyer, *Geschichte der amerikanischen Malerei,* 1974.

R65   Studien zur Kunstgeschichte, 1- . Hildesheim, Olms, 1973- .
Size varies. A series of scholarly studies in the field of art history. Contents: 1. G. C. Rump, *George Romney (1734-1802),* 2v., 1974; 2. A. Preiser, *Das Entstehen und die Entwicklung der Predella in der italienischen Malerei,* 1973; 5. H. R. Schmid. *Lux incorporata. Zur ontologischen Begründung einer Systematik des farbigen Aufbaus in der Malerei,* 1975.

R66   Studien zur Oesterreichischen Kunstgeschichte, 1- . Wien, Böhlaus, 1958- .
Pub. by the Institut für Österreichische Kunstforschung des Bundesdenkmalamtes. Well-illustrated, specialized monographs on Austrian art history, and Austrian and related art in Austrian collections. Examples: 1. G. Aurenhammer, *Die Handzeichnungen des 17. Jahrhunderts in Österreich,* 1958; 4. H. Koepf, *Die gotischen Planrisse der Wiener Sammlungen,* 1969.

R67   Studien zur spätantiken Kunstgeschichte, Bd. 1-12. Leipzig, de Gruyter, 1925-41.
Im Auftrag des Deutschen Archäologischen Institutes. Hrsg. von H. Lietzmann und G. Rodenwaldt. Repr. of Bd. 1-3, 6 & 8, 10-12, announced by de Gruyter, Berlin.
   An old important series treating various subjects of late antique and Early Christian art. Examples: 2. R. Delbrueck, *Die Consulardiptychen und verwandte Denkmäler,* 1929 (repr., 1975); 10. H. P. L'Orange and A. von Gerkan, *Der spätantike Bildschmuck des Konstantinsbogens,* 1939.

R68   Studies in architecture, 1- . London, Zwemmer, 1958- .
Editors: Anthony Blunt, John Harris, Howard Hibbard.
   A most distinguished series; each monograph is an important contribution to the history of architecture. Examples:

519

1. A. Blunt, *Philibert de l'Orme*, 1958; 4.-5. J. S. Ackerman, *The architecture of Michelangelo*, 2v., 1961, rev. ed. 1965; 7. R. Branner, *St. Louis and the court style in Gothic architecture*, 1965; 8. D. Wiebenson, *Sources of Greek revival architecture*, 1969; 10. H. Hibbard, *Carlo Maderno and Roman architecture 1580-1630*, 1971; 12. W. Herrmann, *The theory of Claude Perrault*, 1973; 14. D. Watkin, *The life and work of C. R. Cockerell*, 1974.

R69  Studies in British art. Under the auspices of Paul Mellon Centre for Studies in British Art. New Haven, Yale Univ. Pr., 1967- .

An unnumbered series of specialized studies on topics in British art. Examples: R. Raines, *Marcellus Laroon*, 1967; A. Crookshank, *Irish portraits 1660-1860*, 1969; R. Paulson, *Hogarth: his life, art and times*, 2v., 1971; E. Adams, *Francis Danby: varieties of poetic landscape*, 1973.

R70  Studies in manuscript illumination, 1- . Princeton, Princeton Univ. Pr., 1947- .

A numbered series, each of which represents scholarly research of the highest order. Limited to ancient, Early Christian, and Byzantine manuscript painting. Examples: 2. K. Weitzmann, *Illustrations in roll and codex*, 1947, expanded ed. 1970; 5. J. R. Martin, *The illustrations of The heavenly ladder of John Climacus*, 1954; 6. G. P. Galavaris, *The illustrations of the liturgical homilies of Gregory Nazianzenus*, 1969.

R71  Studies in Mediterranean archaeology, 1- . Göteborg, Åstrom, 1962- .

An important series of scholarly monographs on topics concerning the archaeology and art of the ancient Mediterranean world. Usually in English. Examples: 1. P. Ålin, *Das Ende der mykenischen Fundstätten auf dem griechischen Festland*, 1962; 12. M. R. Popham, *The destruction of the palace at Knossos; pottery of the late Minoan IIIA period*, 1970; 27. M. Saflund, *The east pediment of the temple of Zeus at Olympia*, 1970; 39. R. S. Merrilless, *Trade and transcendence in the bronze age Levant*, 1974.

R72  Studies in Pre-Columbian art and archaeology, 1- . Wash., D.C., Dumbarton Oaks, Trustees for Harvard Univ., 1966- .

Short, well-illustrated scholarly monographs concerned chiefly with iconography. In general based on objects in the Robert Woods Bliss collection at Dumbarton Oaks. Examples: 4. G. Kubler, *The iconography of the art of Teotihuacan*, 1967; 7. P. D. Joralemon, *A study of Olmec iconography*, 1971; 11. C. Moser, *Human decapitation in ancient Mesoamerica*, 1973; 12. J. Wilbert, *The thread of life: symbolism of miniature art from Ecuador*, 1974.

R73  Studies of the Warburg Institute, 1- . London, Warburg Institute, Univ. of London, 1938- . (Repr. of series: Nendeln, Liechtenstein, Kraus, except 3, 11, 14, 16, 18-21, 23- .)

A continuation of *Studien der Bibliothek Warburg* (R62).

An important series of scholarly works concerning art history, in particular iconography and theory; recently there has been greater emphasis on individual works and individual artists. Examples: 2. H. Buchthal, *The miniatures of the Paris Psalter*, 1938; 6. R. Hinks, *Myth and allegory in ancient art*, 1939; 10. A. Katzenellenbogen, *Allegories of the virtues and vices in medieval art from early Christian times to the thirteenth century*, 1939; 15. F. Yates, *The French academies of the sixteenth century*, 1948; 16. D. Mahon, *Studies in Seicento art and theory*, 1947; 19. R. Wittkower, *Architectural principles in the age of humanism*, 1st ed. 1949; 21. P. P. Bober, *Drawings after the antique by Amico Aspertini*, 1957; 26. E. Panofsky, *The iconography of Correggio's Camera di San Paolo*, 1961; 33. B. Rekers, *Benito Arias Montano*, 1972; 34. O. Kurz. *European clocks and watches in the Near East*, 1975.

R74  United States. National Gallery of Art. Kress Foundation studies in the history of art, 1- . London, Phaidon, 1966- .

Important monographs on European art, on the whole masterpieces of research and writing by outstanding scholars. Examples: 1. W. Stechow, *Dutch landscape painting in the 17th century*, 1966; 2. M. Meiss, *French painting in the time of Jean de Berry*, 2v., 1968; 5. D. Posner, *Annibale Carracci*, 2v., 1971.

R75  Venice. Biennale internazionale d'arte. Catalogo. Venice, 1895- . (Repr.: *Catalogues of the Venice Biennale*, 1895-1920 (12v.), N.Y., Arno, 1971.)

First exhibition held in 1895; none held between 1914-20. Title of exhibition varies. None issued in 1974. Issued by the sponsoring society: La Biennale di Venezia.

Catalogues of the large international exhibition of contemporary art, held biennially in Venice. The themes of these exhibitions vary. Valuable for research in the field of modern art.

R76  Walter W. S. Cook Alumni lectures, 1959- . Published for the Institute of Fine Arts, New York Univ. by Locust Valley, N.Y., Augustin, 1960- .

Brief scholarly studies based on lectures selected from those delivered annually. With some exceptions these are by former students of the Institute of Fine Arts, New York Univ. Well-illustrated. Examples: M. Meiss, *Giotto and Assisi*, 1960; P. Lehmann, *The pedimental sculptures of the Hieron in Samothrace*, 1962; F. Hartt, *Love in Baroque art*, 1964; J. Ackermann, *Palladio's villas*, 1967; C. Gilbert, *Change in Piero della Francesca*, 1968.

R77  Walter Neurath memorial lectures, 1- . London, Thames & Hudson, 1969- .

Short texts (under 100p.) of annual lectures given at Birbeck College, Univ. of London. Written by distinguished art historians on topics of European art and architecture. Illustrated. Examples: 2. H. R. Trevor-Roper, *The plunder of the arts in the seventeenth century*, 1970; 5. J. Summerson, *The London building world of the eighteen-sixties*, 1973.

R78  The Wrightsman lectures, 1-7. New York Univ. Pr., 1966-72; Ithaca, Cornell Univ. Pr., 7-, 1976- .

Monographs by leading scholars. Based upon lectures presented annually since 1964 under the auspices of New York Univ. Institute of Fine Arts. Examples: 2. E. Panofsky, *Problems in Titian, mostly iconographic*, 1969; 3. O. Demus, *Byzantine art and the West*, 1970; 6. B. Ashmole, *Architect and sculptor in classical Greece*, 1972; 8. J. Białostocki, *The art of the Renaissance in Eastern Europe*, 1976.

# Author-Title Index

A magyar művészet története. Kampis. I408

A magyar művészettörténeti irodalom bibliográfiája. Biró. A155

A magyar művészettörténeti irodalom bibliográfiája. A156

A talha em Portugal. Smith. I459

À travers cinq siècles de gravures, 1350-1903. Bourcard. N18

A. W. Mellon lectures in the fine arts. R1

Aachen (Germany). Rathaus. R21

Aanhangsel op de drie deelen bevattende necrologie. Eynden. M418

AARP: art and archaeology research papers. Q1

Abbey, John Roland. N101

Abbey Collection of English Coloured Books. N101

Abbigliamento e costume nella pittura italiana. Cappi Bentivegna. P126

Abbot Suger on the Abbey Church of St. Denis and its art treasures. Panofsky, ed. H18

Abecedario biografico dei pittori, scultori ed architteti cremonesi. Grasselli. E117

Abecedario de P. J. Mariette. H104, H131

Abecedario pittorico. Orlandi. H110

Abendländische Miniaturen bis zum Ausgang der romanischen Zeit. Boeckler. M127

Abiko, Bonnie F. I550

About photography and photographers. Pritchard. O33

Abrégé de la vie des plus fameux peintres. Dézallier d'Argenville. H89

Abstract of an artist. Moholy-Nagy. I239

Abstract painting. Berckelaers. M149

Abstracts of technical studies in art and archaeology. Gettens & Usilton. A36

Academia todesca della architectura, scultura & pittura. Sandrart. H74

Académie des Inscriptions et Belles-Lettres. Q5, Q6

Académie Royale de Peinture et de Sculpture (Paris). H91, H146, I272

Academies of art, past and present. Pevsner. G22

Academy and French painting in the nineteenth century. Boime. M193

Accademia Romana di Archeologia. Q7

Les accessoires du costume et du mobilier. Allemagne. P81

Account of medieval figure-sculpture in England. Prior & Gardner. K143

Account of the lives and works of the most eminent Spanish painters, sculptors and architects. Palomino. H111

Achaemenid sculpture. Farkas. K22

Acker, William Reynolds Beal. H216

Ackerman, James S. G1, I8

Ackerman, Phyllis. I548, P632

Acqua, G. A. dell'. M335, M336

Acquarone, Francisco. M374

Acta ad archaeologiam et artium historiam pertinentia. R2

Acta archaeologica. Academiae Scientiarum Hungaricae. Q8, Q9

Acton, Harold. I327

Acuña, Luis Alberto. E121

Adam, Leonhard. I582

Adam, Sheila. K36

Adam and Hepplewhite and other neo-classical furniture. Musgrave. P188

Adam silver, 1765-1795. Rowe. P513

Adama van Scheltema, Frederick. I421

Adams, Clinton. N63

Addis, Denise. H83

Adeline, Jules. E1

Adeline art dictionary. E1

Ades, Dawn. O57

Adhémar, Hélène. M174, M175, M409

Adhémar, Jean. H91, I273, N11, N37, N50, N78, N79, N86

Adiciones al Diccionario de los más ilustres profesores de las bellas artes en España de D. Juan Agustín Céan Bermudez. Viñaza. E166

Adler, Leo. J32

Adriani, Achille. I80

Advisory list to the National Register of historic places. U.S. Office of Archeology and Historic Preservation. J335

Aegean art. Demargne. I92

Aegyptus. A78

Aeschlimann, Erardo. A22, M12

Aesthetic movement. Aslin. I306

Aesthetics today. Philipson. G25

Aesthetisches Wörterbuch über die bildenden Künste. Watelet & Levesque. E24

Affecter. Mommsen-Scharmer. M62

Affreschi lombardi del Quattrocento. Mazzini. M336

Affreschi lombardi del Trecento. Matalon. M335

Africa. Murdock. I596

Africa: the art of the Negro peoples. Leuzinger. I3

African art. Leiris & Delange. I594

African art. Willett. I598

African art and leadership. Fraser & Cole, eds. I592

African art in cultural perspective. Bascom. I589

African art in motion. Thompson. I597

521

531

533

Brandt, Elfriede. P591
Branner, Robert. J39, J158, J159, M176
Brascaglia, M. H66
Brateau, Paul. P243
Braun, Eleanor. B21
Braun, Joseph. F28, P495
Braun-Feldweg, Wilhelm. P456
Braun-Ronsdorf, Margarete. P110
Braunfels, Wolfgang. I185, J34, J226
Bravmann, René A. I591, I592
Bravo, Carlo del. K150
Bray, Warwick. E2
Brayda, Carlo. J235
Breasted, James H. M52
Bredius, Abraham. H201, H207
Bréhier, Louis. I275, K79
Breman, Paul. H83, J3
Brendel, Otto J. I18, I119
Brenton, Jane. N85
Brenzoni, Raffaello. E106
Brepohl, Erhard. P471
Bresset, Édouard. K89
Breton, Arthur J. A165
Brett, Katherine B. P679
Breuil, Henri. M50
Breunig, L. C. I240
Breve historia de la pintura española. Lafuente Ferrari. M476
Breve racconto delle miglior opere d'architettura. Mola. R54
Bréviaires manuscrits des bibliothèques publiques de France. Leroquais. M134
Brewington, Marion Vernon. K195
Brickbuilder. Q39
Bride stripped bare by her bachelors, even. Duchamp. I239
Bridgwater, Derek. P547
Brieger, Peter. I313
Briegleb, Jochen. I111
Brière, Gaston. K121
Briganti, Giuliano. M325
Brilliant, Richard. I87, I120, K63
Brinckmann, Albert Erich. J122, K94, K95
Brinton, Christian. I426, M433
Brinton, Selwyn. M293
Briquet, Charles Moïse. N75
Britannica encyclopaedia of American art. E169
British antiques yearbook. Smith & Dick, eds. P7
British archaeological abstracts. Lavell, ed. A138
British architects, 1840–1976. Wodehouse. J205
British art and the Mediterranean. Saxl & Wittkower. I314
British Institute of Archaeology at Ankara. Q21

British Institution, 1806–1867. Graves. M272
British journal of aesthetics. Q112
British landscape painting of the 18th century. Herrmann. M275
British mezzotint portraits. Smith. N111
British miniaturists. Long. M278
British Museum. I196
   Department of British and Medieval Antiquities. P459
   Department of Prints and Drawings. L3, L38, L43, L63, N148
   Department of Western Asiatic Antiquities. K19, K20
British Museum quarterly. Q113
British Museum yearbook. Q113
British painting. Baker. M246
British porcelain. Godden. P325
British pottery. Godden. P326
British rings, 800–1914. Oman. P606
British school. Davies. M6
British School at Rome. Papers. Q115
British School of Archaeology at Athens. K36, Q114
British School of Archaeology in Iraq. Q190
British School of Archaeology in Jerusalem. Q224
British Society of Aesthetics. Q112
Britt, David. O20
Britten's old clocks and watches. Baillie, Clutton, & Ilbert, eds. P234
Britton, John. J25, J195, J196
Brizio, Anna Maria. H47, I22
Broadbent, Sylvia M. I631
Brockhaus, H. H41
Broder, Patricia J. K196
Broderie du XIe siècle jusqu'à nos jours. Farcy. P691
Brodrick, Alan Houghton. I29
Broglis, Raoul. I2
Bromberger, Troy-Jjohn. D10
Brøndsted, Johannes. K181
Bronze and stone sculpture of China. Mizuno. K212
Bronze casting and bronze alloys in ancient China. Barnard. K207
Bronze Statuetten und Geräte. Schottmüller. K96
Bronzes and jades of ancient China. Mizuno. K213
Bronzes antiques. Boucher. I2
Bronzes grecs. Charbonneaux. K41
Bronzes of Kashmir. Pal. K228
Bronzes; sculptors and founders, 1800–1930. Berman. K99
Bronzes of the American West. Broder. K196
Brookes, P. Cannon. K8
Brooklyn Institute of Arts and Sciences. K21, P410

Brooks, Harold Allen. J306
Brosch, O. A125
Broscio, Valentino. P193
Brown, David. P32
Brown, Frank E. E32, J39
Brown, Gerard Baldwin. I307
Brown, J. Carter. P55
Brown, Jonathan. H6
Brown, Julian. M186
Brown, Milton W. M497
Brown, Percy. J349, M558
Brown, R. A. J180
Brown, W. Llewellyn. K64
Brown decades. Mumford. I482
Browne, N. E. F81
Bruce-Mitford, R. L. S. P459
Bruchmann, C. F. H. F24
Die Brücke. A134
Bruckmann's Deutsche Kunstgeschichte. I298
Brückner, Wolfgang. N93
Brueckner, Alfred. K44
Brulliot, Franz. E54
Brun, Carl. E167
Brun, Wolfgang. P86
Brundage, Avery. I508, K206
Brune, Paul. E71
Brunet, Marcelle. I1, P306
Brunn, Heinrich von. K27, K28
Brunner, Felix. N65
Brunner, Helmut. I36
Brunner-Traut, Emma. I44
Brunov, Nikolai. I394
Brussels. Académie Royale d'Archéologie de Belgique. Q293
   Institut Royal du Patrimoine Artistique. Q116
   Palais des Beaux-Arts. R21
Brusselsche steenbikkeleren. Duverger. E127
Bryan, Michael. E38
Bryan's dictionary of painters and engravers. Bryan & Williamson. E38
Buberl, Paul. M11
Bucarest. Académie de la République Socialiste de Roumanie. Q302
Buch der Malerzeche in Prag. H5
Buch der ostasiatischen Lackkunst. Herberts. P717
Buch von der Kunst. Cennini. H5
Buch von der Malerei. DaVinci. H5
Buchelius, Arend van. H207
Buchheim, Lothar-Günther. N94
Buchholz, Hans-Günter. I67
Buchowiecki, Walther. J172
Buchthal, Hugo. M4, M128
Buck, Anne Mary. P115
Buck, Peter. I584, I634
Buckingham Collection. Art Institute of Chicago. N145
Buckland, Gail. O10, O75

535

Catalogue of Italian maiolica. Victoria and Albert Museum, London. Rackham. P345

Catalogue of Italian sculpture in the Victoria and Albert Museum. Pope-Hennessy. K170

Catalogue of Japanese and Chinese woodcuts. British Museum. Binyon. N148

Catalogue of paintings and sculpture. Vol. III: Canadian school. National Gallery of Canada, Ottawa. Hubbard. I270

Catalogue of reproductions of paintings 1860-1973. UNESCO. D15

Catalogue of Spanish rugs. Washington, D.C. Textile Museum. Kühnel. P616

Catalogue of the Acropolis Museum: Archaic sculpture. Dickens. K52

Catalogue of the ancient Persian bronzes in the Ashmolean Museum. Moorey. K24

Catalogue of the Anglo-Saxon ornamental metalwork 700-1100 in the Department of Antiquities, Oxford University, Ashmolean Museum. Hinton. P463

Catalogue of the collection of drawings in the Ashmolean Museum, Oxford University. Parker. L55

Catalogue of the drawings collection of the Royal Institute of British Architects, London. J59

Catalogue of the Epstean Collection on the history and science of photography and its applications especially to the graphic arts. Columbia University. Library. O3

Catalogue of the Greek and Roman sculpture. Cambridge, Fitzwilliam Museum. Budde & Nicholls. K29

Catalogue of the Harvard University Fine Arts Library. A63

Catalogue of the Japanese paintings and prints in the collection of Mr. & Mrs. Richard P. Gale. Hillier. M570

Catalogue of the Library of the Graduate School of Design, Harvard University. J10

Catalogue of the Library of the National Gallery of Canada. A71

Catalogue of the Nimrud ivories. British Museum. Barnett. K20

Catalogue of the painted enamels of the Renaissance. Walters Art Gallery, Baltimore. Verdier. P445

Catalogue of the Persian manuscripts and miniatures. Chester Beatty Library, Dublin. Arberry et al. M114

Catalogue of the photographic library of the Camera Club, New York. O2

Catalogue of the recorded paintings of successive dynasties. Ferguson. M520

Catalogue raisonné des peintures du moyen-âge, de la renaissance et des temps moderne: Peintures flamandes du XVe et XVIe siècle. Paris. Musée National de Louvre. Michel, ed. M395

Catalogue raisonné d'une collection de livres, pièces et documents, manuscrits et autographes relatifs aux arts de peinture, sculpture, gravure et architecture. Goddé. A37

Catalogue raisonné of the works of the most eminent Dutch, Flemish and French painters. Smith. M428

Catalogues of the Berenson Library of the Harvard University Center for Italian Renaissance Studies, Florence. A64

Catalogues of the National Gallery, London. M6

Catalogues of the Paris Salon. Janson, comp. H146

Catalogues of the Venice Biennale. R75

Catalogus der Kunsthistorische Bibliotheek in het Rijksmuseum te Amsterdam. A57

Catalogus van meubelen en betimmeringen. 3. druk. Amsterdam. Rijksmuseum. P203

Catello, Elio. P516

Cathedral antiquities. Britton. J196

Cathédrales, abbatiales, collégiales, prieurés romans de France. Aubert & Goubet. J156

Catlin, Stanton Loomis. I363

Cato, Jack. O68

Caucasian rugs. Schürmann. P628

Causa, Raffaello. M292

Cavalcaselle, Giovanni Battista. M294, M329, M330

Cavallo, Adolph S. P634

Caw, Sir James Lewis. M262

Céan Bermúdez, Juan Agustín. E151, E152, E157, E166, J291

Cecchi, E. M319

Ceci, Giuseppe. A142

Cederholm, Theresa Dickason. E170

Cela, Camilo José. P251c

Celio, Gaspare. H60

Cellini, Benvenuto. H36

Celtic art. Finlay. I141

Cennini, Cennino. H5, H17

Census of pre-nineteenth century Italian paintings in North American public collections. Fredericksen & Zeri. M298

Central American and West Indian archaeology. Joyce. I613

Central Italian and North Italian schools. Berenson. M320

Centre d'Études Supérieures de Civilisation Médiévale. A81

Centre National de la Recherche Scientifique, Paris. A76, A80, A178, Q292

Centres de style de la sculpture nègre africaine. Kjersmeier. K249

Centro Bibliografico della Copia Vaticana del "Princeton art index." A53

Centro Internazionale delle Arti e del Costume, Venezia. P79

Centro Internazionale di Studi d'Architettura Andrea Palladio, Vicenza. Bollettino. Q131

Centro Italiano di Studi sull'Alto Medioevo, Spoleto. K152

Century of British painting. Redgrave & Redgrave. M281

Century of cameras from the collection of the International Museum of Photography at George Eastman House. Lothrop. O35

Century of Dutch manuscript illumination. Delaissé. M403

Century of French painting. Ring. M187

Century of loan exhibitions 1813-1912. Graves. M273

Ceramic art of China, and other countries of the Far East. Honey. P356

Ceramic art of Great Britain. Jewitt. P328

Ceramic art of Korea. Kim & Gompertz, eds. P387

Ceramic collectors' glossary. Barber. P257

Ceramic literature. Solon. P256

Ceramic wares of Siam. Spinks. P389

Cerámica del Levante español. González Martí. P350

Cerámica y vidrio. Ainaud de Lasarte. I438

Ceramics from the world of Islam. Freer Gallery of Art, Washington, D.C. Atil. P291

Céramique ancienne de l'Asie. Koyama. P357

Céramique chinoise. Beurdeley. P359

Céramiques américaines. Reyniers. I2

Ceramisti. Minghetti. P276

Cerulli Irelli, G. M80

Cescinsky, Herbert. P175, P248

Česky barok. Neumann. I411

541

545

la storia artistica ferrarese. Citta-della. H175

Documenti inediti per la storia dell'arte a Napoli. Strazzullo. H196

Documenti per la storia dell'arte senese. Milanesi. H186

Documenti per la storia, le arti e le industrie delle provincie napoletane. Filangieri, ed. H179

Documenti sul barocco in Roma. Orbaan. H192

Documenti toscani per la storia dell'arte. Bacci, ed. H154

Documentos inéditos para la historia de las bellas artes en España. Zarco del Valle, ed. H215

Documentos para a história da arte em Portugal. Lino, Silveira & Oliveira Marques. H210

Documentos para el estudio del arte en Castille. García Chico, ed. H211

Documentos para la historia del arte en Andalucía. Seville. Universidad. Laboratorio de Arte. H214

Documents de sculpture française. Vitry & Brière. K121

Documents du Minutier Central concernant les peintres, les sculpteurs et les graveurs au XVIIe siècle. Fleury. H134

Documents du Minutier Central concernant l'historie de l'art. Rambaud. H135

Documents du Minutier Central des Notaires de la Seine. H147

Documents et extraits divers concernant l'histoire de l'art dans le Flandre. Deshaines. H202

Documents inédits sur les artistes français du XVIIIe siècle. Wildenstein, ed. H147

Documents of modern art. Motherwell, ed. I239

Documents of 20th century art. Motherwell, Karpel & Cohen, eds. I240

Dodd, Erica. Cruikshank. P474

Dods, Agnes M. M502

Dodwell, Charles Reginald. H19, M130, M251

Doeringer, Suzannah F. K33

Doerner, Max. M32

Dohme, Robert. E39

Doi, Tsugaru. M578

Doi, Tsuguyoshi. I552

Dokumentation der Kunst des 20. Jahrhunderts. Arntz, ed. A100

Dolce, Lodovico. H5, H39, H156

Dolce's "Aretino" and Venetian art theory of the Cinquecento. Roskill, ed. H39

Dolger, Franz Joseph. F45

Dolloff, Francis W. N68

Domestic architecture of the American colonies and of the early Republic. Kimball. J321

Domestic colonial architecture of Tidewater Virginia. Waterman & Barrows. J339

Domínguez Bordona, Jesús. I438, M471

Dominici, Bernardo de. H92

Domus. Q161

Donatello. Semper. H5

Donati, Lamberto. M1

Donin, R. K. I297

Donzelli, Carlo. M356, M357

Doppelmayer, Johann Gabriel. H93

Doran, Genevieve C. E173

Doria-Pamphilj archives. H194

Dörig, José. I86

Dorigo, Wladimiro. M78

Dorival, Bernard. I13, M200

Dorregaray, José Gil. J292

Dorta, E. M. I438

Doty, Robert. O58, O98

Douglas, Frederic Huntington. I605

Douglas, Langton. M294

Douroff, M. B. P582

Douze crayons de François Quesnel. Dimier. M198

Downes, Kerry. J180, J208

Downing, Antoinette F. J309

Downs, Joseph. P217

Doxiadis, Constantine. J33

Drake, Wilfred James. P435

Drawings by the old masters at Christ Church, Oxford. Byam Shaw. L4

Drawings from the Clark Art Institute. Haverkamp-Begemann, Lauder & Talbot. L16

Drawings from New York collections. L46

Drawings in Swedish public collections. Bjurström. L2

Drawings of Antonio Canaletto. Parker. L60

Drawings of Domenichino. Pope-Hennessy. L60

Drawings of G. B. Castiglione and Stefano della Bella. Blunt. L60

Drawings of Leonardo da Vinci. Clark. rev., Pedretti. L60

Drawings of the Carracci. Wittkower. L60

Drawings of the Florentine painters. Berenson. L42

Drawings of the Venetian painters in the 15th and 16th centuries. Tietze & Tietze-Conrat. L58

Drenowatz Collection, Zürich. M540

Drepperd, Carl William. P252

Dresden. Staatliche Kunstsammlungen. Jahrbuch. Q162

Dresden china. Honey. P311

Dresdner, Albert. G5

Dress art and society. Squire. P101

Dress in Italian painting. Birbari. P125

Drevnerusskoe iskusstvo v Sobranii Pavla Korina. Antonova. I409

Drexler, Arthur. J355

Dreyfus Collection. P568

Dreyfuss, Henry. F4

Drie eeuwen vaderlandsche geschie-duitbeelding. Waal. I391

Dritte Folge. Q343

Droulers, Eugène. F5

Drucker, Philip. I606, I607

Drudi Gambillo, Maria. M358

Dryden, Alice. P703

Du Colombier, Pierre. J111, J173

Du Fresnoy, Charles Alphonse. H61

Du Peloux, Charles. E73

Du romantisme au réalisme. Rosenthal. M212, M213

Ducati, Pericle. I121, I122, M58, M80

Duchamp, Marcel. A109, I239

Duchartre, Pierre-Louis. N131

Ducret, Siegfried. P267, P307–P309 P351

Dudley, Donald Reynolds. H11

Dve tratti. Cellini. H36

Dumbarton Oaks bibliographies based on *Byzantinische Zeitschrift*. Allen, ed. A93

Dumbarton Oaks Center for Byzantine Studies, Washington, D.C. A93

Dumbarton Oaks colloquim on the history of landscape architecture. R24

Dumbarton Oaks papers. I157

Dumitrescu, Vladimir. I54

Dumuis, Henriette, K119a

Dunbar, John G. J181

Duncan, Dorothy. P151

Duncan, George S. P391

Duncan Phyfe and the English Regency. McClelland. P223

Dunlap, William. I473

Dunn, Dorothy. M583

Dunn, Nancy. M441

Duplessis, Georges. A33, C14, N4, N26, N87

DuPont, Henry Francis. P217, P218

Dupont, Jacques. M131

Dupuis, André. P93

Dura-Europos and its art. Rostovtsev. I171

Durán Sampere, Agustín. I438

Dürer, Albrecht. H5, H99

Dürers Briefe, Tagebücher und Reime. Dürer. H5

Durliat, Marcel. I442-I444, J284

Durm, Josef. J44

Düsseldorf. Kunstmuseum. P393

547

549

551

Fondation Wildenstein de New York. H147

Fondazione Giorgio Cini. E4, M116
Centro di Cultura e Civiltà. Istituto di Storia dell' Arte. R26

Fondazione Giovanni Trecanni degli Alfieri. P127

Fondo Editorial de la Plástica Mexicana. I370

Fong, Wen. M552, M573

Fontaine, André. H133, I279

Fontein, Jan. I491, M514

Fontenay, Abbé de, see Bonafons, Louis Abel de.

Fonti e commenti per la storia dell'arte senese. Bacci. H155

Forbes, Edward W. M34

Forbes, Henry A. Crosby. P543

Ford, Colin. A47

Forlani, Anna. L45

Form and space. Trier. K107

Forman, Henry Chandlee. J312

Formation of Islamic art. Grabar. I176

Former clock and watchmakers and their work. Baillie, Clutton & Ilbert, eds. P234

Formes. Q171

Forms and functions of twentieth-century architecture. Hamlin. J43

Fornari, Salvatore. P517

Foroughi Collection. I549

Forrer, Leonard. P562

Forschungsunternehmen neunzehntes Jahrhundert. A111

Forsyth, William H. K112

44 modern Japanese artists. Petit. N161

Foskett, Daphne. M267

Fossati, Paolo. P49

Foster, Ethel M. M16

Foster, J. R. I97, I127, I281

Foster, Joshua James. M16

Foto-auge. Roh & Tschichold. O64

Fotografiet i Danmark 1840–1940. Ochsner. O91

Fotographie als Kunst. Kahmen. O30

Fotokunst en België 1839–1940. Magelhaes & Roosens. O87

Foucher, Alfred. I532

Foundations of Chinese art from Neolithic pottery to modern architecture. Willetts. I527

Fountains of Florentine sculptors and their followers. Wiles. K171

Four books of architecture. Palladio. H46

Four hundred centuries of cave art. Breuil. M50

Fourest, Henry Pierre. P300

Fowler, John Stewart. P181

Fowler, Lawrence Hall. J13

Fowler Architectural Collection of the Johns Hopkins University. Fowler & Baer, comp. J13

Fox, Milton S. M312

Franca, José Augusto. I445, I446, M472

France. Archives Nationales. H134, H135

France. Comité des Travaux Historiques et Scientifiques. Bulletin archéologique. Q172

France. Ministère de l'Education Nationale. J149

France and England, 1600–1750. Costello. H6

Francheschi, Pietro di Benedetto dei. H195

Francisco Goya. Sánchez Cantón. I438

Francke, A. H. I506, I507

Francovich, Géza de. K156

Frank, Edgar Black. P553

Frank Lloyd Wright. Sweeney. R7

Frankenstein, Alfred. M499

Frankfort, Henri. I52, I70

Frankfort, Henriette Antonia (Groenewegen). I34, I53

Frankfurt am Main, Städelsches Kunstinstitut. L32

Frankfurter Künstler. Zülch. E90

Frankl, Paul Theodore. G6, J113, J114

Frankl, Wolfgang. J93

Franz, Heinrich Gerhard. J265, M404

Franz Josef Dölger-Institut, Universität Bonn. Q200

Französischen Zeichnungen der Kunstbibliothek Berlin. Kritischer Katalog. Berckenhagen. L26

Frapsauce, F. P484

Frasché, Dean F. P388

Fraser, Douglas. A179, I584, I585, I592, J56

Frazer, Alfred. J50

Frazer, J. G. H8

Fredeman, William Evan. M268

Frederick Law Olmsted and the American environmental tradition. Fein. J56

Fredericksen, Burton B. M298

Frederiks, J. W. P522

Freedberg, Sydney Joseph. M331, M332

Freeland, John Maxwell. J143

Freeman, Phyllis. I362

Freer Art Gallery, Washington D.C. A36, A62, K208, K224, M532, M568, P291, Q58, R27

Freer Chinese bronzes. Freer Art Gallery. Pope et al. K208

Freer Indian sculptures. Lippe. K224

Frégnac, Claude. P156, P305

Freie Kunst. Q215

Fremantle, Richard. K14, M333

French, Hollis. P538

French cabinetmakers of the eighteenth century. Frégnac, ed. P156

French cathedrals. Bony. J157

French clocks. Edey. P242

French decorative art. Savage. P43

French drawings in the collection of His Majesty the King at Windsor Castle. Blunt. L29

French faience. Giacomotti. P301

French faïence. Lane. P303

French, Italian, Spanish, and Portuguese books of devices and emblems. Landwehr. F75

French master goldsmiths and silversmiths from the seventeenth to the nineteenth century. P487

French original engravings from Manet to the present time. Roger-Marx. N88

French painting between the past and the present. Sloane. M214

French painting, from Fouquet to Poussin. Châtelet & Thuillier. M195

French painting, from Le Nain to Fragonard. Thuillier & Châtelet. M215

French painting in the time of Jean de Berry. Meiss. M182

French painting 1774–1830, the age of revolution. M204

French painting, the nineteenth century. Leymarie. M209

French porcelain of the 18th century. Honey. P302

French primitive photography. Jammes. O73

French royal furniture. Verlet. P166

French school. London. National Gallery. Davies. M6

French sculptors of the 17th and 18th century. Souchal. K119a

French stained glass. Witzleben. P441

French tapestry. Weigert. P648

Freund, Gisèle. O72

Frey, Dagobert. H193, I297

Fribourg, Jean. I522

Frick Collection. I1

Friedlaender, Walter F. H54, M205

Friedländer, Max J. I19, L61, M405, M406, M419

Frisch, Teresa G. H6

Fritz Thyssen-Stiftung. A103, A111, G7, R64
Neunzehntes Jahrhundert. R42

Frizzioni, Gustavo. H45

Frodl-Kraft, Eva. I302, P417, P434

From Baudelaire to Surrealism. Raymond. I239

From castle to teahouse. Kirby. J353

557

Hainisch, E. I297
Hairs, Marie-Louise. M422
Hall, H. van. A151
Hall, Henry C. E94
Hall, James. F7
Hall, Margaret M. I494, P680
Hall, *Sir* Robert de Zouche. J177
Hall marks on gold & silver plate. Chaffers. P500
Hallade, Madeleine. I535
Hallensleben, Horst. M438
Halliday, Sonia. P438
Hamann, Richard. I300, M230
Hamann-MacLean, Richard H. L. M438
Hamberg, Per Gustaf. K69
Hamburger Kunsthalle. Q196
Hamilton, George Heard. I247, I406
Hamilton, Sinclair. N141
Hamlin, Alfred Dwight Foster. P69
Hamlin, Sarah Hull Jenkins Simpson. J315
Hamlin, Talbot Faulkner. J42, J43, J315
Hammacher, Abraham Marie. K103
Hammelmann, Hanns. N103
Hammer, H. I297
Hammond, William Alexander. A189
Hampe, Theodor. H5
Han, Cho. H221
Han tomb rt of West China. Rudolph. K215
Hand coloured fashion plates. Holland. P112
Hand list of illuminated Oriental Christian manuscripts. Buchthal & Kurz. M4
Handboek tot de geschiedenis Nederlandsche bouwkunst. Vermeulen. J261
Handbook of American museums. B14
Handbook of Chinese art for collectors and students. Medley. I518
Handbook of Chinese ceramics. Valenstein. P378
Handbook of Christian symbols. Waters. F56
Handbook of costume. Arnold. P82
Handbook of English costume in the eighteenth century. Cunnington & Cunnington. P116
Handbook of English costume in the nineteenth century. Cunnington & Cunnington. P117
Handbook of English costume in the seventeenth century. Cunnington & Cunnington. P118
Handbook of English costume in the sixteenth century. Cunnington & Cunnington. P119
Handbook of English costume in the twentieth century. Mansfield & Cunnington. P124

Handbook of English mediaeval costume. Cunnington & Cunnington. P120
Handbook of graphic reproduction processes. Brunner. N65
Handbook of Greek and Roman architecture. Robertson. J70
Handbook of Greek art. Richter. I107
Handbook of Latin American studies. A147
Handbook of Middle American Indians. Wauchope, ed. I611
Handbook of Mohammedan decorative arts. Dimand. P35
Handbook of Muhammadan art. New York. Metropolitan Museum of Art. Dimand. P35
Handbook of ornament. Meyer. P73
Handbook of pottery and porcelain marks. Cushion & Honey. P265
Handbook of Romanesque art. Timmers. I208
Handbook of symbols in Christian art. Sill. F53
Handbook of wrought iron. Hoever. P548
Handbook on the care of paintings. Keck. M38
Handbook to the drawings and watercolours in the Department of Prints and Drawings, British Museum. Popham. L3
Handbuch der afrikanischen Plastik. Sydow. K251
Handbuch der Archäologie. I35
Handbuch der Archäologie im Rahmen des Handbuchs Altertumswissenschaft. Hausmann, ed. I36
Handbuch der Architektur. J44
Handbuch der deutschen Kunstdenkmäler. Dehio. I296, I297
Handbuch der Holz- und Metallschnitte des XV. Jahrhunderts. Schreiber. N52
Handbuch der Kunstwissenschaft. I10
Handbuch der Museen. B17
Handbuch des europäischen Porzellans. Danckert. P266
Handbuch für Kupferstichsammler. Heller. N30
Handlist of museum sources for slides and photographs. Petrini & Bromberger. D10
Handwoven carpets, Oriental and European. Kendrick & Tattersall. P611
Handzeichnung des 17. Jahrhunderts in Österreich. Aurenhammer. L30
Handzeichnungen. Düsseldorf, Städtisches Kunstmuseum. L47
Handzeichnungen alter Meister aus

der Albertina und anderen Sammlungen. Schönbrunner & Meder. L15
Handzeichnungen schweizerischer Meister des XV.-XVIII. Jahrhunderts. Ganz. L77
Handzeichnungen spanischer Meister. Mayer. L75
Hanfmann, George M. A. I110, I126, J68, K5, K30
Hanguk sǒhwa immyǒng sasǒ. Kim. E180
Haniwa. Miki. I550
Haniwa, the clay sculptures of protohistoric Japan. Miki. K232
Hanks, David A. P53
Hanloser, Hans R. E7
Hannover, Emil. I426, M453, P271
Hannover. Kestner-Gesellschaft. O61
Hansen, Hans Jürgen. J45
Hansford, S. Howard. E181, I513, P711
Hanson, John Arthur. E32
Harada, Kinjiro. M537
Harada, Minoru. I550
Harari collection of Japanese paintings and drawings. Hillier, comp. M571
Harbeson, Georgiana Brown. P692
Harbeson, John F. J322
Harbison, Peter. K142
Harcourt, Raoul d'. P683
Harden, Donald Benjamin. I79
Hardie, Martin. M274
Harding, Anne Dinsdale. A182
Hardoy, Jorge. J56, J364
Hare, Richard. I407
Harksen, Sibylle. A127
Harle, J. C. K225
Harling, Robert. P28
Harper, J. Russell. E64, M167, M168
Harris, Ann Sutherland. L47
Harris, Cyril M. J27
Harris, Eileen. H84, J9
Harris, John. H83, H84, J28, J59, J183, R68
Harris, Neil. I476
Harrison, Evelyn B. K46, K47
Härtel, Herbert. I494
Hartt, Frederick. I11, I332
Harunobu. Takahashi. N156
Harvard University.
  Busch-Reisinger Museum of Germanic Culture. L34
  College Library, Department of Graphic Arts. N33
  College Library, Department of Printing and Graphic Arts. N17
  Fine Arts Library. A63
  Graduate School of Design. J10
  William Hayes Fogg Art Museum. K127

Institute for the Study of Universal History through Arts and Artifacts. R32

Institute of Art History of the Hungarian Academy of Sciences. Q56

Institute of Arts, Detroit. I327

Institute of Classical Studies, London University. A95

Institute of Early American History and Culture, Williamsburg, Virginia. A167

Institute of Fine Arts, New York University. A1, I396, J93, Q233, R76, R78

Institute of International Education. B9

Institute of Latin-American Studies, University of Texas. A183

Instituto Diego Velázquez. A162, Q53

Instituto Español de Arqueologia. Q52

Instituut Kern, Leiden. A176

Interaction of color. Albers. M28

Interconnections in the ancient Near-East. Smith. I59

Interior design. Paston. P6

Interior design and decoration. Lackschewitz. P3

Interior design and decoration. Whiton. P30

International African Institute. A180

International antiques yearbook. P9

International art market. Katzander, ed. C6

International Association for Classical Archaeology, Rome. A84

International Association of Art Critics. B4

International Association of Plastic Arts. E185

International auction records. Mayer. C7

International awards in the arts. B9

International Center of Medieval Art. The Cloisters. Q176

International Center of Romanesque Art. Q176

International Centre of Arts and Costume, Venice. P79

International Congress of the History of Art. 1965. A108, R34

International directory of arts. B10

International directory of historical clothing. Huenefeld. P80

International directory of photographic archives of works of art. UNESCO. D16

International Federation of Renaissance Societies and Institutes. A104

International folklore bibliography. A190

International Gothic in Italy. Castelfranchi. M328

International history of city development. Gutkind. J41

International Institute for Conservation of Historic and Artistic Works. A1, Q330

International modern glass. Beard. P392

International Museum of Photography at George Eastman House, Rochester, New York. O4, Q184

International Photography Hall of Fame. O17

International repertory of glass museums and glass collections, Paris. International Council of Museums. P402

International repertory of the literature of art. A15

International Studio. Q188, Q331

International Union of Academies. E34

International vocabulary of town planning and architecture. Calsat & Sydler. J31

International yearbooks of sales. C7

Internationale Bibliographie der Kunstwissenschaft. A39

Internationale volkskundliche Bibliographie. A190

Internationales Kunst-Adressbuch. B10

Introduction aux études d'archéologie et d'histoire de l'art. Lavalleye. G15

Introduction to a history of woodcut. Hind. N32

Introduction to Benin art and technology. Dark. K246

Introduction to English church architecture. Bond. J194

Introduction to Etruscan art. Riis. I134

Introduction to Italian sculpture. Pope-Hennessy. K164

Introduction to the study of Southwestern archaeology. Kidder. I617

Inventaire après décès et de collectionneurs français du XVIIIe siècle. Wildenstein, ed. H148

Inventaire des mosaïques de la Gaule et de l'Afrique. Académie des Inscriptions et Belles Lettres, Paris. M95

Inventaire descriptif des monuments du Cambodge. Lunet de Lajonquière. I578

Inventaire du fonds français: graveurs du XVIIIe siècle. Paris. Bibliothèque Nationale. N86

Inventaire du fonds français: graveurs du XVIIe siècle. Paris, Bibliothèque Nationale. N86

Inventaire du fonds français: graveurs du XVIe siècle. Paris, Bibliothèque Nationale. N86

Inventaire du fonds français après 1800. Paris, Bibliothèque Nationale. N86

Inventaire général des dessins des écoles du nord. Bibliothèque Nationale, Paris. Lugt & Vallery-Radot. L1

Inventaire général des dessins des écoles du nord. Paris. Musée National du Louvre. Demonts. L36

Inventaire général des dessins des écoles du nord: École flamande. Paris, Musée National du Louvre. Lugt. L70

Inventaire général des dessins des écoles du nord: Maîtres des anciens Pays-Bas. Paris, Musée National du Louvre. Lugt. L69

Inventaire général des dessins des musées de province. I2

Inventaire général des dessins du Musée du Louvre et du Musée de Versailles. Guiffrey & Marcel. L28

Inventaire général des dessins italiens. Paris, Musée National du Louvre. L56

Inventaire général des écoles du nord. École hollandaise. Paris, Musée National du Louvre. Lugt. L71

Inventaire général des monuments et des richesses artistiques de la France. A120, I280, J150, P639

Inventaire général des richesses d'art de la France. J151

Inventaires des collections publiques françaises. I2

Inventário artístico de Portugal. Academia Nacional de Bellas Artes. I449

Inventario dei codici decorati e miniati della Biblioteca Ambrosiana, Milan. Gengaro & Villa Guglielmetti. R60

Une invention du XIXe siècle. Societé Française de Photographie. O65

Invention of liberty. Starobinski. I229

Inventory of the historical monuments in England. Royal Commission on the Ancient and Historical Monuments and Constructions of England. J182

Inverarity, Robert Bruce. I612

Ippodamo di Mileto. Castagnoli. J67

Iran: Parthians and Sassanians. Ghirshman. I78a

Iranians & Greeks in South Russia. Rostovtsev. I505

Iranica antiqua. Q189

Iraq. Q190

565

Lavell, Cherry. A138
Laver, James. N106, P91, P92, P100, P113
Lavignino, Emilio. I336, I337
Lavin, Marilyn Aronberg. H198
Lawder, Standish D. L16
Lawrence, Arnold Walter. J74, K32, K49
Lawrie, Leslie Gordon. P654
Lawton, Thomas. M532
Lazarev, Viktor Nikitich. M101, M441
Leach, Bernard Howell. P279
Leach, Elizabeth. A47
Leask, Harold Graham. J186
Lebel, Gustave. A44
Leben des Michelangelo Buonarroti. Condivi. H5
LeBlanc, Charles. N38
Leblond, Victor. E78, H141
LeBonheur, Albert. I494
Lebov, Lois. A179
LeCannu, Marc. M370
LeCoq, Albert von. I501, I506
LeCorbeiller, Clare. P372
LeCorbusier. Evenson. J56
Lécuyer, Raymond. O31
Ledoux, Louis Vernon. N155
Ledoux-Lebard, Denise. P159
Lee, Cuthbert. F83
Lee, David. J359
Lee, Lawrence. P438
Lee, Lena Kim. I566
Lee, Rensselaer Wright. G16
Lee, Sherman E. I495, I516, I555, I556, I566, M539
Lees-Milne, James. I452, J184
Lefèvre-Pontalis, E. A121
Lefuel, Olivier. P487
Legend in Japanese art. Joly. F68
Legend of Roland in the Middle Ages. Lejeune & Stiennon. I199
Legends of the Madonna as represented in the fine arts. Jameson. F37
Leger, F. I240
Legrand, Francine Claire. M424
Lehmann, Walter. I619
Lehmann-Brockhaus, Otto. H23, H24
Lehrs, Max. N39, N40
Leiris, Michel. I594
Leiss, Josef. P721
Lejeune, Jean. I186
Lejeune, Rita. I199
Leloir, Maurice. P93, P114
LeMay, Reginald Stuart. I575
Lemmens, G. M405
LeMoël, M. J149
Lemos, Carlos A. C. J252
Lenormant, François. P567
Lentz, W. I506
Leonardo. Q223

Leone Battista Alberti's kleinere kunsttheoretische Schriften. Alberti. H5
Leostello, Joampiero. H179
Lépicié, François Bernard. H102
Leporini, Heinrich. L9
Lerius, Theodore François Xavier van. E131, H199
Leroi-Gourhan, André. I30
Leroquais, Victor. M134–M138
Leroy, Jules. M139
LeRoy, Julien. P245
Lespinasse, Pierre Eugène de. E79
Lessard, Michel. P39
Lessing J. Rosenwald Collection. National Gallery of Art. N59, N60, N119
Lester, Katherine Morris. P94
Letteratura artistica. Schlosser. A49
Lettere inedite di artisti del secolo XV cavate dall' archivo Gonzaga. Braghirolli. H170
Lettere senesi di un socio dell'Academia di Fossano sopra le belle arti. Valle. H124
Leurs, Stan. I385
Leuzinger, Elzy. I595
Levant. Q224
Levasseur, H. K12
Levens-beschryvingen der Nederlandsche konst-schilders en konst-schilderessen. Weyerman. H129
Levens en werken der Hollandsche en Vlaamsche kunstschilders. Immerzeel. E129
Levens en werken der Hollandsche en Vlaamsche kunstschilders. Kramm. E130
Levenson, Jay A. N119
Lever, Jill. J28
Levesque, P. C. E24
Levey, Michael. I23, I220, I221, I281, M6, M145, M361
Lévi, S. I506
Levi Pisetzky, Rosita. P127
Lévi-Provençal, E. E34
Levis, Howard Coppuck. N5
Levy, Saul. P195, P196, P343
Lewine, J. N7
Lewis, Frank. M393
Lewis, Stephen. O5
Lewis, Wilmarth. H128
Lewismaler. Smith. M58, M59
Lexicon Nederlandse beeldende kunstenaars 1750–1950. Scheen. E133
Lexikon baltischer Künstler. Neumann. E62
Lexikon der alten Welt. Bartels & Huber, eds. E30
Lexikon der christlichen Ikonographie. Aurenhammer, ed. F26

Lexikon der christlichen Ikonographie. Kirshbaum & Bandmann, eds. F42
Lexikon der Kunst. Alscher, ed. E9
Lexikon der Marienkunde. Algermissen, Böer, Feckes & Tyciak, eds. F43
Lexikon liv- und kurländischer Baumeister. Campe. E61
Lexique des termes d'art. E1
Lexique polyglotte des termes d'art et d'archéologie. Réau. E18
Lexow, Einar Jacob. I427
Leymarie, Jean. M160, M209, M394, N85
Lezzi-Hafter, A. M62
Lhotsky, A. I231
Li, Chu-tsing. M540
Library of illuminated manuscripts. M140
Libro dell'arte. Cennini. Thompson, ed. H17
Liche und Farbe aus Frankreichs Kathedralen. Witzleben. P441
Licht, Fred. K5
Liczbińska, Maria. A157
Lieb, Norbert. E7
Liebaers, H. P651
Liebmann, Michael. A7
Lietzmann, Hans. F45
Lietzmann, Hilda. A7, A18, A115, R67
Life and times of the New York School. Ashton. M488
Life in England in aquatint and lithography. Abbey. N101
Life library of photography. O32
Life-work of the American architect, Frank Lloyd Wright. Q347
Liggeren en andere historische archieven der Antwerpsche Sint Lucasgilde. Rombouts & Lerius. H199
Lightbown, Ronald. K170
Lilienfeld, Karl. H207
Lilja, Gösta. E147
Limbourgs and their contemporaries. Meiss. M184
Limners and likenesses. Burroughs. M498
Limoges painted enamels, Oriental rugs and English silver. The Frick Collection. Verdier, Dimand & Buhler. I1
Lin Ch'üan Kao Chih. Hsi. H218
Lin, Yu-T'ang. H220
Lindberg, Carolus. I436
Lindblom, Andreas A. F. I428, M455
Lindhagen, Nils. N134
Lindsay, K. C. I240
Lindström, A. M458
Lindwall, Bo. I422
Linea dell'arte italiana dal simbolismo alle opere moltiplicate. Ballo. I321

M. & M. Karolik Collection of American paintings. Boston. Museum of Fine Arts. M495

M. & M. Karolik Collection of American water colours & drawings. Boston. Museum of Fine Arts. Rossiter, comp. L80

M. T. Hindson Collection. K229

Maandblad voor beeldende kunsten. Q228

Mabel Brady Garvan Collection, Yale University. Art Gallery. P252a

McAllister, Marian Holland. E32

McAndrew, John. J256

McCarthy, Frederick D. I633

McClellan, Elisabeth. P129

McClelland, Ellwood Hunter. P442

McClelland, Nancy Vincent. P223

McCoubrey, John W. H6, I468

McCoy, Garnett. A165

McCracken, Harold. K196

McCulloch, Alan. E60

McCune, Evelyn. I569

MacDonald, Colin S. E65

MacDonald, William L. E32, J39, J88, J92

MacGibbon, David. J189

McGinniss, Lawrence. H42

McGraw-Hill dictionary of art. E10

Machado, Cyrillo Volkmar. E156

McInnes, Graham. I268

McKay, Alexander G. J89

Mackay, Dorothy. I539

Mackay, Ernest John Henry. I539

McKearin, George Skinner. P427, P428

McKearin, Helen. P427, P428

McKee, Harley J. J317

Mackenzie, Donald Alexander. F23

Mackowitz, H. I297

Mackrell, Alice. A2

Macku, A. I297

Mackworth-Young, Gerard. K52

Maclagan, Eric Robert Dalrymple. K162

Maclaren, N. M6

McLean, Ruari. N107

McPherson Library, University of Victoria, Toronto. E63

McQuaid, James. O5

Macquoid, Percy. P177, P186, P187

MacTavish, Newton. I269

Madhloom, T. A. I72

Madrid. Museo Nacional de Pintura y Escultura. L74

Madrider Forschungen. R40

Madsen, Herman. K178, M456

Madsen, Karl J. V. M457

Madsen, Stephan T. I250

Maeda, Robert J. H221

Magazine of art. Q229

Magazine of art (London). Q230

Magelhaes, Claude. O86, O87

Magi, F. M80

Magic image. Beaton & Buckland. O10

Magnuson, Torgil. J241

Magnusson, Magnus. I525

Magyarországi ötvösjegyek. Köszeghy. P527

Mahler, Jane G. I24

Mahon, Denis. I338

Mailey, Jean. P627

Maillard, Robert. K104, M153

Maillé, Marquise de. J154

Maiolica italiana sino alla comparsa della porcellana europea. Liverani. P342

Maison du XVIIIe siècle en France. Verlet. P167

Maîtres ornemanistes. Guilmard. P68

Maiuri, Amedeo. M79, M80

Majolika. Berlin, Kunstgewerbemuseum. Hausmann. P337

Major themes in Japanese art. Yoshikawa. I552

Making of urban America. Reps. J329

Mâle, Émile. I200, I222, I283–I286

Malerei der deutschen Romantiker und ihrer Zeitgenossen. Deusch. M223

Malerei der Donauschule. Stange. M240

Malerei der Spätrenaissance in Rom und Florenz. Voss. M351

Malerei des Barock in Rom. Voss. M371

Malerei nach 1945 in Deutschland, Österreich und der Schweiz. Schmied. M236

Malerei und Zeichnung. Rumpf. I35

Malerwerke des neunzehnten Jahrhunderts. Boetticher. M151

Malhotra, R. N28

Malle, Luigi. I339, I357

Mallett, Daniel Trowbridge. E44

Mallett's index of artists. E44

Malraux, André. I4

Maltese, Corrado. I340

Malvasia, Carlo Cesare. E105, H65–H67, H178

Manchester studies in the history of art. R41

Mancini, Giulio. H68

Mander, Carel van. H69, H207

Mango, Cyril. H6, I146, I169, I464, J52

Maniera italiana. Briganti. M325

Mankowitz, Wolf. P332

Mann, Margery. O13

Mannerism. Shearman. I228

Mannerism and *maniera*. Smyth. M349

Mannerism, the crisis of the Renaissance and the origin of modern art. Hauser. I215

Manni, Domenico M. H51, H52

Manni, M. M80

Manning, W. H. P32

Mansfield, Alan. P122–P124

Mansions of Virginia. Waterman. J338

Mansuelli, Guido Achille. I130

Mantova, le arti. Istituto Carlo d'Arco. Mantova. I341

Manual of the furniture arts and crafts. Johnson & Sironen, comps. Etten, ed. P147

Manual on the conservation of paintings. International Museum Office. M37

Manuel d'archéologie égyptienne. Vandier. I48

Manuel d'archéologie gallo-romaine. Grenier. I125, J86

Manuel d'archéologie grecque. La sculpture. Picard. K53

Manuel d'archéologie orientale depuis les origines jusqu'à l'époque d'Alexandre. I50

Manuel d'archéologie préhistorique, celtique et gallo-romaine. Déchelette. I140

Manuel d'architecture grecque. Martin. J75

Manuel d'art byzantin. Diehl. I156

Manuel de l'amateur de la gravure sur bois et sur métal au XVe siècle. Schreiber. N54

Manuel de l'amateur d'estampes. Dutuit. N125

Manuel de l'amateur d'estampes. Le Blanc. N38

Manuel de l'amateur d'estampes du XVIIIe siècle. Delteil. N23

Manuel de l'amateur d'estampes des XIXe et XXe siècles. Delteil. N24

Manuel de la conservation et de la restauration des peintures. International Museum Office. M37

Manuel de porcelaine européenne. Danckert. P266

Manuel des artistes et des amateurs. Petity. F14

Manuscript painting in Paris during the reign of St. Louis. Branner. M176

Many faces of primitive art. Fraser. I584

Marburger Index. D7

Marburger Jahrbuch für Kunstwissenschaft. Q231

Marc, F. I240

Marcadé, Jean. H14

Marçais, C. E34

Marçais, Georges. J102

Marcel, Adrien. P44

Marcel, Pierre. L28

March, Benjamin. M542

March of photography. Stenger. O41

Mycenae and the Mycenaean age. Mylonas. I102

Mycenaean civilization publications since 1935. Moon. A95

Myers, Bernard S. M380

Mylonas, George E. I102

Mystic art of ancient Tibet. Olschak & Wangyal. I540

Mythische Kosmographie der Griechen. Berger. F24

Nachleben der Antike. Newald. A194

Nachrichten von Frankfurter Künstlern und Kunst-Sachen. Hüsgen. H98

Nadeau, Maurice. I251

Naef, Weston J. O15, O83, O101

Nagler, Georg Kaspar. E47, E58

Nakamura, M. I552

Nakano, Masaki. I550

Nakata, Yujiro. I552

Namban art of Japan. Okamoto. I552

Napoli nobilissima. Q252

Nara Buddhist art. Kobayashi. I552

Narazaki, Muneshige. N156, N160

Narrative picture scrolls. Okudaira. I550

Nash, Ernest. J90

National Academy of Design
    Exhibition record, 1826–1860. Cowdrey, ed. I484
    Exhibition record, 1861–1900. Naylor, ed. I483

National Art Library Catalogue, Victoria and Albert Museum. A73

National Central Museum, Taiwan. M546, P371

National Gallery of Canada, Ottawa. A71, I270, I271

National Palace Museum, Taiwan. M546, P371

National Palace Museum. Tokyo. P653

National Register of Historic Places. U.S. Department of the Interior, National Park Service. J334

National Treasures of Japan. I554

National Trust for Historic Preservation. Q182

Nature morte de l'antiquité à nos jours. Sterling. M26

Naumann, Rudolf. J65

Navarro, José Gabriel. K173

Naylor, Colin. E48

Naylor, Gillian. P48

Naylor, Maria. I483

Nazarenes: a brotherhood of German painters in Rome. Andrews. M216

Neal, David S. P32

Neapolitan Baroque and Rococo architecture. Blunt. J234

Nebehay, C. M. Q338

Nederlands Historisch-Archaeologisch Instituut in het Nabije Oosten. K22

Nederlands Instituut te Rome. Mededelingen. Q253

Nederlands kunsthistorisch jaarboek. Q254

Nederlandsche houtsneden, 1500–1550. Nijhoff. N128

Nederlandse fotographie. Magelhaes. O86

Nederlandse goud-en zilvermerken. Voet. P525

Nederlandse klokken- en horlogemakers vanaf 1300. Morpurgo. P251

Nederlandse monumenten van geschiedenis en kunst. I386

Nederlandse musea. B22

Needlework through the ages. Antrobus & Preece. P688

Negerkunst und Negerkünstler. Himmelheber. I593

Nelki, Andra. D4

Nelson, Cyril I. P216

Németh, Lajos. I410

Neo-classicism. Honour. I249

Neoclassicism and Romanticism. Eitner, ed. I242

Neo-classicism in France. Eriksen. P41

Neo-Impressionism. Herbert. M155

Neo-Impressionists. Sutter, ed. M164

Neolithic cultures to the T'ang dynasty. Akiyama, Andō, Matsubara et al. I509

Nersessian, Serarpie de. I169

Nervi, Pier Luigi. J52

Netherlandish drawings in the Budapest Museum. Gerszi. L64

Netherlandish painters of the seventeenth century. Bernt. M416

Netherlands. Rijksbureau voor Kunsthistorische Documentatie. A152, F18

Netherlands Rijkscommissie voor de monumentenzorg. I387

Netherlands yearbook for history of art. Q254

Netsuke, a comprehensive study based on the M. T. Hindson Collection. Davey. K229

Netsuke handbook. Ueda. K233

Neubauer, Edith. A130

Neuberg, Frederic. P413

Neudörfer, Johann. H5

Neue Münchner Beiträge zur Kunstgeschichte. Sedlmayer, ed. R46

Neuer Bildniskatalog. Singer. F86

Neues allgemeines Künstler-Lexikon. Nagler. E47

Neumann, Erwin. I297, I418

Neumann, Jaromír. I411

Neumann, Wilhelm. E62

Neumeyer, Alfred. M504

Neunzehnte Jahrhundert. Pauli. I295

Neunzehntes Jahrhundert. Fritz Thyssen Stiftung. R42, R64

Neurdenberg, Elisabeth. P346

Neurussische Kunst. Wulff. I420

Neuweiler, Arnold. M486

Neuwirth, Waltraud. P276a, P315, P320, P408

New art of color. Delaunay & Delaunay. Cohen, ed. I240

New art/the new life. Mondrian. Holtzman, ed. I240

New dictionary of modern sculpture. Maillard, ed. K104

New encyclopedia of furniture. Aronson. P136

New England glass and glassmaking. Wilson. P431

New history of painting in Italy. Crowe & Cavalcaselle. M294

New Japanese architecture. Tempel. J358

New Japanese photography. Szarkowski & Yamagishi, eds. O112

New vision. Moholy-Nagy. I239

New York (City) Museum of Graphic Art. N138

New York. Metropolitan Museum of Art. A67, K51, K200, M171, M300, M505, P21, P35, P295, P378, P627, P643, Q236

New York. Museum of Modern Art. A68, J355

New York. Museum of Primitive Art. Lecture series. R47

New-York Historical Society. F84
    Dictionary of artists in America. Groce & Wallace. E174

New York painting and sculpture. Geldzahler. I474

New York Public Library. Research Libraries. A69, N139
————. ————. Prints Division. N9

New York School. Ashton. M488

New York School: painters and sculptors of the fifties. Sandler. M509

New York State Historical Association. Guide to historic preservation, historical agencies, and museum practices. Rath & O'Connell, comp. J15

New York University, Institute of Fine Arts. Q88, Q233, R78

Newald, Richard. A194

Newby, Frank. P391

Newcomb, Rexford. J326

Newhall, Beaumont. O16, O22, O29, O36, O37, O52, O102

Newhall, Nancy. O16

Ross, Marvin C. P348
Ross, Thomas. J189
Rossi, Giovanni Battista de. I170
Rossiter, Henry P. I471, L80
Rostenberg, Leona. N109
Rostovt͡sev, Mikhail I͡vanovīch. I171, I504, I505
Rostrup, Haavard. M466
Roters, Eberhard. M236
Roth, Henry L. P545
Rothschild Collection at Waddesdon Manor. P19
Rotili, Mario. M311
Rott, Hans. H152
Rounds, Dorothy. A98
Rouse, Irving. I617
Rousseau, Henry. K175
Roussell, A. P434
Roux, Marcel. N83
Rovinskiĭ, Dmitriĭ A. N132
Rowe, John H. I631
Rowe, Robert. P513
Rowland, Benjamin, Jr. A171, I3, I500, I542, M565
Rowley, George. M544
Roy, Marc. P8
Roy, Maurice. I289
Royal Academy of Arts. Graves. E93
Royal Academy exhibitors, 1905-1970. E97
Royal Archaeological Institute of Great Britain and Ireland. Q31
Royal Commission for the Description of Monuments of History and Art, Netherlands. I386
Royal Institute of British Architects, London
    Journal. Q310
    Sir Bannister Fletcher Library. J20, J59
Royal Photographic Society of Great Britain. O6
Royal Society of British Artists — members exhibiting 1824-1930. Bradshaw, comp. E98
Royal Society of Painters in Water colours. M282
Rubens, Alfred. P100
Rubin, William Stanley. I259
Rubow, Jørn. M466
Rückert, Rainer. P317
Rud, Mogens. E142
Rudisill, Richard. O104
Rudolph, Richard C. K215
Rudy, S. I592
Rugerus, see Theophilus.
Ruhemann, Helmut. M44
Rump, G. C. R65
Rumpf, Andreas. I35, M58, M59
Runciman, Steven. I23

Runes, Dagobert David. E19
Rūpam. Q311
Rupprecht, Bernhard. G14, K117
Russell, Charles E. N110
Russian art from Scyths to Soviets. Bunt. I398
Russian art of the avant-garde. Bowlt, ed. I240
Russian experiment in art, 1863-1922. Gray. I405
Russian icon. Kondakov. M439, M440
Russian mediaeval architecture. Buxton. J263
Russian porcelains. Post & Ross. P348
Russian school of painting. Benois. M433
Russkai͡a khudozhestvennai͡a fotografia, 1839-1917. Morosov. O89
Russkie emali XI-XIV VV. Pisarskaja, Platonova & Ul'Janova. P451
Russkoe zolotoe i serebri͡anoe delo. Gol'dberg. P526
Russoli, Franco. K167, M159
Rutledge, Anna Wells. I488
Rutteri, Maria Grazia. H78
Ruz, Alberto. I366
Ryan, Granger. F35
Ryberg, Inez Scott. K73
Rydbeck, Monica. K180
Ryerson Library. Chicago. Art Institute.
    Surrealism and its affinities. A109
    Index to art periodicals. A19
Rykwert, Joseph. H31

Saalman, Howard. J39, J56
Sachs, Eleanor B. P668
Sachs, Paul Joseph. N51
Sächsische Akademie der Wissenschaften zu Leipzig. F22
Sackler Collection. M533
Sacramentaires et les missels. Leroquais. M138
Sacred and legendary art. Jameson. F38
Sacred shrine. Hirn. F34
Saddrudin Collection. I180
Safford, Carleton L. P678
Saggi e memorie di storia dell'arte. Q312
Saggi e studi di storia dell'arte. R57
Saggi sulla architettura del rinascimento. Giovannoni. J237
Saggs, H. W. F. I76
Saglio, Edmond. E28
St. Louis and the court style in Gothic architecture. Branner. J159
Saints and their attributes. Roeder. F48
Sakanishi, Shio. H222
Sakonides. Rumpf. M58, M59
Sakrale Plastik. Fründt. K125
Saldern, Axel von. N28, P416, P601
Salerno, Luigi. G24, H68

Salet, Francis. P643
Salin, Édouard. I202
Salinger, Margaretta. M171
Salis, Arnold von. I226
Sallberg, Harald. N134
Salmi, Mario. H195, K166, M312
Salmony, Alfred. K241, P713
Salons. Diderot. H91
Saltillo, Miguel Lasso de la Vega y López de Tejeda, marqués del. E163
Salverte, François. P163
Salverte, Hubert de. P163
Salvini, Roberto. K5
Salzburger Malerei von den ersten Anfängen bis zur Blütezeit des romanischen Stils. Swarzenski. M242
Salzman, Louis Francis. J201
Sammlung Baron Eduard von der Heydt, Wein. Griessmaier, ed. Q349
Sampaio de Andrade, Arsénio de. E164
Samuel H. Kress Collection. M9, P21, P568
Samuel H. Kress Foundation. M9
Sánchez Cantón, F. J. H71, H213, I438, I455, L76
Sancho Corbacho, Heliodoro. H214
Sandars, Nancy K. I33
Sandler, Irving. K204, M509, M510
Sandler, Lucy Freeman. M249, Q233
Sandon, Henry. P329
Sandrart, Joachim von. H74
Sandri, Maria Grazia. J224
Sandström, Sven. N134
Sanfaçon, Roland. J165
Sanford, Trent Elwood. J258
Santangelo, Antonio. P675
Santaniello, A. E. H47
Santiago de Compostela. Palacio Gelmírez and the Cathedral/Museum. R21
Santos, Reynaldo dos. I456, K187
Sarcofagi cristiani antichi. Wilpert. K85
Sarmiento, Fray Martín. H213
Sasson, Jean-Pierre. M411
Satō, Masahiko. I550
Sauer, Joseph. J120
Sauerländer, Willibald. K118, K119
Saunders, O. Elfrida. M257
Savage, George. P26, P43, P277, P318
Sawa, Takaaki. I552
Saxa loquuntur: Steinereden. Weber. N61
Saxl, Fritz. I314, K144, M4
Sbornik materialov dli͡a istorii I. S.-Peterburgskoĭ akademii khudozhestv za 100 let. Petrov. I413
Scamozzi, Vincenzo. H75
Scandinavian archaeology. Shetelig & Falk. I433

597

Watches. Clutton & Daniels. P236
Watchmakers and clockmakers. Baillie. P233
Watchmakers and clockmakers of the world. Loomes. P239a
Watelet, Claude Henri de. E24
Water-colour painting in Britain, Hardie. M274
Waterer, J. W. P32
Waterhouse, Ellis K. M287, M372, M373, P19
Waterman, Thomas T. J337–J339
Watermarks in paper in Holland, England, France, etc. Churchill. N76
Watermarks, mainly of the 17th and 18th centuries. Heawood. N77
Waters, Clara (Erskine) Clement. E53, F56
Waters, Grant M. E100
Watkin, David. P184
Watney, Bernard. P335
Watrous, James. L24
Watson, Forbes. Q91
Watson, *Sir* Francis J. B. P31, P142a, P166, P170, P171
Watson, John. I52
Watson, Walter C. J295
Watson, William. I525, I526, K220, K236, P58
Wauchope, Robert. I611
Wayment, H. P434
Webb, Geoffrey Fairbank. J203
Webb, Glenn J. I558
Webber, Frederick Roth. F57
Weber, George W. K221
Weber, Ingrid. P569
Weber, Victor F. E182
Weber, Wilhelm. N61
Webster, Donald Blake. P40, P297
Webster, Mary. M247
Webster, Thomas Bertram Lonsdale. I114, M58
Wechsler, Herman J. N25
Wegner, Wolfgang. L68
Wehlte, Kurt. M48
Weigel, Rudolf. A55, N13
Weigert, Hans. I305
Weigert, Roger-Armand. N86, P305, P647, P648
Weihrauch, Hans R. K97
Weil, Stephen E. B5
Weilbach, Philip. E148
Weilbachs kunstnerleksikon. Bodelsen & Engelstoft, eds. E148
Weinreb, Benjamin. J3
Weinreb catalogues. Breman, comp. J3
Weisbach, W. I19
Weise, Georg. J296, K188, K189
Weismann, Elizabeth Wilder. K174
Weiss, Gustav. P409

Weitenkampf, Frank. N141, N144
Weitzmann, Kurt. K81, M84, M106–M108
Welch, Anthony. I180, M125
Welch, Stuart C. I545, M555
Welling, William. O56, O109
Welsh painters, engravers, sculptors. Rees. E96
Weltkunst. Q346
Wend, Johannes. N62
Wendingen. Q347
Wenham, Edward. P502
Wennberg, Bo Göte. M463
Wennervirta, Ludvig. I436, M464, M465
Werk/Archithese. Q348
Werk/Oeuvre. Q348
Werke niederländischer Meister in den Kirchen Italiens. Fokker. I380
Werkkataloge zur Kunst des 20. Jahrhunderts. Arntz, ed. A107
Werkstoffe und Techniken der Malerei. Wehlte. M48
Werner, A. E. A. I26a
Werner, Edward T. C. F71
Wesenberg, Rudolf. K133
Wessel, Klaus. E33, P446
West African weaving. Lamb. P684
Westdeutsches Jahrbuch für Kunstgeschichte. Q344
Western, Dominique Coulet. A180a
Western Asiatic jewellery. Maxwell-Hyslop. P595
Western European painting of the Renaissance. Mather. M146
Western Islamic architecture. Hoag. J39
Westheim, Paul. I366
Westlund, Per-Olaf. J276
Westwood, J. O. P72
Wethey, Harold E. J260
Weyerman, Jacob Campo. H129
Whalley, Irene. A47
What is art history? Roskill. G23
Wheel of fashion. Braun-Ronsdorf. P110
Wheeler, James. P142a
Wheelwright, Carolyn. M573
Whiffen, Marcus. J340
Whineray, B. B. P190
Whinney, Margaret Dickens. I313, K146, M413
White, Christopher. L38
White, D. Maxwell. L54
White, John. I358, M352
White, Katherine C. I597
White Pine series of architectural monographs. J324, Q283
Whitehead, Russell F. J324
Whitehill, Walter Muir. A167, J297
Whitfield, Roderick. M552
Whiting, Gertrude. P709

Whitley, William Thomas. I316–I318
Whitney Museum of American Art. K205
Whiton, Augustus S. P30
Whittick, Arnold. F19, J33, J140
Who's who among Japanese artists. E185
Who's who in American art. B1, E179
Who's who in art. E101
Who's who in modern Japanese prints. Blakemore. N146
Wichmann, Hans. A135
Wickberg, Nils Erik. J277
Wickhoff, Franz. I139, M11
Wiebenson, Dora. J56, J141
Wiener Beiträge zur Kunst- und Kulturgeschichte Asiens; Jahrbuch. Q349
Wiener Genesis. Wickhoff. Hartel, ed. I139
Wiener Jahrbuch für Kunstgeschichte. Q350
Wiener Keramik. Neuwirth. P315
Wiercińska, Janina. A157
Wilber, Donald Newton. J106
Wilcox, Ruth Turner. P102
Wild, J. P. P32
"Wild Beasts": Fauvism and its affinities. Elderfield. M201
Wilde, Johannes. L43, L60
Wildenstein, Daniel. H147, H148
Wildenstein, Georges. A72, H149, Q97
Wildenstein collection of illuminations — the Lombard school. Levi D'Ancona. R60
Wilder, Elizabeth. A148
Wilenski, Reginald Howard. M248, M398
Wiles, Bertha Harris. K171
Wilkins, Ruth S. P543
Wilkinson, Alix. P597
Wilkinson, Charles K. I78b, P295
Wilkinson, J. V. S. M113, M114
Willett, Frank. I592, I598, K253
Willetts, William. I527
Willey, Gordon R. I611, I631
William, Denis. K254
Williams, Charles Alfred Speed. F71a
Williams, Hermann Warner. M512
Williams, Iolo Aneurin. M288
Williamson, George Charles. E38, H45, M27
Williamson, Scott Graham. P56
Willigen, Adriaan van der. E134, M418
Willis, Robert. J204
Wills, Geoffrey. P422, P714
Wilm, Hubert. K134, K135
Wilman-Grabowska, H. de. F67
Wilmann, Preben. M458
Wilmerding, John. I489, M513

# Subject Index

This subject index complements the classification, as outlined in the table of contents. It brings together the literature according to country, region, culture, and period. It also provides a key to the books on major art movements.

Etchers. *See* Prints: printmakers
Etchings. *See* Prints: etchings
Ethiopia: manuscript painting, M139
Etruria
    architecture, J56, J83
    bibliography, A84
    cities, J67
    decorative and applied arts
        furniture, P150
        gold and silver, P473
        jewelry, P602–P603
    dictionaries and encyclopedias, E29,
        E30
    general histories, I18, I115, I122, I124,
        I129, I130, I132, I134
    painting, M75, M80, M81
    periodical, Q329
    sculpture, K26, K72
    series: monographic, R41
Exhibition catalogues: bibliography,
    A2, A9–A10, A17, A74, A111
Exhibition records. *See* subdivision
    "exhibition records" under indivi-
    dual countries
Expressionism
    bibliography, A113, A117, A134
    painting, M237
    prints, N94

Fauvism, I239, M201
Ferrara. *See* Italy: Cities and regions:
    Ferrara
Festschriften: bibliography, A48, A98
Finland
    architecture, J275, J277
    artists, E144
    general histories, I430, I435, I436
    painting, M458, M464, M465
Flemish art. *See* Belgium; Early Nether-
    landish art
Florence. *See* Italy: Cities and regions:
    Florence
Folk art. *See also* Japan: decorative
    and applied arts: folk art; Mexico:
    decorative and applied arts: folk
    art; United States: decorative and
    applied arts: folk art
    bibliography, A190
    ornament, P66a
Folklore: bibliography, A190
Fontainebleau, School of, I276, N89,
    M192
Forgeries: bibliography, A193
France
    architecture, H25, H26, H81, H105–
        H107, I290, J112, J115, J146–
        J170, J173, P41, P42
    architects, J147, J152
    dictionary of churches, J148

artists, E66–E69, E71–E81, E132,
    H82, H102, H132, H136, H137,
    H145–H147
bibliography, A119–A123, E73, P153,
    P482, P639, P647, P648, P687
collectors, E70
decorative and applied arts, P41
    clocks, P241–P246
    clockmakers, P243
    costume, P108
    embroidery and needlework, P647,
        P687
    enamels: Limoges, P448, P449,
        P482
    furniture, H94, P31, P38, P41, P45,
        P153–P171
        cabinetmakers, P44, P156, P159,
            P163
    glass, P414, P415, P434, P440, P441,
        Q126
    gold and silver, P482–P494
        gold- and silversmiths, P494
        hallmarks, P483, P484, P486,
            P489, P490, P492, P493
    ironwork, P19, P550–P553
    lace, P699
    medals and plaquettes, P566–P569
    pewter, P582
    pottery and porcelain, P31, P298–
        P306, Q126
    rugs and carpets, P612, P613
    tapestries, P639, P640, P647, P648
    textiles, P670
drawings, L2, L11, L13, L16, L26–
    L29, L37
exhibition catalogues: Paris Salon,
    H137, H146
general histories and handbooks,
    I272–I291
inventories: topographical, A120,
    I280, J150, J151, P639
museums, B15
painting, H146, M170–M215, M428
    painters, M197, M428
periodicals, H131, H144, Q22, Q48
    (Alsace), Q59, Q64, Q77, Q89,
    Q103, Q118, Q119, Q126, Q135,
    Q172, Q241, Q289, Q297, Q320,
    Q321
photography, O70–O73
portraits, M198, N84
prints, N2, N23, N39, N58, N78–N89
sculpture, J164, K91, K108–K121,
    M197
    sculptors, K115, P44
sources and documents, H7, H18,
    H20, H25, H26, H38, H58, H61,
    H62, H81, H82, H91, H94, H102,
    H106, H113, H114, H131–H149,
    I279, M210, Q320

archives: guide, A119
stained glass, P434, P440, P441
Friuli. *See* Italy: Cities and regions:
    Friuli
Furniture. *See also* subdivision "furni-
    ture" under individual countries
    bibliography, Q173
    dictionaries and encyclopedias, P136,
        P137, P141, P177
    general histories and handbooks,
        P138–P140, P142–P148
    periodical, Q173
Futurism
    bibliography, A106
    histories, I240, I343
    painting, M354, M358

Galicia. *See* Spain: Cities and regions:
    Galicia
Gallo-Roman art and archaeology
    histories and inventories, I125, I140,
        I142
    mosaics, M95
    sculpture, K66
Gems. *See also* subdivision "gems and
    jewelry" under individual countries
    and regions
    general works, P465, P584–P589
Genoa. *See* Italy: Cities and regions:
    Genoa and Liguria
Germano-Roman art: inventory of mo-
    saics, M94
Germany
    architecture, I296, J115, J118, J171–
        J176
    artists, E82–E85, E88–E90, H93, H98
    bibliography, A124, A126–A135, P687
    decorative and applied arts, P46
        clocks, P235, P247
        costume, F28
        embroidery and needlework, P687,
            P695
        furniture, P172; P173
        glass, P400, P408, P416, P417, P434
        gold and silver, I292, P495–P499
        jewelry, P604
        medals and plaquettes, P563, P566,
            P569
        pewter, P576, P583
        pottery and porcelain, P19, P307–
            P309, P311–P314, P316–P319
        tapestries, P634, P635, P649
        textiles, P671
    dictionary, E87
    drawings, L1, L2, L11, L13, L18, L31,
        L32, L34–L37
    general histories and handbooks,
        I210, I216, I223, I292–I296, I298,
        I300, I303–I305

porcelain, P351
watches, P251d
drawings, L1, L2, L31, L36, L77
general histories, I216, I460–I463
inventories: topographical, I462
museums, B17, B19
painting, M236, M239, M483–M486
periodicals, Q313, Q355
photography, O93
prints, N136
sculpture, K190
series: monographic, R11, R14
sources, H7, H151, H152
**Symbolism in art.** *See also* Iconography
bibliography, F1
dictionaries, F2–F7, F11, F14
general histories and handbooks, F8, F18, F19
periodicals, F1 (note)
**Symbolist movement**
bibliography, A105
painting, M159
**Synthetism,** M163
**Syria and Lebanon.** *See also* Dura-Europos
history, I79b
periodicals, Q106, Q332

**Tapestries**
bibliography, P631, P647
general histories, handbooks, collections, P632–P646
techniques, P639
**Techniques.** *See also* Conservation and restoration; and subdivision "techniques" under specific media
dictionary, E11
general histories and handbooks, I26, I26a
sources, H17, H19
**Textiles.** *See also* subdivision "textiles" under individual countries, regions, and periods
bibliography, P654
collections, P663
encyclopedia, P657
general histories and handbooks, P655–P664
periodicals, P660, P661 (note)
techniques, P654, P655, P660
**Thailand**
bibliography, A176
general histories, I571, I573
painting, M581
sculpture, K237, K239
**Theory.** *See* Art theory
**Tibet**
general histories, I492, I540, I541
iconography, F61, I540
painting, M518

**Tunisia**
architecture, J100, J102
mosaics, M88
**Turin.** *See* Italy: Cities and regions: Piedmont
**Turkey.** *See also* Anatolia
architecture, J298–J300
general histories and handbooks, I464–I466
painting, M118–M121, M515
**Tuscany.** *See* Italy: Cities and regions: Tuscany
**Twentieth-century art.** Only general works are listed here. *See also* individual countries, and specific movements, e.g., Cubism
architecture, J39, J43, J52, J126–J131, J133–J140, J142
artists, E40, E48, E52, E56
bibliography, A68, A100–A103, A106, A107, A109–A113, A116–A117, J126
decorative and applied arts, P37
costume, P110, P111
glass, P392, P396, P404
tapestry, P640
drawings, N51
histories, handbooks, exhibitions, I235–I241, I243–I245, I247, I256, I257, I259, I260, I262
recurrent exhibitions, R37, R75
painting, I239, I240, M149, M150, M153, M154, M160
painters, M150, M152–M153
photography, O57–O67
photographers, O10, O12, O13, O17
prints, N19, N24, N25, N51, N57
sculpture, K98–K105, K107
sculptors, K104
sources, I238–I240

**Umbria.** *See* Italy: Cities and regions: Umbria
**Union of South Africa:** artists, E149
**Union of Soviet Socialist Republics.** *See* Russia
**United States.** *See also* Indians of North America
architecture, I482, J301–J341
architects, J4, J303–J304, J341
architectural firms, J328b
art organizations, B1
art dealers and galleries, B6, B11
artists, E173–E179, I473
Afro-American artists, E170
women artists, E171
bibliography, A50, A56, A164–A167, J11, J301–J303a, J313, K191, M487, N5
decorative and applied arts, I469, I471, P52–P56

antiques, P54
clocks and clockmakers, P252, P252a
copper and brass, P462
costume, P128–P130
embroidery and needlework, P678, P689, P692
folk art, I478, I479, K194, K196, K197, M491, P52, P55
furniture, J314, P212–P227
cabinetmakers, P213
glass, P427–P431
ironwork, P559, P560
jewelry, P586
pewter, P573, P577–P580
pottery and porcelain, P353
marks, P352, P354
silver, P470, P501, P534–P542
hallmarks, P536–P540
textiles, P672, P677
drawings, I488, J322, L11, L79–L82
encyclopedia, E169
exhibition records, I472, I483, I488
general histories and handbooks, I467–I489
libraries, B3
museums, B12, B14
painting, M487–M513
indexes to reproductions, D8, D12
inventory of paintings, M511
painters, M511
Mexican-American painters, M511
periodicals, Q14–Q17, Q49, Q68, Q187, Q260, Q278, Q351
photography, O94–O109
prints, N5, N106, N137–N144
sculpture, K191–K205
sources and documents, A165, H6, Q49
**Urartian art.** *See* Anatolia
**Urbino.** *See* Italy: Cities and regions: Urbino
**Uruguay:** painting, M378

**Valencia.** *See* Spain: Cities and regions: Valencia
**Vase painting.** *See* Greece: painting
**Venezuela:** painting, M375
**Venice.** *See* Italy: Cities and regions: Venice
**Vercelli.** *See* Italy: Cities and regions: Vercelli
**Vernacular architecture:** bibliography, J177
**Verona.** *See* Italy: Cities and regions: Verona
**Vietnam,** I573
**Viking art**
gold, P530
histories, I433, I437

Designed by John Grandits
Composed by Linguatype, Chicago, in Alphatype Times
  Roman with Optima display type
Printed on 50-pound Warren's Olde Style, a pH neutral
  stock, by Chicago Press Corporation
Bound by Zonne Bookbinders, Inc.